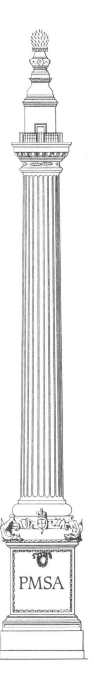

Public Sculpture of Greater Manch.

Public Monuments and Sculpture Association
National Recording Project

Public Sculpture of Britain Volume Eight

PUBLIC
SCULPTURE OF
GREATER
MANCHESTER

Terry Wyke
with Harry Cocks

Manchester
Metropolitan
University

LIVERPOOL UNIVERSITY PRESS

First published 2004 by LIVERPOOL UNIVERSITY PRESS,
Liverpool, L69 7ZU

HERITAGE LOTTERY FUND

The National Recording Project is supported by the
National Lottery through the Heritage Lottery Fund

Copyright © 2004
Public Monuments and Sculpture Association

The right of Terry Wyke and Harry Cocks to be
identified as the authors of this work has been
asserted by them in accordance with the
Copyright, Design and Patents Act 1988

British Library Cataloguing-in-Publication Data
A British Library CIP record is available

ISBN 0-85323-557-0 (cased)
ISBN 0-85323-567-8 (paper)

Design and production, Janet Allan

Typeset in 9/11pt Stempel Garamond
by XL Publishing Services, Tiverton, Devon
Originated, printed and bound in Great Britain by
Henry Ling Ltd, Dorchester

SUPPORTED BY
·A·G·M·A·
ASSOCIATION OF
GREATER MANCHESTER
AUTHORITIES.

Preface

This is the eighth volume in a series, the *Public Sculpture of Britain*, which will eventually extend to the whole of Britain. Already many of the major commercial and industrial cities of northern and central Britain, Liverpool, Birmingham, Newcastle, Glasgow, Coventry, Leicester, and now the Greater Manchester area, have been covered. They prospered above all in the mid- and later nineteenth century just when monuments and sculpture first appeared in large numbers in British streets, and they can be seen, with London, as the heartland of British public sculpture. In Manchester, Piccadilly and Albert Square contain superb displays of statues to local and national great men, which reach their climax inside Alfred Waterhouse's magnificent town hall. There statues of Joule by Alfred Gilbert and of Dalton by Francis Chantrey face each other in the vestibule, with the two famous Manchester scientists seated, brooding on their discoveries. The statues of Humphrey Chetham by William Theed and of Thomas Fleming by E.H. Baily in Manchester Cathedral are part of this series of monuments to great Manchester figures. In 1846 Salford's Peel Park was one of the first public parks in Britain, and it soon displayed one of the first groups of public statues erected in Britain. Bolton has a notable statue of Samuel Crompton, the inventor of the spinning mule, by William Calder Marshall, who also provided the sculpture on the town hall. Harry Bates's relief in Manchester University's Council Chamber, *Socrates Teaching the People in the Agora*, represents perfectly the populist ethos of the new redbrick universities including Manchester. It is also one of the most significant examples of the 'New Sculpture'. From the twentieth century there are Eric Gill's touching relief on Manchester Cathedral, *St Mary, St Denys, St George and the Christ Child*, and Barbara Hepworth's abstract *Two Forms (Divided Circle)* in Bolton. The Irwell Sculpture Trail, begun in 1997, is one of the most ambitious contemporary public art programmes in Britain. Public art in Greater Manchester is perhaps best known through Ford Madox Brown's great murals in Manchester town hall with their highly imaginative and original pictorial account of the growth of the city. This volume demonstrates that there is public sculpture throughout the area of comparable quality and inventiveness.

All the volumes in this series so far have been written by art historians, representing a discipline now well established in many British universities and colleges. The author of this volume, Terry Wyke, belongs to a rather different tradition. He is a lecturer in social and economic history in Manchester Metropolitan University's Department of History and Economic History, with a special interest in cultural history. He has worked for over 25 years on the social and cultural history of the Manchester region. He is one of the leading historians of the area and has served for many years as editor of the *Manchester Region History Review* and of the *Bibliography of North West England*. In the cultural sphere he has published on Manchester's novelists, cartoonists, theatres, public buildings, churches and book trade, as well as on its public sculpture. In this volume he has been greatly assisted by Harry Cocks of Birkbeck College, London University, who shares his interest in Manchester's art and culture. The study of public art demands above all a deep consideration of the role of the artist within society, and Terry Wyke's interdisciplinary qualifications and abilities make this book a classic account of the social, political and cultural function of sculpture.

The *Public Sculpture of Britain* is the work of the Public Monuments and Sculpture Association, which was founded in 1991 to encourage both the study and the protection of public sculpture and monuments. The Association believes that the publication of intensive research into the commissioning, execution and reception of public sculpture will both justify policies of conservation and increase general awareness of these important works of art, which are so familiar along our streets and so significant a part of our history and heritage. The Association of Greater Manchester Authorities, the Paul Mellon Centre for Studies in British Art, and the Henry Moore Foundation all gave generous grants towards the publication of this volume. Liverpool University Press, particularly publisher Robin Bloxsidge and designer Janet Allan, have lavished their unstinted support and cooperation in the production of all the volumes, and the Editorial Board is immensely grateful to them.

EDWARD MORRIS
Chairman of the Editorial Board

Contents

Introduction

During a visit to Manchester the American travel writer, Bill Bryson, stood in Albert Square and wondered about its statues. Who were these bronze and marble figures, all frock coats and mutton chops? Bryson could not identify any of these worthies and, on this occasion, his usual curiosity went no further.[1] This volume does go further. Its aim is the seemingly simple one of identifying and recording the public sculpture of Greater Manchester. It is based on research undertaken for the National Recording Project organised by the Public Monuments and Sculpture Association. The National Recording Project was established in 1993 with the ambitious goal of identifying, recording and creating a database for all public sculpture in Britain. Ten years later the database exceeds 9,000 entries and seven volumes have been published on public sculpture in different cities and areas of England and Scotland. It is an impressive achievement in a short space of time, but with an estimated 15,000 works of public sculpture in Britain, much remains to be done.

Readers will appreciate that such a project raises many definitional and practical issues. In a catalogue of the public sculpture of Greater Manchester all of the key terms – public, sculpture and Greater Manchester – are problematic. It will be helpful to users of this volume to identify its scope, omissions and limitations.

Geographical Area

The area covered in this study is Greater Manchester; that is, the district administered by the Greater Manchester Metropolitan Council between 1974 and 1986. It comprises ten unitary authorities: Bolton Metropolitan Borough, Bury Metropolitan Borough, City of Manchester, Oldham Metropolitan Borough, Rochdale Metropolitan Borough, City of Salford, Stockport Metropolitan Borough, Tameside Metropolitan Borough, Trafford Metropolitan Borough and Wigan Metropolitan Borough. It covers an area of 128,584 hectares and in 2001 contained a population of almost 2.5 million. To those people who are more familiar with the older county boundaries, the area represents most of what was south-east Lancashire and parts of north Cheshire, north-west Derbyshire and the West Riding of Yorkshire.

It includes some of the largest cities and towns in north-west England, communities that read like a roll call of those involved in the industrial revolution. Manchester was at the epicentre of that revolution. For centuries Manchester was an important market town, but it was industrialisation that transformed it into one of Britain's dominant industrial and commercial cities. The expansion of industry, especially cotton, underpinned these changes, and was also responsible for the growth of neighbouring communities: Bolton, Bury, Oldham, Rochdale, Stockport, Wigan. Manchester was, and remains, at the centre of this conurbation. It would have been possible to produce a single volume on the city of Manchester alone, but in the time available for this survey it was believed that a larger study area would allow the identification of a more diverse range of public sculpture, revealing different patterns of commissioning and patronage, different attitudes towards the processes surrounding memorialisation and the sculptures and monuments produced. In what ways would the history of public sculpture in Bolton be different from that in Bury or Oldham? Tempting as it is to regard these satellite towns as sharing a common history, their similarities are frequently superficial. This extension of the geographical boundary has meant that the detail provided for some entries has been reduced, but this has been offset by the increased breadth of the area studied. It should also be understood that, although Greater Manchester may appear to be a coherent region, it is essentially a boundary of convenience. The inclusion of Blackburn and Preston, for example, would have added to our understanding of the patterns of public sculpture in the economic region that used to be referred to as 'Textile Lancashire'.

Public Sculpture

Constructing a definition of public sculpture is not a simple matter. Both terms, public and sculpture, raise difficult conceptual issues, and translating them into practical working definitions is not as straightforward as one might assume. Our principal concern has been to identify sculpture which is accessible to the general public or visible from the public highway. For the majority of entries these criteria raise few problems, but those who set out to visit particular sculptures should keep in mind that works which are visible from a public road can be located on private property. We have also had to give special consideration to works located in hospitals and educational institutions – places where the security considerations of patients and students are now a matter of great importance. In dealing with these institutions we have generally restricted ourselves to identifying works visible from the public highway.

Although the principal focus is on outdoor sculpture we have also included, because of their historical significance, works located inside a number of public buildings. Sculpture displayed inside the region's town halls is included in this category. To have omitted, for example, the statuary in Manchester Town Hall – including Chantrey's *Dalton* and Gilbert's *Joule* – would have considerably reduced the usefulness and pleasure of consulting this volume.

Ecclesiastical monuments and sculpture have been generally excluded from the National Recording Project but in this volume we have noted the existence of certain sculpture in churches, for example commemorative statues in Manchester Cathedral. These are works which would certainly have been recorded had they been located outdoors. But it is important to note that, crucial as the church is for understanding the wider processes of public memorialisation – one need only consider the subject of commemorative stained glass – this volume is not a catalogue of ecclesiastical sculpture. It should be noted that the related and even larger subject of sepulchral sculpture is not part of the National Recording Project. In this volume we have paused on occasion to note the existence of important public, as distinct from family, monuments in churchyards and cemeteries.

In short, this survey is principally concerned with identifying the significant examples of secular public sculpture in Greater Manchester. This has meant focusing on a number of different categories of sculpture, the main ones being portrait statues and busts, architectural sculpture, war memorials with statuary, modern public sculpture and public art. We have also recognised, however, other forms of public monument such as obelisks, drinking fountains, crosses and towers. Sculptural considerations have been the deciding factor in the selection of each entry but we have been aware that in some communities certain non-sculptural works are recognised as important public monuments.

Portrait Statues

Larger-than-life-size portrait statues, usually surmounting stone pedestals inscribed with details of the individual commemorated, represent one of the most identifiable forms of public sculpture. Although the idea of raising a commemorative statue was discussed as early as 1675 in Manchester, no public statue was commissioned until the nineteenth century.[2] In fact, Manchester lagged behind other major provincial towns in acquiring such monuments. The town's first free-standing public statue dates from 1838. Chantrey's marble statue of the scientist, John Dalton, was unusual in two respects: firstly, it honoured a living person, and, secondly, it was protected from the town's already notoriously smoky atmosphere, and from the majority of its inhabitants, by being exhibited inside Charles Barry's Royal Manchester Institution.

It was the great wave of public commemoration following the death of Sir Robert Peel in 1850 that proved the decisive event in the history of public statuary in the region. Manchester, Salford and Bury were among the Lancashire towns that raised outdoor statues. Commemorative statues to other national figures and local worthies followed in Manchester and Salford. Salford rapidly developed a major collection of marble and bronze statues in the grounds of Peel Park. In the smaller cotton towns the outdoor public statue arrived later: in Bolton in 1862, Oldham in 1868, Rochdale in 1878, Stockport in 1886, Ashton-under-Lyne in 1887

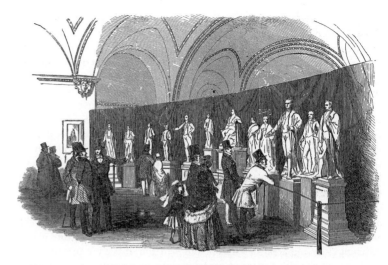

Exhibition of models for Peel statue, Bury, 1850

and Wigan in 1910. Most memorialised either national or local worthies. Oldham's first statue honoured Joseph Howarth, the town's blind bellman, a reminder that not all statues were raised to municipal politicians or philanthropists. Indeed, in trying to relate these acts of public commemoration to the key values and aspirations represented in Victorian Manchester it is noteworthy that the city did not erect a single statue to any of the great entrepreneurs or to even one of the textile inventors, without whom Manchester would not have become Cottonopolis. The small number of public monuments raised to individual women, excepting royalty, is less surprising, mirroring their position in Victorian and Edwardian society. Prominent in a short list are John Cassidy's statue of Mrs Rylands, who was to be placed looking towards her husband in the library she built in his memory, and the memorial fountain honouring Sarah Lees in Oldham.

Statues were more than simple acts of memorialisation, honouring a respected individual. They involved ideological, aesthetic, cultural and political agendas. Supporters of free trade, for example, were prominent in commissioning statues to proclaim their economic creed. The placing of the statues of three living Liberal politicians – Gladstone, Bright and Villiers – in Manchester Town Hall was a political act, declaring that their new municipal palace was but a Gothic extension of the city's other great public building, the Free Trade Hall. And such political expression was not confined to the Liberals. In Bolton the Conservatives set about memorialising Disraeli, whilst in Wigan the monuments raised to local MPs, including Sir Francis Sharp Powell, meant that unveiling ceremonies took on the tenor of political meetings despite claims to the contrary.

Statues were also part of the aesthetic of the industrial town, a response to the ugliness of the Coketowns of the industrial revolution. The creation of civic spaces, in which the portrait statue was a defining element, was an important part of the making of the Victorian city: a counter to those who believed that the beautiful and the ornamental could not take root in utilitarian soil.

It is important not to exaggerate the number of public statues erected in the region. Arguments about the appropriateness of providing practical memorials rather than raising a public statue were common throughout the Victorian period. Such debates were resolved increasingly in favour of the 'living' memorial. Impressive as Onslow Ford's *Queen Victoria* is as a public monument in the centre of the Piccadilly Esplanade in Manchester, examination of the region's response to the Diamond Jubilee reveals the greater importance of subscription lists opened to establish nursing homes, hospital beds, scholarships and the rest. Manchester also erected a statue in memory of Edward VII, but it was the gift of a private individual. No such tribute was extended to either George V or George VI.

The prevailing mood turned against portrait statuary. Commemorative statues, even when erected within living memory, began to be regarded as eyesores. Whatever civic ideals or lessons of municipal or national history these monuments represented, it was widely felt that they would be better removed to the municipal park. Such attitudes remained prevalent throughout the twentieth century, although the closing decades did witness the commissioning of a number of portrait statues. Significantly

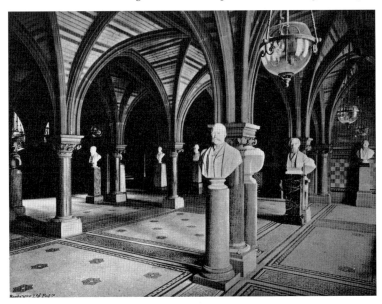

Sculpture Hall, Manchester Town Hall, c. 1895

none honoured recent politicians or civic leaders, but rather sportsmen, including the cyclist, Reg Harris, and Manchester United's manager, Sir Matt Busby.

Portrait Busts

The public commissioning of portrait busts was closely related to that of statues, and in this survey we have included a number of such busts. Outdoor monuments such as John Cassidy's bust of James Prescott Joule in Worthington Park, Sale, would have been included automatically in the catalogue, but we have also identified portrait busts located inside certain public buildings. In particular, we have focused on the region's town halls. Manchester has by far the largest collection. Busts were an important part of the process of public commemoration in both the nineteenth and twentieth centuries. Councils did not usually have a policy for commemorating local worthies, but relied on busts being presented by memorial committees or individuals. Thomas Bayley Potter, Liberal MP and mainstay of the Cobden Club, appears to have been a particularly enthusiastic donor of political busts. It is important to distinguish busts presented in this way from those acquired as the gift of the family, in some cases years after the individual commemorated had died. To display a bust of Richard Cobden in Rochdale Town Hall or of Oliver Cromwell in Manchester Town Hall was more than a simple act of public commemoration. We have concentrated on the town halls but note should be made of busts to be found in other public institutions, including libraries, hospitals and universities as well as private businesses such as banks. We should also remind ourselves that, as was also the case with statues, support could be given for a bust that would not be displayed locally. A 'colossal bust' of Lord Shaftesbury (by Matthew Noble) presented to him by Lancashire trade unionists as a tribute to his efforts to improve their working conditions, is a case in point.[3] A fuller study is necessary to do justice to the place of the portrait bust in the culture of public memorialisation in the Greater Manchester region.

Architectural Sculpture

Selecting which works of architectural sculpture to include in this survey has proved difficult, as one might expect in communities that came of age in the Victorian and Edwardian periods. In towns where there is an abundance of two- and three-dimensional decorative ornament, it was not possible to identify every building embellished with a fancy keystone or florid carved panel. We have chosen to concentrate on the larger, original works of architectural sculpture rather than on the more modest and mass-produced decoration. Inevitably, this has meant excluding many buildings which have decorative flourishes, but we believe it was more important to examine in greater detail the sculptural schemes enriching

buildings such as Bolton Town Hall and Bury Art Gallery and Library. Public buildings feature heavily in this listing.

The inclusion of architectural sculpture was almost always a contested area in the commissioning and building of municipal buildings. Civic grandeur, as George Ashworth pointed out at the opening of Rochdale Town Hall, cost money, and it was money that many citizens were unwilling to spend. Economy-minded councillors thumped their fists when the subject of ornamental sculpture came up in discussions on municipal buildings. In many cases the result was that the architect's vision was never fully realised. Designs were modified: tympanums remained blank, niches were left empty. Occasionally, as in the case of Rochdale Art Gallery, publicly spirited individuals might be found who were willing to provide the funds to complete a decorative scheme. But such economies did not always apply either to public or to private buildings. John Thomas's marble essay in liberal political economy on Walters's Free Trade Hall – architectural sculpture as frozen economics – is a reminder that purses could be opened as well as closed. Alfred Waterhouse was responsible for two of the region's most important buildings featuring major schemes of architectural sculpture: Manchester Assize Courts and Manchester Town Hall. The former has not survived but sufficient sculpture was saved to underline its claim to be one of the great lost Victorian buildings. Waterhouse was also to be influential in encouraging the use of terracotta for architectural decoration, a material that particularly suited smoky industrial environments.[4] George Willoughby and Harry Fairhurst were among the Manchester architects who were to exploit terracotta's decorative potential.[5]

The piecemeal redevelopment of town centres was one feature of the urban growth associated with industrialisation. It posed a threat to existing monuments, most notably in the removal of market crosses, those most public of a community's monuments associated with its rituals and ceremonies.[6] Architectural sculpture also felt the forces of progress. In some instances, such sculpture might be saved: the façade of Manchester's first town hall was not demolished but removed to the relative safety of Heaton Park, an act of architectural preservation that secured the survival of two of the city's oldest outdoor statues. In other cases, such as the Royal Cotton Exchange, determining the fate of the sculptural decoration removed during its various rebuildings has proved a more difficult task. Although many of the important commissions for architectural sculpture went to London firms, the demand was sufficient to provide work for a number of local firms, some of whom were to establish reputations outside the region.

Obelisks

The obelisk, usually in the form of a polished column on a pedestal, was another type of outdoor public monument that became popular in the Victorian period. Some included sculptural decoration, and we have focused on these in this survey. In some public memorial schemes, obelisks were the preferred form of commemoration; in other cases they were chosen because funds were insufficient to commission even a cheap stone statue. Obelisks were raised in memory of philanthropists, doctors, clergy, working-class radicals and trade unionists. John Grundy of Tyldesley, for example, was remembered by a grateful congregation for devising a more practical form of church heating.[7] Salford raised an obelisk to Mark Addy, a swimmer who had saved many people from drowning in the River Irwell. The obelisks memorialising Henry Hunt in Manchester, Samuel Bamford in Middleton and Joseph Rayner Stephens in Ashton-under-Lyne were used both to remember and to further political causes. In the Wigan district, as in other coal-mining areas, the obelisk served as a public memorial, raised to the men and boys who had lost their lives in mining disasters. Many of these public monuments were located in cemeteries, but they also occupied positions in parks and other public spaces.

Fountains

Further types of public monument favoured by the Victorians were the ornamental fountain and the drinking fountain.[8] Many drinking fountains were plain, utilitarian pieces of street furniture and, as such, are outside the concerns of this volume. Our focus is on those fountains with sculptural features. In smaller communities a drinking fountain, usually installed in a prominent location, was, in the absence of an ancient cross and before the raising of a war memorial, often the only public monument. Some fountains honoured individuals. Public subscriptions were sometimes sufficient to provide elaborate examples, as in the case of the fountains erected in memory of Robert Ockleston in Cheadle and Walter Ramsden in Dobcross. Both Ockleston and Ramsden were doctors, a profession that features frequently in local memorials. Some of the more ornate fountains, as in Bury and Manchester, were gifts to the community from individuals. Ellen Mackinnon presented Rochdale with an Angel fountain, carved by Francis Williamson, in memory of her mother. Rochdale was also one of a number of Lancashire towns that had fountains presented by the local co-operative society, usually to mark a municipal anniversary. Temperance sentiments were attached to such monuments, though the participation of local temperance societies is not always evident in such schemes. During the twentieth century both ornamental and drinking fountains have suffered from neglect. Some have been removed from their original location, others have been abandoned, left to deteriorate. The restoration of the region's Victorian parks, which began in the 1990s, has given new life to some of the region's larger fountains. Manchester was unusual in that it decided to restore and return to the city centre the fountain given to mark Victoria's Diamond Jubilee, which an earlier generation had removed from Albert Square to Heaton Park.

Towers

A number of the region's most conspicuous types of public monument take the form of stone towers, located on prominent hillsides. Although the sculptural detail on these structures is often minor, it was decided to include them in this survey. Such structures often claimed long histories as beacon sites, though the historical record is frequently thin. They were also subject to rebuilding, occasions when they acquired new historical associations.[9] The Peel Tower in Holcombe may be an exception to this pattern, having been built on an entirely new site. It was, as its name suggests, one of the Lancashire memorials raised in memory of Sir Robert Peel. If most towers were architecturally plain, this was certainly not the case with the Ellesmere Memorial Tower at Worsley. It would have borne comparison with any of the more extravagant and ornate observation towers erected by the Victorians. Its present condition provides little sense of what was one of the region's most imposing monuments. Observation towers on publicly accessible land became popular destinations, attracting many hundreds of visitors on Sundays and holidays. Their often remote location, however, made them vulnerable to vandalism. The deliberate damaging of such monuments, as the eighteenth-century tablet set into Hartshead Pike testifies, has its own long history.[10]

War Memorials

War memorials represent an obvious form of public monument and in some communities the war memorial is often regarded as the only public monument. This survey does not identify all war memorials as it is principally concerned with those outdoor memorials which feature significant sculptural decoration, particularly figurative sculpture. These represent a tiny fraction of the region's war memorials. The Imperial War Museum's UK National Inventory of War Memorials will eventually provide a definitive listing of all the country's war memorials.[11]

Although memorials such as the Tyldesley Monument in Wigan are a reminder that the public memorialisation of war began long before the twentieth century, the first main group of war memorials identified in this catalogue are those which commemorate the soldiers, many of whom were volunteers, who served and died in the South African War.[12] These include major regimental memorials in Bury, Manchester and Salford, all exuding feelings of pride and patriotism through representations of the ordinary fighting soldier. Wigan selected William Goscombe John to sculpt its memorial, also of a soldier in battle. Most South African War memorials, however, took the form of more prosaic plaques and tablets displayed in a public place. Institutions, such as Manchester University and Manchester Grammar School, also unveiled memorials in honour of students and staff who had taken part in the conflict.[13]

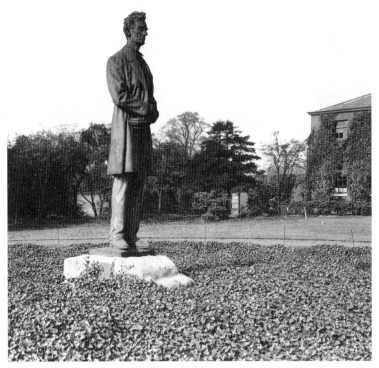

Abraham Lincoln in Platt Fields, Manchester

It was the First World War that saw the greatest number of memorials raised by communities, monuments to all those 'Owdham Toms, Salford Jacks and Bowton Bobs' who did not return from the fighting.[14] These monuments to the Absent Dead became the central public symbol of the conflict and the sacrifice, surrogate graves for those in mourning.[15] The culture of memorialisation began with street shrines and rolls of honour, some erected at the same time as new recruits were still leaving to fight. After the war, most communities determined to erect a formal monument in a public space, and, as was the case with Victorian statue committees, the business of raising a war memorial had many common features – the first public meeting, the election of a memorial committee, the canvassing for funds, the selection of the design and site, the organisation of the unveiling ceremony – regardless of the size of the community. A closer examination, however, indicates important differences between communities. Some were quick to set about organising a memorial and some were clearly more skilful than others in collecting funds, a task that became more difficult following the end of the post-war boom. The form

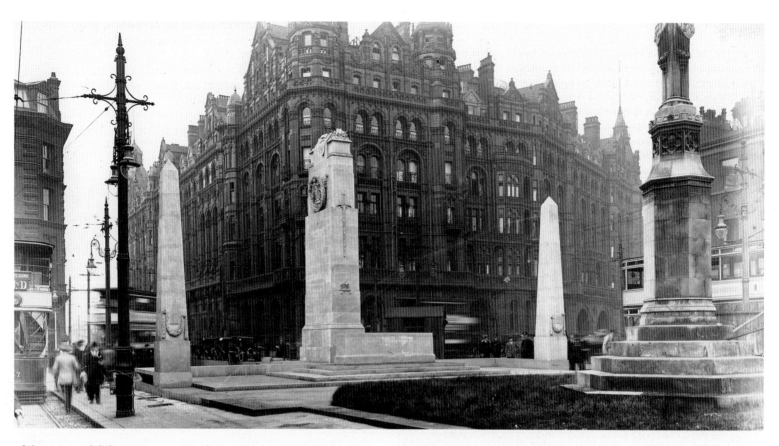

St Peter's Square, 1923, showing Lutyens's Cenotaph and lower part of Temple Moore's St Peter's Cross

of the memorial did not go uncontested in communities. Public debates indicate that there was support for providing more practical memorials: a village hall, cottage hospital, playing fields and, most commonly, education scholarships for the children of dead soldiers. Bury was one town which eventually provided a number of public memorials, including a children's hospital ward.[16] In Manchester and Oldham the question of the location of the memorial became an especially contentious issue. In the selection of sculptor and/or architect there was some preference shown to local artists, or to those who, such as Ferdinand Blundstone at Stalybridge, could demonstrate local connections. But, as in the nineteenth century, the more prestigious projects usually went to London-based sculptors. The all-important unveiling ceremony also echoed the Victorians in that it could become more than an act of public remembrance and dedication. The ideas expressed on such occasions altered over time, just as the sentiments depicted in Frederick Wilcoxson's Hale war memorial were far removed from those expressed in John Ashton Floyd's memorial to the postal workers of Manchester. The

majority of the principal community memorials were located outdoors. An important exception was to be found in Stockport, where Gilbert Ledward's white marble *Britannia* filled Theo Halliday's impressive Hall of Memory.

Numerous war memorials were also raised in churches, schools, railway stations, shops, offices and factories. They were usually modest in design. A powerful exception was Charles Sargeant Jagger's *The Sentry*, commissioned for the workers in S. and J. Watts's Manchester warehouse, a work which ranks in artistic terms as one of the most important in the region. Fortunately, unlike a large number of company memorials, it remains in its original location.

New memorials were not generally commissioned to mark the Second World War, communities deciding simply to add the details of the conflict and the names of the dead to the existing memorial.

Modern Sculpture

In spite of the unveiling in 1919 of one of the region's most important portrait statues, George Grey Barnard's *Abraham Lincoln*, the dislike of 'coat-and-trousers' commemorative statues, already evident before the First World War, deepened in the inter-war years. City-centre statues were discussed as public eyesores rather than civic monuments. These were years in which, leaving aside the war memorials, little new outdoor public sculpture was to be commissioned. Changes in architectural tastes also favoured plainer buildings in which sculptural ornamentation was subdued. Architectural sculpture did, however, continue to be commissioned. Some work – *Neptune* on Fairhurst's Ship Canal House – looked back to an earlier tradition, whilst other commissions – Eric Gill's carving for Manchester Cathedral's new choir school – were distinctively modern. Vincent Harris's extension for Manchester Town Hall epitomised the shift in attitudes that had occurred. Unlike its Gothic neighbour, it included only two statues, both of which were placed far above street level.

A general suspicion continued to surround modern sculpture after the Second World War. Manchester City Council's unwillingness in 1954 to purchase one of Henry Moore's sculptures, even at an advantageous price, was a decision that would have been echoed in many British towns.[17] Commissions involving modern abstract sculpture found comparatively little support. The decision to commission Elisabeth Frink to provide a sculpture for Manchester's new airport terminal was a bold one, but one that was criticised at every stage. It was clear that the majority of people would have been happier with a copy of William McMillan's more conventional bronze study of Alcock and Brown than with an aluminium flying man. Initiatives to install works of modern sculpture in some of the region's new schools prompted a chorus of criticisms. People strained to find the aesthetic criteria to judge such works; there was no simple standard such as the 'good likeness' which had been available to the Victorians when assessing the portrait statue.

This did not mean that any more notice was taken of Victorian statuary. Some city-centre monuments found themselves removed to suburban public parks, but, wherever they were located, almost all outdoor sculpture suffered from inadequate cleaning and fitful maintenance. In Salford the council removed a number of their major statues from Peel Park to make way for an extension of the technical college, but instead of restoring and relocating them, they were placed in store and eventually sold to a private individual. But these were not the only losses: the closure of churchyards and cemeteries resulted in the destruction or disappearance of a number of public monuments.

The expansion of higher and further education which began in the 1950s provided the opportunity for commissioning new works, particularly architectural sculpture. At the University of Manchester, which displayed a number of important commemorative busts, the majority of which had been acquired before the First World War, architectural sculpture featured on a number of buildings erected in the boom of the 1960s. The courtyard of Salford's new technical college was filled with one of William Mitchell's concrete sculptures, but such sculpture was usually an afterthought. It was only in later years, and then only at the University of Manchester Institute of Science and Technology

The carving of Archimedes, Tom Dagnall, 1989

(UMIST), that free-standing outdoor sculpture was to have a definite and coherent presence on any of the campuses of the region's four universities.

It would be easy to exaggerate the extent of new outdoor sculpture. As late as 1984, Strachan's survey of the region's modern sculpture only identified four pieces, of which Keith Godwin's *Vigilance* was the only free-standing one in Manchester city centre.[18] Outdoor modern sculpture was almost entirely absent from the surrounding towns. Some new sculpture was to be found inside the new churches: works such as Robert Brumby's altar mural in St Augustine's, Manchester (1968). Sculpture was also to be seen in the new shopping centres that began to redefine urban retailing from the 1970s onwards. In most instances, as at Rochdale where the developers presented a sculpture of bronze sheep, this was usually little more than an afterthought. Such works were also vulnerable, liable to be swept away in the first wave of refurbishment. In most cases this was unimportant, but Manchester Arndale Centre's decision to scrap Franta Belsky's *Totem* represented a more serious loss. It was, however, not the only modern sculpture to be lost: Hugh Dalton's *Icon*, presented to the Domestic and Trades College, was later discarded.[19]

Public Art

The category of work included under the broad and evolving heading of public art has challenged us as much as it had done other contributors to the National Recording Project. In a category that ranges from light installations to street furniture, and from murals to beer mats, we have concentrated chiefly on identifying free-standing sculpture.

In the 1990s public art became part of local authority regeneration agendas, promoted as a means of enhancing the economic, environmental and social well-being of communities.[20] Public art provided symbols of modernity for the post-industrial city. Paradoxically, a common response of artists working in public art was to root their work back into a community's past, researching its history and myths for inspiration. A related development was to display the machinery of now redundant industries – steam engines and colliery winding wheels – as industrial sculpture. The strength of the commitment shown to public art varied between districts; budgets were frequently small and vulnerable, and the post of public arts officer was rarely a full-time appointment. Low-cost projects were the order of the day, but in a number of districts it did result in the commissioning of a number of noteworthy works. Both Oldham and Wigan were to create their own urban sculpture trails.

Greater Manchester also included a large section of one of the country's most ambitious outdoor public sculpture schemes, the Irwell Sculpture Trail. This is a 50-kilometre trail of linked footpaths following the River Irwell from Bacup in Lancashire to Salford Quays. It received one of largest lottery grants awarded to public art in Britain, £2.3 million

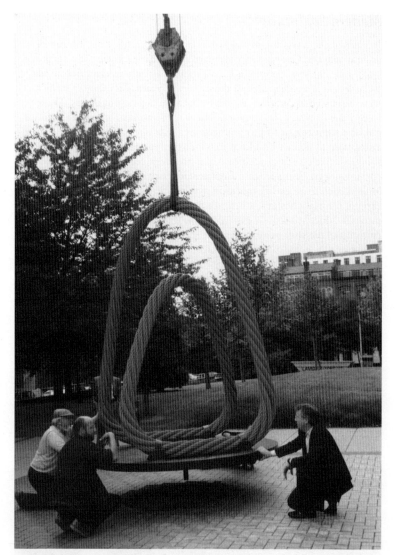

Installation of Technology Arch, UMIST, 1989

in 1996.[21] Its programme included some 50 projects ranging from the establishment of artist-in-residency schemes for young sculptors to the commissioning of major works from internationally recognised sculptors. Sculptures by Ulrich Rückriem, Edward Allington and Rita McBride were among those installed on the Bury and Salford sections of the trail.

The increasing prominence of the public sector did not entirely

overshadow private initiatives. Portrait statues of Reg Harris and Alan Turing in Manchester were organised through public subscriptions that would have been familiar to the Victorians. Private enterprise also provided public sculpture: sculpture featured on both the inside and outside of John Whittaker's Trafford Centre. The co-operative movement marked its 150th anniversary by installing a modern sculpture in Rochdale and a copy of a statue of Robert Owen in Manchester.

But although the number of works of public sculpture and art have increased throughout the region in recent years, one should not exaggerate the public acceptance of such art. Public sculpture still remained a marginal element in the design process, usually added, if at all, late in the development process. Percent for Art schemes were stillborn. Public sculpture was a peripheral concern, for example, in the massive redevelopment of Manchester city centre following the IRA bomb in 1996. Only one major public sculpture was commissioned in the region's preparations for the 2002 Commonwealth Games. Public reaction to new

Marshall, Sir Robert Peel, removed for restoration, 2001

sculpture, at least as reported in the local media, also suggested that, in spite of the efforts made to consult and involve communities in public art projects, a considerable gap existed between the public understanding of such sculpture and the intentions of the artists and planners. Reactions were frequently negative, ranging from those who saw such art as possessing little aesthetic merit, spoiling rather than enhancing public spaces and buildings, to the widely expressed view that the money, generally assumed to have come from local ratepayers, could and should have been spent on more essential community projects.[22] Nonetheless public art had become part of the post-industrial landscape, contributing to the creation of a visually richer urban environment. Contentious as public sculpture was, it was perceived by planners and those involved in urban regeneration schemes to be a symbol of innovation and modernity. It was in this context that in 2003 Manchester announced its intention of commissioning the country's tallest public sculpture.

The public monuments and sculpture detailed in this volume represent a rich collection, ranging from magnificent sculptural monuments and imaginatively designed and executed architectural sculpture to pedestrian portrait statues and simplistic works of public art. The works of internationally recognised artists are by accidents of geography juxtaposed with works by stonemasons whose names are unknown outside their own communities. The entries can be studied and appreciated in many different ways. We would simply point out that an appreciation of the historical context in which any work was commissioned, located, displayed and responded to provides an essential layer of understanding in the interpretation and assessment of public sculpture. Public sculpture also represents an important artefact and visual source for historians, who in their studies of Lancashire towns have not usually recognised its place in the physical, ideological, cultural and political constructions of the urban world. An understanding of the history of the commissioning and location of public monuments ought also to be of interest to those charged with the care and maintenance of those monuments.

Finally, and importantly, as with the other volumes already published in this series, this catalogue, although providing much historical information, is not a history of public sculpture in Greater Manchester. It is rather a starting point for that history. It should also be regarded as one of the building blocks for that grander and more challenging project that arises out of the Public Monuments and Sculpture Association's National Recording Project, a history of public sculpture in Britain.[23]

Arrangement of Entries

The volume is organised into ten chapters, each one relating to a metropolitan administrative district. Following Manchester and Salford, the districts are arranged alphabetically, and in each one the towns and

streets are also listed alphabetically. The maps and the general index should enable the reader to navigate their way smoothly to a particular entry. Each chapter is prefaced with a brief overview of public sculpture in the district. In these introductions we have also drawn attention to works that have not been included, for the reasons indicated above, as separate entries in the catalogue. Inevitably, others will have been missed out because of ignorance.

For each entry we have provided basic information beginning with location, title, the name of the sculptor and/or architect, the date of the unveiling or installation (where known), the materials out of which the work is constructed, its dimensions (given approximately when precise measurement was not possible); signature of artist, if provided on the work; inscriptions where they appear on the work or on an associated plaque or tablet; the ownership of the work where it could be established; a broad assessment of the current condition of the work; listed status where applicable; and a brief physical description of the work. This information is followed by an account of the commissioning of the sculpture or monument, the selection of the site, the unveiling ceremony and the later history of the work. The principal sources consulted in writing the individual histories are referenced at the end of each entry.

The detail provided in each entry varies, due largely to the availability of different sources. Only a small number of the minutes and correspondence of Victorian and Edwardian memorial committees are extant for this region. Municipal archives, where available for public research, do not always cover matters relating to statuary and architectural sculpture in the detail one might have expected. This has meant that we have had to rely on the local newspaper press and the specialist metropolitan art and architectural press, sources which have their own limitations. In the case of modern works it has been possible to obtain information directly from artists as well as from individuals involved in the commissioning process. It should also be noted that whilst some entries reflect the paucity of sources, in other cases the historical account could have been extended considerably. A number of the works recorded here, including ones by Matthew Noble, Thomas Woolner, Harry Bates, Hamo Thornycroft, Richard Goulden, Eric Gill and Elisabeth Frink, warrant more detailed studies. Less obviously, the same can be said for such sculpturally drab monuments as the Failsworth Pole and Hartshead Pike.

Notes
[1] B. Bryson, *Notes From A Small Island* (London: Doubleday, 1993) pp.222–3. [2] F.R. Raines and C.W. Sutton, *Life of Humphrey Chetham, Founder of the Chetham Hospital and Library* (Manchester: Chetham Society, 1903) Vol. II, p.224. [3] *Bolton Chronicle*, 13 August 1859; Gunnis (1968) p.275. [4] M. Stratton, *The Terracotta Revival* (London: V. Gollancz, 1993). [5] G. H. Willoughby, *The Advantages of Terracotta relative to our Town and City Buildings* (Manchester: Manchester Society of Architects, 1890). [6] H. Taylor, *The Ancient Crosses and Holy Wells of Lancashire* (Manchester: Sherratt and Hughes, 1906). [7] Monument in Tyldesley top chapel graveyard, The Square, Elliott Street, Tyldesley, Wigan. [8] P. Davies, *Troughs and Drinking Fountains: Fountains of Life* (London: Chatto and Windus, 1989). [9] W. Harrison, 'Ancient beacons of Lancashire and Cheshire', *Transactions of Lancashire and Cheshire Antiquarian Society*, 15 (1897) pp.16–44. [10] Rivington Pike, which is generally associated with Bolton, is not included in this survey because it is located outside of Bolton Metropolitan Borough. See the description in *An Illustrated Itinerary of the County of Lancaster* (London: How and Parsons, 1842) pp.280–1. [11] *War Memorials Handbook* (London: Imperial War Museum, 2001) 2nd edn. [12] L. Weaver, *Memorials and Monuments: Old and New* (London: Country Life, 1915). [13] *Manchester Guardian*, 7 and 24 September 1904. [14] From the dialect poem, *Private Bob of Bolton*, printed copies of which were sold to raise money during the war. [15] A. Borg, *War Memorials: from Antiquity to the Present* (London: Leo Cooper, 1991); J. Davies, 'Reconstructing enmities: War and war memorials, the boundary markers of the West', *History of European Ideas*, 19 (1994) pp.47–52; J. Winter, *Sites of Memory, Sites of Mourning. The Great War in European Cultural History* (Cambridge: Cambridge University Press, 1995). [16] G. Moorhouse, *Hell's Foundations. A Town, Its Myths and Gallipoli* (London: Hodder & Stoughton, 1992) p.180. [17] R. Berthoud, *The Life of Henry Moore* (London: Faber & Faber, 1987) p.243. [18] W.J. Strachan, *Open Air Sculpture in Britain A Comprehensive Guide* (London: A. Zwemmer, The Tate Gallery, 1984) pp.183–4. [19] *Manchester Guardian*, 4 December 1959. [20] *Bringing Britain Together: A National Strategy for Neighbourhood Revival* (Social Exclusion Unit, 1998); Wigan Metropolitan Borough Council, *Public Art Policy for Wigan* (February 1996). [21] *Manchester Evening News*, 13 May 1996. [22] *Bolton Evening News*, 20 and 26 February 1998. [23] J. Darke, 'Information, education and preservation: The Public Monuments and Sculpture Association', *Transactions of the Ancient Monuments Society*, 44 (2000) pp.87–106.

Acknowledgements

The researching and writing of this book on the public sculpture of Greater Manchester could not have been completed without the help and encouragement of many individuals and organisations. The Greater Manchester Regional Archive Centre was established in the Department of History and Economic History at Manchester Metropolitan University thanks to the generous financial support provided by the Public Monuments and Sculpture Association, which had received an award from the Heritage Lottery Fund, and the Manchester Metropolitan University. This support allowed us to employ Harry Cocks as a research assistant and to undertake a region-wide survey of public sculpture covering Greater Manchester rather than a single-city study of Manchester. Within the university Professor Diana Donald arranged for the Department of Art History to carry out the photographic record of the monuments and sculpture included in the survey. In the later stages of the project significant support towards the costs of publishing the volume was provided by the Association of Greater Manchester Authorities (AGMA), the body established following the abolition of Greater Manchester Council in 1986, the Henry Moore Foundation and the Paul Mellon Centre for Studies in British Art. We are most grateful to all of these organisations for their support and interest in the project.

We have been fortunate in being able to call upon the expertise of many organisations, societies and individuals in the ten districts of Greater Manchester in identifying and researching individual sculptures and monuments. Local history societies and civic societies provided us with invaluable listings, particularly drawing our attention to extant and lost statuary, fountains and other public memorials. Not all of these qualified for inclusion in the survey but we were pleased to know of their existence. In the ten local authorities we have been helped by conservation officers, public art officers and other officials who have supplied us with often elusive information, or have pointed us in the direction of possible answers to our questions. Cathy Newbery and the staff of the Irwell Sculpture Trail supplied us with information on some of the region's most recent public art. We should also like to thank the many living sculptors who responded to requests for information about themselves and their work. Understandably, the majority of the research undertaken for the volume was carried out in the district's libraries, archives, museums and art galleries. The courteous and professional assistance provided by their staff has sweetened the labour involved. In particular, we wish to thank Barry Mills and his staff at Bolton Local Studies and Archives, Penney Farrell and staff at Reference and Information Services, Bury Central Library, Kevin Mulley at Bury Archives, Michael Powell and staff at Chetham's Library, Vincent McKernan and staff at Greater Manchester County Record Office,

Richard Bond and staff at Local Studies and Archives, Manchester Central Library, Virginia Tandy and staff at Manchester City Art Gallery, John Hodgson and staff at John Rylands University Library of Manchester, Marion Hewitt and staff at the North West Film Archive, Manchester Metropolitan University, Terry Berry and staff at Oldham Local Studies and Archives, Pam Godman and staff at Rochdale Local Studies Library, Tim Ashworth and Sandra Hayton at Salford Local History Library and Archives, David Reid and staff at Stockport Local Heritage Library, Alice Lock and staff at Tameside Local Studies Library, Sheila O' Hare and Karen Cliff at Trafford Local Studies Library, Alastair Gillies and Tony Ashcroft at the History Shop, Wigan and Leigh Local Studies Library. In addition, we would like to acknowledge the assistance we have received from many scores of individuals, some through correspondence, others whilst literally researching in the street, all of whom have helped us to clarify and strengthen individual entries.

We are especially indebted to Stephen Yates of the Department of Art History, Manchester Metropolitan University for taking most of the photographs. This involved a number of memorable excursions which frequently took the form of leaving a sunny Manchester to arrive at a destination that was cloaked in the thick humidity that historians point to when explaining the astonishing rise of the Lancashire cotton industry. As the text was drafted we were able to ask a number of friends and colleagues to comment on particular chapters. We are extremely grateful to John Archer, Derek Brumhead, Michael Creswell, John Cole, Morris Garratt, Clare Hartwell, Alan Kidd, Shirley McKenna, Michael Nevell, Philip Powell, Alan Rose and Evelyn Vigeon for offering sound criticisms, pointing out foolish mistakes and suggesting new entries. Diana Donald cast a sharp eye over the whole text, improving the final version in both style and substance.

We are also grateful for the help provided and comments received on the text from members of the editorial board of the Public Monuments and Sculpture Association. Edward Morris has given good counsel and many additional references, and been tolerant of our inability to provide a more precise date for the completion of the volume. Janet Allan has taken the manuscript and the photographs through the press – that simple phrase covering a far from simple process – with expertise and humour. Finally, we would like to join that ever growing group of students of public sculpture who are indebted to Jo Darke for all she has done to encourage a deeper appreciation and understanding of the historical and cultural importance of the monuments and sculpture that adorn and define Britain's public spaces and buildings.

Sources of Illustrations

The majority of the illustrations for this volume were taken by Stephen Yates of the Department of Art History, Manchester Metropolitan University as part of the Greater Manchester Recording Project. For the other photographs and illustrations grateful acknowledgment is made to Bolton Local History Library (p.203, 215); Bury Archives (p.237); Chetham's Library (p.x, 4, 6, 8, 154, 157, 161, 204); Conway Library, Courtauld Institute of Art (p.15, 25, 26, 27, 28, 29 30, 39, 40, 41, 74, 92, 104, 109, 110, 114, 115, 116); Jim Cook (p.160); Tom Dagnall (p.xv); Thomas Heatherwick (p.9); John Rylands University of Manchester Library (p.69); Chris Makepeace (p.5); Manchester Central Library, Local Studies and Archives (p.20, 161); Manchester City Art Gallery (p. 106); Manchester International Airport (p. 150); Manchester Metropolitan University (p.xi, 20, 156, 236, 306); Oldham Local Studies (p.272, 273, 274); Adam Reynolds (p.63); Rochdale Local Studies (p.306, 332); Stockport Local History Library (p.336); Tameside Local Studies (p.351, 352, 353); Trafford Local Studies (p.383, 384); Jenny Walsh (p.231); Wigan History Shop (p.409, 410, 427) and Ted Wilson (p.62, 118, 125).

MANCHESTER

MANCHESTER

0 2 kilometres

0 2 miles

CRUMPSALL

BLACKLEY

Blackley

CHARLESTOWN

Moston

MOSTON

HARPURHEY

LIGHTBOWNE

Harpurhey

CHEETHAM

NEWTON HEATH

Collyhurst

Ancoats

BESWICK &
CLAYTON

CENTRAL

Clayton

BRADFORD

Hulme

ARDWICK

GORTON NORTH

HULME

MOSS SIDE

LONGSIGHT

GORTON
SOUTH

Moss Side

RUSHOLME

WHALLEY
RANGE

FALLOWFIELD

Fallowfield

LEVENSHULME

CHORLTON

OLD
MOAT

WITHINGTON

BARLOW
MOOR

BURNAGE

DIDSBURY

NORTHENDEN

Didsbury

BROOKLANDS

BAGULEY

BENCHILL

Wythenshawe

SHARSTON

WOODHOUSE
PARK

Ringway

Introduction

The township of Manchester formed the nucleus of the municipal borough when it was established in 1838. Manchester was designated a city in 1853. Subsequent extensions of the municipal boundaries – notably in 1890, 1904 and 1931 – created the modern city. In the local government reorganisation of 1974 the existing boundaries were not significantly altered. The present-day city of Manchester covers an area of 11,612 hectares. Its recorded population in 2001 was 392,819.

Centuries of involvement in the manufacturing and selling of textiles established Manchester as one of the leading commercial and manufacturing centres in south-east Lancashire. In 1773 the population of the township was some 25,000 and rising. The development of the factory-based cotton industry in the following decades was at the centre of the changes that transformed the town into one of the country's largest and most important cities. A new landscape of factories, warehouses, canals, railways and terraced houses was created. Economic change was accompanied by profound social change. It was by any standards a spectacular transformation. In 1851 the population was 303,000 and rising; in 1901 it was 543,000 and rising.

Outsiders represented Manchester as a city of contrasts, a place of enormous wealth that was also a byword for poverty and squalor. Philistinism was widely assumed to be a defining trait in the character of the 'Manchester Man'. Yet, in spite of criticisms that Manchester was a drab and uninspiring place, created and controlled by boorish businessmen, the city centre bristled with architecturally distinguished commercial and public buildings. Manchester also displayed one of the largest collections of public statues outside London. The commissioning of its public statues, however, lagged behind Liverpool and Birmingham. Early proposals, including a statue to Sir Richard Arkwright, were not realised.[1] Manchester also did not follow other provincial towns in raising monuments to Nelson. Its first major public commission for statuary was not until the 1820s, when James Bubb provided the statues and other sculptural decoration for the new town hall in King Street. The Town Hall Committee's dealings with Bubb were a salutary introduction to the municipal patronage of art. In 1833 a public subscription was opened for a marble statue of the town's most famous living person, the scientist John Dalton. Chantrey's statue was displayed in the town's most prestigious cultural building, the Royal Manchester Institution. Other proposals at this time, including statues of James Watt and Francis Egerton, Third Duke of Bridgewater, were not carried out.[2] Such schemes, however, did draw attention to the town's public spaces and the potential role of statues in defining and distinguishing them.[3] The 1840s were a barren period for statuary, and the few works that were installed, such as the statue of Shakespeare on the new Theatre Royal, were mediocre.

It was the 1850s that saw the decisive change in attitudes towards public sculpture. It began, as in many other provincial towns, with the commissioning of a memorial statue to Sir Robert Peel in Piccadilly. Statues of the Duke of Wellington, John Dalton and James Watt soon followed. Together, they transformed the area in front of the Royal Infirmary, formerly the site of a pond, into Cottonopolis' principal public space. The civic importance of this space would have increased further had monuments honouring the third Duke of Bridgewater and, most notably, Prince Albert, been raised in Piccadilly.[4] The scale of these projects was such that London was compelled to take notice of Manchester, a scrutiny that was usually framed by condescension.[5] Mid-Victorian Manchester emerged as an important centre of sculptural patronage, helping to establish the reputation of artists such as William Theed and Matthew Noble. Theed's first local commission was for a statue in Manchester Cathedral, a reminder that although sculpture inside churches is not generally included in this survey, a full understanding of the processes associated with public memorialisation require its discussion. The memorials, for example, in St John's Church, Manchester, honouring the charismatic Reverend John Clowes, would be of interest even if they had not been carved by Flaxman and Westmacott.[6] St John's also displayed a suitably symbolic public memorial to William Marsden, the young man credited with establishing the Saturday half-holiday in Manchester.[7]

The refusal to place Worthington's Gothic monument to Prince Albert in Piccadilly was directly responsible for the creation of a new public space in the city. The 'uncultivated city wilderness' in front of the Town Yard was the site chosen for the memorial, but the real significance of what was to be Albert Square only became apparent when Waterhouse's new town hall began to take shape. Over the next generation the addition of statues of James Fraser, John Bright, Oliver Heywood and William Gladstone extended and consolidated this important civic space. Marshall Wood's *Richard Cobden* and Hamo Thornycroft's South African War Memorial also altered the character of one of the city's oldest public spaces, St Ann's Square. In contrast, however, to Salford and the smaller

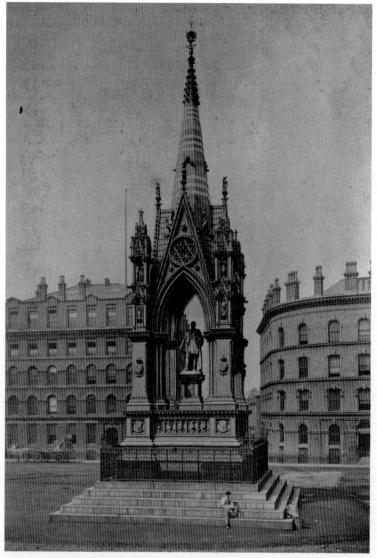

Thomas Worthington, *Albert Memorial, c. 1870*

monumental *Edward VII*, but the history of the commission indicates that it had been originally intended to place it in Piccadilly.

Onslow Ford's *Queen Victoria* was given pride of place on the Piccadilly Esplanade. Howls of criticism preceded and followed its unveiling, though there were critics, including the *Manchester Guardian,* who recognised its qualities.[8] Long before Victoria died, doubts were being voiced over the purpose and appropriateness of such public monuments. The art dealer, William Agnew, who did much to define artistic tastes in parvenu circles, was scathing about the city's outdoor statues, claiming 'a sufficient number of iconoclasts in the circle of his acquaintance who would be willing to subscribe in order to raze several of them'.[9] Others found it difficult to appreciate the aesthetic qualities of statuary that the continuous smoke of Manchester had transformed into 'befouled effigies'.[10]

Smoke was a problem to all architects commissioned to design buildings in Manchester. The introduction of architectural ornament was done in the knowledge that it would soon be smothered in soot. Even so Manchester buildings displayed important examples of architectural sculpture, and commissions helped to support a number of local firms, including T.R. and E. Williams, Joseph Bonehill, J.J. Millson and Earp & Hobbs. But a study of the more prestigious architectural sculpture commissions – for the Royal Manchester Institution (John Henning), the Free Trade Hall (John Thomas), the Assize Courts (Thomas Woolner and the O'Shea brothers) and the John Rylands Library (Robert Bridgeman) – suggest that architects preferred carvers from outside the city. The age of terracotta ornamentation, ushered in locally by Dunn and Hansom's St Bede's College, also found its modellers in London and elsewhere.[11] It was Farmer and Brindley whom Waterhouse employed to carve the extensive sculptural scheme on the exterior of the town hall.

The town hall also became an important repository for public statuary, though this aspect of civic art has tended to be overlooked by those who come to admire and study Ford Madox Brown's murals. In the Great Hall the statues of Villiers, Bright and Gladstone, all living politicians, indicated that Manchester Liberals wanted visitors to be left in no doubt about the economic creed responsible for such civic grandeur. The Sculpture Hall on the ground floor also took on the appearance of a Liberal Valhalla, but not all statuary was political. The marble statues of Manchester's greatest nineteenth-century scientists, Dalton and Joule, the first objects visitors saw on entering the town hall, offered a different explanation of the city's greatness.

It should be noted, however, that, as in the surrounding cotton towns, public monuments took more prosaic forms: obelisks such as the one erected in Great Ancoats Street to John Aston Nicholls, an employer whose treatment of his workers was held up as a model of improved class relations.[12] Public monuments were also to be found in the local churchyards and cemeteries. The radical leader, Henry Hunt, was

cotton towns, Manchester's parks did not become important spaces for displaying commemorative statues. The first portrait statue to be located in any Manchester park was of the dialect writer, Ben Brierley. It was unveiled in Queen's Park, Harpurhey, some 50 years after the park's opening. Whitworth Park became the location for John Cassidy's

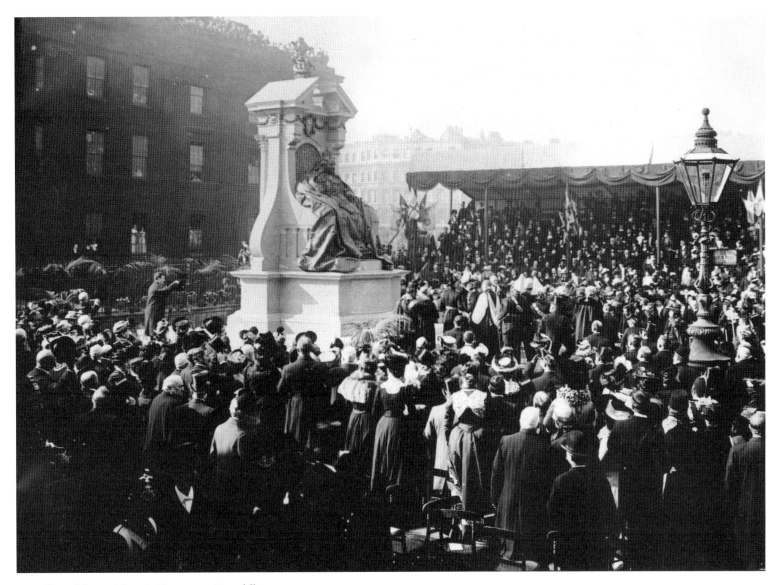

Unveiling of Queen Victoria Monument, Piccadilly, 1901

remembered by an obelisk in the burial ground of the Bible Christian Church in Ancoats.[13] A plain grey and red granite monument was placed above the grave of the Chartist, Ernest Jones, in Ardwick Cemetery.[14] The commissioning of medallion portraits, such as those honouring William Langton (John Adams-Acton), James Heywood (William Theed) and Richard Cobden (William Theed) in the Manchester Athenaeum, should also not be forgotten.[15]

Manchester's collection of outdoor statues might have been even larger had even a few of the many projected schemes been realised. In spite of various proposals, the city never commissioned a statue to commemorate any of the heroic inventors and entrepreneurs responsible for making it a world city. More predictably, schemes to memorialise women associated

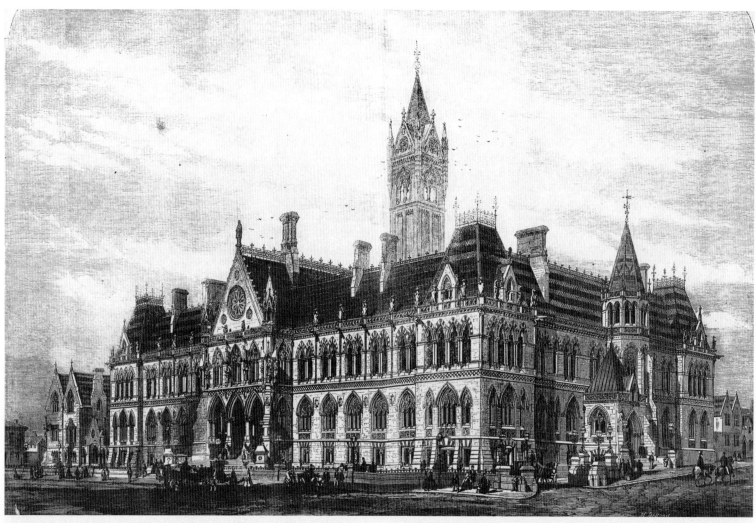

Manchester Assize Courts. Architect: Alfred Waterhouse; Sculptor: Thomas Woolner

with Manchester rarely went further than suggestions in the letter columns of the local press. The idea of a statue of the novelist, Elizabeth Gaskell, was discussed at the time of the centenary celebrations of her birth, but did not progress.[16] A tablet commemorating the momentous occasion when Christabel Pankhurst and Annie Kenney raised the question of votes for women was eventually installed in the Free Trade Hall, but when a statue was raised to Mrs Pankhurst it was in London, not Manchester.[17]

Redevelopment, especially in the older parts of the town, posed a threat to existing public sculpture and monuments. The town's market and boundary crosses were among the earliest casualties of this process.[18] More recent sculpture was also vulnerable. The architectural sculpture on the Royal Cotton Exchange, including work by John Thomas and Edgar Papworth, was a casualty of what appeared to be the almost continuous rebuilding of the 'parliament of the cotton lords'. Some threatened sculpture, however, was saved. James Bubb's undistinguished *Solon* and *Alfred the Great* survived because they were part of the town hall façade removed to Heaton Park before the First World War.

Manchester saw an unprecedented outburst of public memorialisation

following the First World War. The city's main war memorial was Lutyens' cenotaph in St Peter's Square, a commission that prompted widespread public argument, particularly over its location. Community memorials were also erected in the different districts of the city. The Ardwick Battalion of the Manchester Regiment remembered its dead by erecting a Portland stone monument on Ardwick Green.[19] Factories, warehouses and other businesses commissioned memorials to those workers who did not return to take up their jobs. Mather and Platt, Tootal, Refuge Assurance and the *Manchester Guardian* were among the firms who raised such memorials.[20] None was more impressive and solemn than Charles Sergeant Jagger's *The Sentry*, positioned in the entrance area of the Watts Warehouse in Portland Street, and none revealed the changing attitudes towards memorialisation better than the Post Office's peace memorial. Amidst such activity, the city also saw the arrival of one of its most important portrait statues: George Gray Barnard's *Abraham Lincoln*. Originally intended to be displayed in London, it was redirected to Manchester, where its historical connections were rearranged to emphasise Lancashire's rather than Britain's special relationship with the United States.

The installation of so many new monuments did not thaw the growing coldness towards the city's Victorian statues. Calls to banish the 'monstrosities in stone trousers' from the city centre – statues of worthies who could not be named by many citizens – became more frequent.[21] Mancunians even looked enviously at Leeds, which had embarked on a more radical policy of removing its statues.[22] Schemes of public commemoration became equated with demonstrably practical memorials. When the city launched its George V memorial appeal, it was for 500,000 shillings to provide hospital beds, not a public statue.[23]

Manchester might have lost almost all of its outdoor bronze statues in 1940, had proposals to melt them down for the war effort been carried out.[24] The city's statuary escaped this threat but not the bombing raids. In retrospect, the loss might have been far more extensive, given the damage inflicted on the Cathedral, the Free Trade Hall and the Assize Courts. Public sculpture continued to be vulnerable after the war. Planners and architects, setting out to create a modern city, had little enthusiasm for Victorian things. The statues in Albert Square became, not for the first time, a particular focus of attention, prompting the *Manchester Guardian* to warn about sweeping away the city's history in 'a gale of Philistine modernism'.[25] In the event, few statues were removed from the city centre.[26] William Theed's *John Dalton* was removed from Piccadilly in 1966, and Matthew Noble's *Oliver Cromwell*, long regarded as a traffic obstacle, was exiled to Wythenshawe Park in 1968. A long-running argument over the repair and, at times, the very existence of the Albert Memorial eventually resulted in a major restoration in the 1970s. But, important as this particular campaign was in encouraging an admiration for the city's Victorian architecture, it did not usher in a wider

programme of conservation of the city's other public statues.

The neglect of older statuary did not imply that modern sculpture was valued. In general, it was treated with suspicion. The installation of abstract sculpture in a number of Wythenshawe schools in the 1950s provoked accusations of council wastefulness. Similar sentiments greeted Elisabeth Frink's sculpture honouring Alcock and Brown's first transatlantic flight when it was eventually installed in Manchester's Ringway Airport. 'I have never seen anything so ugly in all my life. I don't think it's obscene but even so it's not the sort of thing a woman wants to look at' was representative of the public comments that the press chose to report.[27] A plan, in the early 1970s, to install a Bernard Schottlander sculpture outside the new magistrates' courts in Crown Square was rejected on the grounds that it was unsuitable, unnecessary and uneconomic. The £7,000 metal sculpture, which took the form of two crosses, one on top of the other, was briskly dismissed by one councillor as looking like 'an advertisement for Littlewoods football pools'.[28] When modern public sculpture was commissioned for a building, it was usually as an afterthought. The unprecedented expansion of the University of Manchester in the 1960s released a massive building programme – 'an empire on which the concrete never set' – but one that critics judged as producing far too many ordinary buildings.[29] Abstract sculptures featured on a number of the new buildings, including works by Mitzi Cunliffe (Moberly Tower), Lynn Chadwick (Williamson Building), Hans Tisdall (Chemistry Building) and Michael Piper (Schuster Building).[30] William Mitchell clad the new Humanities Building in his instantly recognisable patterned concrete panels.[31] The obligatory Hepworth – in this case, the *Head of Ra* – was to be found in the inner courtyard of the new Architecture and Planning Building. Even so these decorative flourishes could do little to improve what was widely seen as an uninspiring collection of buildings. Across the city the number of works of modern sculpture remained small. Keith Godwin's *Vigilance*, commissioned by the Scott Trust, was one of the few free-standing abstract public sculptures to be actually located in the city centre. Of course, once a work was installed, there was no guarantee that it would survive. *The Runner*, a bronze study of an athlete by John Bailie Longden, was stolen from Heaton Park in 1968.[32] Hubert Dalwood's *Icon*, donated by the Leonard Cohen Fund to the new Domestic and Trades College (renamed Hollins College) was also to disappear.[33]

It was not until the middle of the 1980s that municipal attitudes to public sculpture showed signs of changing. Sculpture began to be regarded by some councillors and senior officers as an asset, not an albatross: something that could contribute to the development of a more attractive environment for workers, shoppers and visitors. There was optimistic talk of sprinkling the city with sculpture and fountains.[34] 'Sculpture for Peace' competitions organised by the City Council resulted in four public sculptures. Arrangements were also made to move the

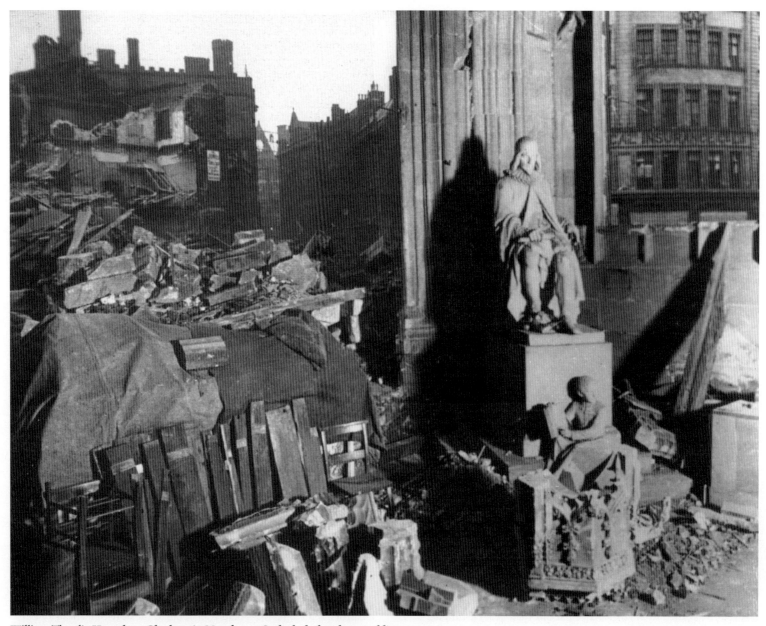

William Theed's *Humphrey Chetham in Manchester Cathedral after the 1940 blitz*

Barnard *Lincoln* from Platt Fields to the newly-named Lincoln Square in the city centre. More provocatively, the City Council purchased Noble's statue of Joseph Brotherton, formerly owned by Salford City Council, and erected it on the Manchester bank of the Irwell. Another initiative was the opening of a sculpture park for black artists in Moss Side, but after the installation of Kevin Johnson's *Mother and Children* this particular project was neglected. In contrast, a more successful initiative involving the city's ethnic minority communities was the erection of a massive Imperial Chinese Arch in Faulkner Street, the centre of the city's Chinatown. It was unveiled by the Duke of Edinburgh in 1987.[35] Manchester had not seen this level of interest in public sculpture since the 1850s. But the installation of new sculpture underscored the dirty and deteriorating condition of many of the older works in the city centre and the suburbs. A regular maintenance and conservation programme remained a pressing issue. Revealingly, one official survey concluded that a number of the city's older memorials could not be readily located.[36]

In the early 1990s initiatives taken by the council and bodies such as the Central Manchester Development Corporation saw public art linked more closely to urban regeneration projects. Public art was acknowledged as having a positive role in establishing more attractive environments, contributing towards the creation of new identities for specific areas of the city. The Northern Quarter, for example, saw a co-ordinated programme of public art works, ranging from ceramic murals and poetry tiles to landmark sculptures, including David Kemp's *Tib Street Horn*.[37] Public art was also a feature of the Hulme regeneration programme.[38] Not all of the projects worked. Whilst a new fountain by Peter Randall-Page in St Ann's Square was generally welcomed, an obelisk introduced as a focal point in Market Street was soon removed, and later found a more suitable home in Crumpsall Park.

Not all initiatives came from the public sector. The Co-operative Bank was responsible for a statue of Robert Owen, a copy of one by Gilbert Bayes, in Corporation Street. A statue of the world champion cyclist, Reg Harris, installed in the Manchester Velodrome, was paid for by public subscription. Similarly, the donations of many individuals ensured that the idea of a statue of the mathematician, Alan Turing, was realised. Support for this particular work came from within the city's gay community, and it was sited in Sackville Park, an open space which had become part of the gay village. Even so, in the absence of a Percent for Art programme the massive redevelopment of the city centre, especially after the 1996 bombing, produced few examples of public sculpture.

The new century opened with the relandscaping of what had remained, in spite of generations of indecision and failed schemes, one of the city's premier civic spaces, Piccadilly Gardens. Although there had been a proposal to remove all of the Victorian sculpture, it was finally agreed to keep the four principal portrait statues. After years of neglect they were restored and, once again, became defining features in this most important

Model of Thomas Heatherwick's B of the Bang, 2003

of public spaces. The opportunity, however, of returning Theed's *John Dalton* to partner his *James Watt* was not taken up. This restoration programme was driven by the city's desire to improve its major public spaces for the Commonwealth Games in 2002. Only one major sculpture was commissioned to mark this sporting festival: a monumental bronze athlete by Colin Spofforth. It was located close to the new City of Manchester Stadium in east Manchester, one of a number of prestige buildings that became the symbols of Manchester's ambitions to regain its status as a city of international rather than regional importance. In keeping with this renaissance, the year 2003 opened with the announcement that a landmark steel sculpture, Thomas Heatherwick's *B of the Bang*, would be located close to the stadium. At 56 metres high, it will allow the city to lay claim to be the location of the tallest public sculpture in Britain.[39]

Notes

[1] *Manchester Mercury*, 31 July 1792. [2] *Manchester Courier*, 9 January 1836; *Manchester Guardian*, 16 January 1836; *The Times*, 23 August 1838.
[3] W. Fairbairn, *Observations on Improvements of the Town of Manchester: particularly as regards the importance of blending in those improvements, the chaste and beautiful, with the ornamental and useful* (Manchester, 1836) pp.iv, 13. [4] *The Times*, 1 October 1852. [5] [R. Leake], *Piece Work in the Overtime of a Business Man* (Manchester: Palmer, Howe & Co, 1893) pp.180–98; *Art Journal*, 1 October 1857 p.309. [6] J. Evans, 'Memorials of a Manchester parish church', *Papers of the Manchester Literary Club*, 5 (1879) pp.121–2. [7] W.E.A. Axon, *Annals of Manchester* (Manchester: J. Heywood, 1886) p.245. [8] *Manchester Guardian*, 11 October 1901. [9] *Ibid.*, 20 October 1874. [10] *Ibid.*, 9 May 1923. [11] R. Cochrane and A. McErlain, *Architectural Terracotta* (Manchester Metropolitan University Department of History of Art and Design Slide Sets, 1999) pp.15–29.
[12] *Manchester Guardian*, 21 July 1860; *Proceedings of Manchester City Council*, 1 August 1860 p.196. The electrification of the tramways caused its removal to the grounds of Nicholls Hospital, Hyde Road in 1904, *Manchester City News*, 17 February 1923. [13] V.I. Tomlinson, 'Postscript to Peterloo', *Manchester Region History Review*, vol.3 no.1 (1989) pp.55–8. [14] *Manchester Examiner*, 10 April 1871; *Manchester Guardian*, 19 and 24 April 1913, 1 September 1913. [15] *The Manchester Athenaeum: Commemoration Notice of the Origin, Progress and Present Purpose of the Institution* (Manchester, 1903). [16] *Manchester City News*, 8 November 1913. [17] *The Times*, 12 February 1930, 7 March 1930; *Manchester Guardian*, 8 October 1959. [18] R.B. Wild, 'Hyde's Cross', *Transactions of Lancashire and Cheshire Antiquarian Society*, 26 (1908) pp.114–23.
[19] *Manchester Guardian*, 25 November 1920, 18 July 1921. [20] Mather and Platt, Park Works, Newton Heath, unveiled 16 December 1920 (*Manchester Guardian*, 17 December 1920); *ibid.*, 9 February 1923; K. Grieves, 'C. E. Montague, Manchester and the remembrance of war 1918–25', *Bulletin of John Rylands Library*, 77 no.2 (1995) pp.85–104. [21] *Manchester City News*, 18 July 1931.
[22] *Daily Express*, 18 August 1933. [23] *The Times*, 16 May 1936.
[24] Cinetopicalities in Brief (no.127) 9 September 1940, BritishPathe.com.
[25] *Manchester Guardian*, 24 July 1948, 27 July 1948; *Manchester Evening News*, 26 July 1948; *Manchester Evening Chronicle*, 22 June 1949. [26] *Manchester Guardian*, 7 November 1957; *Gorton and Openshaw Reporter*, 8 November 1957; *Manchester Guardian*, 6 November 1958, 12 November 1958. [27] *Daily Mirror*, 30 October 1964. [28] *Manchester Evening News*, 7 September 1972. [29] B. Pullan *A History of the University of Manchester 1951–73* (Manchester: Manchester University Press, 2000) p.197; *Daily Telegraph*, 18 April 1962. [30] C. Hartwell, *Manchester* (London: Penguin, 2001) pp.114–21. [31] *The Surveyor and Municipal Engineer*, 20 February 1965. [32] *Manchester Evening News*, 16 October 1968.
[33] *Manchester Guardian*, 4 December 1959. [34] *Manchester Evening News*, 21 September 1984. [35] *Ibid.*, 5 December 1987. [36] *Ibid.*, 16 January 1992.
[37] Northern Quarter Association, *Applied Art in the Northern Quarter* [n.d.].
[38] *Manchester Evening News*, 29 May 1996. [39] *Guardian*, 4 January 2003, 12 May 2004.

Albert Square

Albert Memorial

Architect: Thomas Worthington

Sculptor: Matthew Noble

Architectural sculptors: T.R. and E. Williams, Joseph Bonehill

23 January 1867
Sicilian marble statue
Statue 2.74m high approx; memorial 22.86m
high approx × 6.1m square base
Inscription round base of memorial: IN
GRATEFUL ACKNOWLEDGMENT OF PRIVATE
AND PUBLIC VIRTUES / ALBERT, PRINCE OF
SAXE COBURG AND GOTHA, CONSORT OF HER
MAJESTY, QUEEN VICTORIA / ERECTED BY THE
INHABITANTS OF MANCHESTER A.D. 1866 /
THIS STATUE WAS PRESENTED TO HIS FELLOW-
CITIZENS BY THOMAS GOADSBY, MAYOR OF
MANCHESTER 1861–2. – on pedestal of statue:
ALBERT
Status: Grade I
Condition: fair
Owned by: Manchester City Council
 Description: Memorial rises on stepped
granite blocks to a tall square base, above this
four arches support a grand canopy, forming a
shrine, in the centre of which stands a marble
statue of Prince Albert, surmounting polished
red and grey granite pedestal. Albert is dressed
in the robes of the Order of the Garter, the
rules of the Order held in his right hand. The
arches are surmounted by lofty gables, each one
containing an elaborately pierced circular open
panel. In the three triangular spandrels are
medallions, containing twelve heads
representative of the Arts and Sciences:
Michaelangelo, Wren, Inigo Jones, Raphael,
Beethoven, Mendelssohn, Goethe, Schiller,
Milton, Shakespeare, Tasso and Dante. Above
the four gables are winged angels holding gilt
trumpets. The four piers or buttresses rise from
the base, ending in elaborately decorated
pinnacles. Each pinnacle has two stages above

the springing of the arches, the upper stage
being an open canopy supported on polished
granite shafts. The canopies contain figures
representing Art, Science, Agriculture and
Commerce. In the lower stages, beneath the
principal figures, are four subordinate figures.
At the front of the memorial Art is supported
by figures representing Music, Sculpture,
Painting and Architecture; and Science by
Astronomy, Mechanics, Chemistry and
Geometry. At the rear Agriculture is supported
by Spring, Summer, Autumn and Winter; and
Commerce by Europe, Asia, Africa and
America. On the centre of the piers or
buttresses are carved shields representing the
arms of England, Saxony and Prince Albert's
own arms. Each shield is surmounted by the
Prince's coronet and encircled by the Garter.
These shields are repeated on the panels around
the basement. The monument culminates in a
highly enriched octagonal spire banded with
polished grey granite.

Following Prince Albert's death in December
1861, a committee of influential Mancunians,
chaired by the mayor, Thomas Goadsby,
established a fund to provide an appropriate
local memorial. Numerous suggestions were
made about its possible form, including the
establishment of a School of Science, an Albert
Gallery of Art, a convalescent hospital, a public
park and model cottages for the working
classes.[1] 'A Working Man' proposed that
Manchester should erect a 'monument in the
same style as the Scott Monument in
Edinburgh'.[2] However, in view of the eventual
decision, the discussion at the very first public
meeting to establish the memorial fund was
significant. A number of speakers raised the
idea of a memorial statue. Commenting on this,
Joseph Heron, Manchester's ever-purposeful
town clerk, observed that

the atmosphere of Manchester might not suit
statues, and he was tired of bronze statues.
Nothing more beautiful, however, could be

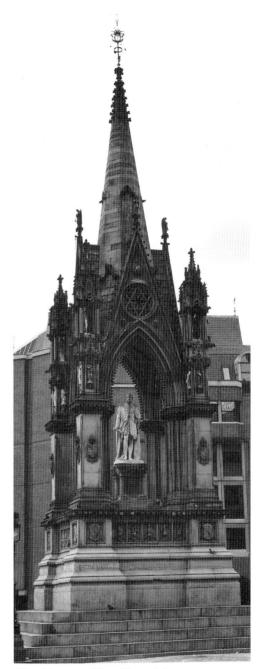

Worthington, *Albert Memorial*

seen than the marble statue of the Prince in the Town Hall, and he thought it might be arranged to have a marble statue of the Prince enclosed in a proper temple erected somewhere in this city, like the monument to the poet Burns, enclosed on Carlton Hill, Edinburgh.[3]

The 'statue' Heron was referring to was the bust, sculpted by Matthew Noble, and presented to the city following the Art Treasures Exhibition of 1857.[4] To what extent the idea of a full-length marble statue had been discussed before the meeting is unclear, but Goadsby responded to Heron's proposal with a pledge of £500 if the idea of a marble statue was taken up.[5] This was not the first time that Goadsby had considered financing a public

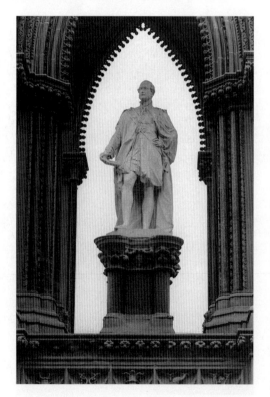

Noble, *Prince Albert*

statue in Manchester, as he had previously discussed the idea of raising a monument to Oliver Cromwell.[6] Initially, however, there continued to be a strong feeling that any tribute to the Prince Consort should be a living memorial, related to one of his many public interests. Such suggestions may also have been made with a view to creating employment in a community in the grip of the Cotton Famine. But by February such schemes were marginalised, when Goadsby announced his willingness to present the city with a marble statue of Prince Albert at his own expense, providing that an appropriate building could be supplied to accommodate it.[7] Discussions in the memorial committee turned to the questions of providing a suitable canopy for the promised statue and securing an appropriate site. The sculptor of the statue was to be Matthew Noble, who, because of his many works in Manchester and Salford, must have been well known to the members of the memorial committee. Noble was certainly known to Goadsby, who described him as 'one of his warmest and sincerest personal friends'.[8] Noble's position as the city's 'official sculptor' was underlined when he was awarded the commission to provide Salford's memorial statue of the Prince Consort. This, too, was to be in marble and to stand outdoors, but in Salford there were no plans to shelter it under a canopy.[9] Noble also sculpted statues of Albert in Leeds and the Victoria and Albert Museum in Bombay.[10] For Manchester's Albert, Noble selected a marble from a 'new quarry in Sicily' rather than Carrara because of its superior weathering properties.[11]

A sub-committee, whose members included William Fairbairn, Thomas Bazley, Thomas Ashton, James Prince Lee, Bishop of Manchester, and Goadsby, was left to clarify the form of the memorial. The question of a canopy was settled relatively quickly, when the sub-committee invited the local architect, Thomas Worthington, himself a member of the General Committee, to discuss the subject and

to submit designs.[12] Worthington produced two designs: one based on the Temple of the Winds, Athens, and the other on the medieval chapel of Santa Maria della Spina, Pisa.[13] No illustration has survived of the only other design known to have been sent to the committee, 'voluntarily submitted' by the Manchester architects, Clegg and Knowles.[14] It was Worthington's Italian Gothic design that the committee selected.[15] Fortunately for the committee, Worthington, drawing on his knowledge of Italian architecture, produced an inspired response to the problem of housing Noble's statue. It was in the form of a ciborium, a magnificent shrine-like canopy.[16] Any public discussion that might have occurred over the decision was effectively closed when it was reported that Queen Victoria, having studied a drawing of the intended monument, gave it her approval.[17] Worthington did, however, make changes to the original design as the project went forward.[18] Matters were progressing rapidly, though it was significant that the committee had settled the question of the memorial's design without having agreed upon a location.

Finding a site for the memorial proved less easy to arrange. Nine possible locations were identified by the committee, but there was a clear preference for Piccadilly, where four statues had already been erected on the Esplanade in front of the Royal Infirmary.[19] In fact, three locations in Piccadilly were suggested: the top of Portland Street, the top of Mosley Street, and, more obviously, the space in front of the Infirmary between the Peel and Wellington monuments. The memorial committee and the Corporation approved the latter site, but discussions with the Infirmary trustees began badly, following the council's hasty construction of a fence on what was, apparently, the Infirmary's land.[20] The publication of a drawing of the intended memorial in the *Builder* – Worthington later credited the Bishop of Manchester with the idea of publishing it – did not receive the local approval that the committee probably

anticipated.[21] Doubts began to be expressed about the suitability of placing a Gothic monument in front of the Infirmary's Ionic portico. The construction of a wooden 'skeleton frame of the memorial' on the proposed site did nothing to reduce these concerns.[22] Although the Infirmary trustees had been generally supportive of the earlier statues and improvements in Piccadilly, there was less enthusiasm for this particular monument, even if it was honouring the late husband of their patron. In this particular 'Battle of the Styles' the Gothic was not to be triumphant. The attention of the memorial sub-committee turned towards the Portland Street end of Piccadilly.[23] Locating the memorial here also required the co-operation of the Infirmary, particularly as land would have to be given up.[24] The Infirmary trustees were more sympathetic to this location, indicating their willingness to sell land to the council. But after a closer consideration of the site the council's Improvement Committee decided against it, claiming that it was too expensive. Goadsby tried to get the decision reversed at the January meeting of the City Council, arguing that the Portland Street site was suitable, and that, moreover, the Infirmary was willing to sell the land at well below its market value. In what was the first of a series of crucial council votes, the report of the Improvement Committee was accepted by 27 votes to 26.[25] By the winter of 1862–3 the Memorial Committee, which had expected the memorial's foundations in Piccadilly to have been already completed, was compelled to consider sites in other parts of the town. One correspondent in the local press wondered, not unreasonably, whether in the pursuit of architectural harmony it was still possible for the committee to revise Worthington's design.[26]

In February 1863 the Improvement Committee made another decisive intervention. At a meeting with the memorial committee the case for locating the memorial in Bancroft Street was made. This was probably the least

promising of all the locations. However, it was already known to members of the memorial sub-committee, as they had inspected it in the previous year, after a meeting with Worthington.[27] Bancroft Street was an unremarkable location in front of the Town Yard, covered by a clutter of undistinguished buildings; a place which most Mancunians would have had difficulty in locating, let alone envisaging as a public space containing the city's most striking public monument.[28] Other agendas were at work here. In particular, some councillors had recognised that Manchester would eventually need a new town hall, and that the Town Yard was a probable site.[29] The Improvement sub-committee urged the Albert Memorial Committee to consider the unpromising Bancroft Street site, but with the expectation that it would become part of a much grander scheme of civic redevelopment. In February 1863 the Memorial Committee agreed, by six votes to three, to place the Albert Memorial on Bancroft Street, 'subject to the understanding that the present intentions of the Corporation as shown in the accompanying plan be carried out'.[30]

The decision to locate such a magnificent memorial in the 'backwoods' of the city could not and did not pass without comment.[31] The Improvement Committee had to obtain the approval of the full council for Bancroft Street to become a new square, a public space defined by the Albert Memorial. A substantial number of councillors were not convinced of the need to spend what appeared to be a considerable and largely unspecified amount of money to acquire the site. One councillor observed that a sum of £28,000 had been rumoured, somewhat more than the £1,000 mentioned for the purchase of the land in Portland Street. The possibility that this would be the first stage of an even larger municipal improvement scheme raised further questions. Goadsby, still disappointed that the memorial was not to be in Piccadilly, indicated that he was willing to accept the Bancroft Street site, but only if it was

'the prelude to the erection of a commodious town hall in that neighbourhood'.[32] Alderman Curtis 'hoped that the council would never think of erecting a town hall so far from the centre of the city as Bancroft Street'.[33] The meeting became acrimonious. The vote was tied and it was left to the mayor, Abel Heywood, to ensure that the site in front of the Town Yard was acquired. The land that would become Albert Square, the city's most prestigious civic space, was determined by the exceptional use of the mayor's casting vote.[34]

Some 18 months after the Albert Memorial Committee's first meeting, construction of the memorial began. The work did not proceed smoothly as the site, which had included a public house, revealed unexpected difficulties. The foundations soon used up the 50,000 bricks gifted by the local Brickmakers' Association.[35] The Manchester firm of J. and H. Patteson was awarded the main contract for the stonework. Soon additional funds were needed, but the committee found it increasingly difficult to raise money in a community still struggling with the Cotton Famine.[36] Canvassing was renewed, potential subscribers being sent a carte-de-visite of the memorial.[37] In an unprecedented initiative to boost funds, all ratepayers were asked to pay a voluntary one penny rate towards the memorial.[38] Some £660 was raised by this means. Work on the memorial continued, but progress was slow. One of the difficulties was in obtaining suitable stone. Reporting in the summer of 1865, Worthington concluded that substantial further funds would still be needed if the memorial was to be finished as planned.[39] By November, Worthington had revised his estimates of the shortfall to £2,500.[40] The recanvassing of subscribers was proposed. Thomas Ashton and Oliver Heywood argued for an even bolder approach, that of asking the council for money. This direct approach proved successful, the council agreeing to pay £500 into the memorial fund.[41]

By Spring 1866 the project was moving

forward again, with the committee employing T.R. and E. Williams 'to execute the whole of the sculptures and carving for £767. 17s. 0d.'.[42] The Manchester sculptor, Joseph Bonehill, was also hired to assist with the carving of the memorial's upper stages. Even so, there still remained a shortfall, and the presentation of the larger bills had the potential to embarrass the committee. Throughout the project Worthington remained closely involved, examining stone and checking details, though his absence from one meeting was explained by the fact that he was attending a wedding, his own.

By the autumn of 1866 the project looked as if it might finally be completed. Noble had finished the statue, and it was ready to be sent to Manchester. The carving on the memorial was nearing completion; information on the prince's armorials being supplied by the Queen's Librarian at Windsor.[43] As Thomas Goadsby had died earlier in the year, it was his widow, Elizabeth, who saw that her husband's gift was delivered to the committee. Consideration began to be given to arranging an unveiling ceremony worthy of the memorial. But, once again, the committee saw its plans thwarted. It was assumed that such a splendid monument would warrant a royal inauguration, but the Prince of Wales proved to be unavailable, whilst the Queen, who had admired Worthington's work, had all but withdrawn from public life.[44] The Prime Minister, 14th Earl of Derby, also declined, as did, somewhat more unexpectedly, the Bishop of Manchester. In the end the memorial committee agreed to hold two ceremonies. The first was in the town hall, where Elizabeth Goadsby formally handed over the statue that her late husband had agreed to give to the city some five years before. A procession then walked from the town hall in King Street to what would become known as Albert Square, where the act of unveiling the city's grandest public monument was performed by the engineer, William Fairbairn.[45] The ceremony

did not pass without incident, as the large crowd included a number of the city's roughs – 'Deansgate, Angel Meadow and other delectable neighbourhoods', commented the *Manchester Courier*, 'seemed to have poured forth their full [*sic*] of the profani vulgi.'[46] – whose behaviour would definitely not have amused 'Albert the Good'.

Manchester's Albert Memorial had taken five years to complete. The total cost, excluding the statue, was some £6,225. Over half of the money came from individual subscribers, who each gave £50 and more to the memorial fund. Those involved were generally the wealthier members of Manchester's middle classes, some of whom, such as the firm of Ermen and Engels, had German connections. The region's economic difficulties partly explain the extended financial problems faced by the committee, though the fact that the memorial was not a practical one should also be recalled, in accounting for the dearth of voluntary subscribers.[47] The end result was nevertheless an elaborate and distinctive monument. It was widely praised, even if the *Manchester Guardian*'s correspondent claimed that two of the buttresses appeared to be falling outwards.[48] To what extent Worthington's Gothic canopy influenced George Gilbert Scott's even more magnificent memorial in London remains conjectural, at least to non-Mancunians.[49]

The Albert Memorial did become, as a small group of Liberal councillors had envisaged, the focal point of an important public space. Construction of Manchester's new town hall on the Town Yard site confirmed Albert Square's civic importance. The memorial, if not the statue, was admired, a building to show off to visitors to the city, a civic asset worth repairing and cleaning.[50] (To what extent the Gothic canopy sheltered the statue from Manchester's slanting rain and smoky atmosphere is unknown.) Attitudes were, however, to change, and following the First World War a proposal to locate the city's war memorial in Albert Square would have involved removing the

Albert Memorial.[51] This scheme was defeated, but it foreshadowed a shift in architectural tastes that was increasingly dismissive of all things Victorian. The Albert Memorial, carefully sandbagged during the Second World War, escaped damage, only to be threatened after the war, when the new city plan envisaged an Albert Square without its memorial (and without Waterhouse's Town Hall).

Attitudes towards the Albert Memorial became more polarised: some wished to see it preserved, while others wished to see it moved or even demolished. Its condition also deteriorated – parts of the structure, including the pinnacles, had already been removed for safety reasons – and there was a reluctance to use scarce resources to restore an unfashionable monument.[52] When the memorial was added to the list of Manchester's buildings 'of special architectural or historic interest', the decision was derided by one councillor, who dismissed it as 'a very expensive pigeon loft which ought to be demolished forthwith'.[53] But, in spite of its listed status, the memorial continued to be neglected. In 1968 the council agreed to spend £22,000 on its repair and cleaning, though Councillor M. Taylor's suggestion that a better way of dealing with it would be to use a stick of dynamite was not without public support.[54] In fact, little was done to stop the memorial's decay, a deterioration that was made all the more obvious when the exterior of the town hall was cleaned.

The early 1970s saw conservation groups pressing the council to acknowledge its responsibilities and restore the memorial.[55] Once again, plans to restore it were opposed, and in July 1971 the council, rescinding an earlier resolution, agreed, by 71 votes to 31, to dismantle and dispose of it.[56] No action was taken, however, following the announcement of plans to construct an underground railway link across Manchester, including a station in Albert Square. This scheme raised wider questions about the future layout of the whole square.[57] The tension between conservation groups and a

Worthington, *Albert Memorial (detail)*

(right) Worthington, *Albert Memorial (detail)*

council unwilling or unable to carry out its statutory duties remained. By 1973 the idea of dismantling what was now officially a Grade I listed building became more problematic.[58] Pressure to restore the memorial continued to mount. An exhibition on Thomas Worthington was held in Manchester, and the Victorian Society organised a 2,700–name petition to keep the memorial in the square.[59] This culminated, in the autumn of 1976, in the launch of an enormously ambitious campaign to raise £50,000 to restore the memorial.[60] The 'Save Albert' campaign did not reach its target, but sufficient money was raised to carry out a major, if not complete, restoration. The work included cleaning the monument, and replacing damaged and missing stonework, including

broken statuettes and the pinnacles, removed for safety reasons a few years before. Some £11,000 of the £27,000 raised came from voluntary contributions, whilst a number of firms provided their services either free or at a reduced cost. The restored memorial was unveiled to the public in November 1977.[61]

In the following years the layout of Albert Square was altered in an attempt to create a more attractive public space. Among the changes was the closure of the road in front of the Town Hall. In 1987–8 the enlarged square was entirely relaid in granite setts and stone flags.[62] Throughout these alterations the Albert Memorial remained the central point of the square, an architectural feature that, along with the town hall, became one of the visual symbols

of a modern city with a Victorian past. After its restoration both the memorial and the statue continued to need attention and they were cleaned and repaired on a number of occasions, most recently in 2002 as part of the preparations for the city's hosting of the Commonwealth Games.

Notes
[1] The Prince Consort Memorial Fund Manchester Minute Book, Report of sub-committee, 5 February 1862 (Chetham's Library, A7.7) [hereafter PCMF]. [2] PCMF sub-committee, 13 February 1862. [3] *Manchester Daily Examiner and Times*, 7 January 1862. [4] See below, p.37. [5] *Manchester Courier*, 11 January 1862; *Manchester Guardian*, 7 January 1862. [6] See below, p.152. [7] PCMF General Committee, 3 February 1862. [8] *Ibid.*, 17 September 1862. [9] See below, p.178. [10] E. Darby and N. Smith, *The Cult of the Prince Consort* (New Haven: Yale University Press, 1983) p.81. [11] PCMF General Committee, 17 September 1862. [12] PCMF sub-committee, 28 and 31 May 1862. [13] N.C. Smith, 'Imitation and invention in two Albert Memorials', *Burlington Magazine*, April (1981) pp.232–6. [14] PCMF sub-committee, 2 July 1862. [15] PCMF General Committee, 17 September 1862. [16] *Builder*, 27 September 1862, p.699. [17] PCMF General Committee, 17 September 1862; A.J. Pass, *Thomas Worthington Victorian Architecture and Social Purpose* (Manchester: Manchester Literary and Philosophical Society, 1988) p.46. [18] Smith, *op. cit.*, p.235. [19] PCMF sub-committee, 24 February 1862. [20] *Ibid.*, 11 September 1862, 8 October 1862; letter from Heron to Infirmary trustees (dated 12 August 1862), Manchester Royal Infirmary General Board Minutes, 20 October 1862; *Manchester Courier*, 4 October 1862. [21] *Builder*, 8 November 1862, p.805; Pass, *op. cit.*, pp.45–6. [22] PCMF sub-committee, 23 October 1862; Manchester Royal Infirmary Weekly Board Minutes, 27 October 1862; *Manchester Courier*, 22 November 1862. [23] *Builder*, 8 November 1862, p.805. [24] Manchester Royal Infirmary Weekly Board Minutes, 27 October 1862; Manchester Royal Infirmary General Board Minutes, meetings of sub-committee, 2 December 1862, 12 December 1862 (Manchester Royal Infirmary Archives). [25] *Manchester Guardian*, 8 January 1863. [26] *Manchester Daily Examiner and Times*, 10 January 1863. [27] PCMF sub-committee, 2 July 1862. [28] Letter from Francis Smith, *Manchester Courier*, 28 February 1863. [29] J.H.G. Archer, 'A civic achievement. The building of Manchester Town Hall'. *Transactions of Lancashire and Cheshire*

Antiquarian Society, 81 (1982) pp.5–11.
[30] *Manchester Guardian*, 5 March 1863. [31] PCMF minutes, 12 February 1863; *Manchester Courier*, 14 February 1863. [32] *Manchester Courier*, 7 March 1863. [33] *Manchester Guardian*, 5 March 1863. [34] *Ibid.* [35] PCMF General Committee, 15 July 1863, 28 July 1863. [36] *Ibid.*, 26 August 1863, 7 October 1863. [37] *Ibid.*, 7 October 1863. [38] *Ibid.*, 24 August 1864. [39] *Ibid.*, 3 July 1865. [40] *Ibid.*, 13 November 1865. [41] Manchester City Council General Purposes Committee, 1 February 1866; PCMF General Committee, 17 January 1866, 11 April 1866. [42] PCMF General Committee, 17 May 1866. [43] Pass, *op. cit.*, p.46. [44] PCMF General Committee, 3 September 1866. [45] *Manchester Examiner and Times*, 24 January 1867; *Manchester Guardian*, 24 January 1867; *Manchester City News*, 26 January 1867; *The Times*, 24 January 1867. [46] *Manchester Courier*, 24 January 1867. [47] *Report Presented to the Committee on the Occasion of the Inauguration of the Memorial* [Manchester, 1867]. [48] *Manchester Guardian*, 24 January 1867. [49] S. Bayley, *The Albert Memorial. The Monument in its Social and Architectural Context* (London: Scolar Press, 1971) pp.23–4; G. Stamp, 'George Gilbert Scott, the Memorial Competition, and the Critics' in C. Brooks (ed.) *The Albert Memorial* (New Haven and London: Yale University Press, 2000) p.124; C. Stewart, *The Stones of Manchester* (London: E. Arnold, 1956) p.82. [50] *Builder*, 7 November 1896, p.372; *Proceedings of Manchester City Council*, 1877–8, p.241; 1891–2, p.469; 3 August 1901, p.548; *Manchester Guardian*, 19 January 1911. [51] *Manchester Evening Chronicle*, 17 February 1923. [52] *Manchester Evening News*, 20 October 1950. [53] *Manchester Evening News and Chronicle*, 5 February 1964. [54] *Ibid.*, 6 February 1968. [55] *Ibid.*, 24 June 1971; *Guardian*, 25 June 1971, 1 July 1971, 15 July 1971, 6 August 1971. [56] *Manchester Evening News and Chronicle*, 28 July 1971; *Guardian*, 10 July 1971, 29 July 1971; *Daily Telegraph*, 15 July 1971. [57] *Guardian*, 9 March 1972. [58] *Manchester Evening News*, 15 February 1973, 20 August 1973. [59] *Ibid.*, 13 September 1973. [60] *Daily Telegraph*, 4 October 1976; *Manchester Evening News*, 29 September 1976, 3 October 1976. [61] *Manchester Evening News*, 24 October, 1977, 25 October 1977. [62] *Manchester: 50 Years of Change. Post-war Planning in Manchester* (London: HMSO, 1995) pp.63–5.

James Fraser
Thomas Woolner

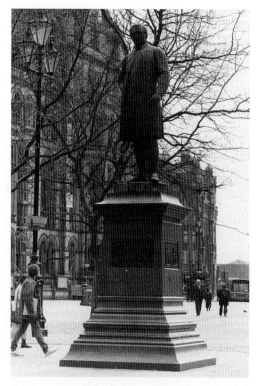

14 April 1888
Bronze statue; granite pedestal
Statue 2.74m high approx; pedestal 2.59m high × 2.11m square
Signed on plinth: T. Woolner Sc. London 1887
Inscription: JAMES FRASER D.D. / BISHOP OF MANCHESTER / 1870 – 1885 / BORN 18TH AUGUST 1818 / DIED 28TH OCTOBER 1885 / ERECTED / BY PUBLIC SUBSCRIPTION / 1887
Status: Grade II
Condition: fair
Owned by: Manchester City Council
Description: Portrait statue; a bronze larger than life-size statue of Fraser. He is shown dressed in long coat and gaiters, in the act of addressing a meeting. The statue surmounts an Aberdeen grey granite pedestal decorated with three rectangular bas-reliefs depicting different aspects of Fraser's work in the diocese: Fraser the Churchman (conducting a confirmation); Fraser the Citizen (addressing men in a work-yard); and Fraser the Charitable Man (visiting a public institution).

Woolner, *James Fraser*

James Fraser was born in Prestbury, Gloucestershire in 1818, the son of a retired India merchant. He was educated at Bridgnorth and Shrewsbury before entering Oxford University in 1836. He was ordained in 1846, becoming curate at Colderton, Wiltshire. Fraser continued his connection with Oxford University; he had been elected a fellow of Oriel College in 1840, becoming a chaplain and examiner. In 1860 he became rector of the small rural parish of Upton Norvet, Berkshire. His interest in elementary education resulted in his being appointed a commissioner in the government inquiry into foreign education systems. In 1870, following the death of James Prince Lee, Fraser was appointed as Manchester's second bishop. The Manchester diocese contained over two million people and 800 clergy. Fraser was virtually unknown in the

city, but his straightforwardness, simplicity and sincerity soon struck a chord with Lancashire people. He gave up the bishop's suburban residence, Mauldeth Hall, moving closer to the centre to be with the people. He was a man of wide sympathies, and his willingness to listen and to find common ground with opponents were qualities that enabled him to move across both religious and social boundaries. All this was in contrast to his predecessor. Suspicion towards Fraser turned into admiration, and in the following years the country rector became the 'Bishop of All Denominations'. His death on 22 October 1885 brought trading to a halt on the Cotton Exchange.[1]

The widespread respect felt for Fraser meant that, following his death, he received that rare

honour for a Victorian bishop, the raising of an outdoor public statue. The first public meeting to discuss a memorial statue was held in Manchester Town Hall in November 1885.[2] A large memorial committee, including ministers from the principal denominations, was established. A public subscription was opened 'to which persons of all religious denominations' were asked to contribute; within a few weeks some £3,000 had been collected or promised. A sub-committee was charged with making the arrangements for the memorial. It recommended approaching Thomas Woolner to sculpt the statue.[3] Woolner, one of the Pre-Raphaelite Brotherhood, who had produced the principal statuary for the city's Assize Courts in the 1860s, agreed to the commission.[4] A fee of £3,250 (excluding fitting) was agreed for a statue that would be nine feet tall and would include a pedestal with three bas-relief panels.[5] Woolner represented Fraser in his ordinary working clothes, whilst the panels depicted him in three guises: Fraser as the churchman, the citizen and the charitable man. The location of the statue was to be on the edge of Albert Square, close to Princess Street: a site agreed with the Paving Committee.

While the statue was being planned, arrangements were also in hand for a separate diocesan memorial in the cathedral. This was a life-size marble effigy of Fraser in his bishop's robes, recumbent on an ornately carved altar tomb. The figure was sculpted by James Forsyth, the tomb being the work of Earp, Son and Hobbs. It was officially inaugurated in a chapel provided by Fraser's widow, Agnes, in July 1887.[6] Delays prevented Woolner's statue from being ready until the following spring. The casting was carried out at James Moore's foundry in Thames Ditton, and Woolner wrote to the committee stating that he considered it to be 'one of the best casts he ever made'.[7] The statue was delivered and erected in the square,

Woolner, *James Fraser, bronze reliefs on pedestal*

Woolner, *James Fraser, bronze relief on pedestal*

with Woolner apparently deciding that its best position was looking towards Princess Street rather than facing towards the town hall or the square.[8] This decision appears to have been taken at the last moment because the inscription was now on the rear rather than on the front of the pedestal. Fraser's biographer, John Diggle, refers to a much longer inscription on the pedestal – it spoke of his 'untiring industry, noble simplicity of character, large views and kindness of heart' – but this was dropped in favour of a briefer one.[9]

The unveiling ceremony in April 1888 attracted a large crowd keen to see Manchester's statue of its 'Citizen Bishop'. Two notable absentees in an otherwise formidable group of principal guests were Thomas Woolner and Mrs Fraser.[10] The ceremony was conducted with the usual generous speeches, the honour of

unveiling the statue going to the mayor, James Harwood.[11] The statue was well received, except for Woolner's decision to position it so that it was looking away from the square and the town hall. Calls were made for this 'blunder' to be rectified, but no action was taken.[12] The final sum subscribed for the statue amounted to £3,946, leaving a small surplus to be paid into Bishop Fraser's Scholarship Fund.[13] The three plaster reliefs (bronzed) made for the Fraser statue were sold at the auction of Woolner's studio in 1913.[14]

Since the unveiling of the statue, further calls have been made to turn either the figure or the pedestal.[15] But, in spite of the addition of further statues in the square, all facing the town hall, Fraser has remained looking towards Princess Street, or, as some have assumed, towards the cathedral. An opportunity to turn the statue offered itself in 1960 when a lorry collided with it. Fraser was removed from his pedestal, but the bishop was not for turning:

when he was put back he was still facing away from the square.[16]

Notes
[1] T. Hughes, *James Fraser, Second Bishop of Manchester. A Memoir, 1818–1885* (London: Macmillan, 1887); J.W. Diggle, *The Lancashire Life of Bishop Fraser* (London: Sampson Low, 1889). [2] *Manchester Guardian*, 3 November 1885. [3] B. Read, 'Thomas Woolner' in B. Read and J. Barnes (eds), *Pre-Raphaelite Sculpture. Nature and Imagination in British Sculpture* (London: Henry Moore Foundation and Lund Humphries, 1991) pp.21–33. [4] See below, p.74. [5] *Manchester Guardian*, 11 April 1888. [6] *Ibid.*, 8 July 1887. [7] *Ibid.*, 14 March 1888. [8] *Manchester Courier*, 11 April 1888. [9] Diggle, *op. cit*, pp.549–50. [10] *Manchester Evening News*, 13 April 1888; *Manchester Courier*, 16 April 1888. [11] *Manchester Guardian*, 16 April 1888; *Manchester Courier*, 16 April 1888; *The Times*, 16 April 1888. [12] *Manchester Guardian*, 16 April 1888. [13] *Ibid.*, 14 April 1888. [14] *A Catalogue of the Remaining Works of the late Thomas Woolner R. A.* [1913], No.269. [15] *Manchester Examiner and Times*, 12 October 1891; *Manchester Guardian*, 19 January 1911. [16] *Guardian*, 25 July 1960, 9 November 1960.

John Bright
Albert Bruce Joy

10 October 1891
Sicilian marble statue; granite pedestal
Statue 3.2m high; pedestal 2.8m high × 1.92m × 1.84m
Signed on plinth: A. Bruce Joy Sc. 1891
Inscription: JOHN BRIGHT / 1811–1889
Status: Grade II
Condition: fair
Owned by: Manchester City Council
Description: Portrait statue; marble statue of Bright on grey granite pedestal. Bright is shown in modern clothing, waistcoat and light topcoat. His right hand is by his side whilst in his left hand, raised to his chest, he is holding a speech.

John Bright, the son of Jacob Bright, a successful cotton manufacturer, was born in Rochdale in 1811. He received a Quaker

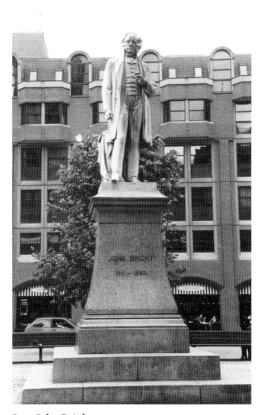

Joy, *John Bright*

education at schools in Lancashire and Yorkshire. This education helped to develop in Bright a passionate commitment to political and religious equality. Bright worked in the family business in Rochdale and also became involved in local politics, including the campaign against the economic privileges of the Anglican Church. In 1839, he joined the Anti-Corn Law League, establishing himself as one of its most forceful and popular public speakers. Bright attacked the privileged position of the landed aristocracy and argued that its selfishness was the cause of much working-class suffering. In 1843 he was elected as MP for Durham. Following the repeal of the Corn Laws in 1846, Bright and Cobden were political heroes. Bright used his high standing to campaign for progressive causes. With Cobden he opposed Britain's aggressive foreign policy, a stance that led to their campaign against the Crimean War. The two men were much abused by the press and in the 1857 general election, both Bright and Cobden lost their parliamentary seats. Five months later, Bright won a by-election in Birmingham. He refused, however, to change his view on Britain's foreign policy. As a Quaker he was opposed to slavery and was a passionate supporter of the Union in the American Civil War. A believer in universal male suffrage and the secret ballot, Bright was an important figure in the Liberal campaign for parliamentary reform. When Gladstone became prime minister in 1868 he appointed Bright President of the Board of Trade. Ill-health forced him to retire from the cabinet in 1870. Bright went on to hold other government offices, but he was never slow to criticise what he considered to be the mistaken policies of his own party. He was widely acknowledged as one of the great public speakers of the nineteenth century. He remained MP for Birmingham until his death on 27 March, 1889.

Bright's death brought forward a number of memorial schemes in Lancashire, including a statue in Rochdale and the idea of a clock tower in Milnrow.[1] Manchester also decided to honour him, even though it had in 1878 installed a marble statue of him in the new town hall.[2] Twenty-one years before it had burnt him in effigy. The idea for a second statue originated in the Manchester Chamber of Commerce, an association that shared Bright's belief in the importance of destroying commercial and political monopolies. The scheme was publicly launched at a meeting in October 1889, some six months after his death.[3] Benjamin Armitage, a friend and fellow Liberal, was chairman of the memorial committee. Other committee members included local MPs and prominent public figures, including Thomas Ashton, Oliver Heywood and William Agnew. The inclusion of the cotton trade union leader, James Mawdsley, suggested a wider working-class support for the memorial. In the end just over 200 subscribers provided the necessary funds. The selection of the sculptor appears to have caused little debate, it being agreed that the commission should go to Albert Bruce Joy. He had already produced a marble statue of Bright for Birmingham, a representation that Bright was known to have approved.[4] Moreover, Joy had taken a copy of Bright's skull after death.[5] As in Birmingham, the statue was to be in marble. This choice of material did not appear to raise any concerns, even though it was understood that it would be located out of doors. In contrast, Rochdale had rejected marble for its memorial statue, following concerns that it would not resist, as readily as bronze, the town's smoky atmosphere. There was more debate over the location of the statue. Various sites were considered and, unsurprisingly, there was a feeling that St Ann's Square would be the most appropriate location, because it already contained Marshall Wood's statue of Cobden. Here was an opportunity to reunite the two men who had made Manchester's politics the nation's politics. In spite of promptings from the mayor, John Mark, to choose St Ann's Square, it was finally decided to place the statue in Albert Square, facing the town hall.[6]

Joy completed the statue by the autumn of 1891 and it was brought to Manchester, where it was placed on a polished grey granite pedestal, supplied by John Freeman and Sons of Penrhyn, Cornwall. The public unveiling in Albert Square took place in October 1891.[7] The individual chosen to carry out the unveiling was not a leading Liberal but the natural leader of Lancashire conservatives, Lord Derby, 15th Earl, a decision that was meant to emphasise the broad support for the memorial statue. Heavy rain shortened the outdoor ceremony, but on retiring inside the town hall, Lord Derby praised his political opponent for his moral courage, determination and oratory. Bright, above all, was a Lancashire man:

...we in Lancashire claim him specially, not merely because he was born and bred among us, but because he embodied in a peculiar degree those qualities which are usually held to be characteristic of Lancashire – strong and clear opinions, determined purpose, and plain, uncompromising speech.[8]

A special presentation book recording the deed of transfer of the statue from the committee to the Corporation was handed over to the mayor.[9]

Albert Bruce Joy's representation of Bright was praised in the local press: the *Manchester Courier* called attention to the fine head and the expressive features 'depicted with a care which appears to amount almost to affection on the part of the sculptor'.[10] As in his other commissions, Joy was concerned that the statue be positioned so that it could be viewed in the best light. It was for this reason that he had it placed so that the figure faced the Albert Memorial, advising that the best time to view it was in the late morning and 'not in the afternoon when the sun would be shining obliquely upon it'.[11] It was, however, made clear that this would be a temporary arrangement, as the statue would be eventually turned to face the town hall. This was done shortly afterwards. The intention to inscribe on the pedestal one of Bright's memorable phrases – 'Be just, and fear not' – which had been painted on for the ceremony, was never realised.[12]

Poster advertising public meeting to discuss a 'suitable memorial' for John Bright, October, 1891

Notes

[1] See below, p.318. [2] See p.35. [3] *Manchester Guardian*, 30 and 31 October 1889; *The Times*, 30 October 1889. [4] G.T. Noszlopy, *Public Sculpture of Birmingham* (Liverpool: Liverpool University Press, 1999) pp.36–7; *The Times*, 12 April 1888. [5] *Dictionary of National Biography*. [6] *Proceedings of Manchester City Council*, 6 May 1891, pp.396–7; 15 July 1891, p.614. [7] *Manchester Guardian*, 12 October 1891; *Manchester Examiner and Times*, 12 October 1891; *Manchester Courier*, 12 October 1891. [8] *Ceremony of Unveiling the Statue of the late John Bright M.P.* (Manchester, 1891) p.14. [9] Manchester Town Hall muniments Box 56 Pcl 1. [10] *Manchester Courier*, 10 October 1891. [11] *Ibid.*, 12 October 1891. [12] *Manchester Guardian*, 3, 5 and 6 August 1908. The words are spoken by Wolsey in Shakespeare's *Henry VIII* Act 3, Scene 2.

Oliver Heywood
Albert Bruce Joy

11 December 1894
Sicilian marble statue; granite pedestal
Statue 3.2m high approx; pedestal 2.8m high × 1.92m × 1.84m; steps 3.65m × 3.58m × 59cm high
Signed on plinth: A. Bruce Joy Sc. 1894
Inscription on pedestal: OLIVER HEYWOOD 1825–1892 / ERECTED BY / THE CITIZENS OF MANCHESTER / TO COMMEMORATE A LIFE / DEVOTED TO THE PUBLIC GOOD
Status: Grade II
Condition: fair
Owned by: Manchester City Council
 Description: Portrait statue; a larger than life-size marble statue of Heywood, who is shown dressed in modern clothing, with an open topcoat. His left hand is placed on the top of a column on which are documents. The statue surmounts a grey granite pedestal.

Oliver Heywood was born in 1825 in Manchester, the son of the banker, Sir Benjamin Heywood. He was educated at St Domingo House, Liverpool, and at Eton. The family contributed greatly to the improvement of Manchester during the nineteenth century. Oliver's father, Benjamin Heywood, was a key

figure in the establishment of the Manchester Mechanics' Institute and the movement to provide public parks. Oliver entered the family business, Heywood's Bank, St Ann's Square, in the 1840s but devoted considerable time to assisting public charities and causes on both sides of the Irwell. Education was a particular interest and the Mechanics' Institute, Working Men's College, Chetham's Hospital, Manchester Grammar School and Owens College were among the city's educational institutions that benefited from his personal involvement. At a time when many wealthy citizens were deserting the city, and failing to fulfil their public duties, Heywood's willingness to devote both time and money to local affairs was viewed as exemplary. In 1888

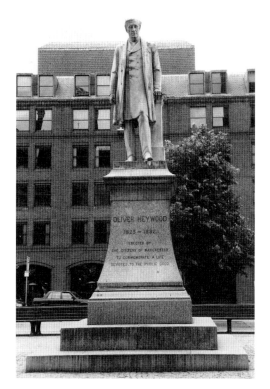

Joy, *Oliver Heywood*

his work was recognised, when he was made Manchester's first Honorary Freeman. In the same year he was made High Sheriff of Lancashire. Heywood died in 1892 and was buried at St John's, Irlam o'th' Heights.[1]

Following Heywood's death, the call for a public statue received enthusiastic support. What was characterised as a large and influential memorial committee was established in April 1892. It initiated a subscription fund.[2] The record of the 332 subscribers, whose donations amounted to £2,665, provides a handy check-list of the city's late-Victorian establishment. The memorial committee decided to commission Albert Bruce Joy to produce a marble statue to stand in Albert Square, complementing his earlier statue of John Bright. Joy agreed to the commission, informing the committee that he could complete a marble statue in two years but 'very probably 18 months', whilst promising that a small model (based on photographs of Heywood) would be ready for the committee's approval within three weeks. Joy reminded the committee that it was the usual practice to advance one-third of the commission price. In an equally businesslike manner, the committee sent a telegram to the sculptor's West Kensington studio reminding him not to mention the commission price of 2,000 guineas to the press.[3] The commission did not, however, proceed entirely smoothly, as an accident to Joy prevented him from making an early delivery. The statue was finally completed by the end of 1894.

The statue was installed in Albert Square where, in December 1894, it was unveiled by James Moorhouse, Bishop of Manchester. The speeches at the ceremony all testified to the truthfulness of the inscription on the pedestal: that the life of the gentle and modest Heywood had been one 'devoted to the public good'.[4] The *Manchester Guardian* acknowledged that the sculptor had produced 'a competent piece of work, which does not make us ridiculous', before expressing deeper concerns about the artistic limitations of the public portrait statue.[5]

Notes
[1] *Manchester Faces and Places*, 1 (1889) pp.33–7; *Manchester Guardian*, 18 March 1892; *Transactions of Lancashire and Cheshire Antiquarian Society*, 10 (1892) pp.257–8. [2] *Manchester Guardian*, 27 April 1892. [3] Oliver Heywood Memorial correspondence, Box 56 Pcl 22 (Town Hall Muniments). [4] *Manchester Guardian*, 12 December 1894; *Manchester Courier*, 12 December 1894; *Manchester Evening News*, 11 December 1894. [5] *Manchester Guardian*, 18 December 1894; *Manchester Faces and Places*, Vol.9 (1897–8) p.233.

William Ewart Gladstone

Mario Raggi
23 October 1901
Statue 3m high; pedestal 3.05m high
Bronze statue; granite pedestal
Signed on plinth: M. Raggi Sc
Inscription on pedestal: WILLIAM EWART GLADSTONE
Status: Grade II
Condition: good
Owned by: Manchester City Council

Description: Portrait statue; larger than life-size bronze statue of Gladstone surmounting an ornate hexagonal-shaped red Peterhead granite pedestal. Gladstone, in modern dress with open topcoat showing his waistcoat, is depicted speaking in the House of Commons, his right hand outstretched and the notes of his speech in the other hand.

William Ewart Gladstone was born in Liverpool in 1809, the son of Sir John Gladstone, a merchant and MP. He was educated at Eton and Oxford. His parliamentary career began in 1832, when he was elected as the Tory MP for Newark. He was a supporter of Peel and held a number of ministerial posts. His move to Liberalism began after the repeal of the Corn Laws and the death of Peel. He was Chancellor of the Exchequer in the coalition government of 1852. He became the dominant figure of Victorian Liberalism and was Prime Minister on four occasions: 1868–74,

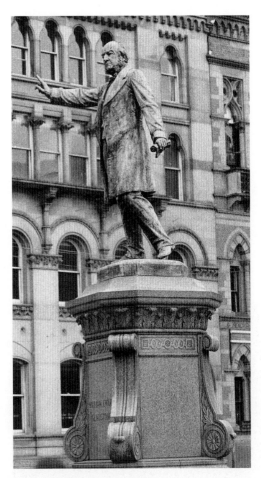

Raggi, *William Ewart Gladstone*

many occasions. In 1837 he was unsuccessful when standing as a Conservative candidate for one of the borough's two parliamentary seats. In 1893 he assisted in obtaining the title of Lord Mayor for the city's chief magistrate. The esteem Gladstone enjoyed locally was shown when a statue of him was placed in the new town hall in 1879.[1] Manchester's outdoor statue of Gladstone was erected after his death. Its origins were not in a public subscription but in a legacy left by the Manchester architect and surveyor, William Roberts. Roberts was not to be numbered among the great architects of Victorian Manchester, though over the years his bread-and-butter work enabled him to enjoy a comfortable living. He was Unitarian in religion, Liberal in politics and a strong admirer of Gladstone. The extent of that admiration was revealed after his death in 1899, when Roberts, who had never married, left £4,500 out of an estate of over £23,000 to erect a bronze statue of Gladstone in Manchester.[2] The city had already begun supporting the scheme for a national memorial, but had not seriously considered raising one of its own.[3] It was Roberts's executors, James Green, Edward Rowland and Samuel Horrocks, who were responsible for carrying out his wishes. They invited a number of leading sculptors to present models and, before making the final choice, sought the opinions of members of Gladstone's family, including Herbert Gladstone and the Revd Stephen Gladstone.[4] The outcome was that the commission was given to the London sculptor, Mario Raggi, who depicted Gladstone speaking in the House of Commons during the debate on the Irish Home Rule Bill in 1893. Raggi had witnessed that decisive debate and sketched the Prime Minister as he presented his arguments in favour of the bill. Raggi had no previous commissions in the city, but as a pupil of Matthew Noble, one assumes that he may have worked on some Manchester or Lancashire statuary.[5] The question of the site for the Gladstone statue was decided after discussions between the trustees and the city council.[6]

Although Roberts had expressed the hope that the statue might be placed on the Esplanade in Piccadilly, this was not regarded as a suitable location by the council. Three other sites – the junction of Exchange Street and Market Street, the junction of Mosley Street and Piccadilly, and the junction of Portland Street and Piccadilly – were considered but again ruled out.[7] Finally, it was agreed to place the statue in Albert Square, next to the Oliver Heywood statue, thus balancing those of Bright and Fraser on the other side of the Albert Memorial. Raggi completed the model with relatively few problems, the casting being carried out by Singers of Frome.[8]

The unveiling ceremony in October 1901 was presented as a non-political event, honouring Gladstone the statesman and patriot rather than Gladstone the politician of Victorian Liberalism. Local Conservative and Liberal MPs stood side by side during the ceremonies. It was the Conservative MP, Sir William Houldsworth, who introduced John Morley to unveil the statue. Morley, who was then working on his own Gladstone monument – the three-volume biography whose publication was to be the literary event of 1903 – removed the coverings to reveal the statue. The 'Grand Old Man' was to the cheering Mancunians also a 'Lancashire Man'. However, it was difficult to steer such an event into non-partisan channels, though Morley's speech in the Great Hall of the Town Hall, following the unveiling, did try to strip the politics out of the man.[9] It was an all but impossible task, not least in a room where Gladstone was already memorialised in marble. Amidst the panegyrics, the Tory *Manchester Courier,* for one, could not resist reminding its readers that many of the current problems facing the country, including the South African War, could be traced directly back to Gladstone's policies.[10] For its part, the Liberal *Manchester Guardian* listed the great institutions, including a free press and elementary schools, which Gladstone had helped to shape.[11]

1880–5, 1886 and 1892–4. The cause of Home Rule for Ireland became a major concern in his later political life. His first Home Rule Bill introduced in 1886 led to resignation and the return of the Conservatives to power. His second Home Rule Bill of 1893 was successful in the Commons but defeated in the Lords. Gladstone resigned as Prime Minister in 1894. He died at his home at Hawarden in 1898 and was buried in Westminster Abbey.

Gladstone had a long connection with Manchester, visiting and speaking in the city on

Raggi's representation of the 'Grand Old Man' was admired for its liveliness and for the manner in which he had captured the expression of Gladstone and his presence as a public speaker, epitomised in the forcefulness of the outstretched right arm. The sculptor's previous commissions had included a statue of Benjamin Disraeli in Parliament Square, London. One pedantic observer, however, felt that the statue could be improved: Signor Raggi had not represented Gladstone true-to-life, having taken artistic licence in restoring the finger on the statesman's left hand, which had been lost in a shooting accident as a young man.[12] Mancunians were sometimes over-eager to claim that their statue was the first major public memorial to be raised after Gladstone's death, a claim that ignored other monuments, including Adams-Acton's marble *Gladstone* in Blackburn.[13]

Notes
[1] See p.36. [2] *Manchester Evening News*, 23 February 1899; *Manchester Guardian*, 24 February 1899. [3] *Proceedings of Manchester City Council*, 16 November 1898. [4] *Manchester Courier*, 22 October 1901. [5] S. Nairne and N. Serota, *British Sculpture in the Twentieth Century* (London: Whitechapel Art Gallery, 1981) pp.41, 44. [6] *Manchester Guardian*, 10 April 1899; Manchester City Council Minutes, April 1899. [7] *Manchester Guardian*, 26 June 1900, 20 July 1900. [8] *Ibid.*, 20 July 1900. [9] *Manchester Evening News*, 23 October 1901; *Manchester Guardian*, 24 October 1901; *Manchester Courier*, 24 October 1901; *Manchester City News*, 26 October 1901.
[10] *Manchester Courier*, 24 October 1901.
[11] *Manchester Guardian*, 24 October 1901.
[12] *Ibid.*, 25 October 1901. [13] *Ibid.*, 10 November 1899.

Jubilee Fountain

Architect: Thomas Worthington and Sons

Sculptor: John Cassidy

5 January 1898; reinstalled 22 July 1997
Bolton Wood sandstone; red and grey granite
4.57m high approx; lower basin 6.4m diameter

approx; middle basin 2.75m diameter approx; top basin 1.07m diameter approx
Inscription around middle basin: ERECTED IN THE SIXTIETH YEAR OF THE REIGN OF HER MOST GRACIOUS MAJESTY QUEEN VICTORIA EIGHTEEN HUNDRED AND NINETY-SEVEN – on plaque on floor: The / Queen Victoria Jubilee / Fountain / Completed July 1997 / Funded by / Manchester City Council / North West Water / European Regional Development Fund / This fountain / was originally sited / in this location / to commemorate / the supply of water from / the Thirlmere Reservoir
Status: Grade II
Condition: good
Owned by: Manchester City Council
 Description: Ornamental fountain, hexagonal in plan. Rising from granite steps, the lower basin is constructed from unpolished red granite with square piers and moulded caps at the six angles. The second basin is made of Bolton Wood sandstone and rises from the centre of the lower basin, supported by granite shafts with carved capitals. The sides of the basin have moulded and traceried panels, two of which bear the arms of the City of Manchester and the Duchy of Lancaster. At the angles of the basin, bronze dragon gargoyles discharge water into the lower basin. Above this is a smaller and shallower basin of red granite from which rises a moulded stem of red granite with a spreading cap, upon which is a bronze dolphin.

Late-Victorian Manchester saw an increase in the number of its drinking and ornamental fountains. James Jardine, a Manchester cotton

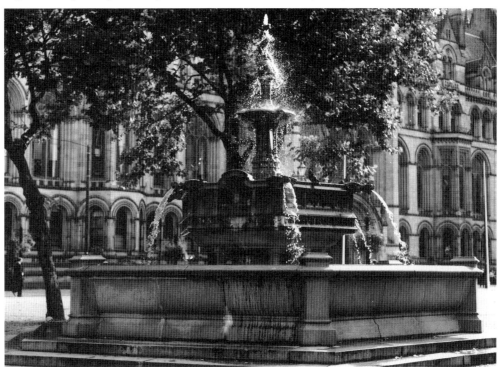

Worthington, *Jubilee Fountain*

manufacturer, left money for the erection of two fountains. Albert Square was considered as a possible site for one of them, replacing an existing one which had been installed to mark the arrival of water from the Thirlmere reservoir in the Lake District.[1] In the end the two fountains were installed elsewhere in the city: one at All Saints, Oxford Road, and the other outside Jardine's cotton mill in Butler Street, Ancoats.[2] A substantial drinking fountain was also raised at the entrance to Peel Park to mark its golden jubilee in 1896. The idea of erecting a new fountain in Albert Square took a decisive turn when, in the summer of 1896, the council was informed by the Manchester architects, Thomas Worthington and Sons, that an anonymous donor wished to present the city with a large ornamental fountain to stand in the square.[3] Worthingtons were responsible for the design, a three-basin fountain in granite and sandstone topped by a bronze dolphin, modelled by John Cassidy. The council accepted the gift and agreed that it would be placed between the statues of John Bright and Bishop Fraser. Construction went ahead under the supervision of Thomas Worthington and Sons, with most of the work being carried out by J. and H. Patteson.[4] The fountain was turned on by the Lord Mayor, Robert Gibson, in January 1898.[5] Its cost was estimated at between £1,000 and £1,200.[6]

Not everyone regarded the fountain as an improvement: some saw it as one memorial too many, whilst for others the unpredictability of the local wind resulted in a sudden soaking. One Edwardian correspondent called for this 'useless and irritating object' to be moved to a more suitable open space in the city.[7] For a time it was left 'dry'.[8] The fountain was eventually moved in the 1920s to Heaton Park. The idea of returning the fountain was mooted in the 1970s, but it was in 1986 that plans were announced to restore the fountain and return it to the city centre. It was to become the focal point of a new open space in front of the Corn Exchange.[9] This plan was not realised. The fountain was,

however, returned to the city centre in 1997 when it was placed once more between the statues of Bright and Fraser in Albert Square. The £250,000 cost was funded by the City Council, North West Water and the European Union. The restored fountain, which incorporated a sophisticated system for regulating the flow of water, was officially switched on by the deputy prime minister, John Prescott, in July 1997.[10]

Notes
[1] *Illustrated London News*, 20 October 1894, p.493; *Proceedings of Manchester City Council*, 13 February 1895, pp.153–4, 20 February 1895, pp.173–4. [2] *Proceedings of Manchester City Council*, 7 August 1895, p.819. Jardine's mill was in Butler Street. [3] *Ibid.*, 7 October 1896, pp.1414–15, 1 December 1897, pp.388–9. [4] *Manchester Weekly Times*, 29 October 1897; *Manchester Guardian*, 26 November 1897. [5] *Manchester Guardian*, 6 January 1898. [6] *Proceedings of Manchester City Council*, 1 December 1897, p.387. [7] *Manchester City News*, 24 September 1904. [8] *Manchester Evening News and Chronicle*, 13 August 1971. [9] *Manchester Evening News and Chronicle*, 13 August 1971; *Manchester Evening News*, 29 December 1986. [10] *Manchester Evening News*, 23 July 1997.

Town Hall, Albert Square
Architect: Alfred Waterhouse

13 September 1877

By the early 1860s there was a recognition among some Manchester councillors of the difficulties of administering a major Victorian city from the Georgian town hall in King Street. The building of a new town hall became part of the debate over the siting of the Albert Memorial.[1] The outcome was the decision to locate Manchester's new town hall on the Town Yard, a triangular-shaped site, fronting Albert Square. It was Alfred Waterhouse's Gothic design that was selected in the subsequent two-stage competition. The foundation stone of the new building was laid by the mayor, Robert Neill, on 26 October 1868. Nine years later the

building was completed. Queen Victoria turned down the invitation to open the town hall, a request that had been baited with the additional attraction of inspecting the Albert Memorial.[2] It was the mayor, Abel Heywood, who had been at the very centre of the project, who opened Manchester's 'Municipal Palace' on 13 September 1877.[3] The cost of the land and the building work approached £1,000,000.

Statuary was regarded by Waterhouse as an integral part of his scheme for the decoration of the town hall. Spaces were provided for statues on all sides of the building, especially on the Albert Square elevation. These included statues above the central entrance, and, in particular, in the pavilion on the Albert Square–Princess Street corner. Here Waterhouse included six statues in canopied niches to emphasise this corner of the building. He also recommended historical figures to fill these niches: Elizabeth I, Charles I, Roger de Poitiers, Thomas de Gresley, Thomas de la Warre and Humphrey Chetham; individuals chosen because of their historical associations with the city, though to what extent Waterhouse sought advice in making this selection is not clear. He also identified other historical figures for the statues on other parts of the building.[4] His suggestions, however, were revised, presumably following discussions in the Town Hall Building Committee, whose members included John Thompson and Abel Heywood. In respect to the pavilion statues only two on Waterhouse's list – Thomas de la Warre and Humphrey Chetham – survived; four new 'Manchester Worthies' – Henry, First Duke of Lancaster, Thomas de Gresley, John Bradford and Charles Worsley – being agreed upon. The consequence was that the pavilion statues now proclaimed a more radical view of the town's history. The removal of Charles I and the inclusion of General Charles Worsley, who had taken part in the removal of the Long Parliament and fought against the Royalists in the Civil War, underlined the shift in historical emphasis. These changes to the external statuary were occurring as Heywood and other

councillors continued to press for a marble statue of Oliver Cromwell inside the town hall.[5] But, if not all of the exterior figures or their locations were to be those originally proposed by Waterhouse, their execution by Farmer and Brindley did meet his requirement that they were to be of 'as picturesque a character as possible'.[6] Farmer and Bindley was widely acknowledged as one of the country's leading firms of architectural sculptors. A smaller, but not insignificant, feature of the external architectural sculpture was the introduction of the coats of arms of individuals associated with Manchester's development. These included not only ancient families associated with the town, but, less predictably, many more recent families who were still contributing to the making of Cottonopolis. Indeed, had appropriate armorial bearings been available, John Thompson was in favour of further extending this modern roll call by including inventors and captains of industry.[7] Both Waterhouse and Axon provided descriptions of the external statuary.[8]

Notes
[1] See above, p.13. [2] *Proceedings of Manchester City Council*, 11 April 1877 p.175. [3] J.H.G. Archer, 'A civic achievement: The building of Manchester Town Hall. Part One: The commissioning', *Transactions of Lancashire and Cheshire Antiquarian Society*, 81 (1982) pp.3–29; J.H.G. Archer (ed.), 'A Classic of its Age' in J.H.G. Archer (ed.), *Art and Architecture in Victorian Manchester* (Manchester: Manchester University Press, 1985) pp.127–61; C. Cunningham, *Victorian and Edwardian Town Halls* (London: Routledge and Kegan Paul, 1981) pp.49–5, 182–8. [4] Report by Alfred Waterhouse to the New Town Hall Committee on the positioning of statues in the Great Hall (Manchester Central Library, Local Studies and Archives M79/8). [5] See below, p.152. [6] Town Hall Committee (M9/75/1). [7] Papers of John Thompson (City of Manchester Archives, M79/2); drawings of the Albert Square entrance in *Building News*, 14 July 1876. [8] A. Waterhouse, 'Description of the new Town Hall at Manchester', *Royal Institute of British Architects*, February (1877) pp.117–36; W.E.A. Axon (ed.), *An Architectural and General Description of the Town Hall, Manchester* (Manchester: A. Heywood, 1877).

(right) Farmer and Brindley, *St George*

Central gable, Albert Square

St George

St George, patron saint of England, depicted in armour, resting on his shield. The gable contains the coat of arms of the city of Manchester, dated 1873.

Niches beneath gable

Henry III

It was during Henry's reign that Manchester was granted a charter. He is depicted in royal costume, the sceptre in his right hand and the orb in his left.

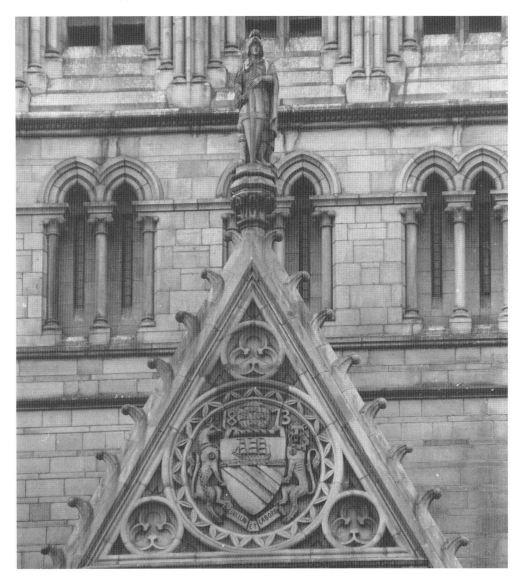

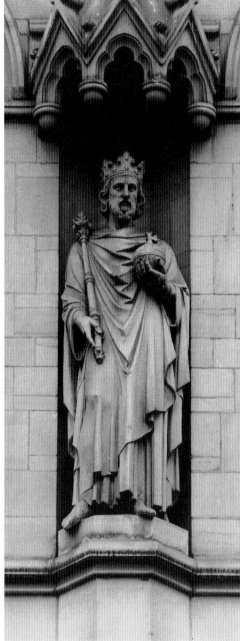

Farmer and Brindley, *Henry III*

Farmer and Brindley, *Elizabeth I*

Elizabeth I

During Elizabeth's reign Manchester market privileges were extended. She is shown holding a sceptre in her right hand and the sealed charter in the other hand. Waterhouse had proposed Edward the Saxon and William the Conqueror for these two niches.

Porch gable

Agricola

Agricola, the Roman general and statesman. It was during his period as Governor of Britain that the Romans established a settlement in Manchester. The Roman fort was located at present-day Castlefield.

Albert Square–Princess Street corner

Six larger than life-size statues (2.44m high) arranged on the Albert Square and Princess Street corner of the town hall. The figures are in niches and surmount octagonal pedestals, inscribed with their names. The statues of Gresley and de la Warre flank the windows whilst the other four figures are arranged in pairs. They were carved by Farmer and Brindley and installed in March 1877.[1] They are from left to right:

Note
[1] *Manchester Guardian*, 17 March 1877; Description of Sculpture by Farmer and Brindley (M79/5–7).

Thomas de Gresley

Thomas de Gresley (Grelley) was the Lord of the Manor when Manchester was granted its charter in 1301. He is depicted holding the sealed charter in his hands and with a shield hanging by his side. The inscription on the pedestal reads: THOMAS DE GRESLEY.

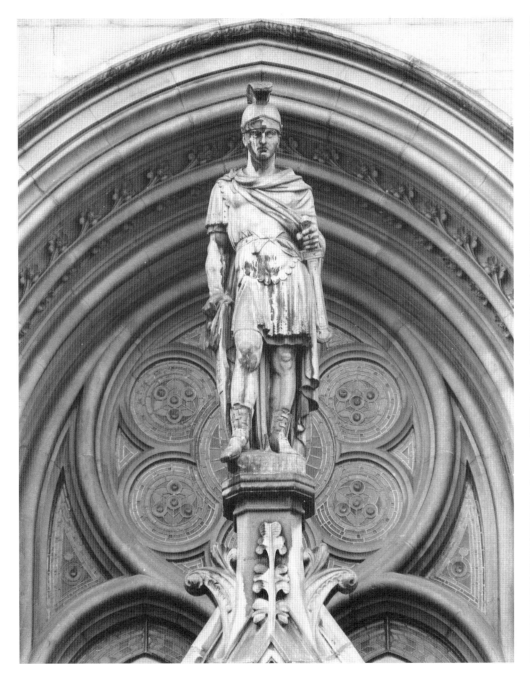

Farmer and Brindley, *Agricola*

Farmer and Brindley, *Thomas de Gresley*

Farmer and Brindley, *Thomas de la Warre*

Farmer and Brindley, *John Bradford; General Charles Worsley*

Thomas de la Warre

Thomas de la Warre was the Lord of the Manor, Rector of Manchester and, in 1421, the founder of the Collegiate Church. He made an important contribution to the expansion of the church buildings, part of which was to find a new use in the seventeenth century as Chetham's School and Library. Warre died c.1427. He is dressed in clerical robes and holds a model of the Collegiate Church in both hands. The inscription on the pedestal reads: DE LA WARR (sic).

John Bradford

John Bradford (1510?–55) was born and educated in Manchester and was a popular Protestant preacher. He continued to preach during the reign of Queen Mary, was imprisoned, and burnt at the stake in Smithfield, London. Bradford became known as the 'Manchester Martyr'. He is depicted preaching, dressed in his MA gown, and holding an open book in his right hand. The inscription on the pedestal reads: BRADFORD.

General Charles Worsley

Charles Worsley (1622–56) was born at Platt Hall, Rusholme, the son of Ralph Worsley. He was an officer in the Parliamentary army and represented Manchester in the parliament of 1654. He is shown, bareheaded, in military uniform with the characteristic armour and high boots of the period. The inscription on the pedestal reads: WORSLEY.

Humphrey Chetham

Humphrey Chetham (1580–1653) was a Manchester merchant and philanthropist responsible for the founding of Chetham's Hospital and Library. The likeness is based on the portrait in Chetham's Library, and he is shown holding an unfurled parchment, his will, in his right hand, and a model of the school in

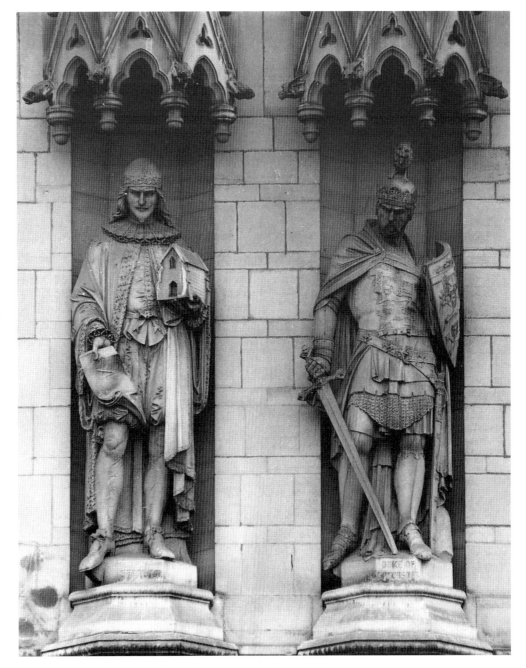

Farmer and Brindley, *Humphrey Chetham; Henry, Earl of Derby, First Duke of Lancaster*

the other hand. The inscription on the pedestal reads: CHETHAM.

Henry, Earl of Derby, First Duke of Lancaster

'Henry the Good' was created Earl of Derby in 1337 and the first Duke of Lancaster in 1351. He was one of the original Knights of the Garter. He is depicted in full armour and with his sword and shield ready for action, the costume and arms being based on his effigy in the Elsyng Brass. The inscription on the pedestal reads: DUKE OF LANCASTER. Farmer and Brindley's plaster model has survived and is displayed inside the town hall. It is believed to have been painted for the municipal centenary in 1938.

Princess Street façade

Edward III

Flemish weavers settled in England during Edward's reign in the fourteenth century. He is depicted in full armour, bearing a shield with the arms of France quartered with England and a down-turned sword. The inscription on the pedestal reads: EDWARD III.

Weaving

Beneath the oriel window a roundel depicts a youth working on a handloom. His costume and the fly shuttle suggest the eighteenth century.

Cooper Street façade porch gable

Edward the Saxon

Edward the Elder was the son of Alfred the Great, succeeding his father as king in 899. He was reported to have fortified Manchester. Waterhouse had originally recommended a figure of Britannia for this position.

(right) Farmer and Brindley, *Edward III*

Lloyd Street façade

Spinning

Stone roundel of female spinning cotton by hand in the eighteenth century. This was a companion piece to Weaving on Princess Street. It was removed from the Lloyd Street elevation

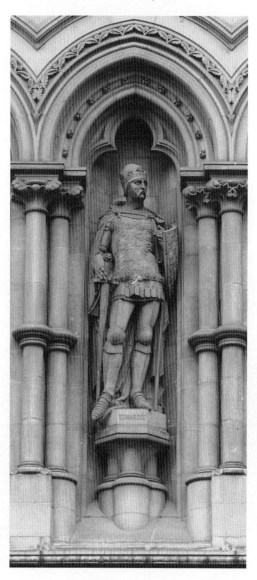

Farmer and Brindley, *Weaving*

during the building of the town hall extension in the 1930s and placed inside the town hall. It is currently displayed in the Sculpture Gallery. It has been suggested that this and the weaving roundel may be the work of Thomas Woolner rather than Farmer and Brindley.[1]

Note
[1] C. Hartwell, *Manchester* (London: Penguin, 2001) pp.74-5.

Farmer and Brindley, *Spinning*

Manchester Town Hall Interior

Waterhouse provided spaces for portrait sculpture in the interior of the town hall. These included three 'admirable positions' for life-size statues in the Great Hall: one between the entrance doors, and the other two in niches on either side of the orchestra. Statues could also be displayed in the vaulted space on the ground floor, designated the Waiting Hall in earlier plans but referred to as the Sculpture Hall by the time of the official opening.

Discussions about which statues would occupy the positions in the Great Hall were taking place as work continued on completing the room. Two statues had been promised for the new town hall: one of Charles Pelham Villiers and the other of Oliver Cromwell. It was the latter that concerned Waterhouse, but not solely for the obvious political reasons. He acknowledged that the Cromwell statue was 'a matter of some little delicacy', because it was the gift of Elizabeth Heywood, the wife of Abel Heywood. Moreover, in donating the statue she was fulfilling the wish of her first husband, Thomas Goadsby, that a statue of Cromwell should be presented to the city and put on public display. Waterhouse made his views clear to the Town Hall Committee:

> I understand that we are likely to owe to the munificence of one donor a statue of Cromwell by Noble and to that of another, a statue of Charles Villiers by Theed. Mr Theed has seen the positions referred to and thinks that one of them would do well for his statue but Mr Noble is of opinion that neither of them would exactly do for his. Though I am most unwilling to offer any criticism at all of an apparently obstructive character to anything which would beautify and add interest to the Hall, as statues of such men by such artists, I must venture to remark that it is most injurious to the appearance of a room, that is not in itself colossal, to place in it statues of colossal proportions as one instinctively takes one's

scale of a room by any figures which may be in it.[1]

Waterhouse's preference appears to have been to install the Villiers and a smaller statue of Cromwell in the niches on either side of the orchestra, and a third statue, one of the Queen, in the space between the entrance doors. Whether Waterhouse's reservations influenced those promoting the Cromwell statue, or whether other arguments began to dilute their resolve to install a marble statue of a still contentious historical figure, the outcome was that the idea of a marble Cromwell standing inside the town hall was transmuted into a bronze statue located out of doors.[2] Waterhouse's suggestion of a statue of Queen Victoria, a preference he was still expressing in February 1877, was not taken up.[3] Instead the Great Hall was to have two statues: one of Villiers, already commissioned, and another of Gladstone, both sculpted by Theed. The Villiers

statue was in place for the official opening, at which time the Gladstone statue, to be placed in the niche between the entrance doors, had been commissioned.[4] Two such representations of living politicians, men so closely associated with the economic creed that had become synonymous with Manchester, could hardly have been a more direct political gesture. To place them in the Great Hall, where the ceiling was an illuminated check-list of the city's trading partners, was to secure a version of Manchester's recent political and commercial history that was as significant, and more explicit, than the history that Ford Madox Brown would later paint on the walls of this most important of public rooms. The same group of Liberals which presented the Villiers and Gladstone figures continued their argument in marble by commissioning a statue of another

View of Sculpture Hall 2000

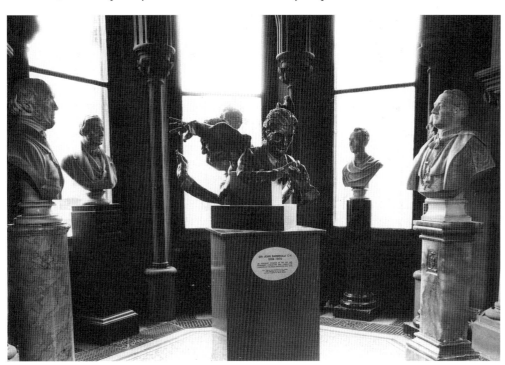

living Liberal hero, John Bright. This, again, was prominently positioned in the building, on the grand staircase. Yet, puzzlingly, no other statue was commissioned for the Great Hall, leaving the niche to the right of the orchestra untenanted. There appears to be no recorded discussion of who might have filled this important space: Cobden, of course, would have been the obvious choice.

The intention to display statues and busts on the ground floor resulted in the substantial waiting area being transformed into a sculpture hall. The plan, never fully realised, was to turn the hall into a Valhalla, honouring those citizens who had contributed to the city. The collection developed in a largely unplanned manner, mainly through gifts. However, as in the Great Hall, there was a propensity to feature men whose political and economic beliefs were congruent with those of the local Liberal élite.[5] But by the Edwardian period the flow of memorial busts had all but stopped. An intriguing curiosity in this impressive vaulted space is the introduction of a short piece of the carved foliage, animals and birds that feature in the decorative scheme in the Natural History Museum, perhaps a reminder from Waterhouse of the connections between these two great Victorian public buildings.

The vestibule contained two of the city's finest portrait statues. These marble statues of Dalton and Joule, both claimed by the city as Manchester scientists, were the work of two of the nineteenth century's most admired sculptors, Chantrey and Gilbert. Neither sculptor would have approved of the often thin light in which their works have to be viewed, but their symbolic significance as one enters the town hall is plain for all to see.

Notes
[1] Letter to New Town Hall Committee in Report of New Town Hall Committee (Manchester Central Library, Local Studies and Archives). [2] See below, p.152. [3] A. Waterhouse, 'Description of the new Town Hall at Manchester', *Royal Institute of British Architects Transactions*, February (1877) pp.126–7.

[4] *Manchester Courier*, 10 September 1877.
[5] *Manchester New Town Hall. General History and Detailed Description of the Building* (Manchester: John Heywood, [1877]) p.6.

Vestibule

John Dalton
Sir Francis Chantrey

August 1838
Marble
3m high approx; pedestal: 80cm high
Signed on chair: Chantrey, Sculptor 1837
Inscription on pedestal: JOHN DALTON DLC
Status: Grade II
Condition: good
Owned by: Manchester City Council

Description: Portrait statue; marble statue of Dalton dressed in academic robes, seated in chair. His right hand is raised to his chin, a book in his left hand. Scientific apparatus and a scroll are at his feet. The sculpture surmounts a marble pedestal.

John Dalton was born at Eaglesfield, Cumberland, on 6 September 1766, the son of a Quaker weaver. He was educated at a Quaker school and showed an early interest in mathematics and science. The following years were spent chiefly in teaching at schools in Cumberland and in extending his own study of the sciences. John Gough, a Quaker and natural philosopher, was influential in directing his studies. He began keeping a meteorological journal in 1787. Dalton arrived in Manchester in 1793 to teach mathematics and natural philosophy at Manchester New College, a position he held for six years, after which he devoted himself to private teaching and research. In 1794 he became a member of the Manchester Literary and Philosophical Society. His researches into gases resulted in his propounding a radically new atomic theory in 1803. The importance of his ideas was recognised in the scientific community in Britain and on the

Continent. In 1833 he was awarded a civil list pension. Dalton's health deteriorated after 1837 and he died in Manchester on 27 July 1844. His funeral was marked by an unprecedented demonstration of public feeling; 40,000 people filed past his coffin in the town hall. He was buried in Ardwick Cemetery.[1]

The idea of a public statue of Dalton originated among his friends and former pupils in 1833. They were conscious that, whilst other prestigious institutions had recognised the importance of his scientific discoveries, Manchester had not formally acknowledged his achievements. William Henry, Peter Ewart and Revd Dr Calvert were among those who organised the memorial.[2] Around the same time Henry was also one of the individuals involved in securing Dalton a government pension.[3] A careful canvassing of the town's middle classes

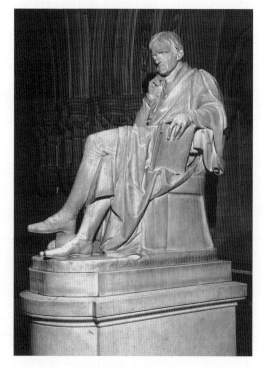

Chantrey, *John Dalton*

raised some £2,000. The commission for the statue went to the country's leading sculptor, Sir Francis Chantrey, who agreed to produce the statue and pedestal in marble for 2,000 guineas within two years. As 'the subject is too important and too interesting to be dispatched in a hurried visit to Manchester', Chantrey required Dalton to come to London.[4] Dalton visited Chantrey in May 1834 and later recalled the sculptor's working methods.

He took a profile as large as life by a camera lucida, and then sketched a front view of the face on paper. We took a walk through his rooms, and saw busts and statues without end. He then gave me the next day for a holiday, and told me I should see my head moulded in clay on Wednesday morning, at which time he invited me to breakfast. I went accordingly, and found, as he said, a head apparently perfect. He said he had not yet touched it, the head having been formed from his drawings by some of his assistants. He set to work to model, and polish a little whilst I was mostly engaged in reading the newspaper, or conversing with him. On looking right and left he found my ears were not alike, so that he immediately cut off the left ear of the bust and made a new one more resembling the original.[5]

Chantrey's technique of relaxing his sitters and studying their expressions in an informal atmosphere was documented by other writers.[6] The Royal Manchester Institution on Mosley Street agreed to display the statue, though the question of public viewing was left to be arranged 'according to such regulations as may hereafter be agreed upon'.[7] However, Charles Barry, then near finishing the building, was critical of the idea that it might be placed on one of the pedestals of the main staircase.[8] When Chantrey visited Manchester, he agreed, somewhat reluctantly, that the statue should be positioned in the entrance hall, though initially it was to be displayed in the exhibition room, where the superior light would allow a better appreciation of 'its true character'.[9]

The Royal Manchester Institution was keen to display the statue, enquiring of Chantrey when it would be ready for delivery.[10] The statue finally arrived in Manchester in August 1838, and was put on display.[11] A model of the statue was included in the collection that Chantrey's widow presented to the University of Oxford.[12]

Chantrey's representation of Dalton was generally praised – 'A beautiful and all but speaking statue' – though William Henry, Dalton's friend and biographer, suggested that the sculptor had exaggerated the forehead.[13] However, there was a feeling that it was not displayed to the best effect in the entrance hall.[14] Moreover, the Institution was not generally open to the public, and many Mancunians were probably unaware of its existence, or, after 1855, were more familiar with Theed's bronze copy in Piccadilly than with the marble original.[15] In 1862 it was displayed at the International Exhibition.[16]

In 1884, following the transfer of the Royal Manchester Institution to Manchester Corporation and its conversion into the City Art Gallery, it was decided to move Chantrey's *Dalton* to the town hall, where it would become 'a noble addition to the Sculptors' Gallery'.[17] At the same time, Dalton was also being commemorated in Ford Madox Brown's frescoes in the Great Hall. The statue was placed in the vestibule, a location that, in view of Chantrey's concern about good lighting, would presumably not have received his approval.[18] It has remained there, its historical and artistic significance strengthened by the arrival of Alfred Gilbert's statue of Dalton's pupil, James Prescott Joule. Chantrey's *Dalton* has continued to be an admired work – the *Manchester Guardian* considered its 'distinguished frigidity' worthy of a place in Baedeker.[19] Each year it is passed by more people than filed past Dalton's coffin in the King Street Town Hall, most of them unaware that this was Manchester's first major public statue, a monument raised to a living celebrity rather than a posthumous tribute.

Notes
[1] F. Greenaway, *John Dalton and the Atom* (London: Heinemann, 1966); D.S.L. Cardwell (ed.), *John Dalton and the Progress of Science* (Manchester: Manchester University Press, 1968). [2] *Manchester Guardian*, 7 September 1833; *Wheeler's Manchester Chronicle*, 8 March 1834; Greenaway, *op. cit.*, pp.191–3. [3] A. Thackray, 'John Dalton' in *Dictionary of Scientific Biography* (New York: Scribner and Sons, 1971) Vol.3, pp.545–6. [4] Letters from Chantrey 4 February, 12 February, 28 February 1834, Dalton Testimonial Committee Minute Book, John Dalton Paper No.313 (John Rylands University Library of Manchester). [5] W. Henry, *Memoirs of the Life and Scientific Researches of John Dalton* (London: Cavendish Society, 1854) p.184; *Manchester Evening Chronicle*, 7 June 1899. [6] G. Jones, *Francis Chantrey, R.A. Recollections of his Life, Practice and Opinions* (London, 1849) p.82. [7] Royal Manchester Institution Minutes, 19 February 1834 (Manchester Central Library, Local Studies and Archives, M6/1/1/1). [8] *Ibid.*, 6 March 1834, 11 April 1834 (M6/1/49/2, M6/1/51/66) [9] *Manchester Guardian*, 8 December 1893. [10] Royal Manchester Institution Minutes, 11 August 1837, 11 July 1838 (M6/1/49/2). [11] Dalton Testimonial Committee Correspondence pp.48–9 Dalton Papers No.313 (John Rylands University Library of Manchester). [12] A.J. Raymond, *Life and Work of Sir Francis Chantrey* (London, 1906) p.61. [13] Henry, *op.cit.*, pp.185, 224. [14] Jones, *op. cit.*, p.84. [15] See below, p.61. [16] Royal Manchester Institution Minutes, 5 February 1862 (M6/1/49/7). [17] Town Hall Committee Letter Book, 16 June 1884 (M9/75/2/2). [18] *Manchester Guardian*, 8 December 1893. [19] *Ibid.*, 28 October 1905.

James Prescott Joule
Alfred Gilbert

8 December 1893
Marble statue and pedestal
2.5m high approx; pedestal 1.14m × 1.02m
Signed on rear of chair: Alfred Gilbert 1893
Inscription on pedestal: JOULE
Status: Grade II
Condition: good, part of scientific instrument held in left hand is missing
Owned by: Manchester City Council

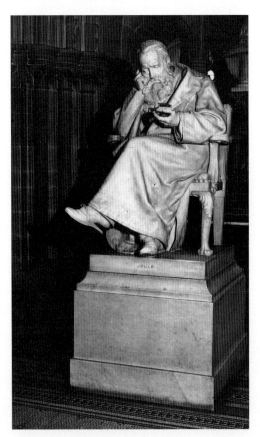

Gilbert, *James Prescott Joule*

Description: Portrait statue; Joule is shown seated on an ornate chair, wearing a large dressing jacket and slippers; his head is resting against his right hand as if in deep thought, whilst in his other hand he holds a scientific instrument.

James Prescott Joule was born on 24 December 1818 in Salford, the fourth son of Benjamin and Alice Joule. He was educated by a series of tutors, including John Dalton. His independent means allowed him to undertake his own scientific researches in a laboratory built in his father's home. His early investigations were concerned with heat, and it was on this subject

that, at the age of 21, he published his first paper in the *Proceedings of the Royal Society*. Joule was acknowledged as an exceptional experimental scientist, and the fundamental importance of his research into energy and related subjects was recognised long before his death. He was elected a Fellow of the Royal Society in 1850, and his public honours included degrees from Dublin, Oxford and Edinburgh. He died on 11 October 1889 at Sale, near Manchester. The joule, a unit of energy, is named after him.[1]

The principal impetus for a memorial statue to Joule came from within Manchester's scientific community, in particular from the Manchester Literary and Philosophical Society.[2] At a public meeting held in November 1889, Oliver Heywood formally proposed the erection of a marble statue as a mark of the benefits resulting from Joule's scientific researches.[3] The influence of Chantrey's *Dalton* on the memorial scheme became evident when the committee expressed its intention to commission not one but two works: a marble statue which would be a companion piece to the Dalton in the town hall, and a bronze copy to be placed outdoors in the city. Although the public subscription attracted support from the local business community, educational institutions and trade unions, as well as the scientific community, the £2,500 raised was only sufficient to provide the marble statue.

In 1890 the memorial committee commissioned Alfred Gilbert to produce the statue. His exceptional artistic talents were already recognised, and the *Manchester Guardian* hardly exaggerated when it informed its readers that he was 'perhaps the most distinguished member of that little band of young and rising artists which makes the contrast between English and French sculpture something better than merely painful'.[4] It was decided that the statue would be located in the town hall, though the exact position was not determined. Even so it must have been made clear to Gilbert that his work would be viewed

as a companion piece to Chantrey's *Dalton*. Gilbert, however, unlike Chantrey, had to work from photographs rather than the living model. His response was to show the great scientist not in academic robes but wrapped in a large dressing coat, a counterpoint to Chantrey's formal study. Gilbert promised to complete the work in 15 months, and good progress appears to have been made, as in May 1892 it was reported that 'only the finishing touches' were required from the sculptor.[5] In fact, the statue was not to be delivered until the end of 1893; a delay that, given Gilbert's list of commissions and other problems, might almost qualify as punctual.[6] In the early summer of that year Gilbert had finally completed the Shaftesbury memorial fountain in Piccadilly Circus, London. The Joule memorial committee, keen that the statue should be shown off to full effect, proposed that both the Joule and Dalton statues would be best displayed on the landing, near the entrance of the Great Hall. The Town Hall Committee could not be persuaded, and the two scientists were placed facing each other in the grey light of the vestibule.

The statue was unveiled in December 1893 by one of the country's leading scientists, Lord Kelvin (William Thomson), whose warm tribute was based on a personal knowledge acquired when the two scientists had worked together.[7] The memorial committee, having paid the necessary bills, transferred a small surplus to the Manchester Literary and Philosophical Society, where it formed the nucleus of a Joule Memorial Fund. Gilbert's *Joule*, although regarded as part of his 'bread-and-butter work', was quickly recognised as one of the city's finest statues.[8] Its juxtaposition to Chantrey's *Dalton* remains a forceful reminder that the achievements of Manchester (and Salford) men in the nineteenth century reached far beyond the manufacturing and selling of cotton. Twelve years after the inauguration in Manchester Town Hall, Joule's achievements were again remembered with the unveiling of a memorial bust in Sale.[9] At a later

date part of the instrument in Joule's left hand was stolen. It has not been replaced.

Notes
[1] D.S.L. Cardwell, *James Joule: A Biography* (Manchester: Manchester University Press, 1989); *Manchester Examiner and Times*, 15 October 1889. [2] *Manchester Guardian*, 19 November 1889; *Manchester Courier*, 19 November 1889. [3] *Manchester Guardian*, 26 November 1889; *Manchester Courier*, 26 November 1889. [4] *Manchester Guardian*, 9 December 1893. [5] *Ibid.*, 14 May 1892. [6] R. Dorment, *Alfred Gilbert* (London and New Haven: Yale University Press, 1985); R. Dorment, *Alfred Gilbert Sculptor and Goldsmith* (London: Royal Academy of Arts, 1986) pp.16–18. [7] *Manchester Guardian*, 9 December 1893; *The Times*, 9 December 1893; *Magazine of Art*, March (1894) p.252. [8] R. Dorment, 'Alfred Gilbert' in *Victorian High Renaissance* (Minneapolis: Minneapolis Institute of Arts, 1978) p.163. [9] See below, p.344.

Principal staircase

John Bright
William Theed

June 1878
Marble statue; Spinkwell sandstone pedestal
2.1m including plinth
Signed: W. Theed Sc 1878
Inscription on pedestal: BRIGHT
Status: Grade II
Condition: fair
Owned by: Manchester City Council
 Description: Larger than life-size standing statue of Bright surmounting octagonal pedestal. Bright is shown in modern dress in the attitude of the public speaker. His right hand is held forward whilst in the other are rolled papers of a speech.
 Biography: see above, p.18.

A full-length marble statue of John Bright was one of three portrait statues – Villiers and Gladstone were the other two – commissioned by the same group of Manchester Liberals to be placed in Manchester's new town hall. The leaders of the group, who included Sir Edward

Theed, *John Bright*

Watkin and Hugh Mason, seemed intent that their political beliefs would be highly visible in the new building. William Theed was the chosen sculptor. The choice of Bright was noteworthy, because it marked his complete rehabilitation and acceptance in Manchester. Bright, moreover, agreed to the highly unusual honour of a public statue while he was still alive. However, following a visit to the

sculptor's studio, principally to see the Manchester *Gladstone* that Theed was also working on, he confided to his diary his regrets about his statue, but 'not because I do not like it as a work of art'.[1] The statue of Bright arrived at the town hall at the end of May 1878, and arrangements were made for a formal unveiling ceremony in the following month. It was a ceremony attended by the main subscribers.[2] Some time in 2001 two fingers on the right hand of the statue were broken off.

Notes
[1] *The Diaries of John Bright* (London: Cassell, 1930) p.405. [2] *The Times*, 31 May 1878; *Manchester Guardian*, 31 May 1878; *Manchester City News*, 1 June 1878.

Great Hall

Charles Pelham Villiers
William Theed

September 1877
Marble
1.83m high approx
Signed: W. Theed. Sc. London 1876
Inscription: VILLIERS
Status: Grade II
Condition: good
Owned by: Manchester City Council
 Description: Portrait statue; life-size marble statue of Villiers who is shown in the familiar role of public speaker, holding notes in both hands. His weight is on his right foot, which projects over the edge of the plinth.

Charles Pelham Villiers was born in 1802, the younger brother of the Earl of Clarendon. He was educated at Haileybury and Cambridge, and was called to the Bar in 1827. In 1835 he was elected as MP for Wolverhampton. He associated himself with the Radical party and was a strong supporter of free trade, presenting one of the first parliamentary motions for the repeal of the Corn Laws. He was a conspicuous

figure in the Anti-Corn Law League, becoming well known to the League's Lancashire supporters. He went on to hold a number of government offices, and was influential in reforming the administration of the New Poor Law. Villiers served as MP for Wolverhampton for 63 years, and for some years he was the 'Father of the House'. He died in 1898.

Sir Edward Watkin, Hugh Mason, Nathaniel Buckley, William Agnew, Benjamin Whitworth, Henry D. Pochin and Samuel Watts presented Manchester with a life-size marble statue of Villiers to stand in the city's new town hall.[1] It was one of three statues – the others were of Bright and Gladstone – that this group of Manchester men presented, with the intention that they would occupy prominent positions in the building. All the chosen individuals were living statesmen, all recognised for their contribution to Liberal causes. Villiers did not achieve the political stature of Gladstone and Bright, but he was widely known as a sympathetic and active MP on questions of reform. In particular, he had been an early and resolute supporter of free trade.[2]

The statue was commissioned from William Theed. John Bright noted visiting Theed to see the statue in January 1877.[3] It was the first of the statues to be completed, and was installed in the Great Hall in time for the formal opening of the building in September 1877.[4] It occupied a niche on the wall at the front of the hall, to the right of the organ. Theed was also commissioned by Villiers's Wolverhampton constituents to provide a bronze copy, thus placing Villiers in that very select group of Victorians who were honoured with two statues during their lifetime. The Wolverhampton statue was unveiled in 1879.[5]

Notes
[1] *Proceedings of Manchester City Council*, 5 September 1877, pp.337–8; *Manchester City News*, 8 September 1877. [2] W.O. Henderson, *Charles Pelham Villiers and the Repeal of the Corn Laws* (Manchester, 1975). [3] *The Diaries of John Bright* (London: Cassell, 1930) p.361. [4] *Manchester Courier*, 10 September 1877. [5] *Manchester Guardian*, 1 November 1876, 7 June 1879. The statue now stands in West Park, Wolverhampton.

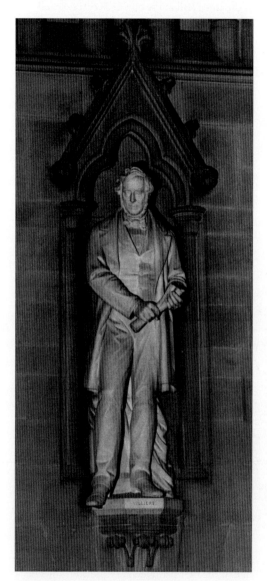

Theed, *Charles Pelham Villiers*

William Ewart Gladstone
William Theed

April 1879
Marble
2.1m high including plinth
Signature: W. Theed. Sc. 1879.
Inscription: GLADSTONE.
Status: Grade II
Condition: good
Owned by: Manchester City Council
Description: Portrait statue; a larger than life-size marble statue of Gladstone who is shown standing with his arms crossed, the right hand gripping the sleeve of his other arm. His coat is open showing his waistcoat. The statue stands on an octagonal plinth, and is positioned in a niche between the two main entrance doors.
Biography: see above, p.21.

Sir Edward Watkin, Hugh Mason and other leading Manchester Liberals were responsible for commissioning a marble portrait statue of Gladstone for Manchester's new town hall. The commission, like those for the statues of Villiers and Bright, was given to William Theed. He depicted the Liberal leader in that most Gladstonian of roles, 'addressing an assembly'.[1] The statue was completed in 1879 and occupied the post of honour inside the Great Hall, between the two main entrance doors.[2] This was the space that Waterhouse had suggested might be occupied by a statue of Queen Victoria. Theed's *Gladstone* was installed in April 1879 and judged by the *Manchester Guardian* to be an 'excellent likeness'.[3] It was not the first public statue of Gladstone to be completed during his lifetime, Liverpool having unveiled one in 1870.[4] Two further statues were to follow, both in London: in Bow in 1882, and in the City Liberal Club in 1883.[5]

Notes
[1] *Manchester Guardian*, 25 April 1879. [2] Gunnis (1968) p.387, dates it 1878, but it is signed and dated 1879. [3] *Manchester Guardian*, 25 April 1879. [4] *The Times*, 9 May 1870. [5] *Ibid.*, 18 August 1882, 14 December 1883.

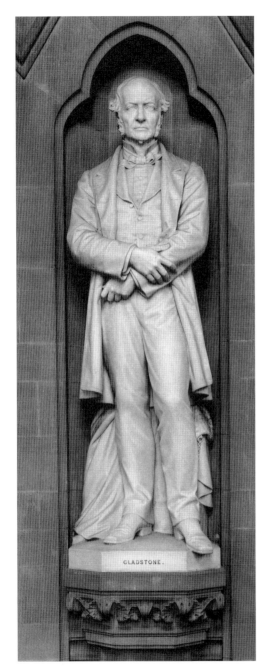

Queen Victoria
Matthew Noble

30 August 1856
White marble set on stone corbel
1m high
Condition: fair, requires cleaning
Owned by: Manchester City Council

A colossal marble bust of Queen Victoria was commissioned by Alderman Robert Barnes for Manchester, as a memento of the Queen's visit to the city in 1851. Barnes had been mayor at the time of the visit. The bust was presented to the council in August 1856 and originally stood on a black marble pedestal in the town hall in King Street. Barnes expressed the hope that the gift might encourage the erection of a full-length statue of the Queen.[1] The sculptor was Matthew Noble. The Queen, who sat for the bust in Buckingham Palace, was shown wearing a royal diadem and the Order of the Garter. It was judged 'a very perfect portrait' by *The Times*, uniting 'the feminine expression of the original features with the dignity of Royalty'.[2] It also proved profitable for Noble who received orders for eight copies, including local ones from the Earl of Ellesmere and the Bishop of Manchester.[3] Both this bust and the one of Prince Albert were transferred from the old town hall into the Great Hall of the new building, where they were placed on stone brackets, in time for the official opening.[4]

Notes
[1] *Manchester Guardian*, 4 September 1856. [2] *The Times*, 29 April 1856. [3] *Manchester Courier*, 6 September 1856. [4] *Ibid.*, 10 September 1877.

Prince Albert
Matthew Noble

5 January 1859
White marble; stone corbel
1m high
Condition: fair, requires cleaning
Owned by: Manchester City Council

The bust of Prince Albert, by Matthew Noble, was presented by Thomas Fairbairn on behalf of the Executive Committee of the Manchester Art Treasures Exhibition. Prince Albert had shown a strong interest in the exhibition, and officially opened it in May 1857. Noble sculpted the bust, which must have been viewed as a companion to that of Queen Victoria already on display in Manchester Town Hall in King Street. The finished bust received the approval of Prince Albert, and it was officially accepted by the council in January 1859.[1]

Note
[1] *Proceedings of Manchester City Council*, 5 January 1859, pp.32–3.

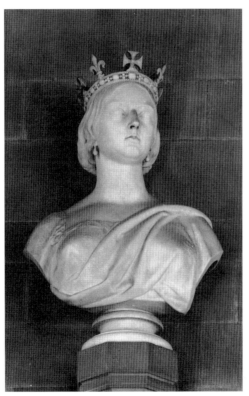

Theed, *William Ewart Gladstone*

Noble, *Queen Victoria*

Noble, *Prince Albert*

Albert Edward, Prince of Wales
Marshall Wood

7 October 1863
White marble
1m high
Condition: fair, requires cleaning
Owned by: Manchester City Council

This marble bust of Prince Albert Edward (the future Edward VII) was presented to Manchester by Abel Heywood in October 1863. It recalled the recent marriage of the Prince of Wales and Princess Alexandra, an event celebrated during the year of Heywood's mayoralty. Marshall Wood was given the commission, and Heywood was generous in his praise of the sculptor's work, noting that he had

been responsible for arranging the sittings. The new bust was placed alongside the busts of the Queen and Prince Albert in the Town Hall in King Street before being moved to the new town hall.[1] The installation on the rear wall of the Great Hall possibly took place in 1879, as in March of that year Waterhouse informed the Town Hall Building Committee that he had prepared sketches of the busts of the Prince and Princess of Wales, presumably identifying their positions on the wall.[2]

Notes
[1] *Proceedings of Manchester City Council*, 7 October 1863, pp.261–2; *Manchester Courier*, 10 October 1863; *Manchester Guardian*, 8 October 1863.
[2] Town Hall Committee Letter Book, 18 March 1879 (M9/75/2).

Alexandra, Princess of Wales
Marshall Wood

11 December 1867
White marble
92cm high
Status: Grade II
Condition: good
Owned by: Manchester City Council

This marble bust of the Princess of Wales (the future Queen Alexandra) was presented by the mayor, Alderman Robert Neill, in December 1867. It was a companion piece to the bust of the Prince of Wales presented by Abel Heywood. Once again, the commission was given to Marshall Wood. Following the bust's installation, Heywood pointedly referred to it as a valuable addition to the 'the few works of art' displayed in the town hall.[1] It remained there until its removal to the Great Hall of the new building.

Note
[1] *Manchester Guardian*, 12 December 1867.

Sculpture Hall

The busts and statue in the Sculpture Hall are listed chronologically by the date presented to the city.[1]

Note
[1] The busts identified here were surveyed in March 2000. A number of busts listed in the records are in other areas of the Town Hall not accessible to the public.

Joseph Brotherton
Matthew Noble

7 March 1860
Marble bust; square black basalt pedestal
Bust 72cm high; pedestal 1.15m high
Signed: M. Noble. Sc. London 1856
Inscription on pedestal: JOSEPH BROTHERTON,
 M.P. / PRESENTED / BY THE / BROTHERTON /
 MEMORIAL COMMITTEE / 1860
Condition: good
Owned by: Manchester City Council

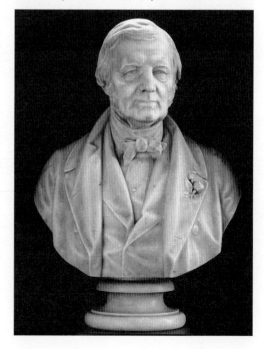

(right) Noble, *Joseph Brotherton*

The Brotherton Memorial Committee having already provided two permanent memorials in Salford – in Peel Park and Salford Cemetery[1] – decided to use some of its additional funds for a further memorial in Manchester, a recognition of Brotherton's connections with the city. The bust was commissioned from Matthew Noble, who sculpted the Salford statue. It was presented by John Kay on behalf of the Brotherton Memorial Committee in March 1860, some three years after Brotherton's death.[2] In acknowledging the gift, the mayor, Ivie Mackie, recalled that Brotherton, although MP for Salford, had worked to promote the best interests of both towns. It was one of the busts transferred from the old town hall to the new building.

Notes
[1] See below, pp.51, 175. [2] *Proceedings of Manchester City Council*, 7 March 1860 pp.106–7; *Manchester Courier*, 10 March 1860; *Manchester Guardian*, 8 March 1860.

Thomas Goadsby
Matthew Noble

1862
Marble bust; brown marble drum pedestal
Bust 69cm high; pedestal 1.3m high
Inscription: THOMAS GOADSBY. / MAYOR. / 1861–2
Condition: good
Owned by: Manchester City Council

Thomas Goadsby was born in Salford in 1806. He served an apprenticeship in his father's chemist's shop and went on to develop the business. He was involved in local politics in the 1830s, serving as a councillor 1844 to 1866, and occupying the mayor's chair in 1861–2. Goadsby agreed to present a statue of Prince Albert to the city, but died before the Albert Memorial was completed. It was his widow, Elizabeth, who was responsible for arranging for the statue of Prince Albert to be delivered and handed over to the city. The bust, which

like the statue was commissioned from Matthew Noble, was presented by Mrs Goadsby on 4 December 1867.[1]

Note
[1] *Proceedings of Manchester City Council*, 4 December 1867.

Oliver Cromwell
Matthew Noble

July 1874
Marble bust; square grey-pink marble pedestal
Bust 85cm high; pedestal 1.32m high
Signed: M. Noble London 1861
Inscription on base of bust: CROMWELL
Condition: good
Owned by: Manchester City Council

The bust of Cromwell was presented to the council by Thomas Bayley Potter, MP, in July 1874 along with busts of his father, Sir Thomas Potter, and his brother, Sir John Potter. Writing from the Reform Club in London, Potter asked the council to find a place in the new town hall for the bust which he described as 'the original of the Cromwell by Noble'. This presentation followed the council's decision not to place a full-length statue of Cromwell in the town hall: a statue which Mrs Heywood, 'carrying out her late husband's intentions', had offered them.[1] In his letter Potter referred to the efforts made by Thomas Goadsby (Mrs Heywood's first husband) and himself to set up a statue of Cromwell in Manchester. Noble produced at least three Cromwell busts, one of which Potter presented to the Reform Club in London in 1864.[2] According to Gunnis, this was the second Cromwell bust by Noble acquired by the club.[3] The *Art Journal*'s writer, visiting Noble's studio in 1861, had been impressed by a clay model of a bust of Cromwell: 'The reading of the head is to some extent new, but it is permeated with that energy, decision, and mental power, which were so characteristic of its subject.'[4]

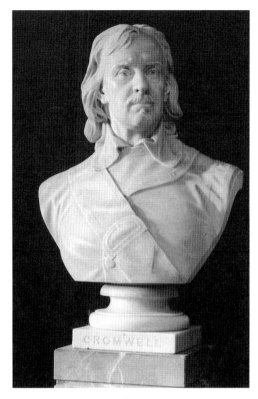

Noble, *Oliver Cromwell*

Notes
[1] *Manchester Guardian*, 2 July 1874; *Manchester Courier*, 2 July 1874, p.6; see below, p.152. [2] *Art Journal*, May 1864, p.155; Gunnis (1968) p.275. [3] Gunnis (1968) p.275. [4] *Art Journal*, February 1861, p.62.

Sir Thomas Potter
Matthew Noble

1 July 1874
Marble bust; square stone pedestal
Bust 77cm high; pedestal 1.49m high
Signature: M. Noble 1864
Inscription: SIR THOS POTTER / MAYOR 1838.9.
Condition: good
Owned by: Manchester City Council

The bust of Sir Thomas Potter (1774–1845) was presented to the council in 1874 by his son, Thomas Bayley Potter, the Liberal MP for Rochdale. Sir Thomas Potter was a key figure in the often turbulent politics of Manchester in the second quarter of the nineteenth century. His contribution to the establishment of the new municipal corporation was recognised by his serving as its first mayor in 1838–9 and again in the following year. He was knighted in 1840. Matthew Noble's classical portrait bust was commissioned almost 20 years after his death.[1] At the same time Thomas Bayley Potter presented busts of his elder brother, Sir John Potter, and of Oliver Cromwell. Potter expressed the view that all three would be worthy of a place in the new town hall when the building was finally completed.[2] The bust now stands outside the entrance of the Great Hall.

Notes
[1] B. Read, *Victorian Sculpture* (1982), p.172.
[2] *Proceedings of Manchester City Council*, 1 July 1874, pp.357–8; *Manchester Courier*, 2 July 1874; *Manchester Guardian*, 2 July 1874.

George Wilson
Henry Stormouth Leifchild

12 January 1876
Marble bust; square grey marble pedestal
Bust 73cm high; pedestal 1.45m high
Signed: H. S. Leifchild London
Inscription on base of bust: GEORGE WILSON / CHAIRMAN / OF THE / ANTI-CORN LAW LEAGUE
Condition: good
Owned by: Manchester City Council

George Wilson (1808–70), whose main business interests were the management of railways and telegraphs, had a long and central involvement in the Liberal politics of Manchester, assisting in the movement that led to incorporation in 1838. He was to become more widely known

Leifchild, *George Wilson*

through the free trade movement, serving as the inimitable chairman of the Anti-Corn Law League. His public services were recognised with a public testimonial of £10,000 and a portrait presented to the Corporation.[1] Wilson died in December 1870. A bust was presented to his widow, Mrs Mary Wilson, by a number of friends, who expected that it would be placed eventually in a public building in the town, presumably either the town hall or the Free Trade Hall. Leifchild was the sculptor, and he

exhibited the bust at the Royal Academy in 1871.[2] The wish that the bust should be publicly displayed was realised in 1876 when Abel Heywood offered it on behalf of Mrs Wilson to the Corporation, secure in the knowledge that it would be placed in the new town hall.[3] But there may have been some delay because, in a letter of 1879, Waterhouse refers to plans to display the bust, presumably in the Sculpture Hall.[4]

Notes
[1] Accepted by council, 17 December 1851. [2] A. Graves, *Royal Academy of Arts*, Vol.5 (1904) p.27. [3] Proceedings of Manchester City Council, 12 January 1876, pp.87–8; *Manchester City News*, 15 January 1876. [4] Town Hall Committee Letter Book, 18 March 1879 (M9/75/2).

Sir Joseph Heron
John Warrington Wood

7 August 1878
Marble bust; green marble drum pedestal
Bust 83cm high; pedestal 1.37m high
Signed: Warrington Wood, 1878
Inscription: SIR JOSEPH HERON
Condition: good
Owned by: Manchester City Council

Joseph Heron was the Town Clerk of Manchester Corporation from its inception in 1838 until his death in 1889. A sharp intellect, exceptional organisational skills and finesse made Heron the central figure in the emergence of an effective system of modern municipal government in the city. His work was recognised with a knighthood in 1870 and other tributes. The bust 'of their excellent friend' Sir Joseph Heron was a personal gift by Alderman John King, Jnr, to the council in 1878. It was given at a time when Heron's health was poor, and there was a likelihood that he might have to relinquish his position. King, who had been mayor in 1874–5, described Heron who

if not the father of the Corporation, was at

Warrington Wood, *Sir Joseph Heron*

least present and giving valuable assistance at its birth, and… has ever since for a period of forty years been its vigilant and judicious guide and guardian.[1]

Heron approved of the idea of the bust, which was the work of the Rome-based, but Lancashire-born, sculptor Warrington Wood.[2]

Notes
[1] *Proceedings of Manchester City Council*, 7 August 1878, pp.298–300; *Manchester City News*, 10 August 1878. [2] M.J. Taylor, 'Between Phidias and Bernini. The Life and Work of John Warrington Wood 1839–1886', Diploma in Art Gallery and Museum Studies, University of Manchester, 1984, p.55. [Information from Edward Morris.]

Sir William Fairbairn
E. Edward Geflowski

November 1878
Marble
Statue 2.2m high; pedestal 1.02m
Signed: E. E. Geflowski 1878
Inscription on pedestal: FAIRBAIRN
Status: Grade II
Condition: good
Owned by: Manchester City Council

Description: Portrait statue: a larger than life-size marble statue surmounting grey granite pedestal. Fairbairn is shown in a thoughtful mood, wearing an open frock-coat, holding an eye-glass in his raised right hand, and papers in the other. Two books rest on the plinth at the rear.

Sir William Fairbairn was born in 1789 in Kelso, Roxburghshire, the son of a farmer. He was apprenticed as an engineer, making the acquaintance of George Stephenson. He moved to Manchester, where he eventually set up his own business, manufacturing textile machinery and, later, boilers for railway engines. Fairbairn was also a pioneer in the construction of iron-hulled ships. He collaborated with Robert Stephenson to build the Menai Straits Bridge. His scientific interests extended beyond metals, and at various times he worked with Eaton Hodgkinson, Joule and William Thomson. His publications included *Useful Information for Engineers* (1856), *A Treatise on Mills and Millwork* (1861) and *A Treatise on Iron Ship Building* (1865). In *Observations on Improvements of the Town Of Manchester* (1836) he made proposals for the redesign of Piccadilly, including the erection of portrait and symbolic statues. He was knighted in 1869. Fairbairn was deeply involved in the public life of Victorian Manchester and among the offices he held was president of the Manchester Literary and Philosophical Society (1855–60). His son Thomas was chairman of the

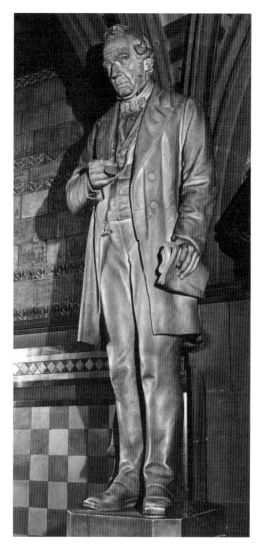

Geflowski, *Sir William Fairbairn*

Manchester Art Treasures Exhibition, 1857. Fairbairn died in August 1874 at Farnham, Surrey.

Hugh Mason, Oliver Heywood, Sir Edward Watkin, Bishop James Fraser and the Revd William Gaskell were among the influential group who met in the Mayor's Parlour in the

town hall in King Street in October 1874 to consider raising a permanent memorial to Sir William Fairbairn. Fairbairn was being remembered for his engineering achievements and his contribution to the modernisation of Manchester, not least in his support for improvement of the city's public buildings and spaces. The group was divided between those sympathetic to establishing a practical memorial, such as an educational endowment, and those who felt that a visible memorial in the form of a statue was appropriate. William Romaine Callender favoured a utilitarian gesture, dismissing the idea of a statue as 'what Manchester people would call a bad investment of capital. It would return no interest.'[1] Sir Joseph Heron, Manchester's commanding Town Clerk, spoke in favour of a statue. There were also differences of opinion as to whether it should be a bronze sculpture, and perhaps positioned near to the Watt and Dalton monuments on the Infirmary Esplanade, or a marble located inside the new town hall. Heron hinted that, whatever the meeting decided, 'he did not despair' of eventually seeing a statue of Fairbairn in the town hall.[2] The meeting concluded by establishing the usual memorial committee to raise funds for both a statue, its form and location still to be decided upon, and an educational endowment, associated with Owens College.[3] The Fairbairn Memorial Committee was soon requesting subscriptions.[4]

The commissioning process did not proceed as smoothly as might have been expected, especially given the experience of the committee members. The selection of the sculptor was the cause of much acrimonious argument. Following the events in the local press (in the absence of the committee's records), it appears that the memorial committee, having considered a number of leading sculptors, decided to commission Thomas Woolner. The decision was not unanimous as there had been support for an almost unknown sculptor, Edward Geflowski. Following a number of votes, Woolner was selected. In many respects

it was difficult to fault the choice. Woolner's talents were widely acknowledged, and he had also known Fairbairn, having completed a number of commissions for him. Woolner indicated that a marble portrait statue would cost £1,500. The matter appeared settled. But, at the next committee meeting, attended by a number of subscribers not present at the previous meeting, the subject was reopened and the commission given to Edward Geflowski. Hugh Mason was among the committee members infuriated at what he considered to be the committee's highly irregular behaviour. Moreover, the commission had been awarded to a sculptor who had still to make his reputation. Mason, who had favoured Woolner, made the debate public in the correspondence columns of the *Manchester Guardian*, prompting letters of both denunciation and vindication.[5] The fact that Geflowski was only going to charge £840 for the sculpture became one of the issues. As the committee had raised some £2,700, economies appeared unnecessary, unless the intention was to save money on the statue so that a larger sum would be available for the educational scholarships. The view that Manchester was about to add to its stock of indifferent public statues was also voiced. Mason pointed out that among Geflowski's supporters at the crucial meeting were some who had not apparently subscribed to the memorial fund, though his main suspicions appeared to be directed at Sir Joseph Heron. Mason mobilised support among his fellow subscribers, including Thomas Agnew, Richard Peacock, John Watts and Thomas Wrigley, but even this influential lobby failed to secure the reinstatement of Woolner.[6] Geflowski, who rarely exhibited at the Royal Academy and who some opponents alleged did not even have a studio large enough to carve a portrait statue, was confirmed as the sculptor.[7] The commission went ahead and was completed with few delays, being delivered to the new town hall in May 1878.[8] In the same year Geflowski also completed a marble bust of the

Lancashire writer, Edwin Waugh.[9] The Fairbairn statue was installed, though without the full public ceremonial that the great engineer and promoter of Manchester warranted.[10] The statue has not always been displayed in its present position in the Sculpture Hall.

Notes
[1] *Manchester Guardian*, 20 October 1874. [2] *Ibid.*, 20 October 1874. [3] W. Pole (ed.), *The Life of Sir William Fairbairn Bart* (1877, reprinted Newton Abbot: David & Charles, 1970) pp.442–6. [4] *Manchester Guardian*, 31 October 1874. [5] *Ibid.*, 23 December 1875. [6] *Ibid.*, 23, 24 and 29 December 1875, 1 January 1876, 1 and 2 February 1877. [7] Geflowski exhibited four works at the Royal Academy between 1867 and 1872. [8] *Manchester City News*, 1 June 1878. [9] The bust was purchased by Salford and displayed in the Art Gallery, Peel Park. It was sold in 1969. There is a terracotta bust of Waugh by Geflowski in the Walker Art Gallery, Liverpool. [10] *Illustrated London News*, 15 November 1879, p.461.

Reverend Dr William McKerrow
Joseph William Swynnerton

1 October 1879
Marble bust; square marble pedestal
Bust 76cm high; pedestal 1.28m high
Inscription: WILLIAM MCKERROW. D. D. / BORN 7th SEPTEMBER 1803 / DIED 4th JUNE 1878
Condition: good
Owned by: Manchester City Council

The Scottish-born Revd William McKerrow (1803–78) was one of the leading Presbyterian ministers in Victorian Britain. He was ordained as a minister in 1827 and settled in Manchester where he served as minister at the Lloyd Street Chapel and, later, at the Brunswick Street Chapel. His support for reform movements embraced both the Anti-Corn Law League and the United Kingdom Alliance. Education was another of his concerns, and he was elected to the first Manchester School Board. Following McKerrow's death in June 1878, a committee

was formed to provide a memorial bust. Swynnerton received the commission. The completed bust was presented to the council by Frederick Holt on behalf of the memorial committee in 1879. In welcoming the gift, Alderman Thompson recalled among McKerrow's many interests his strong support for free trade and education.[1]

Note
[1] *Manchester Guardian*, 2 October 1879.

Abel Heywood
Joseph William Swynnerton

20 October 1880
Marble bust; square black and yellow mottled
 marble pedestal
Bust 92cm high; pedestal 1.2m high
Inscription: ALDERMAN ABEL HEYWOOD,
 MAYOR, 1862. 1876
Condition: good
Owned by: Manchester City Council

Abel Heywood (1810–93) was one of Manchester's leading radical Liberals. As a young man he established a large business as a wholesaler and retailer of books, magazines and newspapers. He came to prominence in the campaign over the taxes on knowledge, and was imprisoned for selling unstamped newspapers. Heywood took an increasingly active part in local politics, being elected to the borough council and serving on a number of important committees. He was best remembered for chairing the committee which oversaw the building of the new town hall. He was mayor in 1862–3 and again in 1876–7, on the latter occasion being given the honour of opening the building. He was father of the council when the bust was presented, an apt tribute to a man who himself had been involved in many schemes to provide commemorative statues and busts in the city. The bust was sculpted by Joseph Swynnerton (1848–1910), who was to marry the

Manchester-born artist, Annie Robinson (1844–1933).[1] The bust was presented by Dr John Watts and Henry Slatter on behalf of the subscribers in October 1880. Before its arrival in the town hall it was displayed in Swynnerton's studio in the Barton Arcade.[2]

Notes
[1] *Macmillan Dictionary of Art*, Vol.30, p.157.
[2] Town Hall Committee Letter Book, September 1880 (City of Manchester Archives, M9/75/2/3 p.67); *Proceedings of Manchester City Council*, 20 October 1880, pp.273–4; *Manchester Guardian*, 21 October 1880.

William Romaine Callender
John Warrington Wood

20 October 1880
Marble bust; square marble pedestal
Bust 80cm high; pedestal 1.28m high
Signed, in a flowing script, on rear:
 J. Warrington Wood, Sculpt. Rome. 1880
Inscription on pedestal: W. ROMAINE
 CALLENDER, M.P.
Condition: good
Owned by: Manchester City Council

William Romaine Callender was one of the leaders of the Conservatives in south-east Lancashire, being elected as MP for Manchester in 1874. His father, also William Romaine Callender, had been a Whig, who had campaigned for the incorporation of the borough of Manchester and was elected to the first town council. Callender junior was also a prominent freemason. He supported a number of public institutions in the city, including the Athenaeum, of which he was secretary for some 20 years. He died, aged 51, in January 1876. The bust was presented to the council by Charles Heywood on behalf of a few friends in 1880.[1]

Note
[1] *Manchester Guardian*, 21 October 1880.

James Fraser, Bishop of Manchester
John Warrington Wood

5 October 1881
Marble bust; square brown marble pedestal
Bust 83cm high; pedestal 1.27m high
Signed: J. Warrington Wood Roma 1881
Inscription: DR FRASER. 2ND BISHOP OF
 MANCHESTER.
Condition: good
Owned by: Manchester City Council

James Fraser (1818–85) was Bishop of Manchester from 1870 to 1885.[1] Four years before his death, a Bishop's Testimonial Committee was established to raise funds to commission a bust. The sculptor was John Warrington Wood.[2] Alderman Henry Patteson presented the bust to the council on behalf of the committee in October 1881. When the bust was handed over, only one critical voice was to be heard among the usual declarations of thanks, that of Charles Rowley, who expressed disappointment that the sculptor had failed to capture the full force of Fraser's character.[3]

Notes
[1] See above, p.16. [2] Mary J. Taylor, 'Between Phidias and Bernini. The Life and Work of John Warrington Wood 1839–1886', Diploma in Art Gallery and Museum Studies, University of Manchester, 1984, p.54. [3] *Proceedings of Manchester City Council*, 5 October, 1881, pp.568–9; *Manchester Guardian*, 6 October 1881.

Sir Rowland Hill
William Theed

6 July 1881
Marble bust; square red marble pedestal
Bust 75cm high; pedestal 1.31m high
Inscription: SIR ROWLAND HILL
Condition: good
Owned by: Manchester City Council

Following the death of Sir Rowland Hill in

1879, Manchester was one of a number of communities that decided to pay tribute to the man acknowledged as the founder of the penny post, even though he had no direct connection with the city. Full-length statues were raised in London and his native town, Kidderminster. A subscription list was opened by the Manchester Sir Rowland Hill Memorial Committee with the intention of providing a portrait bust. The bust was to be the work of William Theed. It was presented by Alderman Henry Patteson on behalf of the committee to the council in July 1881.[1]

Note
[1] *Proceedings of Manchester City Council*, 6 July 1881, pp.218–19; *Manchester Guardian*, 7 July 1881.

Richard Cobden
Edgar George Papworth jnr

1881
White marble bust; square grey marble pedestal
Bust 72cm high; pedestal 1.37m high
Signed: E. G. Papworth Sculp: 1866.
Inscription: RICHARD COBDEN / ALDERMAN: / 1838–44
Condition: good
Owned by: Manchester City Council

This bust of Richard Cobden was probably one of four busts – the others being of Bright, Villiers and Gladstone – that Sir Thomas Bazley gave to the council in 1881. The Liberal Bazley, who at various times was a local councillor, President of the Manchester Chamber of Commerce and borough MP, referred to them as 'historic records of our age', asking that they be placed on the staircase of the public library (the former town hall) in King Street, next to the bust of Sir John Potter. Here the public would be able to contemplate the benefits brought by these living statesmen 'to the families of mankind'.[1] The precise details of the commission are not known but the sculptor was probably Edgar Papworth, Jnr, as his father's

career was all but at an end by 1866.[2] The bust was placed in the library in King Street but later transferred to the town hall, presumably after the library was closed prior to the demolition of the building before the First World War.

Notes
[1] *Proceedings of Manchester City Council*, 4 May 1881, pp.135–6; 1 June 1881, p.148. [2] The bust was not exhibited at the Royal Academy nor is it listed in Gunnis (1968).

John Bright
John Adams-Acton

1881
Marble bust
73cm high; pedestal 1.28m high
Condition: good
Owned by: Manchester City Council

This was the gift of Sir Thomas Bazley, who gave four busts – Gladstone, Bright, Cobden and Villiers – in May/June 1881.[1] Bazley requested that they be placed on either side of the bust of Sir John Potter in the Reference Library in King Street. During his sitting for the bust, Bright's tired face was said to have been animated by the conversation of Jeannie Adams-Acton, the sculptor's wife.[2] The bust was later transferred to the town hall.

Notes
[1] *Proceedings of Manchester City Council*, 4 May 1881, pp.135–6; 1 June 1881, p.148. [2] A.M.W. Stirling, *Victorian Sidelights from the papers of Mrs. Adams-Acton* (London: Ernest Benn, 1954) pp.222–3; B. Read, *Victorian Sculpture* (1982) p.39.

Charles Pelham Villiers
Nevil Northey Burnard

1881
Marble bust; red marble drum pedestal
Bust 72cm high; pedestal 1.36m high
Signed: Neville Burnard, October 1860

Inscription: C. P. VILLIERS
Condition: good
Owned by: Manchester City Council

This marble bust of Villiers was the gift of Sir Thomas Bazley. It was one of four busts – Bright, Cobden, Villiers and Gladstone – that he gave to the council in May 1881.[1] It is unclear whether Bazley originally commissioned the bust from Burnard.[2] He did request, however, that the busts be placed on either side of the bust of Sir John Potter on the staircase of the Reference Library in King Street. The bust was later removed to the new town hall.

Notes
[1] *Proceedings of Manchester City Council*, 4 May 1881, pp.136–7; 1 June 1881, p.148. [2] Not listed in Gunnis (1968).

William Ewart Gladstone
John Adams-Acton

1881
Marble bust; square grey marble pedestal
Bust 83cm high; pedestal 1.28m high
Inscription: WILLIAM EWART GLADSTONE
Condition: good
Owned by: Manchester City Council

This bust of Gladstone was the gift of Sir Thomas Bazley who gave four busts – Bright, Cobden, Villiers and Gladstone – to Manchester Corporation in May 1881. The sculptor and his wife were friends of the Gladstones, and he produced a number of statues (Liverpool and Blackburn) and busts of Gladstone.[1] The four busts were to be placed on either side of the bust of Sir John Potter, on the staircase of the public library (the former town hall) in King Street.[2]

Notes
[1] A.M.W. Stirling, *Victorian Sidelights from the papers of Mrs. Adams-Acton* (London: Ernest Benn, 1954); B. Read, *Victorian Sculpture* (1982) pp.174,

363. [2] *Proceedings of Manchester City Council*, 4 May 1881, pp.136–7; 1 June 1881, p.148.

John Benjamin Smith
John Adams-Acton

2 August 1882
Marble bust; square green marble pedestal
Bust 85cm high; pedestal 1.23m high
Inscription on pedestal: JOHN BENJAMIN SMITH / FIRST PRESIDENT / OF THE / ANTI-CORN LAW LEAGUE / BORN 7. FEBRUARY 1794, / DIED 15. SEPTEMBER 1879.
Condition: good
Owned by: Manchester City Council

This bust of John Benjamin Smith was given to the council by Edwin Durning-Lawrence.[1] Smith was a Manchester cotton merchant who had been a prominent figure in the Anti-Corn Law League. He served as Liberal MP for Stockport from 1852 to 1874. He died in September 1879. Durning-Lawrence, Smith's son-in-law, contacted the council in 1880 to ascertain whether they would accept a bust from the family, indicating that he expected John Adams-Acton to have completed it by the following year.[2] It was presented to the council in August 1882. At the same time, the family also presented another bust, again by Adams-Acton, to Owens College.[3]

Notes
[1] *Proceedings of Manchester City Council*, 2 August 1882, p.226. [2] Town Hall Committee Letter Book, 17 May 1880 (M9/75/2/3). [3] P.J. Hartog, *The Owens College, Manchester* (Manchester: J. E. Cornish, 1900) p.151.

Henry Patteson
Sculptor: unknown

1888
Marble
Bust 82cm; pedestal 1.22m high
Inscription: HENRY PATTESON / MAYOR 1879–80

Condition: good
Owned by: Manchester City Council

The bust, considered to be an excellent likeness of Henry Patteson, was presented to the council by his family in 1888. Patteson had served as mayor in 1879–80. It was accepted by the mayor, Alderman Harwood, and ordered to be placed in 'the Sculpture Gallery of the Town Hall'.[1]

Note
[1] *Proceedings of Manchester City Council*, 4 April 1888, p.192; *Manchester Courier*, 5 April 1888.

John Knowles
Sculptor: unknown

1888
Marble bust; square black wood pedestal
Bust 48cm high; pedestal 1.1m high
Inscription reads: JOHN KNOWLES / 1810 1880 / BORN IN MANCHESTER, WHO BUILT IN 1845 THE THEATRE / ROYAL IN PETER ST. WHICH HE OWNED & MANAGED UNTIL 1875 / PRESENTED BY HIS GRANDSON J. A. KNOWLES RENSHAW
Condition: good
Owned by: Manchester City Council

The Manchester businessman John Knowles was best known for owning the Theatre Royal, though this was only one of his Manchester business interests. He died in 1880. The bust was a gift to the city from his family in 1888.[1]

Note
[1] D. Brumhead and T. Wyke, *A Walk Round Manchester Statues* (Manchester: Walkround Books, 1990) p.22.

Cardinal Vaughan
William Charles May

15 January 1894
White marble bust; square pink alabaster pedestal

Bust 87cm high; pedestal 1.02m high
Signed: W. Charles May Sc. Et Pinxt Hampstead. London. 1894
Inscription: CARDINAL VAUGHAN / 20 YEARS / BISHOP OF SALFORD
Condition: good
Owned by: Manchester City Council

Herbert Albert Vaughan (1832–1903) was enthroned as Bishop of Salford in 1872, a position he held until he became Archbishop of Westminster in 1892.[1] Vaughan expanded the influence of the Catholic Church during his years in Salford, showing a willingness to involve himself in different aspects of community life. The move to provide a bust came after he had been created a cardinal in 1893. The commission was given to William Charles May, a sculptor well known for his portrait busts. Unlike the majority of the busts installed in the sculpture gallery, the bust of Cardinal Vaughan was officially unveiled, the ceremony being performed by Sir John Harwood.[2] The arms of the diocese were included on the pedestal.

Notes
[1] R. O'Neil, *Cardinal Herbert Vaughan* (Tunbridge Wells: Burns & Oates, 1995). [2] *Manchester Guardian*, 16 January 1895; *Harvest*, February 1895, p.37.

Sir Anthony Marshall
Everard Stourton

1895
Marble bust; grey marble drum pedestal; square base
Bust 83 cm high; pedestal 1.22m high
Signed: Everard Stourton Sculp. London 1895
Inscription: SIR ANTHONY MARSHALL, KNIGHT / LAST MAYOR 1892–93 / AND FIRST LORD MAYOR OF MANCHESTER / JULY 3 – NOVEMBER 9 1893
Condition: good
Owned by: Manchester City Council

Anthony Marshall, a textile merchant, was a Conservative member of Manchester City Council from 1882 to 1894. This bust was presented in recognition of Marshall's service on the council which included occupying the mayoral chair in the year when the title Lord Mayor was bestowed on the city. Remembered as a man who 'was rather a worker and thinker than a talker', he was knighted by Queen Victoria on her visit to the city in 1894. He died in 1911.[1] The bust is currently placed on the landing outside the Great Hall.

Note
[1] *Manchester Courier*, 18 May 1911.

Sir Charles Hallé
Edward Onslow Ford

9 December 1897
Marble bust; black wood square pedestal
Bust 79cm high; pedestal 1.12m high
Signed: E. Onslow Ford 1897
Inscription: SIR CHARLES HALLE
Condition: good
Owned by: Manchester City Council

The pianist Charles Hallé, born in Germany in 1819, came to Manchester in 1848, and after some initial misgivings, settled and remained there for the rest of his life. He reinvigorated the Gentlemen's Concerts, and following the Art Treasures Exhibition of 1857 formed his own orchestra. The Hallé Orchestra established a reputation as one of the country's leading orchestras. Hallé was also a key figure in promoting music education in the city and lived long enough to see the opening of the Royal Manchester College of Music. A public subscription to provide a suitable memorial was opened following his death in 1895. A total of £1,635 was raised. A marble bust was commissioned from Onslow Ford, which was presented to the council by Sir William Houldsworth on behalf of the subscribers in a ceremony at the Art Gallery in December

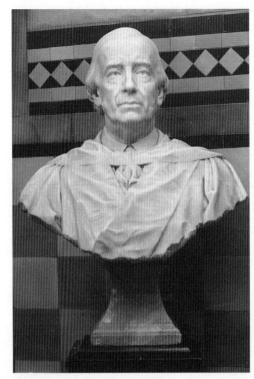

Onslow Ford, *Sir Charles Hallé*

1897.[1] The remaining funds were used to establish scholarships at the College of Music.

Note
[1] *The Times*, 10 December 1897; *Manchester Guardian*, 10 December 1897.

Jacob Bright
Edward Onslow Ford

October 1898
Marble bust; square marble pedestal
Bust 82cm high; pedestal 1.22m high
Condition: good
Owned by: Manchester City Council

Jacob Bright, the brother of John Bright, had a distinguished political career. He was a

supporter of many advanced Liberal causes, including women's rights. Bright died in 1896. A memorial committee was established in Manchester to honour his public work, an act that was especially appropriate for a man who had shown a keen interest in the public memorialisation of other Liberal politicians and statesmen. The idea of a bust to be placed in a public building was agreed upon, and Edward Onslow Ford was commissioned to sculpt it. It was presented to the council on behalf of the committee by C.P. Scott in October 1898.[1]

Note
[1] *Proceedings of Manchester City Council*, 26 October 1898; *Manchester Guardian*, 7 November 1898.

Alcock and Brown
John Cassidy

1921
Bronze tablet; marble frame
79cm × 64cm
Inscription: THIS TABLET IS ERECTED BY THE CORPORATION OF MANCHESTER TO RECORD THE / GREAT ACHIEVEMENT OF TWO MANCHESTER MEN, CAPT. SIR JOHN ALCOCK, K. B. E., D.S.C. / AND LIEUT. SIR ARTHUR WHITTEN BROWN, K.B.E., WHO ON THE 15th OF JUNE 1919 / WERE THE FIRST TO FLY WITHOUT A STOP ACROSS THE ATLANTIC OCEAN FROM / AMERICA TO THE BRITISH ISLES, THE TIME TAKEN IN COVERING THE DISTANCE / BEING 15 HOURS 57 MINUTES, THE DISTANCE BEING 1,950 ENGLISH STATUTE MILES / AND THE AEROPLANE USED BEING ENTIRELY OF BRITISH MANUFACTURE.
Condition: good
Owned by: Manchester City Council

Alcock and Brown's flight across the Atlantic in June 1919 was a milestone in the history of aviation. Their achievement was honoured in a number of ways, including a celebration organised in Manchester, the city in which both of them had spent most of their lives. The

Cassidy, Alcock and Brown

Sir John Barbirolli
Byron Howard

14 July 1975
Aluminium; steel
Figures 60cm high approx; base 39cm high ×
 65cm triangular base
Inscription on pedestal: SIR JOHN BARBIROLLI
 CH / 1899–1970 / AN HONORARY FREEMAN OF
 THE CITY AND / PERMANENT CONDUCTOR
 AND CONDUCTOR / LAUREATE OF THE HALLE
 ORCHESTRA 1943–1970 / THIS TRIPTYCH WAS
 UNVEILED BY HIS WIDOW, / LADY BARBIROLLI,
 ON 14 JULY 1975 / AND WAS SCULPTED BY
 BYRON HOWARD
Condition: good
Owned by: Manchester City Council
 Description: Sculpture of three head-and-
shoulders-studies of Barbirolli conducting with
a baton in his hand. They surmount a two-
tiered triangular base.

The Yorkshire sculptor Byron Howard's
passion for Barbirolli's music began when he
saw him conduct the Hallé Orchestra in
Sheffield. He went on to sculpt a number of
studies of Barbirolli, some of which were
purchased by private collectors. One study was
acquired by the Royal Festival Hall. One of his
most ambitious works was a triptych, providing
different views of an animated Barbirolli
conducting. It was exhibited at the City Art
Gallery in 1974, where it was purchased by
Lady Barbirolli. She subsequently presented it
to the City Council which displayed it in the
town hall. For some years it was sited on the
principal landing, the preferred location, before
being moved into the Sculpture Hall. The
batons that were part of the original work are
now missing. It is one of the few sculptures to
have been added to the town hall collection in
the second half of the twentieth century.[1]

Note
[1] *Daily Telegraph*, 15 July 1975; information from
Byron Howard.

council had decided to commission a bronze
tablet for the town hall to mark their historic
flight, and also to provide them with gold medals,
but neither the tablet nor medals were ready
when Alcock and Brown came to Manchester in
July 1919. The civic welcome proved to be a
somewhat low-key affair, and there was a feeling
that it did not do justice to their achievement. It
was what the *Manchester Weekly Times*
referred to as a 'badly bungled' occasion.[1]

 The commission for a bronze tablet and for
the medals was given to John Cassidy. His
design for the tablet depicted the coastlines of
North America and Europe, separated by the
Atlantic Ocean. The figure of a native Indian
was placed on Canada whilst on Britain was a
female figure. The two airmen were also
depicted. The inscription repeated part of the
description of the flight included on the
illuminated address that was presented to
Alcock and Brown during their visit in July
1919. The tablet was unveiled in the Sculpture
Hall in 1921.[2] Alcock did not live to see the
tablet, as he died in an aeroplane accident at the
end of 1919. Some 40 years later the two airmen
were the subject of Elisabeth Frink's sculpture
in Manchester Airport.[3]

Notes
[1] *Manchester Weekly Times*, 19 July 1919.
[2] *Proceedings of Manchester City Council*, 2 July
1919, pp.354–5; 7 January 1920, p.79; 2 March 1921,
p.24. [3] See below, p.150.

Mahatma Gandhi

S.D. Sathe

Bronze
Bust 29cm high; wooden pedestal 1.23m high
Signed: S. D. Sathe
Inscription on plaque: MAHATMA GANDHI /
(1869–1948) / Apostle of Peace, Non-
Violence and Humanity / Presented by /
H.E. Dr. L.M. SINGH / High Commissioner
for India In Commemoration of / Mahatma
Gandhi's 125th Birth Anniversary Year /
Gifted by / JAMNALAL BAJAJ FOUNDATION,
India 1995
Condition: good
Owned by: Manchester City Council

This smaller than life-size bust of Gandhi was
the gift of the Jamnalal Bajaj Foundation. It
surmounts a workmanlike wooden pedestal.

Manchester Town Hall extension

Architect: E. Vincent Harris

Architectural sculptor: Hermon Cawthra

18 May 1938
Stancliffe stone
Statues 3.65m high approx; relief figures 3.65m
high approx
Status: Grade II
Condition: good
Owned by: Manchester City Council
 Description: Two larger than life-size stone
statues in niches above carved panels on
staircase bays. Two larger than life-size reliefs
of female figures on gable in Lloyd Street.

Manchester City Council took what was
effectively the decision to extend the town hall
in 1919. Some eight years later Vincent Harris
was the successful architect in the competition
to design the extension. Construction
eventually began in 1934, the same year in
which Harris's neighbouring Central Library

Cawthra, 'Philosopher'

building was opened. He included some
statuary on the exterior of the extension,
though this did not feature in the original
design. The principal architectural sculpture
took the form of two long rectangular carved
panels on the staircase and lift bays at opposite
ends of the curved southern side of the building
(Library Walk). The design featured the
national coat of arms, cotton flowers and the
Lancashire rose. Above each panel, high on the
wall, in a niche was the statue of a standing male
figure. These represented a philosopher and a
counsellor. The sculptor was Hermon Cawthra.
They were popularly known as 'Mr Therm', a

reference to the presence of the council's much
publicised gas showrooms in the new building.
Cawthra was probably also responsible for the
two larger than life-size relief female figures on
the gable at the Lloyd Street and Cooper Street
end of the building. Both were wearing shawls
on their heads, the figure on the left holding a
ship in her hand whilst the other is holding a
distaff. They represented commerce and cotton.
It is not certain who carved the panels but they
may have been the work of Earp, Hobbs and
Miller.[1] The two coats of arms (Lancashire and
Manchester) in the lunettes above the entrance
doors on Cooper Street and Lloyd Street may
be faience by Shaws of Darwen. The town hall
extension was opened by George VI in May
1938.[2]

Notes
[1] *The City of Manchester Town Hall Extension*
(Manchester: Manchester Corporation [1938])
pp.18–19, 35; *Daily Dispatch*, 21 May 1937.
[2] *Manchester Guardian*, 18 and 19 May 1938.

Corner of Albert Square and Mount Street

St Andrew's Chambers

Architect: George Tunstall Redmayne

Architectural sculptors: Earp and Hobbs

1872
Darley Dale sandstone
Roundel 91cm diameter; statue 1.83m high
approx
Status: Grade II
Condition: fair
Owned by: unknown
 Description: On the Albert Square elevation
is a roundel depicting almsgiving; the central
figure is seated holding a box inscribed with the
word 'fund'. On the left is a kneeling female
figure receiving money from the fund, on the
right is the standing figure of a young boy

holding a bag of money. On the Mount Street elevation is a larger than life-size statue of St Andrew holding his cross. It surmounts a circular plinth and is placed in a niche.

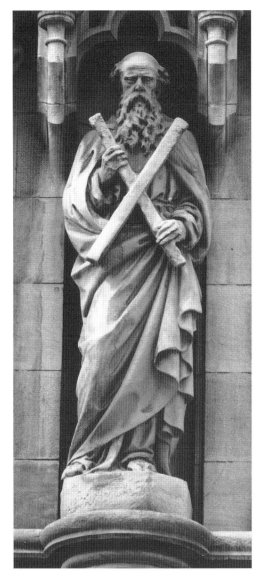

St Andrew

George Tunstall Redmayne was the architect of St Andrew's Chambers on the corner of Albert Square and Mount Street. Completed in 1872, Redmayne's use of the Gothic derived not just from being a pupil of Waterhouse but also from the recognition that his building would be eventually juxtaposed against the town hall, then still under construction. It included a number of substantial examples of architectural sculpture, the work of Earp and Hobbs. On the Albert Square elevation Redmayne included a roundel symbolising the work of one of the main businesses occupying the new premises, the Scottish Widows Assurance Company. In a niche on the Mount Street side was a life-size statue of St Andrew. This had obvious Scottish connections but it may also have referred to St Andrew's Presbyterian church which had previously been connected with the site. The original statue was reputedly too large for the niche and a second one had to be carved. The building proved worthy of the square, and was identified in the *Builder* in 1896 as 'one of the best examples of street architecture in the city'.[1]

Note
[1] *Builder*, 7 November 1896, p.371; J. J. Parkinson-Bailey, *Manchester: An Architectural History* (Manchester: Manchester University Press, 2000) p.119; *Daily Dispatch*, 21 May 1937.

Booth Street West

Royal Northern College of Music

Frederick Chopin
Ludwika Nitschowa

17 October 1973
Bronze statue; marble base
Statue 2.3m high approx; pedestal 50cm high
Signed: Ludwika Nitschowa
Inscription on plaque attached to base: IN COMMEMORATION OF THE 125TH ANNIVERSARY OF FREDERICK CHOPIN'S CONCERT IN MANCHESTER / THIS MONUMENT, SCULPTED BY LUDWIKA NITSCHOWA, WAS OFFERED / BY THE FREDERICK CHOPIN SOCIETY IN WARSAW 1973
Status: not listed
Condition: good
Owned by: Royal Northern College of Music
Description: portrait statue; a larger than life-size representation of Chopin, who is depicted walking, holding the collar of his long cloak with his left hand. The bronze statue stands on a square polished marble base.

Frederick Chopin was born in 1809 near Warsaw. He made his first public appearance as a pianist aged nine and published his first composition in 1825. He came to public notice in Paris in the 1830s, where he composed and gave music lessons. His musical compositions were principally for the piano, including many nocturnes, études and waltzes. His relationship with George Sand, to whom he was introduced by Liszt, began in 1836. He rarely gave public concerts, but did perform in London, Edinburgh, Glasgow and Manchester during his visit to Britain in 1848. He died of consumption in Paris in October 1849.

The Frederick Chopin Society of Poland presented a bronze statue to the Royal Northern College of Music to mark the 125th anniversary of Chopin performing in Manchester. Chopin's recital in August 1848, the year before his death, had been well received.[1] The college, which had just been formed by a merger of the Royal Manchester College of Music and the Northern School of Music, had various contacts with Poland including the pianist Ryszard Bakst, who was a member of the teaching staff.[2] In carrying out the project, the Frederick Chopin Society was assisted by Fine Arts Studios Enterprise and the Polish Ministry of Culture and Arts.[3] This unsentimental representation of Chopin was the work of the Polish sculptor, Ludwika Nitschowa, whose public sculpture included a statue of the composer in Warsaw's Royal Lazienki Park. The statue was presented to the

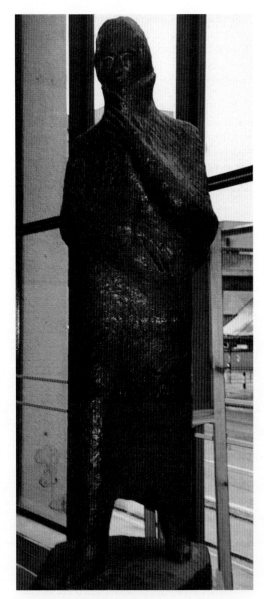

Nitschowa, *Frederick Chopin*

college in August 1973, and formally unveiled by the Polish ambassador in October, on the anniversary of Chopin's death. The ceremony took place during the interval of a concert of the composer's music.[4] The larger than life-size bronze statue stands near to the entrance of the Brown Shipley Concert Hall, one of the most public areas of the college. This was not the last of the Chopin Society's sculptural gifts, as they also presented a bust (sculpted by Jozef Markiewicz) to the Chopin Circle in Edinburgh.

Notes
[1] *Manchester Guardian*, 30 August 1848; M. Kennedy (ed.), *The Autobiography of Charles Halle* (London: Elek, 1972) p.57. [2] M. Kennedy, *The History of the Royal Manchester College of Music 1893–1972* (Manchester: Manchester University Press, 1971). [3] Correspondence with Hanna Wroblewska-Straus, Chopin Museum, Warsaw. [4] *Guardian*, 18 October 1973.

Bridge Street West

Doves of Peace
Michael Lyons

8 September 1986
Steel; concrete pedestal
40.57m high × 30.66m × 20.74m; pedestal 1.65m
 high × 1.65m square base
Inscription around top of pedestal: THE
 WORLD'S FIRST NUCLEAR FREE CITY AND
 SPONSORED BY THE PLANNING COMMITTEE
 OF MANCHESTER CITY COUNCIL
Status: not listed
Condition: fair
Owned by: Manchester City Council
 Description: steel sculpture representing 15 doves, their wings entwined, rising up into the sky. The birds are painted white and surmount a white concrete pedestal

Michael Lyons was one of the five short-listed sculptors in the 'Sculpture for Peace' competition organised by Manchester City Council in 1985.[1] A study of the horse-chestnut bud – its bottom section opening like outstretched hands and its leaves spreading out like wings – was the basis of his original idea for a sculpture. This went through a number of changes before the final version of the soaring doves emerged.[2] Lyons had envisaged the sculpture standing at ground level, possibly in the centre of a basin filled with water. The winner of the competition was Barbara Pearson, whose *Messenger of Peace* was placed in the open space behind the town hall.[3] However, there was strong support within the selection

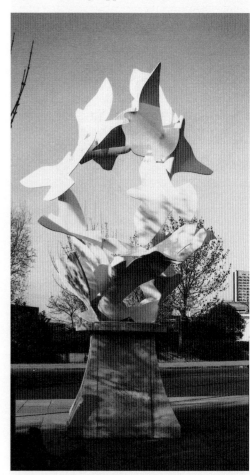

Lyons, *Doves of Peace*

panel for Michael Lyons's entry and it was decided to commission it. Lyons, a lecturer in Fine Art at Manchester Polytechnic, was an established sculptor, having been awarded a number of important public commissions. One of his works, *Phalanx*, was displayed in front of Manchester's Whitworth Art Gallery.[4] Several sites in the city, including Crown Square, were investigated for the new sculpture, before it was decided to locate it on the former Albert Place, an open space near Albert Bridge. One of the advantages of this site was that the sculpture would be seen by the many motorists travelling between Manchester and Salford. It was, however, necessary to alter the design, the sculpture being placed on a concrete pedestal rather than at ground level. The sculpture was produced in steel sprayed with zinc and coated with epoxy paint. The complex task of bending the steel to produce the bird shapes was carried out at the Mayflower Engineering Works, Sheffield.[5] At the installation in September 1986 Councillor Arnold Spencer welcomed the new sculpture both as an improvement to the city, and for the ideas it represented.[6]

Notes
[1] *Manchester Evening News*, 22 April 1985. [2] D. Brumhead and T. Wyke, *A Walk Round Manchester Statues* (Manchester: Walkround Books, 1990) p.42. [3] See below, p.65. [4] W.J. Strachan, *Open Air Sculpture in Britain* (London: A. Zwemmer. Tate Gallery, 1984) p.184. [5] Correspondence with Michael Lyons, 1991 and 1999. [6] *Manchester Evening News*, 8 September 1986.

Riverside Walk

Joseph Brotherton
Matthew Noble

5 August 1858; removed April 1954;
 erected Gawsworth Hall 1969; relocated
 Manchester 1986
Bronze statue; brick pedestal
Statue 2.9m high; pedestal 1.72m high × 1.80m ×
 1.48m

Signed on plinth: M. Noble. Sculpt London
 1858
Original inscription: JOSEPH BROTHERTON /
THE FIRST / AND FOR UPWARDS OF TWENTY
FOUR / SUCCESSIVE YEARS (FROM 1832 TO
1857) / THE FAITHFUL / REPRESENTATIVE OF
THE BOROUGH OF SALFORD / IN THE / HOUSE
OF COMMONS / BORN MAY XXII MDCCLXXXIII /
DIED JANUARY VII MDCCCLVII – left-hand
side: ERECTED BY / PUBLIC SUBSCRIPTION /
A.D. MDCCCLVIII – right-hand side: 'MY
RICHES CONSIST, / NOT IN THE EXTENT OF MY
POSSESSIONS, / BUT IN THE FEWNESS OF MY
WANTS.'
Status: Grade II
Condition: poor
Owned by: Manchester City Council
 Description: Portrait statue; a larger than life-size bronze statue of Brotherton, who is depicted in the role of public speaker, holding a speech in his right hand. The statue is placed on a pedestal of red brick, on which is placed the front panel of the original pedestal.

Joseph Brotherton was born in 1783, the son of John Brotherton, a schoolmaster and exciseman, who established a cotton-spinning mill in Manchester in 1789. Joseph became a partner in the firm, which proved sufficiently successful for him to retire from the business in 1819. He then devoted himself to the public affairs of Salford. Brotherton was an active and reforming local politician whose criticisms and exposures of existing local government bodies contributed towards the establishment of the new borough in 1844, and its extension in 1853. In 1832 he was returned as the borough's first MP, representing Salford until his death. Brotherton acquired a reputation for integrity, and in parliament he championed a number of progressive causes, including the establishment of public museums, parks and libraries. He also supported legislation for improving working conditions in factories. In response to a personal attack made on him during a parliamentary debate on child labour in the

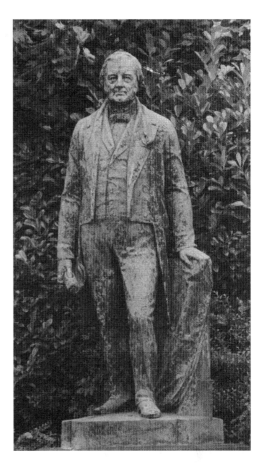

Noble, *Joseph Brotherton*

cotton factories, he declared that his 'riches consisted not so much in the largeness of his means as in the fewness of his wants'. Brotherton was a member of the Bible Christian Church, a small but influential local dissenting sect which was notable for its belief in teetotalism and vegetarianism. He later served as pastor to the church. Brotherton died suddenly on 7 January 1857 while travelling in an omnibus from Pendleton to Manchester, in the company of Sir Thomas Potter and Sir Elkanah Armitage.[1]
 Following Brotherton's unexpected death,

the need to erect an 'enduring memorial' to mark his contribution to the public affairs of Salford was recognised at a public meeting chaired by the mayor, Stephen Heelis.[2] The public subscription launched at the meeting quickly raised over £2,550. Although donations came from the Operative Fine Spinners' Association and from two workplace collections, the majority of the 198 subscribers were solid middle-class citizens of Salford and Manchester. The committee decided to provide two tributes: a statue to be located in Peel Park, Salford, and a memorial to be placed above Brotherton's grave in Weaste Cemetery. Later, a third memorial – a marble bust to be placed in Manchester Town Hall – was also agreed upon.[3] This memorialisation of Brotherton was on an unprecedented scale for a merely local figure. Even so, it did not exhaust the money raised, and the memorial committee found itself with a surplus which it used to establish a fund to purchase books for local public libraries and mechanics' institutes.[4]

It was, once again, the reliable Matthew Noble to whom the memorial committee turned to provide the statue of Brotherton. Noble depicted a confident and purposeful public man, the lapel of his frock-coat adorned with the buttonhole of a single flower that Brotherton replaced each day. The commission proceeded smoothly and the bronze statue was cast by Robinson and Cottam at their foundry in Pimlico. It cost £1,050. The speakers at the inauguration in Peel Park, Salford, in August 1858 offered generous tributes to Brotherton's character and public life.[5] Sir Thomas Potter, who had been with Brotherton when he died, praised the causes Brotherton had taken up on behalf of all classes, concluding with the hope that the statue

> would remain under the good care of the present mayor, and the future authorities in Salford, and that it might ever stand to remind them of the good deeds of him to whose memory it was raised.[6]

The Bishop of Manchester, James Prince Lee, congratulated the memorial committee on placing the statue in the beautiful park which Brotherton had helped to establish, rather than in a busy street or in the town hall.

Situated near the main entrance of Peel Park and within sight of the borough's library and museum, institutions that Brotherton had supported, the statue could hardly have had a more appropriate setting. It remained a landmark of Salford for almost a century. In 1954 it and the statues of Sir Robert Peel and Richard Cobden were removed to make way for an extension to the city's technical college.[7] They were placed in storage and remained there until 1969, when the Brotherton and Peel statues were sold to Raymond Richards of Gawsworth Hall, Macclesfield. Brotherton was placed in the grounds of the hall, close to a public car park, but not on his pedestal.

The statue remained at Gawsworth Hall for some 15 years. It was then purchased by Manchester City Council from a member of the Richards family for £5,000. The council decided to display the statue in the city centre, and, in a decision that might have been regarded as an attempt to blow life into the cold ashes of civic rivalry, located it on the recently created Riverside Walk, close to Albert Bridge, with Brotherton looking across the River Irwell towards Salford. The five-tonne statue was placed on a new brick pedestal, on which was fixed one of the extant panels from the original pedestal. Brotherton has remained in this riverside location, somewhat neglected and in the summer months overhung by trees.

Notes
[1] R.L. Greenall, *The Making of Victorian Salford* (Lancaster: Carnegie Publishing, 2000) ch.2; *Dictionary of National Biography*. [2] *Manchester Guardian*, 20 January 1857. [3] See pp.38, 175. [4] *Brotherton Memorial Committee. Final Report of the Proceedings of the Committee* (Salford, 1861) p.4. [5] *The Inauguration of the Statue of Joseph Brotherton, Esq, M.P., in Peel Park, Salford* (Manchester: I.W. Petty, 1858). [6] *Manchester Guardian*, 6 August 1858; *Manchester Courier*, 6

August 1858. [7] Undated photograph of Brotherton statue being removed from its pedestal, Salford Local History Library (719.32).

Lower Byrom Street

Manchester Museum of Science and Industry

Anamorphic Mirrors
Andrew Crompton

1989
Stainless steel
Cone 2.35m high; sphere 1.55m high
Condition: good
Owned by: Manchester Museum of Science and Industry
Description: Public sculpture consisting of a stainless steel inverted cone and sphere situated in a paved area outside the museum entrance. On the paving stones are the images of four local scientists that are reformed in the cone.

As part of the development of the Greater Manchester Museum of Science and Industry in the late 1980s its director, Patrick Greene, commissioned the Building Design Partnership to provide a public sculpture as a focal point for a landscaping scheme on the Lower Byrom Street side of the museum. Andrew Crompton developed the idea of a sculpture that illustrated the principles of anamorphic art, that is, the process by which a distorted image becomes recognisable by appearing as a reflection. In this instance the images reflected in a stainless steel cone were of four world-famous scientists who had worked in Manchester: John Dalton, James Prescott Joule, Henry Rutherford and Bernard Lovell. Concrete artists, Richard and Jack Doyle, of MPPO were responsible for the paving slabs on which the images were fixed. The work also included a stainless steel sphere in which the surrounding buildings were reflected. A time capsule and secret objects were placed inside the cone and sphere. The

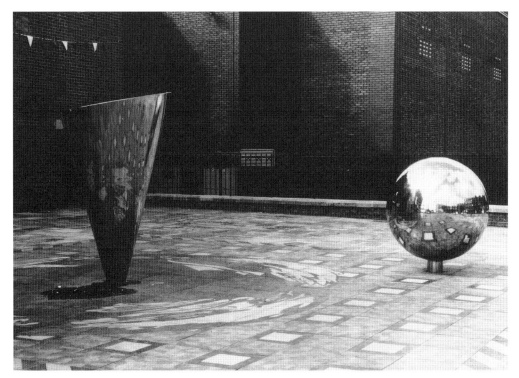

Crompton, *Anamorphic Mirrors*

Castlefield

Bridgewater Canal Basin

Navvies Dinner
Locky Morris

1985
Mild steel plate
1m high × 3.2m long
Signed on handle: Locky
Status: not listed
Condition: poor
Owned by: Manchester City Council
 Description: A navvy's shovel on which a large steak is being cooked above a fire. The shovel is painted black and grey, the fire yellow and red. It is sited at ground level by the canal side, the handle finding an extra use as a seat.

Navvies Dinner was one of the earliest public art works to be installed in the Castlefield Urban Heritage Park. The Irish sculptor, Locky

(below) Morris, *Navvies Dinner*

work was funded by the Central Manchester Development Corporation and unveiled by its chief executive, John Gleister, in 1989. Alterations to the museum entrance in 1999 resulted in the work being removed and re-sited closer to the new entrance.[1]

The entrance area on Lower Byrom Street is also the location of a landmark industrial sculpture which incorporated two beams that had been part of the engine room of the Deptford Power Station, the world's first high voltage electricity generating plant.

Note
[1] Information from Andrew Crompton and Greater Manchester Museum of Science and Industry.

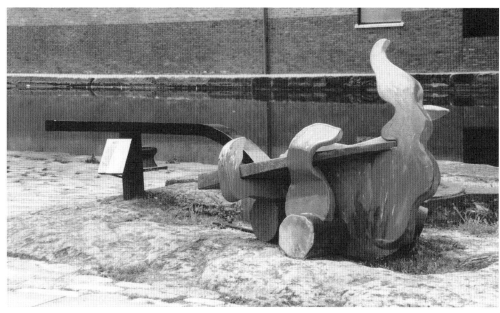

Morris, was commissioned by Manchester City Council, following a competition to provide a sculpture that would assist in the regeneration of this historically important part of the city. Castlefield was the terminus of both the Bridgewater and Rochdale Canals, and Morris's sculpture of a navvy's shovel was a reminder of the men – the navigators – who had built the canals. It was also meant to prompt a smile, as the shovel was being used not to dig out earth but to cook food over a fire, a reminder of the alfresco culinary practices of the canal builders. The use of bright colours – yellow and red – echoed those of the passing barges. As the handle of the shovel was set close to the ground, it also served as a seat for visitors to rest on and watch the barges. *Navvies Dinner* was originally sited on the towpath by the Duke's Lock, the last lock of the Rochdale Canal, but following the re-development of this part of Castlefield it was moved, in 1998, to its present position by the side of the Bridgewater Canal basin.[1]

Note
[1] Information from Locky Morris, October 1999.

Roman Fort

Sheep
Ted Roocroft

26 February 1986
Derbyshire limestone; concrete; Coniston green
 slate
1.24m high; base 30cm × 1.54m × 1.24m
Inscription on base: SHEEP / BY / TED
 ROOCROFT / 1986
Status: not listed
Condition: poor
Owned by: Manchester City Council
 Description: Group of three black-headed
moorland sheep standing and sitting on green
slate and stone pedestal

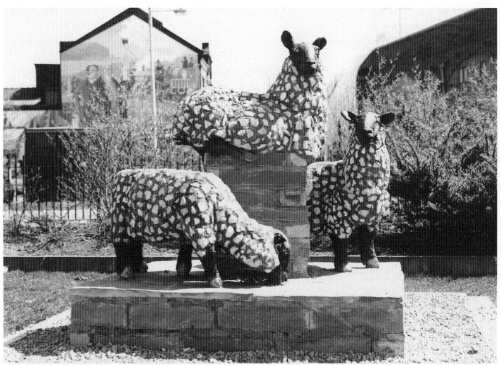

Roocroft, *Sheep*

The animal sculptor, Ted Roocroft, had been short-listed in the 'Sculpture for Peace' competition organised by Manchester City Council in 1985. His sculpture of sheep had been admired by the judges, and, following the commissioning of Barbara Pearson's winning sculpture, the decision was taken to commission two of the other entries: Michael Lyons's *Doves of Peace* and Roocroft's *Sheep*. Both sculptors were lecturers at Manchester Polytechnic. Roocroft's sculpture was considered as particularly suited for the landscaped area in front of the recently reconstructed Roman fort at Castlefield.[1] It was installed there in 1986. The low pedestal meant that the sculpture was accessible to the public, and, as Roocroft anticipated, it was damaged, in spite of modelling the bodies on a vandal-proof frame reinforced with scrap metal. He made a point of visiting the sculpture and carrying out repairs. Since his death in 1993 repairs appear to have stopped, with the result that the sheep and the pedestal are in need of restoration.

Note
[1] *Guardian*, 31 October 1985.

Cateaton Street

Mynshull's House
Architects: Thomas Brookes Elce and William Ball
Architectural sculptor: J.J. Millson

1890
Corsehill stone
Lions 91cm high approx; inscription panel
 1.22m high × 3.65m long
Inscription: THOMAS MYNSHULL, SOMETIME
 APOTHECARY OF THIS TOWN BEQUEATHED

THIS PROPERTY TO TRUSTEES TO APPRENTICE
POOR, SOUND, AND HEALTHY BOYS OF
MANCHESTER IN HONEST LABOUR AND
EMPLOYMENT

Status: Grade II
Condition: fair
 Description: Red stone Jacobean-style
building surmounted by two stone lions on
pedestals displaying shields. Above the second-
storey bay window is a large florid panel
containing an inscription describing the charity.

Mynshull's House, a late-Victorian building,
occupies a site with rich local historical
associations in the old part of the town. In the
seventeenth century it was the site of two
houses owned by the apothecary, Thomas
Mynshull. He bequeathed them to establish a
charity for the apprenticeship of young boys.
The charity survived, the property producing
an annual income of £153 by the end of the
nineteenth century. The property was rebuilt in
1890. Ball and Elce's Jacobean revival building
included a pair of lions with shields providing
the dates and places of Mynshull's birth and
burial. The other sculptural decoration,
described in the *British Architect* as leaning
towards the bizarre, included an ornately
framed red stone inscription recalling
Mynshull's philanthropy. J. J. Millson was the
sculptor.[1]

Note
[1] *British Architect*, 2 May 1890, pp.311, 323;
T. Swindells, *Manchester Streets and Manchester Men*
(Manchester: J. E. Cornish, 1906) Vol.1 pp.66–7.

Cathedral Street

Manchester Cathedral

Thomas Fleming
Edward Hodges Baily

14 September 1852
Marble statue; marble pedestal
Statue 1.9m high; pedestal 1.29m high

Signed: E. H. Baily R. A. Sculp. London 1851
Inscription on pedestal: SACRED TO THE
MEMORY / OF / THOMAS FLEMING, ESQRE. /
BORN AT MANCHESTER, SEPTEMBER 26TH
1767, / DIED AT BROUGHTON VIEW,
PENDLETON, JUNE 26TH / 1848 AGED 80
YEARS. / DURING A LONG LIFE EVER
REMEMBERING / THAT MAN IS NOT MADE FOR
HIMSELF ALONE / HE DEVOTED AN
EXTRAORDINARY DEGREE OF BODILY AND
MENTAL ENERGY / TO THE IMPROVEMENT OF
HIS NATIVE TOWN, / IN WHICH / THOSE WHO
SURVEY ITS VALUED INSTITUTIONS AND
SPACIOUS STREETS, / WILL FIND FEW WHICH
DO NOT BEAR TOKENS OF / HIS
DISINTERESTED, SUCCESSFUL, AND LONG
CONTINUED SERVICES / AMONGST THE
BENEFACTORS OF MANCHESTER / HIS ARDENT
ZEAL, ENLIGHTENED PUBLIC SPIRIT, AND
DETERMINED PERSEVERANCE, / EVIDENCED BY
THE LABOURS OF HALF A CENTURY, / AND
PARTICULARLY BY THE MEASURE WHICH
SECURED / A PRINCELY REVENUE TO THE
TOWN, / THE APPROPRIATION OF THE GAS
PROFITS TO PUBLIC PURPOSES / ENTITLE HIS
NAME TO BE PERMANENTLY RECORDED. / AND
AMONG THE EXAMPLES WHICH IT HAS /
PRODUCED / OF A CONSISTENT AND
CONSCIENTIOUS DISCHARGE / OF ALL PUBLIC
AND PRIVATE DUTIES, / OF SINCERE AND
UNOBTRUSIVE PIETY, / AND OF A DEVOTED
ATTACHMENT TO THE CHURCH OF ENGLAND /
THE ONE WHICH HE HAS AFFORDED WILL NOT
SOON BE FORGOTTEN.

Status: Grade II
Condition: fair
Owned by: Manchester Cathedral
 Description: Portrait statue; larger than life-
size marble statue of Fleming, dressed in an
open frock-coat, showing his waistcoat,
breeches and shoes with buckles. In his left
hand he is holding a scroll. His right hand
points down to other scrolls on a pillar. A cloth
is draped across the pillar and arranged behind
the figure. The drum pedestal carries a long
inscription.

Thomas Fleming was born in 1767, the son of
Augustine Fleming. The family were dyers with
works in Manchester. Fleming entered the
family firm where his practical nature, attention
to detail and shrewdness helped him to become
a successful and wealthy businessman. Those
same traits were also evident in the contribution
he made to public affairs. Fleming was one of
the central figures in the government of
Manchester during the industrial revolution. He
was especially involved in the improvement
schemes for the town's highways and bridges.
More particularly, Fleming was one of the key
figures in ensuring the development of the
town's gas works, whose considerable profits
were made available for public purposes. He
was also active in a number of the town's
charities and public institutions, including the
Natural History Society and the Botanical
Gardens. Fleming was a Tory and Churchman
with a reputation for a short temper. He had a
distinctive appearance:

> He was a large-boned man, though not
> corpulent, was beginning to stoop a little,
> walked with rather a quick step, the
> expression of his face indicating that he was
> very much in earnest about something, and
> was most respectfully dressed in black,
> wearing the usual knee breeches of the
> period, with silver knee-buckles and black
> stockings, and having on a pair of gold
> spectacles.

He died in June 1848.[1]
 By the time of Fleming's death, the reform
of municipal government in Manchester had
seen power pass from the Tory élite, with
which he had been associated, into the hands of
a largely Liberal and nonconformist élite: a shift
of power which helps explain why there was no
move to organise a subscription for a public
memorial. Nonetheless, Fleming's memorial
was to be a public one, but it was provided by
his children, William and Mary. William
Fleming (1799–1880), who took the main role
in the commissioning process, was a

Manchester doctor and antiquarian who was to be remembered as the first honorary secretary of the Chetham Society.[2] Discussions about a statue of Fleming were taking place early in 1850, when William Fleming secured the agreement of the Dean of Manchester to place a statue in the cathedral.[3] William and Mary spent a month in London, visiting sculptors' studios and studying the public sculpture, before reaching an agreement with Edward Hodges

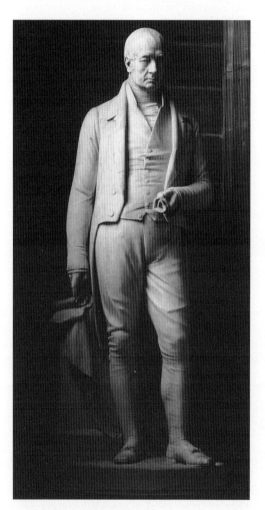

Baily, *Thomas Fleming*

Baily to sculpt a marble statue of their father.[4] Baily was recognised as one of the country's leading sculptors, having established a reputation for both his symbolic sculpture and portrait statues. William Calder Marshall would have received the commission had Baily turned it down.

Fleming kept in close contact with Baily during the different stages of the commission, which began with him providing a portrait and clothes belonging to his father. Comments on the accuracy and style of Baily's initial sketch were offered by Fleming and by friends of his father, including the lawyer and bibliophile, James Crossley.[5] Similarly, when the model was ready to view, not only did Fleming travel to London where he spent 'several hours alone' considering it, he also invited other Manchester men – including the Bishop and Dean, the Mayor and the Town Clerk – to view it and proffer comments. Fleming's own list of suggested changes ran literally from the end of his father's nose to the tips of his shoes.[6] If Baily found his new Manchester patron too fastidious, he did not complain, not least because Fleming was able to provide him with information about the ongoing Manchester Peel memorial. Indeed, Fleming, when the opportunity permitted, pressed Baily's case.[7]

The carving of the statue made good progress and was completed in 1852, ahead of schedule. Baily exhibited it at the Royal Academy before sending it to Manchester.[8] In appearance and colour the statue was considered excellent, having been cut from what Edgar Papworth described as 'a very fine block' of marble.[9] The quality of the statue was evident even to the correspondent of the Liberal *Manchester Guardian,* who praised Baily's skill in depicting Fleming's modern clothes.[10] It was also admired by other artists including the Scottish sculptor, John Steell, who ranked it, with the exception of Flaxman's *Sir John Moore,* as the best portrait statue in Britain.[11] The Flemings paid the £1,000 fee in five instalments, sometimes paying in advance,

much to Baily's relief.

The statue was placed by the east end wall in the south aisle of the cathedral in September 1852. This caused some difficulty because of its weight. There appears to have been no formal unveiling ceremony. As a precaution, railings were installed around the statue 'to protect it from injury', in what was described as a busy part of the church.[12] The long inscription on the drum pedestal was provided by Fleming's friend, James Crossley. It was what the *Manchester Courier* referred to as a 'true description', a reference to what had become Fleming's disputed role in the establishment and operation of the town's gas works. In the Liberal version of that history it was George William Wood rather than Fleming who received the public credit.[13] Crossley's tribute left readers, of all political persuasions, in no doubt as to what he considered to be the correct version of this particular chapter of Manchester's municipal enterprise.

The statue of Thomas Fleming was the first one to be installed in the cathedral, and was dutifully recorded as a feature of the building in subsequent guidebooks.[14] It was moved on a number of occasions in the following years. It appears to have been only slightly damaged when the Cathedral was bombed in December 1940. The missing thumb on the right hand and the chipped scroll are presumed to have been caused by the blitz. The statue now stands in the outer south aisle (the former Brown Chapel), close to the south porch.

Notes
[1] *Manchester Guardian*, 8 July 1848; W.E.A. Axon, *Annals of Manchester* (Manchester: J. Heywood, 1885) pp.245–6. [2] A.G. Crosby, '*A Society With No Equal': The Chetham Society 1843–1993* (Manchester: Chetham Society, 1993) p.1. [3] W. Fleming to Dean of Manchester, letter dated 12 February 1850; 'a record of all the transactions referring to the erection of my late father's monumental statue in the Cathedral of Manchester effected at the joint and equal cost of my sister and myself, arranged by William Fleming M.D. 1868' (Manchester Central Library, Local Studies and Archives, FMS 923.6 FL1). [4] Agreement between W. Fleming and E.H. Baily

dated 1 August 1850. [5] William Fleming to E.H. Baily, letter dated 20 August 1850. [6] William Fleming to E.H. Baily, letter dated 8 November 1850. [7] E.H. Baily to W. Fleming, letters dated 15, 20 and 24 August 1850, 25 October 1850, 18 November 1850, 11 December 1850. [8] *Literary Gazette*, 24 July 1852, p.580; A. Graves, *The Royal Academy of Art* (1970 reprint) Vol.1, p.353. [9] E. Papworth to W. Fleming, letter dated 17 June 1851. [10] *Manchester Guardian*, 18 September 1852. [11] Note in Fleming correspondence, 1853. [12] Letter dated 28 January 1853. [13] *Manchester Courier*, 2 October 1852; *Manchester Guardian*, 8 July 1848. [14] T. Perkins, *The Cathedral Church of Manchester* (London: G. Bell, 1901) p.33; *Handbook to the Cathedrals of England. Northern Division Part 2* (London: J. Murray, 1903).

Humphrey Chetham
William Theed

3 October 1853
Italian marble statue; Kendal marble pedestal
Chetham 1.65m high approx; schoolboy 83cm
 high; base 1.68m × 2.15m
Signature on base of Chetham: W. Theed Scpt
 1853
Inscription on pedestal, front: HUMFREDO CHETHAM / HOSPITII ET BIBLIOTHECAE / FUNDATORI / D.D. / GRATUS ALUMNUS / MDCCCLIII – right-hand side: HE THAT FOLLOWETH AFTER / RIGHTEOUSNESS AND MERCY, / FINDETH LIFE, RIGHTEOUSNESS, / AND HONOUR / PROV. XXI–21. – on scroll in Chetham's right hand: In the name of God Amen / The 16th day of December 1651 / I Humfrey Chetham of Clayton – on open Bible held by schoolboy: PSALM CXII VERSE 9 He hath dispersed / abroad, and given / to the poor and / his righteousness / remaineth for / ever.
Status: Grade II
Condition: fair
Owned by: Manchester Cathedral
 Description: Marble statue depicting the seated figure of Chetham dressed in early seventeenth-century costume. He is wearing an embroidered cap, ruff and ruffles, doublet, hose and a fur-trimmed cloak. His right foot rests on a footstool. He is holding a scroll, his last will, in his right hand. A schoolboy, wearing the uniform associated with Chetham's Hospital, is seated on the stone steps, in front of the pedestal, holding a Bible in his right hand, and pointing to a verse from the Book of Psalms. His cap and two books are on the step beside him.

Humphrey Chetham was born in 1580, the son of Henry Chetham of Crumpsall. He was a successful textile merchant whose fortune came from 'dealing in Manchester commodities'. Chetham occupied an influential position in early seventeenth-century Manchester. In 1635 he served as High Sheriff of the county of Lancaster. A devout Christian, he supported charities during his lifetime, though it was those founded under the terms of his will that were to perpetuate his name. Chetham's principal bequests established a charity school for 40 poor boys and a library to be used by the inhabitants of the town. Further bequests of land provided income for the development of these two institutions. Humphrey Chetham died at Clayton on 20 September 1653 and was buried in the Collegiate Church, Manchester.[1]

 Plans were put forward by the feoffees of Chetham's Hospital in 1675–6 to provide two memorials to Humphrey Chetham in Manchester. One was a marble stone to mark his burial place in the Collegiate Church, and the other was a statue to be placed in the school. The statue was to be no minor tribute, as the feoffees' minutes for 27 March 1676 record that it was to be 'cut in white marble of six foot in height with a pedestall and suiteable appurtenances'.[2] Neither memorial was realised. At the beginning of the nineteenth century, apart from the living monuments of the school and library on Long Millgate, there was still no formal public memorial of Chetham in Manchester. Moreover, his burial place in the Collegiate Church had been lost due to changes to the interior. A scheme, made public in 1833, to erect a memorial tower in his honour at Turton, near Bolton, prompted Mancunians to discuss raising their own monument in the Collegiate Church. Once again, neither scheme was to be realised.[3] 'It is very much to be regretted', wrote Samuel Hibbert Ware

> and, indeed, not very creditable to the towns which have obtained such singular advantages from his charities – that there is no monumental inscription – not even the smallest memorial to point out the place wherein his remains have been deposited.[4]

This remained the case until 1852, when a statue of Chetham was commissioned by George Pilkington, a successful wine merchant. Pilkington had been one of the charity scholars at Chetham's College, and attributed his success in life to this early education. He was a devout Christian, a regular attender of the services at the cathedral, and the supporter of many local charities. The statue would be placed inside the cathedral. As the bicentenary of Chetham's death approached, Pilkington, who wished to remain anonymous, appointed three friends to oversee the commission.[5] It is not known why William Theed was selected, but he may have been recommended by Edward Baily, whose pupil he was; Baily had recently completed the statue of Thomas Fleming in the cathedral.[6] Theed based the likeness on the well-known portrait in Chetham's Library, a painting which the feoffees allowed him to borrow.[7] The statue was carved from a six-tonne block of Italian marble which was said to have cost Theed 140 guineas.[8] He showed Humphrey Chetham in a relaxed pose, holding a copy of his last will, with the figure of a Chetham's charity schoolboy, in front of the pedestal, pointing to a text in the Bible.[9] Theed exhibited the statue of Chetham at the Royal Academy in 1853 before sending it to Manchester.[10] The full sculpture was completed and installed by Theed in the cathedral in early October 1853, a few days before the 200th anniversary of Chetham's death.[11] There appears to have been no public

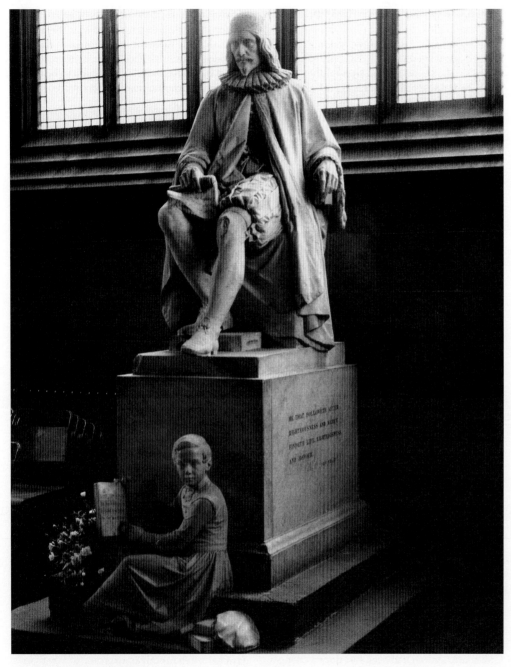

Theed, *Humphrey Chetham*

unveiling ceremony, though shortly after its installation the schoolboys listened to an address about the founder and the statue. This was followed by a dinner of roast beef and plum pudding, during which they drank to the memory of Humphrey Chetham with 'some bottles of wine kindly supplied to them by the donor of the statue'.[12] Although the gift of the statue was supposed to be anonymous, it was widely known that Pilkington was the donor.[13] The statue was placed at the east end of the north aisle of the choir, and railings were installed to 'guard it from accident and mischief'.[14] Pilkington also provided new glass for the nearby window so that the full beauty of the statue could be appreciated. Two small bronze copies of the statue are in the possession of Chetham's School.[15] Thomas Agnew presented a bust by Theed to Salford Museum and Art Gallery.[16] The statue was admired, and for Theed it proved to be the first of a number of Manchester commissions. In the same year he completed a memorial to the physician, Richard Baron Howard (now in the Manchester Royal Infirmary)[17] and later statues of Dalton, Watt, Villiers, Bright and Gladstone.

The statue remained in its original position, but by the mid-1860s one visitor to the cathedral expressed surprise on finding such a beautiful sculpture covered with dust and apparently neglected – it 'wastes its sweetness', he observed.[18] The statue was damaged in 1940 when the cathedral was bombed. The most noticeable damage was to Chetham's left knee, the fingers of his left hand, the scroll in his right hand, and the bottom of his cloak. The schoolboy also lost his feet, the middle finger and the top of the thumb of his right hand, and part of his cap. Repairs have been made to the work subsequently, but the scars of the blitz are still visible. The monument is now positioned at the western end of the outer north aisle, near the north porch.[19]

Notes
[1] S.J. Guscott, *Humphrey Chetham 1580–1653* (Manchester: Chetham Society, 2003). [2] F.R. Raines

and C.W. Sutton, *Life of Humphrey Chetham* (Manchester: Chetham Society, 1903) Vol.II p.224. [3] *Wheeler's Manchester Chronicle*, 17 August 1833, 26 October 1833, 2 November 1833. [4] S. Hibbert, *History of the Foundation in Manchester of Christ's College, Chetham Hospital and the Free Grammar School* (Manchester, 1833). [5] *Manchester Guardian*, 7 May 1853. [6] See above, p.55. [7] Chetham's Library Feoffees Minutes, April 1852 (Chetham's Library). [8] *Manchester Courier*, 8 October 1853; *Manchester Faces and Places*, 3 (Manchester, 1893) p.93. [9] The inscription on the will reads: 'In the name of God, Amen / The 16th Day of December, 1651 / I Humfrey Chetham of Clayton'. *Manchester Guardian*, 5 October 1853. [10] *Art Journal*, 1 November 1853, p.297. [11] Installed 3 October, *Manchester Courier*, 8 October 1853. [12] *Ibid.*, 22 October 1853. [13] J. Evans, 'Canon Parkinson', *Papers of the Manchester Literary Club*, 4 (1878) pp.89–90. [14] *Manchester Guardian*, 5 October 1853. [15] Information from Michael Powell, Chetham's Library. [16] *County Borough of Salford. Catalogue of Loan Collection of Pictures Jubilee Exhibition* (Salford [1894]) p.88. [17] J. Hartwell, *Manchester* (London: Penguin Books, 2001) p.313. [18] *Manchester Courier*, 28 April 1865. [19] Minutes of the Meetings of the Dean and Chapter, 27 November 1951 (Manchester Cathedral Archives M21/6); T. Wyke, 'So Honest a Physiognomy: Memorialising Humphrey Chetham', *Transactions of Lancashire and Cheshire Antiquarian Society*, 99 (2003) pp.21–41.

St Mary, St Denys, St George and the Christ Child

Eric Gill

September 1933
Stancliffe stone
91cm × 91cm
Not signed
Status: Grade I
Condition: fair
Owned by: Manchester Cathedral
 Description: Carved stone panel set above entrance door to former choir school. The relief depicts Mary holding the infant Christ whose arms are outstretched; beneath her feet is a serpent. They are flanked by the standing figure of St Denys holding a crook, and the kneeling figure of St George holding a spear.

Gill, *St Mary, St Denys, St George and the Christ Child*

In 1933 Eric Gill was commissioned to provide a sculptural panel for the exterior of Manchester Cathedral's new choir school, designed by the Manchester firm of Worthington's.[1] The subject was to be the three saints – the Virgin Mary, St Denys, patron saint of France, and St George, patron saint of England – to whom the church was dedicated. Drawings were prepared in March and April and a design agreed. Later, Gill observed that, as was the case when he was preparing the Stations of the Cross for Westminster Cathedral, he would have liked more definite instructions from his patrons.[2] The balance of power between artist and patron, he informed a reporter from the *Manchester Guardian*, had changed.

 In the last few centuries the attitude to the artist in the studio had overflowed to the artist on the scaffold or in the public square, and had given the general public the wrong idea that the artist was a seer who was not to be dictated to. The artist was given duties that were not rightly his.[3]

The commission came at a time when Gill was engaged on another work in the North West, the Portland stone relief of Odysseus and Nausikaa for the Midland Hotel, Morecambe. The preliminary work on the cathedral panel was done in his Buckinghamshire studio by one of his apprentices, leaving Gill to complete the carving on site during the second and third weeks in September. The fact that the Stancliffe stone was set sideways to the building posed technical as well as artistic challenges. Such problems were probably not acknowledged in what Gill noted as the 'unenlightened and unrestrained' comments of 'idle lookers on', who were intrigued by the sight of this unconventional artist – the 'Married Monk' – working in the churchyard.[4] When the choir school was opened in December 1933, Gill's panel was politely noticed rather than adding to that public notoriety he had acquired through commissions such as the sculptures for the BBC headquarters in London.[5]

Notes
[1] *Manchester Guardian*, 2 March 1933. [2] J. Collins, *Eric Gill The Sculpture: A Catalogue Raisonné* (London: Herbert Press, 1980) p.185. [3] *Manchester Guardian*, 24 August 1933. [4] *Ibid.* [5] *Manchester Evening News*, 16 December 1933; *Manchester City News*, 16 December 1933; F. MacCarthy, *Eric Gill* (London: Faber & Faber, 1989) pp.245–7.

Madonna and Child

Sir Charles Wheeler

6 April 1958
Bronze gilt
Statue 1.68m high; plinth 15cm high
Not signed
Status: Grade I
Condition: fair
Owned by: Manchester Cathedral
 Description: Figurative sculpture; standing life-size figure of the Virgin Mary, wearing a shawl over her head, holding out the infant Jesus in her hands. The sculpture is located in a niche on the east wall of the Lady Chapel.

Wheeler, *Madonna and Child*

The Lady Chapel (formerly the Chetham Chapel) was so badly damaged when the cathedral was bombed in 1940 that it was rebuilt after the war. The Manchester architect, Hubert Worthington, was responsible for designing the new chapel, the construction of which began in the mid 1950s. Worthington included a niche on the exterior wall on the east side of the chapel, intending that it would be filled by a sculpture. Sir Charles Wheeler, President of the Royal Academy, was approached by Worthington to produce the sculpture. A drawing of the proposed work, a life-size figure of a Madonna and Child, was submitted to the Dean and Chapter in November 1956. It was proposed that the work would be in bronze gilt. Some criticisms were offered on the intended statue, variously described as 'St Mary', 'Mother and Child' and 'Madonna and Child'. After further discussions, Wheeler, who offered 'to make a half-size casting of the Madonna whether the full-size statue is accepted or not', was given approval to proceed in the spring of 1957.[1] Wheeler dressed Mary in a shawl, reminiscent of those worn by Lancashire women. The statue was installed for Easter Sunday 1958, when it was welcomed by the Dean as the culmination of the enormous restoration programme begun after the war.[2] The cost of the statue, £1,000, was largely met by the Friends of the Cathedral. It is popularly referred to as the 'Lancashire Madonna'.

Notes
[1] Minutes of the Meetings of the Dean and Chapter, 24 September 1956, 5 November 1956, 1 December 1956, 13 May 1957 (Manchester Cathedral Archives M21/6). [2] *Manchester Guardian*, 7 April 1958.

Manchester Cathedral, Victoria Street

Queen Victoria

Princess Louise

12 March 1902
Yellow sandstone

1.83m high approx
Inscription beneath statue: INE.SALVAM / FAC.REGINAM. – the dates MDCCCXXXVII / MDCCCXCVII are carved on either side of the statue
Status: Grade I
Condition: poor
Owned by: Manchester Cathedral
Description: life-size stone portrait statue of Queen Victoria in niche beneath canopied hood, above the doorway of the cathedral's west porch.

The west porch of Manchester Cathedral was commissioned to mark Queen Victoria's diamond jubilee. It was part of a wider scheme to improve the appearance of the cathedral which involved reducing the area of the churchyard. The porch was designed by the architect, Basil Champneys, who was then

Princess Louise, *Queen Victoria*

completing the John Rylands Library in the city. It was dedicated in 1898.[1] Champneys introduced a number of niches into the design with the intention that they would be occupied by statues. The principal niche above the doorway was filled by a life-size statue of Queen Victoria which was sculpted and presented to the cathedral by Princess Louise (Duchess of Argyll), the Queen's daughter. The princess had visited Manchester on a number of occasions for charity functions and on one occasion stayed with Bishop Moorhouse and his wife. As was the case with the statue of her mother in Kensington Gardens, London, she chose to depict Victoria as a young woman, early in her long reign, rather than as the elderly monarch at the time of the diamond jubilee. The queen was shown as a standing figure holding the symbols of office. It was not unveiled, as was also the case with Onslow Ford's jubilee statue in Piccadilly, until after Victoria's death. The ceremony was performed by the Prince of Wales, the future George V, during his visit to the city to open the Whitworth Hall.[2] The intention of Dean Maclure, one of the principal individuals behind the improvement of the cathedral, that the other niches on the porch would contain statues of the patron saints was not realised. The sandstone statue of the queen has not withstood the testing Manchester atmosphere, and now shows signs of severe weathering especially around the head.

Champneys was also responsible for the annexe on the south side of the cathedral, dedicated in 1904.[3] It included a niche, on the west side, in which was placed a life-size statue of Bishop James Moorhouse, the third Bishop of Manchester. Moorhouse, who resigned in 1903 and at that time had discouraged any such testimonial schemes, was depicted in his episcopal robes and holding his pastoral staff.[4] Moorhouse died in 1915. (We have not identified the sculptor of this fine statue.) The stone memorial cross on the lawn in front of the Moorhouse statue commemorates John Gough

McCormick, the Dean of Manchester Cathedral from 1920 to 1924.[5] It was designed by Hubert Worthington and unveiled in June 1926.

Notes
[1] *Manchester City News*, 12 November 1898; *Manchester Courier*, 14 November 1898; A. Boutflower, *Personal Reminiscences of Manchester Cathedral 1854–1912* (Leighton Buzzard: Faith Press, [1913]) pp.18–19. [2] *Manchester Courier*, 12 and 13 March 1902; *Manchester City News*, 3 January 1925. [3] *Manchester Evening Chronicle*, 16 July 1904; *Manchester Courier*, 18 July 1904. [4] *Manchester Guardian*, 7 October 1903, 18 August 1904. [5] *Manchester City News*, 6 September 1924.

Chester Street

off Oxford Road

John Dalton

William Theed the Younger, after Chantrey

26 July 1855; re-sited May 1966
Bronze statue; sandstone pedestal
Statue 2.1m high; pedestal 1.31m high × 1.68m long × 1.02m wide
Signed: W. Theed. Copio. 1855
Inscription on pedestal: DALTON
Status: Grade II
Condition: fair
Owned by: Manchester City Council
 Description: Portrait statue; an enlarged bronze copy of Chantrey's statue of John Dalton. The scientist is depicted seated, dressed in academic robes, his right hand raised to his chin and the left hand resting on a book. Scientific instruments and a scroll are placed at his feet. The statue surmounts a bow-fronted pedestal.
 Biography: see above, p.32

The unprecedented display of public feeling in Manchester following John Dalton's death in 1844 prompted discussions about providing a further monument to the scientist. Chantrey's marble statue of Dalton was already displayed

in the Royal Manchester Institution.[1] Various ideas were suggested in the press, including the erection of a memorial clock tower in Piccadilly.[2] When the subject was discussed at a public meeting, called by the mayor in October 1844, the memorial project centred on establishing a Dalton professorship of chemistry and placing a 'simple and suitable memorial' over his grave.[3] What was needed, it was argued, was a living memorial rather than a statue that would inevitably deteriorate in the town's rain and smoke.[4] In any case, Manchester already had an exceptional statue of 'Quaker Dalton'.[5] The idea of an educational memorial may have found favour among Manchester's scientific community, but it did not apparently attract the necessary wider support. The plan to provide a memorial faltered, and the only immediate public acknowledgment was the naming of a new street after the famous scientist.[6] Public discussion about a memorial abated. Occasional requests in the local press for information about a Dalton memorial do not appear to have prompted a response.[7] This inaction did not, however, stop Manchester from acquiring its first outdoor statue of Dalton. It was erected by the Quaker, Peter Bowker, on the first storey of a building he owned on the corner of John Dalton Street and Deansgate.[8] The seven-foot-high (2.15m) Caen stone statue was probably the work of Charles Edward Smith of Liverpool, who based the likeness on Chantrey's *Dalton* in Manchester.[9] It remained a feature of this busy street until 1933, when it became unsafe and had to be removed.[10]

It was not until 1853 that the idea of providing a public memorial to Dalton was revived. Alderman William Neild, who had been one of Dalton's pupils, was one of the individuals who helped rekindle interest in the scheme. Support, as in 1844, was to be found among members of the Manchester Literary and Philosophical Society. In proposing a new memorial there was a tangible sense of embarrassment over the failure of the earlier

scheme. The aims of the new scheme were to place a suitable memorial, possibly a statue, over Dalton's grave, and to use any additional money to found chemistry and mathematics scholarships at the recently-established Owens College.[11] A subscription fund was launched, which eventually collected some £5,300, of which £232 was from the earlier scheme. The new scheme, however, underwent an important change during 1853, when the idea of a Dalton statue became part of the wider public discussions about the civic space then being created in Piccadilly. This was already the intended site of the Peel and Wellington monuments. Whatever the exact origins of the idea, the Dalton Committee responded favourably, and decided that, in addition to marking Dalton's grave in Ardwick Cemetery with a simple red granite tombstone and railings (designed by Richard Lane), it would commission a statue to stand in Piccadilly. It would be located in front of the wall that separated the Infirmary's grounds from the proposed Esplanade, then being designed by Sir Joseph Paxton. J.C. Harter, the Infirmary's treasurer, was among the individuals who helped to implement this change. There appears to have been no major disagreement within the committee that the statue would be a copy of Chantrey's *Dalton*. This decision reflected the esteem in which the latter was held, and also related to the cost of commissioning a new work. One correspondent writing in the *Manchester Guardian*, however, disapproved, rebuking the committee for its unwillingness to commission its own statue, and pointing out the weaknesses in both Chantrey's sculptures and his working methods.[12] But the committee, perhaps recalling the recent disputes over statues in Piccadilly, did not proceed independently, seeking advice from, amongst others, Sir Charles Eastlake and William Calder Marshall.[13] The outcome was the engagement of William Theed to produce a larger than life-size copy of the statue in the Royal Manchester Institution.[14] It was cast at Robinson and

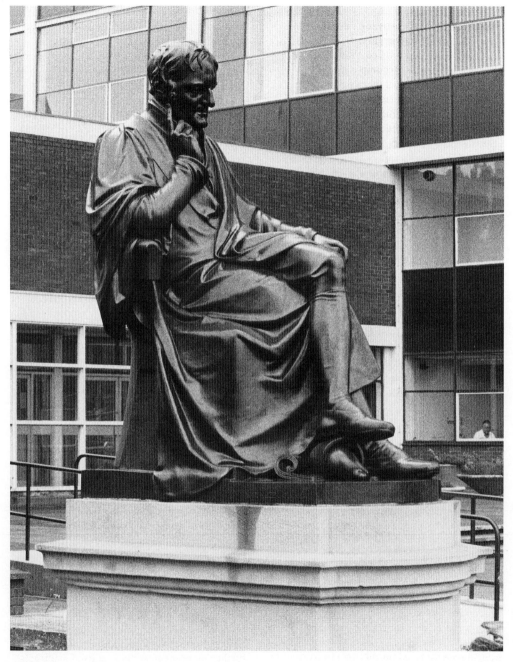

Theed, *John Dalton*

Cottam's foundry.[15]

Theed's copy of Chantrey's *Dalton* was unveiled in Piccadilly in July 1855. It was a rather modest ceremony, compared to the celebrations that had accompanied the inauguration of the Peel memorial. The mayor, Benjamin Nicholls, performed the unveiling.[16] The statue cost an estimated £900, leaving the bulk of the money collected to support the Dalton scholarships and prizes at Owens College.[17]

The Dalton statue along with others in Piccadilly was threatened with removal at various times during the twentieth century. It remained there until the 1960s. In 1966, ironically the bicentenary of Dalton's birth, the building of an electricity sub-station necessitated its removal.[18] Rather than relocating the statue in Piccadilly, it was decided to place it outside the main entrance of the recently opened John Dalton College of Technology (now incorporated into Manchester Metropolitan University) in Chester Street.[19] At the same time, part of Dalton's granite tomb, saved following the closure and landscaping of Ardwick Cemetery, was placed next to the statue.[20]

Notes
[1] R.W. Jones and T. Wyke, 'The man who started the chain reaction', *BBC History Magazine*, Vol.5 No.1 (2004) pp.32–5. [2] *Manchester Guardian*, 9 October 1844. [3] *Manchester Courier*, 5 October 1844. [4] *Manchester Guardian*, 5 October 1844. [5] See above, p.xxx. [6] Proposed by Louis Schwabe, *Manchester Guardian*, 5 October 1844, 19 October 1844. [7] *Ibid.*, 18 August 1849. [8] An undated Victorian illustration of Nash's shop in John Dalton Street shows the statue positioned in an alcove on the corner of the building. John Dalton Street file, Chetham's Library. [9] *Art Journal*, February 1851 p.61; *Manchester City News*, 1 August 1925, 26 September 1925; Royal Manchester Institution Minutes, 2 March 1848, 8 June 1848 (Manchester Central Library, Local Studies and Archives, M6/1/49/4). [10] *Manchester Evening Chronicle*, 5 August 1933. [11] *Manchester Courier*, 29 January 1853. [12] *Manchester Guardian*, 7 September 1853, 14 September 1853, 17 September 1853. [13] *Ibid.*, 14 January 1854. [14] Royal Manchester Institution Minutes, letter from Theed requesting permission to copy statue, 2 November 1853 (M6/1/1/3); *Manchester Guardian*, 25 March 1854. [15] Inscribed on base of statue. [16] *Manchester Guardian*, 27 July 1855. [17] *Manchester Courier*, 28 July 1855. [18] *Guardian*, 10 March 1966; *Manchester Evening News*, 10 March 1966, 12 May 1966; *The Times*, 13 April 1966. [19] A. Fowler and T. Wyke, *Many Arts, Many Skills. The Origins of the Manchester Metropolitan University* (Manchester: Manchester Metropolitan University Press, 1993) pp.70–4. [20] *Manchester Evening News*, 5 August 1960.

Reynolds, *Graduate Training*

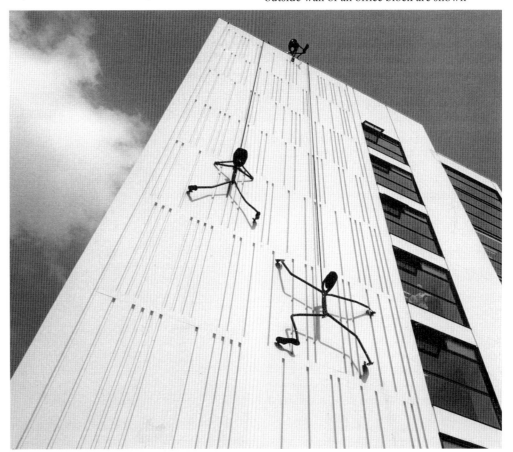

Chorlton Street

Arthur House

Graduate Training
Adam Reynolds

June 1998
Painted steel; rope
25m high × 5m × 1m
Status: not listed
Condition: good
Owned by: Magnus Limited
 Description: Two stick-like figures on the outside wall of an office block are shown

struggling to climb a rope to the top of the building where a third figure looks down at them, exasperated at their slow progress.

Magnus Ltd, a Cheshire-based commercial property company, commissioned Adam Reynolds to provide a sculpture to go on the outside of a modern office block it was refurbishing in the city centre. Reynolds had previously provided two works for the company's headquarters in Macclesfield. Working with the project's architects, Hattrell and Partners, he came up with the idea of a humorous narrative work to be fixed on the Chorlton Street side of the building. Constructed from steel and rope, it depicted two individuals struggling to scale the building, while a third individual already at the top looks down at them. The £8,000 cost was paid for by Magnus Ltd. It was installed in 1998. The work quickly became one of the best-known local examples of modern sculpture and has been included on tours of the city centre.[1]

Note
[1] 'Public art in the city', *City Life*, January 2001; correspondence with Adam Reynolds 2002; www.adamreynolds.co.uk.

Church Street

Junction of Church Street and Tib Street

Tib Street Horn

David Kemp

10 June 1999
Welded steel: galvanised ducting; *objéts trouvés*
10m high × 15m long
Status: not listed
Condition: good
Owned by: Manchester City Council
 Description: Large coloured metal sculpture of serpent-like musical instrument coiled round the remains of a Victorian building.

A programme of public art was recognised as one of the initiatives that would assist in promoting and establishing the identity of Manchester's Northern Quarter. As the programme developed there was a recognition that alongside the smaller forms of public art – ceramic tiles, murals and poetry paving – a larger 'gateway' sculpture would assist in establishing the area's identity as the city's 'creative quarter'.[1] David Kemp, a sculptor based in Cornwall, was approached by the Northern Quarter Association with a view to providing a sculpture. He spent time studying the history, buildings and cultural life of the area before proposing a work to be located on the corner of Tib Street and Church Street. The site was dominated by the remains of an industrial building – a former hat factory. It was opposite Affleck's Palace, a popular shopping venue. Kemp's landmark sculpture was a massive musical instrument, to which were

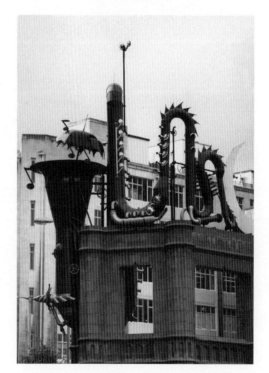

attached various eye-catching objects; the whole serpentine composition being coiled in and around the remains of the building.[2] It was by far the largest piece in a series of 'Unsound Instruments' that Kemp had worked on over a number of years: representations of instruments whose music had to be imagined from their shape. It was commissioned in 1996. Finance for the project came from the Arts Council through the National Lottery, the City Council, National Car Parks Ltd and the Northern Quarter Association. National Car Parks, the owners of the site, agreed to the erection of the sculpture. Kemp made some small changes as the project developed. It was finally completed in 1999.[3] Fixing the different sections of the sculpture to the building took ten days. The ceremony in June 1999 to welcome the 'The Big Horn' included the performance of a piece of music especially composed for the event.[4] To the question of what it was, Kemp responded:

> It's not really a saxophone, nor a dragon, coiled on the Gothic stump of a Victorian hat factory. Perhaps it's a listening device, filtering the left-over sounds from the street corner below, where the past bumps into the future, shooting the lights.[5]

Its form, size, colour and location have resulted in the *Tib Street Horn* becoming one of the most recognisable of the modern public art works installed in the city centre. In addition to Kemp's sculpture, a multi-coloured neon light tower, *Big Boys Toy* (Peter Freeman, 1998) was installed on Tib Street.

Notes
[1] R. Pavey, 'Tib Street trail', *Crafts*, No.157, March/April (1999) pp.20–3. [2] Information from Sarah Rowland. [3] Northern Quarter Association, *Applied Art in the Northern Quarter* [n.d.] pp.1, 7. [4] *Baby Bugle*, 11 June 1999; *Manchester Evening News*, 11 June 1999. [5] Northern Quarter Association press release, 28 May 1999.

Kemp, *Tib Street Horn*

Cooper Street

Waldorf House

Architect: William Mangnall
Sculptor: unidentified

*c.*1864
Yorkshire stone
Statues 1.83m high approx
Status: Grade II
Condition: poor
 Description: On the second storey are four
life-size statues in niches representing Prudence
(holding dividers in right hand), Temperance
(holding a water jug in her left hand), Fortitude
(holding a scroll) and Justice (holding sword
and scales).

The Freemasons' Hall in Manchester was
designed by William Mangnall to serve as the
headquarters of the East Lancashire Province.
An impressive ceremony, followed by a
banquet, marked the laying of its foundation
stone in July 1863. The stone-clad front was
elaborately decorated with symbolic statuary
and masonic symbols. Prominent in this stone
advertisement for freemasonry was a quartet of
statues on the second storey, female figures
representing the values of prudence,
temperance, fortitude and justice. On the very
top of the building was another female figure
depicted providing assistance to a child. This
was one of the most ambitious sculptural
schemes on a non-public building in Victorian
Manchester. The sculptor has not been
identified, but John Bell, a freemason, has been
suggested.[1] The hall remained the centre of
Manchester freemasonry until 1929 when the
Masonic Temple was opened in Bridge Street.
The building in Cooper Street has been
occupied by different businesses in the
intervening years, and is now known as
Waldorf House.[2]

Notes
[1] Information from John Durnall, Librarian,

Freemason's Hall, and Ivan Eastwood. [2] J.J.
Parkinson-Bailey, *Manchester. An Architectural
History* (Manchester: Manchester University Press,
2000) p.322.

Cooper Street and Lloyd Street

Messenger of Peace

Barbara Pearson

3 April 1986
Bronze sculpture; stone pedestal
Sculpture 2.04m × 84cm × 1.14m; base 38cm ×
 4.51m × 3.56m
Inscription on base, front: MESSENGER OF PEACE
 / Barbara Pearson 1986 / – left-hand side:
 SPONSORED BY THE PLANNING COMMITTEE
 OF / MANCHESTER CITY COUNCIL / – right-
 hand side: THE WORLD'S FIRST NUCLEAR FREE
 CITY
Signed on plinth: BP
Status: not listed
Condition: good
Owned by: Manchester City Council
 Description: Figurative sculpture; seated
bronze female figure, holding doves in her
hand. Another dove rests on her right foot
whilst three others are on the stepped stone
base.

The Labour-controlled City Council's decision,
in 1980, to declare Manchester the world's first
nuclear-free city was part of a wider campaign
to adopt a national policy of unilateral nuclear
disarmament. It was followed by a number of
local initiatives aimed at promoting awareness
and understanding of the issues involving
nuclear power. These included the
establishment of peace parks and the provision
of appropriate public sculpture. In 1985 a
'Sculpture for Peace' competition was organised
by the City Council to select a work to be
placed in the new peace garden which had been
created at the rear of the town hall, running
parallel to Mosley Street. Out of the 44 entries
received, five were short-listed and displayed in

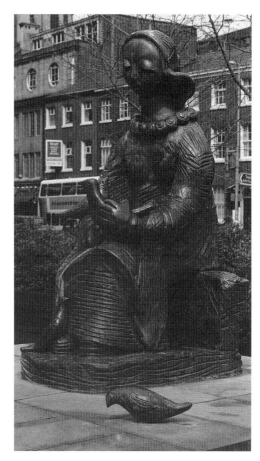

Pearson, *Messenger of Peace*

the Town Hall in June 1985. The submissions
by Barbara Pearson, Michael Lyons, Ted
Roocroft, Robert Scriven and Paul Mason were
assessed according to criteria which included
ease of understanding and durability.[1] The
panel of judges, including the chairmen of the
council's planning and arts committees and
representatives from the City Art Gallery,
decided that the £13,000 commission would go
to the Manchester-born sculptor Barbara
Pearson's design of a seated female in bronze.
The message of this earth-mother figure
surrounded by doves was easily understood.

Originally it was intended to have a larger number of doves on the pedestal, but in the end only three were included. It had been planned to site the work in the sunken section of the newly created peace garden, but this location was changed, in part because of the proposed Metrolink tramway. The open space nearer to the Cooper Street entrance of the town hall became the new location.[2]

Messenger of Peace was unveiled in April 1986. The unveiling of Manchester's first peace sculpture and its first modern outdoor public sculpture by a female artist might have passed off with little public comment had it not been for remarks made by Barbara Pearson. Elaborating on why she had selected a female figure to represent peace, she stated that it was her belief that male and female traits were distinctive: the male being essentially belligerent whilst the female was more understanding with a more deeply rooted desire for peace.[3] It was a controversial view and one that had the potential to embarrass a council that proclaimed political correctness and was publicly known for its support of equal opportunities. Councillor Arnold Spencer, chairman of the Planning Committee, attempted to close any further discussion by declaring that the council very much welcomed the sculpture and the ideas it represented, but that it was not the council's opinion that all men were aggressive.[4] The three doves on the pedestal were stolen shortly after the sculpture was unveiled. Pearson replaced them using stronger fittings. That incident apart, the sculpture has fared reasonably well, in spite of the ease with which it can be approached and climbed.

Notes
[1] *Manchester Evening News*, 22 April 1985. [2] D. Brumhead and T. Wyke, *A Walk Round Manchester Statues* (Manchester: Walkround Books, 1990) p.17. [3] Correspondence with Barbara Pearson, 1990. [4] *Manchester Evening News*, 4 April 1986.

Corporation Street

Junction of Corporation Street and Balloon Street

Robert Owen
Gilbert Bayes

28 May 1994
Bronze statue; granite plinth; brick pedestal
Signed: GILBERT BAYES 1953
Inscription on front of plinth: ROBERT OWEN –
front of pedestal: 1771–1858 – rear of pedestal: THIS STATUE WAS UNVEILED ON 28TH MAY 1994 BY HUGHIE TODNER / PRESIDENT OF THE 1994 CO-OP CONGRESS IN THE PRESENCE OF / THE LORD MAYOR OF MANCHESTER, CLLR. SHEILA SMITH / THE LEADER OF THE CITY COUNCIL CLLR. GRAHAM STRINGER / THE MAYOR OF NEWTOWN CLLR. DAVID PUGH / THE CHAIRMAN OF THE CO-OPERATIVE BANK TOM AGAR / THE MANAGING DIRECTOR OF THE CO-OPERATIVE BANK TERRY THOMAS
Status: not listed
Condition: good
Owned by: Co-operative Bank
Description: Portrait statue; a life-size bronze statue of Robert Owen who is wearing a cloak and boots. Owen is depicted protecting a child who is kneeling by his side, an allusion to his work to improve the working conditions of factory children. It surmounts a short granite pedestal and brick base.

Robert Owen, the son of a saddler and ironmonger from Newtown in Wales, was born in 1771. After working in Stamford and London, Owen, aged 16, found work at a large drapery business in Manchester. He soon became involved in the new cotton-spinning industry, becoming manager of the Bank Top cotton mill, Piccadilly, and later a partner in the larger Chorlton Mills. He became friendly with David Dale, owner of one of the largest cotton-spinning businesses in Britain. In 1799 Owen

married Dale's daughter, Caroline. With the financial support of several businessmen from Manchester, Owen purchased Dale's textile factories in New Lanark, near Glasgow. At New Lanark he began to put into action his belief that the creation of the right working and community environment could produce rational and humane people. It became the model for other co-operative communities in Britain and the United States. Owen's social and moral philosophy was expounded in his writings, including *A New View of Society* (1813). Many of his schemes such as the National Equitable Labour Exchange (1832) and the Grand National Consolidated Trades Union (1834), were considered failures, but their underlying principles continued to shape political thought. Although disillusioned with the failure of most of his political campaigns, Owen continued to work for his 'new moral order' until his death on 17 November 1858. He was buried in his native town of Newtown.[1]

Manchester's statue of Robert Owen is a copy of that erected in Owen's birthplace, Newtown, in 1956.[2] This was designed by Gilbert Bayes and completed by W.E. King. The Manchester statue was commissioned by the Co-operative Bank as part of the 150th anniversary celebrations to mark the birth of the modern co-operative movement. Terry Thomas, managing director of the Co-operative Bank, Manchester, had visited Newtown in 1993 for the annual wreath-laying ceremony at Owen's grave. He returned to Manchester with the idea of commissioning a replica of the Newtown statue to stand outside the bank's headquarters.[3] It was appropriate that Owen should be considered as a suitable subject for such a commemorative sculpture, as he was one of the formative influences on co-operative ideas in Britain. He also had a direct connection with Manchester, having managed a cotton mill in the town before going on to establish his famous industrial community in New Lanark.[4] The site selected for the replica statue was in front of the Co-operative Bank, Balloon Street,

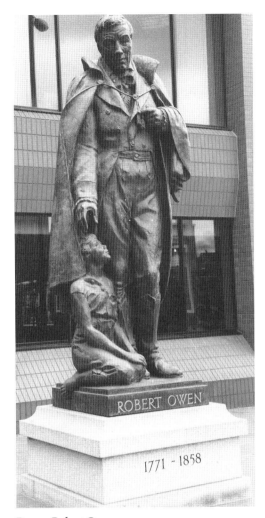

Bayes, *Robert Owen*

The statue was unveiled in May 1994 by Hughie Todner, the president of the Co-operative Congress, which was holding its anniversary congress in Rochdale. Speaking at the ceremony, Terry Thomas pointed to the modern relevance of Owen's ideas, calling on him to be recognised 'as an economic and social guru for the twenty-first century at a time when the extremes of Adam Smith of the right and Karl Marx of the left have lost much of their appeal'.[7] Rochdale unveiled its own sculpture to mark the 150th anniversary of the Rochdale Pioneers in the following year.[8]

Notes
[1] S. Pollard and J. Salt (eds), *Robert Owen Prophet of the Poor* (London: Macmillan, 1971). [2] *Co-operative Review*, May 1956, p.116. [3] Letter to Mayor of Newtown, 5 July 1993 (Co-operative Bank Archives). [4] W.H. Chaloner, 'Robert Owen, Peter Drinkwater and the early factory system in Manchester 1788–1800', *Bulletin of John Rylands Library*, 37 (1954–5) pp.78–102. [5] Correspondence with Jacqui Williams, Co-operative Bank, 28 July 1998. [6] Letter from Burleighfield Arts Ltd to Co-operative Bank, Manchester, 23 December 1993 (Co-operative Bank Archives). [7] *Co-operative News*, 7 June 1994; *Guardian*, 28 May 1994. [8] See below, p.323.

Cross Street

Eagle Insurance Company Offices

Architect: Charles Heathcote

Architectural sculptors: Earp, Hobbs and Miller

1902
Sandstone
1.83m square approx
Status: Grade II
Condition: poor
 Description: Located on an island site, this is an Edwardian commercial building with a richly decorated frontage, including an eagle above the central pediment. Above each of the first-storey corner windows is a sculptural composition featuring a carved shield

in the very heart of a district dominated by co-operative buildings.[5] Arrangements were made, initially with the Morris Singer foundry, to undertake the work, but, due to their financial problems, the contract was given to Burleighfield Arts Ltd in High Wycombe. Bayes's statue was removed from Newtown so that it could be copied, the occasion also being used to repatinate it.[6]

Earp, Hobbs and Miller,
***Eagle Insurance Company Offices* (detail)**

displaying the name of the company, flanked by two youths representing different trades. Each shield is surmounted by an eagle.

The Eagle Insurance Office building was one of the earliest of a number of fine office buildings designed by Charles Heathcote in central Manchester. The building, in white Cullingworth stone, had the unusual feature of a wrought-iron balcony running around the first floor on the three principal sides. The ground floor was designed to be let as shops. The main sculptural decoration, by Earp, Hobbs and Miller, announced to the world the business of the owners. All the corner sculptural compositions were essentially the same – two youths flanking a shield – their symbolism distinguished by the objects they are holding or placed around them.[1] Their condition is generally poor, parts of the original sculpture having weathered badly or been damaged.

Note
[1] *Builder*, 1 March 1902, p.214; *Daily Dispatch*, 21 May 1937.

Deansgate

John Rylands Library
Architect: Basil Champneys
Sculptors: John Cassidy, Robert Bridgeman

Opened 6 October 1899

John Rylands Library was built as a memorial to the cotton merchant, John Rylands, by his wife, Enriqueta Augustina Rylands. The architect was Basil Champneys, whose work up to that date included Mansfield College, a Congregational foundation that the Rylands had supported. Mrs Rylands' original intention had been to provide a theological library, in recognition and remembrance of her husband's love for religious study, but it soon developed into a broader project. Commissioned in 1890, Champneys' Gothic structure was completed in 1899. Throughout the building process, Mrs Rylands kept herself informed of every aspect of the project, engaging in a lengthy correspondence with the architect, and frequently providing detailed instructions and guidance.[1] She also began to collect books for the library, her most important purchase being the justly famous Althorp Library, formerly owned by Earl Spencer. The library was finally opened on 6 October 1899, the Rylands' wedding anniversary. Champneys' work was lauded as 'one of the most perfect architectural achievements of the century' which would take its place 'among the deathless creations of love'. It was, according to the *Manchester Guardian*, 'one of the finest buildings erected in England in this generation, and a very welcome addition to the comparatively few pieces of good architecture which Manchester possesses'.[2] It is a Grade II* listed building. The John Rylands Library and the University of Manchester Library merged in 1972.

Mrs Rylands' influence on the building was especially evident in the sculpture.[3] The main display of sculpture was inside the building, though it should be noted that the architectural sculpture on the exterior – the shields and coats of arms included those of several British universities and the combined arms of Rylands and Tennant – also received the careful consideration of Mrs Rylands. However, in her selection of sculptors, Mrs Rylands did not turn, as she could so easily have done, to some of the leading sculptors of the day. Rather, she chose to rely on the relatively young and inexperienced Manchester sculptor, John Cassidy. It was Cassidy and Robert Bridgeman who were to be responsible for the principal sculpture, in a building that was one of the most generous acts of personal patronage in nineteenth-century Manchester.

Notes
[1] J. Maddison, 'Basil Champneys and the John Rylands Library', in J. Archer (ed.), *Art and Architecture in Manchester* (Manchester: Manchester University Press, 1985). [2] *Manchester Guardian*, 7 October 1899, 5 February 1908. [3] Maddison, *op. cit.*, pp.239–43.

Vestibule

Theology Directing the Labours of Science and Art
John Cassidy

Shawk stone
Theology 1.63m high
Condition: good

Description: Symbolic group of three figures on wall in vestibule. The central figure, Theology, is a standing female figure holding in her left hand a Bible, while with her right hand she directs Science, represented as an old man, seated, studying a globe. To her left, Art is a youthful metalworker making a chalice, who has turned away from his work to listen to Theology.

Champneys' original plan for the vestibule appears to have included three niches for sculpture in the main wall. Mrs Rylands developed the idea for the statuary, making it clear to Champneys that her preference was to place the statues in front of the niches rather than inside them.[1] Early in 1893 she approached John Cassidy, who was already working on a statue of John Rylands for the library, to prepare designs for a sculpture to occupy this important position. Her instructions are not recorded, but she may already have envisaged a symbolic composition relating to Theology. Cassidy's initial ideas did not meet Mrs Rylands' own expectations: 'The present appearance of three statues in a line all one height and size looks to me anything but striking and too much like the statues one sees in a cathedral.'[2] But, if changes were made to the niches, she told Champneys, then she would be able to suggest to Cassidy 'a treatment of the subject more in harmony with what I should like, independent of the details which I must leave him to design'.[3] Further discussions followed, but no immediate commission was offered. When the

Cassidy, *Theology Directing the Labours of Science and Art*

question of the sculpture was returned to in the following year, it was now conceived as a group of three figures, representing Theology, Art and Literature or Poetry, standing on a base in front of a shallow recess. As in the treatment of the statues in the main library, Mrs Rylands' wish to have statues standing clear of any niche had been realised. Cassidy was asked again to submit a sketch.[4] Champneys used the opportunity to advance George Frampton as a possible sculptor. But it was Cassidy who received the commission, agreeing to complete a group of three figures in red shawk stone for £300, 'adapting all sketches and models to Mrs Rylands' entire approval'.[5] Champneys could not have been informed immediately of the selection because a fortnight later he was enquiring whether any decision had been made on the sketch submitted by Frampton.[6] His response to Cassidy's design was qualified praise. He criticised the central figure representing Theology as being too tall for the vestibule, and felt that the base of the figure required a symbolic lift. 'This might be a rock to symbolise confidence, or it might be a dragon to imply that religion subdues and keeps down the power of evil, a symbol very often used in early Italian art', he informed Mrs Rylands.[7] Some reduction was made to the height of the figure, but no change was made to the base. Champneys' concern over this weakness may have influenced him when he submitted his design for the frame of the sculpture, as he included a coat of arms on the corbel. It was an embellishment that did not receive Mrs Rylands' approval.[8] Cassidy installed *Theology Directing the Labours of Science and Art* in February 1898, putting the finishing touches to it in July.[9] An account of it was prepared for the opening of the library, which included an explanation of the allegorical subject: 'The thought conveyed is that Science and Art alike derive their highest impulses and perform their noblest achievements, only as they discern their consummation in religion.'[10]

Notes
[1] Mrs Rylands to Champneys, 24 February 1893, Letter Book Vol.1 (Mrs Rylands' Letter Books, John Rylands University Library of Manchester). [2] *Ibid*. [3] *Ibid*. [4] William Linnell to John Cassidy, 1 November 1894, Letter Book Vol.1. [5] Cassidy to Mrs Rylands, 4 May 1895, Letter Book Vol.2. [6] Champneys to William Linnell, 20 May 1895, Letter Book Vol.1. [7] Champneys to Mrs Rylands, 26 July 1895, Letter Book Vol.1. [8] *Ibid*., 15 November 1895; William Linnell to Champneys, 20 November 1895, Letter Book Vol.2. Champneys to Mrs Rylands, 15 November 1895, 17 January 1896, Letter Book Vol.2. [9] Correspondence between William Linnell and Cassidy, 8 and 9 February 1898, 28 June 1898, 16 July 1898, Letter Book Vol.4. [10] John Rylands Library, *Memorial of the Inauguration, 6th October, 1899* (Manchester, 1899) p.11; H. Guppy, *The John Rylands Library Manchester 1899–1924* (Manchester: John Rylands Library, 1924).

Library

Statues

Robert Bridgeman

Installed 1898
Shawk stone
Figures 1.22m high
Condition: good

A series of 20 statues placed above the bay arcades and on the end walls was an important part of the decorative scheme of the main library. The figures represented 'many of the most eminent men of different ages and countries in the several departments of science, literature and art … making both correspondences and contrasts in character and achievement'.[1] The scheme had similarities with Mansfield College, where Robert Bridgeman had been responsible for the carving. In Manchester the whole process of commissioning, positioning and approving the statues was overseen by Mrs Rylands. As with the other statuary, planning began at an early stage in the library's construction. In April 1893 Mrs Rylands presented Champneys with a plan of the sculpture she wanted in the main room of

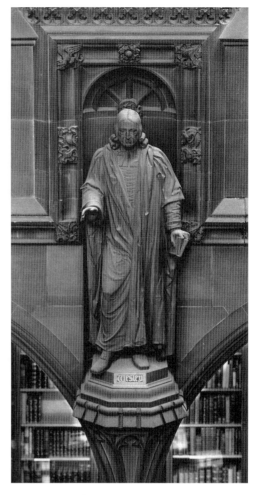

Bridgeman, *John Wesley*

the library. This identified 20 historical figures and their positions, followed by a request that Bridgeman be approached for an estimate. It was made clear that 'Mrs Rylands would of course require a photograph of each figure to be submitted for her approval before it was cut in stone'.[2] Champneys pressed the case for George Frampton to be considered for the work, but the model he submitted cannot have impressed Mrs Rylands.[3] It was agreed that Bridgeman

would carve the figures, at a cost of £30 each. The figures were to be in the same red stone used for the library, a choice that prompted Mrs Rylands to enquire whether sufficiently large blocks would be available for the statues.[4] She was also concerned about their position. Once again, anxious to avoid what she referred to as an ecclesiastical appearance, she instructed Champneys to place the figures in front of rather than inside the niches, as this would allow them 'to be treated with a boldness which cannot attach to figures cramped up in niches'.[5] Additional work and costs would be involved in realising these changes, but Mrs Rylands was adamant.[6]

The majority of the statues were carved in 1895–7. Not all of Bridgeman's work received Mrs Rylands' approval. Decisions about the suitability of the models were usually taken promptly, though in June 1895 Bridgeman wrote to enquire about his Luther and Milton because, as he explained, 'the clay models are getting very hard this dry weather and I fear any alterations will mean fresh models'.[7] Mrs Rylands' attention to detail even extended to the lettering on the pedestals.[8] Bridgeman finished the figures in 1898, the complete gallery of individuals and their positions being exactly as Mrs Rylands had detailed five years before. Apart from the four on the end walls, the figures were placed on the fluted capitals of the minor columns dividing the bays, arranged in facing pairs. At the north end of the library John Wycliffe and William Tyndale were opposite Miles Coverdale and John Rainolds, all four being included as translators of the Bible. Nearest the northern end of the reading room on the western side is Johann Gutenberg, opposite William Caxton on the east side, together representing Printing. Following these are Isaac Newton and John Dalton, representing Science; Herodotus and Edward Gibbon, representing History; Thales of Miletus and Francis Bacon, representing Philosophy; Homer and Shakespeare, representing Poetry; Milton and Goethe,

representing Poetry; Luther and Calvin, representing the Protestant Reformation; John Bunyan and John Wesley, representing British Evangelical Theology.[9] The final costs of the 20 statues were not identified separately in Bridgeman's general account for stone carving, which totalled £7,867. 6s. 7d.

The main reading room also includes two marble statues of Mr and Mrs Rylands, both by John Cassidy.

Notes
[1] Mrs Rylands to Champneys, 5 April 1893, Letter Book Vol.1. [2] William Linnell to Champneys 5 April 1893, Letter Book Vol.1. [3] Champneys to William Linnell, 7 April 1893; Champneys to Mrs Rylands, 26 June 1893, Letter Book Vol.1. [4] William Linnell to Champneys, 2 May 1893, Letter Book Vol.1. [5] Mrs Rylands to Champneys, 24 February 1893, Letter Book Vol.1; J. Aulich, *The John Rylands Library, Manchester 1889–1899*, p.22. [6] Champneys to Mrs Rylands, 11 April 1894, Letter Book Vol.1. [7] Stephen Kemp to William Linnell, 12 June 1895, Letter Book Vol.1. [8] Correspondence between Champneys and William Linnell, 14 October 1896, 19 October 1896, Letter Book Vol.2. [9] John Rylands Library, *Memorial of the Inauguration, 6th October, 1899* (Manchester, 1899) pp.15–17.

John Rylands
John Cassidy

Installed April 1899
Marble; polished granite pedestal
Statue 1.83m high; pedestal 90cm high
Inscription on plinth: JOHN RYLANDS
Condition: good
Owned by: University of Manchester
Description: Portrait statue; a life-size marble statue of John Rylands, who is holding a quill pen in his right hand. The statue stands on a polished granite pedestal.

John Rylands was born at Parr, near St Helens, in 1801. He began working as a textile manufacturer and merchant in 1817 and went on to establish one of the largest cotton businesses supplying the home trade. His manufacturing works expanded to include mills

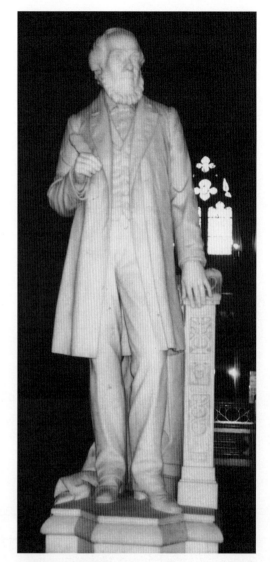

Cassidy, *John Rylands*

at Gorton, Manchester and Swinton. A parallel growth was seen in his Manchester warehouse premises, which opened in 1823. By the 1860s Rylands was recognised as one the leading figures in the Lancashire cotton industry. A Nonconformist in religion, Rylands became an

important philanthropist, supporting local and international charities. He married three times: his first wife Dinah Raby, whom he married in 1825, died in 1843; his second marriage was in 1848 to Martha Carden, who died in 1875; his third marriage was to Enriqueta Tennant in 1875. John Rylands died at Longford Hall, Trafford, on 11 December 1888 and was buried in Southern Cemetery, Manchester. The 'old Field-Marshal of the Home Trade' left a personal estate of some £2.5 million.[1]

Mrs Rylands' plans for the library included an appropriate representation of her late husband. Initially, she considered a bust to be displayed in the apse of the library, but this idea was replaced by one of a full-length marble statue.[2] It appears that the only sculptor she approached to provide the bust and then a statue was John Cassidy. His charge for the statue was £1,325, the work to be completed in 15 months.[3] The commission received Mrs Rylands' usual careful attention. Alterations were made to the plaster model submitted by Cassidy, and considerable time was taken up in discussing the best location for the statue: a discussion that might have been postponed, at least, until the main reading room was roofed.[4] The statue was finally installed in April 1899, some seven years after the initial discussions.[5] Mrs Rylands' concern with the detail continued to the last, in this instance ensuring that Patteson's, one of Manchester's best known architectural sculptors and masons, supplied a granite pedestal in exactly the colour she wanted.[6] Cassidy's statue of John Rylands was placed in front of the arch leading into the apse, a central position which ensured that it was lit by some of the natural light entering the library.[7]

Notes
[1] D.A. Farnie, *John Rylands of Manchester* (Manchester: John Rylands University Library of Manchester,1993); D.A. Farnie, 'Money-making and charitable endeavour: John and Enriqueta Rylands of Manchester', *Journal of United Reformed Church History Society*, 6, No.6 (2000) pp.429–38.

[2] Champneys to Mrs Rylands, 11 November 1892, Letter Book Vol.1. [3] Cassidy to Mrs Rylands, 26 June 1893, Letter Book Vol.1. [4] William Linnell to Champneys, 23 May 1895, Letter Book Vol.2. [5] Stephen Kemp to William Linnell, 15 April 1899, Letter Book Vol.4. [6] Correspondence between William Linnell and J.H. Patteson, 19 October 1898, Letter Book Vol.4. The pedestal cost £100. [7] Cassidy to William Linnell, 16 July 1898, Letter Book Vol.4.

Mrs Enriqueta Augustina Rylands
John Cassidy

9 December 1907
Marble
Statue 1.72m high; pedestal 58cm high
Signed: John Cassidy 1907
Condition: good
Owned by: University of Manchester
 Description: Portrait statue; life-size marble statue of Mrs Rylands surmounting polished granite pedestal.

Enriqueta Augustina Rylands was the third wife of textile magnate John Rylands, and the founder of the John Rylands Library. She was born in Havana, the daughter of a merchant, Stephen Cattley Tennant. She was educated privately in New York, Paris and London, and became companion to John Rylands' second wife, Martha. She married John Rylands in October 1875, Martha having died in the previous February. Although the *Manchester Guardian* described much of her life as 'quiet and uneventful', Mrs Rylands had, in addition to building and stocking the famous library as a memorial to her husband, a long involvement with philanthropic projects in Manchester. She died in Torquay in 1908.[1]

According to Stephen Tennant, Mrs Rylands' brother, the governors of the library, feeling the need for something of a 'personal nature' to connect the library with its founder, explored the possibility of commissioning a portrait of Mrs Rylands to hang in the library. Mrs Rylands' response to the idea was to

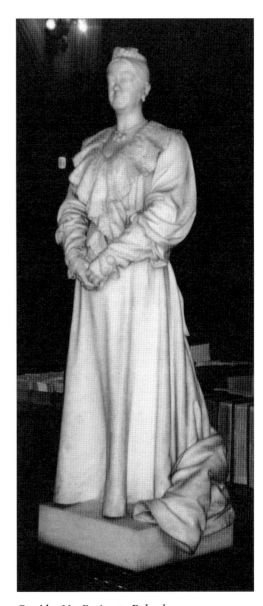

Cassidy, *Mrs Enriqueta Rylands*

propose that she provide a statue instead. This was agreed. The commission was given to John Cassidy, who had already sculpted the statue of her late husband.[2] The Saravezze marble

statue was positioned at the opposite end of the library to her husband's statue, facing him but surmounting a shorter pedestal. It was unveiled in December 1907. At the ceremony, which Mrs Rylands was unable to attend because of illness, the Vice-Chancellor of the Victoria University, Professor Hopkinson, said that they owed the founder a great debt, not only for endowing the library but for 'filling it with those treasures which could only be got by lavish and princely generosity and by direct personal care and interest in the work'. The library, he went on to say, had been her conception, and transcended the mere practicality which was thought to be the guiding principle of Manchester architecture. Instead, it appeared that Mrs Rylands had said to herself, 'Here, in this home of utility, I will build something that is absolutely and perfectly beautiful, so far as choice of materials and workmanship can do it'.[3] Dr Adeney of the Lancashire Independent College spoke of Cassidy's success in rendering Mrs Rylands' dignity, simplicity and intelligence, through which shone 'none of the mere superiority of social position, but the true dignity of a woman who has realised that her mission in the world is not to live to herself'.[4] In the following February Mrs Rylands was dead.[5]

Notes
[1] D.A. Farnie, 'Enriqueta Augustina Rylands (1843–1908) founder of the John Rylands Library', *Bulletin of John Rylands University Library of Manchester*, 71, No.2 (1989) pp.3–38. [2] 'In Memoriam', *ibid.*, 1, No.6 (1908) p.359. [3] *Manchester Guardian*, 10 December 1907. [4] *Ibid.* [5] *Ibid.*, 5 February 1908.

Elliot House, Deansgate

Window surrounds
Architects: Royle and Bennett

1888
Red sandstone
2.44m × 2.29m
Status: Grade II
Condition: fair
Owned by: Bruntwood Estates
Description: Carved red sandstone oval window surrounds featuring putti, foliage and lion's head on the angled corners of the building on Lloyd Street and Jackson's Row.

Royle and Bennett were chosen from seven Manchester architects to design the offices of the Manchester School Board. They chose the Queen Anne Style for the building which is built of red Ruabon brick and terracotta. The architectural decoration was dominated by their treatment of the surrounds of the large windows on the corner splays. These consisted of elaborate carved sandstone surrounds featuring two cherubs, one on either side of the

Royle and Bennett, *Elliot House*

surround.[1] The building was extended during the Edwardian period and continued to be used by Manchester Education Committee until the late 1980s. It was named Elliot House after John Kenneth Elliot, one of the city's dynamic directors of education.

Note
[1] *British Architect*, 2 August 1889, p.86.

Library and Market Building, Deansgate

Commerce supported by Peace and Industry
Architect: George Meek

5 April 1882
Stone
1.22m high × 4.57m long
Status: Grade II
Condition: fair
Owned by: Manchester City Council
Description: A curved pediment containing a stone sculptural composition in high relief above the central entrance-way leading into the market halls. The composition shows Commerce, a crowned female figure on a throne, flanked by two seated female figures representing Peace and Industry, who are themselves flanked by groups of young children symbolising Trade.

In the 1870s Manchester Corporation erected two new market buildings on the Liverpool Road. It decided to erect an entrance building to the markets on land fronting on to Deansgate. In 1879 it was agreed that the building would also accommodate a new branch library.

The ground floor was let as shops and offices whilst the library occupied the first floor. The building was designed by George Meek under the direction of the City Surveyor, John Allison. The importance of the entrance-way leading into the market area was emphasised by

commissioning a sculptural composition to fill the arched pediment. The theme was commerce and the panel symbolically linked commerce, industry and peace.[1] The sculptor has not been identified. Meek completed the Deansgate elevation with a carved stone balustrade in the centre of which was a large and crisply carved municipal coat of arms.[2]

Notes
[1] *Manchester Courier*, 6 April 1882; W.R. Credland, *The Manchester Public Free Libraries* (Manchester: Public Free Libraries Committee, 1899) pp.127–8.
[2] *Manchester Guardian*, 1 April 1882.

Deansgate and John Dalton Street

Queen's Chambers

Architects: Nathan Pennington and Edward Bridgen

1876
Yorkshire stone
1.43m high approx
Status: Grade II
Condition: fair
 Description: Stone portrait statue of a young Queen Victoria in niche on second storey of building.

Queen's Chambers occupies an important corner site at the junction of Deansgate and John Dalton Street. The building was designed in the Gothic style by the local architects, Nathan Glossop Pennington and Thomas Edward Bridgen, a style which they also adopted for other office buildings in the city centre, including the Lawrence Buildings, Mount Street. Queen's Chambers provided both office and retail space. One of the new building's principal occupants was the Queen's Building Society, and its presence may have been responsible for both the building's name and the inclusion of the royal statue between the square-headed windows on the second storey on the John Dalton Street façade. The

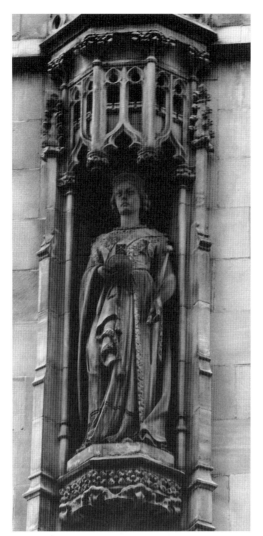

Queen Victoria

building contract went to the Manchester building firm Robert Neill and Sons, but the sculptor employed by the architects has not been identified.[1]

Note
[1] *Builder*, 4 March 1876, pp.214–15; *British Architect and Northern Engineer*, 15 September 1876, p.170.

Deansgate, near entrance to Deansgate railway station

Life Cycle

George Wyllie

1995; relocated 1996
Tubular steel; stone
6.1m high approx × 3.25m wide
Signed: hub of wheel is dated 1994
Status: not listed
Condition: good
Owned by: Manchester City Council
 Description: Representation of bicycle in tubular steel with large oval-shaped wheels which are touching. The crossbar is extended and ends in a vertical pole from which is suspended a piece of rock. On the elongated saddle is a bird. The sculpture is fixed directly to the pavement.

Life Cycle was commissioned by Manchester City Council from the Scottish sculptor, George Wyllie, for an international conference on the environment hosted by the city in 1995.

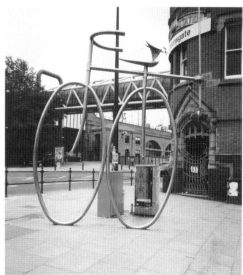

Wyllie, *Life Cycle*

In the arrangements for the conference the idea of commissioning a symbolic sculpture was agreed upon. Wylie, whose interests embraced regenerative art, submitted a design based on a bicycle, which explored the ideas surrounding the balance between man and nature.[1] The tubular steel bicycle was placed in Albert Square during the conference but later moved to a sloping site, close to the entrance to Deansgate railway station.

Note
[1] Information from George Wyllie, April 1999.

Dolefield

Crown Courts

Architectural sculptors: Thomas Woolner, O'Shea Brothers

Manchester Assize Courts opened 26 July 1864; Manchester Crown Courts opened 24 May 1961
Darley Dale sandstone
Status: not listed
Condition: fair
Owned by: The Crown

Description: A series of life-size statues of historical and symbolic figures associated with the law displayed in the court museum, the public concourse and the Judges' Corridor. The museum also contains two punishment capitals, and bosses depicting the monarchs and rulers of England.

Court Museum
(located beneath ceremonial staircase)

Alfred the Great (849–901): dressed in a cloak and wearing a crown, holding a seal and document.

Henry II (1133–89): crowned figure wearing a cloak and carrying a sword, and holding staff of office (damage to face and sword).

Edward I (1239–1307): crowned figure wearing mail armour and cloak, his left hand resting on

Woolner, *Alfred the Great*

Woolner, *Sir Edward Coke*

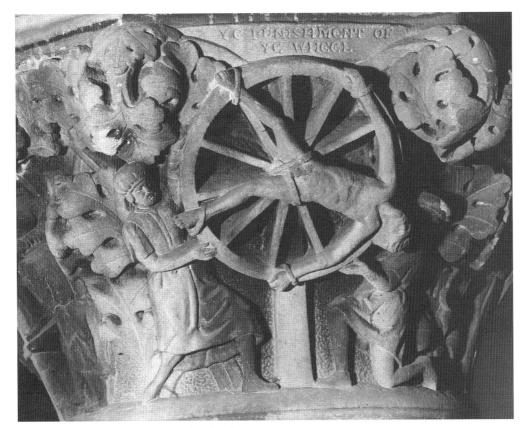

the hilt of his sword. A helmet is placed at his feet.

Sir Edward Coke (1552–1634): figure wearing ruff and long coat, and holding books in his left hand.

Punishment Capitals: two capitals, each one depicting four types of ancient punishment: Ye Punishment Of Ye Wheel, For Scolding Women, Ye Punishments By Weights and Ye Pillory. The punishments represented on the second capital are Ye Guillotine, Torture By Pouring Water Down Ye Throat, Saxon Hanging and Ye Stocks.

42 window bosses representing heads of the country's monarchs, beginning with Alfred the Great and including Oliver Cromwell.

O'Shea Brothers, *'Ye Punishment Of Ye Wheel'*

Great Hall

Mercy: a female figure wearing a long dress, holding her hands (fingers on right hand broken).

Sir William Gascoigne (c.1350–1419): depicted wearing a cloak and holding the hilt of a down-turned sword (damage to right hand).

Sir Thomas More (1478–1535): depicted wearing a fur-trimmed robe and hat.

Sir Matthew Hale (1609–76): depicted wearing robes and a skull cap.

Judges' Corridor

Ranulf de Glanville (d.1190): a standing figure wearing a tunic, cloak and hat. He is holding a book in his left hand whilst the other hand rests on the hilt of his sword (sword and right hand broken and repaired; nose broken and replaced).

The winner of the competition, held in 1859, to design the Assize Courts for the Hundred of Salford (popularly referred to as the Manchester Assize Courts) was the young and then largely unknown architect, Alfred Waterhouse. He chose the Gothic style for his design, a style that, among other things, allowed him to demonstrate for the first time on such a large scale his understanding of the relationship between architecture and sculpture. Waterhouse engaged the O'Shea brothers and the Pre-Raphaelite sculptor, Thomas Woolner, to produce the major pieces of architectural and portrait sculpture for the building. Although the broad features of the history of the sculptural commission can be established, many aspects of the project remain unknown.

The O'Shea brothers, whose work, including the Natural History Museum at Oxford University, Waterhouse would have known, appear to have been responsible for a considerable amount of the interior sculptural decoration.[1] Waterhouse informed the Royal Institute of British Architects that Messrs O'Shea and Whelon had either carved or directed the carving of the extensive foliage work on the capitals. He went on to describe a fireplace in the Judges' Lodgings as one of Paul O'Shea's 'best bits of work'.[2] Most of this carving has been destroyed but, fortunately, one important element, the punishment capitals which decorated the huge granite columns in the principal entrance area, have survived.[3] These two capitals depicted medieval and later punishments, among the more gentle forms of which were 'Ye Pillory' and 'Ye Stocks', in which the miscreants were identified as knave and rogue respectively. It is not known whether

Waterhouse determined the subjects represented. For contemporaries the finished capitals were, predictably, 'sermons in stones', illustrating a judicial system that was moving towards more merciful systems of punishment.[4]

When, in 1861, Thomas Woolner was commissioned to work on the Assize Courts, his reputation as a sculptor was already well established.[5] In Manchester his work had been displayed at the Art Treasures Exhibition, 1857, and local commissions had come from William Fairbairn, among others. This was to be the largest commission of Woolner's career. The centrepiece was eight life-size figures of individuals recognised for their contribution to the development of English law. The series began with Alfred the Great and ended with Sir Matthew Hale. They were on the principal façade facing Great Ducie Street, positioned in canopied niches between the upper-storey windows of the porch, which was the principal entrance into the court. The porch culminated in a gable, on the apex of which was a larger than life-size statue, *Moses holding the Book of Law*. Woolner was also responsible for two symbolic figures, *Justice* and *Mercy*. *Justice*, a seated figure, was positioned in a niche over the entrance of the porch on the Southall Street side of the building. *Mercy*, a life-size standing female figure, was on the corner of the Judges' Lodgings, occupying a niche on the first floor. In addition, Woolner produced a 1.5 metre circular relief, the *Judgement of Solomon*. This was placed above the archway connecting the main court building and the Judges' Lodgings, again facing Great Ducie Street.[6] At the angles of the archway beneath the relief were two figures: the *Good Woman*, shown nursing her child, and the *Drunken Woman*, depicted smashing her infant's head with a wine pot. The majority of Woolner's figures were installed after the opening of the building.

In 1865 Waterhouse referred to Woolner as 'the artist engaged upon the figure sculpture throughout the building'. However, another contemporary description distinguished between Woolner's work in modelling the statues and the carving of them, which was said to have been undertaken by a Polish-born sculptor, Mr Imhoff.[7] This may have been Raphael William Imhoff, who was listed as a sculptor living in Liverpool in 1859.[8] However, in his remarks to the Royal Institute of British Architects, Waterhouse, whilst confirming that Imhoff had worked on the building, only identified him as the sculptor of the heraldic animals which, along with some especially fine gargoyles, decorated the parapet. In the absence of more detailed building records, it is also difficult to identify exactly who was responsible for the design and execution of other sculptural features on the main façade. These included the 44 window bosses, representing English monarchs and rulers from Alfred to Victoria, a portrait gallery that was notable for its inclusion of Cromwell. In a detailed description of the building before its opening the *Manchester Guardian* identified 'Herr Imhoff' as the carver of the best of these heads as well as the punishment capitals in the entrance area.[9] A medallion depicting Herod's murder of the innocents is problematic.[10]

When the Assize Courts were opened in July 1864, the building was immediately recognised as one of the finest of the age. Indeed, some of the praise heaped upon it verged on the extravagant.[11] The sculptural detail, though still incomplete, contributed to its success. The *Manchester Guardian*, however, found serious fault with Woolner's *Moses*. Issue was taken with the novelty of selecting Moses as a symbolical figure and the manner in which the sculptor had interpreted the figure:

> That it fails to convey a grand idea of the Jewish lawgiver is a pardonable fault in the estimation of anyone who knows Michaelangelo's Moses. But it is unpardonable that, as a statue of a man, it represents a constrained if not an impossible attitude, and that the entire centre of gravity is lost. Looked at from either side, the body is bowed … The head-dress, a sort of Phrygian cap, is said upon high authority to be correct; but as the imagination has made wild flights with effects which none approves, in this respect some license of fancy would have been forgiven.[12]

Changes were made to the sculpture, but they did not alter the newspaper's underlying judgement that it was a failure, and ought to have been removed from the building. The *Manchester Guardian*'s opinion of Woolner's *Moses*, however, was to change: in 1919 it considered it to be one of the three best sculptures in the city.[13] But, overall, the building was recognised as a work of the highest order, quality and inventiveness. It was simply, in the words of the *Builder,* 'a building of which any city might be justly proud'.[14]

The Assize Courts were severely damaged by incendiary bombs in 1941, though, fortunately, the main façade, including most of the statuary, was left standing. However, the statue of Moses, nearly 30 metres above the ground, did appear to pose a safety problem. It was badly damaged when an attempt was made to lower it to the ground.[15] After the war the idea of reconstructing the courts was discussed but ruled out. The decision to demolish the surviving building prompted calls for a more imaginative response from the authorities. The Manchester architectural historian, Cecil Stewart, proposed that, at the very least, the vaulted entrance hall should be preserved, with a view to re-erecting it in one of the city's parks.[16] John Summerson supported the idea, judging the courts to be a work of genius: architecture to which 'historians of nineteenth-century buildings will always need to refer'.[17] C. Gustave Agate was also in favour of some form of preservation, suggesting that Woolner's statues might be placed in the sculpture hall in Manchester Town Hall.[18] This public concern did have some impact, and when demolition began in the autumn of 1957, most of the statues and the larger pieces of architectural

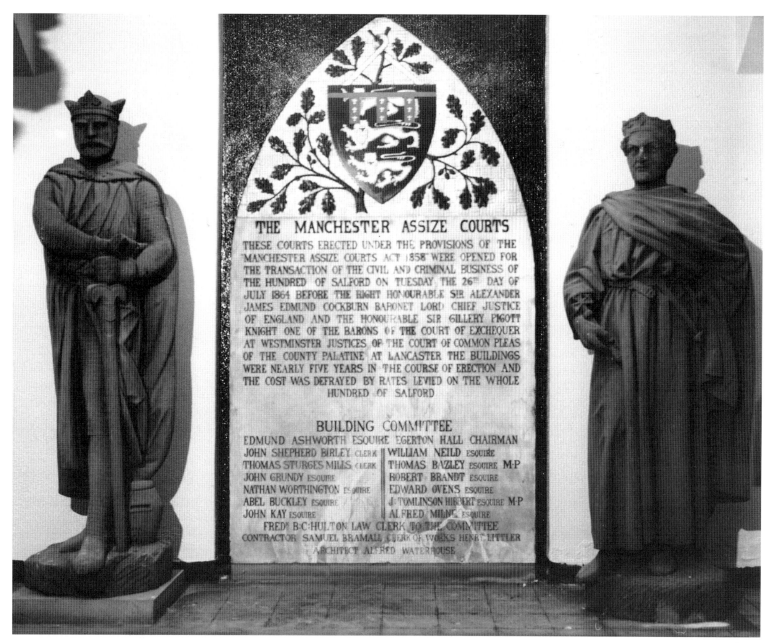

The inscription on the tablet reads:

THE MANCHESTER ASSIZE COURTS

THESE COURTS ERECTED UNDER THE PROVISIONS OF THE "MANCHESTER ASSIZE COURTS ACT 1858" WERE OPENED FOR THE TRANSACTION OF THE CIVIL AND CRIMINAL BUSINESS OF THE HUNDRED OF SALFORD ON TUESDAY THE 26TH DAY OF JULY 1864 BEFORE THE RIGHT HONOURABLE SIR ALEXANDER JAMES EDMUND COCKBURN BARONET LORD CHIEF JUSTICE OF ENGLAND AND THE HONOURABLE SIR GILLERY PIGOTT KNIGHT ONE OF THE BARONS OF THE COURT OF EXCHEQUER AT WESTMINSTER JUSTICES OF THE COURT OF COMMON PLEAS OF THE COUNTY PALATINE AT LANCASTER THE BUILDINGS WERE NEARLY FIVE YEARS IN THE COURSE OF ERECTION AND THE COST WAS DEFRAYED BY RATES LEVIED ON THE WHOLE HUNDRED OF SALFORD

BUILDING COMMITTEE

EDMUND ASHWORTH ESQUIRE EGERTON HALL CHAIRMAN

JOHN SHEPHERD BIRLEY CLERK	WILLIAM NEILD ESQUIRE
THOMAS STURGES MILLS CLERK	THOMAS BAZLEY ESQUIRE M·P
JOHN GRUNDY ESQUIRE	ROBERT BRANDT ESQUIRE
NATHAN WORTHINGTON ESQUIRE	EDWARD OVENS ESQUIRE
ABEL BUCKLEY ESQUIRE	J· TOMLINSON HIBBERT ESQUIRE M·P
JOHN KAY ESQUIRE	ALFRED MILNE ESQUIRE

FREDK B·C·HULTON LAW CLERK TO THE COMMITTEE
CONTRACTOR SAMUEL BRAMALL CLERK OF WORKS HENRY LITTLER
ARCHITECT ALFRED WATERHOUSE

Woolner, *Edward I (left) and Henry II*

sculpture were removed and placed in storage.

It was eventually decided that the eight statues of the lawmakers and the only other standing figure, *Mercy*, would be displayed in the new Crown Courts (architect, Leonard C. Howitt) which were to be built in Gartside Street.[19] Four of Woolner's statues – *Alfred the Great*, *Henry II*, *Edward I* and *Sir Edward Coke* – were located in what became referred to as a museum, situated under the ceremonial staircase of the new courts. The two punishment capitals, the window bosses and the plaque commemorating the opening of the Assize Courts in 1864 completed the exhibits in this well-concealed sculpture gallery. Initially, the other five statues were displayed outside the court, but subsequent building work resulted in their being moved inside.[20] They were placed in the most public part of the building, the Great Hall, with the exception of the figure of Ranulph de Glanville which was located on the Judges' Corridor. The Crown Courts were opened by the Queen in 1961.

The present location of a number of the other pieces of sculpture which were removed from Waterhouse's building is difficult to establish, especially following the City Council's decision to offer some of the rescued sculpture to neighbouring authorities. Some of the sculpture was reported as being sent to Lyme Park, Disley, whilst two of the heraldic beasts were acquired by the Bowes Museum, Barnard Castle, Durham.[21] One of the animal sculptures was given to a Stockport infant school.[22] A Rochdale tea room claims to display a stone head of Judge Jeffreys from the courts.[23] The fate of the seated figure of Justice and the circular relief of the Judgement of Solomon, both presumed to have been saved during the demolition, remains unknown.[24] Nonetheless a significant number of the principal sculptures from one of the important commissions of the Victorian period were saved. Unfortunately, this collection remains little known and, because of the security considerations of the building, even less visited.[25]

Notes

[1] B. Read, *Victorian Sculpture* (1982) pp.237–8; *Manchester Guardian*, 28 June 1864. [2] *Building News*, 23 June 1856, p.441. [3] Read, *op. cit.* [4] *Description of the Hundred of Salford Assize Courts of the County of Lancaster* (Manchester: Beresford and Havill [n.d.]) pp.7, 11. [5] B. Read, 'Thomas Woolner', in B. Read and J. Barnes (eds), *Pre-Raphaelite Sculpture. Nature and Imagination in British Sculpture* (London: Henry Moore Foundation and Lund Humphries, 1991) p.27. [6] A plaster alto-relief of the *Judgement of Solomon* and plaster models of *Mercy* and *Justice* were among the Assize Court works auctioned at Woolner's studio in 1913. See *A Catalogue of the Remaining Works of the late Thomas Woolner R. A.*, [1913], Nos.33–41, 69, 115. [7] *Building News*, 23 June 1856, p.442; *Description of the Hundred of Salford Assize Courts of the County of Lancaster* (Manchester: Beresford and Havill [n.d.]) p.7. [8] *Gore's Liverpool Directory* (1859) pp.112, 261. [9] *Manchester Guardian*, 7 June 1864. [10] W. Proctor, 'The Manchester Assize Courts', *Journal of Manchester Geographical Society*, 53 (1945–7) pp.44–6. [11] *Illustrated London News*, 1 October 1864. [12] *Manchester Guardian*, 7 June 1864. [13] *Ibid.*, 6 May 1919. [14] *Builder*, 7 November 1896, p.373. [15] *Salford City Reporter*, 28 March 1958; *Manchester Evening News*, 25 and 29 May 1996; information from Francis Law. [16] *Manchester Guardian*, 12 April 1957. [17] *Ibid.* [18] *Ibid.*, 13 May 1957. [19] *Guardian*, 4 May 1960; *Manchester Evening News*, 15 July 1960. [20] Photographs in the *Guardian*, 1 February 1961, 29 June 1961. [21] Information from Howard Coutts, Bowes Museum. [22] *Manchester Evening News*, 10 September 1963. [23] Information from proprietor of Millcroft Tea Gardens, Roods Lane, Norden, Rochdale. [24] Photograph of the courts on Southall Street, *Manchester Guardian*, 4 September 1957; *Salford City Reporter*, 28 March 1958. [25] The librarian, Francis Law, who has publicised the existence of the statuary, is concerned about the present condition of the sculptures displayed in the 'museum' beneath the main staircase.

Exchange Square
Tilted Windmills
John Hyatt

15 November 1999
Stainless steel
10m high; windmill blades 2m wide
Status: not listed
Condition: good
Owned by: Manchester City Council

Description: Five windmills resembling children's windmills on tall circular stainless steel poles that are tilted. Each of the windmill blades is double sided and perforated.

The creation of a large public space located between the Corn Exchange and a retail store was one element in the redevelopment of Manchester city centre following the IRA bomb of June 1996. The renowned American landscape design firm, Martha Schwartz Inc., won the international competition for designing the new public space. The topography of the site resulted in a space on two levels connected by stairs and ramps. Thematically the design linked the modern and the old town. The upper level included the idea of a beach with palm trees whilst the lower level contained historical references, notably the creation of an artificial waterway that echoed the ancient river associated with the Hanging Ditch. The idea of palm trees on the upper level proved a controversial one – in part because of concerns about their ability to survive in Manchester's climate – and these were replaced by public sculpture. Manchester Millennium organised a competition in which artists were required to produce a sculpture that echoed the palm trees in shape. The winner was the artist, John Hyatt, head of the Manchester Institute of Research and Innovation in Art and Design (MIRIAD) at Manchester Metropolitan University. Hyatt's design was for five ten-metre-tall steel windmills, placed in a straight line but tilted at ten degrees in different directions (calculated to

Hyatt, *Tilted Windmills*

required the collaboration of a number of specialist firms, most notably the consultant engineers, Ove Arup. Holmark Steel Fabrications was primarily responsible for the construction of the blades, quality managed by Watson Steel. The work was completed and officially switched on in November 1999. Hyatt was generous in acknowledging the different firms and individuals ('my Sancho Panza') who had contributed to making his 'mercurial artist's dream come true'.[2]

Notes
[1] Correspondence with John Hyatt. [2] *Manchester Evening News*, 16 November 1999; *MMyou*, February 2000, No.43.

Granby Row

University of Manchester Institute of Science and Technology (UMIST)

Technology Arch
Axel Wolkenhauer

24 November 1989
Steel rope
3m high; base 2.29m diameter
Inscription on base: TECHNOLOGY ARCH AXEL
 WOLKENHAUER MADE POSSIBLE BY NORTH
 WEST ARTS AND BRITISH ROPES LTD. 1989
Status: not listed
Condition: good
Owned by: University of Manchester Institute
 of Science and Technology
Description: Six steel ropes plaited together and arranged to form two arches. The rope is painted red and fixed to a circular black steel base.

In 1988 UMIST's Campus Appearance Committee, with the assistance of North West Arts, organised a national competition for an outdoor sculpture to be displayed on the university campus. The sculpture was to be related to science or technology.[1] Two possible sites were identified for the £5,000 sculpture.

Wolkenhauer, *Technology Arch*

balance visually from any viewpoint) in front of the glass-fronted entrance of a new retail store. The windmills were clearly reminiscent of those played with by children and might have been the crowning feature of seaside sandcastles. They also alluded to Don Quixote's windmills, illusive and illusory constructs that prompted questions about the nature of public sculpture and the public reception of it.[1] Each windmill was to be powered, allowing it to rotate. Realising the work necessitated solving a number of complex technical problems which

Out of the 37 entries, four were short-listed for further consideration. The winner was the German-born sculptor, Axel Wolkenhauer, whose previous sculptures had made use of industrial materials, including cables and chains. *Technology Arch* used thick steel rope to form a construction of two arches, the rope being mounted on the burnt-off end of a winding drum used in rope making. Due to the costs of realising the proposed design, Wolkenhauer approached British Ropes Ltd of Doncaster for sponsorship of materials and assistance with the construction. The work was made at British Ropes' Gateshead plant. The finished bright red sculpture was placed at ground level in the busy open space between the post-war extension to the original College of Technology and the railway viaduct. It was unveiled in November 1989.[2]

Notes
[1] *Artful Reporter*, April 1988, p.5. [2] Information
from Tony Pass; D. Brumhead and T. Wyke, *A Walk
Round Manchester Statues* (Manchester: Walkround
Books, 1990) p.54; *Artful Reporter*, February (1990)
No.25.

A Monument to Vimto

Kerry Morrison

9 July 1992
Oak
Bottle 3.66m high approx; base 5m diameter
Signed near bottom of bottle: KMM
Inscription on plaque next to sculpture: A
 MONUMENT TO VIMTO / by / Kerry Morrison
 / 1992 / Stained oak taken from a managed
 forest / John Noel Nichols mixed his first
 batch of Vimto at / 49 Granby Row in 1908.
 This sculpture on the site of the / building
 was commissioned at J. N. Nichols (Vimto)
 plc. – on bottle: INVIGORATING /VIMTO / THE
 / IDEAL BEVERAGE
Status: not listed
Condition: fair
Owned by: University of Manchester Institute
 of Science and Technology
 Description: Wooden sculpture of enormous
Vimto bottle surrounded by carved fruits
(raspberries, blackcurrants) and other
ingredients used in making the drink. The oak
sculpture stands on a circular stone tray.

This sculpture arose out of research undertaken
by Sue Nichols into the history of the well-
known soft drink, Vimto.[1] She discovered that
Noel Nichols, the wholesale druggist
responsible for making and marketing the
health tonic drink, had premises in Granby
Row, Manchester when the drink had been
invented; not, as had been generally assumed, in
Salford. The firm's original building, had,
however, not survived, the site having become
part of a lawned area on the UMIST campus.
The company responded enthusiastically to the
idea of a sculpture to mark the site where the

Morrison, *A Monument to Vimto*

first batch had been concocted. It was an idea
that UMIST, which had already begun
installing sculpture on its campus, also found
exciting. A competition was organised for a
£15,000 sculpture relating to Vimto, the work
to be placed on the site of the original premises.
The competition was limited to sculptors and
artists working in the North West. Six entries
were short-listed and the sculptors – Jon
Biddulph, Jon Cattan, Lorna Greene, Andrew
Holmes, Kerry Morrison and Richard
Thornton – were asked to produce a more
detailed model and drawings of their ideas.
These were exhibited at the Manchester City
Art Gallery where comments from the public
were invited. *Grip*, UMIST's student
newspaper, also sought reactions to the six
models.[2] In February 1992 Kerry Morrison's

entry – a sculpture depicting a Vimto bottle
surrounded by fruits and spices, ingredients in
the drink's secret recipe, on a platter – was
selected as the winner. The bottle and tray were
based on a 1930s advert. Not all the details of
Morrison's model were to be included in the
final sculpture. The work of sawing and carving
the oak wood was carried out at the company's
distribution premises in Haydock. The
sculpture was unveiled by the television actress,
Barbara Knox, better known as Rita Sullivan,
the owner of *Coronation Street*'s corner shop,
in July 1992. Since that date one of the berries
has been removed, presumably stolen, and some
wood rot has become evident on the front of
the bottle.

Notes
[1] S. Nichols, *Vimto. The Story of a Soft Drink*
(Preston: Carnegie Press, 1994) pp.143–7. [2] *Grip*,
January 1992; information from Professor
Christopher Rose-Innes.

Railway viaduct, Altrincham Terrace

Archimedes
Thompson W. Dagnall

Unveiled September 1990
Sandstone
Figure 92cm high approx; pedestal 1.3m high ×
 1.25m long
Inscription on pedestal: Archimedes / by /
 Thompson W Dagnall
Status: not listed
Condition: fair
Owned by: University of Manchester Institute
 of Science and Technology
Description: Sandstone sculpture depicting a
naked and bald-headed Archimedes sitting in
his bath at the moment of discovering his
famous principle. His hands are shown gripping

Dagnall, *Archimedes*

the sides of the bath, his face excited. The
elliptically shaped pedestal suggests the bath.
The sculpture surmounts a hexagonal stone
base. It is located beneath an arch of the railway
viaduct.

Thompson Dagnall had been one of the
sculptors short-listed in the competition
organised by UMIST in 1988 that had been
won by Axel Wolkenhauer. Dagnall's sculpture
was a representation of the legendary story of
Archimedes discovering the laws of buoyancy.
The Campus Appearance Committee was
impressed by the concept and, having found
additional money, decided to commission the
work. Dagnall carved the sculpture from a
block of red sandstone. The pedestal was also
sandstone but was deliberately left rough, the
chisel marks clearly evident. It was decided to
locate the sculpture beneath one of the arches of
the railway viaduct that bisects the campus. It
was installed and unveiled in September 1990.
Archimedes has proved a popular sculpture,
though some damage was caused by over-
enthusiastic students climbing on it. This has
been repaired, and railings have been installed
to protect the sculpture. In addition to this
work Dagnall was responsible for a wooden
sculpture, *Luca Pacioli*, located in the Weston
Building, Sackville Street. It was unveiled in
1994 to mark the 500th anniversary of Pacioli's
treatise on the principles of double-entry book-
keeping.[1]

Note
[1] Information provided by Professor Christopher
Rose-Innes and Thompson Dagnall.

Altrincham Terrace

The Generation of Possibilities
Paul Lewthwaite

November 1999
Steel plate and bar
2.27m high × 4.6m long × 1.87m wide
Inscription on plaque fixed to railway viaduct:
 Paul Frank LEWTHWAITE / "THE GENERATION
 / OF POSSIBILITIES" / Winner of the national
 / competition for a / sculpture to mark the /
 175th anniversary of UMIST / 1999
Status: not listed
Condition: good
Owned by: University of Manchester Institute
 of Science and Technology
Description: Two red magnets mounted on
steel blocks, painted black, at an incline facing
each other and rotated at 90 degrees. The
magnets have a coiled bar wrapped around each
arched end.

The sculpture was commissioned by UMIST's
Campus Appearance Committee to mark the
institution's 175th anniversary. A competition
was arranged for a sculpture on the broad
theme of science, technology and innovation
relating to Manchester. It attracted 52 entries,
including some from abroad. Three artists were
short-listed and asked to provide maquettes of
their designs. The judges selected Paul
Lewthwaite's sculpture which was inspired by
the electromagnetic experiments of the
Lancashire-born scientist, William Sturgeon
(1783–1850), research that led to industrial
applications in the form of the dynamo and
electric motor. Sturgeon had spent part of his
later life as a member of Manchester's scientific
community, earning a living by lecturing and as
superintendent of the short-lived Royal
Victoria Gallery for the Encouragement and
Illustration of Practical Science.[1]
 Lewthwaite regarded the work as 'a symbol
of the scientific breakthrough, the potential of
exploration and the pursuit of possibilities'.[2] It

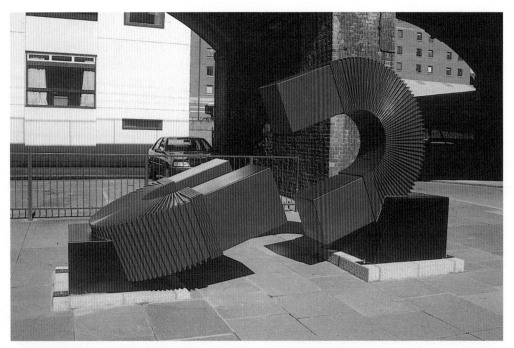

Lewthwaite, *The Generation of Possibilities*

was made in the sculptor's Nottingham studio and installed in July 1999 on the terrace in front of the Victorian railway viaduct. The official unveiling took place in November. The total cost of the whole project was £12,500, of which the sculptor received £9,500.

Notes
[1] R. Angus Smith, *A Centenary of Science in Manchester* (London: Taylor and Francis, 1883) pp.266–87. [2] Correspondence with Paul Lewthwaite, 30 September 1999.

Renold Building

UMIST Cube
Christopher Rose-Innes

1991
1m square
Polished steel sheet

Status: not listed
Inscription: DESIGNED BY / CHRISTOPHER ROSE-INNES / FABRICATED BY STOCKPORT SHEET METAL / 1991
Condition: fair
Owned by: University of Manchester Institute of Science and Technology
Description: Polished metal cube mounted on short stone plinth. On each of the five visible sides is one of the capital letters which spell the institution's acronym, UMIST.

This stainless steel cube was a design realised when Christopher Rose-Innes was studying sculpture at Manchester Metropolitan University. It was originally positioned outside the Weston Building, Sackville Street where it remained until 1999 when building work caused its removal to its present position outside the Renold Building. Another sculpture by Rose-Innes, entitled *Sunbird*, is located in the Grosvenor Place Halls of Residence.[1]

Note
[1] Information provided by Professor Christopher Rose-Innes.

Combustion
Marshall Hall

1994
1.83m high; pedestal 96cm × 1.17m square
Inscription on pedestal: MARSHALL HALL / 'COMBUSTION' / 1994
Status: not listed
Condition: good
Owned by: University of Manchester Institute of Science and Technology
Description: Steel sculpture representing flames rising and twisting in the air, painted orange, surmounting a tapering white concrete pedestal

Combustion was commissioned from Marshall Hall by the Campus Appearance Committee. Hall was a sculpture student at Manchester Metropolitan University at the time. The work represented the explosive power of fire. It was placed on a small lawn outside the Renold Building.

Lawn in front of Ferranti Building

Insulator Family
Arranged by Tony Pass and Christopher Rose-Innes

June 1987
2.29m high; 3.05m high; 4.06m high
Inscription on plaque: Insulator Family / High-voltage insulators / Donated by / Allied Insulators Ltd / Stoke 1987
Status: not listed
Condition: fair
Owned by: University of Manchester Institute of Science and Technology
Description: Three ceramic high-voltage insulators arranged as a group on a lawn. They

are of different heights and arranged to represent a family of two adults and a child. The tapering bodies end in the tops of the insulators which are coated with a fine grit suggesting faces.

The offer to the university of a single high-voltage insulator from Allied Insulators of Stoke-on-Trent was the impetus behind this work. Tony Pass and Christopher Rose-Innes, members of the Campus Appearance Committee, recognised the potential of the gift and persuaded the firm to donate an additional two insulators. These were then arranged by Pass and Rose-Innes to create an industrial sculpture, representing the family, on the lawn in front of the Ferranti Building, home to the Department of Electrical Engineering and Electronics, and the Mathematics and Social Sciences Building. The work was well received and encouraged the commissioning of other open-air public sculptures on the campus.[1]

Note
[1] *Artful Reporter*, April 1988, p.5; information from Tony Pass.

George Begg Building, Sackville Street

The Final Splash
Liam Curtin

1997
Galvanised steel
2.6m high × 3m × 3m × 3m
Inscription: "The Final Splash" / by Liam
 Curtin
Status: not listed
Condition: fair
Owned by: University of Manchester Institute
 of Science and Technology
 Description: Fountain; located on the roof garden, the fountain is formed out of galvanised steel buckets arranged in the shape of a pyramid, the water flowing through the buckets into a triangular metal tray.

Curtin, *The Final Splash*

The Final Splash, a modern fountain constructed out of ordinary domestic galvanised steel buckets, was based on the work of Liam Curtin. The buckets formed a pyramid, ten buckets high and nine buckets wide at the base, standing inside a triangular tray. The buckets had their handles removed and holes were made in them to allow the water to flow out and down, eventually reaching the tray. Curtin had originally constructed and displayed a fountain six tiers high in what was to become the city's Northern Quarter. His purpose was to stimulate a debate about public art in the city. He was then asked to create an even taller temporary fountain – 12 tiers of buckets – outside Manchester City Art Gallery. This exhibit was seen by members of UMIST's Campus Appearance Committee who approached Curtin with a view to reassembling the work on the university campus. It was an initiative that reflected UMIST's catholic approach to public sculpture. The work also appealed to scientists because it illustrated the ideas of the seventeenth-century Italian scientist, Evangelista Torricelli, on air pressure and the movement of water. Curtin was not directly involved in reassembling the work, though he provided his drawings and advice.

The fountain was reduced to ten tiers when it was installed on the roof garden of the George Begg Building.[1]

Note
[1] Information from Liam Curtin and Professor Christopher Rose-Innes.

Grosvenor Street

Manchester Adult Deaf Institute (former)

Christ restoring the Hearing and Speech of the Deaf Man
Architect: John Lowe
Sculptor: unidentified

8 June 1878
Marble
1.83m high approx
Inscription on plinth: EPHPHATHA
Status: Grade II
Condition: poor
 Description: Life-size statue of Christ who is shown as a standing figure, his fingers touching the lips of a man kneeling in front of him. The sculpture is positioned in a niche on the first storey, above the central doorway.

As with many Victorian charities the Manchester Adult Deaf and Dumb Institute operated from rented premises before being able to afford its own purpose-built accommodation. It was in 1878 that the charity finally occupied its own building in Grosvenor Street, about 1½ kilometres from the city centre. It was designed by the Manchester architect, John Lowe, the cost of the building totalling £5,800. The charity was willing to include a surprising amount of architectural and sculptural decoration. In particular, Lowe introduced a religious sculpture depicting Christ restoring the hearing of an unnamed deaf man. The command inscribed on the plinth, 'Ephphatha', meaning 'be opened', was spoken by Christ whilst performing the miracle. At the

Christ Restoring the Hearing and Speech of the Deaf Man

top of the arched entrance the badge of the deaf, a raised hand on a book with a Latin motto, is displayed. The sculptor of the statue and the other decorative embellishments, including an impressive lettered frieze, has not been identified.[1] The Institute moved to new premises in 1975, since which date the façade of the building has been allowed to deteriorate.[2]

Notes
[1] *Manchester Courier*, 10 June 1878. [2] D. Brumhead and T. Wyke, *A Walk Round All Saints* (Manchester: Manchester Polytechnic [1986]) p.32.

Bonehill, *Manchester Wholesale Fish Market* (panel)

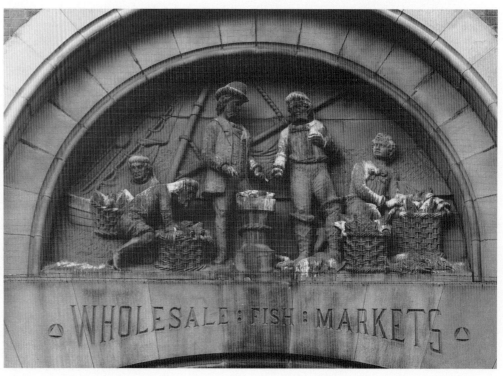

High Street and Salmon Street

Manchester Wholesale Fish Market
Architect: Speakman, Son and Hickson
Architectural sculptor: Joseph Bonehill

14 February 1873
Stone
1.52m high approx × 3.05m wide approx
Status: Grade II
Condition: fair
Owned by: Manchester City Council
 Description: Six semicircular stone panels above arched entrances on the façades fronting High Street and Salmon Street.
High Street (left to right): First panel (above inscription: WHOLESALE: FISH: MARKETS) is a tableau of five figures, four fishermen and a

merchant who is shown purchasing fish. Second panel (above inscription: WHOLESALE: FISH: MARKETS) is a tableau of four fisherman at sea hauling in their nets. Third panel (above inscription: WHOLESALE: FISH: MARKETS) is a tableau of fishermen preparing to go to sea; a mother and child say goodbye to a young boy. Fourth panel (above inscription: OPENED: 14: FEB: 1873: BOOTH: MAYOR) is a tableau of three fishermen unloading their catch after a fishing voyage; on the left are two kneeling female figures sorting a basket of fish.
Salmon Street: first panel is a repeat of the fishermen preparing to go to sea, on the High Street façade, but without the inscription. The second panel is a repeat of the fishermen unloading their catch, on the High Street façade, but without the inscription.

Manchester Corporation decided in the early 1870s to replace the city's main fish market in Strangeways with a new one located near Shudehill, close to the city's other main markets. It was a decision not welcomed by all parts of the fish trade.[1] Designed by the local architects, Speakman, Son and Hickson, the wholesale market incorporated the latest features, including large cellars and ice stores.[2] A small part of the building's £42,000 cost was spent on architectural sculpture in the form of carved stone panels depicting scenes from the working life of fishermen. Six panels were placed above the arched entrances, four on the principal façade on (Upper) High Street and two on Salmon Street. They were the work of Joseph Bonehill of Manchester.[3] The new wholesale fish market was opened by the Mayor, William Booth, on St Valentine's Day, 1873.[4] The wholesale market was later extended by Mangnall and Littlewood.[5] It remained an important part of Manchester's central market system until the 1970s when plans were announced for a new market in Openshaw. There was some concern

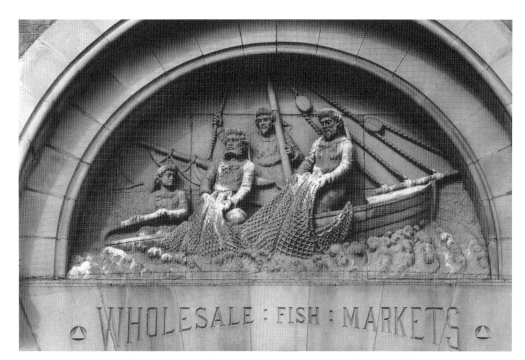

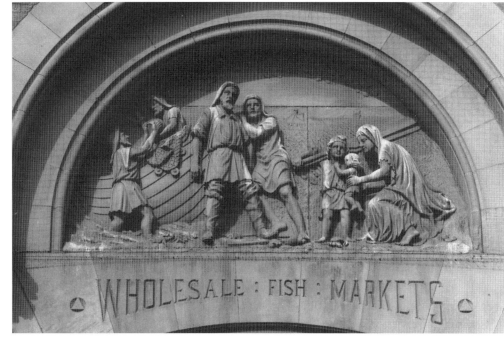

Bonehill, *Manchester Wholesale Fish Market* (panels)

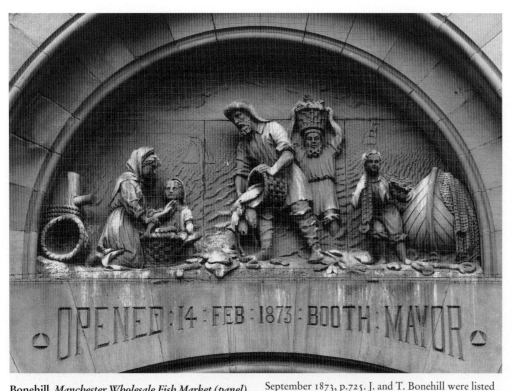

Bonehill, *Manchester Wholesale Fish Market (panel)*

over the fate of the panels, though the idea that they might be re-erected in the new fish market was not realised.[6] In 1977 the building was finally closed and in the following years the roof and some of the walls were taken down. In 1987 the fish market was included in the newly-created Smithfield Conservation Area. The roofless building was used as a garden centre for some years. Plans announced in 2000 for this part of the city's Northern Quarter envisaged a refurbished market building including its 'stone artwork'.[7] Apartments have been constructed inside the shell of the building and Bonehill's panels cleaned.

Notes
[1] *Free Lance*, 11 February 1871, pp.46–7.
[2] *Builder*, 4 November 1873, p.786. [3] *Ibid.*, 13

September 1873, p.725. J. and T. Bonehill were listed as sculptors in marble, stone and wood, chimney-pieces and monuments, Victoria Place, Brook Street in *Slater's Manchester and Salford Directory* (1874). [4] *Manchester Courier*, 15 February 1873; *Manchester Guardian*, 15 February 1873. [5] *British Architect and Northern Engineer*, 7 December 1877, p.281. [6] *Manchester Evening News*, 18 August 1971. [7] *Ibid.*, 28 September 2000.

King Street

Reform Club

Architect: Edward Salomons

Architectural sculptors: T.R. and E. Williams

19 October 1871
Status: Grade II*
Condition: fair
Owned by: Bruntnap

Description: Two sets of three rectangular carved panels, with figures representing trades and industries, set above corner turrets. Corner of King Street and Brown Street (left to right): *Railways*: female figure standing in front of railway viaduct, hands resting on large hammer and wheel; *Cartography*: female figure standing, hand resting on globe; *Building*: female figure standing in front of building, holding trowel and left hand resting on building plans. Corner of King Street and Spring Gardens (left to right): *Agriculture*: female figure standing in front of tree and agricultural implements, sowing seed from basket held in left hand; *The Arts*: female figure standing with left hand holding a wreath and right hand resting on lyre; books and artist's easel and palette at feet; *Weaving*: female figure standing in front of loom, a shuttle in left hand.

One measure of the strength of Liberalism in mid-Victorian Manchester was the building of the Reform Club. The site had been acquired in 1869, near to the club's existing rented premises in a converted warehouse in Spring Gardens. The club's new building was designed by Edward Salomons of the Manchester-based firm of architects, Salomons and Jones, in the Venetian Gothic style.[1] The end result was widely praised though the *Builder* offered a qualified welcome when the club opened in 1871, judging that there was 'a want of refinement and consistency in the treatment of the detail'.[2] Whether this criticism included the two sets of relief panels placed above the first-storey corner windows is unclear. Exactly how the subjects represented on these panels were decided upon is also unclear, avoiding as they do more obvious political and economic references. Indeed, some of the subjects referred to in the panels – cartography, for example – might be considered to have little direct relevance to either Liberalism or Manchester. The architectural sculptors, T.R. and E. Williams, were responsible for carving the panels.[3]

Such reticence was not evident in the interior

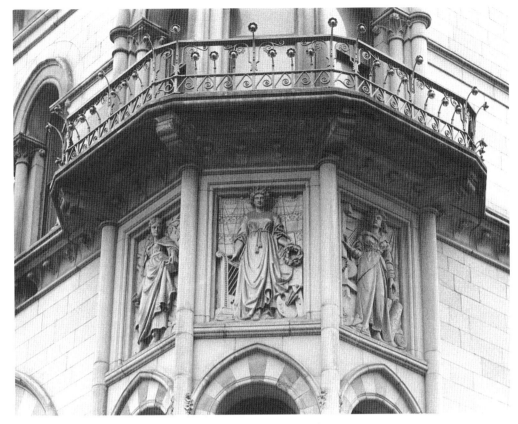

T.R. and E. Williams, *Reform Club, panels representing Agriculture, Art, Weaving*

where a gallery of portraits and busts of Liberal leaders was displayed. A bronze tablet honouring Henry Hunt, the work of John Cassidy, was also installed.[4] The years after the First World War ushered in a period of long decline for the Liberals and the club. Closure was averted in 1967 when it merged with the Engineers' Club to form the Manchester Club. Membership continued to fall and the new club closed in 1987. The building was sold and converted into offices, shops and a restaurant. A life-size statue of Gladstone stands in the latter; this is, however, not the memorial that was displayed in the original club but a more recent plaster copy.

Notes
[1] *Sphinx*, 29 May 1869, p.77. [2] *Builder*, 28 October 1871, p.838. [3] *Manchester Faces and Places*, vol.2 (1892) p.84. [4] See below, p.157. Inventory of the Manchester Reform Club, April 1910 (Manchester Reform Club Archives, MRC 4/1, John Rylands University Library). The collection included two marble busts each of Richard Cobden (Neville Burnard, Edgar Papworth) and John Bright (Matthew Noble and an unidentified sculptor).

Earp, Hobbs and Miller, *Lloyds Bank, Commerce (detail)*

Junction of King Street and Cross Street

Lloyds Bank
Architect: Charles Heathcote
Architectural sculptors: Earp, Hobbs and Miller

1915
Portland stone
2.74m high approx
Status: Grade II
Condition: fair
Owned by: Lloyds Bank Ltd
 Description: Two symbolic groups.
King Street and Cross Street junction: larger than life figure of Britannia who is shown standing on a boat, holding laurel wreath in right hand, flanked by kneeling male figure representing Britain, and the standing figure of a young boy representing the Colonies.
King Street and Cheapside junction: standing

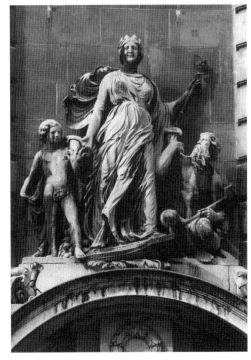

larger than life female figure representing Commerce standing on a boat, flanked by kneeling figure of Neptune and young boy carrying fleece.

Lloyds Bank was built on the site of Manchester's first town hall in Upper King Street. Francis Goodwin's building was demolished in 1912, though not without opposition, the opponents managing to rescue and re-erect the main façade in Heaton Park.[1] The architect of the new bank was Charles Heathcote (1851–1938) who had already completed a number of prestigious financial office buildings in this part of Manchester, including the Lancashire and Yorkshire Bank, King Street, Eagle Insurance Offices, Cross Street and King Street, and Parr's Bank, Spring Gardens. Heathcote chose the Baroque style for the new bank with the main sides faced in Portland stone.[2] In its detail it was an Edwardian extravaganza. Of particular note were the two sculptural compositions introduced on the King Street corners of the building. These were the work of Manchester's principal architectural sculptors, Earp, Hobbs and Miller. The group at the junction of Cross Street and King Street represented the triumphant figure of Britannia flanked by two figures symbolising Britain and the Colonies. The kneeling muscular figure represented Britain and Enterprise in the form of Labour whilst the smaller figure, on her right, 'hints at those younger men of the British race – the Colonies'.[3] This figure was holding in his hands the products of labour, including a sheaf of wheat. The companion group above the entrance on the King Street and Cheapside corner represented international trade. It was dominated by the figure of Commerce, a confident female holding a rod. She was flanked by two figures: on her left a kneeling Neptune holding a trident, and, on her right, the figure of a young boy carrying a fleece. The bank opened for business in 1915.

Notes
[1] See below, p.148. [2] *Manchester Courier*, 8 July 1914.
[3] *Manchester City News*, 6 September 1913.

Ship Canal House
Architect: Harry S. Fairhurst
Architectural sculptors: Earp, Hobbs and Miller

1927
Portland stone
3.04m high approx
Status: Grade II
Condition: fair

Description: Colossal sculptural group above parapet dominated by figure representing Neptune holding a trident in outstretched right arm, flanked by two sea-horses.

The ten-storey Ship Canal House was built as the headquarters of the Manchester Ship Canal Company. It was designed by Harry S. Fairhurst, whose commercial buildings had made him one of the city's best known and most admired architects. Constructed between 1924 and 1927, it was at the time one of the tallest buildings in the country, though the much-discussed height of this 'sky-scraper' was somewhat deceptive as the final three storeys were set back.[1] The King Street façade was suitably impressive, rising from a rusticated base and ending on the sixth and seventh storeys with a colonnade of Corinthian columns. Above this was a cornice and parapet surmounted by a sculptural group symbolic of the sea. The Manchester firm of Earp, Hobbs and Miller carried out the work, which a contemporary journal described as 'one of the finest groups of sculpture to be seen in Manchester'.[2] The group was designed by H.R. Bond, and carved by Bond and Arthur Hall. The Neptune was repaired in 1961 after the discovery of cracks in the statuary.[3] Following the removal of the Ship Canal Company to premises nearer to the Manchester

docks, the building was modernised but the sculptural group remained.[4] In the reception area there is a bronze portrait medallion of Daniel Adamson, by William McMillan, one of the key figures behind the promotion of the canal. It was presented in 1935.[5]

Notes
[1] *Manchester Guardian*, 25 September 1926; *Manchester City News*, 26 February 1927.
[2] *Manchester Guardian*, 25 September 1926.
[3] *Manchester Evening News*, 15 November 1961.
[4] *Ibid.*, 9 March 1983. [5] *Manchester Guardian*, 14 December 1935; *A Memorial to Daniel Adamson, Leader of the Manchester Ship Canal Movement* [Manchester, 1935].

Lincoln Square
Abraham Lincoln
George Grey Barnard

15 September 1919; November 1986
Bronze statue; granite pedestal
Statue 4.06m high; pedestal 2.13m high
Inscription on pedestal, front: ABRAHAM LINCOLN / 1809–1865 / This statue commemorates the support that the / working people of Manchester gave in the fight for / the abolition of slavery during the American Civil War. / By supporting the union under President Lincoln / at a time when there was an economic blockade / of the southern states the Lancashire cotton workers / were denied access to raw cotton which caused / considerable unemployment throughout the cotton industry. / Extracts of President Lincoln's letter to / the working people of Manchester thanking them / for their help are reproduced around this plinth. / This statue was unveiled by Arthur Mitchell, / Director of the Dance Theatre of Harlem, / on 13th November 1986 / at the dedication of Lincoln Square. / Estates Director MEPC plc / J. L. Tuckey / Chair of the Planning Committee / Councillor Arnold Spencer / Sponsored by MEPC plc of Manchester – left-hand side: Lancashire

Cotton Famine 1861–1865 / Free Trade Hall public meeting 31 December 1862 / Chairman Abel Heywood / Extract of an address from the working people of Manchester to His Excellency / Abraham Lincoln / President of the United States of America. / ……. the vast progress which you have made in the short space of twenty months / fills us all with hope that every stain on your freedom will shortly be removed, and / that the erasure of that foul blot on Civilisation and Christianity – chattel / slavery – during your Presidency will cause the name of Abraham Lincoln to be / honoured and revered by posterity. We are certain that such a glorious / consummation will cement Great Britain and the United States in close / and enduring regards……. – right-hand side: Abraham Lincoln / Born 12th February 1809 / Assassinated 15th April 1865 / President of the U.S.A. / 1861–65 / American Civil War 15th April 1861 to 9th April 1865 / Extract of a letter / To the working people of Manchester 19th January 1863 / I know and deeply deplore the sufferings which the working people of Manchester / and in all Europe are called to endure in this crisis. It has been often and studiously / represented that the attempt to overthrow this Government which was built on the / foundation of human rights, and to substitute for it one which should rest exclusively / on the basis of slavery, was likely to obtain the favour of Europe. / Through the action of disloyal citizens the working people of Europe / have been subjected to a severe trial for the purpose of forcing their sanction / to that attempt. Under these circumstances I cannot but regard your decisive / utterances upon the question as an instance of sublime Christian heroism which has / not been surpassed in any age or in any country. It is indeed an energetic / and re-inspiring assurance of the inherent truth and of the ultimate and universal / triumph of justice, humanity and freedom … I hail this interchange of sentiments / therefore, as an augury that whatever else may happen, whatever misfortune / may befall your country or my own, the peace and friendship which now exists / between the two nations will be as it shall be my desire to make them, perpetual. / Abraham Lincoln – rear: This statue is the work of Sculptor George Grey Barnard and was presented to / the City of Manchester by Mr. and Mrs. Charles Phelps Taft of Cincinnati, Ohio.

Original inscription on bronze plaque (later removed): THIS MONUMENT OF / ABRAHAM LINCOLN. / THE WORK OF GEORGE GREY BARNARD / WAS, THROUGH THE FRIENDLY OFFICES OF / THE SULGRAVE INSTITUTION AND / THE ANGLO-AMERICAN SOCIETY, / GIVEN TO THE CITY OF MANCHESTER / BY MR & MRS CHARLES PHELPS TAFT, / OF CINCINNATI, OHIO, U.S.A, / IN COMMEMORATION OF LANCASHIRE'S / FRIENDSHIP TO THE CAUSE FOR WHICH / LINCOLN LIVED AND DIED, AND OF THE / CENTURY OF PEACE AMONG ENGLISH- / SPEAKING PEOPLES. 1919.

Status: Grade II
Condition: good
Owned by: Manchester City Council

Description: Portrait statue; a larger than life-size bronze statue surmounting a tall polished marble pedestal. Lincoln is shown standing, wearing a long frock-coat, with his hands crossed. The pedestal has lengthy inscriptions on three sides.

The origin of George Grey Barnard's bronze statue of Abraham Lincoln was a scheme to raise a memorial to Lincoln in Cincinnati, Ohio, to mark the centenary of his birth. The outcome of a lengthy commissioning process, which revealed the jealousies and resentments between the city's rich merchant families, was that Mr and Mrs C.P. Taft gave a $100,000 commission to the American sculptor, George Grey Barnard, to produce a statue of Lincoln. Charles Phelps Taft was one of Cincinnati's wealthiest businessmen and the half-brother of William Howard Taft, president of the United States from 1909 to 1913. He and his wife Anna were also important collectors of art. By 1910 Barnard, who had trained in Chicago and Paris and had completed a number of important private and public commissions, was recognised as one of the key figures of a new generation of American sculptors. His reputation was soon to be further enhanced by the completion of the sculptural groups on the Pennsylvania State Capitol, Harrisburg.[1] Barnard embarked on a lengthy period of research, determined to produce a work that challenged what he regarded as the staid and conventional portrait statues of Lincoln. His work was to be a Lincoln of the People, the man before he became president. His model for Lincoln's body was a former farmer whom he found through an advertisement placed in a Louisville newspaper. The statue was not completed until 1916 and, having been exhibited in New York, it was sent to Cincinnati where it was unveiled by W.H. Taft in March 1917.[2]

Around the same time it was announced that Charles Taft had agreed to pay for a replica of Barnard's *Lincoln*, which was to be sent to London to stand outside the Houses of Parliament. The genesis of this project also lay in the years before the First World War. Peace centenary committees were established in the United States and Britain to identify ways of commemorating the century-long peace between the two nations which had followed the signing of the Treaty of Ghent in 1814. Discussions between the American and British committees led to the decision to mark the occasion with an exchange of statues.[3] The Americans eventually decided on presenting a copy of Augustus Saint-Gaudens's *Lincoln*, one of the most admired statues of the president. A site in Parliament Square between Westminster Abbey and the Houses of Parliament was agreed upon.[4] However, plans to send the statue

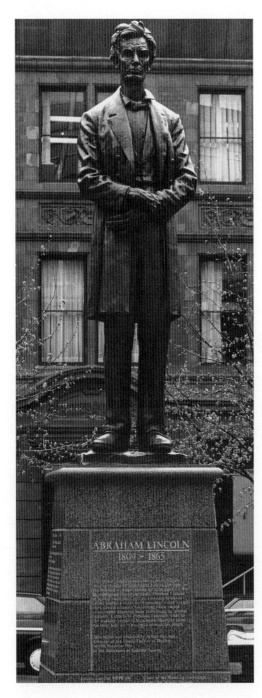

Barnard, *Abraham Lincoln*

to London were interrupted by the outbreak of the First World War. When the scheme was revived early in 1917, it had undergone a significant change, in that Saint-Gaudens's *Lincoln* had been replaced with a copy of Barnard's *Lincoln*. To what extent the American Peace Committee's co-founder and chairman, John A. Stewart, consulted other committee members in making this decision was to become an important issue in the public controversy that followed. It was a controversy that had diplomatic as well as aesthetic dimensions. But at the heart of the public misgivings and criticisms was Barnard's depiction of the physical appearance of Lincoln – the lugubrious expression, the stooped shoulders, the shabby clothes, the gigantic hands and feet – a representation that was condemned as grotesque and defamatory. Robert Lincoln, the son of the dead president, was a prominent voice in a chorus of American objectors.[5] The arguments over Barnard's statue in the United States reverberated in Britain where by September 1917 *The Times* was alerting its readers to the possibility that a 'thoroughly unworthy statue' might be placed outside parliament. Consideration also had to be given to relations with Britain's ally: 'It is exactly the kind of careless trifle which might easily cause bad blood between two peoples with less complete unanimity and less reverence for each other's great men.'[6] What was required was a statesman-like representation of Lincoln rather than a caricature depicting an awkward, shambling figure with big feet.[7] Considerable political and diplomatic manoeuvring followed, before it was agreed to return to the original scheme and present Britain with Saint-Gaudens's *Lincoln*. In fact, this decision was only reached as the war was ending, and, as a copy needed to be made, it was not until July 1920 that Saint-Gaudens's *Lincoln* was finally unveiled in Parliament Square.[8]

This left open the question of what was to happen to the second Barnard *Lincoln* which had been cast in the autumn of 1917, in the expectation that it would soon be standing outside the Houses of Parliament as a permanent symbol of Anglo-American friendship. The Sulgrave Institution of Great Britain and the United States and the Anglo-American Committee, the successor to the American Peace Centenary Committee, made it known that Taft still wished for the statue to go to Britain. Barnard's *Lincoln* was to be offered to a provincial city.[9] The possibility of Manchester acquiring the statue was raised in an editorial in the *Manchester Guardian* in late November 1918. The newspaper's readers were alerted to the opportunity, and warned that if Manchester did not act then the statue would go to another town, possibly to Liverpool.[10] Manchester took action. Members of the Art Gallery Committee were prominent in advancing Manchester's claims to the statue, basing the city's case on its 'long standing and friendly commercial relations with America; its honourable record, second to no other city, in the fight for freedom in the European War; and its leading position in the world of art outside London'.[11] Manchester's formal request for the Barnard *Lincoln* followed shortly after Woodrow Wilson's visit to the city, an occasion on which the American president was made an honorary freeman. Manchester's request was successful.[12] Barnard's *Lincoln* arrived in the city in early April 1919 and was stored in the fire station, Whitworth Street, before being formally handed over in the following month.[13] The *Manchester Guardian,* which had reproduced a photograph of the statue some months before, predicted that it would provoke argument as it had done in America, 'where it has sifted out the sighted from the blind art critics more successfully than any masterpiece of recent years'.[14] But Mancunians appeared to show little concern about the 'tramp with the colic'; a critical letter from the Massachusetts sculptor, Alex Doyle, apparently failing to

ignite a correspondence.[15] Exactly where in the city the statue was to be sited remained undecided, though there was some support for placing it in Piccadilly, in front of the art gallery that the city council was considering building there.[16] The final decision, however, was left to the Sulgrave Institution and the Anglo-American Committee. Following a visit by members of these societies, including John A. Stewart, it was decided to place the statue in Platt Fields, a park in Rusholme acquired by the council before the war. This location was in the inner suburbs rather than the city centre, although it was understood that the statue might be removed to Piccadilly at a later date, assuming that it harmonised with the proposed art gallery.[17] When Stewart was asked why the Barnard *Lincoln* had been given to Manchester, his justification was no longer couched in terms of the generally harmonious relationship between the city and the United States. Instead, he referred directly to the events of the American Civil War:

> The sentiment of London was quite against the Northern States, but Lincoln found in John Bright and Cobden and in all the men of great affairs in Manchester warm friends and sympathizers. It is owing not a little to the way in which the English cotton spinners stood by us which enabled us to preserve the Union and bring the war to a successful conclusion. For that reason we are very grateful.[18]

In August the statue was installed in Platt Fields on a low granite plinth similar to the one in Cincinnati. The second Barnard *Lincoln* was unveiled in a ceremony attended by Judge Alton Parker, president of the Sulgrave Institution, and J.W. Davies, the United States' ambassador.[19] In handing over the statue Judge Parker acknowledged the appropriateness of Manchester as a location, in view of the special relationship forged during the Civil War. The crowd cheered at the mention of the names of Cobden and Bright, and Parker's declaration

that 'Lincoln in Manchester stands at once for the high ideals of the American pioneer and of the Manchester spinner'.[20] An important consequence of recalling and memorialising this special Lancashire relationship was that the original purpose of the scheme – the celebration of the long peace between the two countries – was marginalised; a change of emphasis that was evident in the official inscription.

To what extent ordinary Mancunians concurred with the Lord Mayor when he spoke of 'this fine and beautiful statue' is uncertain. The *Manchester Guardian*'s critic was in no doubt that, whilst London was to receive Lincoln the president, Manchester had got Lincoln the man; a statue of power and dignity, whose face had that 'something fitted to touch the spirit of the children of future generations like the great stone face of another American imagining'.[21] The *Manchester City News* concurred, contrasting Barnard's representation of Lincoln with those 'fantastical sculptures which give us heroes in foolish postures, as they never were and never could be'.[22] When Epstein, who had defended Barnard's *Lincoln* in the press, saw the work during a visit to Manchester in 1939, he was even more convinced of its individuality and presence, and its obvious superiority over Saint-Gaudens's 'commonplace statue'.[23]

Barnard's *Lincoln* was never moved to Piccadilly but remained in Platt Fields until the mid-1980s when, at a time when the council was examining ways of encouraging public art in the city centre, it was decided to move the statue.[24] The chosen location was a new open space created around Queen Street, between Deansgate and Albert Square.[25] The property company, MEPC plc, which had been responsible for the redevelopment of the area, agreed to meet the costs of moving and re-erecting the statue in what was to be known as Lincoln Square. This proved an acceptable proposal. However, concerns over vandalism and security in the city centre appear to have led to the decision that the statue would be

placed on a tall polished granite pedestal rather than at ground level, as Barnard had intended. But it was not the size of the new pedestal – however inappropriate – that was to prove controversial when the statue was unveiled. The city council had decided not to reproduce the original inscription on the new pedestal, but to include extracts from documents by Abraham Lincoln and Abel Heywood in an attempt to explain in greater detail what the original plaque had referred to as the 'Lancashire friendship to the cause for which he lived and died'. It was the presentation of this extended history lesson about Lancashire's support for the Union in the Civil War that turned a public celebration into a public embarrassment. Following the unveiling of the statue by Arthur Mitchell of the Harlem Dance Theatre in November 1986, public attention was drawn to the inscription on the pedestal. The *Manchester Evening News*, not even bothering to publish a photograph of the statue or ceremony, revealed to its readers that the extracts inscribed on the pedestal had been altered in the name of political correctness: references to the working 'men' of Lancashire had been replaced by the working 'people' of Lancashire. These textual alterations were regarded by the newspaper as further evidence of an increasingly detached and arrogant council, riddled with left-wing groups in pursuit of the irrelevant.[26] When Dame Kathleen Ollerenshaw, a former Conservative Lord Mayor, was approached by the newspaper for a comment, she did not disappoint, being characteristically critical about a political party that was contemptuous of tradition: 'These people are re-writing history. History is history. You cannot violate history and change, for example, what Winston Churchill said. I've never heard such bloody nonsense.'[27]

Almost 70 years after its first public exhibition, Barnard's *Lincoln* continued to attract argument, even though it was now the wording on the pedestal rather than the statue itself that was responsible for the controversy. Alterations were not, however, made to the

disputed parts of the inscriptions. In 1991 the statue was cleaned and the bronze treated with a lacquer, returning the statue close to its original colour.[28]

Notes
[1] F.C. Moffatt, *Errant Bronzes. George Grey Barnard's Statues of Abraham Lincoln* (Newark: University of Delaware Press, 1998); *George Grey Barnard 1863 Centenary Exhibition 1963* (Pennsylvania State University Library, 1963).
[2] *Barnard's Lincoln. The gift of Mr and Mrs Charles P. Taft to the city of Cincinnati. The creation and dedication of George Grey Barnard's statue of Abraham Lincoln including the address of William Howard Taft* (Cincinnati: Stewart & Kidd Co., 1917).
[3] *The Times*, 24 May 1913. [4] *Ibid.*, 14 February 1914, 10 March 1914. [5] Moffatt, *op. cit.*, ch.8.
[6] *The Times*, 24 September 1917. [7] *Ibid.*, 25 September 1917, 29 September 1917. [8] *Ibid.*, 29 July 1920; *Spectator*, 7 August 1920 pp.167–9; F.B. Mead, *Heroic Statues in Bronze of Abraham Lincoln* (Fort Wayne, Ind: The Lincoln National Life Foundation, 1932). [9] Moffatt, *op. cit.*, p.172. [10] *Manchester Guardian*, 28 November 1918, 21 December 1918.
[11] *Manchester City Council. Report of Art Gallery Committee*, 1919–20, pp.486–7. [12] *Manchester Guardian*, 30 January 1919. [13] *Ibid.*, 3 April 1919, 6 May 1919. [14] *Ibid.*, 6 May 1919. [15] *Ibid.*, 28 January 1919. [16] *Ibid.*, 30 January 1919, 1 February 1919; *Manchester City News*, 4 January 1919.
[17] *The Times*, 6 May 1919. [18] *Ibid.* [19] *Ibid.*, 16 September 1919; www.BritishPathe.com 198.06 Abraham Lincoln statue unveiled, 18 September 1919. [20] *Manchester Guardian*, 16 September 1919. [21] *Ibid.* [22] *Manchester City News*, 20 September 1919. [23] J. Epstein, *Epstein An Autobiography* (London: Studio Vista, 1963) pp.221–2. [24] *Manchester Evening News*, 20 August 1983. [25] *Ibid.*, 21 September 1984. [26] *Ibid.*, 13 and 14 November 1986. [27] *Ibid.*, 13 November 1986. [28] *Ibid.*, 9 April 1991.

London Road

Fire Station and Police Station

Architects: Woodhouse, Willoughby and John Langham

Architectural sculptor: J.J. Millson

September 1906
Brown glazed terracotta

Status: Grade II*
Condition: fair
Owned by: Manchester City Council
 Description: London Road elevation: rectangular relief panels: *Fire*: panel of three semi-naked females standing against a background of fire; central figure holding torch and snake, figure on left holding a trident; broken pitcher at their feet. *Water*: panel of three female figures carrying and tipping pitchers of water, standing in front of trees; fish at their feet.
Tympanum: *Water*: seated female figure tipping out water from a pitcher with left hand, right hand resting on another pitcher. *Fire*: seated female figure holding torch, fire burning at her feet.
Corner groups on tower: seated female, left arm raised to shield the sun, looking out across the city, a young child and pitcher by her side; seated female holding pitcher in right hand, lion by her side; seated female with lion; seated female with young child by her side.
Whitworth Street elevation: spandrels: male and female figures, heads of horses in background;

male and female figures, sailing ships in background; male and female figures, horses in background; two female figures, one holding banner, the other holding a torch. Archways: *Day*: female figure wearing cloak on shoulders, a cockerel by her side; *Night*: female figure holding cloak over head, an owl by her side; *Justice*: female figure holding sword in right hand; *Truth*: female figure holding mirror in left hand; *Science*: female figure with a book on her knees; *Industry*: female figure holding hammer in right hand.

Woodhouse, Willoughby and Langham were the winners of the competition to design the new headquarters of the city's fire brigade. The building also included a police station and ambulance station. It occupied a large triangular-shaped site bounded by London Road, Whitworth Street and Fairfield Street, and was described by Cecil Stewart as an extravaganza in the Renaissance style.[1] Certainly, the terracotta sculptural decoration was unusually extensive for a municipal building, although the large equestrian group included in the competition

Millson, *Fire*

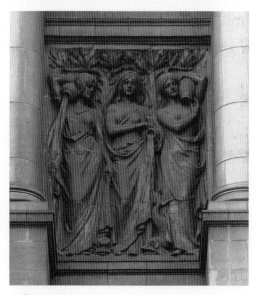

Millson, *Water*

drawings was not to be part of the final scheme.[2] The sculptural decoration was principally on the London Road façade, and comprised a scheme of allegorical figures representing fire and water. Free-standing female figures were also positioned around the towers, depicted protecting the city from fire. J.J. Millson was the artist responsible for the panels and the figures, the work being carried out by Burmantofts. A number of the female figures in the spandrels recall the work of John Broad and W.J. Neatby for Doulton. Neatby had provided the decorative terracotta for Woodhouse and Willoughby's Board School in Chapel Street, Salford.[3] In its scale and complexity this commission was comparable to the Art Gallery and Library in Bury which Millson had completed in the previous decade. The main part of the building was opened in September 1906.[4] The building has been awaiting redevelopment for a number of years, leaving the terracotta ornamentation and sculpture in need of cleaning and, in some places, restoration.

Notes

[1] C. Stewart, *The Stones of Manchester* (London: E. Arnold, 1956) p.152. [2] *Builder*, 30 November 1901, 7 December 1901. [3] P. Atterbury and L. Irvine, *The Doulton Story* (Stoke on Trent: Royal Doulton Tableware, 1979) pp.81, 85. [4] *Builder*, 7 December 1906, pp.412, 480, 512.

Journey
Partnership Art

1992
Bronze
4.2m high approx × 68cm × 10cm
Inscription on bronze disc inset in floor in front of sculpture: 'Journey' A public artwork dedicated to all who have passed through Piccadilly, Manchester. PATHS AND PACES. EXPRESSIONLESS FACES. FRAMED IN TIME. CONFUSED BY DIRECTIONS. SUBJECT TO REGULATIONS. EACH CHOOSE YOUR OWN LINE. BUT THERE'S NO PRESSING OBLIGATION.

OBSERVE YOUR INCLINATION. TOWARD WHATEVER DESTINATION. THIS IS YOUR PASSAGE THROUGH TIME.
Condition: good
Owned by: Manchester City Council
Description: Three long rectangular bronze panels set against a tall white concrete wall. Each panel comprises smaller panels on which are figures, faces, hand prints, boot prints and everyday objects, including tools, nuts and bolts and shells. To the front of the panels set into the floor is a raised bronze circular disc, illuminated, on which is the inscription.

The Central Manchester Development Corporation was responsible for promoting a small number of works of public art as part of its regeneration strategy in the centre of Manchester. One of its most ambitious works was *Journey* which was produced by Partnership Art. The site was on London Road, an open space between the road and a massive curved concrete wall, above which was the road leading into Manchester's main railway station, Piccadilly. Partnership Art worked with pupils from the nearby Shena Simon College to produce a design which was based on the theme of journeys. Using real objects and people the three bronze panels conveyed the busyness and confusion of people on the move. Each panel was made up of smaller rectangular panels. If not readily visible to the thousands who daily used the station, the panels were visible to those walking and driving along London Road. It was also illuminated. The names of those involved in designing and producing the work are identified on the illuminated wheel-shaped disc set into the ground to the front of the panels. Since its installation in 1992 the work has become almost completely hidden because of the ivy covering the wall. The extensive lighting system is also no longer operating.[1]

Note

[1] Undated newspaper cutting in Local Studies, Manchester Central Library and information from Partnership Art.

Partnership Art, *Journey (detail)*

Minshull Street

Manchester Crown Court

Architect: Thomas Worthington

Architectural sculptors: Earp and Hobbs

1873
Stone
Animals: 58cm × 35cm
Status: Grade II
Condition: fair
Owned by: Manchester City Council
 Description: Owls on elongated finials above gables on Bloom Street; grotesque animal figures flank the main entrances.

Manchester Crown Court (detail)

Thomas Worthington won the competition, restricted to Manchester architects, to design the city's Police and Sessions Court in 1867. The site between Minshull Street and Aytoun Street was bounded on one side by Bloom Street and on the other by the Rochdale Canal. The dominant feature of Worthington's restrained Gothic essay was the corner clock and bell tower. Worthington was sparing in his introduction of sculptural decoration. The most obvious were the grotesque animals placed either side of the four doorways, two in Minshull Street, two in Bloom Street. These were all different in their detail and were arranged in pairs, with the exception of those at the principal entrance on Minshull Street where Worthington included both a larger and a smaller creature on either side of the doorway. Less obvious are the gargoyles on the clock tower and chimney, and the solitary owls on the finials of the gables on Bloom Street. One commentator remarked of the latter that they were 'emblematic of the wisdom of the magistrates who will preside below'.[1] A proud lion stands on the gable end high above the principal entrance in Minshull Street. The detail may have been sparing, but the employment of Earp and Hobbs ensured that the carving was of a high quality.[2] In the 1990s the building was extended by James Stevenson, including a new entrance on Aytoun Street. It echoed Worthington's design but chose not to add an owl to the elongated finial above the new gable on the Bloom Street elevation.[3]

Notes
[1] A.J. Pass, *Thomas Worthington. Victorian Architecture and Social Purpose* (Manchester: Manchester Literary and Philosophical Society, 1988) p.62. [2] *Builder*, 8 June 1867, p.415, 15 June 1867, p.434, 28 December 1872, p.1029. [3] J. Stevenson, 'Crown Courts' in J. Parkinson-Bailey (ed.), *Sites of the City. Essays on Recent Buildings by their Architects* (Manchester: Manchester Metropolitan University, 1996); C. Hartwell, *Manchester* (London: Penguin, 2001) pp.172–3.

Mosley Street

Manchester City Art Gallery

Architect: Charles Barry

Architectural sculptor: John Henning the Younger

1837
Stone
91cm square approx
Signed: tablet depicting Mathematics: HENNING. JUN
Status: Grade II
Condition: good
Owned by: Manchester City Council
 Description: Relief panels of allegorical figures representing the arts and sciences on the upper part of the pavilion ends of the main façade of the art gallery, three panels on each end. From left to right: *Painting*: seated female figure drawing a young boy who is standing in front of her, a palette leaning against the stool; *Architecture*: seated female figure in front of a classical building, her right arm resting on a fluted column, the left hand on a rectangular slab of stone; *Sculpture*: seated female figure holding a hammer in her right hand, and a young boy with chisels in his right hand; in the background is a bust of a female figure; *Wisdom*: seated female figure holding a spear in her right hand, the shaft resting on a snake. Her left hand is resting on a shield decorated with an owl; *Mathematics*: seated female figure studying geometrical shapes marked on a board held by a young boy; *Astronomy*: seated female figure instructing a young boy who is standing in front of a carved eagle lectern on which rests a book.

The founding of the Manchester Institution for the Promotion of Literature, Science and the Arts in 1823 was to provide Manchester with one of its most important public cultural institutions. The initial idea of three Manchester artists, who had visited an exhibition organised

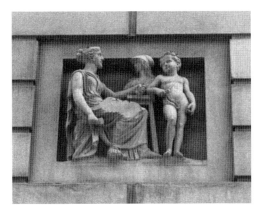

Henning, *Sculpture*

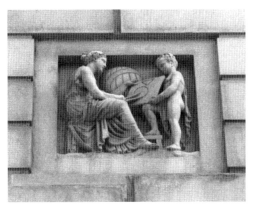

Henning, *Mathematics*

by the Northern Establishment of Artists in Leeds, was transformed into a cultural project in which members of the town's middle-class élite became the controlling presence. An extraordinarily large sum of money was raised to promote the new institution.[1] The Royal Manchester Institution, as it was to become known, set about providing a building in which it could realise its grand ambitions. Mosley Street was to be the location of the proposed building. The 28-year-old Charles Barry was awarded the commission in a limited competition in which his fellow competitors included Francis Goodwin, Lewis Wyatt and John B. Papworth. Barry was not an entirely unknown figure in Manchester as his designs for two local churches – All Saints, Stand, and St Matthew's, Campfield – were in the process of being completed.[2] Barry's design was in the classical style.[3] Sculptural decoration was included on the exterior including panels on the main façade and a sculpture on the roof.[4] The building was to take some ten years to complete, during which time a number of alterations to the original design, both externally and internally, were made. These included abandoning the idea of crowning the building with a large sculptural group.[5] The installation of sculpture in the pediment was also not to be realised even though Barry judged an initial

plan produced by Richard Westmacott, Jnr (1799–1872) as 'magnificent'.[6] Financial considerations played a part in these decisions, and in the end the external sculptural decoration was far more modest, being restricted to six panels on the Mosley Street façade.

The commissioning and completion of the panels proved to be a lengthy process. Barry was asked to provide designs for the panels in 1829.[7] He turned to his friend Westmacott – 'a young man of great talent' – who supplied drawings which Barry felt epitomised the purposes of the Institution. The panels would cost £300. But Westmacott did not proceed with the commission as attention was redirected towards completing the interior. The panels were not discussed again until 1833, though, once again, no commission ensued.[8] This situation finally changed in 1836 when Barry was asked to assess designs for the six panels representing the arts and sciences by Charles Smith and John Henning the Younger.[9] Henning's designs were preferred and he was commissioned to carve them at a cost of no more than £30 for each panel.[10] Work on the blocks eventually began in the spring of 1837, by which time Barry was overseeing the construction of another major Manchester building, the Athenaeum, located next to the Institution. Henning employed a Mr Affleck to

prepare the blocks before he arrived in Manchester to complete the carving.[11] Following a suggestion from Henning the panels were saturated with a wax solution to protect them from the Manchester elements.[12] Henning's symbolic sculptures were well received by the Institution's members, though this did not extend to acquiring the original models, which he offered to them for £14.[13] Neither did they show any interest in examining designs which Henning prepared 'for the whole of the proposed decorations, which I observed marked out in the small model of the building, particularly the running frieze which is left in the rough in front of the building'.[14] Shortly after the panels were completed, the Royal Manchester Institution became the home of the town's first major public sculpture, Chantrey's *Dalton*.[15] The building was transferred into the ownership of Manchester Corporation in 1882 and in the following year was formally opened as the city's art gallery. During the refurbishment and extension of the gallery in 2000–2 the panels, along with the rest of the exterior, were cleaned.

Notes
[1] S.D. Cleveland, *The Royal Manchester Institution* (Manchester, 1931); S. Macdonald, 'The Royal Manchester Institution' in J.H.G. Archer (ed.), *Art and Architecture in Victorian Manchester* (Manchester: Manchester University Press, 1985) pp.28–45; C.P. D'Arcy, *The Encouragement of the Fine Arts in Lancashire 1760–1860* (Manchester: Chetham Society, 1976) pp.66–75. [2] M. Whiffen, 'The Architecture of Sir Charles Barry in Manchester and Neighbourhood' in Archer (ed.), *op. cit.*, pp.48–51. [3] Whiffen, *op. cit.*, pp.52–7; C. Hartwell, *Manchester* (London: Penguin, 2002) pp.89–91. [4] Illustration in Whiffen, *op. cit.*, p.55. [5] Royal Manchester Institution Land and Building Committee, 5 August 1826 (Manchester Central Library, Local Studies and Archives). [6] Royal Manchester Institution Correspondence, 24 November 1829. [7] *Ibid.*, 1 October 1829. [8] Royal Manchester Institution Land and Building Committee, 25 April 1833. [9] Royal Manchester Institution Correspondence, 12 July 1836; Charles Smith (1798–1888), Gunnis, 1968, pp.355–6. [10] Royal Manchester Institution Land and Building

Committee, 30 August 1836. [11] Royal Manchester Institution Correspondence, 17 April 1837, 24 April 1837, 25 May 1837. [12] *Ibid.*, 6 July 1837, 21 September 1837. [13] *Ibid.*, 7 August 1837, 5 and 9 October 1837, 3 November 1837. [14] *Ibid.*, 28 October 1837. [15] See above, p.32.

Barbirolli Square, Lower Mosley Street

Ishinki – Touchstone

Kan Yasuda

December 1996
Carrara marble
1.5m high approx × 3.65m long
Status: not listed
Condition: good
Owned by: Manchester City Council
 Description: polished marble monolith located on pavement outside the Bridgewater Hall.

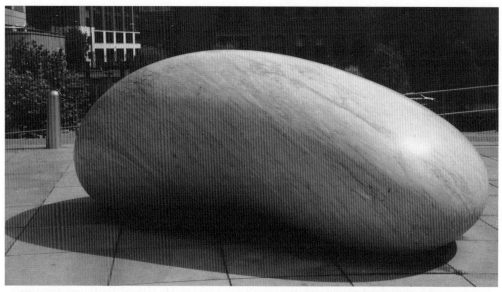

Yasuda, *Ishinki – Touchstone*

Touchstone was commissioned to stand in Barbirolli Square, a new open space created in front of the Bridgewater Hall, a new concert hall that replaced the Free Trade Hall, the long-time home of the Hallé Orchestra.[1] The need for a significant open-air public sculpture was identified at an early stage in the planning of the concert hall. A special committee, part of the Bridgewater Hall Trust, was responsible for commissioning art both inside and outside the building. The commissioning process began in 1995, at a time when the concert hall was still under construction, and when the intended site was easier to identify on the architect's plans than on the ground. Various forms of sculpture were considered for this important space before the choice was narrowed down to two sculptors: Kan Yasuda and Anish Kapoor. Yasuda, whose work had been recently displayed at the Yorkshire Sculpture Park, was selected. He decided, having visited the site, to create a massive rounded and organic work in Carrara marble, which would be accessible to the public by being placed at ground level in the open space. The 18-tonne polished monolith was made in Yasuda's workshop in Pietrasanta, Italy, its form, colour and surface resonating with the influence of Japanese sculpture on his work.[2] It was installed by Yasuda in August 1996, some three months before the hall was officially opened by Queen Elizabeth in December.[3] Locating such an obviously tactile work at ground level required thought to be given to the possibility of vandalism: a problem that Yasuda responded to by treating the stone with a special anti-graffiti solution. Yasuda translated 'Ishinki' as meaning a form returning to its heart. This simple but powerful form has been described as 'an object for intense contemplation – a moment of meditative silence in the heart of the city'.[4] The sculpture cost some £200,000 and was financed by the Arts Council Lottery Fund, Manchester Airport and Manchester City Council.[5]

Notes
[1] L. Grant, *Built to Music. The Making of the Bridgewater Hall* (Manchester: Manchester City Council, 1996). [2] www.kan-yasuda.co.jp [3] *Manchester Evening News*, 5 August 1996. [4] *Ibid.*, 2 August 1996. [5] Information from Fran Toms, Bridgewater Hall.

Sir John Barbirolli

Byron Howard

2 December 2000
Bronze bust; red sandstone pedestal
Bust 1.16m high; pedestal 1.83m × 91cm × 83cm
Signed on bust: Byron Howard '99
Inscription inset on front of pedestal:
BARBIROLLI – rear: SIR JOHN BARBIROLLI CH / 1899–1970 / CONDUCTOR LAUREATE / HALLE ORCHESTRA / "or walk with Kings ~ / nor lose the common touch" / Quoted from If by Rudyard Kipling / THIS MEMORIAL WAS PROMOTED / BY / IVAN SAXTON
Status: not listed
Condition: good
Owned by: Manchester City Council
 Description: Three times larger than life-size bronze head and shoulders of Barbirolli surmounting a sandstone pedestal. It is located outside the main entrance to the concert hall.

John Barbirolli was born in London in 1899, the son of a violinist. He trained as a cellist, before the First World War, and went on to play in a number of orchestras before establishing himself as a conductor. He was appointed conductor of the Scottish Orchestra in 1933, and in 1936 succeeded Toscanini as conductor of the New York Philharmonic Symphony Orchestra. In 1943 he accepted the invitation to become the conductor of the Hallé Orchestra. Under his inspirational leadership, the Hallé reached new heights of popularity both in Britain and abroad. In 1951 Barbirolli and the orchestra returned to the Free Trade Hall, rebuilt following its destruction during the war. Barbirolli was knighted in 1949 and made Honorary Freeman of Manchester in 1958. He died in 1970.[1]

A sculpture of Sir John Barbirolli had been one of the ideas considered at an early stage in the development of the public art programme associated with the Bridgewater Hall. No immediate action was taken, though the square in front of the new hall was named after him. It was the businessman and admirer of Barbirolli, Ivan Saxton, who arranged the funding and commissioning of a bust. Following the recommendation of Lady Barbirolli, Saxton approached Byron Howard, who had been responsible for several studies of the conductor, including a triptych that had been presented to the City of Manchester by Lady Barbirolli.[2] Byron Howard agreed to the commission in 1997, though there was some debate about the form of the portrait. Saxton's preference was for a head and shoulders portrait, similar to that of Charles Wheeler's study of Admiral John Jellicoe in Trafalgar Square. The final study showed Barbirolli wearing his overcoat over his shoulders, the collar upturned, and one of his hands visible. It had been intended to complete the work in time for the centenary of the conductor's birth, but it was not finished until the following year. Howard included a personal dedication on the bust in the form of the inscription 'Audio et Gaudeo', translated as 'I

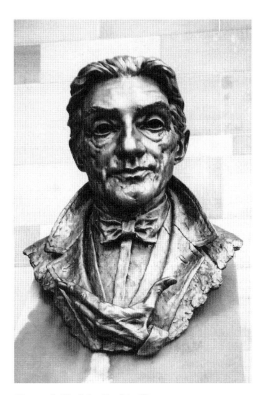

Howard, *Sir John Barbirolli*

hear and rejoice'. The stone used for the pedestal matched that used to face the hall, a choice determined by the decision to locate the bust close to the hall's main entrance in Barbirolli Square. It was unveiled by the Duke of Devonshire in December 2000.[3] Apart from the works by Yasuda and Howard in Barbirolli Square, a number of public artworks were commissioned for the interior of the Bridgewater Hall. A copy of a bust of Charles Hallé by the Manchester sculptor, John Cassidy, is also displayed inside the hall.[4]

Notes
[1] C. Reid, *John Barbirolli. A Biography* (London: Hamilton, 1971). [2] See above, p.47. [3] *Manchester Evening News*, 4 December 2000. [4] Exhibited at Royal Academy, 1897. A. Graves, *The Royal Academy of Arts. A Complete Dictionary of Contributors* (1970 reprint) Vol.1, p.13.

Mount Street

Lawrence Chambers
(see illustration overleaf)

Architects: Nathan Pennington and Edward Bridgen

1874
Stone
Lion 1.37m high; unicorn 1.37m high; Victoria statue 1.83m high
Status: Grade II
Condition: fair
 Description: Stone portrait statue of Queen Victoria in a niche beneath canopy on the second storey of the Mount Street façade. Lion and unicorn, both presenting shields, flanking the arch of the corner entrance.

Occupying a corner site on Mount Street and County Street, Lawrence Chambers was a Gothic building designed by Pennington and Bridgen as offices for the Commissioners of Taxes. There was a profusion of carved detail. In keeping with a building for the use of the Inland Revenue and Excise, the main sculptural decoration included a lion and unicorn flanking the corner entrance. On the second storey of the Mount Street façade a statue of Queen Victoria was placed.[1] Writing some 20 years after its completion, the *Builder* judged the overall design as 'hard and inharmonious'.[2] The architectural sculptors have not been identified.

Notes
[1] *Builder*, 29 August 1874, p.737. [2] *Ibid.*, 7 November 1896, pp.371–2.

(overleaf) *Lawrence Chambers* (entrance)

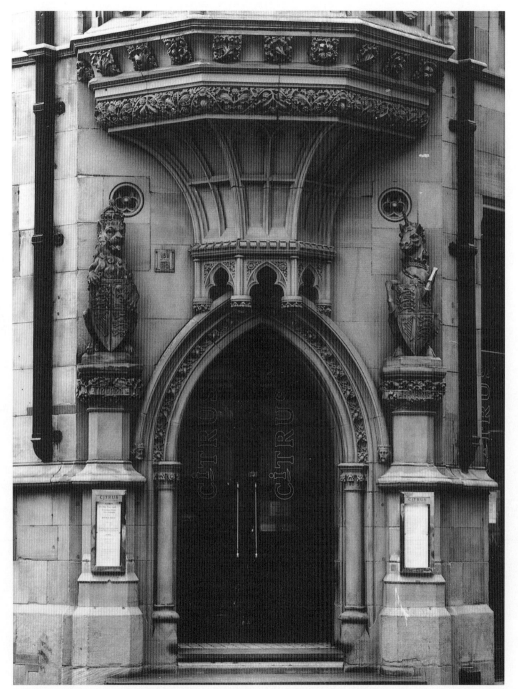

Oldham Road

Post Office Peace Memorial
John Ashton Floyd

17 March 1929; relocated 7 April 1997
Bronze statue; granite pedestal
Statue 1.83m high approx; pedestal 98cm high
Inscription on front: STRIVE FOR / ENDURING
PEACE / 1914–1918 . 1939–1945 / TO THE
MEMORY OF / THE MEN OF / MANCHESTER
POST OFFICE / WHO GAVE THEIR LIVES / FOR
THEIR COUNTRY
Status: not listed
Condition: good
Owned by: Royal Mail
 Description: War memorial; a bronze life-
size group of three figures in which the central
one is an angel symbolising peace. She holds the
torch of peace in her outstretched hand. By her
side are two children, a boy and girl, whom she
is leading forward into a world without war.
Various symbols of war, including a sword and
helmet, are scattered at their feet.

This memorial was raised in memory of the
men of the Manchester Post Office who died
fighting in the First World War. The
comparatively slow collection of funds among
local post office workers may help to explain
the delay in commissioning it, and the fact that
it was associated more closely with peace than
those memorials completed in the immediate
post-war years. It was not finally completed
until almost a decade after the Armistice. The
organising committee made it clear that the
memorial should be one that emphasised peace
not war, the causes of the First World War
being rooted in 'jealousy, intrigue and
armaments', resulting in 'unmeasured havoc in
all combatant countries'. Peace was 'something
for which men and women must strive without
ceasing'.[1] The Manchester sculptor, John
Ashton Floyd, was given the commission for
the memorial. His models included a local child,
Bill Reeves, whom Floyd had seen playing in

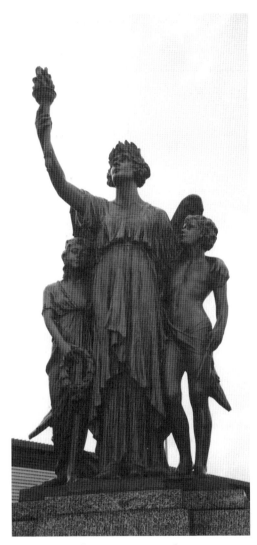

Floyd, *Post Office Peace Memorial*

the street close to his studio in Plymouth Grove.[2] The memorial was to be located in the main hall of the city's new post office in Spring Gardens. It was unveiled in March 1929 by the Revd Dr F.W. Norwood of the City Temple in a ceremony in which the music was provided by the Postmen's Military Band and an 80-strong staff choir. Norwood spoke of the memorial as 'beautifully, reverently dedicated to peace'.[3] It was in keeping with the message inscribed on the pedestal – 'Strive For Enduring Peace' – that the German consul was among the guests.[4]

The memorial remained in Spring Gardens until the 1960s, when the redevelopment of the building resulted in its removal and relocation outside the entrance to the city's parcel office in St Andrew's Street, near Piccadilly Station. Following the closure of that office in 1995, it was transferred to its present, more public position, at the entrance to the city's main sorting office on Oldham Road. The Manchester Post Office Peace Memorial was rededicated by Christopher Mayfield, Bishop of Manchester, in April 1997, the ceremony attracting a far smaller number of people than the 3,000 who had gathered to see it unveiled in 1929.[5]

Notes
[1] *Manchester Post Office Staff War Memorial Benevolent Fund, Order of Service for Unveiling Peace Memorial in Manchester Post Office* [1929].
[2] Royal Mail press release, 21 April 1997.
[3] *Manchester Guardian*, 18 March 1929. [4] *Post*, March 1929, pp.268–9. [5] Information from Barbara Moohan, Royal Mail, Manchester.

Ormond Street, Lower

Grosvenor Building, Manchester Metropolitan University

William J. Neatby

1897–8
Orange terracotta
76cm high approx
Status: Grade II
Condition: fair
Owned by: Manchester Metropolitan University
 Description: Row of two-light windows on the Ormond Street elevation, containing terracotta angels in the spandrels. The angels are shown presenting shields, some of which contain elements of the municipal coat of arms and dates, whilst others are left blank. A terracotta coat of arms is included in each bay above the windows

The Manchester School of Art moved from the city centre into its purpose-built premises overlooking Grosvenor Square in 1881. George Tunstall Redmayne was the architect of the new building, which boasted some particularly fine stone carving of foliage and flowers above the central doorway. The Municipal School of Art, as it became in 1892, was extended for the first time in 1897–8, financed, as the elegant terracotta panel on the Ormond Street side testifies, out of the profits arising from the Manchester Jubilee Exhibition of 1887. Joseph Gibbons Sankey was the architect of the red-brick Royal Jubilee Exhibition Wing. William Neatby, one of Doulton's most accomplished modellers, provided the decorative detail for both the interior and exterior.[1] On the Ormond Street exterior he introduced angels into the spandrels of the terracotta windows. They are shown holding shields, some of which are decorated with elements (a ship, Latin motto) from the municipal coat of arms. Two of the shields record years which are presumably pertinent to the building of the extension.[2] It is unclear, however, why the shield of the angel in the first bay is inscribed with the date 1906. The corbels on the Lower Ormond Street side also feature angels' heads.

Notes
[1] R. Cochrane and A. McErlain, *Architectural Terracotta* (Manchester Metropolitan University Department of History of Art and Design Slide Sets, 1999) p.19; J. Barnard, ' Victorian on the tiles: the work of W.J. Neatby in ceramics', *The Architect*, September (1971) pp.46–51. [2] D. Brumhead and T. Wyke, *A Walk Round All Saints* (Manchester: Manchester Polytechnic, [1986]) pp.25–6; C. Hartwell, *Manchester* (London: Penguin, 2001) p.132.

Neatby, *Grosvenor Building (detail)*

Oxford Road

University of Manchester

John Owens

Harry Bates

Stone
1.52m high approx
Status: Grade II
Condition: fair
Owned by: University of Manchester
 Description: Portrait statue; stone statue of
John Owens, who is wearing a cloak, placed in
a niche above the tower entrance.

John Owens was born in 1790, the son of
Owen Owens, a Welsh hatter. After being
educated privately, he joined his father in the
family business in 1817. They purchased
calicoes and coarse woollens from local
manufacturers and shipped them to China,
India and North America. After his father
retired, John Owens continued to expand the
business. He also became a major investor in
the emerging railway system. Owens, a
Nonconformist, objected to the Church of
England's role in education, and he decided to
leave most of his wealth to establish a higher
education college for men, so that they would
not have 'to submit to any test whatsoever of
their religious opinions'. He died on 29 July
1846 at his house in Chorlton-upon-Medlock.
In his will he left £96,654 for the establishment
of the college that took his name and later
became the University of Manchester.[1]
 When Owens College opened in 1851 it
occupied a house in Quay Street, the former
home of Richard Cobden. In the early 1870s the
college acquired a new and larger site on
Oxford Road. Alfred Waterhouse was
employed as architect, completing the first
major block of buildings in 1874. The next
group of buildings included the museum and
the tower which fronted Oxford Road. These
were opened in 1886. A niche was provided

Bates, *John Owens*

above the main entrance in the tower for a statue of the founder. Waterhouse appears to have commissioned the statue from Bates himself, though whether this commission preceded or followed the commissioning of Bates's *Socrates Teaching* is unclear. The statue was approved by the College Council in the spring of 1886.[2] The details of the commissioning and the date of its installation are not recorded in the university archive. It is not known what likeness Bates used for the statue. The college did already possess a medallion portrait of its founder, a gift from Elizabeth Faulkner in 1878.[3]

Notes
[1] B.W. Clapp, *John Owens Manchester Merchant* (Manchester: Manchester University Press, 1965). [2] Owens College Minutes, 5 April 1886 (University of Manchester Archives, John Rylands University Library of Manchester). [3] *Ibid.*, March 1878.

Council Chamber, Whitworth Building, University of Manchester

Socrates Teaching the People in the Agora

Harry Bates

1886
Marble
1.1m × 2.08m
Signed: Harry Bates 1886
Status: Grade II
Condition: good
Owned by: University of Manchester
 Description: Rectangular marble bas-relief depicting the seated figure of Socrates, holding a staff, who is instructing four young men, two seated and two standing. The base of the curved seat carries a Greek inscription.

Socrates Teaching the People in the Agora was the work which signalled the arrival of Harry Bates as one of the rising stars in a new generation of British sculptors. Bates completed the work, almost certainly in plaster, in 1883 while a student at the Royal Academy Schools, and received a gold medal and a travelling studentship of £200 for it.[1] He used the award to study in Paris where he came under the influence of Rodin.[2] The public praise for *Socrates Teaching* continued when it was exhibited at the Royal Academy in the following year, even though it was now known that Bates, at 33 years old, was not quite the typical young student that many people had first assumed.[3] The work was also reproduced in the *Illustrated London News*.[4] Cosmo Monkhouse identified the work in the *Academy* as 'among the happiest auguries for the future of English art. Mr Bates's work has style, combined with fresh and natural conception.'[5] It clearly stood out from two other exhibits on the same subject by his fellow students, George Frampton and Henry Pegram.[6] Bates was commissioned, presumably in 1884 or 1885, by the architect, Alfred Waterhouse, to produce a larger marble version of the work for Owens College. A painting, *The Sculptor's Studio* (1884–5) by another fellow student and his friend, Tom Roberts, showed Bates in the studio modelling a larger-scale version of *Socrates Teaching*, presumably in preparation for the Manchester marble.[7] Whether Waterhouse had ever come into contact with the sculptor during the years that Bates had worked for the architectural sculptors, Farmer and Brindley, is unclear. The firm had worked on a number of Waterhouse's buildings, including Manchester Town Hall. In the mid-1880s, Waterhouse was engaged on the tower and council chamber of the university in Manchester, and he must have considered the subject of Bates's work as one that was particularly appropriate for an institution of higher learning, even if its classical style might not have been the obvious choice for a Gothic building. The commission appears to have been Waterhouse's initiative as he presented, and presumably paid for, the marble study to the university. The marble relief was shown at the

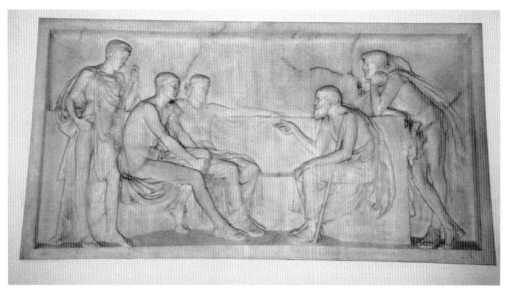

Bates, *Socrates Teaching the People in the Agora*

Royal Academy in 1886 before being sent to
Manchester, where it was installed on the rear
wall of the Council Chamber.[8] The exact date
of installation is not known, but it was in the
university in October 1887.[9] In addition to
commissioning *Socrates Teaching*, Waterhouse
also engaged Bates to provide the university
with a statue of its founder, John Owens.

Socrates Teaching the People in the Agora
continued to be a greatly admired work;
Edmund Gosse confirmed it as one of the pre-
eminent works of the New Sculpture.[10] Bates's
widow presented a plaster version, presumably
the one awarded the gold medal in 1884, to
Bates's old school, the Thomas Alleyne's
Grammar School, Stevenage, in 1900.[11]

Notes
[1] S. Beattie, *The New Sculpture* (New Haven: Yale
University Press, 1983) p.35. [2] W. Armstrong, 'Mr
Harry Bates', *Portfolio*, 1888, pp.170–4. [3] A. Graves,
*The Royal Academy of Arts. A Complete Dictionary
of Contributors* (1970 reprint) Vol.I, p.141.
[4] *Illustrated London News*, 5 January 1884, p.20.
[5] *Academy*, 31 May 1884, p.392. Reference from

Edward Morris. [6] *Art Journal*, 1884, p.244.
[7] M. Eagle, *The Oil Paintings of Tom Roberts in the
National Gallery of Australia* (National Gallery of
Australia, 1997) pp.18–19. Information from Joseph
Sharples. [8] See *Illustrated London News*, 5 January
1884, p.20; S. Beattie, *The New Sculpture* (New
Haven: Yale University Press, 1983) p.155. [9] *British
Architect*, 7 October 1887, p.263. Information from
Edward Morris. [10] E. Gosse, 'The New Sculpture,
1879–1894 III', *Art Journal*, August 1894, pp.278–9.
[11] D. de Salis and R. Stephens, 'An Innings Well
Played': the Story of Alleyne's School, Stevenage,
1558–1989 (Alleyne's Old Boys' Association, 1989)
pp.39, 118; M.E. Newman, 'Sculptors and Sculptures
of Stevenage', *Hertfordshire Countryside*, [n.d.],
pp.31–2 and typescript notes, Stevenage Museum. M.
Ashby, *Stevenage Past* (Chichester: Phillimore, 1995)
pp.101–2. Information from Joseph Sharples, Donna
Milner, Stevenage Museum, and Mr Chilcott, Thomas
Alleyne's School.

Busts and Medallions

From its earliest days as Owens College, the
university has commissioned or, more usually,
been presented with portrait busts and
medallions of individuals associated with the
institution. The Christie Library (now the
Christie Bistro) housed one of the largest
groups of busts, others being placed in
buildings and lecture theatres across the

campus. Over the years some have been
removed and relocated, whilst the whereabouts
of others have been difficult to establish.[1]

The collection includes the following: a
marble bust of the scientist, John Dalton
(Holme Cardwell, 1840) which was presented
to Owens College in 1854 by James Collier
Harter.[2] Cardwell exhibited a bust of Dalton at
the Royal Academy in 1840;[3] a marble bust of
Professor A.J. Scott (Henry Stormouth
Leifchild), who was the first Principal of
Owens College. It was presented by past and
present students of the college in 1860;[4] a
marble bust of James Prince Lee (Matthew
Noble, 1873), the first Bishop of Manchester.
Prince Lee left his library of some 7,000
volumes to Owens College. The bust was the
gift of a group of subscribers;[5] a marble bust of
William Stanley Jevons (E. Roscoe Mullins,
1883), who was Professor of Logic and Political
Economy from 1866 to 1876. It was presented
in memory of him by friends and admirers in
1884;[6] a bronze bust of Charles Frederick Beyer
(J.W. Swynnerton, 1884). It was commissioned
by the university's Court of Governors;[7] a
marble bust of the novelist, Elizabeth Gaskell
(Hamo Thornycroft), a copy of the one of
Elizabeth Stevenson, the future Mrs Gaskell,
executed in 1831 by David Dunbar. It was
donated by her daughters, Marianne and
Margaret Gaskell.[8] The portrait medallions
include one of John Owens (Thomas Woolner),
presented to the college by the late Mrs
Faulkner, whose husband had been in
partnership with John Owens.[9] Woolner was
also responsible for a marble medallion portrait
of Sir Joseph Whitworth. This was
commissioned by the University Council to
mark Whitworth's generous benefactions. It
was specified that the cost should not exceed
200 guineas.[10] In 1897 Sir Henry Enfield Roscoe
presented a marble medallion of himself,
sculpted by John Adams-Acton.[11]

Busts continued to be presented in the
twentieth century. One of the most notable was
a marble bust of Edward VII (Albert Bruce Joy,

1910) which was commissioned by the university as an acknowledgment of the King's position as Visitor.[12] A marble bust of Richard Copley Christie (Joseph Edgar Boehm, 1877) was donated by the family in 1924.[13] Christie was Professor of History, Political Economy and Jurisprudence at Owens College, and provided the funds, £22,000, for a new university library. A bronze bust of Auguste Sheridan Delépine (John Millard, 1923), Professor in Public Health and Bacteriology between 1891 and 1921, was placed in the Department of Bacteriology in a niche designed by Worthington.[14] A bronze bust of Lord Rutherford honoured the Noble Laureate who had been Professor of Physics from 1907 to 1919.[15] The motives behind the presentation of such busts, as with commemorative statues, were not always obvious. Members of Manchester's Jewish community were supportive, for example, of the efforts made to recognise the standing of the philosopher, Samuel Alexander. Following his retirement from the university in 1924, a bronze bust, head and shoulders, was commissioned from Jacob Epstein in 1925.[16] Alexander's sittings for Epstein spurred him to write an essay exploring the subject of artistic creativity.[17] At the unveiling in the university's Arts Building, a ceremony performed by Epstein himself, the philosopher was characteristically generous and perceptive in observing that

> In the future when I am forgotten this bust will be described among the university's possessions as the bust of a professor, not otherwise now remembered, except as an ingredient of the ferment which the earlier years of the 20th Century cast into speculation, but it will be added that it is an Epstein.[18]

Epstein was also the sculptor of another bust with even more obvious Jewish connections. Chaim Weizmann, who became the first president of Israel, had been a chemist at the university. A copy of the bust sculpted by Epstein in 1933 was presented to the university and put on display in the Department of Chemistry.[19]

Notes
[1] P.J. Hartog, *The Owens College, Manchester (1851)* (Manchester: J.E. Cornish, 1900) p.118. [2] *Owens College Calendar, 1862–3*, p.22. [3] Hartog, *op. cit.*, p.148. The bust is now in Dalton-Ellis Hall, Conyngham Road, Victoria Park. [4] *Owens College Calendar 1862–3*, p.23. Leifchild had exhibited a bust of Scott at the Royal Academy in 1851; Gunnis, 1968, p.238. [5] Hartog, *op. cit.* It was in the Christie Library. [6] It is located in the Christie Bistro, Oxford Road. [7] Hartog, *op. cit.*, p.148. [8] Hartog, *op. cit*, p.149. The bust is now in the John Rylands Library, Deansgate. [9] Owens College Minutes, 7 June 1880. [10] *Ibid.*, 10 October 1888, Vol.5, p.144. [11] Proceedings of Council, Owens College, 5 February 1897, p.82. [12] *Illustrated London News*, 18 December 1909; *Pall Mall Gazette*, 16 December 1909; *Manchester Courier*, 2 June 1910. [13] *The Times*, 7 July 1924.

Epstein, *Samuel Alexander*

[14] Now in Stopford Building, University of Manchester. [15] Located in Rutherford Lecture Theatre, Department of Physics, University of Manchester. [16] *Manchester Guardian*, 20 February 1925. It was sculpted in 1925, not 1924 as recorded in Silber; E. Silber, *The Sculpture of Jacob Epstein* (Oxford: Phaidon, 1986) p.157. [17] 'The creative process in the artist's mind', *British Journal of Psychology*, 17 (1926–7) pp.305–21. [18] S. Alexander, *Philosophical and Literary Pieces* (London: Macmillan, 1939) p.73; *Manchester Guardian*, 25 November 1925; *Daily Mail*, 25 November 1925. [19] Silber, *op. cit.*, p.176.

Royal Eye Hospital
Architects: Pennington and Bridgen

15 February 1886
Terracotta
3.05m long × 2.44m high approx
Status: Grade II
Condition: fair
Owned by: Manchester Hospitals Trust
 Description: Rectangular deep red terracotta panel in end bay depicting the miracle of Christ healing the blind man.

Following its foundation in 1815, the Manchester Royal Eye Hospital occupied various premises in the centre of the town. By the mid-1870s it was located in St John Street, but in a building that was too small to cope with an increasing number of patients. Calls were made to find larger premises. The problems of the hospital's accommodation were finally responded to in 1883 when the decision was taken to build a new hospital on Oxford Road. The hospital's governing board, led by Alderman Philip Goldschmidt, commissioned the Manchester architects, Pennington and Bridgen.[1] The new hospital began treating patients in December 1885, but was not formally opened until the following February. Goldschmidt, who by that date was serving his second term of office as the city's mayor, carried out the ceremony.[2] Pennington and Bridgen's three-storey building was in the

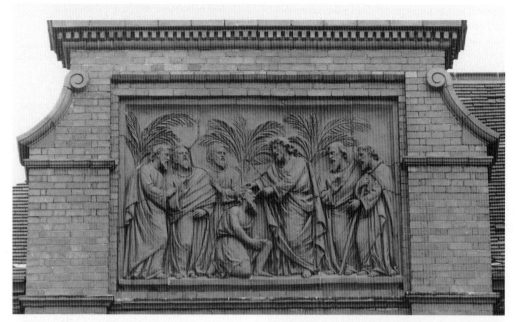

Christ Healing the Blind Man

Queen Anne style, built in red brick with terracotta dressings. They also introduced one piece of decorative sculpture, a terracotta panel containing the entirely appropriate composition of Christ restoring the sight of a blind man. The sculptor has not been identified but the style and subject matter suggest George Tinworth of Doulton as the likely artist.[3] The panel was installed in the left-hand bay on the principal façade facing Oxford Road.

Notes
[1] F. S. Stancliffe, *The Manchester Royal Eye Hospital 1814–1964* (Manchester: Manchester University Press, 1964) pp.58–60. [2] *Manchester Courier*, 16 February 1886. [3] R. Cochrane and A. McErlain, *Architectural Terracotta* (Manchester Metropolitan University Department of History of Art and Design Slide Sets, 1999) p.21.

Manchester Royal Infirmary
Architects: Edwin T. Hall and John Brooke

6 July 1909
Portland stone
2.44m high approx × 3.05m long approx

Good Samaritan

Status: Grade II
Condition: fair
Owned by: Manchester Hospitals Trust
 Description: Carved stone relief depicting the parable of the Good Samaritan above the entrance on the Oxford Road side of the building.

The Manchester Infirmary was founded in 1752 and by 1756 had moved into Piccadilly, occupying the site which is now Piccadilly Gardens. Over the next 100 years the hospital was extended and rebuilt, but, as in other Victorian cities, the problems of operating a major hospital on a cramped city-centre site generated a debate about moving to a more suitable location. This long debate ended in 1903 when it was decided to build a new hospital on Oxford Road, opposite the Whitworth Art Gallery and Whitworth Park. The Piccadilly site was acquired by the Corporation for £400,000. Edwin Hall and John Brooke were the architects of the new infirmary building in the Greenwich Baroque style. Although the *Builder* expressed doubts whether the principal façade was rather too ornate 'for the charitable nature of the building', there was only one major piece of architectural sculpture. In the tympanum, above the main entrance, was a stone relief panel of the parable of the Good Samaritan. Described by the *Manchester Courier* as 'a vast sermon in stone, and a sermon, moreover that speaks of sweet charity', it was in place when the new infirmary was formally opened by Edward VII and Queen Alexandra in July 1909.[1] The hospital contains a number of commemorative plaques and busts including a marble portrait medallion of Richard Baron Howard by William Theed.[2]

Notes
[1] *Manchester Courier*, 6 July 1909; *Manchester Guardian* 7 July 1909. [2] C. Hartwell, *Manchester* (London: Penguin, 2001) p.313 (not listed in Gunnis, 1968).

Edward VII

John Cassidy

16 October 1913
Bronze statue; granite pedestal
Statue 3.05m approx; pedestal 4.6m high ×
 5.27m square base
Signed on plinth: 1913 John Cassidy
Inscription on front of pedestal: EDWARD VII –
 rear: PRESENTED BY JAMES GRESHAM MICE. JP.
 / TO THE CITY OF MANCHESTER
Status: Grade II
Condition: fair
Owned by: Manchester City Council
 Description: Portrait statue; a larger than life-
size representation of Edward VII, who is
shown as a standing figure wearing the robes of
state. The bronze statue surmounts a large
stepped granite pedestal

Towns and cities throughout the United
Kingdom responded to the death of Edward
VII by organising memorial schemes. Some
took the form of funds to assist existing local
charities or the establishment of new ones,
while other communities decided to
commission a memorial statue or bust. In
Manchester a committee of councillors and
other prominent public figures was set up in
November 1910 to recommend the most
appropriate tribute to the late King's life and
reign. Reporting in the following May, it
proposed establishing a fund whose monies
would provide both charitable assistance to the
old and poor in the city and a memorial statue.
The proposals were discussed at a public
meeting called by the mayor, Charles Behrens,
in the town hall. Significantly, it was announced
that the statue would stand in Piccadilly on the
site of the former Infirmary, land that was the
subject of a long-running public debate. The
cost of the statue was not to exceed 5,000
guineas. Some criticisms were voiced about the
idea of a statue, but the proposals allowed

subscribers to specify which element of the
memorial scheme they wished to support.[1] The
scheme was accepted and contributions to the
memorial fund requested.

The memorial committee's plans changed
when it was announced, in October 1911, that a
'private citizen' had agreed to donate a statue of
the late king to the city. The gift appeared to
offer the possibility of using the entire
memorial fund, apart from the money required
to meet the costs of installing the statue, to
support the city's charities. James Gresham, the
owner of a successful engineering company and
art collector, was the donor. He had previously
presented John Cassidy's *Adrift* to the city.[2]
Cassidy had been commissioned by Gresham to
provide a bronze statue of Edward VII in the
previous year, presumably with the intention
that it would be presented to the city.[3] Initially,
Cassidy's model of Edward VII, dressed in the
robes of the Order of the Garter, appeared
acceptable, exemplifying as it did the popular
idea of 'Edward the Peacemaker'. What proved
less acceptable was its intended size. Gresham
envisaged a truly colossal statue: 6 metres tall
on a pedestal of 9 metres, easily exceeding the
height of almost every outdoor statue in the
country.[4] The misgivings were also linked to the
intended site. Placing such a monument in
Piccadilly raised questions about its relationship
to the existing statues on the Esplanade. It also
prompted debate about the future use of what
had become, following the demolition of the
infirmary, the most discussed open space in the
city.

A short leader in the *Manchester Guardian*
expressed the doubts surrounding the placing of
a 'giant effigy' in Piccadilly, doubts fed by
memories of the disappointment that had
greeted Onslow Ford's *Victoria*.[5] Was Cassidy
sufficiently talented to realise such a work? 'A
twenty-foot statue in the centre of a city cannot
afford to be mediocre, it cannot even afford to
be respectably good; it must be great, or it
gibbets its sculptor and the municipality which
sanctioned it.'[6] Pressure to reassess the intended

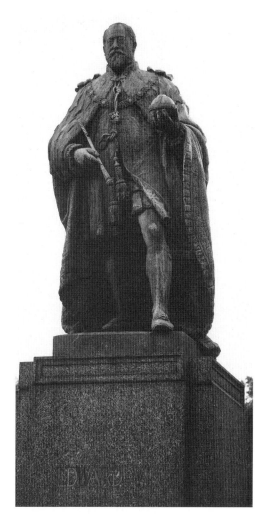

Cassidy, *Edward VII*

memorial mounted, resulting in the
announcement that Cassidy was to scale down
its size.[7] Manchester would not be able to lay
claim to one of the largest bronze statues in
Britain. Equally important, the public debate
over the future use of the former Infirmary site
led to the decision that the statue, even when
reduced in size, would not be located there.
Manchester's *Edward VII* would not be placed

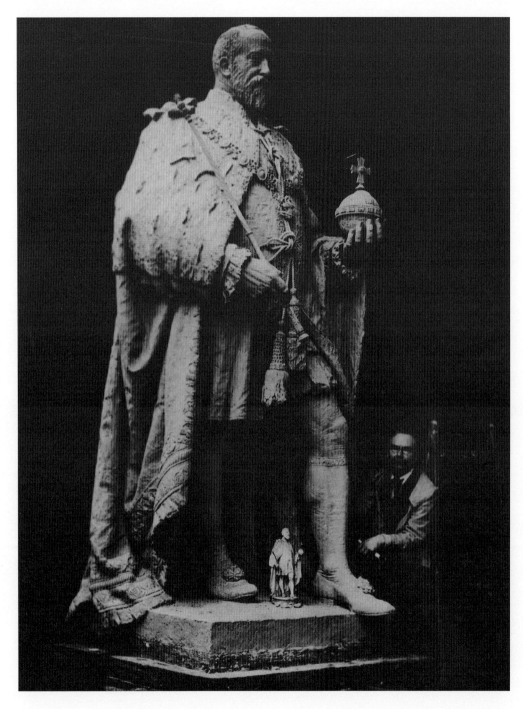

close to his mother's statue, but instead would be in Whitworth Park, over two kilometres from the city centre: a distance that might be regarded as more appropriate given their troubled relationship. More precisely, it was to be placed close to the park's Oxford Road entrance, facing towards the new Manchester Royal Infirmary. This location could be justified by royal connections, the King having opened the hospital on what proved to be his final visit to the city.[8]

Cassidy continued to work on the commission. By November 1912 he was sending out invitations to view the full-size clay model.[9] This differed from an earlier model, Cassidy having removed some of the regal symbolism – the orb in the left hand had been entwined in a spray of olives and surmounted by a winged horse of Victory. The statue was approved and prepared for casting. It was to surmount a massive grey granite pedestal, designed by James Henry Sellers.[10] By the summer of 1913 attention had turned to the arrangements for the unveiling ceremony.[11] It was unveiled in October 1913 by the Lady Mayoress of Manchester, Lady Royse. The ceremony was well attended, but appeared somewhat subdued, compared to earlier inaugurations.[12] The statue was reported to have cost £5,000.[13] At a later date, a flower bed was planted around the pedestal, an instance of the defensive horticulture that William Pettigrew, Manchester's influential superintendent of parks, recommended to stop children climbing onto statues.[14] Those beds were subsequently removed. Over the years the statue has been damaged – the sceptre broken and the cross on the orb snapped off – whilst the large granite pedestal has proved to be a convenient site for fly posters.

Notes
[1] *Manchester Courier*, 5 May 1911; *Manchester*

Cassidy with the maquette and plaster model of Edward VII

Guardian, 5 May 1911; *The Times*, 6 May 1911.
[2] See below, p.162. [3] *Manchester Guardian*, 5
October 1911. [4] *Manchester City News*, 7 October
1911. [5] See below, p.119. [6] *Manchester Guardian*,
6 October 1911. [7] *Ibid.*, 13 October 1911. [8] *Ibid.*,
21 September 1912; Manchester Corporation Parks
Committee Minutes, 20 September 1912 (Manchester
Central Library, Local Studies and Archives).
[9] Invitation card to J. Phelps, cuttings file,
Chetham's Library; Photograph showing first and
final model in D. Brumhead and T. Wyke, *A Walk
Round Manchester Statues* (Manchester: Walkround
Books, 1990) p.58. [10] C. Young, 'Reminiscences' in
Manchester Buildings, *Architecture North West*,
No.19 (1966) p.8. [11] *Manchester Guardian*, 26 July
1913, 4 September 1913, 13 September 1913.
[12] *Manchester Evening News*, 16 October 1913;
Manchester Courier, 17 October 1913.
[13] *Manchester Evening News*, 16 October 1913.
[14] W.W. Pettigrew, *Municipal Parks Layout,
Management and Administration* (London: Journal of
Park Administration, 1937) pp.206–7.

Peter Street

St George's House

St George

Architects: Woodhouse, Corbett and Dean

1911
Terracotta
1.93m high approx
Status: Grade II
Condition: fair
Owned by: Zurich plc
 Description: Terracotta statue, a copy of
Donatello's *St George*, depicted standing with
his shield, in a niche high above the main
entrance

Manchester's Young Men's Christian
Association in Peter Street was built on the site
of the Natural History Museum. It was
designed by Woodhouse, Corbett and Dean,
who used the then novel material of reinforced
concrete, clad with a faience skin. The faience was
produced at the Burmantofts factory. It had been
intended to use a green and cream faience, but
this was replaced by buff and chocolate, out of
consideration for its effect on the neighbouring
Midland Hotel. The decoration was understated
but did include the figure of St George, after
Donatello, occupying a niche on the third
storey, high above the main entrance on Peter
Street. The designer has not been identified. The
building was opened in 1911. The YMCA sold
the premises in the 1990s and they were
subsequently converted into office premises,
taking their name from the terracotta statue.[1]

Note
[1] Cuttings file, Chetham's Library.

St George

Royale Night Club

William Shakespeare

1846
Marble
1.83m high approx
Status: Grade II
Condition: poor
Owned by: unknown
 Description: Portrait statue; copy of
Scheemakers's statue of Shakespeare, depicting
him standing, his right arm resting on a pile of
books and the left hand pointing downwards.

The Theatre Royal in Peter Street was the third
theatre in Manchester to bear the name, the two
previous ones having been destroyed by fire.[1]
John Knowles, who had acquired the patent
rights of the previous theatre in 1844, employed
the Manchester architects, Francis Chester and
John Gould Irwin, to provide an imposing new
theatre. The main façade, dominated by two
lofty Corinthian columns with fine capitals,
announced the theatre's presence on the
increasingly fashionable Peter Street. The
theatre was opened in September 1845 and
dedicated to Shakespeare.[2] In the following year
a marble statue of Shakespeare was placed in the
pedimented niche above the main entrance.[3]
The statue was an inferior copy of the well-
known work sculpted by Peter Scheemakers,
from the design of William Kent, installed in
Westminster Abbey in 1740.[4] Much of the detail
of the original was omitted including the
inscription from *The Tempest* and the heads of
Shakespeare's characters which decorated the
column.
 The installation of the statue did not go
unnoticed in Manchester, one observer
expressing his less than complimentary
opinions in rhyme:

 Old 'Rare Ben Johnson' came to town,
 And from Bank Top soon hurried down,
 Determined Deansgate first to see,
 (For Ben at all times loved a spree.)

As down through Peter-Street he passed,
By chance an eye he upward cast,
And saw above the playhouse door,
A face like one he'd seen before;
Then thought as he advanced more near,
'Twas Shakespeare's, his old crony dear.
'Pray who are you, perched there so high?'
The statue answered with a sigh,
'They say I'm Shakespeare, what think you?'
'Why, if you are, your case looks blue,
You've got a club foot, now I see,
And a white-swelling in your knee
And dropsied legs, and such a phiz,
You must be there for folks to quiz'.
'Alas poor Yorick!'

With a sigh, again the marble made reply;
'O Ben your spite survives yourself,
One of your trade, a tasteless elf,
Placed me thus mutilated here…'[5]

The sculptor was not identified, though it is possible that the statue originated from another of Knowles's Manchester business interests, a marble works in the city centre, located near the Rochdale Canal. A contemporary commercial directory records Knowles as a manufacturer of marble chimney pieces, baths and monuments, and as an importer of Italian marble and statuary.[6] When a correspondent for the *Manchester Guardian* visited the works to report on some new marble-cutting machines which Knowles had helped to develop, his attention was attracted to the Carrara marble statues (including a copy of Canova's *Graces*) for sale, the work of young Italian sculptors.[7] No doubt it was this business interest that prompted Knowles's critics to refer to him as 'The Man with the Marble Heart'. The Shakespeare statue has remained a feature of the building since 1846, watching over its transformation from a theatre into a cinema in the 1920s, into a bingo hall in the 1970s, and into a discotheque and night club in the 1990s. It was in the early 1990s, when the building was cleaned, that the statue was 'protected' by a generous coat of paint, making it impossible for the observer on the ground to confirm or refute the provenance of the original stone.

Notes
[1] T. Wyke and N. Rudyard, *Manchester Theatres* (Manchester: Bibliography of North West England, 1994) pp.57–8. [2] *Manchester Guardian*, 1 October 1845. [3] *Manchester City News*, 26 February 1902. [4] I. Roscoe, *Peter Scheemakers 'The Famous Statuary' 1691–1781* (Leeds: Henry Moore Institute, 1996). [5] 'Lines on the Installation of Something like Shakespeare's Image in front of the Theatre Royal by P.C.', *Manchester Courier*, 2 December 1846. [6] *Slater's Manchester Directory* (Manchester, 1845) p.421. [7] 'An Hour in the Manchester Marble Works', *Manchester Guardian*, 26 April 1854.

William Shakespeare

Free Trade Hall
Architect: Edward Walters
Sculptor: John Thomas

October 1856
Marble
1.83m × 3.05m approx
Status: Grade II*
Condition: fair
Owned by: Manchester City Council
 Description: Nine relief panels relating to free trade in the tympani above the windows along the first floor of the Peter Street façade. The centre panel represents Free Trade: a seated female figure, wearing a corn wreath on her head, flanked by sheaths of corn; her arms outstretched over barrels, bales and rolls of cloth. To the left the panels represent a series of seated female figures: *Asia* is shown wearing a turban, holding a cornucopia in her right hand and a box in her left hand. She is flanked by a chest of tea and large ornate pitcher, camel, boat and barrel of figs. *Europe* is depicted holding her rod of office, flanked by a horse, storage vessel and bust. *The Arts* is shown holding a lyre in her left hand, surrounded by an artist's palette and musical instruments, including a violin and drum. *Industry* is shown holding a distaff in her left hand, flanked by a screw press and boiler, railway engine and anvil. To the right the panels represent a series of seated female figures: *Africa* is shown holding an elephant tusk, flanked by a lion, a chest of fruits, and plants. *America*, her breasts uncovered, is shown holding a spade, flanked by bales of cotton and a barrel of molasses, and buffalo. *Australia* is shown holding a spade, flanked by a cow and a sheep. *Commerce* is depicted in front of a boat, surrounded by various articles of trade including a barrel, a pitcher and rolls of cloth.

The Free Trade Hall, designed by the Manchester-based architect, Edward Walters, was built on the site of two previous halls, both

Thomas, *Free Trade*

Thomas, *Asia*

Thomas, *Industry*

Thomas, *America*

Thomas, *Africa*

of which had been erected by the Anti-Corn Law League, primarily for holding political meetings.

Walters' Free Trade Hall, designed in a style described as Lombardo-Venetian, was on a much more monumental scale. Opened in

October 1856, it was operated by a private company which hired it out for concerts, entertainments and public meetings. Architectural decoration was an integral element of Walters' design for the Peter Street façade. The principal decoration took the form of nine semicircular panels in the tympani above the windows running along the first floor

of the building. These offered a pictorial commentary on the benefits of free trade. They were the work of John Thomas (1813–62), whose reputation as one of the country's leading architectural sculptors had been secured by his work on the new Houses of Parliament.[1] A seated female was the central figure in each of the compositions. The central panel represents Free Trade, whose outstretched arms are pointing to the traded goods. To the left are panels symbolising Asia, Europe, Arts and Industry; to the right the panels representing Australia, America, Africa and Commerce. In addition the façade was enlivened with other architectural carving, including symbolic corn sheaves and the coats of arms of local towns that had supported the campaign against the Corn Laws. But not all the carving was political: in the upper spandrels musical instruments featured, presumably a reminder that the new hall would be used, like the previous one, as a venue for entertainment. The hall's long association with the Hallé Orchestra began in the year of its opening. The hall remained under the control of a private company until it was taken over by Manchester

Corporation in 1920.[2] In December 1940 it was extensively damaged by German bombs, but fortunately, the Peter Street façade, including Thomas's sculptural panels, survived largely undamaged. They were restored during the rebuilding in 1950–1.[3]

Notes
[1] Gunnis, 1968, pp.388–90. [2] T. Wyke, *A Hall for All Seasons. A History of the Free Trade Hall* (Manchester: C. Hallé Society, 1997). [3] Repair and recarving work of the sculptural details on the Peter Street façade was carried out by Frank Hewitt; see [James Atwood], *Reconstruction 1950–1951. Details of Carving. Peter Street Front* [n.d.] (Manchester Central Library).

Windmill Street

Free Trade Hall
Architect: Leonard C. Howitt
Sculptor: Arthur Sherwood Edwards

16 November 1951
Portland stone
1.83m high approx
Status: Grade II*
Owned by: Manchester City Council
 Description: Eight statues surmounting brick piers on the Windmill Street façade: Left to right they are: *Dancing* which is represented by a couple dancing. *Singing* represented by a female soloist. *Music* represented by a conductor, his back facing the viewer. *The Cinema* is represented by a cinematograph operator. *Boxing* is represented by a boxer. *Education* is represented by a teacher presenting a prize to a schoolboy. *Drama* is represented by an actress. *Public speaking* is represented by a male orator.

The Free Trade Hall, the city's most important public hall, was rebuilt after the war. The new building, designed by the City of Manchester's architect, Leonard C. Howitt, incorporated Walters' façade. In spite of being constructed during a time of economy drives and shortages, Howitt's design did not shun all external decoration. Figurative sculptures were placed on the piers which divided the massive brick wall at the rear of the building in Windmill Street. These were designed by Arthur Sherwood Edwards, a local sculptor and artist employed in Howitt's department.[1] The Portland stone figures of dancers, female

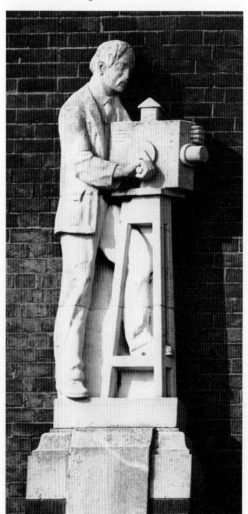

Sherwood Edwards, *The Cinema*

soloist, conductor, cinematograph operator, boxer, schoolmaster and pupil, actress, and orator represented activities associated with the old Free Trade Hall. Not everybody found the scheme appealing and one local artist regretted that the opportunity had not been taken to commission a major artist – Epstein was mentioned – to provide a more inspirational sculptural composition.[2] Another suggestion was for statues of famous Mancunians to be placed on the piers. But such proposals took little account of the limited funds available.[3] Manchester's new Free Trade Hall was opened in November 1951. It resumed its role as an important cultural building; Barbirolli's leadership of the Hallé Orchestra making it a name known to people far beyond Lancashire. The hall continued in use until 1996 when, following the construction of a new international concert hall, the Bridgewater Hall, it was closed. The City Council agreed to sell the Free Trade Hall, and plans were announced to demolish most of the building and erect a multi-storey hotel on the site. A campaign to preserve the hall only resulted in a modification of the plan. The original Peter Street façade, including Thomas's panels, was to be incorporated in the new building, but Howitt's building was to be demolished. Demolition began in June 2002. Sherwood Edwards's sculptures on Windmill Street were taken down with the intention that, after restoration, they would be displayed inside the new hotel.[4] They were restored and positioned in the atrium lightwell inside the hotel at the end of 2003.

Notes
[1] *Manchester Guardian*, 13 April 1950.
[2] *Manchester Evening Chronicle*, 13 April 1950.
[3] *Daily Dispatch*, 13 April 1950. [4] Information from Howard Elkins, La Sande, Stockport.

Piccadilly

Sir Robert Peel
William Calder Marshall

12 October 1853
Bronze statues; granite pedestal
Peel statue 3.2m high; female figures 2.13m
 high; pedestal 3.66m high × 4.4m × 2.26m
Signed on plinth: W.C. Marshall R.A. / Sculp /
 1853; The Bronze Works, Pimlico – on
 pedestal: W. Calder Marshall R.A. / Sculp
 London / 1853
Inscription on front of pedestal: PEEL – rear:
 BORN FEBRUARY V. MDCCLXXXVIII / DIED JULY
 11. MDCCCL / ERECTED BY PUBLIC
 SUBSCRIPTION / MDCCCLIII
Status: Grade II
Condition: good
Owned by: Manchester City Council

Description: Portrait statue; a larger than life-size bronze statue of Peel surmounting a stepped granite pedestal. Peel is shown in the act of public speaking, a cloak draped across the right shoulder and holding a scroll in his right hand. Two symbolic female figures are seated on the first stage of the pedestal. To Peel's right is a crowned female figure representing Manchester, holding a spindle of yarn in her left hand, while the other hand rests on a bale of cotton goods. To Peel's left, the female figure symbolises the Arts and Sciences. She is holding a book or tablet inscribed 'Ars et Scientia', and in her right hand a wreath. Objects associated with the arts and sciences – including a palette, sculptor's mallet and retort – are placed by her feet.

Biography: see p.250.

Manchester's first outdoor statue funded by public subscription was erected in memory of Sir Robert Peel in 1853. Previous proposals for such a statue, made at the time of the repeal of the Corn Laws, had not been taken forward.[1] Peel's sudden death brought unparalleled demonstrations of public feeling in Manchester

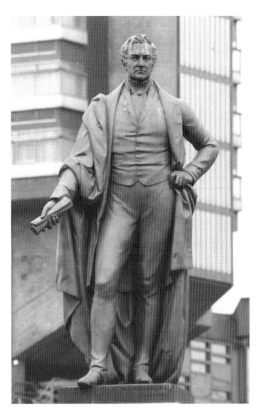

Calder Marshall, *Sir Robert Peel*

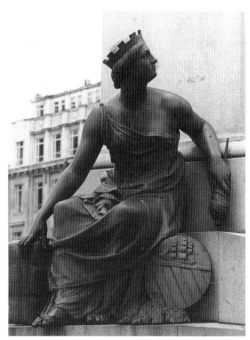

Manchester

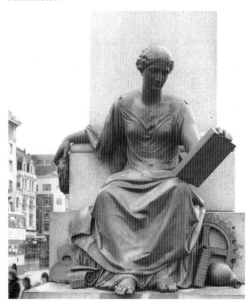

Arts and Sciences

and the satellite cotton towns. Arrangements were soon in hand to provide a permanent memorial to the man popularly regarded as having given the country the 'cheap loaf'. The Manchester Peel Memorial Committee was established in early July 1850, and determined on erecting a large outdoor statue. Within four days £3,000 had been subscribed, even though individual subscriptions were limited to 20 guineas.[2] The final sum totalled more than £5,000, collected from 1,057 individuals and businesses, as well as a small number of workplace collections.

Conscious of other Peel memorial projects and keen to obtain the best possible monument, the Manchester committee proposed a limited

competition, inviting sculptors to submit designs for a bronze portrait statue.[3] Edward Hodges Baily, John Lough and Patrick MacDowell were among those contacted in a list that also included a number of less established sculptors, including Marochetti and Theed. Concerned that the competition should not be settled by 'personal friendships or influential connections', the committee made James Prince Lee, Bishop of Manchester, responsible for its organisation. Models were to be submitted and displayed anonymously, Prince Lee alone knowing the names of the sculptors who had entered the competition.[4] The prickly question of how Peel should be dressed was left open, though the debate within the committee revealed strong opinions on the familiar issue of the suitability of using contemporary dress. Absalom Watkin implored the committee to abandon the practice of 'dressing up British statesmen in togas, as if they were going to a masquerade or fancy dress ball'.[5]

In spite of the efforts made to ensure openness and fairness in the competition, it was impossible to separate the raising of a memorial to Peel from party politics, especially as those politics had become a distinctive part of Manchester's own identity. Peel may have been a Conservative, but he had repealed the Corn Laws, the *raison d'être* of Manchester's Anti-Corn Law League. Thus whilst the memorial committee emphasised that support came from all parts of the community, not everyone was willing to set aside their political beliefs. The Manchester Tory, William Fleming, who had commissioned a statue of his late father from Edward Hodges Baily, wrote a 'strictly confidential' letter to the London sculptor which suggested the anxieties Manchester Tories had about the Peel memorial. He went on to suggest that the commissioning arrangements may not have been as open and fair as publicly stated.

I was in conversation the other day with a worthy Knight (Sir J. Potter) the antipodes to me in both politics and religion. For a purpose I stated to him the leading object of my protracted sojourn in London. 'Ah', he said, 'I called upon a London artist (in favour of whom Mr Milner Gibson interests himself) the other day with our Member for Salford about our Peel statue but he was not in London'. I remarked 'I have nothing to do with the Peel Testimonial because I regard it, first and last, as a free trade movement'. He replied 'most assuredly it is'. Now I know Milner Gibson to be hand in glove with Cobden, and I know in whose studio in London I saw Cobden's bust. I know that the owner of that studio was in the country about the time my worthy Knight was in London. I think I can guess very shrewdly who is likely to be patronised by the Free Trade Party if the thing be closely done. My motto for that artist would be 'quick and cheap'.[6]

Fleming was hardly an impartial witness and, moreover, he was not above pressing Baily's case in the competition, but his views do help to explain why some prominent Manchester individuals were absent from the subscription list.

Nine sculptors submitted 17 statuettes, which were placed in the Royal Manchester Institution for the committee to view.[7] How anonymous some of the entries were was debatable: William Calder Marshall's model was similar to one he had recently displayed in the town.[8] After a lengthy viewing the committee reduced the number of the models, before finally awarding the 3,000 guineas commission to Marshall, a sculptor better known for his poetic sculpture than for portrait statues. Marshall's model, which included two symbolic figures, had not impressed all the members of the selection committee.[9] Absalom Watkin noted that eleven members had supported Marshall with nine against, the decision being 'contrary to my opinion, but in

deference to that of the Bishop'.[10] For the losers there was the usual disappointment, though when Baily received his models back without even a formal letter, he was indignant about the boorish behaviour of these provincials:

I am very sorry I ever consented to enter the competition. It is the last I shall do so for I cannot afford to sacrifice thirty years reputation to the mere whim or ignorance of any set of Gentlemen however clever they may be in their own business, they know very little of art, for quantity seems to be the free trade motto.[11]

The memorial committee also had to decide on a site for the monument: an issue that was not straightforward, as Manchester had no obvious civic public space. It was Piccadilly or, more precisely, the area in front of the Manchester Royal Infirmary, that became the focus of the committee's discussions. The possibility of erecting the statue here became part of a wider project to create a more impressive public space.[12] Such a space might also be used to display other monuments. As early as November 1850, such speculation had reached Edward Hodges Baily, who, no doubt thinking of future commissions, was noting that Manchester intended to erect a number of statues in front of the Infirmary: 'viz Her Majesty, The Duke of Wellington and Sir Robert Peel which in my opinion will give good interest to that locality'.[13] The Infirmary Trustees, who had already embarked on a programme of improving the hospital's appearance, were generally sympathetic to the proposed changes, which would create a much grander public space – 'a most important and ornamental public improvement' – in front of the hospital.[14] By the time the negotiations were completed in 1853, it was evident that the Peel statue would not be the only one to be installed in Piccadilly. It was to be located at the Mosley Street end of the open space, whilst a monument to the Duke of Wellington would be placed at the Portland Street end. Thomas

Worthington produced a plan for the layout of the Esplanade, a design that was soon replaced by one from Sir Joseph Paxton.[15] The idea of a monument to Francis Egerton, the 'Canal Duke', was also revived, but, in the end, Liberal Manchester's foremost outdoor public space was to be dominated by colossal statues of two former Conservative prime ministers.[16]

A sub-committee of the memorial committee, whose members included Thomas Bazley and Salis Schwabe, liaised with Marshall over the details and production of the three figures.[17] In 1853 Marshall exhibited the plaster models of Peel and the two supporting figures at the Royal Academy.[18] The statues were cast at Robinson and Cottam's Pimlico foundry, the firm's technique of casting the entire figure in one piece impressing the correspondent of the *Art Journal*.[19] Peel was duly delivered to Manchester in early October 1853, though, for reasons unexplained, one of the subsidiary female figures appears not to have been completed in time for the inauguration.[20]

Manchester's Peel memorial was unveiled in October 1853, a day of public ceremony and political demonstration, in which Manchester's Liberal élite was prominent.[21] The chief guest was W.E. Gladstone. It was Sir John Potter, chairman of the memorial committee, who struck the keynote in declaring that

> most of us think that the welfare of our country, that the progress of our country, is mainly dependent upon the existence of commerce, that commerce has carried with it civilisation to the furthest corners of the world, but, above all, the measures of Sir Robert Peel have increased the contentment, the comfort, and the happiness of millions of operatives who inhabit this country.[22]

Peel was remembered as a Lancashire man and the statesman who had won the gratitude of ordinary people by his decision to repeal the Corn Laws. That the statue celebrated free trade was even more evident in the following week, when the missing female figure, representing Manchester, was installed. Observers could now note that the statue included a shield, bearing the borough's coat of arms, placed symbolically on top of a sheaf of corn. Peel may have taken the decision to repeal the Corn Laws, but it was the Anti-Corn Law League organised and based in Manchester that had made their continuation untenable.[23]

In spite of the committee's efforts to obtain the best statue, some questioned whether Marshall's *Peel* could be considered as a work of art. There was a sense of disappointment surrounding the work. One critic argued that the sculptor had failed to capture either a good likeness or a sense of the true character of Peel; the body was 'a jumble of evolutions' with a pointed knee, the 'creation of an effeminate hand'.[24] But the suggestion that the statue should be scrapped and recast was not taken up. The only minor change to the monument occurred at the time of the installation of the Wellington memorial, when it was raised to be in keeping with the landscaping of the Esplanade.[25]

The Peel monument quickly became a landmark in this busy part of the city. In the early twentieth century the Town Hall Committee considered re-siting it and the other statues on the Esplanade inside the grounds of the Infirmary but this plan was not implemented.[26] When the competition to design an art gallery and library for the site previously occupied by the Manchester Royal Infirmary was announced in 1911, architects were requested to take into consideration the adjacent statues, including the Peel monument. The proposed cultural building was never built, the site, instead, being laid out as a public garden. However, the plans announced in 1999 to redesign Piccadilly Gardens did result in the moving of some of the statues. In June 2001, the Peel monument was dismantled and the sculptures taken away for cleaning and conservation. The monument was reinstated in 2002, a short distance from its original location.

Notes

[1] *Manchester Guardian*, 5 and 23 May 1846, 18 July 1846. [2] *Ibid.*, 13 July 1850. [3] *Ibid.*, 12 October 1850. [4] *Ibid.*, 10 August 1850, 8 January 1851. [5] *Ibid.*, 31 August 1850; A.E. Watkin (ed.), *Absalom Watkin Extracts from his Journal 1814–1856* (London: T. Fisher Unwin, 1920) p.262. [6] W. Fleming to E.H. Baily, letter dated 20 August 1850. (Manchester Central Library, Local Studies and Archives). [7] Royal Manchester Institution Minutes, 5 December 1850, 8 December 1850 (Manchester Central Library, Local Studies and Archives, M6/1/49/5). *Manchester Guardian*, 8 January 1851. [8] *Manchester Guardian*, 9 October 1850. [9] W. Fleming to E.H. Baily, letter dated 26 January 1851. [10] Watkin, *op. cit.*, p.265. [11] E.H. Baily to W. Fleming, letter dated 10 February 1851. [12] *Manchester Guardian*, 10 July 1850, 7 August 1850. [13] E.H. Baily to W. Fleming, letter dated 5 November 1850. [14] Manchester Infirmary General Board Minutes, 4 April 1853, 15 April 1853, 9 May 1853. (Manchester Royal Infirmary Archives). [15] A.J. Pass, *Thomas Worthington Victorian Architecture and Social Purpose* (Manchester: Manchester Literary and Philosophical Society, 1988) pp.28–9. [16] *The Times*, 1 October 1852. [17] *Manchester Guardian*, 8 February 1851. [18] A. Graves, *The Royal Academy of Arts. A Complete Dictionary of Contributors*, Vol.3 (1905, 1970 reprint) p.196. [19] *Art Journal*, October 1853, p.267. [20] *Manchester Guardian*, 19 October 1853. [21] *The Times*, 14 October 1853. [22] *Manchester Courier*, 15 October 1853; *Manchester Examiner and Times*, 15 October 1853. [23] *Manchester Guardian*, 15 October 1853. [24] Nicodemus Newcomb the Elder, *The 'Wise Judgement' Examined, and Gabriel Tinto also. An epistle which may be found to have something of Gospel in it (and in which revelations of the Peel statue form the basis of prophecies as to the Wellington one) addressed to the promoters of fine art embellishments in Manchester* (Manchester, 1853). [25] *Manchester Courier*, 15 December 1855; *Manchester Guardian*, 1 September 1856; *Leisure Hour*, 6 (1857) p.125. [26] *Manchester Guardian*, 2 and 6 May 1904.

Duke of Wellington
Matthew Noble

30 August 1856
Bronze statues; granite pedestal
Wellington statue 3.9m high approx; seated
 figures 2.44m approx; pedestal 5.80m high ×
 5.7m square

Inscription: WELLINGTON / BORN MAY I /
MDCCLXIX / DIED / SEPTEMBER XIV /
MDCCCLII / ERECTED BY PUBLIC
SUBSCRIPTION / MDCCCLVI

Status: Grade II

Condition: fair

Owned by: Manchester City Council

Description: Portrait statue; a larger than life-size bronze statue of Wellington surmounting grey granite stepped pedestal at the corners of which are four seated symbolic figures. Wellington, dressed in frock-coat with military decoration, is depicted speaking in the House of Lords. A pile of Wellington's published military despatches is placed behind his right foot. The four bronze figures are seated on projecting pedestals. At the front is Mars, a sword in his hand, exemplifying valour, and the helmeted figure of Minerva representing wisdom. At the rear are two female figures: Victory, holding a wreath of oak leaves and a palm, and Peace, who is depicted holding a palm, and with a cornucopia at her feet. Four rectangular bas-relief panels acknowledge Wellington's roles as military commander and statesman. The panel between Peace and Victory depicts the Battle of Assaye, an engagement during Wellington's military service in India. The Battle of Waterloo is the subject of the panel between Minerva and Mars. The outcome of the Duke's military successes is represented on the panel between Peace and Minerva, where Wellington is shown receiving the thanks of the House of Commons in 1814, and on the panel between Mars and Victory which depicts him at the Congress of Vienna in 1815.

Arthur Wellesley was born in Dublin in 1769, the son of the Earl of Mornington. Following an education that included Eton and a French military school, he was commissioned into the army in 1787. His military talents became evident in India and included the decisive victory at Assaye in 1803. In 1809 he commanded the army in Portugal and Spain

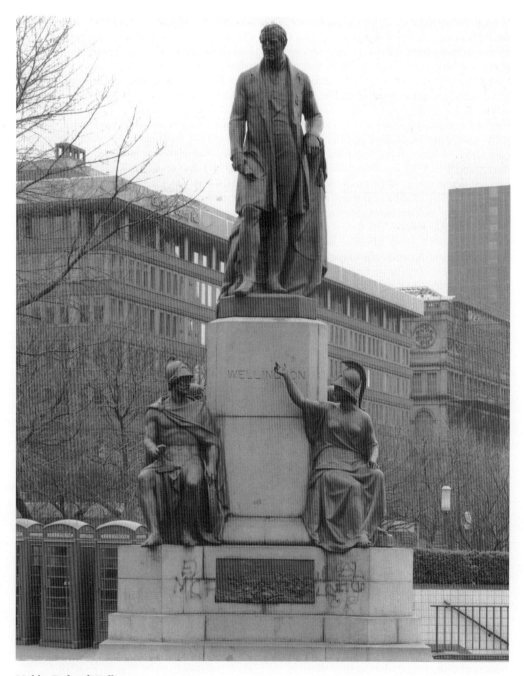

Noble, *Duke of Wellington*

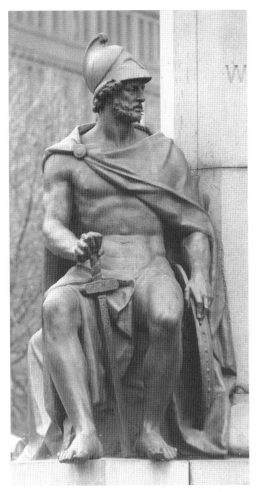

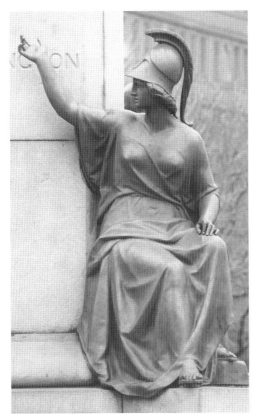

(left) *Mars*

(above) *Minerva*

(right) *Victory*

which eventually resulted in the defeat and expulsion of the French forces. Many public honours, both British and foreign, followed these military successes. Wellesley was created Duke of Wellington in 1814, and in the same year he thanked members of the House of Commons for their tributes which included a grant of £400,000. In 1815 he commanded the British forces that, with Blucher, defeated Napoleon at Waterloo. The following years saw him return to a political career. He had first held public office when MP for Rye, Sussex (1806–9). Wellington became Prime Minister in

1827, following Canning's death, and led the Tory government until he lost office during the reform crisis of the early 1830s. In 1834 he returned to government, but served as Foreign Secretary, having recommended Peel as Prime Minister. He continued to support Peel during the 1840s, though after his retirement he played a less obvious part in the nation's affairs. He died at Walmer Castle on 14 September 1852 and was buried with enormous ceremony in St Paul's Cathedral.[1]

Wellington's death was followed by a number of schemes to commission

commemorative statues. Monuments and statues, amongst which were works by Sir Richard Westmacott and Chantrey, had already been raised during his lifetime.[2] Manchester was one of the first provincial cities to decide to erect a public monument. Four days after Wellington's death a letter in the local press called for a statue to be placed in Piccadilly, adding that others might also be raised to honour the Duke of Bridgewater and James Watt.[3] By the end of September Manchester's Wellington Memorial Committee was established and its members, many of whom

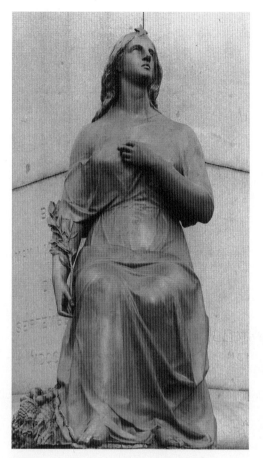

Peace

no more than two models on a scale of one inch to the foot. The memorial, including the pedestal, was to cost no more than £7,000. In what appears to have been an attempt to avoid the problems encountered in the commissioning of the Peel memorial, it was decided to leave the selection of the design to a small group of individuals: the Earl of Ellesmere, the Earl of Wilton and James Prince Lee, Bishop of Manchester. These were individuals who could be deferred to as connoisseurs, though the popular view of the Earl of Wilton was of an aristocrat more knowledgeable about horseflesh than art.[4] The committee did reserve the right, however, to reject the judges' decision.[5] On the question of location it was decided that the proposed statue would stand with the Peel monument in Piccadilly, but at the other end of the Esplanade.

Twenty-nine sculptors anonymously submitted 37 models for the Manchester competition. The models were put on display at the Royal Manchester Institution. In November 1853 the trio of judges examined the models and selected a formal standing portrait statue, the work of Matthew Noble, as the winner. This decision was subsequently confirmed by the general committee.[6] Controversy followed the public announcement of the decision. Popular feeling had favoured an equestrian statue, confirming Wellington in his role as a military leader, rather than one depicting him as an elderly politician. Correspondents writing to the local newspapers were in agreement that the committee had made the wrong choice, especially as one of the competition models, an equestrian figure by John Bell, had impressed many of the visitors to the exhibition.[7] Pseudonymous pamphleteers stirred up the public argument, declaring that Manchester was making a mistake, selecting a statue that was both inferior and uninspiring.[8] The *Builder* reflected the dissatisfaction, claiming that 20,000 of the 23,000 people who had visited the exhibition were in favour of Bell's model.[9] The London art press, which had become increasingly critical of the way in which rules were being flouted in provincial competitions, expressed surprise that a competition attracting many of the country's leading sculptors had been won by 'an artist of very third-rate power, and ability'.[10] Metropolitan critics were left to repeat their view that an appreciation of art was underdeveloped in money-making Manchester.

By January 1854 the recently established Sculptors' Institute entered the debate, asking the Manchester Wellington Committee some pointed questions about the organisation of the competition. Attention was drawn to the apparently brief time taken by the judges – said to have been as little as 20 minutes – to consider the models, and the fact that Noble had submitted three not two models. At the centre of these rumours and allegations was the Bishop of Manchester, who according to some reports had made it known before the competition that an equestrian statue was unsuitable, thus excluding 31 of the 37 models. The *Art Journal* focused on the public gossip flowing around Prince Lee:

> For whether we may, or may not believe that, before a single work in competition was sent in, the Bishop intended the testimonial to be executed by Mr Noble, and whether it be or be not true that the Bishop had previously intimated his conviction that an equestrian statue would not be selected, – thereby inducing Mr. Noble to send *three* figures, neither of which was equestrian – little doubt exists in Manchester, and as little among the sculptors who competed – that the 'examination' was merely a matter of form, and that Mr Noble was so well assured of the issue, that he might have pointed the marble a month or two before the award was made – while, indeed, the Right Reverend Prelate was in his *atelier*, examining the models during their preparation and progress.[11]

Prince Lee, no stranger to seeking legal redress when publicly attacked, did not respond

were able to draw on their experience as members of the Peel Memorial Committee, were beginning to seek subscriptions. The response to the idea of a memorial statue was surprisingly strong in a community in which Wellington had not always been politely received, and in which the dominant politics were Liberal. Within a week £3,937 had been collected or promised, a sum that was to increase to some £7,000. A competition was announced, and established artists, having first submitted their names and evidence of their work to the committee, were asked to provide

to these charges. The memorial committee, itself divided over the judges' decision, closed ranks; its secretary, Thomas Worthington, skilfully played a dead bat to the questions from the Sculptors' Institute and others.[12] The decision was not to be reconsidered, a new competition would not be organised.

Noble may have been only a relatively junior sculptor, but his reputation was beginning to take root in Lancashire, where the Peel statue mania had resulted in commissions in Liverpool and Salford.[13] The Manchester *Wellington* confirmed the promise of these works. Even so, the controversy could not be extinguished. In the spring of 1854 a letter signed by 21 Manchester artists and architects called on Bell to return his model to Manchester, so that it could be shown to the public again.[14] But the likelihood of reversing the decision was remote; moreover, Noble had started work on the commission. Changes to the original design were made as the work progressed. Wellington was now shown holding a document rather than the Field Marshal's baton – further reinforcing the characterisation of him as statesman, not military hero. It was in the treatment of the subsidiary allegorical figures and, in particular, in the historical incidents recorded in the bronze panels that the more popular view of the Iron Duke's military career was expressed. Robinson and Cottam cast the sculpture in their Pimlico foundry in May 1855. The casting was reported in the *Art Journal*, whose correspondent found the sculpture far more impressive than had been anticipated.[15] Noble, who was also completing a marble statue of Wellington for the East India Company's offices, was beginning to be recognised as more than a journeyman artist.[16]

The unveiling ceremony in August 1856 was a colourful spectacle, attracting a crowd estimated at 100,000. A parade of Waterloo veterans was a feature of the proceedings. After the main speeches and the transfer of the statue from the committee into the ownership of the corporation, it was left to the Bishop of

Manchester to thank the sculptor for producing this 'noble work – this lesson to posterity'.[17] No allusion was made to the controversies of the winter of 1853–4 but these must have been in Prince Lee's mind. Subsequently, he must have read the reports on Manchester's *Wellington* in the metropolitan press, notably in the *Art Journal*, as it too reassessed Noble's talents.[18] Manchester's *Wellington* monument strengthened Noble's reputation as a rising talent both in Lancashire and nationally. It also confirmed Piccadilly as the city's principal civic space; the installation of two major monuments having transformed the Esplanade into a public area of some distinction. Noble later presented a bust based on the statue to Salford Museum and Art Gallery.[19]

The Wellington monument became an important and much photographed feature of Piccadilly. Over 150 years its condition has varied with the council's willingness to spend money on cleaning and repairs. Road widening has also severely reduced the open space directly in front of the monument. In the 1990s its condition deteriorated, a neglect that was most obvious in cracks visible on the symbolic figures. The re-design of Piccadilly Gardens in 2001–2, which included the construction of a new office block on the Portland Street side, resulted in the temporary removal of the monument. Following cleaning and restoration it was returned to its original position in 2004.

Notes
[1] E. Longford, *Wellington* (London: Weidenfeld and Nicolson, 1969–1972) 2 vols. [2] B. Read, *Victorian Sculpture*, 1982, pp.91–3. [3] *Manchester Courier*, 18 September 1852. [4] [R. Leake], *Piece Work in the Overtime of a Business Man* (Manchester: Palmer, Howe & Co, 1893) pp.184–5. [5] *Art Journal*, May 1853, p.138. [6] *Manchester Courier*, 12 November 1853. [7] *Ibid.*, 19 November 1853, 26 November 1853, 3 December 1853, 10 December 1853. [8] Gabriel Tinto, *The Wise Judgement; being a chapter on the competing models for the Manchester Wellington Testimonial* (Manchester, 1853) p.11. [Gabriel Tinto was George William Anthony.] Nicodemus Newcomb the Elder, *The 'Wise Judgement' Examined, and Gabriel Tinto*

also. An epistle which may be found to have something of Gospel in it (and in which revelations of the Peel statue form the basis of prophecies as to the Wellington one) addressed to the promoters of fine art embellishments in Manchester (Manchester, 1853). [9] *Builder*, 3 December 1853, p.741, 4 March 1854, p.109. [10] *Art Journal*, December 1853, p.321. [11] *Ibid.*, January 1853. [12] *Manchester Guardian*, 15 March 1854. [13] T. Cavanagh, *Public Sculpture of Liverpool* (Liverpool: Liverpool University Press, 1997) pp.270–2; see below, pp.177, 195. [14] *Manchester Guardian*, 9 April 1854. [15] *Art Journal*, 1 June 1855, p.195. [16] *The Times*, 15 September 1855; *Art Journal*, October 1855, p.287. [18] *Manchester Guardian*, 1 September 1856; *Manchester Courier*, 6 September 1856; *The Times*, 1 September 1856. [18] *Art Journal*, 1 October 1856, p.319. [19] *Catalogue of Loan Collection of Pictures Jubilee Exhibition* (Salford [1894]) p.86.

James Watt
William Theed, after Chantrey

26 June 1857
Bronze statue; stone pedestal
Statue: 2.1m high approx; pedestal 2.4m × 1.49m × 2.37m
Signed on plinth: W. Theed – Copio 1857; Robinson & Cottam Statue Foundry Pimlico
Inscription on pedestal: WATT
Status: Grade II
Condition: good
Owned by: Manchester City Council
 Description: Portrait statue; a larger than life-size bronze statue of Watt who is shown seated, holding a pair of dividers in his right hand, ready to take measurements from a drawing of a steam engine shown on a scroll resting on his lap. The statue surmounts a stone pedestal.

James Watt, engineer and inventor, was born in Greenock in 1736. He trained as an instrument maker in Glasgow and then went to London, where he established a business. In the 1760s he began investigating ways to improve existing steam engines. His improvements, including the separate condenser, were commercially exploited in his partnership with Matthew

Boulton. Beginning in 1774 at the famous Soho works, Birmingham, Boulton and Watt manufactured the engines that made the use of steam power a practical reality for many industries. Watt was a versatile engineer and inventor. The design of an effective sculpture-copying machine was one of the mechanical problems that occupied him for many years. By the time of his death in 1819 Watt was already recognised as one of the central figures of the industrial revolution: the man who, more than any other, had made possible the Age of Steam.[1]

Manchester's statue of James Watt is the survivor of a pair of bronze statues that were originally positioned at the approach to the main entrance of Manchester Royal Infirmary. In planning the Piccadilly Esplanade in the early 1850s, it had been intended to place statues on and in front of the wall separating the Infirmary from the Esplanade. The first statue to be installed was of John Dalton, a bronze copy by William Theed of the marble statue carved by Chantrey. It was unveiled in 1855.[2] Shortly afterwards, the idea of a companion statue representing Watt was made public. It

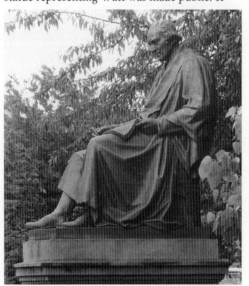

Theed, *James Watt*

was not the first time that Manchester had considered honouring Watt. A subscription list for a Watt statue had been opened in 1836, and a committee appointed to contact Chantrey, who had already been responsible for a number of statues of Watt including those in Westminster Abbey, Birmingham and Glasgow. However, no statue was commissioned.[3] The idea of a Watt statue was revived in 1855, and, as with the Dalton statue, it was the Manchester Literary and Philosophical Society that was the driving force. The Watt Memorial Committee was formally established at a public meeting held in the town hall in December.[4] It resolved that,

> considering the immense influence of the discoveries of James Watt on the progress of society, and the beneficial application of them in this community, a statue ought to be erected in this city, in honour of his memory and services.[5]

It was estimated that a statue would not cost more than £1,000. Watt may not have been a Manchester man (though his son James (1769–1848) had lived for a time in the town and had been a member of the Literary and Philosophical Society); but it was made clear that Mancunians had a duty to honour the individual without whom the world's first industrial city would not have been created. Following speeches acknowledging Watt's originality as an inventor and engineer, J.C. Dyer argued that Manchester should go further than a simple monument, and give consideration to founding a Watt Institute which would encourage the application of the mechanical sciences to industry.[6] Financial support for the statue came from other local associations including the Manchester Chamber of Commerce, as well as from individuals and businesses, some of whom had subscribed to the Dalton monument. As the statue was seen as a companion to that of John Dalton, the committee turned again to William Theed to provide a bronze copy of Chantrey's marble statue of Watt in Westminster Abbey.[7] Theed

accepted the commission, though whether he employed one of Watt's sculpture-copying machines to assist him is unknown. The casting, as with the earlier Dalton statue, was carried out by Robinson and Cottam of Pimlico.

The statue was unveiled by the Manchester engineer, William Fairbairn, in June 1857.[8] Fairbairn's own considerable achievements were to be recognised by a statue in Manchester Town Hall in 1878.[9] The ceremony was a rather low-key event compared to previous ones, perhaps a consequence of the grip that the Art Treasures Exhibition had on the city. The new statue appears to have been commissioned, produced and installed with few problems, leaving a small surplus to divide between the Literary and Philosophical Society and the Royal Infirmary.[10] But, whilst not receiving the publicity surrounding the Peel and Wellington monuments, this new addition to the public statuary in Piccadilly did not go unnoticed. The correspondent for the London-based *Art Journal* was unimpressed, rebuking a city with 'art pretensions' for not choosing to commission a new statue. Manchester, having already copied Chantrey's *Dalton*, was 'getting into the way of dealing in the old clothes of Art'.[11] Whatever the justice of such criticism, the two bronze copies of Watt and Dalton were powerful symbols of the worlds of science and technology, at whose junction were released the forces which made Manchester the world's first industrial city.

In the following years both the Watt and Dalton statues lost some of their visual presence, particularly following the demolition of the Infirmary in 1909. However, unlike the Dalton statue, *Watt* remained in Piccadilly. As part of the relandscaping of the gardens in 2001–2, the statue was restored and relocated at the front of the new gardens.

Notes
[1] L.T.C. Rolt, *James Watt* (London: Batsford, 1962). [2] See above, p.61. [3] *Manchester Courier*, 9 January 1836, 16 January 1836; *Manchester Guardian*, 16 January 1836, 23 January 1836; J.P. Muirhead, *Life of Watt* (London: J. Murray, 1858) pp.534–5. [4] *The*

Times, 12 December 1855. [5] *Manchester Guardian*, 15 December 1855; *Manchester Courier*, 15 December 1855; *Art Journal*, February 1856, p.57.
[6] *Manchester Courier*, 15 December 1855.
[7] Chantrey also produced a bronze in George's Square, Glasgow and marble ones in Handsworth Church, Glasgow College and Greenock Library; Muirhead, *op. cit.* [8] W. Pole (ed.), *The Life of Sir William Fairbairn Bart* (1877, reprinted Newton Abbot: David & Charles, 1970) pp.377–8. [9] See above, p.41. [10] *Manchester Courier*, 29 August 1857. [11] *Art Journal*, 1 October 1857, pp.308–9.

Queen Victoria
Edward Onslow Ford

10 October 1901
Bronze statues; Mazzano marble throne and pedestal
Statue of Victoria 2.9m high; throne 5.8m high approx; pedestal 1.52m high × 9.90m square. Statue of Motherhood 2.43m high approx
Inscription on pedestal: HER MOST GRACIOUS MAJESTY / QUEEN VICTORIA / ERECTED BY THE CITIZENS OF MANCHESTER IN 1901 TO COMMEMORATE / THE COMPLETION IN 1897 / OF THE SIXTIETH YEAR OF HER REIGN – pedestal beneath Motherhood: 'Let me but bear your love, I'll bear your cares'.
Status: Grade II
Condition: good
Owned by: Manchester City Council
 Description: Portrait statue; a larger than life-size bronze statue of Victoria seated on a large throne, holding a sceptre in right hand, an orb in the left. She is wearing a lace dress with the Order of the Garter; under the coronet is a veil. Above the Queen's head is the royal coat of arms. On the top of the Mazzano marble surround framing the statue is a bronze figure of St George fighting the dragon. On the rear of the surround, positioned in a recess decorated in coloured mosaic tiles, is a bronze sculpture of a female figure, representing Motherhood. She wears a crown of roses and thorns beneath drapery, and holds two infants in her arms. Beneath is a quotation from *Henry IV Part II*. The monument rises from six steps.

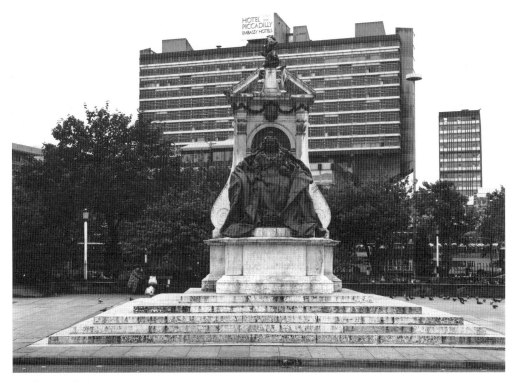

Onslow Ford, *Queen Victoria*

The idea that Manchester might raise a public statue of Queen Victoria was suggested on a number of occasions during her reign. Thus when, in 1854, Sir Joseph Paxton proposed a statue of the Queen as part of a plan for the Piccadilly Esplanade, he was merely repeating an idea that had been current for a number of years.[1] A statue of the Queen was also one of the ideas suggested by Alfred Waterhouse for the new town hall.[2] None of these particular schemes was realised, but Queen Victoria was to be commemorated in the city. A marble bust by Noble was presented to the City Council in 1856.[3] Out of doors, statues of the Queen were to be seen on the Queen's Buildings, John Dalton Street, the Lawrence Buildings, Mount Street and, shortly after her death, on the Victoria Porch, Manchester Cathedral.[4]

However, unlike Salford, where a life-size marble statue was installed in Peel Park in 1857, Manchester did not acquire a major public statue of the Queen until the beginning of the twentieth century.

The celebrations surrounding the 1897 Jubilee proved the catalyst for the commissioning of Manchester's statue of Queen Victoria. As in other communities, Manchester established a Jubilee Commemoration Fund. It collected some £19,000, a sum that was thought by some people to be disappointing but was explained in part by the fact that it followed almost immediately on the fund-raising efforts to relieve victims of the Indian famine. The Jubilee Commemoration Fund Committee, chaired by Sir Frank Forbes Adam, decided that part of the money raised would be used to

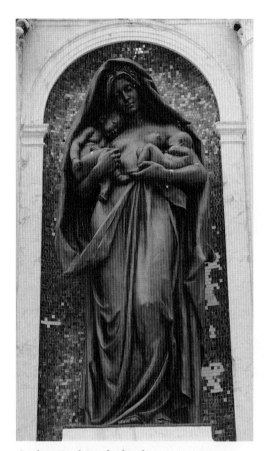

Onslow Ford, *Motherhood*

sculptors to provide outline designs for Manchester's *Victoria*. Having considered the drawings and photographs submitted, they agreed that no further competition would be necessary, believing that they had seen the best British sculptors. They then decided that Manchester's most important commission since the Albert Memorial would be awarded to Onslow Ford, who had emerged out of the 'new sculpture' movement to become one of the country's most admired and sought-after portrait sculptors. Ford accepted the commission, estimating that it would take some two years to complete. The cost would be between 2,000 and 2,500 guineas.[5] Ford was to have the benefit of a personal sitting from the Queen. A bust, exhibited at the Royal Academy in 1899, was commissioned for the royal collection.[6]

The Manchester commission did not proceed without changes, one of the most significant being the decision to use bronze rather than marble. This was attributed to the Queen's concern that marble would weather poorly in Manchester's notoriously smoky atmosphere.[7] The committee also settled the question of location, obtaining the necessary permissions to place the statue in front of the Infirmary, halfway between the Peel and Wellington monuments.[8] This was almost the exact location denied to the Albert Memorial in 1862.[9] By August 1900 Onslow Ford reported that the statue was at the foundry.[10] However, the promise that the memorial would soon be completed was not realised. It was not until the spring of 1901 that the work was sufficiently completed to be exhibited at the Royal Academy.[11] Victoria died in January 1901. In addition to the main statue Onslow Ford also decided to include a statue symbolising motherhood on the rear of the marble surround. Apart from its symbolic resonances, this sculpture avoided leaving pedestrians to stare at a blank marble wall on this busy public promenade. It also looked directly towards the entrance of the Royal Infirmary.

provide a statue. It was left to a sub-committee, appointed in May 1897, to determine the sculptor, the form of the statue, the site and the amount of money that would be spent on this part of the commemoration. At the first meeting of the Jubilee Committee, the essential features of the scheme were agreed upon: the statue would be of a colossal size and in Carrara marble, and it would be sited outside, preferably on the Esplanade in Piccadilly. On the question of the sculptor, the sub-committee sought advice from the Royal Academy about artists who had already sculpted the Queen. The sub-committee then approached nine

The inauguration of Manchester's Victoria jubilee memorial was a solemn occasion because of the Queen's death.[12] The statue was unveiled by Lord Roberts, Commander-in-Chief of the Army, in a ceremony that was notable for the lack of public order usually present on such occasions. One reason for this was that grandstands built to accommodate the 'privileged citizens and their ladies' obscured the view of sections of the huge crowd gathered in Piccadilly.[13] Confusion ensued as people pushed each other in an effort to find a better viewing point. Although the *Manchester Evening News* reassured its readers that 'nine-tenths of the people packed behind the barrier…were men of a distinctly rough type, who could well withstand the many rude buffetings they were necessarily subject to', others in the crowd proved less robust and required medical treatment.[14] Calls for order had little effect and only a few of the thousands gathered in Piccadilly could have heard Lord Roberts' speech. At the close of the ceremony some of the privileged guests found themselves using chairs and even a ladder 'to cross the spiked railing dividing Piccadilly from the Infirmary grounds', in an effort to avoid the crush. Although the unveiling ceremony was captured on film, the surviving newsreel footage concentrates on the unveiling rather than on the accompanying disturbances.[15] It was, the *Manchester City News* concluded, simply good fortune that no one was killed.[16] All this was clearly a long way removed from the visit made by the Queen to Manchester 50 years before to the very day, when she had confided that:

> There are 400,000 inhabitants in Manchester, and everyone says that in no other town could one depend so entirely upon the quiet and orderly behaviour of the people as in Manchester. You had only to tell them what ought to be done, and it was sure to be carried out.[17]

Onslow Ford's statue proved to be a controversial representation of the Queen. Even

before its arrival in Manchester it was severely criticised in the London press. Its reception at the Royal Academy in May 1901 was far from encouraging.[18] Critics found fault with both the statue and its architectural surround. The *Athenaeum* focused its criticisms on the Baroque marble frame:

> The architectural setting of the sculpture is, we think, altogether unfortunate. Massive supports of three different and incongruous varieties combine to uphold over the back of the throne a broken pediment. The angle at which the halves of this are set and the meagre proportions of the mouldings give them the ridiculous appearance of the folding lids of a box, out of which one expects at any moment some preposterous climax will emerge. The utter want of continuity in the style of this hybrid structure is still further seen in the quasi-Romanesque decorations of the side of the throne. With such a basis for the sculpture few designs could be expected to succeed, and Mr Onslow Ford's figure of the Queen has surely succumbed.[19]

The *Westminster Review* was equally disapproving, dismissing the setting as 'at once the most pretentious, the most incoherent and the most inept of any sculptural monument one has ever seen in England, which is notorious for its inadequacy in this particular line'.[20] Following the unveiling, Manchester voices swelled the chorus of fault-finders. Onslow Ford's sombre and weary-looking queen did not impress. Letters to the local newspapers expressed deep disappointment, unable to understand how the Jubilee Committee could have agreed to select such a representation of the elderly queen. One correspondent summed up the popular feeling: 'It is that as a work of art it is bad, and as a work of patriotism it is futile.'[21] A further indication of the popular mood was to be found in Salford Council chamber where references to Manchester's *Victoria* provoked laughter during discussions

of its own *South African War Memorial*.[22] Appreciative assessments were less easy to find.[23] One came from one of the leader writers of the *Manchester Guardian* who recognised the quality and distinctiveness of Onslow Ford's interpretation, asserting that the only sculpture in the city that warranted comparison with it was Chantrey's *Dalton*, Woolner's *Moses* and Gilbert's *Joule*.[24] The *Encyclopaedia Britannica* (1911) found it a work worthy of note, concluding that it was 'the most discussed and the least to be admired' of Onslow Ford's public sculptures.

Loathed or admired, Manchester's *Victoria* was simply too large and too centrally located not to become a landmark. It was, however, not immune to vandalism: the cross on the Imperial Crown was broken off before the First World War. In later years other parts – the cross on the orb, the cords on the Queen's robe, and St George's lance – were either removed or broken. The steps, when not protected with flower planters, also served as a meeting place for individuals and as a ready-made platform for unofficial public meetings.[25] Over the years calls were made for the monument to be moved out of the city centre or even demolished.[26] It was cleaned intermittently, and on one such occasion the operation was filmed.[27] By the 1990s the whole monument's condition was a cause for concern: the statue was damaged, cracks were evident in the marble surround, mosaic tiles were missing from the niche, graffiti and bird dirt abounded and the steps suffered from the skateboard craze. Plans to relandscape Piccadilly Gardens by Tadao Ando might have resulted in the removal of the monument, but it was eventually decided to leave it in its original position. The monument was cleaned and the sculpture restored in time for the opening of the new gardens in May 2002.

Notes
[1] A.J. Pass, *Thomas Worthington. Victorian Architecture and Social Purpose* (Manchester: Manchester Literary and Philosophical Society, 1988)

pp.28–9. [2] A. Waterhouse, 'Description of the new Town Hall at Manchester', *Royal Institute of British Architects Transactions*, February (1877) pp.126–7. [3] See above, pp.31, 37. [4] See above, pp.60, 73, 97. [5] *Manchester Guardian*, 30 September 1897. [6] M.H. Spielmann, *British Sculpture and Sculptors of Today* (London: Cassell and Co., 1901) p.54; A. Graves, *The Royal Academy of Arts. A Complete Dictionary of Contributors* (1970 reprint) Vol.2, p.137. [7] *Manchester Guardian*, 31 October 1899. [8] *Proceedings of Manchester City Council*, 2 May 1900, p.495. [9] *Manchester Guardian*, 1 August 1900. [10] *Ibid.*, 1 August 1900. [11] Graves, *op. cit.* [12] *Manchester Guardian*, 11 October 1901; *Manchester Courier*, 11 October 1901. [13] *Manchester City News*, 12 October 1901. [14] *Manchester Evening News*, 10 October 1901. [15] Film made by Thomas Edison Company. Shown in 'Time To Remember' series, Channel 4, June 1989. [16] *Manchester City News*, 12 October 1901. [17] A.C. Benson and V. Esher, *The Letters of Queen Victoria* (London: Murray, 1908) Vol.I. [18] A. Graves, *op. cit.* [19] *Athenaeum*, 8 June 1901, p.731. [20] Quoted in *Manchester City News*, 22 June 1901. [21] *Ibid.*, 26 October 1901. [22] *Bury Times*, 18 March 1905. [23] Letter from Stanley Withers in *Manchester City News*, 19 October 1901. [24] *Manchester Guardian*, 11 October 1901. [25] *Guardian*, 8 February 1970, 25 January 1971, 1 February 1971. [26] *Manchester Evening News*, 4 May 1963. [27] North West Film Archive, Manchester Metropolitan University. Film made by UMIST TV Society (No.785).

Portland Street

Britannia Hotel

The Sentry
Charles Sargeant Jagger

1921
Bronze statue; granite pedestal
Statue 2.13m high approx; pedestal 1m × 1.17m × 83cm
Signed on plinth: C. S. Jagger Sc
Inscription on panel fixed on opposite wall:
> 1914 1918 / TO THE ENDURING MEMORY / OF THOSE MEMBERS OF THE / STAFF OF S. & J. WATTS & CO. / WHO LAID DOWN THEIR LIVES / FOR THEIR KING AND COUNTRY / IN THE CAUSE OF / TRUTH JUSTICE AND FREEDOM /

DURING THE GREAT WAR [followed by the names of dead]
Status: Grade II
Condition: good
Owned by: Britannia Hotels Ltd
Description: War memorial; bronze statue of an ordinary soldier standing on guard, his hands holding the barrel of his rifle with bayonet fixed. A cape hangs heavily from his shoulders and arms, on his legs is the sacking used by soldiers to provide extra protection from the mud and water of the trenches. It surmounts a plain granite pedestal.

After the First World War, S. and J. Watts, one of Manchester's largest textile merchants, commissioned a memorial for those of its employees who lost their lives in the war. The Sheffield-born sculptor, Charles Sargeant Jagger, was awarded the commission. Jagger had joined the Artists' Rifles in 1914, and saw service in Gallipoli and France, being wounded and gassed. It was in his war memorials that Jagger began to find his own voice as a sculptor.[1] The recommendation of Sir George Frampton had been important in Jagger being awarded the war memorial at Hoylake and West Kirby, Wirral, and Jagger was working on this when he accepted the Manchester commission.[2] The location of the memorial was to be in the main entrance area of the Watts' building on Portland Street.

For the Manchester memorial Jagger returned to the powerful image of the solitary, ordinary soldier.[3] He depicted a solitary standing soldier, alert and determined, his cape and the sacking around his legs suggesting the terrible conditions endured at the front. The granite pedestal is plain, the inscription being on a panel mounted on the opposite wall. The latter was the work of Hubert Worthington. A bronze maquette of the memorial survives.[4] Shortly after its installation, the powerful dignity of the sculpture was recognised by the Liverpool architect, Charles H. Reilly. He wrote:

It is extraordinarily impressive as it stands there with intense immobility, a little large and crude perhaps for its surroundings; such a figure makes one understand the rock of national character against which the German flood broke in vain. It is truly monumental in its combined steadfastness and power. It is sculpture like this, and this only, free from any trivial suggestions, that can at all express the depth of feeling the war called forth. Some day Messrs Watts should remodel

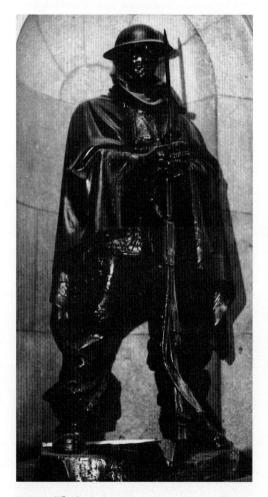

Jagger, *The Sentry*

their loggia to suit better their fine and solemn memorial.[5]

Francis Jones, president of the Manchester Society of Architects, also found it impressive.[6]

The memorial stands in what has long been recognised as one of the city's most architecturally distinctive commercial buildings. It served as the head office of the Watts company from its opening in 1858 until taken over by Courtaulds in 1966. The problems of the cotton industry, however, continued and the building, like those who worked in it, became redundant. It stood empty for a number of years, until it was eventually converted into a hotel. The Britannia Hotel opened in 1984. *The Sentry*, however, unlike some of the memorials in other Manchester warehouses and businesses, survived these changes. It remains in its original position, looking across an entrance area that has remained largely unaltered, an important and powerful memorial. The firm erected a separate memorial, depicting the risen Christ, after the Second World War, later extended to include the dead of the Korean War.

Notes
[1] Ann Compton (ed.), *Charles Sargeant Jagger. War and Peace Sculpture* (London: Imperial War Museum, 1985). [2] C. Moriarty, 'Narrative and the Absent Body. Mechanisms and Meaning in First World War Memorials', unpublished PhD thesis, University of Sussex, 1995, p.126. [3] *The Sentry* was one of a number of memorials depicting soldiers in the trenches but not in combat. For example, *Soldier with Rifle*, *Soldier Reading a Letter*. [4] In the Council of the British School at Rome. [5] *Manchester Guardian*, 9 February 1923. [6] *Builder*, 15 December 1922, p.910.

Quay Street

The Opera House

The Dawn of the Heroic Age

Architects: H. Farquharson, Albert Richardson and Lovett Gill

Architectural sculptors: John Tanner and Son

26 December 1912
Stone
3.05m high × 6.85m long approx
Inscription on frieze: THE PLAY MIRRORS LIFE
Status: Grade II
Condition: fair

Description: Tympanum containing a bas-relief depicting a charioteer pulled by three horses, with a second man following the chariot. The panel is above a frieze on which is the inscription.

The New Theatre on Quay Street was designed by H. Farquharson, Albert Richardson and Lovett Gill. When it opened in 1912 it was the city's largest theatre. The tympanum above the Ionic columns on the Quay Street façade contains a large bas-relief entitled *The Dawn of the Heroic Age*. It was the work of John Tanner and Son. Charles Reilly was generous in his praise of the building, including the relief.[1] The theatre was managed by Richard Flanagan whose Shakespeare revivals at the Queen's Theatre had made him a leading figure in Edwardian Manchester. Changes in ownership and name followed and it was at the beginning of the 1920s that the theatre took on its now familiar name. For the next 50 years the Opera House was to be one of the city's most popular theatres. It closed in 1979, but the closure proved not to be permanent, and, in 1984, it reopened as a theatre.[2]

Notes
[1] C. Reilly, *Some Manchester Streets and their Buildings* (Liverpool: Liverpool University Press, 1924) pp.118–19. [2] T. Wyke and N. Rudyard, *Manchester Theatres* (Manchester: Bibliography of North West England, 1994) pp.44–5.

Tanner and Son, *The Dawn of the Heroic Age*

Sackville Street

Sackville Park

Alan Turing

Glyn Hughes

23 June 2001
Silicon bronze
Statue 1.35m high; bench 90cm × 1.57m
Signed: Glyn Hughes; Tianjin Focus Foundry
Inscription on plaque in front of bench: ALAN MATHISON TURING / 1912–1954 / FATHER OF COMPUTER SCIENCE / MATHEMATICIAN, LOGICIAN, / WARTIME CODEBREAKER, / VICTIM OF PREJUDICE / "Mathematics, rightly viewed, possesses not only truth but supreme beauty, a beauty cold and austere like that of sculpture". – Bertrand Russell – on bench: ALAN MATHISON TURING 1912–1954 / IEKYF ROMSI ADXUO KVKZC GUBJ
Status: not listed
Condition: good
Owned by: Alan Turing Memorial Trust

Description: Portrait sculpture; a life-size figure of Alan Turing who is shown seated on a park bench, dressed in his everyday clothes, holding an apple in his right hand.

Alan Mathison Turing was born in 1912 in Paddington, London. He was an undergraduate at King's College, Cambridge, in the early 1930s and later went on to study for a PhD at Princeton University. In 1936 he published his seminal paper on computable numbers. During the Second World War he was employed at Bletchley Park, decrypting the German Enigma code. After the war he worked in the National Physical Laboratory in London before arriving at the University of Manchester in 1948; there he developed programming for the earliest computers, working on the Manchester Automatic Digital Machine. He was arrested and prosecuted for homosexual behaviour in Manchester in 1952. In 1954 he committed suicide at his home in Wilmslow, near

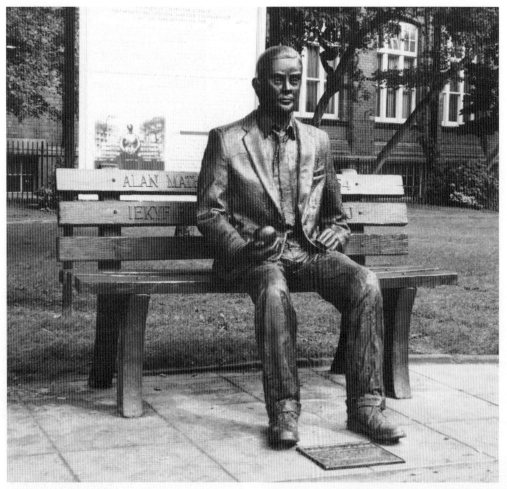

Hughes, *Alan Turing*

Manchester, by taking a bite from an apple poisoned with cyanide.

Public interest in the life and work of the mathematician, Alan Turing, increased enormously in the 1980s. The publication of Andrew Hodges' biography, *Alan Turing the Enigma* (1983) and Hugh Whitemore's play, *Breaking the Code* (1988) contributed to a broader awareness of Turing's contribution to computer programming, and also the prejudice

he experienced as a homosexual. A blue plaque was unveiled at his birthplace in London, while in Manchester, where there was a large and well-organised gay community, a section of the city's ring road was renamed the Alan Turing Way. In 1996 a memorial fund was established with the intention of raising funds to commission a statue to be placed in Manchester. An initial target of £50,000 was set. Sir Derek Jacobi, who had portrayed Turing in Whitemore's play, was the fund's patron. Fund-raising progressed slowly, support coming from the British Society for the History of

Mathematics and Manchester City Council, though most of the money was donated by individuals. The reluctance of the world's major computer companies to support the project was noteworthy.

Glyn Hughes, an industrial designer based in Adlington, Lancashire, who had taken a special interest in the project, was given the commission. Hughes, dissatisfied with the conventions surrounding public statues, decided to portray Turing sitting on a park bench, wearing his everyday, somewhat scruffy, clothes. John Coll's sculpture of the poet Patrick Cavanagh on the Grand Canal, Dublin was an influence. The only obvious visual clue to a less ordinary life was the apple placed in Turing's right hand, a symbol that echoed his tragic death and, of course, linked Turing to Newton. The inscription on the bench included a string of letters representing the Enigma code.[1] Discussions on the location of the statue resulted in Manchester City Council granting permission for it to be sited in Sackville Park, a park situated appropriately between the University of Manchester Institute of Science and Technology and the city's gay village. An HIV/AIDS memorial, *The Beacon of Hope*, a tall stainless steel column perforated with hearts, designed by Warren Chapman and Jess Bryne-Daniel, was also to be located in the park.[2]

Some £15,000 had been contributed to the Turing fund by the end of 2000, a sum that was still far short of the original target. This shortfall prompted a new course of action. It was decided to have the sculpture cast in China – by the Tianjin Focus Arts and Crafts Company – rather than in Britain. This arrangement worked reasonably smoothly and the statue was delivered to Manchester in 2001. Hughes installed the sculpture, placing a personal computer in the foundations of the site. The sculpture was unveiled on 23 June 2001, the anniversary of Turing's birth, by Andrew Hodges, the author of *Alan Turing the Enigma*, and by Dr Judith Field, former

President of the British Society for the History of Mathematics. The ceremony was attended by what was described as an 'exotic crowd' who heard speakers emphasise Turing's path-breaking work in mathematics and computing, and the prejudices directed at his sexuality.[3]

Notes
[1] Information from Glyn Hughes, June 1999. The original encoded letters read 'Founder of Computer Science'. [2] *Manchester Evening News*, 20 August 1999. [3] *Ibid.*, 25 June 2001.

St Ann's Square
Richard Cobden
Marshall Wood

22 April 1867
Bronze statue; granite pedestal
Statue 3.05m high approx; pedestal 2.26m high
 × 1.65m square
Signed on plinth: Marshall Wood. Sc 1867
Inscription: COBDEN
Status: Grade II
Condition: good
Owned by: Manchester City Council
 Description: Portrait statue; a larger than life-size bronze statue of Cobden, who is depicted addressing a public meeting. His right arm is outstretched with the index finger of the hand raised, his other hand is inside his waistcoat. The statue surmounts a granite pedestal inscribed with the single word, 'Cobden'.

Richard Cobden was born in Heyshott, near Midhurst, Sussex, in 1804, the son of an unsuccessful small farmer. He received little formal schooling and at the age of 14 became a clerk in the cloth trade. He later started his own business selling calico prints. He moved to Manchester, where in the 1830s he emerged as one of the leading figures in the campaign to establish a democratically elected local council. Cobden was elected as one of the first aldermen of the new borough council. He was also a supporter of economic reform and his involvement in the campaign to repeal the Corn Laws led in 1839 to the establishment of the Anti-Corn Law League. Cobden and John Bright, whom he recruited to the League, became the most famous of the League's organisers. In 1841 Cobden was elected MP for Stockport, by which time he was already a national figure. The repeal of the Corn Laws in 1846 saw him fêted as a hero in Lancashire. He continued to campaign for Liberal causes, especially parliamentary reform and education. His house in Quay Street was to become the first home of Owens College, the forerunner of the University of Manchester. Cobden's determined opposition to an aggressive foreign policy, especially during the Crimean War, caused public opinion to turn against both himself and Bright. Both men lost their seats in the general election of 1857. Cobden re-entered parliament as the member for Rochdale in 1859. In 1860 he was instrumental in negotiating a new commercial treaty with France. On 2 April 1865, Cobden died of bronchitis.[1]

In the weeks following Cobden's funeral a number of Lancashire towns announced schemes to erect public monuments.[2] At Manchester's first public meeting, called by the mayor, John Marsland Bennett, on 18 April, rich tributes were paid to Cobden by fellow Liberals and free traders, including Henry Ashworth, Thomas Bayley Potter and Edward Watkin. The need to raise a statue was accepted, though Potter, who had been at Cobden's deathbed, pointed out that Cobden himself would not have wanted it. Rather, he would have said: 'Establish some institution, establish some chair of political economy, or some scholarship, by which the doctrines I have preached and held forth may be spread throughout the length and breadth of the land.'[3] But the overwhelming feeling was that Manchester should raise a statue, with any surplus money being used for educational purposes. A subscription list was opened to all classes.[4] The commission for the statue was given to the Manchester-born sculptor, Marshall Wood, whose bust of Cobden had been enthusiastically praised by the *Manchester Guardian* when displayed at the Royal Exchange in Manchester.[5] Wood depicted Cobden addressing the House of Commons in 'an argumentative rather than declamatory attitude'.[6] The memorial committee explored a number of possible sites for the statue. The idea of placing Cobden between the Peel and Wellington monuments in Piccadilly was turned down by the Infirmary trustees, who indicated that this particular site should be kept for a royal memorial. Other locations were considered before the memorial committee

Wood, *Richard Cobden*

decided on St Ann's Square, where the statue was to face towards the Royal Cotton Exchange. The Corporation agreed to the committee's request. Raising the necessary funds proved a relatively easy matter. The major part of the £4,460 subscribed was given by over 800 'commercial men and firms', though the committee drew attention to the £85 collected in local factories and warehouses, as well as from the pupils of the Manchester Grammar School. Wood appears to have encountered few problems in producing the statue, which was cast at Henry Prince's foundry in Southwark.[7]

The unveiling of the Cobden statue on Easter Monday, 1867, was a carefully choreographed political occasion, when the region's Liberals celebrated their beliefs and Cobden's contribution to them. An enormous procession – trade societies, friendly societies, co-operative societies, temperance societies and political societies – made their way around the town before converging on St Ann's Square.[8] The presence of the Reform League and of the National Reform Union was a reminder of ongoing political campaigns. Of the banners and symbols carried in the procession, none spoke more to the crowd than two imitation loaves of bread: an enormous loaf bearing the message 'Free Trade' contrasting with a smaller one labelled 'Protection'. The memorial committee had hoped Gladstone would unveil the statue, but in his absence the honour was given to George Wilson, the popular and ever efficient chairman of the Anti-Corn Law League, who had worked closely with Cobden.[9] Speakers remembered Cobden's achievements and his connections with Manchester, though, understandably, no reference was made to those occasions when Cobden's politics had not found favour in the city. It was difficult to sum up the career of one of the century's most important politicians, but Wilson found the appropriate words. He reminded the crowd that Cobden's true monument was not to be found in St Ann's Square or in other Manchester

buildings – the Free Trade Hall and the Athenaeum; rather, his real monument was 'to be seen three times a day in the homes and on the tables of the working men of this country'.[10] Although the region's leading Liberals were present at the unveiling, a notable absentee was John Bright, but this did not stop the huge crowd giving him three cheers.[11]

In welcoming Manchester's statue to the 'Apostle of Free Trade', the *Manchester Guardian* agreed that the city 'had done no more than justice to its own intelligence and gratitude'.[12] The subscription fund easily covered the £2,300 costs. The surplus was used to establish a chair of political economy at Owens College and provide prizes for teachers.[13] The local tributes to Cobden did not stop there. Salford erected its own commemorative statue in Peel Park, and Stockport also, belatedly, raised one.[14] Cobden was further memorialised in the Manchester Athenaeum with a marble medallion by William Theed – an acknowledgment of his role in founding the institution.[15] More predictably, busts were also displayed in the town hall and the Reform Club.[16]

The Cobden statue remained in its original position, in the centre of St Ann's Square, near to the Royal Cotton Exchange, until 1984, when landscaping and further pedestrianisation of the square resulted in its being moved to its present position, nearer to St Ann's church.[17]

Notes
[1] N.C. Edsall, *Richard Cobden: Independent Radical* (Cambridge, Mass: Harvard University Press, 1986). [2] See below, p.198. [3] *Manchester Guardian*, 19 April 1865. [4] *The Times*, 19 April 1865. [5] *Art Journal*, November 1865, p.346; Gunnis, 1968, p.274 attributes the statue to Noble not Wood.
[6] *Illustrated London News*, 27 April 1867.
[7] Inscribed on plinth. The alloy contained only copper and tin, no zinc. [8] *Illustrated London News*, 27 April 1867; *The Times*, 23 April 1867.
[9] *Manchester Guardian*, 10 April 1867. [10] *Ibid.*, 23 April 1867. [11] W. Robertson, *Life and Times of the Right Honourable John Bright* (London: Cassell & Co, 1884) vol.2, pp.50–1. [12] *Manchester Guardian*, 23 April 1867. [13] *Ibid.*, 2 March 1866, 6 March

1866. [14] See below, p.344. [15] *Novelty Magazine*, 1 July 1883, p.168; *The Manchester Athenaeum* (Manchester, 1903) p.22. [16] See above, pp.44, 86. [17] P. Stewart, *Central Manchester* (Stroud: Chalfont Publishing, 1995) pp.41–2; *Manchester Evening News*, 20 August 1983, 25 June 1984.

South African War Memorial
William Hamo Thornycroft

26 October 1908
Bronze sculpture; granite pedestal
5m high approx; pedestal: 4m × 1.5m square
Signed: Hamo Thornycroft R.A. Sc. 1907
Inscription around top of pedestal: TO THE MEMORY OF THE FOLLOWING / OFFICERS NON-COMMISSIONED OFFICERS / AND MEN WHO FELL IN THE WAR / IN SOUTH AFRICA 1899–1902 / GALLANTLY SERVING THEIR SOVEREIGN & COUNTRY – front at base: THIS MONUMENT IS ERECTED BY PUBLIC SUBSCRIPTION
Status: Grade II
Condition: good
Owned by: Manchester City Council
Description: War memorial; a larger than life-size soldier of the Manchester Regiment is shown standing with his rifle and bayonet fixed, defending a wounded comrade who, slumped at his feet, is offering him a cartridge to continue the fight. The plinth represents a large rough rock, on the front of which is a wreath of bay leaves. Bronze plaques are fixed on all sides of the pedestal, three recording the names of the dead, ending with the phrase 'and those others who cannot be named'.

The memorial raised to the men of the Manchester Regiment who died in the South African War was the city's first major outdoor war memorial. Calls for a memorial had been made during the war itself, following reports of the heroic actions of the Manchester Regiment, but it was felt that such an act would be premature.[1] Towards the end of 1902 the Manchester Regiment began to consider

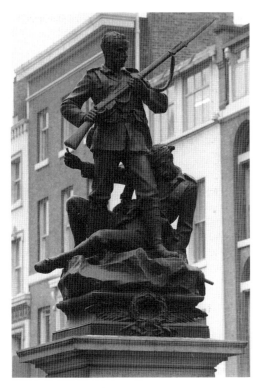

Thornycroft, *South African War Memorial*

schemes to memorialise their fallen comrades. Proposals included an outdoor war memorial, a tablet in Manchester Cathedral and, more ambitiously, a soldiers' club. The idea of the outdoor war memorial and a smaller one in the Cathedral was accepted. The initial proceedings of Manchester's Soldiers' War Memorial Fund were uncontroversial as the committee set about raising £2,000, the sum it set to realise the project. By January 1904 subscriptions totalled over £1,900, and the committee turned to the question of selecting a sculptor.[2] A limited competition appeared to be the way forward, and the executive committee recommended that six sculptors – George Frampton, William Hamo Thornycroft, Henry Pegram, Alfred Drury, Frederick Pomeroy and John Cassidy – be invited to submit designs.[3] But this

recommendation was not accepted by the general committee, which decided to appoint Thornycroft. The decision upset some subscribers who believed that there should have been an open competition. It was 'the narrowest and worst form of Protection, unworthy of a broad-minded, progressive Free Trade city like Manchester'.[4] More particularly, a group of subscribers seemed to have wanted the commission to go to the Manchester sculptor, John Cassidy, and they used the press to draw attention to what they regarded as the disreputable behaviour of Thornycroft's supporters on the committee.[5] The upshot was that the Lord Mayor called a special private meeting of the committee to examine the case, but the decision was not changed, Thornycroft was to be the sculptor.[6] Thornycroft's announcement that, because of other commissions, he would not be able to complete the memorial for two and a half years did little to quieten the grumblings over his selection. Cassidy, however, was not forgotten by his supporters, being commissioned privately to produce his intended memorial.[7]

When Thornycroft eventually began work on the memorial, the composition was based on an incident during one of the regiment's most celebrated engagements, the fighting at Caesar's Camp, near Ladysmith. It depicted two figures, one soldier standing over a wounded comrade who is holding out a cartridge to continue the fight.[8] The models were two soldiers from the regiment; one was Captain Edmund Nelson Fisher, whose family was later presented with a bust based on the statue.[9] Thornycroft had been right to warn that the memorial would not be completed quickly. It was cast at Singer's foundry at Frome in 1907 but not finally finished until the following year.[10] The committee was also still requesting funds, pointing out that Thornycroft's fee of 2,000 guineas was not the memorial's true value. The sculptor had not been concerned with cost but with ensuring that 'his first statue in Manchester should be worthy of himself and the

gallantry of the Manchesters in South Africa'.[11]

The war memorial's location was still undecided in 1907 when the memorial committee approached the Town Hall Committee to discuss placing it in Albert Square. It was suggested that it might be located on the site of the Jubilee Fountain, the removal of which was being contemplated, or, if that was not suitable, that Bishop Fraser's statue should be moved to that location so that Thornycroft's memorial could be positioned on the edge of the square.[12] The Town Hall Committee, however, ruled out Albert Square. Further discussions followed, resulting in an agreement to locate the memorial in St Ann's Square. Local shopkeepers, campaigning to improve the square, welcomed the idea.[13]

As preparations for the long-awaited inauguration were being made – Salford's memorial had been unveiled three years before – a further appeal was made to reduce the outstanding deficit.[14] Manchester's principal South African War memorial was unveiled in October 1908, almost six years after the first official meetings. General Sir Ian Hamilton recalled the heroic deeds of the Manchester Regiment in South Africa, including their battle at Elandslaagate, before he removed the Union Jack covering the memorial.[15] Thornycroft's depiction of the dramatic episode in the war found widespread approval, a sculpture that was an important addition to the city's public monuments. In the words of the *Manchester Guardian,* it was a work that was 'dignified, impressive and rich with virile beauty'.[16] But had journalists made a closer study of the sculpture, particularly the names of the dead, they would have discovered that this was a soldiers' memorial; not all those killed in the war were recorded. Among the names missing was Edward Scott, the *Manchester Courier*'s correspondent (Scott was to be remembered in William Goscombe John's journalists' memorial in the crypt of St Paul's Cathedral).[17] The war memorial became a place of remembrance for the Manchester Regiment on

Elandslaagate Day (October 21) and, later, on Remembrance Day.[18] In spite of the many changes made to the square, especially in recent years, the memorial has remained in its original position, the granite protectors at the corners of the pedestal a reminder of a time when wheeled traffic filled the square.

Notes
[1] *Manchester Guardian*, 21 and 24 April 1900.
[2] *Ibid.*, 9 January 1904. [3] *Builder*, 86 (1904) p.232.
[4] *Manchester Guardian*, 11 March 1904. [5] *Ibid.*, 20 February 1904, 14, 17 and 23 March 1904, 18 April 1904. [6] *Ibid.*, 14 April 1904. [7] Exhibited at the Royal Academy in 1905. [8] E. Manning, *Marble and Bronze. The Art and Life of Hamo Thornycroft* (London: Trefoil Books, 1982) pp.150–1, 197.
[9] Letter from M. Walford, 10 January 1997; information provided by Robert Bonner.
[10] *Manchester Courier*, 27 October 1908.
[11] *Manchester Guardian*, 10 October 1907.
[12] *City of Manchester Council Proceedings*, October 1907; *Manchester Guardian*, 10 October 1907.
[13] *Manchester Evening News*, 12 October 1908.
[14] *Manchester City News*, 24 October 1908.
[15] Colonel H.C. Wylly, *History of the Manchester Regiment* (London: Forster Groom, 1925) Vol.2, pp.76–9; *Manchester Guardian*, 27 October 1908; *Manchester Courier*, 27 October 1908; *The Times*, 27 October 1908. [16] *Manchester Guardian*, 27 October 1908. [17] L. Weaver, *Memorials and Monuments* (London: Country Life, 1915) p.295, 297.
[18] *Manchester Courier*, 16 October 1913.

Manchester Liners House

Architect: Harry S. Fairhurst

Architectural sculptors: Earp, Hobbs and Miller

1922
Portland stone
3.05m high approx × 1.52m approx
Condition: good
Description: Stone carving on the splayed corner of the former Manchester Liners offices, above doorway. The carving represents the prow of a boat with a ram's head as the figurehead. The boat is surmounted by an eagle and at its base are two dolphins.

Manchester Liners House (detail)

The shipping company, Manchester Liners, was established following the opening of the Manchester Ship Canal. The North American trade was the foundation of its prosperity, and after the First World War its presence in the city was underlined by its commissioning the Manchester architect, Harry Fairhurst, to design new company offices. The site was at the junction of Old Bank Street and St Ann's Square. The five-storey building was in

Portland stone. In keeping with the design, the architectural decoration was restrained. However, the corner splay facing into the square offered the opportunity for some sculptural decoration, an opportunity that Fairhurst could not resist. Earp, Hobbs and Miller were the firm responsible for the appropriately nautical subject of a richly decorated ship's prow ploughing through the sea. It is a lively piece and fills the bottom of the long rectangular space.[1] The company moved into its new building in August 1922.[2] In the inter-war years it was one of the city's most admired commercial premises, though not all critics would have gone as far as Charles Reilly, who declared that 'the elegant lady-like strip of the Manchester Liners Building' was one of the few points of architectural interest in St Ann's Square.[3] In 1969 Manchester Liners moved to new offices on Salford docks.

Notes
[1] *Builder*, 28 July 1922, p.131, 15 December 1922, pp.918, 923. [2] R.B. Stoker, *The Saga of Manchester Liners* (Douglas, Isle of Man: Kinglish, 1985) p.18.
[3] *Manchester Guardian*, 7 June 1924.

Fountain

Peter Randall-Page

June 1996
Red Taivassalo granite; black Zimbabwe granite
Central carving 2.2m high × 2m wide; drum 4m diameter; basin 6m square
Condition: good
Owned by: Manchester City Council
Description: Fountain in the form of a carved stylised flower bud, surmounting a circular black granite base standing inside a square stone basin edged in the same pink stone as the flower bud. The water cascades over the black drum into the basin, creating the effect of the bud floating on top of the water.

Manchester City Council began work on a major landscaping and pedestrianisation scheme

for St Ann's Square in 1993. The scheme included a fountain to be located in the centre of this important public space. The first phase of the scheme included the introduction of slab seating and 'cannonball' bollards, features that received both praise and criticism.[1] A limited competition was organised for the fountain. Designs were submitted by seven sculptors: David Backhouse, Graham Ibbeson, David Norris, Peter Randall-Page, Edwin Russell, Alan Sly and Andrew Wallace. Models and drawings were put on public display in the town hall.[2] Peter Randall-Page's closed flower bud, resembling a water-lily, resting on a circular dark granite drum in the centre of a shallow square basin was selected. His inspiration came from the influence of plant forms on his work as well as a recognition of the frequent use of plants in the architectural decoration in Manchester. Initially, he had explored the idea of using a more obvious botanical reference – the cotton plant – but rejected it, believing that its form was not suitable for a stone sculpture. He was asked, however, to look at making the fountain more

thematically relevant to the city, and, following further study of the cotton plant, he incorporated elements of an opening cotton boll into the design. The light red granite stone selected for the bud acknowledged the red sandstone of St Ann's Church. The work was funded by the City Council in partnership with the European Regional Development Fund and businesses associated with the square. The fountain was being installed in June 1996, at the time when an IRA bomb devastated this part of the city. The fountain was undamaged but the problems in the aftermath of the bomb help to explain why there was no formal unveiling ceremony.[3]

Notes
[1] *Manchester Evening News*, 15 September 1993, 16 March 1994, 12 January 1995, 4 December 1995.
[2] *Ibid.*, 7 February 1995. [3] Information from Peter Randall-Page.

Randall-Page, *Fountain*

St Peter's Square

St Peter's Cross
Temple Moore

29 September 1908
Portland stone
10m high approx; pedestal 2.1m × 60cm
Inscription: THIS CROSS ERECTED IN AD 1908
RECORDS THE PLACE WHERE THE CHURCH OF
ST PETER'S STOOD FROM A.D. 1794 TO 1907
Status: Grade II
Condition: poor
Owned by: Unknown
 Description: Portland stone memorial cross rising from a stepped base. The column is decorated with three angels holding shields on which are carved the keys of St Peter.

This cross marks the site of St Peter's Church. Designed by James Wyatt, St Peter's was built to meet the demand for church accommodation at a time when Manchester's population was increasing rapidly. Even so, when it was consecrated in 1794 it still looked out across open land, including what was to become known as St Peter's Fields. The church was supported by a large congregation for many years, but by the middle of the nineteenth century attendances fell as middle-class families moved to the suburbs. The church was eventually closed and demolished in 1907. Discussions about what should be done with the site led to the decision that in a city short of open spaces, it was not to be built upon. The trustees, however, had reserved the right to erect a memorial to mark the site of the church. They commissioned Temple Moore to provide a memorial cross. Moore, who had studied under George Gilbert Scott, was recognised as one of the foremost church architects. His response was a Gothic cross, which, if not as grand as the one he designed for Sledmere, North Yorkshire, was suitably distinctive. The idea of the cross, however, did not receive the approval of all those who took an interest in the

Moore, *St Peter's Cross*

appropriate choice for the site.[1] Secondly, criticism was directed at the decision to position the cross on the site of the church's altar rather than locating it nearer to the junction of the roads in the square, where it would be more visible. Calls were made to erect a 'rough model' of the intended memorial.[2] The trustees did not alter their plans and the cross was unveiled in September 1908.[3] Manchester's new monument pleased some though there still remained those who believed that the erection of such a 'feeble' and 'starved' column was a deplorable mistake.[4] In the 1920s the idea of removing the cross to improve the sight lines for the cenotaph was never realised. The stone has weathered over time and parts of the inscription are now almost illegible.

Notes
[1] Correspondence in *Manchester Guardian*, 1 August 1908, 3 August 1908, 27 August 1908.
[2] *Ibid.*, 25 June 1908, 31 July 1908, 1 August 1908.
[3] *Manchester Guardian*, 30 September 1908.
[4] *Manchester City News*, 10 October 1908.

Cenotaph
Sir Edwin Lutyens

12 July 1924
Portland stone
Pylon 9.75m high × 4.27m × 3.66m; obelisks
 7.01m high; war stone 1.02m × 3.66m × 66cm
Inscription on pylon (north-east side): TO THE
HONOURED MEMORY OF THOSE WHO GAVE
THEIR LIVES FOR THEIR COUNTRY – (south-
west side): O LORD GOD OF OUR FATHERS
KEEP THIS FOR EVER IN THE IMAGINATION OF
THE THOUGHTS OF THE HEART OF THY
PEOPLE – war stone: THEIR NAME LIVETH FOR
EVERMORE – obelisks: MCMIV MCMIX
Status: Grade II
Condition: fair
Owned by: Manchester City Council
 Description: War memorial; the central feature is a pylon surmounted by a moulded and carved bier, upon which is the prone figure

scheme. Two main criticisms emerged. Firstly, objections were raised over the style. A correspondent to the local press, signing himself 'An Architect who has travelled', argued that a Renaissance cross would have been a more

of a fighting man covered by his greatcoat. On each of the flank sides are carved the City of Manchester's coat of arms encircled by large laurel wreaths, bound and supported by ribbons. On the ends are carved swords in enriched sheaths and the Imperial Crown in bold relief. Flanking the pylon are two obelisks, on which the dates of the Great War are carved. To the front is the Great War Stone, a replica of the stone of remembrance erected in the military cemeteries in France. It rests on a surround of three steps.

Memorials and rolls of honour began to be commissioned and erected in different districts of the city immediately after the war. However, it was not until 1922 that the plan to provide a city war memorial moved forward.[1] The Manchester branch of the British Legion initiated the project.[2] Ernest Simon, the serving Lord Mayor, established a war memorial committee with representatives from different military associations, the business community and the council.[3] A subscription was opened and quickly raised some £10,000, the maximum sum it had been agreed to spend on a monument. In a city where unemployment was rising, prospective subscribers were informed that the work associated with the memorial would benefit local firms. Controversy, however, soon engulfed the memorial scheme.

Identifying 'the best available site' for the memorial proved problematic. Initially, the war memorial committee considered three possible locations: Albert Square, Piccadilly and St Peter's Square. The favoured site was Albert Square, the city's principal civic space, where it was proposed to remove all of the existing statuary, including the Albert Memorial, so that the war memorial would stand alone, a powerful expression of the community's loss.[4] The committee moved quickly, approaching the King, who indicated that he had no objection to the removal of his German grandfather's memorial.[5] The Albert Square site was strongly favoured by the British Legion. But, perhaps

anticipating opposition to this location, the committee also considered St Peter's Square as an alternative site, the Lord Mayor stating that they had also obtained the consent of the Bishop of Manchester and the trustees of St Peter's for the removal of Temple Moore's cross.[6] The articles and letters which appeared in the local newspapers following the announcement of Albert Square as the unanimous recommendation of the war memorial committee suggested that many Mancunians did not share the committee's view.[7] The Manchester Art Federation, which included the Manchester Society of Architects and Manchester School of Art, led the protests. Opposition also came from the Royal Manchester Institution, which argued that the proposed removal of the statues represented the breaking of a 'sacred trust' with past generations.[8] The Manchester sculptor, John Cassidy, also doubted whether Albert Square was the best available site.[9] When the City Council came to debate the issue, the arguments against moving the statues had already been well rehearsed in the press. There was now opposition to using Albert Square, and even a proposal that only the Albert Memorial would be removed to make way for the war memorial was defeated.[10] Piccadilly emerged – by a vote of 71 to 30 – as the favoured location. Placing the memorial there, in the open space created by the demolition of the Infirmary, found particular support from members of the Art Gallery Committee, who envisaged the memorial standing in front of the art gallery that the council intended to build there.[11] But uncertainties still surrounded the development of Piccadilly, and, in May 1923, the war memorial committee, anxious to see the scheme move forward, agreed to locate the memorial in St Peter's Square.[12] In this scheme it was understood that, in order to create a suitable space and to allow the memorial to be seen from Mosley Street, the cross erected to mark the site of St Peter's Church would be removed. But the suitability of the location, selected, as

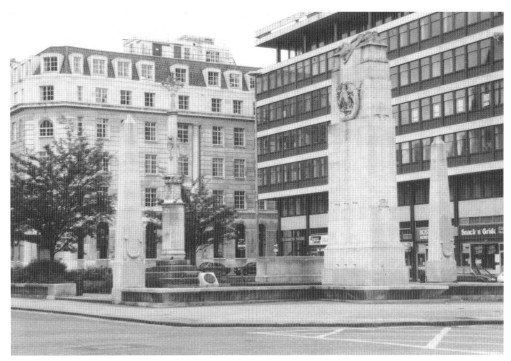

Lutyens, *Manchester Cenotaph*

one correspondent to the *Manchester Guardian* put it, 'more or less casually by a number of laymen, acting in a spirit of compromise', continued to be questioned. Whether the square could ever provide a suitably dignified setting, being so close to the city's theatre and cinema district, remained an underlying concern.

The selection of the design of the memorial also proved contentious. The importance of organising an open competition for such an important memorial was emphasised by the Manchester Art Federation and the Royal Society of British Sculptors during the discussions over the site.[13] The war memorial committee appeared to agree, appointing the Manchester architect, Percy Worthington, as the assessor. However, controversy erupted when it was announced that the memorial committee was unwilling to leave the decision entirely to Worthington, reserving the right to overturn his selection. This announcement prompted an understandable reaction from

architects and their professional association. Correspondents in the local press expressed surprise and annoyance over what they saw as the committee's arbitrary and arrogant stance.[14] The *Manchester Guardian* turned to Charles Reilly, Professor of Architecture at Liverpool University, to explain the principles at issue to its readers.[15] Paul Waterhouse, the son of Alfred Waterhouse, who had recently served as president of the Royal Institute of British Architects, regretted the deadlock, whilst suggesting that he knew much more about the committee's internal wrangles than he would discuss publicly. The Lord Mayor, William Cundiff, was equally diplomatic, referring to 'certain insuperable difficulties' within the committee, whilst confirming that it was to go ahead and select its own designer. A sub-committee was appointed and instructed to

approach an architect 'who can be trusted to prepare a suitable design'.[16] That architect was Sir Edwin Lutyens.

Lutyens' design for Manchester's war memorial was a cenotaph, and, as with those he designed for other provincial towns (including Rochdale), the essential elements of the London cenotaph were immediately recognisable.[17] It was a simple, well-proportioned undenominational shrine comprising a central pylon which bore the 'Unknown Soldier', flanked by obelisks. Manchester's memorial was to be in Portland stone. Another feature of the design was the elegance and restraint of the lettering.[18] It represented 'the triumphant end of the war as well as the sadness and sorrow it entailed'.[19] The proposed design was accepted by the committee in September 1923.[20] But not all of those who studied Lutyens' design were convinced of its suitability. Some reacted to its modernity, others continued to doubt the validity of any formal memorial. One correspondent writing to the *Builder* argued for a simple open space.

> Surely the creation of some fine square or some much-needed street widening would be a more fitting memorial of the recent war than any monolith, which, after all, can never convey the magnitude of the debt the city owes to its brave dead.[21]

Encrusted in debate and argument, Manchester's cenotaph finally went ahead. The foundation stone was laid in November 1923, and by the early summer of 1924 the memorial cenotaph was nearing completion.[22] Lutyens' use of the London-based Nine Elms Stone Masonry Works to erect the memorial suggests that the intention of providing work locally was not fully realised. It cost £6,490, the residual funds being used to provide beds in local hospitals.[23] The unveiling ceremony in July 1924 was an occasion for dignified remembrance. No part of the ceremony was more suffused with symbolism than the unveiling itself, which was carried out by the 17th Earl of Derby and by Mrs Bingle – 'a citizen of the working-class district of Ancoats' – whose three sons had died in the war. The memorial was dedicated by the Revd J.G. McCormick, the Dean of Manchester.[24]

Once unveiled, Manchester's cenotaph found supporters. Henry Cadness, a Manchester artist, acknowledged its simple beauty and dignity, providing 'an environment of consolation which will be ever sacred for all'.[25] But it could not have gone unnoticed in the packed square at the ceremony that some people's view had been obscured by Temple Moore's cross. Negotiations to remove the cross started again, but the trustees were reluctant to comply. The issue was a delicate one: following further discussion the question was effectively closed when Lutyens agreed to let the cross remain because of the 'susceptibilities of the donors'.[26] Misgivings also remained about the suitability of the site. These doubts surfaced again in 1925, when renewed discussions about a new city art gallery broadened to include the question of moving the cenotaph to Piccadilly.[27] But no action was taken, leaving Lutyens' cenotaph as the focal point of St Peter's Square. In the following years the surrounding area underwent dramatic changes with the building of the central library and the town hall extension.

After the Second World War elaborate and costly plans for a Manchester war memorial – centring on a Hall of Freedom at All Saints – eventually faltered, and a more modest memorial scheme was undertaken. This involved creating a Garden of Remembrance next to the cenotaph. The new garden, including a low wall with seating, provided a clearer sense of this public space. It was the work of the corporation's architect, Leonard Howitt.[28] It was dedicated in March 1949, the dates of the recent conflict being added to the obelisks.[29] In the following years the idea of removing the cenotaph to a more appropriate location in the city was to be revived on a number of occasions – Crown Square, for example, was proposed in 1973 – but the cenotaph and St Peter's Cross have remained.[30] The appearance of the memorial was, however, absolutely changed in 1992, following the construction of a new tram line. In a planning decision that suggested contempt rather than carelessness, a new tram-stop was built directly up against the cenotaph and the wall of the Garden of Remembrance. It was an act that, if nothing else, ought to have reignited the debate about whether St Peter's Square was the most appropriate site for the city's principal war memorial.

Notes

[1] Letter signed Lest We Forget, *Manchester Guardian*, 7 November 1921. [2] *Manchester Guardian*, 1 and 13 July 1922. [3] *Proceedings of City of Manchester Council*, 2 August 1922, p.423; *Manchester Guardian*, 11 October 1922. [4] *Manchester Evening News*, 6 February 1923. [5] *Proceedings of City of Manchester Council*, 11 April 1923, pp.276–7. [6] *Daily Mail*, 7 February 1923; *The Times*, 8 February 1923. [7] *Manchester City News*, 17 and 24 February 1923; 3 March 1923; *Manchester Guardian*, 9 April 1923. [8] *Proceedings of City of Manchester Council*, 11 April 1923, pp.278–9; D. Boorman, *At The Going Down of the Sun. British First World War Memorials* (York: Ebor Press, 1988) p.123. [9] *Manchester City News*, 3 March 1923. [10] *Ibid.*, 14 April 1923. [11] Minutes of City of Manchester Art Gallery Committee, 15 February 1923. [12] *Manchester Evening News*, 16 May 1923; *Manchester City News*, 19 May 1923. [13] *Proceedings of City of Manchester Council*, 11 April 1923, pp.280–1. [14] *Manchester Guardian*, 6, 10, 11, 12 and 13 July 1923. [15] *Ibid.*, 9 July 1923. [16] *Manchester City News*, 7 July 1923; *Manchester Guardian*, 20 September 1923. [17] Preliminary studies and designs listed in M. Richardson (comp.), *Catalogue of the Drawings Collection of the Royal Institute of British Architects Edwin Lutyens* (Farnborough: Gregg International Publishers Ltd, 1973) p.39; C. Hussey, *The Life of Sir Edwin Lutyens* (London: Country Life, 1950) p.474; *Manchester Evening News*, 20 September 1923. [18] *Daily Mail*, 20 September 1923. [19] *Proceedings of City of Manchester Council*, 6 August 1924, p.403. [20] *Manchester Guardian*, 20 September 1923; *The Times*, 5 September 1923. [21] 'Manchester Present and Possible', *Builder*, 15 December 1922, p.931. [22] *The Times*, 9 November 1923. [23] *Proceedings of City of Manchester Council*, 6 May 1925, p.334. [24]

Manchester Guardian, 14 July 1924. [25] *Manchester City News*, 5 July 1924. [26] *Proceedings of City of Manchester Council*, 6 May 1925, pp.333–4. [27] *Manchester Evening Chronicle*, 18 September 1925. [28] *Manchester Evening News*, 29 April 1947; *Manchester Guardian*, 6 May 1948. [29] *Manchester Evening News*, 30 March 1949; *Manchester Guardian*, 1 April 1949. [30] *Daily Telegraph*, 8 September 1971; *Manchester Evening News*, 27 June 1973.

Struggle for Peace and Freedom
Philip Jackson

26 July 1988
Bronze sculpture; granite pedestal
Statues 2.5m high approx; pedestal: 3.6m × 3.3m × 44cm
Inscription on pedestal: STRUGGLE FOR PEACE AND FREEDOM PHILLIP JACKSON (1989) / SPONSORED BY THE PLANNING COMMITTEE MANCHESTER CITY COUNCIL
Status: not listed
Condition: poor
Owned by: Manchester City Council
 Description: Figurative sculpture; six larger than life-size male and female bronze figures linked together. Their powerful forward thrusting movement culminates in the outstretched arm and hand of the corner figure signifying an end to conflict. None of the faces of the figures is detailed. The sculpture surmounts a low granite pedestal.

Following the success of its first competition for a peace sculpture, the Manchester City Council Planning Committee decided in 1986 to organise another in which the theme was the struggle for peace. The national competition attracted 46 entries with the model submitted by Philip Jackson being selected. The six interlinked figures represented the idea that peace must be fought for and defended by ordinary people. As only £15,000 was available for realising the commission, the sculpture was produced in cold cure bronze. During the work, members of the planning committee visited Jackson's studio to observe the work in progress. They also suggested changes to the figures. Discussions also took place over the form of the pedestal which were finally resolved in favour of a low rather than a tall pedestal. The location also involved lengthy discussions. When the competition was held it had been intended to place the new sculpture at the St Peter's Square end of the Peace Garden facing towards Barbara Pearson's *Messenger of Peace*. But before the new sculpture was completed, the building of a children's play area in the open space prompted a change. It was decided to locate the sculpture closer to St Peter's Square, with the figures now facing towards the square. The sculpture was unveiled in July 1988.

Councillor Andrew Fender observed that ' This group could be called "the Burghers of Manchester" who are committed to the promotion of peace – and it fits in with our policy of making City Centre Manchester a more interesting and pleasant place to be in.'[1] Some embarrassment was caused when it was revealed that the sculptor's name had been mis-spelt on the pedestal, a mistake that has remained uncorrected. The sculpture has weathered badly and in 2004 discussions took place about removing it to a more suitable location.

Note
[1] Manchester City Council press release, July 1988; Information from Henry Blachnicki.

Jackson, *Struggle for Peace and Freedom*

Manchester Central Library

'The Reading Lady'
G. Ciniselli

Marble
1.02m high; pedestal 89cm high
Signed on plinth: G. Ciniselli in Roma
Inscriptions on reliefs on pedestal: EDUCATE
 ILLOS IN DISCIPLINA / DOCTRINA STULTOROM
 FATUITAS
Condition: good
Owned by: Manchester City Council
 Description: Life-size marble statue of a
seated young woman, dressed in a shift, reading
a book, which is held in her right hand. The
figure surmounts a drum pedestal which
features two marble reliefs: one is of a mother
and children reading, and is inscribed: EDUCATE
ILLOS IN DISCIPLINA [Bring them up with
learning]; the other depicts a woman and two
children and is inscribed: DOCTRINA
STULTOROM FATUITAS [Silliness teaches people
to be foolish].

This nineteenth-century marble sculpture by
Giovanni Ciniselli was originally owned by the
businessman Daniel Adamson, who purchased
it in Rome and brought it back to his home in
Manchester. Adamson was a well-known public
figure in Manchester, best remembered for his
part in initiating the building of the Manchester
Ship Canal. The sculpture was given to the
library in 1939 by members of the Parkyn
family in memory of their grandfather.[1] The
theme of the reading girl or lady was one that
attracted a number of Victorian sculptors.[2] It
was a suitably symbolic and didactic work that
has welcomed, and perhaps occasionally
inspired, the thousands of people who have
climbed the library stairs to reach the main
reading room.[3]
 The library also possesses a marble bust of
Sir John Potter (Patric Park, 1854) which was

Ciniselli, *'The Reading Lady'*

presented in 1854 by R.N. Phillips as a tribute
to Potter's work in establishing Manchester's
first modern public library. It is on display,
appropriately, in the Local Studies and Archives
Department. In the main reading room is a
bronze plaster bust of Charles Sutton, chief
librarian from 1879 to 1920, the individual who
more than any other was responsible for
creating one of the great municipal libraries.
The sculptor was John Cassidy.

Notes
[1] 87th Annual Report of Libraries Committee
ending 31 March 1939, p.998. [2] *Art Journal
Illustrated Catalogue of the International Exhibition
1862* (Wakefield: EP Publishing, 1973) p.322. [3] The
Manchester novelist, Howard Jacobson, discussed the
significance of the sculpture in a South Bank
programme on ITV in 2001.

Crowne Plaza, The Midland
Architect: Charles Trubshaw

Architectural sculptor: E. Caldwell Spruce, Burmantofts

5 September 1903
Burmantofts faience
1.22m high × 2.46m long
Signed: E.C. Spruce Modr. Des. Burmantofts
 Faience Leeds
Status: Grade II*
Condition: good
Owned by: Bass Hotels and Resorts plc
 Description: Four semicircular glazed
terracotta panels representing different arts.
Literature is represented by a seated female
figure holding a quill pen in her right hand,
books at her feet, and the names of Homer and
Shakespeare set in wreaths. Sculpture is
represented by a seated female figure holding a
small sculpture and looking at an oval portrait,
and the names of [Michel]Angelo and Flaxman
set in wreaths. Architecture is represented by a
seated female figure holding dividers in her
right hand, a model of St Paul's Cathedral to
her left, and the names of Palladio and Wren set
in wreaths. Art is represented by a seated female
figure holding a palette in her left hand, and the
names Titian and Millais set in wreaths.

The main entrance of the Midland Hotel is on
the south side of Peter Street, but the building
reaches into St Peter's Square. It was built as the
terminus hotel for the Midland Railway

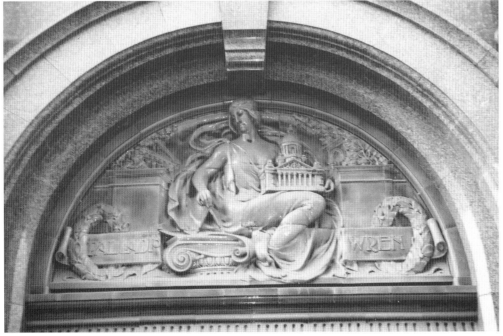

Company, some 20 years after the opening of Central Station (now G-Mex). Charles Trubshaw (1841–1917) designed a ten-storey railway hotel which in scale and detail effortlessly trumped his hotels at Leeds and Bradford. Polished granite, red brick and terracotta were the principal building materials.[1] Construction began in 1898 and the hotel opened to the public in September 1903. 'The Midland' immediately became one of the city's most recognisable buildings, and its facilities and hospitality were enjoyed as much by Mancunians as by the visitors who stayed in its 400 rooms. It was to play an prominent part in the life of twentieth-century Manchester.

Architectural judgements have not always been favourable; Reilly looked hard for an architectural logic in what appeared to him to be a 'vast and disordered mess'.[2] The Midland included some noticeable architectural decoration including a unicorn and company shield (on the Peter Street and Mount Street corner), and the Wyvern, the chimerical dragon that was the company's symbol, in a roundel above the arches of the main entrance. The hotel's name was spelt out in distinctive raised lettering on a frieze above the main entrance. But the main sculptural decoration was not on the Peter Street façade, but on Lower Mosley Street, where four tympana, semicircular brown terracotta panels representing literature, sculpture, architecture and art, were installed above the ground-floor level. It is unclear why these particular cultural activities were represented, especially as the hotel included an impressive concert hall. The Gentlemen's Concert Hall was one of the buildings demolished to make way for the hotel.[3] The designer of the panels was Edward Caldwell Spruce, who was originally from Knutsford, Cheshire. Each panel included a symbolic female figure and the names of two celebrated

(top) Caldwell Spruce, *Art*

(bottom) Caldwell Spruce, *Architecture*

practitioners of the particular art represented. They were manufactured at the famous Burmantofts works in Leeds. The firm's faience proved to be both a practical and an attractive material with which to cover a new generation of commercial and public buildings in Edwardian Manchester. The Midland Hotel was a prestigious project for Burmantofts and it appeared in a number of their catalogues.[4] A change in ownership in the 1990s resulted in a renaming of the hotel, a change that has yet to be accepted by Mancunians.

Notes
[1] C. Stewart, *The Stones of Manchester* (London: E. Arnold, 1956) p.130. [2] C.H. Reilly, *Some Manchester Streets and their Buildings* (Liverpool: Liverpool University Press, 1924) p.57. [3] C. Hartwell, *Manchester* (London: Penguin, 2001) pp.202–3. [4] R. Cochrane and A. McErlain, *Architectural Terracotta* (Manchester Metropolitan University Department of History of Art and Design Slide Sets, 1999) p.23.

Charles Rolls and Henry Royce
Lynda Addison

7 June 1999
Terracotta
1.73m high approx × 1.18m wide
Inscription beneath the panel: This plaque was
 erected to Commemorate the Meeting that
 took place in this Hotel on 4th May 1904
 between the Hon Charles Stewart Rolls MA
 and Frederick Henry Royce which led to the
 Formation of Rolls Royce Limited. /
 Midland Hotel and Conference Centre Ltd.
 Lynda Addison – Sculptor BM Partnership –
 Architects. Designers
Status: not listed
Condition: good
Owned by: Bass Hotels and Resorts plc
 Description: Red terracotta panel depicting
Charles Rolls and Henry Royce meeting in the
Midland Hotel in 1904. The background
includes depictions of the hotel and a Rolls-
Royce car.

This terracotta panel, mounted on the wall in the main entrance area of the hotel, commemorates the meeting in the hotel of Charles Rolls (1877–1910) and Henry Royce (1863–1933) which resulted in the establishment of the world-famous car manufacturer. Royce had considerable experience in engineering, having established his own engineering company in Manchester in 1884. By 1904 his company had begun manufacturing motor vehicles in the inner-city district of Hulme. Charles Rolls too was a pioneer motor car manufacturer. He was also a keen aviator, and was to be killed in a plane crash in 1910, leaving Royce to oversee the development and diversification of the company.

 The panel was suggested by the hotel's manager, Sean McCarthy, who identified the need for a more public monument to celebrate

Addison, *Charles Rolls and Henry Royce*

the famous meeting of Rolls and Royce: busts of both men were displayed inside the hotel but these were not on view to all visitors. The site selected was the wall of the former carriage court, part of the hotel's principal entrance. Discussions with the hotel's consultant architects, BM Partnership, resulted in commissioning a local sculptor, Lynda Addison. Following historical research and a study of the two existing busts, Addison created a maquette in the form of a wall-mounted panel, representing the two men at the time of their first meeting. Further discussions with the manager and architects resulted in slight changes being made to the design. The work was completed and installed by the end of 1998, though it was not until June 1999 that the panel was formally unveiled.[1]

Note
[1] Information from sculptor and BM Partnership.

Spinningfield, Deansgate
Vigilance
Keith Godwin

27 May 1971
Stainless steel; concrete
5.5m high approx
Inscription: on plaque set into paving: THIS
 SCULPTURE WAS / PRESENTED BY / THE
 TRUSTEES OF THE / SCOTT TRUST TO THE /
 MANCHESTER EVENING / NEWS TO MARK /
 ONE HUNDRED YEARS OF / SUCCESSFUL
 PUBLICATION.
Status: not listed
Condition: fair
Owned by: *Manchester Evening News*
 Description: Abstract sculpture, concrete
pedestal surmounted by stainless steel fins and
disc.

Vigilance, the first major abstract sculpture to be installed in the city centre, was commissioned by the Scott Trust to mark the

centenary of the *Manchester Evening News*, an anniversary also celebrated by the planting of trees in Albert Square. The *Manchester Evening News* began publication as a Liberal election sheet in October 1868, but was soon acquired by Edward Taylor, owner of the *Manchester Guardian*. Laurence Scott, grandson of C.P. Scott, promoted the idea of the sculpture, to be located in the forecourt of the company's new offices in Deansgate. Advice on the sculpture was sought from Norman Reid, Director of the Tate Gallery, Norbert Lynton, art critic of the *Guardian*, and Jo Grimond MP, among others. A modern sculpture, a tall vertical object, was seen as appropriate for the pedestrianised space in Spinningfield, between the newspaper's offices and the John Rylands Library. A number of sculptors were approached but it was Keith Godwin, Head of Sculpture at the Manchester Regional College of Art, who was awarded the commission. Godwin explained his design:

> The nature of the site and the function of the building imply 'meanings' of various kinds but these have not been run after. I have dealt with order and harmony of shape and dimension rather than meanings, this order arising from the deliberate ratio of dimension according to the Golden Section. Inside this geometry I have used non-geometric shapes to move the sculpture up and out so that, although as a whole it is basically symmetrical, it has opposing movements within itself.[1]

Godwin's concern was with presenting bold determined shapes, but the surrounding buildings were not ignored. The red granite aggregate chosen for the base acknowledged the red sandstone of the neighbouring library. Godwin also ensured that the nearby benches used the same concrete aggregate. The tall two-part base met a concern over possible vandalism.[2] The sculpture was ready for the trustees to view in November 1970. Godwin did not provide the work with a title but Laurence Scott appears to have decided on

Godwin, *Vigilance*

Vigilance, an apt title for a sculpture associated with the press. It was unveiled, somewhat belatedly, in May 1971 by Sir William Haley, the former editor of the *Manchester Evening News* and *The Times*.[3] The strong contrasting

elements of the work were commended by some members of the large crowd (including Godwin's students) attending the ceremony, but others were disappointed to find that, apart from the inscription on a bronze plaque set into the floor, no explanation was provided of its meaning. The final cost of the commission was £7,000. A major redevelopment of the Spinningfield area resulted in the (temporary) removal of *Vigilance* in 2003.

Notes
[1] Undated letter [1969], *Manchester Evening News* Sculpture file, Scott Trust Presentation 1971 (Scott Trust, Manchester). [2] W.J. Strachan, *Open Air Sculpture in Britain: A Comprehensive Guide* (London: A. Zwemmer/The Tate Gallery, 1984) p.183; correspondence with sculptor 1989. [3] *Manchester Evening News*, 27 May 1971; *Guardian*, 28 May 1971.

Thomas Street

A New Broom

George Wyllie

7 June 1999
Painted steel; stone
5.92m high, base 1.58m × 1.44m × 84cm
Status: not listed
Condition: good
Owned by: Manchester City Council
 Description: Over-size steel brush standing upright, mounted on two rectangular blocks of stone, the first block with a hole through it. A shovel is leaning against the stone.

A New Broom was commissioned as part of the public arts programme linked to the regeneration of Manchester's Northern Quarter. Workshops were organised for artists by the Northern Quarter Association, at which ideas for public art in the district were developed and discussed. The Scottish sculptor, George Wyllie, who already had one public sculpture, *Life Cycle*, displayed in the city, was invited to visit the district, and he proposed a

work that was eye-catching, humorous and symbolic of the changes occurring in this formerly run-down area of the city. At the unveiling ceremony in June 1999, *A New Broom* was presented to the city's Operational Services Department. There followed a 'sweep-in', guests being provided with brooms by the Department. In addition to being an easily recognisable symbol of the district's regeneration, the new sculpture, as Liam Curtin, the Northern Quarter's public arts officer explained, celebrated 'the ordinary working people, who give the area its character and vitality, and whose contribution is rarely acknowledged'.[1] The shovel has been removed on a number of occasions by revellers.

Note
[1] *Baby Bugle*, 11 June 1999; *Manchester Evening News*, 8 June 1999.

Wyllie, *A New Broom*

sculpture to be sited in a small open space near to the junction of Thomas Street and John Street. His idea was for a larger than life street sweeper's brush and shovel in painted steel, a

Victoria Station Approach

Victoria Railway Station

Lancashire and Yorkshire Railway War Memorial

Designer: Henry Shelmerdine

Unveiled: 14 February 1922
Bronze; Cornish granite and Connemara marble
9.8m × 2.5m
Inscription above the panels listing the names of the dead: THIS TABLET IS ERECTED TO PERPETUATE THE MEMORY OF THE MEN OF THE LANCASHIRE AND YORKSHIRE RAILWAY / WHOSE NAMES ARE HERE RECORDED AND WHO GAVE THEIR LIVES FOR THEIR KING AND COUNTRY IN THE GREAT WAR, 1914–1919. –

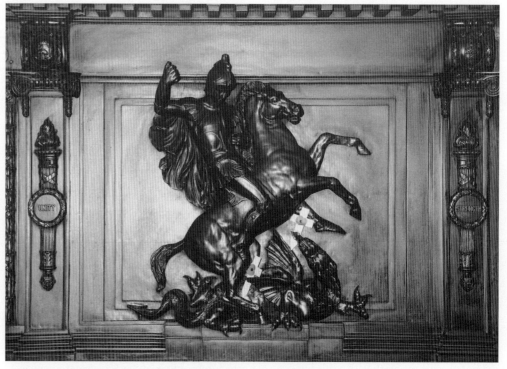

Lancashire and Yorkshire Railway War Memorial, St George (detail)

below the panels on marble band: THEIR
GLORY SHALL NOT BE BLOTTED OUT AND
THEIR NAME LIVETH TO ALL GENERATIONS
ECCLESIASTICUS XLIV, VERSES 13.14.
Status: Grade II
Condition: fair
Owned by: Network Rail
Description: War memorial; bronze
rectangular wall-mounted tablet located inside
the entrance to the station. The bronze tablet
rests on a band of marble and a granite base, in
front of which are short bronze columns
decorated with torches and wreaths. In the
centre of the tablet are seven panels on which
are listed the names of the railwaymen who lost
their lives in the war. These are surmounted by
the principal inscription and coats of arms of
towns in Lancashire and Yorkshire. Symbolical
figures of St Michael (standing, a sword raised
above his head and the devil at his feet) and St
George (on horseback, in the act of killing a
dragon) are placed on either end of the
inscription panels, flanked by pilasters on
which are torches representing courage and
sacrifice, unity and strength. Verses from
Ecclesiasticus are inscribed on the band of
marble immediately below the tablet.

After the First World War it was felt
appropriate that, as Manchester was the centre
of the Lancashire and Yorkshire Railway
Company's network, the main memorial to the
company's railwaymen who had died fighting
in the war should be situated at Victoria Station.
Some 10,400 of the company's staff had
enlisted, of whom 1,465 died. Selecting the site
for the memorial presented problems, as the
company had no suitable land in front of the
station on which to place a free-standing
memorial. A space inside the busy station was
also difficult to identify. Discussions resulted in
the decision to site the memorial on the wall at
one of the entrances to the station in the
booking hall. The original design for the
memorial came from the company's architect,
Henry Shelmerdine (1865–1935), and was

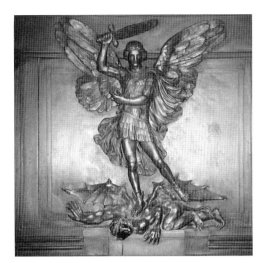

*Lancashire and Yorkshire Railway War Memorial,
St Michael (detail)*

realised by the firm of George Wragge.[1] It was
unveiled by Earl Haig in a ceremony which was
reported as simple and dignified, in spite of the
fact that some trains continued to run.[2] In the
same year, the Lancashire and Yorkshire
Railway Company was absorbed into the
London and North Western Railway
Company. The memorial has suffered
vandalism over the years, including the removal
of the lance in St George's right hand and three
of the seven columns at the base.

Notes
[1] *Manchester Guardian*, 21 January 1922.
[2] *Manchester Evening News*, 14 February 1922;
Manchester Guardian, 15 February 1922; *The Times*,
15 February 1922.

Boggart Hole Clough

Blackley War Memorial

Louis Frederick Roslyn

28 May 1921
Bronze sculpture; Stancliffe stone pedestal
Sculpture 2.13m high approx; column 6.1m high
 approx; 1.99m square base
Inscription on front of column: TO THE /
GLORIOUS MEMORY / OF THE MEN OF /
BLACKLEY / WHO MADE THE / SUPREME
SACRIFICE / IN THE / GREAT WAR / 1914–1919
/ THEIR NAME LIVETH / FOR EVERMORE / IN
MEMORY OF THOSE / WHO GAVE THEIR LIVES
/ IN THE SECOND GREAT WAR / 1939–1945 –
rear: ERECTED BY / THE PEOPLE OF BLACKLEY
/ UNVEILED MAY 28TH 1921
Status: not listed
Condition: poor
Owned by: Manchester City Council
Description: War memorial; bronze figure of
winged Victory, standing with her left foot on a
globe, holding a wreath in her right hand. The
figure surmounts a stone column to which are
attached bronze panels recording the names of
the fallen.

A total of 341 men from Blackley were killed
fighting in the First World War. The
importance of raising a memorial to them was
recognised immediately after the war and a
memorial committee was established and funds
amounting to some £2,000 were collected. The
commission for a public war memorial was
awarded to the London sculptor, Frederick
Roslyn.[1] He produced an impressive
composition, with the figure of Victory
surmounting a tall column rising from a stone
platform, at the corners of which were stone
pillars surmounted by smaller bronze figures
representing the fighting services: Army, Navy,
Air Force and Nursing. The location chosen for

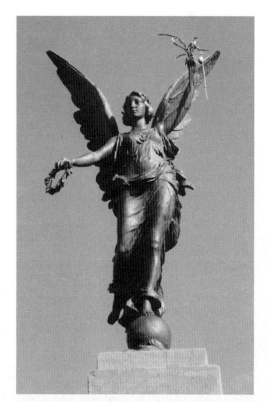

Roslyn, *Blackley War Memorial (detail)*

CLAYTON

Stuart Street

Manchester Velodrome

Reg Harris

James Butler

8 October 1994
Bronze and stainless steel sculpture; Welsh slate
 plinth
Sculpture 1.35m high; slate plinth 58cm high ×

1.05m long × 58cm wide
Signed: Butler 94
Inscription on plinth: REG HARRIS O.B.E. /
 1920–1992
Status: not listed
Condition: good
Owned by: Reg Harris Memorial Committee
 Description: A bronze life-size figure of
Harris who is shown riding a racing bicycle,
leaning to the left as he applies power to the
pedals. The figure is coloured – brown for skin,
black and brown for clothing. The stainless
steel bicycle is not an accurate representation
but catches the essential lightness of the
professional racing bicycle. The sculpture
surmounts a sloping slate plinth adding to the
sense of speed.

Reg Harris was born in Birtle, Bury in 1920. He
took up cycling as a teenager, eventually joining
the Manchester Wheelers in 1938. Harris
dominated track racing in the post-war years,
winning the World Professional Sprint
Championship on four occasions between 1949
and 1954. He also held a number of national
and world speed records. Harris was a well-
known figure in the Manchester area and used
to race at the open-air track in Fallowfield. In
1974, aged 54, he returned to the sport and
succeeded in winning the British Professional
Sprint Championship. He was twice voted
BBC's Sports Personality of the Year. He died
in 1992.[1]

 The idea of erecting a statue to Reg Harris
began to be considered shortly after his death.
The Reg Harris Memorial Fund Committee,
under the chairmanship of Sandy Roberts,
managing director of Raleigh Cycles, was
formally established in 1994. It raised some
£60,000, the majority of which was donated by
individuals and clubs. The committee invited
three sculptors to submit drawings for a
sculpture. The design proposed by James Butler
was selected. Butler used photographs and film
showing Harris racing in preparing his model.
Harris's widow, Jennifer, also visited the

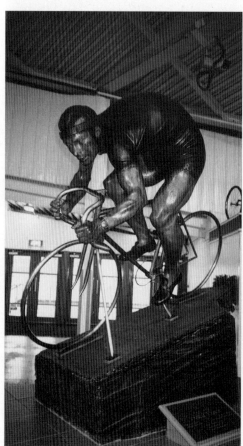

Butler, *Reg Harris*

the memorial was Boggart Hole Clough, the
district's principal park, where it was placed on
the side of the main valley, enabling it to be
seen from a considerable distance. Dr Herbert
Levinstein unveiled the memorial in May 1921.
Alderman Sir William Kay accepted it on behalf
of the district from the memorial committee.[2]
Over the years the memorial has suffered from
vandalism including the removal of the four
smaller sculptures surrounding the base.

Notes
[1] B. Wilde (comp.), *A Book of Remembrance*
(Manchester [1921]); D. Boorman, *At The Going
Down of the Sun. British First World War Memorials*
(York: Ebor Press, 1998) p.136. [2] *Manchester
Evening News*, 28 May 1921; *Manchester Guardian*,
30 May 1921.

sculptor's studio to view the work in progress and advise on the likeness.[2] It was decided that the National Cycling Centre, the country's first purpose-built velodrome, then under construction in Manchester, would be the most appropriate location for the sculpture.

Butler's finished work shows Harris with the characteristic sprinter's hump, applying power to the pedals. The coloured bronze figure reveals Harris's powerful muscles. The bicycle is not meant to be an accurate representation – the wheels are spokeless and there are no pedals – but it suggests the lightness and speed of the professional racing bicycle. Raleigh, the Nottingham-based bicycle manufacturer, which had sponsored Harris for most of his career, assisted Butler in making the stainless steel frame. Smaller replicas of the sculpture were sold to raise funds to encourage young racing cyclists.[3]

The sculpture was unveiled by Jennifer Harris in October 1994, shortly after the official opening of the Velodrome.[4] It was placed inside the building, close to the south curve, and is visible from most points of the arena. When the sculpture was installed, it was necessary to include a support to ensure its safety. The plinth of Welsh slate is mounted on a much larger rectangular pedestal faced in green tiles. Additional plaques have been attached to the pedestal providing further information on Harris's cycling achievements.

Notes
[1] *Daily Telegraph*, 23 June 1992; G. Pearson, *Reg Harris: An Authoritative Biography* (Temple Press, 1950). [2] Correspondence with James Butler, 1999. [3] One maquette remains in the possession of Raleigh of Nottingham. [4] *Manchester Evening News*, 14 September 1994; *Guardian*, 10 October 1994.

Rowsley Street
City of Manchester Stadium
The Runner
Colin Spofforth

9 July 2002
Bronze; stone
Figure 6m high approx; globe 3m high; base 50cm high
Inscription on bronze band around the base: THE RUNNER BY COLIN SPOFFORTH / A CELEBRATION OF THE SPIRIT OF FRIENDSHIP AND THE XVII COMMONWEALTH GAMES, MANCHESTER / IN THE GOLDEN JUBILEE YEAR OF HER MAJESTY THE QUEEN [followed by the names of the countries participating in the Commonwealth Games beginning with Anguilla and ending with Zimbabwe]
Status: not listed
Condition: good
Owned by: Manchester City Council
 Description: Larger than life-size bronze statue of a male sprinter, wearing shorts and running shoes, who is shown beginning to run at the start of a race. The figure surmounts a bronze globe, which rests on a sloping stone base around which runs a bronze band on which is the inscription.

The Spirit of Friendship Festival, a festival of cultural and sporting events, was organised by Manchester City Council as part of the preparations for the holding of the XVII Commonwealth Games in the city. The public were asked to submit ideas for projects to be part of the festival. Among the hundreds put forward was one for a heroic-size sculpture of an athlete. It was proposed by Colin Spofforth, an Altrincham-based artist whose local work included a sculpture of New Orleans jazz musicians in Trafford.[1] Spofforth's idea was taken up and he was commissioned to produce the sculpture which was to be located close to the new City of Manchester Stadium. *The Runner* was an exploration and celebration of

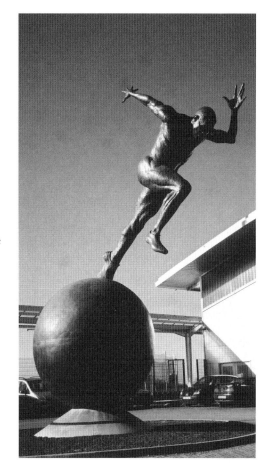

Spofforth, *The Runner*

the beauty, the power and the determination of the competing athlete. Spofforth depicted a male sprinter, his muscles tensed, right leg raised and arms stretching out, at the very moment he leaves the blocks after the starter's gun has fired. Standing over 6 metres high, it was on a truly monumental scale, towering over the viewer, and providing a perspective which the sculptor described as 'feeling like you are lying on the track'. No specific athlete was used as a model. The work was commissioned towards the end of 2001, leaving a

comparatively short period of time to ensure that what was claimed to be the largest bronze sporting sculpture ever made in Britain was completed before the opening of the games. Castle Fine Arts Foundry in Llanrhaedr-Ym-Mochant, Powys, was responsible for casting the seven-tonne sculpture.[2] *The Runner* was unveiled by the middle-distance runner, Steve Cram, in July 2002, a few weeks before the official opening of the games. Funding for the sculpture came from a number of different bodies including the Department for Culture, Media and Sport.[3]

Notes
[1] See below, p.388. [2] Information from Claire Livingstone, Brimstone Artworks Ltd. [3] *Manchester Evening News*, 9 July 2002.

COLLYHURST

Collyhurst Road
Nothing To Worry About
Jonathan Woolfenden

1994
Mild steel plates
6.9m high
Status: not listed
Condition: good
Owned by: Guest H. Marcel Ltd
 Description: Representation of a polished steel battleship which is shown sinking. A single funnel and guns are visible as the ship goes down. It is placed on a lawn, close to the factory entrance.

Nothing To Worry About was commissioned by Stephen Falder, director of HMG Paints, from the Manchester sculptor, Jonathan Woolfenden. Falder wanted a piece of public art to be placed on land adjoining the paint factory: a sculpture that would both amuse his staff and catch the attention of passing motorists. The idea of a large ship came from Woolfenden, who

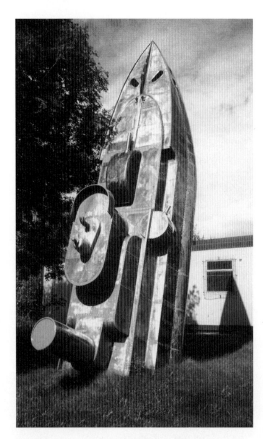
Woolfenden, *Nothing To Worry About*

recognised the incongruity of such a work on the particular site. The ship is made of thin mild steel plates. It is loosely based on a Dreadnought – the title of the sculpture being an outrageous pun on this. It has no obvious connection with the firm, the ship even lacking that coat of Battleship Grey which could have been mixed so easily in the factory. The sculpture was fixed on a large concrete block, buried beneath the grass. It was installed in a ceremony which involved its being pulled along the road by workers from the factory. The intention that it should prompt a response and serve as a source of amusement appears to have been successful. *Nothing To Worry About* is the

only Manchester sculpture known to have featured in a caption competition in the *Daily Star*.[1]
 Woolfenden was also responsible for *Fantastic Parade*, a kinetic sculpture installed inside The Pump House, National Museum of Labour History, Manchester.

Note
[1] Information from Steve Falder, November 1999.

Sand Street
Breaking the Mould
Andrew McKeown

2000
Reconstituted stone; cast iron
Stones 1.9m × 58cm × 68cm, 50cm × 1.06m × 89cm; seed 75cm high × 1m long
Status: not listed
Condition: fair
Owned by: Manchester City Council
 Description: Cast-stone sculpture in six sections, arranged on the ground. Two of the blocks are standing upright, a third is horizontal on the ground. The fourth is also horizontal but this has been split into two pieces. Each block reveals the impression of a large seed. On the ground in the middle of the blocks is a large iron egg-shaped seed that has emerged out of what was clearly once a single stone.

In 1999 the environmental regeneration charity, Groundwork UK, organised an open competition for a marker sculpture to be located on the 21 sites in England and Wales that comprised their 'Changing Places' project. These derelict brownfield sites were to be transformed into play areas, community spaces and nature reserves. Three of the sites were in Greater Manchester.[1] Andrew McKeown, a sculptor from Middlesbrough, was awarded the £150,000 commission. Over a period of 30 months he visited all of the different sites,

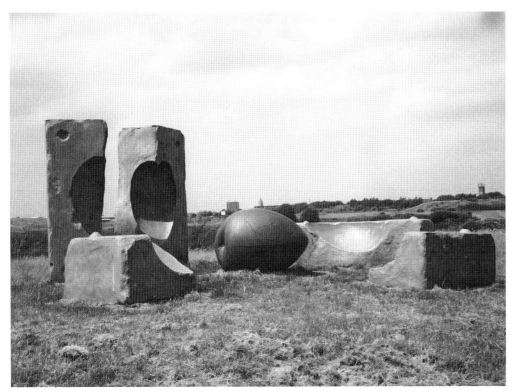

McKeown, *Breaking the Mould*

Wilmslow Road

J. Milson Rhodes Clock Tower

Architect: E.B. Norris

Sculptor: J. Smithies

28 January 1911
Portland stone clock tower; bronze plaque with
 relief portrait
Tower 6.4m high approx × 1.83m square
Signed on plaque: J. Smithies Wilmslow 1910
Inscription on plaque: ERECTED IN MEMORY OF
 / Dr J. MILSON RHODES J. P: C. A. / "A FRIEND
 TO HUMANITY" / BORN SEP: 14 1847 / DIED
 SEP: 25 1909
Condition: poor
Owned by: Manchester City Council
 Description: Square stone clock tower with
four-sided clock-face located on pavement in
centre of Didsbury. At the base on opposite
sides are two recessed drinking fountains. A
bronze plaque with Rhodes's portrait in relief is
on the east side above the doorway providing
access to the clock.

organising workshops to obtain and develop
ideas on the theme of environmental
transformation. The logistics of the commission
were, as McKeown recalled – 'dealing with 21
groups of people with 21 sets of ideas' –
extraordinarily complex.[2] The final work was a
six-piece cast stone and iron sculpture
representing a seed emerging from an old
industrial mould, symbolising the theme of
rebirth: 'old to new, inorganic to organic,
growth, change and metamorphosis, work,
effort and industry, interlocking and coming
together'. He had tested its suitability at each
site by installing a full-size polystyrene model.
A plaster mould was then made and multiple
castings produced. One of the Changing Places
projects was in Miles Platting, a working-class
district in east Manchester. Here on a rising
piece of land near Sand Street, part of the Irk
Valley Trail, McKeown installed a red stone
version of the sculpture. Other copies, in white
stone, were installed in Newton Heath,
Boarshaw Clough, Middleton and Gorse Hall,
Stalybridge.[3] Malcolm Barton, manager of the
project, expressed the charity's delight with the
final works: '*Breaking the Mould* beautifully
encapsulates the need to adopt a more
sustainable lifestyle but also the way in which
environmental action can be the seed that gives
a community a new-found confidence and
purpose.'

Notes
[1] Groundwork Trust, *Changing Places. Breaking
the Mould* (Birmingham, Groundwork UK [2001]).
[2] Correspondence with Groundwork UK and
Andrew McKeown. [3] See below, pp.313, 374.

Milson Rhodes Clock Tower (detail)

John Milson Rhodes, born in Manchester in 1847, pursued a career in medicine, obtaining qualifications at Manchester, Edinburgh and Brussels. In 1874 he established himself as a general practitioner in the affluent suburb of Didsbury. He became a well-known local figure, noted for his involvement in social questions. He took a particular interest in the problems of the underprivileged, becoming, through his membership of the Chorlton Board of Guardians, an internationally-recognised authority on the poor laws. He died in September 1909.[1]

Following Rhodes's death, a public subscription was opened with a view to providing a permanent memorial in Didsbury. In all some £360 was raised, most of which came from local people, though subscriptions from A.J. Balfour and John Burns were an indication that Rhodes's reputation extended beyond Manchester. A thoroughly practical memorial – a clock tower incorporating drinking fountains – was agreed upon. The architect was Edward Berks Norris (1880–1961). A commemorative bronze plaque with a portrait of Rhodes is signed J. Smithies of Wilmslow. The chosen location was in the centre of the village, opposite the public library which was then under construction. The clock tower was unveiled by Councillor J.W. Cook who repeated the widely held view that Rhodes's commitment to public work had contributed to his death.[2] The stonework of the tower has deteriorated over the years and the drinking fountains are dry. The drinking troughs for animals beneath the main fountains have been removed.

Notes
[1] J. Barclay, 'John Milson Rhodes, 1847–1909', *Manchester Region History Review*, 6 (1992) pp.107–12. [2] *Manchester Courier*, 30 January 1911; *Manchester Guardian*, 30 January 1911.

FALLOWFIELD

Telfer Road
Manchester Grammar School

Hugh Oldham
William McMillan

October 1931
Bronze statue; granite pedestal
Statue 1.83m high; pedestal 89cm high
Signed: The Morris Singer Company London
Inscription: HUGH OLDHAM / BISHOP OF EXETER / AND FOUNDER OF THIS / SCHOOL ANNO DOM 1515 / ERECTED BY A GRATEFUL / SCHOLAR ANNO DOM 1931
Status: not listed
Condition: good
Owned by: Manchester Grammar School
Description: Portrait statue; a life-size bronze of Hugh Oldham, who is shown as a standing figure wearing clerical robes, including a fur-trimmed coat. His right hand is held out whilst in the other hand he holds the model of a building. The statue is placed near to one of the entrances to the school, in a brick niche. It surmounts a short two-stage granite pedestal.

Hugh Oldham, Bishop of Exeter, was the founder of Manchester Free Grammar School in 1515. Apart from promoting education in his native parish, he also left substantial endowments to Corpus Christi College, Oxford. Work on building the grammar school was already under way by 1519, the year of his death.

Manchester Grammar School occupied premises in the centre of Manchester, close to Long Millgate, for over 400 years. As the school expanded, especially during the Victorian and Edwardian years, its accommodation problems increased. These eventually resulted in its moving to purpose-built premises, set in 12 hectares of grounds, in the suburb of

McMillan, *Hugh Oldham*

Fallowfield in 1931. Percy Worthington and Francis Jones were the architects. The new school was officially opened by 17th Earl of Derby on 17 October 1931. A bronze statue of the founder, sculpted by William McMillan, was installed in the new school in time for the opening. It was positioned in a niche outside the pupils' entrance.[1] The sculpture was the gift of an 'Old Mancunian' – a former pupil of the school, who wished to remain anonymous. McMillan was also responsible for the delicate bronze figure symbolising Youth that was placed in the school's main hall, a building

raised to the memory of those old boys of the school who had lost their lives in the First World War. The school also possesses a marble bust of Frederick Walker, High Master (1859–77) by Albert Bruce Joy, and a bronze portrait tablet of J.L. Paton, High Master (1903–24) by John Cassidy, Walker and Paton being two of the school's most influential headmasters.[2]

Notes
[1] *Builder*, 30 October 1931. [2] J. Bentley, *Dare To Be Wise. A History of the Manchester Grammar School* (London: James and James, 1990) p.121 plate 8.

MOSS SIDE

Alexandra Road

St Bede's College

Architects: Archibald Dunn and Edward Hansom

Architectural sculptor: John Broad

1877–1884
Vitreous enamelled terracotta
Panels 1.36m × 89cm
Signed: panel depicting Commerce is signed:
 DOULTON LAMBETH / 1881 – panel depicting
 Divinity is signed: DOULTON LAMBETH
Status: not listed
Condition: poor
Owned by: St Bede's College
 Description: Four inset coloured terracotta panels, two either side of main entrance of school built in red brick and terracotta. The subjects, modelled in high relief, represent Commerce, two men in front of ship, one standing and the other tightening the rope on a bale; the Arts, two men, one seated who is drawing, the other standing engaged in sculpting a frieze; Divinity, a priest seated at a desk holding a book instructing a young man; and the Law, the seated figure of a judge,

Broad, *St Bede's College (panels)*

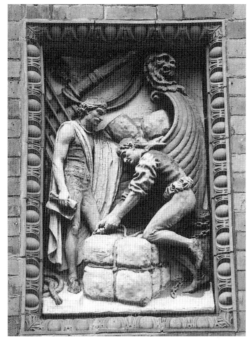
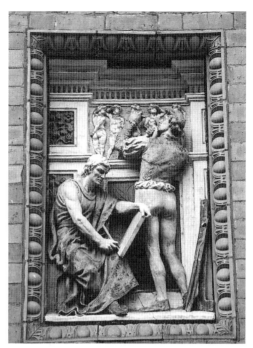
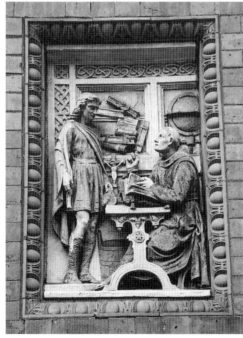
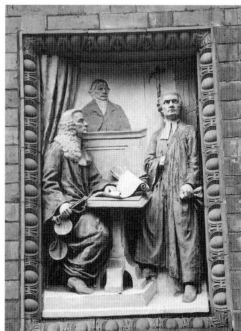

holding scales of justice in his right hand, a lawyer in a court room, and in the background a man standing in the dock.

The Roman Catholic college of St Bede's was founded by Henry Vaughan, Bishop of Salford, in 1875. It occupied temporary premises in Grosvenor Square, Manchester until a new building was opened on Alexandra Road, Moss Side. The new college opened its doors in 1877, in what had been the Manchester Aquarium. Over the next seven years the premises were substantially expanded.[1] The new buildings were in the Italian Renaissance style and the funds were sufficient to allow the architects, Dunn and Hansom, to provide an elaborate and original decorative scheme, principally in the then somewhat unusual material of terracotta. The main entrance to what is now the Vaughan Building included a pair of blue glazed columns flanked by four coloured terracotta panels. These were designed by John Broad of Doultons and employed the experimental technique of coloured enamelled glaze. They represented commerce, the arts, religious education and the law, subjects taught at the school. Terracotta bees were also introduced as decorative features on the entrance.[2] A stone balustrade surmounting the entrance was embellished by four life-size statues (now in very poor condition) including St Bede and the Virgin Mary and child. A fine gallery of unnamed and mainly unidentifiable heads looks out from the pediments of the ground-floor windows. These were also modelled by John Broad.[3] St Bede's was one of the first buildings in the Manchester region to make extensive use of terracotta for decorative purposes.[4]

Notes
[1] *British Architect and Northern Engineer*, 1 September 1876, p.142, 2 November 1877, p.222.
[2] P. Atterbury and L. Irvine, *The Doulton Story* (Stoke on Trent: Royal Doulton Tableware, 1979) p.78. [3] *Builder*, Vol.36, p.637; information from Alex McErlain. [4] R. Cochrane and A. McErlain, *Architectural Terracotta* (Manchester: Manchester Metropolitan University 1999) p.15.

Lloyd Street North

Mother and Children
Kevin Johnson

2 December 1988
Cement sculpture; brick pedestal
Statue of mother 1.9m high
Inscription: Sculpture by Kevin Johnson 1988 / Assertion needs no aggression / Education is our right / Moving forwards, no steps backwards / And tomorrow… / You can no longer halt our progress / Too many rivers of time, have flowed / We are now up and coming / And tomorrow… / Su Andi
Status: not listed
Condition: poor
Owned by: Manchester City Council
Description: Three figures in a group. The central figure is a female, slightly larger than life-size, standing on the ground, with her right arm raised; to her right is the seated figure of a girl, her daughter, holding her head in her hands; to the left is a male figure, her son, half-kneeling, his right hand held high and straight in the air. The two flanking figures surmount separate brick pedestals.

The emergence of Black Art was a notable feature of Manchester's politics and culture in the 1980s, eventually leading to the founding of the Black Arts Alliance. This movement was supported by Manchester City Council and North West Arts. One early initiative was the establishment of a sculpture park in a deprived inner city area, Moss Side. The park adjoined the Ducie Education Centre (now Ducie Central High School). In 1986 a number of sculptors were approached, and Kevin Johnson, an artist, who had only recently graduated, was commissioned to produce a sculpture for the new park. Johnson worked closely with pupils at Ducie Education Centre in developing the work. Different groups in Moss Side were also approached for their ideas about the sculpture. The final sculpture presented what appeared to

Johnson, *Mother and Children*

be a familiar theme, that of the family. It was used, however, to explore the purpose and potential of education in liberating the disadvantaged within the Black community. In the sculpture the mother symbolises the importance of education whilst the two children represent different outcomes: in the case of the girl it is failure, she having given up on education, whilst her brother represents those who are moving forward because of education. The figures were created on wire frames and covered with a rough skin of silica cement, suggesting an unrealised fulfilment within the Black community.[1] The Black poet and performance artist, Su Andi, who had taken

a prominent role in the project, provided a verse to accompany the sculpture. *Mother and Children* was unveiled by the poet, Benjamin Zephaniah, in December 1998.[2] A small number of sculptures made by students from the school were added to the park in the following years, but no other major work was commissioned. This pioneering initiative in promoting Black sculpture was not to be sustained, and over time the sculpture park has been neglected, and Johnson's sculpture has been vandalised, leaving only part of the kneeling male figure intact. In 2003 plans were announced to clear the land for a new school building.

Notes
[1] Information from Kevin Dalton Johnson. [2] D. Brumhead and T. Wyke, *A Walk Round Manchester Statues* (Manchester: Walkround Books, 1990) p.7.

MOSTON

Lightbowne Road

St Joseph's Cemetery

Manchester Martyrs Memorial

John Geraghty

27 November 1898
Marble; stone
9.14 m high approx; base 3.95m square
Inscription beneath portrait of Allen: OF YOUR CHARITY PRAY FOR THE SOULS OF / WILLIAM PHILIP ALLEN. MICHAEL LARKIN. / AND MICHAEL O'BRIEN. / WHO DIED ON THE 23RD OF NOVEMBER 1867. / THIS MONUMENT IS ERECTED TO THEIR MEMORY / BY PUBLIC SUBSCRIPTIONS OF THE IRISH PEOPLE / GOD SAVE IRELAND – lower base: STONE / LAID BY / JAMES STEPHENS ESQ. / NOVEMBER 27, /1898
Status: not listed
Condition: poor
Owned by: unknown
Description: Irish Celtic cross surmounting an elaborate stepped pedestal. Sixteen stones at

Manchester Martyrs Memorial

the base of the cross represent the counties of Ireland (the stones being quarried from each of the counties), the corner stones represent the four provinces. The names of the provinces and counties are inscribed on the stones. A life-size figure of Erin, holding a sword and shield, stands at the base of the cross. At the rear is a miniature Irish round tower. Portrait medallions of Allen, Larkin and O'Brien are displayed on three sides, an Irish harp on the remaining side. Irish wolfhounds sit alert at the base of the cross. Four seated female figures at the lower level symbolise Unity, Justice, Literature and Art.

William Allen, Michael Larkin and Michael O'Brien were executed for the murder of Sergeant Brett at New Bailey Prison, Salford on 23 November 1867. Brett had been killed during an attempt to free two Fenian leaders – Colonel Kelly and Captain Deasy – who were

travelling in a prison van along Hyde Road, Manchester. The evidence of the three men's guilt was slight, and later another Fenian, present at the attack, admitted to shooting Brett. The executions became one of the defining events in the long and sour history of Anglo-Irish relations in the nineteenth century. Allen, Larkin and O'Brien – the Manchester Martyrs – were added to the list of those who had died in the struggle to establish an independent Ireland, and the day of their execution added to those to be remembered in the calendar of Irish struggle.[1]

Many memorials, especially in the form of Celtic crosses, honouring the Manchester Martyrs were raised in Ireland in the following years. The Sunday closest to the day of execution became a day of demonstration and remembrance for the three hanged men.[2] It was, however, not until the end of the century that plans to raise a monument in Manchester were made public. The centenary of the failed Irish rebellion of 1798 was marked by various schemes to erect memorials, some of which became associated with the Manchester Martyrs. It was at this time that it was decided to erect a monument in Manchester. Funds for the memorial came from Ireland, as well as from within Manchester's large Irish community. The site of the memorial was to be the Catholic cemetery in Moston. The *Manchester City News* reported that 'the memorial has been designed and will be carried out by Mr. J. Geraghty of Bootle'.[3] The ceremony of laying the foundation stone drew enormous crowds, both along the route taken by the procession and in the cemetery itself. The stone, brought from the Hill of Tara, was laid by James Stephens, one of the leaders of the Fenian movement. Short speeches were made by Stephens and Maude Gonne.[4] The ornate memorial with its rich symbolism was completed and unveiled in the following year.[5]

The monument became, as intended, an important symbol for the Manchester Irish sympathetic to the cause of an independent

Ireland. Political demonstrations held to mark the anniversary of the executions ended at the memorial. Prominent Irish figures visiting Manchester made their way to the memorial. One of these was Captain Edward O'Meagher Condon, who had been sentenced to death for his part in the attack in 1867 but reprieved because of his American citizenship.[6] The memorial was also subject to attacks by those unsympathetic to the Fenian cause. In 1967, the centenary of the executions, the Manchester Martyrs and Easter Week Commemoration Committee launched an appeal to clean and restore the memorial.[7] At the same time, the Connolly Association proposed to install a memorial on the site of the New Bailey Prison in Salford where Allen, Larkin and O'Brien were executed. The memorial was to take the form of a 2-metre square slab of Irish granite, on which was to be a plaque containing representations and inscriptions relating to the events of 1867. It was to be the work of the Liverpool sculptor, Arthur Dooley. The scheme was opposed. Initially, Salford Planning Committee refused the necessary permission but amid accusations that the decision was driven by 'prejudice and bias', the issue was reconsidered, only to be refused once again. Only when Dooley agreed to change the memorial so that the inscription read: 'Pray the four men may rest in peace', thus acknowledging Brett's death,[8] was official permission given. This still required the casting vote of the deputy mayor, after the council's vote was tied 25 for and 25 against.[9] The memorial, however, was not to be installed. The anniversary march to the memorial in Moston has continued to be a controversial event, particularly during periods of IRA activity in England. Calls were made to ban the march.[10] The present condition of the century-old monument – the broken statuary, paint-daubed stones, graffiti – is testimony to the continuing divisions that exist over the idea of a united Ireland.

Notes
[1] P. Rose, *The Manchester Martyrs. The Story of a Fenian Tragedy* (London: Lawrence and Wishart, 1970); J. McGill and T. Redmond, *The Manchester Martyrs* (Manchester: Connolly Association, 1963). [2] J. Hill, *Irish Public Sculpture. A History* (Dublin: Four Courts Press, 1998) pp.114–20. [3] Rose, *op. cit.*, p.123. [4] *Manchester Courier*, 28 November 1898; *Manchester City News*, 3 December 1898. [5] P. Salveson, *The People's Monuments. A Guide to Sites and Memorials in North West England* (Manchester: Workers' Educational Association, 1987) pp.54–5. [6] *Manchester Guardian*, 27 September 1909. [7] *Manchester Evening News*, 22 March 1967. [8] Sergeant Brett was remembered with a marble tablet, now in St Ann's Church, St Ann's Square, Manchester. [9] *Daily Telegraph*, 2 and 27 November 1967, 7 December 1967; *Manchester Evening News*, 4 April 1967, 12 October 1967, 27 November 1967, 6 December 1967; *Guardian*, 25 September 1967, 13 October 1967, 2 November 1967. [10] *Manchester Evening News*, 30 November 1981, 12 December 1984; *Daily Telegraph*, 21 November 1987.

PRESTWICH

Heaton Park

Solon and *Alfred the Great*
Architect: Francis Goodwin
Sculptor: James Bubb

Coade stone statues
1.83m high approx
Status: not listed
Condition: poor

Description: Life-size statues of standing figures representing Solon and Alfred the Great, each figure positioned in niche.

The Manchester Police Commissioners recognised the need for larger administrative premises towards the end of the Napoleonic Wars. Property was purchased in King Street and it was on this land, a sloping site, that Manchester's first town hall was to be built. Francis Goodwin's classical building was based on the Erechtheion at Athens, and the dome on the Temple of the Winds. The principal public room, running the whole length of the building, was also inspired by the Greek style, and later enlivened by the Italian, with the introduction of Aglio's controversial frescoes.[1] Building began in 1822 but was subject to delays and spiralling costs. Goodwin's design included sculpture. A large statuary group was to be placed on the top of the building, and statues in the two niches above the entrance doors on the principal façade. The sculpture is shown in John Fothergill's 1822 drawing of the intended building, presumably based on Goodwin's plans.[2]

The London sculptor, James Bubb, was chosen from the three sculptors Goodwin approached for estimates. It was a decision that was difficult to separate from Goodwin's friendship with Bubb.[3] However, Goodwin's confidence in his choice – 'Mr Bubb stands pre-eminent in this country as a sculptor in this particular branch of the Arts' – was to be tested as the commission went forward.[4] Bubb proposed that the main sculptural group should symbolise Manchester. This composition comprised a central female figure elevated on a throne, the base of which is decorated with festoons of oak, sustained by fasces, and encompassing the sword and scales of judicial authority, this combining the emblems of British strength and integrity, her justice and her mercy. The throne is surmounted by British lions, guarding as constitutionally maintained by national principles, and by which her prosperity is ensured.[5]

This figure was supported by two others representing Commerce, and Manufactures and Navigation. In addition, the parapet was decorated with two panels containing medallion portraits of Pythagoras and Newton, and Lycurgus and Sir Matthew Hale. The question of which two figures were to be placed in the niches was discussed at some length by the committee, following Bubb's suggestion of Solon and Alfred the Great. Nelson, Wellington

and George IV were among those considered, but in the end the committee concurred with Bubb's proposal of the two law-makers.[6] Sculpting the two figures proved a tortuous affair as Bubb's first sculptures turned out to be too large for the shallow niches. Concerned for his reputation, he set to work on a second pair at his own expense.[7] The replacements were not entirely successful, as they were not raised on pedestals, thus making them appear too short for the space.[8] The problems did not end there, as Bubb's delicate financial position further complicated the carving of the main group,

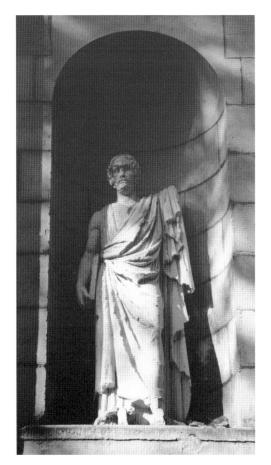

Bubb, *Solon*

emblematic of Manchester. This work was not completed until 1827. But it was not to become a permanent feature of the building. Less than ten years after its installation, it was decided that it was in a dangerous condition and that it would have to be taken down.[9] *Manchester* was removed to the town's Botanical Gardens.

When Waterhouse's new town hall opened in 1877, Goodwin's town hall found a new use as the city's reference library. It continued in this role until 1912 when, after long negotiations, the council sold the site for commercial development. The proposed demolition of the former town hall prompted a campaign, led by the architect, Edgar Wood, to save at least parts of the building. Money was raised to remove, transport and re-erect the main part of the façade in Heaton Park.[10] It was sited near the new boating lake, where it was hoped that, over time, it would become a harmonious part of the landscape.[11] Cecil Stewart referred to it as a 'monument to the Classical Revival, to Francis Goodwin, and to the initiative of a few good men who thought it worthwhile to preserve some part of Manchester's artistic heritage'.[12] But as the façade also included the apparently diminutive *Solon* and *Alfred* – Manchester's first outdoor public statues – the name of James Bubb should be added to Stewart's list. The current condition of the statues is poor, largely a consequence of the Manchester weather. Fortunately, their position on the building has saved them from vandalism.

Notes

[1] *A Description of the Fresco-Paintings in the Town-Hall, Manchester* (Manchester: Henry Smith, 1833). [2] The drawing was published for T. Rogerson by Thomas Sowler in 1823. Copy in Manchester Central Library. [3] Goodwin, 14 November 1822, Police Commissioners' Letter Book (Manchester Central Library, Local Studies and Archives, M9/62/1/1); M. Port, 'Francis Goodwin 1784–1835: An architect of the 1820s', *Architectural History*, 1 (1958) pp.61–71. [4] Goodwin to Town Hall Committee, 19 July 1823, Police Commissioners' Letter Book (M9/62/1/68). [5] Bubb to Town Hall Committee, 30 June 1823, Police Commissioners' Letter Book (M9/62/1/2).

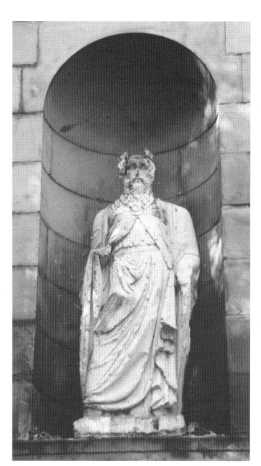

Bubb, *Alfred the Great*

[6] *Ibid.*, 25 and 29 October 1823, 5 November 1823, 4 December 1823, Police Commissioners' Letter Book (M9/62/1/2). [7] Bubb to Goodwin, 7 August 1824; Goodwin to Boroughreeve, September 1824, Police Commissioners' Letter Book (M9/62/1/2). [8] Goodwin to Town Hall Committee, 30 August 1827, Police Commissioners' Letter Book (M9/62/1/4). [9] *Bradshaw's Manchester Journal*, 26 June 1841, p.129. [10] *Manchester Guardian*, 25 January 1912, 3 February 1912, 8 May 1912, 18 May 1912, 15 June 1912; *Proceedings of Manchester City Council*, 7 June 1912. [11] *Illustrated Handbook of the Manchester City Parks and Recreation Grounds* (Manchester, 1915) pp.55–6. [12] C. Stewart, *The Stones of Manchester* (London: Arnold, 1956) p.18.

Manchester International Airport

Alcock and Brown Memorial

Elisabeth Frink

29 October 1964
Aluminium sculpture; stone pedestal
58cm × 3.71cm × 2.54m approx
Signed on pedestal: Elisabeth Frink sculpt
Inscription on pedestal beneath bronze plaque:

THIS SCULPTURE COMMEMORATES / THE FIRST
NON-STOP FLIGHT ACROSS THE ATLANTIC / BY
/ CAPTAIN SIR JOHN ALCOCK K.B.E. D.S.C. /
AND / LIEUTENANT SIR ARTHUR WHITTEN
BROWN K.B.E. / (BOTH OF MANCHESTER) / ON
THE 14TH–15TH JUNE 1919 / THE FLIGHT WAS
MADE IN A VICKERS VIMY / BOMBER POWERED
BY ROLLS-ROYCE ENGINES

Status: not listed
Condition: good
Owned by: Manchester Airport plc

Description: Abstract figure of flying man
with wings instead of arms, surmounting a tall
slender stone pedestal. An oval-shaped bronze
plaque on the pedestal depicts the profiles of
the two airmen.

John Alcock was born in 1892 in Old Trafford,
but spent most of his childhood in Fallowfield,
Manchester. He worked as a mechanic and
became involved in the early period of flight
before the First World War. He was an
experienced pilot when he joined the Royal
Naval Air Service in 1914 and flew many
missions before being shot down, captured and
made a prisoner of war in Turkey. After the
war Captain Alcock became a test pilot and
took up the challenge of flying across the
Atlantic, spurred on by a newspaper's offer of a
£10,000 prize. He was the pilot of the plane that
undertook the historic 3,000-kilometre flight
across the Atlantic on 14–15 June 1919. Alcock
died in a flying accident in France in December

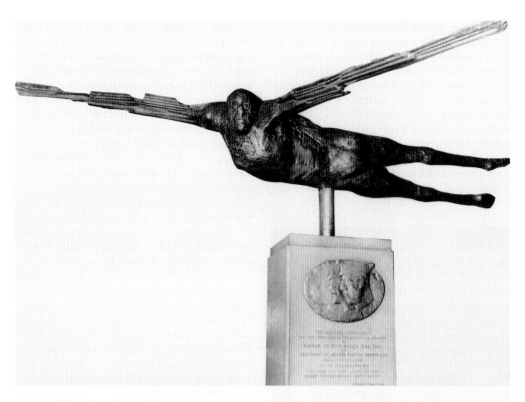

1919, and was buried in Southern Cemetery,
Manchester.

Arthur Whitten Brown was born in Scotland
in 1886 but brought up in Manchester, living in
Chorlton-cum-Hardy. He trained as an
engineer and worked for the Westinghouse
company. During the war he served in the
army, before transferring in 1915 to the Royal
Flying Corps. His plane was shot down and he
spent nearly two years as a prisoner of war.
Lieutenant Brown was the navigator of the
Vickers Vimy aircraft that took off from St
John's, Newfoundland, and landed some 16
hours later in a Galway bog, near Clifden. He
and Alcock were both knighted for their
achievement. He died in 1948.

The construction of a new terminal at
Manchester's Ringway airport at the end of the
1950s provided the impetus for commissioning
a public sculpture. The idea of a sculpture

Frink, *Alcock and Brown Memorial*

located in the concourse of the new building
was discussed by the members of the Airport
Committee of Manchester City Council before
the building was completed. In October 1959
four sculptors were invited by the City Council
to provide designs for a work which would
honour Alcock and Brown's first non-stop
flight across the Atlantic in 1919. A figurative
sculpture was envisaged, similar to William
McMillan's statue of the two aviators, installed
at London Airport some five years before.[1]
There was even the suggestion that it might
stand on a pedestal of wood from
Newfoundland, the place from where their
historic flight had begun.[2] Elisabeth Frink was
the artist selected, but the commission did not
proceed smoothly. An appeal for funds was

launched by the Lord Mayor in October 1961.[3] By August 1962 it was reported that discussions were taking place with Frink about the work. It had been intended to commission it in the previous year, but this had not been possible because of 'legal complications'.[4] When, in June 1963, Frink showed a model of the intended sculpture to the city's Airport Committee, various members expressed their dissatisfaction. Councillor J.G. Hopkins captured the attention of the press with his alliterative observation that the proposed sculpture resembled 'a bewitched, bewildered and bemused budgerigar'.[5] More prosaically, others wondered if the cost of £3,250 was somewhat extravagant for a sculpture that prompted sentiments of sarcasm and scorn rather than pleasure and pride. The idea of establishing a new fund to commission a more conventional sculpture was mentioned, as was the possibility of acquiring a copy of the McMillan statue. Further delay followed when it was discovered that no provision appeared to have been made in the estimates to purchase the sculpture.[6] In spite of the criticisms, the project continued to be supported by other members of the Airport Committee, including Councillor Tom Farrell. Frink's sculpture was finally allowed to proceed.[7]

For Frink the commission enabled her to explore further the theme of flight, and the finished sculpture, with its characteristic rough surface texture, is an important example of those flying figures and birds which marked this period of her work.[8] In October 1964, some two years after the opening of the new terminal, the sculpture was placed in the airport concourse, where a large abstract stained glass window by Margaret Traherne had already been installed as a tribute to the thousands of paratroopers who had trained at the Parachute Training School at Ringway during the Second World War.[9] The Lord Mayor of Manchester, Dr William Chadwick, unveiled the new sculpture. Opinions about the work remained divided. Of Alcock's surviving brothers who attended the ceremony, one felt the sculpture

was appropriately modern and 'in keeping with the jet age', whilst the younger brother believed that 'a replica of the Vimy plane would have been more appropriate'.[10] Elsie Moseley, Brown's sister, condemned it as 'sordid, vulgar and obscene', claiming that her brother would have been speechless had he been there to see it. The Airport Committee also remained divided. One unidentified member suggested 'Ox Roasting' as an alternative title. It was left to Councillor Farrell to continue to defend the sculpture as a truly modern work of art, entirely appropriate for its setting. 'It was', he remarked, 'no solid lump of graceless stone.'[11]

Frink's controversial sculpture was not to remain in the main concourse. Alterations to the terminal building prompted the removal of the sculpture to an outdoor garden area, next to the airport police station, a move which the sculptor approved.[12] Further building work, however, resulted in its being moved back inside the airport buildings in 1997. It is now inside the departure area of the international terminal, a location that means it is not accessible to all those using the airport.

Notes
[1] *The Times*, 16 June 1954. [2] *Manchester Guardian*, 3 October 1959. [3] *The Times*, 13 October 1961. [4] *Guardian*, 17 August 1962. [5] *Daily Telegraph*, 21 June 1963. [6] *Ibid.*, 26 June 1963. [7] *Ibid.*, 24 July 1963. [8] *Elisabeth Frink Sculpture. Catalogue Raisonné* (Salisbury, Wiltshire: Harpvale, 1984) pp.55–8. [9] *Manchester Evening News*, 23 April 1963; *Sunday Times*, 19 May 1963. [10] *Manchester Evening News*, 29 October 1964. [11] *Daily Mirror*, 30 October 1964; *Guardian*, 30 October 1964. [12] S. McDonald, *First and Foremost. In Celebration of Fifty Years of Manchester Airport* (Manchester Airport plc, 1988) p.71.

WYTHENSHAWE

Moor Road

Brookway High School

Man and Technic
Mitzi Cunliffe

1957
Bronze sculpture; slate pedestals
2.74m high
Signed on right-hand pedestal: MITZI CUNLIFFE SCULPSIT – on left-hand pedestal: MCMLVII
Condition: fair
Owned by: Manchester City Council
 Description: Larger than life-size figure of semi-naked male who is shown kneeling, holding a firebrand in his outstretched right hand and a large wheel (now missing) in his left. The figure is kneeling on two short pedestals.

In 1956 Manchester Education Committee commissioned a sculpture for its new secondary technical school in Wythenshawe. The sculptor chosen was Mitzi Cunliffe, who had already completed a number of local works including a sculptural panel at the Manchester High School for Girls.[1] She lived locally in Didsbury. Cunliffe created an inspirational sculpture of a larger than life-size youth who was shown holding a firebrand in his right hand and an open wheel in the other.[2] The work was to be in bronze and located outside of the main school building. The commission, along with that of Austin Wright's sculpture for Poundswick Grammar School, became the subject of controversy in both the council and the press in the winter of 1956–7.[3] Critics voiced concern over the suitability of the design and its cost. It was also assumed that the decision to proceed with the sculpture had been slipped through the council without proper discussion. Many of the critics also assumed that the £1,200 cost of the sculpture could be simply transferred to

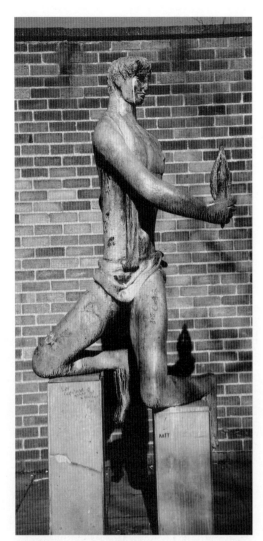

Cunliffe, *Man and Technic*

another, more deserving, part of the council's education budget. However, as the council had already contracted Cunliffe to provide the work, there was little opponents could do except agree to be more vigilant when similar 'wasteful' projects arose in the future. The sculpture was completed and installed at the school in 1957. Since that date it has remained in its original position but has suffered vandalism, notably the removal of the wheel and damage to both pedestals.

Notes
[1] Photograph No.36830, Manchester Central Library, Local Studies and Archives. [2] *Manchester Evening News*, 22 January 1957, 1 February 1957; illustration of clay model in *Wythenshawe Reporter*, 8 February 1957. [3] *Manchester Guardian*, 16 October 1956, 2 February 1957; *Wythenshawe Recorder*, 16 November 1956.

Wythenshawe Road
Wythenshawe Park

Oliver Cromwell
Matthew Noble

1 December 1875; removed and re-sited May 1968
Bronze statue; granite pedestal
Statue 2.74m high; pedestal 2.74m high; base 1.68m high × 4.52m square
Inscription on pedestal: OLIVER / CROMWELL / BORN 1599 / DIED 1658 / THE GIFT OF / ELIZABETH SALISBURY HEYWOOD / TO THE CITIZENS OF MANCHESTER / AUGUST, 1875
Owned by: Manchester City Council
Condition: poor
Description: Portrait statue; larger than life-size bronze statue depicting Cromwell in military costume, wearing a leather coat, across which is a broad sash, cavalry boots and spurs. His right hand rests on the hilt of his sheathed sword which is placed in the ground. His hat lies on the ground behind his left foot. The statue surmounts a massive rough granite pedestal rising from a base of four granite stone steps.

In spite of the reassessment which was taking place in early Victorian England of Oliver Cromwell's role in the making of the modern state, the idea of raising a memorial to the Old Protector revealed conflicting views within Victorian society.[1] In Manchester the idea of a Cromwell statue appears to have been first suggested in 1860 by a group of Liberals including Edward Watkin, Thomas Bayley Potter and R.N. Philips, who were willing to proclaim him as an important figure in the development of their own political ideas. Potter commissioned a bust of Cromwell from Matthew Noble, the clay model of which was generously praised by the *Art Journal*.[2] Thomas Goadsby, who was to present the town with a marble statue of Prince Albert, was also one of the supporters of the project.[3] It was later stated that the Market Place had been identified as a possible site for a statue.[4] But the project for a full-length portrait statue stalled, in part because of the Cotton Famine, in part because of the efforts directed towards other public projects including the completion of the Albert Memorial. As a consequence the idea of full-length Cromwell remained unrealised at the time of Goadsby's death, and it was left to his widow, Elizabeth, to fulfil his wishes. She had additional reasons for pursuing the project because her own family had connections with the Parliamentary side in the Civil War in the North West. Once again, Matthew Noble, who had discussed the commission with Goadsby before his death, was the preferred sculptor. Noble produced a model which was seen in his London studio by, among others, Sir Joseph Heron, Manchester's indefatigable town clerk. Noble wrote in 1869 to the City Council about the intended statue, pointing out that it was his understanding that although it was a private commission, it would be placed in a prominent public space in the city, either outdoors or 'as was most desired in the new Town Hall'. There was support within the council's General Purposes Committee though any proposal concerning the statue was hardly likely to pass without comment.[5] When the subject was discussed in the full council, Abel Heywood, who had married Elizabeth Goadsby, appeared intent on restricting debate, claiming that the statue was a personal matter, and to avoid embarrassment requested that references were removed from the council minutes.[6] Nonethe-

less, Heywood and his allies seemed confident that a marble Cromwell would stand in Manchester's new town hall. More specifically, it was intended to place it in the very heart of the building, the Great Hall. However, given the pace of the construction work, there was, as yet, no real urgency. Noble's *Cromwell*, however, attracted the attention of other radical Liberals. In 1871 Noble's plaster model of Cromwell was installed, at the request of Acton Ayrton, the Commissioner of Works and a radical Dissenter, outside the Houses of Parliament. It was a provocative act that prompted, as Ayrton and other Liberals intended, arguments both inside and outside parliament.[7] It was soon removed. Westminster would have to wait until 1899, the tercentenary of Cromwell's birth, before it displayed a more permanent Cromwell monument.[8]

When Alfred Waterhouse was able to turn his attention to the question of sculpture inside Manchester Town Hall, he was opposed to the idea of placing a colossal marble statue of Cromwell in the Great Hall. Heywood and other supporters reluctantly reconsidered the scheme. The outcome was that Manchester was finally to have its statue of Cromwell, but it was to be in bronze not marble, and it was to stand out of doors not inside the new 'municipal palace'. This did not mean that Cromwell was absent from the town hall. Thomas Bayley Potter presented a marble bust of Cromwell by Noble to the city. It would be displayed in the Sculpture Hall on the ground floor.[9]

A council sub-committee, whose members included Abel Heywood and John Thompson, investigated a suitable location for the Cromwell statue. The site selected was the junction of Cateaton Street and Deansgate, close to the spot where the first blood of the Civil War had been spilt in 1642.[10] (An incident which was to be one of the subjects of Ford Madox Brown's murals in the Great Hall.) Apart from its historical associations, the site, a busy road intersection, allowed Noble to position the statue so that it was visible from

the Royal Cotton Exchange along Victoria Street. Noble depicted Cromwell in military dress, his right hand clenching the hilt of his sword. Old Noll's uncovered head showed a full moustache, suggesting that the sculptor had studied the painting by Samuel Cooper, as well as Lely's better-known 'pimples, warts and everything' portrait. The gunmetal bronze statue was cast at Cox and Son's foundry, Thames Ditton. The cost including the pedestal was £1,600.

The unveiling of Manchester's *Cromwell* took place at the end of November 1875, not August as the inscription had anticipated. This was some 15 years after Manchester Liberals had mooted the statue. The ceremony was kept deliberately low key, a decision that met the wishes of Elizabeth Heywood, whilst also trying to avoid the controversy that a more publicised unveiling might have attracted.[11] At a meeting inside the town hall, Elizabeth Heywood transferred ownership into the hands of the council. Speakers acknowledged the contentious historical reputation of Cromwell, though Thomas Bayley Potter, for one, would not dilute his opinions, pointing out that 'This tardy act of justice to the memory of Cromwell was most appropriate in this great city, where the greatest movements in progress had been carried on'.[12] The inauguration of the statue followed, the ceremony being conducted by the mayor.[13] Ill-health unfortunately prevented Noble from attending the unveiling of what was to be his last major Manchester statue, and, indeed, one of his last public monuments.

Judged as a work of art, Noble's heroic statue, rooted in its massive, roughly cut pedestal of Cornish granite, found general approval.[14] *The Times* concluded that 'the longer we contemplate the statue the more we perceive that it contains the aggregate of the whole man – his wisdom in peace and his strength in war, his unflinching ambition and his severe piety'.[15] But the country's first major public statue of Cromwell could not be considered so narrowly. Although the historical

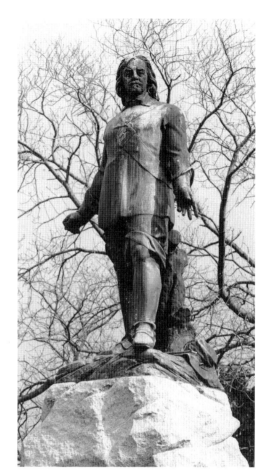

Noble, *Oliver Cromwell*

reassessment of Cromwell was under way, older views of the regicide and despot remained firmly in place. Leeds had turned down the offer of a Cromwell statue because, it was said, public opinion was not ready for it.[16] The republican principles embodied in the Manchester statue were suitably denounced in the pages of the local Conservative press, Manchester being cast as a community 'befooled and betrayed' by 'the preposterous whims of some of our municipal Solons' who had raised an 'odious effigy of a traitor and

regicide', a man who had 'treated Scotland as a conquered province and massacred the Irish in cold blood'.[17] Other publications joined in the attack.[18] Cromwell remained a contentious historical figure, and the statue was a touchstone for distinguishing political beliefs. There may not have been widespread support for republicanism in Manchester, but Cromwell became, for some, another symbol of the city's long tradition of political radicalism. Whether it was responsible for Victoria's refusal to open the new town hall in 1877 may be doubted, but it was a symbol that was far too visible and new to avoid in such arguments, and over time it

was to become the popular explanation of her unwillingness to visit the city. Such arguments conveniently forget that the Queen and other members of the royal family were said to have admired Noble's original model.[19] A bust based on the statue was presented by Noble to Salford Museum and Art Gallery.[20]

Before the First World War demands began to be made for the Cromwell statue to be removed from Deansgate, but for reasons connected with easing the traffic flow, rather than political objections.[21] Similar calls were repeated in the following years.[22] St Mary's Gardens was suggested as one alternative site in the 1930s.[23] But Cromwell managed to avoid such calls until 1967, when it was finally decided to move the statue to Wythenshawe

Park, Wythenshawe, a district on the southern boundary of the city.[24] The park included Wythenshawe Hall which had been besieged by parliamentary soldiers during the Civil War. Sir Richard Harper, one of the city's senior councillors, was particularly active in the discussions over the relocation. Cromwell was finally moved in the following year.[25] Almost immediately, the statue was daubed with paint, the first of a number of acts of vandalism that included the removal of Cromwell's sword.[26] Discussions about the location of the city's statues in the 1980s raised the idea of returning Cromwell to the city centre, but this was not followed up. Cromwell remains exiled (and neglected) in Wythenshawe Park.[27]

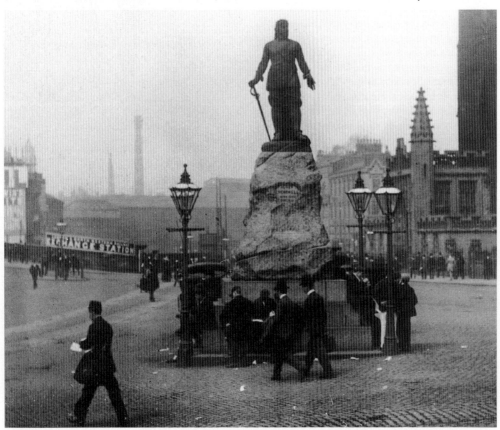

Noble, *Oliver Cromwell statue, Deansgate c.1905*

Notes

[1] For example the correspondence and reports on proposed statues of Cromwell in London, *The Times*, 5 September 1845, 13 September 1845, 13 March 1868. [2] *Art Journal*, February 1861, p.62. [3] See above, p.11. [4] *Manchester City News*, 4 December 1875. [5] *Proceedings of Manchester City Council*, Report of General Purposes Committee, July 1869, p.297; *Manchester Guardian*, 30 July 1869. [6] *Manchester Guardian*, 6 August 1869. [7] *The Times*, 10 August 1871; B. Worden, 'Putting the Protector on a Pedestal', *BBC History Magazine*, 3 January (2002) pp.40–2. [8] The statue was by Hamo Thornycroft. [9] See above, p.39. [10] *Proceedings of Manchester City Council*, 1 July 1874, p.368, 7 April 1875, p.218. [11] *Ibid.*, 15 November 1875, p.77. [12] *Manchester City News*, 4 December 1875. [13] *Manchester Courier*, 2 December 1875; *The Times*, 2 December 1875. [14] *Art Journal*, 1876, p.108. [15] *The Times*, 16 August 1875. [16] *Ibid.*, 7 December 1875. [17] Letters in *Manchester Courier*, 30 November 1875, 1 December 1875. [18] *Freelance*, 10 December 1875. [19] *Manchester Courier*, 27 November 1875. [20] *County Borough of Salford. Catalogue of Loan Collection of Pictures Jubilee Exhibition* (Salford [1894]) p.89. [21] *Manchester Evening News*, 20 November 1913; [22] *Manchester Evening Chronicle*, 18 March 1926. [23] *Daily Express*, 18 August 1933; *Manchester Guardian*, 17 August 1933, 16 September 1933. [24] *Wythenshawe Express*, 13 April 1967, 19 June 1967. [25] *Manchester Evening News*, 16 and 20 May 1968; *Guardian*, 20 May 1968. [26] *Manchester Evening News*, 3 June 1968. [27] *Ibid.*, 21 March 1981, 20 August 1983.

Cross Street

Royal Manchester Exchange

The dominant theme in the history of the Manchester Royal Exchange building in the nineteenth century was of reconstruction and enlargement, a response to the business needs of an expanding cotton industry. The first Manchester Exchange in the nineteenth century, designed by Thomas Harrison, was completed in 1809. It was located at the junction of Market Street and Exchange Street, overlooking the Market Place. In 1849 it was replaced by a larger building designed by Alexander W. Mills. The reception of Queen Victoria in this building in 1851 resulted in its title of the Royal Manchester Exchange. The stone royal coat of arms that was subsequently commissioned for the outside of the building was the work of John Thomas. The continuing pressure on space resulted in a further scheme to extend the Exchange. The winning design in a competition which attracted over 50 architects was from Alexander W. Mills and James Murgatroyd. The new exchange was opened in two stages, in October 1871 and October 1874.[1] It had considerably more external sculpture than the previous building, most notably above the portico on Cross Street. This was carved by E.G. Papworth jnr, who may also have been responsible for the semicircular marble panels on the Market Street corner.

But like its predecessors, Mills and Murgatroyd's Exchange was also to be extended and altered. Plans for a far larger building, designed by Bradshaw Gass and Hope, were agreed in 1914. Special dispensation was given to allow building to take place during the war.[2] The extended exchange was not finally completed until 1921. One of the most obvious changes to the exterior was the removal of the grand portico in Cross Street along with the sculpture with which Mills and Murgatroyd had embellished their exterior.[3] Whatever advantages the new exchange offered, Manchester lost one of its most important displays of architectural sculpture.[4] The sculpture was taken down and is presumed to have been sold. The royal coat of arms which had been placed on the pediment appears to have been rediscovered in a garden in Timperley in 1963.[5] Another piece of the architectural sculpture, part of the coat of arms, was sold at Sotheby's in the 1990s.[6]

Notes
[1] *Builder*, 17 October 1874, pp.859–60.
[2] *Manchester Guardian*, 2 July 1915. [3] *Manchester City News*, 8 October 1921. [4] R.J. Allen, *The Manchester Royal Exchange: Two Centuries of Progress* (Manchester Royal Exchange Limited, 1921). [5] *Manchester Evening News*, 25 July 1963. [6] Information provided by Sotheby's, Petworth office.

Market Street

Arndale Centre

Totem

Franta Belsky

1977
Aluminium filled glass reinforced resin on steel frame
9.45m high approx

Franta Belsky was commissioned by the developers of the Market Street Arndale shopping centre to provide a sculpture to occupy a prominent space on the ground floor

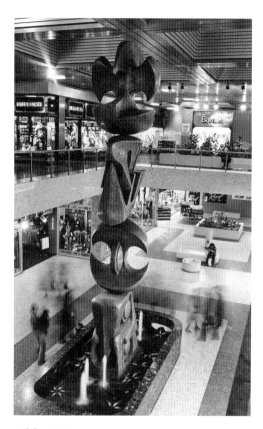

Belsky, *Totem*

of the new centre. Belsky's sculpture took the form of a large totem, made up of four separate sections which were connected to each other. The design of each section reflected aspects of the region's history and economy, including a capstan from the Manchester Ship Canal. The top section – the Bird – emerged as an independent form when viewed from the first floor. *Totem* stood on a polished terrazzo base

which included a fountain bowl with water jets.[1] Belsky had intended that the sculpture would include waterways, allowing water to fall into containers, making interesting noises, but this idea was abandoned by the developers. *Totem* was awarded a medal from the Royal Society of British Sculptors for 1976, an enlarged replica of the medal being fixed on the base. The sculpture was installed in 1977, shortly after the opening of the first phase of the shopping centre.[2] It remained a distinctive feature of the lower mall until the centre's interior was redesigned in 1987–8. At that time the sculpture was dismantled, with no apparent plans either to resite it or to contact the sculptor about preserving it.[3] It is presumed to have been discarded.

Notes
[1] *The Times*, 25 November 1975, p.17. [2] L.G. Redstone and R.R. Redstone, *Public Art. New Directions* (New York: McGraw Hill Book Company, 1981) p.141. [3] F. Belsky, *Franta Belsky: Sculpture* (London: A. Zwemmer, 1992); correspondence with Franta Belsky, 1999.

Oxford Road

Whitworth Park

Christ Blessing the Little Children
George Tinworth

5 May 1895
Terracotta group; salt-glaze stoneware base
Statue 1.83m high approx; pedestal 1.22m high
 approx
Inscription: JESUS SAID / "LET THE LITTLE CHILDREN COME / UNTO ME AND FORBID THEM NOT, FOR / OF SUCH, IS THE KINGDOM OF HEAVEN".
AS A CHILD JESUS GREW IN WISDOM AND STATURE, AND IN FAVOUR WITH GOD AND MAN.
JESUS SAID / "BLESSED ARE THE PEACEMAKERS: / THEY SHALL BE / CALLED THE CHILDREN OF GOD".
DEDICATED TO NEIGHBOURS AND CHILDREN,

MANCHESTER WHITWORTH INSTITUTE MAY 1895
Description: Life-size sculpture depicting Jesus and three children. Jesus is seated, two of the children are standing either side of him, and an infant is asleep at his feet. His left hand is placed on the head of the child offering him a flower.

This terracotta sculpture was the gift of R.D. Darbyshire, one of the trustees responsible for dispensing the large fortune that Sir Joseph Whitworth left to Manchester. That fortune was used principally to establish the Whitworth Institute for Art in Grove House on Oxford Road. Some £70,000 was also used to purchase and transform the adjoining rough fields into

Tinworth, *Christ Blessing the Little Children*

Whitworth Park. Darbyshire intended the sculpture to be placed in the park, which the Whitworth Trustees had presented to Manchester City Council. The sculptor was George Tinworth (1843–1913) of the Royal Doulton Works, Lambeth. Tinworth was an accomplished modeller and sculptor who became especially well known for his sculptures on biblical themes, including *Preparing for the Crucifixion* and *Gethsemane*. For the Manchester commission he took as his subject the text, 'Let the little children come unto me'.[1] The completed work was installed close to the centre of the park in May 1895.[2] It was the first major commissioned sculpture to be installed in any Manchester park. It found favour with the late-Victorian Manchester press; one publication commenting that 'The children are charming in pose and expression, and the figure of Christ, if somewhat conventional, is still eminently pleasing and conveys an impression of tenderness in admirable keeping with the incident'.[3]

The sculpture – referred to variously as *Jesus and the Children*, *Christ and the Children* and *Christ Blessing the Little Children* – was a popular landmark in the park, appearing on postcards and remembered by visitors.[4] In the early years of the Second World War the terracotta sculpture was damaged – whether by a barrage balloon or vandals is unclear – and was removed from the park.[5] It was not repaired and it is presumed to have been discarded.[6] The pedestal fared somewhat better, remaining in the park for a further 50 years before it too was removed.

Notes
[1] P. Rose, *George Tinworth* (Los Angeles, California: C.D.N. Corporation, 1982) p.182; P. Atterbury and L. Irvine, *The Doulton Story* (Stoke-on-Trent: Royal Doulton Tableware, 1979) pp.88–9. [2] *Manchester Weekly Times*, 10 May 1895; Whitworth Institute minutes, 27 April 1895, 12 June 1895 (Whitworth Institute). [3] *Manchester Faces and Places*, 7 (1895–6) p.75. [4] W.W. Pettigrew, *Municipal Parks Layout, Management and Administration* (London: Journal of Park

Administration, 1937) plate LII; *Manchester Evening News*, 4 June 1973. [5] Undated cutting in Parks file, Chetham's Library. [6] Information from City Parks Department, 1990.

ANCOATS

Every Street

Henry Hunt Monument

16 August 1842; demolished October 1888
Stone
9.75m high
 Description: Stone obelisk surmounted by statue of Henry Hunt.

Plans to raise a memorial to Henry Hunt in Manchester came to fruition in 1842. 'Orator' Hunt had been a major figure in the movement for political reform, and in Manchester he was best remembered for being the principal speaker at a reform meeting in St Peter's Fields in 1819 which, because of the actions of the Manchester Yeomanry, became the Peterloo Massacre. Hunt was imprisoned after Peterloo but on his release he continued to campaign for parliamentary reform. He died in 1835. Plans to erect a memorial to Hunt in Manchester were announced shortly after his death.[1] The Revd James Scholefield was a leading figure in the movement to raise a memorial, support coming from Chartists and other working-class radicals. It was decided to locate it in the churchyard of Scholefield's Chapel in Every Street, Ancoats. The Chartist leader, Feargus O'Connor, presided at the laying of the foundation stone on Good Friday, 25 March 1842.[2] It was planned to unveil the monument on the anniversary of Peterloo, 16 August, but the programme was overtaken by events, notably the outbreak of industrial strikes which began earlier in the month. The authorities responded by restricting meetings in the town. As a consequence, the monument erected to perpetuate the memory of Hunt and the victims

of Peterloo 'to show to future generations how the people of these times esteem sterling worth, and how they appreciate genuine patriotism' was never officially inaugurated.[3] A contemporary illustration shows the obelisk surmounted by a statue of Hunt, but it appears that this was never completed.[4] The memorial cost £65.5s.6d. A Staffordshire china model of

the memorial was produced but does not appear to have sold in large numbers.[5]

 In the following years the condition of the monument, sited in one of Manchester's most deprived and overcrowded districts, deteriorated. In the late 1880s its future became problematic following the sale of the chapel and in October 1888, the monument was

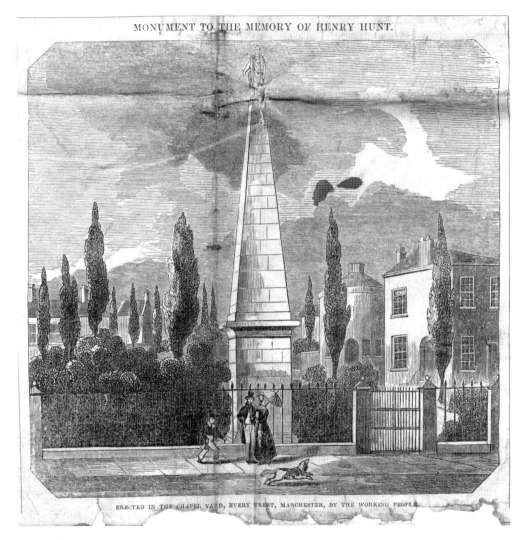

MONUMENT TO THE MEMORY OF HENRY HUNT.

ERECTED IN THE CHAPEL YARD, EVERY STREET, MANCHESTER, BY THE WORKING PEOPLE.

Henry Hunt Monument

demolished and the stone sold.[6] The destruction of the monument to Hunt and the victims of Peterloo did not go unnoticed. One radical Manchester publication condemned the action, and went on to call for a fountain to be placed in Stevenson Square which would be 'crowned with the figure of Britannia, and surrounded with life-size figures of men who have helped to make Manchester and English history'.[7] An appeal was launched to erect a new monument to Hunt, but the response was such that no action was taken. Some 20 years later, the idea of a memorial to Hunt was revived and John Cassidy was commissioned to produce a medallion portrait. The intention was to fix it on the Free Trade Hall, the site of the Peterloo Massacre, but this proved difficult to arrange. Instead, a new location, the vestibule of the Manchester Reform Club, was agreed upon. It was unveiled by C.P. Scott, editor of the *Manchester Guardian*, in June 1908.[8] The inscription beneath the medallion read: 'Henry Hunt who for his part in the Great Reform Meeting in St Peter's Fields Manchester (Peterloo) Aug. 16 1819 suffered two years' imprisonment.' At the same time, a collection of prints, pamphlets and newspapers relating to the Peterloo Massacre was presented to the Reform Club.

Notes
[1] J. Belchem, *Orator Hunt: Henry Hunt and English Working-Class Radicalism* (Oxford: Clarendon Press, 1985) p.276. [2] *Manchester Guardian*, 26 March 1842. [3] A. Marcroft, *Oldham Liberal Bazaar Souvenir. Landmarks of Local Liberalism* (Oldham, 1913) p.71. [4] 'Henry Hunt and the Manchester "Massacre"' (Leeds: J. Hobson [n.d.]) (Broadside, Chetham's Library); *The Pioneer: A Political Handy-Sheet for Men and Women*, 27 October 1888, No.63. [5] *Transactions of Lancashire and Cheshire Antiquarian Society*, 7 (1889) pp.325–6. [6] V.I. Tomlinson, 'Postscript to Peterloo', *Manchester Region History Review*, 3, no.1 (1989) pp.56–8. [7] *The Pioneer: A Political Handy-Sheet for Men and Women*, 27 October 1888, No.63. [8] Unveiled 29 June 1908. *Manchester Guardian*, 30 June 1908; *Manchester City News*, 4 July 1908.

HARPURHEY

Rochdale Road
Queen's Park

Ben Brierley
John Cassidy

30 April 1898
Portland stone statue; stone pedestal
Statue 2.36m high approx; pedestal 2.44m high
Inscription on front of pedestal: BEN BRIERLEY / 1825–1896 – left-hand side: IN MY EARLY DAYS THERE WERE / FEW SCHOOLS TO HELP US IN THE / PURSUIT OF LEARNING. IF WE / WANTED TO CLIMB WE HAD FIRST / TO MAKE OUR OWN LADDERS. – right-hand side: IN PROSE AND VERSE, AND IN / THE DIALECT SPOKEN BY THEMSELVES / HE SET FORTH WITH GREAT / FAITHFULNESS AND POWER / THE LIFE OF THE WORKING-FOLK / OF LANCASHIRE. – rear: ERECTED / BY / PUBLIC SUBSCRIPTION / APRIL 1898
Description: Portrait statue; Brierley, who is dressed in a frock-coat, is depicted giving a public recital, his left hand holding the manuscript from which he is reading, in his other hand are the finished pages.

Ben Brierley was born in 1825 into a working-class family in Failsworth, near Manchester. He had little formal education, and began working in the local textile industry while still a young boy. A passion for literature led him into writing, some of his earliest work being published in local newspapers. By 1863 he had left the factory to take up a position as sub-editor of the *Oldham Times*. He continued writing and his dialect sketches, especially those featuring Owd Ab-o'th'-Yate, proved immensely popular in Lancashire. His reputation grew, and by the 1870s he was recognised, along with Edwin Waugh, as one of the leading Lancashire dialect writers. His

published works include *The Layrock of Langleyside* (1864), *Irkdale* (1865) and *Ab-o'-th'-Yate on Times and Things* (1868). He also founded and edited *Ben Brierley's Journal* from 1869 to 1891. An autobiography, *Home Memories,* was published in 1886. In the previous year his Lancashire admirers presented him with a testimonial of £650, the cheque suitably enclosed in an old stocking. He was a founder member of the Manchester Literary Club. Brierley served as a city councillor for St Michael's ward from 1875–81. He died on 18 January 1896 and was buried in Harpurhey Cemetery.[1]

Following Brierley's death discussions among his friends, including many from the Manchester Literary Club, moved from raising a memorial over his grave to the more ambitious idea of raising a public statue. When the idea was discussed publicly in the summer of 1897 there appeared to be wider support.[2] A memorial committee, chaired by George Milner, president of the Manchester Literary Club, was formed. Turning expressions of support into subscriptions proved a harder task. There were many small donations from working people but the available funds clearly constrained the committee. The Manchester sculptor, John Cassidy, was commissioned to carve a portrait statue, but only in Portland stone, a material that was optimistically referred to as both durable and capable of resisting the city's smoky atmosphere.[3] Cassidy began carving the five-tonne block of stone in the first week of February 1898 and completed the statue by the last week of April. He worked from photographs, producing a likeness that received the approval of Brierley's widow and others who had known him.[4] The final cost of the memorial was some £350. Queen's Park, Harpurhey, was the location agreed with the City Council. The park was a place Brierley knew well and was next to the cemetery in which he was buried.[5]

Ben Brierley was not only the first portrait statue to be placed in one of the Manchester

Cassidy, *Ben Brierley, 1989*

Notes
[1] *Papers of Manchester Literary Club*, 22 (1896) pp.489–509. [2] *Manchester Guardian*, 18 July 1897, 4 September 1897. [3] *Ibid.*, 4 December 1897. [4] *Manchester City News*, 30 April 1898. [5] *Manchester Guardian*, 4 and 18 December 1897. [6] *Ibid.*, 2 May 1898; *Manchester City News*, 7 May 1898. [7] *Manchester Guardian*, 2 May 1898; *Manchester Faces and Places*, Vol.9 (1898) p.198. [8] *Manchester City News*, 29 January 1927. [9] Letter from City of Manchester Cultural Services to Jo Darke, 27 July 1988.

HULME

Rolls Crescent

Four Estates

William Mitchell

1970
Concrete
3.05m high approx

Description: Square concrete column decorated on each side with abstract pattern representing the crown, church, army and law. The sculpture was located in the centre of an open space surrounded by shops.

The London sculptor, William Mitchell, was commissioned to provide a piece of sculpture to serve as focal point for an open space in a small retail development on the new Hulme housing estate. Constructed out of concrete, with each side covered in abstract patterns, it was a characteristic example of Mitchell's work. In this case each side of the column represented one of the estates: the crown, the church, the army and the law. Mitchell's works had the attribute of being difficult to vandalise. The sculpture survived all the problems of one of the most deprived districts of the city. It appears to have been removed during the redevelopment of the estate some time in the mid-1990s and is believed to have been discarded. A number of public art projects have been included in the redevelopment of Hulme,

parks, it was also the first statue raised in the city to a local literary figure. It was unveiled by George Milner in April 1898. The ceremony attracted a large crowd in spite of the rain. Milner, who had known Brierley well, paid tribute to the dialect writer, whom he characterised as a typical Lancashire man. Support for the statue, he pointed out, had come from all social groups but particularly from the working classes. Milner traced this support to the love of Brierley's writings among Lancashire working families. Brierley also provided 'a noble example of what a poor man, suffering from absolute poverty and even starvation in his youth, could do to get himself an education'.[6] Milner spoke again at a further celebration in the evening – all of the recitations were from Brierley's writings – recalling

Brierley's achievements and reminding his listeners that they had raised a truly democratic monument, erected 'to a man of the people, who was a poor man, and never aspired to be more than a poor man'.[7]

The Portland stone did not prove as hard-wearing as had been expected. By the 1920s Owd Ben's statue was showing signs of 'serious deterioration from the unpropitious atmosphere'.[8] The problem was discussed by the Town Hall Committee, resulting in the statue being restored in 1929. It remained a feature of the park until the 1980s, when it was pushed off its pedestal and severely damaged. The pieces were collected and stored at Heaton Park. An assessment was made to repair the statue but it was rejected on the grounds of cost.[9] The pedestal, however, remains in its original position in Queen's Park.

including a millennium mural, the work of Hulme urban potters, on the local library and adult education centre.[1]

Note
[1] *Manchester Evening News*, 30 September 2002.

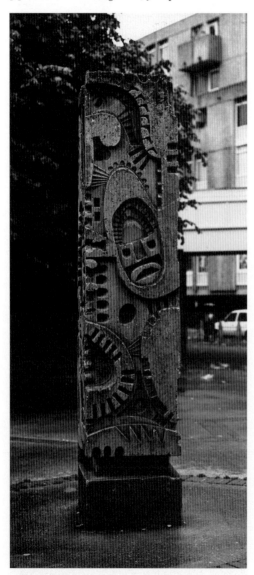

Mitchell, *Four Estates*

Simonsway

Parklands High School (formerly Poundswick Grammar School)

Acrobats

Austin Wright

1956
Concrete; fibreglass
3m high
 Description: Sculpture of three balancing figures in concrete covered with fibreglass surmounting a square stone pedestal.

The building in the mid-1950s of two new educational institutions, Poundswick Grammar School and a technical college, both located in Wythenshawe, provided Manchester Education Committee with the opportunity to commission a work of art for each school. Under the funding terms the local education authority was permitted to use, at their discretion, 0.5 per cent of the capital budget for art works. It was decided to commission an outdoor sculpture for Poundswick. Initially, it appears that Maurice Lambert was approached to provide a sculpture but his idea of a human figure holding a bowl was not considered suitable. A new sculpture was sought. A committee, whose members included S.D. Cleveland, Director of Manchester City Art Gallery, John Holden, Principal of Manchester Regional College of Art, and Leonard Howitt, the City Architect, agreed to commission a work from the Yorkshire sculptor, Austin Wright. It comprised three skeletal figures representing acrobats, two of whom were being supported by the third figure. They symbolised the vitality of youth.[1] Wright's recollection of the work was of its being commissioned at a much earlier date, in 1952, but then being delayed.[2] The work, made of concrete covered with fibreglass, was placed on a low square

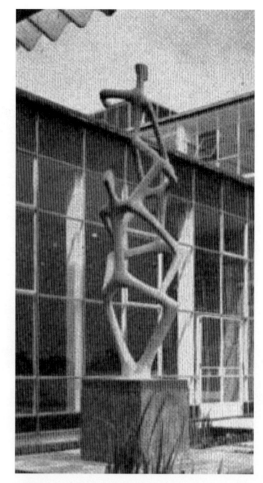

Wright, *Acrobats*

pedestal, sited in a pond at the rear of the school. It was only towards the end of 1956, after the school had opened, that the work appears to have attracted wider public attention. Some councillors expressed concern over the commissioning process and, somewhat more predictably, the cost of the sculpture – some £800. Modern sculpture in the setting of a modern school did not suit all tastes, leaving one councillor to dismiss the work as being 'like a well-plucked turkey standing on its tail

end'.[3] But Wright's sculpture was not removed, and it remained a feature of the school for over 20 years, years which saw Poundswick become a comprehensive school. Climbing the sculpture was a challenge that some students could not resist, and, inevitably, it was damaged. Some time in the early 1980s the remains of the figures were taken down and stored in an old cottage on the school premises. The cottage was demolished in about 1987, at which time, it is believed, the remaining parts of *Acrobats* were discarded.[4] Poundswick High School and South Manchester High School merged in 1999 to form Parklands High School.

Notes
[1] *Manchester Guardian*, 16 October 1956.
[2] J. Hamilton, *The Sculpture of Austin Wright* (Leeds: Henry Moore Foundation in association with Lund Humphries, London, 1994) p.26.
[3] *Manchester Evening News*, 9 January 1957.
[4] Information from Jim Cook; www.poundswick.org.uk.

Moor Road

Wythenshawe City College

Untitled

Malcolm Hughes

1959
Tubular steel; wire alloy and mosaic
2.5m high × 2m approx
 Description: Abstract sculpture in four sections constructed out of tubular steel and mounted on the exterior wall of the college.

In the autumn of 1958 members of Manchester Education Committee took the decision to commission a sculpture to be displayed on one of the outside walls of the new West Wythenshawe College of Further Education. The commission went to the London artist and designer, Malcolm Hughes, who produced an abstract sculpture in four sections using tubular steel and mosaic. It was placed on the curved end wall of the college's lecture theatre. The

Hughes, *Untitled*

response to the sculpture echoed that surrounding earlier schemes in Wythenshawe's schools. Critics complained that the project had only come to light after the crucial decisions to commission the work had been taken. In the case of Hughes's sculpture it was not until March 1959 that the question of how and why £800 had been spent on a sculpture was raised by councillors who clearly regarded the work as both unsuitable and unnecessary. Press coverage followed, chiefly hostile to the sculpture.[1] The sculpture remained in its original position, but in recent years climbing plants have all but obscured it. It has also been vandalised. The work appears to have been discarded when the building was demolished in 2004.[2]

Notes
[1] *Manchester Evening Chronicle*, 3 March 1959, 20 March 1959; *Manchester Guardian*, 12 March 1959; *Wythenshawe Recorder*, 3 March 1959.
[2] Information from Joyce Williamson, Wythenshawe City College.

Longden, *The Runner*

Heaton Park

The Runner

John Longden

July 1960; stolen October 1968
Bronze
1.78m high approx.
 Description: life-size figure of athlete shown breasting the tape in a running race, mounted on bronze plinth.

This bronze study of an athlete was the work of John Longden, who had been born in Ashton-under-Lyne in 1882. The work was said to have been a self-portrait. Its date of completion is unknown but it was presented to Manchester by his brother, Edward, a past president of the Institute of British Foundrymen, in 1959. The City Council decided to display the work in Heaton Park where it was unveiled in June 1960. The statue remained in the park until October 1968 when it was stolen.

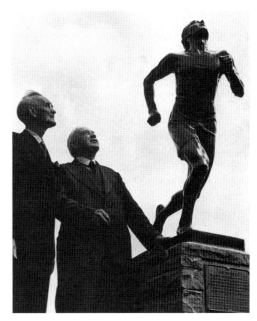

Piccadilly

Adrift

John Cassidy

3 June 1908
Bronze sculpture
Sculpture 2.1m high; pedestal 45cm high ×
1.03m long × 1.58m wide
Signed: John Cassidy fecit 1907
Inscription (now missing): HUMANITY ADRIFT
ON THE SEA OF LIFE, / DEPICTING LIFE'S
SORROWS AND DANGERS, HOPES AND FEARS
AND / EMBODYING THE DEPENDENCE OF
HUMAN BEINGS UPON ONE ANOTHER, / THE
RESPONSE OF HUMAN SYMPATHY TO HUMAN
NEEDS, / AND THE INEVITABLE DEPENDENCE
UPON DIVINE AID.
Status: Grade II
Condition: fair
Owned by: Manchester City Council
 Description: Bronze sculpture depicting a
family clinging to a raft in a stormy sea. The
central life-size figure is a half-naked man,
holding a sheet aloft in his right hand, calling
for help. Arranged around him are the figures
of his wife and three children. His wife is
shown leaning over and kissing their infant son.
To the left is the daughter, her raised arm held
in her father's left hand. At the rear is the prone
figure of a youth, the elder son, holding his
breast. Parts of the raft are visible in the waves
which make up the base.

Adrift was Manchester's first modern figurative
outdoor sculpture. It was the work of the Irish-
born sculptor, John Cassidy, who developed a
successful studio in Manchester, following his
success at the 1887 Jubilee Exhibition. Local
commissions included statues of John and
Enriqueta Rylands, Sir Benjamin Dobson and
Ben Brierley. He was also responsible for
numerous busts of local individuals including
Charles Hallé and Charles Sutton.[1] *Adrift*
indicates the influence of the 'new sculpture'
movement on Cassidy. The theme of the work
was the changes and sorrows experienced by
human beings, illustrated by the image of a
shipwrecked family clinging to a raft on the
ocean at the very moment when there seems the
possibility of rescue. The work was modelled at
Cassidy's studio in Plymouth Grove,
Manchester and completed in 1907. It was
exhibited at the New Gallery, London.[2] It was
purchased by James Gresham, whose local
engineering business provided him with the
means to build up an extensive art collection in
both his London and Manchester homes.[3]
Gresham had trained as an artist before
deciding to go into business. Cassidy also
sculpted a portrait medallion of Gresham.[4]
Gresham decided to present the sculpture as a
gift to the City Council with the intention that
it would be displayed in a new municipal art
gallery that was to be built on the site of the
demolished Royal Infirmary in Piccadilly. The
donation had the proviso that 'my gift of this
statuary… become absolute when a permanent
home is found for it in your new gallery'.[5] The
gift was accepted but the new gallery in
Piccadilly was never realised. Following the
First World War the much-discussed fate of the
'Great Hole of Piccadilly' was finally settled by
creating a public garden. *Adrift*, however, was
not forgotten, and the sculpture that Gresham
had hoped to see inside a modern municipal art
gallery in Piccadilly was placed there as the
centrepiece of a sunken garden.[6] The sculpture,
surmounting a low rectangular stone base,
remained in the centre of the gardens until
around 1953 when the construction of a
Coronation fountain resulted in its removal to
the southern side of the gardens. During a
revival of interest in public sculpture in the
1980s it seemed possible that a restored *Adrift*
would be transferred to new gardens at the rear
of the town hall.[7] But this was not realised, and
it remained on a cheap and steadily
disintegrating pedestal in the gardens, overhung
by trees. The plan, announced in 1999, to build
an office block on this part of Piccadilly
Gardens necessitated the removal of the statue.
It has been removed for much-needed
restoration, with the intention that it will be re-
sited either in the new gardens or in another
location in the city centre.

Notes
[1] Bust of Charles Sutton, signed by Cassidy, in
Manchester Central Library. [2] *Pall Mall Magazine*,
May 1908, p.118. [3] *Manchester Faces and Places*, 9
(1898) pp.108–14. [4] Catalogue of Small Collection
of Sculpture by John Cassidy (G. Falkner and Son,
Manchester [printer]) no.74 (Manchester City Art
Gallery). [5] Letter from Gresham to Art Gallery
Committee, May 1908, Manchester City Council
Epitome of Proceedings of Committees, 1907–8.
[6] Sculpture loaned to Parks Committee, Manchester
City Council Epitome of Proceedings of Committees,
18 May 1920, p.407. [7] Correspondence between
City Art Gallery and City Architect, July 1984.

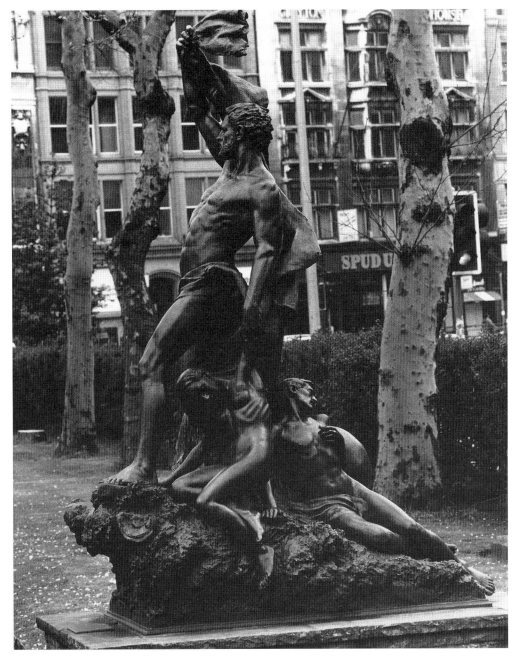

Cassidy, *Adrift*

St Mary's Gate

The Little Prince

Jane Ackroyd

21 May 1985
Painted steel; black marble pedestal
5.49m high approx

 Description: Abstract sculpture, multi-coloured steel sculpture rising from a polished stone base.

Greater Manchester Council decided to commission a sculpture as part of a major redesign of the St Ann's Square and Exchange Street area of the city centre undertaken in 1984–5. The sculpture was to be located at the junction of Exchange Street and St Mary's Gate, creating a new focal point. It was a location that had been identified previously as a possible site for the city's statue of Abraham Lincoln.[1] An open competition was organised and Jane Ackroyd's work was chosen from the 18 entries. It was entitled *The Little Prince*, having been inspired by Antoine de Saint-Exupéry's book of the same name, with its themes of the magic of the sky and landscape. In her submission Ackroyd argued that the bold shapes of the sculpture would fit well into the new space, 'because the abstract shape would make an interesting contrast to both the architecture and the more formal figurative studies in the area'.[2] The large abstract sculpture would rise from a low sloping marble pedestal.

 The Little Prince was unveiled in May 1985.[3] Reaction to the city's newest and one of its few abstract sculptures was less than appreciative, shouts of disapproval being heard at the official unveiling. Such critical attitudes were well represented in the opinions recorded in the columns of the *Manchester Evening News*, where the dominant response of the 'man in the street' was to dismiss the sculpture as an eyesore, and the £13,000 spent on it as wasted money. Tenants in the surrounding shops went further, claiming that the sculpture interfered

with their trade, and called on the council either to remove it or reduce their rates.[4] But *The Little Prince* was not moved. The introduction of seats and other street furniture helped the area to become the focal point desired by the planners, though, at the same time, weakening the sculpture's visual presence. The sculpture with its low plinth also attracted skateboarders, whose recreational activities contributed to the damage of the plinth. Rusting became evident on the sculpture.[5] Eventually, in 1993 plans were announced to remove the unpopular *Little Prince* and use the space for disabled toilets.[6] The sculpture was taken down and placed in a council store but with no definite plans to re-site it.[7]

Notes
[1] *Manchester Evening News*, 20 August 1983.
[2] *Artful Reporter*, June 1985. [3] *Manchester Evening News*, 22 May 1985. [4] *Ibid.*, 20 May 1985.
[5] *Ibid.*, 16 January 1992. [6] *Ibid.*, 25 January 1993.
[7] Information from Manchester City Planning Department, May 2000.

Ackroyd, *The Little Prince*

SALFORD

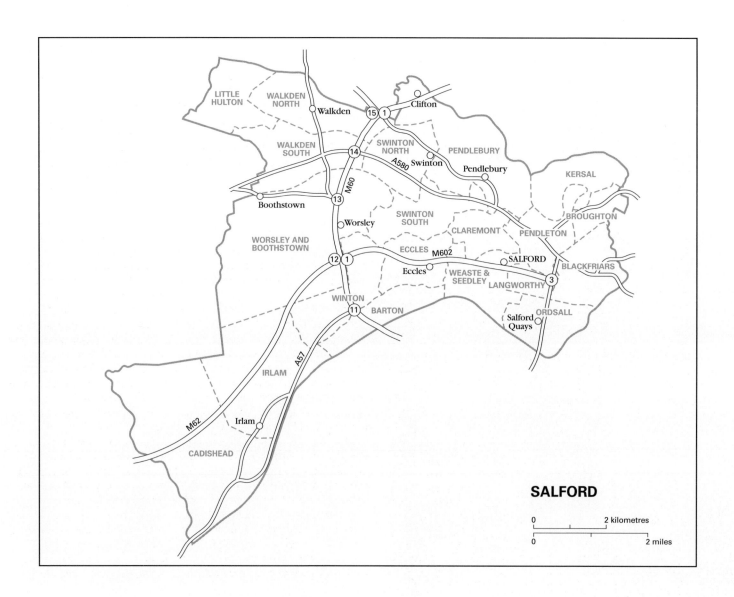

SALFORD

0 2 kilometres

0 2 miles

Introduction

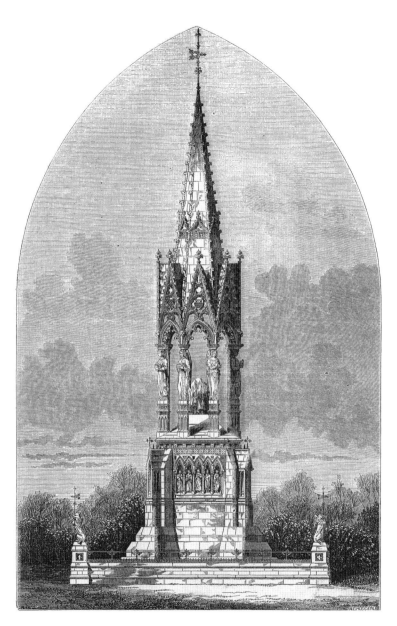

Brotherton Memorial, Salford

The present city of Salford was created in the local government reorganisation of 1974, amalgamating Salford with the municipal boroughs of Eccles, Swinton and Pendlebury, and the urban districts of Irlam and Worsley. The city lies to the immediate north-west of Manchester and covers an area of 9,677 hectares, the smallest of the ten districts covered in this survey. The population in 2001 was 216,119.

Salford can lay claim to a history far older than most Lancashire towns, having been identified in the Domesday survey and receiving its charter from Randle de Blundeville, sixth Earl of Chester, around 1230. In the following centuries the town's development was slow, especially in comparison with its neighbour to the east, Manchester. By the seventeenth century Salford was already in the economic shadow of Manchester. Few communities were transformed as suddenly and as dramatically by the industrial revolution as Salford. Cotton factories, engineering works, railways and terraced housing created the quintessential industrial landscape. The population increase was rapid, indeed giddy, even by the standards of nineteenth-century industrial towns. Living conditions were harsh and the provision of even basic amenities was slow in reaching the majority. Visiting Salford in 1851, Queen Victoria noted 'a very intelligent but painfully unhealthy looking population'.[1] Conditions were slow to change and many generations lived out their lives in what was memorably referred to as 'the classic slum'. Such rapid development involved considerable new building, as well as the pulling down of existing structures. One notable public monument to be lost was the elegant Salford Cross in Greendale, demolished in 1824.[2] In neighbouring Eccles, part of the market cross appears to have survived and was possibly incorporated into the base of the present cross.[3]

The borough of Salford was established in 1844, and was later extended to include Broughton, Pendleton and parts of Pendlebury. If slow in responding to many of its social problems, Victorian Salford was a pioneer in providing public parks (Peel Park opened in 1846) and public libraries (Salford Free Library opened in 1850). It also became an enthusiastic patron of public sculpture, Peel Park becoming home to one of the most important collections of outdoor commemorative statuary in the north of England. Salford's first public statue was raised, as in a number of other provincial towns, to Sir Robert Peel, and appropriately sited in the park that had been named after him, an acknowledgment of

his support for the project. The borough's Liberal élite, encouraged by the success of the Peel monument, went on to raise further statues to local and national figures – Joseph Brotherton and Richard Cobden – whose politics, particularly in supporting free trade, were also their own. Royalty was also honoured with statues to Queen Victoria and Prince Albert. All were the work of Matthew Noble, who might have been thought by other artists to have become the town's official sculptor. An equally revealing collection of busts of local worthies was acquired and displayed in the museum and art gallery located in the park.[4] Once again, Noble's work was well represented. Copies of classical statuary were also put on display in other parts of the park. A more prosaic memorial was a plain stone obelisk, erected by the council, recording the water level in the devastating flood of November 1866.[5] Salford may have been a 'dirty ol' town', but Peel Park with its statues was among its most important public spaces, an oasis of civic pride in the midst of factories and endless rows of terraced houses. Outside of the borough, the elaborate public memorials raised to the Earl and Countess of Ellesmere in Worsley and Walkden confirmed the district as one rich in Victorian public monuments, whilst suggesting the continued vitality of more traditional networks of influence.

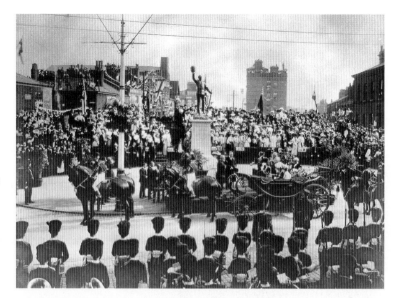

Unveiling of South African War Memorial, Salford, 1905

This mid-Victorian burst of memorialisation did not continue – a change in attitudes towards commemorative statues and public monuments was evident by the closing decades of the century. The memorials erected by the late Victorians were more modest expressions of public admiration. The Salford life-saving hero, Mark Addy, was remembered, for example, by an obelisk in Weaste Cemetery, a cemetery in which the previous generation had raised a truly monumental Gothic memorial to Joseph Brotherton. When public memorials were raised, there was also a tendency, as in other towns, to prefer practical ones such as drinking fountains.[6] For a town of its size Salford's public and larger commercial and retail buildings were not overly distinguished by high-quality architectural sculpture. Even in the golden age of terracotta, its flagship technical college and board school apart, Salford did not run after what many of its citizens would have dismissed as superfluous decoration.[7]

War memorials were chiefly responsible for the increase in the borough's stock of public monuments in the twentieth century. Salford's first major outdoor war memorial commemorated those who had fought and died in the Boer War: George Frampton's statue of a cheering fusilier. It was a copy of the one already erected in Bury.[8] Salford saw a flush of memorials to remember the men who did not return from the First World War. The principal memorial was the Lancashire Fusiliers' cenotaph erected in Albion Place, opposite the entrance to Peel Park. Memorials were also raised in other parts of the borough, as well as in those neighbouring districts which were to become part of Salford.[9] Churches, schools and workplaces also raised memorials. At Agecroft, for example,

a memorial to the local miners who had died in the war was provided by the colliery owners, Andrew Knowles and Sons.[10] Public memorials were also sited in cemeteries.[11] Organising committees took a pride in having their memorial designed and built by local craftsmen using local materials.[12] But, whilst new memorials were unveiled, older ones were deteriorating. Public monuments suffered in Salford's polluted atmosphere.[13] The likelihood that they would be cleaned and conserved diminished as the reaction towards things Victorian hardened. The dismantling of Peel Park's Victoria Arch – erected in 1860 to mark the Queen's second visit to the park, and paid for principally by local working people – was an early casualty of such attitudes.[14]

Public statues were to become especially vulnerable to this cultural reassessment. Monuments once cocooned in local pride were now ignored and neglected. This was especially evident in 1969, when the council sold two of its public statues. Fifteen years before Salford had agreed to remove three of its outstanding portrait statues – Peel, Brotherton and Cobden – to make way for an extension to the technical college in Peel Park. However, instead of being conserved and re-sited in another open space, they were placed in storage, and remained there until 1969. The possibility of re-siting them in Peel Park was examined at that time but this idea was apparently not pursued.[15] Instead, two of the statues were sold to a private collector who had approached the council with a view to purchasing them. Salfordians wanting to admire the bronze representations of Sir Robert Peel and Joseph Brotherton, which an

Noble, *Peel statue in Peel Park, Crimean War cannon (foreground)*

The commissioning of new public sculpture did not make up for the losses. The rebuilding of Salford which was occurring at this time was an opportunity for such initiatives but one that was not taken up in any systematic way. Some of the city's new schools, as in Manchester, did include sculpture commissions: including Alan Lee's concrete mural on the Margaret Whitehead School, Seedley,[19] and a bronze peacock by Gertrude Hermes outside a school in Ordsall.[20] A fibreglass sculpture by Alan Boyson was installed in Swinton's new shopping precinct.[21] Not all were to survive. In the courtyard of the city's new technical college a composition of concrete totems was created by William Mitchell. The college was soon to become part of the new University of Salford, an institution that showed little interest in commissioning outdoor public sculpture.[22] Indeed, apart from a bust of Prince Philip, Chancellor of the University from 1967 to 1990, sculpted by Sam Tonkiss, the main examples of public sculpture on the university's campuses were inherited at the time of mergers.[23]

Salford was a city in the grip of economic decline as its traditional industries closed down. All the main indicators of social deprivation were moving in the wrong direction. In a community where the demands to respond to dire problems of housing, health and education far exceeded funds, little money was available to spend on new public sculpture or the conservation of existing works. Vandalism compounded these difficulties. The district's war memorials were a frequent target of vandals. The damage to Irlam's war memorial in Princes Park led to its demolition.[24] In the case of Swinton, the council responded by removing the memorial from Victoria Park to the comparative safety of the Civic Centre.[25] No effective policy was developed to respond to the ongoing deterioration of other public monuments. The condition of the Brotherton Memorial in Weaste Cemetery and the Ellesmere Memorials at Worsley and Walkden, three of the region's most important Victorian public monuments, continued to deteriorate.

A more positive attitude towards public sculpture became apparent in the 1990s. Salford recognised, earlier than some neighbouring councils, that public art could have a role in helping regenerate depressed and environmentally neglected areas. The ambitious plan to redevelop the Manchester Ship Canal docks – renamed Salford Quays – included a number of sculptures, though given the levels of investment in infrastructure and new buildings at the Quays, the completed projects were disappointing in both their number and their ambition.[26] None of the newer works challenged Doug Cranmer's totem pole as the most eye-catching piece of public art on the Salford side of the Quays. Public reaction to new sculpture was predictably critical. Money spent on new public art, as in St John's Square, Salford, or in the re-siting of existing works, such as Frampton's South African war memorial, provoked the commonplace but clearly heartfelt criticism from local people that what they perceived as ratepayers' money was being wasted.[27] Towards the end

earlier generation had placed into the apparently secure hands of the City Fathers, now had to travel to Cheshire to do so. Unfortunately, the official record of the discussions and negotiations surrounding this sale is frustratingly slight.[16] But, whilst Noble's Peel and Brotherton did survive, his marble statue of Cobden appears to have been lost, presumed destroyed. Other less well-known park statuary was also discarded in these years.[17] This squandering of Salford's Victorian heritage was not limited to its outdoor statues. In 1968 the City Art Gallery disposed of a significant number of the marble busts of local worthies acquired by the Victorians and Edwardians.[18] These acts of civic myopia were later to turn into public embarrassment when the City of Manchester purchased Noble's statue of Joseph Brotherton, and installed it on the Manchester bank of the River Irwell, leaving Salford's first MP staring across at the city that he had worked so long to improve.

of the 1990s, Salford became one of the three councils involved in establishing the Irwell Sculpture Trail. A number of works have been installed in Salford including Julia Hilton's *The Fabric of Nature* in Peel Park and Rita McBride's *Arena* in Lower Kersal. But public attitudes towards public sculpture and its role in restoring community pride remained sceptical. Vandalism has also continued to be a problem. For those interested in public sculpture in Salford, the ramming by stolen cars and setting on fire of a sculpture – the work of Kevin Harrison – that had not even been officially unveiled was a particularly depressing incident.[28] *Arresting Time*, a sculpture by Jill Randall, was also vandalised in spite of its somewhat inaccessible position overlooking the River Irwell.

Notes

[1] *The Letters of Queen Victoria*, Vol.2 (London: J. Murray, 1908). [2] *Views of the Ancient Buildings in Manchester drawn from nature by John Ralston and on stone by A. Aglio* (Manchester, 1825; reprinted 1975); H. Taylor, *The Ancient Crosses and Holy Wells of Lancashire* (Manchester: Sherratt and Hughes, 1906) p.431. [3] H. Taylor, 'The ancient crosses of Lancashire: The Salford Hundred', *Transactions of Lancashire Antiquarian Society*, 22 (1904), p.31; *Eccles and Patricroft Journal*, 15 March 1929, 28 July 1950, 26 January 1951; T. Gray, *Greetings from Eccles 1892–1992* (Eccles, 1992) pp.31, 33, 34, 66, 90. [4] Report of museum in *Salford Weekly News*, 8 June 1867. [5] *Ibid.*, 17 November 1866; *Annual Report of Salford Museum, Library and Park Committee*, 31 October 1867, p.277. [6] For example, the fountain presented by the Walkden Co-operative Society to commemorate the coronation of Edward VII, illustration in *Old Worsley and Little Hulton* (Worsley, 1973). [7] W.J. Neatby was responsible for the decoration on Woodhouse and Willoughby's Board School in Chapel Street, see P. Atterbury and L. Irvine, *The Doulton Story* (Stoke on Trent: Royal Doulton Tableware, 1979) p.85. [8] See above, p.256. [9] Irlam War Memorial, unveiled 7 April 1923; Eccles War Memorial, unveiled 15 August 1925; Worsley War Memorial, unveiled 21 November 1925; Swinton War Memorial, unveiled 30 November 1930. [10] M. Stedman, *Salford Pals* (London: Leo Cooper, 1993) p.197. Andrew Knowles and Sons Ltd erected a memorial in Pendlebury in memory of workers from their collieries, unveiled 25 November 1919. [11] The memorial in Weaste Cemetery, in the form of an angel carrying a cross, was the gift of J.E.C. Lord, unveiled on 27 March 1920, *Manchester Guardian*, 29 March 1920.

[12] Unveiling of Clifton War Memorial, designed by Gordon Forsyth of Royal Lancastrian Pottery, *Manchester Guardian*, 4 October 1920. [13] *Builder*, 24 July 1858. [14] The architect was Thomas Groom Barker. *Builder*, 3 December 1859, p.793; *Salford Weekly News*, 28 July 1860; *Salford City Reporter*, 23 July 1937. [15] *City of Salford Art Galleries, Museums and Libraries Committee minutes*, 3 April 1969 (Salford Archives). [16] *Salford City Reporter*, 5 September 1969. There appears to be no record in the minutes of the *City of Salford Art Galleries, Museums and Libraries Committee*. It is widely asserted in Salford that the price paid for each statue was £10. [17] These included two statues of working children: *The Sweep* and *The Shoeshine Boy*. The former was the work of John Simpkin (photograph in Salford Local Studies). They appear to have been placed in storage and then lost. Another lost work was a plaster copy of Joseph Leyland's *Thracian Falconer* which was transferred from the art gallery to the park in 1897–8. Information from Evelyn Vigeon. [18] These included busts of Joseph Brotherton (Matthew Noble, 1856); Thomas Goadsby (Matthew Noble, 1860); Sir Elkanah Armitage (Matthew Noble, 1861); Edwin Waugh (E.E. Geflowski, 1878); Duchess of Kent (Louis Gardie, 1850) and Edward VII (John Cassidy, 1910), *Catalogue of Loan Collection of Pictures Jubilee Exhibition 1894* (Salford, [1894]) pp.62–92; *City of Salford Art Galleries, Museums and Libraries Committee*, 10 April 1968, 23 May 1968 and information from Judith Sandling, Salford City Art Gallery. Raymond Richards purchased many of the works, some of which were subsequently disposed of at auction. [19] *Salford City Reporter*, 6 June 1969. Now the New Croft High School. [20] The peacock sculpture originally stood outside Ordsall Secondary Modern School for Girls (opened 1960). It appears to have been removed when the school was closed. It has recently been rediscovered in the grounds of Salford College, Lissadel Street. Information from James Hamilton and Stewart Vann. [21] Commissioned by the centre's developers, Milbury (Northern) Investment Co. Ltd, it was unveiled by Ken Dodd at the official opening of the shopping centre, 16 May 1969. *Swinton and Pendlebury Journal*, 22 May 1969. [22] The bronze bust of Benjamin Robinson in the Peel Building, the former Royal Salford Technical College, commemorates one of the principal founders of the Victorian institution. (There is no visible signature.) [23] Bust signed and dated 10/12/74. It is located in the foyer of the Maxwell Building along with a bronze medallion head of John Brentnall who laid the foundation stone of the Maxwell Building in 1956. [24] Unveiled 7 April 1923. [25] *Swinton and Pendlebury Journal*, 17 April 1986, 12 June 1986. [26] *Salford Quaylink*, Summer 1990, p.10. [27] *Salford City Reporter*, 16 November 1989. [28] *Manchester Evening News*, 16 November 2000; *Salford Advertiser*, 23 November 2000.

CLIFTON

Clifton House Road

Clifton Country Park

Dig

Rosie Leventon

7 October 1999
Glossop gritstone
19m long × 5m wide × 1m deep
Condition: good
Status: not listed
Owned by: Salford City Council
 Description: Canal boat, constructed out of flagstones, set into the earth. The stone flags have been roughly shaped to fit each other, the side slots being carved in the negative. The interior of the boat includes seating, allowing the space to be used by the public.

Rosie Leventon was selected from a short-list of four artists in 1997 to provide a sculpture in Clifton Country Park as part of the Irwell Sculpture Trail. The park is particularly rich in industrial archaeology, and includes a former colliery, which was drained by an ingenious system devised by James Brindley. Leventon's ideas for the sculpture were shaped by her interest in burial ships, particularly the Sutton Hoo ship in Suffolk. The more immediate stimulus came from the 'Starvationer' boats used to transport coal from the local mines. Once a familiar sight on the region's canals, these boats took their name from their distinctive internal ribs. The final work was selected by the public from five proposals put forward by the sculptor. An open area of grassland close to the Wet Earth Colliery was the agreed site.[1] Leventon included seating inside the boat, encouraging people to sit in the work rather than simply viewing it from the outside. *Dig* was unveiled in October 1999. A second public art work, also in stone, *The*

Leventon, *Dig*

Lookout by Tim Norris, was installed in the park in 2001.[2]

Notes
[1] Information from Rosie Leventon and Cathy Newbery. [2] Unveiled 21 September 2001.

ECCLES

Church Street

Eccles Public Library

Architects: Potts, Son and Hennings

Architectural sculptor: Shaws of Darwen

19 October 1907
Ruabon brick, terracotta
Panels 51cm × 91cm
Condition: fair
Status: Grade II
Owned by: Salford City Council
 Description: Twelve terracotta panels arranged as pairs decorating three windows on the front elevation and three on the side elevation of the library. The figures, all seated, represent the arts, music, literature, science and technology.

Eccles opened a purpose-built library in 1907. The Manchester architect, Henry Potts, was the moving force in the project, helping to approach and obtain from Andrew Carnegie a grant of £7,500 to meet the building costs. The new library was located in Church Street, on a site which had been cleared of slum housing. Potts designed the building, giving his services for free. A public hall was included in the

Shaws, *Eccles Library (detail)*

Shaws, *Eccles Library (detail)*

Notes
[1] *Manchester Evening Chronicle*, 26 March 1906.
[2] *Eccles Journal*, 25 October 1907.

Eccles War Memorial
John Cassidy

15 August 1925
Bronze figure; Portland stone column and
 bronze panel
Column 5.5m approx; sculpture 1.22m approx
Signed on panel: J. Cassidy 1925
Inscription beneath figure: IN MEMORY / OF
 THOSE FROM THE / BOROUGH OF ECCLES /
 WHO GAVE THEIR LIVES / IN THE WARS OF /
 1914–1918 / 1939–1945
Condition: good
Status: Grade II
Owned by: Salford City Council
 Description: War memorial; tapering
Portland stone column with a moulded plinth
surmounted by a bronze figure of Victory
holding the palm of Victory in her outstretched
right hand. On the front of the shaft beneath
the inscription PAX is a bronze panel of a soldier
in relief, standing with arms reversed.

The scheme to commission a war memorial for
Eccles was launched in February 1924.[1] This
was later than in many other Lancashire towns,
a delay that was partly due to the memorials
raised in the district's smaller communities
immediately after the war.[2] Various ideas about
the form of the memorial were discussed –
including a new peal of bells for the parish
church and a bridge across the Manchester Ship
Canal – before it was decided to commission a
conventional memorial on a site in the centre of
the town, close to the public library and town
hall. The commission was given to the
Manchester sculptor, John Cassidy. Funds were
still being collected when, in January 1925,
Cassidy exhibited a model of the proposed
memorial in Eccles. When the foundation stone
was laid, scrolls taken from local street
memorials were placed beneath it.[3] The

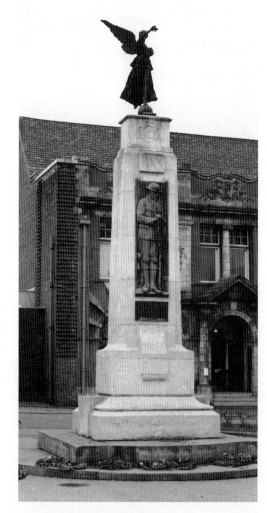

Cassidy, *Eccles War Memorial*

memorial was unveiled in August 1925 by Lord
Derby, who acknowledged its symbolism,
observing, that among the different purposes it
served, was to be 'an unspeaking appeal to those
who came after us to avoid war as far as honour
would allow'.[4] The landscaping of the area
around the memorial emphasised the
importance of this new public space.

original scheme but financial considerations
meant that only the library was built.[1] The two-
storey building was in the Renaissance style,
Potts using Ruabon brick and stone-coloured
terracotta. The terracotta decoration was
especially evident on the ground-floor
windows, on both the front and side elevations,
where panels were introduced, featuring seated
figures representing science, industry, art, music
and literature. The terracotta panels were
manufactured by Shaws of Darwen. Potts
opened the library in October 1907 with the
usual ceremonies and expectations.[2] The
interior of what was referred to as 'the Eccles
University' included a suitably impressive set of
plaster portrait medallions depicting famous
writers, including Shakespeare and Dickens.

Notes
[1] *Eccles and Patricroft Journal*, 8 February 1924, 21 March 1924. [2] Memorials in, for example, St Mark's, Winton, Christ Church, Patricroft, Eccles Grammar School, Monton Secondary School and Patricroft railway works. *Eccles and Patricroft Journal*, 14 August 1925. [3] *Ibid.*, 24 April 1925, 8 and 15 May 1925. [4] *Manchester Guardian*, 17 August 1925; *Eccles and Patricroft Journal*, 21 August 1925.

SALFORD

Albion Place

Lancashire Fusiliers' War Memorial

J. and H. Patteson

17 July 1922
Portland stone
5.7m high approx × 3.84m × 1.37m
Inscription on front panel beneath regimental badge: IN MEMORY OF / THE OFFICERS, W.O's, N.C.O's. & MEN OF / THE 1/7TH, 2/7TH, 3/7TH, 1/8TH, 2/8TH, 3/8TH, / 15TH, 16TH, 19TH, 20TH & 21ST / BATTALIONS / THE LANCASHIRE FUSILIERS / AND OF / OFFICERS, W.O's, N.C.O's. & MEN / OF SALFORD / SERVING IN OTHER BATTALIONS OF THE REGIMENT / WHO GAVE THEIR LIVES / IN THE GREAT WAR / 1914–1919 / ALSO / THOSE WHO GAVE THEIR LIVES / IN THE WORLD WAR / 1939–1945 – rear (facing former fire station): THIS MEMORIAL WAS ERECTED BY / THE LANCASHIRE FUSILIERS / SALFORD WAR MEMORIAL COMMITTEE / AND WAS UNVEILED BY / THE RT. HON. THE EARL OF DERBY K.G. P.C. G.C.B. G.C.V.O. / ON THE 17TH JULY, 1922 / NEARLY THREE QUARTERS OF THE MONEY RAISED / WAS HANDED TO THE LANCASHIRE FUSILIERS / COMPASSIONATE AND WAR MEMORIAL FUND / FOR THE ASSISTANCE OF THE MEMBERS OF / THE REGIMENT AND THEIR DEPENDANTS – left-hand side: beneath carved wreath: 1914–1919 / GALLIPOLI / SALONICA / SINAI / 1939–1945 / BURMA / MALTA G.C. / NORTH AFRICA / SICILY / ITALY – right-hand side: beneath carved wreath: 1914–1919 / FRANCE / BELGIUM / EGYPT 1939–1945 / GREAT BRITAIN / FRANCE / BELGIUM / HOLLAND / GERMANY.
Status: Grade II
Condition: fair
Owned by: Salford City Council
Description: War memorial; a Portland stone cenotaph surmounted by the sphinx of the Lancashire Fusiliers. The sphinx is on a pedestal, on which is carved the single word EGYPT. The Rose of Lancaster decorates the top corners of the cenotaph. The side panels feature a large carved wreath and the names of campaigns in which the regiment took part.

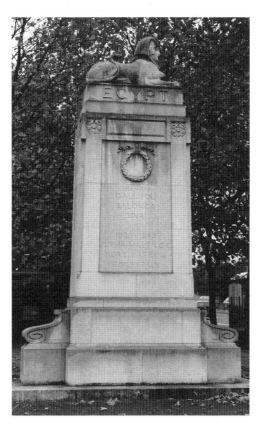

Patteson, *Lancashire Fusiliers War Memorial*

Salford lost some 5,000 men from the 11 battalions it provided for the Lancashire Fusiliers in the First World War. The raising of a memorial to honour the dead was carried out by a committee chaired by Colonel A.J. Bailey. The appeal for funds was to provide both a war memorial and assistance to wounded soldiers and the dependants of those who had died. In all some £5,000 was raised, leaving, after the costs of the memorial had been paid, £3,275 for the Lancashire Fusiliers' Compassionate Fund.[1] The memorial, in the form of a cenotaph, was designed by the long-established Manchester firm, J. and H. Patteson. The selection of a suitable location proved difficult and several sites were rejected – some in the city's principal parks – before Albion Place on the Crescent was settled upon. This land, in front of the city's fire station, was a gift from the Corporation. It had to be cleared before the memorial could be installed.[2]

The 17th Earl of Derby unveiled the memorial in July 1922.[3] In his speech he emphasised the 'spirit of Lancashire' exemplified in those men who had enlisted and fought. The Lancashire Fusiliers' Roll of Honour contained 13,549 names. Sir Montague Barlow MP formally handed over the memorial to the Mayor of Salford. The regiment's losses were also remembered in the memorial, designed by Lutyens, in Bury.[4]

In the mid-1980s there was discussion about moving the memorial to Swinton, in part because of plans to convert the fire station into an exhibition centre. In the end the memorial was left, but the area immediately around it, which had become used for car parking, was landscaped, both to protect and to preserve the dignity of the memorial.[5]

Notes
[1] John Cecil Latter, *The History of the Lancashire Fusiliers 1914–1918* (Aldershot: Gale and Polden, 1949) pp.187–8. [2] *Manchester Guardian*, 7 March 1922. [3] *Ibid.*, 18 July 1922; M. Stedman, *Salford Pals* (London: Leo Cooper, 1993) pp.196–7. [4] See below, p.239. [5] *Salford City Reporter*, 12 October 1984; *Manchester Evening News*, 24 May 1985.

Cemetery Road, Weaste

Weaste Cemetery

Mark Addy Memorial
James Hilton

9 May 1891
4.56m high approx × 1.07m square base
Peterhead granite
Inscription on front: Sacred To The Memory
Of / Mark Addy / The Salford Hero / Who
Died 9th June 1890 / In The 52nd Year Of
His Age. / He Saved More Than 50 Persons
From Drowning In / The River Irwell For
Which He Received / Amongst Other
Rewards / The Albert Medal (1st Class)
From H.M. The Queen / Life's Work Well
Done: / Life's Race Well Run: / Life's
Victory Won: / He Rests In Peace. / Erected
By Public Subscription – rear: MEMORIAL
COMMITTEE / CHAIRMAN / THE MAYOR OF
SALFORD COUNCILLOR B. ROBINSON, J.P. /
VICE CHAIRMAN / THE REVD G.W. PETHERICK,
B.A. [followed by names of the committee]
Condition: poor
Status: Grade II
Owned by: Salford City Council
 Description: Slender polished red granite
obelisk rising from a stepped granite base. On
the shaft is an oval bronze plaque with a
portrait head of Mark Addy, above a carved
lifebuoy and rope encircling Addy's initials.
Bronze plaques on the base depicting incidents
from Addy's life are missing.

Mark Addy (1838–90), boatman and innkeeper,
was reputed to have saved over 50 people from
drowning in the River Irwell which runs
between Manchester and Salford. His first life-
saving feat, at the age of 13, was to rescue a
friend by paddling a plank out into the river.
He and his brother Dick helped out in their
father's boat-hire business and became
proficient oarsmen, both being members of the
famous Colleen Bawn racing crew. Mark Addy
became the licensee of the Old Boathouse Inn

in Everard Street in Ordsall, Salford, close to
the river, and continued his life-saving
activities, for which he was much decorated by
his compatriots. In January 1878 he was
presented with a loyal address of appreciation

Hilton, *Mark Addy Memorial*

and a purse of 200 guineas from the citizens of
Salford. The following year he received the
Albert Medal from Queen Victoria for his
gallantry and daring after representations by the
Mayor of Salford and the prime minister, Lord
Beaconsfield.[1] It was stated that he had saved 36
people from drowning. He also received medals
from the Humane Society. Addy died in June
1890 after contracting tuberculosis following
another rescue from the Irwell.[2]
 By the time of his death Addy was already a
celebrated local figure, who had attracted the
interest and patronage of the powerful. After
his death a public meeting was held in July
1890, chaired by the mayor, at which it was
agreed to erect a memorial. Addy's remarkable
courage was admired: 'To plunge into ordinary
water requires pluck', observed Alderman
William Bailey, 'but to plunge into that
miserable sink, the Irwell, requires heroic
qualities, such as we cannot value too highly.'[3]
Some £275 was subscribed to the memorial
fund, out of which £100 was set aside to
provide prizes (the 'Mark Addy prizes') at the
Regent Road baths, intended to 'encourage the
art of swimming'.[4] The memorial,
commissioned from the Manchester
stonemasons, Hilton and Son, for £120, was an
obelisk decorated with bronze plaques. These
included a portrait medallion of Addy and
plaques depicting incidents from his life,
including one of him saving a woman from
drowning in the Irwell, and another showing
him reviving a person he had rescued from the
river.[5] The obelisk was sited in a prominent
position in Weaste Cemetery. At the unveiling
of the memorial in May 1891, a crowd of 1,000
people heard further tributes paid to Addy and
witnessed the monument being handed over
into the keeping of the Council.[6] The memorial
has been neglected and vandalised over the
years, although Addy's name and exploits are
still recalled, a riverside pub and a bridge being
named after him.

Notes
[1] *Salford Chronicle*, 18 January 1879. [2] *Manchester Faces and Places*, 1890, (Manchester: J.G. Hammond) pp.172–5. [3] *Ibid.*, p.175. [4] *Salford Reporter*, 16 May 1891. [5] *Ibid.*, 4 April 1891. [6] *Manchester Guardian*, 11 May 1891; *Salford Reporter*, 16 May 1891.

Joseph Brotherton Memorial
Architects: Holmes and Walker
Architectural sculptor: T.R. Williams

1859
Mansfield limestone; Darley Dale stone
9.14m high approx
Inscription around base: Here / Rest The Mortal Remains Of / Joseph Brotherton / The First And Faithful Representative / In Parliament Of The Borough Of Salford / From A.D. 1832 TO 1857 [rest illegible] – on slate plaque on front of memorial: IN MEMORY OF / JOSEPH BROTHERTON / SALFORD'S FIRST MEMBER OF PARLIAMENT / AND THE FATHER OF / THE PUBLIC LIBRARY MOVEMENT
Status: not listed
Condition: poor
Owned by: Salford City Council
Description: Richly decorated Gothic memorial. The memorial rises from a stepped octagonal base with angular buttresses. Between the buttresses on each side is an arcade of five niches in which are carved figures. Above is an ornate open canopy supported by six pillars carved as angels. The spire of the canopy ends in a metal vane. Beneath the canopy is a draped urn.
Biography: see p.20.

Joseph Brotherton made contributions to many areas of Salford's public life, including serving as the borough's first MP. Following his unexpected death in January 1857, a public subscription was opened to provide a suitable memorial. The money raised was sufficient to commission both a full-length portrait statue

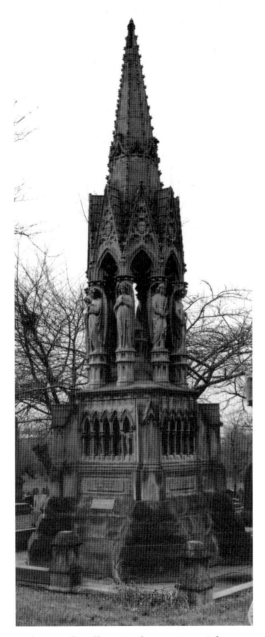

Holmes and Walker, *Brotherton Memorial*

and a memorial over his grave in the new municipal cemetery at Weaste. 'Artists' were invited to present designs for the memorial, which was to cost no more than £525. Almost 100 entries were received from 74 competitors. The designs were put on public display in Salford Royal Museum in Peel Park.[1] Not all of the entries followed the rules, which had specified that the memorial was not to take the form of a statue. The *Art Journal* was scornful of a number of the entries, discerning in them further evidence of those underdeveloped artistic sensibilities to be found in the provinces:

> The mingling here of fancy run wild with matter of fact grown rampant, is something incredible. Art is utilised by some of these candidates after a fashion which would leave behind even the town of Chelmsford, – the town that put up its statue of Judge Tindale on the borough pump. Essex, we think, has certainly the credit of having led the way in the training of the Sculptural Muse to make herself useful, and was the first to put the goddess out to service, but, let her look to her laurels![2]

The design selected was a Gothic memorial, submitted by the Manchester architects, Holmes and Walker. They employed T.R. Williams to build and carve it. The final cost was almost £950, a far larger sum than the one proposed at the time of the competition. It was the first major memorial to be erected in the cemetery. During the twentieth century it was neglected, and has suffered extensive vandalism. The stonework has cracked in a number of places, and the severe weathering of the stone has resulted in the loss of much of the original inscription. A number of the carved figures have also been removed, presumably stolen. Salford, having sold one of its Brotherton monuments in the 1960s, does not appear to have plans, at present, to restore its other major public memorial to Joseph Brotherton.

Notes
[1] *The Brotherton Memorial. Specifications of the Designs and Models sent in for competition...* (Manchester: I.W. Petty, [1857]). [2] *Art Journal*, 1 October 1857, p.309.

Chapel Street

Junction of Chapel Street and Oldfield Road

Lancashire Fusiliers' South African War Memorial

George Frampton

13 July 1905; re-sited October 1990
Bronze statue; sandstone pedestal
Statue 2.44m high; pedestal 2.9m high × 1.42m square base
Signed on pedestal: Geo. Frampton. R.A. 1905
Inscription on pedestal: front: ERECTED / BY THE / COUNTY BOROUGH / OF / SALFORD / TO THE / MEMORY OF MANY / TOWNSMEN WHO SERVED THEIR / SOVEREIGN AND COUNTRY / IN / SOUTH AFRICA / 1899–1902 / AND / PARTICULARLY IN HONOUR / OF THE / VOLUNTEER / ACTIVE SERVICE COMPANIES / OF THE / LANCASHIRE FUSILIERS / DARING IN ALL THINGS – rear: KING EDWARD VII, / ACCOMPANIED BY / QUEEN ALEXANDRA, / UNVEILED / THIS MEMORIAL / JULY 13TH 1905.
Status: Grade II
Condition: fair
Owned by: Salford City Council

Description: War memorial; larger than life-size bronze statue depicting a cheering Lancashire Fusilier dressed in 'review order', holding his busby in his raised right hand and a rifle in his left. The figure stands on a plinth representing a stone outcrop. The statue surmounts a pedestal on which are inscriptions and the carved badge of the regiment.

The Lancashire Fusiliers' memorial in Salford marks the long connection between the regiment and the city. It shares its origins with the regiment's South African war memorial in Bury.[1] At a meeting of the Lancashire Fusiliers' Compassionate Fund in 1902, a memorial for Bury (the regimental headquarters) was suggested by Sir Lees Knowles. At the same time it was decided that a copy of the figure should be erected in Salford. A public meeting was held in Salford Town Hall to discuss the question on 17 September 1902, with the mayor, Alderman Samuel Rudman, presiding. The memorial, Rudman suggested, would have two worthy functions. It would 'honour the names of those who went to the front', whilst providing 'a very great inducement and encouragement to the young men of the borough who some time might be called upon to do likewise'.[2] James G. Groves, MP for Salford, observed that the reception given by Salford to its South African veterans contrasted unfavourably with the celebrations elsewhere. It was time, he said, 'to give a right-down good Salford welcome' to the troops, to show the work they had done for King and Country was appreciated. He also hoped that the memorial would remind Salford's employers of their obligation to reinstate veterans at their former jobs with no loss of status. A subscription list was opened and £200 was immediately subscribed.[3] The site, provided by the Council, a small piece of land at the junction of Chapel Street and Oldfield Road facing the Salford Royal Infirmary, was remembered as a popular local meeting place.[4] It was there that the statue was unveiled in the briskest of ceremonies by Edward VII during a royal visit to Manchester and Salford in July 1905. A mere six minutes passed between the arrival and departure of the royal party, during which time neither the King nor Queen Alexandra left their carriage.[5] The principal difference between the Salford and the Bury memorials was the pedestal: the Salford pedestal did not include the decorative bronze panels recording the names of the dead.

The decision in 1989 to make alterations at this busy road junction necessitated moving the memorial back some five metres. Despite the

Frampton, *Lancashire Fusiliers' Memorial*

fact that three-quarters of the £83,000 cost was met by the central government, local residents objected to the scheme. Thirty members of a tenants' group held a demonstration against the plan.[6] In the following year the statue was moved, cleaned and the surrounding area landscaped, providing what the council now fashionably referred to as a 'gateway into the old city'.[7]

Notes
[1] See below, p.256. [2] *Salford Reporter*, 20 September 1902. [3] *Ibid.* [4] Letter in *Manchester City News*, 8 July 1905. [5] *Salford Chronicle*, 15 July 1905; *Salford Reporter*, 8 and 15 July 1905; *Manchester Guardian*, 14 and 15 July 1905; T. Gray, *Greetings from Eccles 1892–1992* (Eccles, 1992) p.7. [6] *Manchester Evening News*, 26 October 1989; *Salford City Reporter*, 5 October 1989, 16 November 1989. [7] *Manchester Evening News*, 11 October 1990; *Salford City Reporter*, 5 October 1989.

Crescent

Queen Victoria
Matthew Noble

6 May 1857
Marble statue; granite pedestal
Statue 2.9m high; pedestal 3.65m high × 1.95m square
Inscription on pedestal: TO COMMEMORATE / THE VISIT / OF HER MOST GRACIOUS MAJESTY / QUEEN VICTORIA / TO THIS PARK / OCTOBER 10TH 1851 / AND HER RECEPTION / BY MORE THAN / EIGHTY THOUSAND / SUNDAY SCHOOL TEACHERS AND SCHOLARS / INAUGURATED / BY HIS ROYAL HIGHNESS / THE PRINCE CONSORT / MAY 6TH 1857.
Status: Grade II
Condition: poor
Owned by: Salford City Council

Description: Portrait statue; larger than life-size Sicilian marble statue of Queen Victoria who is shown dressed in state robes and wearing a coronet. Her right hand rests on an imperial crown placed on a pillar and cushion; her other hand is raised to her breast. The statue surmounts a pedestal which rises from three granite steps.

This statue of Queen Victoria, one of the earliest to be erected during her reign, commemorates her visit to Salford in October 1851. This included a visit to the recently opened Peel Park, where some 80,000 children, drawn from over 220 local Sunday schools, sang to the Queen. It was an event that impressed the Queen and the other 20,000 spectators who had gathered in the park. Many of the children became so excited that the words of the second verse of the National Anthem (rewritten for the occasion by the Manchester poet, Charles Swain) were lost in the general cheering. What was described as the 'most original and striking spectacle ever presented to do honour to Royalty in any age' was widely reported in the local and London press.[1] Subsequent discussions among the organisers led to the idea of raising a permanent memorial to mark the occasion. A committee, chaired by Thomas Agnew, was established to provide a statue of the queen, which was to be paid for principally by the Sunday school children who had made up the enormous choir. The committee included many of the men who had helped to organise the event. Matthew Noble was commissioned to produce the statue, for which he received 1,000 guineas. Collecting the funds took a considerable time, and in the end further subscriptions were needed to supplement the pennies given by the children. Agreement was reached that the green at the main entrance to Peel Park, in front of the recently extended museum, was the most appropriate site for the statue.

Prince Albert unveiled the statue on a visit to Manchester and Salford in May 1857, which also saw him open the Art Treasures Exhibition. His visit to Salford centred on Peel Park, where he viewed the library and museum, including an exhibition of paintings by local artists. The unveiling ceremony was a suitably splendid civic occasion – a 21-gun salute, the ladies in their brilliant dresses, the singing of the national anthem – on a fortunately sunny day.[2] Thomas Agnew made a speech emphasising the importance of Sunday schools to the nation. The sentiments in Prince Albert's reply pointed to those values which connected the Monarchy and the People:

> … may succeeding generations, seeing the Queen's Statue in the midst of this Park, find in its contemplation an assurance that where loyalty and attachment to the Sovereign as the representative of the institutions of the country are linked to an ardent love of progress, founded upon self-reliance and self-improvement, a country cannot fail to prosper under the favour of the Almighty.[3]

What was to be remembered by most of those present as a glorious occasion was spoilt for some of the Sunday school children and their teachers by the unsatisfactory seating arrangements.[4] The allocation of only 2,000

Noble, *Queen Victoria*

places for the Sunday schools was clearly insufficient to meet the demand. Moreover, some of those fortunate enough to obtain a ticket were unable to gain entrance to the park.[5] Another correspondent in the local press found mistakes in the inscription.[6] The sharp-eyed also noted that because the memorial's granite steps had not been delivered, the organising committee had improvised a pedestal base of stone and brick covered with granite-patterned paper. Queen Victoria did not attend the ceremony – she had recently given birth to Princess Beatrice – but she did admire Noble's statue when visiting Salford later in the year.[7] When the statue of Prince Albert was placed in the park, it was decided to install the queen's statue on a new pedestal, in order that they could be viewed as a pair.[8] The statue has weathered badly over the years, most obviously on the face and back. The hands have also been damaged.

Notes

[1] J. Plant, *The Memorial Statues and Royal Free Museum and Library, Peel Park, Salford* ([Salford], 1879) 2nd edn, p.5. [2] *Manchester Guardian*, 7 May 1857; *Manchester Courier*, 9 May 1857; *The Times*, 11 May 1857; *Art Journal*, June 1857, pp.198–9; *Illustrated London News*, 9 and 23 May 1857; *Report of the proceedings of the Executive Committee for arranging the assemblage of Sunday School Scholars in Peel Park on the occasion of Her Majesty's visit* (Manchester: Cathrall and Co., [1851]). [3] Plant, *op. cit.*, p.8. [4] *Manchester Guardian*, 22 April 1857; Letter from Sunday school teacher, *Manchester Guardian*, 27 April 1857. [5] *Ibid.*, 7 May 1857. [6] Correspondence in *ibid.*, 7 and 11 May 1857. [7] *Ibid.*, 2 July 1857. [8] Plant, *op. cit.*, p.10.

Prince Albert
Matthew Noble

7 November 1864
Marble statue; granite pedestal
Statue 2.95m high; pedestal 3.4m high × 2.27m × 2.23m
Inscriptions on pedestal: front: ALBERT / PRINCE CONSORT / PRINCE OF SAXE-COBURG AND GOTHA / CHANCELLOR / OF THE UNIVERSITY OF CAMBRIDGE &c. / BORN / AUGUST 26. MDCCCXIX / DIED / DECEMBER 14. MDCCCLXI. – rear: ERECTED / BY PUBLIC SUBSCRIPTION / 1864. – left-hand side: THE HIGHEST LEARNING / IS TO BE WISE / AND THE GREATEST WISDOM / IS TO BE GOOD. – right-hand side: 'I CONCEIVE IT TO BE / THE DUTY OF EVERY EDUCATED PERSON / CLOSELY TO WATCH AND STUDY / THE TIME IN WHICH HE LIVES / AND AS FAR AS IN HIM LIES / TO ADD HIS HUMBLE MITE / OF INDIVIDUAL EXERTION / TO FURTHER THE ACCOMPLISHMENT / OF WHAT HE BELIEVES / PROVIDENCE TO HAVE ORDAINED.' / THE PRINCE CONSORT 1850

Status: Grade II
Condition: fair
Owned by: Salford City Council

Description: Portrait statue; a larger than life-size Sicilian marble statue of Prince Albert standing on a granite pedestal, rising from three steps. Albert is depicted wearing the robes of the Chancellor of the University of Cambridge, the robes being sufficiently open to reveal the ribbon of the Garter over his left shoulder. In his right hand is the university cap, in his other hand a scroll. The cap rests on a globe and books, placed behind his left foot.

The idea of raising a statue as a memorial to Prince Albert was first proposed by Alderman James Woods Weston at a meeting in Salford Town Hall in December 1861, called to finalise the arrangements for a public church service to mark the Prince Consort's death. The idea of a memorial statue moved forward with full council support; a committee was established and a public subscription opened. The subscription raised £1,932, including, as the press was keen to point out, donations from the working classes and collections organised by local Sunday schools.[1] It was decided that the statue would stand facing that of Queen Victoria, at the front of Peel Park.

Matthew Noble, who had sculpted the three statues – Peel, Victoria and Brotherton –

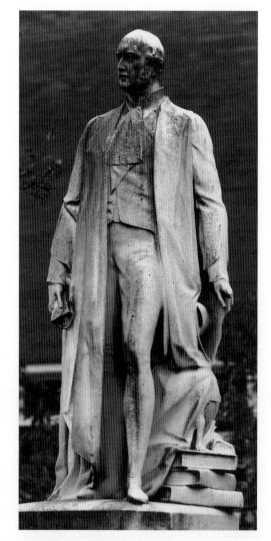

Noble, *Prince Albert*

already erected in the park, was commissioned to produce the new statue. The Queen gave her approval to a model of the proposed memorial and a drawing showing its location in relation to the surrounding buildings in the park. Noble portrayed Albert in his academic robes as Chancellor of the University of Cambridge, a

choice which emphasised his interests in education, as well as providing the sculptor with a form of dress which sidestepped the problems of depicting the Prince Consort in his everyday clothes.[2] The pedestal was inscribed on all sides, the most significant being an extract from one of Albert's speeches, emphasising the need for educated people (the middle classes) to involve themselves in public questions.

It was the Bishop of Manchester, James Prince Lee, who formally handed over 'the Salford Albert Memorial' to the Corporation in November 1864. In replying to the vote of thanks, Prince Lee's sense of 'public duty and private friendship' led him to acknowledge Noble's skills as a sculptor.[3] The statue cost £1,100, including transport and fixing costs. The surplus funds were spent on a new pedestal for the Queen Victoria statue and on acquiring marble sculpture for the museum, though some of the public felt the money might have been better spent on the town's hospital.[4] The stone has not weathered to the same extent as on the Victoria statue but it has suffered some minor damage, notably to the left hand and the university cap.

Notes
[1] *Manchester Courier*, 11 January 1862; *Salford Weekly News*, 18 January 1862. [2] E. Darby and N. Smith, *The Cult of the Prince Consort* (New Haven: Yale University Press, 1983) pp.80–1. [3] *Manchester Courier*, 8 November 1864; *Manchester Guardian*, 8 November 1864. [4] *Salford Weekly News*, 25 January, 1 February 1862.

University of Salford

Peel Building

Architect: Henry Lord

Architectural sculptors: Earp, Son and Hobbs

25 March 1896
Terracotta
Panels: centre panel 3.35m × 1.22m approx; left-hand side panel 1.22m × 1.22m approx; right-hand side panel top 1.22m × 76cm approx; right-hand side panel bottom 1.22m × 92cm approx; panel on side elevation 3.5m × 1.22m approx
Condition: fair
Status: Grade II
Owned by: University of Salford
Description: Three-storey building in Renaissance style, built in Ruabon brick with terracotta decoration, 13 bays on either side of the central gabled bay. In the spandrels above the main entrance are two bas-reliefs of women, larger than life-size, representing Art and Science. Near the top of the gable, above an arched window, is a large rectangular terracotta panel of five female figures representing the arts and sciences. At the very top of the gable is the borough coat of arms. Below a terracotta balustrade on either side of the main gable are three terracotta panels depicting trades and industries associated with the school. On the left-hand side is a single square panel representing Science, a composition of four men engaged in scientific work in a laboratory: the central figure, striking a dramatic pose, is holding up and looking at a cup or beaker; a young boy, seated on a stool, is working with a pestle and mortar. On the right-hand side is a rectangular panel representing Building, two men lifting a block of stone with a hoist, the third laying mortar with a trowel. Below is a larger rectangular panel representing Engineering, a composition of four men, three of whom are in their shirt sleeves working on machinery, including one man kneeling down

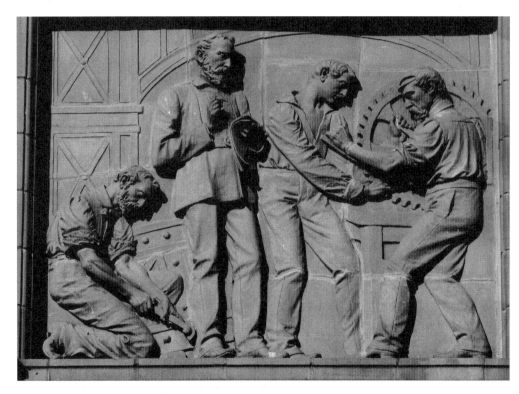

Earp, Son and Hobbs, *Engineering*

tightening a rivet or bolt. The central figure is wearing a jacket and studying papers held in his left hand.

On the side elevation is a long narrow panel divided into two by a semicircular window. On the left-hand side are four female figures representing Spinning, one figure holding out spun thread to the four female figures on the right-hand side representing Weaving, two of whom are holding a weaving frame and one a roll of cloth.

Salford Royal Technical School was opened in 1896 to further technical and scientific education in the borough. It was one of a number of technical institutes established after the Technical Instruction Act of 1889, which empowered local authorities to set aside funds for technical education, and was driven by a desire to retain British industrial superiority over Germany and other industrialising economies. The question of whether to build a technical school had been aired in the Salford local elections of November 1889, and soon afterwards a motion was proposed by the council in its favour. Early in 1890 a Technical Instruction Committee (TIC) was created which set about examining the establishment of a new technical school. Visits to technical schools in other towns confirmed the need for a similar institute in Salford. When the committee reported in July 1890, the school at Huddersfield, which had cost £22,000, was suggested as a model. The TIC recommended that the school should include departments for the study of machine construction and drawing, magnetism and electricity, building construction, spinning and weaving, bleaching and dyeing, art and chemistry. The first site suggested was that of the Salford Working Men's College in Great George Street, but this was rejected in favour of Marlborough Square, adjoining Peel Park, land which the council

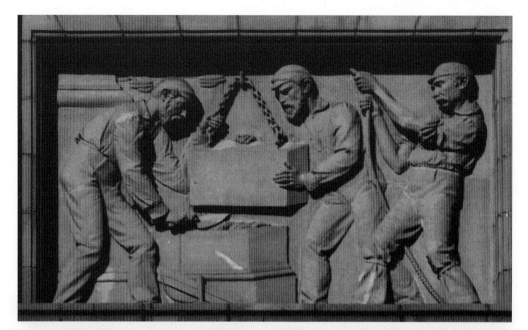

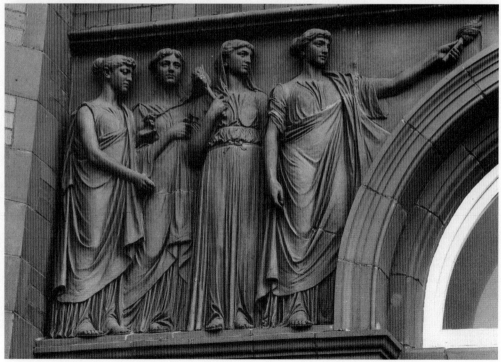

Earp, Son and Hobbs, *Building* **(top);** *Spinning* **(bottom)**

already had in its possession. The lease was acquired from the 15th Earl of Derby in September 1890. The choice of Henry Lord as the architect for the project was a matter of some controversy, since he was a founder member of the TIC, and therefore in a far more favourable position than other bidders. 'That his appointment as architect was proceeded with in a fashion which is open to grave objection', the *Salford Reporter* commented, 'does not, we think, admit of any dispute.'[1] His estimate of £55,000 for the building was considered somewhat large, but an application to the Local Government Board to sanction the borrowing was made. The main building contract went to Wilson and Toft of Ardwick. Earp, Son and Hobbs of London and Manchester were responsible for the building's

Earp, Son and Hobbs, *Weaving*

terracotta panels, the designs of which reflected subjects taught in the institution. The foundation stone was laid on 1 October 1892 by Benjamin Robinson, the TIC chairman.[2]

The final cost of the whole project, some £70,000, inevitably attracted criticism. The loudest abuse was reserved for the Council as a whole, which, early on in the project, had used £12,000 of the Technical School's budget to reduce the rates. Yet, the large budget also ensured that 'however much people may differ as to the expedience of providing so lavishly for a demand the extent of which is as yet largely problematical', Salford had acquired a 'magnificent building' which 'for generosity of proportions, architectural ornamentation, and wealth of colour' was 'unsurpassed by any public building in the borough'.[3] The building was opened by the Duke and Duchess of York (the future George V and Queen Mary) in March 1896.[4] Following the royal visit the

institution was granted permission to take the title of the Royal Salford Technical Institute.

In the following century the building remained the central institution in Salford's further education system. Its status and name altered in line with those national changes which redefined further and higher education, the school becoming a technical college in 1921, a College of Advanced Technology in 1956, and the University of Salford in 1967.[5] The original building was also renamed the Peel Building. The exterior, including the terracotta panels, was repaired and cleaned in 1999.

Notes
[1] *Salford Reporter*, 4 April 1896. [2] *Manchester Guardian*, 3 October 1892. [3] *Salford Reporter*, 4 April 1896. [4] *Manchester Evening News*, 25 March 1896; *Salford Reporter*, 28 March 1896. [5] C. Gordon, *The Foundations of the University of Salford* (Altrincham: J. Sherratt, 1975).

Cross Lane, Pendleton

Oliver Heywood Memorial

J. and H. Patteson

28 October 1893
Granite
9.15m high approx × 1.88m × 1.88m
Signed on steps: J. & H. Patteson Manr.
Inscription on base, beneath medallion: OLIVER
 HEYWOOD / BORN 1825 / DIED 1892.
Status: Grade II
Condition: poor
Owned by: Salford City Council
 Description: A red granite obelisk on a stepped base with supports at the corners. A circular bronze medallion of Oliver Heywood is on the front and bronze coats of arms of the Heywood family and of the borough of Salford on the sides.
 Biography: see p.20.

Oliver Heywood, banker and philanthropist, was one of the central figures in the public life of Victorian Manchester and Salford. He died in

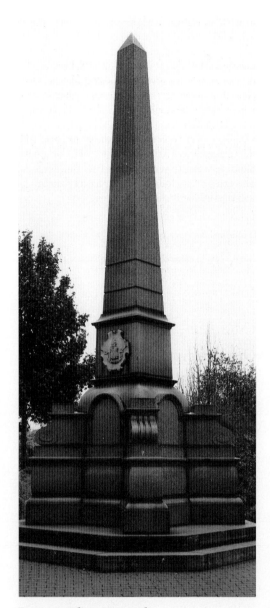

Patteson, *Oliver Heywood*

1892.[1] Shortly after his death, a meeting of his friends was convened by the Mayor of Salford, Peter Keevney, at which resolutions were passed in favour of erecting a monument. This acknowledged the fact that for almost all of his life Heywood had lived in Salford. At the same time, plans were in hand to raise a statue to 'Oliver the Good' in Manchester.[2] Subscriptions collected by the Salford Oliver Heywood Memorial Committee soon amounted to £850 and the Manchester firm of monumental sculptors and masons, J. and H. Patteson, was engaged to produce a memorial. The agreed design took the form of a red granite obelisk, on which would be a portrait medallion. Agreement was reached between the memorial committee and the borough council that the memorial would be located on a triangular enclosure at the junction of Cross Lane and Broad Street, Pendleton, a busy site that would enable it to be seen by many people.[3] The memorial was conceived, as the mayor put it at the unveiling in October 1893, as the best means to

> bear witness to this and future generations to Mr Heywood's splendid services to the people, and as an enduring testimony of the regard and veneration in which he was held by all classes and conditions of men.[4]

The monument was dedicated by the people of Salford to inspire others to follow in his footsteps of public service. A marble bust of Heywood, dated 1896, the work of Joseph William Swynnerton, was also added to Salford's extensive municipal collection of portrait busts.

In the twentieth century there was pressure for the monument to be relocated. After the Second World War the Council gave consideration to moving the memorial to Light Oaks Park, but in the end decided against it.[5] In the 1980s a new road scheme did result in the memorial being re-sited, a short distance away, on an open space at the corner of Cross Lane and Broad Street. Further development of the

surrounding site has meant that access to the memorial is now through the car park of a McDonald's fast-food restaurant. Algae, graffiti and chipped stone suggest that the memorial has been neglected.

Notes
[1] *Eccles and Patricroft Journal*, 18 March 1892. [2] See above, p.20. [3] City of Salford Museum, Libraries and Parks Committees, 11 October 1892; *County Borough of Salford. Proceedings of the Council*, 28 October 1892, p.574. [4] *Manchester Guardian*, 30 October 1893; *Salford Chronicle*, 4 November 1893; *Salford Reporter*, 4 November 1893. [5] *Salford Parks and Cemeteries Committee*, 2 December 1948, 7 April 1949; *City of Salford. Proceedings of the Council*, 2 December 1948, p.591; 5 January 1949, p.728; 6 April 1949, p.984.

Frederick Road Campus, University of Salford

Allerton Building

Untitled

William Mitchell

1966
Concrete; coloured tiles
5.6m–6m high approx × 1.52m square base
Status: not listed
Condition: fair
Owned by: University of Salford
 Description: Three tall square concrete columns, coloured and decorated with patterns and tiles suggesting figures from Mayan culture, arranged in a group in a courtyard.

The Allerton Building of the University of Salford was originally Salford Technical College. It was designed by the Manchester-based architects, Halliday Meecham. They recognised the need for a sculpture to provide a point of interest in the forecourt of the new building, and commissioned the London sculptor William Mitchell to provide it. Mitchell's work was already known in Manchester, as he had produced a concrete mural in the entrance hall of the Co-operative

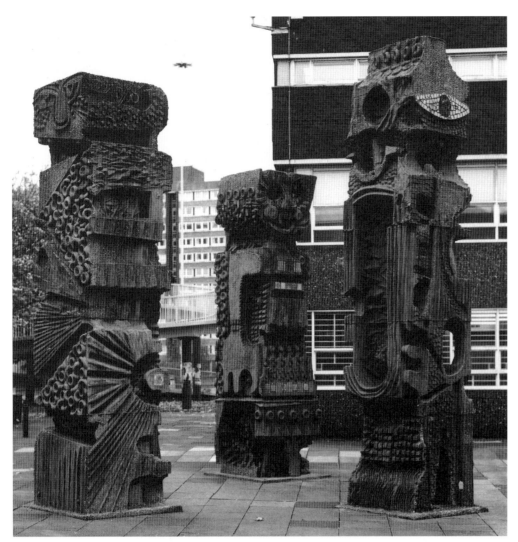

Hardy and Willis' (after the shoe retailer) and, less imaginatively, the totem poles. Mitchell was also responsible for a concrete mural in the concourse of the building.

Notes
[1] *Manchester Guardian*, 30 May 1966. [2] *Salford City Reporter*, 30 September 1966.

Lower Kersal

Littleton Road

Arena

Rita McBride

17 August 2002
White ferrocement
7m high approx × 10m wide approx; 5m base
 diameter
Condition: fair
Owned by: Salford City Council
 Description: Free-standing sculpture, in white ferrocement, of a bowl-shaped amphitheatre incorporating curved support ribs and 22 tiers of seating located on a bank between the River Irwell and playing fields.

Arena was one of the most ambitious sculptures commissioned for the Salford section of the Irwell Sculpture Trail. The specific location was in the Lower Kersal district of Salford, close to the River Irwell, overlooking the Littleton Road Playing Fields. A major flood prevention scheme had been implemented on this part of the river. A curator, Andrea Schlieker, was appointed for the project. She presented a short-list of four artists to a selection panel made up of officers and councillors of Salford City Council, local community representatives, the Environmental Agency, the Arts Council of England and two practising artists. Following presentations by the artists, the panel selected the American sculptor, Rita McBride, who had

Insurance Society Building. His response to the open space was to propose a composition of three concrete figures. Each figure was unique, but the features of all suggested the influence of Mayan or Aztec culture. Coloured mosaic tiles were used to highlight features of the figures. The patterns of swirls, squares and shells on the concrete reinforce the connection to Mayan culture. Each figure was constructed from four concrete blocks, each one having a distinctive

colour: sandy white, flaky black and pale terracotta.[1] The erection of the figures took Mitchell and his team one week, sufficient time to ensure that they were positioned 'so that the morning and evening sunshine will fall on the faces of the figures'.[2] Mitchell was characteristically silent about their meaning. In the absence of any explanatory plaque, staff and students have blessed the three concrete figures with a number of names including 'Freeman,

McBride, *Arena*

exhibited in the United States and Europe and had been awarded the DAAD fellowship in Berlin. She proposed a large bowl-shaped sculpture based on the theme of the arena. Her work was concerned with the space between sculpture and architecture, creating interactive forms and spaces that invite the viewer to use them as recreational spaces. The concept of the arena had been a subject she had worked on for a number of years and the Salford *Arena* can be traced back to works such as *Arena (1997)* which had been commissioned by the Witte de With Centre for Contemporary Art in Rotterdam.[1] The Salford commission was McBride's first major publicly sited work, allowing her to produce a work that was 'both beautiful and functional', informed by her interest in the 'formal language of the sports

stadium'.[2] The 22- tiered arena stood some 7 metres high and was placed on a bank allowing it to be seen from a considerable distance. Its size also meant that it could be used by people, a place to sit and picnic. The chosen material was white ferrocement. Construction was underway by early summer.[3] The work cost £250,000, finance coming from Salford City Council, the North West Development Agency, the Arts Council and the National Lottery. *Arena* was officially opened in August 2002 in a colourful ceremony that included a specially commissioned performance work, 'Dramarena', by the local community theatre group, Wisemonkey. It was welcomed as an example of high quality public art that had 'a vital part to play in the urban renaissance of the north west'.[4] Since its opening *Arena* has been spoilt by vandals, who have set fires inside the bowl of the amphitheatre and broken off parts of the lower tiers.

Notes
[1] Rita McBride interviewed by Dominic van den Boogerd, 1997. www.wdw.nl.info@wdw.nl
[2] Salford Council press release 19 February 2002.
[3] Information from Gaynor Seville; *Manchester Evening News*, 15 April 2002. [4] Baron Isherwood, Director of North West Development Agency, quoted in *Manchester Evening News*, 8 July 2002.

Peel Park

The Fabric of Nature

Julia Hilton

17 June 2000
Cast brick; stainless steel; brass; earth and turf
2.8m high × 32m wide
Inscription etched on stainless steel panels inset into brick floor: We are but whirlpools in a river of ever-flowing water / We are not stuff that abides but patterns that perpetuate themselves.
Condition: good
Status: not listed
Owned by: Salford City Council
 Description: Earthwork in the shape of a bud and leaf unfurling up into a double spiral mound, leading to a curved seating area. A series of leaf images and inscription etched in stainless steel are set into the brick floor, to the front of a brick seat.

In the mid-1990s Salford City Council began to take action to restore its inner-city parks, which had suffered from decades of underfunding and neglect. A major plan to redesign and improve Peel Park was developed by the council and the University of Salford. Public sculpture was recognised as part of these improvements. As a partner in the Irwell Sculpture Trail, Salford commissioned two sculptures for the park. Julia Hilton was appointed to a residency in 1997, with the aim of collaborating on the design of the park. Out of discussions with the landscape architect she developed the idea of an earthwork sculpture that would provide seating, a play area and more colour to an area

Hilton, *The Fabric of Nature*

of the park – it included disused tennis courts – that had become an eyesore.[1] The construction of the work proceeded ahead of the larger redesign of the park. Hilton's sculpture drew its inspiration from the patterns of nature, the park's flower beds and the nearby river, and, less obviously, Salford's buildings. She wrote that

> from above the earthwork image is like a piece of Victorian textile design although the initial inspiration for the image came from detailing on the former education building on Chapel Street which was then adapted and refined to allow it to work on the site.[2]

The central seating area contained a series of stainless steel panels etched with images of the leaves of trees growing in the park. Further patterns and colours were added by the planting of herbs, including lavender, rosemary and sage.

Throughout the design, Hilton kept in contact with Adrian Moakes, who was creating a neighbouring sculpture. The completed work was unveiled in June 2000 by the Mayor of Salford.

Notes
[1] Correspondence with Julia Hilton. [2] Draft press release, 25 April 2000.

Monument to the Third Millennium
Adrian Moakes

17 June 2000
Galvanised and painted mild steel
Inner cone 5m high × diameter 1.9m
Condition: good
Status: not listed
Owned by: Salford City Council
 Description: Steel sculpture representing a swirling shoal of fish swimming upwards through a vortex of water. The outer, spiralling

latticework of 'water' appears to move as one walks around the sculpture.

Following a national competition, Adrian Moakes was selected to provide a sculpture in Peel Park. He worked on his ideas with

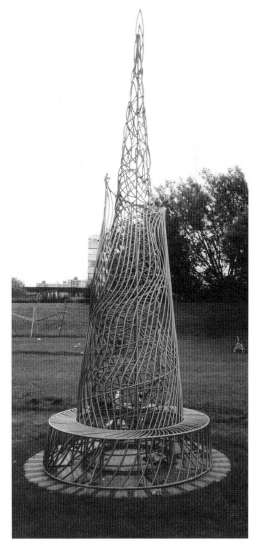

Moakes, *Monument to the Third Millennium*

students from the University of Salford during a three-month residency in 1997. The final work was influenced by its proximity to the River Irwell, which in this part of Salford was prone to flooding. It had once been rich in wildlife, but industrial pollution had killed off the fish. The idea of the sculpture depicting a swirling shoal of fish swimming up through a vortex of water was to celebrate the river's recent regeneration, including the reappearance of fish and wildlife. It symbolised 'a positive attitude to environmental regeneration in the new century'.[1] A circular seating area was incorporated in the base, from which the public could view the park. The specific site was selected by the sculptor and Julia Hilton, who was also working on a related commission – *The Fabric of Nature* – in the park. It was officially unveiled by the Mayor of Salford, Councillor Barry Warner, in June 2000.

Note
[1] Correspondence with Adrian Moakes, August 2000.

St John's Square
The Pyramid
Janet Fitzsimons

March 1992
Florentine aggregate
3.56m high approx; octagonal base 2.85m wide
Inscription in incised letters on plinth: St.
 John's Square / 1992
Status: not listed
Condition: good
Owned by: Salford City Council
 Description: A solid polished 'concrete' pyramid resting on four spheres and a square plinth, rising from an octagonal base of two steps.

The Pyramid was designed and installed as part of a £400,000 facelift of the area at the rear of St John's Cathedral, a project that included the creation of public gardens and a paved square.

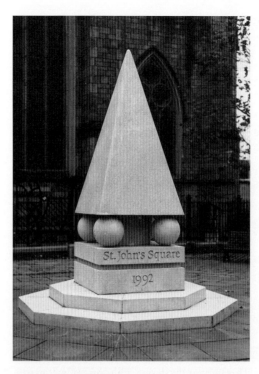

Fitzsimons, *The Pyramid*

The cost of the scheme was defrayed by money from the government's urban programme. Janet Fitzsimons, a landscape officer with Salford Council and a member of the team responsible for landscaping the area, designed *The Pyramid* as a focal point of the paved square. Its strong geometric shapes echoed those of the neighbouring cathedral. It was cast by Forticrete Architectural Masonry, Bootle, in an aggregate stone-effect finish called Florentine.[1] Local tenants were not impressed, describing the sculpture as a 'monstrosity' and the £12,000 spent on it as a waste of money. At the time of its installation a tenants' spokesman called for the money to be spent on the cathedral's drop-in centre for the poor and homeless.[2] In the following year, the landscaping scheme, including *The Pyramid*, as the unnamed design was widely referred to, won an award in a

design contest organised by a local government publication.[3] It has suffered vandalism and was repaired and cleaned in 1999.

Notes
[1] *Architecture Today*, July 1992. [2] *Manchester Evening News*, 30 March 1992. [3] *Ibid.*, 25 September 1993; correspondence with Janet Fitzsimons, June 1999.

St Philip's Square
Seed
Andrew McKeown

11 December 2002
SG iron
2m high × 3.5m wide × 75cm deep
Condition: good
Status: not listed
Owned by: Salford City Council
 Description: Cast-iron sculpture in the shape of a large sycamore seed positioned at ground level in the centre of the open space adjacent to St Philip's Church.

Seed was commissioned as part of the Irwell Sculpture Trail. The Middlesbrough artist and sculptor, Andrew McKeown, was selected from the artists who had responded to a request to produce a work that was to be located in the old centre of Salford, near St Philip's Church. McKeown had previously contributed a sculpture as part of a regeneration project in Miles Platting, Manchester. The Salford

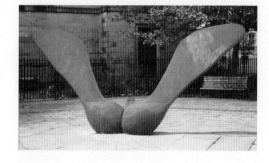

McKeown, *Seed*

commission was inspired by the theme of regeneration and renewal, ideas that echoed the wider process of industrial change in Salford, a community that was experiencing regeneration following the collapse of its traditional manufacturing industries. As part of the commission McKeown worked on possible designs with children from St Philip's Primary School. The image of a large sycamore seed emerged as the most appropriate one, in part because of the sycamore trees on the site. The completed sculpture was some 100 times larger than an actual sycamore seed, the surface revealing the veins of the seed. Rising directly from the floor, the sculpture also suggested angel wings, an association that connected it to the nearby Angel Community Centre and Angel public house. The work was cast in SG iron, a metal slightly stronger than cast iron, at Davison Tyne Metal Ltd foundry in Hexham. The iron was left untreated, leaving the sculpture to rust naturally.[1] McKeown decided to leave the work without an explanatory plaque. It is also unsigned.

Note
[1] Information from Andrew McKeown and Gaynor Seville.

SALFORD QUAYS

Anchorage Quay

Anchorage
Wendy Taylor

1991
Mild steel; forged steel
8.08m high approx
Condition: good
Status: not listed
Owned by: AMEC Developments Ltd
 Description: Steel anchor and chain, tilted at an angle, painted black, located on the quayside at the end of the dock.

Wendy Taylor was commissioned in 1990 to provide a sculpture which would stand on Salford Quays as a symbol of the regeneration of the old docks. The project was part of an initiative by Salford City Council, which had recognised that public sculpture had a role in the area's redevelopment.[1] Taylor produced *Rope Circle*, a 3.5 metre-high bronze work, part of a theme she had been working on over a number of years. The intended site was the South Bay area of the Quays.[2] However, as the sculpture neared completion, financial problems forced the firm sponsoring the work to withdraw from the project. Salford City Council did not have the resources to continue with the £25,000 commission. The project was in danger of collapse, when AMEC Developments, which was developing another site on the Quays, agreed to take over the sculpture. They did so on the condition that it would be located outside their new building, near the Erie Basin. On visiting the new site, Wendy Taylor concluded that *Rope Circle*, although already well advanced, would be entirely inappropriate for it. She proposed a new sculpture:

> … I persuaded the new client to give me at least an opportunity to consider the new site completely afresh, but obviously within the original budget and time-schedule. When I presented the alternative idea, which had the right height and scale for the surroundings, they agreed to let me proceed, and released Rope Circle. In my opinion I had no choice. It was very exciting to realise the work proposed, even if it left me with a minus sign financially. The consolation is that it was always the right decision.[3]

The choice of an anchor was inspired by the new setting, and was a natural extension of her work on industrial chains, work that had included the study of dock equipment. However, rather than looking like a discarded remnant of the once busy docks, Taylor wanted the anchor and chain 'to be alive – to be active'.

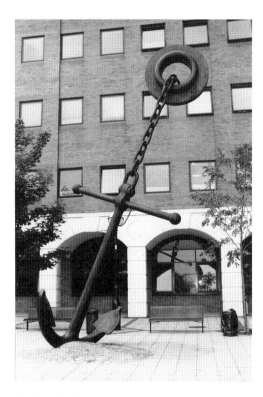

Taylor, *Anchorage*

This quality was realised by its size, and by the near-perpendicular angle which suggested that it was attached to the building behind, as if it was mooring the whole structure.[4] The 5,600kg work was installed in 1991. *Rope Circle* was installed in 1997 in Hermitage Wharf, Wapping, London.[5]

Notes
[1] Information from Barry Whitmarsh, Salford City Council. [2] E. Lucie-Smith, *Wendy Taylor* (London: Art Books International, 1992) p.107. [3] *Ibid.*, p.107. [4] *Ibid.*, p.108. [5] Information from Wendy Taylor.

Ontario Basin

Four Corners

Noah Rose

14 March 1997
Mild steel; stainless steel
4.75m high × 2.2m × 2.2m
Inscription on stainless steel plaque fixed on
 ground: 'FOUR CORNERS' / Sculpture by
 Noah Rose for Ordsall Community Arts /
 The Docks were opened by Queen Victoria
 in 1894, and at their height in the 1950s /
 formed part of Britain's third busiest port.
 For over 80 years, cargo from the four
 corners / of the world sailed up the
 Manchester Ship Canal into Salford over 60
 miles from the sea. / The images on the
 etched panels show some of the stories,
 scenes and characters from the / life of the
 Docks, designed during workshops with
 former dock workers led by artists / Noah
 Rose, Ian Cantwell, & Nancy Barrett. /
 Commissioned by Beefeater Restaurant &
 Pub / Officially unveiled by / The Right
 Worshipful Mayor of Salford / Cllr. John
 Gaffney on March 14th 1997.
Status: not listed
Condition: good
 Description: A steel sculpture whose shape is
inspired by the propellers and hulls of the ships
that once used the Manchester Ship Canal. The
main body is divided into four curved fins,
painted blue, to which are attached 24 stainless
steel panels, on which are etched images and
words depicting and recalling life in the docks.
On the top is a stainless steel weather-vane in
the form of a bird, its shape based on a plan of
the docks.

When Whitbread plc purchased land on the
Salford Quays to build a hotel, it was agreed
with Salford City Council that the development
would include a public sculpture. Noah Rose, a
Manchester sculptor, was commissioned to
produce the work. The ideas for the work arose
from a series of workshops organised by
Ordsall Community Arts and Salford Quays
Heritage Centre in May 1996. In these
workshops local residents and former
dockworkers shared their reminiscences about
the docks and the aim became one of creating a
durable sculpture which would be a tribute to
the once bustling port and the men and women
who had worked there. Ian Cantwell designed
and etched the stainless steel panels
incorporating the stories and images provided
by former dockworkers. These included a
recollection of the artist, L.S. Lowry, and the
crest of the National Dock Labour Board with

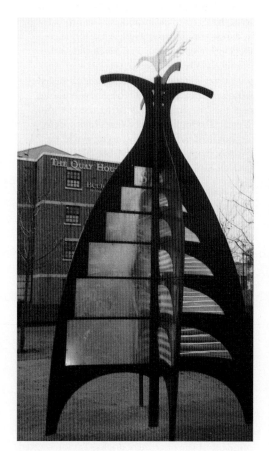

Rose, *Four Corners*

its motto 'Let them not be out of work against
their will'. The sculpture's title refers to the fact
that cargo came to the docks from all corners of
the world. It was unveiled by the Mayor of
Salford, John Gaffney, in March 1997.[1]

Note
[1] *Manchester Evening News*, 13 March 1997;
correspondence with Noah Rose, February 1999.

Furness Quay

Furness House

Totem Pole

Douglas Cranmer

12 December 1969
Columbian pine
9.76m high
Inscription on plaque in front of pole: THIS
 TOTEM POLE / WHICH WAS CARVED BY THE /
 KWAKIUTL INDIANS IN BRITISH COLUMBIA /
 COMMEMORATED THE OPENING OF /
 MANCHESTER LINERS HOUSE / ON THE 12TH
 DECEMBER 1969 BY / HIS EXCELLENCY MR.
 CHARLES S. A. RITCHIE, C.C., / HIGH
 COMMISSIONER FOR CANADA.
Status: not listed
Condition: fair
Owned by: Furness Withy and Co. Ltd
 Description: Pine totem pole carved with
animals and figures important in Kwakiutl
culture. These include the eagle, representing
the noble and omnipotent ruler of the skies; the
killer whale, representing the master of the seas;
and the raven, representing the messenger. At
the base is the figure of a tribal chief holding
coins, symbolising wealth and power.

The totem pole was commissioned by Robert
Stoker, chairman of Manchester Liners, to be
erected outside the company's new offices,
close to the Manchester Ship Canal.[1] Stoker
regarded the pole as a monument, a reminder of
the historic trading links between Manchester
and Canada, a trade in which Manchester

Cranmer, *Totem Pole*

Liners played an important part.[2] The pole, made of Columbian pine (most poles were of red cedar), was shipped to England in the summer of 1969.

The carving of totem poles is an important part of the culture of the Indian tribes who inhabit the coastal regions of British Columbia. Poles are powerful and distinctive cultural statements, the meanings of the different symbols represented on the poles being related to the myths and history of the particular tribe. Their erection was the occasion for great communal feasts. The stylised figures of animals and birds represented on poles are part of often complex and profound myths and stories associated with the group, the family or the individual. They are rarely capable of simple explanation.[3] The carving of poles went into decline from the late nineteenth century as the indigenous traditions and rituals of the native tribes were attacked by missionaries and the government. A renaissance of wood-carving skills occurred in the second half of the twentieth century as part of a wider reassertion of Indian culture.[4] The Kwakiutl Indians, who inhabit part of Vancouver Island and land to the immediate north, are one of the groups who have been prominent in this revival of native wood-carving techniques. The Kwakiutl artist, Douglas Cranmer, was central to the resurgence of interest in the culture of the totem pole. Salford's totem pole has remained in its original position, although it now stands outside Furness House, the change in name occurring after Manchester Liners was taken over by Furness Withy Shipping Ltd.

Notes
[1] R.B. Stoker, *The Saga of Manchester Liners* (Douglas, Isle of Man: Kinglish, 1985) pp.48–9.
[2] *Salford City Reporter*, 12 December 1969; *Manchester Liners News*, March 1970, p.8.
[3] M. Barbeau, *Totem Poles* (National Museum of Canada, Bulletin No.119, Ottawa, 1950) Vol.1, pp.1–14; M.M. Halpin, *Totem Poles. An Illustrated Guide* (Vancouver: University of British Columbia Press, 1981) pp.28–30. [4] Aldona Jonaitis, *From the Land of the Totem Poles. The Northwest Coast Indian Art Collection at the American Museum of Natural History* (New York: American Museum of Natural History, 1988) pp.241–50.

Manchester Road

Countess of Ellesmere Memorial
Architect: T. Graham Jackson
Architectural sculptors: Farmer and Brindley

26 July 1869; relocated 1968
Hollington stone
15.25m high approx; base 2.62m square
Inscription around four sides of the cornice on the lower stage: A PUBLIC TRIBUTE OF AFFECTION / AND RESPECT TO THE MEMORY OF / HARRIET WIDOW OF FRANCIS / FIRST EARL OF ELLESMERE. AD. 1868
Status: Grade II
Condition: poor
Owned by: Salford City Council
 Description: Gothic monument in three stages: a square base, rising from a pyramid of stone steps, on which is a large central column with clustered columnettes at the corners, carrying arches surmounted by pediments with crockets and finials. At each corner there is an enriched pinnacle with a niche containing statues of working people: collier, cotton operative and two factory girls (now missing). The second stage, octagonal in plan, contains larger niches with canopies in which are statues representing Charity, Piety, Prudence and Munificence. The final stage, cruciform in plan, with gablets on the four sides, is surmounted by a spirelet and cross.

Lady Harriet Catherine Egerton (1800–66), first Countess of Ellesmere, was the daughter of Charles and Charlotte Greville. She married Lord Francis Egerton, later the first Earl of Ellesmere, in 1822. The Earl inherited the fortune of the third Duke of Bridgewater, whose famous canal began at the coal mines at Worsley. The couple came to live in Worsley in

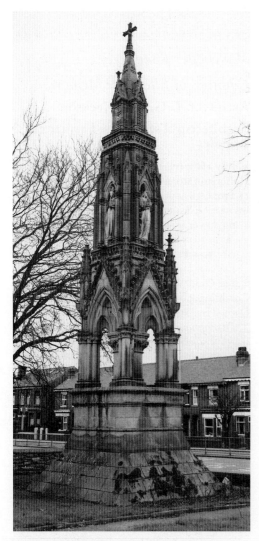

Farmer and Brindley, *Countess of Ellesmere Memorial*

1837. The Countess took an interest in the welfare of the local population, supporting a number of charities. She was also the author of three religious works, *Questions on the Epistles* (1832), *Journal of a Tour in the Holy Land* (1841) and *The Believer's Guide to the Holy*

Communion by J. H. Grand-Pierre; a *translation* (1849). After her husband's death in 1857 she lived chiefly in London. She died in April 1866 and was buried next to her husband in St Mark's Church, Worsley.

On the day of Lady Ellesmere's funeral, the 'principal tenants' of the Worsley estate met in the court house to form a memorial committee. The Revd St Vincent Beechey of St Mark's Church presided.[1] Despite the patronage of the church and local gentlemen, the subscription was remembered as a 'spontaneous effort of the villagers in and around Walkden Moor', by whom the duchess was 'greatly revered and beloved'.[2] In all some £1,000 was raised. Designs 'for a monument of durable and visible character' were solicited from architects and were exhibited at the court house. T. Graham Jackson was awarded the commission, the assessor being George Street.[3] Jackson's design was inspired by an Eleanor Cross. Farmer and Brindley were commissioned to provide the architectural sculpture, which included four figures representing working people and four figures representing the virtues. After some discussion it was decided to site the memorial at the crossroads in the centre of Walkden Moor, whose labouring population had been helped by the Countess, rather than closer to the tower raised in memory of her husband.

At the inauguration in July 1869, which was attended by around 2,000 people, 'for the most part workpeople', the personal charity of Lady Ellesmere was recalled. Fereday Smith declared that when she and her husband had arrived in Worsley, it was a 'comparative moral wilderness'. Blasphemy, drunkenness and crime had flourished, but through Lady Ellesmere's efforts 'all had been quite reversed'.[4] The monument, he said, should remind rising generations of her example. In reply the Earl of Ellesmere commented on the appropriateness of the site, as Walkden had been the place where his grandfather had built the first church and school, and begun measures to prevent girls and young women working in the coal-mines. But

not everyone appreciated the new memorial. It was said that the statue of the coal-miner on the memorial, modelled on a local miner who was an unpopular overlooker, was damaged by miners he had mistreated.[5] However, for most local people the monument was a prominent landmark in a district where the architecture was undistinguished.

Attitudes towards the Walkden Monument, as it was widely referred to, changed in the twentieth century. The railings surrounding the memorial were removed during the First World War, and in 1927 a tramway time-keeper's hut was erected next to it. The demands of road traffic began to transform the memorial from an object of architectural delight into an obstacle. The idea of moving it to the local park was suggested.[6] By the 1960s the junction was regarded as a traffic bottleneck, and Worsley District Council proposed the memorial's removal as part of a road improvement scheme. At the meeting of the General Purposes Committee in November 1967 the fate of the memorial appeared to arouse no great sentiment. It was even suggested that it be given back to the Ellesmere family. Councillor Ward implied that the monument only belonged to the public by default, since the subscriptions to the memorial had been given 'under duress'.[7] Some of the residents of Walkden were more attached to the monument, and started a petition which urged the council to 'recognise their responsibility as custodians of the town's amenities'.[8] This pressure proved ineffective and the cost of removal was eventually borne by the Ministry of Transport. The monument was moved to the nearby grounds of St Paul's Church, on the south side of Manchester Road, in 1968.[9] Unfortunately, the four statues of working people were stolen while the monument lay in pieces awaiting re-erection.

An ambitious project, led by Walkden Rotary Club, was launched in 1999 to restore the much-neglected monument and return it close to its original site. Initial meetings with the council to discuss the creation a new

landscaped area, Millennium Green, between Bolton Road and Harriet Street, were positive, but subsequent discussions about the site and the difficulties of raising £100,000 have meant that the memorial has yet to be either restored or re-sited.[10]

Notes
[1] *Salford Weekly News*, 21 and 28 April 1866. [2] *Ibid.*, 31 July 1869. [3] *Builder*, 11 July 1868, p.509. Jackson was referred to as 'of London, Fellow of Wadham College, Oxford'. [4] *Manchester Courier*, 27 July 1869; *Manchester Guardian*, 27 July 1869; *Salford Weekly News*, 31 July 1869. [5] C.E. Mollineux's notes on Walkden Monument (Walkden Library). [6] *Farnworth and Worsley Journal*, 17 October 1952. [7] *Ibid.*, 9 November 1967. [8] *Ibid.*, 23 November 1967. [9] *Ibid.*, 3 November 1968. [10] *Advertiser and Salford City Reporter*, 15 April 1999, 29 July 1999; *Bolton Evening News*, 29 July 1999. Information from Derek Unsworth, President of Walkden Rotary Club.

WORSLEY

The Green

Bridgewater Fountain

1905
Brick; stone
9.15m high approx
Inscription on stone steps: ALTA COLUMNA FUI, SPIRAMINA NARIS ANHELAE. / ARTE CYCLOPEA FACTA, FABRILE DECUS. / DUX OLIM AUCTOR ERAT CUI PONS FLUVIALIBUS UNDIS / IMPOSITUS LATE NOMEN HERILE DEDIT.
NUNC LOCA, QUAE CHALYBUM CIRCUMSPICE CARE VIATOR. / FERVEBANT STREPITU, PACE SEPULTA SILENT. / NI MIHI QUA, FONTIS VEROS IMITATUS HONORES. / SUBSILIT EX IMA SEDE CADITQUE LATEX.
VAE MIHI! QUOT TERRAS ME DESPEXISSE JUVABAT! / QUAM SUBITO EX QUANTA QUANTULA FACTA FUI! / NEC TAMEN OMNINO MORIAR: PARS ECCE SUPERSTES / QUID SIM, QUID FUERIM, TESTIFICATA MANET.

Condition: fair
Status: Grade II
Owned by: Salford City Council
 Description: Memorial fountain; a central carved stone bowl on an ornate scrolled pedestal, standing on a platform of four stone steps. It stands beneath a brick tower with four arched openings. The tower has an entablature with debased triglyphs, a cornice and a pierced parapet.

Francis Egerton, third Duke of Bridgewater, born in 1736, was the younger son of the first duke, Scroop Egerton and his second wife, Lady Rachel Russell, daughter of the Duke of Bedford. His father died when he was young, and at the age of 12 he inherited the title on the death of his brother. After his engagement to Elizabeth, Duchess of Hamilton, was broken off he left London in 1758 and settled on his Lancashire property at Worsley Old Hall near Salford, where he devoted his time to the development of its resources. In 1759 he obtained an act of parliament, authorising him to develop a canal from Worsley to Manchester. His initial plan of using the path of the Irwell was modified by the engineer James Brindley, whose successful scheme to carry the canal over the Irwell via an aqueduct, completed in 1761, made the Bridgewater Canal the first in England which throughout its course was independent of a natural stream. The canal was later extended to Runcorn, thereby linking Manchester and Liverpool. The Duke also spent £170,000 on the development of his coal mines, making underground canals ('the Delph') at Worsley, now flooded, to link the mines and Manchester coal markets. By the time of the Duke's death in 1803 the financial returns from the canal testified to his determination and entrepreneurial abilities.
 Calls were made on a number of occasions in the Manchester region for an appropriate public monument to be erected in honour of the third Duke of Bridgewater. An outdoor statue in Manchester was proposed in the 1840s. During the Cotton Famine a Bridgewater Park with a

statue of the Duke was also suggested.[1] It was not until the Edwardian period, however, that a memorial was finally realised. It took an unusual form. The site was formerly the works yard of the Bridgewater Canal at Worsley, famous as the place where the clock struck 13 instead of one, to make sure that workers were in no doubt that it was time to return to work. When the Worsley works were removed to Walkden in 1903, the base of the main chimney, which dated from the eighteenth century, was kept. The third Earl of Ellesmere decided to use it as a memorial to the third Duke of Bridgewater. The chimney was rebuilt with arches and inside the base a stone bowl on a

Bridgewater Fountain

scrolled pedestal was installed. A number of model dwellings were also built around the Green at this time.[2] James Rhoades composed the Latin verses inscribed on the stone steps. One translation, offered at the time the memorial was erected, read:

> A lofty column, vaunting to the skies
> Alike my own and my great author's worth
> Proud offspring of the smithy's clamorous mirth,
> I gloried in my station and my size.
> Now may the voyager, with wondering eyes,
> See that great factory that gave me birth
> And Vulcan's forge lie level with the earth,
> Their shuddering fall announcing my demise.
> Now am I shrunken from my lofty seat,
> No more the spreading landscape meets my gaze,
> Yet, where the bridge and rushing waters meet,
> A humbler testimony I may raise,
> And sparkling water keep his memory sweet
> Who bridged the water in those earlier days.[3]

The memorial was restored by Salford Council in 1980, following a request from the Worsley Civic Trust.[4] Weathering has left the inscription faint in places. In spite of frequent proposals to raise a statue or monument, this remains the only major memorial in the region to the famous 'Canal Duke'. James Brindley, the engineer of the Bridgewater and other canals, has fared somewhat better than his employer, being remembered by a bronze statue in Coventry.[5]

Notes
[1] *Manchester Guardian*, 14 September 1863. [2] J.A. Barnes, *The Worsley Trail* (City of Salford Education Department, 1978). [3] Henry V. Hart-Davis, *A Short History of Worsley* (1914). (A different translation is provided on the interpretation board at Worsley Green.) [4] Salford City Council Minutes, September–October 1980, nos 121, 307; *Manchester Evening News*, 16 October 1980. [5] Sculpted by James Butler, unveiled in 1998.

Leigh Road
Ellesmere Memorial
Charles Driver and Webber

10 August 1860
Ashlar; marble; Minton tiles
Originally 40.8m high approx
Inscription: AN AFFECTIONATE TRIBUTE TO THE MEMORY OF FRANCIS EGERTON, THE FIRST EARL OF ELLESMERE, K.G., FROM THE TENANTRY, SERVANTS, CARRIERS, AND OTHERS, CONNECTED WITH HIS LANDED AND TRADING INTERESTS, 1860
Status: Grade II
Condition: poor
Owned by: unknown [in private ownership]
Description: Gothic memorial tower. The original tower, ashlar, some 40.6 metres high, consisted of a square base richly decorated with sunken panels and coloured tiles, surmounted by a tall octagonal shaft, with a spiral belt of tiles and windows, terminated by a corbelled gallery and a central spirelet. At the base of the shaft on each face were windows surrounded by a decorated canopy. The main section of the octagonal shaft was taken down in 1939 and the spirelet placed on the base and remaining section of a shaft.

Francis Egerton, first Earl of Ellesmere, was born in 1800 in London, the younger son of the second Marquess of Stafford and Elizabeth, Countess of Sutherland. He was educated at Eton and Christ Church, Oxford before entering the Staffordshire Yeomanry as a lieutenant in 1819. Elected MP for Bletchingley, Surrey, in 1822, he associated himself with the liberal conservatism of Canning, and spoke in favour of free trade and the endowment of Catholic clergy. He was afterwards MP for Sutherland (1826–35), and South Lancashire (1835–46). Egerton held a number of government posts and was made a Privy Councillor in 1828. He also pursued a literary career, which included a translation of Goethe's

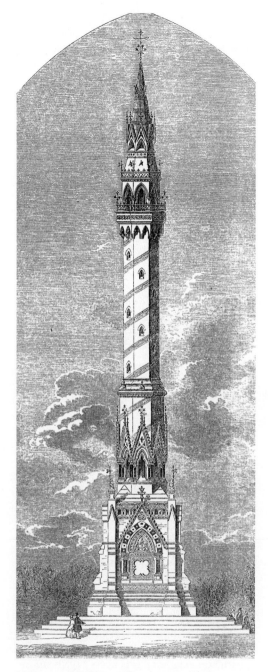

Driver and Webber, *Ellesmere Memorial*

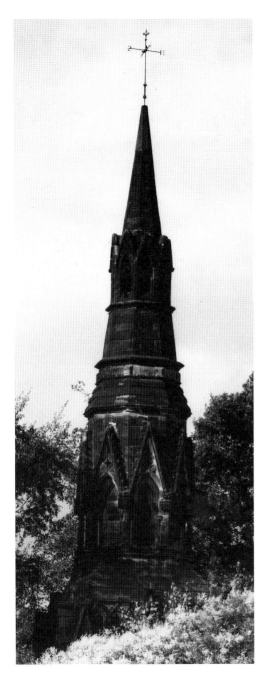

Driver and Webber, *Ellesmere Memorial (remains)*

Faust (1823), 25 other works of translation and military history, and a play, *Catherine of Cleves,* which was performed at Covent Garden. He inherited the estates and fortune built up by the third Duke of Bridgewater. In June 1846 he was created Viscount Brackley and Earl of Ellesmere, and was made a Knight of the Garter in 1855. In addition to his literary activities, he was involved in other scholarly projects, including terms as the president of the Camden Society and the Royal Geographical Society. He died in London on 18 February 1857 and was buried in St Mark's Church, at Worsley.[1]

Shortly after the death of the first Earl a subscription was opened 'chiefly among the Ellesmere tenants' to fund a memorial. Some £1,840 was collected, of which £270 represented small donations given by the Earl's employees.[2] In February 1858 the memorial committee advertised for designs, specifying a number of conditions. These were that the design should not be a statue, that it should cost £1,800, and that it should be 'substantial and durable rather than elaborate and ornamental, and that it should easily be seen from a distance'. Those entering the competition were also reminded that the memorial would be in a district where 'tall chimneys abounded'.[3] The memorial was to be sited on a ridge to the north of the new Worsley Hall, a location that would allow it to be seen from a considerable distance.[4] Of the 161 designs submitted, six were chosen for examination by the assessor, Edward Barry. First prize went to London architects Driver and Webber, the second to John Lowe of Manchester and the third to Edward Bassett Keeling of London. Driver and Webber's Gothic design was a tower some 40 metres high which included at the base of the spire a viewing gallery, accessed by an iron staircase.[5] Architectural sculpture featured on the base, in the form of 'figures of satyrs, dragons and nondescripts'. These were the work of George Seal.[6]

The foundation stone was laid on 17 November 1858, and work progressed rapidly in spite of difficult weather conditions.[7] The monument was inaugurated by Fereday Smith, the Superintendent of the Bridgewater Trust, in August 1860.[8] He stated that the object of the subscribers was not only to pay tribute to the late Earl, but also to 'testify to the present earl and countess, and to the dowager countess, those feelings which were decidedly felt by the whole population of the neighbourhood'.[9] A few days before the ceremony, an elaborate stone tomb, designed by George Gilbert Scott, with a marble sculpture of the Earl by Matthew Noble, had been placed in St Mark's Church at Worsley.[10]

In 1923 the tower passed into the ownership of the Bridgewater Estates which acquired it with the Ellesmere estate. It remained a landmark of northern Manchester until 1939, when the central column was deemed unsafe and was taken down, and the original capital was placed on top of the base.[11] Since that date the memorial has been neglected in spite of calls that it should be restored and moved to a more suitable location.[12] The ownership of the memorial has also been surrounded with uncertainty. After being threatened with demolition by the then owners Bridgewater Estates, it was sold to a private individual in 1986, along with a house in Leigh Road.[13] However, enquiries by Salford Council in 1994 failed to establish ownership. It was said to have been sold in that year to an individual living in Swinton, but when the *Salford Advertiser* enquired, he claimed only to own the house in front of the monument.[14] The memorial was protected by a security fence. It remains in a poor condition.[15] In February 2003 it was advertised for sale at a price of £225,000.[16]

Notes
[1] J. Evans, *Lancashire Authors* (London: Houlston and Stoneman, 1850) pp.85–8; *Dictionary of National Biography.* [2] Ellesmere Memorial List of Subscribers [n.d.] 8pp. [3] *Builder,* 24 July 1858, pp.499–500. [4] Ordnance Survey plan, 1893.
[5] *Builder,* 6 November 1858, p.747. [6] *Weekly*

Observer, 4 August 1860. [7] *Manchester Courier*, 20 November 1858; *Builder*, 12 May 1860, p.301. [8] *Builder*, 18 August 1860, p.535. [9] *Salford Weekly News*, 11 August 1860. [10] *Builder*, 15 September 1860, p.592; *Salford Weekly News*, 4 August 1860; *Bolton Chronicle*, 11 August 1860. [11] *Old Worsley and Little Hulton* (Worsley Urban District Council, 1973). [12] *Eccles and Patricroft Journal*, 13 August 1975. [13] *Swinton and Pendlebury Journal*, 13 February 1986; *Eccles Journal*, 27 March 1976. [14] *Salford Advertiser*, 1 December 1994. [15] The memorial can be viewed from the end of the roadway which runs along the side of The Lodge, 300 Leigh Road. [16] *Salford Advertiser*, 6 February 2003.

Worsley Brow

St Mark's Church

Joseph Evans Memorial

12 June 1875
Polished granite
2.74m × 86cm × 86cm
Inscription: JOSEPH EVANS / BOTANIST / BOOTHSTOWN / BORN JULY 5TH 1803 / DIED JUNE 23RD 1874 – left-hand side: PLANTS I LOVE AND CHERISH, IN / THEM THE WISDOM AND GOODNESS / OF THE CREATOR ARE MANIFEST – right-hand side: THIS MEMORIAL WAS ERECTED / BY PUBLIC SUBSCRIPTION / AS A TRIBUTE OF RESPECT / AND ESTEEM – rear: HE BRINGETH FORTH GRASS FOR / THE BATTLE, AND GREEN HERE / FOR THE SERVICE OF MEN. PSALM LIV
Status: not listed
Condition: fair
Description: Red granite pedestal and pillar surmounted by cross located near to the entrance of the church.

Joseph Evans was born into a working-class family in 1808. He acquired an interest in plants from his father, William, who was a keen botanist and herbal doctor. Joseph worked as a handloom weaver, and moved to Boothstown, near Worsley, after his marriage in 1827. He had a deep interest in botany and was an active member in a number of local botanical societies. He also continued his father's work as a herbal doctor, and 'Doctor Evans', instantly recognisable in his top hat, became known for treating ordinary working people. His reputation as a herbalist eventually reached far beyond Boothstown. Following his funeral in June 1874, a public subscription was organised to provide the 'Doctor' with a suitable memorial. This was unveiled in the churchyard of St Mark's, Worsley in the following year. The pedestal was inscribed with a quotation from Evans and a verse from the Psalms. This is an example of an important type of Victorian public monument which, whilst having modest sculptural features, can be found in many communities, usually in graveyards and cemeteries.[1] St Mark's Church contains the tomb of the first Earl of Ellesmere by George Gilbert Scott and Matthew Noble.[2]

Notes
[1] Paul Salveson, *The People's Monuments* (Manchester: Workers' Educational Association North Western District, 1987) p.58. [2] T. Billington (ed.), *Parish Church of St. Mark, Worsley. A Souvenir Handbook* (Birkenhead: Merseyside Press, 1954).

Joseph Evans Memorial

Gawsworth, Cheshire
Gawsworth Old Hall

Sir Robert Peel
Matthew Noble

8 May 1852; removed from Peel Park April
 1954; relocated 1969
Bronze statue
Statue 3.05m high approx
Signed on plinth: M. Noble Sc. London
Inscription on pedestal, front: PEEL – right-
 hand side: SIR ROBERT PEEL, BART / BORN
 FEBRUARY 5TH, 1788 / DIED JULY 2ND, 1850 /
 ERECTED BY PUBLIC SUBSCRIPTION, FEBRUARY
 1852. – left-hand side: "IT MAY BE THAT I
 SHALL / LEAVE A NAME SOMETIMES /
 REMEMBERED WITH EXPRESSIONS / OF
 GOODWILL IN THE ABODES / OF THOSE
 WHOSE LOT IT IS / TO EARN THEIR DAILY
 BREAD / BY THE SWEAT OF THEIR BROW /
 WHEN THEY SHALL RECRUIT / THEIR
 EXHAUSTED STRENGTH / WITH ABUNDANT
 AND UNTAXED / FOOD, THE SWEETER BECAUSE
 / IT IS NO LONGER LEAVENED / BY A SENSE OF
 INJUSTICE."
Condition: poor
Owned by: Mr Timothy Richards
 Description: Portrait statue; a larger than life-
size bronze statue showing Peel in a
characteristic stance when speaking in public,
his right hand resting on his hip. He is wearing
a cloak.
 Biography: see p.250.

Salford's first public statue was also one of the
first of the many public memorials raised to the
statesman, Sir Robert Peel (1788–1850).
Following Peel's unexpected death, 'a general
desire was expressed that some memorial in
honour of him should be erected in Peel Park'.[1]
It had not been the first call for a statue to be
raised in the park to the 'wisest and best prime
minister'.[2] On 12 July 1850 a 'large and
influential meeting' at Salford Town Hall,
presided over by the mayor, Edward R.
Langworthy, began to take the necessary action
to provide a suitable monument. A committee
was appointed, with Langworthy as chairman,
Oliver Heywood as treasurer, and Nathaniel
Shelmerdine, John Leeming and James Renshaw
as honorary secretaries. Some £250 was
subscribed immediately. Another committee,
made up of working men and called The
People's Monument Committee was formed
independently, under the leadership of the
attorney, Frederick Copley Hulton and James
Livingston, a plumber. This body set about
organising subscriptions from factories and
workshops, eventually collecting £402 from
9,020 individual contributions, more than one-
third of the total subscription of £1,200.
Donations were also put in a collection box at
the entrance to Peel Park. The decision to locate
the statue in the park was the obvious and
popular choice, the park having been named
after Peel, a tribute to the political assistance
and generous personal support he had given to
the establishment of public parks in Manchester
and Salford.
 An unrestricted competition for designs was
launched in September 1850. The entries of
some 70 artists were exhibited in the Peel Park
Library and Museum. The proposals included
statues, memorial temples and a Gothic cross.
The committee clearly had a statue in mind,
having addressed the problem of clothing the
figure in both modern dress and a pseudo-

Noble, *Sir Robert Peel*

classical robe, which, nevertheless, was not to be 'an imitation of ancient sculpture' but ought to 'avoid stiffness'.[3] The committee selected a portrait statue submitted by Matthew Noble, then a young and relatively unknown sculptor, whose model had been completed before Peel's death. Thomas Worthington and Edward Stephens were the runners-up, Worthington having submitted a design for a fountain.[4] Some of the models appear to have been kept and in later years were displayed in the public library which was situated in the park.[5] Noble may have benefited from an introduction to the committee by Robert Peel Willock, though it was pointed out that 'with one exception' he was not known to the committee.[6] A special committee was appointed to 'treat with the artist and carry out the completion of the statue', a brief which included identifying appropriate inscriptions. It was originally intended that the inauguration should take place on 5 February (Peel's birthday), but owing to Noble's illness, the ceremony was put back. On 18 March 1852 Noble's suggested site, 'decidedly the best in the park', was ratified by the Parks Committee. It was close to the park's main entrance. A date in early May was also finally settled for the unveiling of what was to be Salford's first public statue and also one of the first public monuments honouring Peel in the country, predating Behnes's statue in Leeds by two months and Baily's in Bury by four.

The statue was presented to the borough by Joseph Brotherton, Salford's senior MP. They had not gathered, he said, 'to deify the man', but to erect 'a symbol of great principle – that principle was free trade. (Hear, hear)'. It was remarkable, Brotherton declared, that the working classes had contributed so much

> in testimony of their gratitude for the services the late Sir Robert Peel had rendered in cheapening the necessaries of life, and securing to them those comforts which he trusted they would long enjoy, and be benefited by in succeeding ages.[7]

For Frank Ashton, the Mayor of Salford, Peel's contribution was to 'establish property and wealth on justice and truth' as well as (through the repeal of the Corn Laws) to secure to the working man 'the satisfaction of knowing that he would receive all he worked for'. These free trade sentiments were underlined by the choice of the main inscription on the granite pedestal, an extract from Peel's memorable resignation speech as prime minister in 1846. At the lunch which followed the ceremony, the establishment of the park was recalled with satisfaction. Sir John Potter called Peel Park 'a monument of the liberality and good feeling of this great community', the use of which had proved that 'the people of England were not the destructives they were a few years since supposed to be'.[8] R. Willock, the only member of the Peel family present, took some satisfaction in having 'been instrumental in introducing Mr Noble to the committee'. Noble was congratulated by members of the committee for his dealings with them, and for producing a figure that was 'dignified, easy and natural', a statue, moreover, that had impressed 'men of refined taste in London'.[9] *Peel* was to be the first of five statues that Noble was to sculpt for the park. In addition, a considerable number of his busts were to be displayed in the neighbouring museum.[10] Noble was also to be responsible for Peel statues in Tamworth, St George's Hall, Liverpool and Parliament Square, London.[11]

Neither the park nor its statues have fared well in the second half of the twentieth century. The Peel statue, along with those of Joseph Brotherton and Richard Cobden, was moved into storage in 1954, to make way for the extension of Salford Technical College (later Salford University).[12] It was initially suggested that the statues be moved to Broad Street Gardens, but they were reportedly 'so weatherworn' that the Parks Committee placed them into storage in Buile Hill Park. In 1969 Salford Corporation, which had been entrusted to look after the statue – in the words of the

deed of transfer, 'to be by them at all times hereafter duly preserved' – sold the statues of Peel and Brotherton to Raymond Richards of Gawsworth Old Hall, Macclesfield. He gave one to each of his sons, and they were installed in the grounds of the hall. The Peel statue was not placed on its pedestal, as only the front panel appears to have been removed to Gawsworth. The statue had also arrived at Gawsworth with the lower part of the left arm missing.[13] It remains on display, along with the surviving part of the pedestal, in the grounds of the hall.

Notes

[1] *Manchester Guardian*, 13 and 20 July 1850. [2] *Ibid.*, 18 July 1846. [3] *Ibid.*, 24 December 1850, 8 January 1851. [4] *Manchester Courier*, 12 and 15 February 1851. [5] B.H. Mullen, *Salford and the Inauguration of the Public Free Libraries* (Salford, 1899) p.40. [6] *Manchester Courier*, 8 May 1852. [7] *Manchester Guardian*, 12 May 1852. [8] *Ibid.*, 12 May 1852; *Manchester Courier*, 8 May 1852; *Illustrated London News*, 15 May 1852, p.389; *Art Journal*, June 1852, p.196. [9] *Manchester Guardian*, 12 May 1852. [10] These included busts of the Prince of Wales, Princess of Wales, Cromwell, Wellington, Peel and Sir John Potter. *Salford City Reporter*, 29 January 1927. [11] *Illustrated London News*, 31 July 1852, 18 November 1854. [12] *Manchester Evening News*, 8 April 1954; *Salford Reporter*, 15 April 1954. [13] Information from Timothy Richards.

Agecroft

Magnesium Elektro

Arresting Time

Jill Randall

December 2001
Steel; stainless steel; copper; brass; magnesium
5m × 5m × 3m
Status: not listed
Owned by: Salford City Council
 Description: Sculpture made of bands of different metals connected together to resemble a machine to collect sound and visual information from the atmosphere. The antennae

wings emerge from a circular pipe attached to a wall, overhanging the river.

As part of the Irwell Sculpture Trail, Jill Randall was appointed artist-in-residence at Magnesium Elektron in 1999. The company, based in the Agecroft district of Salford, processed magnesium. She established a studio in the factory where, with the help of the employees, she set about investigating the processes of casting and recycling magnesium. Out of this research and discussions emerged *Arresting Time*, a metal sculpture whose shape was defined by the magnesium used in the manufacture of the reflectors in radar and satellite technology. It was made from a range of different metals and was attached to a sunken magnesium 'sacrificial anode' which had the effect of turning the work into a giant battery, and in doing so helped to stop corrosion, thus the arresting time of the title. For Randall the work suggested 'the fragility and futility of technology', functioning 'like a curious machine with an unknown or defunct purpose'.[1] The sculpture was placed overhanging a wall at the rear of the factory, above the River Irwell. It was unveiled in December 2001. In spite of its inaccessible position, *Arresting Time* was pulled off the wall by vandals in 2003. The remains of the sculpture have been rescued by the artist.

Note
[1] Correspondence with Jill Randall.

Randall, *Arresting Time*

Richard Cobden
Matthew Noble

26 June 1867; removed from Peel Park, April 1954
Marble statue; granite pedestal
Statue 2.9m high approx; pedestal 3.66m high approx
Inscription on front of pedestal: COBDEN – on side panels, inside laurel wreaths: REPEAL OF THE CORN LAWS / ENGLISH AND FRENCH TREATY OF COMMERCE / EDUCATION AND FREE TRADE / PEACE AND NON-INTERVENTION

Description: Portrait statue; a larger than life-size marble statue of Richard Cobden surmounting a grey granite pedestal. Cobden is shown in modern dress, in a thoughtful attitude, his left hand raised to his chin, the other hand by his side holding a roll of papers. Two bales of cotton, draped by a cloth, provide symbolism and stability at the base.

Biography: see p. 125.

Richard Cobden (1804–65) lived and worked in Manchester for many years, but was best known for his part in the campaign to repeal the Corn Laws. On 5 April 1865, three days after Cobden's death, Salford Council passed a resolution of condolence to his wife and family.[1] Later in the same month a meeting of the 'principal inhabitants' of the borough was convened by the mayor, which resolved that a marble statue in Peel Park would be the best way to memorialise Cobden. In the mayor's words:

> Salford should not let so eminent a man pass away without paying a lasting tribute to his memory in some more substantial way than

mere words, and to hand down to posterity, in a tangible form, an emblem of the estimation in which Mr Cobden was held by his fellow countrymen.[2]

There was also an obvious location in the park: the statue of Cobden – the 'Apostle of Free Trade' – would be placed next to that of Sir Robert Peel.[3] A meeting of working men was convened in the Town Hall on 2 May with the mayor in the chair, at which it was agreed to open subscription lists in the workshops and mills in the borough.[4] Subscriptions from all sources reached a total of some £1,450, which covered the cost of the statue, leaving a small surplus which it was decided to give to the Museum, Library and Park Committee.[5]

Three sculptors, Matthew Noble, Marshall Wood and Edgar Papworth jnr, were invited to submit model busts of Cobden which were then exhibited in the museum in Peel Park. Papworth's bust was in marble, the property of Sir Elkanah Armitage,[6] whilst the ones from Wood (two busts) and Noble were in plaster. Both Noble and Wood had used masks taken after Cobden's death. It was Noble who was again favoured by Salford. The decision did not, however, meet with complete approval. The *Manchester Guardian* argued for the superiority of Wood's recent bust, the likeness of which had been modelled with suggestions from Mrs Cobden. It revealed Cobden as 'the leader of free trade and commercial reform', in contrast to Noble's study of him as the political philosopher.[7] Wood, however, was to be successful in the competition for Manchester's Cobden.[8] A flaw in the block of Campanella marble delayed the completion of the statue. When it finally arrived in Salford it was installed in the park, where, because of the

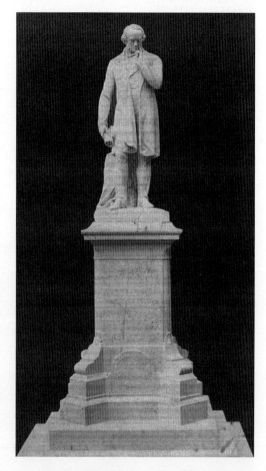

Noble, *Richard Cobden*

impending Whitsun holidays, it was left uncovered for the crowds to see. The official unveiling was scheduled for June to coincide with the anniversary of the repeal of the Corn Laws.

The ceremony was the opportunity to recall Cobden's achievements and, above all, to acknowledge the cornucopia of free trade.[9] Alderman Wright Turner, chairman of the memorial committee, told the crowd that the best monument to Cobden was the increasing prosperity of the manufacturing population. The members of the committee deserved special thanks because they were teaching the youth of the country, via Cobden's example, 'that by undeviating integrity, perseverance, and devotion to public interest, a man may acquire honour and esteem in this country. (Hear, hear)'.[10] Charles Pelham Villiers, who had campaigned alongside Cobden in the Anti-Corn Law League, unveiled the statue of his friend. The celebrations took on a slightly more controversial tone when John Cheetham, Liberal MP for Salford, suggested that Noble's marble statue was superior to the bronze one recently installed in Manchester. Malcolm Ross played down such civic rivalry though he did observe that 'You in Salford seem to get better statues than we do at half the cost we have to pay (laughter)'.[11] Finally, Noble stepped forward to receive 'such a greeting as the surpassing merit of his work deserved'.[12] It was a judgement that was echoed by many others, including the *Illustrated London News* and the *Manchester Guardian*.[13] The reporter for the latter newspaper declared that Noble had produced the best likeness of any of the busts and statues of Cobden he had seen.[14]

The statue, along with those of Peel and Brotherton, was moved in April 1954 to make way for the extension of Salford Technical College (later Salford University).[15] All three were reportedly so weathered that the Parks Committee decided to dismantle and store them in Buile Hill Park rather than, as had been proposed, to re-erect them in Broad Street Gardens.[16] An undated photograph shows the Cobden statue, some time after it had been removed from the park, with its head badly weathered and all the fingers on the left hand missing.[17] Fifteen years later, Raymond Richards of Gawsworth Old Hall, Macclesfield, described in the press as 'a prominent collector of Victoriana', offered to purchase the Cobden statue along with those of Peel and Brotherton from the council.[18] His offer was accepted, and it is assumed that all three were removed to Gawsworth Old Hall. However, there is no record of the Cobden being displayed at the hall, and it is presumed that, if it was taken to the hall, it was discarded.

Notes
[1] *Proceedings of Borough of Salford*, 1864–5, pp.113–14. [2] *Manchester Courier*, 22 April 1865. [3] *Manchester Guardian*, 22 April 1865. [4] *Manchester Courier*, 3 May 1865. [5] Part of the remaining money was used to publish an illustrated guide to the park's statues: J. Plant, *The Memorial Statues and Royal Free Museum and Library, Peel Park, Salford* (W.F. Jackson, Salford [printer], 1868). [6] Not listed in Gunnis (1968) p.290. [7] *Manchester Guardian*, 25 July 1865. [8] See above, p.125. [9] Editorial in *Salford Weekly News*, 29 June 1867; *The Times*, 28 June 1867. [10] *Salford Weekly News*, 29 June 1867; *Manchester Guardian*, 27 June 1867. [11] *Salford Weekly News*, 29 June 1867. [12] *Ibid*. [13] *Illustrated London News*, 14 December 1867, p.648; *The Times*, 28 June 1867. [14] *Manchester Guardian*, 27 June 1867. [15] *Manchester Evening News*, 8 April 1954; photographs in Salford Local History Library. [16] *Salford City Reporter*, 15 April 1954; *Manchester Evening News*, 8 April 1954. [17] Undated photograph of Cobden statue (731.8), Salford Local History Library. [18] *Salford City Reporter*, 5 September 1969.

BOLTON

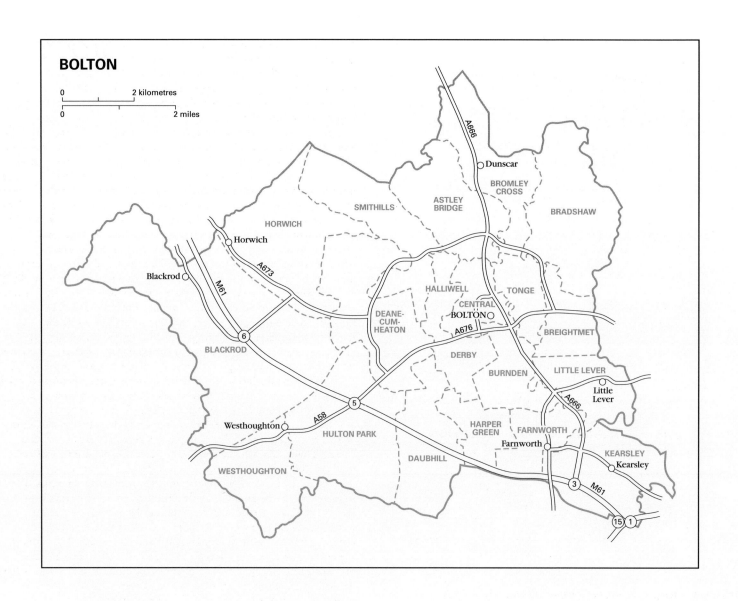

BOLTON

0 2 kilometres

0 2 miles

Dunscar

BROMLEY CROSS

SMITHILLS

ASTLEY BRIDGE

BRADSHAW

HORWICH

Horwich

A673

Blackrod

M61

HALLIWELL

TONGE

DEANE-CUM-HEATON

CENTRAL

BOLTON

A676

BREIGHTMET

6

BLACKROD

DERBY

BURNDEN

LITTLE LEVER

Little Lever

A666

5

A58

HULTON PARK

Westhoughton

HARPER GREEN

FARNWORTH

Farnworth

KEARSLEY

Kearsley

DAUBHILL

WESTHOUGHTON

3

M61

15

1

Introduction

Poster announcing unveiling of Crompton statue, 1862

The Metropolitan Borough of Bolton was established in the local government reorganisation of 1974, amalgamating the county borough of Bolton and the districts of Horwich, Westhoughton, Blackrod, Farnworth, Kearsley, Little Lever and part of Turton. The borough lies to the north-west of Manchester and covers an area of 13,935 hectares. The population in 2001 was 261,035.

Bolton's reputation as a textile centre was established long before the industrial revolution. When, around 1540, John Leland noted that 'Bolton Moore market stands most by cottons and coarse yarns. Divers villages in the moores about Bolton do make cottons', he was describing a complex local economy in which the manufacturing of cloth was already important to Bolton's prosperity. It was an economic specialisation encouraged, as Aikin later pointed out, 'by the barrenness of its situation'.[1] The textile revolution of the eighteenth century drew on this experience and expertise. Samuel Crompton's spinning mule, one of the central inventions that turned cotton spinning into the world's first modern industry, had its origins in the town. Bolton developed at an astonishing rate following the building of its first spinning mill in 1780. Textiles were to remain the largest sector of the economy, but the industrial base expanded to include engineering, coal-mining and paper-making. Investment in canals and railways testified to the need to move ever-increasing quantities of raw materials and goods. By 1838, the year when the new municipal borough was created, Bolton was recognised as one of the largest of Lancashire's fast-growing manufacturing towns. Industrial change also altered the way of life in neighbouring townships. One of these, Turton, might have been the site of the district's first modern public monument, a 30-metre tower honouring the seventeenth-century merchant and philanthropist, Humphrey Chetham, who had lived at Turton Tower. The scheme of 1833, however, did not attract sufficient funds and no 'lasting memorial' was raised on Cheetham Close.[2]

Bolton raised its first public statues in the mid-Victorian years. The first one commemorated the textile inventor, Samuel Crompton, an event accompanied by such extensive ceremonial that it took root in the collective memory.[3] Even so, the idea of the statue did not escape criticism: Bolton's Liberal MP, Joseph Crook, had rejected the project, regarding it 'as foolish as to stand on one's head in the Market Place', preferring a more practical form of memorial.[4] Crompton's statue helped define Nelson Square as one of the town's principal public spaces. It might have been the location of Bolton's next statue, had it not been

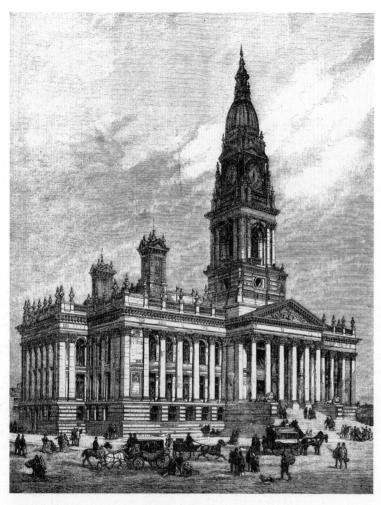

William Hill, *Bolton Town Hall, opened 1873*

decided to place the latter in Victoria Square, in front of the new town hall. The bronze statue of Samuel Taylor Chadwick, a local doctor whose philanthropy extended the town's charitable infrastructure, was noteworthy: not only was he still alive when it was unveiled, but in order to keep the scheme more closely associated with the working classes, the organising committee resolved, initially at least, that no subscription should exceed one guinea. It was 27 years later that a companion statue, John Cassidy's full-length bronze of Sir Benjamin Dobson, was placed in Victoria Square. Dobson's economic and political influence in the town had been extensive, and the statue was an appropriate tribute to the man

who probably did more to shape the public affairs of late-Victorian Bolton than any other individual.

William Hill's town hall dominated Victoria Square. Constructed between 1867 and 1873, this classical building was on a scale that easily surpassed the town's other public buildings. But, as in the case of so many of those other major public buildings which are now read as essays in civic pride, its commissioning and construction were in fact marked by arguments which placed aesthetics against economy. Such arguments inevitably embraced architectural decoration. However, in Bolton they did not stop councillors spending one thousand of the £170,000 that the building eventually cost on a suitably symbolic sculpture by William Calder Marshall to fill the tympanum.[5] Two hundred pounds were also spent on two large recumbent stone lions, which flanked the impressive portico.[6] Bespoke architectural sculpture was not a notable feature of the interior. Among the plaster decorations found in the principal rooms, however, were four large semicircular panels in the main hall. These represented the seasons, each one based around a female figure and two children; compositions which the *Builder* judged to be 'well intentioned and pleasing' rather than 'high art'.[7] They were modelled by a Mr Paul and executed by W. Simpson and Sons.

The hope expressed by the editor of the *Bolton Chronicle* in 1873, that Bolton would raise memorials to individuals 'who in their day and generation have made their names dear to their townsmen', began to be realised in the final quarter of the nineteenth century.[8] But it was to be in Queen's Park rather than in the town centre that the new portrait statues were located. Bolton Park, as Queen's Park was originally named, was formally opened in 1866 by Lord Bradford, an amenity created during the Cotton Famine as a way of providing work for the unemployed.[9] It was the town's principal park, acquiring various educational and recreational attractions, including a museum. Sculpture was initially limited, though it did become the location of a public drinking fountain, notable for its bronze *Rebecca*, the work of the Wills Brothers. Three commemorative statues were installed on the park's main terrace, a much-admired promenade from which it was alleged that one could see (the town's smoke permitting) the Mersey estuary.[10] The first statue to be unveiled was of the Earl of Beaconsfield, paid for by Bolton's working-class Conservatives, and one of the few statues raised to Disraeli in the North West.[11] A different political agenda was evident in 1896, when a statue was raised to the local labour leader, John Fielding, the man praised for bringing the 'golden grain of unity' to Bolton cotton trade unionism.[12] Political motives were also discernible in the statue raised to the Irish-born doctor, James Dorrian, who commanded as great a respect for his treatment of the sick poor as Samuel Chadwick had done in the previous generation. That esteem, however, was insufficient to ensure his place in Victoria Square. Limited funds determined that all three statues were of little artistic significance, the *Lancashire Review* dismissing the 'doll-like'

sculpture of Fielding as 'simply ludicrous' as a work of art.[13]

As in other towns, the sculptural decoration on less important public and private buildings was generally undistinguished. An exception was the representations of sporting equipment carved on the gate-posts of the Gymnasium, Folds Road, a building that was soon incorporated into the Central School. As with so many examples of architectural sculpture in the cotton towns the artist's identity awaits disclosure. Financial constraint was one of the factors determining such ornamentation. Money was not a problem for the memorial fund opened to honour the late Edward VII. It raised a staggering £26,000, enabling a new nurses' home to be built as part of the town's Infirmary. The building, designed by the Bolton architects, Henderson and Brown, acknowledged its origins by including a stone statue of the late king, sculpted by J.J. Millson, over the central doorway.[14] The statue was saved when the nurses' home was demolished, and there are plans to display it in the grounds of the new Royal Bolton Hospital.[15] Bolton's memorialisation of Edward VII did not stop there, as a marble bust was commissioned from George Frampton.[16] It was installed in the town hall: a location which selected itself, as the king, when Prince of Wales, had opened the building. Edwardian Bolton also saw the erection of a new market cross in Churchgate, close to the site of the original. It was notable for the bronze plaques which recorded key events in the town's history from the thirteenth to the twentieth centuries.

The First World War left its mark on all parts of Bolton society. Plans for memorials were under discussion in some communities almost as soon as peace was announced. Regimental memorials were among some of the earliest to be completed. These included the Bolton Artillery memorial in Nelson Square – a Portland stone cenotaph designed by Ormerod, Pomeroy and Foy – and the memorial to the 5th Battalion Loyal North Lancashire Regiment in Queen's Park, unveiled in 1920 and 1922 respectively.[17] In contrast, the erection of the town's main war memorial proved to be a protracted affair, the project not being fully completed until some 14 years after the Armistice. It was distinguished by some fine sculpture, the work of Walter Marsden. In the neighbouring communities the pace of commissioning and completing memorials varied greatly. The collapse of the post-war boom had a major effect on fundraising. Communities also wanted their own memorials, leaving plans for district memorials to run aground on the rocks of localism.[18] Memorials were also commissioned in factories and businesses, remembering work colleagues who had been killed. An exception to the usual stone or wooden panel was the life-size bronze sculpture of a common soldier erected in memory of the more than 100 men who did not return to claim their jobs at the railway engineering works in Horwich. The Bradshaw Cricket Club remembered its 24 members who had 'played the game' with a memorial stone on the club's ground.[19] Apart from the war memorials the years between the wars saw little interest in commissioning public monuments

Sports equipment, Folds Road, Bolton (detail)

and sculpture. Thus when William Hesketh Lever, whose large personal fortune came from manufacturing soap and other household products, died in 1925 there was no strong feeling to raise a statue or some other memorial to honour one of the town's most famous and generous sons. It was left to William Hulme, 2nd Viscount Leverhulme, to erect the slender granite pylons at the entrance to Lever Park as a public reminder of his father's gift of the park to the people of Bolton.[20]

A general indifference to public sculpture continued until long after the Second World War. As in many other industrial towns, municipal interest in sculpture occasionally flickered into life, only to die away. It was not until the early 1970s that Bolton acquired its first piece of modern public sculpture: Barbara Hepworth's *Two Forms (Divided Circle)*. Revealingly, it was initially displayed inside the art gallery rather than out of doors as the artist intended. But, if Bolton appeared

Bonehill, *Processes in cotton manufacture*

indifferent to more conventional forms of outdoor sculpture, it did demonstrate a willingness to rescue and display artefacts associated with its fast disappearing smokestack industries. These included impressive industrial machines such as a Nasmyth & Wilson's steam hammer (1917) which had been in the local Atlas Forge until it closed in the late 1970s. It was placed outside the Bolton Institute of Technology (now Bolton Institute) on Deane Road in 1981. A Corliss condensing steam engine, built by the Bolton firm, Hick Hargreaves & Co., became a much-discussed feature of the new central precinct.[21] Victoria Square also became the location for two cast-iron elephants with castles on their backs, beasts that had originally adorned the gateposts of a local bleachworks until its closure in 1977.[22] This willingness to acknowledge Bolton's industrial past continued with the rescuing of a late-Victorian stone frieze depicting different processes in the cotton industry from the Sunnyside Mills, Daubhill, Bolton. These reliefs were carved by the Manchester architectural sculptor, Joseph Bonehill, under the supervision of the Bolton architect, C.T. Woodhouse. They were cleaned and incorporated into the Bridge Street entrance area of the town's market.[23] Money also had to be found to maintain existing monuments. The struggle for funding, as in the case of the war memorial in Daisy Hill, Westhoughton, revealed the resentment of communities which felt themselves marginalised, pushed to the periphery of the new metropolitan district.[24] But it was not all economy and postponement. The lure of saving some £1,900 by using an inferior stone to repair the borough's main war memorial was resisted.[25]

In spite of its willingness to display industrial objects as public sculpture, by the early 1990s Bolton still appeared tentative about the role that public art could play in establishing a more positive image for the district, even though it was acknowledged as an integral part of the borough's cultural strategy.[26] Those projects that were carried out were generally on a small scale.[27] Moreover, when larger works were undertaken, the results were not encouraging. The hurried removal of Paul Wood's *Mother and Child* from the centre of Westhoughton was a case study in the public misunderstandings about the purposes of public sculpture. By the end of the decade, as regeneration funds became available, the council demonstrated a more structured and purposeful attitude towards public art. Although the available funds were limited, a number of initiatives resulted in the installation of sculpture and smaller works of public art in a number of deprived areas and on strategic routeways. Private initiatives were rarer, though plans have been announced for a statue of one of the town's modern heroes, the footballer, Nat Lofthouse. If the public subscription is successful, it will be located outside Bolton Wanderers' Reebok Stadium.[28]

Bonehill, *Processes in cotton manufacture*

Notes

[1] J. Aikin, *A Description of the Country from Thirty to Forty Miles Round Manchester* (1795; reprinted New York: A. Kelley, 1968) p.260. [2] *Wheeler's Manchester Chronicle*, 10 August, 26 October 1833; *Bolton Chronicle*, 2 November 1833. [3] Langford Saunders's recollections of Bolton in *Manchester City News*, 11 December 1920. [4] *Bolton Chronicle*, 27 November 1862. [5] C. Cunningham, *Victorian and Edwardian Town Halls* (London: Routledge & Kegan Paul, 1981) pp.205–6. [6] The lions were made by Burstall and Taylor at a cost of £201. 17s. 0d. [7] *Builder*, 31 May 1873, p.417. The panels survived the fire which destroyed most of the hall in 1981. [8] *Bolton Chronicle*, 2 August 1873. [9] *Ibid.*, 26 May 1866. [10] *Builder*, 31 May 1873, p.318; Ordnance Survey plan (1912) of Queen's Park. [11] There is a carved representation of Disraeli in Chester Cathedral, *Builder*, 25 September 1880, p.385. [12] *Manchester Guardian*, 13 July 1896. [13] *Lancashire Review*, April 1898, p.244. [14] Edward VII Memorial Committee 18 March 1913 (Bolton Archives, ABZ/59/13); *Bolton Chronicle*, 25 July 1914. [15] Information from Jenny Walsh, Bolton Hospitals NHS Trust. [16] W. K. West, 'Some recent monumental sculpture by Sir George Frampton R.A.', *Studio*, 54 (1911) pp.35–43. [17] Bolton Artillery Memorial, Nelson Square, unveiled 29 July 1920, B. Palin Dobson, *History of the Bolton Artillery 1860–1928* (Bolton: Blackshaw, Sykes and Morris, 1929) pp.199–201; 5th Battalion Loyal North Lancashire Regiment Memorial, Queen's Park, unveiled 20 July 1922, *Bolton Journal*, 21 July 1922. [18] *Bolton Journal and Guardian*, 13 May 1921. [19] Unveiled 29 April 1922. [20] *Bolton Journal*, 14 December 1934. [21] *Bolton Evening News*, 4 June 1973; K. Hudson, *Exploring Our Industrial Past* (London: Hodder and Stoughton, 1975) pp.40–3. [22] Information from Mike Creswell. [23] *Bolton Evening News*, 8 February 1982. [24] *Ibid.*, 8 November 1989, 4 November 1994, 19 April 1995. [25] Bolton War Memorial Committee (Bolton Archives, ABZ/24/8). [26] *Arts in Partnership. Bolton's Cultural Strategy for the 90's* (Bolton Metropolitan Borough Council, 1993). [27] For example Noah Rose's bench sculpture in Ashburner Street, *Bolton Evening News*, 12 May 1995. [28] *Ibid.*, 16 November 2002.

BOLTON

Churchgate

Market Cross

Bradshaw and Gass

August 1909
Dartmoor granite
6.08m high approx; base 3.04m diameter
Signed: Bradshaw & Gass FRIBA Architects
Inscription on plaque: THIS CROSS, SIMILAR TO ONE / WHICH STOOD ON THIS SPOT / FROM 1486 TO 1786, / WAS PRESENTED TO HIS / NATIVE TOWN BY / GEORGE HARWOOD / FOR SOME TIME / MEMBER OF PARLIAMENT / FOR BOLTON. / 1909. – plaque on north side: 1253.A.D. BOLTON A FREE BOROUGH BY CHARTER. / 1256. CHARTER FOR MARKET / BY HENRY III TO BODELTON. / 1337. FLEMISH CLOTHIERS SETTLED. / 1513. "LUSTY LADS FROM BOLTON-I'-TH' / MOORS." (BALLAD OF BATTLE OF FLODDEN FIELD.) / 1540. "BOLTON UPON MOOR STANDETH MOSTLY BY / COTTONS AND COARSE YARNS." (LELAND.) / 1623. LECTURESHIP FOUNDED FOR SERMONS / AT CROSS. 1631. POPULATION 500. / 1641. GRAMMAR SCHOOL FOUNDED. – plaque on east side: 1643–4. DURING THE CIVIL WAR BOLTON BESIEGED THRICE / AND TAKEN ONCE WITH MUCH SLAUGHTER. / 1651. JAMES, SEVENTH EARL OF DERBY, / BEHEADED NEAR THIS SPOT / 1661. "BOWLTON HATH A MARKET ON MONDAYS / WHICH IS VERY GOOD FOR CLOTHING AND / PROVISIONS AND IS A PLACE OF GREAT / TRADE FOR FUSTIANS." (BLOME'S BRITANNIA.) / 1753. CROMPTON, INVENTOR OF THE SPINNING / MULE, THE FOUNDATION OF MODERN / COTTON INDUSTRY, BORN IN BOLTON. / 1760. ARKWRIGHT, FOUNDER OF THE COTTON FACTORY / SYSTEM, KEPT A BARBER'S SHOP IN BOLTON. / 1763. COTTON QUILTINGS & MUSLINS FIRST MADE IN BOLTON. – plaque on south side: 1791. CANAL TO BOLTON OPENED.

/ 1828. FIRST RAILWAY FROM BOLTON OPENED. / 1832. FIRST PARLIAMENTARY ELECTION. / POPULATION 41,195. / 1838. CHARTER OF INCORPORATION. / 1842. PARLIAMENTARY ENQUIRY ABOUT EXTREME DISTRESS IN THE TOWN. / 1852. ADOPTION OF FREE LIBRARIES ACT. / 1861. POPULATION 70,396. / 1872. FIRST EXTENSION OF BOLTON. / 1877. FURTHER EXTENSION, POPULATION 106,214. / 1898. BOLTON AGAIN EXTENDED. / 1901. POPULATION 168,215.
Status: Grade II
Condition: fair
Owned by: Bolton Metropolitan Borough Council
Description: Market cross; tall square tapering column surmounted by a gilt bronze cross, rising from stepped circular base.

From at least the fifteenth until the early nineteenth century, Churchgate was the site of Bolton's market. It was also the site of many of the important events in the town's history, including the execution of James Stanley, 7th Earl of Derby, in 1651. The history of the old cross, located at the junction of the town's four main streets, Churchgate, Deansgate, Bradshawgate and Bank Street, is poorly documented. Scholes's *History of Bolton* dates the first cross to 1482, but there may have been an earlier one. According to Taylor, this structure was probably replaced by an Elizabethan or Jacobean cross which survived until 1776 when it was removed as an obstruction to the markets.[1] The current cross was presented by the local Liberal MP, George Harwood, in 1909, and was welcomed in a town described as being 'none too full of monuments and statues'.[2] It was designed by the Bolton architects, Bradshaw and Gass. It has four plaques, three of which record significant events and facts in the town's history, beginning with the charter of 1253 and ending in 1901, when the population numbered 168,215. It was hoped that such details of local history, which had been approved by the

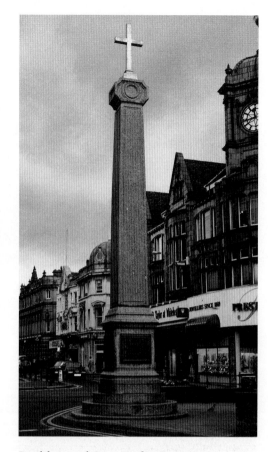

Bradshaw and Gass, *Market Cross*

council, would encourage 'Bolton's sons' to visit the local libraries where they would 'learn more of the history of the town'.[3]

Notes
[1] H. Taylor, *The Ancient Crosses and Holy Wells of Lancashire* (Manchester: Sherratt and Hughes, 1906) pp.472–4. [2] *Bolton Journal and Guardian*, 13 August 1909. [3] *Ibid.*, 15 January, 13 August 1909.

Moor Lane

Junction of Moor Lane and Deansgate

Two Forms (Divided Circle)

Barbara Hepworth

1970; relocated 1982
Bronze sculpture; granite pedestal
2.37m high × 2.34m wide × 54cm deep
Inscription on stone plinth: TWO FORMS
 (DIVIDED CIRCLE) 1969
Condition: fair
Owned by: Bolton Metropolitan Borough
 Council
 Description: Bronze sculpture, two separated
semicircles, each of which is pierced with a
single hole, representing a divided and irregular
circle, surmounting a bronze plinth and granite
base.

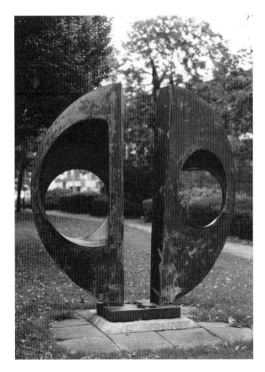

Hepworth, *Two Forms (Divided Circle)*

In 1970 Vincent Smith, Director of Bolton Art
Gallery, having already acquired works by
Henry Moore for the borough's small
collection of modern sculpture, recognised the
need to obtain an example of Barbara
Hepworth's work. The recent Hepworth
retrospective at the Tate Gallery had confirmed
her status as one of the twentieth century's pre-
eminent sculptors. Hepworth was contacted
and visited in her Trewyn studio at St Ives in
Cornwall, where a recent work, *Divided Circle*,
was selected.[1] This was one of the sculptures
which stemmed from her wish to work on a
large scale while her health permitted.[2] The
sculpture, one of six copies of the work, was
purchased for £13,250.[3] The John Bradshaw
Gass Memorial Trust, a local charity which
supported the purchase of works of art, gave
£6,875 towards the cost, with a comparable sum
coming from the Victoria and Albert Museum.
This was supplemented by £500 from the
Calouste Gulbenkian Foundation of Lisbon.
The combined funds enabled the purchase of
Two Forms and another smaller work, *Three
Forms 1968–9 Lignum Vitae*. The price was
described by Smith as a 'purely nominal sum'
for an artist of Hepworth's stature. *Two Forms*
arrived in Bolton in September 1970 and was
formally presented to the mayor in the
following month.[4] It was displayed in the
entrance area of the central museum and art
gallery. It remained there until the early 1980s
when it was decided that it would be more
appropriately displayed out of doors, the work
having been loaned for an exhibition at the
Yorkshire Sculpture Park in 1980. Alterations
to the entrance area also contributed to the
decision. The idea of an outdoor location was
not without its critics, concerned that such a
valuable sculpture might be vandalised.[5] The re-
siting, however, went ahead, and in 1982 the
sculpture was installed on a lawned area at the
junction of Moor Lane and Deansgate, close to
the new law courts.

Notes
[1] Correspondence between Vincent Smith and
Dame Barbara Hepworth, 26 February 1970, 2 March
1970 (Museum and Art Gallery, Bolton Archives).
[2] M. Gale and C. Stephens, *Barbara Hepworth.
Works in the Tate Gallery Collection and the Barbara
Hepworth Museum St Ives* (London: Tate Gallery
Publishing, 1999) pp.252–4. [3] A. Bowness (ed.), *The
Complete Sculpture of Barbara Hepworth 1960–69*
(London: Lund Humphries, 1971) p.48.
[4] Correspondence, Deputy Director of Art Gallery,
28 August 1970 (Bolton Archives). [5] Bolton Leisure
Services Committee, 22 July 1980, p.117;
Correspondence, Dr J.R.A. Gray, 10 September 1980,
31 March 1981 (Bolton Archives).

Nelson Square, Bradshawgate

Samuel Crompton

William Calder Marshall

24 September 1862
Copper-plated bronze statue; granite pedestal
Statue 2.44m high; pedestal 2.75m high × 2.8m
 long × 2.16m wide
Signed on plinth: W. Calder Marshall RAS;
 electro cast by Elkington & Co.
Inscription on front of pedestal: SAMUEL /
 CROMPTON / 1753 – 1827 – rear: ERECTED /
 BY PUBLIC SUBSCRIPTION / 1862 / J. R.
 WOLFENDEN / MAYOR
Status: Grade II
Condition: fair
Owned by: Bolton Metropolitan Borough
 Council
 Description: Portrait statue; Crompton is
depicted as a young man, seated, his legs
crossed, looking downwards. The statue
surmounts a large stepped bow-fronted pedestal
with two inset bronze rectangular panels on the
sides. One panel shows the boyhood home of
Crompton, the place where he invented the
mule. Beneath is the inscription: 'Hall-i'-th'-
Wood'. The other panel depicts Crompton,
seated on a box, next to which is a violin,
working out calculations in front of a prototype
and drawing of his celebrated invention.
Beneath is the inscription: 'The Spinning Mule'.

Samuel Crompton, born 3 December 1753 at Firwood Fold, Tonge, near Bolton, to George and Betty Crompton, was the inventor of the spinning mule. The family moved to Hall-i'-th'-Wood, a large old timber-framed house outside Bolton, when Samuel was still a child. Samuel was 15 when he started work on designing a spinning machine that would produce yarn of a uniform quality. Years of further experiment resulted in the invention of the spinning mule in 1779, a machine which combined elements from the earlier spinning machines of Hargreaves and Arkwright. Crompton, however, lacked the finance and the business skills to patent and exploit his invention, and within a short period of time what proved to be the key spinning technology of the industrial revolution was being adopted by cotton manufacturers. He spent the rest of his life trying to gain recompense for the prosperity his invention had brought to the cotton industry. A petition to Parliament in 1812 resulted in the award of £5,000. In later business schemes the unworldly Crompton was to lose this money. Unlike Sir Richard Arkwright, who also resided for a time in Bolton – a plaque marks the site of the building in Churchgate, where he lived and worked in the 1760s – Crompton was not to be numbered among the world's first industrial millionaires. He died at his home in King Street, Bolton, on 26 June 1827, a poor and broken man.[1]

The raising of a public memorial to Samuel Crompton in Bolton owed much to Gilbert James French, a local textile merchant and antiquarian, whose researches into Crompton's life renewed interest in the man whose spinning mule had transformed the town. In January 1859 French lectured on Crompton at the Bolton Mechanics' Institution, concluding that Crompton's considerable achievements had been shamefully neglected in Bolton. The lecture sparked a discussion in the local press, in which various ideas for honouring Crompton were suggested. Proposals included establishing a Crompton Literary and Scientific Institution

Calder Marshall, *Samuel Crompton*

and the purchase and conversion of Hall-i'-Th'-Wood into an industrial museum.[2] A public statue was also discussed, but initially it was the idea of founding an institution which attracted support. This project, however, ran into difficulties and was abandoned. The idea of a statue was revived in the summer of 1860. At a public meeting called by the mayor, speaker after speaker acknowledged that a statue would be a suitable recognition, however belated, of

Crompton's achievements. One measure of his impact on Bolton was noted by Councillor Barlow, who pointed out that if a levy of 6d per 100 spindles was made on local firms to pay for the proposed statue, the resulting sum would total some £30,000. This novel revenue-raising idea was not pursued but a more conventional public subscription was opened. It received immediate promises of £650.[3] The final subscriptions included money collected from the spinners working in the town's mills.[4] The memorial committee decided against organising a competition or visiting the studios of the leading sculptors, preferring instead to commission the London sculptor, William Calder Marshall. Presumably, some of the committee were familiar with his work, including the Peel monument in Manchester.[5] Marshall presented two models – a standing and a seated Crompton – to the committee, which decided on the latter.[6] The statue was cast at the Birmingham foundry of Elkingtons, using the then novel process of electroplated copper.[7] After some discussion it was decided that the statue would be placed in Nelson Square, an open space in front of the Infirmary. As the scheme for the statue progressed, French was also supporting efforts to mark Crompton's grave in St Peter's churchyard, Bolton. This was realised in 1861, the money for a large granite tomb being raised by, among others, workers employed in Dobson and Barlow's engineering works.

The inauguration of Bolton's first public statue was the reddest of red-letter days in the town, in spite of the difficult economic conditions at the time.[8] The ceremony included a procession of trades and friendly societies carrying their banners, accompanied by numerous brass bands. Other events scheduled for the day included a balloon ascent, a musical concert and a firework display. The cotton manufacturer, Henry Ashworth, handed over the statue to the council with a speech that was suitably generous in its praise of Crompton and his machine.[9] These extensive celebrations were

Calder Marshall, *Samuel Crompton (panel)*

not without their critics, and, whilst the day had begun with the distribution of 'upwards of 2,000 loaves and one or more fat bullock' to the town's poor, the *Manchester Guardian* pointed out that the organisers appeared to have overlooked Crompton's surviving family, his son John having to borrow a suit to attend the inauguration.[10] In all the monument cost some £2,000, including the expenses incurred in organising the ceremony.

The statue made Crompton a most visible part of Bolton's history. His place in that history was further strengthened when, in 1900, his former home, Hall-i'-th'-Wood, was restored and presented to the town by Lord Leverhulme. The statue was the focal point of services organised to mark the centenary of Crompton's death in 1927, the bicentenary of his birth in 1953, and the bicentenary of the invention of the mule in 1979.[11] It was repaired and cleaned in 1927, including the refacing of the original Portland stone pedestal with granite.[12] In 1937 the railings surrounding the statue were removed.[13]

Notes
[1] G. J. French, *Life and Times of Samuel Crompton* (1860, reprinted Bath: Adams & Dart, 1970). [2] M.E. Rose, 'Samuel Crompton, 1753–1827, inventor of the spinning mule', *Transactions of Lancashire and Cheshire Antiquarian Society*, 75–6 (1965–66) pp.11–12; *Bolton Chronicle*, 5 March 1859. [3] *Bolton Chronicle*, 1 September 1860; *Art Journal*, October 1860, p.308. [4] *Bolton Chronicle*, 29 December 1860. [5] See above, p.111. [6] *Bolton Chronicle*, 20 September; 27 October 1860. [7] *Art Journal*, December 1862, p.238. [8] *Official Programme of the Inauguration of the Crompton Statue at Bolton on Wednesday, September 24th* (Bolton, [1862]). [9] *Bolton Chronicle*, 27 September 1862; *Supplement to the Bolton Guardian*, 24 September 1862. [10] *Manchester Guardian*, 25 September 1862; *Manchester Courier*, 27 September 1862; *Illustrated London News*, 4 October 1862. [11] *Bolton Journal and Guardian*, 10 June 1927; *Bolton Evening News*, 3 December 1953; information from Jo Darke. [12] *Bolton Evening News*, 3 June 1927. [13] *Ibid.*, 29 April 1937.

Queen's Park
Benjamin Disraeli
Thomas Rawcliffe

30 April 1887
Yorkshire stone
2.44m high approx; pedestal 3.01m high × 1.45m square base
Signed on pedestal: T. Rawcliffe, Sc., Chorley
Inscription on pedestal: BENJAMIN DISRAELI / EARL OF BEACONSFIELD K.G. / PRESENTED TO THE BOROUGH OF BOLTON BY THE BOLTON & DISTRICT WORKING MEN'S CONSERVATIVE ASSOCIATION. APRIL, 1887.
Status: Grade II
Condition: fair
Owned by: Bolton Metropolitan Borough Council
Description: Portrait statue; larger than life-size statue, showing Disraeli dressed in the robes of the Knight of the Garter, his left arm raised across his chest, holding the robe. The statue surmounts a substantial stone pedestal.

Benjamin Disraeli, statesman and novelist, was born in London in 1804, the son of the Jewish writer, Isaac D'Israeli. He found early fame as a novelist before eventually entering parliament in 1837. He allied himself with the Tories and became the leading figure in the Young England movement, eventually attacking Peel's rejection of protectionism. Disraeli held office, notably as Chancellor of the Exchequer, in the Conservative governments of the 1850s and 1860s. He was chiefly responsible for the passage of the 1867 Reform Act which extended the parliamentary franchise. In the following year he succeeded the 14th Earl of Derby as Prime Minister. He became Prime Minister again in 1874 and served until defeated in 1880. He was created Earl of Beaconsfield in 1876. By the time of his death in 1881, he had transformed the beliefs and support of the Conservative Party. Disraeli visited the Bolton area on a number of occasions, most notably in

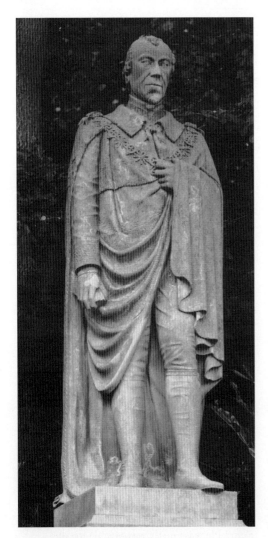

Rawcliffe, *Benjamin Disraeli*

1840, when he went to Barrow Bridge, an industrial community which was to be the basis for Millbank in his novel, *Coningsby* (1844).

The erection of a statue of Disraeli was organised by the Bolton Working Men's Conservative Association, at a time when working-class Conservatism was making deep inroads into traditional Liberal heartlands. In

1886 funds were raised for a statue from local Conservative supporters and a contract was given to Thomas Rawcliffe, a Chorley stonemason, to carve it in stone. But it was when the memorial committee approached the town council for permission to locate the statue in Queen's Park, initially asking for a site in the centre of the ornamental flower garden, that the political significance of the memorialisation surfaced. Permission was given to place the statue in the park, but on the terrace not in the flower garden. However, at a fractious council meeting, the minority Liberal group raised objections to the planned ceremonial. Councillor Brimelow argued that to allow the celebrations would break the by-laws of the park, which prevented religious, political and other public meetings taking place. To do so, he said, would be to offer a 'dangerous precedent' since similar political meetings and celebrations could not be refused in future. He was supported by Councillor Thornley, who said that if the 'demonstration' were allowed 'no doubt when the other party honoured one of their chiefs they would want similar latitude'. In reply, Alderman William Nicholson sought to contradict the impression that the unveiling would be a partisan affair, arguing that it was merely an occasion on which Englishmen could 'perpetuate the memory of one who was undoubtedly a great man'. The Liberals, he said, were 'going a little outside their lines' in this, and would surely be allowed to erect similar memorials to their own leaders. Alderman Dobson concluded the debate with the assurance that the handing over of the statue would be 'entirely non-political'.[1]

Despite these assurances, the inauguration was a deeply partisan affair. Bolton's streets were 'thronged with 4,000 yellow-bedecked Tories'. The moving spirit behind the memorial, John Morris, the president of the Bolton Working Men's Conservative Association, led a procession of local Conservative Associations and bands, who in turn were followed by Tory supporters carrying banners depicting

Conservative leaders, along with others who wore prints of their leaders in their hats. The proceedings in the park were, indeed, scrupulously non-political. The Earl of Onslow, Under-Secretary for the Colonies, confined his remarks to praising Disraeli as an Englishman, and to the suggestion that the statue would be received 'not as a political demonstration, but as a memento of a great statesman'. However, when the proceedings were removed to a nearby field at Halliwell Lodge, the speakers reaffirmed the Conservatism of the occasion, imploring that 'the Conservative Associations would never rest until it became impossible to talk about a Radical being returned in Bolton and district'.[2]

The statue was, in the words of the Liberal *Bolton Journal*, 'a good piece of monumental masonry', a work which had a 'hard and inartistic appearance' which would only be softened by time.[3] The necessity of using a cheap stone had clearly tested Rawcliffe's skills as a sculptor. Over time the Bolton weather has softened the stone, and also exposed its weaknesses. In 1984 the head of the statue was removed by vandals, but was recovered undamaged from the park shrubbery and reaffixed.[4]

Notes
[1] *Borough of Bolton. Proceedings of Town Council*, 7 April 1887, pp.133–41; *Bolton Journal*, 9 April 1887. [2] *Bolton Journal*, 7 May 1887. [3] *Ibid*. [4] *Bolton Evening News*, 24 April, 4 May 1984.

John Fielding
J. William Bowden

11 July 1896
Yorkshire stone
Statue 2.13m high approx; pedestal 3.05m high
× 1.34m square base
Signed on plinth: J. W. Bowden 1896; on pedestal: J. Bowden, Park Rd. Bolton
Inscription on pedestal: J. T. FIELDING J.P.
[borough coat of arms] FOR OVER 20 YEARS /

THE SECRETARY OF THE / OPERATIVE COTTON SPINNERS' ASSOCIATION / AND UNITED TRADES COUNCIL / OF BOLTON AND DISTRICT. / UNITY AND EQUITY WERE THE GUIDING PRINCIPLES OF HIS LIFE. ERECTED BY THE TRADE UNIONISTS AND PUBLIC OF BOLTON AND PRESENTED TO THE BOROUGH ON JULY 11TH 1896

Status: Grade II
Condition: poor
Owned by: Bolton Metropolitan Borough Council
Description: Portrait statue; life-size stone statue of Fielding wearing a suit, holding a paper in his left hand, surmounting a stone pedestal.

John Fielding, trade unionist, was born on 24 September 1849 at Redlaur near Blackburn, the son of Eli Fielding, a cotton worker. The family moved to Bolton in 1859 and two years later Fielding began working in a cotton mill. He remained a millworker until 1874, when he succeeded his father as secretary to the Self-Actor Minders' Association. Over the next twenty years Fielding became the dominant figure in Bolton trade unionism. He was instrumental in uniting the trade unions in the Bolton spinning industry, establishing the Operative Spinners' Provincial Association as one of the most powerful and financially strongest unions. The *Bolton Journal* praised his 'indomitable energy, his great grasp of thought, his forceful character, and his kindliness of disposition', which had 'lifted his fellow workers from the chaotic weakness of disunion to the higher plane of united combined effort' and to the 'proud position they now occupy in the industrial world'. Wider labour issues were advanced through his secretaryship of the Bolton Trades Council. Other public offices followed: in 1879 he was elected to the School Board and in 1886 he became one of the first working-class men to be made a Justice of the Peace. He died on 20 December 1894, after a long illness, aged only

45; as a mark of respect the flag on the town hall was flown at half mast.[1]

Such were the achievements of this 'uncrowned king of men' that following Fielding's death it was considered appropriate that his friends and admirers should get together to perpetuate his memory. A joint memorial committee was appointed, consisting of members of the Spinners' Association and the Bolton Trades Council. Thomas Crompton, a former chairman of the Operative Spinners' Association, was appointed chairman. It was, unsurprisingly, the Operative Spinners' Association which led the project, contributing £105 to the memorial fund, having previously voted £250 to Fielding's widow. The memorial schemes they discussed included establishing a scholarship and placing a monument over Fielding's grave, but the committee decided that a public statue would be a more appropriate form of recognition. The committee, intent on 'aiding local industry', only invited local masons and sculptors to send in plaster busts. Out of the six received, the one from J.W. Bowden & Sons was judged the best. An agreement was signed between the committee and Bowden in January 1896 to complete a stone statue by June for the sum of £175.[2] Bowden carried out the commission with 'the benefit of the committee's advice and suggestions'.[3] The committee had wanted to site the statue in Nelson Square, close to the Crompton statue, but the council was less enthusiastic, preferring the park site.[4] It was the latter site that was settled upon.

The day of the unveiling would, according to the *Bolton Journal and Guardian,* 'live long in the memory of Boltonians as the one on which thousands of working men rose in the full strength of their industrial might' to do honour to a man who had worked tirelessly for the benefit of his fellow workers.[5] Some 4,000 Bolton spinners led a procession of over 20,000 workers to the park, a procession so long that not all arrived in time to see the ceremony.[6]

The statue was unveiled by Lord James of

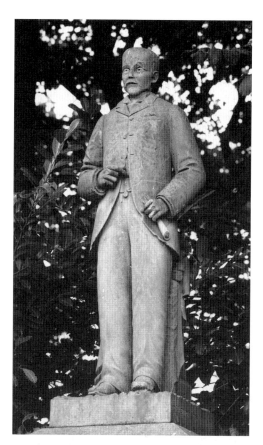

Bowden, *John Fielding*

Hereford, who had known Fielding personally, and was widely respected because of his support for factory legislation. In his speech he praised Fielding as a public servant of high character, whose work had raised trade unionism to a new level. Fielding no doubt would have been pleased to see the occasion used to further the campaign against 'sweating prices' that were forcing down wages in the cotton industry.[7] Given the extent of the demonstration, it was somewhat surprising to recall that the statue had cost so little, paid for out of a subscription fund in which it was announced that 'the gold of the wealthy'

mingled with 'the mite of the little piecer'. But the money raised had been limited, and the committee clearly had little option but to seek out a local stonemason. Bowden's statue would have been harshly criticised by the London art press had they deigned to notice it. The *Lancashire Review* did notice it, judging that it ought to be viewed as 'a sentimental and pathetic tribute to a beloved benefactor, bought with the hardly-spared contributions of those whom he loved and wrought for so well'.[8] The statue has remained in its original position in the park. In 1984 the head was removed by vandals (in the following week the Disraeli statue was also decapitated), but it was recovered and reunited with the body.[9] It is not known whether the damage to Fielding's hands was caused at this time. Both the statue and pedestal have weathered badly.

Notes
[1] *Bolton Evening News*, 20 December 1894; *Cotton Factory Times*, 28 December 1894; *Bolton Journal*, 9 October 1886. [2] Fielding Memorial Committee, Agreement for supply and erection of a stone statue 17 January 1896 (Bolton Operative Cotton Spinners' Provincial Association, BCS1/5/6/22 John Rylands University Library of Manchester). [3] *Bolton Journal and Guardian*, 11 July 1896. [4] *Ibid.* [5] *Ibid.*, 18 July 1896. [6] *Manchester Guardian*, 13 July 1896; *Cotton Factory Times*, 17 July 1896. [7] *Programme. John T. Fielding Statue* (*Daily Chronicle*, Bolton, [1896]). [8] 'Lancashire statues', *Lancashire Review*, April 1898, p.244. [9] *Bolton Evening News*, 19 April 1984.

James Dorrian
John Cassidy

29 January 1898
Portland stone
Statue 2.74m approx; pedestal 2.44m high × 1.73m square base
Signed on plinth: John Cassidy Sculpt 1897
Inscription on pedestal above carving of leaves:
JAMES DORRIAN M.D. / 1826–1895. / ERECTED BY / PUBLIC SUBSCRIPTION / TO COMMEMORATE / A LIFE OF / USEFULNESS
Status: Grade II

Condition: fair
Owned by: Bolton Metropolitan Borough Council
Description: Portrait statue; larger than life-size stone statue of the bearded Dorrian, who is shown standing with his arms folded, a paper in his right hand. The statue stands on a large stone pedestal.

James Dorrian was born in in 1828 in County Down, Ireland, and was educated in Dublin. He arrived in Bolton around 1850, becoming 'one of the best-known medical gentlemen in the town or district'. Many of his patients were Irish Catholics, and he gained a reputation for charity through ministering to the Irish poor, although his philanthropy was not confined to any single group. Though rather brusque in manner, he was said to have 'a heart as tender as a woman's' which was 'ever responsive to the cry of charity'. He was less active in other areas of public life, restricting his participation to the local bench, which he joined as a JP in 1880. He died on 22 March 1895.[1]

About a year after Dorrian's death a public meeting was called by the Deputy Mayor, Alderman Nicholson. It was resolved that Dorrian's 'self-sacrificing devotion and unfailing charity' be recognised by a statue to be placed on the north side of Victoria Square. A committee was established and a subscription list opened amongst the trade and other societies in the town, the responses to which indicated 'the esteem and veneration in which the benevolent doctor was held'. Estimates for a statue were obtained from local sculptors, the commission going to the Manchester sculptor, John Cassidy. His finished Portland stone statue was described as 'of heroic proportions'.[2] There was some dispute over its siting, which touched on some sensitive subjects, and appeared to divide the council between Dorrian's Anglo-Irish champions and the other councillors. At a meeting of the General Purposes Committee in September 1897, Councillor Kearns sought to obtain a site for the

statue in Victoria Square rather than in Queen's Park. Councillor Maginnis seconded Kearns's amendment, arguing that Dorrian had just as much claim to space in the square as the bronze statue of the (Anglican) doctor and philanthropist, Samuel Chadwick, erected in 1873. Dorrian's charity was more than the equal of Chadwick's, Maginnis claimed, since the latter 'was devoted to one section', meaning members of the Church of England. The Mayor concluded by saying that it would 'be a mistake to open the door to filling the square with statuary' and, pointedly, that a stone statue would be out of place.[3] The amendment was lost

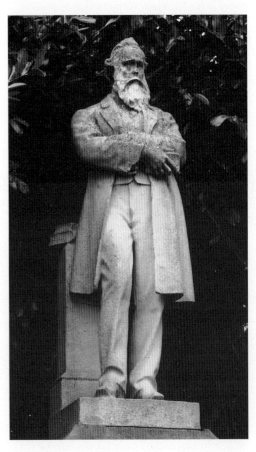

Cassidy, *James Dorrian*

and Dorrian took up residence with the usual ceremony on the Park Terrace in January 1898.[4]

Notes
[1] *Bolton Chronicle*, 23 March 1895; *Bolton Journal and Guardian*, 23 March 1895. [2] *Bolton Journal and Guardian*, 29 January 1898. [3] *Bolton Town Council. Proceedings of General Purposes Committee*, 1 September 1897, pp.285–8. [4] *Bolton Journal and Guardian*, 29 January 1898.

People's Fountain
Sculptor unidentified; original fountain by W.J. and T. Wills

1860; relocated 1866; replaced 1978
Stone
Statue 1.18m high; pedestal 93cm high
Inscription on pedestal: left-hand side: PEOPLES
 DRINKING / FOUNTAIN / ERECTED / 1860 –
 right-hand side: ERECTED BY / PUBLIC /
 SUBSCRIPTION / 1860 – removed to park 1866
Status: not listed
Condition: poor
Owned by: Bolton Metropolitan Borough
 Council
Description: Drinking fountain; female figure, pouring water from a jug into a pitcher surmounting a stone basin and base. The fountain is now dry.

Mid-Victorian Bolton saw the installation of a number of drinking fountains. Apart from the public health arguments and temperance sentiments supporting such amenities, there was an awareness that fountains were being installed in other Lancashire towns, especially Liverpool.[1] Support came from some of the wealthier local inhabitants – James Barlow, Robert Howarth, Samuel Burnside, Arthur Greg – who agreed to meet the costs of providing at least one cast-iron drinking fountain each.

Around the same time a People's Drinking Fountain Committee was formed to provide a more elaborate fountain to stand in the Market Place.[2] Subscriptions were collected from among the workers in the town's larger mills

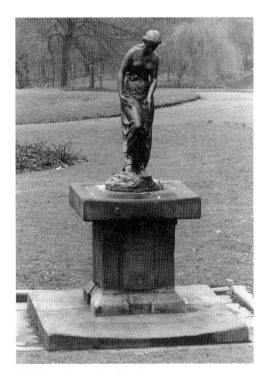

Wills Brothers, *People's Fountain*

and engineering firms. The People's Fountain, as it was significantly named, comprised a metal statue of a female pouring water from a pitcher, probably representing the well-known Biblical story of *Rebecca at the Well*, surmounting a stone pedestal. It was designed by the Wills Brothers and manufactured by the Coalbrookdale Company. They were renowned for their cast-iron work, which may throw doubt on reports that the statue was bronze. A similar figure, also the work of the Wills Brothers, adorned a fountain erected by the Metropolitan Drinking Fountain Association near the Royal Exchange in 1861.[3] By July 1859 the Bolton committee, having collected £60, renewed its call for further donations.[4] On its arrival in the town, the fountain was displayed in Bradshawgate.[5] It appears to have been installed by the end of

1860. The final cost of the scheme was £114, of which £80 was for the sculpture. The fountain, however, did not become a permanent landmark in the town centre because it was decided to remove it to Bolton Park (later Queen's Park), some time before the park opened in 1866. Its new location was close to a walk set aside for women.[6] The fountain remained a feature of the park for over a hundred years. In 1978 the original bronze statue was vandalised and removed from the pedestal. It was not repaired but replaced with an inferior stone version depicting a woman pouring water from a jug.[7]

Notes
[1] Advertisement in *Bolton Chronicle*, 1 January 1859. [2] *Bolton Chronicle*, 5 October 1861. [3] P. Davies, *Troughs & Drinking Fountains* (London: Chatto & Windus, 1989) p.49. [4] *Bolton Chronicle*, 23 July 1859. [5] *Ibid.*, 1 September 1860. [6] *Ibid.*, 26 May 1866. [7] Information from Barry Mills, Bolton Local Studies Library.

People's Fountain

St George's Street

Atlas

Sculptor: unidentified

Re-erected 1985
Composition stone
1.83m high × 1.85m wide × 64cm deep
Inscription on plaque inset on pedestal:
CONCRETE STATUE OF ATLAS / FROM THOMAS
WALMSLEY AND SONS / ATLAS FORGE, BOLTON
[1866–1985] / THE LAST MANUFACTURER OF /
WROUGHT IRON IN THE WORLD / BY THE
PUDDLING PROCESS
Condition: fair

Atlas

Owned by: Bolton Metropolitan Borough
Council
Description: statue of Atlas, who is shown as
a kneeling figure, carrying a globe on his
shoulders. It surmounts a rectangular red-brick
pedestal.

The stone figure of Atlas was originally
displayed on the outside of the Atlas Forge,
Bridgeman Street in Bolton, one of the best-
known engineering and iron and steel works in
the town.[1] There is little reliable evidence on its
commissioning and installation, though it may
date from early in the firm's history. The works
were established by Thomas Walmsley in 1866,
and as late as the 1960s the company was still
producing steel by the puddling process. When
that operation finally ceased, the machinery was
sent to be displayed at the Ironbridge Industrial
Museum in Shropshire.[2] The premises were
closed, but the symbolic figure was saved,
painted white and placed on a brick pedestal in
an open space on St George's Street. It appears
to be made of stone rather than concrete as
described on the plaque.

Notes
[1] Photograph in K. Hudson, *Exploring Our
Industrial Past* (London: Hodder and Stoughton,
1975) p.48. [2] J. Brough, *Wrought Iron: The End of
an Era at Atlas Forge Bolton* (Bolton Metropolitan
Borough Council [n.d.]).

St Helen's Road

*Junction of St Helen's Road and Adelaide
Street*

The Conference of the Birds
Michael Johnson and Hilary Cartmel

2000
Stainless steel, bronze and cast-glass
9m high
Status: not listed
Condition: good
Owned by: Bolton Metropolitan Borough
Council

Description: Tall tapering steel column
surmounted by sculpture representing mythical
birds, made from stainless steel, bronze and
cast-glass. It is located on raised ground
encircled by trees.

In 1999 Bolton Metropolitan Council decided
to install a significant public sculpture in the
Daubhill district of the borough, part of its
Radial Routes initiative. In the previous two
years the council had supported a number of
public art schemes in some of the borough's

Johnson and Cartmel, *The Conference of the Birds*

most deprived areas, in the belief that they contributed towards engendering local pride. The projects included the erection of an Indian archway, designed by the metalwork sculptors, Michael Johnson and Hilary Cartmel, in the Deane district of the town.[1] The announcement of a landmark sculpture in Daubhill was not welcomed by all its residents, some of whom complained that the proposed expenditure, reported to be £53,000, was tangential to the real problems facing the community. The council needed to concentrate on more direct regeneration initiatives.[2] Johnson and Cartmel were commissioned to provide the work. Their proposal was for a sculpture of a flock of birds, made out of stainless steel, bronze and cast-glass, perched on the top of a tapering stainless steel pole. It originated out of work undertaken by the artists with local schools, the children providing drawings of birds from which a number were selected as models for the final design. The title, *The Conference of the Birds*, refers to the mystical poem of the same name written by the Sufi poet, Farid Ud-Din Attar. Daubhill was home to a number of Muslim families. The work, which stood approximately five metres tall, was located on an area of rising ground, at a junction on the busy St Helen's Road. It was installed in the winter months of 1999–2000. In addition, two smaller artworks created by local schoolchildren were installed in the district. The new sculpture became the centre of further controversy in the following summer when it became evident that the trees which surrounded it, when in leaf, obscured all but the very top of the work.[3] Following discussions, the council decided to raise the sculpture rather than prune or remove the trees. It was taken down by the artists, the pole extended and the work reinstated, leaving the birds visible above the trees.[4]

Notes
[1] *Bolton Evening News*, 21 June 1999. [2] *Ibid.*, 29 October 1999. [3] *Ibid.*, 6 July 2000. [4] Information from Michael Johnson.

Victoria Square
Samuel Taylor Chadwick
Charles Bell Birch

1 August 1873
Bronze statue, Cornish granite pedestal
Statue 3.05m high approx; pedestal 3.66m high
 × 1.87m square base
Signed on plinth: C. B. Birch Sc / London.
 1871; H. Prince & Co Founders / Southwark
Inscription on pedestal: CHADWICK
Status: Grade II
Condition: good
Owned by: Bolton Metropolitan Borough
 Council
Description: Portrait statue; larger than life-size bronze statue of Chadwick dressed in a frock coat, his right hand raised to his chest and left hand leaning on a book. On the front of the stepped pedestal is a rectangular bronze bas-relief depicting Mrs Chadwick, seated, with children, her hand pointing towards the orphanage established by her husband.

Samuel Taylor Chadwick, doctor and philanthropist, was born in 1809 in Urmston, Lancashire, into a relatively wealthy farming family. He trained as a doctor and after a period practising medicine in Wigan, he moved to Bolton in 1837. Chadwick developed a reputation as an able doctor with a willingness to treat the poor. He was also concerned to improve the public health of the town, a subject he pursued when serving as a Conservative councillor from 1858–61. Throughout these years Chadwick gave generously in time and money to a wide range of schemes to improve the lives of the local working classes. His personal life was marked by tragedy: he married Anne Hall of Bolton in 1831, and their two children died in childhood. Ill health forced Chadwick to retire from his medical practice in 1863, and he moved to Southport: an occasion marked by numerous tributes, including the commissioning of a full-length portrait paid for

Birch, *Samuel Taylor Chadwick*

by some 7,000 working-class subscribers. His interest in Bolton continued and in 1868 he gave £17,000, later increased to £22,000, to establish an orphanage and model dwellings in the town, the rent from the houses being used to provide revenue for the orphanage. He declined a request to stand as Conservative parliamentary candidate for the borough in 1868. By the time of his death in 1876 Chadwick had seen his orphanage opened. He was buried in the parish church. Among his bequests was £5,000 to establish a natural

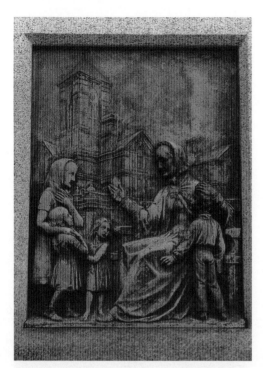

Birch, *Mrs Anne Chadwick and orphans (panel)*

history museum in Queen's Park.[1]

The idea of raising a statue to Chadwick was first discussed in January 1868, immediately after the announcement of his liberal gift to the town. The initial discussions originated among the working classes, the first meeting taking place in the Robin Hood public house, Ashburner Street; but the memorial movement was soon widened, and a public meeting, chaired by the mayor, was held at the end of January.[2] The collecting of funds for a statue was put in motion, with subscription books being sent to the town's mills and workplaces. Reflecting a desire that the scheme should not be dominated by the wealthy, it was announced that no subscription was to exceed one guinea. By June almost 7,000 people had promised a total of £600. Other elements of the scheme also began to be settled. Having debated the merits of a number of locations, Nelson Square was decided upon as the most suitable site. Some designers and sculptors had already declared an interest in the project. William Calder Marshall, whose statue of Samuel Crompton was already in Nelson Square, informed the memorial committee of his interest.[3] Mr W. Bonnar, one-time manager of a local terracotta works, submitted the idea of an extravagant Gothic memorial with a statue of Chadwick beneath a canopy, and figures 'emblematic of the staple trades of Bolton' at the corners of the base.[4] The committee, having taken advice from George Godwin, editor of the *Builder,* invited a number of sculptors to submit designs for a statue. The cost of the work, which was to include a memorial plaque representing Mrs Chadwick, was to be 'about £1,000'. Models were sent in by Charles B. Birch, Joseph Durham, Edward Geflowski, William Calder Marshall, Edgar G. Papworth and John Birnie Philip, but John Bell, Matthew Noble and Thomas Woolner did not take up the invitation. The models were exhibited at the Mechanics' Institution. It was Birch's design, at £850 the cheapest of those submitted, which was selected. Geflowski's design, the only other entry costed below £1,000, was the runner-up. The estimates for Calder Marshall and Birnie Philip were £1,400 and £2,200 respectively.

Birch began work on a full-size model, which received the committee's approval in November 1870. By October 1871 the sculpture had been cast at Prince's Phoenix Foundry, Southwark, and Birch was awaiting instructions about the pedestal.[5] The Memorial Committee, responding to a shortfall in the funds, removed the one-guinea ceiling on subscriptions. It also decided to reopen the question of the site, in response to correspondence in the local press suggesting that if the statue were placed in Nelson Square, it would require the removal or re-siting of the Crompton statue. The Memorial Committee decided to approach the council for permission to place Chadwick in front of the new town hall. There followed another period of inactivity until the spring of 1873, when the Memorial Committee formally approached the Town Hall Committee with what it considered to be a non-controversial request to locate the statue in front of the town hall. The Town Hall Committee's refusal both surprised and galvanised the Memorial Committee.[6] Speakers at a public meeting on 12 May 1873 were suitably indignant about the attitude of those councillors who had refused the statue a place in front of the town hall, especially when it was further reported that the opinion had been expressed that such a civic space should be 'reserved for public men of national importance'.[7] The public indignation was sufficient for the full council to rescind the Town Hall Committee's decision. However, in agreeing to allow the statue into the square, the council did add the barbed rider that if, once installed, it was considered by the council to be unsuitable, then the Memorial Committee would be responsible for removing it to another site. It was also made clear that the statue was not to be unveiled ahead of the royal opening of the town hall. Thus, when the Prince of Wales opened the town hall in June 1873, there was no sign of the Chadwick statue. In the following month members of the Town Hall Committee, the Chadwick Memorial Committee, the town hall architects and the stoical Birch met to finally settle the exact location. The meeting again revealed conflicting views on the use that was to be made of Bolton's principal civic space. Birch had wanted to place the statue closer to the town hall, but had to settle for a location further to the side: a location that some preferred because it was supposedly closer to the site of Chadwick's first surgery.[8]

As the day of the unveiling approached, a last call for funds produced sufficient money to meet the final instalment of the £930 owed to Birch. The larger subscriptions had removed any possible shortfall, although in the final accounts it was recorded that 17,683 subscribers had given sixpence or less.[9] Chadwick's benevolence had touched the hearts of Bolton's

'rough horny-handed people'.[10] The Chadwick statue was unveiled in August 1873 by James Barlow, who had been mayor when the first public meeting had been called five years before.[11] The ceremonies included a procession of the town's trades carrying banners and displaying models of their crafts, and, more poignantly, the placing of flowers around the statue by children from the recently opened orphanage. Henry Whewell designed a commemorative medal for the occasion.[12] Samuel and Anne Chadwick did not attend any part of the ceremonies.[13] Within a few years, concern was expressed about the condition of the town's new statue. Bell was informed by the Borough Surveyor that '…it appears to be undergoing a process of decay or disintegration and looks very unsightly in consequence'.[14] The sculptor was contacted but it is unclear whether the perceived problem was treated or ignored. The statue has remained in the square unaffected by the many changes made to this public space.

Notes
[1] *Bolton Chronicle*, 13 May 1876. [2] *Ibid.*, 13 January 1868, 27 January 1868. [3] See above, p.209. [4] *Bolton Chronicle*, 2 August 1873. [5] *Bolton Evening News*, 30 September 1871. [6] *Ibid.*, 8 May 1873. [7] *Ibid.*, 8 May, 14 May 1873; 30 September 1871; *Bolton Chronicle*, 10 and 17 May 1873. [8] *Bolton Chronicle*, 2 August 1873. [9] *Ibid.* [10] *Bolton Evening News*, 1 August 1873. [11] *Ibid.*; *The Times*, 2 August 1873. [12] *Bolton Evening News*, 29 July 1873. [13] *Bolton Chronicle*, 2 August 1873; *Bolton Guardian*, 2 August 1873; *Bolton Weekly Journal*, 2 August 1873; *Manchester Guardian*, 2 August 1873. [14] Letter dated 3 September 1879, Chadwick Statue correspondence (Bolton Archives, ABCF/9/1).

Sir Benjamin Dobson
John Cassidy

17 February 1900
Bronze statue; granite pedestal
Statue 2.44m high; pedestal 3.05m high × 1.88m square base

Inscription: LIEUT. COL. SIR B. A. DOBSON. / KNIGHT V.D., J.P., C.E., M.I. Mech.E. / CHEVALIER DE LA LEGION D'HONNEUR. / 1847–98. / MAYOR OF BOLTON, 1895. 6. 7. 8. / ERECTED BY PUBLIC SUBSCRIPTION TO / COMMEMORATE / A USEFUL LIFE AND SERVICE TO THE TOWN OF BOLTON / AND UNVEILED BY MR. ALDERMAN NICHOLSON, J.P. / 17TH FEBRUARY 1900.
Status: Grade II
Condition: good
Owned by: Bolton Metropolitan Borough Council
Description: Portrait statue; larger than life-size bronze statue of Dobson, who is dressed in his mayoral robes and chain. The statue stands on a grey granite pedestal.

Sir Benjamin Alfred Dobson, textile machinery manufacturer, was born in 1847 at Douglas on the Isle of Man, the son of a Belfast engineer. He was educated at Carlisle Grammar School and the Collegiate Institute in Belfast, where he studied engineering. He then joined the Belfast and Northern Counties Railway as an engineer before moving to Bolton in 1871, where he joined the family firm, Dobson and Barlow. He and T.H. Rushton were responsible for considerably expanding the firm, which by 1898 employed a workforce of over 5,000. By 1897, the *Bolton Review* judged that Dobson, as a businessman, probably had 'no superior in Bolton'.[1] It went on to declare that he was 'beloved' by his workpeople 'for his geniality and considerate regard for their welfare', even though over the years he had resisted attempts to challenge his authority. During a strike in 1887 he brought in new workers to defeat the strikers, and in 1897 strongly resisted the demands of the Amalgamated Society of Engineers.[2] In spite of this attitude, on the occasion of the firm's centenary in 1890 his workers presented him with illuminated addresses of congratulation, a silver punch bowl and a diamond bracelet for his wife, Coralie. In 1874 he was returned as a Conservative

councillor and was soon regarded as the leader of Bolton's Conservatives. He was elected mayor for the first of four times in 1894. Outside the council chamber he held many posts including president of the Bolton Chamber of Commerce, chairman of the Bolton Ironfounders' Association, and Honorary Colonel of the 2nd Volunteer Battalion, Loyal North Lancashire Regiment. Dobson was one of the moving spirits behind the establishment of the town's Technical School, opened in 1892. In addition, he published many technical papers on cotton spinning and engineering. In 1878 he was awarded the Legion of Honour by the French government in recognition of his services to French industry. He was knighted in 1897 and died on 4 March 1898, leaving a substantial estate.[3]

A meeting called by the Mayor, Alderman

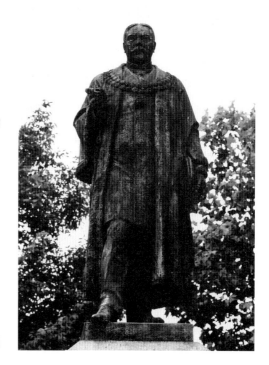

Cassidy, *Sir Benjamin Dobson*

William Nicholson, on 31 March 1898, a few weeks after Dobson's death, considered establishing a memorial in recognition of his services to the borough. After some debate, in which the argument for establishing a practical memorial was strongly made, a resolution for a statue in Victoria Square was passed. In fact the idea of a public statue had found support at a private meeting of the council shortly after Dobson's death.[4] A memorial committee made up of council members was appointed. It was to collaborate with a second committee that included local MPs, representatives of the technical schools and delegates from the Bolton Co-operative Society, Trades Council, Arts Guild and School Board. A subscription list, restricted to a maximum of one guinea, was opened, eventually receiving some 5,000 individual subscriptions. Estimates for a bronze statue were sought from five sculptors, including Hamo Thornycroft and John Cassidy. The commission was awarded to Cassidy who had recently supplied Bolton with a statue of Dr Dorrian. Members of the memorial committee and relatives of Dobson visited Cassidy's Manchester studio to approve the clay model.

The statue was cast at Singer's of Frome. A site on the north-east side of the town hall, the opposite side to the Chadwick statue, was approved by the council. It was unveiled in February 1900 by Dobson's friend and political ally, Alderman Nicholson, in front of a large crowd. The speakers praised Dobson's public work, especially in connection with technical education. The local MP, George Harwood, gave a speech that encapsulated this message, declaring that 'The lesson of the statue was "Go thou and do likewise"'.[5]

Notes
[1] *Bolton Review*, 1 (1897) pp.67–70. [2] G. Holden, 'The Bolton engineers' strike of 1887', *Manchester Region History Review*, 3, No 2 (1989–90) pp.15–20. [3] R. Kirk, 'Sir Benjamin Dobson', *Dictionary of Business Biography* (London: Butterworths) Vol.2, pp.115–17; *Bolton Journal and Guardian*, 5 March

1898, 12 March 1898. [4] *Bolton Chronicle*, 2 April 1898. [5] *Ibid.*, 17 and 24 February 1900; *Bolton Evening News*, 17 February 1900; *Manchester Courier*, 19 February 1900.

Bolton War Memorial
Architect: Arthur John Hope
Sculptor: Walter Marsden

14 July 1928, 11 November 1932
Bronze sculpture; Kemnay granite
Statues 2.44m high approx; memorial 9.15m high approx
Signed on both plinths: W. Marsden Sc.; A. B. Burton Founder
Inscription on front of memorial: LEST WE FORGET / IN UNDYING MEMORY OF THE MEN / AND WOMEN OF BOLTON WHO GAVE / THEIR LIVES IN THE GREAT WAR / 1914–1919 / 1939–1945 – rear: TELL YE YOUR CHILDREN / OUR BROTHERS DIED TO WIN A BETTER / WORLD. OUR PART MUST BE TO STRIVE / FOR TRUTH GOODWILL AND PEACE THAT / THEIR SELF-SACRIFICE BE NOT IN VAIN
Status: Grade II
Condition: fair
Owned by: Bolton Metropolitan Borough Council
Description: War memorial; grey granite memorial in the form of a pylon penetrated by an arch, beneath which is a bronze cross overlaid with a crusader's sword. Bronze figures are positioned on a raised platform on the north and south side of the arch: *Peace Restraining War* is represented by a seated female figure who is gripping the arms of a kneeling male warrior; *Peace Seeing the Horrors of War* depicts a female figure raising her hands in anguish, as the now dead warrior lies prostrate in her lap.

Bolton Council appointed a war memorial sub-committee to consider the question of the town's memorial on 25 September 1920. At that meeting it was resolved that a memorial should

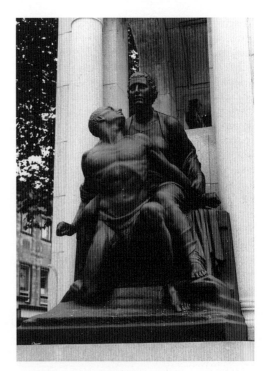

Marsden, *Peace Restraining War*

be sited in Queen's Park, and take the form of a tower 'somewhat after the design of a Campanile' on which the names of all the Bolton servicemen killed in the war should be inscribed. The memorial was to be part of a wider scheme involving a new art gallery and museum. On 10 December, a meeting of 'representative gentlemen' of Bolton was held in the Mayor's dining room at the town hall to ratify the earlier decision and to expand the membership of the committee.[1] However, these initial plans were delayed owing to a combination of the post-war depression and the withdrawal of the Bolton Trades Council from the scheme. Moreover, the mayor told the council, on 26 April 1921, that 'many influential persons' had expressed unfavourable opinions, and had suggested that since memorials had been placed in almost every school and church,

there was no real necessity for a municipal monument. It was therefore resolved that the opening of the fund be deferred for more propitious times.[2] The matter rested until November 1924 when the memorial committee reconvened and resolved to proceed with the scheme. A public meeting was again held in the Mayor's Dining Room on 13 January 1925, when a new committee was appointed and a subscription list was opened.[3] By May 1925 the committee had decided that a new memorial would be commissioned and that it would be located not in the park but in Victoria Square, in front of the town hall. In addition a Hall of Memory containing a roll of honour would be created inside the town hall. A sketch of the proposed monument (somewhat different from that finally adopted) was submitted, which expressed 'the dual purpose of being symbolic of the sacrifice of the fallen and the triumph of victory', with the cross at its centre 'representing the common faith of our Country'. This design also contained sculpture of a winged Victory, flanked with mourning female figures in the Greek style. A composition of this kind was considered preferable to one with military figures. Soldiers in modern uniforms would, the committee thought, 'be considered by future generations [as] a relic, rather than a permanent memorial for all time'.[4] The design was the work of A.J. Hope, a member of Bolton's best-known firm of architects, Bradshaw Gass and Hope. There were some objections to the Victoria Square site because it was such a busy and noisy public space. However, the committee decided that it was the most appropriate site for the memorial.

By May 1927, the committee had finalised the rules for the competition that would decide on the design of the sculptural figures placed on either side of the monument. The bronze groups were to be 'vigorous and full of action', with Victory as the crowning figure of the memorial.[5] Three sculptors were short-listed. Walter Marsden's designs came nearest to the specifications, but the *Bolton Evening News*

declared that not one of the submissions was 'wholly satisfactory'. The Lancashire-born Marsden had been a junior officer in the 1/5th Loyal (North Lancashire) Regiment in the war, and had been decorated twice for bravery before being taken prisoner. He had trained as a sculptor and after the war he completed a number of Lancashire war memorials, including Heywood, Tottington and St Anne's on Sea.[6] He reworked the Bolton designs until they were considered suitable by the committee.[7] Marsden explained that he had tried to avoid realism, which would have fixed the work in time, rendering it 'objectionable' to future generations. The first group (on the north side of the memorial) represented *Struggle* with the female figure of Peace shown trying to hold back Youth, 'characteristic of the best manhood of our Town – clean and fit, with unbounded energy – prepared to give all for its Country'. On the south side, the two figures represented *Sacrifice giving unto Death*. These were again the female figure of Peace, who was now depicted with the prostrate body of Youth in her lap, who had given himself so that 'his country's honour may be preserved'.[8] The committee agreed to the two compositions, abandoning the idea of a central figure representing Victory. Marsden's ideas were scathingly criticised by Walter Gilbert, one of the unsuccessful competitors. He condemned Marsden's figures as 'superficial in sentiment', claiming that they did 'not go deep enough into the fibre of our being' and that they were 'an incentive to cowardice [and] a justification of the outlook of the conscientious objector who reared his head in the last war'.[9]

Bolton's war memorial and Hall of Memory were unveiled and opened by the 17th Earl of Derby in July 1928.[10] Marsden's statuary, however, was not completed at the time of this ceremony. In fact progress on both groups proved slow and they were not finally installed until 1932.[11] They were unveiled by Colonel C.K. Potter as part of the Armistice Day ceremony.[12] The final cost of the memorial was

some £7,600, of which £2,600 was for the statuary.[13] Further inscriptions were added to the memorial after the Second World War.

Notes
[1] Bolton War Memorial Committee, 10 December 1920 (Bolton Archives, ABZ/24/8). [2] *Ibid.*, 26 April 1921 (Bolton Archives, ABZ/24/8). [3] *Ibid.*, 13 January 1925 (Bolton Archives, ABZ/24/8). [4] *Ibid.*, 19 May 1925 (Bolton Archives, ABZ/24/8). [5] *Ibid.*, 26 May 1927 (Bolton Archives, ABZ/24/8). [6] R.Hughes, 'Walter Marsden: soldier and sculptor', *Stand To!*, No.63 (January 2002) pp.37-40. [7] D. Boorman, *At The Going Down of the Sun. British First World War Memorials* (York: Ebor Press, 1988) p.140. [8] Bolton War Memorial Committee, undated cutting (Bolton Archives, ABZ/24/8). [9] *Bolton Evening News*, 27 December 1927. [10] *Programme. Bolton War Memorial Unveiling Ceremony* (Bolton, 1928); *Bolton Evening News*, 16 July 1928; *Manchester Guardian*, 16 July 1928. [11] *Bolton Standard and Weekly Advertiser*, 17 June 1932. [12] *Bolton Evening News*, 11 November 1932. [13] *Bolton Journal and Guardian*, 13 October 1933.

Town Hall

Bolton

William Calder Marshall

5 June 1873
Portland stone
2.13m high approx × 12.19m approx
Status: Grade I
Condition: fair
Owned by: Bolton Metropolitan Borough Council

Description: A symbolic group of larger than life-size male and female figures in tympanum. The central figure represents Bolton, her left hand resting on a shield, on which is the borough's coat of arms. To her right is a seated female figure representing Manufacture, holding a distaff for spinning, and a young African boy carrying a basket of cotton. A reclining female figure, representing Earth, pouring her gifts from a cornucopia, is in the angle of the pediment. Commerce is the theme of the group to the left of *Bolton*. A female

figure represents Commerce, and is shown holding a caduceus and a helm. A young boy is shown holding a boat by the bow. In the angle is the reclining figure of Ocean, watching a dolphin, a reminder of the importance of international trade to the town.

Following a long period of debate and argument, the decision to build a new town hall in Bolton was taken in 1866. The winner of the competition to design the building was the Leeds architect, William Hill. The foundation stone was laid in 1867, but without any ceremony due to a difference of opinion over who should lay it. The town hall was to take seven years to build, sufficient time for concerns about the project to be extensively revisited. Economy-minded councillors were especially

Calder Marshall, *Bolton*

critical of the great clock tower, the building's defining feature. Concerns were also voiced over what was regarded as superfluous ornamentation. However, in spite of the pressure to reduce costs, sculptural detail was introduced. Decorated panels were placed on either side of the main door and a pair of suitably fierce lions, the work of Burstall and Taylor of Leeds, flanked the portico.[1] The main external sculpture was a symbolic statuary group in the pediment above the main portico. Five artists – E.G. Papworth, J. Birnie Philip, W.D. Keyworth, Jnr, Burstall and Taylor, and William Calder Marshall – put forward schemes. These were put on display for council members to view. The Town Hall Committee decided to commission Marshall, whose statue of Samuel Crompton already stood in Nelson Square, even though he had informed the committee that because of the time available he had not been able to prepare a detailed model.[2] His symbolic sculpture

represented Bolton's manufacturing and commerce. But, predictably, some council members objected to the choice, arguing that other artists, such as Burstall and Taylor of Leeds, had submitted designs that were as good and, more to the point, cost far less. Moreover, Marshall's fee of £1,000 excluded the cost of the Portland stone which was to be supplied by the council. But the decision was not rescinded. A deputation from the council visited Marshall's studio in the spring and summer of 1869 to see the models, which, with some minor modifications, they approved.[3] The completed work was in place when, in June 1873, the town hall was opened by the Prince of Wales (later King Edward VII) and Princess Alexandra, with all the ceremony the borough could muster. Marshall's sculpture was well received, apparently justifying the decision not to commission a more economical sculptor. The *Bolton Weekly Journal* judged the work to be

by no means more hackneyed in general idea than most such decorations, it is (as might be expected from the sculptor's reputation) superior to most in artistic design, as well as in the quality of clearly expressing its intended meaning.[4]

Bolton remains the largest and most important example of architectural sculpture in the town.

Notes
[1] *Opening of the Bolton Town Hall* (Bolton: Tillotson and Sons [1873]) p.31. [2] *Bolton Guardian*, 4 December 1869, 11 December 1869, 18 December 1869. [3] *Ibid.*, 19 February 1870. [4] *Bolton Weekly Journal*, 7 June 1873.

Festival Hall, Town Hall

Edward VII

Sir George Frampton

16 December 1912
Marble
Bust 83cm; frame 2.74m × 2.16cm × 4cm
Signed: George Frampton / R. A. 1912
Inscription on pedestal: EDWARD / VII / 1901–1910 / ERECTED BY / PUBLIC / SUBSCRIPTION / 1912 – left-hand side: A GREAT KING / EVER ANXIOUS FOR / HIS PEOPLES GOOD / AND PEACE AMONG / THE NATIONS. – right-hand side: AS PRINCE OF WALES / HE OPENED / THIS TOWN HALL / THURSDAY THE / 5TH JUNE 1873.
Status: Grade II*
Condition: good
Owned by: Bolton Metropolitan Borough Council
Description: Portrait bust; over life-size marble head and shoulders bust of Edward VII, wearing coronation robes and the Order of the Garter, surmounting a pedestal. Surrounded by a green marble frame, surmounted by Bolton's coat of arms with motto, *Supera Moras*. The bust is displayed against the rear wall of the hall.

Following the death of Edward VII, a public meeting was held in Bolton Town Hall in November 1910 to discuss the provision of an appropriate memorial. It was decided to establish a memorial fund with the aim of providing a nurses' home for Bolton Infirmary. In addition, it was agreed that a marble bust would be commissioned and placed in the town hall, a building which the late king, then the Prince of Wales, had opened in 1873. It was suggested that it might be possible to obtain a copy of the bust commissioned by the University of Manchester for £350.[1] The public subscription was well supported, raising over £26,000, including ten separate donations of £1,000. The memorial committee invited Albert Bruce Joy, William Goscombe-John, Sydney March, Walter Merritt, Alfred Drury and Sir George Frampton to submit proposals for a bust, which would be located in the Albert Hall, the main public room inside the town hall.[2] After visiting a number of the sculptors in their London studios, the committee decided to engage Frampton, who had indicated that he could carry out the commission for £500. Frampton, knighted in 1908, was acknowledged to be one of the country's leading portrait sculptors. He had already worked extensively in the North West, having sculpted the statues of Queen Victoria in Southport and St Helen's, and three of the statues which stood in St John's Gardens, Liverpool. When the committee visited Frampton's studio they had been impressed by a model of *Peter Pan*, which was soon to be cast in bronze for Kensington Gardens, and a marble statue of Queen Mary.[3] Following Frampton's visit to Bolton, the original idea of a bust on a pedestal was modified to include a marble surround, an addition which was regarded as making the work more monumental.[4] It also increased his fee to £650.[5] The commission proceeded smoothly, Frampton keeping the committee informed of his progress.[6] He despatched the bust and its surround to Bolton in October 1912. It was installed in the centre of the wall at the rear of the Albert Hall, where it was

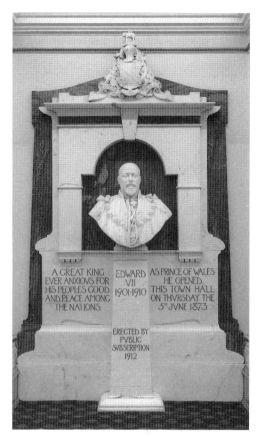

Frampton, *Edward VII*

unveiled by the mayor in December.[7] The serravezza marble bust was widely admired and in the following year, as had been agreed in the original contract, Frampton exhibited it at the Royal Academy.[8] The bust and its surround were not seriously damaged in the fire which destroyed the hall in 1981.[9] The subsequent rebuilding created two halls rather than one, and the bust is now located on the rear wall of what is now the Festival Hall.

Notes
[1] *Bolton Evening News*, 23 November 1910. [2] Correspondence from Town Clerk, 15 March 1911 (Bolton Archives, ABZ/59/22). [3] Report of Edward

VII Memorial Committee (Bolton Archives ABZ/59/11). [4] Correspondence from Frampton to Samuel Parker, Town Clerk, 10 May 1911 (Bolton Archives, ABZ/59/22). [5] Report of Edward VII Memorial Committee, 23 May 1911 (Bolton Archives ABZ/59/13). [6] A. Jezzard, 'The sculptor Sir George Frampton', unpublished PhD. thesis, University of Leeds, 1999, pp.196–8. [7] *Bolton Journal*, 13 November 1912. [8] Graves, *Royal Academy Exhibitors, 1905–1970*. [9] *Bolton Evening News*, 16 November 1981. [10] *Ibid.*, 23 November 1871.

The idea of displaying portraits and busts in Bolton Town Hall was discussed before the building was opened, and a number of portraits were received or promised. In the following years a small number of busts was acquired. Four busts are displayed in the corridor between the Hall of Remembrance and the Festival Hall.

James Fraser, Bishop of Manchester
John Warrington Wood

29 February 1888
Marble bust, square marble pedestal
74cm high
Inscription on pedestal: JAMES FRASER / LORD
 BISHOP OF MANCHESTER / 1870–1885
Condition: good
Owned by: Bolton Metropolitan Borough
 Council

Bolton's response to the death of James Fraser, the second Bishop of Manchester, in 1885 was to establish a fund to provide a memorial in the parish church and a bust in the town hall.[1] Warrington Wood, who had been responsible for the bust of Fraser in Manchester Town Hall, agreed to the commission.[2] However, he died in 1886 before the bust was completed and it was finished under the supervision of his widow. The unveiling ceremony in the town hall in February 1888 was somewhat unusual, in that Alderman Fletcher both presented the bust on behalf of the memorial committee and accepted it on behalf of the council.[3]

Warrington Wood, *James Fraser*

Notes
[1] For Fraser, see above, p.16. [2] See above, p.43.
[3] *Bolton Journal*, 3 March 1888.

William Nicholson
Carl Albetill

September 1894
Marble bust; marble pedestal
73cm high
Signed on back: CARL ALBETILL BOLTON 1.9.94
Inscription on pedestal: WILLIAM NICHOLSON /
 MAYOR / 1892-3-4
Condition: good
Owned by: Bolton Metropolitan Borough
 Council

Albetill, *William Nicholson*

William Nicholson was one of the best-known political figures in late-Victorian and Edwardian Bolton. He was a Conservative councillor and served as mayor on three successive occasions. He was also an active figure in a number of Bolton's charities including the Royal Infirmary. It was in 1894 that Alderman Benjamin Dobson and Councillor W. Cooper organised a collection among Nicholson's friends and admirers in order to present him with a bust of himself, a bust that they intended would be displayed in the town hall. In the previous year Nicholson had sat for a bust by the local sculptor and modeller, Carl Albetill.[1] It is not clear if it was this bust or another one sculpted by Albetill that was placed in the town hall. At the unveiling ceremony Nicholson expressed the

hope that those who saw the bust in the future would recall that it was the bust of a tradesman, 'a representative man drawn from the ranks'.[2]

Notes
[1] *Bolton Journal*, 3 February 1894. He is listed as a sculptor and modeller, residing at 21 Mawdsley Street, Bolton in the *Post Office Bolton Directory for 1894–5*, p.109. [2] *Bolton Journal*, 8 September 1894.

John Kynaston Cross
Edgar George Papworth

November 1895
Marble bust; marble pedestal
83cm high
Signed: E.G. Papworth Sc. 1882.
Inscription on pedestal: JOHN / KYNASTON CROSS / MEMBER OF BOLTON TOWN COUNCIL 1868–1869 / BOROUGH MAGISTRATE / 1874–1887 / COUNTY MAGISTRATE / 1881–1887 / MEMBER OF PARLIAMENT FOR BOLTON / 1874–1885 / UNDER SECRETARY OF STATE FOR INDIA / 1883–1885
Condition: good
Owned by: Bolton Metropolitan Borough Council

John Knyaston Cross was a major figure in the business and political worlds of Victorian Bolton. He was the son of John Cross, one of the town's leading cotton employers. He became a partner in his father's business and helped to expand further this important firm. Cross was an ardent Liberal and he served for a brief period on the council in 1868–9. In 1874 he was returned as one of the borough's two MPs, a seat he held until 1885. He took his own life in 1887.[1] A bust, sculpted by Edgar Papworth during Cross's lifetime, was presented to Bolton Council by his widow, Emily Cross, in 1895.[2]

Notes
[1] *Bolton Journal*, 26 March 1887. [2] Borough of Bolton General Purposes Committee, 18 November 1895.

Samuel Pope
Joseph William Swynnerton

June 1935
Marble bust; marble drum pedestal
79cm high
Inscription on pedestal: SAMUEL POPE Q. C. / RECORDER OF BOLTON 1869–1901
Condition: good
Owned by: Bolton Metropolitan Borough Council

Samuel Pope played an important part in the municipal life of Victorian Bolton. Born in 1826, the son of a Manchester merchant, he gave up a place in his father's business to pursue the law. He became a well-known figure in northern legal circles and served as Recorder for Bolton from 1869 until his death in 1901. His duties included reading the address of welcome to the Prince of Wales on his visit to open the town hall in 1873. A Liberal in politics, Pope failed on two occasions in the 1860s to be returned as MP for the borough. He was also a leading temperance campaigner and for many years served as the Honorary Secretary of the United Kingdom Alliance.[1] The marble bust of him by Swynnerton was presented to the council by his great-nephew in 1935.[2]

Notes
[1] *Bolton Journal and Guardian*, 26 July 1901.
[2] Bolton Council Proceedings minutes, 5 June 1935, pp.5–6; *Bolton Journal*, 12 June 1935.

Banqueting Hall (formerly the Council Chamber)

Queen Elizabeth, the Queen Mother
Sir William Reid Dick

December 1961
Bronze bust
73cm high

In 1961 Councillor Thomas Sharples Barlow presented two busts, both by William Reid Dick, to the council. One was a study of the composer Joseph Ruminsky, the other a bronze of Queen Elizabeth, the Queen Mother. It was decided to place the second bust in the Banqueting Hall of the town hall, a room in which Queen Elizabeth had taken luncheon when visiting Bolton in 1945.[1]

Note
[1] *Bolton Journal and Guardian*, 29 December 1961.

DUNSCAR

Blackburn Road
Junction of Blackburn Road and Darwen Road

War Memorial
Gaffin and Co.

7 May 1921
Bronze statue; Bath stone and granite pedestal
Statue 1.83m high; pedestal 2.52m high × 2.31m square
Inscription encircled by stone wreath on pedestal: OUR / GLORIOUS / DEAD – beneath: THIS MONUMENT WAS ERECTED / IN PROUD AND LOVING MEMORY OF / THE MEN OF / EGERTON, EAGLEY, DUNSCAR / AND BROMLEY CROSS / WHO FELL DURING THE GREAT WAR / 1914–1918 / LEST WE FORGET
Status: not listed
Condition: fair
Owned by: Bolton Metropolitan Borough Council
Description: War memorial; life-size bronze statue of a soldier standing in mourning attitude with rifle reversed, surmounting a stone and polished granite pedestal, rising from three steps.

At the end of the First World War a plan to provide a war memorial – an obelisk on

Dunscar War Memorial

Cheetham's Close – for the Turton district was announced, but failed to progress, as smaller communities expressed the wish to erect their own memorials. A war memorial committee, under the chairmanship of Lieutenant-Colonel J.W. Slater, was set up to arrange a memorial for the villages of Dunscar, Bromley Cross, Egerton and Eagley. It settled on providing a formal memorial. However, this decision was taken only after a debate which saw the eventual rejection of ideas such as the

establishment of educational scholarships for the children of deceased soldiers. Colonel B.W. Greg was influential in finalising the design of the memorial, basing it on a South African war memorial he had seen in Shrewsbury. The work was commissioned from the London firm of Gaffin and Co. at a cost of £1,200. Raising such a large sum proved difficult, though the fund was boosted by money from a sports gala. The location, a triangular-shaped plot of land at a road junction known as Finger Post, was chosen as one that was accessible for all four communities and, moreover, one where communal religious services had been held during the war. Lieutenant-Colonel Slater unveiled the memorial in a ceremony attended by some 2,000 people. The names of his two sons were among those inscribed on the pedestal.[1]

Note
[1] *Bolton Journal and Guardian*, 13 May 1921.

FARNWORTH

Market Street

Farnworth Park

Barnes Memorial
Architect: Bradshaw and Gass
Sculptor: William Charles May

13 June 1895
Ruabon brick; York stone
Inscription: THIS PARK / WAS PRESENTED BY / THOMAS BARNES / ESQ. M.P. / OPENED / BY THE / RIGHT HON. / W. E. GLADSTONE / M.P. / OCT. 28TH 1864.
"In commemoration of / my son's coming of age / and in memory of his / grandfather. I present / and dedicate this Park / to the people of Farnworth / for their benefit for ever."
Condition: poor

Owned by: Bolton Metropolitan Borough Council
Description: Ruabon brick and York stone monument with bronze portrait medallion.

This memorial was erected in 1895 by Farnworth Urban District Council to commemorate the gift of the park to the town by Robert Barnes in 1864. The Barnes family was one of the largest local cotton manufacturers and played a decisive part in the development of nineteenth-century Farnworth. James Rothwell Barnes had established one of the first cotton mills in Farnworth, and it was his son, Thomas, who expanded the business after his father's death in 1849. Thomas was a Liberal in politics and supporter of free trade, who served as MP for Bolton on three occasions. In 1860, at a celebration to mark the coming-of-age of his son, J.R. Barnes, he announced his intention of providing a park for the community. He expressed concern at the speed with which the land close to the town centre was being built upon. Such concern might have been regarded as far-sighted, given that the township's population only numbered some 8,000. In 1864 the park was handed over to the local board in a ceremony that would have been a red-letter day in the history of a Liverpool or a Manchester, let alone in a small community, somewhere near Bolton, whose affairs had only recently come under the control of a local board. The public platform was occupied by some of Lancashire's most powerful and influential figures, who had come to see and to hear the principal guest, William Ewart Gladstone, open the park. Barnes had also invited Richard Cobden, but he was unable to attend. Gladstone did not disappoint the large crowd, delivering a speech that ranged over the state of the nation and Lancashire, whilst depicting Barnes' philanthropy as further confirmation of the new relationship existing between employers and workers.[1] It was an event that celebrated the core Liberal economic and political values, whilst marking an

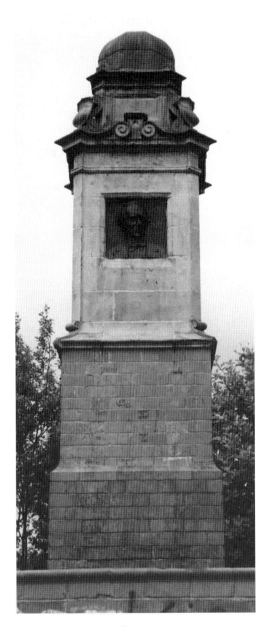

May, *Barnes Memorial*

important moment in the emerging identity of a small community.[2] It was this significant moment in its history that members of the recently created Farnworth Urban District Council acknowledged in erecting a memorial in 1895.[3] The monument was designed by the Bolton architects, Bradshaw and Gass. Barnes (who was still alive) was more particularly memorialised in the bronze bas-relief which was commissioned from the London sculptor, W.C. May. This represented Barnes at the time of the park's opening and was based on photographs supplied by the family. The monument occupied a prominent position in the park, placed in the middle of the terrace, approached along the principal walk. The base rose in three stages to the monument itself, the stages being used as planting areas. In contrast to the original opening of the park, the unveiling of the monument was rather low-key, taking place in the evening following a council meeting. Alfred Topp, whose considerable public services to Farnworth went back to the 1860s, carried out the ceremony, which was followed by a celebration dinner.[4] The memorial has suffered from neglect and vandalism in recent years.

Notes
[1] *Proceedings at the Opening of Farnworth Park, presented to the Township by Thomas Barnes Esq., M.P., on the 12th day of October, 1864* (Bolton: T. Cunliffe, 1865). [2] *Bolton Chronicle*, 15 October 1864. [3] *Souvenir of Farnworth Park Jubilee 1864–1914* (Farnworth Urban District Council, [1914]). [4] *Farnworth Weekly Journal*, 15 June 1895. (A sculpted head of Topp decorates the entrance to the town's Carnegie Library, Market Street.)

Farnworth War Memorial

J. and H. Patteson

16 November 1924
Bronze sculpture; Stancliffe stone shaft
Sculpture 1.52m high approx; column 4.1m high
 approx
Inscription on shaft beneath Farnworth coat of

arms: THEY DIED / THAT WE / MIGHT LIVE / 1914–1918
Status: Grade II
Condition: good
 Description: War memorial; bronze statue of female figure of Peace, crowned with laurel, blowing a trumpet held in her right hand and with a wreath in her other hand. The figure surmounts a tapering stone shaft, decorated with wreaths on all four sides, and with a square base. The base includes an inscription and bronze tablets listing the dead. The memorial rises from two octagonal steps.

The idea of raising a war memorial in Farnworth began to be discussed immediately after the war, a necessary tribute to the many local men who had died.[1] A 'Hero's Fund' had been established in the town, allowing each returning soldier to be presented with a gold watch and an illuminated address. The surplus funds were directed towards a more public memorial to honour those who did not return. But, as in other communities, it proved difficult to reach an agreement on the form it should take, some favouring a hall or a social centre for ex-servicemen, whilst others supported the erection of a conventional war memorial. The subject was allowed to lapse and was not revived until 1923, when R.H. Cunliffe, the new chairman of the council, declared his determination to complete the scheme. It was decided to place the memorial inside the main entrance to Farnworth Park. The commission was given to the Manchester firm of J. and H. Patteson. The memorial took the form of a tapering stone column surmounted by a bronze sculpture of a female figure symbolising Peace. As it neared completion a further appeal was made for funds to liquidate the outstanding debt of £200.[2] The memorial was unveiled in November 1924 by Councillor James Stones, in a solemn ceremony that attracted thousands of the town's inhabitants.[3] Stones spoke of the memorial as 'a credit to the district and one which would compare favourably with other

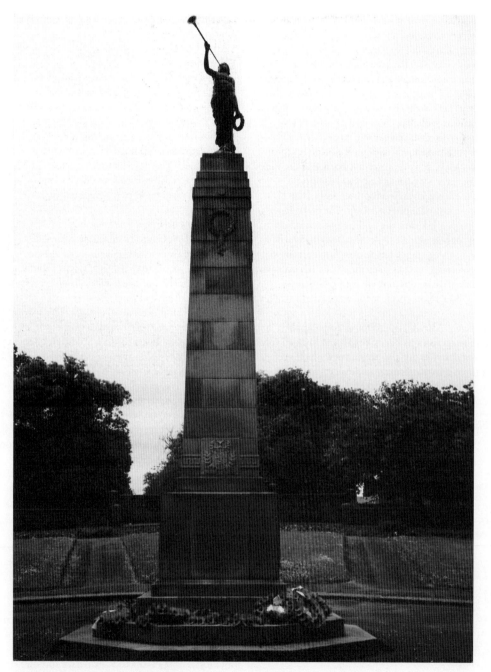

Patteson, *Farnworth War Memorial*

towns of like size and importance'.[4] An additional bronze tablet was added afterwards when it was revealed that some names had been omitted from the 586 listed on the two original tablets.

Notes
[1] N. and S. Richardson, *Fallen in the Fight: Farnworth and Kearsley Men who died in the Great War 1914–1918* (Radcliffe: N. Richardson, 1990). [2] *Farnworth Weekly Journal*, 7 November 1924. [3] *Farnworth War Memorial. Unveiling and Dedication Sunday, November 16th, 1924* [Farnworth, 1924]. [4] *Farnworth Weekly Journal*, 21 November 1924.

HORWICH

Chorley New Road

Horwich Locomotive Workers' War Memorial

Paul Fairclough

27 August 1921
Marble statue; granite pedestal
Statue 1.83m high; pedestal 2.52m high
Inscription on pedestal: TO THE / EVERLASTING
 MEMORY / OF OUR GLORIOUS DEAD /
 1914–1918 / ERECTED BY / HORWICH
 LOCOWORKS / EMPLOYERS
Status: Grade II
Condition: fair; rifle broken and replaced
Owned by: Bolton Metropolitan Borough
 Council
 Description: War memorial; life-size standing figure of a soldier who is shown holding his rifle, surmounting a granite pedestal.

At the beginning of the twentieth century the Lancashire and Yorkshire Locomotive Works was the largest employer in Horwich. Some 800 local locomotive workers enlisted in the First World War, of whom 120 were killed. A memorial was raised by their fellow workers, and took the form of a soldier of the

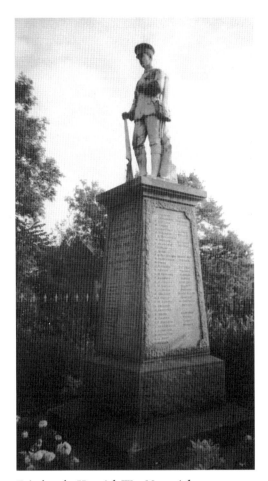

Fairclough, *Horwich War Memorial*

was added after the Second World War. Over the years the memorial became neglected and on one occasion it featured in the local press as the borough's worst kept memorial.[3] As a result of the decline of the railway works the local council acquired the memorial in 1989, from Parkfield Castings, the company which had taken over the works from British Rail in the previous year.[4] The memorial was cleaned and a plaque placed at the base, recording Parkfield's gift to the people of Horwich.

Notes
[1] *Bolton Journal*, 2 September 1921. [2] *Ibid.*, 11 February 1921. [3] *Bolton Evening News*, 20 February 1989. [4] *Ibid.*, 2 February, 24 October 1989.

WESTHOUGHTON

Bolton Road

Westhoughton High School

Mother and Child

Paul Wood

January 1998; removed March 1998; relocated
 December 1998
Griffetonwood stone; Cotswold stone
1.7m high
Status: not listed
Condition: good
Owned by: Bolton Metropolitan Borough
 Council
 Description: Life-size figure of a young
woman carrying a sleeping child on her right
shoulder, standing on a short stone pedestal.

Mother and Child was commissioned by Bolton Metropolitan Council in 1997, with the intention of placing it in the recently refurbished and renamed memorial gardens in the centre of Westhoughton.[1] The initial design evolved from drawings produced by schoolchildren, who participated in workshops

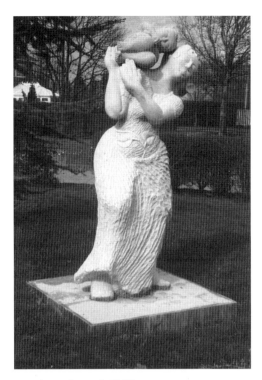

Wood, *Mother and Child*

held at schools in Westhoughton. Two designs were presented to the Council, based respectively on male and female figures, the latter being chosen. The development of the commission was co-ordinated by Raku Works Sculptural Arts, Accrington. Paul Wood carried out the carving at studios in Lancashire and Yorkshire, before completing the work in Leicester. It was installed in the Ditchfield Memorial Gardens, Market Street in January 1998 but was immediately criticised by residents and local councillors. The £5,000 sculpture was condemned as 'horrible', 'rubbish', and 'a waste of money', whilst more sympathetic residents labelled its critics as 'cultural plebs'.[2] The council, however, responded to the criticisms, and in March it removed the sculpture. Protests then followed

Manchester Regiment dressed in full marching order, holding a rifle in his right hand. The names of the dead and their rank were inscribed around the base of the granite pedestal. It was designed by Paul Fairclough and made by Messrs Leonard Fairclough Ltd of Adlington, Lancashire. The memorial, costing £700, was unveiled in August 1921 by George Hughes, chief mechanical engineer at the works.[1] Fairclough's statue was welcomed as a fine and original memorial which captured the character of the Lancashire soldier.[2] A further inscription

from other residents and from the local civic society requesting that 'their statue' be returned to the gardens,[3] but Wood's sculpture was not reinstated. Instead, it was offered to Westhoughton High School, one of the schools that had contributed to the design. The offer was accepted, and the sculpture was placed on a small landscaped roundabout close to the main entrance to the school.[4]

Notes
[1] *Bolton Evening News*, 14 June 1996. [2] *Ibid.*, 19, 20 and 26 February, 9 March 1998.
[3] Correspondence with Paul Wood, 24 May 1999.
[4] *Bolton Evening News*, 17 November 1998; information from Jim Moss, Westhoughton High School.

Church Street

Cemetery, Parish Church

Pretoria Pit Disaster Monument
Sculptor/Architect: unidentified

25 November 1911
Polished marble
4.39m × 1.22m square
Inscription: Sacred / to the memory of / 344 MEN AND BOYS WHO LOST / THEIR LIVES BY AN EXPLOSION / AT THE PRETORIA PIT OF THE / HULTON COLLIERY CO. ON / 21ST DECEMBER 1910, 24 / OF WHOM SLEEP UNDER THIS / MONUMENT, BEING UNIDENTIFIED / AT THE TIME OF BURIAL. / THIS MONUMENT IS ERECTED / BY PUBLIC SUBSCRIPTION, AS A / TOKEN OF SYMPATHY WITH / THE WIDOWS AND RELATIVES / OF THE VICTIMS, 171 OF WHOM / ARE BURIED IN THIS CEMETERY, / 45 IN WINGATES, 20 IN DAISY / HILL, 3 IN THE CONGREGATIONAL / CHURCHYARDS, AND THE / REMAINDER IN VARIOUS / BURIAL GROUNDS. / "BE YE THEREFORE READY ALSO, / FOR THE SON OF MAN COMETH / AT AN HOUR WHEN YE THINK NOT." / ST LUKE XII. 40.
Status: not listed
Condition: good

Owned by: Bolton Metropolitan Borough Council
Description: Square black marble column surmounted by an urn covered with flowers. An inscription in gilt lettering fills the front panel of the column.

The explosion at the Pretoria Pit (Hulton Pit No 3) between Westhoughton and Atherton on 21 December 1910 ranks as one of the worst pit disasters in British history. In all 344 miners died, ranging in age from 14 to 63. Only three miners survived.[1] A national relief fund established for the families of the victims received contributions of over £145,000. Over two hundred of the dead came from Westhoughton and many of these were buried in the cemetery adjoining the parish church, St Bartholomew's. It was decided to raise a public memorial 'as a token of sympathy with the widows and relatives of the victims'.[2] The marble memorial, which included a lengthy inscription, was placed above the grave of 24 of the miners, whose bodies could not be identified, in the cemetery adjoining the parish church. The memorial cost £200. Thousands of people came to view the monument in the following days, amongst whom 'some scenes were very touching'.[3] The anniversary of the disaster is remembered in an annual ceremony when a wreath is laid. The Pretoria Pit monument is one of the best-known of a number of memorials raised to the victims of colliery disasters in Greater Manchester.

Notes
[1] *Manchester Guardian*, 22 December 1910, 3 January, 21 February 1911; J. Lane and D. Anderson, *Mines and Miners of South Lancashire 1870–1950* (Parbold: D. Anderson, 1980). [2] P. Salveson, *The People's Monuments* (Manchester: Workers' Educational Association North Western District, 1987) pp.43–4. [3] *Bolton Chronicle*, 25 November 1911; *Manchester Guardian*, 27 November 1911.

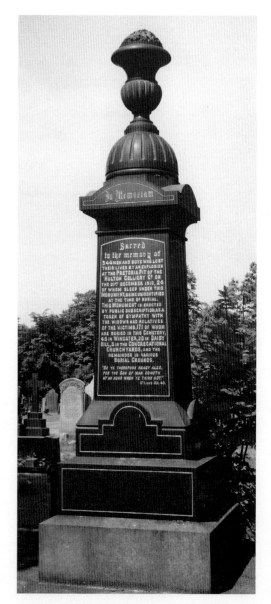

Pretoria Pit Disaster Monument

King Edward VII House, Bolton Royal Infirmary

Edward VII

John Jarvis Millson

18 July 1914, removed 1997
Portland stone
Statue 1.83m high approx
Inscription in raised Gothic lettering on either
 side of statue: King / Edward / VII /
 Memorial / Nurses / Home / opened on /
 the 18th day / of July 1914 / by / Sir Thomas
 / Barlow / Baronet / President of the / Royal
 College / of Physicians
Status: not listed
Condition: fair
Owned by: Bolton Hospitals NHS Trust
 Description: Portrait statue; life-size standing
figure of Edward VII in a carved niche above
the main doorway. The king is dressed in robes
of state, his left hand resting on his sword hilt.

Bolton's response to the death of Edward VII
was to establish a memorial fund, the monies
from which would be principally used to
improve the town's main hospital. The priority
was to build a nurses' home which would be
named after the king. A commemorative marble
bust was also to be placed in the town hall.[1] The
fund raised some £26,000. The design
competition for the home, for which John B.
Gass acted as assessor, was won by the local
firm of architects, Henderson and Brown. Their
response to the requirement that the building's
memorial status be acknowledged was to place a
statue of Edward VII in a canopied niche over
the main entrance.[2] J.J. Millson, the Manchester
architectural sculptor, was commissioned to
provide the stone statue. He depicted the late
king as a standing figure dressed in state robes.
The King Edward VII Memorial Nurses' Home
was officially opened by Sir Thomas Barlow in
July 1914.[3] When the building was demolished
in 1997, the statue with its elaborate canopied
niche and the surrounding inscription, was
saved and placed in storage, with the intention
that it would be displayed in the new Royal
Bolton Hospital, possibly in a courtyard.[4]

Notes
[1] See above, p.223. [2] *Proposed King Edward VII Memorial Nurses' Home… Conditions, Instructions and General Particulars of Competition* [Bolton, November 1910]. [3] *Bolton Evening News*, 18 and 20 July 1914; *Bolton Journal and Guardian*, 24 July 1914. [4] Information from Jenny Walsh, Bolton Hospitals Arts Project.

Millson, *Edward VII*

BURY

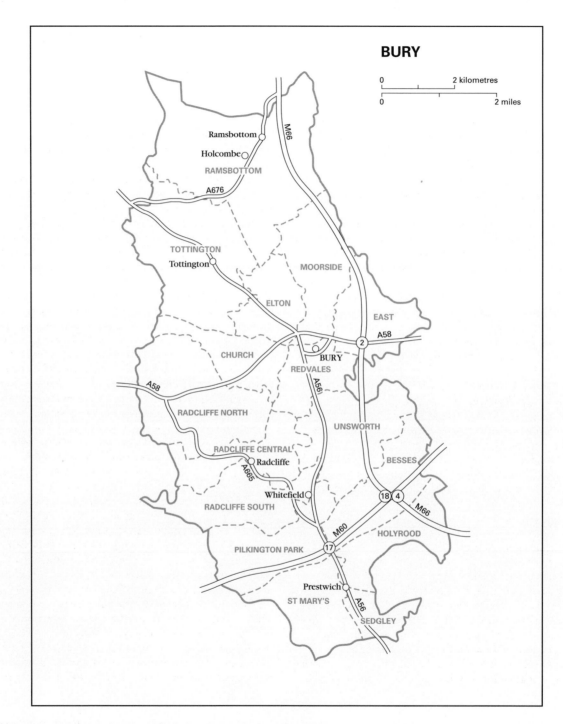

BURY

0 2 kilometres

0 2 miles

Ramsbottom

Holcombe

RAMSBOTTOM

M66

A676

TOTTINGTON

Tottington

MOORSIDE

ELTON

EAST

A58

CHURCH

BURY

REDVALES

A561

A58

RADCLIFFE NORTH

UNSWORTH

RADCLIFFE CENTRAL

Radcliffe

BESSES

A665

Whitefield

18 4

M66

RADCLIFFE SOUTH

HOLYROOD

PILKINGTON PARK

M60

17

Prestwich

ST MARY'S

A56

SEDGLEY

Introduction

The Metropolitan Borough of Bury was created in the local government reorganisation of 1974, amalgamating the county borough of Bury, the boroughs of Prestwich and Radcliffe, the urban districts of Tottington and Whitefield, and part of the urban district of Ramsbottom. The borough lies to the north of Manchester and covers an area of 9,919 hectares. The population numbered 180,612 in 2001, of whom some 60,000 live in Bury itself.

As in the case of other communities that came within the economic orbit of Manchester, it was the industrial revolution in textiles and related industries that determined the modern history of Bury. An abundant water supply – the River Irwell runs through the district – encouraged the establishment of water-powered mills as well as businesses specialising in the dyeing and finishing of cotton cloths. The Peel fortune, one of the largest to be created in the early part of the industrial revolution, was based locally on the printing of cotton cloths.[1] Other industries, notably paper-making, made use of the available water. Coal was also mined locally. Industrialisation confirmed Bury as the principal town of a district in which small villages such as Radcliffe expanded substantially during the nineteenth century. When, in 1876, Bury obtained borough status, its population was approaching 90,000.

Industrial society showed little concern for the public monuments of earlier centuries. Bury's market cross survived until 1818, when it was reported as having been removed from the Market Place.[2] Wayside crosses were also vulnerable and, once lost, were not usually replaced. An exception appears to have been the Pilgrim's Cross on the old road running from Holcombe Moor to Whalley Abbey, which, having been vandalised, was replaced in 1902 by a new stone.[3]

The district owed its first modern monuments to its association with Sir Robert Peel. In 1852 two memorials were erected to the statesman who had been born in the town. A bronze portrait statue, the work of Edward Baily, was located in Bury Market Place, and, at the same time, a massive stone memorial tower was built on Holcombe Hill, near Ramsbottom. Peel Tower complemented another landmark, Grant's Tower, a stone structure on the opposite side of the valley. The latter had been built some twenty years before by William and Daniel Grant, whose bleaching firm was one of the principal local employers.[4] These two towers became conspicuous Victorian landmarks, and popular destinations for walkers and picnickers from the neighbouring towns. As in other Lancashire towns attention was drawn to the broad support the

Peel monuments received from all classes, evidence of a new social cohesion following the divisions of previous decades. However, whilst the pennies of the working classes were recorded alongside the guineas of the middle classes in the published subscription lists, it was recalled that at the entrance to the exhibition of the models for Bury's Peel statue, a sign stated that those wearing clogs would not be admitted, a notice that prompted working men to tuck their clogs under their arm and walk defiantly into the building in their stockinged feet.[5]

Having participated in the great rush to memorialise Peel, Bury did not raise any more major outdoor monuments until the end of the century. The town did, however, obtain some respectable architectural sculpture. The work of the Manchester architectural sculptor, Joseph Bonehill, was displayed on the Bury Bank building in Silver Street and also on the gate piers of the new municipal cemetery.[6] In terms of quality this was overshadowed by privately commissioned memorial statuary, notably that sculpted by John Thomas for John Brooks in St Mary's, Prestwich.[7]

The years from 1890 to 1914 proved to be a golden period for public sculpture in Bury. It was a time of new public buildings, architectural projects in which Bury demonstrated a willingness to go beyond token ornamentation. In particular, the new technical school and the art gallery and library boasted impressive schemes of architectural sculpture, embellishments that one might have expected to see in one of the great northern industrial cities. Other Bury buildings – the textile unions' offices and the Union Bank and Conservative Club – both situated on the town's grandest street, Silver Street, also included sculptural decoration.[8] In 1905 the town acquired its second bronze statue: a memorial to the Lancashire Fusiliers who did not return from the South African War. George Frampton was the sculptor responsible for Bury's 'cheering fusilier'. In the previous year, the town had unveiled a public monument to one of its most famous sons, James Kay, the inventor of the fly shuttle, a technology without which the textile revolution would have stalled. The Bury businessman and philanthropist, Henry Whitehead, funded this memorial to 'the Christopher Columbus of the inventors of Lancashire'. He followed up this gift by providing the town with a stunning decorated clock tower, which included a bronze sculpture, built in memory of his brother, the surgeon Walter Whitehead. The press reported its formal opening alongside the news of the assassination of Archduke Ferdinand in Sarajevo. Public monuments in the smaller neighbouring communities were, predictably, more modest structures. Drinking fountains proved a

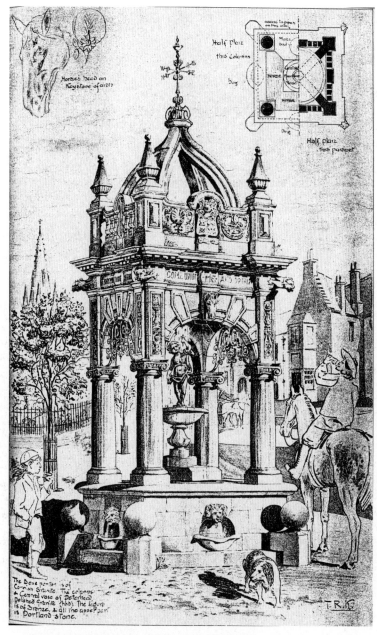

Inside the illustration (handwritten notes):

Horses head on Keystone of arch?

Half plan thro columns

Half plan thro parapet

COM: UNITED AND OMNI

The base portion of Corman Granite. The columns & Central vase of Peterhead polished Granite (red). The figure is of Bronze, & all the upper part is Portland Stone.

T.R.K

T.R. Kitsell, *Jubilee Fountain at Buckley Wells, Bury*

comparatively cheap and demonstrably practical monument. A typical late-Victorian example was the fountain in Radcliffe erected by the executors of Noah Rostron.[9]

The district's First World War memorials ranged from free-standing outdoor monuments to those more prosaic tablets and plaques mounted on the walls of churches, schools and firms. Most war memorials did not include sculpture. Bury's main memorial did, however, incorporate a pair of bronze panels designed by Hermon Cawthra. Of the war memorials unveiled in the surrounding towns, the one in Radcliffe featured a striking sculptural group. This was the work of Sydney March whose firm was also responsible for the memorial in neighbouring Whitefield.[10] Edwin Lutyens designed the Lancashire Fusiliers' memorial situated outside the Wellington Barracks: a commission that was more personal than most of his war memorials because of his family's connections with the regiment. But, apart from the war memorials, these were barren years for public sculpture. Existing works were neglected and sometimes threatened by improvement schemes. The condition of what was regarded as one of the district's most popular monuments, Grant's Tower, became a matter of concern. Unfortunately, Ramsbottom District Council's plans to purchase and restore the tower came too late, and it collapsed in a storm in September 1944, before ownership could be transferred.[11]

A general indifference to public sculpture continued after the Second World War. These years saw Bury begin to suffer from the long decline of its traditional industries, leaving those who returned to 'Black Pudding Country' with uncomfortable images of a community marked by deprivation and poverty; a community, moreover, that was anchored in its past.[12] There was an obvious symbolism in the removal in 1974 of the gritstone statue of John Kay, a figure which had stood for almost a century on top of the premises of Robert Hall & Sons, once one of the town's largest employers.[13] Attitudes towards modern outdoor sculpture were marked by prejudices and misunderstandings. A nude life-size figure representing Nimrod installed in a public park provoked much criticism, leading eventually to its removal and disappearance. Attitudes were to change, but it would be easy to overstate both the speed and extent of the change. By the mid-1990s, however, there was, at least within some sections of the council, a recognition that public sculpture could become part of a wider programme of cultural and environmental regeneration, itself a force in maintaining and promoting economic investment in the district. In 1996 Bury Metropolitan Borough Council took a leading part in developing the Irwell Sculpture Trail. The 50-kilometre trail took the form of a series of linked footpaths following the River Irwell from its source to the north of Bacup, running through Bury and Salford, before ending at Salford Quays. It was developed in partnership with the City of Salford, Lancashire County Council and Rossendale Borough Council, the latter having already pioneered a sculpture trail. A bid to the Arts Council for National Lottery funds

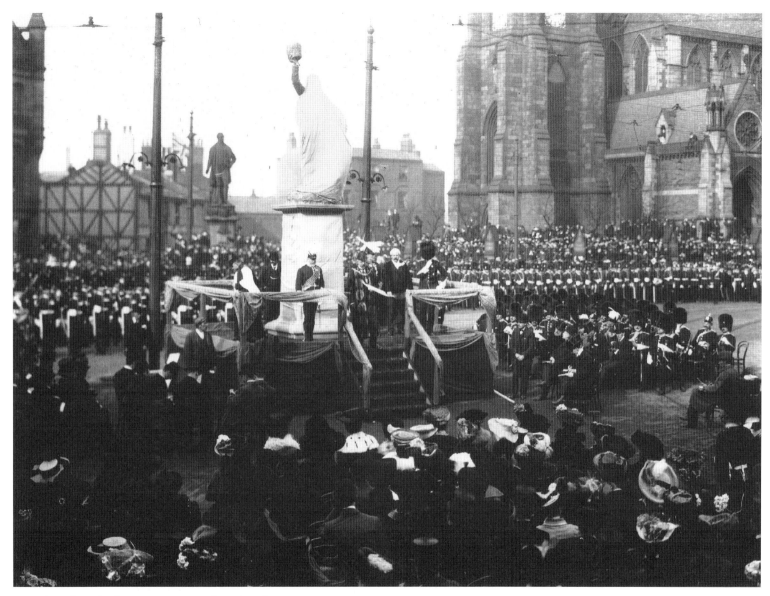

Unveiling of South African War Memorial, Market Place, Bury, 1905

resulted in an unprecedented grant of over £2.3 million, out of which it was intended to produce some fifty works, including eight major commissions.[14] Additional funding was to be provided by the participating councils and local businesses. Since the opening of the trail, the Bury section has seen the installation of a number of sculptures including major works from the internationally recognised artists, Ulrich Rückriem[15] and Edward Allington.[16] These works, installed during what can be viewed as Bury's second golden period of public sculpture, did not necessarily find local approval, in spite of considerable efforts to involve communities in the commissioning process. The controversy over Allington's *Tilted Vase* in Ramsbottom may not be as well documented as Serra's *Tilted Arc* in New York, but it was just as revealing of popular attitudes about the nature and purpose of public sculpture in general, and of the media's representation of public art and public space in particular, at the end of the twentieth century.

Notes
[1] S.D. Chapman, 'The Peels in the early English cotton industry', *Business History*, 11 (1969) pp.61–89. [2] H. Taylor, *The Ancient Crosses and Holy Wells of Lancashire* (Manchester: Sherratt and Hughes, 1906) p.466; A.J. Dobb, *1846 and After. An Historical Guide to the Ancient Parish of Bury* (Eccles Parish Church Council, 1970) p.19. [3] H. Dowsett, *Holcombe Long Ago* (Manchester: J. Heywood, 1902) pp.109–29. [4] *The Pictorial History of the County of Lancaster* (London: G. Routledge, 1844) p.244. [5] 'Breezy Bury', undated newspaper cutting, Chetham's Library. [6] *Bury Times*, 22 May 1869. [7] Gunnis (1968), p.389. [8] The Union Bank and Conservative Club (architects: J.D. Moulds and Porritt) included seated female figures flanking the pediments in Silver Street and Broad Street. *Bury Times*, 25 June, 2 July 1904. [9] Erected at the junction of Stand Lane and Whitefield New Road, August 1896. Revd W. Nicholls, *History and Traditions of Radcliffe* (Manchester: J. Heywood, 1910) p.317. [10] *Radcliffe Times*, 5 February 1921; *Bury Times*, 9 February 1921. [11] *Bury Times*, 23, 27 and 30 September 1944. [12] G. Moorhouse, *Guardian*, 24 April 1971. [13] *Bury Times*, 18 June 1974. [14] *Ibid.*, 6 August 1996. [15] P.L. Tazzi, 'Romancing the stone', *Artforum*, September, 1990, pp.143–7; *Ulrich Rückriem* (London: Serpentine Gallery, 1991). [16] S. Morgan, *Edward Allington: New Sculpture* (London: Riverside Studios, 1985); *Edward Allington* (Manchester: Cornerhouse, 1993).

Whittick and Royle, *Carved panel depicting female cotton operatives, Bury Textile Hall*

Bolton Road

Wellington Barracks

Lancashire Fusiliers' War Memorial
Sir Edwin Lutyens

25 April 1922
Portland stone
6.88m high; base 5.16m diameter
Inscription in incised letters on front face of
obelisk: XX / OMNI AUDAX / MCM / XIV / + /
MCM / XIX – inscription on base: TO THE /
LANCASHIRE FUSILIERS / THEIR / DEEDS AND
SACRIFICES / FOR / KING AND COUNTRY /
MCMXXXIX / + / MCMXLV / AND ALL FUSILIERS
WHO DIED / IN SUBSEQUENT CAMPAIGNS
Status: Grade II
Condition: fair
Owned by: Lancashire Fusiliers
 Description: War memorial; a stone base and
pedestal, square with curved ends, surmounted
by a slender obelisk. Near the top of the shaft is
the regimental badge encircled with laurel
wreaths. Two coloured enamelled stone flags
(the King's Colour and the Regimental Colour)
flank the shaft.

The regimental memorial for the men of the
Lancashire Fusiliers who died in the First
World War was designed by Edwin Landseer
Lutyens who, because of family connections –
his father and great-uncle had been officers in
the regiment – declined a fee for the work.[1] A
committee chaired by Colonel G.E. Wike
oversaw the arrangements for the memorial. In
both form and scale the design owed little to the
cenotaphs that had become Lutyens'
recognisable memorial to the fallen. John
Tinline, a local firm of stonemasons, was
responsible for realising the design. The
memorial was situated at the main entrance to
the Wellington Barracks, the regiment's
headquarters. April 25th, the date chosen for

Lutyens, *Lancashire Fusiliers' War Memorial*

the unveiling, was the anniversary of the
landing at Gallipoli, a day which had seen the
regiment suffer extreme losses and perform
extraordinary acts of bravery. Numbered
among the regiment's 18 Victoria Crosses were
the famous six won before breakfast at
Gallipoli.[2] Understandably, these events were
referred to by Lieutenant-General Sir Beauvoir
de Lisle in his speech before he unveiled the
memorial.[3] After the necessary expenses for the

memorial had been met, the additional money
collected was placed in the regiment's
Compassionate Fund. The memorial remained
at the main entrance to the barracks until 1961,
when, following the reorganisation and
relocation of the regiment, it was moved a short
distance to the front of the new regimental
headquarters and museum.[4] The depot remains
the Lancashire headquarters of the Royal
Regiment of Fusiliers. The memorial is well
maintained, though over time the stone has
weathered and there is evidence of
discolouration.

Notes
[1] J.C. Latter, *The Lancashire Fusiliers 1914–1918*
(Aldershot: Gale and Polden, 1949) pp.182–4.
[2] G. Moorhouse, *Hell's Foundations. A Town, Its
Myths and Gallipoli* (London: Hodder & Stoughton,
1992) pp.179–82. [3] *Bury Times*, 29 April 1922.
[4] *Ibid.*, 24 September 1960.

Broad Street

Bury Arts and Craft Centre
Architect: Joshua Cartwright

Architectural sculptors: J.J. Millson and J.R. Whittick

15 September 1894
Cullingworth limestone
Centre panel 91cm × 2.44m; side panels 91cm ×
 3.66m
Status: Grade II
Condition: fair
Owned by: Bury Metropolitan Borough
 Council
 Description: The town's former technical
school, built in the Free Renaissance style, on a
long irregular site between Broad Street and
Moss Street. The principal elevation is five bays
wide and includes an impressive central
doorway with swan-necked pediment, and the
words 'Technical School' carved on the
pediment. The principal decoration is a frieze of
five sculpted panels stretching across the front
of the building, depicting crafts and skills

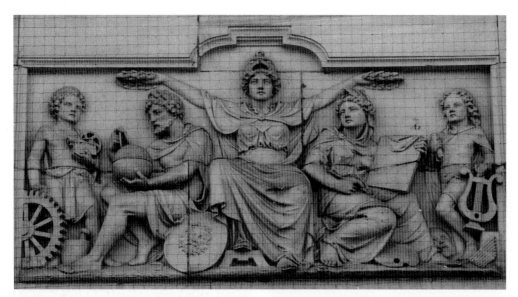

Millson and Whittick, *Arts and Science*

Millson and Whittick , *Industry*

Right-hand side above three-light sash
windows: The near panel represents the Applied
Sciences including Science (a seated male with a
book and telescope); Mathematics (female
measuring with dividers); and Chemistry
(a seated female with a flask). A railway engine
forms the backdrop of the panel. The end panel
represents various aspects of Literature, and
includes an author (a seated male figure writing
at his desk, a sword beneath his foot); reading
(a kneeling youth with books); printing (a boy
operating a printing press); and music (a seated
female, a lyre by her seat).
Left-hand side above three-light sash windows:
The near panel represents the Arts, including
painting (a seated female at an easel); pottery
(a boy decorating a large vase); sculpture (a boy
carving a lion); and architecture (a seated male
holding the model of a building). The end panel
represents Industry, including textiles (a female
handspinner and a male handloom weaver);
mining (a boy carrying a pickaxe and lamp); and
metalwork (a seated male by an anvil, holding a
sledge-hammer). On the gable end at the rear of
the building on Moss Street is a large carved
circular coat of arms of the borough.

taught at the school. Each composition
comprises five people, carved in relief. Above
the doorway is a panel of five figures: the
central one is a female holding wreaths in her
outstretched arms above figures representing
the arts and applied sciences.

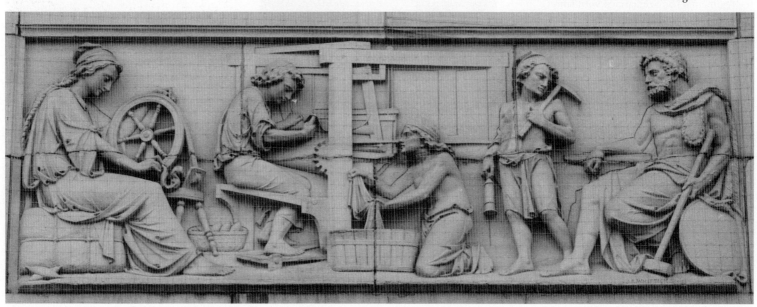

Bury Technical School was built at a rapid pace, only 15 months separating the laying of the cornerstone by Lord Stanley in June 1893 and the official opening by his father, the Earl of Derby, in September 1894.[1] The school's origins lay in the legislation of the early 1890s, which encouraged the establishment of schools for technical education. The council acquired land from the 16th Earl of Derby in the centre of the town in 1892, a plot between Broad Street and Moss Street. The borough engineer, Joshua Cartwright, was responsible for the planning and design of the building, a style he termed as 'Classic with Renaissance ornament'.[2] The design included sculpted panels on the principal façade in Broad Street, depicting subjects taught at the school. These were the work of the Manchester sculptors, J.J. Millson and J.R. Whittick. They were not fully completed at the time of the official opening.

The building remained the town's main technical school until after the Second World War, when changes in the organisation of further education led to its becoming the School of Arts and Crafts and later the Arts and Craft Centre.[3] The panels are in reasonable condition and are protected by bird nets.

Notes
[1] *Bury Times*, 24 June 1893; *Manchester Courier*, 26 June 1893; *Bury Times*, 15 and 19 September 1894. [2] *Bury Times*, 15 September 1894. [3] W. Bohman, *Commemorative History of Bury Arts and Craft Centre 1894–1994* (Bury, 1994).

Buckley Wells

Intersection of Manchester Old Road and Manchester Road

Jubilee Fountain
Architect: Thomas Rodgers Kitsell

15 October 1897
Granite; Portland stone
7.6m high approx × 3m square base
Inscription around cornice: THE FOUNTAIN OF

LIVING WATERS / IF ANY MAN THIRST LET HIM / COME UNTO ME AND DRINK / VIC. REG. 1897 60 YEARS.
Status: Grade II
Condition: poor
Owned by: Bury Metropolitan Borough Council
Description: Drinking fountain, Italianate in style. The base of the fountain is Dartmoor grey granite with semicircular troughs on three sides. (A contemporary drawing shows gargoyles of lion's heads through which water passed into the lower troughs.) Above the base four polished red granite columns support an open balustraded canopy of Portland stone. The canopy is richly decorated, gargoyles at each corner carrying the water away from the roof. The carved head of a man and a horse decorating the arches define the human and animal sides of the fountain. Beneath the canopy was a red granite fountain vase surmounted by a bronze statue of a small boy (now missing).

This ornate drinking fountain was erected to mark the Diamond Jubilee of Queen Victoria. It was donated by Eliza Anne Openshaw, daughter of Oliver Ormerod Openshaw, one of Bury's leading cotton manufacturers. The Openshaws were, according to the *Bury Guardian*, 'one of the oldest of the many old families which Bury can boast': families whose histories were indeed 'a great deal of the history of the town itself'.[1] Miss Openshaw's gift was made through a local vet, William Noar, the brother-in-law of the architect, Thomas Rodgers Kitsell (1864–1917). Kitsell had lived for a time in Bury, though his main practice was in Plymouth, which was also home to the contractors, J. and R. Goad.[2] Perry & Co. were responsible for the bronze putto.[3] Although the fountain had been given anonymously, the identity of the donor soon became an open secret. It occupied a landmark position, Buckley Wells, at the junction of the old and new Manchester Roads, a prominence that was

Kitsell, *Jubilee Fountain*

further emphasised by the creation of a small park on the adjoining land. The fountain was completed in October 1897, but the construction of a railway tunnel across this part of the town and then the laying out of the park meant that it remained boarded up until the summer of 1899.[4] When finally opened to the public, the fountain was welcomed both as architecture and amenity. It was reported to have cost about £600.[5]

The fountain has been neglected and vandalised over the years. Both the basin and

the statue have disappeared, whilst parts of the base appear to have been deliberately broken. In addition, the carved decoration on the Portland stone canopy has weathered severely. The original weather vane, however, appears to have remained intact. The idea of restoring the fountain has been raised on a number of occasions but no action has resulted. In 2002 the Council's intention of siting a 'park and ride' facility in this part of Bury renewed consideration of restoring the fountain.[6]

Notes
[1] *Bury Guardian*, 21 January 1893. [2] H.M. Colvin, *A Biographical Dictionary of British Architects 1600–1840* (London: J. Murray, 1978) p.531. In 1891 Kitsell was living at an address in Manchester Road, Bury. [3] *Builder*, 16 October 1897 p.308. [4] *Bury Times*, 15 October 1897. [5] *Ibid.*, 1 July 1899. [6] Information from Nick Grimshaw, Bury Metropolitan Borough Council.

Burrs Country Park
Waterwheel
David Kemp

1996
Welded steel; stone
2.37m high × 3.88m long
Status: not listed
Condition: good
Owned by: Bury Metropolitan Borough
 Council
 Description: The upper part of a large steel wheel, reminiscent of a turning waterwheel, emerging out of a stone base or wall. An arc of blue fish emerges from the base and is transformed into white birds, flying in a tangential arc across a smaller half-wheel.

Following a competition organised in March 1995, David Kemp was commissioned by Bury Metropolitan Borough Council to provide a sculpture to be sited at the main entrance of Burrs Country Park. The park had been created from largely derelict land over a period of some five years. The sculpture was required to serve

Kemp, *Waterwheel*

as a landmark sign identifying the country park. Kemp found inspiration for the work in both the industrial and the natural history of the area. The large heavy wheel emerging out of the masonry suggested those waterwheels which had been a key power source for the cotton mills in the early industrial revolution. It also represented that process of continual transformation which had shaped and was shaping the landscape: 'the changing of a river into an industrial site and its change back into countryside again'.[1] The silhouettes of fish and birds were introduced on the outer flange and rim. The completed work was installed in 1996 but without any formal ceremony.[2]

Notes
[1] Information from David Kemp, November 1999.
[2] *Bury Times*, 29 February 1996.

Picnic Area
David Fryer

1998
Stainless steel
6.01m × 2.34m × 86cm high
Inscription on plate of trap: PICNIC AREA
Status: not listed
Condition: good
Owned by: Bury Metropolitan Borough
 Council
 Description: Human-size stainless steel mouse trap with the words 'Picnic Area' inscribed upon the plate.

This work was commissioned as part of the Irwell Sculpture Trail, and located in Burrs Country Park. David Fryer's sculpture is a large man-size mouse trap in stainless steel. It is

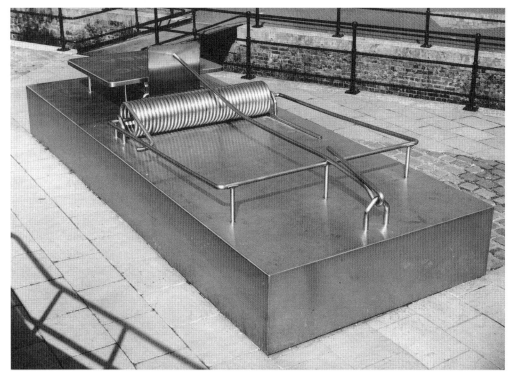

Fryer, *Picnic Area*

Stone Cycle
Julie Edwards

4 November 1997
Gritstone; inlaid metals: copper, brass, stainless
 steel
Stones are approximately 2m high × 61cm long
 × 45cm wide; diameter of area covered by
 stones 24.4m
Status: not listed
Condition: good
Owned by: Bury Metropolitan Borough
 Council
 Description: Forty rectangular stone blocks,
taken from a dismantled local bridge, cut on
one side to present an approximate triangular
shape. They are arranged, either as single pieces
or in pairs, in a series of three circles on the
ground. Carved on the stones are the outlines of
various natural and man-made objects including
leaves, shells, cones, feathers, fish, bobbin,
heald, spanner and bolt. Some of the original

Edwards, *Stone Cycle*

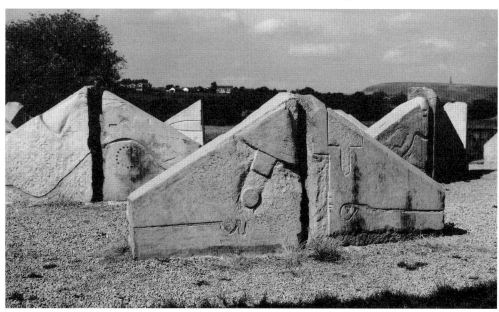

located near the car park, so that it is one of the
first objects seen by visitors to the country
park. Adjacent are the remains of a cotton mill,
one of the earliest to be built in the Bury area.
The title 'PICNIC AREA' is picked out in blue
paint on the baiting area of the trap. Fryer
regarded the work as a wry comment on the
previous history of the site and its new role as a
country park. The inclusion of the words
'Picnic Area' encourages the visitor to question
whether the sculpture can be regarded as a
public amenity or a tourist trap.[1] The Bury Art
Gallery has a maquette.[2]

Notes
[1] Information from Cathy Newbery, Irwell
Sculpture Trail. [2] Information from Richard Burns,
Bury Art Gallery.

mason's marks, cut when the stones were used to build a bridge, are also visible.

The sculpture was created by Julie Edwards during the time she was artist-in-residence at Burrs Country Park. It is located in the park and is part of the Irwell Sculpture Trail. *Stone Cycle* refers to the lives of the people who worked and died in the surrounding district, as well as to the life of the stones themselves. Edwards drew her inspiration from the local textile industry, especially as it existed during the early industrial revolution, when young children worked long hours in often dangerous conditions. The sculpture is thus 'a memorial to this slavery, the symbols on the stones, layered messages of the past'. The locally quarried gritstone came from a former railway bridge. Transporting and placing the stones was a considerable problem because of the site's proximity to the River Irwell and a feeder canal. Julie Edwards observed that 'to re-invent, yet work with the original cut shape, grind away 100 years of industrial grime and discover the marks made by the original masons, added a sense of time to the work'.[1] Braille symbols were incorporated into the design, recognising different needs within the community.

Notes
[1] Correspondence with Julie Edwards, November 1998; *Bury Times*, 1997, undated cutting.

Kay Gardens

Kay Monument
Architect: **William Venn Gough**
Sculptor: **John Cassidy**

6 April 1908
Portland stone; red granite; marble; bronze figures
10.36m high approx × 3.35m wide approx at base
Inscription on bronze panel beneath an oval portrait medallion of Kay: THE GIFT OF HENRY WHITEHEAD OF HASLAM HEY TO HIS NATIVE TOWN / TO PERPETUATE THE NAME AND FAME OF / JOHN KAY / OF / BURY. / WHOSE INVENTION IN THE YEAR 1733 OF THE FLY SHUTTLE / QUADRUPLED HUMAN POWER IN WEAVING & PLACED ENGLAND IN THE FRONT RANK / AS THE BEST MARKET IN THE WORLD FOR TEXTILE MANUFACTURES. / HE WAS BORN IN BURY IN 1704, AND DIED IN EXILE AND POVERTY IN FRANCE, / WHERE HE LIES IN AN UNKNOWN GRAVE – on bronze panel, rear: INVENTOR ALSO OF / METAL REEDS FOR LOOMS. / IMPROVED METHODS OF / SPINNING TWINE, WORSTED / AND MOHAIR, / WIND & HORSEPOWER PUMPS, / POWER TAPE LOOM, / MALT KILNS, SALT PANS, / AND MANY OTHERS.
Status: Grade II
Condition: fair
Owned by: Bury Metropolitan Borough Council
Description: Monument, Italianate in style, sited in the memorial gardens. The monument, standing on a broad octagonal plinth of seven granite steps, is octagonal in shape with a Portland stone dome, surrounded by a balustrade, and surmounted by a bronze female figure representing Fame, who is shown blowing a long thin trumpet and holding a laurel wreath. Four smaller bronze sculptures of male figures are positioned around the canopy. These represent Weaving (a young man wearing a cap and holding a shuttle in his right hand); Engineering (a man holding a compass, his right hand resting on a cogwheel); Mining (a bare-chested man carrying a pickaxe and safety lamp); and Agriculture (a young man holding a sickle in his right hand, mopping his brow with the other hand). The main stage of the monument includes eight red granite Ionic columns breaking forward under an entablature. These frame bronze panels containing the inscriptions and two other panels depicting a handloom and powerloom respectively. The coats of arms of localities with which Kay was associated are included around the cornice.

John Kay, born near Bury in 1704, is remembered for his textile inventions, principally the fly shuttle, a simple device which dramatically increased the output of the handloom. It was widely adopted, stimulating the search for improved technologies in the spinning sector. Kay's contribution to the emergence of factory-produced cloth was

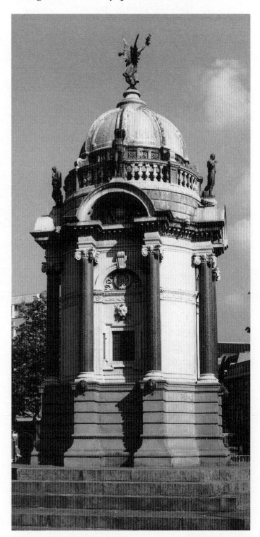

Gough, *Kay Monument*

recognised by the earliest historians of the cotton trade. They portrayed him as an individual whose native intelligence had enabled him to produce one of the key inventions of the industrial revolution but, importantly, also one who never received the financial rewards from his invention that he deserved. In a life that was, in general, weakly documented, one of the most frequently recounted incidents was the attack on his house by workers concerned about the impact his invention would have on their own livelihoods: an episode which forced him to leave Bury. This was the subject of one of the murals painted by Ford Madox Brown in Manchester Town Hall. Kay eventually went to France where he died in c.1780, and was buried in an unidentified common grave.[1]

Although the significance of Kay's invention was recognised in Bury little came of suggestions made during the nineteenth century that the town might acknowledge this connection by raising a public monument. Bury did not follow Bolton's lead when it raised a statue to Crompton, although a rather crude stone statue of Kay was erected by Robert Hall on his ironworks in Union Street.[2] A more concerted and ultimately successful effort to provide a public monument began early in the next century, when celebrations were organised to mark the bicentenary of Kay's birth. In recognising one of the town's most important figures, it was proposed to raise a suitable memorial and, more practically, to establish Kay scholarships to encourage further innovation in the textile industry.[3] William Wilkinson, the weaving union's general secretary, captured the mood in arguing that it was not too late to honour Kay, whose invention, above all others, had allowed the modern weaving industry to develop. Subscriptions began to be collected.[4] It was in 1906 that the idea of a separate monument or statue gained a new impetus. In that year, one of Bury's most prominent and wealthy businessmen, Henry Whitehead, agreed to meet all the costs of creating a new public space in the centre of the town, a space on which he would also place a memorial to Kay. Whitehead's generosity meant that all of the public subscriptions could be used for scholarships.

The new public space was a triangular-shaped area of land previously occupied by the town's Derby Market, a new market hall having been built in 1901. Plans were made to lay out the land as a small public garden on which would stand the new memorial. It was designed by the Bristol architect, William Venn Gogh (1842–1918), memorably described as 'a rogue architect with at times something maniacal about his designs'.[5] He was known in Bury through his work on the grammar school. Whitehead selected the design which was then approved by the council. The Manchester sculptor, John Cassidy, was commissioned to provide the bronze statuary and plaques. In all Cassidy sculpted five figures including four male figures representing different industries. Not all of the work went outside the town, as the local building firm, Thompson and Brierley, was responsible for constructing the memorial. Stone saved from the old market building was incorporated in the lower part of the monument.

Cassidy, *Weaving*

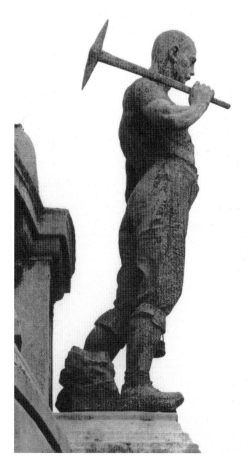

Cassidy, *Mining*

Mrs Henry Whitehead opened the Kay Gardens and the 16th Earl of Derby unveiled the Kay Monument in April 1908. In addition to the memorial, the gardens included a polished granite drinking fountain presented by the Bury businessman and freemason, Colonel John Barlow.[6] The speeches at the ceremony recognised both the debt that was owed to Kay and the great improvement to the town brought about by the new gardens.[7] An editorial on the day's events in the *Manchester Guardian* also pointed to a more practical lesson: the need to strengthen existing patent laws to prevent the losses suffered by inventors such as Kay and Crompton.[8]

The Kay Memorial and the gardens became a popular meeting place in the town centre. When in 1933 the bicentenary of Kay's famous invention was celebrated at the memorial, the Lancashire cotton industry was already in the grip of forces that would eventually lead to its disappearance.[9] Over the following decades the monument began to show obvious signs of neglect. In 1996 it was in such a dangerous condition that it was fenced off to protect the public.[10] The importance of the monument was, however, recognised, and after some delay it was restored. The restoration did not include replacing the original railings on the top step of the plinth.

Notes
[1] J. Lord, *Memoir of John Kay of Bury* (Rochdale: Aldine, 1903). [2] *Bury Times*, 18 June 1974. [3] *Ibid.*, 9 July 1904. [4] *Ibid.*, 20 July 1904. [5] A. Gomme, *Bristol: An Architectural History* (London: Lund Humphries, 1979) p.436. [6] *Bury Times*, 1 and 4 October 1924. [7] *Bury Guardian*, 4 and 6 April 1908; *Manchester Courier*, 6 April 1908. [8] *Manchester Guardian*, 6 April 1908. [9] *Bury Times*, 31 May 1933. [10] *Ibid.*, 7 June 1996.

Manchester Road

Junction of Manchester Road and Moss Street

Bury Art Gallery and Museum and Library

Architects: Woodhouse and Willoughby

Architectural sculptor: John Jarvis Millson

19 October 1901
Darley Dale stone
Library panels: centre panel 91cm × 2.44m, side panels 91cm × 1.83m, return panels 91cm × 1.22m; Art Gallery panels 91cm × 1.83m
Status: Grade II
Condition: good
Owned by: Bury Metropolitan Borough Council

Description: Public art gallery and library in free classical style. It is situated on the junction of Manchester Road and Moss Street. Both of the main elevations have sculptural decoration.

Manchester Road: above the central section of the triple-arched entrance is a cartouche with the borough coat of arms; flanked by two standing figures representing Literature (a male figure holding a book in his left hand and a pen in his right) and Art (a female figure holding a palette in her left hand).

A frieze runs along the top of the first storey of the projecting left-hand bay; two columns divide the frieze into three parts. The overall theme is Literature, represented by the Muses and the Cardinal Virtues. The main figure in the central panel is Mnemosyne (Memory and mother of the Muses) standing in front of a throne, her left hand resting on a book; supported on both sides by figures representing the liberal arts and sciences: to her far left, Grammar (a female figure with scroll inscribed with vowels); Rhetoric (a female figure holding a lyre); and Geometry (a female figure holding

dividers); to her far right, Arithmetic (a male figure with a scroll on which are algebraic formulae); Astronomy (a male figure with celestial globe); and Logic (a male figure). To the left of the centre panel, the frieze contains representations of the muses with the return end depicting some of the Cardinal Virtues. The corner figure is Calliope (a female figure with a tablet and stylus); Polyhymnia (a female figure with scroll); Melpomene (a female figure with crown and sceptre); Thespis (a female figure) and Thalia (a female figure with comedy mask). The return end depicts Justice in the form of Tralencus (a male figure with book resting on sword) administering justice to a male prisoner, flanked by two guards. To the right of the centre panel, the frieze continues with the Muses and Virtues. The corner figure is Erato (a female figure with a lyre and plectrum); Urania (a female figure with a globe); Terpsichore (a female figure with a lyre; Clio (a female figure carrying a book) and Euterpe (a female figure with a flute). The return end depicts Honour, represented by a soldier refusing a bribe, and Virtue, represented by a young female supported by Themis, Goddess of Law, who is holding a cornucopia.

The frieze on the right-hand bay is similarly divided into three parts. The overall theme is the Applied Arts. In the centre panel the main figure represents Art as applied to painting, a female figure standing in front of a throne, her left hand holding a palette. To her left are two figures representing vase painting, and a figure representing architecture (a man holding a model of a building). To her right are two figures representing design and drawing, one representing sculpture (a man holding a maquette). To the left of the centre panel the corner figure is a stonemason (a male figure carrying a carved baluster); a tiler (a male figure holding flooring tiles); two figures carrying textiles; a wood-carver (a man holding a carved wooden panel); and a modeller (a female figure). The return end depicts four workmen, possibly associated with the printing trades. To the right

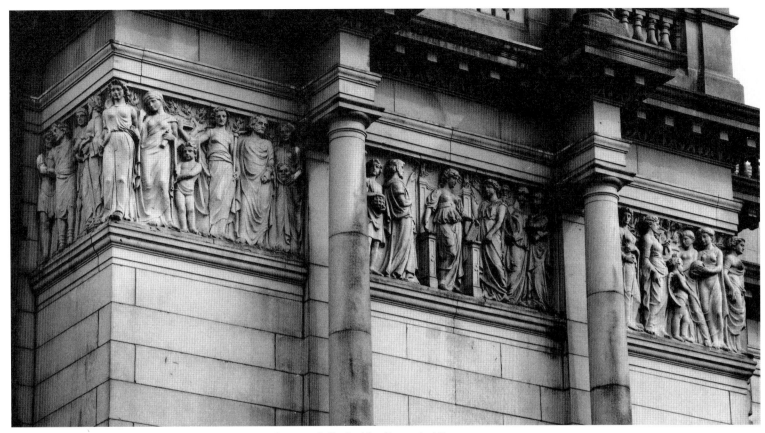

of the centre panel the corner figure represents
heraldry (a male figure holding a shield);
needlework (two female figures engaged in
needlework); three figures engaged in wallpaper
work; and a male craftsmen displaying repoussé
work. The return end depicts four craftsmen in
the building trades.

Moss Street: above the three-bay portico (the
entrance to the art gallery) are three sculpted
panels, divided by two columns, representing
Architecture, Painting and Sculpture. The
centre panel is Architecture, represented by a
seated male figure holding a model of a
building, flanked on either side by three male
figures holding plans and examples of
stonework. The panel to the left represents
Sculpture, a seated male working on a sculpture

of an angel, flanked by figures holding
balustrades, chisels and maquettes. The panel to
the right represents Art, the central figure being
a seated female painting an angel, flanked by
male and female figures.

The stimulus for building a public art gallery in
Bury came from the presentation of the art
collection of Thomas Wrigley to the town in
1897. The gift was made by Wrigley's three
surviving children, and was conditional on the
town providing a building to house the
collection. It was also given to mark the
diamond jubilee of Queen Victoria.[1] 'It was a
gift', observed the *Manchester Courier*, 'that
would make this grim town a Mecca for artistic
pilgrims.'[2] Thomas Wrigley (1808–80) whose

Millson, *Literature flanked by Muses and Virtues*

considerable wealth was derived from a paper-
manufacturing business begun by his father,
was a well-known figure in Bury.[3] He had
taken an active part in its public life, eventually
serving as High Sheriff of the county in 1872.
An interest in art led him to build up a
considerable collection of modern, largely
British, paintings, watercolours and statuary.
The council accepted the collection and
embarked on the task of providing a suitable
building. The project was soon widened to
include a municipal library, the borough having
not adopted at that time the necessary public
library legislation. The new building would

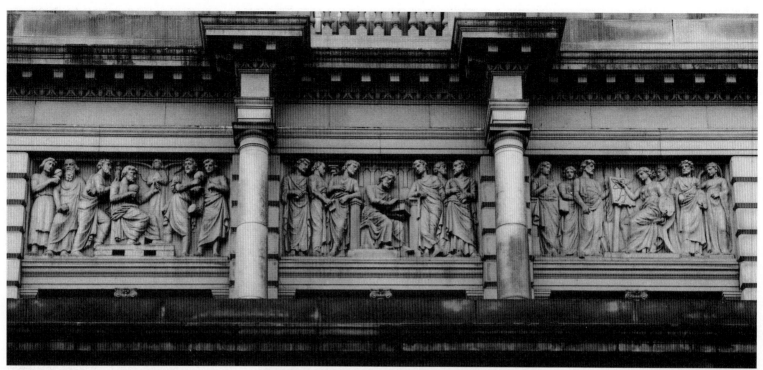

Millson, *Sculpture, Architecture, Art*

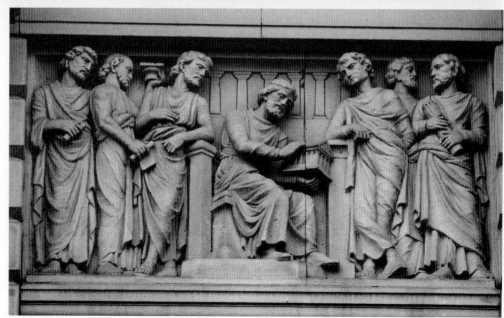

thus house both an art gallery and a library.[4] It was to be sited at the junction of Manchester Road and Moss Lane (later Moss Street). A competition was organised for the building, resulting in the selection of the design submitted by the Manchester architects, Woodhouse and Willoughby, from the 22 entries.[5] Their building was in what was described as the 'eighteenth-century English Renaissance style', and included friezes of sculpted figures on both of the principal elevations.[6] The sculpted panels were the work of the Manchester-based architectural sculptor, J.J. Millson. He produced the designs during a time when he was recovering from an accident. Some changes were introduced to the sculpted figures between the original plans and the final panels.[7] Millson was also responsible for the

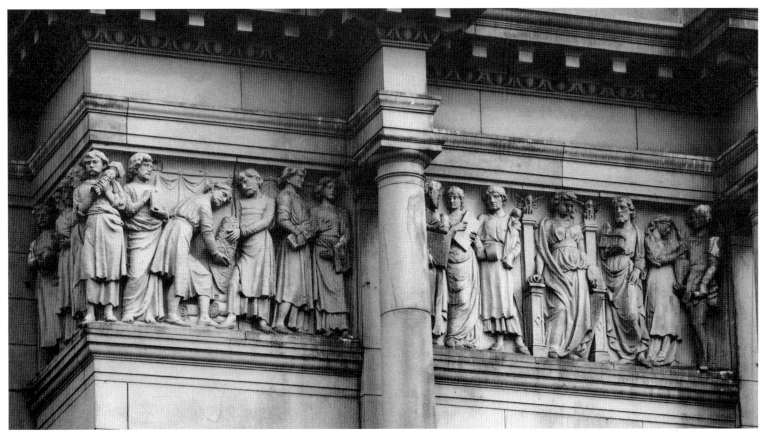

Millson, *Applied Arts*

carved marble tablet inside the gallery, which acknowledged the generosity of the Wrigley family.

Oswald O. Wrigley, the son of Thomas Wrigley, laid the foundation stone of the new gallery and library in April 1899.[8] The finished building was opened by the 16th Earl of Derby in October 1901, a ceremony which attracted a considerable crowd, even though it was a weekday.[9] Bury Municipal Art Gallery and Free Library was immediately recognised as one of the town's finest buildings, a building that would have stood out even in Manchester or Liverpool. Millson's carving strengthened the

building's presence. Some 60 years after it opened, Pevsner was being unnecessarily cautious in identifying it as 'probably the best building in Bury'.[10]

Notes
[1] *Bury Times*, 9 January 1897; *Manchester Guardian*, 8 January 1897. [2] *Manchester Courier*, 8 January 1897. [3] M. Tillmanns, *Bridge Hall Mills* (Tisbury, Wiltshire: Compton Press, 1978) pp.33–44. [4] *Bury Times*, 5 June 1897. [5] Minutes of Bury Art Gallery and Library Committee, 14 and 28 October 1897. [6] *Bury Times*, 5 March 1898; *Builder*, 12 October 1901 p.316. [7] *Bury Times*, 29 April 1899, 12 October 1901. [8] *Ibid.*, 29 April 1899. [9] *Ibid.*, 12 October 1901. [10] Pevsner, *South Lancashire* (1969) p.98.

Textile Hall

Architect: David Hardman

Architectural sculptors: Whittick and Royle

5 May 1894
Yorkshire stone
Centre panel (above door) 2.74m long × 61cm
 high; side panels 2.13m long × 76cm high
Status: Grade II
Condition: good
Owned by: Bury Metropolitan Borough
 Council
 Description: two-storey building with a front
of dressed Yorkshire stone. Above the porch of

Whittick and Royle, *Textile Hall (detail)*

central doorway is a semicircular carved panel of two female figures representing Spinning (her right hand resting on a spinning wheel) and Weaving (holding a shuttle, a power loom at her feet). On the upper storey between the two windows either side of the central porch are carved panels depicting the textile trades. The left-hand panel represents Carding, a male operative standing in front of a carding engine; the right-hand one depicts two female operatives doffing bobbins on a roving frame.

There was a recognition among the local cotton unions in late Victorian Bury that it would be advantageous for them to have their own building, instead of conducting business in rented rooms or public houses. This desire began to take a practical form when, in August 1892, the three main unions – cotton-spinning, carding and weaving – established a joint committee to examine the practicalities of erecting their own purpose-built headquarters. It was decided to go ahead with the project, and land was obtained on Manchester Road, a continuation of the town's most prestigious street, Silver Street. In January 1893 the plans prepared by the Bury architect, David Hardman, were accepted and work was soon under way.[1] Care was taken to employ workers on union rates. The building, which included meeting rooms as well as offices for trade union

officials, clearly marked the growing importance of the unions in the affairs of the town.[2] Union self-confidence was evident in the design of the main façade where decoration in the form of carved panels, representing different textile trades, announced the building's presence.[3] They were the work of the Manchester firm, Whittick and Royle. The Textile Operatives' Hall was opened by Lady Dilke in May 1894, in a ceremony which included a massive and colourful demonstration of trade unions processing through the town.[4]

The contraction of the cotton industry in the twentieth century and the consequent decline in union business led to the building being rented out for other purposes. In 1964 the cotton unions finally took the decision to sell the hall.[5] It was purchased by the borough council in 1971, and has since been home to a number of council departments.

Notes
[1] *Cotton Factory Times*, 26 August 1892. [2] *Ibid.*, 5 August 1892. [3] *Bury Times*, 5 May 1894. [4] *Cotton Factory Times*, 4 and 11 May 1894; *Manchester Guardian*, 7 May 1894; *Bury Times*, 9 May 1894. [5] *Bury Times*, 5 December 1964, 16 January 1965.

Market Place
Sir Robert Peel
Edward Hodges Baily

8 September 1852
Bronze statue; granite pedestal
Statue 3.5m high; pedestal 3.66m high × 1.2m square base
Inscription on front of pedestal, beneath family coat of arms, in raised bronze letters: PEEL –
Inscription on rear set in circular bronze panel encircled by a wreath of corn: "IT MAY BE, / I SHALL LEAVE A NAME / SOMETIMES REMEMBERED / WITH EXPRESSIONS OF GOOD WILL / IN THE ABODE OF THOSE, WHOSE LOT / IT IS TO LABOUR, AND TO EARN THEIR / DAILY BREAD BY THE SWEAT OF / THEIR BROW – WHEN THEY SHALL / RECRUIT THEIR EXHAUSTED STRENGTH / WITH ABUNDANT AND UNTAXED FOOD / THE SWEETER, BECAUSE IT IS / NO LONGER LEAVENED BY A / SENSE OF INJUSTICE"
Status: Grade II
Condition: fair
Owned by: Bury Metropolitan Borough Council
Description: Portrait statue; a larger than life-size bronze statue of Peel in modern dress. He is depicted speaking in public, his right arm held out with the hand open, the left resting on his hip. The plinth represents rocky ground surrounded with sheaves of corn. The squared pedestal of Aberdeen grey granite, raised on two steps, has inscriptions on the front and rear. On the sides are rectangular bronze bas-reliefs representing Commerce, in the form of a female figure, her right arm resting on a tower, and Navigation, a sailor looking out to sea, holding a telescope.

Sir Robert Peel was born at Chamber Hall, Bury in 1788, the eldest son of the first Sir Robert Peel (1750–1830), whose calico printing interests created one of the first industrial textile fortunes. The younger Peel was a

Baily, *Sir Robert Peel*

(below) *Commerce*

brilliant scholar, educated at Harrow and Oxford. He entered public life as a Tory member of parliament when only 21 years old. The success of his political career was such that he held a number of government offices at an early age. In 1822 he became Home Secretary, and initiated fundamental changes in the police and the criminal justice system. After the passing of the 1832 Reform Act, Peel recognised the importance of broadening his party's appeal and of its need to adopt change. When he returned to power in 1841 he introduced a radical programme of financial reform which culminated in his decision to repeal the Corn Laws. Although the decision brought him great popularity in the country – especially among the labouring classes, who associated their subsequent prosperity with the abolition – the more immediate political consequence was to divide the Conservative Party, and Peel lost the office of prime minister. Peel died unexpectedly in June 1850, following a fall from his horse while riding near Hyde Park Corner. On the day of his funeral mill towns stopped work as a mark of respect.[1]

Bury was only one of a number of Lancashire towns which called for a public memorial to be erected following the death of Peel. The project to erect a memorial in Peel's birthplace proceeded comparatively smoothly from the first public meeting early in July 1850.[2] The general idea of providing a 'substantial and appropriate memorial' was quickly refined into erecting 'a colossal bronze statue upon a suitable pedestal'. The site chosen was the Market Place, considered to be the centre of the town, although many of the surrounding buildings were less than grand. A public subscription was opened, and some £1,500 was pledged immediately.[3] The final sum collected was more than £2,700, ranging from the ten, twenty and fifty guinea subscriptions of local manufacturers to the threepences donated by local children.[4] A sub-committee of five – Edmund Grundy, Robert Kay, John Shaw, Samuel Woodcock and William Harper – oversaw the commissioning. It was decided not to hold an open competition, but to invite leading sculptors to submit designs. They included William Behnes, Joseph Durham, John and Edward Foley, William Calder Marshall, John Gibson, John Hogan, Samuel Manning, Baron Marochetti, Thomas Milnes and William Theed.[5] The instructions sent to them included a plan of the site and the recommendation that, if they introduced 'accessories which may be considered illustrative of the life or character of Sir Robert Peel' then such elements were to be subordinate to the statue itself. There was to be no premium for any of the designs submitted; the chosen sculptor receiving a fee not exceeding £2,500, exclusive of installation costs.[6] Three months were allowed for the submission of designs, but the committee was to change its position. It agreed to consider designs from other sculptors, including Matthew Noble, the architect, George Truefitt, and, more locally, Thomas Duckett of Preston and a Mr Chatwood of Bury. In the end some 20 sculptors and architects submitted designs.

The statuettes and models were put on public display in the town's recently opened assembly room, though it was made clear that the architectural schemes were inadmissible. The identification of the artists was seen as a welcome innovation.[7] Local journalists reviewing the various models found much to criticise.[8] The general committee's choice came down to the submissions by Baily and Marochetti, with the committee finally deciding by 20 votes to 13 to select Baily's No.1 design. It showed Peel in modern dress, standing on a plinth which featured wheat. This symbolism concerned some of the committee's members who felt it might be interpreted as 'Peel trampling upon agriculture'.[9] Baily, eager to obtain the commission after his disappointment in not being chosen for Manchester's Peel monument, had submitted five designs in all, including Peel in a toga. The selection of Baily, as the correspondent of the *Manchester Courier* made clear, did not meet with everyone's approval.[10] A plaster model of the final design, signed and dated 1852, is in Bury Art Gallery.[11] Baily met the committee in Bury towards the end of February, the beginning of a relationship that was not without its difficulties: 'the Bury people are a queer lot', he confided privately, particularly when it came to arranging payments.[12] An article in the *Art Journal* on the subject of the unwillingness of memorial committees in the 'north of England' to pay sculptors in instalments may have been prompted by discussions with Baily.[13] The statue was completed by August 1852, having been cast at Robinson's foundry in Pimlico.

Arrangements were made for the unveiling ceremony. There was a slight alteration in the proposed position of the statue, to take account of changes proposed to the Market Place.[14] Bury's Peel statue was unveiled in September 1852, the previous months having seen Peel statues inaugurated in Salford, Preston, Tamworth and Leeds. It was a day of celebration that began with a procession from the house – Chamber Hall – in which Peel had

been born. Frederick Peel, Peel's son and the recently elected MP for Bury, unveiled the statue before a crowd estimated at between 12,000 and 20,000.[15] The platform speeches emphasised Peel's local connection and his stature as a statesman. Peel's decision to repeal the detested Corn Laws was underlined by the inscription on the pedestal, an extract from his final speech as Prime Minister to the House of Commons. Thomas Bazley, chairman of the Manchester Chamber of Commerce, was one speaker who explicitly connected the improvement in living standards now being enjoyed by the working classes to Peel's self-sacrificing decision to repeal the Corn Laws.[16] It was left to the Liberal *Manchester Guardian* to underline the humiliation that the Tories were now suffering through their ostracism of Peel:

> They must also see that the English nation appreciates and respects in Sir Robert Peel those virtues in which his present successors are grievously deficient. They cannot refuse to learn that frankness to avow conviction, high-mindedness, and love of country before self, count for something more in the estimation of an honest people, than, during years of studied duplicity, they had allowed themselves to suppose. Lord Derby has a seat in the House of Lords, and may, for all we know, have a tomb in Westminster Abbey; but when will he get a corner in the market place of a dozen English towns, or a niche in the households of the people?[17]

The fact that Lord Derby was the largest landowner in Bury and that the Derby Arms fronted on to the Market Place would not have escaped the attention of many of the newspaper's readers.

The correspondent of the *Illustrated London News* followed the general sentiment in approving of Baily's representation of Peel. It was a work in which

> the features are truthful and striking. The

figure looks rather massive in regard to breadth, but it is very much admired and highly spoken of by those present who were best acquainted with Sir Robert Peel.[18]

While Baily had included some telling points of detail, such as the ribbon attached to Peel's eye-glass, sharp-eyed observers were to point out that the treatment of the waistcoat appeared to be incorrect, as Peel buttoned his waistcoats on the opposite side, following a shooting accident which resulted in the loss of the thumb on his right hand. This 'mistake' apparently had been pointed out to Baily, who decided not to alter the waistcoat.[19]

Baily's statue of Peel has remained in the old Market Place, but over the years changes have both enhanced and devalued this important public space.[20] The siting of underground public conveniences with an entrance close to the statue was not one of the most sensitive examples of civic improvement. Other changes have included the removal of the bronze railings which originally protected the statue.[21] However, despite occasions when it was suggested that the statue might be moved, no action was taken.[22]

Notes
[1] N. Gash, *Mr Secretary Peel* (London: Longmans, 1972); T.A. Jenkins, *Sir Robert Peel* (New York: St Martin's Press, 1999). [2] Peel Memorial Committee Minute Book, 10 July 1850 (Bury Archives). [3] Peel Memorial Subscription Book (Bury Archives). [4] Peel Memorial Committee Minute Book, 24 September 1850 (Bury Archives). [5] Peel Memorial Committee Minute Book, October 1850 (Bury Archives). [6] *Ibid.*, (Bury Archives). [7] *Illustrated London News*, 22 February 1851, p.161. [8] *Manchester Guardian*, 12 February 1851; *Manchester Courier*, 15 February 1851. [9] Peel Memorial Committee Minute Book, 25 February 1851(Bury Archives). [10] *Manchester Courier*, 22 February 1851. [11] B. Read, *Victorian Sculpture*, pp.29–30. [12] E.H. Baily to W. Fleming, letters dated 19 June 1851, 3 July 1851 (Manchester Central Reference Library, Local Studies Department). [13] *Art Journal*, April 1851, p.105. [14] Peel Memorial Committee Book, 30 January 1852 (Bury Archives); *Programme. Inauguration of the Peel Statue, Bury* (Bury: J. Heap [1852]). [15] *Manchester*

Guardian, 11 September 1852; *Manchester Courier*, 11 September 1852; *The Times*, 10 September 1852. [16] *Manchester Guardian*, 11 September 1852. [17] *Ibid.* [18] *Illustrated London News*, 18 September 1852. [19] James Shaw, *East Lancashire Review*, May 1890. [20] *Bury Times*, 1 November 1969, 20 October 1972. [21] Paintings and photographs in Bury Local History Department. [22] *Bury Times*, 1 November 1969, 20 October 1972.

Bury War Memorial
Architect: Sir Reginald Blomfield
Sculptor: Joseph Hermon Cawthra

11 November 1924
Granite; bronze panels
Cross 10.36m high; bronze panels 3.32m × 70cm
Signed on both panels: H. Cawthra R.S.S. Scul.
Inscription on pedestal beneath a laurel wreath:

> TO THE MEMORY OF THE MEN / OF BURY WHO GAVE THEIR / LIVES IN THE GREAT WAR / 1914 / 1918

Status: Grade II
Condition: good
Owned by: Bury Metropolitan Borough Council

Description: War memorial; granite cross on pedestal flanked by curving wing walls on which are rectangular bronze panels. The panel on the left-wing wall depicts military life and includes figures from the three armed forces and a female nurse. In the centre soldiers are shown carrying a stretcher on which is a wounded man. On the end of the wall is the carved shield of the arms of Bury beneath the words Pro Rege. The panel on the right-hand wing depicts the Home Front, represented by men and women from different occupations, including coal-mining, engineering, carpentry and munitions. The wall terminates with a carved shield of the arms of the county beneath the words Pro Patria.

Bury decided to commemorate the local men who had lost their lives in the First World War

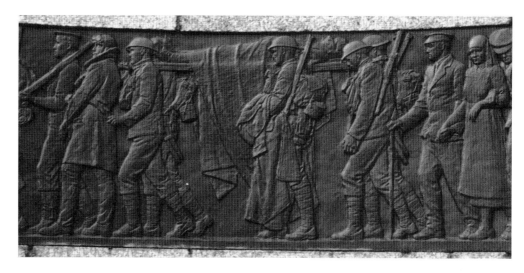

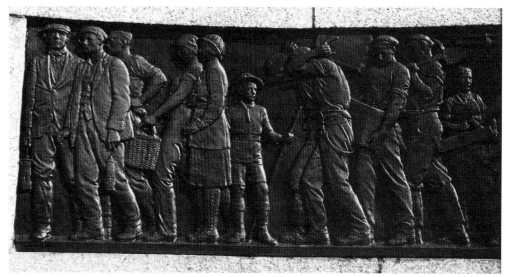

Cawthra, *Bury War Memorial (panels, details)*

by establishing a children's wing to the Bury Infirmary and erecting a formal memorial in the town centre. Raising the enormously ambitious sum of over £50,000 to build and endow the children's wing was the memorial committee's priority. A visible memorial was seen as less

important, in part because of the erection of local memorials, including the one erected outside the headquarters of the Lancashire Fusiliers. The issue of a town memorial was, however, finally settled by an anonymous donor who promised to give £1,000 on the understanding that a memorial was erected in the Market Place. The memorial committee responded positively to the offer. The exact site

was on the edge of the Market Place, the land, part of St Mary's churchyard, being provided by the church. St Mary's had a long connection with the Fusiliers and contained many regimental memorials and tributes. The memorial was designed by the architect and garden designer, Sir Reginald Blomfield, whose work, in particular for the Imperial War Graves Commission, made him an influential figure in the post-war years. Built of Cornish granite, the Bury memorial took the form of a cross surmounting a pedestal, flanked by curving walls, a design that acknowledged the shape and restrictions of the site. The construction of the memorial was undertaken by Kirkpatrick's of Trafford Park, Manchester. Hermon Cawthra was responsible for the two bronze panels on the wing walls. These depicted military and civilian life in the war, in the form of a procession of representative figures. Cawthra's other war memorials included one at Bootle, Lancashire. The Bury memorial was unveiled on Armistice Day, 1924 by Mrs Peachment, whose eighteen-year-old son, George, had been awarded a posthumous Victoria Cross.[1] On the following Saturday the children's ward was opened by the 17th Earl of Derby.[2]

Notes
[1] *Bury Times*, 12 November 1924, 15 November 1924. [2] *Ibid.*, 19 November 1924.

St Peter's Road
Bury Cemetery

Cemetery Gates
Architect: Henry Styan

Architectural sculptor: Joseph Bonehill

May 1869
5.94m high approx
Status: Grade II
Condition: fair
Owned by: Bury Metropolitan Borough
 Council

Description: Cemetery gates; four stone piers, gothic in style. The inner piers are decorated with elaborate crocketted canopies and niches in which are the figures of angels holding scrolls.

Victorian Bury opened its municipal cemetery in 1869. Located to the south of the town, off the Manchester Road, the 13-hectare cemetery was laid out and designed by the borough surveyor, James Farrar, and the Manchester architect, Henry Styan. The main entrance on St Peter's Road was marked by an impressive and ornate gateway. The inner piers, in particular, were decorated with some fine carving including the figures of angels. This was the work of the Manchester sculptor, Joseph Bonehill. Ornamental globe lamps (now missing) surmounted the piers. Some 2,000 people attended the official opening.[1]

Note
[1] *Bury Times*, 22 May 1869.

Silver Street

Barclays Bank
Architect: Blackwell and Son and Booth

Architectural sculptor: Joseph Bonehill

1868
Ashlar
Status: Grade II
Condition: good
Owned by: Barclays Bank plc
 Description: Two-storey building designed in an enriched classical style for the Bury Banking Company. The columns on the front culminate in a segmented pediment, above a cornice supported by corbels decorated with lions' and dolphins' heads. The pediment

Bonehill, *Barclays Bank*

contains a sculpture of six young children, shown carrying out various banking activities. Two seated figures are shown writing, whilst the two standing figures are operating a paper press. Above the pediment is a panel with the word 'Bank' carved in large raised letters.

This imposing commercial building was constructed for the Bury Banking Company in 1867–8. It was designed by Blackwell and Son and Booth of Manchester and Bury. The Manchester firm of Henry Southern was responsible for the construction, with the sculptural decoration being carried out by Joseph Bonehill, also of Manchester.[1] The carving is of a high quality. Other decoration includes the head of Plutus on the keystone of the arch above the principal doorway. The lower storey of the building used stone from the former Fletcher Bank. When opened, the bank was regarded as one of the town's most impressive buildings and for a time was used by the local council for its meetings. Amalgamations in the banking industry in the late nineteenth and twentieth centuries resulted in the Bury Banking Company becoming part of the Lancashire and Yorkshire Bank, then Martin's Bank, and, finally, Barclays Bank.

Note
[1] *Bury Times*, 30 November 1867.

Whitehead Clock Tower Gardens

Between Manchester Road and Knowsley Street

Whitehead Clock Tower

Architects: Maxwell and Tuke

Sculptor: Moreau

Architectural sculptor: John Jarvis Millson

27 June 1914
Portland stone; granite; bronze sculpture
20.42m high approx; statue 1.83m high approx

Inscription on tower: TIME AND TIDE WAIT FOR NO MAN / TIME SPIRITS AWAY – bronze plaque to left of door: WALTER WHITEHEAD / LSA. LOND. 1864 / FRCS EDIN. 1866 – bronze plaque to right of door: incorporating borough coat of arms: COUNTY BOROUGH OF BURY / THIS CLOCK TOWER / WITH THE LAND ADJOINING / WAS PRESENTED TO THE TOWN / BY / HENRY WHITEHEAD / OF HASLAM HEY / IN MEMORY OF HIS BROTHER / WALTER WHITEHEAD / AN EMINENT SURGEON AND NATIVE OF BURY / JUNE 27TH 1914
Status: Grade II
Condition: fair
Owned by: Bury Metropolitan Borough Council
Description: Clock tower; a square Portland stone tower featuring a large dial clock on each side. The tower is highly decorated and topped with an ogee cap of copper, with a crown motif. Octagonal turrets rise from the corners of the tower at the points of an overhanging cornice. About half-way up on each side is a canopied niche, the one on the main façade contains a life-size bronze statue of a figure personifying Time. An internal staircase provides access to the clock and tower, but, contrary to expectations, there are no bells. The tower rises from a stepped base of Aberdeen granite, set on a raised terrace approached by Portland stone steps.

The idea of erecting a clock tower in the centre of Bury originated with the prominent local businessman and philanthropist, Henry Whitehead, who wished to provide a suitable memorial for his recently deceased brother, Walter Whitehead (1840–1913). Walter Whitehead was an innovative and admired surgeon who had a long association with the hospitals in Manchester. He retired in 1903 to Wales, where he died in August 1913.[1] Henry Whitehead, who had already been responsible for providing the Kay Memorial and its gardens in the centre of Bury, approached the council with a plan to present the town with a clock

Maxwell and Tuke, *Whitehead Clock Tower*

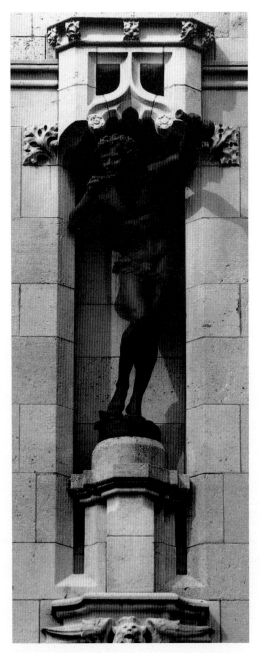

Moreau, *Time* (detail)

tower and public gardens in memory of his brother.[2] Whitehead had already settled the main features of the scheme before they were made public. He had purchased the site, a triangular piece of land between Knowsley Street and Manchester Road, land which had once been occupied by a private lunatic asylum. He had also approached the architects, Maxwell and Tuke, to design the clock tower. The firm, which had long connections with Bury – Maxwell had been born in the town – produced a decorated tower in Portland stone, which they classified as 'thoroughly Old English in style and character, and... of the late Tudor period'.[3] The council approved of the scheme.

The project proceeded remarkably quickly. By the New Year of 1914 the contractors, F.M. and H. Nuttall of Whitefield, were preparing the foundations.[4] John Millson was employed to provide the extensive stone carving which decorated the tower.[5] High up on the front of the tower was a canopied niche containing a bronze statue, a figure symbolising Time. This was stated to be the work of Moreau, though which of the French sculptors of that name is not made clear.[6] By the early summer the Shropshire clockmakers, J.B. Joyce, were installing the clock. The Whitehead memorial clock tower and gardens were opened by Sir Frederick Treves in June 1914. In a tribute, which must have found special approval among his audience, Treves spoke of Whitehead as 'a Lancastrian among surgeons'.[7] The clock tower became an immediate landmark in the town, but as the first visitors came to admire it and the surrounding gardens, the reports of the assassination of Archduke Ferdinand in the local press offered an alternative topic of conversation.

Notes
[1] W. Brockbank, *The Honorary Medical Staff of the Manchester Royal Infirmary 1830–1948* (Manchester: Manchester University Press, 1965) pp.61–3, 147; *Manchester Guardian*, 21 August 1913. [2] *Bury Times*, 11 October 1913, 1 November 1913. [3] *Ibid.*, 1 July 1914. [4] *Ibid.*, 24 January 1914. [5] *Ibid.*, 1 July 1914. [6] *Ibid.*, 27 June 1914. (The French sculptor Hippolyte-François Moreau (1832–1917) was active at this time; another French sculptor, Mathurin Moreau, died in 1912). [7] *Bury Times*, 1 July 1914; *Manchester Guardian*, 29 June 1914.

Lancashire Fusiliers' South African War Memorial

George Frampton

18 March 1905
Bronze statue; sandstone pedestal
Statue 2.44m high approx; pedestal 3.66m high approx × 1.61m square base
Inscription on bronze panel, beneath regimental badge set in a laurel wreath, on pedestal: TO THE GLORIOUS MEMORY / OF LANCASHIRE FUSILIERS, / LINE, MILITIA & VOLUNTEER / WHO GAVE THEIR LIVES FOR / THEIR SOVEREIGN & COUNTRY / IN SOUTH AFRICA, 1900–2. / THIS MONUMENT IS ERECTED / BY THEIR COMRADES OF ALL / RANKS & BY FRIENDS OF / THE REGIMENT.
Status: Grade II
Condition: good
Owned by: Bury Metropolitan Borough Council
Description: War memorial; a larger than life-size bronze statue of soldier who is depicted cheering, holding his busby in his raised right hand and rifle in his left hand. The soldier stands on a sandstone pedestal on which is the principal inscription and, on the other three sides, bronze panels listing the names of the officers and men who died in South Africa.

The Lancashire Fusiliers, whose headquarters were in Bury, sent more than 4,000 men to the war in South Africa where they fought in a number of major battles including Spion Kop.[1] The idea of erecting a memorial to the fallen officers and men of the regiment was discussed at a meeting of the Lancashire Fusiliers' Compassionate Fund, before the plans were eventually made public in February 1903.

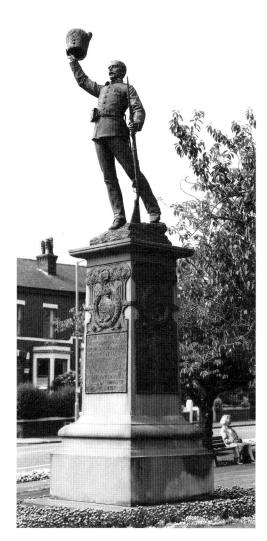

Frampton, *Lancashire Fusiliers' South African War Memorial*

Initially, the fund set out to collect a sum of £1,800, of which some £500 was to be allocated to a memorial. George Frampton – 'an artist of unquestionable skill' – was chosen by the committee to produce the memorial statue. The subscription list was started with sums of £50

and £100 from the Earl of Derby and the officers of the Regiment respectively.[2] Discussions with the Corporation about a possible location resulted in the offer of a site in the Market Place. Frampton approved of the site though the *Bury Times* was less sure, being concerned that the new memorial would diminish the presence of the Peel statue.[3]

Lieutenant-Colonel Sir Lees Knowles MP, the chairman of the memorial committee, liaised with Frampton about the design; discussions later described as having 'exacted a heavy but unavoidable tax on the time and resources of both those gentlemen'.[4] It is unclear to what extent, if at all, these discussions led to alterations in the design. However, Frampton's design of the cheering fusilier was praised for its originality and boldness, and its determination to avoid what was seen as the cliché of the soldier in repose or mourning for his dead comrades. Frampton's fusilier was presented as a proud figure 'cheering for the King; sorrowful, but proud, at the loss of comrades; urging on those who survive to further deeds of heroism'.[5] The fusilier was also dressed in the regiment's home uniform, rather than the one worn in South Africa, a decision that allowed the recent regimental honours – including the primrose-yellow hackle worn on the left side of the busby – to be displayed. Frampton, it was said, 'had a different vision of the character of a man when at war with an enemy'. In the heat of combat, it was suggested, the soldier thirsts for battle, and it was this aspect which Frampton was held to have represented, with the soldier raising 'a cheer of triumph for duty nobly accomplished' which would 'inspire his fellows to fight on for King and Country'.[6] As Frampton worked in London, the model for the soldier was not an actual member of the regiment but Harry Ibell, who had served in the 16th Lancers.[7] The names of the dead were listed on bronze panels beneath a carving of oak trees representing strength, and a laurel wreath representing victory.

The memorial was unveiled by the 17th Earl of Derby in March 1905.[8] The platform speeches were suffused with the ideals of patriotism and bravery, whilst emphasising the connection between the regiment and Bury. In accepting the statue for the town the mayor hoped that it would serve as a stimulus to duty for those who passed by.[9] Three months later a copy of the memorial was erected in Salford.[10] However, the Bury memorial was not to remain in the Market Place. In 1920 the proposal to build a large tram-shelter caused it be moved to the front of the Whitehead Clock Tower Gardens, one of the sites originally suggested in 1905.[11]

Notes

[1] B. Smyth, *A History of the Lancashire Fusiliers (formerly the XX Regiment) 1688–1903* (Dublin; Sackville Press, 1903); Cyril Ray, *The Story of XX. The Lancashire Fusiliers* (London: B.T. Batsford, 1963). [2] Memorial Appeal letter dated 14 February 1903. [3] *Bury Times*, 22 March 1905. [4] 'The Lancashire Fusiliers' War Memorial', *Lancashire Fusiliers' Annual* (1905) p.12. [5] *Ibid.*, p.4. [6] *Bury Times*, 2 February 1905, 18 March 1905. [7] 'The Lancashire Fusiliers' War Memorial', *Lancashire Fusiliers' Annual* (1905) p.10. [8] *Order of Proceedings at the Unveiling of Lancashire Fusiliers' Memorial* [1905]. [9] *Bury Times*, 18 March 1905; *Manchester Guardian*, 20 March 1905. [10] See above, p.176. [11] Bury Council Minutes 1919–20, 18 March 1920, p.261; 7 October 1920, p.559.

HOLCOMBE

Holcombe Hill

Peel Memorial Tower

9 September 1852
Gritstone
39m approx high; 10.68m square base
Inscription in large raised letters above main
 doorway: PEEL – on tablet inside entrance:
 PEEL MONUMENT, HOLCOMBE / ERECTED
 1852 / IN MEMORY OF SIR ROBERT PEEL / "IT
 MAY BE THAT I SHALL LEAVE / A NAME
 SOMETIMES REMEMBERED / WITH

EXPRESSIONS OF GOOD WILL / IN THE ABODE
OF THOSE, WHOSE / LOT IT IS TO LABOUR
AND TO EARN / THEIR DAILY BREAD WITH
THE SWEAT / OF THEIR BROW – WHEN THEY
SHALL / RECRUIT THEIR EXHAUSTED
STRENGTH / WITH ABUNDANT AND UNTAXED
FOOD / THE SWEETER BECAUSE IT IS NO /
LONGER LEAVENED WITH A SENSE OF
INJUSTICE."/ EXTRACT FROM SPEECH / OF SIR
ROBERT PEEL DELIVERED / IN THE HOUSE OF
COMMONS/ JANUARY 27TH 1846.

Status: Grade II
Condition: fair
Owned by: Bury Metropolitan Borough
 Council
Description: Memorial tower; stone tower
with a square lower storey with battlemented
top, surmounted by a tall and slightly tapering
upper tower with corbelled battlemented top.
The lower storey has mullioned windows and
an entrance doorway above which in large
letters is the name 'Peel'. The upper tower also
has mullioned windows (some blocked) on each
side. A stone annexe has been built on the roof
of the lower storey.

At the same time that Bury was arranging to
erect a statue of Sir Robert Peel to stand in the
town centre, a second memorial, in the form of
a stone tower, was also being planned to
honour the recently deceased statesman.[1] It was
to be located outside the town, sited on
Holcombe Hill, 335 metres above sea level. It is
believed to have been designed by members of
the memorial committee who included the local
textile entrepreneur and philanthropist, William
Grant. The site was in a direct line from Grant's
house, Nuttall Hall, and St Andrew's church. A
public subscription provided the £1,000 needed
to build the tower. Local stone obtained from
the hillside was used to build it. Peel Tower was
opened in September 1852, the day after the
inauguration of Baily's statue in Bury. As at the
earlier ceremony, Frederick Peel was the
principal guest of honour and he declared the
monument to be a splendid memorial to his

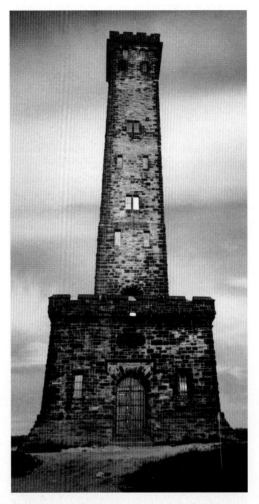

Peel Memorial Tower

father and to the principles of free trade. Other
speakers included Joshua Knowles and John
Robinson Kay. Large numbers of people who
had travelled by excursion train from Salford
arrived too late to witness the ceremony.[2] If the
tower, in the words of the *Manchester
Guardian*, was not 'a specimen of architectural
beauty', it did provide a conspicuous landmark,
and for those who climbed its staircase there

was a viewing platform from which to look out
across the surrounding countryside.[3] It emerged
later that the tower had been built in such haste
that the necessary permission had not been
obtained from the owner of the land, the Duke
of Buccleuch. This matter was eventually
rectified in 1868, when the land was transferred
into the keeping of six trustees, but on the
condition that it was not used for contentious
public meetings.[4]

Peel Tower attracted large numbers of
visitors, particularly at Easter, when it became
something of a local tradition to visit the tower.
Over the years its maintenance was neglected,
and a surveyor's report of 1928 recommended
the replacement of the wooden staircase, the
landings and all of the windows.[5] Some £2,500
was raised through an appeal and in the
following year the necessary repairs, including
the installation of an iron staircase, were made.
The tower was closed because of safety
concerns in 1947. In 1949 Ramsbottom District
Council took over responsibility for the tower
but lacked the resources to repair and reopen it.
The condition of the tower continued to
deteriorate. In 1984 a major restoration scheme
was announced, which resulted in the tower
being reopened to the public in November of
the following year.[6] Holcombe Moor, but not
the tower, was purchased by the National Trust
in 1994.[7] A re-enactment of the opening
ceremony was organised to mark the tower's
150th anniversary in 2002.[8]

Notes
[1] See above, p.250. [2] *Manchester Guardian*, 11
September 1852. [3] *Ibid*. [4] *Bury Times*, 31 May
1922; *Transactions of Lancashire and Cheshire
Antiquarian Society*, 40 (1922–3) pp.203–4.
[5] Ramsbottom Engineer and Surveyor's report,
dated 4 October 1928 (Bury Library). [6] *Bury Times*,
10 August 1979, 9 October 1981, 30 November 1984.
[7] *Ibid*., 11 February 1994. [8] *Ibid*., 14 September
2002.

RADCLIFFE

Blackburn Street

Radcliffe War Memorial
Sydney March

25 November 1922
Darley Dale sandstone obelisk; bronze
 sculpture
Obelisk 7.62m high approx × 2.2m square base
Inscription on shield in raised lettering: TO OUR
 / GLORIOUS / DEAD / 1914–1918
Condition: good
Status: Grade II*
Owned by: Bury Metropolitan Borough
 Council
Description: War memorial; a sandstone
obelisk rising from a square base of seven steps,
with bronze statuary on a cruciform pedestal.
The four main faces of the pedestal have
rectangular bronze panels listing, in relief, the
'Names of the Fallen'. Panels on the narrow re-
entrant sides list the names of those who died in
the Second World War. A down-turned sword
with a laurel wreath around the hilt is on the
main face of the obelisk. The statuary group of
three life-size winged female figures is mounted
at the base of the shaft. The central figure
represents Victory, standing and holding a
laurel wreath in her raised left hand. Her right
hand holds the hand of Liberty, who bears a
flaming torch in her right hand. The third
figure, to the left of Victory, represents Peace.
She is kneeling, listening to the message of the
dove on her right shoulder, a garland of flowers
– roses of remembrance – across her lap. On the
rear face of the shaft is an oval bronze shield
encircled with laurel leaves, surmounted by
Radcliffe's coat of arms.

Plans to erect a town war memorial in Radcliffe
were first publicly discussed in 1919. A
memorial committee, under the chairmanship
of Councillor W. Whewell, was established to

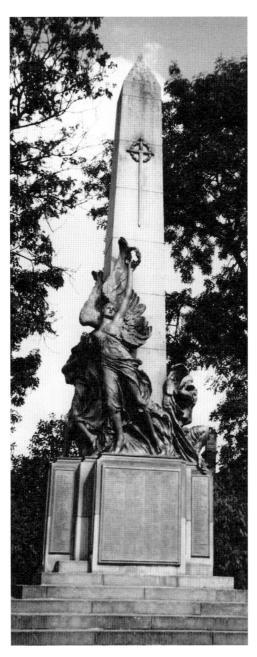

March, *Radcliffe War Memorial*

oversee the project. It examined various ideas
before settling on a memorial to be located on a
small piece of land opposite the town hall.
Sydney March of March Brothers,
Farnborough, was approached to design an
appropriate memorial. March was responsible
for a number of larger public statues, including
ones of Lord Kitchener in Calcutta and
Khartoum. The firm was also to produce many
war memorials including ones in Belfast and
Lewes, and, more locally, in Whitefield and
Glossop. When the design of the proposed
memorial, including the symbolic group of
Victory, Peace and Liberty, was presented at a
public meeting in April 1920, it met with
general approval. Photographs published in the
local newspapers were also well received.[1] A
memorial fund was opened and immediately
raised £1,800, about one-third of the estimated
cost. The sculptural group was completed
without any significant problems and installed
during the summer of 1922. The site was
designed by the London landscape architect, A.
Raines Barker, and the stonework executed by
the local Whitefield firm of F.M. and H.
Nuttall.[2] In the absence of the 17th Earl of
Derby, who was unable to attend because of the
recent general election, the memorial was
unveiled by Dr G. Scarr, the town's senior
councillor, before a crowd estimated at between
15,000 and 20,000.[3]After the Second World War
a plaque was added in honour of those who had
died in that conflict.

Notes
[1] *Radcliffe Times*, 24 April 1920, 1 May 1920.
[2] *Ibid.*, 2 September 1922. [3] *Ibid.*, 2 December
1922; J. Hudson, *Radcliffe in Old Photographs*
(Stroud: Alan Sutton, 1994) p.107.

Britannia Close

In the Bulrushes

William Pym

4 May 2001
Galvanised steel
4m high
Status: not listed
Condition: good
Owned by: Bury Metropolitan Borough
 Council
 Description: sculpture representing
bulrushes; the plants rise from a circular base
which represents a canal barge, before
culminating in a single bulrush.

William Pym's *In the Bulrushes*, like Jack
Wright's *Nailing Home*, arose out of a
partnership between the Irwell Valley Housing
Association and the Irwell Sculpture Trail. The
success of Wright's Radcliffe sculpture
encouraged the housing association to
commission another art work to mark a new
housing development, Britannia Mills, that they
were completing, off Wolsey Road in the town.
William Pym began work on the commission in
2000, finding his inspiration for the design in
the nearby Bolton and Bury Canal. The idea
was to show bulrushes growing out of a sunken
canal barge. The work was made so that it could
be illuminated at night. The £15,000 sculpture
was placed directly in front of the association's
flats. It was unveiled in May 2001, consolidating
Radcliffe's position as one of the centres of the
Irwell Sculpture Trail.[1]

Note
[1] Information from Cathy Newbery, Irwell
Sculpture Trail.

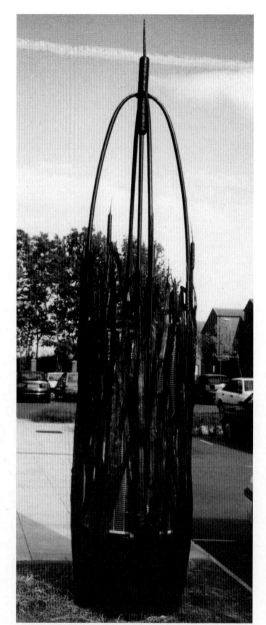

Pym, *In the Bulrushes*

Ringley Road West

Outwood Country Park

Untitled

Ulrich Rückriem

25 May 1998
Porrino granite
Ten stones varying in height: single stones near
 entrance 9.15m high approx × 2.36m wide
 cm × 97cm deep; stones in main group 3.05m
 high approx × 1.52m wide approx × 76cm
 deep approx
Condition: good
Owned by: Bury Metropolitan Borough
 Council
 Description: Abstract sculpture; ten
monolithic granite blocks sited in a country
park, part of which was a former colliery. In the
main group seven stones are placed together in
a clearing, the ground covered with dark stone
chippings. Three taller stones are placed singly
in other areas of the park. Two of them are
positioned at the entrances to the reclaimed
land, and the third, the tallest stone, marks the
former railway track. The rectangular blocks
have been split, vertically and horizontally, and
then reassembled into their original forms. Drill
holes, made when the stone was divided, can be
seen, as can the serrated marks left from the
cutting and splitting of the stone.

This work represents one of the most ambitious
of the sculptures commissioned for the Irwell
Sculpture Trail. Ulrich Rückriem is one of the
best-known of Germany's post-war sculptors,
with works in many European cities.[1] When the
commission was agreed in 1997, councillors
recognised the significance of the work and its
potential for attracting visitors to the area.[2]
Rückriem's approach to sculpture developed
from working in the quarries of Duren,
Germany, and as a mason on Cologne
Cathedral. A number of his works take the
form of large monolithic blocks of stone which

Rückriem, *Untitled*

have been divided and reassembled.[3] Depending on their size, they are displayed either outdoors or in a gallery.

The resulting pieces permeate the dialogue between the pre-existing volumes and the aesthetic decisions imposed upon them. Taking the pieces out of context also allows for a confrontation between the original space the stone belongs to (the quarry, the 'site') with the new location, be it a park, an urban environment or the more sterile space of a museum or gallery (the 'non-site').[4]

Rückriem's composition for the sculpture trail followed this theme, exemplifying the processes of extraction, recomposition and relocation, but it was on a far larger scale than any of his previous stone settings.

On visiting the proposed location, the site of the former Outwood Colliery, Radcliffe, Rückriem spoke of its power and sadness: 'As a colliery it was full of energy, but suddenly it went. It is like an open wound'.[5] The composition comprised ten large granite blocks. The stone came from Spain. The tallest column stands near the former Ringley Road railway station and serves as an introduction to the work, with two more single columns marking the main entrances to the park. The other seven stones were installed on a flat plateau, with sloping land and trees as a backdrop. In this group each block was split into four and then reassembled. On closer examination the grey granite contains pink, black and grey crystals.

The work, which was untitled, was installed in May 1998 and featured as part of the *Artranspennine 98* exhibition.[6] Rückriem's only public sculpture in Britain proved to be one of the exhibition's most discussed works. Bury Council's Arts Development Officer was quoted as saying that with the installation of a work by an artist of Rückriem's stature: 'There is no reason why the town can't be thought of in the same way as traditional centres like New York and Paris.'[7] Some other commentators were less impressed, regarding the work as fatuous, and arguing that it had little or no meaning for the public.[8] The public appeared confused about Rückriem's art, and the

standing stones, soon dubbed the 'New Stonehenge', were predictably criticised by correspondents writing to the local press.[9] Rückriem was not dissuaded by these criticisms and returned to Radcliffe to lecture on his work and discuss future projects, which included the offer of other sculptures to be put on display in the town.[10]

Notes
[1] *Ulrich Rückriem* (London: Serpentine Gallery, 1991). [2] *Bury Times*, 26 September 1998. [3] A. Causey, *Sculpture since 1945* (Oxford: Oxford University Press, 1998) pp.183–4. [4] Exhibition press release for Galeria Heinrich Ehrhardt, 15 December 1999. [5] *Bury Times*, 13 December 1997. [6] *Leaving Tracks: Artranspennine 98: An International Contemporary Visual Art Exhibition Recorded* (London: August Media, 1999). [7] *Manchester Evening News*, 13 May 1998. [8] D. Lee, 'Sod off Rückriem!', *Art Review*, 50, August (1998) pp.60–2. [9] Articles and correspondence in *Bury Times*, 13 June 1998. [10] *Ibid.*, 28 May 1998, 22 October 1999, 17 May 2002.

Trail South, Outwood Country Park

Trinity
Stefan Gec

29 October 1999
Steel
1.4m high × 1.07m diameter
Inscription round column in Gothic letters: harebell / snowdrop / rosemary (repeated three times); grief / consolation / remembrance
Condition: good
Owned by: Bury Metropolitan Borough Council
Description: Steel cylinder inscribed with the names of flowers and sentiments, located by the side of a country path.

Trinity was commissioned for the Irwell Sculpture Trail from the Huddersfield-based artist, Stefan Gec. The industrial history associated with the site at Outwood shaped Gec's ideas for the work. In particular, he saw

Gec, *Trinity*

the work in terms of the railway, which had once run through the site, and the navvies who had constructed it. *Trinity* appears as an industrial object, recalling a railway tunnel ventilation shaft. Steel was the chosen material, again connecting the work to the railway. The idea of associating sentiments with the three flowers named in the inscription on the column, though less remembered today, would have been familiar to the Victorians at the time when the railway was being built. They transform the column into a memorial, asking the viewer to look back and remember workers long dead. The planting of snowdrops, harebells and rosemary around the work reinforces this sense of loss and remembrance. *Trinity* was installed in October 1999. The intention was that the steel would rust over time, allowing the work to become part of the surrounding landscape.[1]

Note
[1] *Bury Times*, 5 November 1999.

Smyrna Street

Junction of Smyrna Street and Ainsworth Road

Nailing Home
Jack Wright

Installed 13 September 1999
Cast iron
2.2m high × 1.2m square base
Inscriptions on nails in raised lettering:
CHILDREN LEARN AS THEY LIVE / IF CHILDREN LIVE WITH SHAME, THEY LEARN TO FEEL GUILTY / IF CHILDREN LIVE WITH RIDICULE, THEY LEARN TO BE SHY / IF CHILDREN LIVE WITH HOSTILITY, THEY LEARN TO FIGHT / IF CHILDREN LIVE WITH CRITICISM, THEY LEARN TO CONDEMN / IF CHILDREN LIVE WITH ENCOURAGEMENT, THEY LEARN CONFIDENCE / IF CHILDREN LIVE WITH APPROVAL, THEY LEARN TO LIKE THEMSELVES / IF CHILDREN LIVE WITH ACCEPTANCE AND FRIENDSHIP, THEY WILL FIND LOVE IN THE WORLD / IF CHILDREN LIVE WITH PRAISE, THEY LEARN TO APPRECIATE / IF CHILDREN LIVE WITH FAIRNESS, THEY LEARN JUSTICE
Status: not listed
Condition: good
Owned by: Bury Metropolitan Borough Council
Description: Group of nine giant horseshoe nails surrounded by a small horseshoe-shaped wall, located at the entrance to Shire Gardens. Each nail is inscribed with a line of poetry based on the European Declaration of the Rights of the Child.

Wright, *Nailing Home*

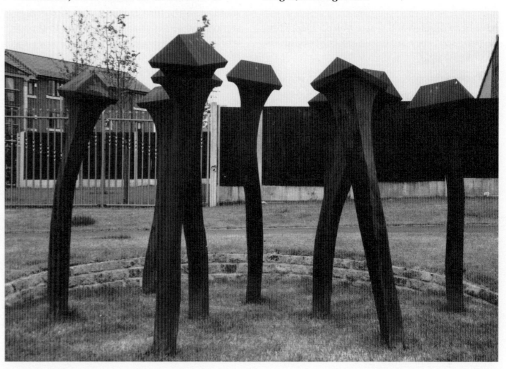

This work was commissioned by the Irwell Sculpture Trail in conjunction with the Irwell Valley Housing Association to mark the entrance to a new housing development in Radcliffe. It was the first major public work by Jack Wright, an artist and sculptor who lived in Manchester. The oversize slightly bent nails represent frost nails, used in the shoeing of shire horses. The work evolved out of discussions with local community groups. Workshops organised with children from a local school, St John's CE Primary School, helped to determine the lines which appear on the side of each nail. These were based on the European Declaration of Human Rights and relate to the key theme – Children Learn As They Live – which is inscribed around the top of the centre nail. The £15,000 cost was met by the housing association and National Lottery funds. It was installed in September 1999.[1] In 2001, Wright was commissioned to provide a sculpture at the entrance to Outwood Country Park.

Note
[1] *Bury Times*, 17 September 1999.

RAMSBOTTOM

Bridge Street

Riverside

The River

Hetty Chapman and Karen Allerton

1997
Stainless steel; wood
88m long
Signed on stainless steel: Hetty Chapman and Karen Allerton The River
Inscription: two poems inscribed on stainless steel: When it is strong the river is hurried, flurried as if it is warned. / When it is sunny the river runs freely, dreamy, all happy to see me. / When it is busy the river is calmed, charmed and never alarmed. / Hurried,

flurried, freely, dreamy, calmed, charmed. / Looks like I'll remember forever, and never forget my dreams. / Lucy Whitton
The river just loves trickling and shimmering in the light / but the lovely thing about it is the peaceful sound at night. / Have you ever seen a badger or a squirrel or a duck? / Have you ever seen a dog in a rabbit hole stuck? / You find them near the river if you lie without a sound, / but if you cough, or sneeze or speak, they'll go back underground. / Richard Renzulli
Status: not listed
Condition: good
Owned by: Bury Metropolitan Borough Council
Description: A narrow ribbon or band of stainless steel, inscribed with poems, meandering through a small park near the River Irwell. At the end of the ribbon path are 34 wooden posts of different heights, made from railway sleepers. Attached to the seven tallest posts are metal plaques engraved with children's writings and drawings.

Hetty Chapman and Karen Allerton were awarded a residency in Ramsbottom in 1997 to produce a work that would be part of the Irwell Sculpture Trail. Discussing potential ideas with local people, they focused on the area's physicality and history. They decided that the work would be about the local river, the Irwell, a celebration of how much the community had depended and continued to depend on it.[1] The piece would be sited in a small park, Ramsbottom Wharf, which had been created on land between the Irwell and the East Lancashire Steam Railway.

The commission involved working with local schools, and it was the schoolchildren who composed the verses that appear on the stainless steel band, as well as the writings and drawings reproduced on the upturned railway sleepers. The latter refer to the history of Jacob's Ladder, a local beauty spot. The proximity of the East Lancashire Railway helped to determine the use

Chapman and Allerton, *The River*

of the sleepers, which also function as a platform from which to view passing steam trains. An exhibition was held in the local library to explain the work.[2] Finance for *The River* was provided by local companies and the National Lottery. It was one of the first works to be completed on the Bury section of the Irwell Sculpture Trail.

Notes
[1] Notice at entrance to the park. [2] *Bury Times*, 17 June 1997.

Market Place

Tilted Vase
Edward Allington

26 July 1998
Bronze
3m high × 4m × 5m approx
Signed on 'stem' of vase: Edward Allington
 Tilted Vase 1998
Status: not listed
Condition: good
Owned by: Bury Metropolitan Borough
 Council
 Description: Bronze fountain in the form of a
large classical-shaped vase with handles placed
on its side, the water pouring from the neck of
the vessel.

In 1997 a shortlist of five artists was drawn up
from thirty who had submitted ideas for a
major public art work which it was intended to
site in the former textile town of Ramsbottom.
The work was to be one of the first major
commissions of the Irwell Sculpture Trail. In
the end, only three of the five artists submitted
designs, resulting in the commission being
awarded to the sculptor, Edward Allington. His
idea was for a large public sculpture in the form
of a classical vase which would function as a
fountain. The large bronze vase would be tilted
on its side, allowing the water to pour from the
mouth into a hole in the stone paving. It was to
be located on the site once occupied by the
town's market, an important and highly visible
public space. Although the commissioning
process had taken care to involve local
councillors and representatives of Ramsbottom
Heritage, a large number of residents
considered the proposed sculpture to be
inappropriate. Even before it was installed, the
'Grecian Urn', as it was referred to, was the
subject of much negative comment from
residents and traders, who felt that the town
could have made better use of the money than
paying out for 'scrap'.[1] Allington's explanation,

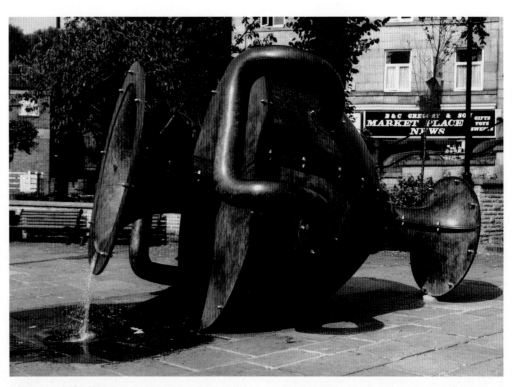

Allington, *Tilted Vase*

that in its construction and in its use of water
the work reflected the community's history and
its future, appeared unconvincing. A petition
was organised to stop the project.[2] 'Whoever
heard of a Grecian Urn in a cotton town? It
would be like sticking Blackpool Tower in the
Sahara Desert', was the pointed comment of
two puzzled residents.[3]
 The commission proceeded. The completed
bronze vase was classical in shape, but it was
explicitly modern in its construction, the bolted
sections being clearly visible. The process of
ensuring that it was securely installed delayed
the planned opening in May 1998. The various
problems were, however, overcome and the
Tilted Vase was finally unveiled by five-year-
old Joel Duncan in July.[4] Attitudes towards the
work have changed since its installation. It has

begun to establish itself as a new symbol of
Ramsbottom, and even found a place on the
town's Millennium Plate, alongside more
familiar landmarks such as the Peel Tower.
However, for some local residents it remains an
unwanted and ugly eyesore, 'a giant, rusty-
looking upturned urn that blights the centre of
Ramsbottom'.[5] A maquette is in the Bury Art
Gallery.[6]

Notes
[1] *Bury Times*, 20 June 1997, 22 August 1997.
[2] *Ibid.*, 18 July 1997. [3] Letter in *Bury Times*, 22
August 1997. [4] *Manchester Evening News*, 13 May
1998; *Bury Times*, 28 and 31 July 1998. [5] Letter
from 'Foaming at the Mouth', *Manchester Metro
News*, 12 November 1999. [6] Correspondence with
Bury Art Gallery, 21 September 1999.

Nuttall Park

Seek and you will Find

Kerry Morrison

2 August 1998
Ash; oak; sycamore; stainless steel
50cm to 95cm high
Status: not listed
Condition; fair, damage to some plants
Owned by: Bury Metropolitan Borough
Council
Description: Carved wooden sculptures of local flowers, placed around the perimeter of the park. A stainless steel map on the floor of the bandstand provides information about the plants and their location in the park.

This sculpture was commissioned as part of the Irwell Sculpture Trail. Kerry Morrison was chosen from a shortlist of artists who had been asked to submit ideas on how they would use a six-month residency in Ramsbottom. Her focus was the local flora and in particular the importance of seeing the plants as individual objects rather than as a group. Having studied the local plants, she selected four – black poplar catkin, bistort, broad-leaved helleborine and ramson herb – to sculpt. These were sawn and carved from ash, oak and sycamore. They were then deliberately concealed at different places around the edge of Nuttall Park, secretive works placed among the very flora that had inspired them. Details about the history of the plants and where the sculpted works might be found were included on stainless steel plaques fixed to the floor of the former bandstand in the centre of the park. This included, for example, the information that the pungent smell of bistort plant earned it the local name of 'sweaty feet', and that its young leaves were cooked in a dish called Easter Hedge Pudding.[1]

Note
[1] Correspondence with Kerry Morrison, 14 December 1998.

Pumping Station, Heaton Park, Heywood Road

Untitled

Mitzi Solomon Cunliffe

21 June 1955
Yorkshire sandstone; Westmorland greenstone

Morrison, *Seek and you will Find*

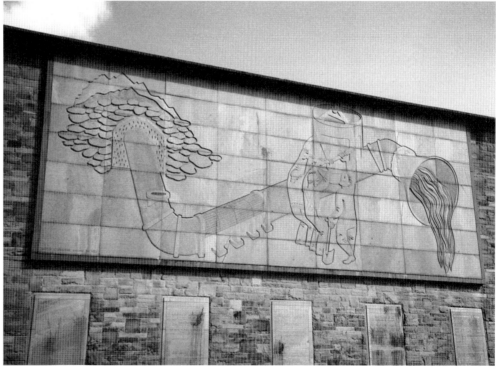

Cunliffe, *Mural depicting construction of pipline*

10.97m approx × 7.31 m approx × 3cm
Signed: Mitzi Cunliffe Sculpsit MCMLV
Status: Grade II
Condition: fair
Owned by: North West Water

Description: Large rectangular stone relief, composed of smaller rectangular sandstone panels, incorporated into the wall of the pumping station. The highly stylised relief uses greenstone to depict the construction of the pipeline which carried water from Haweswater to Manchester. The pipeline is shown emerging from hills representing the Lake District on its journey to Manchester. In the centre three workmen are shown, holding a hopper containing concrete, constructing the pipeline.

The project to construct a 130–kilometre water pipeline from Haweswater to Manchester began with a parliamentary act in 1919. Construction started in 1925 and was eventually finished in 1955. The reservoir at Heaton Park was completed in 1954. It included a pumping station on the perimeter of the park, designed by the City of Manchester Architect's Department for the Corporation's Waterworks Department, engineer Alan Atkinson.[1] It was decided at an early stage in the design of the pumping station to incorporate some form of sculptural panel as a recognition and celebration of this immense, challenging and costly engineering project. A large sculptural panel was commissioned from Mitzi Cunliffe to be placed on the blank wall facing Heywood Road. The panel, made up of 63 smaller ones, showed the pipe under construction, with water gushing out of the open end. Three workmen were included in the scene, testimony to the many hundreds of men who built the pipeline. Five plaques providing historical and other information about the project are inset into the wall beneath the mural. The pumping station was opened by the 18th Earl of Derby in 1955.[2]

Note
[1] C. Hartwell, *Manchester* (London: Penguin, 2001) p.334; Bury Listed Building Schedule 1998.
[2] *Manchester Guardian*, 21 June 1955.

Nimrod
Betty Leuw Green

Bronze resin and fibreglass
 Description: Life-size reclining male nude representing Nimrod, his right arm resting on raised right knee.

Nimrod was created by the Dutch-born sculptor, Betty Leuw Green. She made it while attending the life sculpture class at Bury School of Art. Named after the Biblical figure – Nimrod the mighty hunter – it represented the sculptor's idea of 'the complete handsome male specimen'. In 1974 it was shown in an art exhibition on The Esplanade, Rochdale. It was later purchased by Bury Corporation for £200 and installed in the centre of an ornamental lake in Townside Field Park.[1] Mounted on a pyramid-shaped pedestal, the nude figure attracted adverse comments from people who considered it inappropriate in a place used by children. According to the sculptor, *Nimrod* became a landmark to be reached by children who paddled or sailed boats in the lake. Such high-spirited actions – 'It was loved to death by the children rather than vandalised' – resulted in damage.[2] In 1976 the Director of Recreation and Amenities in Bury had the bronze resin and fibreglass sculpture removed and repaired, but it was not returned to the park. Instead it was put on display at Whitefield Library.[3] At a later date it was removed from the library and passed into the care of the corporation's parks department. It is presumed to have been lost. A study for the head of *Nimrod* was subsequently purchased by Bury Art Gallery.[4]

Notes
[1] *Bury Times*, 25 July 1975. [2] Information from Betty Leuw Green. [3] *Bury Times*, 7 December 1976. [4] Correspondence with Richard Burns, Bury Art Gallery, 21 September 1999.

John Kay
Sculptor: unidentified

1877?; removed 1974
Stone
1.83m high approx
Inscription on plinth: JOHN KAY
 Description: Life-size portrait statue of John Kay who is shown as a standing figure, bareheaded, wearing an open coat and knee breeches. He is holding a shuttle in his left hand which is attached to a shuttle box at his feet. A document with a seal is held in the right hand. The statue stands on a low plinth inscribed with the inventor's name.

Most of the important details relating to the commissioning of the statue of John Kay, which stood on the top of the works of Robert Hall and Sons in George Street, close to the centre of Bury, are obscure. The life-size stone statue of the town's most famous inventor may have been placed on the works in about 1877.[1] The sculptor is unknown but newspaper photographs of the statue suggest that it may have been the work of a more competent artist rather than a local stonemason.[2] The Kay statue became a well-known landmark, associated with a firm that for generations was one of the largest employers in the town. The closure of Hall's resulted in the statue being taken down in June 1974. It was, however, not discarded but purchased by a member of the Hall family, who restored it and put it on display in the offices of Wilson and Longbottom, a textile engineering company in Barnsley. The statue was later removed from the offices and is now in private ownership.[3]

Notes
[1] *Bury Times*, 18 June 1974. [2] *Ibid.*, 14 June 1974. [3] Information from Barnsley Local Studies Library and Mrs Isobel Porter.

OLDHAM

OLDHAM

0 2 kilometres

0 2 miles

CROMPTON Shaw

SHAW

SADDLEWORTH
WEST

Royton

ROYTON
NORTH

Diggle

ROYTON
SOUTH

ST
JAMES

WATERHEAD

CHADDERTON
NORTH

Chadderton

OLDHAM

A669

Uppermill

COLDHURST

Lees

SADDLEWORTH EAST

ST
MARYS

CHADDERTON
CENTRAL

Werneth

WERNETH

Alexandra
Park

21

LEES

22

ALEXANDRA

CHADDERTON
SOUTH

HOLLINWOOD

A627

ST PAULS

M60

Failsworth

FAILSWORTH
WEST

FAILSWORTH
EAST

Introduction

The Metropolitan Borough of Oldham was created in the local government reorganisation of 1974, amalgamating the county borough of Oldham with the neighbouring towns and districts of Chadderton, Failsworth, Shaw, Royton, Lees and Saddleworth. The borough lies to the north-east of Manchester and covers an area of some 14,105 hectares. The population in 2001 was 217,393.

Few towns were transformed by industrialisation as dramatically as Oldham. Some 11 kilometres from Manchester, Oldham had been an established market centre long before the industrial revolution, but it was the new methods of manufacturing cotton thread that were to be fundamental in creating an industrial town. Oldham's reputation and wealth were built on cotton spinning. By 1911 there were 335 mills, their 15.8 million spindles representing some 10 per cent of all the cotton spindles in the world. The town could also lay claim to a substantial engineering sector, including one of the most important of all textile machinery makers, Platt Brothers. The astonishing expansion of population – 12,024 in 1801, 52,820 in 1851 and 147,483 in 1911 – described an industrial history that was of international rather than national significance.

Little of the wealth created in the town was lavished on it. Oldham's public buildings were thoroughly modest, rightly glossed over in guidebooks of the day. The experienced journalist, Angus Bethune Reach, observed that 'the whole place has a shabby underdone look'.[1] Yet Oldham was not short of rich individuals; indeed with a dozen half-millionaires in cotton alone, it produced one of the highest concentrations of wealthy families to be found in any English town.[2] Some families such as the Lees, Radcliffes and Platts were ready to acknowledge that their wealth implied wider social responsibilities, but many of those made rich by cotton and engineering were reluctant to become involved in municipal affairs or provide more than nominal support for public projects. According to one Oldhamer this appearance was deceptive:

> Oldham people were said to be rough and unpolished, but they had the sterling metal in them for all that. They resembled the granite which lay at the base of their own hills, and which, when its asperities were removed, and its irregularities smoothed down, was perhaps susceptible of as high a polish as the Koh-i-noor.[3]

But in a community in which the town hall was unexceptional and amenities such as hospitals, museums and libraries were slow to be established, public statues and monuments were low down on the list of public priorities.

A statue to Robert Peel might have been Oldham's first major public monument had it not been decided to use the bulk of the memorial fund to help provide the town with public baths. A bust of Peel was, however, commissioned from Alexander Munro for the entrance hall of the new building. Another bust, one of Thomas Henshaw by the Manchester-born sculptor, Holme Cardwell, was somewhat less publicly on view in the town's Blue Coat School, a charity established from money left by Henshaw, a successful local hat manufacturer.[4]

Oldham lacked obvious civic spaces in or close to the town centre to display statues and monuments. Consequently, it was the public park that became the main location for statuary. Alexandra Park was the town's first major park, created to provide work for the unemployed during the Cotton Famine. It was designed by Woodhouse and Potts and covered an area of over 28 hectares. The mayor, Josiah Radcliffe, opened it in August 1865, marking the occasion with the presentation of a large ornamental fountain. In a town in which the landscape had been spoiled by industry, the park was one of the few public spaces that could be considered picturesque. No plan existed for acquiring sculpture, but over the years two portrait statues – Joseph Howarth and Robert Ascroft – were installed. The Howarth statue was noteworthy in that it honoured not the usual local worthy but a blind working man. The Ascroft statue was also noteworthy in that at a time when there was increasing pressure to reject statues in favour of a practical, living memorial, the cotton trade unions decided to erect a conventional portrait statue. Winston Churchill noted that the statue had been principally paid for by the cotton operatives:

> They stipulated – and I thought it characteristic of these Lancashire operatives – that the money was not to go on anything useful; no beds at a hospital, no extension to a library, no fountain even, just a memorial. They did not want, they said, to give a present to themselves.[5]

Alexandra Park also acquired a miscellaneous collection of what was essentially garden statuary. John Taylor, a former mayor, presented *Hebe* (after Thorwaldsen), a work that Victorian Oldhamers either mistakenly or deliberately confused with the popular image of the dutiful Biblical female, *Rebecca at the Well*. It was vandalised in May 1956.[6] A pair of stone lions, the gift of another mayor, John Robinson, proved to be a popular feature of the park.[7] They have survived, although their condition testifies to the overeager attention of generations of visitors and the

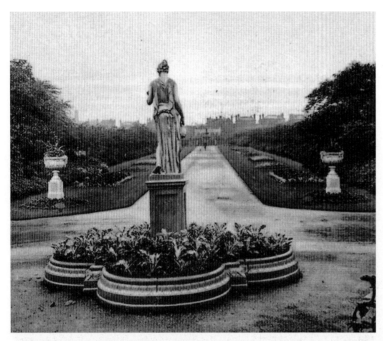

'Rebecca at the Well', Alexandra Park, Oldham

its own golden jubilee with the erection of a meteorological observatory in Alexandra Park rather than a more formal monument.[13]

Oldham remained architecturally uninspiring.[14] 'Our forest is mill chimneys, our lakes are mill lodges, our music is the sound of the loom and the spindle and the rattle of machinery' observed one local journalist in 1889.[15] Oldham's monumental buildings were its cotton mills, although their lack of architectural embellishment again suggested that businessmen were unwilling to spend money on appearances. When the town's new market hall was opened in 1906, the architectural sculpture was modest.[16] The most concerted effort to improve the town's appearance – the Beautiful Oldham Society – barely scratched the soot encrusting the town's buildings. By the beginning of the First World War Oldham's stock of public statuary numbered three portrait statues, two marble busts, an assortment of inferior garden statuary and some rather indistinct representations of Disraeli and Gladstone in the Hilton Arcade. Nor was statuary an important feature of the surrounding towns, other than in the churchyards and cemeteries . The few public monuments that were commissioned tended to take predictable forms such as the memorial fountain and public lamp erected in the centre of the small village of Dobcross, Saddleworth, in honour of a local doctor.[17] The exception to this was the Failsworth Pole. This was a timber pole topped by an ornate weather vane, erected originally as a political symbol but which acquired new meanings as the village of Failsworth was transformed into an industrial community. It was one of the most recognisable sights on the road connecting Oldham and Manchester.

The years following the end of the First World War saw the erection of many fine war memorials in the district. In particular, the main memorials in Oldham and Shaw, the work of Albert Toft and Richard Goulden respectively, were distinctive and exceptional by any standards. Toft's group of soldiers going over the top was an audacious composition, which even its inferior site could not diminish. Goulden's heroic figure, shown in the act of killing wild cats, was a brilliant representation of the past struggle and the defence of the future. Statuary also featured on the memorials in Waterhead and Chadderton. Saddleworth and Royton chose to erect obelisks on prominent hills, memorials continuously in view, prodding the communal memory. The power of Gilbert Howcroft's obelisk in Uppermill came from its size and location.[18] Royton's obelisk on Tandle Hill included sculpture (later stolen).[19]

The inter-war years were not to be another golden age for Lancashire cotton and its associated industries. Oldham became a community in crisis, as districts which had only known the opening of mills began to experience their closure. The engineering industries fared somewhat better, but the long decline of the town's smokestack industries was under way. Apart from the war memorials these years saw the commissioning of few other public monuments. A simple stone obelisk was erected in 1928 by the council on Wotherhead Hill, Grains Bar, to mark the gift of the

town's once richly polluted atmosphere. The fate of *The Flower Girl*, the gift of Councillor John Bamford, chairman of the Parks Committee at the time of the park's opening, is unrecorded.[8]

The public monuments that were raised to prominent figures tended to be modest in design, relying more on the local stonemason than the London sculptor. Edwin Butterworth, journalist and historian, was remembered with an unostentatious memorial in Greenacres Cemetery in 1859, some 11 years after his death.[9] The death of the Liberal MP, James Platt, killed in a shooting accident, was marked by the raising of a carved stone cross close to the spot on the moors where he had died.[10] In fact, only one major public portrait statue was to be located in the town centre. Unveiled in 1878, in memory of the local businessman and Liberal MP, John Platt, it was one of the region's most ambitious monuments. But whilst the dialect writer, Edwin Waugh, declared that the town had now 'begun o'takin to ornament', there was little interest in commissioning further portrait statues.[11] Pointedly, when the Co-operative Society, one of the town's most important institutions, marked Victoria's golden jubilee, it was with the gift of a large ornamental drinking fountain. They used the unveiling ceremony in the Old Market Place to draw attention to the much publicised profits enjoyed by local cotton firms, with the suggestion that this ought not to be their sole purpose.[12] In 1899 the borough marked

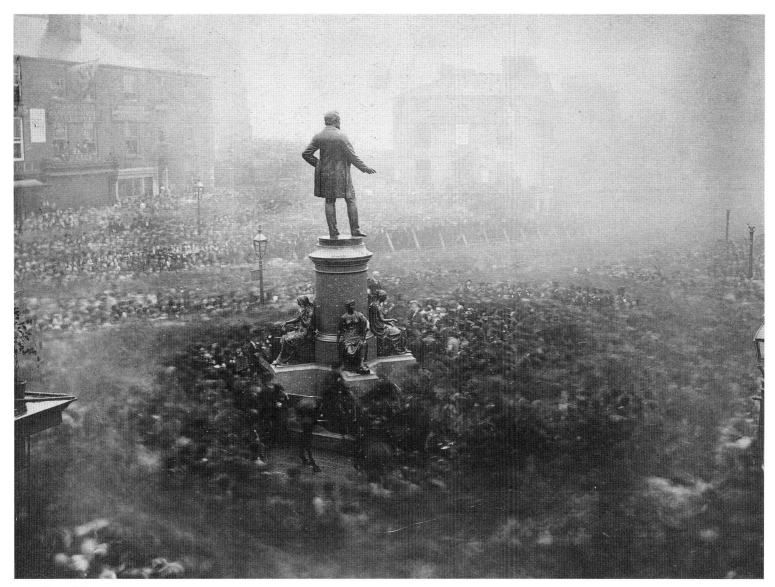

Unveiling of Platt Monument, 1878

surrounding land to the people of Oldham by Ellen Ludlam.[20] The only important sculptural monument to be raised honoured the life and work of Sarah Ann Lees. Nor were public monuments in vogue after the Second World War, when, after a brief recovery, the final chapter of the cotton industry's decline opened. By the 1960s imported cotton goods were on sale in local shops, and the working cotton mill had become an almost novel feature in a town which two generations before had been one of the world's greatest centres of cotton spinning. A sculpture

Unveiling of Oldham War Memorial, 1923

representing a heron, placed on the front of a new office building in Union Street, appears to have been one of the few modern pieces of sculpture installed at this time.[21] Portraits of famous people with local connections, including William Cobbett, Winston Churchill, J.R. Clynes and the suffragette, Annie Kenney, were featured on 'bronze' panels installed in a pedestrian subway leading to a new shopping centre in Oldham.[22]

The new metropolitan borough council, created in 1974, began to respond to the problems of industrial decline, high unemployment and

low investment.[23] Initially, public art was only a very marginal part of the council's regeneration policies. However, by the early 1990s it began to be taken more seriously, and Oldham was one of the first local authorities in the North West to appoint a public arts officer.[24] The development of a new shopping centre, The Spindles, provided the opportunity to commission some substantial works. These included two sculptures in George Square, a new open space adjacent to the shopping centre. *Portals*, a steel fencing screen with symbols representing the town's weather, created by Jill Randall, was also placed in a nearby pocket park.[25] The interior of the shopping centre also boasted impressive and atmospheric stained-glass roof lights, designed by the Oldham-born artist, Brian Clarke.[26] Other public art commissions included railings, seating, signage, and, less predictably, beer-mats.[27] Sculpture also featured at the entrance to a public park from derelict land at Bank Top.[28] A more ambitious project involved the Japanese sculptor, Hideo Furuta, who was commissioned to provide a large stone sculpture for the Holts council estate, reflecting the belief that public art could help build that community pride missing in failed post-war housing developments. Sculpture by the Cheshire-based sculptor, Ondré Nowakowski, was installed in the new Royal Oldham Hospital (not accessible to the public). The *Heroes' Monument* on the outside of the Bangladeshi Cultural Centre in Westwood remembered those who had contributed to the independence struggle in Bangladesh.[29] Not all of these new works were to be found in Oldham. Two public art commissions celebrated the bicentenary of the Failsworth Pole. But many people appeared perplexed by such initiatives. None of these public art projects underlined the gap existing between the artist and the public more than Janet Hodgson's *Piltdown Bungalow*, a temporary house structure erected in Uppermill. It was clearly a project too far for some locals, and the artist's aim of prompting people to reconsider how they viewed the past was lost in a chorus of charges of pointlessness and the wasting of taxpayers' money.[30] Within a few years, declarations about public art and urban regeneration were less confident, and the full-time post of public arts officer was reduced to a part-time appointment.

Those pieces of public sculpture that did appear, such as Nina Edge's *Walking Forward on the Wheel of Time* in the Market Square, Royton were produced with the help of the community on very modest budgets.[31] A belief in public art, however, remained, and the new century opened with Oldham commissioning a number of public art works, financed by the European Regional Development Fund and the North West Development Agency, in the town centre.

Notes
[1] J. Ginswick (ed.), *Labour and the Poor in England and Wales 1849–1851* (London: Frank Cass, 1983) Vol.I, p.93. [2] W.D. Rubinstein, *Men of Property. The Very Wealthy in Britain since the Industrial Revolution* (London: Croom Helm, 1981) p.83. [3] Joseph Mellor speaking at opening of Oldham public baths, *Oldham Chronicle*, 30 September 1854. [4] The bust, signed and dated 1841, continues to be displayed in the school. T.T. Richards, *History of Henshaw's Blue Coat School* (Stalybridge: Whittaker & Sons, 1947); information from Phil Hughes, Blue Coat School. [5] W. Churchill, *My Early Life, A Roving Commission* (London: Odhams Press, 1930) p.217. [6] *Oldham Evening Chronicle*, 6 March 1953 and 31 May 1956. [7] The inscription – Presented by Alderman Robinson – is just legible on the front of both pedestals. [8] *Oldham Evening Chronicle*, 5 March 1953 and 15 April 1976. [9] *Oldham Chronicle*, 3 December 1859; G. Shaw, 'Edwin Butterworth. His life and labours', *Transactions of Lancashire and Cheshire Antiquarian Society*, 22 (1904) pp.61–72; M. Winstanley, 'News from Oldham: Edwin Butterworth and the Manchester Press, 1829–1848', *Manchester Region History Review*, Vol.4, No.1 (1990) pp.3–10. [10] A memorial in the form of a stone cross, a copy of the cross of Iona, was erected on the spot near Ashway Gap, Greenfield. *Oldham Chronicle*, 31 August 1957. [11] Ab' O' th' Yate, 'At the unveiling of the statue', *Ben Brierley's Journal*, 21 September 1878. [12] *Oldham Express*, 23 January 1888; Oldham Industrial Co-operative Society General Minutes, 20 January 1888 (COI/1/9). The fountain (designed by the architects, Wild, Collins and Wild) to commemorate Queen Victoria's Golden Jubilee replaced an earlier one presented by the society in 1859. It was later removed and re-sited outside the entrance to Alexandra Park where it remained until the 1950s. *Oldham Evening Chronicle*, 24 August 1979. [13] The foundation stone of 'The Pagoda', as the building was nicknamed, was laid on 17 June 1899. [14] The borough has no Grade I listed buildings. [15] Quoted in T. Coombs, *Rising from Reality. Art in Oldham from 1820 to 1890* (Oldham Leisure Services, 1990) p.4. [16] The architects of the market hall were Lemming and Leem of London, *Oldham Standard*, 7 April 1906. The stone lions which surmounted the Henshaw Street entrance now guard the entrance to Oldham Museum. [17] *Saddleworth and Mossley Reporter*, 30 June 1900 and 24 August 1901; *Oldham Chronicle*, 24 August 1901. [18] *Saddleworth and Mossley Reporter*, 13 October 1923. [19] Unveiled 22 October 1921. *Oldham Evening Chronicle*, 24 October 1921; *Oldham Standard*, 29 October 1921; information from John Crothers. [20] *Oldham Evening Chronicle*, 20 August 1928; Oldham Parks and Cemeteries Committee, pp.196–7 (CBO 18/1/1/16). [21] Sculpture on Phoenix House, Union Street. The sculptor has not been identified. [22] *Oldham Evening Chronicle*, 3 October 1974. [23] B.R. Law, *Oldham Brave Oldham. An Illustrated History of Oldham* (Oldham: Oldham Metropolitan Borough Council, 1999). [24] *Manchester Evening News*, 18 November 1993. [25] *Oldham Evening Chronicle*, 2 August 1993. [26] Clarke's design paid homage to the Oldham-born composer, William Walton. *Brian Clarke Architectural Artist* (London: Academy Editions, 1994); *Brian Clarke. Designs on Architecture. Oldham Art Gallery 2 October – 19 November 1993* (Oldham: Oldham Leisure Services, 1993). [27] 'Art Under a Pint' commissioned artists to provide designs for beer-mats to be distributed in local public houses. Oldham Public Arts Officer press release, 1993. [28] Sculptures of animals in stone and metal by Victoria Brailsford and David Mayne, *Oldham Evening Chronicle*, 27 April 1995. [29] Designed by Free Form Arts Trust. [30] Articles and correspondence in *Oldham Evening Chronicle*, 30 September 1993, and *Advertiser*, October 1993. [31] *Oldham Evening Chronicle*, 15 September 1998.

Middleton Road

Chadderton War Memorial
Architects: Taylor and Simister
Sculptor: Albert Toft

8 October 1921
Bronze statue; granite pedestal
Statue 2.16m high; pedestal 5.31m high
Signed on plinth: A. Toft Sc
Inscription: IN HONOUR OF THE MEN OF
 CHADDERTON / WHO MADE THE SUPREME
 SACRIFICE / AND IN GRATEFUL REMEMBRANCE
 OF / ALL WHO SERVED THEIR COUNTRY / IN
 THE WARS OF / 1914–1919 / AND / 1939–1945
Status: Grade II
Condition: good
Owned by: Oldham Metropolitan Borough
 Council
Description: War memorial; grey granite
obelisk approached by three steps; on a bow-
fronted projection is the bronze statue of an
ordinary soldier, holding a rifle in his right
hand. He is standing on a short plinth
representing rough ground.

In addition to organising the erection of a
public war memorial, the Chadderton War
Memorial Committee also agreed to establish
scholarships for children whose fathers had
been killed in the war. The Oldham architects,
Taylor and Simister, were responsible for
designing the memorial, the focal point of
which was to be the figure of a soldier in
uniform. Albert Toft, who had been
commissioned to design the main Oldham war
memorial, was engaged to provide the
sculpture. A site in front of the town hall was
chosen. The memorial was completed and
installed by the autumn of 1921.[1] Kirkpatrick's
of Manchester was the contractor. Councillor
Ernest Kempsey was given the honour of

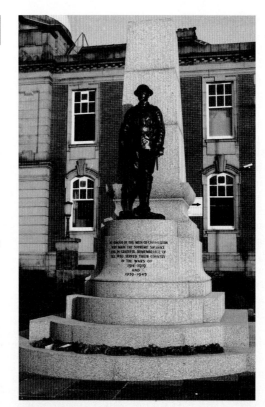

Toft, *Chadderton War Memorial*

unveiling the memorial in a ceremony that was
observed by one of the largest gatherings ever
seen in the town. After the formal ceremony,
long lines of local inhabitants waited
respectfully to view the memorial.[2] The final
cost of the memorial was £2,000.

Notes
[1] *Oldham Chronicle*, 8 October 1921. [2] *Oldham
Evening Standard*, 10 and 15 October 1921.

Oldham Road

Failsworth Clock Tower and Pole
Architect: E.D. Turner

15 May 1958
Brick tower; steel pole
Tower 10.2m high approx; pole 6.25m high
 approx
Inscription: A number of plaques with
 inscriptions were attached to the new clock
 tower, providing details of the earlier poles
 and the new structure – left-hand side:
 plaque with Failsworth coat of arms
 inscribed: FAILSWORTH POLE / ON THIS SITE,
 THE CENTRE OF LOCAL LIFE / AND REPUTED
 FROM TIME IMMEMORIAL TO BE / THE SITE OF
 A MAYPOLE, WAS ERECTED A NEW / POLE
 WITH THE FOLLOWING INSCRIPTION:- /
 "THIS, OUR LOYAL STANDARD OF
 FAILSWORTH WAS / ERECTED ON THE 1ST. OF
 JANUARY, 1793, TO THE / KING, CHURCH &
 PRESENT GLORIOUS CONSTITUTION" /
 THE SECOND POLE WAS ERECTED ON THE
 24TH. AUGUST. 1850 / AND A THIRD POLE
 ERECTED ON THE 24TH. AUGUST. 1889. / THE
 FOURTH POLE WAS ERECTED AND UNVEILED
 ON THE / 24TH. AUGUST. 1923. BUT WAS
 DESTROYED IN A GALE ON / EASTER MONDAY
 THE 10TH. APRIL. 1950 – right-hand side:
 FAILSWORTH CLOCK TOWER / THIS CLOCK
 TOWER WITH A REPLICA OF THE ORIGINAL /
 POLE WAS ERECTED TO REPLACE THE FORMER
 WOODEN POLES, / AS A PERMANENT FEATURE
 OF THE URBAN DISTRICT, AND / WAS
 INAUGURATED TO THE PUBLIC SERVICE ON
 THE / 15TH MAY 1958 / [followed by council
 coat of arms and list of committee and local
 councillors] – on the ground in front of the
 clock tower is a bronze plaque inscribed:
 THIS OUR LOYAL STANDARD OF FAILSWORTH /
 WAS ERECTED ON THE 1ST OF JANUARY 1793 /
 TO THE KING CHURCH AND PRESENT
 GLORIOUS CONSTITUTION / JOHN MOFFATT

WROTE THE FOLLOWING LINES IN 1830 / THIS STANDARD STANDS UNDER A COCK AND A CROWN / THREE BOARDS FOR THREE ROADS ARE FIXT ON'T LOWER DOWN / HANDS WITH LONG FORE-FINGERS ARE PAINTED ON THEM / TO POINT UNTO A(SHTON) UNTO O(LDHAM) UNTO M(ANCHESTER) / N.E.W.S. ARE FOUR LETTERS WHICH SHEW / THAT NEWSPAPERS COME FROM FOUR QUARTERS. WINDS BLOW / LO! UNDER THE CROWN ARE TWO G'S AND TWO R'S / WHICH HAVE BEEN RENEW'D SINCE THE END OF THE WARS / A PATRIOT KING IS A NATION'S DELIGHT / HIS YOKE IS IT EASY HIS BURDEN IS LIGHT / NOT LIKE THE FRENCH COCK TURN'D BY EVERY WIND / OF FAVOURITES FLATTERERS AND SUCH LIKE KIND / PRESENTED BY FRED DAY (FAILSWORTH AND THORNTON). / TO PERPETUATE THE MEMORY OF HIS MOTHER & FATHER

Status: not listed
Condition: fair
Owned by: Oldham Metropolitan Borough Council
Description: Brick clock tower surmounted by steel pole and the weathercock.

The *Failsworth Pole* stands at the junction of Main Street and Pole Lane and the Oldham Road in Failsworth. It is widely accepted that a pole of some sort, probably a maypole, has stood on or near this site for hundreds of years. The first documented pole was a political symbol, erected as part of an elaborate demonstration organised in the 1790s by local 'Church and King' loyalists, in which an effigy of the radical Tom Paine was paraded, executed and burned. Following on from these events, a more permanent pole – an oak tree encased in timber boards – was erected opposite the gallows. Placed on top of the pole was a crown, beneath which in gold letters was the inscription: 'This Standard of Loyalty was erected by the inhabitants of Failsworth on the 1st day of January 1793, to the King – the Church – and the Constitution.'[1] Although these years saw many public expressions and

celebrations of patriotism from the 'Church and King' party in the Manchester region, the erection of a pole was unusual.[2] The pole survived for over 50 years, a period of unprecedented social tensions and protests, during which its political genesis was not entirely forgotten. It was blown down in a gale on 7 October 1849. A new pole, made from a

Failsworth Pole

ship's mainmast, was erected on 24 August 1850, during the Wakes holiday.[3] It was almost 25 metres high and 50 centimetres in diameter.[4] On its top was mounted an ornate weathervane, which included a crown and the letters V.R., and a copper weathercock. The cost was met by public subscription. This eventually fell into decay and was replaced by a third pole. It was erected on 24 August 1889 at a cost of around £100, which again was raised by public subscription. This 28-metre pole was brought from Liverpool to Manchester by train and then to Failsworth by road. It was sunk over 3 metres into the ground leaving a visible pole of over 27 metres, the additional height being due to the ornamental ironwork including a copper weathercock. The fourth and last wooden pole was erected on 24 August 1924. It stood 25 metres high and cost £300, the funds being raised again by public subscription. This pole was blown down on Easter Monday, 10 April 1950. Throughout these years the pole had become a symbol of the community, the focus for many public events and activities.[5]

A committee was established and a fund opened to replace the pole. After long discussions within the community and the local council, it was decided to erect a more substantial and enduring public monument. A competition was organised and the winning design, in concrete, was from John Sutcliffe. However, after further discussions, the council rejected Sutcliffe's design, deciding instead to erect a tapering brick clock tower surmounted by a replica steel pole. It was designed by the District Surveyor, E.D. Turner.

Failsworth's new clock tower and pole was eventually inaugurated in May 1958. The fifth 'pole' still remains the centre of a community, whose physical boundaries have long since disappeared, a consequence of the industrial and residential development occurring between Oldham and Manchester. Parts of the previous two wooden poles are kept in the nearby Robert Sidlow Library.[6]

Notes

[1] *Manchester Mercury*, 8 January 1793. [2] A. Booth, 'Popular Loyalism and Public Violence in the North-West of England, 1790–1800', *Social History*, 8, No.3 (1983) pp.295–313. [3] *Manchester Courier*, 31 August 1850; *Manchester Guardian*, 31 August 1850. [4] 24.38m high, 51cm diameter. [5] J. Middleton, '*The Old Road*'. *A Book of Recollections* (Oldham: E.J. Wildgoose, printers [1920]) p.115. [6] Charles H. Shaw, *The Bicentenary of the Failsworth Pole* (Failsworth Local History Society, [n.d.]); D. Ball, *The Story of Failsworth* (Oldham Cultural and Information Services, 1987) pp.76–80.

Outside Inn
Timothy Shutter

5 June 1993
Stanton Moor sandstone
1.6m high × 3.57m long × 85cm broad
Inscription on rear of seat: Unveiled to / Commemorate / the Two Hundredth / anniversary of the first / Failsworth Pole / 5th June 1993 / by the Worshipful / the Mayor of Oldham / Councillor Brian Mather
Status: not listed
Condition: good
Owned by: Oldham Metropolitan Borough Council

Description: Free-standing sculpture, made from sandstone blocks, representing a pub interior. It is also a public seat. Off-centre is a fireplace, on the mantelpiece of which are two pint pots in relief. A lamp is placed to the left of the mantelpiece. Flanking the fireplace is a stool and a long bench seat on which is a cushion. In silhouette the sculpture shows a gable end, a window and chimney.

Outside Inn was commissioned to mark the 200th anniversary of the Failsworth Pole. It was located between the clock tower and the main road, the site being chosen with the intention that a suitable sculpture would help to create a more defined and friendlier public space. Tim Shutter, who had contributed to an urban sculpture trail in Bradford, was approached

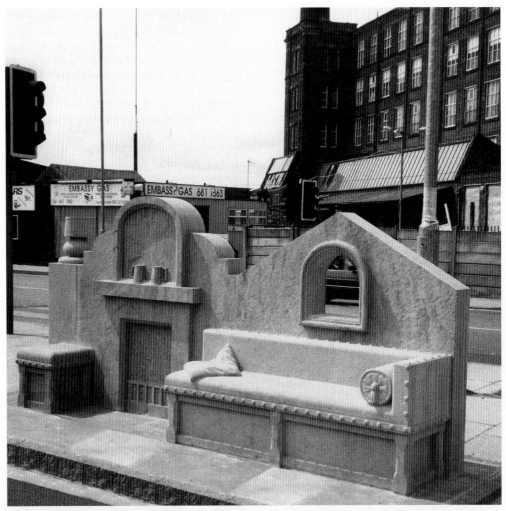

Shutter, *Outside Inn*

directly by the Oldham public arts officer to provide the work. Shutter took his inspiration from the many public houses surrounding the pole. His declared aim was to bring the snug of a Victorian pub out of doors, allowing drinkers to be sitting outside yet 'inside'.[1] Thus an important feature of the work was the inclusion of a seat, encouraging people to use the

sculpture, rather than simply look at it. Shutter observed that

the style of the furniture reflects the architectural period of most of the surrounding houses and, by using this clear imagery, I have tried to make the seating act as a unique marker for this community and for this particular place.[2]

The work was carved out of sandstone blocks. It was unveiled by the borough's mayor in June

1993.[3] Its location, between a busy main road and what has subsequently become a car park, appears to have worked against its being used as a place where people would choose to sit and relax. However, the space above the mantelpiece has become a public notice-board for recording the relationships of young people, a use that the artist may not have had in mind when he spoke of making an accessible work that reflected the community.

Notes
[1] Correspondence from Tim Shutter, 6 May 2000.
[2] Tim Shutter, quoted in *Manchester Evening News*, 13 June 1993. [3] *Oldham Evening Chronicle*, 7 June 1993.

Rochdale Canal
More Poles
Martin Nash

1993
7.5–9m high
Status: not listed
Condition: fair
Owned by: Oldham Metropolitan Borough
 Council
 Description: Sheet metal sculptures, representing aspects of the district's history, surmounting telegraph poles positioned along the towpath of the Rochdale Canal.

More Poles was commissioned to celebrate the bicentenary of the Failsworth Pole. The project was developed by the Oldham Leisure Services and Planning Departments and funded by the government's Urban Programme. The artist and sculptor, Martin Nash developed seven separate images based on the district's history and culture. These included 'The Runner', representing a strong urgent figure beginning a race or starting out on a journey, and referring to the Oldham Road, the district's principal road, once the Roman road linking Manchester and York; 'The Three Arrows', consisting of three poles, representing three tall, straight trees

at Wrigley Head, the site of a mock hanging organised by Failsworth weavers as a protest over their wages and working conditions; 'The Leaping Horse', representing the time when horses pulled wagons on the roads and barges on the canal between Lancashire and Yorkshire; and 'The Herald', representing a heraldic bird or standard with outstretched wings, facing Manchester: a reference to the 'Cock-of-the-North' on top of the Failsworth Pole.[1] The images, cut out of steel plate, were mounted on recycled telegraph poles of varying heights, which were positioned by the side of the Rochdale Canal. The renovation of the canal in 2000–2 resulted in a number of the poles being removed.

Note
[1] Public Arts Officer press release, Oldham Metropolitan Borough Council, 1993.

HOLTS

Near Birches Parade
Unity
Hideo Furuta

28 April 1995
Granite
2.74m high × 3m wide × 12cm
Inscription: 'UNITY' / This sculpture by artist
 Hideo Furuta was unveiled by / Peter Styche
 / for the Government Office of the North
 West / on April 28 1995 / Sculpture
 commissioned by / Holts Village Estate
 Management Board / Oldham Metropolitan
 Borough as part of the / Council's Public
 Art Programme.
Status: not listed
Condition: fair
Owned by: Oldham Metropolitan Borough
 Council
 Description: Stone ring constructed out of five pieces of stone; parts of the surface have

been smoothed, parts incised with curved lines, and other parts left rough. It stands directly on the ground.

Oldham Metropolitan Borough Council decided to commission a work of sculpture as part of a programme of refurbishment and landscaping of Holts, a run-down housing estate on the outskirts of the town. The Japanese sculptor, Hideo Furuta, who was working at the time in Northumberland, was commissioned to produce a suitable sculpture. He spent some time living on the estate in an effort to discover the residents' feelings towards modern public sculpture. A number of ideas were proposed by the sculptor before the final design, an open stone ring symbolising unity, was agreed upon. The scheme included seating and smaller pieces of stone, sited on the land between the main sculpture and the nearby shops. A mural was also designed with the help of local children. The stone was brought from

Furuta, *Unity*

Northumberland. The sculpture was unveiled by Peter Styche of the North West Government Office.[1] A stainless steel plaque attached to a nearby wall records the opening ceremony and the organisations involved in the project. The relevance and significance of *Unity* (known locally as 'the polo mint') continue to divide local residents.

Note
[1] *Oldham Evening Chronicle*, 1 May 1995.

LEES

Thomas Street

Lees Cemetery

Lees War Memorial
Malle and Sons

12 November 1921; relocated October 1949
Bronze statue; Portland stone pedestal
Statue 1.83m high approx; pedestal 3.05m high
Inscription on front of pedestal: TO / THE MEMORY OF / THOSE WHO GAVE / THEIR LIVES / AND IN HONOUR OF / THOSE WHO SERVED / IN THE / GREAT WAR / 1914–1918. – rear: THE GLORIOUS DEAD / THEIR SEED SHALL REMAIN / FOREVER AND THEIR GLORY / SHALL NOT BE BLOTTED OUT – left-hand side: LEES / WAR MEMORIAL / ERECTED BY / PUBLIC SUBSCRIPTION / 1921. / RE-ERECTED / 1949. – right-hand side: THEY FOUGHT IN WAR / THAT WE AT PEACE / MIGHT LIVE / THEY GAVE THEIR BEST / SO WE OUR BEST / SHOULD GIVE
Status: Grade II
Condition: fair
Owned by: Oldham Metropolitan Borough Council
Description: War memorial; life-size bronze statue of soldier in uniform, standing at ease with a rifle in his right hand. The statue surmounts a Portland stone pedestal, decorated with a

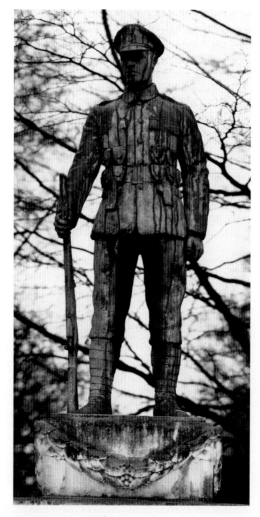

Lees War Memorial

garland of leaves, rising from three stone steps.

Plans to erect a public war memorial in Lees began to take shape soon after the end of the war. A memorial committee, under the chairmanship of W. Lees, was responsible for determining the design and organising the collection of the necessary funds. The site

selected was at the junction of the High Street and Hawkshead Street which, in spite of a nearby telegraph pole and tram standard, was considered to be the best available central location. Unsuccessful negotiations to have the telegraph pole moved confirmed the 'autocratic despotism' popularly associated with remote government departments.[1] The London firm of Malle and Sons was responsible for designing and erecting the memorial. Lees war memorial was unveiled in November 1921, on the day following Armistice Day, by Austin Hopkinson, the local MP, in a ceremony said to have been attended by the whole village.[2]

The rise in road traffic resulted, in 1949, in the decision to remove the memorial from the centre of Lees.[3] A garden of remembrance was created in the local cemetery, Thomas Street. In October 1949, Lieutenant-Colonel J.B. Whitehead unveiled the restored memorial which included a plaque, in the form of an open book, recognising those who had served and died in the more recent war.[4]

Notes
[1] *Oldham Standard*, 12 November 1921.
[2] *Oldham Evening Chronicle*, 14 November 1921; *Oldham Standard*, 14 November 1921; F. Millett, *Looking Back at Lees* (Oldham Education and Leisure, 1996) p.33. [3] *Oldham Evening Chronicle*, 3 August 1949. [4] *Ibid.*, 17 October 1949.

OLDHAM

Albion Street

H₂O
The Art Department

28 November 2001
Polished stainless steel
5.28m × 1.51m × 76cm
Condition: good
Owned by: Oldham Metropolitan Borough Council
Description: Drinking fountain; stainless

steel sculpture in form of the letter H surmounted by the letter O which spells out the chemical formula for water. A drinking fountain is placed in a recess on the side.

At the end of the 1990s, Oldham Council renewed its interest in public art. A number of specially commissioned pieces were to be placed in the new art gallery, scheduled to open in 2001, and plans were also made to install new works in the town centre, especially in the area

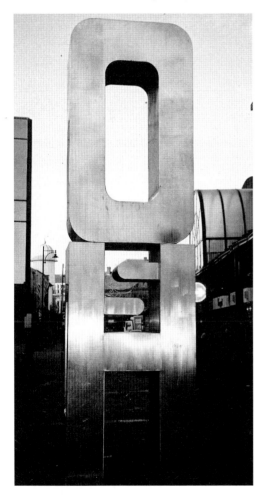

The Art Department, *H₂O*

around the market. A number of artists were considered for these projects, with the result that the work of organising and carrying out the commissions was awarded to The Art Department, a Manchester-based public art company. Following a meeting between councillors, council officers and artists, the idea emerged of installing on Albion Street, in front of the Market Hall, a large sculpture which would also function as a drinking fountain. This choice was influenced by the recollection that in the Victorian period an ornate drinking fountain had stood in this part of the town. The design of the fountain, however, did not look back to the past. Its shape was determined by the letters and the number of the chemical formula of water. It was to be constructed in polished stainless steel. The fountain, which was over five metres high, was fabricated by a local firm, Hollinwood Welding and Engineering Company Ltd. Lights were also provided, allowing the work to be illuminated at night. Around the same time, a number of other smaller public art works, including a pavement clock and a public seat in the shape of a textile mill, were also commissioned for the town centre. The completed fountain was declared open by Councillor Eleanor Ritchie in November 2001.[1]

Note
[1] *Oldham Chronicle*, 28 November 2001.

Alexandra Park

Joseph Howarth

Henry Burnett

9 May 1868
Yorkshire stone
Statue 1.98m high; pedestal 1.58m high × 63.5cm square
Signed on base of pedestal: H. Burnett. Sc. Clegg St. Oldham.
Inscription: JOSEPH HOWARTH / UPWARDS OF 40 YEARS THE WELL KNOWN / BLIND BELLMAN OF OLDHAM. / ERECTED BY VOLUNTARY SUBSCRIPTIONS. / PRESENTED TO THE PARK COMMITTEE / MAY 9TH 1868. / HE DIED ON THE 17TH DAY OF MAY 1862, / IN THE 76TH YEAR OF HIS AGE.
Status: Grade II
Condition: fair
Owned by: Oldham Metropolitan Borough Council
Description: Portrait statue; Howarth is shown dressed in his familiar heavy coat, holding his bell in his right hand. The statue surmounts a stone pedestal.

Joseph Howarth was the town's bellman and a popular Methodist lay preacher. He was born in Oldham *c.*1786 into a poor family; his father was a hatter, then one of the principal local trades. Howarth was blind from birth, but in spite of this disability he became a popular and respected local character. 'Blind Joe', as he was widely known, possessed a remarkable memory and a strong voice, both of which attributes he put to use in his job as the town's bellman. His voice was also familiar to local congregations as a Methodist lay preacher and teacher. His facility in remembering passages from the Bible was considered remarkable. Howarth's religious beliefs also influenced his work: he refused to announce dubious sales or events which he considered to be improper. For some 40 years he was a familiar sight in the streets of Oldham. He retired in 1860 and in his final years he received a small weekly allowance from the local Preachers' Mutual Aid Society. He died in May 1862 and was buried in Chadderton Cemetery.[1]

The idea of erecting a public monument to Howarth was not discussed immediately after his death, but appears to have followed on from the opening of Alexandra Park in 1865, his admirers concluding that a statue of the old bellman would be a fine ornament for the new park.[2] James Bailey and Joseph Lunn were prominent in organising the scheme. The collection of funds for such a novel purpose was a slow task in a community that was still

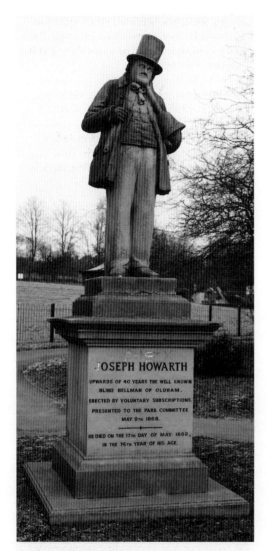

Burnett, *Joseph Howarth*

figure in Yorkshire stone, quarried in Huddersfield, though there were difficulties in obtaining a suitable block of stone. Burnett, working from a photograph of Howarth posed shortly before his death, depicted the old bellman in a heavy open coat, wearing his familiar top hat, grasping a walking stick in his right hand whilst in the other hand was his famous bell.[4] It was a representation Oldham people instantly recognised and there was general agreement that it was a good likeness. The council having decided to accept the statue, it was left to the Park Committee to select the site, having made it clear that the council would not meet the installation costs. The Park Committee did not permit the names of the organisers to be inscribed on the statue.[5]

The unveiling ceremony of the town's first outdoor statue was opened by the ringing of Howarth's own bell. It was a ceremony of celebration and speeches, when eulogies of Howarth were laced with expressions of civic pride. 'Blind Joe' was remembered as an honest and religious man, whose life of struggle was neatly fitted into the ideals of working-class self-improvement. Howarth was a man to be admired, a man who might serve as an example to others. That he was little known outside the town did not deter Oldham people from publicly recognising his worth. The mayor observed:

> Some towns did not do these things till they had got or reared a statesman, but the Oldham people were not waiting so long as that, seeing they could erect a statue even for a bellman.[6]

In a community where class relations had been fractious, other members of the town's élite saw significance in a statue being raised to a working man:

> Mr. Howarth was a poor man, and yet such a thing had been done for him. How beautifully did this statue contrast with that other of the goddess Hebe on the other side

of the footpath. While Joseph handed mutton pies to the people of Oldham, the other handed nectar to the gods.[7]

'Blind Joe' quickly became a familiar local landmark, and in a town, embarrassingly short of photogenic sites, the statue became a much-reproduced image.[8] Statuettes were also produced for sale.[9] Over the years the sandstone weathered and flaked. In 1976 the statue was cleaned and impregnated with a silicate resin in an attempt to stop deterioration.[10] In 2001, as part of a major restoration of the park, the statue was cleaned and repaired, but, unfortunately, it was soon damaged by stone-throwing vandals.

Notes
[1] *Wesleyan Methodist Magazine*, 1886, pp.842–8; *Oldham Chronicle*, 11 November 1954. [2] First public meeting held 24 April 1867, *Oldham Chronicle*, 16 May 1868. [3] *Worrall's Oldham Directory* (1871) p.28. [4] *Oldham Chronicle*, 29 March 1879. [5] Oldham Park Committee, Book No.2, 1 April 1868 (Oldham Local Studies CBO/18/1/1/2). [6] *Oldham Chronicle*, 16 May 1868. [7] *Ibid.*, 16 May 1868. [8] For example the photograph in James Middleton, *Oldham, Past and Present* (Edwards & Bryning, [1903]) [9] *Oldham Evening Chronicle*, 18 February 1977. Starring Pottery of Littleborough was one manufacturer. Oldham Museum have a number of the statuettes, and also Howarth's bell. [10] *Ibid.*, 19 October 1976.

Radcliffe Fountain
Sculptor: unknown

1865
Granite; stone
4.57m high approx
Inscription round the basin: PRESENTED BY
 JOSIAH RADCLIFFE ESQUIRE MAYOR 1865
Status: Grade II
Condition: fair
Owned by: Oldham Metropolitan Borough
 Council
Description: Ornamental fountain; fountain comprising two circular bowls, the smaller

recovering from the Cotton Famine. The limited funds available ruled out commissioning a statue from the studio of an established sculptor. It was Henry Burnett, identified in a contemporary town directory as a 'tobacconist and monumental mason', who was given the job of making the statue.[3] Burnett sculpted the

upper bowl being supported by one central grey granite column and four red granite columns. A stone figure of a young boy holding a fish, and standing among bulrushes, surmounts the fountain. The fountain is in the centre of a large circular stone pool.

This substantial ornamental fountain, situated at the end of one of the park's principal walks, was installed at the time of the park's opening in 1865. It was the gift of Josiah Radcliffe, a central figure in the Liberal élite which was so influential in the municipal life of mid-Victorian Oldham. Radcliffe's wealth was based on cotton. He further extended the cotton business established by his father, Samuel

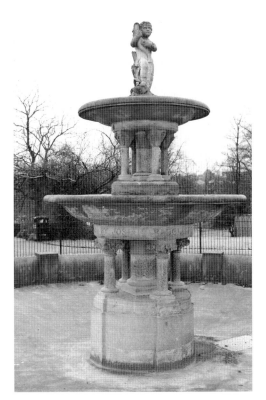

Radcliffe Fountain

Radcliffe, and was also successful in insurance and shipping. He was related to the Platt family by marriage. He served as mayor on three occasions in the 1850s and 1860s.[1]

The fountain, sited on the appropriately named Mayor's Walk, was an obvious focal point for visitors to the park. Over time its maintenance became less regular and by the second half of the twentieth century there were obvious signs of neglect. The fountain was restored in 1987 and again in 2001.[2]

Notes
[1] *Oldham Chronicle*, 6 December 1884. [2] *Oldham Evening Chronicle*, 5 June 1987; information from Keith Bennell.

John Platt
David Watson Stevenson

Unveiled: 14 September 1878; relocated 1924
Bronze statues; granite pedestal
Platt statue 3.05m high; female figures 1.68m high; pedestal 3.86m high
Signed on pedestal: D. W. Stevenson, A.R.S.A. Sc Edinr
Inscription: JOHN PLATT M.P. / ERECTED / 1878
Status: Grade II
Condition: fair
Owned by: Oldham Metropolitan Borough Council
Description: Portrait statue; John Platt is shown dressed in a buttoned frock-coat over which is a light overcoat. He is depicted speaking in public, his right hand extended and open while the other hand rests on his hip. The circular polished granite pedestal is flanked by four seated female figures symbolising subjects associated with Platt. The figures at the front represent Engineering, a plan resting across her lap and compasses in her right hand, and Manufacture, who is depicted holding a distaff. At the rear are Art, represented in the act of drawing, a tablet held in her left hand and a crayon in the right, and Science, shown contemplating a chemical experiment, a flask on

her right knee. She is the only one of the four figures whose head is covered with a veil. Each of these figures is placed on a raised rectangular stone base.[1]

John Platt was born in Dobcross, Saddleworth, in 1817. He entered the family business of textile machinery makers in 1837 and, following the deaths of his father and elder brother, he was instrumental in building up the firm into one of the largest textile machinery makers in the world. His younger brother James also

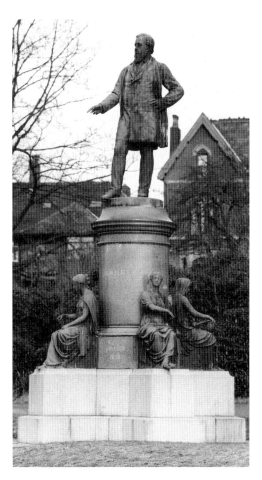

Stevenson, *John Platt*

Stevenson, *Science*

assisted in the running of the firm until his tragic death in 1857. Platt Brothers, as it had become known, continued to expand, and at the time of John Platt's death employed 7,600 people. From an early age, Platt took an active interest in the political questions of the day. He was a strong supporter of the Anti-Corn Law League, making his first public speeches on its behalf. His advocacy of free trade continued and his business knowledge took him to Paris with Richard Cobden, to assist in the negotiations of the French Commercial Treaty. He was elected as MP for the borough in 1865 and again in 1868. Platt took an active part in the public affairs of Oldham, helping to establish the municipal borough in 1849. Improvements to the town's water and gas supplies owed much to his organisational skills. He also took a keen interest in promoting

educational and cultural schemes, including the Oldham Lyceum and Oldham School of Science and Art. His interest in technical education led him to endow a chair in engineering at Owens College, the forerunner of the University of Manchester. He served as mayor in 1854–5 and 1855–6, and again in 1861–2. He was still comparatively young when at the age of 54 he died in Paris from typhoid fever in May 1872.[2]

Platt's untimely death stunned Oldham. His funeral was the largest the town had witnessed. It was in the spring of 1873 that the idea of providing a public memorial to Oldham's most famous townsman took shape. A public meeting was called and a committee formed 'to establish and maintain some worthy memorial of his many public virtues and beneficent life'. An initial sum of £575, including 100 guineas from a former mayor, John Robinson, was subscribed.[3] By the end of the year the appeal had raised over £3,500.[4] Lengthy discussions about the form of the memorial were eventually settled by the committee agreeing to erect a statue rather than a public library or memorial hall.[5] Designs were requested and the one by the Scottish sculptor, David Stevenson, who had contributed statues to the Albert Memorial and the Scott Monument in Edinburgh, was selected.[6] Stevenson kept in close touch with the committee over the details of the statue, using photographs provided by the family to produce the desired likeness. In scale the memorial was an ambitious one, including as it did four symbolic life-size female figures. The sculptures were cast in the foundry of Sir John Steell in Edinburgh, one report claiming that it was the largest ever memorial cast in the city. In all, Stevenson worked on it for three years. Discussions over the location, resulted in the decision to place it at the top of Clegg Street, looking down Yorkshire Street. This site, between the town hall and the parish church, was one of the most important public spaces in the town, close to where the hustings were erected at election time.

The unveiling of the statue proved to be a memorable day in Oldham's history. In spite of the weather, thousands of people filled the streets to see the ceremony honouring their most famous townsman. A procession of some 10,000 people representing the town's organisations and trades was impressive. Bands were much in evidence, and among the music included was a march composed especially for the unveiling. A medal was also struck to commemorate the event.[7] It was Mrs Alice Platt, his widow, who unveiled the statue.[8] The celebrations continued into the evening. For the élite there was a banquet in the town hall whilst outside the working population came to see the statue and enjoy the illuminations on the town's principal buildings. Stevenson's composition was generally approved of, though there was some disagreement about whether the statue

Stevenson, *Art*

had captured the real man. Ben Brierley, the popular Lancashire dialect writer, caught these different reactions to the new statue:

> Some said it wur a likeness, others said it wurno. Some said he're smilin, others said he're lookin sollit, as if he're calkilatin th' cost o' someb'dy's new stock o' machinery, an' th' chances he had o' gettin paid for it. Th' whul statty's wonderfully life like. One arm points to'ard th' King's Arms dur, an' I could fair see him say – 'Wilt' goo in, an' have a gill, Ab?'[9]

What was not in dispute was that Oldham's first major bronze statue was also one of the region's most monumental sculptural compositions. According to the *Manchester Guardian*, Stevenson depicted Platt as if in the 'attitude of directing some work to be done'.[10] The quartet of symbolic female figures was raised on a set of rectangular stone bases. These enhanced the overall monumental appearance, but were also visually necessary, as the memorial was originally surrounded by ornamental railings, some 1½ metres high. The pedestal was the work of McDonald and Field of Aberdeen.

The statue remained on its original site until October 1924 when, as a consequence of redevelopment in the town centre, it was decided to move it to Alexandra Park. It was placed on the park's main promenade, but without the protective railings and lamps that had surrounded it in the town centre.[11] Engineering's missing compasses and Art's broken crayon testify to vandalism over the years. Unfortunately, the recent £3.2 million project to restore Alexandra Park did not include the full restoration of the monument. The question of returning the monument to its original location near the town hall has been raised in recent years but it appears that it is to remain in the park.[12]

Notes
[1] *Oldham Standard*, 14 September 1878. [2] A. Marcroft, *Landmarks of Local Liberalism* (Oldham: E.J. Wildgoose, 1913) pp.205–11. [3] *Oldham Standard*, 3 May 1873; *Oldham Chronicle*, 3 May 1873. [4] *Oldham Chronicle*, 1 January 1874. [5] *Manchester Guardian*, 15 October 1874. [6] B. Read, *Victorian Sculpture* (1982) p.117. [7] Medal cast by George Kenning of Manchester; *Oldham Evening Chronicle*, 3 February 1989. [8] *Oldham Standard*, 14 and 21 September 1878. [9] *Ben Brierley's Journal*, 21 September 1878, p.303. [10] *Manchester Guardian*, 16 September 1878. [11] Oldham Corporation Park and Cemeteries Committee, 23 July 1924, p.303; 26 November 1924, p.340. [12] Information from Keith Bennell.

Robert Ascroft
Frederick William Pomeroy

20 June 1903
Bronze statue; granite pedestal
Statue 2.44m high approx; pedestal 3.65m high × 1.34m square
Signed on plinth: F. W. Pomeroy
Inscription: ROBERT ASCROFT / M.P. FOR OLDHAM / 1895–1899 / "THE WORKERS' FRIEND" / THIS STATUE WAS / ERECTED BY PUBLIC SUBSCRIPTION. 1903
Status: Grade II
Condition: fair
Owned by: Oldham Metropolitan Borough Council
Description: Portrait statue; larger than life-size bronze statue of Ascroft. He is dressed in a frock-coat, and shown in the act of public speaking, his right hand held out in front of him, the left hand holding his lapel. The statue stands on a massive granite pedestal.

Robert Ascroft, born in 1847, was a local solicitor who played an important part in the public life of late-Victorian Oldham. His father was an attorney, and Ascroft's legal apprenticeship was served in his father's office in Oldham. A competent and respected solicitor, Ascroft helped to increase the firm's reputation. After his father's death in 1882 he became head of the firm. He served on Oldham

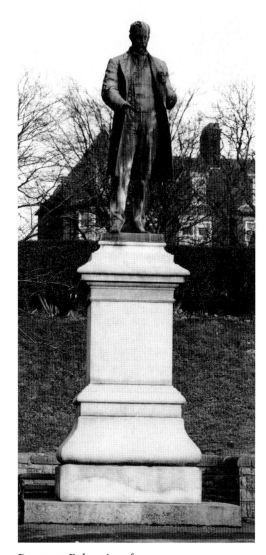

Pomeroy, *Robert Ascroft*

Council from 1871–3, but this initial involvement in local politics was not continued at that time. Ascroft's position as a public figure arose out of his involvement in the industrial relations of the cotton industry. He was the

solicitor and adviser to the Cardroom Amalgamation, and his expertise and tact did much to strengthen their position in the industry. Recognised as a skilful conciliator, he was called upon both to prevent and to resolve disputes. This role was especially evident in bringing to an end the bitter trade dispute of 1892–3, out of which came the Brooklands Agreement, a measure which placed industrial relations in the cotton industry on a new footing. Bob Ascroft, as he was always known, was elected as the Conservative MP for the town in 1895. In parliament he never missed the opportunity of furthering his election pledge of 'Something for Oldham', although the cotton operatives were not the only group of workers who found him a sympathetic spokesman. The news of his death in June 1899 sent a community celebrating the jubilee of its incorporation into mourning.[1]

The idea of raising a statue to Ascroft was first publicly discussed and agreed upon in October 1899. It was among the cotton unions, especially those in Oldham, that the idea of a memorial to 'The Workers' Friend' was strongest. His attitude towards labour was summed up in one trade union leader's assessment, that 'if Mr Ascroft had been a working man instead of a lawyer he could not have better advanced our cause in parliament'.[2] Progress on the memorial proved slow. In part this was due to the demands being made on the charitable public by the Boer War, but also because of an apparent reluctance of some textile unions to support the project. It was decided to postpone the scheme. Relaunched at a public meeting in July 1901 with Thomas Ashton, general secretary of the Oldham Spinners, in the chair, and other leading cotton union leaders on the platform, the proposal for a memorial statue finally went forward.[3] A fund was launched which collected £1,550, some two-thirds of which was provided by the cotton unions. The Spinners' Amalgamation, the most powerful and wealthy of the textile unions, provided £500, with a further £250 coming

from the Cardroom Amalgamation. The commission for the statue was awarded to Frederick Pomeroy. The site was settled after discussions with Pomeroy, who having visited Oldham rejected the idea of placing the statue in the town centre because, in his opinion, there were no suitable public spaces.[4] The statue was to be located on the main promenade in Alexandra Park, in a paved area with seating. Pomeroy appears to have had few problems in producing the statue which showed Ascroft in the familiar role of public speaker. The massive pedestal was supplied by Kirkpatrick Brothers, Trafford Park, Manchester.[5]

In June 1903 the statue was inaugurated before 'an immense concourse of spectators'. The ceremony was particularly noteworthy for the presence of the cotton union leaders, underlining their growing public status. Thomas Ashton carried out the unveiling of the statue, whilst William Mullin, the Cardroom's leader, formally transferred ownership to the mayor.[6] The ceremony was also marked by the presence of the town's Conservative MP, Winston Churchill, who had been persuaded by Ascroft, shortly before his death, to stand with him as a Conservative candidate in Oldham. Churchill had failed to be elected for the cotton constituency in 1899, but was successful in the 'Khaki' election of 1900.[7]

Notes
[1] *Ashton Standard*, 24 June 1899; A. Bullen and A. Fowler, *The Cardroom Workers' Union* (Rochdale: Amalgamated Textile Workers' Union, 1986); A. Fowler and T. Wyke (eds), *The Barefoot Aristocrats. A History of the Amalgamated Association of Operative Cotton Spinners* (Littleborough: G. Kelsall) pp.103–12. [2] *Oldham Chronicle*, 24 June 1899; *Manchester Evening News*, 24 June 1899. [3] *Oldham Evening Chronicle*, 11 July 1901; *Cotton Factory Times*, 12 July 1901. [4] *Oldham Standard*, 22 June 1903. [5] Signed on rear of pedestal close to the base. [6] *The Ascroft Memorial 1903. A souvenir and programme* (Oldham [1903]); *Cotton Factory Times*, 26 June 1903. [7] W. Churchill, *My Early Life. A Roving Commission* (London: Odhams Press, 1930) pp.216–18.

George Square

Vertex

Shirley Diamond

August 1993
Stainless steel and copper
2.3m high × 1.46m length × 30cm wide
Status: not listed
Condition: good
Owned by: Oldham Metropolitan Borough
 Council
Description: Abstract sculpture; three pairs of stainless steel and copper blade-shaped structures set in a paved circle and bisected by a walkway. The polished faces of the triangular structures have varying patterns and geometric shapes producing subtle changes in reflection.

Vertex was the first public sculpture to be installed in George Square, adjacent to the new Spindles shopping centre.[1] It occupies a central position in this pedestrianised space, a scheme that received a special mention in the Civic Trust National Environmental Design Awards in 1996.[2] The council asked artists to submit their ideas for a sculpture for the new public space. The entries were displayed at Oldham Art Gallery and members of the public were asked to choose their favourite. The result was that the proposals from Shirley Diamond and Andy Robarts received the same number of votes, a situation that was resolved by the decision to commission both works. The size and form of Shirley Diamond's composition took into account the sloping nature of the site, as well as the surrounding buildings, which included the shopping centre and a police station.[3] Positioned at ground level, it invited the viewer to walk through and around the sections. Diamond included a plaque on which she indicated the ideas behind the work:

My work responds to the visual world by simplifying its shapes, rhythms and textures. For example the outline shapes of the work refer to the contrast between the uprights of

Diamond, *Vertex*

Here
Andy Robarts

September 1993
Bronze
70cm × 65cm × 1.45m
Status: not listed
Condition: good
Owned by: Oldham Metropolitan Borough
 Council
 Description: Three bronze boulders placed at different points on the sloping pavement which passes through George Square. They represent a glacial boulder which collects objects associated with the history and everyday life of Oldham as it moves down the natural slope. The first boulder has only a few objects – buttons, a clog bottom and a bottle – attached to its surface, but these increase in number until the final boulder is almost entirely covered. The artefacts collected include a headstone from St Mary's Parish Church, a gargoyle from St James's

Robarts, *Here*

the buildings and the curving branches of the trees, with the tops emphasising the downward slope of the site. In this way the work is altered when approached from different directions, a change magnified by walking through or around the sculpture.[4]

The cost of the sculpture was met by Burwood House plc, the developers of the shopping centre, the government's urban programme and the council.

Notes
[1] *Advertiser*, 8 April and 26 August 1993; *Oldham Evening Chronicle*, 20 August 1993. [2] *Oldham Evening Chronicle*, 12 April 1996.
[3] Correspondence with Shirley Diamond, October 1999. [4] Plaque attached to wall, George Square.

Church, Derker, architectural detailing from a plaque at Oldham Coliseum, a cast of the front page of the *Oldham Evening Chronicle* (16 April 1993), pieces of mill machinery and clog irons.

The competition organised to select a sculpture for George Square resulted in the commissioning of two works: one by Andy Robarts and the other by Shirley Diamond. Robarts's work was more directly rooted in Oldham's history and culture. It represented boulders moving down a slope, picking up objects associated with the town and its institutions, including some from the famous Tommyfield Market.[1] *Here* was installed in the autumn of 1993. On a stainless steel plaque, fixed to the pavement, the artist noted:

> The idea of boulders being carried along by a glacier and themselves being used as tools to shape the landscape seemed to coinside [*sic*] with my growing interest in bringing the landscape into the town.

The full understanding of the sculpture is obtained by following the bronze boulders down the slope as they acquire their objects. Changes in the patina suggest that Oldhamers have begun to realise the sculptor's wish that the boulders would not be simply passed by, but touched to 'bring out the deep bronze colour'.[2] The work was financed by Burwood House plc, the government's urban programme and the council.

Notes
[1] *Oldham Evening Chronicle*, 17 June 1993, *Advertiser*, 9 September 1993. [2] *Oldham Evening Chronicle*, 5 April 1993; correspondence with Andy Robarts, 7 July 2000.

Lord Street
Sports Centre

Sir Robert Peel
Alexander Munro

25 September 1854
Marble
1.1m high
Signed: Alex Munro Sculpt
Inscription on plinth: THESE PUBLIC BATHS / ORIGINATED FROM A SUBSCRIPTION RAISED / IN HONOUR OF THE MEMORY OF / SIR ROBERT PEEL, BART. / THEY WERE ERECTED BY THE CORPORATION OF THIS BOROUGH / WITH THE AID OF THE FUNDS SUBSCRIBED / A.D. 1854
Status: not listed
Condition: fair
Owned by: Oldham Metropolitan Borough Council

Description: Marble bust of Peel and marble tablet with inscription.

Oldham followed the example of other Lancashire towns in establishing a public subscription to provide a memorial to Sir Robert Peel, following his untimely death in June 1850. The discussions within the Peel Testimonial Committee centred on providing a memorial of 'public utility' rather than a statue.[1] Suggested memorials included a park and an infirmary for the expanding town.[2] Guided by the committee's chairman, John Platt, it was finally decided that the money would be put towards providing public baths.[3] The £1,066 raised was insufficient to cover the full cost, leaving the council to supply the bulk of the money. In the end, the memorial committee only gave £900, less than a quarter of the total cost, as it used the remaining funds to provide a marble bust of Peel. The commission went to Alexander Munro who, at that time, was establishing himself as a portrait sculptor.[4] The bust and a suitably inscribed marble tablet were placed in the entrance hall of the new baths in Union Street in time for the official opening in September 1854. Walter Tittensor, the Oldham architect who had designed the building, performed the unveiling.[5] Speaking at the luncheon after the opening, John Platt acknowledged that the desire to memorialise Peel had been the spur in establishing the baths, trusting that 'future generations would often recall his memory and dwell with gratitude on the disinterested services which he had rendered to his country'.[6]

The public baths were extended during the Victorian period and continued to operate until they were replaced by a new sports centre. In 1975 the bust was transferred to the foyer of the new centre in Lord Street.[7] It was placed in the entrance area against a wall, but was, unfortunately, mounted on a shoddy base covered with mosaic tiles and Formica.

Munro, *Sir Robert Peel*

Notes
[1] *Manchester Courier*, 20 July 1850. [2] *Ibid.*, 3 August 1850; *Manchester Guardian*, 17 August 1850. [3] *Borough of Oldham Jubilee of Incorporation* (Oldham [1899]) p.18. [4] Gunnis (1968) p.267. [5] *Oldham Chronicle*, 30 September 1854. [6] *Ibid.* [7] The Sports Centre opened 9 May 1975; information supplied by Arthur Frost.

Union Street

Oldham Public Library and Art Gallery
Architect: Thomas Mitchell
Architectural sculptor: J.J. Millson

1883
Stone
Relief 80cm high approx × 2.2m wide approx; female figure 1.53m high approx
Status: Grade II
Condition: fair
Owned by: Oldham Metropolitan Borough Council
Description: Semicircular stone panel above principal entrance, containing a relief composition depicting a female figure seated on a throne and reading a scroll. In front of her is the figure of a kneeling man holding a book; to the left stand two children, both holding books, next to a bookcase. Surmounting the gable is a stone statue of a female figure holding a book in her left hand and a wreath in the other. The figure is standing on an octagonal pedestal. At intervals along the upper storey on both sides of the building are carved stone heads. On the west side (Southgate Street) the 'representative heads' are those of Shakespeare, James Watt, Rubens, Michelangelo, George Stephenson and Samuel Crompton; on the east side they are of Raphael, Handel, Mozart, Milton, Dante and Chaucer. Following the extension in 1894, the heads of Bacon, Newton and Darwin were added on the west side, and Swift, Harvey and Johnson on the east side.

Controversy surrounded the planning and building of Oldham's public library and art gallery. It was in 1880 that the Corporation appointed a committee to examine the possibilities of establishing a public library. In the following year the project moved forward, though not without opposition, when it was agreed to provide a reference library, museum and art gallery in a single building. The designs submitted by the Manchester architect, Thomas Mitchell, were selected. The main part of the building was officially opened in August 1883, although it was not until two years later that the library was fully opened to the public.[1] The final cost of the building far exceeded the original estimate of some £8,000. An industrial exhibition organised to coincide with the opening, which attracted a staggering 286,000 visitors, surprisingly added to the corporation's financial embarrassment. A court case in which Mitchell sued one of the councillors for slander over suggestions of overcharging was a further

Millson, *Head of Raphael*

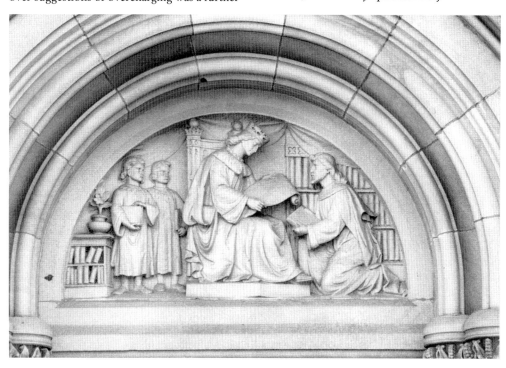

Millson, *Narrative Tympanum Relief*

awkward episode in a municipal project intended to provide a building that the community could point to with pride.[2]

The library was situated on Union Street, already the location of a number of the town's main public buildings. Mitchell emphasised the practicalities of his Gothic-influenced design: 'There is, therefore, no attempt to impose upon you by an exhibition of towers, pinnacles, or other extraneous frivolities, which are utterly beyond the scope of £8,000.'[3] But he did include some sculptural flourishes including a symbolic panel above the principal doorway, and the statue of a female figure surmounting the Union Street gable. Her identity is unknown, but the local tradition is that she was nicknamed 'Lady Wrigley', intended as a slight on the colourful local councillor, 'Colonel' William Wrigley, who had been vocal in opposing the idea of spending ratepayers' money on a public library. (The metal strip that girdles the figure like some form of chastity belt is part of a lighting conductor.) Both the panel and the figure were the work of the Manchester firm of architectural sculptors, J.J. Millson.[4] They cost £15 and £13.10s. respectively.[5] John Millson was also responsible for the twelve sculpted heads which punctuate the upper storey on the sides of the building. These represent individuals whose achievements in the arts, science and industry could be identified with the building's role as a centre of culture and learning.[6] All were household names, although only one, Samuel Crompton, had a strong Lancashire connection. Millson charged £2 for each head.[7] These external sculptures, although weathered, have fared better than the copies of classical statuary, obtained at around the same time from the South Kensington Museum, for display inside in the building.[8] They were a feature of the building for many years before being removed and presumably discarded.

Notes
[1] *Oldham Chronicle*, 4 August 1883. [2] *Ibid.*, 25 July 1885. [3] *Oldham Free Library and Museum. Descriptions and Illustrations by F.S.A.* [Thomas Mitchell] p.1. [4] John Jarvis Millson, sculptor, 26 City Road, Hulme. *Slater's Manchester Directory, 1884.* [5] Oldham Free Library and Museum Committee Minutes, 7 and 11 October 1882 (Oldham Local Studies BO 20/1/1/1). [6] Turner was included in the original list of 12 but was replaced by Raphael, see Oldham Free Library and Museum Committee Minutes, October 1882, p.34 (Oldham Local Studies BO 20/1/1/1). [7] Oldham Free Library and Museum Committee Minutes, 3, 7 and 11 October 1882 (Oldham Local Studies BO 20/1/1/1). [8] Oldham Library and Art Gallery Committee Minutes, 27 July 1889, 25 January 1890, 26 June 1890, 26 March 1891.

Yorkshire Street
Oldham War Memorial
Albert Toft

28 April 1923
Bronze sculpture; granite base
Sculpture 4.27m high; pedestal chamber 3.81m high × 3.35m square
Signed on plinth: Albert Toft Sc
Inscription: above the doors of chamber: DEATH IS THE GATE OF LIFE / 1914–1918; TO GOD BE THE PRAISE
Status: Grade II
Condition: good
Owned by: Oldham Metropolitan Borough Council
　Description: War memorial; bronze sculpture depicting a group of five soldiers in the act of coming out of their dug-out, advancing along the trenches and then going over the top. The group surmounts a granite base, containing a chamber, entered through bronze doors, in which is a roll of honour.

Plans to erect a memorial to those Oldhamers who had died fighting in the First World War began to take shape shortly after the war ended. Oldham had provided large numbers of fighting men – including one of the Pals' regiments – and suffered considerable losses. A target of £20,000 was set to provide both a memorial and scholarships for children whose fathers had been killed in the war. Any remaining money

was to go to the Oldham Royal Infirmary. There was a strong initial response to the memorial fund and by June 1919 some £9,000 had been raised.[1] Albert Toft was commissioned to provide the memorial. Toft was an established sculptor whose war memorials, including the Welsh National Memorial for the South African War, were commended.[2] The project made good progress. Toft proposed a complex and dynamic composition, depicting soldiers about to go into battle. The main standing figure, having climbed out of the trenches, was shown calling on his comrades moving along the trenches to advance towards the enemy. Importantly, Toft intended the memorial to be viewed from all

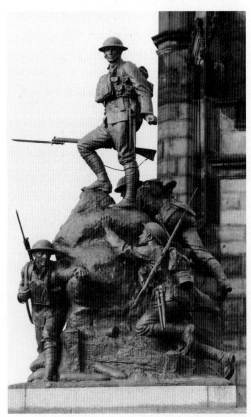

Toft, *Oldham War Memorial (detail)*

sides. By 1922 the figures had gone to the foundry.[3] A major dispute, however, arose over the siting of the memorial.

In planning the memorial, the memorial committee had assumed that a suitable site would be provided by the council. Initially, the preferred location appears to have been the Market Place, but doubts began to be expressed about its suitability, in part because the intended site was occupied by public lavatories. Alternative sites began to be considered, notably one in front of St Mary's church, almost directly opposite the town hall.[4] The latter site, although in the centre of the town, was also problematic because it would mean that the memorial would be close to a large public house. An approach to the Oldham Brewery Company to purchase the Greaves Arms Hotel was rejected.[5] Over a number of months arguments in the council and the press tested the suitability of this and alternative sites, including the main promenade in Alexandra Park and the open land next to the public library on Union Street. Support continued for the site by the parish church, and a canvas frame was erected to provide a clearer idea of the space required.[6] Toft's own views on the most appropriate site changed before he finally declared himself in favour of placing the memorial on the promenade in Alexandra Park. He was evidently keen to ensure that it could be seen easily from all sides. The debate was finally concluded when the council decided that the memorial would be located in the town centre, in front of St Mary's and next to the Greaves Arms Hotel.

The preparation of the site, including the building of a new wall in front of the church, was supervised by the architect, Tom Taylor. The installation of the memorial was not without incident, as the sculptural group was originally placed so that the principal figures faced the church rather than Yorkshire Street. With less than a month before the scheduled unveiling ceremony the decision was taken to rebuild the memorial so that the figures looked out towards the main street and the town hall. In agreeing to the change Toft reminded the committee that the memorial had not been intended for this site, and that it was a misconception to speak of the work being installed back to front.[7]

Oldham's principal war memorial was unveiled by General Sir Ian Hamilton in April 1923 before a crowd estimated at over 10,000. William Temple, Bishop of Manchester, provided the dedication.[8] The interior of the pedestal contained a chamber in which were placed books containing the local Roll of Honour. There was also a space in which people could pray. The chamber was entered through two substantial bronze doors.[9] The design of the memorial was widely praised but the location remained contentious. In particular, complaints were voiced that it was not respected by the customers of the neighbouring public house.

After the Second World War it was decided to incorporate a Book of Remembrance into the base of the original memorial as a tribute to those who had died in the recent war.[10] The book's pages were turned automatically. This addition to the original memorial was unveiled in 1955,[11] but it was the location which continued to be a concern. The monument was also the target of vandals.[12] However, in the 1980s, a concerted effort, led by the British Legion, to move the memorial to a more suitable location was unsuccessful.[13] Toft's memorial remains a prominent, if disrespected, landmark in Yorkshire Street.

Notes
[1] Oldham War Memorial Fund Appeal, 30 June 1919. [2] *Architectural Review*, 46 (1919) p.45. [3] *Daily Dispatch*, 6 April 1922. [4] *Oldham Standard*, 6 April 1922. [5] Oldham Council Proceedings, December 1921, p.369. [6] Oldham Council Minutes, 2 February 1922, p.306, 22 June 1922, p.370; Oldham Council Proceedings, July 1922, pp.1513, 1531–4, 1719–20. [7] *Manchester Guardian*, 31 March 1923, 3 and 4 April 1923. [8] *County Borough of Oldham. Unveiling of the War Memorial* [Oldham, 1923]; *Oldham Evening Chronicle*, 30 April 1923. [9] County Borough of Oldham, *Unveiling of the War Memorial* (Oldham, 1923). [10] *Oldham Evening Chronicle*, 8 October 1954. [11] *Ibid.*, 7 November 1955. [12] *Oldham Weekly Chronicle*, 16 May 1981. [13] *Oldham Evening Chronicle*, 15 April 1981; *Oldham Weekly Chronicle*, 9 January 1982; *Oldham Evening Chronicle*, 23, 28 and 31 January 1986, 7 April 1986.

ROYTON

Market Square

Walking Forward on the Wheel of Time

Nina Edge

September 1998
Mild steel
3.42m long × 1.7m high at centre
Condition: good
Status: not listed
Owned by: Oldham Metropolitan Borough Council
 Description: A curved low pierced steel screen resembling a fence of posts and rails, at the centre of which is a circular panel divided into eight sections, each section decorated with two shoes and one boot.

The Liverpool artist, Nina Edge, was commissioned by Oldham Council to produce a work of public art for the Market Square in Royton. Teenagers from Royton Youth Centre contributed ideas to the design of a sculpture resembling a pierced steel screen. The work, which cost £7,000, was placed in the town's refurbished shopping centre. At its unveiling the Director of Oldham Technical Services pointed out that the work reflected the industrial heritage of the town and had only been installed after 'extensive consultation' with the residents of Royton.[1] The artist, however, missed the ceremony because of transport problems.

Edge, *Walking Forward on the Wheel of Time*

Note
[1] *Oldham Evening Chronicle*, 15 September 1998.

Tandle Hill Country Park
Royton War Memorial
John Ashton Floyd

22 October 1921
Bronze sculpture; Portland stone obelisk
10.36m high approx
Inscription: IN MEMORY OF THE MEN OF
　ROYTON WHO GAVE THEIR LIVES FOR THE
　FREEDOM AND HONOUR OF THEIR COUNTRY
　IN THE GREAT WAR, 1914–19. "THEIR NAME
　LIVETH FOR EVERMORE"
Condition: poor
Status: not listed
Owned by: Oldham Metropolitan Borough
　Council
　Description: War memorial; a stone obelisk,
rising from a base which was surmounted by a
bronze life-size female figure personifying

Peace, a Crusader's sword, symbolising Justice,
in her left hand, and an olive branch in her
raised right hand. On three sides of the obelisk
were bronze laurel wreaths, beneath which
were engagement bands identifying the
different campaigns in which the local men had
fought. Bronze plaques identifying the names of
the fallen were included on the base.

Royton's principal war memorial to the men
who died in the First World War occupies a
prominent position on Tandle Hill, a viewing
point for the Greater Manchester area. In 1919
Tandle Hill and the surrounding land were
given to the people of Royton by Norris
Bradbury, 'a thank offering' to celebrate the
peace. This new park was an obvious, if slightly
inaccessible, site for the town's war memorial.
Plans to erect a war memorial were publicly
discussed in the town in 1919 and the task of
raising the necessary funds begun.[1] The
memorial was an obelisk rising from a square
base. A life-size bronze angel, the work of John
Ashton Floyd, was positioned above the base.
　The memorial was unveiled in October 1921
by the 17th Earl of Derby, in a ceremony which

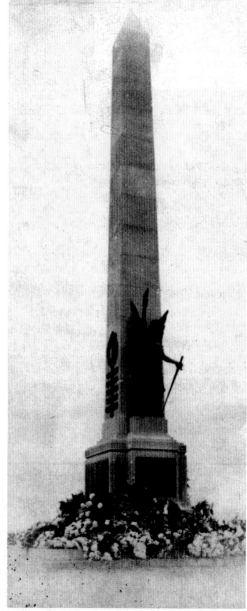

Floyd, *Royton War Memorial*

the heavy rain made all the more sombre. The procession began at Royton Town Hall and proceeded to Tandle Hill, the walkers 'wending their way along paths deep in mud, with a fierce storm sweeping across the open stretch of land'.[2] The dead of the Second World War were later remembered by the placing of three tablets at the foot of the memorial.[3] In the 1960s the main sculpture was stolen. On another occasion the plaques were also stolen, replaced, and stolen again. It was finally decided to install the plaques beside the parish church.[4] A new war memorial inscribed with the names of the dead of both world wars was unveiled in Royton Park in 2002.[5] The obelisk remains on the hillside, a still powerful if increasingly forlorn monument.

Notes
[1] *Varley's Royton Annual 1916–1919* (Royton, 1919). [2] *Oldham Evening Chronicle*, 24 October 1921; *Oldham Standard*, 29 October 1921; *Varley's Royton Annual 1923* (Royton, 1923). [3] *Urban District Council of Royton, Unveiling of Memorial Plaques, Tandle Hill, 25 July 1954* [1954]. [4] Information from John Crothers and Royton Library. [5] *Oldham Evening Chronicle*, 22 April 2002.

SADDLEWORTH

Diggle

Diggle Mill Level, off Marsh Head, off Sam Lane

Jephthah
Sculptor unknown

Stone
1.93m high including plinth
Status: not listed
Condition: poor
Owned by: Malcolm Taylor
 Description: Figurative sculpture; life-size sculpture depicting Jephthah, the Old Testament figure, dressed in tunic and sandals,

his right arm (now broken) is raised and presumably held the weapon with which he was about to kill his daughter. Her slumped body is placed to his left. The statue is on an oval plinth surmounting a rough millstone grit pedestal.

The provenance of this sculpture is uncertain. It is believed that it may be the only surviving piece from a collection of garden statuary belonging to the Victorian owner of the nearby Diggle New Mill. The statue is reputed to represent Jepthah in the act of sacrificing his daughter, a biblical story which attracted a

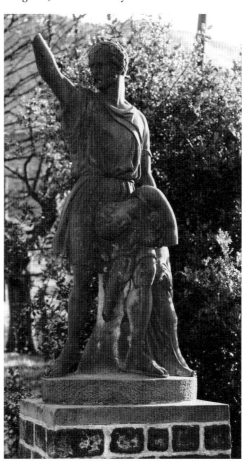

Jephthah

number of Victorian sculptors, though it does have similarities with representations of Virginius, another historical incident involving a father sacrificing his daughter.[1] Over the years, considerable damage appears to have been done to the statue. The female figure has lost the lower half of her body and also the lower part of her left arm and right hand. Jephthah's right arm below the elbow is also missing. Much of this damage is old but there is evidence of more recent vandalism. In 1998 the present owner repaired the sculpture and the stone pedestal on which it now stands.[2]

Notes
[1] P. MacDowell, *Art Journal*, September 1853, p.228. [2] Information from Malcolm Taylor, November 1998.

Dobcross

The Square

Ramsden Memorial Fountain
Architect unknown

17 August 1901
Polished granite; stone
3.05m high approx (excluding lamp and step)
Inscription: W.H.F. RAMSDEN / PHYSICIAN AND
 SURGEON. / BORN 1833. DIED 1900. /
 ERECTED 1901 BY PUBLIC / SUBSCRIPTION TO
 COMMEMORATE / HIS DEVOTED SERVICES TO
 THE / PEOPLE OF SADDLEWORTH. / "Write
 me as one that / loves his fellow-men".
Status: not listed
Condition: fair
Owned by: Oldham Metropolitan Borough
 Council
 Description: Drinking fountain situated on a sloping site in the centre of the village of Dobcross. The pedestal of the fountain, faced with panels of polished Aberdeen granite, rises into a carved finial, above which is an ornate lamp standard, originally lit by gas. As well as serving as a fountain for humans, there was also a drinking trough for animals.

Walter Henry Fox Ramsden was born in Oldham in 1833. He trained as a doctor in London and returned to his home town to practise medicine. In 1864 he moved to Saddleworth having purchased the practice of Dr Beckett Bradbury in Dobcross. In the following years the unselfish (and sometimes unpaid) medical assistance he provided to the working people of Saddleworth was widely appreciated. He became a prominent figure in the community and for some 25 years was

Ramsden Memorial Fountain

Saddleworth's Medical Officer of Health. Although essentially a country doctor his interest in medicine led him to publish articles in the national medical press.[1] He died in June 1900.

The idea of erecting a memorial to Ramsden was discussed shortly after his unexpected death. A committee, chaired by Revd Harry Edwards of Holy Trinity, Dobcross, was formed and decided that the memorial should take the form of a drinking fountain. Ramsden himself had expressed support for such an amenity to be installed in the district during his lifetime. After a hesitant start, a total of £190.2s.10d. was collected from the villages of Saddleworth. The centre of Dobcross, the village in which Ramsden had lived, was selected as the site for the memorial. This required the removal of the lamp that occupied the site.[2] The fountain was designed for use by both humans and animals. The Ashton District Waterworks Company agreed to supply the water free of charge. Saddleworth's first public monument was unveiled by Miss Brierley, who declared Ramsden to be a man 'who had made England what she is, and Saddleworth had good reason to be proud of him'.[3] The ceremony attracted the usual large crowd. The inscription included a line from the popular Victorian poem, 'Abou Ben Adhem', by Leigh Hunt. In 1976 the fountain was renovated, electric lighting replacing the original gas lamp.[4]

Notes
[1] *Saddleworth and Mossley Reporter*, 30 June 1900.
[2] Information from Peter Fox, Oldham Museum.
[3] *Oldham Chronicle*, 24 August 1901; *Saddleworth and Mossley Reporter*, 24 August 1901. [4] *Oldham Evening Chronicle*, 3 February 1976.

Uppermill

High Street

Ammon Wrigley

James Collins

25 May 1991
Bronze statue; concrete pedestal
1.70m high
Inscription on pedestal: AMMON WRIGLEY / 1861–1946 / POET AND HISTORIAN
Status: unlisted
Condition: good
Owned by: unknown

Description: Portrait statue; life-size bronze statue depicting Wrigley standing on the moors, his hands thrust into the pockets of an unbuttoned long coat. He is wearing a flat cap and a muffler. The statue is mounted on a short rough concrete pedestal.

Ammon Wrigley lived and died 'on the cold grey hills' of Saddleworth. He was born in Friarmere, Saddleworth, in 1861 into a working-class family which was familiar with hardship and poverty. By the age of nine Wrigley was working as a part-timer in a local textile mill. He showed an early interest in books and literature and wrote his first poem at the age of 12. An interest in the folklore and history of the district followed, and it was these aspects of Pennine culture that he recorded and celebrated in his writings. In prose and poetry he offered an intensely parochial vision of a world that he realised was disappearing. For Wrigley, towns such as Oldham and Ashton-under-Lyne, which had 'thrust their great, grimy faces into the green breasts of the hills and fastened their thirsty mouths on the sweet nipples of the waters' of Saddleworth, represented a culture soured by greed.[1] Wrigley preferred wandering the sheep tracks on the moors and the company of Saddleworth folk around the fireside of a moorland inn. His published works included *The Annals of Saddleworth* (1901), *Saddleworth*

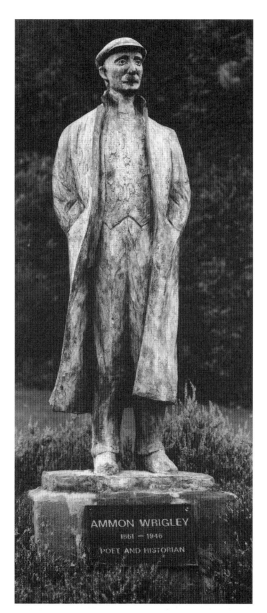

Collins, *Ammon Wrigley*

Superstitions and Folk Customs (1910), *Songs of a Moorland Parish* (1912), *The Wind among the Heather* (1916), *O'er the Hills and Far Away* (1931) and *Songs of the Pennine Hills* (1938). Their themes appealed to a largely local and increasingly enthusiastic readership; an Ammon Wrigley Fellowship founded during his lifetime was a remarkable public testament to the popularity of his work.

Wrigley died in 1946 and, in keeping with his own wishes, his ashes were scattered at the Dinner Stone on Millstone Edge, Delph, where a bronze memorial plaque was fixed.

The idea of raising a statue to Ammon Wrigley came from a local businessman, Roger Tanner, who had done much to encourage interest in Saddleworth's history, including the development of a local museum. Tanner commissioned the statue to coincide with the 1991 Saddleworth Arts Festival.[2] The Manchester-based sculptor James Collins was chosen to provide the work. Collins based the sculpture on a well-known drawing of Wrigley, which showed the poet on the moors in his hat and coat. The bronze sculpture was unveiled by the local MP, Richard Wainwright, in May 1991. The work was not without its critics, though most of the public comments were directed at the pedestal rather than at the statue. Objections were raised to the use of concrete, when local stone would have been more in keeping with the site and, more importantly, the man. Security was one of the considerations which had led to fixing the statue in concrete.[3] The planting of heather around the base has done something to hide the incongruity. The site itself was also problematic as Wrigley's love of the moors might have argued for a more remote location – 'I have no love for handmade artificial scenery, and that is why I avoid parks and public gardens', he wrote in his autobiography.[4] However, the effect of selecting a location close to the main road in Uppermill is that Saddleworth's most famous writer is seen by thousands rather than scores of people.

Notes
[1] A. Wrigley, *Songs of a Moorland Parish* (Saddleworth: Moore and Edwards, 1912) p.273. [2] Correspondence with Roger Tanner. [3] *Oldham Evening Chronicle*, 5 June 1991. [4] A. Wrigley, *Rakings Up. An Autobiography* (Rochdale: E.Wrigley, 1949) p.91.

SHAW

High Street

Memorial Garden

Crompton War Memorial

Richard R. Goulden

Unveiled: 29 April 1923
Bronze sculpture; granite pedestal
Sculpture 3.05m high; pedestal 3.76m high × 6.1m × 3.25m
Signed on plinth : R. R. Goulden Sculp; rear of plinth: A. B. Burton Founder
Inscription in raised bronze letters on front of pedestal: IN MEMORY OF MEN OF CROMPTON / WHO FOUGHT AND GAVE THEIR / LIVES TO FREE MANKIND FROM / THE OPPRESSION AND BRUTAL / TYRANNY OF WAR / 1914–1919 / 1939–1945
Status: Grade II
Condition: good
Owned by: Oldham Metropolitan Borough Council
Description: War memorial; bronze group in which the central figure, of heroic size, is a man, naked except for a cape, who is shown killing with his sword two wild lions who are attacking the six naked infants around his feet. The sculpture surmounts a stepped and tapering Scottish granite pedestal. Two bronze rectangular side panels on the pedestal have reliefs of the heads of men from the armed services, beneath which are the names of those who died in the First World War. A third panel records the dead of the Second World War.

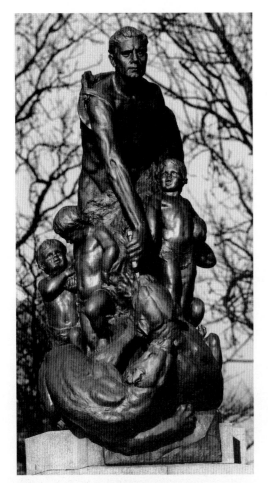

Goulden, *Crompton War Memorial*

The Crompton War Memorial Committee considered that depictions of soldiers, incidents of battle and 'engines of war' failed to convey the self-sacrifice of those local men who had given their lives 'to prevent the will of a great and aggressive nation being brutally forced upon us'.[1] Thus, in selecting their memorial, the committee decided on a symbolic design submitted by Richard Goulden, which depicted the safeguarding of the young, looking to the future whilst acknowledging the past. The

memorial cost some £4,000, but the landscaping of the site raised the total cost to £6,067. The memorial was unveiled in April 1923 by General Sir Ian Hamilton.[2] Those attending the ceremony included Mrs Hopley, three of whose eight sons were named on the memorial. A lead casket had been placed inside the memorial, which, in addition to the usual coins and a copy of the local newspaper, contained cops of spun cotton and a length of local cloth. A third panel listing the names of the dead from the Second World War was added to the pedestal in 1950.[3]

Goulden's allegorical group was one of the most impressive of the region's war memorials, and it contrasted with the bronze tablet erected in 1904 to commemorate those local soldiers who had died in the South African War.[4] Goulden was to provide a further war memorial for Crompton, in the form of a fountain that was dedicated to the women of the district.[5]

Notes
[1] *Crompton War Memorial Souvenir, April 29th 1923* [1923]. [2] *Oldham Standard*, 30 April 1923; D. Boorman, *At the Going Down of the Sun. British First World War Memorials* (York: Ebor Press, 1988) pp.94, 97. [3] 12 November 1950. [4] Unveiled by James T. Travis on 25 June 1904. Originally located in front of the town hall, it was re-sited in 1930 in the gardens at the rear of the public library. [5] See below, p.301.

St James's Street

St James's Church

Education

Hamo Thornycroft

July 1919; re-sited February 1976
Bronze sculpture
1.78m high
Signed on plinth: Hamo Thornycroft RA. Sc.;
 Albion Art Foundry Ld. Parsons Green. SW
Inscription on plinth: EDUCATION
Condition: fair
Status: unlisted

Owned by: Oldham Metropolitan Borough
 Council
Description: Seated figure of a female with a book on her lap; to her right is the figure of a young boy dressed in a tunic with a coat, at his feet are a cricket bat and ball. She is looking at the child, her right arm around him, her left arm outstretched, pointing to the future.

Education, a didactic sculpture of a mother and child, was one of the four supporting groups sculpted by Hamo Thornycroft for the London Gladstone Memorial, which was completed in 1905.[1] A bronze copy of *Education* was purchased by James Cockcroft, who presented

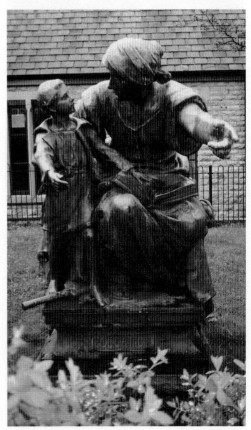

Thornycroft, *Education*

it to the people of Shaw and Crompton in 1919. Cockcroft, a prominent local employer, also took an active role in the public life of the fast-growing cotton town. He was a strong advocate of public libraries and in 1907 was given the honour of opening the town's new library, a building funded by Andrew Carnegie. In donating *Education* to the town he proposed that it should be placed in the entrance hall of the library, where it would be 'an inspiring object to the youth, and I hope the adults of our village'.[2] A plaque commemorating the official ceremony in July 1919 read: 'Presented by James William Cockcroft as a token of love and respect for his native village and in grateful acknowledgment of many benefits received by him.'[3]

Education remained an imposing feature of the library until 1975 when, because of the need for additional space, it was decided to remove it. The Arts and Recreation Committee of the recently established Oldham Metropolitan Borough Council considered the matter and concluded that the sculpture was of little artistic interest and could be sold for its scrap value.[4] The decision provoked angry local protests, causing the committee to call in an art expert for a more considered assessment. At the same time 'a reputable scrap-dealer' reported that the scrap value of the phosphor-bronze would not be as large as had been first assumed.[5] The original decision to dispose of the sculpture was rescinded, and it was agreed to find a suitable outdoor location in the town. A small public garden on Chamber Road, close to the former home of the Cockcroft family, was proposed, but the residents objected.[6] In the meantime, the statue was removed from the library and stored in a council yard. The problem of a suitable site was finally resolved when it was agreed to place it in the churchyard of St James's, a church with which the Cockcroft family had been associated.[7] After some further delays, in February 1976 the sculpture, mounted on a short stone pedestal, was placed in a small garden between the church and the

parish room, formerly the church school.[8] Although the location was regarded by some people as a temporary one, the sculpture has remained.

Notes
[1] E. Manning, *Marble and Bronze. The Art and Life of Hamo Thornycroft* (London: Trefoil Books, 1982) pp.137–40, 202. [2] Shaw Free Library and Baths Committee minutes, 10 February 1919, p.179. [3] Plaque now in Oldham Archives (Misc 35, Crompton Box 2/41). [4] *Oldham Evening Chronicle*, 18 July 1975. [5] *Ibid.*, 4 August 1975. [6] *Ibid.*, 27 and 28 August 1975. [7] *Ibid.*, 31 October 1975. [8] *Ibid.*, 24 February 1976.

WATERHEAD

Huddersfield Road

Junction of Heywood Street and Brideoak Street

Waterhead War Memorial

George Thomas

17 April 1920
Bronze statue; sandstone pedestal
Statue: 1.83m high; pedestal 2.44m high
Signed on plinth: George Thomas M.C. Sculp. 1920; Albion Art Foundry Parsons Green S.W.
Inscription on front of pedestal: TO / THE MEN OF / WATERHEAD / WHO FOUGHT / AND FELL / IN THE / GREAT WAR / 1914.1919 – left-hand side: IN MEMORY OF / THE MEN AND WOMEN / OF THIS PARISH / WHO FELL DURING THE / 1939.1945 / WAR / "AT THE GOING DOWN OF THE SUN / AND IN THE MORNING / WE WILL REMEMBER THEM." – rear: ERECTED / BY PUBLIC / SUBSCRIPTION / UNVEILED BY / ELISHA BARDSLEY. J.P. / APRIL 17TH 1920
Condition: fair
Status: not listed
Owned by: Oldham Metropolitan Borough Council

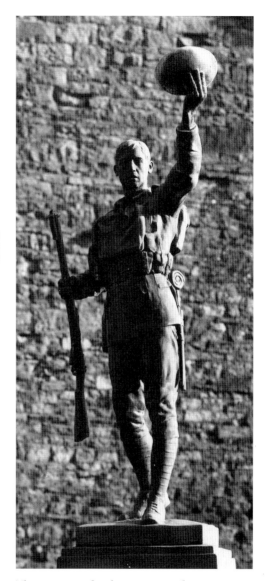

Thomas, *Waterhead War Memorial*

Description: War memorial; life-size bronze statue of an ordinary soldier, who is depicted advancing at the moment of victory. His left arm is raised aloft holding his helmet, whilst in

his other raised hand is his rifle. The statue surmounts a stone pedestal.

Waterhead's war memorial was one of the first to be commissioned and completed in the Oldham district. The London artist, George Thomas, was selected to sculpt it. Thomas, who had fought in the war, produced a representation of the ordinary soldier, jubilant at the moment of final victory. The memorial was unveiled by Elisha Bardsley, who had been a central figure in organising the project. In his speech to the large crowd which had gathered to witness the unveiling, Bardsley took the opportunity to remind local employers of the need to provide jobs for those who had returned disabled from the war.[1] Thomas, who also attended the ceremony, was described in one of the local newspapers as 'a brilliant young sculptor from that home of artistic genius, Chelsea'.[2]

The memorial, which was situated at the junction of Oldham Road, Huddersfield Road and Brideoak Street, was damaged in June 1930 when a car hit the pedestal and the statue fell onto the car. The memorial was repaired. In February 1976 it was moved a short distance from the road junction and placed in a newly-landscaped area.[3] It has suffered from vandalism. The bayonet on the soldier's rifle which had been broken off in 1972 was found by a former SAS soldier in 2002 and welded back on.[4]

Notes
[1] *Oldham Evening Chronicle*, 19 April 1920.
[2] *Oldham Standard*, 19 April 1920. [3] *Oldham Chronicle*, 28 February 1976. [4] *Oldham Evening Chronicle*, 17 August 2000.

Manchester Road

Werneth Park

Sarah Lees Memorial

W. Hargreaves Whitehead

25 September 1937
Column 7.92m high approx
Inscription: THIS MEMORIAL IS ERECTED / BY THE TOWNSPEOPLE OF / OLDHAM AND FRIENDS / TO THE MEMORY OF / DAME SARAH A. LEES D.B.E. L.L.D. / SHE TRUSTED GOD / AND SERVED THE PEOPLE.
Status: Grade II
Condition: good
Owned by: Oldham Metropolitan Borough Council
Description: Ornamental fountain; central stepped and tapering stone column, representing growth and dignity, standing in the centre of a circular fountain pool. The bronze base of the column is in two sections. The upper hexagonal part consists of six panels: one panel has a portrait of Dame Sarah Lees, one the inscription, and four panels represent the seasons. The lower part of the bronze base is circular, with representations of the twelve signs of the zodiac. The zodiacal signs are placed directly beneath the appropriate season. On the outside of the pool are four drinking fountains, set at the principal points of the compass, with stone female figures representing the winds.

Sarah Lees was an influential figure in the public, philanthropic and political life of Oldham. She was born in 1842, the youngest daughter of John Buckley, a textile manufacturer in Mossley. She married Charles Lees, a successful Oldham industrialist, whose business interests included cotton, coal and iron. Lees took a great interest in art and his

Whitehead, *Sarah Lees Memorial (detail)*

collection of watercolours was eventually given to the town's art gallery. His death in 1894 left his widow an extremely wealthy woman, with assets of £890,000 excluding land and property. Her involvement in the town's medical, educational and children's charities increased in the following years. She was also a prominent figure in the Beautiful Oldham campaign. These interests were in keeping with the traditional role of wealthy middle-class women, who recognised philanthropy as a natural public arena in which they could operate.[1] More innovative was her role in local politics. She was elected as a Liberal councillor for the Hollinwood ward in 1907, one of the country's first female councillors. Three years later she became the borough's first female mayor, again one of the first women in the country to hold

this office.[2] Her contribution to the town was recognised by her being the first person to be given the Freedom of the Borough. Sarah Lees also took a particular interest in the problems of women, serving on the committee of the National Union of Women Workers and supporting the franchise for women. She died in 1935.

The organising committee responsible for providing a memorial to Sarah Lees emphasised that the appeal for subscriptions had been responded to from all sections of Oldham society. The appeal was sponsored by Aldermen Wrigley and Bainbridge along with the mayor. A local sculptor, W. Hargreaves Whitehead, a teacher at Oldham School of Art, was commissioned to provide a memorial, which it had been agreed would be located in Werneth Park, the home of the Lees family.[3]

The house and its extensive grounds were given to the people of Oldham in 1936 by Marjory Lees, Sarah's daughter.[4] Whitehead's design took its inspiration from the words 'Service to Humanity through all Time', the form being suggested by the growth of a bulb, incorporating the ideals of the Beautiful Oldham Society and Youth. The column represented dignity and a striving upwards, forcing its way through the base which symbolises time. The detail was considerable, including the varied treatment of the four stone figures, placed at the points of the compass, representing the winds. The figure for the north is huddled up, the figure for the east suggests the piercing cold wind, the south shows contentment, and the west is depicted pulling on a cloak as a protection against the rain.

Marjory Lees, who had continued her mother's example of public service, unveiled the memorial in September 1937. Speaking at the ceremony, Whitehead stated that his design should be seen as a symbol of the public work done by Sarah Lees, tactfully pointing out that as much local labour as possible had been employed in the memorial. It has stood in Werneth Park since that date, a prominent

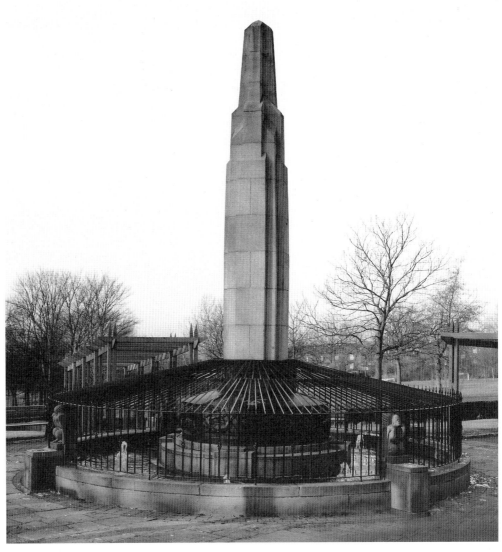

Whitehead, *Sarah Lees Memorial*

reminder of the woman who devoted herself to improving the lives of those who lived in Oldham. The stone statuettes of the Four Winds were stolen in 1991, but recovered in a second-hand shop in Shaw, near Oldham and reinstalled in 1992.[5] In 1998–9 the area around the memorial was landscaped and pergolas added. Protective railings were also installed above the basin, unfortunately obscuring parts of the sculpture on the bronze drum at the base of the column. The Four Winds were stolen again in August 2000.[6]

Notes
[1] J. Collins, 'Women's Work within Philanthropy
and Local Government with particular reference to
the Oldham area and the work of Dame Sarah Lees
and Mrs Mary Higgs', BA Dissertation, University of
Salford, 1997. [2] P. Hollis, *Ladies Elect. Women in
English Local Government 1865–1914* (Oxford:
Clarendon Press, 1987). [3] W. Beck, *Oldham Art
and Artists* [Reprinted from *Oldham Chronicle*,
1936]. [4] *Oldham Evening Chronicle*, 1 June 1936.
[5] *Ibid.*, 7 March 1991. [6] *Ibid.*, 17 August 2000.

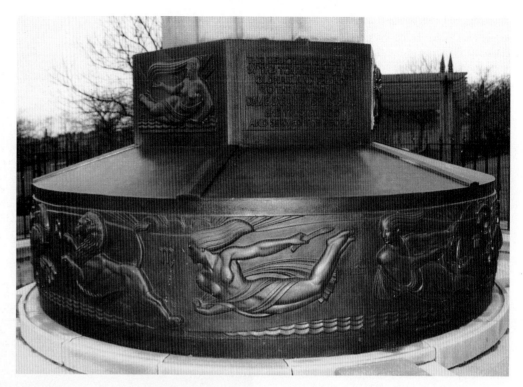

Whitehead, *Sarah Lees Memorial,*
base depicting signs of the zodiac

Dun Wood Park, Shaw
Memorial Drinking Fountain
Richard R. Goulden

Unveiled: February 1926; stolen April 1968
Bronze sculpture; granite pedestal
Inscription on bronze plaque fixed on column:

THIS FOUNTAIN IS PLACED HERE AS A MARK
OF APPRECIATION OF THE SELF-SACRIFICE
AND DEVOTION OF THE WOMEN OF
CROMPTON DURING THE GREAT WAR. HELP
ONE ANOTHER.

Description: Drinking fountain; stone
column rising from a stepped base, surmounted
by two bronze figures of a seated female
holding an infant, whose legs reach down over
the top of the column.

Richard Goulden, who had been responsible for
Crompton's principal war memorial, was also
the sculptor of a second local memorial. The
details of the commission remain unclear, but it
is known that a bronze sculpture of a mother
holding her infant child was one of two works
by Goulden displayed at the British Empire
Exhibition in 1924. It was priced at £300.[1] The
sculpture was purchased by a Crompton
resident and presented, anonymously, to the
town as a tribute to the contribution made by
local women to the war effort. The sculpture
was incorporated into a drinking fountain and
installed in Dun Wood Park, Shaw in 1926.[2] It
was stolen from the park in April 1968 and has
not been recovered.[3]

Notes
[1] *British Empire Exhibition (1924) Wembley,
London. Palace of Arts Catalogue* (London: Fleeting
Press, 1924) p.67. [2] Crompton Council Minutes,
Parks and Cemetery Committee, 11 May 1925, p.279;
Oldham Standard, 6 February 1926; *Oldham
Chronicle*, 6 February 1926. [3] *Oldham Evening
Chronicle*, 4 May 1968.

ROCHDALE

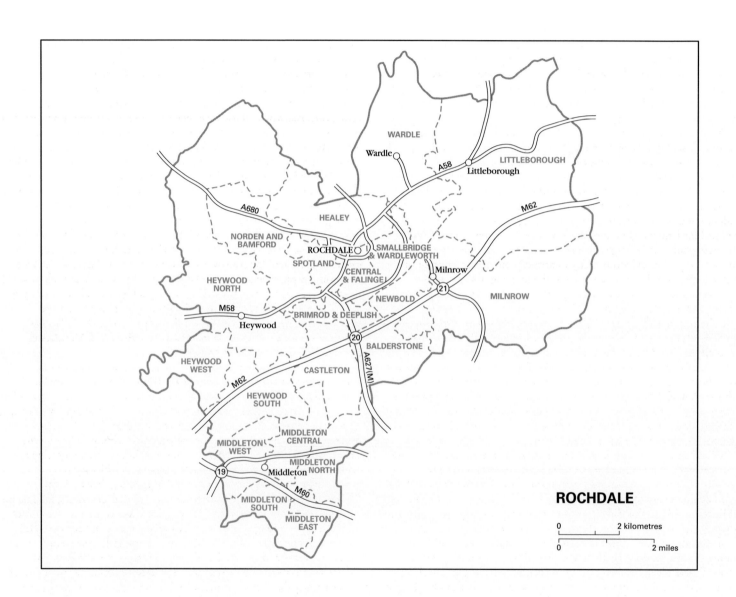

ROCHDALE

0 2 kilometres

0 2 miles

Introduction

The Metropolitan Borough of Rochdale was created in the local government reorganisation of 1974, amalgamating the county borough of Rochdale with the neighbouring districts of Heywood, Middleton, Littleborough, Wardle and Milnrow.[1] The district covers an area of 15,957 hectares, the second largest of the Greater Manchester authorities. In 2001 the population was 205,233.

The parish church of Rochdale, St Chad's, was founded around 1170, but the archaeological evidence suggests Anglo-Saxon origins. The parish covered a large area and became one of the richest livings in the North West.[2] By the seventeenth century Rochdale – 'a pretty neate towne built all of stone' – was recognised as an important centre for the production of woollen textiles. Other local trades included the making of hats.[3] Evidence of the new industrial society was apparent when John Aikin compiled his famous account of the Manchester region in 1795.[4] Mills were being built in the neighbouring Pennine valleys where the water supply was reliable and stone easily quarried.[5] The construction of the Rochdale Canal and, a generation later, the opening of the Leeds–Manchester Railway were both a response and a further stimulus to the ongoing industrial development. The rapid expansion of the parish was most obvious in Rochdale itself, where the population increased from 29,178 in 1851 to 83,114 in 1901. Antiquated parish authorities were eventually replaced by modern forms of local government, Rochdale being created a municipal borough in 1856. Such change was not without costs, these years being ones of social tension and protest. Rochdale had a turbulent labour history. However, it was to be best remembered as the place where, in 1844, the Rochdale Equitable Pioneers Society established their first store, an act that proved to be a decisive moment in what was to become a worldwide Co-operative movement.

Rochdale's market cross appears to have been an early casualty of the town's growth, though local antiquarians and archaeologists have struggled to date and identify the circumstances of its removal.[6] Rochdale lagged behind many of the neighbouring cotton towns in erecting its first public statue. When this did occur in 1878, it was not surprising that the individual honoured was a local manufacturer and Nonconformist, one of the men who had been at the heart of the Liberal élite responsible for shaping the town's mid-Victorian fortunes. The statue of George Ashworth was placed in the recently opened Broadfield Park, looking across a town that now boasted one of the finest town halls in England, a building that owed much to Ashworth. The statue was welcomed by the Liberal press, which saw it as both a fitting memorial and a work of art, in a town set on improving its public face.[7] However, not all Rochdalians were as enthusiastic. For some, the town hall – William Crossland's design included a 74-metre tower topped by a statue of St George – was better read as a lesson in municipal mismanagement than as a statement of civic pride. Ashworth himself had been accused of letting the project slide out of control, allowing money to be wasted on unnecessary decoration.[8] Many Rochdalians preferred utility to beauty, and were unimpressed by arguments connecting architecture and statuary to the elevation of public taste. Henry Holiday, the artist responsible for painting *The Signing of the Magna Carta* in the Great Hall, recalled 'the deadness of spirit which hangs heavy in a place given over to the dehumanising work of money making'.[9] Whether further money would have been spent on the town hall, in particular the statues intended to adorn the tower, can never be known, as the tower burnt down in 1883. Niches for statuary were not included in Alfred Waterhouse's replacement tower. The town hall did, however, become home to a small collection of portrait busts, all of which were of local Liberal worthies. They were paid for by public subscription or gifted by individuals. Not all such gifts appear to have survived. Numbered among those missing is a life-size plaster cast of Thomas Woolner's portrait statue of James Fraser, the Bishop of Manchester, donated by Dean Maclure in 1893.[10]

Unsurprisingly, one of the marble busts in the town hall was of Rochdale's most famous politician, John Bright. It was Bright who was memorialised in Rochdale's second (and final) portrait statue. Unveiled in 1893, it was situated on land between the town hall and the River Roch, helping to define an emerging civic space. Shortage of funds meant that other public monuments were somewhat less ambitious in form. One such Edwardian memorial honoured local dialect writers, reflecting a pride that people felt about Rochdale's place in the history and continuing promotion of Lancashire's disappearing dialect culture. Paradoxically, it celebrated nineteenth-century dialect writers, making no reference to Tim Bobbin (John Collier), the father of Lancashire dialect literature, who, though not born in Rochdale, had long been claimed by the town as one of its own.[11] Other public memorials were to be found in the churchyards and cemeteries. Thomas Livsey's grave in Rochdale Cemetery was marked by a substantial granite sarcophagus, the work of Edgar Papworth: a tribute paid for by his admirers, not his family.[12] An elegant granite obelisk was raised in the churchyard of St James, Milnrow

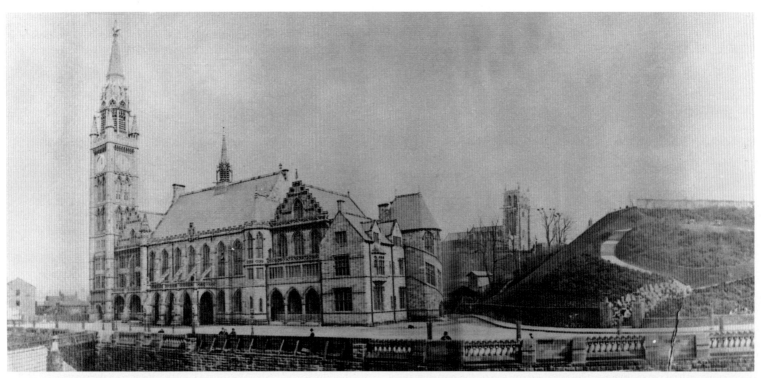

Rochdale Town Hall c.1875, showing the original tower

in memory of the Anglican minister and antiquarian, Canon Francis Raines.[13] When Colonel Henry Fishwick surveyed the borough's first 50 years, it was evident that its civic buildings, with the exception of the town hall, were, in general, architecturally modest. External ornamentation was slight, though not entirely absent. It was revealing that the sculptural panels that made the art gallery one of the town's most notable public buildings had only been commissioned because of the personal generosity of a small group of local individuals.

Commemorative public sculpture in the smaller neighbouring towns favoured the obelisk. None was more revealing than that erected in Middleton to Samuel Bamford, its unveiling being the occasion for the Liberals to recast Bamford's life, not for the first time, in their own image. Drinking fountains also proved to be a practical and comparatively inexpensive form of public monument. They were usually the gift of individuals or associations, though none appears to have been the direct gift of a temperance society. Rochdale boasted two substantial examples. Ellen Mackinnon presented a drinking fountain in 1899, the principal figure being a marble angel notable for having the left rather than the

right arm raised. It was located outside Broadfield Park and quickly became one of the town's landmarks. Some eight years later the Rochdale Provident Co-operative Society commissioned a substantial drinking fountain to mark the borough's jubilee. It was placed inside Broadfield Park. Fountains were also erected in the neighbouring towns where, once again, the municipal park was the preferred location. Of these, none was more impressive than the three-basin ornamental fountain, decorated with dolphins and swans, in Queen's Park, Heywood. It was in place for the park's opening in 1879, an occasion that helped to define the civic identity of this rapidly expanding cotton town.[14] Shortly afterwards, the council purchased a life-size statue of Paris and a bust of Bacchus, which were placed in a sunken garden in the park.[15] In other towns the fountains were more prosaic, though in and around Middleton, two were designed by Edgar Wood.[16]

As in other districts, the post-war years saw many war memorials unveiled, ranging from the town memorial to the smaller tributes raised by schools, churches and businesses. Rochdale's decision to employ Lutyens to design the borough's main memorial and to site it near the town hall underlined its communal importance. The scheme was pushed along with some determination, ensuring that there was none of the embarrassment and delay which had marked the scheme to provide a

memorial to those local men and women who had died in the South African War.[17] Whether a memorial included statuary depended on many factors, including the preferences of the memorial committee. In this district the memorials at Heywood and Milnrow included statuary, whilst other impressive schemes, notably at Middleton, were realised without making statuary a major part of the design.[18]

Commissioning statues and busts as a way of acknowledging the public contribution made by individuals found little support in twentieth-century Rochdale. Existing monuments were also vulnerable, subject to changing attitudes and circumstances. When, in the inter-war years, it was proposed to move John Bright's statue from the town centre as part of a traffic improvement plan, only one councillor spoke out against the scheme. Rochdale's most famous citizen was duly exiled to the north-west slopes of Broadfield Park.[19] Such attitudes continued and, apart from an occasional wash, the borough's outdoor monuments appear to have been increasingly neglected.

That indifference was still evident when local government was reorganised in 1974. In the new Metropolitan Borough Council it was not entirely clear which department was responsible for the maintenance of public statuary. The significance of works such as John Warrington Wood's *Jephthah's Daughter* – part of the extensive group of art works given by Robert Taylor Heape to the people of Edwardian Rochdale – also appears to have been forgotten.[20] This marble sculpture, depicting the biblical story that attracted a number of Victorian sculptors, was eventually placed in a corner of the town hall. The opening of new shopping centres was marked by the commissioning of some public sculptures. Not all were well received. A mural sculpture of the Crucifixion by Michael Dames in Middleton's Arndale Centre received much adverse publicity and was eventually vandalised. Judith Bluck's *Sheep* in Rochdale fared slightly better. Constantine Smith's *The Middleton Archer*, commissioned for a public house, also survived. Local people appeared more comfortable with projects such as the installation of a reconstructed market cross which was sited some distance away from the original market place.[21]

It was only in the closing years of the twentieth century that public sculpture made a more obvious impact on the borough. The initiative came from the council, which was persuaded that public art could be a positive agent in projects of environmental and economic improvement. Its most controversial expression came with the installation of *The Spires*, part of an initiative to strengthen the identity of Rochdale's civic quarter. Not all of the new works commissioned were in Rochdale. In Middleton public art was an integral part of environmental improvement schemes, including Jane Poulton's sculpture trail at Bowlee and Brian Fell's gateway sculpture at Boarshaw Clough. These projects purposefully set out to involve the local community, acknowledging that such artworks could be a force in restoring local pride as well as derelict land.[22] Paradoxically, one of the borough's most challenging public art commissions, Chris Drury's *Long Vessel*, was at the same time one of its most inaccessible. Not everybody responded positively to the new works. *The Spires* found more critics than supporters, at least in the local press. When a 14-metre high sculpture of cubic boulders was proposed for the Stakehill Industrial Estate, near Middleton, it was dismissed as a monstrosity; the local press raising, somewhat confusingly, the spectre of

Jubilee Fountain, Broadfield Park, 1907

another *Angel of the North*.[23] Some people expressed a wish for more conventional sculpture. A commemorative statue of Gracie Fields would have found strong support among older Rochdalians.[24] By the beginning of the new century there was also the long-overdue recognition that existing public monuments and statues required more than cosmetic attention. A restoration programme for war memorials was begun whilst plans to restore the borough's parks included a number of long-neglected monuments.[25]

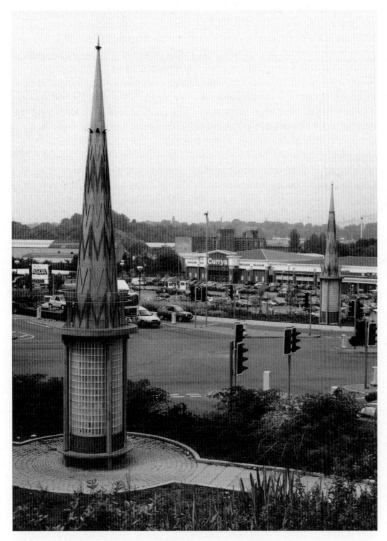

Partnership Art, *The Spires (from Broadfield Park)*

Notes
[1] The Metropolitan Borough is divided into four townships: Rochdale, Heywood, Middleton and Pennines (former urban districts of Littleborough, Wardle and Milnrow & Newhey). [2] A.S. Wild, *Top o' th' Steps. A History of St Chad's Parish Church, Rochdale* (Rochdale: St Chad's Educational Trust: Rochdale, 1981). [3] W. Robertson, *Old and New Rochdale and its People* (Rochdale: The Author, [1881]) pp.13–14. [4] J. Aikin, *A Description of the Country from Thirty to Forty Miles round Manchester* (London, 1795; reprinted New York: A. Kelley, 1968) pp.246–59. [5] *An Illustrated History of the County of Lancaster* (London: How & Parson, 1842) pp.167–8; A.P. Wadsworth, 'The early factory system in the Rochdale district' *Transactions of the Rochdale Literary and Scientific Society*, 19 (1935–7) pp.135–56. [6] W. Robertson, *A History of Rochdale. Past and Present* (Rochdale, [1875]) pp.247–8; H. Fishwick, *The History of the Parish of Rochdale* (Rochdale: J. Clegg, 1889) p.537; 'The old Rochdale Cross', *Rochdale Observer*, 7 and 14 October 1922. [7] Editorial in *Rochdale Observer*, 1 June 1878. [8] J.L. Maxim, *Rochdale Town Hall* (Rochdale: G. and A.N. Scott, 1959). [9] Quoted in [J. Sharples], *Rochdale Town Hall. An Illustrated Guide* (Environment and Employment Department, Rochdale MBC, [n.d.]) unpaginated. [10] Rochdale Council General Purposes Committee, 13 December 1893, p.28; *Rochdale Observer*, 16 December 1893. [11] Tim Bobbin and Edwin Waugh were among the 'literary giants' honoured on the windows of the town's public library, *Rochdale Times*, 1 November 1884. [12] *Rochdale Observer*, 11 November 1865. [13] Unveiled 25 June 1879, *Rochdale Observer*, 28 June 1879. [14] *Heywood Advertiser*, 2 August 1879. (Designed by Messrs Brown of Harrogate.) [15] Purchased by Heywood Local Board for £28, *Rochdale Observer*, 4 October 1879. The Bacchus has survived but Paris's fate is unknown. In the 1920s a bust of Councillor David Healey, who had donated additional land to the park in 1923, was placed in the park. It is also missing, presumed destroyed. Information from Sheila Hill. [16] J.H.G. Archer, 'Edgar Wood: a notable Manchester architect', *Transactions of Lancashire and Cheshire Antiquarian Society*, 73–4 (1963–4) pp.153–87; *Middleton Guardian*, 21 March 1996, 28 March 1996. The fountain at Birch was listed Grade II in 2001. [17] *Rochdale Observer*, 29 June 1907; J. Cole, *Rochdale Revisited. A Town and its People* (Littleborough: G. Kelsall, 1990) p.30. [18] The Middleton memorial was designed by the Oldham architects, Taylor and Simister; unveiled 23 October 1927. [19] *Rochdale Observer*, 3 June 1933. [20] M.J. Taylor, 'Between Phidias and Bernini. The Life and Work of John Warrington Wood 1839–1886', Diploma in Art Gallery and Museum Studies, University of Manchester, 1984, p.55. Information from Edward Morris. [21] Correspondence from A.G. Parke, Rochdale Museum, to M.R. Taylor, British Museum, 24 May 1967, Rochdale Art Gallery and Museum Service. The cross was sited at the top of a flight of steps, in front of a small pond, leading into St Chad's Gardens. The head of the 'original' cross remains in the borough's museum's collection. Information from Andrew Moore, Rochdale Art Gallery and Museum Service. [22] Groundwork Rochdale, Oldham & Tameside exhibition leaflet, Middleton Library, March–April 1998. [23] *Middleton and North Manchester Guardian*, 22 April 1999. [24] Joan Moules, *Gracie Fields. A Biography* (Chichester: Summersdale, 1997) p.232. [25] Rochdale MBC Resources Sub-Committee, 19 October 1998.

Church Street

Heywood Library

Architects: Sidney Vincent North and Charles Collas Robin

17 March 1906
Stone
1.83m approx
Status: Grade II
Condition: fair
Owned by: Rochdale Metropolitan Borough
 Council

Description: Two reclining life-size figures, representing Art and Literature, above a central doorway. The male figure, representing Art, is shown studying, holding a pair of dividers in his right hand, whilst the female, representing Literature, is depicted writing, a scroll stretched across her lap.

In 1904 Heywood applied successfully to the American philanthropist, Andrew Carnegie, for funds to construct a purpose-built public library. The existing library was housed in two rooms in the council offices. The new library was designed by the architects Sidney North and Charles Robin. It cost £6,300. Some observers felt that the site, close to the market place and dilapidated housing, was not the most appropriate for what would be one of the town's important civic buildings.[1] The official opening in March 1906 (the building is dated 1905) was an occasion for the usual public celebrations. A gold key to the library was presented by the architects to the mayor, Councillor Alfred Smith, and the hope expressed that it would open the door to 'much pleasure and profit'. North and Robin's building was described as in the Renaissance style with 'a touch of the Elizabethan'.[2] Darley Dale stone was used for the main façade. The principal entrance on Church Street was

North and Robin, *Heywood Library*

imposing. It was flanked by columns with Ionic capitals, above which was a pediment and tympanum, surmounted by two reclining life-size figures, representing Art and Literature. The architectural sculptor responsible for the figures has not been identified.

Notes
[1] *Heywood Advertiser*, 23 March 1906. [2] *Ibid.*

Heywood War Memorial

Walter Marsden

22 August 1925
Bronze statue; stone pylon
7.02m high approx × 9.15m long × 3.5m deep; statue 2.74m high
Signed on plinth: W. Marsden Sc. 1925

Inscription on pylon: TO THE / MEN OF HEYWOOD / WHO GAVE THEIR LIVES / FOR US DURING THE / GREAT WAR 1914–1918 / AND THE / WORLD WAR 1939–1945
Status: Grade II
Condition: fair
Owned by: Rochdale Metropolitan Borough
 Council

Description: War memorial; a sarcophagus, the sides decorated with wreaths and crosses, from which rises a plain shaft with tapering sides. In front of the pylon is a bronze female figure standing with bowed head, the palm of victory in her hands, surmounting a pedestal with inscriptions. The whole memorial stands on a stone plinth.

The proposal for a Heywood war memorial was made at a public meeting on 25 March 1919. In the following month a war memorial committee

was appointed: the members included the Mayor, Joseph Nuttall, and the chairmen of the various corporation committees.[1] In discussing the form of the memorial, there was a desire to see one which emphasised peace rather than war. The discussions on the most appropriate location resulted in the selection of the old town market. Walter Marsden was commissioned to provide the memorial. Marsden, who had been born in Church, near Accrington, had trained as a sculptor at the Manchester School of Art and the Royal College of Art before enlisting as a soldier in the First World War. The Heywood memorial

was one of his first major public commissions.[2] The completion of the memorial, however, proved to be a slow business. It was unveiled by the Dean of Manchester, Hewlett Johnson, in August 1925.[3] Characteristically, Johnson's speech focused less on heroism and more on the

> war-wastage of human life, our sons, the sons of our Allies, the sons of our enemies…the wastage of treasure [and] the wastage of civilisation, which we are feeling today in our unemployment.[4]

The inaugural procession included wreath-laying by the children, widows and relatives of the fallen. It was, however, not until the following year that the surrounding garden of remembrance was completed, allowing the memorial to be viewed properly. A further lack of funds meant that the roll of honour was not engraved on the memorial at this time. It was not until 1986 when, following lobbying by the Heywood British Legion, a grant was secured from Rochdale Council to cover the cost of inscribing the names of the fallen from both world wars.[5]

Notes
[1] Heywood Council General Purposes Committee, 9 April 1919, p.140. [2] R.Hughes, 'Walter Marsden: soldier and sculptor', *Stand To!*, No. 63 (January 2002) pp.37–40. [3] *Borough of Heywood. War Memorial Unveiling Ceremony. Saturday, August 22nd, 1925* [1925]. [4] *Heywood Advertiser*, 28 August 1925. [5] *Ibid.*, 18 June 1987, 17 July 1987, 6 July 1989.

Queen's Park Road

Queen's Park

Albert Lee Memorial

Architect: H.C. Anderson

11 April 1908
Halifax stone
5.18m high approx; 1.37m square base
Inscription (originally in lead lettering): THIS
MEMORIAL WAS ERECTED / BY PUBLIC

Marsden, *Heywood War Memorial*

Albert Lee Memorial

SUBSCRIPTION / TO COMMEMORATE THE / GALLANT / AND HEROIC CONDUCT OF / ALBERT LEE / OF 79, STARKY STREET, / HEYWOOD, / AGED 15, / WHO LOST HIS LIFE / IN ATTEMPTING / TO RESCUE HIS / COMPANION, / DAVID ASHWORTH, / FROM / DROWNING IN THE RIVER ROACH / OPPOSITE / THIS SPOT ON / SATURDAY AFTERNOON THE / 15 JUNE 1907. / 'GREATER LOVE HATH NO / MAN THAN THIS / THAT A MAN LAY DOWN HIS / LIFE FOR HIS FRIENDS'/ JOHN XV. 13.

Condition: poor
Status: not listed
Owned by: Rochdale Metropolitan Borough Council
Description: Plain stone obelisk in three stages, with an inscription on pedestal. It is located on sloping ground in the park.

The deaths of Albert Lee and David Ashworth in June 1907 greatly affected the town of Heywood. The boys had been out playing when Ashworth, trying to catch wood, fell into the swollen River Roch. Lee jumped in to save him but both boys drowned. Lee's body was not found until a week after the tragedy. To mark this act of self-sacrifice the community decided to erect a memorial. A sum of £50 was collected. The memorial took the form of a stone obelisk – plans for a turret clock having been abandoned – erected close to the site of the tragedy.[1] The Mayor, David Healey, in the absence of Edward Holden MP, unveiled the memorial. His remarks on the unselfish courage of Albert Lee, a non-swimmer, in trying to rescue his friend from the flooded river, were echoed by other speakers and by the press of the day. A certificate from the Royal Humane Society was presented to Lee's family. The monument was the work of a local stonemason, Messrs S. and A. Taylor.[2] The memorial was restored in 1951.[3] In 1993 it was sandblasted, removing both graffiti and a coat of paint which had been applied to 'protect' the stone, before being sealed with a coat of silicone.[4]

Notes
[1] Heywood Council. Park and Cemetery Committee Minutes, 26 August 1907, 1 October 1907. [2] *Heywood Advertiser*, 17 April 1908. [3] *Ibid.*, 31 August 1951. [4] *Ibid.*, 8 July 1993.

MIDDLETON

Cemetery Street

Middleton Cemetery

Samuel Bamford Memorial
Architect: Joseph Chatwood
Sculptor: Joseph Swynnerton

6 October 1877
Stone
7.63m high approx
Signed: J. Grundy & Sons. Middleton
Inscription: front: SAMUEL BAMFORD / BORN 28TH FEBRUARY 1788 / DIED 13TH APRIL 1872 – right-hand side: ERECTED / BY / PUBLIC SUBSCRIPTION, / IN THIS / HIS NATIVE TOWN, / 1877. / '*Bamford was a Reformer / when to be so was unsafe, and / he suffered for his faith.*' / JOHN BRIGHT – left-hand side: AN EARLY ADVOCATE / OF / CIVIL & RELIGIOUS LIBERTY, / FREE TRADE / AND PARLIAMENTARY REFORM / AUTHOR / OF / '*passages in the life of a radical.*' AND / OTHER WORKS, / IN / PROSE AND VERSE.

Status: not listed
Condition: poor
Owner: Rochdale Metropolitan Borough Council
Description: Obelisk rising from three steps. A bronze bas-relief portrait medallion of Bamford as an old man is inset on the front.

Samuel Bamford is remembered as a working-class political reformer and as the writer of books, articles and poetry which were rooted in the Lancashire communities in which he spent most of his life. He was born in Middleton in

Samuel Bamford Memorial

1788 and remained close to the town even later in his life when he was no longer living there. Bamford was best known for his involvement in the political reform campaigns early in the nineteenth century. He led the Middleton contingent at Peterloo and his recollections of that day, published in his *Passages in the Life of a Radical*, provide one of the most striking first-hand accounts of that pivotal event. By the early 1850s Bamford had become widely

recognised as a leading example of the Lancashire working-class writer. He died in 1872 and was buried in the family grave in Middleton Cemetery.[1]

That Bamford's achievements should be recognised by erecting some form of memorial was first suggested immediately after his funeral. The raising of the necessary funds proved a slow business.[2] By the summer of 1874 only £183 had been subscribed. Various sites were suggested for the monument, including the Market Place in Middleton and, more poignantly, on St Peter's Field in Manchester, the site of the infamous Peterloo Massacre. A portrait of Bamford had been displayed in the old Manchester Reform Club before his death.[3] Further discussions led to the decision to site the memorial in Middleton Cemetery overlooking the town, a place which it was known Bamford had been fond of as a boy.[4] It was some 50 yards from his grave. The monument was finally completed in 1877, Joseph Swynnerton providing the portrait medallion.[5] The cost was nearly £400.

The unveiling ceremony in October 1877 proved to be a day of celebration. Flags were displayed in the main streets and the crowds, including people from outside Middleton, came to pay tribute. Edwin Waugh and Ben Brierley, the two best-known Lancashire dialect writers, were amongst those attending. Yet the formal ceremony was made the occasion not so much for remembering Bamford's later writings as for fulsome tributes to his work in the cause of liberty. Bamford was recalled as a liberal pioneer whose struggles in the cause of reform (for which he had twice been imprisoned) had laid the foundations for the order and security which the people currently enjoyed. Opening the speeches, Samuel Barlow, the chairman of the memorial committee, emphasised that Bamford had served his nation rather than party, and that, despite appearances, the inauguration was not a political demonstration. 'They might', he continued, 'with propriety call on their Conservative friends to join in paying

tribute' since 'they now participated in the benefits which he [Bamford] and his co-patriots laboured to secure'. Despite these protestations, the ceremony bore all the hallmarks of a Liberal rally. John Bright had been invited to perform the inauguration, but in his absence the task fell to the Liberal MP for Oldham, John Tomlinson Hibbert. Bamford, he declared, was a man who had spoken out for liberty and freedom, at great personal hazard, and had 'lived to see the fruits of the seed which he had sown'. The entire gathering represented a concerted attempt to remake Bamford's radicalism into the seeds of early Liberalism.[6]

The memorial is a neglected feature in a depressingly neglected cemetery. Parts of the stone have been damaged, the double row of chains around the base is missing and the portrait is covered in graffiti. It remains to be seen whether those now responsible for it will honour the sentiments expressed by the chairman of the Middleton Commissioners in 1877 that 'should the monument at some distant period fall into decay, the authorities of the town would do still greater honour to Bamford than they had done on that occasion'.[7]

Notes
[1] M. Garratt, *Samuel Bamford. Portrait of a Radical* (Littleborough: G. Kelsall, 1992); J. Evans, *Lancashire Authors* (London: Houlston and Stoneman, 1850) pp.17–22. [2] *Manchester Guardian*, 17 March 1873. [3] *Sphinx*, 17 July 1869, p.135. [4] Garratt, *op. cit.* [5] *British Architect*, 17 August 1877, p.90. [6] *Middleton Albion*, 13 October 1877; *Manchester Guardian*, 8 October 1877. [7] *Middleton Albion*, 13 October 1877.

Heywood Old Road

Bowlee Community Park

Bowlee Art Trail

Jane Poulton

November 1998
Woodkirk sandstone
Stones vary in size, 1m high × 1.5m wide approx

Status: not listed
Condition: good
Owned by: Rochdale Metropolitan Borough Council
Description: Nineteen large roughly-cut blocks of brown sandstone placed close to the roadside in the park. On each block are either one or two carved images relating to Middleton's history.

A sculpture trail was incorporated in Bowlee Community Park, a 36-hectare area of land formerly owned by the Ministry of Defence, as part of a redevelopment programme for the park. The trail takes the form of large stone boulders which have been placed alongside the main pathways in the park. On each stone is either one or a pair of carved images relating to the history and folklore of Middleton. The designs were produced by Jane Poulton, who was awarded the commission following an open competition. She involved local people in deciding the subjects to be included in the carvings. Some refer to local people (Richard Assheton, Edgar Wood), local events (the flood of 1927), local folklore (Owd Mal) and local industries (cotton and silk). In total there are 19 carvings: The Mullet and Pheon, Football,

Poulton, *Shuttle, Bowlee Art Trail*

Moonraker, Longbow and Pierced Mullet, The Horse, The Boar, Key and Shoe, Silk Moth and Cotton Boll, Briar Rose, Flood Water, The Bell and Chain, The Verjuice Stone and Pond, The Apple, Shuttle and Shears, The Poppy, The Daisy, Lily of the Valley and the Wheel, The Chimney and The Clasped Hands.[1] Tracy Howe, a stonemason from Rossendale, was responsible for the carvings. Shortly after the stones were installed, the enthusiastic attentions of skateboarders made it necessary to re-carve and re-site two of the stones.[2]

Notes
[1] Bowlee Art Trail [1999]. Leaflet produced by Rochdale Metropolitan Borough Council.
[2] Information from Jane Poulton.

Kemp Street

Middleton Archer

Middleton Archer

Constantine Smith

January 1974
Bronze resin fibreglass
2.2m high
Status: not listed
Condition: fair
Owned by: Lees Brewery
 Description: Sculpture representing a medieval archer, fixed to the front of a public house. The thin elongated figure is holding a longbow in his right hand and is drawing an arrow from a quiver with his left.

The Middleton Archer public house was built by John Lees, a local brewery, to replace one demolished in the redevelopment of the town centre. As in many of their other pubs, the brewery set out to create an identity that related to a particular aspect of the history or folklore of the community. In this case it appears to have been the Middleton Archers who, under the command of Richard Assheton, played a decisive part in the victory of the English over

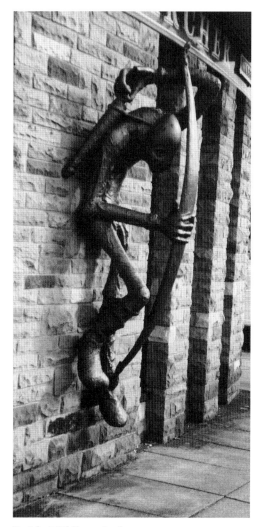

Smith, *Middleton Archer*

the Scots at the Battle of Flodden (1513). This military exploit has long been an important part of Middleton's history and was commemorated in the Flodden window in the parish church, regarded by locals as one of the country's oldest war memorials. The fibreglass figure of the Middleton Archer was commissioned from a Cheshire sculptor, Constantine Smith. It was

installed when the pub was opened in 1974.[1] Given its location the damage to the sculpture – the fingers are broken and arrows and the bowstring are missing – is slight.

Note
[1] *Middleton Guardian*, 1 February 1974; 10 June 1988.

Rochdale Road

Boarshaw Clough

Millennium Gateway

Brian Fell

21 July 1999
Mild steel
Gateway: 4.57m high approx × 2.09m wide
Status: not listed
Condition: good
Owned by: Rochdale Metropolitan Borough
 Council
 Description: Steel gateway located at entrance to Boarshaw Clough decorated with wildlife and plants around a representation of a pond. Individual bronze sculptures of a kingfisher, frog, fish, and dragonfly are placed close to the pathways in the Clough.

Boarshaw Clough was one of 21 brownfield sites in England and Wales that comprised the Changing Places programme organised through Groundwork UK. The aim was to transform the Clough into a nature reserve and recreational area. The commissioning of public sculpture was an integral part of that transformation.[1] Brian Fell was selected from a short-list of four sculptors to carry out the work. The commission required community involvement, and children from the local primary school, St John Fisher, were among those who provided ideas for possible sculptures. The principal sculptural work was a gateway, representing different aspects of the area's natural history. Fell's design incorporated representations of a kingfisher, dragonfly, frog

Fell, *Frog*

and fish. In addition, sited alongside or close to the paths in the Clough were five bronze sculptures of different creatures – a frog, fish (perch), fox, grasshopper and dragonfly – that could be found in the Clough. Excepting the fox, each was securely fixed to a large stone block. Boarshaw Clough's Millennium Gateway was officially opened in July 1999, though at that time not all of the planned sculptures had been completed.[2] A number of the sculptures have been vandalised since their installation and the bronze frog stolen. In addition to Fell's sculptures, the Clough also contains one of Andy McKeown's sculptures entitled *Breaking the Mould*.[3]

Notes
[1] Groundwork Trust, *Changing Places. Breaking the Mould* (Birmingham, Groundwork UK [2001]).
[2] *Middleton Guardian*, 29 July 1999; information provided by Sarah Wallbank, Groundwork Rochdale, Oldham & Tameside and Andrew McKeown . [3] See above, p.142.

MILNROW

New Hey Road

Milnrow Park

War Memorial

George Thomas

3 August 1924; relocated October 1951
Bronze statue; Bollington stone pedestal
Statue 2.44m high; pedestal 3.2m high
Signed: G. Thomas Sc. 1923; M. Manenti
 Foundry London
Inscription on stone plaque: IN MEMORY OF THE
 MEN / OF THE MILNROW URBAN DISTRICT /
 WHO DIED FOR ENGLAND / 1914–1918 –
 bronze plaque inscribed: IN MEMORY OF THE
 MEN / OF THE / MILNROW URBAN DISTRICT /
 WHO DIED FOR ENGLAND / 1939–1945 – stone
 plaque inscribed: TO ALL THOSE / WHO DIED
 IN THE SERVICE / OF THEIR COUNTRY
Status: Grade II
Condition: fair
Owned by: Rochdale Metropolitan Borough
 Council
Description: War memorial; larger than life-size bronze statue of a helmeted soldier who is depicted about to advance on the enemy, holding a rifle in his right hand, and in the act of drawing his bayonet. It surmounts a tapering stone pedestal inscribed with the names of the dead.

As in many other towns, the need to raise some form of memorial to those who had died in the First World War was acknowledged in Milnrow before the war had finished. Of the 1,150 local men who had joined the armed services, 168 lost their lives. The first public meeting to discuss a town war memorial was held on 4 February 1919. A memorial committee was established and the decision taken to erect an appropriate memorial. In selecting the design, the committee was influenced by the recent

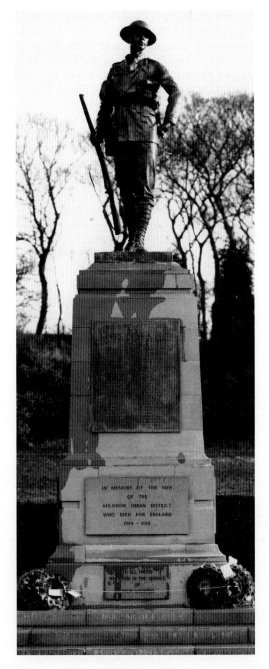

Thomas, *Milnrow War Memorial*

memorial unveiled in Waterhead, Oldham, the work of George Thomas. A visit was arranged to view it in the company of Elisha Bardsley, who had helped to organise its erection.[1] Impressed with the 'beauty and suitability' of the sculpture, they decided to contact Thomas with a view to designing a memorial for Milnrow. As Thomas was due shortly to visit the area to consider a war memorial at Shaw, a meeting was arranged with him. The preliminary discussions went well and included a visit to the proposed site at the junction of Dale Street and Kiln Lane.[2] It was estimated that £2,500 would be required to provide the memorial and install it in suitably landscaped grounds. The all-important task of raising funds was under way by November 1920. In the following March, Thomas produced two models for the committee to consider. The agreed memorial was not finally completed until 1924. It was sited on a specially landscaped area of land in Dale Street. The memorial was unveiled on a wet August Sunday afternoon in 1924 by Major General A. Solly-Flood, who hoped that it would be 'a solace to the bereaved and a true example of citizenship to all generations'.[3] The war memorial remained in Dale Street, a busy part of the town, until October 1951, when it was removed to an elevated, and quieter, position in the Cliffe House Memorial Gardens, Newhey Road.[4] The statue has been painted at some time but appears to be in a reasonable condition. The only visible damage is to the rifle strap, part of which is missing.

Notes
[1] See above, p.297. [2] Milnrow War Memorial Committee Minutes, 30 October, 6 November 1920 (Rochdale Local Studies Library). [3] *Rochdale Observer*, 6 August 1924. [4] *Ibid.*, 14 November 1951.

ROCHDALE

Broadfield Park, St Alban's Street

George Leach Ashworth

W.J. and T. Wills

1 June 1878
Marble statue; Cornish granite pedestal
Statue 2.44m high approx; pedestal 2.69m high × 1.37m square base
Signed on pedestal: W. & T. Wills Sc. London
Inscription on pedestal: ALDERMAN / G. L. ASHWORTH. J.P. / TWICE / MAYOR OF ROCHDALE / BORN, AUG. 1ST 1823. / DIED, AUG. 6TH 1873 / ERECTED / BY PUBLIC SUBSCRIPTION / IN LOVING REMEMBRANCE / OF A DEVOTED FRIEND / TO THE PEOPLE, / 1877.
Status: Grade II
Condition: poor
Owned by: Rochdale Metropolitan Borough Council
Description: Portrait statue; larger than life-size statue of Ashworth who is shown wearing modern dress. His top coat is open, revealing his waistcoat; a book is held in his right hand. The statue surmounts a stone pedestal, rising from two steps. It is located in the centre of a formal garden in the park.

George Leach Ashworth was born in Rochdale in 1823, the eldest son of George Ashworth, a woollen manufacturer. He was educated locally and at an early age worked in the family business. He helped to develop and diversify the business, and acquired a reputation as a paternalistic employer who promoted the education of his workers. Ashworth became involved in the public affairs of Rochdale early in life, serving as an Improvement Commissioner in the 1840s, and being made an Alderman after the incorporation of Rochdale in 1856. As chairman of the General Purposes Committee he was in a position to direct public

works and improvements in the town. He supervised the municipalisation of the water supply, the construction of new roads and the building of the town hall. Ashworth was also a central figure in the Relief Committee during the Cotton Famine of 1861–5. He was twice

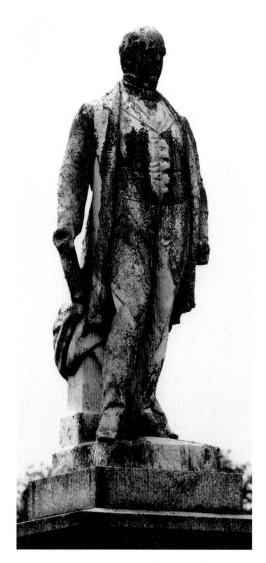

Wills Brothers, *George Leach Ashworth*

mayor of the borough. A successful businessman, radical Liberal and active Methodist, he was one of a group of like-minded men who shaped the public world of Victorian Rochdale. He died on 6 August 1873.[1]

The scheme for what was to be Rochdale's first public statue was initially suggested at a meeting of 'a few earnest men' shortly after Ashworth's death. On 17 September 1873 a public meeting was held, at which it was agreed that the memorial should take the form of a statue, a recognition of the contribution Ashworth had made to the town. A public subscription was launched.

The scheme, however, was not without its critics, some of whom were politically motivated. The town was canvassed, but money came in slowly. The commission for a portrait statue was given to the London sculptors, W.J. and T. Wills, whose work included statues of Sir Humphrey Davy in Penzance and the Earl of Mayo at Cockermouth. They consulted with the family, who visited the studio to comment on the work in progress.[2] It was decided to place the statue in Broadfield Park, the town's main park and another of the municipal projects supported by Ashworth.

At the unveiling ceremony in June 1878, Ashworth was portrayed as a local Liberal hero who had always sought to fulfil his public duty and follow the will of the people. James Tweedale, the Mayor, accepted the statue on behalf of the Council 'in the spirit in which it was intended, as being the gift of the working classes of the town of Rochdale'. Following the Mayor, Thomas Bayley Potter, Liberal MP for Rochdale, recalled Ashworth's spirit of public duty and his espousal of Liberal beliefs – popular sovereignty, free trade and peace – which were now under attack in some communities. The statue, Potter argued, should serve as a reminder of the importance of these principles. The sculptors were thanked, and W. Wills responded 'as a good Liberal' suggesting that 'in all our great manufacturing towns we ought to have statues of men like Cobden, Earl

Russell, and a great number of other good men'.[3] (The Wills brothers had already been responsible for the Cobden statue at Camden.) The celebrations, however, did not conclude the enterprise because the memorial committee still faced a shortfall of subscriptions to cover the £800 that the statue had cost.

Since the 1980s Broadfield Park, including the Ashworth statue, has been neglected and suffered from vandalism. However, the recent inclusion of the park on the Register of Parks and Gardens of Historic Interest and the award of Heritage Lottery funds to restore it marks the beginning of a new phase in the park's history. The Ashworth statue is included in the restoration programme.

Notes
[1] *Rochdale Observer*, 9 August 1873; *Rochdale Household Almanack* (Rochdale, 1874). [2] *Rochdale Times*, 1 June 1878. [3] *Rochdale Observer*, 8 June 1878; *Manchester Guardian*, 3 June 1878.

Jubilee Fountain
Architect: J. Kilpatrick

2 November 1907
Peterhead and Aberdeen granite; stone
4.38m high approx
Inscription in raised letters on bronze panel:
PRESENTED / TO THE / CORPORATION OF ROCHDALE / FOR PUBLIC USE / 1907
Status: not listed
Condition: poor
Owned by: Rochdale Metropolitan Borough Council
Description: Drinking fountain; an ornate drinking fountain comprising a polished granite base with projecting sides; semicircular basins (now dry) on each side of the base. A decorative canopy carried on four red granite columns and

Kilpatrick, *Jubilee Fountain*

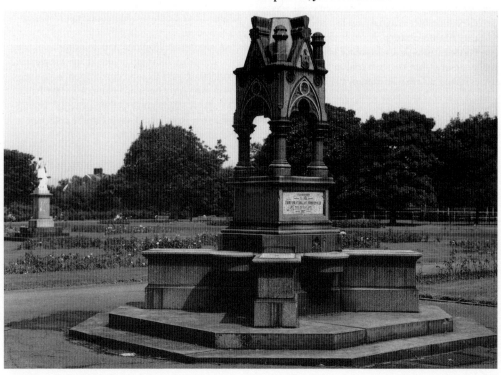

terminating in a finial (now missing) rises from the base. Coats of arms of the borough and the Co-operative Society, with the dates 1856 and 1906, are included on the canopy. Four stone lions originally positioned on the projecting pedestals at the base have been removed. Of the two inset bronze panels only one remains. The structure rises from two octagonal steps.

This impressive fountain was given to the town by the Rochdale Provident Co-operative Society to celebrate the golden jubilee of the founding of the borough. The cost, some £350, was part of the £1,000 that the society donated to mark the jubilee. The fountain was unveiled and presented by Evan Evans, the society's president. He believed that the fountain would add to the beauty of the park, and in so doing remind people that Rochdale was not a town that had been overrun by industry, but a community that possessed desirable sights and amenities. The gift was welcomed as further evidence of the benefits which co-operation had brought and continued to bring to the town. 'Co-operation', opined one speaker, was 'one of the greatest forces that will keep in check that rabid Socialism which is so much preached today', whilst another hoped that this gift would encourage local textile manufacturers, now earning high profits, to recognise their public duties and provide the town with similar amenities.[1]

For much of the twentieth century the fountain was an admired feature of the park. In more recent years its condition has deteriorated significantly, due largely to vandalism. Plans for a major restoration of the park were announced in 2001, a project that will include the fountain. The restoration of the fountain will include the return of two of the original sculpted lions, which, fortunately, had been removed and placed in storage.[2]

Notes
[1] *Rochdale Observer*, 6 November 1907; *Rochdale Times*, 6 November 1907. [2] Information from Malcolm Hill, Rochdale Metropolitan Borough Council.

Lancashire Dialect Writers' Memorial
Architect: Edward Sykes
Sculptor: John Cassidy

27 October 1900
Granite; bronze; stone
4.5m high approx, base 1.26m square
Inscription: front: IN GRATEFUL MEMORY OF / FOUR ROCHDALE WRITERS OF THE / LANCASHIRE DIALECT WHO HAVE PRESERVED / FOR OUR CHILDREN, IN VERSE AND PROSE / THAT WILL NOT DIE, THE STRENGTH / AND TENDERNESS, THE GRAVITY AND / HUMOURS OF THE FOLK OF OUR DAY, / IN THE TONGUE AND TALK OF THE PEOPLE. / THIS MEMORIAL WAS ERECTED A.D. 1900. – above this: BORN ROCHDALE 27TH JANY 1817 / EDWIN WAUGH / DIED NEW BRIGHTON 30TH APRIL 1890 / "COME WHOAM TO THI CHILDER AN ME." – rear: BORN CARLOW IRELAND 10TH MAY 1831 / MARGARET REBECCA LAHEE / DIED ROCHDALE 14TH JUNE 1895 / "WHEN WE LAY DEAUN LIFE'S SHUTTLE AN / STON BEFORE TH GREYT JUDGE HE'LL / WANT TO KNOW WHAT SOOART O A PIECE / WE'N WOVEN, AN HOW MANY FLOATS THERE'S / IN IT, HE WINNOT CARE ABEAWT EAWR / HEE SEAUNDIN NAMES AN WORLDLY / POSSESSIONS. HE'LL AX US HOW WE GEET / EM AN WHAT WE DID WI' EM." – left-hand side: BORN MILNROW 22ND JANY 1857 / JOHN TRAFFORD CLEGG / DIED BOURNEMOUTH 18TH MARCH 1895 / "SAY NOWT AGAIN FOLK BEHIND THEIR / BACKS, SUP NOWT STHRONGER NOR WOM / BREWED, AN NOANE TOO MICH O THAT / KEEP LOW THOUGHTS EAUT O THI MIND / BI FILLIN IT WI THINGS BRODE AN HEE / FESTIN THI E'EN ON TH SKY ITS AS YEZZY / TO LOOK UP AS DEAWN, AN IT MAKES / A VAST DIFFERENCE IN A MON." – right-hand side: BORN ROCHDALE 21ST JUNE 1811 / OLIVER ORMEROD / DIED ROCHDALE 1ST NOVEMBER 1879 / "AW SED AW'M O RACHDE FELLEY / MON UN WE'RE METERLY FAUSE THEERE / AW'LL WARRUNT TE." / "OLIS LET O MON DOO THAT UTS REETE / UN E'S SARTIN SHURE FUR TO KOOME / EAWT TH BEST UT LAST OV O."
Status: not listed
Condition: poor
Owned by: Rochdale Metropolitan Borough Council
Description: Memorial column; the base is a square pedestal of red Peterhead granite, the corners of which are marked by double fluted columns of the same material. Recessed into each side of the pedestal are polished grey granite panels containing the main inscriptions. Rising above the pedestal is a tapering grey granite column ending in a fluted cap and circular terminal. At the base of the column are bronze portraits of the four writers (Clegg missing). The whole memorial rises from a stone stylobate.

The idea of honouring Rochdale's dialect writers with a memorial appears to have been first suggested during a ceremony to mark the restoration of the grave of John Collier in June 1892. Collier, better known as Tim Bobbin, was acknowledged as the father of Lancashire dialect writing. In addressing the crowd gathered around Collier's grave in the parish church of St Chad's, Archdeacon Wilson spoke of the vitality of dialect culture in the Lancashire textile towns in general, and in Rochdale in particular. Rochdale could claim an association with many of the leading dialect writers; some of them, such as Edwin Waugh, had recently died, whilst others, such as John Trafford Clegg and Margaret Lahee, were listening to Wilson's speech.[1] The idea might have gone no further had it not been for Wilson. His enthusiasm for the subject was to place him in the role of organiser of an ambitious scheme to celebrate the town's dialect writers. The deaths of Lahee and Clegg in 1895 were the catalysts.

Wilson outlined the principal features of a scheme to erect a dialect writers' memorial at a public meeting in Rochdale Town Hall in April

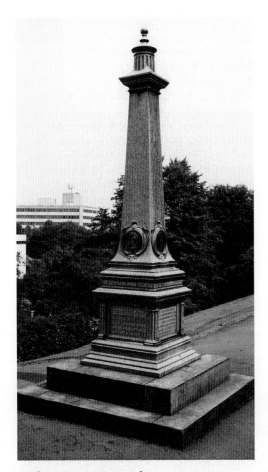

Dialect Writers' Memorial

1896.[2] Four writers – Oliver Ormerod (1811–79), Edwin Waugh (1817–90), Margaret Rebecca Lahee (1831–95), and John Trafford Clegg (1857–95) – whose work had 'faithfully pictured the real life of the people', were to be memorialised.[3] Presumably because of the effort already made to preserve Tim Bobbin's grave, he was not included. It was estimated that a modest £250 would be sufficient to provide a suitable memorial. However, the scheme did not proceed as rapidly as the memorial committee would have wished. There was a

disappointing response to the appeal for funds. The final subscription list contained less than 300 names, providing a total of around £185. The majority of the donations were of ten shillings or less.[4] This compared to the 1,150 subscribers who provided £95 to repair Collier's grave in 1892.[5] The monument, after discussions and modifications, took the form of an obelisk which, in spite of the shortage of funds, included a bronze portrait of each writer as well as extracts from their writings. It was designed by the local architect, Edward Sykes, in what was termed the 'English Renaissance style'.[6] The extracts inscribed on the base were taken from Lahee's *Left to His Fate*, Trafford Clegg's *Lijah's Fortin*, and Ormerod's *Th' First and Second Visit to th' Greyt Eggshibhnn London*. John Cassidy was responsible for the four bronze portrait medallions.[7] It was agreed that the memorial would be placed on the Broadfield Slopes, a recently landscaped area of Broadfield Park, overlooking the town's library. The memorial committee looked to the council to meet the costs of the foundations.[8]

The Lancashire Dialect Writers' Memorial was eventually unveiled in October 1900 by Archdeacon Wilson, in a ceremony which began with the welcome news that Alderman G. Ashworth had offered to meet the shortfall in the committee's funds. It was perceived as a commendable example of 'local patriotism' and one that would have the effect of keeping the dialect culture as a living part of the community.[9] Dialect writers also expressed their feelings about the occasion, and a tribute by Allen Clarke, who had taken over the mantle of Waugh and Brierley, was characteristically optimistic about the future of the dialect:

> So Rachda's dialect quartette
> (Wi' teicher Tim close by, yo' known),
> Is livin, speikin, singin' yet, -
> An' may its fame outlast this stone![10]

The monument, one of a small number honouring working-class writers, confirmed Rochdale's position as the historic centre of the

Lancashire dialect, and for many years afterwards a visit to the memorial and to Tim Bobbin's grave was an essential part of any outing to Rochdale by students of the dialect. No further names were added to the memorial until 1987, when it was agreed to include the name of a fifth dialect writer, Harvey Kershaw (1908–86).[11] The memorial has been neglected in recent years, the corners are chipped and the portrait medallion of John Trafford Clegg has been stolen. It is intended to restore the memorial as part of a major restoration of the park announced in 2001.

Notes
[1] *Rochdale Observer*, 8 June 1892; *Manchester Guardian*, 6 June 1892. [2] *Rochdale Times*, 11 April 1896; *Manchester Weekly Times*, 16 October 1896. [3] *Proposed Memorial to Lancashire Dialect Writers* [Rochdale, 1896]. [4] *Subscriptions to Dialect Writers' Memorial* (Rochdale Local Studies Library). [5] *Rochdale Observer*, 8 June 1892. [6] *Manchester Weekly Times*, 16 October 1896; *Rochdale Observer*, 25 July 1899. [7] *Rochdale Times*, 27 October 1900. [8] *Bury Times*, 29 July 1899. [9] *Rochdale Times*, 31 October 1900. [10] *Rochdale Observer*, 27 October 1900. [11] *Ibid.*, 28 January 1987. The inscription reads: b1908 HARVEY KERSHAW M.B.E. 1986 / "A MON WI' T' COMMON TOUCH".

John Bright
Hamo Thornycroft

24 October 1891; moved June 1933
Bronze statue; granite pedestal
Statue 2.89m high; pedestal 3.35m × 1.60m square base
Signed: on plinth: Hamo Thornycroft R.A. Sc. 1891
Inscriptions on pedestal: front: JOHN BRIGHT / BORN 16TH NOVR 1811 / DIED 27TH MARCH 1889. / "BE JUST AND FEAR NOT" – rear: MEMBER OF PARLIAMENT / FOR / DURHAM (CITY) 1843–1847 / MANCHESTER 1847–1857/ BIRMINGHAM 1857–1889 / APPOINTED A MEMBER OF HER MAJESTY'S / MOST HONOURABLE PRIVY COUNCIL 1868. / PRESIDENT OF THE BOARD OF TRADE /

1868–1870 / CHANCELLOR OF THE DUCHY OF / LANCASTER 1873–1874 / AND 1880–1882. – left-hand side: THIS STATUE / OF / ROCHDALE'S GREATEST TOWNSMAN / WHO DEVOTED THE LABOURS OF A LIFE AND / THE MIGHT OF AN UNEQUALLED ELOQUENCE / TO THE ADVANCEMENT / OF JUSTICE, OF FREEDOM, AND OF PEACE, / LOOKING FOR NO EARTHLY REWARD / IS ERECTED / AS A MARK OF THE LOVE AND VENERATION / WITH WHICH HIS MEMORY IS CHERISHED / BY ALL CLASSES OF HIS COUNTRYMEN / OCTOBER 1891. – right-hand side: "MY CONSCIENCE TELLS ME THAT I HAVE / LABOURED HONESTLY ONLY TO DESTROY / THAT WHICH IS EVIL AND TO BUILD UP / THAT WHICH IS GOOD." / HOUSE OF COMMONS. 23. APR. 1866. / "FOR TWENTY FIVE YEARS I HAVE STOOD / BEFORE AUDIENCES – GREAT MEETINGS / OF MY COUNTRYMEN – PLEADING ONLY / FOR JUSTICE. / MY CLIENTS HAVE NOT BEEN / GENERALLY THE RICH AND THE GREAT, BUT / RATHER THE POOR AND THE LOWLY. THEY / CANNOT GIVE ME PLACE AND DIGNITIES / AND WEALTH: BUT HONOURABLE SERVICE IN / THEIR CAUSE YIELDS ME THAT WHICH IS / OF HIGHER AND MORE LASTING VALUE." / BIRMINGHAM. 26. JAN. 1864

Status: Grade II
Condition: fair
Owned by: Rochdale Metropolitan Borough Council
Description: Portrait statue; Bright is shown in the familiar pose of the public speaker, his right arm extended and notes in his left hand. The statue stands on a tapering square granite pedestal, rising from two stone steps. All four sides of the pedestal carry inscriptions.
Biography: see above, p.18.

The Liberal politician, John Bright, who had been born in Rochdale and maintained close links with the town throughout his life, died in March 1889.[1] Members of Rochdale Town Council responded to Bright's death by passing a resolution of condolence and taking the first steps towards the erection of a public memorial. They were conscious that 'some permanent memorial should be erected to mark the esteem and veneration felt for him by those who knew him best'. Alderman Thomas Schofield moved a resolution in favour of a memorial and proposed a committee be established to take charge of the matter. A committee consisting of prominent council members was formed and, at its first meeting in April 1889, it was decided to recommend to a public meeting that the memorial take the form of a bronze statue, with remaining funds to be used to establish an English literature scholarship at Owens College, Manchester. A town meeting on 26 April sanctioned the plan. Bronze was selected in preference to marble as it was asserted that 'marble will not long resist the acids which lie in the smoky atmosphere of this part of the country'.[2] It was Alderman John E. Petrie who was the central figure in organising the memorial.[3] A sub-committee was given the task of selecting a sculptor, and, after visiting a number of London sculptors, they decided on Hamo Thornycroft, whose credentials as a sculptor of public statues had been confirmed by his *General Gordon* in Trafalgar Square.[4] The fee was to be £2,000. By 1891 the memorial fund contained £3,902, the majority of the money having come from Rochdale itself. Apart from the larger individual subscriptions, many of which came from members of the local Liberal élite and business community, there were numerous smaller donations, including some £200 collected from workers in the town's mills and workshops. Rochdale's co-operative societies also featured prominently in the subscription list: the Equitable Pioneers' Society donated £100 and the Provident Co-operative Society £21. The only note of discontent was over the proposal that the surplus funds would be used to support a Manchester rather than a Rochdale educational institution.

Thornycroft studied portraits and photographs of Bright and prepared his

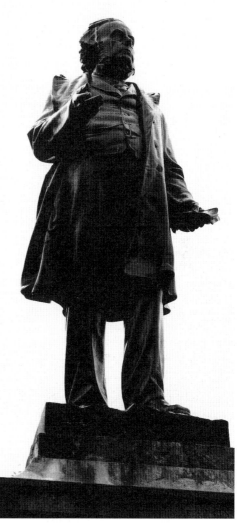

Thornycroft, *John Bright*

preliminary drawings. A wax model was made and approved by the committee in January 1890. Charles J. Allen, Thornycroft's recently appointed assistant, helped in preparing the full-size clay model.[5] The work progressed well, though Thornycroft found the modelling of

Bright's trousers more challenging than expected. Visits from members of the committee also brought suggestions for additional details. These included the idea that Bright should be shown holding a scroll inscribed 'Church Rates', an allusion to one of his earliest political campaigns in Rochdale, rather than the customary blank one.[6] The casting was carried out by James Moore of Thames Ditton in September 1891.[7]

On the important question of the site, the idea of placing the statue in Broadfield Park, where the George Ashworth statue already stood, was considered, but it was finally agreed that Bright's stature warranted an even more prominent public location. The site decided upon was the Town Hall Square. It was there on Saturday, 24 October 1891, before one of the largest crowds ever seen in the town, that the larger than life-size bronze statue was unveiled by the Blackburn-born Liberal politician, biographer and editor, John Morley. Gladstone had been the first choice for the ceremony but was unable to attend. Thornycroft, who was present, was praised for the care he had taken to ensure a faithful likeness of Bright.

Following the outdoor ceremony, Morley spoke about Bright's character and achievements in the town hall. This part of the day's events did not go entirely to plan when those placed at the back of the hall occupied the seats reserved for the 'privileged persons' at the front.[8] Mr and Mrs William Petrie of Castlemere House, with whom Thornycroft stayed when visiting Rochdale, received one of the small bronze replicas of the statue, produced by A.L. Collie, from the sculptor.[9]

The Bright statue remained in the Town Hall Square until 1933, when alterations to the road layout resulted in its being moved to Broadfield Park.[10] Only isolated voices of dissent were to be heard, complaining that the town's most famous son had been 'carted away without ceremony and put on Sparrow Hill to address the birds'. In fact, the new site on the park

slope, close to the junction of The Esplanade and Manchester Road, was a very public one, providing, initially at least, pedestrians and road users with an uninterrupted view of the complete monument.[11] Unfortunately, the subsequent growth of trees in this area of the park has left the statue with a better view of Rochdale than Rochdalians have of the statue of their 'greatest townsman'. To compound this slight, in an act of inappropriate conservation the bronze statue has been 'protected' with what appears to be a coat of black paint. Plans for the restoration of Broadfield Park announced in 2001 should mean that the statue and pedestal will be fully restored.

Notes
[1] See above, p.18. [2] *Rochdale Observer*, 27 April 1889. [3] *Rochdale Household Almanack* [Rochdale, 1900] pp.20–3. [4] S. Beattie, *The New Sculpture* (1983) pp.203–5. [5] J. Carpenter, *The Life and Works of Charles John Allen, Sculptor (1862–1956)*, typescript, School of Architecture and Building Engineering, University of Liverpool, 2000. [6] E. Manning, *Marble & Bronze. The Art and Life of Hamo Thornycroft* (London: Trefoil Books, 1982) p.115. [7] *Ibid.*, p.198. [8] *Rochdale Observer*, 24 and 28 October 1891; *Rochdale Times*, 24 October 1891; *Manchester Guardian*, 26 October 1891; *The Times*, 26 October 1891. [9] The replica, one of a number produced, was purchased by Rochdale Art and Heritage Services in September 1996. The top of the plinth is signed and dated by the sculptor, and the rear inscribed:'Published by Arthur Leslie Collie, 39B Old Bond Street, London, Sept 10th 1891.' See Beattie (1983) p.188. [10] *Rochdale Observer*, 3 June 1933; J. Cole, *Yesterday's Rochdale* (Nelson: Hendon Publishing Co., 1983). [11] Photograph of Bright statue, Neg.7961 (Rochdale Local Studies Library).

The Esplanade

Touchstones

Architects: Jesse Horsfall, Percy W. Hathaway

Architectural sculptors: Charles John Allen, John Jarvis Millson

3 April 1903; extension 7 February 1913

Sandstone
1903 panels 2.78m wide × 1.90m high approx; side panels 1.96m wide × 1.9m high approx
1913 panels 4.5m × 2.2m high approx; side panels 1.07m wide × 2.20m high approx
Condition: fair
Status: Grade II
Owned by: Rochdale Metropolitan Borough Council
Description: 1903 building: Three sculpted stone panels above first-storey windows. The centre panel of five figures represents Art. In the middle is a female figure, wearing a crown of laurels, her left arm outstretched over a model of a building, representing Architecture. On her right are figures representing Pottery (a youth with pot) and Sculpture (a man holding model of Fame and a hammer); and on her left are figures representing Metalwork (a man working at an anvil) and Art (a female figure holding a palette). The smaller panel to the left is of three figures representing Science: the central female figure, an eagle at her feet, is flanked by a man holding dividers and a globe, and a younger man holding a fruit in his raised right hand, and a chemical flask in his other hand. The smaller panel on the right-hand side is a composition of three figures representing Literature: the central female figure is holding a lyre, and is flanked by a younger man holding the masks of comedy and tragedy, and an old actor holding a sash.[1]

1913 extension: Three sculpted stone panels above a decorative bay window on the diagonal gable end of the building. Above the panels is a cartouche with 'Art Gallery 1912' in raised letters. The theme of the panels is the arts applied to peace. The centre panel contains seven figures and represents Victory crowning the Arts and Crafts. The central figure is an angel with wings reaching behind the three figures on either side. To the angel's far left is a female holding the model of a ship, her hands resting on an anchor; a workman whose right hand is resting on a large pair of tongs; and a female figure holding the model of a building.

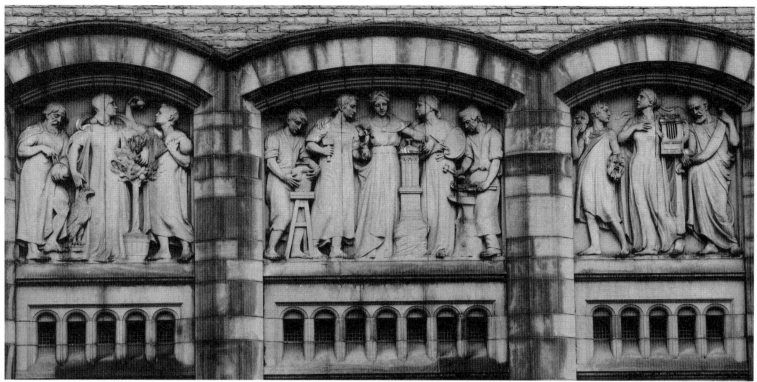

Charles John Allen and J. J. Millson, *Science, Art and Literature*

On the angel's right are three further figures: a female holding a star-shaped medallion in her hand; a blacksmith working at an anvil; and a female holding a palette in her left hand and a palm in her right. The smaller panel on the left-hand side comprises a male and a female figure; the woman examining patterned cloth held by the man. The panel on the right-hand side depicts a lady and a knight in armour.

Rochdale Art Gallery and Museum was opened in April 1903 by Lieutenant Colonel Henry Fishwick. Designed by the Todmorden architect, Jesse Horsfall, the two-storey building adjoined his public library building of 1884 on The Esplanade. In his original plan Horsfall had included three sculpted panels as decoration on the front gable, but for reasons of cost the council decided not to include them. However, they were restored to the project due to the generosity of three senior councillors, William T. Heap, Miles Ashworth and James E. Jones.[2] Charles John Allen of University College, Liverpool, was responsible for designing the panels which were carved by the Manchester architectural sculptor, J.J. Millson.[3] The theme of the centre panel was Art with two smaller panels representing Science and Literature.[4] The late decision to include them in the scheme meant that they were not completed in time for the building's official opening.

An extension to the art gallery was opened in February 1913.[5] Designed by Percy W. Hathaway (1880–1938), an architect in the borough surveyor's department, the two-storey extension followed Horsfall's original building both in style and in the use of sculpted panels for decoration. In this instance three sculpted panels were situated above the large decorative bay window on the diagonal gable end. The theme was the arts applied to peace. Once again, the funds agreed for the building proved insufficient to complete the panels. Money was available to commission the two smaller panels, and these were completed and fitted in time for the opening.[6] The designer is not identified in the extant council records, though they appear to be stylistically close to Allen. They were executed by Martin Brothers of Cheltenham.[7] In September 1912 the Council agreed to give the plaster casts of the sculpted panels to the art gallery.[8] The larger centre panel – Victory crowning the Arts and Crafts – was completed after the building had opened, the £200 cost being met by private donations.[9]

In 1994 the building became the Rochdale Arts and Heritage Centre following the transfer

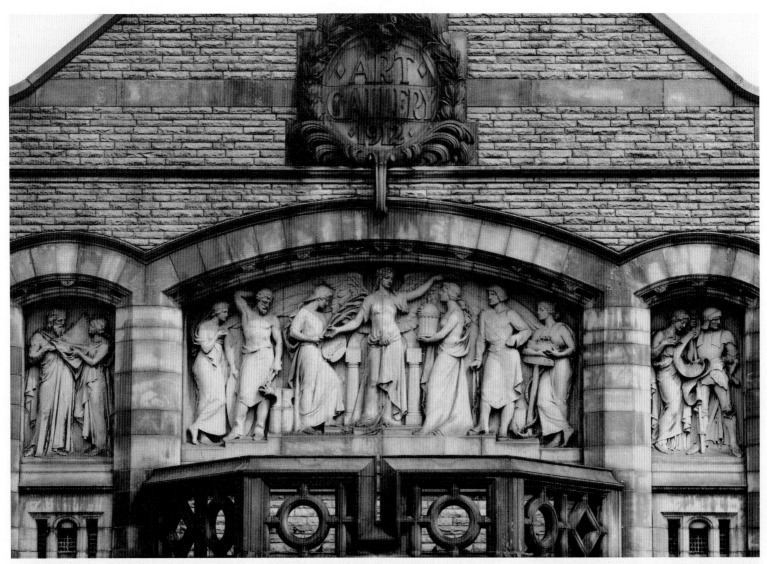

***Rochdale Art Gallery extension, Arts applied to
Peace***

of the main public library into a new building.
Plans were finalised in 2000 to restore the
original building to accommodate a museum,
art gallery and local studies library. The new
centre, Touchstones, opened in 2002.

Notes
[1] Alderman Fishwick, ed., *Rochdale Jubilee, A
Record of Fifty Years' Municipal Work 1856 to 1906*
(Manchester: G. Falkner, 1906) pp.194–5. [2]
Rochdale Council Proceedings. Minutes of Public
Libraries, Art Gallery and Museum Committee, 5
November 1902, p.84; *Rochdale Observer*, 4 April
1903. [3] Rochdale Council Proceedings. Minutes of
Public Libraries, Art Gallery and Museum
Committee, 3 December 1912, p.37. [4] Alderman
Fishwick, *op. cit.*, pp.194–5. [5] *Manchester Courier*, 8
February 1913. [6] Photograph showing blank panel
in *Rochdale Observer*, 8 February 1913. [7] Rochdale
Council Proceedings. Minutes of Public Libraries,
Art Gallery and Museum Committee, 17 April 1912,
p.64. [8] *Ibid.*, 4 September 1912, p.63. [9] *Ibid.*, 18
December 1912, p.64; *Rochdale Times*, 1 and 8
February 1913; *Rochdale Observer*, 8 February 1913.

Unity
Alec Peever

10 March 1995
York stone
Sculpture 1.88m high; stone base 1.2m × 1.2m
Signed on base: Alec Peever 1994
Inscription on separate plaque sited next to
sculpture: 'UNITY' / COMMEMORATES THE
150th / ANNIVERSARY OF / THE ROCHDALE
PIONEERS / SPONSORED BY MANCHESTER
AIRPORT PLC / PRESENTED BY SIR GILBERT
THOMPSON OBE / Vice President of
Manchester Airport / 10 MARCH 1995
Status: not listed
Condition: good
Owned by: Rochdale Metropolitan Borough
Council
Description: Stone sculpture of four figures –
two male and two female – with their arms
raised and hands joined above their heads,
holding a beehive, the historic symbol of the
co-operative movement. The figures rise from a
rounded, carved stone plinth on which the title
is inscribed. The sculpture is set on a square
base of stone slabs.

Unity, a work in York stone by the sculptor
and stone-carver, Alec Peever, was
commissioned by Rochdale Council as a
permanent memorial to mark the 150th
anniversary of the foundation of the Co-
operative Movement by the Rochdale Pioneers.
It was funded by the council in association with
Manchester Airport. The work was chosen
from some 20 designs submitted as part of a
national competition to provide a sculpture to
be located in Lord Square. Alec Peever outlined
two possible ideas. The first was a dissected
beehive surrounded by seven slate honeycomb
tablets, representing the seven principles of co-
operation, on which were to be carved texts
relating to co-operation. The second proposal
was for a sculpture of four figures with their
hands joined together, again surrounded by

slate tablets.[1] The latter design was chosen,
though the tablets were not included in the final
work. Peever explained that the design was
influenced in part by the ideas behind
traditional market crosses, raised as both a
symbol of the market and as a reminder to
traders of their duty to trade fairly.[2]

When the design was made public, the
apparent nakedness of the figures led to some
objections, particularly from the Labour leader
of Manchester City Council, Graham Stringer.
He found the statue 'frankly inappropriate' and
informed the selection committee that he did
not wish to be associated with the 'Rochdale
bottoms'.[3] Rochdale's Civic Society also
weighed in against the statue on the grounds

Peever, *Unity*

that it was badly designed and the gender of the
figures was ambiguous.[4] However, the
sculpture was defended by Rochdale's Liberal
leader, Paul Rowen, who accused Stringer of
'lacking culture'. The figures were, he said,
'perfectly tasteful'.[5] An exhibition was held at
the Arts and Heritage Centre to explain the
design and the making of the sculpture.[6] The
finished sculpture was unveiled in March 1995,
but on The Esplanade not in Lord Square as
had been the original intention.[7] The cost was
£20,000.

Notes
[1] Alec Peever, Ideas for a Sculptural Installation at
Lord Square, Rochdale. (Rochdale Art Gallery files.)
[2] Exhibition leaflet [Rochdale Metropolitan
Borough Council, 1998]; Rochdale Council Press
Release [September, 1998]; information from Alec
Peever. [3] *Manchester Evening News*, 26 May 1994.
[4] *Rochdale Express*, 29 April 1994. [5] *Manchester
Evening News*, 26 May 1994. [6] 'From Maquette to
Monument' exhibition, Rochdale Arts and Heritage
Centre, November 1995–January 1996. [7] *Rochdale
Observer*, 18 March 1995.

Rochdale War Memorial
Sir Edwin Lutyens

26 November 1922
Cornish granite; stone
Cenotaph 9.76m high × 3.96m long × 2.14m
wide; War Stone 1.07m high × 3.66m long ×
84cm wide
Inscription on Cenotaph: north end: TO THE
MEMORY / OF THE MEN OF / ROCHDALE /
WHO / GAVE THEIR LIVES / IN THE GREAT WAR
– south end: THEY WERE A WALL / UNTO US
BOTH BY / NIGHT AND BY DAY – east and west
ends: 1914–1919 AND 1939–1945
Inscription on War Stone: THEIR NAME
LIVETH / FOR EVERMORE
Status: Grade II
Condition: good
Owned by: Rochdale Metropolitan Borough
Council
Description: War memorial; rising from six
steps is a cenotaph, of light grey granite, which

Lutyens, *Rochdale War Memorial*

recedes as it rises to a smaller pier with semi-columns. Above the abacus is a smaller pier, upon which is placed the sarcophagus containing the recumbent figure of the unknown soldier. The central section has rounded ends, on which are carved the principal inscriptions. Two furled flags, carved in stone and coloured, representing the nation and the armed services, project from the flank sides. Between them are the dates of the two world

wars, beneath carved laurel wreaths encircling the Rochdale coat of arms. In front of the cenotaph is the rectangular War Stone. Four ornate cast-iron lamp-posts on a granite plinth mark the corners of the open space surrounding the memorial.

A public meeting to discuss the building of a suitable town war memorial was held in Rochdale Town Hall on 10 February 1919. It was decided that in addition to the construction of a memorial, the fund would be used to provide assistance to the dependants of servicemen killed or disabled during the war.[1] A committee, chaired by Alderman W. Davidson, was formed to oversee the raising of funds, the design and siting of the memorial. The response to the memorial appeal was impressive; money came in rapidly, and the final fund recorded £29,443.10s.0d. It was a substantial sum, partly explained by the prosperity which marked the immediate post-war years, but also to the fact that, as the *Rochdale Observer* expressed it, 'the town was still throbbing with pride in its heroes and sympathy with their relatives'.[2]

Recognising the need to provide a memorial worthy of the town, the committee approached Sir Edwin Lutyens. A site in the vicinity of the town hall was favoured, but as no specific location had been decided upon, Lutyens, who visited the town on a number of occasions, appears to have considered two schemes. The first placed the memorial on the bridge over the River Roch, with high pedestals supporting urns placed at the corners of the bridge. The second design placed the memorial on a site opposite the town hall.[3] It was this latter design that the committee agreed with Lutyens in November 1921.[4] Lutyens brought a scale model in plaster of Paris to explain his design which was based on those distinctive elements of his war memorials: the pylon surmounted by the recumbent figure of the unknown soldier, and the War Stone, echoing the Stone of Remembrance erected in the military cemeteries of France. The proposed site was on land which

was neither empty nor owned by the council. It was occupied by the 'Manor House', an eighteenth-century building that had more recently served as a recruiting station. However, its owner, Alderman William Cunliffe, gave the land to the town, and preparations went ahead to clear the site. Public interest in the construction of the monument was reflected in the local press. The biblical inscription on the memorial, 'They were a wall unto us both by night and by day. I Samuel xxv, 16', was selected from suggestions submitted by readers of the *Rochdale Observer*.

Rochdale's granite cenotaph was unveiled by the 17th Earl of Derby on the final Sunday in November 1922.[5] The final cost was £12,611.[6] Although minor criticisms were voiced about the memorial, chiefly over the positioning of the unknown soldier, it was widely considered to be a most fitting tribute to the 2,000 Rochdalians who had lost their lives.[7] Later commentators have also been generous in praising it. Butler considered it to be a design of exceptional quality that bore comparison with the work of Alfred Stevens.[8]

After the Second World War the appropriate dates were included on the memorial, and, at a later date, a further inscription remembering all those who died in the service of their country was added at the base. The memorial was restored in 2000 as part of a programme to restore all of the borough's principal war memorials.

Notes
[1] *Rochdale Observer*, 11 February 1919.
[2] *Souvenir of the Rochdale War Memorial* (Rochdale: *Rochdale Observer*, 1922); *Rochdale War Memorial 1919–1933* (Rochdale, [1933]) pp.4–5.
[3] Preliminary studies and designs for Rochdale War Memorial in RIBA Drawings Collection, see list in M. Richardson (comp.) *Catalogue of the Drawings Collection of the Royal Institute of British Architects: Edwin Lutyens* (Farnborough: Gregg International Publishers Ltd, 1973) p.44. [4] *Rochdale Observer*, 19 November 1921. [5] *Souvenir of the Rochdale War Memorial* (Rochdale: *Rochdale Observer*, 1922); *Manchester Guardian*, 27 November 1922; *Rochdale Observer*, 29 November 1922; *The Times*, 27

November 1922. [6] D. Boorman, *At the Going Down of the Sun. British First World War Memorials* (York: Ebor Press, 1988) p.124. [7] *Rochdale Observer*, 7 December 1921. [8] A.S.G. Butler, *The Architecture of Sir Edwin Lutyens* (Country Life, 1950) Vol.III, p.39.

Rochdale Town Hall
Architect: William Henry Crossland

Rochdale Town Hall, designed by the Leeds architect, William Crossland, was opened on 27 September 1871. A 74-metre tower and spire was the dominant feature of the exterior of the building. The octagonal spire was topped by a 3.6-metre-high wooden statue of St George and the Dragon, carved by Earp.[1] Above the entrance to the tower were 13 decorated canopies intended to hold statues of statesmen and scientists.[2] They appear not to have been commissioned.[3] The devastating fire in 1883 destroyed the entire tower including the statue of St George. Four years later, a new tower was completed, but one in which the architect, Alfred Waterhouse, did not include statuary. This left the four gilded stone lions above the main entrance as the most obvious examples of sculptural decoration on the exterior. A war memorial to those killed in the South African War, in the form of a bronze wall tablet designed by Percy Hathaway, was added to the front of the building in 1907.[4]

The interior of the town hall is known for its decorative art work, an ambitious scheme that helps to explain why the building's final construction cost of £155,000 was far in excess of the original estimate. Following its opening, and in the absence of a municipal art gallery, a small collection of busts of individuals associated with Rochdale was put on display in the town hall. The only addition in the twentieth century has been a bust of Gracie Fields.

Notes
[1] *Rochdale Observer*, 26 November 1870. [2] *Ibid.*, 30 September 1871; Alderman Fishwick, ed.,

Rochdale Jubilee, A Record of Fifty Years' Municipal Work 1856 to 1906 (Manchester: G. Falkner, 1906) p.205. [3] A carved head of Richard I, said to have been on the tower, is displayed at the Millcroft Tea Gardens, Roods Lane, Norden, Rochdale. [4] Unveiled in June 1907 by Brigadier General Fry. *Rochdale Observer*, 29 June 1907.

Principal staircase half-landing

John Fenton
Edgar G. Papworth, Jnr

1872
White marble bust
72cm high
Signed: E. G. Papworth 1872
Inscription on pedestal: JOHN FENTON / FIRST REPRESENTATIVE / OF THIS BOROUGH / IN PARLIAMENT / THIS BUST / IS PRESENTED TO

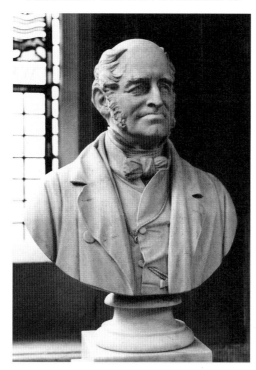

Papworth, *John Fenton*

THE TOWN OF / ROCHDALE. / BY HIS WIDOW / 1872.
Condition: good
Owned by: Rochdale Metropolitan Borough Council

John Fenton (1791–1863) was Rochdale's first MP following the passing of the Reform Act. He served as MP from 1832 until 1835, and again from 1837 to 1841. In the following years he continued to be involved in the town's public affairs. The bust appears to have been commissioned by his widow, who presented it to the Corporation on 23 March 1872.[1] Edgar Papworth also received a number of other local commissions, including busts of the Manchester businessmen and politicians, Sir Elkanah Armitage and Robert Neill.[2]

Notes
[1] *Annals of Rochdale*, p.57. [2] A. Graves, *The Royal Academy of Art* (1905, reprinted Wakefield: S.R. Publishers, 1970) Vol.3, pp.48–50.

Richard Cobden
Matthew Noble

April 1866
White marble bust; polished granite pedestal
84cm high
Signed: M. Noble Sc. London, 1865
Inscription on plinth: COBDEN / BORN JUNE 3RD 1804 / DIED APRIL 2ND 1865 / PRESENTED BY THOMAS BAYLEY POTTER ESQ M.P. 1866
Condition: good
Owned by: Rochdale Metropolitan Borough Council

Richard Cobden – 'The Apostle of Free Trade' – was elected as MP for Rochdale in 1859. He remained an influential political figure, and it was during this period that he negotiated the commercial treaty with France. He was still the borough's MP when he died suddenly in April 1865. The bust was the gift of Thomas Bayley Potter, who succeeded Cobden as Rochdale's

MP. Potter, a close friend of Cobden, offered the bust to Rochdale Corporation in April 1866, requesting that it should be placed in the borough's new town hall when the building was completed.[1] Later in the same year Potter also presented portraits of Cobden and Bright to the borough.

Note
[1] *Manchester Guardian*, 6 April 1866.

John Bright
Albert Bruce Joy

2 August 1890
White marble bust; granite pedestal
84cm high
Signed: Albert Bruce Joy, Sc. 1890
Inscription: on plinth: JOHN BRIGHT / BORN NOVr 16th 1811. / DIED MARCH 27th 1889. / PRESENTED BY / JOHN BRIGHT & BROS. / WORKPEOPLE
Condition: good
Owned by: Rochdale Metropolitan Borough Council

Following John Bright's death in 1889, Rochdale's main public memorial was the Thornycroft statue. However, a separate memorial, a marble bust, was commissioned and paid for by the workers in Bright's Rochdale textile mills. It was the work of Albert Bruce Joy and cost 500 guineas. The unveiling ceremony on Saturday, 2 August 1890, at which the Marquess of Ripon was the main speaker, proved an embarrassing event, as the bust was missing, having been 'lost' in transit on the railway. 'There is a bad quarter of an hour in store for someone', observed one of the leader writers of the *Manchester Guardian*.[1] It was decided to proceed with the ceremony in the absence of the bust, which arrived in Rochdale in the following week.[2]

Notes
[1] *Manchester Guardian*, 4 August 1890.

[2] *Rochdale Observer*, 4 August 1890; *The Times*, 4 August 1890.

Thomas Bayley Potter
Matthew Noble

White marble
78cm high
Signed: M. Noble Sc. London, 1860
Inscription: Thomas Bayley Potter, Rochdale MP (1865–1895)
Condition: good
Owned by: Rochdale Metropolitan Borough Council

Thomas Bayley Potter, born in 1817, was a member of one of the most prominent Liberal families in the North West. His father, Sir Thomas Potter, had been the first mayor of Manchester whilst his elder brother, Sir John Potter, served as the city's mayor and its MP. Thomas Bayley Potter was a leading figure in the Union and Emancipation Society. He succeeded Cobden as Rochdale's MP, following the latter's death in 1865, and held the seat for the next thirty years. Potter, a vocal supporter of free trade, was founder and secretary of the Cobden Club. He died in November 1898 in Cobden's former home in Midhurst.[1] Noble's bust of Potter was presented to the borough by the family in 1899.[2] It was appropriate that it was placed in the town hall, for not only was he one of the borough's longest-serving MPs, but he presented a number of political works of art to the town, including a portrait of Oliver Cromwell and busts of Cobden and Garibaldi.[3] It is also not entirely inappropriate, in view of the fact that his life was so closely entwined with Cobden's, that for many years his bust has been placed on Cobden's pedestal in the town hall.

Notes
[1] *Manchester Guardian*, 8 November 1898.
[2] Letter from Arthur Potter, Rochdale Council General Purposes Committee, 12 April 1899.
[3] *Annals of Rochdale* (1931) p.150.

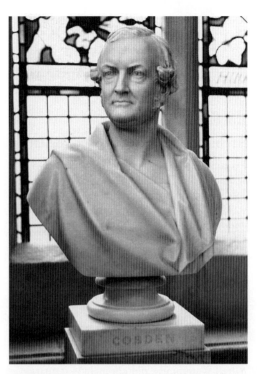

Noble, *Thomas Bayley Potter (on Cobden's pedestal)*

The Exchange, Ground Floor

Gracie Fields
David Rawnsley

1964
Bronze bust
68cm high
Signed: Gracie 1964 David Rawnsley Capri
Condition: good
Owned by: Rochdale Metropolitan Borough Council

Gracie Fields was born Grace Stansfield in Rochdale on 9 January 1898. She made a career as an entertainer and was a successful singer of sentimental and comic songs in revues in the

Rawnsley, *Gracie Fields*

1920s. Her appearance in films in the 1930s made 'Our Gracie' the best-known and most successful female entertainer in Britain. After the Second World War she retired to live in Capri with her husband, Monty Banks. He died in 1950. Her public performances in Britain continued, though on a reduced scale, into the 1970s. On one of her final visits to Rochdale, in 1978, she opened a theatre named in her honour. David Rawnsley sculpted a bronze bust of Gracie Fields in 1964 that she kept in her home in Capri. She died there in 1979, aged 81, and the bust was one of a number of personal items left by the entertainer to Rochdale. After a long correspondence and many delays, it was eventually sent from Capri to Rochdale.[1] It was the centrepiece of a small exhibition celebrating the star – including an aspidistra – located in the entrance hall of the town hall. There are plans to display the bust in the town's new museum, Touchstones.[2]

Notes
[1] *Daily Telegraph*, 4 July 1983. The bust finally arrived in c.1990. [2] Information from Rochdale Museums.

Manchester Road and The Esplanade

The Spires

Partnership Art

July 1998
Slate; stone; glass; steel and copper
13m high
Inscription around the base of spire
 (Manchester Road junction): SPIRE – INSPIRE
 – SPIRE – ASPIRE
Status: not listed
Condition: good
Owned by: Rochdale Metropolitan Borough
 Council
 Description: Two spires placed diagonally opposite each other at a road junction. The structures rise on a circular base of green slate and blue glass bricks with the spires being made of steel, ending in copper verdigris. The spire on the Manchester Road junction includes a metal seat round the base.

Rochdale Council commissioned *The Spires* in 1997 as symbolic gateways to the town, and, more specifically, to what council officials referred to as the 'cultural corridor' leading into the civic quarter. Designed by Jem Waygood of Partnership Art, the two spires were a conscious response to the existing spires in the town centre, particularly those on the Town Hall, Touchstones (formerly the art gallery and library) and St Chad's Church. The work took the form of two tall spires positioned diagonally opposite each other at the intersection of The

Partnership Art, *The Spires*

Esplanade and Manchester Road, and of St Mary's Gate and Dane Street. Their colouring and patterning also echoed the neighbouring civic buildings. They were designed to be illuminated at night. A metal seat was fitted to the spire at the corner of Manchester Road because, unlike the other spire, it was accessible to the public. According to the Council the words 'Inspire' and 'Aspire', which appear on the Manchester Road spire, were chosen because they were 'enigmatic' and for their 'resonances with Rochdale's radical and influential history'.[1] The artist also advanced the idea of four smaller spires in the nearby Memorial Gardens.[2]

In spite of the council's efforts at public consultation *The Spires* provoked considerable adverse local comment. The *Rochdale Observer* led the catcalls, calling the new additions to the town 'awful' and 'monstrosities'. A poll conducted by the newspaper found that 73 per cent of callers agreed with assistant editor Martyn Green's view that the spires were 'pathetic, and a complete and utter waste of money'.[3] The cost, said to be £85,000, generated further criticisms.[4] The knee-jerk accusation of squandering ratepayers' money was, however, hardly appropriate, as the project was financed by Trafford Park Estates Plc, the developers of a new supermarket on the St Mary's Gate side of the junction, and money received through a scheme managed by the Association of Business Sponsorship of the Arts.[5] Since its installation the work has become more generally accepted as a landmark in this part of the town.

Notes
[1] Undated document in Public Art file (Rochdale Local Studies Library). [2] *Rochdale Observer*, 11 June 1997. [3] *Ibid.*, 11 July 1998. [4] *Ibid.*, 22 July 1998. [5] *Manchester Evening News*, 1 August 1997.

Nelson Street
The Rochdale Olympics
Adrian Moakes

21 July 2002
Steel plate
Panels 1.24m high × 3.25m long approx; area covered 14m × 4m approx
Status: not listed
Condition: good
Owned by: Rochdale Metropolitan Borough Council
Description: Steel sculpture representing in 11 cross sections the Rochdale Olympic motor car. Each panel includes the relevant details of the car, and is painted a bright red. The hub caps of the wheels have inscriptions outlining the history of the car and the commission.

This sculpture was part of the regeneration scheme for the Drake Street area of Rochdale, public art having been recognised as an integral part of the regeneration strategy. Rochdale Development Agency commissioned the work on behalf of the Rochdale Challenge Company Partnership. Adrian Moakes was selected from a number of artists who had been invited to put forward ideas for public art in the area. He examined different sites and developed a number of ideas for a sculpture. Transport was one of the ideas, a theme related to the intended construction of the Metrolink tram along Drake Street. One of the most interesting locations for

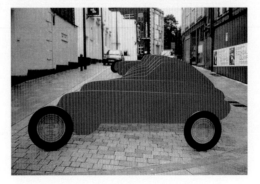

Moakes, *The Rochdale Olympics*

a sculpture was Nelson Street, off Drake Street, a sloping site bounded by shops. Moakes explored various ideas for the site, before being shown an article in an old car magazine about a 1960s sports car manufactured in Rochdale. The Rochdale Olympic was designed by Richard Parker and produced by Rochdale Motor Panels, a firm established in the late 1940s by Frank Butterworth and Harry Smith. It was a kit car with a glass fibre monocoque chassis. Some 400 were manufactured between 1960 and 1973. Moakes made a preparatory model of the work.

> With a stroke of luck I was able to see a beautifully restored Olympic at a classic car show… It was then that the sculpture really came to life, as I discovered the fascinating history of the people who designed and produced the car.[1]

His proposed sculpture took the form of a car sliced into sections. The steel profiles were cut by a firm in St Helens and then finished by Moakes in his Manchester workshop. Each section was painted bright red. As the intention was to fix the sculpture at ground level, attention was given to ensuring that it could not be easily vandalised, including the use of scratch-resistant plate steel. The North West Development Agency provided the largest part of the £50,000 project costs.

The work was unveiled by Frank Butterworth, Harry Smith and Hilary Parker, widow of Raymond Parker, in July 2002. The ceremony attracted a large crowd keen to see both the new sculpture and a number of the original Olympic cars brought along for the occasion by their devoted owners. The initial reaction to the sculpture in the local press was favourable. One specialist car magazine has pointed out that *The Rochdale Olympics* is one of the few sculptures honouring a classic car.

Note
[1] Rochdale Council press release, 10 July 2002.

Yorkshire Street

Rochdale Exchange Shopping Centre

Sheep
Judith Bluck

15 September 1978; relocated 1997, 2000
Bronze sculpture; sandstone rag
68cm high × 1m long; 60cm × 80cm long
Condition: fair
Status: not listed
Owned by: Co-operative Insurance Society
 Description: Three moorland sheep lying
down on blocks of sandstone; the two smaller
sheep are joined together.

Laing Properties Ltd, the developers of a new
shopping centre in Rochdale in the 1970s,
commissioned a public sculpture for the centre.[1]
The commission marked the end of a project
which had been beset by financial and planning
problems. Judith Bluck's submission was
selected in a public competition. She only
entered the competition at the last moment
having believed she was ineligible because of an
earlier award from the developers.[2] Her
sculpture of three moorland sheep was
interpreted as a reminder of an earlier period in
Rochdale's history, when the manufacture of

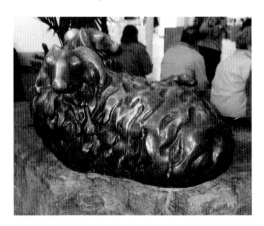

Bluck, *Sheep*

woollen cloth was the dominant local industry.
It was placed outside the main entrance to the
new shopping centre, the sheep and the blocks
of Yorkshire sandstone being arranged so as to
allow public seating.[3] *Sheep* was presented by
the developers as a 'gift to the people of
Rochdale for their tolerance during the years of
building operations'.[4] It was unveiled in
September 1978 by Rochdale's best-known
personality, Gracie Fields, during one of her
rare visits to her native town.[5]

The sculpture proved to be a popular
meeting place for people using the centre,
especially children who were able to climb over
and between the sheep. When the shopping
centre was refurbished in 1997 it was decided to
move the sculpture inside, placing it in the
middle of a new seating area, opposite the
entrance to a department store.[6] Once again, the
sculpture proved a popular feature, but safety
concerns led to the decision to re-site it. In 2000
the three sheep, but not the sandstone blocks,
were removed to the entrance to the centre's
open car park level. Some shoppers complained,
annoyed that what they regarded as a feature of
the centre had been relegated to a less public
location. Public safety concerns still surround
the sculpture, and the shopping centre has
offered it to the council, but, as yet, no suitable
location has been identified.[7]

Notes
[1] 'Pride of our Alley', *Surveyor*, 20 December 1979,
pp.14–15. [2] Information from Judith Bluck,
September 1999. [3] *External Works* (Landscape
Promotions Ltd, 9th edn) p.512. [4] *Ibid.*
[5] *Guardian*, 16 September 1978; Joan Moules,
Gracie Fields. A Biography (Chichester: Summersdale,
1997) p.223. [6] The Rochdale Exchange Shopping
Centre was reopened on 30 October 1997.
[7] Information from Margaret Cigna, Rochdale
Exchange Shopping Centre.

WARDLE

Ramsden Road

Watergrove Reservoir

Long Vessel
Chris Drury

August 1995
Dry-stone walling
18m long × 1.75m high at centre
Condition: fair
Status: not listed
Owned by: Rochdale Metropolitan Borough
 Council
 Description: An upturned longboat
constructed from pieces of gritstone, positioned
on the hillside overlooking the reservoir. There
are two gaps in the centre of the boat.

Chris Drury, a leading proponent of Land Art,
constructed *Long Vessel* in the summer of 1995.
It was at a time when an exhibition of his works
was being held in Rochdale.[1] The work is
located high on the valley side above
Watergrove Reservoir, close to where Higher
Slack Brook flows into the reservoir. The
construction of the reservoir in the 1930s
necessitated the flooding of the small village of
Watergrove, and a number of date-stones from
the lost buildings have been set into the
reservoir wall to form part of a 'Wall of
History'. Drury's sculpture resembles an
upturned Viking longboat and is made out of
the roughly shaped pieces of millstone grit
taken from abandoned dry-stone walls. It fits
naturally into the landscape and serves as a
challenge to conventional expectations of public
sculpture and art.[2] It was built as a hollow cairn,
with two central gaps or doorways which allow
sheep to pass through the sculpture.[3] The vessel
would appear to meet at least one of Drury's
criteria for Land Art:

I make art in the quiet, secret places of the

world. Most of these works disintegrate; some I dismantle, some if they are unobtrusive, I leave for others to use, but I see art as communication, that is why I bring objects and photographs into the cities and gallery spaces of the world.[4]

The absence of any explanatory plaque or even a signpost means that many visitors to the reservoir leave without seeing this example of Land Art. In 1999 Drury produced *Coming Full Circle*, a dry-stone waterwheel, at Stacksteads, as part of the Irwell Valley Sculpture Trail.

Notes
[1] *Chris Drury. Vessel. Sculpture 1990–1995* (Collaboration between Inverleith House, Royal Botanic Garden, Edinburgh and the Towner Art Gallery, Eastbourne) [1995]. [2] C. Drury, *Silent Spaces* (London: Thames and Hudson, 1998) p.25. [3] *Guardian*, 27 July 1995; *Manchester Evening News*, 28 July 1995. [4] Rochdale Art Gallery press release for exhibition of Chris Drury's works 1990–5.

Drury, *Long Vessel*

Mackinnon Memorial Fountain
Francis John Williamson

October 1899
Marble
4.57m high approx including pedestal
Inscription: PRESENTED TO THE TOWN OF / ROCHDALE / BY ELLEN MACKINNON. / IN MEMORY OF HER MOTHER / AUGUSTA / SISTER OF THE LATE JOHN SMITH ENTWISLE / OF FOXHOLES. / 1899.
Description: Fountain; a marble angel with outstretched wings, dressed in a long flowing robe, the left arm raised to heaven, surmounting a dome-shaped pedestal. Two separate stone water troughs for animals stood in front of the pedestal.
(see illustration overleaf)

The Mackinnon Memorial Fountain – popularly known as 'The Angel' – was presented to Rochdale by Ellen Mackinnon in memory of her mother in October 1899. Ellen Mackinnon was the granddaughter of John Entwisle, Rochdale's first Conservative MP, and a member of a family that had long connections with the town. The Entwisle family owned the Foxholes estate. It was John's daughter, Augusta, who married Captain Lauchlan B. Mackinnon, who was the object of the memorial. Both the figure and dome-shaped plinth were carved in Sicilian marble. The pedestal was of Yorkshire stone. The sculptor was Francis Williamson, who was well known because of his royal patronage.[1] The height including the pedestal was approximately 15 feet. It was located at the junction of The Esplanade and Sparrow Hill Road, close to one of the entrances leading into Broadfield Park. A drinking trough for horses and a smaller one for dogs were placed immediately in front of the pedestal. In line with the wishes of Miss Mackinnon, who lived in Surrey, there was no formal inauguration ceremony.[2]

At different times in the twentieth century the idea of removing 'The Angel' from what had become a busy road junction was raised. One alternative location suggested was the grand staircase in the town hall, but no action was taken. Over the years the condition of the monument deteriorated. Finally, in April 1961, it was removed to Entwisle Road transport depot where it is presumed to have been left to disintegrate.[3]

Notes
[1] Williamson's studio was in Esher, Surrey. M.H. Spielmann, *British Sculpture and Sculptors of Today*, (London: Cassell, 1901) pp.18–19. [2] *Rochdale Household Almanack and Corporation Manual* (Rochdale, 1900) pp.9–10; *Rochdale Observer*, 21 October 1899. [3] *Rochdale Observer*, 10 December 1975; information from John Cole.

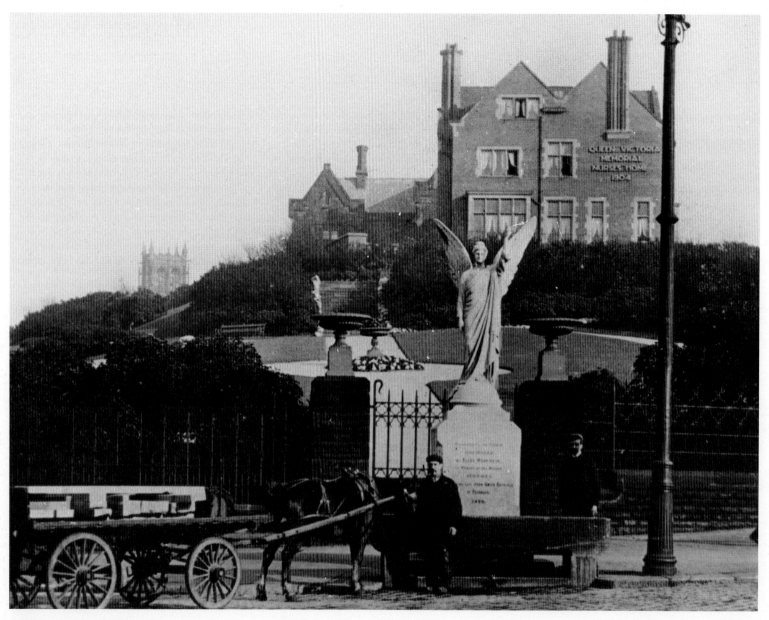

Williamson, *'The Angel'*

STOCKPORT

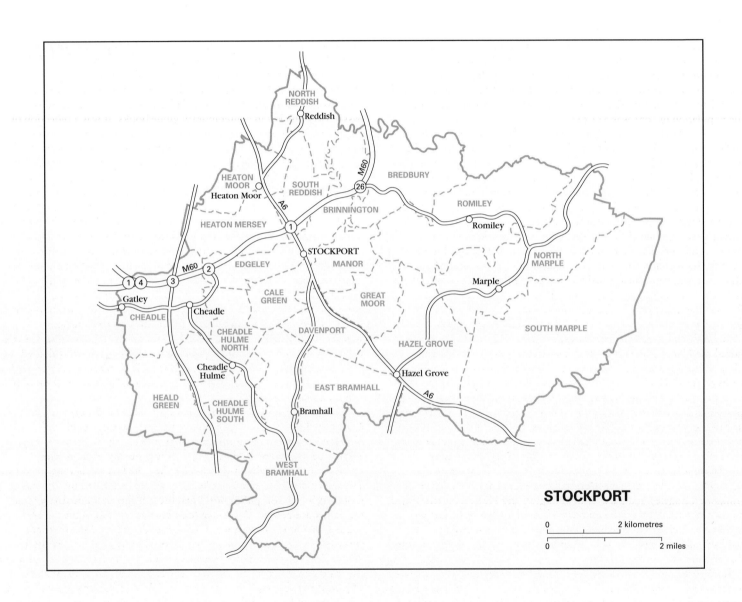

STOCKPORT

NORTH
REDDISH

Reddish

HEATON
MOOR

Heaton Moor

SOUTH
REDDISH

BREDBURY

M60

26

BRINNINGTON

ROMILEY

HEATON MERSEY

Romiley

1

STOCKPORT

A6

EDGELEY

MANOR

NORTH
MARPLE

M60

2

Marple

3

CALE
GREEN

GREAT
MOOR

1 4

DAVENPORT

SOUTH MARPLE

Gatley

CHEADLE

Cheadle

HAZEL GROVE

CHEADLE
HULME
NORTH

Cheadle
Hulme

Hazel Grove

EAST BRAMHALL

A6

HEALD
GREEN

CHEADLE
HULME
SOUTH

Bramhall

WEST
BRAMHALL

STOCKPORT

0 2 kilometres

0 2 miles

Introduction

The Metropolitan Borough of Stockport was created in the local government reorganisation of 1974, amalgamating Stockport and the surrounding Urban Districts of Cheadle and Gatley, Bredbury and Romiley, Hazel Grove and Bramhall, and Marple. The borough lies to the immediate south-east of Manchester and covers an area of 12,605 hectares. The population in 2001 was 284,544.

Stockport has a long recorded history and, although not mentioned in the Domesday Survey, it was to be the site of a Norman castle. In the thirteenth century Stockport's importance as a centre for agriculture was evident in the granting of a charter and the right to hold a regular market and annual fair. By the seventeenth century it was recognised as one of the most important towns in Cheshire; its dynamism already owing much to its proximity to the neighbouring Lancashire economy. A silk mill, built in 1732, was one of the first such industrial workplaces in the country, and signalled the beginning of a new economic age. However when the industrial revolution took hold, it was the spinning of cotton rather than silk that transformed Stockport and the surrounding villages, the town's rivers proving a key factor in the subsequent development. The manufacturing of hats also became an important industry. Aikin recorded 23 cotton factories in 1795.[1] But even more spectacular than its cotton mills was the construction of the massive railway viaduct, which carried the Manchester and Birmingham Railway across the Mersey valley. Completed in 1841 the viaduct – 'one of the most stupendous works of art to which the railway has given birth' – was one of the largest brick structures built during the nineteenth century.[2] Industrial Stockport appears to have had little to commend it. Frederick Engels' description of the town as 'one of the darkest and smokiest holes in the whole industrial area' would have been contradicted by few, either inside or outside the town.[3] Poverty was extensive in a community which had seen its population increase from some 3,000 in the early 1750s to more than 30,000 in 1851. The municipal borough created in 1835 included Brinksway, Edgeley and parts of Brinnington and Heaton Norris but, as in other industrial towns, the municipal boundary was to be further extended to include not only neighbouring Cheshire townships but Reddish and other districts which had been part of Lancashire. Stockport became a county borough in 1888.

Stockport's rapid growth resulted in the destruction of what appeared in retrospect to be picturesque features of the old town. The market cross, situated in the Market Place, between the parish church and the ruins of the castle, was one of the casualties in this age of improvement.[4] The date when the cross was removed is unrecorded, an absence of elementary information affecting the history of other local crosses.[5] Victorian Stockport showed little concern for the public aesthetic and even its principal public buildings (Market Hall, Infirmary) were ignored or passed over quickly in contemporary guide books. It was a reflection of this architectural barrenness that Stockport Sunday School, one of the town's best-known buildings, was famous for its sheer size rather than any architectural features. In terms of public monuments and statues the town had little to offer. It appears that one of the first modern public memorials to be raised was in memory of Enoch Hill, a private in the Stockport Volunteers who was accidentally killed in 1799. It stood in the parish churchyard.[6] In the Victorian period the few schemes which set out to raise public monuments were bedevilled by controversy or lost in inertia. The town's decision to raise a 'permanent memorial' to Sir Robert Peel, following his death in 1850, was unsuccessful.[7] Stockport's only major outdoor Victorian statue was raised to Richard Cobden, the 'Apostle of Free Trade', who had first entered parliament as the borough's MP.[8] But, with a gestation period of some 20 years, it hardly fitted the typical Victorian model of public memorials to eminent statesmen. The final result was a staid portrait statue, the work of George Adams, displayed in a cramped public space. Other local worthies, whose civic contribution might have been honoured in other communities with a bust if not a full-length statue, appear not to have been memorialised in either marble or bronze.[9]

The opening in 1858 of Vernon Park provided Stockport with an obvious public space in which commemorative statuary could be displayed, but there was no concerted plan to use the park in this way. The statues that were displayed there were generally of an inferior quality, gifts from individuals who may have had no further use for them. These included a life-size Napoleon Bonaparte, presented by Thomas Goulden, which was pulled down and broken almost immediately after the park was opened.[10] Alderman John Hampson's gift of the marble statue *Venus at the Bath*, a work to 'elevate the tastes of the visitors', survived longer, but was eventually removed to the park's museum. Its present location is unknown.[11] A more modest four-foot high sculpture in the 'hard grey stone of the district' depicted a local character, William Oliver. It was the work of an unidentified local stonemason, and showed Oliver, cap in hand, on the occasion when he appeared before the bench

for insulting local magistrates. The subject was not considered to be an entirely appropriate one, the correspondent of the *Builder* observing that 'a public reprimand for insolence ought not to be the means of rendering its recipient famous'.[12] This statue is no longer in the park and is presumed to have been destroyed. A bronze ornamental fountain, paid for by the workers of James Kershaw's India Mills, and a drinking fountain paid for by the workers of Greg's Mill in Reddish, were more in keeping with the values embraced by the park's promoters.[13] An ambitious plan by local friendly societies to erect a tower and observatory, designed by James Stevens, in the park was a saga of disputes and delays before being abandoned.[14]

Stockport's public buildings also showed few of those architectural embellishments that were to be found in many other towns of a similar size. Brumwell Thomas' 'wedding-cake' town hall of 1908 was late by the standards of the cotton towns, and, although it boasted some sumptuous spaces and stained glass, statuary was not a feature of either the interior or the exterior.[15] Neither did it become home to a collection of the busts of municipal worthies. In the following years only two busts found a place in the town hall. The first was of the cotton manufacturer and Liberal politician, Sir Joseph Leigh (1841–1908), who had been the borough's mayor on four occasions before becoming its MP.[16] The second was of a later but equally influential local politician, Walter Cumston Knight (1914–76), who served on Stockport Council from 1945 to 1974, before becoming the first mayor and leader of the new Metropolitan Borough Council in 1974. This bronze bust was the work of the local sculptor,

John Blakeley.[17]

In the surrounding villages the drinking fountain, sometimes incorporating a public lamp, was the preferred public monument. A particularly fine example was in Cheadle, erected in memory of a local doctor, Robert Ockleston; more prosaic and typical was the one raised to commemorate Victoria's Golden Jubilee in Hazel Grove.[18] Not all of these fountains have survived – the one at Woodley, erected in about 1881, was taken down in 1935 – and, as in other districts of Greater Manchester, precise information about their history and fate is surprisingly vague.[19]

This coolness towards public monuments and sculpture was put aside in a spectacular manner when the borough erected its memorial to the 2,000 local men who had died fighting in the First World War. Stockport's principal memorial was an ambitious project, in which the architect, Theo Halliday, and the sculptor, Gilbert Ledward, combined to produce a building that was both monumental and practical, with its central internal space dominated by a marble sculpture of stunning quality. The district also had a full complement of village war memorials as well as those raised by individual firms, schools, voluntary societies,

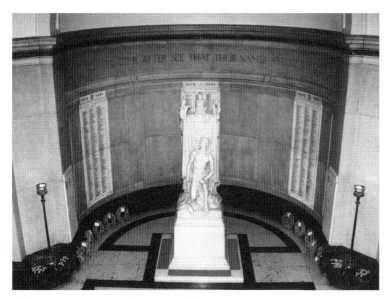

Theodore Halliday, *Stockport Hall of Memory (interior)*

sports clubs and the rest.[20] Churches also remembered parishioners who had lost their lives, memorials ranging from the simple wall tablet inside a church to the more striking outdoor monument, as at St George's, Stockport.[21]

However, war memorials apart, for most of the twentieth century there was an indifference to public sculpture. Up to the middle of the century it was hard for even the most civic-minded Stopfordian to provide anything more than an embarrassingly brief list of local public monuments.[22] Most lists began and ended with Richard Cobden, although even Stockport's most famous politician could not be guaranteed the sympathetic attention of posterity. In the 1950s, when a bust of Cobden was offered to the town by a former mayor, it was refused by a number of the local government departments before being taken in by the Stockport Reform Club.[23]

The reorganisation of local government in 1974 saw Stockport become the centre of a large metropolitan borough. A number of commemorative fountains and village war memorials were among the monuments that became the responsibility of the new authority. Nevertheless there was little new sculpture to be seen in these years. The construction of the Merseyway shopping precinct in Stockport did not include any significant examples of public art, except for a historically-referenced concrete relief, the work of Henry and Joyce Collins, on the wall of a department store. New office buildings were not the occasion for commissioning a modern piece of sculpture. The 72 victims of the Hopes Carr air crash were remembered by a simple metal plaque set in stone. The internationally-known sculptor John Blakeley, who had worked in Stockport for most of his life, never realised his ambition of providing his native town with a major outdoor public sculpture.[24] In the 1990s Stockport Metropolitan Borough showed a more sympathetic attitude towards public art, though initial projects such as the decorative railings erected where the Rivers Goyt and Tame met – the work of the Scottish artist Alison Simpson – were on a small scale, and did not appear to spark the public imagination.[25] The current inventory of Stockport public sculpture still remains notable for its brevity, and, as in the past, it is to the parish church of St Mary, with memorials by Daniel Sephton, Sir Richard Westmacott, Matthew Noble and others, that those wishing to find the finest local collection of sculpture and monuments should journey.[26] This might be followed by a walk through the town's Victorian cemetery, where, even allowing for the slow forces of weathering and the more recent random attacks of muscular delinquents, some fine public funerary monuments remain, including one to Howard Beckwith, Superintendent of Stockport's fire brigade, who died in an accident in 1926.[27]

Notes

[1] J. Aikin, *A Description of the Country from Thirty to Forty Miles Round Manchester* (London: J. Stockdale, 1795, reprinted New York: A. Kelley, 1968) p.446. [2] *Bradshaw's Miscellany* quoted in M. Hughes and V. Holland, *Stockport Viaduct* (Stockport, 1970). [3] F. Engels, *The Condition of the Working Class in England* (Oxford: Basil Blackwell) 1958 ed., p.52. [4] H. Heginbotham, *Stockport: Ancient and Modern* (London: Sampson Low, Marston & Co., 1892) Vol.1, p.263; Vol.2, p.98. [5] The history of the township boundary crosses has puzzled local historians; see J.E. McDonald, 'The lost crosses of Stockport', *Stockport Advertiser*, 18 January 1929. [6] J. Dugdale, *The New British Traveller* (London: J. Robins, [1819]) pp.351–2. [7] *Manchester Guardian*, 27 July 1850. [8] Pevsner and Hubbard (1971), p.340. [9] A marble bust of John Benjamin Smith in Stockport Museum, Vernon Park may be the exception. Smith was Stockport's MP from 1852 until his retirement in 1874. It was Smith and his fellow Liberal MP, James Kershaw, who gifted the museum to the town. Smith also presented the museum with a collection of oil paintings. *Stockport Advertiser*, 19 September 1879. [10] *Ibid.*, 24 September 1858, 1 October 1858. Apparently, the statue had been attacked in Goulden's own garden. The sculptor is not identified. [11] Letter to *Stockport Advertiser*, 1 October 1858; F. Galvin, '130 years of Stockport Museum', *Manchester Region History Review*, 5, no.1 (1991) pp.40–1; correspondence with Tessa Wiley, Collections Officer, Stockport, 16 September 1998. [12] *Builder*, 2 October 1858. [13] *Vernon Park Jubilee 1858–1908. Town Hall Sketches* [Stockport, 1908] p.43. The India Mills' fountain was removed for scrap in the Second World War. The present fountain is a modern copy installed as part of the restoration programme for the park. [14] *Stockport Advertiser*, 28 September 1860; W. Astle, *History of Stockport* (Stockport, 1922, reprinted S.R. Publishers, 1971) p.78. The remaining funds were donated to the local hospital. [15] *An Illustrated Description of the Stockport Town Hall with a few historical notes* (Stockport: Swain and Co.,[1908]); M. Garratt and S. McKenna, *Stockport* (Temple Publishing, 1999) pp.65–8. [16] Marble bust of Sir Joseph Leigh, unsigned and undated. [17] *Stockport Express*,

14 August 1977; *Stockport Messenger*, 18 September 1981. Works by Blakeley were displayed in nine countries including a memorial at Ravensbruck concentration camp. [18] R.J. Fletcher, *A Short History of Hazel Grove from Olden Times* (Stockport: Hurst Brothers, 1901) p.43; *Stockport Advertiser*, 8 July 1898. [19] R. Frost and I. Simpson, *Woodley and Greave. All about two villages* (Stockport: Stockport Leisure Services Division, 1988) pp.11–12. [20] Memorials in workplaces, schools, clubs and societies included Stockport Lacrosse Club (26 September 1919), Stockport Cricket Club (7 May 1921), Stockport Grammar School (11 November 1921) and Christy and Co. (10 November 1923). [21] S. Jones, *The History of St George's Church, Stockport 1897–1997* (Stockport Council, 1997); Pevsner and Hubbard (1971), p.344. [22] Correspondence in *Stockport Express*, 5 June 1969. Most would have been memorials in churches including the one to John Marsland by Matthew Noble (Gunnis (1968) p.275). [23] *Manchester Guardian*, 9 August 1957. [24] Blakeley's principal local work was a marble sculpture, *Young Christ in the Temple*, St Mary's Church. It was dedicated in 1976. *Stockport Advertiser*, 27 November 1975, 15 January 1976. [25] The decorative railings feature local landmarks including the viaduct and railway station, the glass 'pyramid' office block and Edgeley Park football ground. They were based on drawings produced by local people. *Stockport Express and Advertiser*, 15 November 1995. [26] H. Heginbotham, *Stockport. Ancient and Modern* (1892) Vol.1, pp.226–41; Gunnis (1968) pp.275, 347, 426. [27] There is also a plaque to Beckwith in Stockport Bus Station. See also the report of the Orrell memorial in the cemetery, *Builder*, 19 April 1851.

CHEADLE

Queen's Gardens

Ockleston Fountain

Architect: Alfred Darbyshire

30 March 1889; relocated 1967
Granite; limestone; Titancrete
5.2m high approx
Inscription round abacus: ROBERT OCKLESTON
 DIED 1888 MEMORIAL ERECTED 1889
Status: Grade II
Condition: fair
Owned by: Stockport Metropolitan Borough
 Council
Description: Drinking fountain; the basin of
the fountain is octagonal in plan, on which are
four polished granite canopies which originally
contained drinking cups. A polished granite
column rises from the centre of the basin,
surmounted by an ornate stone capital with
carvings including herons and lilies, and the
coat of arms of Cheshire. Originally, above the
column was an ornate canopy, inside which was
a lamp. The fountain also had water troughs for
animals at the base.

Robert Ockleston came to live in the village of
Cheadle in the 1830s as an assistant to the local
doctor. He eventually established his own
practice and became known for his kindness
and 'his innocent-looking little white pills'
which proved to be 'the best engineer in the
district for making a road through anyone'.[1] He
enjoyed the rural life, being a passionate
horseman. Ockleston took an interest in the
wider public affairs of the village, and, in a
memorable phrase, he came to represent 'the
keystone of their identity as a village'. Shortly
after his death in February 1888, it was
proposed that a memorial be erected to honour
his work and place in the village.[2] A committee
was established, a circular distributed and a
subscription opened. The memorial took the

practical form of a drinking fountain and public
lamp. The scheme found support 'in all classes
and stations of life, spread over a very wide
area'. The Manchester architect, Alfred
Darbyshire, designed the memorial. He created
an elaborate ornamental drinking fountain from
traditional materials including Aberdeen granite
and Mansfield limestone, as well as more
modern ones such as Titancrete, which was
used for the water trough. It also included a
lamp, based on those Darbyshire had designed
for the Manchester 1887 Jubilee Exhibition.[3]

At the unveiling ceremony, Sir Edward

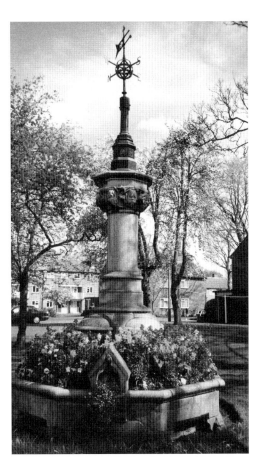

Darbyshire, *Ockleston Fountain*

Watkin, who had that morning attended the
funeral of John Bright, sought to compare the
two men. He told the large crowd that, if the
spirit of Bright had been there, it would have
said 'that even beyond the services of the orator
and statesman are the quiet services of the
village doctor to scores and hundreds of
suffering persons'.[4] The memorial was unveiled
and handed over to the Local Board by the
Lord of the Manor, James Watts of Cheadle
Hall. It was a ceremony which reaffirmed
relationships between those on the platform
and those in the crowd.

This picturesque and useful memorial was
prominently sited in front of Cheadle Green at
the junction of the High Street and Manchester
Road. By the end of the century extra lamps
were added. As horse-drawn traffic declined,
the water trough was less used, and less
maintained. The memorial remained on its
original site until 1967, when a new traffic
scheme resulted in its removal to Queen's
Gardens.[5] In its new location the fountain was
cleaned, a weather vane replaced the original
lamp pendant and canopy, and the troughs were
planted with flowers.

Notes
[1] Fletcher Moss, *A History of the Old Parish of
Cheadle in Cheshire* (1894, reprinted Manchester:
Morten, 1970) p.186. [2] *Stockport Advertiser*, 3
February 1888, 9 March 1888. [3] Photograph dated
1890 (S730 – 36477) in Local Studies, Manchester
Central Library. [4] *Stockport Advertiser*, 5 April
1889. [5] Heather Clarke, *Cheadle Through the Ages*
(Manchester: Morten, 1972) p.12.

CHEADLE HULME

Manor Road and Ravenoak Road
Cheadle Hulme War Memorial
Architect: Arthur Beresford Pite
Sculptor: Benjamin Clemens

29 May 1921
Rainhill sandstone; granite; bronze figures
5.66m high × 1.76m × 1.53m
Inscription on front at bottom of shaft:
ERECTED BY THE INHABITANTS / OF CHEADLE
HULME – rear: THEY SHALL NOT GROW OLD
AS WE THAT / ARE LEFT GROW OLD. AGE
SHALL NOT / WEARY THEM NOR THE YEARS
CONDEMN, / AT THE GOING DOWN OF THE
SUN AND IN / THE MORNING, WE WILL
REMEMBER THEM. – on a bronze band at
bottom of base: TO THE EVER GLORIOUS
MEMORY / OF THE MEN AND WOMEN WHO
FELL IN THE / WARS 1914–1918 AND
1939–1945
Status: Grade II
Condition: fair; weathering of stone
Owned by: Stockport Metropolitan Borough
Council
Description: War memorial; a tapering red
sandstone column surmounted by a decorated
cross. Two bronze figures of a soldier and sailor
are placed on each side of the shaft, below the
cross. The shaft stands on a substantial
rectangular sandstone pedestal and a smaller
one of rough granite. The principal face of the
shaft is decorated with the arms of the County
Palatine. Inscribed on bronze panels on three
sides of the shaft are the names of those who
lost their lives in the First World War. The
names of the dead of the Second World War are
recorded on bronze panels fixed to the
sandstone pedestal.

Various proposals, including a library and clock
tower, were put forward to memorialise those
Cheadle Hulme men who had died in the First
World War. A public meeting in February 1919
discussed the various schemes and agreed that
the memorial should be 'a chaste and simple
monument with or without figures'.[1] A
committee was formed to consider the design
and location of the memorial, and to organise
the raising of funds.[2] After considering a
number of sites, the junction at Manor Road
was selected.[3] The memorial was designed by
Arthur Beresford Pite, the London architect
whose own commercial practice was limited by
his duties as Professor of Architecture at the
Royal College of Art.[4] It took the form of a
stone cross in the tradition of an early English
cross, although the decoration was more
elaborate.[5] It was described as 'ornate, though
not profusely so'.[6] The memorial included two
bronze figures of a soldier and sailor, the work
of the London sculptor, Benjamin Clemens.
F.M. and H. Nuttall of Whitefield were
responsible for the stonework. The memorial
cost about £1,300. After some delays, the
memorial was erected and unveiled with the
usual ceremonies in May 1921.[7] The original
inscription read:

ERECTED BY THE INHABITANTS OF CHEADLE
HULME TO THE EVER GLORIOUS MEMORY OF
THE NOBLE MEN WHO FELL IN THE GREAT
WAR FOR GOD, KING AND COUNTRY, 1914–18.
HE WILL SWALLOW UP DEATH IN VICTORY
AND THE LORD WILL WIPE AWAY TEARS FROM
OFF ALL FACES. MAKE THEM TO BE NUMBERED
WITH THE SAINTS IN GLORY EVERLASTING.

This was changed to allow for the introduction
of new panels to record the dead of the Second
World War. The extract from Binyon's famous
poem, however, was not altered. The memorial
has remained on the Manor Road site, although,
on a number of occasions, the local British
Legion has campaigned to remove it to a quieter
location.[8]

Pite, *Cheadle Hulme War Memorial*

Notes
[1] *Stockport Advertiser*, 14 February 1919. [2] *Ibid.*,
7 March 1919. [3] *Ibid.*, 18 July 1919. [4] A. Service,
'Arthur Beresford Pite' in A. Service (ed.), *Edwardian
Architecture and its Origins* (London: Architectural
Press, 1975) p.399. [5] *Stockport Advertiser*, 27 May
1921. [6] *Ibid.*, 11 June 1919. [7] M. Garratt, *Cheadle
Hulme* (Wilmslow: Sigma Leisure, 1998) pp.54–5;
Stockport Advertiser, 3 June 1921. [8] *Stockport
Advertiser*, 27 November 1969, 15 August 1974, 7
November 1974.

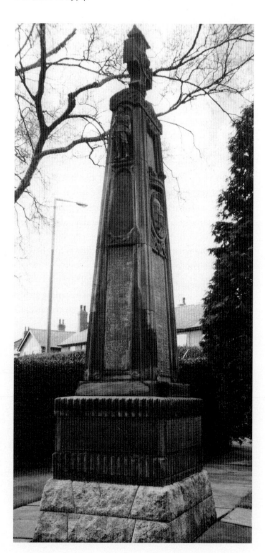

HEATON MOOR

Heaton Moor Road

Heaton Moor War Memorial

John Cassidy

30 January 1921
Bronze statue; Portland stone pedestal; ashlar
wall
Statue 1.83m high; pedestal 1.87m high × 99cm
square base
Inscription on front of pedestal: IN MEMORY OF
/ THE MEN OF / HEATON CHAPEL / AND /
HEATON MOOR / WHO GAVE THEIR LIVES / IN
/ THE GREAT WAR / 1914–1919 – rear: THEIR /
NAME / LIVETH / FOR / EVERMORE
Status: Grade II
Condition: poor
Owned by: Stockport Metropolitan Borough
Council
Description: War memorial; life-size bronze
statue of an ordinary soldier holding his rifle. It
surmounts a substantial square stone pedestal,
on which are the principal inscriptions and
bronze panels recording the names of the dead.
The original bronze panels included a depiction
of soldiers in the trenches. One of these panels
has been stolen and replaced with an inferior
plain panel. A panel naming the dead of the
Second World War has been added to the
pedestal.

This memorial was erected to commemorate
those servicemen from Heaton Moor and
Heaton Chapel killed in the First World War.
The initial public meetings and correspondence
in the press centred on whether the community
should erect a conventional memorial or
provide a more utilitarian one in the form of a
gymnasium.[1] A public meeting decided in
favour of a memorial. The Manchester sculptor,
John Cassidy, was approached for a design and
proposed two: a bronze memorial of a soldier
and one of an angel on a stone pedestal. The

former was chosen, Cassidy agreeing not to use
the same model for any other memorial within
a 50-kilometre radius.[2] The estimated cost was
£1,800–£2,000. The site chosen was in front of
St Paul's church, Heaton Moor Road, on land
obtained from the church.[3] James Henry Sellers
was responsible for the laying out of this space.
A semicircular ashlar wall was built, but the
available funds did not allow for the provision
of stone seating.

The completed memorial was unveiled in
January 1921. Cassidy was congratulated for
producing a statue which 'suggested great
ideals: it suggested something of the infinite; it
suggested heroic endurance and sustained
fortitude and triumph in the face of
overwhelming odds'.[4] In accepting the
memorial on behalf of the people of Stockport,
the mayor, Charles Royle, took pleasure in the
fact that it was a universal memorial, subscribed
to by 'all classes and all creeds, without
distinction'.[5]

After the Second World War a panel naming
the fallen of that conflict was added to the
pedestal. The memorial has suffered from
vandalism over the years and one of the original
bronze panels is now missing. Concern over the
condition of the memorial has prompted
questions about who was responsible for its
maintenance.[6] Repairs to the wall were
necessary in 2000 following a road accident.

Notes
[1] *Stockport Advertiser*, 21 February 1919, 28
February 1919, 7 March 1919. [2] *Ibid.*, 18 April 1919.
[3] E.M. Openshaw, *The Story of St Paul's Church
Heaton Moor 1877–1976* (Manchester; [1976]).
[4] *Stockport Advertiser*, 4 February 1921. [5] *Ibid.*, 4
February 1921; *Stockport Express*, 10 February 1921.
[6] *Stockport Advertiser*, 20 February 1958, 13 August
1958.

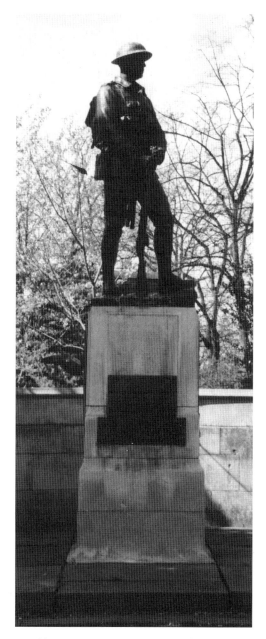

Cassidy, *Heaton Moor War Memorial*

MARPLE

Memorial Park

Marple War Memorial

Sculptor: unidentified

22 July 1923
Stone statue; polished granite pedestal
Statue 1.22m high approx; pedestal 2.1m high ×
1.01m square base
Inscription on front of pedestal: WAR /
MEMORIAL / PARK / THIS LAND WAS GIVEN /
BY THE CARVER & BARLOW / FAMILIES OF THIS
PARISH / IN MEMORY OF THE MEN / OF
MARPLE WHO FELL / IN THE GREAT WAR /
1914–1918 / AND THE LAYING OUT / WAS
DONE BY PUBLIC / SUBSCRIPTION
Status: not listed
Condition: good
Owned by: Stockport Metropolitan Borough
Council
Description: War memorial; stone statue of a
female figure holding a cross to her breast,
surmounting a polished granite pedestal.
Inscriptions on the pedestal include the names
of the servicemen killed in the First World War.
It stands in a central position in the memorial
park.

Public meetings to discuss the form of a war
memorial for Marple took place in the winter of
1918–19. Two schemes were the focus of
detailed consideration: the creation of a
memorial park in the centre of Marple and the
establishment of scholarships for local children,
especially those whose fathers had fought in the
war. It was the scheme for the park which
found the widest support. The land for the park
was part of the Hollins estate. Initially, Ernest
Bagshaw and Frank Barlow both agreed to
purchase 1½ hectares each of the land to create
the new park.[1] The council estimated that
£1,500 would be needed to lay out the park,
plus a further endowment fund of £3,000 'so

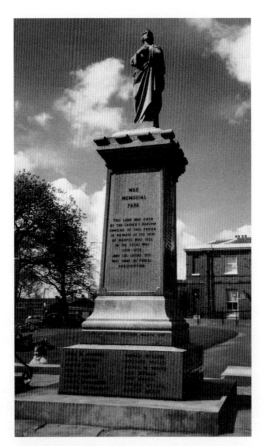

Marple War Memorial

that there would be no call on the rates'.[2] It was
agreed that a more formal memorial would also
be erected in the park. As the scheme
progressed, the land was given by the Barlow
and Carver families. The design for a memorial,
a female figure surmounting a granite pedestal,
was approved by the council in May 1921.[3] The
memorial was dedicated and the park opened in
July 1922, in a ceremony which included a
historical pageant.[4] Mrs Barlow laid the first
wreath.[5] The names of the servicemen killed in
the Second World War are inscribed on stones
placed on either side of the memorial.[6]

Notes
[1] *Stockport Advertiser*, 7 February 1919, 18 April
1919. [2] *Ibid.*, 6 June 1919. [3] Marple Urban District
Council Minutes, 2 May 1921. [4] *Marple 1220–1918.
For Remembrance* (Marple [1922]); G. A. Swindells,
A History of Marple (Marple Antiquarian Society,
1974). [5] *Manchester Guardian*, 24 July 1922; *North
Cheshire Herald*, 28 July 1922. [6] P. Clarke, A. Cook
and J. Bintliff, *Remembered. Marple Men Who Fell in
the Great War* (Marple, 1999).

REDDISH

Houldsworth Square

Houldsworth Clock and Fountain

J. and H. Patteson

11 September 1920
Granite; Stancliffe stone; bronze medallion
4.56m high approx × 1.12m × 1.1m
Inscription on front of base: DEDICATED / TO
THE MEMORY OF / SIR WILLIAM HENRY
HOULDSWORTH / BARONET / BY THE PEOPLE
OF REDDISH / IN GRATEFUL REMEMBRANCE /
OF THE BOUNTIFUL GIFTS WHEREBY / HE
ENRICHED AND ADORNED THEIR VILLAGE /
AND MANIFESTED HIS CONCERN FOR THEIR /
SPIRITUAL MENTAL AND PHYSICAL WELFARE.
Status: Grade II
Condition: fair
Owned by: Stockport Metropolitan Borough
Council
Description: A memorial stone clock and
fountain, taking the form of a four-sided clock
with a gable top and foliated finial rising from a
slender shaft of four red granite columns with
carved capitals. The base included a drinking
fountain, and ground-level water troughs for
dogs and other animals (both removed). A
bronze portrait roundel of Houldsworth and
inscription are on the pedestal.

Sir William Henry Houldsworth, born in 1834,
was the fourth son of the cotton spinner, Henry
Houldsworth. He was educated privately and at

St Andrews University and then joined the family firm. In 1865, towards the end of the Cotton Famine, the firm relocated from central Manchester to a purpose-built mill at Reddish, at that time a model of design and employment practices. Integral to the relocation plan was the building of a factory community, which included a school, working-men's club, recreation ground and church: institutions which allowed Houldsworth to structure the lives of his employees.[1] The employment of Alfred Waterhouse as architect for St Elisabeth's Church was an indication that this was not a community without an aesthetic.[2] In the following years two more mills were built, confirming Houldsworth as the district's largest employer.[3] In later years he became a key figure in establishing and operating the Fine Cotton Spinners' and Doublers' Association Ltd. Houldsworth stood unsuccessfully as a Conservative candidate for parliament in 1880, but was elected three years later. His efforts in the Tory cause were rewarded by Lord Salisbury with a baronetcy in 1887. As an MP he was an active supporter of free trade (until 1903 when he declared in favour of tariff reform), bimetallism, and amalgamation within the cotton industry; all subjects close to his and his constituents' interests. Houldsworth was also active in public affairs in Manchester, including supporting Owens College. He was presented with the Freedom of the City of Manchester in 1905. In the following year he retired to Scotland, where he died in April 1917.[4]

Plans to raise a memorial to Houldsworth in Reddish moved forward after the end of the First World War. A committee was established and by February 1919 it had collected subscriptions totalling £707. These included £50 from the managers of Houldsworth Schools, £90 from Houldsworth Working Men's Club and £20 from the Reddish Conservative Club. The largest donation was £250 from the Fine Cotton Spinners' Association.[5] The exact form of the memorial remained undecided, while the location, Houldsworth Square in the centre of Reddish, had already been agreed upon. Further discussions led to the decision to erect a clock tower and fountain. The monument, based on a similar one in Douglas, Isle of Man, was designed and erected by J. and H. Patteson of Manchester. It was unveiled by Colonel D. Phillips-Brocklehurst, Director of the Fine Spinners' Association, in September 1920.[6]

The monument immediately became a landmark, although over the years the electric clocks did not always show the same time. In 1986 the memorial was moved to the centre of a raised brick-paved area with seating, part of a community programme scheme to redesign Houldsworth Square.[7] The original water troughs at the base have not survived.

Notes
[1] R.N. Holden, *Stott and Sons. Architects of the Lancashire Cotton Mill* (Lancaster: Carnegie, 1998) pp.140–1. [2] C. Cunningham and P. Waterhouse, *Alfred Waterhouse, 1830–1905. Biography of a Practice* (Oxford: Clarendon Press, 1992) p.258. [3] M. Williams and D. Farnie, *Cotton Mills in Greater Manchester* (Preston: Carnegie, 1992) pp.178–9. [41] A.C. Howe, 'Sir William Henry Houldsworth', *Dictionary of Business Biography*, Vol.4, pp.359–66. [5] *Stockport Advertiser*, 14 February 1919. [6] *Ibid.*, 17 September 1920; *Manchester City News*, 18 September 1920. [7] *Stockport Advertiser*, 26 September 1986, 12 September 1990.

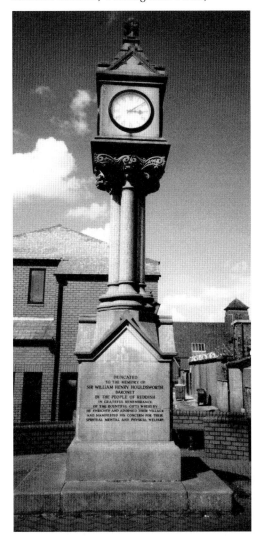

Patteson, *Houldsworth Clock*

STOCKPORT

Merseyway Precinct

Deanery Way

Wall Relief, British Home Stores
Henry and Joyce Collins

1978
Concrete; mosaic tiles
Panels range in size from 3.35m high × 5.1m long to 2.52m high × 3.56m long
Signed: Henry and Joyce Collins 1978.
Status: not listed
Condition: good
Owned by: British Home Stores
Description: Concrete mural made up of five rectangular panels mounted on the side of a department store. Four panels depict in relief individuals, buildings and artefacts associated with the history of Stockport; the final panel depicts goods sold in the department store.

A mural was commissioned in 1977 by British Home Stores as part of their new town-centre store designed by the Leeds architects, Braithwaite and Jackman. The design left the exterior wall of the store in Deanery Way, connecting the Merseyway Precinct to Princes Street, without windows.

Instead of leaving the wall blank, it was decided that it should 'present something of local interest and at an acceptable scale to this pedestrian link'.[1] The result was that Henry and Joyce Collins were commissioned to produce a mural. Following research into the history of the town, they developed a design which focused on individuals associated, some more directly than others, with the history of the town.[2] The finished work comprised five panels, four of which contained representations of local worthies. The figures are shown in the costume of their period, some of the clothes being decorated with mosaic tiles. Except for the figures in the fourth panel, the individuals represented are identified by a single date, not by name. Beginning at the Princes Street end, the figures in the first panel are Sir Robert de Stokeport (dated 1239) and Edward, Earl of Chester (dated 1260). The two figures in the next panel are Richard de Vernon, Rector (dated 1334) and Sir Edmond Shaa, founder of the Grammar School (dated 1487). The third panel contains representations of Colonel Robert Duckenfield (dated 1642) and the silk manufacturer, Thomas Lombe (dated 1732). The figures in the fourth panel are the Woodbank farmer and tax protestor, Jonathan Thatcher, the political radical, Samuel Bamford, and the free trader and local MP, Richard Cobden. The final panel depicts various clothes, toys and other goods sold in the store. The town's railway viaduct provides a unifying motif in the different panels. Artefacts of local interest including coins, trade tokens and heraldic symbols are also incorporated into the design.[3] The panels were manufactured by Hutton (Builders) Ltd of Colchester.

Notes
[1] Correspondence with Braithwaite and Jackman, 25 May 1999. [2] Letter from Henry Collins to Braithwaite and Jackman, 16 May 1977. [3] Newspaper article dated December 1978 in Stockport Local Studies cuttings file.

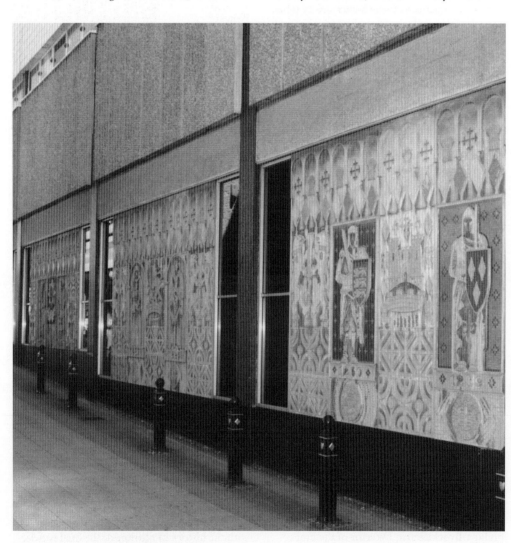

Henry and Joyce Collins, *Wall Relief*

St Peter's Square

Richard Cobden

George Gamon Adams

27 November 1886
Bronze statue; granite pedestal
Statue 2.44m high; pedestal 2.65m × 1.31m
 square
Signed: G. G. Adams. Sc. London; foundry H.

Young & Co. Art Founders. Pimlico. S.W.
Inscription on front of pedestal: COBDEN
Status: Grade II
Condition: good
Owned by: Stockport Metropolitan Borough
 Council

Description: Portrait statue; larger than life-size bronze statue of Richard Cobden surmounting a grey granite pedestal inscribed with the single word, 'Cobden'. Cobden is shown in the act of public speaking, a scroll is held in the left hand whilst the right one is held forward. By his right leg is a pedestal on which are carved various fruits and corn. Above them is the date 1846, the year of the repeal of the Corn Laws. Above the date is a French eagle, an allusion to Cobden's contribution in negotiating the Commercial Treaty of 1860 between Britain and France.

Biography: see p.125

The idea of erecting a memorial to Cobden in Stockport followed almost immediately after his death in April 1865. Cobden had a long connection with the town. He had first stood for election as the borough's MP on a free trade platform in 1837 but was unsuccessful. He was returned in 1841 and it was as Stockport's MP that he spoke in parliament during the major debates which saw the eventual abolition of the Corn Laws. In the general election of 1847 he was re-elected with an overwhelming majority, but at the same time he was also elected as the member for the West Riding of Yorkshire. He decided, apparently because the Yorkshire constituency was the larger one, to give up Stockport.[1] A public meeting, at which the speakers included J.B. Smith, MP for Stockport and the first Chairman of the Anti-Corn Law League, recalled these connections with the town, agreeing that it was 'peculiarly fitting' to raise a memorial statue to their former MP.[2] Over £800 was pledged at the meeting, representing half of the £1,500 that Major Coppock stated would be the sum required to commission a statue from a first-rate sculptor.

John Benjamin Smith and Sir Edward Watkin subscribed £100 each.[3] A workplace collection was proposed in order that working men could contribute towards the statue. Initial suggestions about possible sites included placing it outside the town hall that the council was proposing to build. Other subscribers argued that the site of the ill-fated observatory in Vernon Park would provide a more suitable location.[4] But for some 'unaccountable reason', possibly divisions within the committee, the Stockport statue, unlike the ones in Manchester and Salford, did not proceed at that time.[5] The money continued to be held by the Cobden Memorial Committee, but there appeared to be no urgency to use it for the purpose for which it was collected.

It was not until 1884 that the scheme was revived by the surviving members of the committee.[6] In the intervening years two further statues of Cobden had been unveiled in London and Bradford.[7] That the revival was occurring at a time when the principles of free trade were being publicly debated was not lost on some observers, including local Conservatives for whom free trade had become an 'obsolete and distasteful' doctrine.[8] A bronze Cobden would stand as a powerful and eloquent symbol of the gospel of free trade. Attending to the necessary practical side of the scheme, the memorial committee set about collecting those subscriptions that had been promised but not paid some 20 years before, as well as making an appeal for new funds.[9] They also sought the public's views on possible sites before finally deciding that the statue would stand in St Peter's Square.[10] The commission for the statue was given to the London sculptor, George Adams.[11] John Bright was among those who visited Adams' studio to view the work in progress.[12]

The unveiling ceremony in November 1886 was used by the region's free traders to stage an impressive demonstration. Liberal supporters processed through the town wearing ears of corn in their buttonholes and carrying free

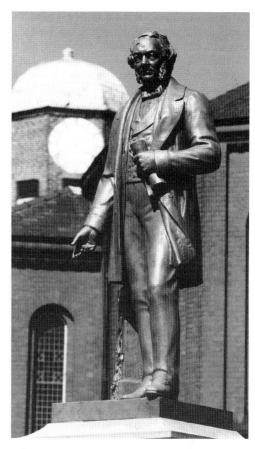

Adams, *Richard Cobden*

trade banners. Liberal MPs and other prominent party members appeared on the platform, though a notable absentee was John Bright. The partisan character of the event was underlined by the tactical absence of Stockport's Conservative MP, Louis Jennings.[13] Jane Cobden unveiled the statue of her father. The ceremony, however, nearly turned into a disaster because of the large numbers – the crowd was described as being 'packed almost to suffocation' – attempting to find a vantage point in the small square.[14] In the crush, the reporters' table and chairs were wrecked. Presumably,

only a small section of the crowd managed to hear the speech made by the Marquess of Ripon – he spoke by climbing on to a table – in which he reminded people of the inviolable truth that was free trade. Similar sentiments were expressed at a dinner organised for the principal guests in the Pendlebury Memorial Hall. The spectre of tariff reform may have been seen even in the Manchester Chamber of Commerce, but as a leading article on the unveiling in *The Times* observed, 'with the world as it is, his statue is that of a standard bearer. Until Protection be in its grave, Cobden survives to combat it.'[15]

Cobden was to be Stockport's only major portrait statue. During the twentieth century it appears to have been newsworthy only when schemes were proposed that involved removing it to other locations. Thus, when in 1919 St Peter's Square was discussed as a possible site for the town's war memorial, the idea of Cobden being moved found approval in some quarters.[16] One tariff reformer suggested that the statue might be presented to the Reform Club, where it could serve as a 'shrine to all those free trade fossils who still cling to prehistoric theories'.[17] Occasionally, Stockport's Liberals revealed a proprietorial concern over the possible fate of the town's most distinguished Liberal.[18] Plans to modernise the town centre in the 1960s did result in the statue being moved, but only to a new position in the square, a site that has became a pedestrian refuge from the traffic in the square.

Notes
[1] See above, p.125. [2] *Manchester Guardian*, 26 April 1865; *Stockport Advertiser*, 28 April 1865. [3] Memorial fund subscription lists in *Stockport Advertiser*. [4] Correspondence in *ibid.*, 5 May 1865. [5] *Manchester Courier*, 29 November 1886. [6] *The Times*, 12 December 1884. [7] *Ibid.*, 13 June 1868, 2 October 1872. [8] *Stockport Advertiser*, 3 December 1886; *Manchester Courier*, 29 November 1886. [9] *Stockport Advertiser*, 12 December 1884. [10] *Stockport Echo*, 21 February 1885. [11] Gunnis (1968) p.14 gives 1862 as the date for the statue.

[12] *The Diaries of John Bright* (London: Cassell, 1930) p.538. [13] *Stockport Advertiser*, 19 November 1886, 26 November 1886; *The Times*, 29 November 1886. [14] H. Heginbotham, *Stockport Ancient and Modern* (London: S. Low, Marston, Searle & Rivington, 1877) p.309. [15] *The Times*, 29 November 1886. [16] Stockport War Memorial Fund Minutes, 7, 21 and 24 July 1924 (B/AA/4/1). [17] *Stockport Advertiser*, 28 March 1919. [18] *Stockport County Express*, 27 May 1965.

Wellington Road

Stockport Art Gallery, junction of Wellington Road South and Greek Street

Stockport War Memorial
Architect: James Theodore Halliday
Sculptor: Gilbert Ledward

15 October 1925
Marble
Statue 2.44m high; pedestal 1.09m high
Signed: G. LEDWARD. SCULPTOR 1923–1925
Status: Grade II
Condition: good
Owned by: Stockport Metropolitan Borough
 Council
Description: War memorial; a white marble life-size figure of Britannia surmounting marble pedestal located in the Hall of Memory. Britannia, draped with a flag, holds the sword of honour in her raised right hand and the laurel wreath of victory in her left. On the strap around the hilt of the sword are carved the words 'Freedom and Honour'. At her feet is the kneeling figure of a young man, symbolising the men who died in the war. Victory is also expressed by a serpent crushed beneath the shield on which the young man is kneeling. The sacrifice of the men is further signified by a broken sword.

A 'representative meeting of ladies and gentlemen' called by the mayor first discussed the idea of providing a war memorial for Stockport in February 1919.[1] The establishment

of a museum, a recreation ground, and the planting of an avenue of trees (one for each soldier killed) along one of the main roads were among the schemes put forward. The idea of building an art gallery, on the site of the town's old grammar school, inside of which would be a memorial, was also proposed.[2] It was this latter scheme which was taken up. A preliminary report by the Manchester architect, Theodore Halliday, emphasised the importance of the elevated site, at the junction of Greek Street and Wellington Road. It offered the opportunity to provide an important building that would, given the presence of the nearby town hall and infirmary, reinforce the area as the civic centre of Stockport. Halliday suggested a 'building of small dimensions designed in a severe and monumental style, built of Portland stone'.[3] He also envisaged a sculptural memorial standing in front of the building. A further public meeting in September 1919 resolved that the town's memorial should combine a commemorative sculpture, a memorial hall and an exhibition gallery. A determining factor in the project was the donation of the site on the corner of Greek Street by the trustees of the estate of Samuel Kay. The conditions of the donation were that the building should house an art gallery, rooms for technical and higher education, and space for exhibitions of science, art and technology. It was also to provide a site, if required, for the extension of the Municipal Technical School. Initial estimates put the cost of building work at around £30,000, but this was revised to £22,000 by 1923.[4] Post-war depression, fluctuating prices in the building industry and the high cost of the project meant that, despite some substantial initial donations from local businesses and individuals, sufficient funds were not immediately forthcoming. The decision was taken to erect a temporary memorial until more permanent arrangements could be made. This memorial was unveiled on 31 July 1921, the anniversary of the opening of the third battle of Ypres in 1917.[5] On that day, the locally recruited 6th Battalion Cheshire

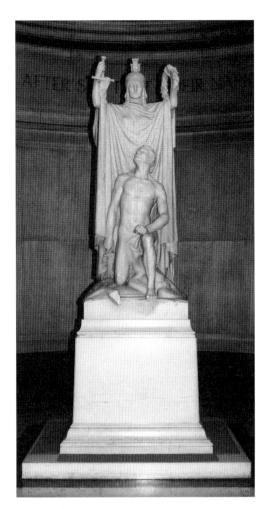

Ledward, *Stockport War Memorial*

designs for the memorial which would be the focal point of the interior of Halliday's building. It was a memorial that, in the words of Charles Royle, 'should be something of an emblematic nature, always having for its purpose the uplifting of everyone who saw it and indicative of the great sacrifice of the men to whose memory it was erected'. Ledward's design was selected by a committee which had sought the advice of Francis Dodd.[7] It was, according to Royle, 'head and shoulders above anything else shown to them'. It depicted two figures: a life-size Britannia standing over the figure of a young man, symbolising the sacrifice and devotion of those who had fought and died for their country. A cast of the statue exhibited at the Royal Academy had received 'many fine comments'.[8] The foundation stone of what was already being recognised as one of the town's most important public buildings was laid on 15 September 1923 by Royle, who told the crowd that their purpose was not to 'glorify war or warlike things', but to 'glorify the idea of sacrifice'.[9]

The building was inaugurated on 15 October 1925 by Prince Henry, George V's son.[10] The Prince declared himself 'particularly impressed by the architectural beauty with which the memorial itself has been designed and carried out'. Ledward also pronounced himself satisfied with the way the project had been completed, reserving particular praise for the architect's work in the Hall of Memory, where the lighting through the stained glass dome, and the use of different coloured marbles made it 'the most beautiful and dignified memorial I have seen'.[11] Some further work on the building was required before it was finally transferred to the Corporation. The final cost of the project was £24,000, of which some £2,100 was for the sculpture.[12]

Stockport War Memorial remains one of the most impressive of the region's First World War memorials. The main building is in Portland stone and is entered up a broad sweep of steps through a portico of four Corinthian columns. The focal point of the interior is the Hall of Memory. The hall rises to the full height of the building and is lit through a stained-glass roof dome. The walls and floor are of different marbles.[13] Marble tablets on the walls record the names of some 2,000 servicemen killed in the war. Above the tablets were carved the inscriptions: 'Their name liveth for evermore', 'They died for freedom and honour', and 'Let those who come after see that their names are not forgotten'. Further marble tablets have been added to commemorate the dead of the Second World War and later conflicts. Ledward's sculpture occupies the centre of this dramatic space. A maquette, on display in the Hall of Memory, shows that Ledward had originally conceived Britannia holding a feathered quill rather than a wreath in her left hand.[14]

Notes

[1] *Stockport Advertiser*, 28 February 1919. [2] *Ibid.*, 13 and 21 March 1919. [3] Stockport War Memorial Fund Minutes, 10 June 1919; *Stockport Advertiser*, 13 June 1919. [4] War Memorial Fund Appeal leaflet [December, 1919] (B/AA/4/2). [5] The temporary memorial was designed by Halliday and cost £135, *Stockport Express*, 4 August 1921; *Stockport Advertiser*, 3 August 1923. [6] Stockport War Memorial Fund Minutes, 1 July 1921. [7] *Stockport Advertiser*, 17 May 1923. [8] *Ibid.*, 21 September 1923. [9] *The Times*, 16 October 1925. [10] *Stockport Advertiser*, 16 October 1925; *Manchester Guardian*, 16 October 1925. [11] *Stockport Advertiser*, 22 October 1925. [12] Stockport War Memorial Fund Accounts, June 1926; *Stockport Advertiser*, 4 June 1926; D. Boorman, *At The Going Down of the Sun. British First World War Memorials* (York: Ebor Press, 1988) p.119. [13] The marble was the work of H.T. Jenkins and Son of Torquay. [14] The maquette (slightly damaged) was presented by Ledward to Charles Royle.

Regiment had mounted an attack on the ruined village of St Julien. Although their objectives were initially secured, it was at the cost of nearly 500 soldiers, an encounter remembered in Stockport as 'the sacrifice of St. Julien'.[6]

The call for subscriptions was renewed as economic conditions improved. 'A number of very eminent sculptors' – Reid Dick, Gilbert Ledward, Frederick Wilcoxson, John Cassidy and James Millard – were invited to submit

Stockport Town Hall

Sir Joseph Leigh
Sculptor: unidentified

Marble bust
68cm high; marble pedestal 23cm square
Inscription on plinth: SIR JOSEPH LEIGH KNIGHT
/ 1841–1908
Description: Marble bust on pedestal with
turned column, located in main entrance area at
the foot of the marble staircase.

Sir Joseph Leigh was born in Stockport in 1841,
the son of a cotton manufacturer. He was
educated at Stockport Grammar School and
assumed control of the family business on the
death of his father. His local business interests
diversified and he later became a director of the
Manchester Ship Canal. In 1875 he was elected
as a Liberal councillor for Portwood and went
on to become the leader of the town's Liberals,
serving as mayor on four occasions. He was
elected MP for the borough twice, between
1892 and 1895, and 1900 to 1905. He was
instrumental in the foundation of Stockport
Technical School (1897) to which he
contributed £3,500. Leigh was made a Freeman
of the borough in 1888 and knighted in 1894.
He died in 1908.[1] The bust, which is not signed,
appears to have been presented to the council
after Leigh's death.

Note
[1] *Manchester Guardian*, 23 September 1908;
Stockport Advertiser, 25 September 1908.

Walter Cumston Knight
John Blakeley

Bronze bust
55cm high
Inscription on plinth: WALTER CUMSTON
KNIGHT J. P. / 1914–1976 / Member of
Stockport County Borough Council
1945–1957 & 1958–1974 / Mayor of
Stockport 1968–1969 / Member and Leader
of Stockport Metropolitan Borough Council
1974–1976 / Sculptor John Blakeley
Description: Bronze bust of Walter Cumston
Knight, who is wearing a rosette in his lapel.
The bust surmounts a square marble plinth on
which is the inscription.

The bust was in preparation shortly before
Walter Knight's death. He was one of the most
influential local politicians in post-war
Stockport. It was the work of the local sculptor,
John Blakeley, who was also a friend of
Knight's. It was privately funded.[1] It is not
signed. Mrs Knight described the tribute to her
husband as 'beautiful'. Blakeley was an
internationally known sculptor with works in
nine countries including a memorial at
Ravensbruck concentration camp. He was also
responsible for the work entitled *Young Christ
in the Temple* at St Mary's Church, Stockport.

Note
[1] *Stockport Express*, 14 August 1977; *Stockport
Messenger*, 18 September 1981.

TAMESIDE

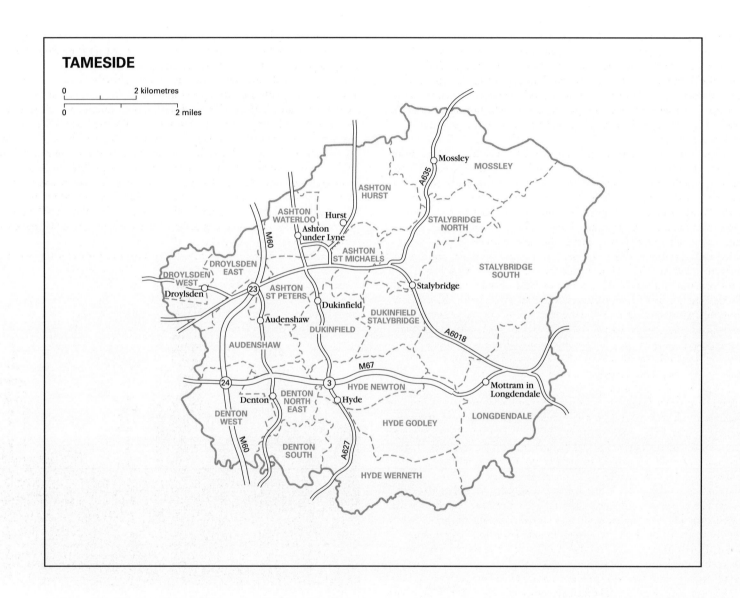

TAMESIDE

0 2 kilometres

0 2 miles

Mossley

MOSSLEY

ASHTON
HURST

ASHTON
WATERLOO

Hurst

STALYBRIDGE
NORTH

Ashton
under Lyne

ASHTON
ST MICHAELS

STALYBRIDGE
SOUTH

DROYLSDEN
EAST

DROYLSDEN
WEST

Stalybridge

23

ASHTON
ST PETERS

Droylsden

Dukinfield

DUKINFIELD
STALYBRIDGE

Audenshaw

DUKINFIELD

AUDENSHAW

A6018

M67

24

3

HYDE NEWTON

Mottram in
Longdendale

Denton

DENTON
NORTH
EAST

Hyde

LONGDENDALE

DENTON
WEST

HYDE GODLEY

DENTON
SOUTH

HYDE WERNETH

Introduction

The Metropolitan Borough of Tameside was created in the local government reorganisation of 1974 from nine separate districts: Ashton-under-Lyne, Denton, Audenshaw, Droylsden, Stalybridge, Hyde, Dukinfield, Mossley (part of south-east Lancashire) and Longdendale (part of north-east Cheshire). The authority's name was taken from the principal river which flows through the district. The borough lies to the east of Manchester and covers an area of 10,314 hectares. Its population in 2001 was 213,045.

Before the industrial revolution this part of Lancashire and Cheshire consisted of scattered rural settlements, with the economy given over to farming and the domestic production of textiles. Ashton-under-Lyne was one of the earliest communities to develop: a market charter was granted in the Middle Ages, whilst the parish church of St Michael and All Angels dates from the thirteenth century. Most of the surrounding communities remained small until the latter part of the eighteenth century. Factory-based cotton spinning was at the heart of the changes which transformed Ashton, Stalybridge and Hyde into important textile towns. It was a transformation impossible to ignore, intruding even into the pages of the district's first history; James Butterworth's attention being drawn away from the past to comment on the present, where 'very large cotton mills are erected, and others in a state of great forwardness, with numerous warehouses, cottages, shops'.[1] Cotton was not the only industry to develop. In Dukinfield and Hyde the presence of coal resulted in the sinking of some of the deepest pits in the country.

Denton's industrial history followed a different trajectory, as the town became one of the leading centres for the manufacturing of hats. But, for the nineteenth century and for the first half of the twentieth century, it was cotton that was central to the district's fortunes: in 1851 some 90 per cent of workers in Stalybridge and 80 per cent in Ashton-under-Lyne depended directly on cotton.[2] In these communities, single large employers – Thomas Ashton in Hyde, Hugh Mason in Ashton, Robert Platt in Stalybridge, John Whittaker in Hurst, John Mayall in Mossley – exerted an enormous influence, although in Ashton and Stalybridge the paternalism of older landed families persisted. Conditions varied greatly between and within these raw towns. Engels dismissed Stalybridge as 'a disgustingly filthy town'.[3] Yet when Coningsby, the eponymous hero of Disraeli's novel, came to Manchester to see the new industrial society at first hand, it was to Stalybridge that he was advised to go.[4]

The granting of municipal borough status – to Ashton in 1847, Hyde in 1881 and Dukinfield in 1899 – was a measure of the growth of these communities. In the Victorian period they began to acquire the public services associated with the control of the urban world. Public buildings were also erected, but most were architecturally unimpressive. Architectural sculpture was limited: the six suitably fierce stone lions mounted over Ashton-under-Lyne's mid-Victorian market hall being something of an exception.[5] The district's public monuments and statues were also suitably unpretentious. The oldest and most visible of local monuments was Hartshead Pike, a stone tower from which views of four counties could be enjoyed, weather and smoke permitting. Considered to be the site of an older if not ancient monument, the present tower dates from the years of the Cotton Famine. The district also had its ancient crosses, a number of which were to be restored or reinvented by the Victorians. Mottram in Longdendale boasted a Crown Pole, a tall wooden pole and weather vane generally believed to have been erected to mark the coronation of George III.[6]

It was the death of Sir Robert Peel which led to a project for providing

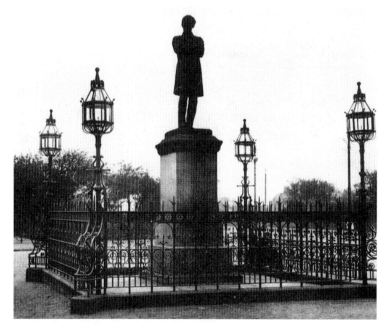

Swynnerton, *Hugh Mason, in Chester Square*

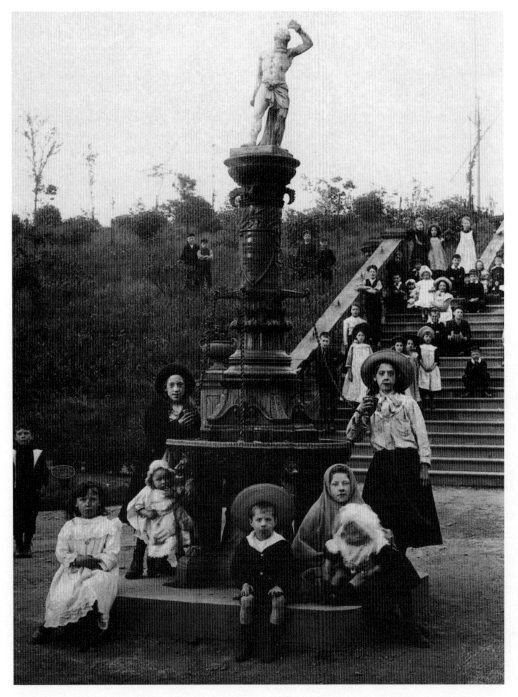

what would have been the district's first modern public monument. However, unlike in Manchester, Salford, Preston and Bury, the response in Ashton-under-Lyne was insufficient to raise a statue.[7] In fact the only public portrait statue to be erected in the nineteenth century was to Hugh Mason. Joseph Swynnerton's stiff and uninspiring representation of Mason was politely welcomed as a 'capital likeness'.[8] Stamford Park, opened in July 1873, was the district's principal public park, and it was to become the location for a number of more prosaic public monuments.[9] Significantly, these honoured working men rather than members of the local élite. The granite obelisk memorialising Joseph Rayner Stephens was a tribute to a political radical, but one who, by the 1880s, could be presented as an individual who had championed factory reform. However, the motives of those who supported such schemes, as, for example, the cotton trade unionists on the platform at the unveiling of the Stephens memorial, or the Orangemen prominent at the inauguration of the Earnshaw memorial in Mottram, were anything but simple. More modest memorials were raised to other working-class individuals: a simple obelisk in St Mary's churchyard, Droylsden honoured the local bard, James Burgess, whilst Samuel Laycock, Stalybridge's best-known dialect poet, was to be remembered by a bronze tablet in the Mechanics' Institute where he had been librarian.[10]

Nonetheless, such memorials were hardly numerous and provide some support for the view that such 'work-a-day, practical' towns were little concerned with spending money on ornament.[11] There was also a preference for the practical tribute. The public work of the Stalybridge textile manufacturer, Robert Platt, was recognised by installing a fountain in front of the market hall, the busiest of the town's public spaces.[12] A drinking fountain in Stamford Park commemorated the botanist,

Samson Fountain, Dukinfield Park, c.1910

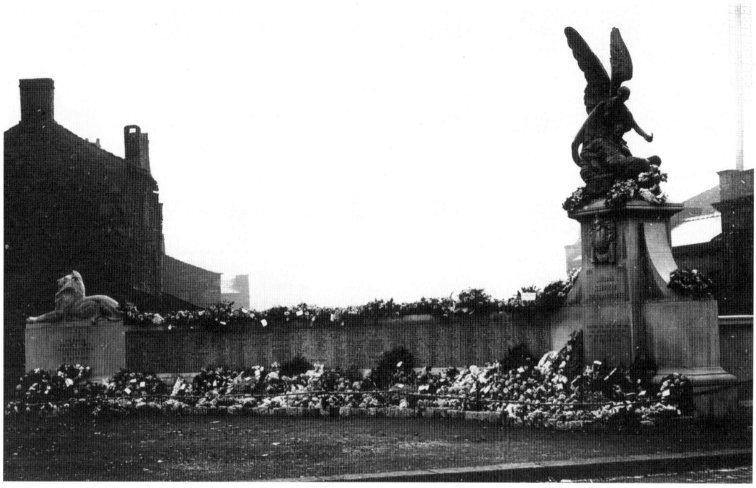

Blundstone, *Stalybridge War Memorial, unveiling, 1921*

William Hannam.[13] Over the years such fountains have suffered from a lack of maintenance. An exception to this general neglect, however, is the wall fountain installed to mark the arrival of a new public water supply in Mottram.[14]

Memorial committees with limited funds tended not to look outside the district when commissioning monuments. John Eaton, who had established his architectural practice in Ashton-under-Lyne in 1839, and whose family firm was to be responsible for many of the district's public buildings, also designed a number of its monuments. Other monuments were the work of local stonemasons. Such financial restraints did not restrict the wealthier cotton families: the family memorial to John and Hannah Whittaker at Hurst was commissioned from John Henry Foley.

It uplifted Pevsner's spirits as he worked his way across a district that he found, in general, architecturally drab.[15] In 1999 this important work was seriously damaged by fire.

As in the other districts covered in this study, it was the years immediately following the First World War that proved to be the most important ones for public sculpture and monuments. Memorials had begun to be raised even during the war by local communities, such as the one unveiled in Newton Wood, Dukinfield, in 1917.[16] However, suggestions for larger town memorials, for example a proposal for a

memorial chapel in Ashton-under-Lyne in 1916, were regarded as inopportune.[17] The major town memorials awaited the ending of the war. There was an awareness of the hazards of commissioning memorials that were trite: ones that in the words of the *Ashton Reporter*, 'arrested the attention for a fleeting moment and then in the lapse of time becomes an eyesore'.[18] The memorials in Stalybridge and Ashton certainly avoided such pitfalls although the individual histories of these commissions emphasise the differences between towns which appear to share many common features. Few communities resolved the public debates over the form of their memorial as satisfactorily as Stalybridge, which produced a splendid memorial that combined public remembrance and civic improvement. Hyde's decision to erect an obelisk on a commanding rural site rather than in the town centre was also bold and imaginative, and, as in other communities, such as Saddleworth and Scarborough, which adopted this type of memorial, the simplicity of the design combined with the location to provide a memorial which, if geographically remote, was a powerful and ever-present reminder of the war. Important as the main town memorials were, there were also many district and parish memorials, a recognition that those who died belonged first and foremost to smaller strongly-defined communities.[19] Somewhat surprisingly, among the many public memorials raised, none remembered the civilians who died when a munitions factory exploded in Ashton, even though the relief fund had attracted considerable sums of money.[20]

No comparable outburst of monument building occurred after the Second World War. The money raised to remember the dead was generally devoted to what were viewed as more practical projects, reserving the public memorialisation to the carving of names and dates on existing memorials. The post-war years were ones in which there was a declining interest in public sculpture. Public and civic priorities had changed. The statue of Hugh Mason, erected by the Victorians in the expectation that it would stand 'as an incentive to others to copy every noble feature of his life', was now dismissed as a traffic obstacle.[21] It was to be moved. Other monuments were simply left, neglected and underappreciated. The local government reorganisation of 1974 had little immediate impact on the district's stock of public monuments and sculpture.

Attitudes only began to change in the 1990s, when Tameside Metropolitan Borough Council started to take a more active role in encouraging public art and sculpture. Initially, this was not part of an overall strategy for public art – the council did not follow neighbouring authorities and appoint a public arts officer – but arose out of individual development projects, most notably the building of a new shopping centre in Ashton. In particular, the council commissioned a number of works from the metalsmith sculptor, Paul Margetts, beginning with *Glory of the Garden*, the centrepiece of the transplanted Radcliffe Freedom Gardens. Groundwork Trust, the environmental regeneration charity,

also commissioned sculpture to create focal points in a number of its land improvement projects, along the district's canals and at Gorse Hall, Stalybridge.[22] Yet such projects were on a modest scale and not part of a co-ordinated public arts policy. Ironically, whilst these years saw an increased public recognition of the importance of the histories of the different communities within Tameside, the achievements of two of its most famous citizens were commemorated elsewhere. Both Arthur Brooke, founder of the Brooke Bond tea company, and Frank Hampson, creator of Dan Dare, the space traveller whose adventures appeared in the children's comic, the *Eagle*, were remembered in bronze, the former in Trafford and the latter in Southport.[23] The new century opened with a number of larger public art commissions, the most ambitious being a work by the Liverpool sculptor, Stephen Broadbent. In a community where the heavy hand of the past seemed ever present, the bronze sculpture, *Pulling the Plug*, was an unashamed celebration of the district's radical working-class history.

Notes

[1] J. Butterworth, *History and Description of the Town and Parishes of Ashton-under-Lyne* (1823; reprinted Didsbury, Manchester: Morten, 1972) p.188. [2] .N. Kirk, *Growth of Working Class Reformism in Mid-Victorian England* (London: Croom Helm, 1985) p.39. [3] F. Engels, *Conditions of the Working Class in England* (Panther edn, 1969) p.53. [4] B. Disraeli, *Coningsby* (1844) Book 4, p.167. [5] Sculptor unidentified. D. Hodson, 'Civic identity, custom and commerce: Victorian market halls in the Manchester region', *Manchester Region History Review*, 12 (1998) pp.34–43. [6] J. Powell, *Longdendale in Retrospect* (Longdendale Amenity Society, 1977) n.p. [7] *Manchester Guardian*, 13 July 1850. [8] *Ashton Reporter*, 17 September 1887. [9] J. Cassidy, 'A guide to Stamford Park', in S. Harrop and E.A. Rose (eds), *Victorian Ashton* (Tameside Libraries and Arts Committee, 1974) pp.50–7; A. Lock, *History of Stamford Park* [Typescript, 1997]. [10] *Ashton Reporter*, 23 and 30 September 1922. [11] Speeches at unveiling of Thompson Cross, *ibid.*, 3 June 1893. [12] *Stalybridge Reporter*, 21 May 1927. The fountain was later moved to one of the parks and subsequently returned to the town centre. It is now located in the gardens created as a result of the demolition of the town hall, off Market Street. [13] A memorial fountain to William Isaac Hannan was erected in Stamford Park in 1909 by the Ashton and District Linnaean Botanical Field Naturalists' Society. It is located next to the bowling pavilion in the park. [14] The wall fountain on the Court House, Market Place, Mottram. The water supply was turned on on 23 July 1888. [15] Pevsner, *South Lancashire* (1969) p.126; B. Read, *Victorian Sculpture* (1982) p.186. [16] *Ashton Reporter*, 20 October 1917; M. Pavasovic, *Men of Dukinfield. A History of Dukinfield during the Great War* (Radcliffe: Neil Richardson, 1997) pp.23–5. [17] *Ashton Reporter*, 18 and 25 November 1916. [18] *Ibid.*, 20 March 1920. [19] The researches of Mike Pavasovic are invaluable in identifying the borough's war memorials. [20] J. Billings and D. Copland, *The Ashton Munitions Explosion 1917* (Tameside Leisure Services, 1992). [21] *Ashton Reporter*, 17 September 1887. [22] For example the installation of *Flying Geese* (Paul Margetts), Donkey Stone Wharf, Lower Wharf Street, Ashton-under-Lyne in 1999 and Andrew McKeown, *Breaking the Mould*, Gorse Hall, Stalybridge. [23] A statue of Arthur Brooke (sculptor: Anthony Stone) was unveiled in the Trafford Centre, Trafford in December, 1999 (see below, p.389); a bust of Dan Dare (sculptor: John Fowler) was unveiled in Southport, 15 April 2000.

ASHTON-UNDER-LYNE

The Arcades

Arcades Shopping Centre

The Black Knight of Ashton

Marjan Wouda

26 October 1995
Bronze sculpture with copper pennant; steel
 base
Sculpture 5.5m high (including pole) × 2.05m
 long × 90cm wide; base 81cm high × 2.5m
 diameter
Inscription around top of base: Sweet Jesu, for
 thy Mercy sake. And for thy bitter passion.
 Save us from the axe of the Tower, And
 from Sir Ralph of Assheton
Condition: good
Status: not listed
Owned by: MAB (UK) Ltd

Description: Life-size knight in armour on
horseback. The knight is depicted as a slightly
comical and pompous figure, who is just about
to be thrown off his horse. In his left hand is a
pennant inscribed with the motto 'Every Night
Has Its Day'. The surface of the sculpture
incorporates different kinds of fabric, rope,
chains, machinery and cast-iron decorations,
objects associated with the industrial history of
the town. The sculpture is mounted on a
circular metal pedestal.

MAB (UK) Ltd decided to commission a
sculpture for a new shopping centre, The
Arcades, which they were developing in the
centre of Ashton-under-Lyne. The company
was part of an international business group with
headquarters in Holland. A short-list of five
sculptors was put together by the director of
the British company and designs for a sculpture
were invited. The director made a
recommendation to the chairman in Holland
but this was rejected, the chairman choosing
instead the proposal submitted by Marjan
Wouda. The fact that a Dutch company selected
a Dutch-born artist was a coincidence, as no
details of the competitors were known when
the decision was taken.[1]

Marjan Wouda's sculpture refers to the
popular local Easter Monday custom of Riding
the Black Knight or Black Lad, which involved
parading an effigy of a knight through the
streets of Ashton. The origins of this folk
custom have been much debated.[2] By the end of
the eighteenth century, when written accounts
began to appear, there was already little
agreement about the identity of the Black
Knight.[3] In one of the most popular
explanations of the custom, the knight in
question is said to be Sir Ralph de Assheton, a
fifteenth-century local landowner, who
incensed his tenants through the arbitrary use
of his powers. Assheton became a figure of fear
and hatred, and he was eventually killed in
Ashton, presumably by those he had
mistreated. One version of the tale included the
invocation in verse:

> Sweet Jesu, for thy mercy's sake,
> And for thy bitter passion;
> Save us from the axe of the Tower,
> And from Sir Ralphe of Ashton.[4]

Unlike many folk customs it survived the
pressures of the new industrial urban society

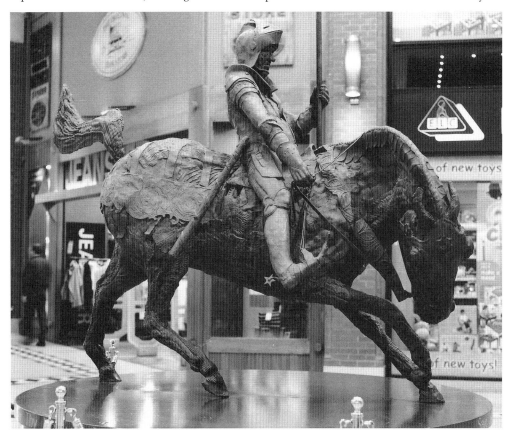

Wouda, *Black Knight of Ashton*

and continued as a popular pageant into the twentieth century, though it became less associated with the older tradition of redressing the abuse of power by those in authority. Wouda modelled the face of the knight on drawings made of local people, in particular the Stalybridge painter, George Hodgkinson. The finished sculpture of the *Black Knight* was installed in time for the official opening of The Arcades shopping centre in October 1995. It was unveiled by the Mayor of Ashton, Alan Whitehead, in a ceremony attended by Ton Meijer of MAB.[5] The *Black Knight* occupies a prominent position in the centre, and its present condition suggests that it has escaped the attentions of shoppers on Easter Mondays as well as other days of the year.

Notes
[1] Correspondence with Marjan Wouda. [2] W. Glover (comp.), *History of Ashton-under-Lyne and the surrounding district* (Ashton-under-Lyne: J. Andrew, 1884) pp.98–114; J. Walker and M. Nevell, *The Folklore of Tameside* (Tameside: Tameside Metropolitan Borough Council, 1998). [3] J. Aikin, *A Description of the Country from Thirty to Forty Miles Round Manchester* (London: J. Stockdale, 1795) pp.224–5. [4] Butterworth in Glover, *op.cit.* (1884) p.109. [5] Information from Jonathan Hardy, The Arcades Shopping Centre, May 1999; *Ashton and Audenshaw Reporter*, 2 November 1995.

Fletcher Street

Junction of Fletcher Street and Market Street

The Family

Paul Margetts

Unveiled 24 July 1995
Mild steel plate; brick pedestal
Sculpture 3.5m high × 1.2m square; pedestal 42cm high × 1.5m square
Inscription on rear of plinth: 'THE FAMILY' BY PAUL MARGETTS / COMMISSIONED AND DONATED BY / MAB (UK) IN 1994 / THE YEAR OF THE FAMILY
Condition: good

Status: not listed
Owned by: Tameside Metropolitan Borough Council
 Description: Semi-abstract sculpture depicting a family group of three figures, of diminishing sizes. Each figure has only one arm but is arranged so that they appear outstretched in a joyous pose. It surmounts an octagonal brick base.

In 1994 Tameside Metropolitan Borough Council in conjunction with MAB (UK) Ltd, the firm responsible for developing the Arcades shopping centre in Ashton-under-Lyne, decided to provide a sculpture which would be a focal point in a pedestrianised area by the

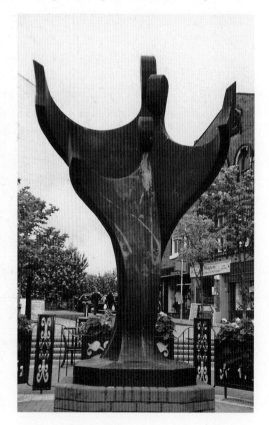

Margetts, *The Family*

town's market hall. The theme of the family was chosen because 1994 was the Year of the Family. Paul Margetts, who had recently completed a sculpture in the new Radcliffe Freedom Gardens, was awarded the commission. He identified the 'area's hospitality and the strong sense of family' as the inspiration for the work.[1] The sculpture was constructed from steel plate finished in a hand-mixed graphite paint. *The Family* was unveiled by the Mayor of Tameside, Alan Whitehead, in July 1995.[2] At a later date, the introduction of ornate plant containers and fencing around the sculpture helped further to define this public space.

Notes
[1] www.forging-ahead.co.uk; correspondence with Paul Margetts, 21 April 1999. [2] *Ashton Reporter*, 27 July 1995.

Hartshead Pike

Hartshead Pike Tower

Architect: John Eaton

Rebuilt 1863; restored 1928
Stone
25.9m high approx; 6.1m diameter approx
Inscriptions on stone tablets inset above doorway: first tablet: Look Well at me Before You Go / And See You Nothing at me Thro / This Pike Was Rebuilt By Pub- / lick Contributions: Anno: Do / 1751 – second tablet: AND / RE ERECTED / BY PUBLIC SUBSCRIPTION / TO COMMEMORATE / THE MARRIAGE OF – third stone tablet: H.R.H. ALBERT EDWARD, PRINCE OF WALES / TO H.R.H. THE PRINCESS ALEXANDRA OF DENMARK / AND TO RESTORE / THE ANCIENT LANDMARK OF / HARTSHEAD PIKE – fourth tablet: THE RT. HON. GEORGE HARRY, 7TH EARL OF STAMFORD & WARRINGTON / BEING THE LORD OF THE MANOR. ARTHUR S. PAYNE ESQ. STEWARD./ THE FOUNDATION STONE WAS LAID BY / SAMUEL DUNCUFT LEES M.D. MAYOR OF THE MANOR / SEPTEMBER 17TH 1863. /

JOHN EATON. ARCHT.
Status: Grade II
Condition: fair
Owned by: Tameside Metropolitan Borough
 Council
 Description: Tower; circular stone tower
with steep conical roof, and hexagonal windows
placed at the cardinal points in the roof.

Hartshead Pike Tower is Tameside's most
prominent public monument, standing on
Hartshead Hill between Ashton-under-Lyne
and Oldham. Various folk tales account for the
building and naming of Hartshead Pike, but it
seems likely that the hill was probably first used
as the site for a beacon.[1] One of the earliest
documented references to a tower appears to be
from a meeting of the Ashton Court Leet in
October 1750, which sought to impose fines on
those who threw things at the structure: 'if any
persons shall in any way abuse Hartshead Pike
either with stones or clods or in any way deface
the weathermark they shall for every such
offence, lose 3s 4d each'.[2] The tower appears to
have been rebuilt in 1751 and included a stone
inscribed with the admonitory verse, 'Look
well at me before you go, And see you nothing
at me throw!' The tower deteriorated in the
following years and in 1794 a lightning strike
caused considerable damage. When Aikin
reported on the Pike, it was in need of repair:

> It is now split from top to bottom near half a
> yard in width. A few pounds laid out in
> repairs, if done in time, might prepare this
> pile for a century to come. On the top are
> the small remains of a weather-cock,
> probably a hart's-head.[3]

But this or any other damage is not evident in
the undated illustration included in Aikin's
book. The tower appears not to have been
repaired and eventually collapsed. It remained
in ruins until the 1860s. Sarah Lees (1842–1935)
of Oldham remembered playing as a child on
the hillside 'when there was no tower, only a
circle of stones amongst which my sister and

myself have had many merry games'.[4] In
February 1863, the inhabitants of Ashton
resolved to restore the Pike as a tribute to the
marriage of the Prince of Wales and Princess
Alexandra of Denmark.[5] On 17 September 1863
the foundation stone of a new tower was laid,
on land donated by the Earl of Stamford and
Warrington. The Earl 'acted very generously
towards the committee who were appointed to
carry out the rebuilding of Hartshead Pike'.[6]
The site was a short distance to the south of the
Georgian tower. The mayor of the manor,
Samuel Duncuft Lees, who performed the
foundation laying with a specially made silver
trowel, and with full Masonic honours, trusted
that the tower would 'endure for ages as a mark
of their loyalty, as an ornament to the manor,
and as a meeting place for the recreation of the
people'.[7] A bottle was buried in the foundations
containing copies of the Ashton newspapers,
coins, a note outlining the purpose of the
restoration and 'some verses by a native of
Hartshead whose name he was not at liberty to
mention, but who was known to most of
them'.[8] The poem, by James Dawson, declared
that the chief purpose of the re-erection of the
pike was to connect Ashton with its own
history: 'To mark a spot which links us to the
past, We raise this ancient tower from sad
decay, and wipe our taunted apathy away'.[9]
However, apathy, or lack of funds, meant that
the building was not immediately begun, and it
is unclear when it was finished.

John Eaton, the Ashton-based architect, was
responsible for designing the new tower with its
distinctive steep conical roof. The four
hexagonal windows set in the roof allowed
those inside the building to look out. For this
purpose the new pike contained a staircase,
which gave access to a viewing platform. Stone
tablets with inscriptions, including one rescued
from the original pike, were placed over the
door in the west side of the tower. After some
delay, the new tower was opened to the public
and soon became a popular local attraction,
particularly at weekends and in the Wakes

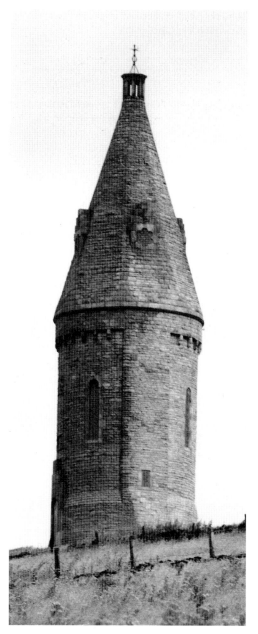

Hartshead Pike Tower

holidays. A caretaker was employed to look after the pike.

In 1911 the trustees of the Earl of Stamford and Warrington gave the tower and the surrounding moorland to Hartshead Parish Council for the use of the public. A restoration fund was set up to repair the Victorian tower.[10] By 1928 the tower was once again in need of repair. A meeting, supported by all of the neighbouring local authorities and held at Ashton Town Hall on 12 April 1928, proposed substantial repairs and invited subscriptions to cover the necessary costs. Reginald Earnshaw told the meeting that the tower had been damaged by a combination of recent severe gales and the attentions of 'rough lads', who thought it fair game 'to make it a target for every kind of missile'.[11] The restoration was carried out under the supervision of J. Lindsay Grant, Principal of the Manchester School of Art. By October the work was complete and the pike was reopened on 17 November 1928.[12] The tower was used as an observation post during the Second World War.[13] Hartshead Pike remains a prominent and much-visited landmark, even though access to the interior has not been possible for many years.

Notes

[1] J. Walker and M. Nevell, *The Folklore of Tameside* (Tameside: Tameside Metropolitan Borough Council, 1998) p.14; W. Harrison, 'Ancient beacons of Lancashire and Cheshire', *Transactions of Lancashire and Cheshire Antiquarian Society*, 15 (1897) p.35. [2] W.M. Bowman, *England in Ashton-under-Lyne, being the History of the Old Manor* (Ashton: Ashton Corporation, 1960) p.280. [3] J. Aikin, *A Description of the Country from Thirty to Forty Miles Round Manchester* (London: J. Stockdale, 1795) p.232. [4] *Hartshead Pike* (Stalybridge: Whittaker, [n.d.]) p.29. [5] *Ashton and Stalybridge Reporter*, 21 February 1863; 14 March 1863. [6] *Ibid.*, 19 September 1863. [7] *Ibid.* [8] *Ibid.* [9] *Hartshead Pike* (Stalybridge: Whittaker, [n.d.]) p.52. [10] W. Bowman, *5,000 Acres of Old Ashton* (Ashton: J. Andrew [n.d.]) p.258. [11] *Ashton Reporter*, 14 April 1928; Hartshead Pike Restoration Fund leaflet [1928]. [12] *Ashton Reporter*, 27 October 1928; *Hartshead Pike* (Stalybridge: Whittaker, [n.d.]). [13] N.P. Lawton, *Owd Archie Peyeke* [typescript n.d.].

Memorial Gardens

Ashton-under-Lyne War Memorial
Architect: Percy Howard
Sculptor: John Ashton Floyd

16 September 1922
Bronze sculptures; Portland stone
9.15m high approx; base 8.24m long × 3.49m wide
Inscription on panel on base: ERECTED IN HONOUR OF THE MEN OF / ASHTON-UNDER-LYNE AND DISTRICT / WHO FOUGHT FOR KING AND EMPIRE IN / THE GREAT WAR. ESPECIALLY THOSE / WHO SACRIFICED THEIR LIVES AND / WHOSE NAMES ARE RECORDED HEREON / 1914–1919 / 1939–1945 – on front of column beneath bronze wreath: BELGIUM / FRANCE / GALLIPOLI / EGYPT / ITALY – on rear of column beneath bronze wreath: MESOPOTAMIA / AFRICA / TURKEY / MACEDONIA / RUSSIA
Status: Grade II
Condition: fair
Owned by: Tameside Metropolitan Borough Council
Description: War memorial; a central tapering Portland stone column, surmounted by sculpture of a soldier and a female figure symbolising Peace. The kneeling wounded soldier holds aloft the sword of honour in his right hand and a laurel wreath in his left hand. Standing above him is the female figure who is receiving back the unbroken sword. Objects associated with the armed forces – rifle, helmet, gas mask, trench mortar for the Army; ropes and anchor for the Navy; propeller and steering wheel for the Air Force – are placed around the plinth. On the front and rear of the column are bronze wreaths, beneath which are the names of military campaigns. Two large bronze lions, symbolising the Empire, are placed on the base on either side of the central column. One lion is depicted fighting the serpent of evil, the other sits triumphant, having killed the serpent. Bronze panels attached to the base carry the

principal inscription and the names of the servicemen who died in the First World War (38 panels) and the Second World War (2 panels). The whole memorial rises from three steps.

A public meeting was held on 3 February 1919 in Ashton Town Hall to consider what form the borough's war memorial would take. The meeting agreed on two points: that there should be a memorial in a public place and that it should be representative of all and 'not of any sect'. Present at the meeting were the mayor and several councillors, the town clerk, local military men and churchmen along with several others, 'including a large number of ladies, many of whom were in mourning'. Although the idea of a memorial was agreed upon, this did not stop several speakers suggesting that other more practical memorials – an extension of the District Infirmary and the building of a YMCA – might also be pursued by the community. It was left to a committee, chaired by the mayor, to consider the details of the scheme. 'Artistic direction' was offered to the committee by J.H. Cronshaw, the art master at the Heginbottom School of Art in Ashton.[1]

The initial contract for the memorial was given to Cronshaw and his colleague in the art department at Heginbottom Technical School, J.L. Robinson. Their design proposed a central bronze statue of a mounted St George and the dragon placed on a cylindrical pedestal, with two curved walls interrupted by four pilasters to each side of the statue. Between each pilaster would be a bronze panel containing the roll of honour. In front of the walls would be a raised section with three flights of steps, situated at either end and in the centre. The central steps were to be flanked with two recumbent lions, one lying down with a lamb and the other with its paw on the head of a serpent.[2] The cost was estimated at around £10,000, and perhaps gives a clue as to why this somewhat grandiose design was ultimately rejected. It was meant to be located in the centre of a new open space,

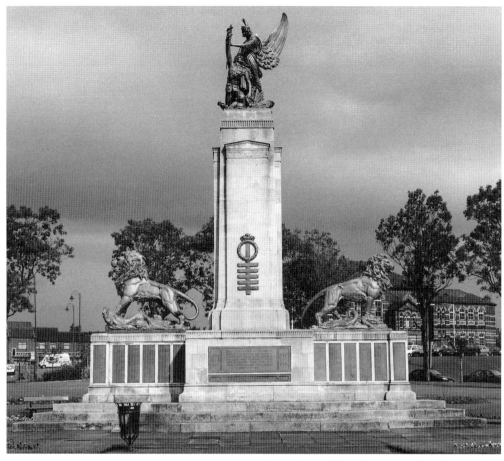

Ashton-under-Lyne War Memorial

created close to the centre of the town. The memorial scheme appears not to have been pushed forward with the determination evident in a number of other cotton towns.[3] Another line of blame was evident when the mayor, Councillor J.J. Broadhurst, addressed the Ashton Chamber of Trade. He confessed that he was finding himself 'practically begging' for money for the memorial, even though 'many people had made money out of the war, and had not sacrificed in any shape or form'.[4] This apparent reluctance to support such an

important public scheme contributed to a wider debate in the town. It was suggested that there was a decay of public spirit, with Ashton men apparently unwilling to take on the responsibilities of public life.[5] Fundraising, even when boosted by events such as concerts, moved forward at a slow pace.[6] The collapse of the post-war cotton boom did not help. Discussions were reopened over Cronshaw's and Robinson's proposed design, with the result that it was decided to select a new design. This was the work of the local architect, Percy Howard, and the Manchester-based sculptor, John Ashton Floyd, who were also responsible for the war memorials in the Waterloo and

Taunton districts of the town.[7] The central feature of their design was a sculptural group of Peace and a soldier surmounting a tall column.[8] The new design was generally welcomed, but some concern was expressed over the suitability of using Portland stone in the 'damp, chemical-laden northern atmosphere'.[9] The commission, however, went ahead. John Rowbottom, the Borough Surveyor, also went ahead with his landscaping of the site, a block of land close to the town centre, which the council had earmarked for an open space before the war.

Ashton's principal war memorial was unveiled by General Sir Ian Hamilton on 16 September 1922 and dedicated by the Revd W.A. Parry. Wreaths were laid by four girls whose fathers had fallen in the war.[10] The ceremony was marred when a viewing platform collapsed, injuring a number of spectators. The memorial cost some £8,000, a sum which on the day was dismissed as 'a mere bagatelle compared with the sacrifice of the 1,512 men whose names adorn the panels'.[11] In 1926 the Memorial Gardens were improved, when some of the surrounding older property was pulled down. Panels listing the 301 servicemen killed in the Second World War were added later. In more recent decades changes in road layout and increased motor traffic have altered the character of the Memorial Gardens and Howard's and Floyd's splendid monument. This may also have contributed to the neglect of the monument which requires cleaning and the replacement of stone that has been broken off the base.

Notes

[1] *Ashton Reporter*, 8 February 1919. [2] *Ibid.*, 20 March 1920. [3] *Ibid.*, 6 March 1920. [4] *Ibid.*, 17 April 1920. [5] *Mossley Reporter*, 5 November 1921. [6] *Ashton Reporter*, 20 March 1920. [7] Unveiled 23 April 1923, located at junction of Oldham Road and Taunton Road, *ibid.*, 30 April 1921. [8] *Ibid.*, 26 February 1921. [9] Letter in *ibid.*, 25 June 1921. [10] *Borough of Ashton-under-Lyne. Unveiling of the Ashton-under-Lyne War Memorial* [1922]; *Ashton Reporter*, 16 and 23 September 1922. [11] *Ashton Reporter*, 23 September 1922.

Oldham Road

New Radcliffe Freedom Gardens

Glory of the Garden
Paul Margetts

1994
Forged mild steel; brick base
2.95m high × 1m diameter base
Inscription: GLORY OF THE GARDEN / BY / PAUL MARGETTS / 1. 3. 94 – round the base: So when your work is finished you can wash your hands and pray for the Glory of the Garden that it may not pass away and the Glory of the Garden shall never pass away Rudyard Kipling
Status: not listed
Condition: fair
Owned by: Tameside Metropolitan Borough Council
Description: A tall forged steel sculpture of a floral column, including foxgloves, lilies and other plants, surrounded by a large 'skirt' of leaves. It stands on a circular sloping stone base, around which is a steel plate inscribed with lines from Kipling's poem.

Glory of the Garden was commissioned by Tameside Metropolitan Borough Council as part of a project which involved the creation of a new public garden close to the town centre. The gardens, known as the New Radcliffe Freedom Gardens, replaced the original ones, which had been built over in the re-development of the town centre. Financial assistance for the project was provided by the developers, MAB (UK) Ltd. The new gardens were situated on a site off Oldham Road, land which had previously been used as a car park. The council decided to commission Paul Margetts to provide a suitable sculpture as a focal point in the new gardens.[1] Margetts' response to the site was an elegant steel

sculpture entitled *Glory of the Garden*, a quite literal description of plants, inspired by Kipling's much loved poem of the same name.[2] The work was installed in the centre of the gardens, the meeting point of a number of pathways. It was unveiled in 1994.

Notes
[1] Information from Derek Ollerenshaw, Tameside Metropolitan Borough Council. [2] Correspondence with Paul Margetts, October 1999.

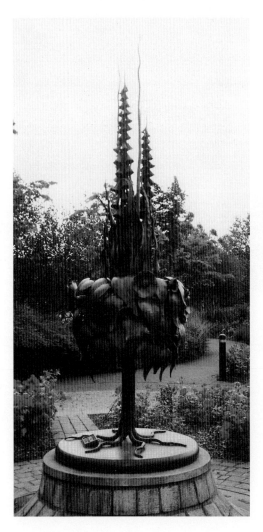

Margetts, *Glory of the Garden*

Stamford Street

Stamford Park

Ashton Old Cross

*c.*1793
Stone
2.6m high approx × 61cm square at base
Inscription: Erected / by / Thos. Walker / John Knight / Robert Lees / Constables / 1793 [?]
Status: Grade II
Condition: poor, sides worn and chipped, extensive weathering
Owned by: Tameside Metropolitan Borough Council
Description: Cross, rectangular stone shaft with dome-shaped crown. The shaft is cracked and chipped, and metal rods on the rear face suggest that at some time it may have been fixed to another piece of stone or used to support a lamp.

Documented evidence on the early history, design and exact location of Ashton-under-Lyne's first market cross is slight. The right of holding a market in Ashton dates back to the early fifteenth century when Sir John Assheton was given this right. During the Commonwealth the cross, like others, became the legally defined place for the proclamation of marriage banns.[1] Bowman states that Joseph Hampson was paid £2. 15s. 0d. for making a new cross in 1763/4. It was an elaborate structure, on the top of which was a crown.[2] A contemporary illustration shows the cross rising from three steps, a crown surmounting the tall pillar. This cross, for reasons unknown, did not survive for as long as the borough's officers had intended, and in the 1790s a new cross was carved. It carried an inscription on the front (now faint) of the names of the officers of the town responsible for its erection. This cross was still in situ in 1827. In 1829–30 a new market place was established and it may have been around this time that the cross was removed. It was not destroyed, for at a later date it came into the

possession of Isaac Watt Boulton, a local engineer, who discovered the cross in a scrapyard and rescued it.[3] A drawing published in 1884 shows a rectangular shaft surmounted by a carving which appears to represent a crown, standing on a plain base. There is an inscription on the front face of the shaft.[4] The exact date when the cross was re-erected in Stamford Park is not known. An approximate replica of the cross was placed in a traffic island at the junction of Old Street and Mossley Road in the 1980s.[5]

Notes
[1] H. Taylor, 'The ancient crosses of Lancashire', *Transactions of Lancashire and Cheshire Antiquarian Society*, 16 (1898) pp.48–50. [2] W.M. Bowman, *England in Ashton-under-Lyne* (Altrincham: Sherratt, 1960) p.204. [3] J. Cassidy, 'A guide to Stamford Park', in S. Harrop and E.A. Rose (eds), *Victorian Ashton* (Tameside Libraries and Arts Committee, 1974) p.54. [4] W. Glover (comp.), *History of Ashton-under-Lyne and the surrounding district* (Ashton-under-Lyne: J. Andrew, 1884) p.99. [5] The actual site of the old cross is marked on the road which now crosses the original square.

Jethro Tinker Memorial
Alfred Wilde

18 July 1874
4.75m high approx, base 1.17m square
Signed: Alfred Wilde. Sc. Wakefield Road
 Stalybridge
Inscription on front: JETHRO TINKER / BORN /
 25TH SEPTEMBER 1788 / DIED / 10TH MARCH
 1871. – rear: ERECTED BY THE FRIENDS / AND
 / ADMIRERS OF / NATURAL HISTORY / 1874 –
 left side: A FIELD NATURALIST / FROM / EARLY
 YOUTH / TO OLD AGE – right side: OUR
 LOCAL / LINNAEUS
Status: not listed
Condition: poor
Owned by: Tameside Metropolitan Borough
 Council
Description: Stone column consisting of a stepped square base in three sections decorated

Ashton Old Cross

with carvings, including waterflowers. Above this was the inscription stone, the corners of which were carved with the blackberry, vine, rose and geranium. Above this was an octagonal column, the front faces decorated with ferns, lilies, ivy and flowers, with an ornate capital, decorated with plants, on which stood a circular vase with further carved flowers.

Jethro Tinker, weaver, naturalist and auto-didact, was born at North Britain Farm, near Hollingworth, in the parish of Mottram, on 25 September 1788. His interest in natural history began early in his life and over the years he developed a detailed knowledge of the natural history of the districts around Stalybridge. To him 'Mottram and its neighbourhood was his ideal of paradise on earth'.[1] Entomology was a particular interest and he amassed a large

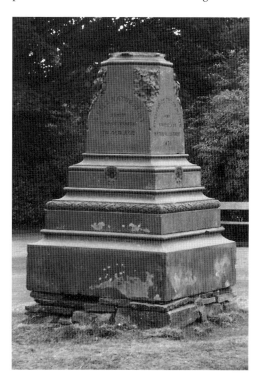

Jethro Tinker Memorial (base)

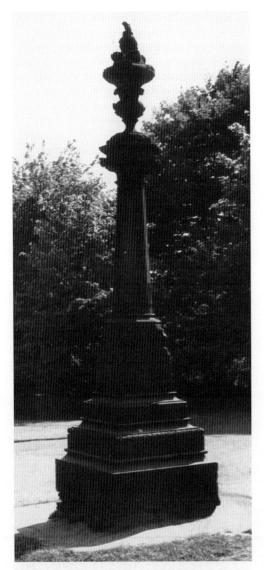

Jethro Tinker Memorial

collection of insects. Although he rarely travelled outside the district, he was a well-known figure among that small group of admired Lancashire working-class naturalists, and his work was recorded in publications such

as James Cash's *Where There's A Will There's A Way!*[2] A public testimonial was organised for him in 1858. Tinker died in 1871.

The idea of a memorial to Tinker originated with the Stalybridge Naturalists' Society, a body that Tinker had belonged to and supported for many years. Some of his 'friends and admirers' along with other 'lovers of science' determined to erect a suitable memorial. A memorial fund was opened and some £80 was collected, in part through exhibiting Tinker's own collections. The funds determined a simple monument. A number of designs were considered by the memorial committee before selecting one submitted by the Stalybridge architectural sculptor and stonemason, Alfred Wilde.[3] The recently opened Stamford Park, which straddled the boundary between Ashton and Stalybridge, was thought to be the best location for the memorial. Permission was given by the trustees even though the site, close to the Stalybridge entrance, was one that some people believed should have been reserved for a monument to Samuel Oldham, whose generosity had led to the establishment of the park.

The attendance at the unveiling ceremony was reduced considerably by the fact that it took place on Wakes Saturday, the appeal of the 'mummeries of the market ground' being used to account for a somewhat thinly-attended procession through the streets to the park. Thomas Harrison, President of the Stalybridge Naturalists' Society, unveiled the richly carved monument. Wilde was complimented for the design and the skill 'displayed in the use of the chisel'.[4] In the speeches that followed Tinker was remembered as an ordinary working man dedicated to scientific enquiry, at a time when amateur natural science was ignored or even ridiculed. Harrison concluded that, if those who saw the monument and considered Tinker's achievements 'could be persuaded to pick up a few pebbles on the sea shore of science, then those who had subscribed to it would be satisfied that their intentions had been realised'.[5]

In 1997 the memorial was vandalised, the main column being pulled down and broken. The pieces were collected and stored in the park, leaving the ornate stepped base on display. The broken shaft remains in storage, but there has been no proposal to restore the monument.[6]

Notes
[1] *Ashton Standard*, 25 July 1874. [2] J. Cash, *Where There's a Will There's a Way! or, Science in the Cottage, an Account of the Labours of Naturalists in Humble Life* (London: Robert Hardwicke, 1873) p.135. [3] Alfred Wilde and his brother Herbert are listed as sculptors, High Street, Stalybridge and St Paul's, Stayley in *Morris and Co's Commercial Directory of Ashton-under-Lyne and district* (Nottingham, 1878) p.347. [4] *Ashton Reporter*, 25 July 1874. [5] *Ibid.* [6] In 2002 it was stored outside behind a skip in the park maintenance depot.

Joseph Rayner Stephens Memorial
Wilde & Son

19 May 1888
Granite
5.9m high approx; base 1.17m square
Inscription on front: JOSEPH RAYNER STEPHENS / BORN 1805. DIED 1879. – rear: ERECTED / BY THE FACTORY WORKERS OF / LANCASHIRE AND CHESHIRE / IN THANKFUL REMEMBRANCE / OF A LONG LIFE SPENT / IN THEIR SERVICE / 1888 – left-hand side: AN EARNEST ADVOCATE / OF THE TEN HOURS BILL. / AN ABLE DEFENDER OF / TRADES UNIONS / AND DETERMINED OPPONENT OF / THE NEW POOR LAW./ 'THE ONLY TRUE FOUNDATION OF / SOCIETY IS THE SAFETY, THE SECURITY / AND THE HAPPINESS OF THE POOR, FROM / WHOM ALL THE OTHER ORDERS OF SOCIETY / ARISE.' / DEFENCE AT CHESHIRE. – right-hand side: SCATTER THE SEED, THE SEED OF TRUTH / BELIEVING IT WILL GROW, / LOOK ON THE WILDERNESS IN RUTH, / IT WAS NOT ALWAYS SO. / A GARDEN ONCE, IT MAY AGAIN, / A LOVELY GARDEN BE, / IT WANTS THE SUN, IT WANTS THE RAIN, / OF

GODLIKE CHARITY. / WE WORK AND WAIT, WE TOIL AND TRUST, / SURE THAT THE END WILL COME, / THIS WILDERNESS OF EVIL MUST, / BE CLOTHED WITH HEAVENLY BLOOM. / J. R. S.

Status: Grade II
Condition: fair
Owned by: Tameside Metropolitan Borough Council
Description: Granite obelisk rising from a square base. The base includes a bronze oval portrait medallion and inscriptions.

Joseph Rayner Stephens, minister, was born in Edinburgh in 1805, the son of a Methodist preacher. In 1825 he became a Wesleyan minister himself and began to preach in Yorkshire and later on the Continent. He came to Ashton in 1832, soon making himself a reputation as a champion of disestablishment. This led to his resignation from the Wesleyan conference in 1834. Soon afterwards he became prominent in campaigns against the factory system and the New Poor Law. By 1838 Stephens, dubbed 'His Satanic Majesty's Chaplain' by one Liberal critic, was involved with Chartist agitation. His attacks on the Poor Law Commissioners, the factory system and the government from his pulpit in Ashton, combined with local unrest which some laid at his door, led to his arrest and trial for sedition and unlawful assembly at the Chester Assizes in August 1839. Stephens spoke for over six hours in his own defence, but was found guilty and sentenced to 18 months' imprisonment. Later he settled in Stalybridge, where he continued to campaign for factory reform. He died on 18 February 1879. His grave in St John's churchyard, Dukinfield was marked by a baptismal font from his chapel in King Street.[1]

The movement to memorialise Stephens began to be organised by his friends and admirers shortly after his death. George Jacob Holyoake was prompted to write a short biography of Stephens, which included details of the memorial committee.[2] The collecting of funds, however, proved to be a slow process,

and it was not until nine years after his death that sufficient money had been raised and a monument commissioned. The commission for a simple granite obelisk was given to the local firm of architectural sculptors and masons, headed by Alfred Wilde. The sculptor of the bronze relief portrait is not recorded. On the base were a number of inscriptions, including part of Stephens' defence when on trial at Chester and lines from his poem 'Scatter the Seed'.[3] The cost of the obelisk, £290, was said to have been borne entirely by the 'working population' in Lancashire, Cheshire and Yorkshire. Permission was given to place the monument in Stamford Park.

Stephens' memorial was unveiled by his nephew, John Stephens Storr, in a ceremony that celebrated Stephen's work, particularly his efforts to improve the conditions of mill workers. Significantly, many leading cotton trade unionists were on the platform.[4] Speakers recalled Stephens' life and struggles, glossing over his more incendiary pronouncements in favour of his efforts to unite masters and men. Emphasis was placed on the progress of the nation from the discord of Stephens' early life to a period of peace, order, justice and popular sovereignty. David Holmes, president of the Northern Weavers' Association, moved a resolution to the effect that 'this meeting rejoices to know that during Her Majesty's reign, owing to the enactment of wise and just laws, the relations between employers and employed have greatly improved in all respects'. If it had not been for 'a class of men composed of persons like Mr. Stephens', he went on, 'they [the working classes] would today perhaps have been in a far worse position (Hear, hear).'[5] Tom Sidebottom, one of three MPs present, agreed, telling the crowd that, despite the anguish of the past,

the great truth is now fully apprehended and thoroughly recognised and insisted on that the interests of employers and employed are identical, that they are absolutely bound up

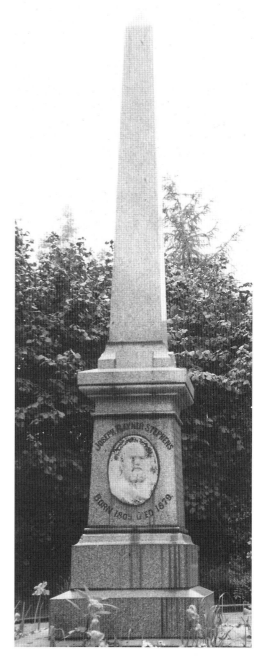

Wilde and Son, *Joseph Rayner Stephens Memorial*

together, and that the prosperity of the one reacts on the other (Hear, hear).

Stephens' opinions, he conceded, had once been 'of a somewhat advanced character' but he had ended up as a true and firm conservative.[6] The monument has remained an important landmark in the park, unchanged except for the railings which enclosed it.[7]

Notes

[1] M.S. Edwards, *Purge This Realm. A Life of Joseph Rayner Stephens* (London: Epworth Press, 1994); T.M. Kemnitz and F.J. Jacques, 'Stephens and the Chartist movement', *International Review of Social History*, 19 (1974) pp.211–27; N.A. Spence, 'Joseph Rayner Stephens – He Hath Done What He Could' in A. Lock (ed.), *Looking Back at Stalybridge* (Libraries and Arts Committee, Tameside Metropolitan Borough, 1989) pp.35–48. [2] G.J. Holyoake, *Life of Joseph Rayner Stephens. Preacher and Political Orator* (London: Williams and Norgate, 1881) pp.14, 237. [3] The line inscribed 'Look on the wilderness in Ruth' appears as 'Look on the wilderness in truth' in Stephens' published poems. W. Glover (comp.), *History of Ashton-under-Lyne and the surrounding district* (Ashton-under-Lyne: J. Andrew, 1884) p.325. [4] *Cotton Factory Times*, 25 May 1888. [5] *Ashton Herald*, 24 May 1888. [6] *Ibid.*; *Ashton Reporter*, 26 May 1888; *Manchester Guardian*, 21 May 1888. [7] Photograph dated 1899 (N5517, Tameside Local Studies Library, Stalybridge).

Stockport Road

Trafalgar Square

Hugh Mason

Joseph W. Swynnerton

10 September 1887; relocated 1965, 1972
Bronze statue; granite pedestal
Statue 2.44m high; pedestal 2.04m × 1.09m × 1.25m
Signed on plinth: J. W. Swynnerton. Sc.
Inscription: HUGH MASON / BORN 1817 DIED 1886
Status: Grade II
Condition: fair
Owned by: Tameside Metropolitan Borough Council

Description: Portrait statue; a larger than life-size bronze statue of Hugh Mason, who is shown standing with his arms folded, a pose contemporaries considered characteristic. It stands on a granite pedestal inscribed with his name and dates.

Hugh Mason, textile manufacturer and Liberal politician, was born in 1817 in Stalybridge, the youngest son of a cotton manufacturer. He was educated in Ashton, worked in the family firm and joined a local bank at the age of 14. Rejoining the family business in 1838, he was instrumental in the firm's decision to build two mills (in 1845 and 1851) and a workers' colony at Oxford, next to the Manchester–Ashton Canal.[1] By 1860 Mason had sole control of the firm. He combined the qualities of an astute businessman with those of a paternalistic employer. A library and reading room were among the amenities provided at the Oxford colony. Mason was also deeply involved in the business affairs of Manchester, serving as president of the Chamber of Commerce between 1871 and 1874. As well as being a staunch Nonconformist and supporter of temperance, he also found time for a political career, being (Liberal) mayor of Ashton from 1857 to 1860 and MP from 1880 to 1885. As a public speaker he was known for not mincing his words: 'He had a way of expressing himself in vigorous and uncompromising terms', observed the Conservative *Manchester Courier*.[2] He espoused Radical causes, including women's suffrage, and was a founder member of the Manchester Reform Club. Mason died unexpectedly in February 1886 following his narrow defeat in a parliamentary election. At the time of his death a recount of the votes was underway.[3]

The origins of the memorial lay in a suggestion made in a letter to the *Ashton Reporter* shortly after Mason's death. This was followed by a request for the mayor to call a public meeting to consider the question.[4] This was held in March 1886 and although other

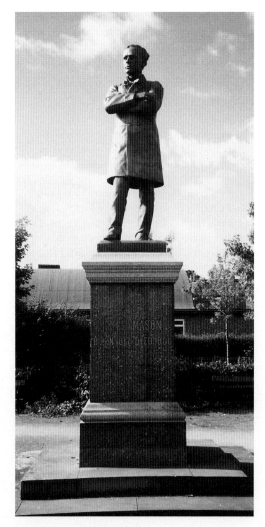

Swynnerton, *Hugh Mason*

commemorative ideas were suggested, the statue scheme was adopted. A committee was appointed 'representative of every class and interest in the community'.[5] Calls for subscriptions were answered enthusiastically, over £1,670 being collected. The money came not from a few rich men, but 'by the help of at least some 2,500 individuals'.[6] Joseph

Swynnerton was chosen as the sculptor, not only for his ability but also because he knew Mason personally. To avoid delays as the project neared its end, the statue was cast in Paris rather than in London. Apparently the London foundries were busy, a change which helps to explain the crossing out of the English foundry name on the plinth. After considering a number of sites in the town, the memorial committee decided to place the statue in Chester Square.

A crowd of 15,000 was present in September 1887 to see Mason's widow unveil the statue and listen to the speeches. Although they were celebrating a Liberal icon, the speakers went out of their way to point out the non-partisan character of the occasion, and to pronounce upon the benefits of Mason's example to all the people of Ashton. The presence of John Addison, who had defeated Mason in the previous year's election, was appreciated by the press and the crowd, all the more so when he did 'the gracious thing' and delivered an encomium to his former rival, 'a man whose name was a household word in Lancashire'.[7] In fact, many of those taking part in the ceremony were Liberals and Nonconformists, with the Methodist churches well represented in the procession. Councillor Reyner presented the statue to the council on behalf of the committee, saying that he hoped Mason's life would inspire future generations to do all they could for the welfare of the town. The 'handsome balance' left in the memorial fund was put aside to pay for the cleaning and maintenance of the statue.[8] The statue was protected by iron railings and illuminated by ornate corner lamps, later removed.[9] Its position in the square, facing a public house and with its back to St Peter's Church, gave rise to the low but well-suited local rhyme: 'Ther' stands Hugh Mason on his perch, His face to the gin-shop, his arse to the church.'

Mason's statue remained in Chester Square until 1965, when changes in the road layout resulted in its being moved a short distance.

Some councillors, evidently more concerned about the cost of re-siting the monument than about its historical significance, had favoured scrapping it.[10] Seven years later further 'traffic improvements' resulted in the statue being removed to Henry Square.[11] In the mid-1990s, plans to redevelop Henry Square caused the statue to be moved yet again, this time to Trafalgar Square, an open space, close to the famous Oxford Mills colony which Mason had been responsible for developing.

Notes
[1] O. Ashmore and T. Bolton, 'Hugh Mason and the Oxford mills and community, Ashton-under-Lyne', *Transactions of Lancashire and Cheshire Antiquarian Society*, 78 (1975) pp.38–50. [2] *Manchester Courier*, 3 February 1886. [3] E.A. Rose, 'Hugh Mason' in *Dictionary of Business Biography* (London: Butterworths, 1995) Vol.4, pp.176–8; *Manchester Guardian*, 3 February 1886. [4] *Ashton Reporter*, 13 March 1886. [5] *Ibid.*, 20 March 1886. [6] *Ibid.*, 10 and 17 September 1887. [7] *Ibid.*, 17 September 1887; *North Cheshire Herald*, 17 September 1887. [8] *Manchester Guardian*, 12 September 1887. [9] Undated photograph in A. Lock, *Ashton in Old Photographs* (Libraries and Arts Committee, Tameside Metropolitan Borough Council, 1981). [10] *Stalybridge Reporter*, 26 March 1965. [11] *Ashton Reporter*, 13 October 1972.

AUDENSHAW

Cemetery Road
Audenshaw Cemetery

Audenshaw War Memorial
Percy George Bentham

27 November 1920
Bronze statue; granite pedestal
Statue 1.83m high; pedestal 2.95m × 3.04m × 3.04m
Signed: P. G. Bentham. RBS.
Inscription on front: IN MEMORIAM / IN PROUD AND GRATEFUL MEMORY OF THOSE WHO / GAVE THEIR LIVES FOR KING AND COUNTRY /

THE GREAT WAR 1914–1919 / ERECTED BY THE INHABITANTS OF AUDENSHAW 1920 – rear: IN MEMORIAM / THEY PASSED OUT OF THE SIGHT OF MAN BY THE / PATH OF DUTY AND SELF-SACRIFICE. / PEACE – left-hand side: IN MEMORIAM / LET THOSE WHO COME AFTER SEE TO IT THAT THEIR / NAMES BE NOT FORGOTTEN. / LIBERTY – right-hand side: IN MEMORIAM / THEIR BRIGHT SPIRITS STILL TENANT THE HEARTS / OF THOSE WHO LOVED THEM. / VICTORY
Status: Grade II
Condition: poor
Owned by: Tameside Metropolitan Borough Council
Description: War memorial; a life-size statue of a soldier in battle-dress, both hands holding

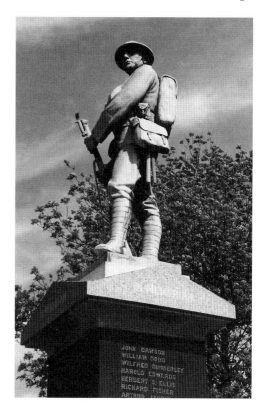

Bentham, *Audenshaw War Memorial*

rifle, surmounting a light-grey granite pedestal with cornice. Inscriptions appear at the base of the pedestal on all four sides.

Public meetings to discuss the erection of a war memorial in Audenshaw were organised during the winter of 1918-19. The public appeal for funds met initially with a good response, the donations given by individuals and businesses being supplemented by money raised at events such as cinema shows.[1] Designs submitted for the proposed memorial resulted in the commission being awarded to the London sculptor, Percy Bentham. After considering six sites in Audenshaw it was decided that the most suitable location for the memorial would be inside the entrance to the town's cemetery.[2] Bentham produced the statue promptly, and the Dukinfield firm of monumental masons, W. Hewitt and Son, was responsible for the stonework.

The service of dedication in November 1920 began with a procession of some 7,000 people from Coronation Square to the cemetery. Councillor W. Richardson unveiled the memorial, on which were inscribed the names of over 140 servicemen.[3] At the time of the unveiling some £240 remained outstanding of the total cost of £1,270. The organisers had intended to hold a collection at the ceremony, but overlooked the need to obtain the necessary permission from the police.[4] Following the Second World War stone tablets recording the names of the dead were placed around the base. The statue has been neglected in recent years. There is evidence of rust and the rifle bayonet has been broken off.

Notes
[1] *Ashton Reporter*, 15 March 1919. [2] *Ibid.*, 3 May 1919. [3] *Ibid.*, 27 November 1920; 4 December 1920. [4] *Ibid.*, 4 December 1920.

DENTON

Market Street
Garden of Remembrance

Broken Sword
Paul Margetts

1996
Mild steel
4m high × 73cm square base
Status: not listed
Condition: good
Owned by: Tameside Metropolitan Borough Council
Description: War memorial; a broken sword, the point of which is used to form a cross, surmounting a hollow obelisk filled with steel poppies. It is set on a circular brick base.

Denton's principal war memorial, a granite and marble cenotaph designed by Arnold Radcliffe and James Hirst & Son, was located in Victoria Park. It was unveiled in July 1921.[1] The dead of both world wars were remembered with the opening of Denton Remembrance Garden in May 1958. When the memorial garden was being restored in 1995, council officers decided that the inclusion of a piece of sculpture would be appropriate. Paul Margetts, who had already provided a number of public art works for the council, was asked to submit a design for a sculpture which would stand in the centre of the small garden.[2] Margetts's design was heavily symbolic, the broken steel sword representing the end of war, while the cross shape it created was reminiscent of the simple grave markers to be found in the battlefields of the First World War. The obelisk and the poppies have an obvious relevance.[3] *Broken Sword* was installed in 1996 but without any formal ceremony.

Notes
[1] *Denton War Memorial. Unveiling Ceremony Souvenir* [Denton, 1921]. [2] Information from Derek

Margetts, *Broken Sword*

Ollerenshaw and Philip Rogerson, Tameside Metropolitan Borough Council. [3] Correspondence with Paul Margetts, April 1999.

DUKINFIELD

Chapel Hill

The Crescent

Dukinfield War Memorial

Sculptor: Percy George Bentham

Unveiled: 30 July 1922
Bronze statue; Windy Way stone pedestal
Statue 2.29m high; pedestal 4.37m high × 1.83m
 square base
Signed on plinth: P. G. Bentham R.B.S.
Inscription on frieze above coat of arms on
 pedestal: TO OUR NOBLE DEAD – rear: MEN OF
 DUKINFIELD
Status: Grade II
Condition: good
Owned by: Tameside Metropolitan Borough
 Council
 Description: War memorial; larger than life-
size bronze statue of a soldier in battle-dress,
standing at ease, a rifle in his right hand,
surmounting a tapering ashlar sandstone
pedestal, rising from two steps. The pedestal is
decorated with bay leaf wreaths on three sides,
and the borough's coat of arms is in relief on
the front. Four bronze panels record the names
of the dead. The cap of the pedestal is richly
decorated with laurel and ribbons buttoned at
the corners. The principal inscription is carved
in solid letters on the frieze.

A meeting of ratepayers was held in Dukinfield
Town Hall in February 1919 to decide whether
a public war memorial should be erected to the
town's 460 dead, and what form such a
memorial should take. The meeting was
attended mainly by members of the local
council. There was unanimous agreement that a
memorial should be erected but no agreement
as to its form. Members of the neighbouring
town and district councils had already met and
sent a letter to the meeting, suggesting that a
fitting memorial would be the extension of the
District Infirmary. Other councillors were in
favour of building a large public hall, which
could contain a suitable memorial plaque.
Councillor Grundy argued that, in addition to
the problems of cost, 'monuments were not
suitable in a district like this on account of the
prevailing atmospherical conditions'.[1] The Revd
E.G. Evans was of the opinion that since the
war 'to a large extent had been won by the
children of the poor' they should provide
secondary school and university scholarships to

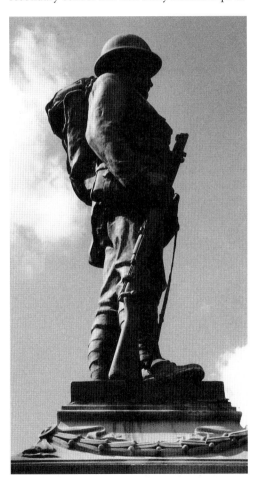

Bentham, *Dukinfield War Memorial*

the working classes. The Revd C. Jackson
Shawe, an army chaplain and one of the few
members of the public at the meeting, argued
that the memorial should not be merely
utilitarian or ornamental. He called for a
memorial that would serve the purpose of
'spiritual reconstruction', and 'give their young
people ideals'.[2] The case for putting up a
memorial statue, placed in front of the town
hall, rather than erecting a useful building, was
rehearsed in the local press before the next
public meeting.[3] A meeting on 5 May decided
that memorial panels containing the roll of
honour should be placed in the council
chamber, but in the following months this i
dea failed to attract much support or funds
from the public. In September a further meeting
was called, at which a stronger feeling was
evident for providing a more conventional
outdoor memorial.[4] This scheme finally gained
approval and the necessary arrangements
began to be made. Designs were invited, and
three were short-listed, the final selection being
made by a vote at a public meeting in April
1920. The winning design – a statue of a soldier
on a square stone pedestal, the work of the
London firm, A.R. Mowbray and the sculptor,
Percy Bentham – received half of all the votes.
The estimated cost was £1,750. The question
of location was also put to a vote, with
Chapel Hill winning out over proposed sites
in front of the Town Hall and in the park.[5]
Two years were to pass before the memorial
was in position.[6] Bentham had the statue
cast at the Morris Art Foundry, Clapham,
London.

 Dukinfield's main war memorial was
unveiled by Sir John Wood MP and dedicated
by the Revd W.H.F. Palin, 'in the presence of
many thousands of spectators' at the end of
July 1922.[7] Sergeant Brooks, an ex-serviceman
blinded in the war, laid the first wreath. The
Mayor, Alderman Underwood, addressed the
crowd, saying that whatever sacrifices they
were called on to make in their lives, they
'would be as nothing compared with the

sacrifices their brave men had made for them'.[8] Between two and three hundred wreaths were then laid, completely covering the base of the memorial. The original cast-iron pillars which surrounded the memorial were removed in the Second World War. A plaque acknowledging the dead of the Second World War was unveiled on 11 November 1952.

Notes
[1] *Ashton Reporter*, 8 February 1919. [2] *Ibid.* [3] *Ibid.*, 15 February 1919. [4] *Ibid.*, 13 September 1919. [5] *Ibid.*, 17 April 1920. [6] M. Pavasovic, *Men of Dukinfield. A History of Dukinfield during the Great War* (Radcliffe: Neil Richardson, 1997). [7] *Ashton Reporter*, 19 August 1922. [8] *Ibid.*, 19 August 1922.

King Street

Dukinfield Park

Colonel Duckenfield

Stephen Broadbent

1996
Stainless steel plate; stone pedestal
3.25m high × 84cm diameter at base; pedestal 62cm high
Inscription between column and helmet:
Colonel Robert Duckenfield 1619–1689
Status: not listed
Condition: good
Owned by: Tameside Metropolitan Borough Council
Description: Tapering column made from two intersecting steel panels, painted black, surmounted by the helmet of a Roundhead soldier, and encircled by flames made from polished stainless steel. The outline shape of objects associated with Robert Duckenfield and the English Civil War – a sword, musket, pike, breastplate, cavalry officer's boot, the Duckenfield family standard and the emblem of the Isle of Man – have been cut out of the panels, and set into the concrete circle around the stone base. Four benches, including inset metal plaques with information about

Duckenfield and the objects depicted, are placed around the sculpture.

Colonel Duckenfield occupies a prominent position in Dukinfield Park, near to one of the main entrances. The terrace site was occupied by an ornate drinking fountain, an amenity which, over the years, was neglected and vandalised. In 1996 it was decided to replace it with a modern sculpture. The initiative was linked to the council's involvement in the 'Britain in Bloom' competition. The Liverpool sculptor, Stephen Broadbent, was approached to create a sculpture, but had to do so in a short space of time and within a budget of £8,000. Following research into the town's history, Broadbent put forward the idea of a work that recalled one of the district's best-remembered historical figures, Robert Duckenfield (1619–89). Duckenfield was a local landowner and Puritan, who became a commander in the Parliamentary army during the Civil War. He took part in fighting in Cheshire and later helped to secure the Isle of Man. After the Restoration he was tried for his involvement in the court martial of the Earl of Derby but acquitted. He is buried in St Lawrence's, Denton.[1]

Broadbent produced a maquette which was accepted. Seating was also included in the commission, a feature that the council believed would help to restore the use of this once important public space in the park. The sculpture was completed on time and, with the council's assistance, efficiently installed.[2] There appears to have been no official unveiling, but the work has been generally welcomed by the people of Dukinfield.

Notes
[1] M. Nevell, *Tameside 1066–1700* (Tameside Metropolitan Borough Council, 1991) pp.74–6.
[2] Information from Stephen Broadbent.

Broadbent, *Colonel Duckenfield*

HURST

Queen's Road

Hurst Cross, junction of Queen's Road and King's Road

Hurst Cross

Architect: John Eaton

5 October 1869
Sandstone
4.27m high approx; 1.27m square base
Inscription: front: THE / FOUNDATION STONE / OF THIS CROSS / WAS LAID ON THE / 13TH APRIL 1868 / BY / OLDHAM WHITTAKER ESQRE / OF HURST HALL / DEPUTY LIEUTENANT / OF THE / COUNTY OF LANCASTER. – rear, north: PUBLIC / PROPERTY / DEMANDS / PUBLIC / PROTECTION – left-hand side, east: THE FOLLOWING GENTLEMEN ACTED AS THE COMMITTEE [followed by names, now illegible] – right-hand side, west: THIS CROSS / WAS ERECTED / BY PUBLIC / SUBSCRIPTION / AND FINISHED / 15 AUGUST 1868.
Status: not listed
Condition: poor
Owned by: Tameside Metropolitan Borough Council
Description: Cross; stone cross, decorated with interconnected initials HC, masonic symbols and flowers, surmounting square pedestal with corner columns. The structure rises from two stone steps. The names of the memorial committee inscribed on the east side have been worn away by weathering.

Hurst Cross was erected in 1868 on what was assumed to be the site of a former cross. In fact little was, and is, known of the original cross. In the 1860s all that the older local inhabitants could remember of the junction where the cross was sited was 'a heap of stones placed in a circular form but which have been gradually removed'.[1] The idea of erecting a new village

Hurst Cross

cross was raised in the late 1860s. A committee comprising local businessmen and members of the Hurst Local Board, under the chairmanship of Handel Wallwork, arranged for the collection of subscriptions, the release of the necessary land from the Earl of Stamford, and the design of the cross. The foundation stone was laid by Oldham Whittaker on Easter Monday, 1868, in a colourful ceremony which concluded with a dinner for 170 gentlemen at the Hurst Mechanics' Institute. Whittaker, with

his brother John, was the largest employer in Hurst. Besides commemorating the earlier cross, it was suggested that the new cross might be associated with the recent extension of parliamentary democracy following the passing of the Reform Act. The cross, designed by the Ashton architect, John Eaton, was welcomed as an improvement in a community increasingly conscious of its identity and status. The cross itself was erected within four months, but it was not until October 1869 that the Hurst Memorial Cross Committee finally handed it over it to the Hurst Local Board. The finished memorial was surrounded by railings and included a lamp which illuminated this important junction.[2] At their final meeting the members of the memorial committee congratulated themselves on raising the £120 to provide their village with this improvement, taking particular satisfaction in the fact that 'it was not a Hartshead Pike affair', that is, a memorial that was only half paid for and half-finished.[3] In later years the number of lamps surrounding the cross was increased to four. The cross remained in its original position until 1983, when changes in the road layout caused it to be moved a short distance.[4] The original railings have not survived.

Notes
[1] *Ashton Reporter*, 18 April 1868. [2] *Ibid.*, 9 October 1869. [3] *Ibid.*, 16 October 1869; Revd W. Augustus Parry, *History of Hurst and neighbourhood* (Ashton-under-Lyne, 1908) pp.93–5. [4] *Ashton Reporter*, 16 September 1983.

HYDE

Market Street

Pull the Plug, Ring the Change
Stephen Broadbent

28 November 2002
Bronze figures; cast aluminium pedestal
Figures 2.13m high approx; pedestal 3.56m ×

1.26–1.8m × 39 cm

Inscriptions: on the banner linking the two figures are the phrases, front: Pull the Plug; Ring the Change – rear: Chartists of Hyde The pedestal includes twelve inset panels, six on each side, inscribed with information and illustrations relating to the history of the nineteenth-century working class. The themes are: front: 1802 The Health and Morals of Apprentices Act; 1819 The Factory Act; 1833 Althorp's Factory Act; 1847 The Fielden's Act; 1853 Act; 1875 Act. – rear: Our Gratitude; Hyde Chartists; Six Point Charter; 19th Century Working Conditions; Children and Women; Chartist Movement

Status: not listed
Condition: good
Owned by: Tameside Metropolitan Borough Council

Description: Two larger than life-size bronze figures of a young boy and girl who are shown running. The boy is holding a boiler plug in his right hand whilst his left hand reaches out towards the outstretched left arm of the running figure of the girl, who is ringing a handbell in her right hand. The figures are naked but covered by a banner which links them together. They surmount a curved and rising steel pedestal, made up of six sections bolted together.

Following the completion of *Colonel Duckenfield* in Dukinfield Park in 1996, Stephen Broadbent put forward the idea of another sculpture. It was intended that it would be, as with the previous sculpture, a part of the council's programme of landscape improvements associated with 'Britain in Bloom'. The new sculpture celebrated the radical politics of the district, especially its involvement in the Chartist movement. It was to be located in Hyde. The idea found approval among some of the leading members of the council, but it did not progress further at that time. The project was returned to at the time of

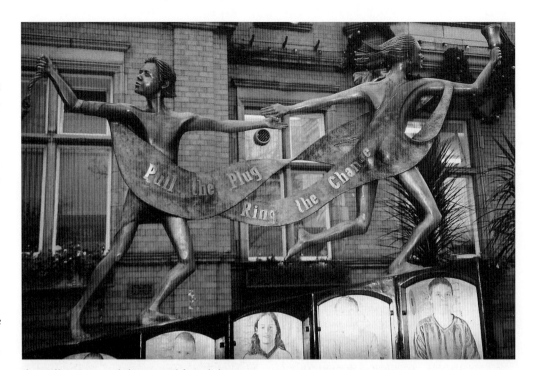

Broadbent, *Pull the Plug*

the Millennium, and the council found the necessary funds to commission Broadbent to produce the work he had proposed some four years earlier. It depicted two young people, one holding the plug from a factory boiler, and the other a handbell. The removal of plugs from factory boilers had been a defining act in the industrial protests of 1842, a protest dubbed by the authorities as the plug riots.[1] The handbell was a reference to one used by local Chartists to call public meetings. When the scheme was made public, there was some opposition, criticisms centring on its cost, some £90,000, and on the appropriateness of a sculpture which celebrated acts of civil disobedience. As the project developed, Broadbent involved local schoolchildren, eventually reproducing images of six of them, aged from six to fourteen years old, on the pedestal. It was also decided to include information and illustrations about working conditions and Chartism on panels which would be featured on the pedestal. Harry

Lever assisted with the historical research. The bronze sculpture was cast at Tanat Art Foundry in Powys and the pedestal at the Leander foundry in Dove Holes, Derbyshire. It had been originally decided that the work would be located close to the market in Hyde. Various sites were considered in the vicinity, before it was agreed to place it in front of the town hall, facing the market.[2]

The sculpture was unveiled by the leader of Tameside Council, Roy Oldham, and by the former local MP, Lord Tom Pendry. It was praised by Councillor John Bell, who had previously criticised the project, as a valuable addition to the town and a novel way of remembering its history. Councillor Frank Robinson also recognised that the work represented an important and necessary reminder of the part that workers had played in

establishing modern democracy, rights, he added, that people now took for granted.[3]

Notes
[1] The historical information provided on the sculpture refers mistakenly to 1848. [2] Information from Philip Rogerson, Education and Cultural Services, Tameside Council and Stephen Broadbent. [3] *Tameside Advertiser*, 5 December 2002; *Tameside Reporter*, 5 December 2002.

Victoria Street, Newton

Victoria Street and Cartwright Street

Victoria Street War Memorial
Wiloughby, Wilde and Sons

13 March 1920
Portland stone; sandstone pedestal
Statue 1.94m high approx; pedestal 3.65m high approx × 1.22m square
Signed: Wiloughby Wilde & Sons, Hyde
Inscription: front: ERECTED / BY THE RESIDENTS / OF VICTORIA STREET AND / DISTRICT, / IN HONOUR OF THE MEN / WHO ANSWERED THEIR / COUNTRY'S CALL. / THE BATTLE FOUGHT THE VICTORY WON / UNVEILED AND DEDICATED BY / ALDERMAN TURNER MARCH 13TH 1920. – rear: FRATERNITY and names – left: LIBERTY and names – right: PATRIOTISM and names
Status: not listed
Condition: poor
Owned by: Tameside Metropolitan Borough Council
Description: War memorial; a life-size stone statue of a soldier holding a rifle across his chest, surmounting a stepped pedestal. On three sides of the pedestal are the names of the soldiers from the district who fought in the war.

The idea of erecting a memorial in the Victoria Street district of Dukinfield was first discussed in August 1917. A committee was established, funds raised and a memorial commissioned from the stonemasons, Wiloughby, Wilde and

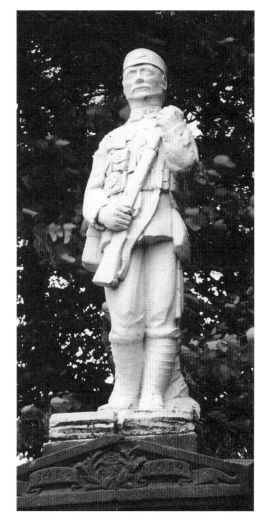

Victoria Street War Memorial

Sons. It was located at the junction of Victoria Street and Cartwright Street, the site having been presented by Alderman H.G. Turner. The memorial was not of the highest quality, either in terms of the material used or the carving; it only cost £282. Alderman Turner unveiled the memorial in March 1920. It is a revealing example of the district war memorials erected

throughout the cotton towns, although it was somewhat unusual in featuring a sculptural figure. On a number of occasions the memorial has been damaged, which may explain the rather incongruous face and hat of the present soldier.

Werneth Low Country Park

Hyde War Memorial
J. Whitehead and Sons

25 June 1921
Cornish granite
8.38m high; 3.81m square at base
Inscription on front of base: THE GREAT WAR / 1914–1919 – rear: IN MEMORY OF / THE MEN AND WOMEN OF HYDE / WHO LOST THEIR LIVES IN THE WAR / 1939–1945 – left-hand side: IN HONOUR / OF THE 710 MEN / OF HYDE WHO GAVE / THEIR LIVES FOR / KING AND COUNTRY – right-hand side: THEY WILLINGLY LEFT / THE UNACHIEVED PURPOSE / OF THEIR LIVES IN ORDER / THAT ALL LIFE SHOULD / NOT BE WRENCHED / FROM ITS PURPOSE.'
Status: Grade II
Condition: good
Owned by: Tameside Metropolitan Borough Council and Hyde War Memorial Trust
Description: War memorial; a granite obelisk sited at Hackingknife, Werneth Low, a hillside overlooking Hyde. The obelisk is in five sections and surmounts a square base; both obelisk and base are pick dressed. Inscriptions are included on the four sides of the base. The principal inscription is beneath a bronze coat of arms of the borough.

Discussions about erecting a war memorial in Hyde began in the winter of 1919–20. An ambitious scheme was agreed upon: it included the purchase of part of Werneth Low, an area of moorland on the edge of the town, the creation of a maternity home, education scholarships for the children of soldiers, and the commissioning

of a war memorial.[1] It was estimated that £12,500 would be needed to realise the full scheme. Although there were some dissenting voices about the suitability of Werneth Low as a site for the memorial – it was felt that a more central location such as the market place might be more appropriate – the scheme went ahead. This was in large part due to the mayor, Councillor E. Bury, who opened the war memorial fund with the announcement of donations totalling £7,000, £5,000 of which had been given by eight individuals. Bury's collecting policy was simple: 'He did not ask for small amounts, he was hunting big game'.[2] Moreover, the memorial fund was only to be opened for a limited period of time. Before the end of May the mayor was congratulating the people of Hyde for donating nearly £14,000. Some £4,000 was used to purchase the land between the Old Mottram Road and Werneth Low Road to create a memorial park for 'the resort and recreation of the inhabitants of Hyde, and for promoting the health of the community'.[3] Advertisements for designs for a war memorial attracted 40 entries, from which the entry submitted by the London firm of J. Whitehead and Sons was selected. They proposed a granite obelisk, a rather unremarkable design that owed everything to its intended position, high on the hillside above the town. The granite was to come from the same Cornish quarry that had provided the stone for the London Cenotaph.

Over 12,000 people attended the unveiling ceremony in June 1921. Five oak panels on which the names of the borough's dead had been recorded were brought from the town hall and placed around the foot of the memorial.[4] Mrs Evelyn Welch, the mayoress from 1914 to 1916 and founder of the Tipperary League, unveiled the memorial.[5] The final cost of the memorial was £2,000. The obelisk was surrounded by plain metal railings decorated with corner wreaths, painted red. A plaque commemorating the military and civilian dead of the Second World War was added in 1963.[6]

In 1979 the memorial land became part of Werneth Low Country Park, operated by Tameside Council and the Hyde War Memorial Trust. A small exhibition in the park's visitor centre relates the history of the war memorial.

Notes
[1] *Hyde Reporter*, 28 February 1920. [2] *Ibid.* [3] Hyde Memorial Trust Deed. [4] The panels, presented by Stanley Welch and T. Owen Jacobsen, had been commissioned during the war; see M. Pavasovic, *The War Memorials of Hyde* [typescript in Tameside Local Studies Library]. [5] *Hyde Reporter*, 2 July 1921. [6] *North Cheshire Herald*, 10 May 1963.

MOTTRAM-IN-LONGDENDALE

Church Brow

Mottram Cemetery

Lawrence Earnshaw Memorial

John Eaton

10 April 1868
Huddersfield stone
4.90m high approx; 76cm square base
Signed on base: John Eaton / Ashton
Inscription: on front of base: LAWRENCE EARNSHAW / MOTTRAM / DIED MAY 12TH 1767, / AND WAS BURIED IN THE / ADJOINING CHURCHYARD. – rear: BY HIS SKILL IN GEOMETRY / AND / ACQUIREMENTS AS A MECHANICIAN / HE DESIGNED AND CONSTRUCTED / AN ASTRONOMICAL CLOCK / REGISTERING THE REVOLUTIONS / OF THE HEAVENLY BODIES AND / THE FLOW OF THE TIDES. – left-hand side: A SELF TAUGHT GENIUS AND / OF HUMBLE BIRTH, HIS TALENTS / AS AN INVENTOR ANTICIPATED / BY MANY YEARS THE DISCOVERIES / OF OTHER EMINENT MEN. – right-hand side: A CENTURY AFTER HIS DECEASE / THE ADMIRERS OF HIS GENIUS / AND WORTH / ERECTED THIS MEMORIAL. / A.D. 1867.

Status: not listed
Condition: poor
Owned by: Tameside Metropolitan Borough Council
Description: A tapering octagonal column ending in a capital decorated with carvings of a telescope, a pair of compasses, a pinion wheel and an hour glass. The whole is surmounted by a celestial globe and a plain cross (now missing).[1] The square base is inscribed on all sides.

Lawrence Earnshaw, clock-maker and inventor, was born in 1707 at Mottram, the son of weavers. He was apprenticed to a clothier at Stalybridge for seven years and then served a further four years as an apprentice tailor. By this time Earnshaw was known for making clocks and machines, including a spinning machine which antedated Hargreaves' and Arkwright's inventions. Earnshaw is said to have destroyed his spinning machine because he felt that it would ruin manual labour. His most famous invention was an astronomical clock, which reproduced the annual and diurnal rhythms of the earth. Despite attracting the attention of the aristocracy (Lord Bute bought one of his clocks), he died in 1767 in poverty and was buried in an unmarked grave in the churchyard of St Michael and All Angels, Mottram.[2] His life and talents, however, were not to be forgotten. Indeed, before the end of the eighteenth century Earnshaw was being lauded in the *Gentleman's Magazine* and other publications as an example of the struggling and unselfish working-class inventor.[3]

Interest in 'the Mottram genius' was revived by an article in the *Ashton Reporter* of 16 March 1867 by the Chief Constable of Stalybridge, William Chadwick. The article was based on an earlier tribute that Chadwick had written about Earnshaw in his book, *Reminiscences of Mottram*. The resulting correspondence in the *Ashton Reporter* suggested that 'the people of Mottram are duty bound to do something at the centenary of his

death which will rescue the name of Lawrence Earnshaw from the position in which it has been allowed to fall'.[4] A public meeting was suggested with a view to establishing a memorial, and on 30 March a memorial in the form of a marble tablet was proposed.[5] However, the *Reporter* suggested that since Earnshaw had died a pauper, it would be fitting to erect a proper monument over his grave. A meeting was eventually held on 13 May 1867, the day after the centenary of Earnshaw's death, and memorial committees were established in Mottram, Stalybridge and Ashton.[6] These met with different levels of support. Although the committee in Stalybridge was 'very active', the one in Ashton 'came to grief'. Donations came in, however, from Hadfield, Stalybridge and Rochdale. A donation of three guineas from Robert Platt of Stalybridge was one of the largest in the £60 collected. The Ashton architect, John Eaton, designed the memorial. The vicar of Mottram, the Revd William Henry Jones, was less enthusiastic about the veneration of a man who had, according to legend, preferred to mend clocks rather than go to church. He not only suggested that the money would be better spent on the debts of the parish church, but ridiculed Earnshaw because he had destroyed his pioneering spinning machine. If they wanted to perpetuate his memory, they could have done this more effectively by 'erecting a public pump in the Market Place' than by building any 'costly monument or princely cenotaph'.[7] Such views were probably not a surprise to a number of Jones's parishioners who had become increasingly critical of his autocratic behaviour and attitudes. The vicar's antipathy probably explains the fact that the monument was finally built, not in the parish churchyard, but in the adjacent cemetery, which belonged to the Mottram Burial Board. The decision to unveil the memorial on Good Friday, 1868, was taken in part with Jones in mind.

The ceremony attracted 'thousands of people'. Notable in the mile-long procession was a large contingent of Orangemen, carrying an eye-catching banner showing William of Orange crossing the Boyne. Everybody 'except the rector seemed to be in good temper and genial spirits'.[8] Jones had followed his attack on Earnshaw by complaining to the local magistrates and the Home Office. It was said that he had scheduled a service to coincide with the unveiling, so that he could claim authority to clear the churchyard where the crowds were gathering. On leaving the church to accomplish this task, he was supposed to have struck a man 'who appeared to be a labourer or a navvy, upon which the man returned the compliment, knocking the vicar's hat off and finally bringing him to the ground'.[9] At the dinner following the unveiling, Earnshaw's memory was drunk to, and the press thanked for their part in reviving the memorial scheme. Councillor Lees recalled that about 30 years previously a memorial had been mooted, but the idea had fallen away. The difference now was that the press was able to assist, and had ensured the completion of the scheme. The Reverend Jones's view of the ceremony was less complimentary as he recalled a day of shame for Mottram: a day in which he had been assaulted and the cemetery 'invaded by roughs from Stalybridge, Hyde and Ashton, and dancing going on in the churchyard to the tunes played by the band outside'.[10] During the twentieth century the monument has become neglected, parts of the stonework have fallen off, and the railings, which once surrounded it, have been removed.

Notes
[1] The illustration of the memorial in W. Chadwick's *Reminiscences of Mottram* shows the cross.
[2] W. Chadwick, *Reminiscences of Mottram* (Stalybridge, 1882) pp.24–30; M. Duckworth, 'Lawrence Earnshaw. A remarkable clockmaker', *Journal of British Astronomical Association*, 78, No.1 (1967) pp.22–7. [3] J. Aikin, *A Description of the Country from Thirty to Forty Miles Round Manchester* (London: J. Stockdale, 1795) pp.466–8. [4] *Ashton Reporter*, 23 March 1867. [5] *Ibid.*, 30 March 1867. [6] *Ibid.*, 18 May 1867. [7] *Ibid.*, 18 April 1868. [8] *Ibid.* [9] *Ibid.* [10] *North Cheshire Herald*, 18 April 1868.

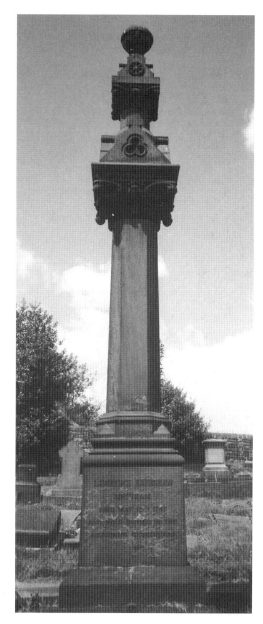

Lawrence Earnshaw Memorial

Warhill

Sundial

Restored 1897
Sandstone
3.66m high approx
Inscription: on plinth: RESTORED / IN COMMEMORATION OF / THE SIXTIETH YEAR / OF THE REIGN OF / QUEEN VICTORIA / 1897 – front face of sundial: Hora Pars Vitae – rear face of sundial: Watch and Pray / Time Hastens Away / When Time Is Done / Eternity Comes On
Status: Grade II
Condition: fair
Owned by: Tameside Metropolitan Borough Council
Description: Sundial; a tapering stone octagonal shaft on a moulded base, rising from a circular ashlar plinth and surmounted by a cubical sundial with three copper faces, of which two are inscribed.

It is widely assumed that the present sundial stands on or close to the site of the Mottram Cross. However, both the documentary and archaeological evidence of an older cross is slight.[1] Writing shortly after the erection of the present monument, Thomas Middleton repeated the local tradition that the cross was erected in or about 1760, but noted that there appeared to be some confusion whether this referred to the Mottram Crown Pole, which was also raised to commemorate the coronation of George III.[2] Aikin, or more likely Stockdale, who had first-hand knowledge of Mottram, noted the existence of an ancient cross by the churchyard in the much-quoted volume of 1795.[3] Notes made by John Wagstaffe, churchwarden at St Michael's, state that the sundial was the work of a Mr Wardleworth.[4] The sundial was erected to commemorate Queen Victoria's Diamond Jubilee in 1897 and was placed a short distance from where the old cross stood. It was paid for by 'a few private

subscribers'.[5] The monument was restored for the Queen's silver jubilee in 1977.[6]

Notes
[1] J.P. Earwaker, *East Cheshire: Past and Present* (London, 1880) Vol.II, p.137; M. Nevell, *Tameside 1066–1760* (Tameside Metropolitan Borough Council, 1991) p.101. [2] T. Middleton, *Annals of Hyde and District* (Manchester: Cartwright and Battray, 1899) p.310. [3] J. Aikin, *A Description of the Country from Thirty to Forty Miles round Manchester* (London: J. Stockdale, 1795) p.458. [4] Annotated copy of Middleton's *Annals*, information from Mrs Joyce Powell. [5] Middleton, *op. cit.* [6] Newspaper cutting dated 21 October 1977.

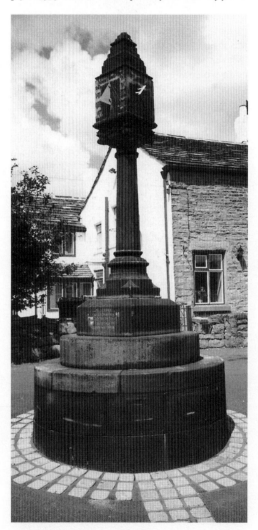

Sundial

STALYBRIDGE

Gorse Hall Drive

Gorse Hall

Breaking the Mould

Andrew McKeown

2000
Reconstituted stone; cast iron
Stones 1.9m × 58cm × 68cm, 50cm × 1.06m × 89cm; seed 75cm high × 1m long
Status: not listed
Condition: fair
 Description: Cast-stone sculpture in five sections, arranged on the ground. Two of the blocks are standing upright, a third is horizontal on the ground. The fourth is also horizontal but this has been split into two pieces. Each block reveals the impression of a large seed. On the ground in the middle of the blocks is a large iron egg-shaped seed that has emerged out of what was clearly once a single stone.

Gorse Hall takes its name from the house that used to stand on the land. New Gorse Hall was demolished before the First World War and over the years the land, which offered splendid views of the Pennines, had become derelict. Gorse Hall was one of the 21 sites in England and Wales selected to be transformed by the environmental regeneration charity, Groundwork UK. The Changing Places project included public sculpture and, as at the other sites, a copy of Andrew McKeown's six-piece cast stone and iron sculpture, *Breaking the Mould*, was installed.[1] It was placed on an open

area of ground, but unlike the version in Manchester the stone was coloured white rather than red.[2]

Notes
[1] Groundwork Trust, *Changing Places. Breaking the Mould* (Birmingham, Groundwork UK [2001]).
[2] See above. p.142.

Stamford Street

Stamford Street and Rassbottom Street

Thompson Cross

Architect: John Eaton

Sculptor: William L. Hindle

2 June 1893
4.88m high approx; base diameter 1.93m
Signed on lower step: W. L. Hindle, Monumental Sculptor, Stalybridge
Inscription: on cross: THOMPSON / CROSS – on steps: RE-ERECTED 1893. UNVEILED BY MISS MARY HARRISON OF WEST HILL [followed by names of the committee]
Status: not listed
Condition: fair
Owned by: Tameside Metropolitan Borough Council
Description: Cross; a plain stone cross surmounting a circular pillar, rising from a circular stepped base.

The Thompson Cross of 1893 was erected near the site of what was possibly an ancient boundary cross. Its last fragment was removed from the bottom of Ridge Hill Lane by Thomas Harrison early in the nineteenth century, and kept in the grounds of his house which was named Thompson Cross.[1] Taylor speculated that it might have been a boundary cross, whilst other sources associate it with the Revd William Thomson, Vicar of Ashton from 1535 to 1553.[2] The base of the old cross was later placed in the neighbouring Stamford Park. The promoters of a new cross were the Chief Constable of Stalybridge and local antiquarian, William

Chadwick, who had also been the moving spirit behind the Lawrence Earnshaw memorial in Mottram, and Alderman Emmett. A committee was formed at a public meeting on 6 July 1891

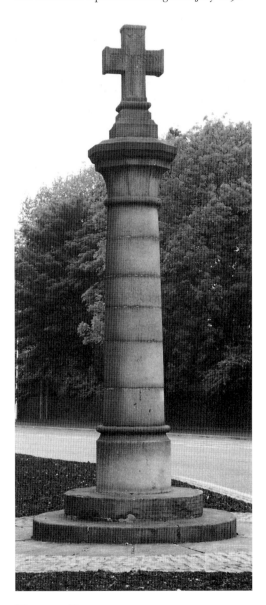

Thompson Cross

to supervise the restoration, but it met with little popular enthusiasm.[3] It was, the *Ashton Reporter* commented, 'hardly a movement calculated to hit the popular taste, whose tendencies are practical rather than sentimental'. Memories of the original cross were also sketchy. Not only had the cross disappeared, but so had any traditions and history associated with it. There was, then, 'next to nothing to appeal to the imagination or sympathy of the inhabitants'.[4]

The restoration of the cross was a conscious attempt to link Stalybridge with its past. Chadwick's speech at the unveiling began with the admission that 'it has been said that Stalybridge has no history of its own', which, he conceded, was 'true to a considerable extent', since it was usually subsumed in the histories of neighbouring communities.[5] The secretary of the restoration committee, Mr Saville, also said that, although Stalybridge was 'somewhat lacking in relics of the past', they had nevertheless restored one of them, and 'if it did not represent all that they might have done in the way of ornament, it embodied to some extent their characteristics of sturdiness and industry – (Applause)'. Miss Mary Harrison, the great-granddaughter of the man who had removed the last remnant of the original cross, was called upon to perform the unveiling. The cross was the work of the local monumental sculptor, William Hindle.[6] Changes to the road junction in the 1980s necessitated moving the cross a short distance from its original position.

Notes
[1] The Ordnance Survey plan (1894) identifies the junction as Thompson's Cross. [2] H. Taylor, 'The ancient crosses of Lancashire', *Transactions of Lancashire and Cheshire Antiquarian Society*, 16 (1898) p.51; J. Cassidy, 'A guide to Stamford Park', in S. Harrop and E.A. Rose (eds), *Victorian Ashton* (Tameside Libraries and Arts Committee, 1974) p.56. [3] *Stalybridge Reporter*, July 1891. [4] *Ashton Reporter*, 3 June 1893. [5] *Ibid.* [6] *Slater's Directory of Ashton-under-Lyne, Dukinfield, Hyde and Stalybridge* (Manchester, 1888) lists Hindle as a monumental mason, High Street, Stalybridge.

Trinity Street

Victoria Bridge

Stalybridge War Memorial
Ferdinand Blundstone

6 November 1921; extension 23 April 1950
Bronze sculptures; limestone walls and
 pedestals; granite panels
Statue 2.44m high; pedestal 2.8m high; wing
 walls 1.5m high approx
Signed: on plinth: F.V. BLUNDSTONE
Inscriptions on naval pedestal: 1914–1918 /
JUTLAND. / ZEEBRUGGE. / THE FALKLAND
ISLES. / REMEMBER THE LOVE OF THEM WHO /
CAME NOT HOME FROM THE WAR. / SEE YOU
TO IT THAT THEY SHALL / NOT HAVE DIED IN
VAIN. – army pedestal: 1914–1918 / THE
MARNE / YPRES / THE SOMME / ALL YOU WHO
PASS BY / REMEMBER WITH GRATITUDE / THE
MEN OF STALYBRIDGE / WHO DIED FOR YOU –
new pedestal: 1939–1945 / ON LAND ON SEA
AND IN THE AIR / AT HOME AND ABROAD
'NOW HEAVEN IS BY THE YOUNG INVADED/
THEIR LAUGHTER'S IN THE HOUSE OF GOD.'
Status: Grade II*
Condition: fair
Owned by: Tameside Metropolitan Borough
 Council
Description: War memorial; bridgehead,
symmetrical composition, with one side
dedicated to the army and the other to the navy.
Bronze sculptures are mounted on the two main
pedestals facing each other on either side of
Trinity Street. From these pedestals curved wing
walls extend outwards, before ending in smaller
pedestals surmounted by lions. The principal
pedestal on the east is surmounted by a bronze
composition of an angel ministering to a dying
barefoot sailor, whose cap by his side bears the
name 'Good Hope'. In her outstretched left
hand she is holding an eternal flame. The ashlar
pedestal is decorated with the borough's coat of
arms, beneath which are the dates of the war,
the names of battles and the charge that the

people guard the peace. The curved wall, inset
with granite tablets on which are inscribed the
names of the fallen, terminates in a pedestal
surmounted by a lion couchant. This pedestal is
inscribed with the names of military campaigns:
FRANCE, PALESTINE, MESOPOTAMIA, EGYPT, E.
AFRICA. On the west side the main pedestal is
surmounted by the bronze figure of an angel
ministering to a dying soldier. The pedestal is
again decorated with the borough's coat of
arms, beneath which are the names of battles in
France and the call to remember those who
died. Originally the wing wall terminated, as on
the opposite side, in a smaller pedestal
surmounted by a lion couchant. It was
inscribed FLANDERS, GALLIPOLI, SALONIKA,
ITALY, S. W. AFRICA. It was extended as a
memorial to the dead of the Second World War.
The extension consisted of a further section of
low wall which was linked by bronze railings,
incorporating the borough's coat of arms, to the
original memorial. The lion couchant was
moved to the pedestal at the end of the new
wall.

More than 620 servicemen from Stalybridge
died in the First World War. The idea of
erecting a public memorial to them began to be
discussed shortly after the end of the war, and,
as in other communities, a memorial committee
was soon established to resolve the questions of
the type of memorial, design and location. The
decision to site the memorial by Victoria Bridge
proved to be a decisive factor both in
determining the design and in providing the
town with a war memorial that could also be
regarded as a civic improvement. The choice of
the London-based but Stalybridge-born artist,
Ferdinand Blundstone, was another decision
which was generally welcomed. His proposal
for a memorial with two focal points, in the
form of two bronze sculptural compositions,
one dedicated to the army and the other to the
navy, on the bridge, flanked by a low wall on
either side, met with general approval when
reproduced in the press. A model of the

intended memorial was displayed at the public
library.[1] The statuary depicting a dying soldier
and sailor respectively, being taken into the
arms of angels, was also well received. It was a
subject that was far from common among
British war memorials, although Blundstone
did reprise elements of the design for the
Prudential Assurance Company in Holborn,
London.[2] The memorial was all the more
impressive because of its central location, facing
the town hall (demolished in 1989). The
collecting of funds does not appear to have been
hampered by the problems experienced in some
cotton towns, and within a few months
subscriptions totalled over £5,000. Since the
estimated cost of the scheme was £4,200, a
surplus was available for 'furthering the
education and interest generally of children of
the fallen'.[3]

Nearly 24,000 people attended the unveiling

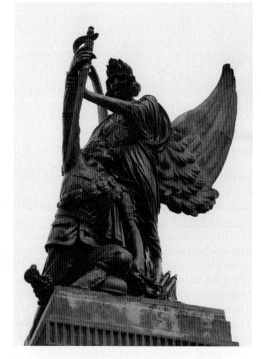

Blundstone, *Stalybridge War Memorial (detail)*

in November 1921, a figure nearly equal to the post-war population of Stalybridge. The *Ashton Reporter* commented that 'never in the history of Stalybridge had there been such a gathering of people'. The unveiling of the naval pedestal was performed by 'the War Mayor' James Bottomley, whilst the army pedestal was unveiled by the current mayor, Ada Summers.[4] The memorial was dedicated by the Rural Dean of Mottram, Revd Canon T.H. Sheriff. Two former privates of the Cheshire Regiment, Joseph Lowden and Henry Roberts, both of whom had been blinded in the war, laid the first wreaths. Soon after the ceremony the whole base of the wall (some thirty metres) was covered with wreaths and flowers. One wreath, from the employees of the Joint Board, carried the poignant message, 'These men played the game'. In accepting the memorial on behalf of the town, Ada Summers made a promise to protect it

> as our proudest possession, not for its beauty, which is wonderfully great, but for that which it represents – the courage and devotion to duty, and the fine spirit of self-sacrifice of all those men of Stalybridge whose names, carved in granite, tell to all who pass this way that they died that we might live ourselves.[5]

The symmetry of the original monument was altered when the army side was extended to incorporate a memorial to the dead of the Second World War. The pedestals in the new section of wall were inscribed with lines from Katherine Tynan's poem 'Flower of Youth'. A small garden of remembrance was also included as part of the new design. The extension, costing £2,400, was unveiled in April 1950 by Mrs Gertrude Monday, who had lost her husband in the First World War and her son in the Second World War. The ceremony attracted a noticeably smaller attendance than the one in 1921. The Stalybridge memorial is one of a small number of structures, and the only war memorial, with a Grade II* listing in Tameside.

Notes
[1] *Ashton Reporter*, 13 September 1919. [2] A. Borg, *War Memorials from Antiquity to the Present* (London: Leo Cooper, 1991) p.112.; S. Bradley and N. Pevsner, *London I. The City of London* (Harmondsworth: Penguin, 1997) p.518. [3] *Stalybridge Reporter*, 12 November 1921; D. Boorman, *At the Going Down of the Sun. British First World War Memorials* (York: Ebor Press, 1988) pp.92–3. [4] *Stalybridge Reporter*, 12 November 1921. [5] *Ibid*.

Stalybridge Library

Robert Platt
John Warrington Wood

6 February 1871
Marble
82cm high
Signed: signature not visible

Robert Platt, textile manufacturer, was born in Stalybridge on 11 November 1802, the son of a cotton manufacturer. He was educated in Chester, and entered the family firm as a clerk and manager at the Bridge Street Mill. On the death of his father in 1831 he assumed sole control of the business. He married Miss Margaret Higgins of Salford in 1839. Platt was well known for philanthropic activities in Stalybridge and Manchester, being a patron of the arts, a supporter of the local mechanics' institute, local churches and Owens College. Stalybridge owed its public baths to Platt. He died on 13 June 1882 and was buried in St. Paul's Church, Stayley.

The busts of Robert and Margaret Platt were paid for by public subscription among the inhabitants of Stalybridge, to mark their gift to the town of the public baths. Some £250 was subscribed in amounts varying from two shillings to £10. The commission was given to the Lancashire-born sculptor, John Warrington Wood, who resided in Rome.[1] Accepting the two busts on behalf of the town the Mayor declared them to be 'beautiful models of the generous donors'. Alderman Kirk, who unveiled the busts, agreed that they were 'very good specimens of art', but added that Platt's likeness was not so good as that of his wife.[2] The busts were originally displayed in the entrance area of the public baths. When the baths were closed in the early 1980s they were moved to the public library, where they are now displayed in the local studies room.

Notes
[1] T. Wilmot, 'John Warrington Wood, Sculptor', *Magazine of Art* 14 (1891) pp.136–40. [2] *Ashton Reporter*, 11 February 1871.

Mrs Robert Platt
John Warrington Wood

6 February 1871
Marble
82cm high
Signed: J. Warrington Wood Sculp Rome 1870

Margaret Platt was born in Salford in 1818, the daughter of a machinist. She married Robert Platt of Stalybridge in September 1839. Margaret participated in her husband's philanthropic activities and is said to have earned herself the title 'the Queen of Kindness'. She and her husband were honoured by Platt's workforce in December 1857 with a tea party and presentation at the Foresters' Hall, at which Mrs Platt was presented with a silver inkstand by the workers. Her husband paid her tribute on this occasion, saying that in her the people of Stalybridge 'have always had a warm friend, ever desirous to promote your good and happiness'.[1] She died in 1888.

Note
[1] S. Hill, *Bygone Stalybridge: Traditional, Historical, Biographical* (Stalybridge: Whittaker, 1907) pp.231–3; *Ashton Reporter*, 11 February 1871.

Charity
John Henry Foley

1861, relocated 1968, 2000
Carrara marble
1.22m high approx × 1.83m wide approx
Signed: J. H. Foley R.A. London 1861
Inscription (now destroyed): SACRED TO THE
MEMORY OF JOHN WHITTAKER OF HURST
HOUSE WHO DEPARTED THIS LIFE ON THE
14TH OF SEPTEMBER, 1840, IN THE 65TH YEAR
OF HIS AGE, AND WAS INTERRED IN ST PETER'S
CHAPEL, OLDHAM. / HE CAME TO THIS
VILLAGE IN THE YEAR 1806, AND COMMENCED
BUSINESS AS A MANUFACTURER. HIS
INTEGRITY AND PLAIN DEALING SECURED HIM
UNUSUAL CONFIDENCE AND RESPECT, WHICH,
ALONG WITH HIS INDUSTRY AND
PERSEVERANCE RENDERED HIM EMINENTLY
SUCCESSFUL. / AS AN EXTENSIVE EMPLOYER OF
LABOUR, HE CHERISHED A DEEP SOLICITUDE
FOR THE WELFARE OF HIS WORKPEOPLE. HE
WAS AN EARNEST PROMOTER OF EDUCATION;
A ZEALOUS ADVOCATE FOR THE DIFFUSION OF
KNOWLEDGE; AND AN INFLUENTIAL LEADER
IN THE CAUSE OF SUNDAY SCHOOLS. / THE
FIRST SUNDAY SCHOOL IN HURST WAS
FOUNDED BY HIM, AND IT WAS HE WHO
ERECTED THE FIRST PLACE OF WORSHIP HERE.
BUT WHILE CONSTANTLY DEVOTING HIMSELF
WITH ESPECIAL INTEREST TO THOSE ABOUT
HIM, HE NEVER FORGOT OTHERS. TO THE
CLAIMS OF CHARACTER, WHEREVER
EXPRESSED, HIS HEART WAS ALWAYS OPEN. TO
ADVANCE THE SOCIAL AND RELIGIOUS
CONDITION OF HIS NEIGHBOURS WAS ONE OF
HIS GREATEST JOYS. WHILE HE LIVED, HIS
UNIFORM KINDNESS AND BENEVOLENCE WON
THE ESTEEM OF ALL CLASSES, AND WHEN HE
DIED THERE WAS GREAT LAMENTATION. / 'HE
BEING DEAD YET SPEAKETH.'
SACRED ALSO TO THE MEMORY OF HANNAH,
HIS DEARLY BELOVED WIFE, WHO DEPARTED
THIS LIFE ON 26TH OCTOBER 1832, IN THE
53RD YEAR OF HER AGE, AND WAS INTERRED
IN THE SAME GRAVE. / SHE WAS AN
AFFECTIONATE PARTNER, A TENDER AND
DEVOTED MOTHER, A SINCERE AND CONSTANT
FRIEND. AMIABLE IN DISPOSITION, MODEST
AND RETIRING IN DEMEANOUR, SHE WAS
REVERED BY HER FAMILY AND BELOVED BY
ALL WHO KNEW HER. / TO DO GOOD THOUGH
UNSEEN WAS HER DELIGHT. HER ACTS OF
PIETY AND BENEVOLENCE WERE WRITTEN ON
THE HEARTS OF THE POOR AND NEEDY. SHE
WAS EYES TO THE BLIND AND FEET TO THE
LAME. / THE BLESSING OF HIM WHO WAS
READY TO PERISH CAME UPON HER, AND HE
CAUSED THE WIDOW'S HEART TO SING FOR
JOY. FOR MANY YEARS SHE WAS AN
EXEMPLARY MEMBER AND AN ORNAMENT OF
THIS CHURCH. THE PUREST VIRTUES
ADORNED HER CHARACTER AND CAST LUSTRE
UPON HER PIOUS AND USEFUL LIFE. SHE
LIVED AND DIED A CHRISTIAN.[1]

Status: not listed
Condition: poor; broken in several places and
severely damaged in fire, inscription
destroyed
Owned by: in trust to Tameside Metropolitan
Borough Council
Description: Marble panel; composition of
eight figures, in which John and Hannah
Whittaker are shown, seated, in the act of
dispensing charity. John Whittaker is
presenting a Bible to a young child whose
mother kneels beside him, while his proud
father, a muscular workman dressed in his
working clothes with his sleeves rolled up,
presumably a Whittaker employee, looks on. In
front of him stands his daughter holding a
book, presumably a Bible. To the left of this
family group is a young girl leading away a
blind woman, who has been given a shawl by
Hannah Whittaker. The lengthy inscription
(destroyed by fire) emphasised the Whittakers'
concern to promote the welfare of their
employees and the wider community.

The success of John Whittaker (1776–1840) as a
cotton manufacturer was responsible for
transforming Hurst into a distinctive industrial
community. Whittaker was by far the largest
employer in Hurst, and his paternalistic
attitudes meant that his influence stretched far
beyond the factory gate.[2] His sons, John and
Oldham Whittaker, continued to expand the
family business following their father's death. A
Methodist New Connexion Chapel, situated in
Queen's Road, opened in 1846 and extended in
1857, was one of the more visible social
institutions which benefited from the family's
money. It was in the chapel that the younger
John Whittaker (1804–64) placed a memorial to
his parents.[3]

John Henry Foley, already acknowledged as
one of the country's most talented sculptors,
was commissioned to provide the memorial.
Foley had recently completed a much-admired
portrait statue of Sir Charles Barry. The marble
bas-relief epitomised paternalistic philanthropy,
a tableau of eight figures in which John and
Hannah Whittaker were shown personally
dispensing charity. It was believed locally that
Foley had based some of the figures on workers
whom he had met during a visit to Hurst. The
memorial cost £2,000.[4]

Charity remained in the Queen's Road Methodist New Connexion Chapel, Hurst until 1968 when the impending demolition of the chapel led to its removal to St John's School. The school was then being converted into the village community centre. Mounted on the wall of the community centre, Foley's work became a much more public monument than it had been in the chapel. A fire in May 2000 seriously damaged the building and the memorial. It was subsequently removed to Tameside Museum, where arrangements were made to repair and conserve it. Once this has been done, it is intended to display the work in the Central Art Gallery, Ashton-under-Lyne.[5]

Notes
[1] Copied from *Ashton Reporter*, 5 February 1937.
[2] I. Haynes, *Cotton in Ashton* (Libraries and Arts Committee, Tameside Metropolitan Borough Council, 1987) p.16. [3] E.A. Rose, *Methodism in Ashton-under-Lyne 2: 1797–1914* (1969) pp.24–6, 65–8. [4] *Ashton Reporter*, 5 February 1937.
[5] Information from Emma Smith, Director of Tameside Museums.

Foley, *Charity, following fire in Hurst Community Centre*

Dukinfield Park, Dukinfield

'Sampson' Drinking Fountain

W. Macfarlane

26 June 1902
Cast iron
3.35m high approx
Inscription on plaque on column: PRESENTED /
BY / MRS UNDERWOOD / IN
COMMEMORATION OF / THE CORONATION /
OF / KING EDWARD VII / AND THE OPENING
OF / THIS PARK / JUNE 26TH / 1902
Description: Drinking fountain; the circular
basin rose from a base decorated with lions.
Rising from the basin was an ornate column,
suspended from which were four drinking cups.
The column was surmounted by the figure of a
man wearing a loin cloth, his left arm raised
above his head.

Dukinfield decided to mark the Queen's
Diamond Jubilee in 1897 by establishing a large
public park. The project took a number of years
to realise, but as it neared completion, Mrs
Annie Underwood donated a drinking fountain
for the park. She was the wife of William
Underwood, the mayor of Dukinfield on three
occasions, and whose building firm was largely
responsible for carrying out the work of laying
out the park.[1] Macfarlanes of Glasgow, a
company famous for designing and producing
ornamental ironwork, supplied the fountain. It
was an ornate model which included a muscular
male figure surmounting a column. Locals
referred to it as Sampson. The fountain was
situated on the first landing of the terraces,
facing the King Street entrance. It was installed
in time for the opening of the park in June
1902.[2] The ceremony had been arranged to
coincide with the Coronation celebrations, but
the King's illness caused the day's events to be
changed. Councillor James Grime opened the

park, using his speech to reply to those people
who had disapproved of this particular
municipal project. In welcoming Mrs
Underwood's gift, he called on 'those captious,
carping critics' of the park to 'Go ye, and do
likewise'.[3] A second fountain, promised by Mrs
J.F. Astley-Cheetham, was not installed at the
time of the opening. The *Sampson* fountain
remained in the park until the 1980s when,
following the vandalism and theft of the statue,
it was decided to remove it. Stephen
Broadbent's *Colonel Duckenfield* now occupies
the site. An inscribed plaque, once attached to
the fountain, was found in 2001.[4]

Notes
[1] J. Edward Hickey, *Dukinfield Past and Present*
[1926] (Reprinted Leeds: M.T.D. Rigg Publications,
1992) p.81; *Ashton Reporter*, 30 August 1924.
[2] Dukinfield Council, Park and Recreation Grounds
Committee minutes 1901–02 (CA/DUK/111).
[3] *Ashton Reporter*, 28 June 1902. [4] *Tameside
Advertiser*, 20 December 2001.

TRAFFORD

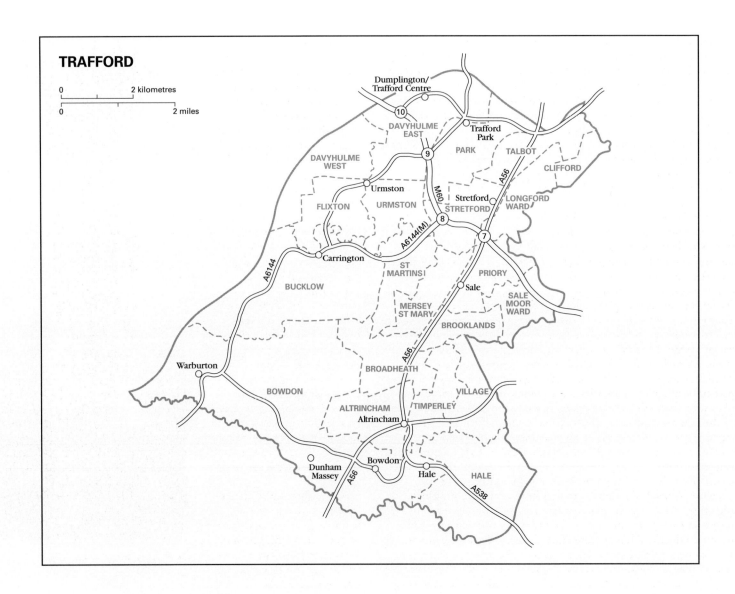

TRAFFORD

0 2 kilometres

0 2 miles

Dumplington/
Trafford Centre

10

DAVYHULME
EAST

Trafford
Park

PARK

TALBOT

DAVYHULME
WEST

9

CLIFFORD

A56

Urmston

Stretford

LONGFORD
WARD

FLIXTON

URMSTON

M60

STRETFORD

8

7

A6144(M)

Carrington

ST
MARTINS

PRIORY

A6144

BUCKLOW

SALE
MOOR
WARD

Sale

MERSEY
ST MARY

BROOKLANDS

A56

Warburton

BROADHEATH

VILLAGE

BOWDON

ALTRINCHAM

TIMPERLEY

Altrincham

Dunham
Massey

Bowdon

A56

Hale

HALE

A538

Introduction

The Metropolitan Borough of Trafford was established in the local government reorganisation of 1974. It consists of the Lancashire borough of Stretford and the urban district of Urmston, the Cheshire boroughs of Sale and Altrincham, the urban districts of Hale and Bowdon, and the parishes of Carrington, Dunham Massey and Warburton. The borough lies to the immediate south-west of Manchester and covers an area of 10,556 hectares. The population in 2001 was 210,135.

Transport developments provide the simplest key to understanding the recent history of this diverse district. Canals made an early impact. The first and the last of the modern canals built in Britain – the Bridgewater Canal and the Manchester Ship Canal – proved catalysts for economic change, especially in Stretford and Urmston. Similarly, the construction of the Manchester, Altrincham and South Junction Railway heralded change in communities further to the south. Opened in 1849, this railway carried Manchester's first generation of commuters, middle-class businessmen and professionals living in comfortable homes far away from the smoke and noise of 'Cottonopolis'. The pace and character of the transformation of an essentially rural world into a suburban one differed in its detail from place to place, but the opening of the railway station – as at Hale in 1862 – was always a decisive moment. The residential building which followed can still be seen in the architect-designed villas, substantial semi-detached houses and the more prosaic terraced houses in Sale and Altrincham, Bowdon and Timperley. Pevsner found these communities all but indistinguishable, though, of course, beneath superficial similarities their social and economic histories were distinct.[1]

As the entries in this section suggest, neither the industrial north nor the suburban south of Trafford contained communities particularly sympathetic to the idea of raising public monuments or statues. Even when, from the late nineteenth century onwards, the larger communities began to establish their own public and civic buildings, there was little evidence of architectural embellishment, let alone public statuary.[2] Altrincham, which had received a charter in 1290, was the principal market town. In the smaller communities the ideals of suburban life among commuters, who became an increasingly influential presence in determining the character and amenities of 'their' villages, did not extend to public monuments. Indeed, prevarication and the postponement of schemes for even fundamental amenities were a distinctive thread running through the records of the Victorian local boards and district councils. The reluctance of Sale ratepayers to pay for the landscaping of the local park, even though the land had been given by a local resident, was only one such expression of an ingrained parsimony. Even the memorialisation in Sale Park of James Prescott Joule, the Salford-born scientist who spent the final years of his life in the district, was a tribute that might never have been realised but for support from outside the district.[3] Those few public monuments that were erected were almost exclusively drinking fountains, the most important examples being, significantly, the gifts of individuals rather than the outcome of public projects. The Gothic-style drinking fountain in Bowdon, dated 1872, was a memorial to Francis Marriott, erected by his wife.[4] The drinking fountain and public lamp at Ashton-upon-Mersey, which became a local landmark, was the gift, in 1881, of William Cunliffe Brooks, the banker, local landowner and Conservative MP.[5]

Such attitudes also offered little protection to older monuments and, as in the other parts of Greater Manchester, market and boundary crosses, where they had survived, were often neglected. The recorded history of the ancient crosses in

Dr Thomas White's Monument, Sale

the district is sparse.[6] The remains of only two crosses appear to have survived to the present day: the base of Stretford Cross, sited originally at the junction of King Street and Chester Road, is preserved in St Matthew's churchyard;[7] and the equally undistinguished stump of Warburton Cross is located at the junction of Paddock Lane and Townfield Lane, Warburton.[8] The latter cross was demolished by the Puritans during the Civil War because it was considered to be 'of dangerous consequences and inconsistent with our purified religion'.[9] Altrincham's market cross was removed by progress-minded Victorians, the present cross being a modern copy put back by heritage-conscious residents.

It was only with the erection of memorials commemorating the First World War that most communities could point to a recognisable outdoor public monument. The debates within communities over the form their war memorial should take produced a range of designs. Not all were erected without controversy, though the ferocity of the public debate over the location of Stretford's principal memorial suggests a wider political agenda on the part of the protestors.[10] Some memorials were of a high quality, and included statuary. The memorial at Hale, designed by Frederick Wilcoxson, is among the most impressive; it is dominated by a bronze figure suggesting the stolid determination and bravery of the common soldier. The local sculptor, Arthur Sherwood Edwards, was responsible for the delicate figure of St George in mourning on Sale's memorial. A smaller St George (after Donatello) decorated the memorial cross outside the parish church in Bowdon.[11] The interlacing patterns on Altrincham and Dunham Massey's memorial – a Celtic cross – were especially fine, the work of James Lonegan of Nuttall and Co., monumental masons of Whitefield.[12] Davyhulme's memorial took a more practical form by incorporating a clock tower.[13] But, apart from war memorials, the inter-war years saw few other notable additions to the district's meagre stock of public monuments and sculpture. The exceptions were two bronzes, the work of the Bromsgrove Guild, placed in Stretford's new town hall, and the massive granite monument raised to remember the equally massive contribution made by Marshall Stevens in developing the Trafford Park industrial estate. In scale it was eclipsed only by Stevens' own tomb overlooking the Ship Canal at Barton. But the district also lost monuments, most notably the sandstone pillar raised in 1790 to the memory of Thomas White, one of the doctors responsible for establishing the Manchester Royal Infirmary. Located in Sale, it collapsed shortly before it was due to be removed to the Infirmary.[14]

There appears to have been no strong interest in promoting public sculpture in the 1950s and 1960s in any of the districts that became part of the new metropolitan borough in 1974. It was only with the Trafford Park Development Corporation, established in 1987, that public art became a more explicit part of an agenda of economic and environmental regeneration.[15] Brian Fell's forceful *Skyhooks* and James Wines' sorrowful

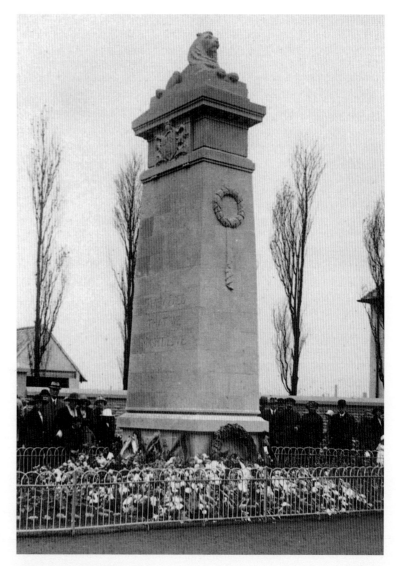

Patteson, *Stretford Cenotaph*

Silent Cargoes were its two most important commissions, indeed, two of the most ambitious works installed in the whole of Greater Manchester in the 1990s. More prosaic parts of the Development Corporation's programme included the installation of sculptured railings. Private companies also began to fund public sculpture. The centenary of the Manchester Ship Canal in 1994 was marked by the installation of a work

paid for by the Manchester Ship Canal Company, a company owned by Peel Holdings. It was unveiled by Princess Anne, almost 100 years to the day from when Queen Victoria had opened the Ship Canal.[16] Peel Holdings was also responsible for developing the Trafford Centre, a colossal shopping and entertainment complex at Dumplington. Opened in 1998, it provided a venue for sculpture including Colin Spofforth's *Spirit of New Orleans* and Anthony Stones' *Arthur Brooke*. Twenty-two larger than life-size classical figures also featured on the exterior: works that would not have embarrassed Las Vegas.[17] New public sculpture was also unveiled at the district's best-known address, Manchester United Football Club, Old Trafford. The football club commissioned Philip Jackson to sculpt a statue of the late Sir Matt Busby, the manager responsible for making Manchester United known to millions around the world. It is the most recognisable and most photographed statue identified in this survey.[18] This was followed by the statue of another Scotsman who left his mark on Manchester United, the footballer Dennis Law. It was unveiled in 2001. Plans in other parts of the borough to raise public sculpture had mixed success: Altrincham's plan to commission a millennium statue faltered.[19] Hale, however, did succeed in erecting a modern public clock, a structure that overshadowed the village's drinking fountain.[20] It was noteworthy that almost all of this activity was due to private initiatives. Trafford Metropolitan Borough Council was not one of the Greater Manchester authorities that expressed an obvious enthusiasm for public art and sculpture.

Notes
[1] Pevsner and Hubbard, *Cheshire* (1971) pp.59, 364; M. Nevell, *The Archaeology of Trafford* (Trafford Metropolitan Borough Council, 1997); N.V. Swain, *A History of Sale – from the Earliest Times to the Present Day* (Wilmslow: Sigma Press, 1987); D. Laver and D. Rendell, *Hale and Ashley. The Past 100 Years* (Hale Civic Society, 1987). [2] The marble statue of Eve (J.R. Whittick, 1882) now in the foyer of the town hall extension, was originally in Stamford Park. [3] The only outdoor sculpture in Trafford noted in Pevsner. Pevsner and Hubbard, *op. cit.*, p.330. [4] The fountain was originally located in the centre of the junction of Stamford Road and The Firs, Bowdon, but later moved to its present position in front of the Stamford Arms. [5] Photograph of fountain in Trafford Local Studies Centre. *Sale Guardian*, 7 July 1950, 15 May 1964, 11 and 15 June 1965, 21 April 1966, 5 May 1966, 7 July 1966. [6] H. Taylor, *Ancient Crosses and Holy Wells of Lancashire* (Manchester: Sherratt and Hughes, 1906) pp.438–9. [7] It was moved c.1863 and used as the base for a sundial. It is Grade II listed. Taylor, *op. cit.* [8] It is Grade II listed. [9] N. Warburton, *Warburton: The Village and the Family* (London: Research Publishing Co., 1970) p.54. [10] *Daily Dispatch*, 7 March 1923. [11] The work of Arthur Hennings; Grade II listed. [12] Unveiled 13 November 1920. *Altrincham and Sale Guardian*, 12 and 19 November 1920; *Altrincham County Express*, 3 October 1961, 30 November 1961. [13] *Manchester City News*, 25 October 1924. [14] *Sale and Stretford Guardian*, 1 April 1935, 12 April 1935. [15] C. Pepinster, 'Trafford Park Manchester UDC', *Building*, 25 September 1987, pp.44–5. [16] *Manchester Evening News*, 20 May 1994. [17] The statuary is the work of Guy Portelli. [18] A memorial plaque to Matt Busby commissioned by the supporters of Manchester United was placed on the outside of the stadium near the Stretford Road end in 1996. [19] *Sale and Altrincham Messenger*, 1 November 2000. [20] *Ibid.*, 5 July 2000. Designed by the Wilmslow architect, John Sheridon.

ALTRINCHAM

Goose Green

Two Geese

Sean Crampton

20 October 1982
Phosphor bronze
75cm high; base 152 cm high × 75 cm square
Inscription inset on pedestal: GOOSE GREEN
　　CONSERVATION AREA / Enhancement Scheme
　　by / Trafford Borough Council and The
　　Greater Manchester County Council / 'Two
　　Geese' by Sean Crampton / Sculpture
　　donated by A. Booth (Estates) Ltd. / Seating
　　donated by The Rotary Club of Altrincham
　　/ The ceremony to mark the completion of
　　the scheme was performed on / 20th
　　October 1982 by / Sir William Downward,
　　J.P., LL.D., Lord Lieutenant of Greater
　　Manchester.
Status: not listed
Condition: fair; damage to wings
Owned by: A. Booth (Estates) Ltd
　　Description: Phosphor-bronze sculpture of
two standing geese, alert, their attention drawn
towards the same object, surmounting a square
brick pedestal around which is a seat.

Crampton, *Two Geese*

'Two Geese', one of the few modern examples
of public sculpture in Altrincham, was
commissioned as part of the redevelopment of
Goose Green conservation area, which took
place between 1978 and 1983. In the eighteenth
and nineteenth centuries this was a part of the
village occupied by working families, close to
Hale Moss, a site of local fairs and other
entertainments.[1] The redevelopment, which
involved converting the existing workers'
cottages into shops and offices, was designed by
the architect, Harry Kennedy, and won awards
from the Civic Trust.[2] The sculpture was
commissioned by Mark Rubin of A. Booth
(Estates) Ltd, the developers of the project, as a
focal point for the open space in front of the
refurbished buildings. Mark Rubin approached
Sean Crampton, having seen his work in the
Alwin Gallery, London. Crampton, who was
born in Manchester, agreed to the commission
and visited the site to make drawings. A study
of two standing geese was agreed upon, a
subject which both echoed the area's name and
served as a reminder of an earlier period of its
history, when geese had been kept by the local
inhabitants.[3] The sculpture was placed on a
brick pedestal, around which was a seat. Sir
William Downward, the Lord Lieutenant of
Greater Manchester, unveiled the sculpture in
October 1982.[4] It immediately attracted the
attention of local groups who wanted to
commemorate the recent Falklands War. It was
suggested that a memorial plaque be added to
the pedestal to mark the engagement fought at
Goose Green on the Falklands by the Parachute
Regiment. The idea was debated and rejected by
the council. Over the years the sculpture has
suffered some damage: the wing feathers have
been 'clipped' by vandals, and, more recently, a
failed attempt to steal the sculpture necessitated
repairs and a strengthening of the fixings.

Notes
[1] D. Bayliss (ed.), *Altrincham. A History*
(Timperley, Altrincham: Willow Publishing, 1992)
pp.56–7. [2] Awards in 1981 and 1983.
[3] Correspondence with Mark Rubin, who owns the
maquette. [4] *Altrincham Express*, 22 October 1982.

Old Market Place

Market Cross

7 October 1990
Kelsall red sandstone
3.66m high; base 3.69m diameter
Inscription on plaque at base of column: This
 replica of Altrincham's historic Market
 Cross / was dedicated by the / Right
 Reverend Frank P. Sargeant, / Bishop of
 Stockport, in the presence of / The
 Worshipful The Mayor of Trafford, /
 Councillor James R. Haydock, J.P., / on the
 seventh day of October, / Nineteen
 Hundred and Ninety, in the Seven /
 Hundredth Year of the granting of /
 Altrincham's Royal Charter. / The Cross
 was commissioned by / ALTRINCHAM AND
 BOWDON CIVIC SOCIETY. The names of those
 who provided the funds enabling / it to be
 erected are inscribed on the steps below. –
 base of column: ALTRINCHAM AND BOWDON
 CIVIC SOCIETY / J. A. LITTLER / MRS. LESLIE
 RYAN / D. G. BAYLISS / PRES / CHAIRMAN /
 HON SEC
Status: not listed
Condition: good
Owned by: Trafford Metropolitan Borough
 Council
 Description: Market cross; a sandstone cross
decorated with blind holes, surmounting a
column rising from six circular stone steps.

The idea of providing Altrincham with a new
market cross was proposed and organised by
the Altrincham and Bowdon Civic Society to
mark the 700th anniversary of the town's
charter. An earlier attempt by the Court Leet to
replace the lost cross had been refused by
Trafford Borough Council on the grounds that
it was 'out of keeping with the character of the
Old Market Place'.[1] The Civic Society's scheme
did, however, receive the necessary approval.[2]
The history of the town's earlier crosses
remains speculative, but it is known that a cross
stood in front of the Butter Market in the
Market Place in the late seventeenth century.[3]
This cross was rebuilt in 1730,[4] and, along with
the Butter Market and stocks, was pulled down
in the 1850s to accommodate road
improvements.[5] It was supposed to have been
put in safe keeping but was lost.

The new cross was designed by Don Bayliss,
a member of the local civic society, who based
it on surviving nineteenth-century drawings of
the older market cross.[6] It was made from a red
sandstone, a common building stone in the
district. The Timperley stonemasons, T. Crosby
and Sons, were responsible for making and
installing the cross. The principal inscription
was on a metal plaque fixed to the base of the
column, whilst the names of the companies
which contributed funds were carved on the

Altrincham Market Cross

stone steps.[7] It was positioned on the west side
of the Old Market Place, where replicas of a
whipping post and stocks were also erected, as
part of the wider scheme to strengthen the
historical points of interest in this conservation
area. The cross was completed by the spring of
1990, but it was not until October that it was
dedicated by the Bishop of Stockport.[8]

Notes
[1] *Altrincham Guardian*, 9 November 1978, 6
September 1979. [2] *Altrincham and Sale Guardian*, 9
March 1989. [3] Draft design for cross in D. Bayliss
(ed.), *Altrincham. A History* (Willow Publishing,
1992) p.145. [4] A. Ingham, *A History of Altrincham
and Bowdon* (1879, reprinted Warrington: Prism,
1983) p.187. [5] C. Nickson, *Byegone Altrincham.
Traditions and History* (Altrincham: Mackie & Co.,
1935; reprinted 1971) pp.30–1, 35; and information
supplied by D. Bayliss. [6] Correspondence with D.
Bayliss. [7] Inscribed on the risers of the steps are the
names of companies who financed the scheme: Barry
& Gail Whitby, Hill & Company and Lloyds Bank
plc. [8] *Ashton and Sale Guardian*, 12 April 1990.

DUMPLINGTON

Old Barton Road

Stevedore

Brian Fell

1987
Steel
3.05m high; base 1.4m diameter
Status: not listed
Condition: good
Owned by: Trafford Metropolitan Borough
 Council
 Description: Steel sculpture representing a
dock worker, constructed from steel shackles
and other dockside hardware, mounted on a
circular base.

Stevedore was commissioned by Partnership
Art on behalf of Gillespies Landscape
Architects for Trafford Park Development

Fell, *Stevedore*

Corporation. It was to be a feature in the small park which was created alongside the Manchester Ship Canal, close to the place where the famous Barton Aqueduct had crossed the canal. The Glossop-based sculptor, Brian Fell, was commissioned and he provided an industrial sculpture which suggested a powerful yet almost machine-like dock labourer.[1] It comprised a collage of dockside hardware, including shackles, hooks and crane components. It was installed in 1987.

Note
[1] Information from Brian Fell.

Trafford Centre

Spirit of New Orleans
Colin E. Spofforth

8 September 1998
Bronze
1.83m high; base 2.51m × 1.37m
Signature on banjo: Spofforth
Inscription: The Spirit of New Orleans / Colin E. Spofforth / Commissioned by / Peel Holdings p.l.c. for / The Trafford Centre, Manchester. 1998.
Status: not listed
Condition: good
Owned by: Peel Holdings plc

Spofforth, *Spirit of New Orleans*

Description: Life-size bronze sculpture of four New Orleans jazz musicians playing banjo, clarinet, trombone and trumpet.

The *Spirit of New Orleans* is located inside the Trafford Centre, one of Britain's largest retailing and leisure centres. The shopping centre, built on open land near the Manchester Ship Canal, was opened in 1998. Peel Holdings, the owners and developers of the centre, commissioned the work. They wanted a sculpture to stand at the entrance to a restaurant and leisure section which included a replica of the New Orleans French Quarter. In January 1997 Colin Spofforth was approached to produce a suitable sculpture. He decided to focus on jazz, the music associated with New Orleans, intending the sculpture to capture and

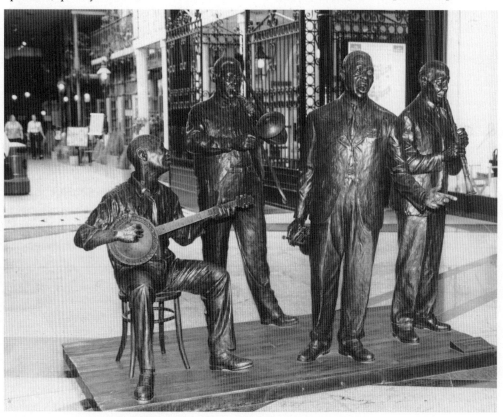

convey the spirit of jazz in its heyday. Spofforth visited the famous Preservation Hall in New Orleans in order to model the work on actual jazz musicians. He made sketches of four men – Maynard Chitters (trombone), David Grillier (clarinet), Elmar Hubbard (banjo) and Reginald Kollier (trumpet and vocals) – and these became the basis for the animated quartet in the final sculpture. The figures are life-size and were sculpted in clay: 'the qualities of the clay have been captured in the casting of the piece in bronze'.[1] The sculpture was unveiled by David Glover in September 1998, a few days before the public opening of the shopping centre.[2]

Notes
[1] Information supplied by Colin E. Spofforth and Peel Holdings plc. [2] *Manchester Evening News*, 8 September, 1998. Spofforth also carved the *Hands of Christ*, a small American boxwood sculpture in the shopping centre's prayer room.

Untitled
Guy Portelli

September 1998
Marble resin
Figures 3.66m high
Status: not listed
Condition: good
Owned by: Peel Holdings plc
 Description: Twice life-size figures of females, dressed in loose shifts, positioned above the colonnade and inner courtyard area leading into the Trafford Centre. There are three main designs – a dancing female holding a gilded oak branch in her raised right hand, another dancing female holding a gilded oak branch in her left hand, and a seated female blowing a gilded trumpet. The 36 figures are arranged as either single figures or in pairs, or in groups of four and six. In addition, on each of the two side walls are three individual figures – one holding a pitcher, one playing a lyre and one holding a basket of grapes – surmounting Corinthian columns.

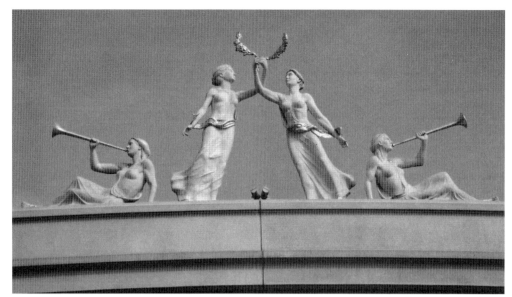

Portelli, *Female figures, Trafford Centre*

In 1997 as the Trafford Centre neared completion, John Whittaker, Chief Executive of the developers, Peel Holdings, decided that sculpture was needed to enliven the courtyard directly in front of the main entrance. The idea of a group of statues was discussed, to be treated in such a way that they would provide a further point of visual interest, an addition to the architectural theatricality of the centre. The architects, Chapman Taylor, approached the sculptor, Guy Portelli, who had carried out a commission for the firm in Piccadilly Circus, London. Portelli submitted three possible schemes, of which the one featuring female figures, lightly robed in classical dresses, was preferred. Although the figures might not have immediately suggested any local connection, Portelli had carried out research into the district's history, linking the sculptures to the Roman occupation, and by including in the design more recent historical references such as griffins, mythical beasts which feature in the arms of the Trafford family. The design was approved by Whittaker as being in keeping with the retro-classicism of the centre. The models used for the statues were photographed by

Portelli using costumes borrowed from a local theatre. The statues were made from marble resin. Additional staff were employed to assist in making the 36 figures, a job that expanded as additional sculptural features – including 108 eagles – were commissioned for the centre.[1] In its extent, it was probably one of the largest sculptural commissions in the North West in the 1990s. The figures were all installed in time for the centre's official opening in 1998.[2]

Notes
[1] Information from Guy Portelli and Peel Holdings plc. [2] *Manchester Evening News*, 9 September 1998.

Arthur Brooke
Anthony Stones

7 December 1999
Bronze
Sculpture 1.83m high; tea-chest 63cm high × 60cm square
Inscription: ARTHUR BROOKE / 1845–1918 /

Founder of the Brooke Bond Tea Company / who opened the first Brooke Bond shop / in Manchester in 1869. / Sculpted by Anthony Stones. / Donated to the Trafford Centre by / The Brooke Bond Tea Company.

Status: not listed
Condition: good
Owned by: Peel Holdings plc

Description: Portrait statue; a life-size bronze statue of Arthur Brooke who is shown wearing a frock coat, standing proud and confident, his arms outstretched, a teapot held in his right hand, a cup and saucer in the other hand. He is standing on a tea-chest.

Arthur Brooke was the founder of the famous Brooke Bond tea company. He was born in Ashton-under-Lyne in 1845, and after an unsuccessful period working in the cotton industry, entered in the family's ailing grocery and tea business. Brooke built up the business, opening his first shop in Market Street, Manchester, in 1869. Although the company's name suggested another partner there was in fact no Mr Bond: Brooke simply believed that the additional name added a certain *gravitas* to the fledgling firm. The company grew rapidly and had become a household name by the time Brooke retired in 1910. He died in 1918.

In 1999 Brooke Bond plc decided to commission a portrait statue of their founder. Anthony Stones was approached and agreed to sculpt the figure, a commission that was notable for the fact that the company required the work to be finished within two months. Photographs of Brooke were studied by Stone, a pose determined, suitable clothes collected, and, using his own son as a model, the work begun. For Stones, who had lived near Manchester as a child, Brooke was to be depicted as a 'cheerful icon of Lancashire hospitality'.[1] Representatives of the company and a member of the Brooke family visited Stone's studio to study the work in progress. Progress was rapid and Stones wondered whether he might have broken the

world record for modelling a life-sized historical figure in clay for bronze.[2] The figure was sculpted with a rough texture and the bronze finished with a rich tea-coloured patina. The teapot and cup and saucer were life casts, Stones having been dissatisfied with his own models. The completed statue, including its tea-chest pedestal, was delivered to Manchester, where arrangements had been made for it to be placed in the Trafford Centre. It was located on the first floor in the centre, in the Orient section, and unveiled in December 1999.[3] Unfortunately, its impact was reduced by its location against a wall and by the decision to raise it on an additional base covered in green tiles, with stone chippings filling the space around the tea-chest and the base.

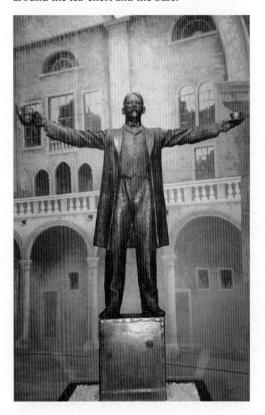

Stones, *Arthur Brooke*

Notes
[1] Correspondence with Anthony Stones. [2] *Ibid.*
[3] *Manchester Evening News*, 8 December 1999.

HALE

Ashley Road

Drinking Fountain
Architect: B.A. Pickering

28 September 1908
Tegsnose stone; granite columns
2.7m high × 1.22m × 1.08m
Inscription on pediment: 1908 / TO THE MEMORY OF / GEORGE BAKER WALSH
Status: not listed
Condition: fair; weathering of stone on base and capitals of columns, fountain dry, trough missing
Owners: Trafford Metropolitan Borough Council

Description: Drinking fountain; rising from a base of Tegsnose stone, four polished black and white granite columns on circular stone bases support a stone canopy, surmounted by a Maltese cross. Beneath the canopy is a circular granite basin (part of the bronze fountain head remains).

This ornate public drinking fountain, designed in what a contemporary referred to as the Ionic style, was a gift to Hale from T.M. Walsh, a former resident, in memory of his son, George Baker Walsh. It had been intended to situate the fountain on Hale Road, but when the Ashley Road site became available, the council, having purchased the land for £1,000, decided to locate it there, closer to the centre of the village. As part of the site had been previously occupied by Siddeley's Brewery, local temperance supporters would have had an additional reason for welcoming the fountain.[1] The unveiling ceremony in 1908 was a unique occasion for local officials, as this was the first such public

Hale Fountain

residents, who were 'enjoying the pleasure of residing in such a grand locality, the best within miles and miles of Manchester', might follow his example.[2] The fountain was built by F. Plumbley of Winsford. It has remained on its original site, although the water has long since stopped and a drinking trough for animals has been removed. A public clock tower was erected adjacent to the fountain to mark the end of the second millennium.

Notes
[1] *Altrincham and Sale Guardian*, 3 March 1983.
[2] *Altrincham, Bowdon and Hale Guardian*, 30 September 1908.

Hale Road

Broomfield Gardens, Hale Road and Broomfield Lane

Hale War Memorial

Frederick John Wilcoxson

11 March 1922
Bronze statue; Portland stone pedestal
Statue 2.13m high; pedestal 6.1m high × 2.4m × 2.28m
Signed on plinth: F. J. Wilcoxson 1921
Inscription in incised lettering on front of pedestal: THIS / MEMORIAL / IS DEDICATED TO THE / IMMORTAL HONOUR / OF THE / MEN OF HALE / WHO FELL IN THE / GREAT WAR / 1914–1918. / Their name liveth for evermore
Status: Grade II
Condition: fair; weathering and some staining of stone, lettering faint on entablature
Owned by: Trafford Metropolitan Borough Council
Description: War memorial; a bronze statue of an ordinary soldier standing ready for action, his rifle on his right shoulder, the helmet of a German soldier in the other hand. The figure surmounts a stepped Portland stone pedestal, around the top of which are carved the names of military campaigns. A bronze plaque identifies the 156 local men who died in the

First World War. A plaque, recording the names of a further 57 servicemen, was added after the Second World War.

The Hale War Memorial Committee, under the chairmanship of Mr E.T. Nelson, commissioned Frederick Wilcoxson, who taught sculpture at the Royal College of Art, to design the main Hale war memorial. Wilcoxson produced a powerful representation of the common soldier, which emphasised the stolid

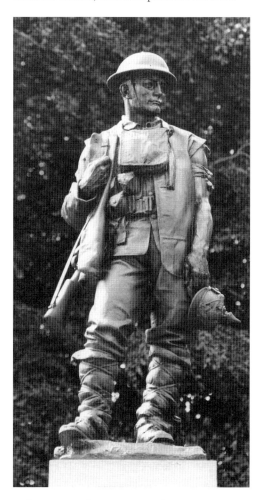

Wilcoxson, *Hale War Memorial*

monument gifted to the community. Accepting the fountain on behalf of Hale Council, F.R. Hughes praised Mr Walsh's 'deep love and sympathy for dumb animals'. The hope was also expressed that some of Hale's wealthier

determination of the ordinary fighting man. The sacking tied with string around the soldier's legs was a vivid reminder of the conditions endured on the battlefields of France. A model of the sculpture was exhibited at the Royal Academy and the Walker Art Gallery before it was erected.[1] Wilcoxson's other northern war memorials included one at Ripon.[2] The construction of the memorial was carried out by B. Barton and Co. of Thames Ditton.

The site selected was Broomfield Gardens at the junction of Hale Road and Broomfield Lane. A casket containing the Annals of Hale was placed at the base of the memorial on 21 October 1921. The unveiling ceremony took place the following spring, on a day which the local press rightly recognised as one that would be remembered when 'the local historian comes to bring the story of Hale and the War up to date'. In a ceremony presided over by the Earl of Stamford, the memorial was unveiled by Lieutenant-General Sir Beauvoir de Lisle. In dedicating the memorial, the Bishop of Chester spoke of Wilcoxson's sculpture as one that represented 'the grim reality of war'.[3]

Notes
[1] Wilcoxson exhibited a statuette of the soldier in 1921 and *The Victor* in 1922, *Royal Academy Exhibitions 1905–1970* (London: Royal Academy, 1982); Walker Art Gallery Autumn Exhibition, 1921. [2] A. Borg, *War Memorials from Antiquity to Present* (London: Leo Cooper, 1991) p.89. [3] *Altrincham, Bowdon and Hale Guardian*, 17 March 1922.

SALE

Broad Road
Sale Leisure Centre

Untitled
Keith Brown

1974
Stainless steel
Status: not listed
Condition: good
Owned by: Trafford Metropolitan Borough Council

As part of their design for Sale Leisure Centre the architects, Howitt and Tucker, commissioned a sculpture to be placed on the main external brick wall. The theme was to be sports activity. The sculptor was Keith Brown, then a student at the Royal College of Art. He produced a sculpture which took the form of interlocking fins, intended to express a balance between opposing sides. 'As you move towards the piece or from side to side the equilibrium is disturbed and the dynamic shifts and increases in favour of one side or the other.'[1] It was made of fabricated mirror-finish stainless steel. Originally the area directly underneath the sculpture was turfed, but this was later paved and a bicycle rack installed.

Note
[1] Correspondence with Keith Brown, June 1999.

Brown, *Untitled*

Cross Street
Crossford Court, junction of Cross Street and Dane Road

Alter
Adam Reynolds

12 June 2000
Painted mild steel; mirrored steel
6m high × 1.5m square
Inscription on pedestal: 'ALTER' / ADAM REYNOLDS / JUNE 2000 / UNVEILED BY THE WORSHIPFUL / THE MAYOR OF THE BOROUGH OF TRAFFORD / COUNCILLOR JOHN ACKEREY / 12TH JUNE 2000
Status: not listed
Condition: good
Owned by: Magnus Limited
Description: Abstract sculpture; stylised winged figure holding aloft a second smaller figure or cross. The work is in steel, painted red, and decorated with mirrored steel discs. It surmounts a square concrete pedestal painted black.

G.E. Capital commissioned Adam Reynolds to provide a distinctive sculpture to stand outside Crossford Court, an office building it was refurbishing in Sale. They wanted a distinctive sculpture that would serve as both an advertisement and a locator for the building. Reynolds' response was a work inspired by the Ordnance Survey symbol for a spireless church. In part this was a humorous acknowledgment of the location, Crossford Court, and the building's flat roof line. The title *Alter* continues the play on words. The two figures, their wings suggesting angels, can also be interpreted as representing ambition, support and change.[1] Benson-Sedgwick Engineering of Dagenham was responsible for manufacturing the work. It cost £1,200 and was unveiled in June 2000. *Alter* was located on a raised bank by the side of the building, where its bold shapes and colour catch the attention of motorists on the busy main road. At the

Reynolds, *Alter*

unveiling ceremony, the Trafford mayor, John Ackerley, welcomed the work, commenting that 'Sale is a vibrant go-ahead town which is in the process of great change and improvement. Works of art like this will certainly brighten up the area.'[2]

Notes
[1] *Sale and Altrincham Messenger*, 14 June 2000; correspondence with Adam Reynolds. [2] *Sale and Altrincham Messenger*, 14 June 2000.

School Road

Sale and Ashton-upon-Mersey War Memorial

Arthur Sherwood Edwards

23 May 1925
Marble statue; granite pedestal
Statue 2.43m high; pedestal 3.3m high × 1.22m
 square
Inscription in incised lettering on pedestal: LEST / WE / FORGET / TO THE / HONOURED MEMORY / OF THE MEN OF / SALE / AND / ASHTON-UPON-MERSEY / WHO GAVE THEIR LIVES / DURING THE GREAT-WAR / FOR THEIR KING / AND / COUNTRY / 1914–1919 / AND / 1939–1945
Status: not listed
Condition: good; sword repaired, algae on
 statue plinth; marks on front of pedestal
Owned by: Trafford Metropolitan Borough
 Council
Description: War memorial; a statue of St George in mourning, his hands on the hilt of his down-turned sword, standing on a rectangular pedestal which is decorated with a sculpted laurel wreath. The whole surmounts a tall grey granite pedestal, on the front face of which is the principal inscription. Rectangular bronze plaques listing the names of the dead (in both world wars) are fixed to the other three sides of the pedestal.

Sale's principal memorial to the fallen of the First World War was selected from 26 entries by the town's War Memorial Committee. The winning design was the work of a local artist and sculptor, Arthur Sherwood Edwards of Ashton-upon-Mersey. The chairman of the

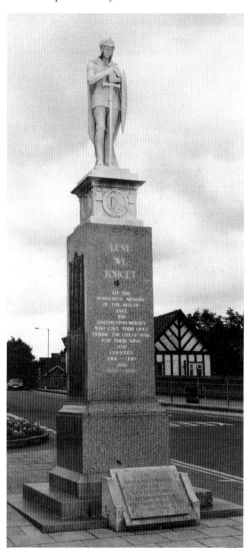

Sherwood Edwards, *Sale and Ashton-upon-Mersey War Memorial*

memorial committee, G.F. Gordon, observed that Edwards, who had served in the war, had 'approached the question from the standpoint of giving of his best to the district, and to the honour of his old comrades who had not returned'. The 'clean lines and balance' of the memorial were admired, producing an aesthetic effect absent in other 'conventional and laboured designs'.[1] The £600 cost of the memorial was raised by public subscription. Various locations were considered before it was decided that the best available site was directly in front of the town hall.[2] The memorial was unveiled by Major-General A. Solly-Flood, Commanding Officer of the 42nd (East Lancs) Division, before a crowd of some 10,000 people in May 1925. Somewhat unusually Solly-Flood's speech extended beyond the usual tributes, referring to the industrial disputes then affecting the country.[3]

Following the Second World War the discussions about a suitable war memorial included the idea of lowering the existing one and creating a memorial garden with seating. One of the contributors to the debate dismissed Edwards' statue as 'feeble in the extreme'.[4] None of the proposals, however, was implemented, and in the end the names of those men and women killed in the recent war were simply added to the existing pedestal, and a stone tablet, placed at the foot of the memorial, was inscribed to their memory.[5] In September 1985 the war memorial was vandalised – the sword having been broken off at the hilt and stolen. Rapid repairs ensured that the memorial was ready for the Remembrance Day service.[6]

Notes
[1] *Altrincham, Bowdon and Hale Guardian*, 29 May 1925. [2] Sale Urban District Council Minutes, 3 June 1924, 3 February 1925, 3 March 1925. [3] *Order of the solemn ceremonial and service appointed for the use on the occasion of the unveiling of the memorial to the men of Sale and Ashton-upon-Mersey* [1925]; *Manchester Guardian*, 25 May 1925; *Altrincham, Bowdon and Hale Guardian*, 29 May 1925. [4] *Sale and Altrincham Guardian*, 17 December 1948. [5] *Sale Pioneer*, 8 November 1947; 9 April 1949; *Sale*

and Stretford Guardian, 16 September 1949; *Sale and Altrincham Guardian*, 17 December 1948, 11 September 1953, 4 December 1953, 19 March 1954. [6] *Altrincham and Sale Guardian*, 24 October, 7 November 1985.

Northenden Road
Worthington Park

James Prescott Joule
John Cassidy

28 October 1905
Bronze bust; granite column
Bust 1.07m high approx; pedestal 2.44m high × 61cm × 46cm
Signed on rear of bust: John Cassidy Sculp. 1905
Inscription in raised bronze lettering on pedestal: JOULE / 1818:1889
Status: not listed
Condition: fair; algae on lower part of bust, scratches on pedestal
Owned by: Trafford Metropolitan Borough Council

Description: Portrait bust; a half-length bust of Joule surmounting a tapering polished granite pedestal on which is the inscription. Joule is shown holding manuscript papers, on the front of which is a diagram of the tangent galvanometer.

Biography: see p.33.

The idea of erecting a memorial in Sale to James Prescott Joule was made public by the local council in 1901, some eight years after Alfred Gilbert's statue had been unveiled in Manchester Town Hall. Joule had moved from Salford to Sale in the early 1870s for reasons of his health, occupying a house in Wardle Road.[1] By this time, the fundamental importance of his researches on the mechanical equivalent of heat and other subjects had been recognised, and he was acknowledged as one of the century's most important scientists. Joule died in 1889.[2] To commemorate his connection with the district it

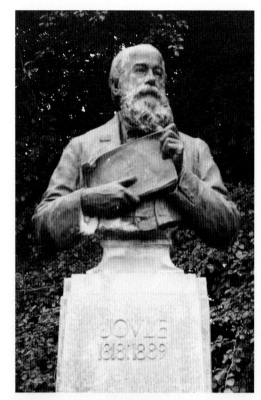

Cassidy, *James Prescott Joule*

was proposed to build a tower, to be used for meteorological observations, in the recently opened Sale Park. A public appeal for funds was launched, and support came from members of the scientific community in Britain, Europe and the United States: 13 of the 68 individuals on the first subscription list were Fellows of the Royal Society. In contrast, the support from local residents was disappointing with Mrs James Worthington, who had already given the park to the town, providing by far the largest donation, a sum of £100.[3] Efforts to increase subscriptions by linking the tower to the forthcoming coronation celebrations were also disappointing.[4] This lack of support led to the scheme being revised, and the idea of a tower was replaced by the more modest one of a bust.

Under the chairmanship of Dr Charles Lees of Owens College, fund raising was relaunched and the project went forward. The Manchester sculptor, John Cassidy, was commissioned to provide the bust. Cassidy showed Joule reading a scientific paper to an audience, the subject of the lecture being related to his tangent galvanometer, the outline of which was on the front of the papers he was holding. The clay model was completed by April 1905.[5] The memorial was unveiled by Sir William H. Bailey, the president of the Manchester Literary and Philosophical Society, an office which Joule had also held. Bailey and other speakers paid generous tribute to the importance of Joule's discoveries for modern physics; less was said of Joule's connections with Sale.[6]

The Joule Memorial has remained a feature of the park, which on its golden jubilee in 1950 was renamed Worthington Park, after its benefactor.[7] The bust has certainly fared better than the park's lions, presented to the council in 1903 by a Mrs Grimshaw. These stone beasts were roughly treated over the years and the surviving lion has now been moved to the comparative safety of Sale Library.[8] The Joule memorial is in good condition however, an apt reminder that whilst all matter is subject to change, certain forms take longer to be transformed than others.

Notes
[1] D.S.L. Cardwell, *James Joule. A Biography* (Manchester: Manchester University Press, 1989) p.264. [2] See above, p.33. [3] *Sale Urban District Council, Joule Memorial Tower, July, 1902* [1902]. [4] *Manchester Guardian*, 12 January 1904, 1 December 1904. [5] *Ibid.*, 7 April 1905. [6] *Manchester Evening News*, 28 October 1905; *Manchester Guardian*, 30 October 1905; *Altrincham, Bowdon and Hale Guardian*, 4 November 1905. [7] Pevsner and Hubbard, *Cheshire* p.330. [8] *Sale Guardian*, 25 June 1954; *Sale Messenger*, 19 March 1993.

STRETFORD

Gorse Hill
Chester Road

Stretford War Memorial

Architects and sculptors: J. and H. Patteson

25 August 1923
Darley Dale limestone
6.7m high approx × 2.14m long × 1.53m wide
Inscription beneath Stretford coat of arms (left-hand side): THEY DIED / THAT WE / MIGHT LIVE / 1914–1918 – beneath Lancashire coat of arms (right-hand side): IN MEMORY / OF THE / HEROIC DEAD / 1914–1918
Status: Grade II
Condition: good
Owned by: Trafford Metropolitan Borough Council
Description: War memorial; a cenotaph located in the centre of a memorial garden. The tapering shaft rises from a base of three steps and is surmounted by a lion couchant, symbolising courage, nobility and England. A single laurel wreath and pendant sculpted in relief decorate the front face. The coats of arms of Stretford and the county of Lancaster, surmounted by crowns, are carved on the entablature beneath the pediment on the sides. Bronze tablets listing the dead from the First World War are mounted on a semicircular stone wall at the rear of the garden.

Stretford's main war memorial is located in a specially created memorial garden, off the Chester Road, directly opposite the entrance to Gorse Hill Park. A memorial appeal organised by Stretford Council at the end of the Great War raised £9,274, of which £6,000 was given by the Stretford Red Cross Society. The

majority of the money was used to establish a 'living memorial' in the form of a District Nursing Service. Some £2,000 was used to provide a more conventional memorial to the 580 local servicemen who died. The site of the memorial was on land on the Chester Road which was given by the De Trafford trustees. It

Patteson, *Stretford War Memorial*

had been intended to position the memorial on the other side of the road, in front of the monumental gateway which now served as the entrance to Gorse Hill Park, but this was deemed unsuitable.[1] The choice of site caused a heated local debate, which escalated into a struggle for control of the memorial itself. The War Memorial Committee, which consisted of the senior council member for each ward and the Chairman of the General Purposes Committee, was persistently challenged by a large group of ratepayers who objected to the Chester Road site. The ratepayers, who effectively constituted a rival committee, complained that a new building behind the proposed site would detract from the solemn effect of the memorial. They suggested alternative sites, but each one was turned down. They eventually called for a cessation of work on the memorial until a public meeting could be held to consider the question, and advertised that such a meeting was going to take place in the council offices on 20 March 1923. The council had not given permission for the meeting, with the result that '80 persons were present on the premises without authority, but were not admitted to the council chamber'.[2] However, the council did concede to put the matter to a vote of the relatives of the fallen, subscribers and members of the committee organising the Remembrance Day pageant. Of 480 votes returned, a large majority were in favour of the original site, opposite the Gorse Hill gates.[3] Despite their defeat, some of the criticisms of the ratepayers were taken on board. The effect of the new building behind the memorial was mitigated by the planting of poplars at the rear of the garden, and an agreement with the lessee, whereby it was agreed to curtail development, subject to compensation. The memorial was designed and made by the Old Trafford firm of architectural sculptors, J. and H. Patteson, in consultation with the Borough Surveyor, Ernest Worrall. After all the disputes the unveiling ceremony passed off without incident. The cenotaph was

unveiled by the Secretary of State for War, the 17th Earl of Derby, and dedicated by the Revd Canon Rowntree, Rector of Stretford, in August 1923.[4] The inscriptions on the bronze panels name soldiers from over 60 regiments, besides those who died in the other services. The small formal garden surrounding the cenotaph continues to be well maintained, though some elements of the original design – the railings and lamps – have been removed.

Notes
[1] Borough of Stretford General Purposes Committee Minutes, 4 April 1922. The relocation of the entrance lodge to the front of Gorse Hill Park was completed in September 1922. [2] *Daily Dispatch*, 7 March 1923; Borough of Stretford General Purposes Committee Minutes, 20 March 1923. [3] Borough of Stretford General Purposes Committee Minutes, 10 and 23 April 1923. [4] *Manchester Guardian*, 27 August 1923; *The Times*, 27 August 1923.

Cornbrook
Brindley Road

The Crane
David Petersen

1991
Stainless steel; brick and stone column
3m high approx; column 16.76m × 1.51m square
Status: not listed
Condition: good
Owned by: City Park Management Ltd
 Description: Stylised representation of a crane about to take off into flight, standing on a stainless steel dish. The sculpture surmounts a tall brick and stone column.

This sculpture was part of a wider project to develop a business park on land in Cornbrook, close to the Bridgewater Canal. The landscape architects, Camlin Lonsdale, concluded that because of the park's location there was a need for a distinctive piece of sculpture that would serve both as a recognisable locator and as a focal point for the park. London and

Metropolitan Investment Ltd, the company responsible for the site, agreed to commission a work. Research undertaken into the history of the district revealed that Cornbrook had been known as Cranesbrook, because of the cranes that nested there, and this became the theme for the sculpture. Further discussions resulted in the Welsh sculptor, David Petersen, being commissioned to produce a suitably prominent sculpture. His work had recently been on view at the Cardiff Garden Festival.[1] He produced a representation of a crane about to fly in steel which was placed on the top of a tall column. Movement was introduced into the work by allowing the dish to rock in the wind. *The Crane*, as it is generally referred to, has become a distinctive and recognisable symbol of an area which has undergone further changes since the sculpture was installed.

Note
[1] Information from Steve Thomasson, Grantchester Holdings plc.

Sir Matt Busby Way
Manchester United Football Stadium

Sir Matt Busby
Philip Jackson

27 April 1996; July 2000
Bronze
2.90m high; 81cm square base
Signature on plinth: Jackson
Inscription on plinth: SIR MATT BUSBY
Status: not listed
Condition: good
Owned by: Manchester United Football Club
 Description: Portrait statue; a larger than life-size statue of Sir Matt Busby, showing him relaxed and smiling, wearing the club blazer; his right hand resting on his hip, whilst in his other hand is a football.

Matt Busby was born in Bellshill, Lanarkshire, in 1909. His career as a professional footballer –

he played for Manchester City, Liverpool and Scotland – was modestly successful, but what proved to be the decisive moment in his life came in 1945, when he was appointed manager of Manchester United. Success in the FA Cup and League soon followed. In the 1950s he assembled a team of young players who became a byword for exciting and winning football. Their potential was never realised, as many were killed in the Munich air disaster in 1958. Busby survived the crash and went on to create a new team, which succeeded in winning the European Cup in 1968. In the following year he retired as team manager, though the managerial culture he had created remained influential in the club long afterwards. His remarkable

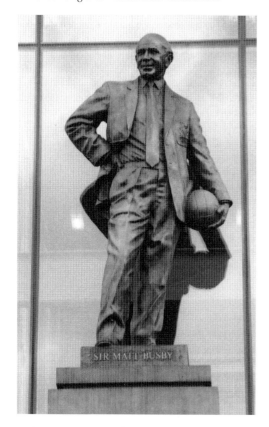

Jackson, *Sir Matt Busby*

achievement in building and rebuilding Manchester United into one of Europe's leading and best-supported football teams, was recognised locally by his being made a Freeman of the City in 1967, and nationally by the award of a knighthood in 1968.[1] Busby died in January 1994.[2]

Busby personified Manchester United and the idea of the football club memorialising him was discussed soon after his death. Various suggestions of ways to mark his contribution were made, including renaming the stadium after him, before it was finally decided that a statue would be an appropriate tribute. This decision may have been influenced by the knowledge that some European clubs had erected statues to great players. The commission was given to Philip Jackson who depicted Busby in 1968, the year of United's European Cup victory. The Busby family were consulted throughout the commission. The finished statue was positioned on the outside of the stadium, at the east end of the ground, above the executive entrance, looking out across the road, now renamed Sir Matt Busby Way. It was unveiled by Sandy and Sheena Busby, his children, in April 1996.[3] Three years later, the construction of a new stand led to the statue being taken down and put on temporary display in the ground-floor entrance to the club's museum. It was re-erected in June 2000 on the outside of the new stand, again looking across Sir Matt Busby Way.

Notes
[1] E. Dunphy, *A Strange Kind of Glory. Sir Matt Busby & Manchester United* (London: Heinemann, 1991) p.319. [2] *Manchester Evening News*, 21 January 1994. [3] *Ibid.*, 29 April 1996. A smaller version of the statue is displayed in the club museum. Another smaller bronze model is awarded by the club to the Sir Matt Busby Player of the Year.

Munich Memorial

25 February 1960; 1976; April 1996; 2001
Millstone grit; granite

2.9m × 2.29m
Inscription: IN MEMORY OF THE OFFICIALS & PLAYERS WHO LOST THEIR LIVES / IN THE MUNICH AIR DISASTER ON THE 6TH FEBRUARY 1958 / WALTER CRICKMER / TOM CURRY / BERT WHALLEY / ROGER BYRNE / GEOFF BENT / MARK JONES / EDDIE COLMAN / DAVID PEGG / DUNCAN EDWARDS / TOMMY TAYLOR / BILLY WHELAN
Status: not listed
Condition: good
Owned by: Manchester United Football Club
Description: Memorial; rectangular stone and granite memorial representing a bird's-eye view of the stands and pitch of Old Trafford football ground. The pitch is marked out, with a football filling the centre circle, and the names of the eleven team officials and players who died in the Munich air crash inscribed on the pitch. Above the stone memorial is a carving in wood of a player and spectator holding a wreath above a football on which is the year, 1958.

Three versions of the memorial to the eight players and three officials of Manchester United who died in the plane crash at Munich Airport on 6 February 1958 have been displayed at Old Trafford. The need to erect a suitable memorial at the football ground was acknowledged soon after the initial shock of the disaster. Several ideas for a memorial were considered by the club, before a design based on the Old Trafford ground was decided upon. The design was attributed to a local architect, J. Vipond.[1] Faience was the dominant material; green being used for the pitch, and mauve and grey for the terraces and steps. The stand roofs and perimeter path were made of quartzite, with the boundary wall in red Balmoral granite.[2] The names of those who died were incised in black and gold glass on the green faience. The construction of the memorial was undertaken by Messrs Jaconello (Manchester) Ltd. The cost was £2,100. Above the memorial was a carving in teak of two figures, representing the players and spectators, standing with bowed heads on

Munich Memorial

either side of a wreath, beneath which was a football, inscribed with the date, 1958. The memorial was placed above the main entrance to the Directors' box. It was unveiled by Matt Busby in a ceremony attended by the relatives of those who had died, survivors of the crash and members of the current team.[3] Two further memorials were unveiled on the same day: a bronze plaque naming the eight journalists who died in the crash was placed in the press box by Frank Taylor of the *News Chronicle* (a survivor of the crash) on behalf of the Football Writers' Association, and a memorial clock, paid for by the Ground Committee, was erected at the front of the stadium.

Alterations to the ground in the mid-1970s necessitated the removal of the memorial. However, due to its fragile nature it proved impossible to do this without damaging it, and the decision was taken to leave it *in situ* (now forming part of the East Stand), and to commission a new memorial. This was a somewhat simpler and smaller representation of a football pitch in slate, on which the names of

the dead were recorded.[4] It was installed in 1976. A third memorial was commissioned to coincide with the installation of the statue of Sir Matt Busby, it having been decided that the statue would be placed beneath the memorial at the Old Trafford end of the ground. This followed more closely the design of the original memorial, depicting a bird's-eye view of the pitch and stands, with the names of the eleven players and club officials inscribed on the pitch. It was the work of Mather & Ellis, stonemasons, Trafford Park. The new memorial was installed in 1996.[5] Further extensions to the East Stand resulted in the memorial being taken down in 1999. Following the completion of the building work, it was put back on display, but on the north side rather than on the front of the East Stand.[6] The teak carving of the player and supporter in mourning was also placed above the memorial.

Notes
[1] *Manchester Evening News*, 5 June 1959.
[2] *United Review*, Official Programme, 5 March 1959. The memorial measured 2.36m × 1.83m.
[3] *Manchester Evening Chronicle*, 25 February 1960; *Manchester Guardian*, 26 February 1960. [4] 1.64m × 1.08m; now in store at Old Trafford.
[5] Correspondence from Mather and Ellis, 28 August 1999. [6] Information from Mark Wylie, Curator, Manchester United Museum.

Denis Law
Ben Panting

23 February 2002
Bronze
Statue 2.84m high approx; plinth 18cm high × 1.48m diameter
Signature on plinth: Ben Panting 2001
Inscription on plinth: Living for Kicks / Denis Law
Owned by: Manchester United Football Club
Condition: good
 Description: Portrait statue; a larger than life-size statue of Denis Law. He is shown running and smiling, his right arm raised having just scored a goal. He is holding the cuffs of his

long-sleeved football shirt in his hands. The statue surmounts a short circular plinth, the top of which represents grass.

Denis Law, professional footballer, was born 24 February 1940 in Aberdeen. He played first-team football for Huddersfield when aged 16, later moving to Torino. He joined Manchester United in 1962, scoring in his debut match. He went on to establish a reputation as one of the club's greatest and most popular forwards, scoring 236 goals in 393 appearances. He also gained 55 caps for Scotland. Law ended his football career playing for Manchester City, and in 1974, his last league season, he scored the goal in a Manchester derby match which was widely regarded as relegating Manchester United to the Second Division. Law went on to become a football commentator on television and radio.[1]

A statue of Denis Law was commissioned in 2000 by Manchester United Football Club. It was to be placed in the new West Stand (the old Stretford End) in an area called the Fanzone. Law was one of the club's most popular players, regarded as someone who epitomised its spirit and the strong relationship between

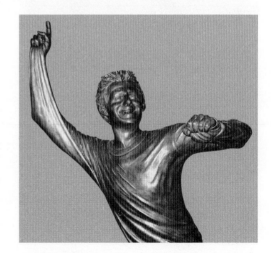

Panting, *Denis Law*

players and supporters. Nicknamed the 'King of the Stretford End', he was an obvious choice as the subject of a statue in this part of the ground. The London-based sculptor, Ben Panting, who had already sculpted a bust of Jimmy Murphy for the club, was commissioned to provide the larger than life-size statue of Law.[2] Panting worked from photographs and depicted Law in one of his characteristic poses: his arm held aloft after scoring a goal for United, his hands gripping the cuffs of his long-sleeved shirt. It had been hoped to complete the statue in 2001, but it was not finally ready until the following year. It was installed on the concourse of the upper tier of the West Stand and unveiled in February 2002, a Saturday when Manchester United were playing at home. Denis Law attended the ceremony.[3] The statue was originally placed almost in the centre of the concourse but was soon moved to the back of this busy public area, where it was placed behind large metal railings, which obscured the lower part of the work. This was the second statue to be raised to a Manchester United player, a bronze statue of Duncan Edwards, the work of James Butler, having been installed in Dudley in 1999.

Notes
[1] B. Hughes, *The King: Denis Law, Hero of the Stretford End* (Manchester: Empire Publications, 2003). [3] Information from Ken Merrett, Secretary, Manchester United Football Club. [3] *The Guardian*, 25 February 2002.

Talbot Road

Trafford Town Hall

Electra and Niord

Bromsgrove Guild

9 November 1934
Bronze
Electra 1.4m × 1.21m × 53cm; Niord 1.51m × 1.21m × 53cm
Signed on plinths: Bromsgrove Guild Ltd

Inscription: Electra: ELECTRA / Garlanded she rises, sending forth her light / enveloping the earth. Niord: NIORD / I stay the tempests and the foaming chariots / of the Sea Gods
Status: Grade II
Condition: good
Owned by: Trafford Metropolitan Borough Council
Description: Pair of bronze sculptures, facing each other on the the the main staircase inside the town hall. Electra is a life-size female figure kneeling among the clouds and lightning, her left hand resting on a globe around which is coiled a cable. Niord is a life-size male figure, half-kneeling on the ocean, from which rise horses and on which sails a steamship.

Stretford Town Hall, located at the junction of Talbot Road and Warwick Road, was opened by the 17th Earl of Derby in September 1933.[1] The architects were Bradshaw Gass and Hope of Bolton. A prominent businessman and former chairman of Stretford Urban District Council, Thomas B. Finney, decided to mark the occasion by presenting some statuary for the new building. Two major bronze sculptures, representing *Electra* and *Niord*, were commissioned from the Bromsgrove Guild in Worcestershire.[2] The choice of the Bromsgrove Guild appears to have followed advice from J. Millard, Head of the School of Modelling and Sculpture at the Manchester School of Art. *Electra*, one of the seven sisters in Greek mythology, symbolised the power of electricity controlled, whilst *Niord*, the Norse god of the winds and sea, represented Stretford's connections with the sea, culminating in the port established by the Manchester Ship Canal. Alexander 'Mac' Allan and Ernest W. Pickford of the Bromsgrove Guild attended meetings in Stretford to discuss aspects of the commission, and it is probable that one or both of them were involved in the design.[3] Alan Hodgetts was responsible for the inscriptions.[4] The Town Clerk monitored the progress of the commission, visiting

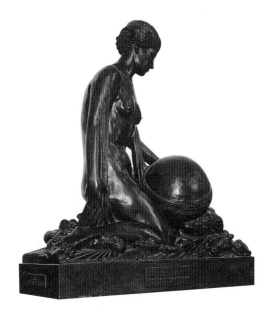

Bromsgrove Guild, *Electra*

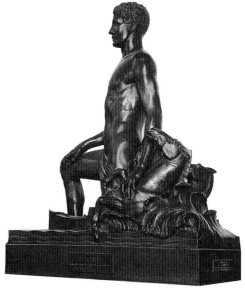

Niord

Bromsgrove to see the bronzes. The sculptures were unveiled in a ceremony in November 1934.[5] The cost of the works was £450. 12s. 10d. Finney also presented the council with two French bronze sculptures: a life-size figure of the springing *Mercury* (after Jean Bologne) and *Fortuna* (after Fulconis). They were displayed on the half-landing of the grand staircase. In 1974 Stretford Town Hall became the administrative headquarters for the new Trafford Metropolitan Borough Council. An extension to the town hall was completed in 1983. It contains a marble statue of Eve (J. R. Whittick, 1882) that was originally located in Stamford Park, Altrincham.[6]

Notes
[1] *Stretford Borough News*, 16 September 1933.
[2] Q. Watt (ed.), *The Bromsgrove Guild. An Illustrated History* (Bromsgrove: Bromsgrove Society, 1999). [3] Memo of Town Clerk's interview with Mr Allan and Mr Pickford, 18 October 1934 (Stretford Borough Council Archives 1934 / 024).
[4] *Bromsgrove Society Newsletter* 23 No.2 (2003) pp.10, 14. [5] *Borough of Stretford, Presentation and Unveiling of Bronze Groups* (Stretford [1934]); *Stretford Borough News*, 16 November 1934.
[6] Information from Angela Thomson and Karen Cliff, Stretford Local Studies.

Waters Meet, off Moss Road

Whirlwind
Adrian Moakes

1997
Stainless steel; mild steel; aluminium
5m high
Status: not listed
Condition: fair
Owned by: unknown
 Description: A steel sculpture representing the swirling funnel of a wind, rising from ground, surrounded by stone blocks.

Moakes was commissioned by the Trafford Park Development Corporation to provide a sculpture at the point in Trafford Park where

the Bridgewater Canal divided, one arm going towards Worsley and the other towards Runcorn. Moakes had previously created a maze and seating area from recycled stone blocks, a work entitled *The Eye of the Storm*, at the site. The new stainless steel sculpture, suggesting a powerful swirling wind, was placed

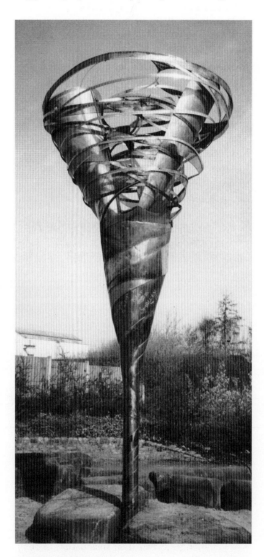

Moakes, *Whirlwind*

in the centre of the stones. The sculptor did not expect the work to be permanent.[1]

Note
[1] Information from Adrian Moakes.

Trafford Wharf Road

Trafford Wharf Road and Wharf End; Trafford Wharf Road and Victoria Place

Skyhooks
Brian Fell

1995
Steel
17m high × 4.42m square base
Status: not listed
Condition: good
Owned by: Trafford Metropolitan Borough Council
 Description: Two enormous industrial hooks and chains (five and a half links) positioned at opposite ends of a range of industrial buildings. The hooks appear suspended and purposeful. Each skyhook, painted black, rises from a sloping base of dark industrial brick, fixed on a raised area of red sandstone.

Public art was accepted as an integral part of the regeneration programme of the Trafford Park industrial estate, spearheaded by the Trafford Park Development Corporation between 1987 and 1998. Trafford Park had opened in 1896, two years after the Manchester Ship Canal, and, after some initial problems, it became home to some of the country's largest engineering and industrial companies, including British Westinghouse (later Metropolitan Vickers) and the Ford Motor Company. In devising its strategy for the economic regeneration of an area which had experienced severe economic decline, the Development Corporation

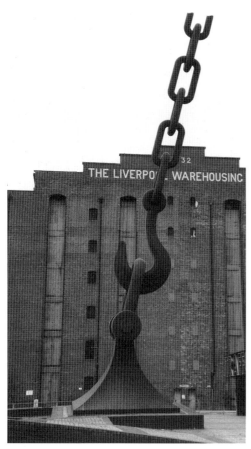

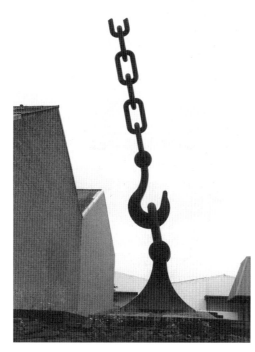

Fell, *Skyhooks*

recognised the importance of a complementary programme of environmental regeneration. This aimed to create a business location which would both encourage existing firms to remain and invest in the park, and attract new ones to move there. Derelict buildings were cleared, landscaping was undertaken and improvements were made to the external appearance of buildings. The Development Corporation acknowledged the role of public art in engendering 'a sense of identity' in the estate. The Wakefield-based organisation, Public Arts, was chiefly responsible for co-ordinating this part of the Development Corporation's work.

The public art included signage and fencing as well as the installation of landmark sculptures. One of these was a project to erect a dramatic and visually powerful symbol at the eastern gateway to Trafford Park. A competition was organised and Brian Fell was chosen to carry out the commission. Fell proposed two 17-metre-high industrial chains with hooks, to stand at opposite ends of the proposed site. They were both a response to the area's industrial past, particularly the large engineering firms whose own histories were inextricably associated with that of the world's first industrial estate, and a declaration of a new beginning. The engineering of such large objects was a challenge, as was their installation in 1995 on the two landscaped sites. They stand, huge

and challenging, metaphors for the regeneration of Trafford Park.[1]

Note
[1] G. Roberts, 'Regeneration X. The Artistic Factor', *On the Waterfront*, No.2, February 2000.

Quayside Walk
Silent Cargoes
SITE (James Wines)

1996
Area covered 49m × 7.5m approx
Micro-silicate concrete; galvanised metal objects
Inscription: *Commissioned by Trafford Park Development Corporation / During the Centenary year of Trafford Park to portray the changing / activities on Trafford Wharf over the past 100 years / Public Arts / Putting art in public places*
Status: not listed
Condition: reasonable; some of the smaller objects stolen or prised loose
Owned by: Trafford Metropolitan Borough Council
Description: The work consists of a large number of artefacts, associated with the industries of Trafford Park and the docks, arranged along the quayside of the Manchester Ship Canal. The industrial objects include machinery, barrels, bales, boxes, metal pipes, tools, oil drums, chains, trolleys, anvil and horseshoes. All of the objects have been galvanised or painted grey and, where necessary, stiffened with micro-silicate concrete. The work covers an area of some 350 square metres.

The idea of a landmark sculpture to be located on the Trafford side of the Manchester Ship Canal was discussed in 1994 by Trafford Park Development Corporation and Public Arts of Wakefield, the company responsible for overseeing the installation of public art in Trafford Park. The outcome was the decision to

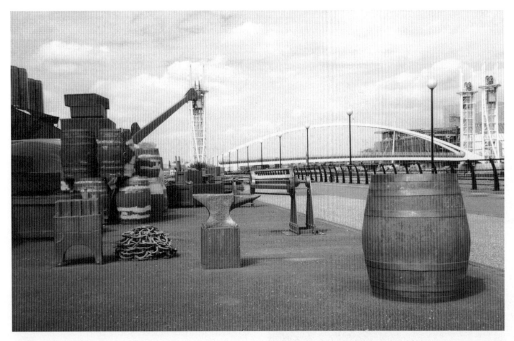

SITE, *Silent Cargoes*

commission a work from SITE (Sculpture in the Environment), the New York-based firm founded and led by the designer and architect, James Wines. It was internationally recognised for its innovative integration of sculpture in public spaces. Graham Roberts of Public Arts had been impressed with a design that SITE had submitted for a competition in Liverpool. The work intended for Trafford was to celebrate and memorialise the area's extraordinary industrial history. *Silent Cargoes* took the form of an arrangement of industrial artefacts – machinery, tools, chains, barrels and other objects – associated with the docks and the firms that once provided employment for tens of thousands in this part of the city. All the objects were treated so that they appeared a ghostly grey, providing them with a sense of detachment from the present day as well as imbuing them with a commemorative feeling, honouring the lost legacy of the docks. On

closer inspection some of the artefacts bear the names of companies associated with the industrial estate: for example, the radiator of a Ford car and a dynamo manufactured by the Lancashire Dynamo Company. The work embodied a sense of the emptiness associated with industrial decline, the workmen's clothing (flat cap, gloves) lying on the tops of boxes prompting thoughts of those whose jobs were lost as industry and the docks closed.[1] Extensive as the area covered by the sculpture was, the original idea was for an even larger work, and one that could be added to over time.[2]

Realising the work in a durable form posed technical problems. Two processes were used to produce the finished objects: some objects were hot dipped and galvanised in zinc whilst for others a vacuum mould of the object was prepared and then filled with micro-silicate concrete. John King, a Liverpool artist, assisted in the preparation and installation of the

artefacts. Problems surrounding the financing of the project resulted in SITE withdrawing before it was completed.[3] The work was installed on the canal quayside in 1996, the centenary of the industrial park. Surprisingly, for such an important work, it does not appear to have been officially unveiled. The work has suffered some minor vandalism since its installation – some of the smaller hand tools and sacks having been prised off. Repairs were carried out in 1999.

Notes
[1] Information supplied by John King, September 1999. [2] Information supplied by Graham Roberts, 2002. [3] Correspondence with James Wines, Department of Architecture, Pennsylvania State University.

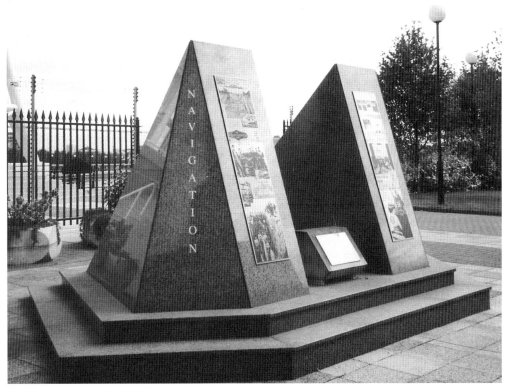

Partnership Art, *Ship Canal Centenary*

Quay West

Ship Canal Centenary

Partnership Art

20 May 1994
Rosso marble
1.83m high
Inscription: TO COMMEMORATE THE CENTENARY
OF THE OPENING OF THE MANCHESTER SHIP
CANAL / BY HER MAJESTY QUEEN VICTORIA
ON 21 MAY 1894 / IT WAS FROM A PAVILION
NEAR THIS SITE THAT / HER MAJESTY SET SAIL

ABOARD THE R.Y. 'ENCHANTRESS' FORMALLY
TO DECLARE THE CANAL OPEN / unveiled by
HRH Princess Anne as part of the events
arranged to mark the canal's centenary.
Status: not listed
Condition: good
Owned by: Peel Holdings plc

The Manchester Ship Canal Company (part of
Peel Holdings plc) commissioned a public art
work to mark the centenary of the opening of
the Ship Canal. Partnership Art produced the
work which was a symbolic representation of
the canal with the sloping uprights representing
the canal banks and the space between them
representing the canal. The panels were
inscribed with images of the canal, including
extracts from documents about the canal and
other artefacts relating to it. The work was
placed at the front of the modern office block,
Quay West, directly between the building and
the canal. Princess Anne unveiled the work in
May 1994 as part of the centenary celebrations.[1]

Note
[1] *Manchester Evening News*, 20 May 1994;
information from Manchester Ship Canal Company
and Peel Holdings plc.

Marshall Stevens Memorial
Arthur Sherwood Edwards

1 October 1937; re-sited March 1993; removed
2000
Welsh granite; bronze portrait medallion
4.87m high × 1.75m × 1.1m
Inscription: MARSHALL STEVENS / 1852–1936 /
TO WHOSE FORESIGHT, ENERGY AND ABILITY,
/ THE SUCCESSFUL DEVELOPMENT OF
TRAFFORD PARK / AS AN INDUSTRIAL AREA IS
DUE. / *Erected by the Directors and
Shareholders of Trafford Park Estates Ltd.*
Status: not listed
Condition: good
Owned by: Trafford Park Estates
 Description: A colossal 20-tonne block of
grey granite with a bronze medallion portrait of
Stevens attached to the smoothest face. Beneath
the portrait is an inset bronze panel with an
inscription.

Marshall Stevens was born in 1852 at Plymouth,
the eldest son of shipping magnate, Sanders
Stevens. He was educated at the Mansion
House in Exeter and entered the family
shipping business around 1868.[1] In 1877 he
moved to Garston on the Mersey and
established himself as a steamship agent,
beginning a lifelong battle with rail freight
monopolies. The Manchester Ship Canal was
built partly as a response to the extortionate
railway rates between Manchester and
Liverpool, and Stevens joined the project as one
of the founder members of the canal committee.
He threw himself wholeheartedly into the
enterprise, becoming provisional manager of
the Canal Company in 1885. The volume of
traffic on the canal in its early years failed to

live up to expectations, and Stevens was forced
to reduce freight charges and extend control
over the dock workforce. He banned unions
and introduced piece-work, thereby raising

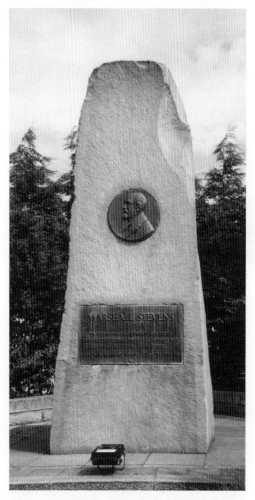

Sherwood Edwards, *Marshall Stevens Memorial*

productivity levels above those of his principal
rival, Liverpool docks. When he left the Canal
Company in 1897 he was presented with an
illuminated address, signed by 361 members,
which praised Stevens' 'indomitable
perseverance, untiring zeal, ability and excellent
judgment'.[2] Stevens' next project, equal in
vision and scale, was the development of
Trafford Park, formerly the estate of
Humphrey de Trafford, into the first and
largest industrial estate in Europe. The railway
companies again proved obstructive and the
enterprise struggled until the transfer of port
traffic from the east coast after the outbreak of
war in 1914 brought success and prosperity to
the company.[3] Stevens was elected a director of
Manchester Chamber of Commerce in 1916 and
Conservative MP for Eccles in 1918, winning
the largest majority in the history of the
constituency. He was defeated, however, in
1922 and again in 1923 after running a
virulently anti-socialist campaign. His interests
in the Estates Company gradually lessened, and
in 1932 he retired to Monte Carlo, and died in
August 1936 at Plymouth.[4] He is buried in the
family vault he had purchased in 1928 at St
Catherine's Church, Barton, overlooking the
two enterprises – the Ship Canal and Trafford
Park – which had occupied so much of his life,
and which contributed so much to the
restructuring of the region's economy.[5]
 After Stevens' death it was decided to raise a
memorial to him. It was paid for by a
subscription among shareholders in Trafford
Estates. The memorial was designed and
executed by the Ashton upon Mersey sculptor,
Arthur Sherwood Edwards. It took the form of
a colossal block of Welsh granite with a bronze
bas-relief portrait medallion and inscription

panel.[6] Metrovicks produced the medallion. It was located at the junction of Trafford Park Road and Ashburton Road.[7]

The memorial was neglected as the docks and the industrial park declined. The renaissance of Trafford Park started in the late 1980s and included the construction of a new road system. One part of it, the Europa Way, caused the removal of the memorial in September 1992. It was re-sited on Trafford Wharf Road, close to the Elevator Road junction, an area which had been landscaped as part of the Development Corporation's policy of reclaiming derelict land. The memorial was unveiled for a second time in March 1993 by Sir Dermot de Trafford, grandson of Sir Humphrey Francis de Trafford, the man who had sold the Trafford Park estate in 1896. The stone work for the new site was carried out by Mather and Ellis.[8] In 2000 the building of the Imperial War Museum North caused the memorial to be removed again. The future location of the monument, raised to the man who more than any other was responsible for making Trafford Park one of the industrial wonders of twentieth-century Britain, remains undecided.[9]

Notes
[1] This draws heavily on the entry by D.A. Farnie in the *Dictionary of Business Biography* (London: Butterworths, 1986) Vol.5, pp.312–25. [2] D.A. Farnie, *The Manchester Ship Canal and the Rise of the Port of Manchester* (Manchester: Manchester University Press, 1980); Ian Harford, *Manchester and its Ship Canal Movement* (Keele: Ryburn Publishing, 1994). [3] R. Nicholls, *Trafford Park: The First Hundred Years* (Chichester: Phillimore, 1996); T.H.G. Stevens, *Some Notes on the Development of Trafford Park 1897–1947* (Manchester, 1947). [4] *Manchester Guardian*, 13 August 1936. [5] St Catherine's was demolished in 1972, but the vault remains, although it has been vandalised. [6] *Manchester Guardian*, 1 October 1937. [7] Nicholls, *op. cit.*, p.84. [8] *Ibid.*, pp.84, 125. [9] Correspondence with Kevin Flanagan, St Anthony's Centre, Trafford Park; *Trafford Park Heritage News*, September 2002.

WIGAN

WIGAN

0 — 2 kilometres
0 — 2 miles

M6
27 Standish
A49
LANGTREE
ASPULL-
STANDISH
Haigh
Country
Park
Aspull
BEECH
HILL
ISWINLEY
WHELLY
NORLEY Newtown
WIGAN
A577
Orrell
A577
A58
NEWTOWN
Ince in
Makerfield
26
INCE
Hindley
HINDLEY
WINSTANLEY
WORSLEY
MESNES
HINDLEY
GREEN
Atherton
HINDSFORD
ORRELL
ATHERTON
Tyldesley
TYLDESLEY
EAST
25
Astley
A580
Abram
A58
ABRAM
LEIGH
CENTRAL
A579
Boothstown
BRYN
A573
Leigh
LEIGH
EAST
24
Ashton-in-
Makerfield
M6
ASHTON-
GOLBORNE
HOPE
CARR
BEDFORD-ASTLEY
Golborne
A580
LIGHTSHAW

Introduction

The Metropolitan Borough of Wigan was established in 1974, comprising Wigan County Borough, Leigh Municipal Borough, the urban districts of Abram, Aspull, Atherton, Hindley, Ince in Makerfield, Orrell, Standish and Tyldesley; parts of the urban districts of Ashton-in-Makerfield, Billinge and Golborne, and part of Wigan Rural District. The borough lies to the north-west of Manchester. It is the largest of the metropolitan boroughs in the Greater Manchester conurbation, covering an area of 19,884 hectares. The population in 2001 was 301,417.

Wigan is one of the four oldest boroughs in Lancashire, having received a royal charter from Henry III in 1246. As well as being an important agricultural centre, it developed a varied industrial base with a tradition of textile production including woollens, linens and other cloths. Wigan also established a reputation for craft industries, notably the making of guns and clocks. But it was coal that was to prove central to its modern economic history; legal disputes over the digging of coal in the back gardens of properties in the town in the seventeenth century are reminders that its importance was recognised long before the industrial revolution. Leigh, the borough's second largest town, was more obviously an agricultural centre than Wigan – it was famous for its toasting cheese – though here too textile manufacturing and coal-mining were important before the nineteenth century.

King Coal and King Cotton transformed this area of Lancashire. Wigan, which had appeared to Celia Fiennes as 'another pretty market town built of stone and brick',[1] was transmuted into the 'monstrous scenery' of factories and slag-heaps recalled so vividly by George Orwell.[2] The opening of new collieries and an almost unbroken increase in the output of coal characterised nineteenth-century Wigan. At its peak in 1907 the Wigan coalfield was producing 26 million tonnes from some 350 collieries.[3] The cotton mill was the other great symbol of the district's industrialisation, and in towns such as Leigh and Atherton it challenged coal-mining as the dominant employer. The digging of coal and the expansion of other heavy industries – ironmaking, engineering and metal trades – created an environment that was both grim and grimy. Working conditions were unenviable and remained so for generations. It is to be doubted whether any of the men working the furnaces at Kirkless Hall ironworks, Ince, would have recognised the description of their foundry as 'imparting a Rembrandt-like hue to their surroundings'.[4] Living conditions were equally unpleasant. Lyon Playfair's judgement of 1845 that Wigan was 'one of the most unhealthy towns in the kingdom', was to hold true until after the founding of the post-war Welfare State.[5]

Although, at first glance, this was not a district where one might expect a rich crop of public monuments and sculpture, it did have a considerable number of small ones. It can also claim some of the oldest extant public monuments in Greater Manchester. Wigan's most famous monument is Mab's Cross, a fame derived from its association with the penance undertaken by the bigamous Lady Mabel Bradshaigh. It is a historical landmark of the late-medieval period.

Many of the district's crosses have been either destroyed or lost, or only parts of them have survived. The cross at Newton in Makerfield was taken down and apparently lost whilst the surviving parts of the cross at Leigh were incorporated into an obelisk.[6] The base and lower shaft of the Goose Green cross have survived.[7] The village cross at Standish appears to be an exception to this familiar story of neglect, damage and removal.[8] Apart from Mab's Cross itself, Wigan has one other important pre-industrial outdoor monument, a stone column memorialising Sir Thomas Tyldesley. It was erected, after the Restoration, near to the place where he was killed, in what proved to be the last local battle of the English Civil War.

One of the district's first nineteenth-century monuments was a private one, an obelisk raised in the grounds of Bispham Hall, Billinge, to mark the victory of the Duke of Wellington and his allies at Waterloo.[9] An elaborate stone cross, erected in 1852 in front of the church of St John's,

Removal of Mab's Cross, Standishgate, 1919

Standishgate, was one of the first memorials to be raised in Victorian Wigan. It was a memorial to the Walmesleys, one of the district's prominent Catholic families, and was stated to be the work of Pugin.[10] In fact, it is in the district's churchyards and cemeteries that one can find a considerable number of public memorials commemorating local individuals or events. These include a portrait statue of Revd J.J. Middlehurst in Leigh Cemetery,[11] and a marble angel symbolising charity erected as a tribute to Dr John Grindall Brayton – 'The Friend of the Poor' – in Hindley Cemetery.[12] A memorial to Thomas Houghton from his fellow railway workers stands in Ince Cemetery. Tyldesley Cemetery contains memorials to Thomas Syms, the long-serving manager of the weaving department of the local Burton Mills, and Robert Isherwood, agent for the Lancashire and Cheshire Miners' Federation.[13]

John Grundy, who devised a new system of heating for churches, was remembered by a public monument in the graveyard of a chapel at Tyldesley. Twenty thousand miners subscribed to a memorial to their leader, William Pickard, in Wigan Cemetery.[14] When the colliery manager, James McGeever, died in 1901, his workpeople, who were said to have 'idolized' him, contributed towards a portrait sculpture to be displayed on his gravestone in St Oswald's churchyard, Ashton-in-Makerfield.[15] A special and poignant category of public memorials to be found in the district's cemeteries commemorate the 'boys and men' killed in colliery disasters: for example, to those who died in the Bedford Colliery Explosion on Friday 13 August 1886, and to the 75 victims of the Maypole Colliery, disaster in August 1908.[16] Such memorials, surrogate graves for mourning families, were almost always of a simple design, their significance being in their very presence and their inscriptions. The district also had examples of that more practical type of Victorian public monument, the drinking fountain. In Tyldesley, a fountain was erected from the money left by John Buckley, a Liberal supporter and local historian. It was, somewhat unusually, a scheme that had its local critics.[17] The drinking fountain installed to mark Victoria's diamond jubilee in Standish proved less contentious.[18]

Victorian Wigan itself showed no strong interest in raising statues to either national figures or local worthies. Paradoxically, this was not the case in other countries where Wigan men were memorialised. Thus the contribution of Myles Standish to the history of modern America – Standish had sailed with the Pilgrim Fathers on the *Mayflower* and served as the military commander of the new settlement at Plymouth, Massachusetts – was remembered by a statue standing on a massive granite tower on Captain's Hill, outside Plymouth. It was completed in 1898.[19] Wigan had to wait until the Edwardian period before it acquired its first modern statues. The first was in the form of a war memorial, raised to those local soldiers who had died in the South African War. The sculptor was William Goscombe John. The second one honoured the local Conservative MP and philanthropist, Sir Francis Sharp Powell. It

was the work of Ernest Gillick, and it was to be the town's only true portrait statue.[20] Both were placed in the town's main park, Mesnes Park. Other schemes were less successful. The plan to raise a statue to Colonel Blundell, another local Conservative MP, failed to raise sufficient funds, forcing the memorial committee to alter its plans and erect an obelisk in Alexandra Park, Newtown.

Although some of Wigan's late-Victorian and Edwardian buildings did announce their presence with some sculptural decoration – the terracotta flourishes on the Municipal Buildings, Library Street, and Tower Buildings, Wallgate (both by Bradshaw and Gass) are noteworthy – these were hardly comparable to the architectural sculpture on display in Bolton, Bury and Rochdale.[21] In the context of other major Lancashire towns, Wigan Town Hall was also unconvincing, although perhaps not quite warranting Pevsner's dismissal as 'not worth a line'.[22] More predictably, large-scale schemes of architectural sculpture were rarely to be found in the smaller towns. Leigh Town Hall, which employed Farmer and Brindley, was the exception.

All of the district's towns and villages commissioned memorials to remember the dead of the First World War. Some memorial committees turned to local architects: Leigh's cenotaph was designed by Ernest Prestwich.[23] Other committees looked outside the district: Atherton commissioned Bradshaw and Gass of Bolton. Wigan, somewhat belatedly, commissioned Giles Gilbert Scott to provide its principal war memorial, a design that drew on the vocabulary of the Eleanor Crosses. It was an impressive memorial. Few of the district's memorials, however, included sculptured figures. An exception was the life-size statue of a soldier on the memorial placed in St Peter's churchyard, Westleigh.[24]

By the time many of these memorials were being unveiled, the whole district was in the grip of industrial problems. The long contraction of the coal and cotton industries had begun. The rate and impact of that decline

Unveiling of Francis Sharp Powell's statue, Mesnes Park, 1910

varied between towns, but by the 1930s the sense of decay was impossible to ignore. By the 1950s any hope that the situation could be reversed was being replaced by a realisation that the decline was terminal.[25] The closing of pits and mills became an all too familiar story reported in the local press. Such economic conditions were not conducive to erecting new sculpture, or even to the maintenance and removal of grime from existing ones.[26] The condition of some monuments would have deteriorated even further, had it not been for action taken by civic groups and local history societies.[27] Almost inevitably, there were losses. In 1968 Goscombe John's heavily vandalised war memorial was removed from Mesnes Park and, apparently, discarded. Other monuments also suffered. A memorial stone seat erected to the Wigan cotton manufacturer and politician, Nathaniel Eckersley, as the centrepiece of the Eckersley Memorial Gardens in the Poolstock district of the town, was vandalised and eventually removed. The seat had included a bronze portrait medallion.[28] The Blundell monument in Newtown fared little better. Some sculptural pieces did manage to avoid destruction: the stone lion that had watched over Wigan from the parapet of the town's gas works was eventually moved to Haigh Hall Country Park.[29]

There was little new outdoor sculpture to compensate for these losses. New public and educational buildings were rarely embellished with sculpture. An exception was the new public library (later the Turnpike Centre) at Leigh, which included a decorative abstract concrete mural by the London sculptor, William Mitchell.[30] But, as in the majority of the towns covered in this survey, it was only in the 1990s that an obvious change in attitudes towards public sculpture and art became evident. The decade opened with impressive brick sculptures of the figure of Justice and the royal coat of arms on the exterior of Wigan's new magistrates' court.[31] In 1996 the Metropolitan Borough Council announced its policy to encourage 'the provision of appropriate new works of art for public places in Wigan to contribute to the economic, environmental and social well-being of the borough'.[32] The result was the commissioning of a number of public art projects, including Sebastien Boyesen's mosaic in Wigan Market Place, a work which acknowledged the earlier market cross and the town's trade and industries.[33] Trencherfield Mill, the home of the Wigan Pier Experience, became the site for one of the region's largest public art works, Andy Hazel's automaton heads.[34] Other smaller works have followed in Wigan, sufficient for the town to organise its own public art trail. One of the more recent works is Joanne Risley's bronze rugby ball. Some sculptures have been welcomed, others criticised. The reaction in Leigh to the removal of Marjan Wouda's *Pit Pony* and the installation of *The Leigh Spindle* suggests that the public's attitude towards modern public sculpture continues to be ambivalent.

Notes
[1] C. Morris (ed.), *The Illustrated Journeys of Celia Fiennes 1685–c.1712* (London: Macdonald, 1982) p.161. [2] G. Orwell, *The Road to Wigan Pier* (1937; Penguin edition, 1962) p.16; B. Crick, *George Orwell. A Life* (London: Secker and Warburg, 1980) pp.182–7; R. Pearce, 'Revisiting Orwell's Wigan Pier', *History*, 82 (1997) pp.410–28. [3] D. Anderson and A. A. Farnie, *Wigan Coal and Iron* (Wigan: Smiths Books, 1994). [4] B. Blakeman, *Wigan A Hundred Years Ago* (Staining: Bob Dobson, 1990). [5] D.C. Crompton, 'Infant Mortality in Wigan 1900–1914' (unpublished MA thesis, University of Manchester, 1990) p.57. [6] H. Taylor, 'The Ancient Crosses of Lancashire. The Hundred of West Derby', *Transactions of Lancashire and Cheshire Antiquarian Society*, 19 (1901) pp.226–38. [7] Remains of Goose Green boundary cross, St Paul's School, Warrington Road, Wigan (Wigan Metropolitan Borough Council Listed Buildings, WIG 78 24–1/5/125). [8] Wigan Metropolitan Borough Council Listed Buildings, STA8 2/120; illustrations in N. Webb, *Standish and Shevington* (Stroud: Tempus, 1999). [9] Grade II listed; W.B. Savigny, *History of Bispham Hall* (South-West Lancashire Boy Scouts Association, 1954). The monument is on land owned by the Scout Association, not open to the public. [10] Grade II listed; Pevsner, *South Lancashire* (1969) p.425. [11] Information from Philip Powell. The sculptor was James Hilton. [12] *Wigan Observer*, 20 December 1893. [13] Information from Philip Powell. [14] P. Salveson, *The People's Monuments* (Manchester: Workers' Educational Association, 1987) p.33. [15] *Wigan Examiner*, 12 January 1901. [16] Memorials in Leigh Cemetery and St John Evangelist churchyard, Warrington Road, Abram, respectively. *Manchester Guardian*, 16 August 1886, 19 August 1908. Information from Philip Powell. [17] J. Lunn, *A Short History of the Township of Tyldesley* (Tyldesley: Tyldesley Urban District Council, [1953]). [18] Located in the High Street, Standish; *Wigan Observer*, 12 October 1898. [19] S.M. Allen, *Myles Standish: with an account of the exercises of consecration of the monument on Captain's Hill, Duxbury, August 17, 1871* (Boston, 1871). [20] Pevsner, *South Lancashire*, p.426. [21] *Wigan Town Centre Trail* (Wigan MBC, 1998) 2nd ed. [22] Pevsner, *South Lancashire* (1969) p.426. [23] *Leigh Chronicle*, 29 September 1922, 6 October 1922. [24] Located on Firs Lane, Westleigh. The sculptor was Bratt of Leigh; unveiled 1919. [25] K. Allsop, 'The problem of a dying coalfield', *Picture Post*, 8 January 1955, pp.29–32. [26] *Lancashire Evening Post and Chronicle*, 28 October 1968. [27] *Wigan Observer*, 16 June 1961. [28] The gardens, located between St James's Church and Poolstock, were given to Wigan by Lt.-Col. Nathaniel Eckersley, son of the former local MP and benefactor. *Wigan Observer*, 13 November 1928, 15 September 1928. The foundations of the seat can still be seen. [29] Pevsner, *South Lancashire* (1969) p.427. [30] *Leigh Library* (undated brochure, Leigh Library [1971]), opened 3 November 1971. [31] Located in Darlington Street, Wigan. Information from Richard Healey, Baggeridge Brick, Sedgley, Dudley. [32] *Public Art Policy For Wigan* (Wigan Metropolitan Borough Council, 1996). [33] Unveiled in 1998. [34] Wigan Metropolitan Borough Council, Draft Public Art Strategy prepared by Public Arts [1999].

ASTLEY

Higher Green Lane

Red Rose Mining Museum

Leigh Pit Pony

Marjan Wouda

1991; relocated 2001
Fibreglass; resin and coal dust
1.4m × 2. m × 55cm
Status: not listed
Condition: good
Owned by: Wigan Metropolitan Borough
 Council
 Description: Life-size sculpture of harnessed
pit pony, wearing blinkers to keep the coal dust
out of its eyes. Objects associated with the
mining industry are embedded in the animal's
skin.

Wouda, *Pit Pony*

Marjan Wouda was commissioned by
Groundwork Trust Wigan to produce a
sculpture as part of a residency at Leigh CE
Junior School. Children from different classes
were involved in creating the sculpture. The
subject was a pit pony, a single animal
representing all those ponies which had worked
underground in the local coal-mines, pulling
tubs of coal on rails. By the 1980s almost all the
local mines had been closed and the few
remaining working pit ponies were pensioned
off. The skin of the pony was encrusted with
objects – rope, chains and buckles – associated
with the mining industry.[1] The completed
sculpture was presented to the owners of the
Spinning Gate shopping centre in Leigh, where
it was displayed in the main mall before being
moved to the market hall entrance. Changes to
the shopping centre in 2001 resulted in the
council deciding to remove the sculpture to the
Astley Mining Museum. The removal was
followed by an outburst of protest from
Leighites demanding the return of their pit
pony. Among those critical of the decision, seen
by some as another instance of Wigan's high-
handed treatment of its neighbours, were the
headmaster and pupils of the school where the
work had been created.[2]

Notes
[1] Correspondence with Marjan Wouda, March
2000. [2] Leigh Town Centre Newsletter, October
2001; *Leigh Journal*, October 2001.

DALTON

Ashurst Hill

Ashurst Beacon

Stone
10.68m high approx × 4.3m square base
Inscription on plaque attached to doorway:
PRESENTED TO / THE CORPORATION OF
WIGAN / ON THE 12TH DECEMBER 1962 BY /
MRS FLORENCE MEADOWS / IN MEMORY OF
HER HUSBAND / THOMAS MEADOWS /
JOURNALIST (1872–1956) / WHOSE DESIRE IT
WAS THAT THIS LAND / SHOULD FOREVER
REMAIN A BEAUTY SPOT / FOR THE
ENJOYMENT OF THE PEOPLE OF WIGAN
Condition: fair
Owned by: Wigan Metropolitan Borough
 Council
 Description: Stone beacon comprising a large

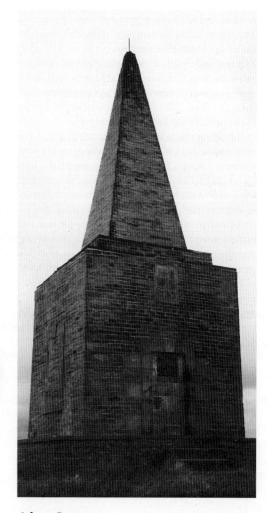

Ashurst Beacon

square base (the doorway and windows filled in) surmounted by a pyramid. The whole structure rises from a smaller stone base which serves as a viewing platform.

Ashurst Hill takes its name from a seventeenth-century family who owned the site, and one of whose members became High Sheriff of Lancashire.[1] It was reputed to be the site of an ancient beacon, but the present structure probably dates from the late eighteenth century. It is identified on Yates's 1786 map of the county.[2] The 'extensive prospect' from the beacon was noted by a number of contemporaries, including Aikin.[3] Baines records the beacon being manned during the Napoleonic wars.[4] During the nineteenth century Ashurst Hill became a popular destination for walkers and picnic parties. The land including the beacon was acquired by Thomas Meadows, editor of the *Wigan Observer*, during the 1920s. He restored the structure twice at his own expense.[5] The view was considered so exceptional that when the electricity system was being developed at the end of the 1930s, underground cables were substituted for overhead pylons.[6] The beacon and the surrounding seven hectares were donated to Wigan Corporation in 1962 by Meadows' widow, Florence.[7] Mr Meadows had, she said, always intended to hand over the land on condition that it remained a public park and was not built upon. At the time of the donation the Corporation promised not to include the site in the proposed new town of Skelmersdale. A plaque acknowledging the donation was added in 1966, shortly after the death of Mrs Meadows.[8]

Ashurst Beacon remains the property of Wigan Metropolitan Borough Council although Dalton became part of West Lancashire in the local government boundary changes of 1974. It has suffered from vandalism over the years and the doorway and windows have been blocked up. The stone on the lower sections is marked by considerable (and patiently carved) graffiti.

Notes
[1] *Victoria History of the County of Lancaster* Vol.4 (1911) p.97. [2] W. Harrison, 'Ancient beacons of Lancashire and Cheshire', *Transactions of Lancashire and Cheshire Antiquarian Society*, 15 (1897) pp.32–3. [3] J. Aikin, *A Description of the Country from Thirty to Forty Miles round Manchester* (London, 1795; reprinted New York: A. Kelley, 1968) p.296. [4] E. Baines, *History of the County Palatine and Duchy of Lancaster* 3rd ed. (Manchester, 1891) Vol.4, pp.297–8. [5] *Wigan Observer*, 8 December 1961. [6] *Ibid.*, 20 May 1939. [7] *Ibid.*, 11 May 1962. [8] *Ibid.*, 1 April 1966.

LEIGH

Bradshawgate

The Leigh Spindle

Camm Design, Craig and Mary Matthews

16 July 2001
Stainless steel; aluminium; bronze cog
5m high; base 80cm diameter
Inscription on plaque by the side of the
 sculpture: The invention of multiple thread
 spinning is Leigh's contribution / to the
 global textile industry. This work is both a
 tribute to the / town's past and expression of
 confidence in its future / Artists for the
 project – Camm Design / Leigh Spindle:
 2001 / The project was implemented by: /
 Coalfield Challenge / Wigan Council
Status: not listed
Condition: good
Owned by: Wigan Metropolitan Borough
 Council
Description: A metal cone representing an imaginary textile machine. The 12–sided base rises in two stages, separated by a bronze cog. It comprises aluminium panels decorated with images associated with Leigh's industrial history and, above these, stainless steel panels

Camm Design, *The Leigh Spindle*

depicting rugby league players. This is surmounted by a coil of woven steel cables, from which individual cables spin upwards, creating a narrow cone.

The Leigh Spindle was commissioned as part of Wigan Metropolitan Borough Council's programme of environmental improvements. Beginning in the mid-1990s the Coalfield Challenge initiative had focused on Leigh, recognising that improvements in the town's

physical environment were important in sustaining the economic and social well-being of the community. These improvements included the town's main shopping street, Bradshawgate; it was partially pedestrianised, and new street furniture was introduced. As part of this improvement programme, in 2000 the council advertised for artists to provide a landmark sculpture or gateway feature in Bradshawgate. Craig and Mary Matthews of Camm Design, Wallasey, were chosen from a short-list of interviewed artists. The narrowness of the proposed site and the surrounding street furniture proved to be a determining factor in the design. There was also a restriction on the height of any sculpture. The outcome of consultations between the artists and local shopkeepers, residents' associations, the council and the general public were for a modern sculpture rather than a traditional one. The result was a work that represented an imaginary, futuristic piece of textile machinery. Yet in creating the piece Craig and Mary Matthews, whilst looking to the future, also acknowledged the town's industrial past. Leigh had been an important centre for manufacturing cotton, and could claim in Thomas Highs one of the men whose inventions had started the textile revolution of the eighteenth century. Leigh also developed as an important centre for the manufacture of cables, and was home to a number of the industry's major companies. It was these two industries that inspired Craig and Mary Matthews to explore the relationship between the spinning of cotton thread and the spinning of wire into cable. The outcome was a tall slim spire-like structure made of stainless steel, aluminium and bronze. The bottom section of cast aluminium panels included low-relief images of industrial buildings, transport and artefacts, including spindles, associated with the economic history of the town. A bronze cog, suggesting rotation, separated it from the second section, in which stainless steel filigree panels depicted Leigh's rugby league players. Above this was a coil of stainless steel

cable, representing weft threads, from which cables, the warp threads, were spun to form the final section of the cone. The structure included a lighting box which allowed it to be illuminated with a cool blue light at night.[1] *The Leigh Spindle* was unveiled by the leader of Wigan Council, Lord Peter Smith, in July 2001. In spite of the extensive consultations undertaken by the artists, the letters published in the local press were largely critical, comparing the new sculpture to a mobile phone booster aerial, a lightning conductor and a dog post. At the same time Leighites were calling for the return of a more traditional sculpture, Marjan Wouda's *Pit Pony*, which had been recently removed from the town's market hall.[2]

Notes
[1] Correspondence and conversations with Craig Matthews, 2002. [2] *Leigh Journal*, 17 August 2001.

Civic Square

Obelisk

c.1769; rebuilt 1859–60; relocated 1969, 1986
Peel stone
7.60m high approx × 1.18m square base
Status: Grade II
Condition: fair
Owned by: Wigan Metropolitan Borough
 Council
 Description: Stone obelisk with sunken panels on a rusticated stone pedestal with moulded base and capping.

The present obelisk was erected on or close to the site of the old market cross in the town's market place. The earliest reference to a cross on this site is from 1581. This is likely to have been replaced by an obelisk in the 1760s, though some authorities suggest that a market cross may still have been standing in the 1790s.[1] It seems more probable that the cross had been demolished some time before Robert Gwillym Atherton, Lord of the Manors of Atherton and Pennington, erected the obelisk.[2] In 1859 the

obelisk was taken down because it was in a dangerous condition, and the interior was found to be filled with 'mortar and rubbish'.[3] It was re-built with a new sandstone shaft, placed on the original eighteenth-century rusticated pedestal. Pevsner observed that although the obelisk was erected in the Victorian period it appeared Georgian.[4]

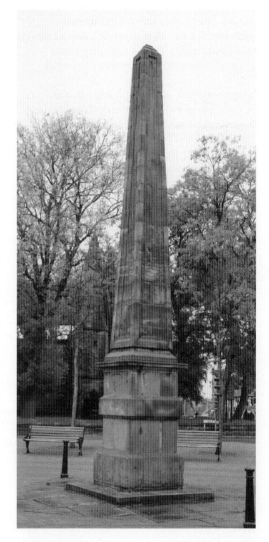

Leigh Obelisk

The obelisk remained the focal point of the town's market place for more than 100 years. In October 1969 it was moved some ten metres to the west of its original position to make way for the widening of Leigh Road.[5] It was moved again a short distance in 1986, to enhance its position in what was renamed Civic Square, a space surrounded by the Victorian parish church, the Edwardian town hall and the modern Turnpike Centre. On this occasion, the opportunity was taken to renew part of the stone pedestal.[6]

Notes
[1] J. Lunn, *The Historical Past of a Lancashire Borough* (Leigh: Leigh Borough Council, 1960) p.184. [2] C. Ward and N. Ackers, *The Old Town of Leigh* (Leigh Local History Society, 1985) p.22. [3] *Leigh Chronicle*, 3 December 1859. [4] Pevsner, *South Lancashire* (1969) p.137. [5] *Leigh Journal*, 9 October 1969. [6] Information from Philip Powell.

Leigh Town Hall

Balcony with carved support
Architect: J.C. Prestwich
Architectural sculptors: Farmer and Brindley

24 July 1907
Darley stone
1.22m high approx × 1.52m wide approx
Status: Grade II
Condition: poor
　Description: Upper body of a female figure, her arms raised supporting a balcony

Leigh Town Hall was designed by the local architect, James Caldwell Prestwich. The building, in the late Renaissance style, was opened with suitable ceremony in July 1907.[1] The main façade facing the Market Place (now the Civic Square) is asymmetric. On the far left on the first floor is a balcony which leads out from a committee room. It is supported by a female figure with her arms half-raised, her long

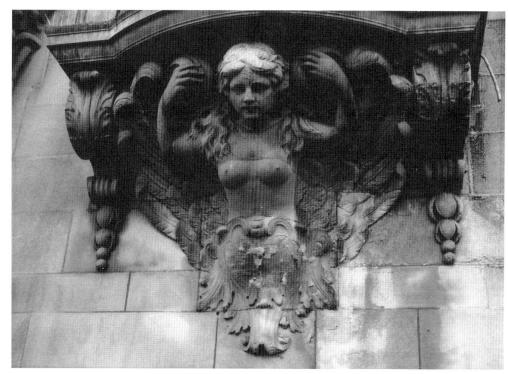

Farmer and Brindley, *Balcony, Leigh Town Hall*

hair reaching down to her breasts. The carving was the work of Farmer and Brindley who, presumably, were also responsible for the borough coat of arms carved in bold relief above the main entrance, and the corbels, crests and putti on the windows on the Market Street elevation.

　Much of the detail of the original carving has been affected by water damage and the general weathering of the stone over the years.

Note
[1] J. Lunn, *Leigh* (Leigh: Leigh Borough Council, [n.d.]) p.291.

The Turnpike

Untitled
William Mitchell

3 November 1971
Concrete
2.74m approx × 7.31m approx
Status: not listed
Condition: fair
Owned by: Wigan Metropolitan Borough
　Council
　Description: Concrete abstract mural above the main entrance, the work consists of four rectangular panels, which have different patterns, made up of lines and swirling shapes, on them.

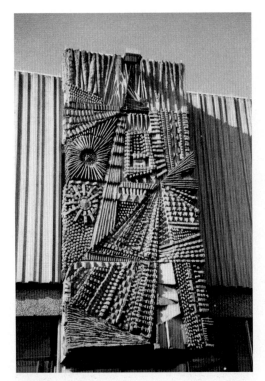

Mitchell, *Untitled*

After years of discussion and postponements, construction of Leigh's new public library and arts centre finally started in 1969. The local firm J.C. Prestwich was the chief architect. The new building was located in the town centre, fronting on to the old Market Place. The design included a large concrete abstract mural on the exterior, directly above the entrance. It was the work of William Mitchell and was installed in 1971. The bold geometric swirling patterns were highly characteristic of Mitchell's work at this time. Leigh's new cultural complex was named The Turnpike.[1]

Note
[1] *Leigh Library* (Leigh, 1971) and cuttings in Leigh Library.

NEWTOWN

Warrington Road

Alexandra Park

Blundell Memorial

John Jarvis Millson

20 October 1907
Polished granite
5.48m high approx
Inscription on plaque (now missing): THIS MONUMENT WAS ERECTED BY PUBLIC SUBSCRIPTION TO THE MEMORY OF COLONEL H. B. HOLLINSHEAD BLUNDELL C.B., WHO REPRESENTED THE INCE DIVISION IN PARLIAMENT DURING THE YEARS 1885 TO 1892, 1895 TO 1906, AND DIED ON THE 28TH SEPTEMBER 1906.
Status: not listed
Condition: poor
Owned by: Wigan Metropolitan Borough Council
Description: Obelisk and drinking fountain; the polished blue-pearl granite obelisk rises from a stepped base of unpolished granite. Two drinking fountains with bronze lion heads (now broken) are positioned on opposite sides of the pedestal. The pedestal originally included a bronze oval medallion of Blundell and a plaque with details of his political career (both missing).

Colonel Henry Blundell-Hollinshead Blundell, born in 1831, was the son of Major-General Richard Blundell-Hollinshead Blundell. He was educated at Eton and Christ Church Oxford, and pursued a military career in the Grenadier Guards. He served in the Crimea and on the Nile Expedition, 1884–5. Blundell, a Conservative, fought several elections in Wigan, first winning the Ince division in 1885. He won again in 1886, but was defeated in 1892. He was returned again in 1895 but was swept away by the Liberal landslide of 1906. As befitted his

constituency Blundell took an interest in mining questions, supporting the passage of the Mines Regulation Act. Military affairs was another subject on which he spoke in parliament. The family had property in Pemberton, and Blundell was remembered for his support of local charities. He died in September 1906.[1]

The idea of memorialising Colonel Blundell was made public at a meeting held in Wigan Conservative Club.[2] A committee was established with the intention of collecting sufficient funds to raise a statue, with any

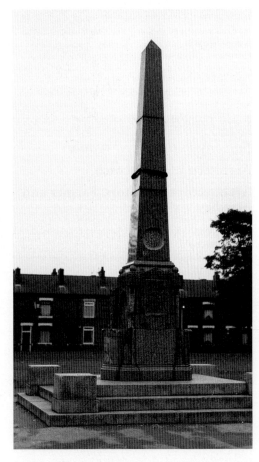

Millson, *Blundell Memorial*

surplus monies being used to establish scholarships at the Mining and Technical College. However, the subscriptions were not as large as expected, and the organising committee revised their plans, deciding to erect an obelisk incorporating a drinking fountain. The memorial was the work of John Millson of Manchester and cost some £460. Arrangements were made to locate it in Alexandra Park in the Newtown district of Wigan, an area of the town which had benefited from Blundell's philanthropy. Simon Brown, cotton-spinner, Justice of the Peace and chairman of the Ince Conservative Association, unveiled the monument before a gathering which had all the hallmarks of a political meeting. Blundell was remembered by his political associates as a public-spirited MP who had always been a supporter of the concerns of mine-workers.[3] The monument has been badly neglected and vandalised in recent years. Parts of the pedestal have been broken and removed, and the portrait medallion is also missing.

Notes
[1] *Wigan Examiner*, 29 September 1906. [2] *Ibid.*, 3 November 1906. [3] *Wigan Observer*, 22 October 1907.

ORRELL

Orrell Road and Moor Road

Orrell Post

Stone
3.3m high × 68cm × 68cm
Status: Grade II
Condition: fair
Owned by: Wigan Metropolitan Borough Council
 Description: Located outside the Stag Inn, the post is a Tuscan column, with a rusticated band around the middle, ending in a square cap and ball finial. The plain square base appears to be of a different stone from the column.

The Orrell Post is located by the side of the Stag Inn, the most recent of the public houses to occupy these busy crossroads. Its history and purpose are surprisingly vague for an object which has given its name to the area. It has been suggested that a post may have stood in this vicinity since 1607.[1] The existence of 'a neat stone pillar, of considerable antiquity, called Orrell Post' was noted in a directory of 1853.[2] Several theories have been put forward as to the origin of the post. It has been asserted that it may have been used as a guide post for pilgrims on their way to Upholland Priory or, even more unlikely, for tethering the horses of the Liverpool–Preston mail coaches.[3] Arthur Hawkes, Wigan borough librarian and local historian, speculated that the Holts of Bispham Hall built it as a companion piece to the obelisk marking the victory at Waterloo situated in the grounds of the hall.[4] The post's date is uncertain though in the twentieth century it was recorded that the date 1750 was visible on the base.[5] Its original position is also uncertain: map evidence appears to contradict the idea that it may once have stood in the middle of the road junction.[6] It is likely that the post was moved at some time, particularly as the old inn was demolished and rebuilt in the early 1920s.[7] A later extension to the Stag Inn has left the post enclosed on two sides by brick walls. Weathering is evident on both the shaft and finial.

Notes
[1] Wigan Metropolitan Borough Council Listed Buildings entry, ORR 13, 4/103. [2] A. Miller, *Orrell in Old Picture Postcards* (Zaltbommell, Netherlands: European Library, 2000) p.3. [3] *Manchester Evening Chronicle*, 4 April 1951. [4] *Ibid.*, 14 April 1951. [5] Undated cutting from *Wigan Observer*, 1922 (Wigan History Shop). [6] Ordnance Survey 1845–6 survey, 1892 survey. [7] *Wigan Observer*, 11 December 1920.

Orrell Post

WIGAN

Central Park Way

The Home of Rugby League

Joanne Risley

October 2001
Bronze
2.6m × 2m × 1.45m
Inscription on bronze plaque on plinth: "THE
HOME OF RUGBY LEAGUE"/ THIS SCULPTURE
BY JOANNE RISLEY IS DEDICATED / TO THE
FOLLOWERS OF RUGBY LEAGUE IN WIGAN /
AND TO THE GREAT PLAYERS WHO MADE
WIGAN / FAMOUS ACROSS THE WORLD SITED
2001 /
6TH SEPTEMBER 1902 WIGAN 14 BATLEY 8 /
5TH SEPTEMBER 1999 WIGAN 28 ST HELENS 20
Status: not listed
Condition: good
Owned by: Tesco plc
 Description: A larger than life-size bronze
rugby ball surmounting a reconstituted stone
plinth and square stone base, with integrated
lights. The ball is angled in the kicking position
and decorated with images of four famous
Wigan rugby league players – Jim Sullivan,
Billy Boston, Tom Bradshaw and Joe Egan –
whose names also appear on the ball.

In 1997 Tesco plc acquired Central Park, the
famous ground of Wigan Rugby Football Club,
to develop as a supermarket. Wigan RFC, one
of the founding members of the Northern
Rugby Football Union and one of the best
known and most successful rugby league clubs,
had played their matches at Central Park since
1902. The decision to sell the ground was a
controversial one, representing as it did the
history of the club – the ashes of players and
supporters had been scattered on the pitch –
and, by extension, of the town.[1] Wigan
Warriors played their last game at Central Park
in 1999, moving to the new JJB Stadium at

Risley, *The Home of Rugby League*

Robin Park. Tesco decided to recognise the
historical importance of the site by
commissioning a sculpture. A competition for
an art work was organised in 2000 and the
commission was awarded to the Cheshire-based
sculptor, Joanne Risley. She proposed a bronze
sculpture of a traditional rugby football. She
carried out further research into the club's
history and its players in order to personalise
the ball. Four of the club's legendary players –
Billy Boston, Tommy Bradshaw, Joe Egan and
Jimmy Sullivan – were depicted on the ball, the
images being based on photographs of them as
players. The work was cast by B.C. Bronze
Casting, Northwich. The patination reproduced
the brown of an old leather football. Lights
were installed in the base to illuminate the
sculpture. The company selected the site,
adjacent to a roundabout, facing motorists

before they turn into the store's car park. *The
Home of Rugby League* was officially unveiled
in October 2001. The project cost £20,000. The
sculpture, mounted on a low plinth, was easily
accessible to the public, and it was soon marred
by graffiti, a problem that caused the sculptor
to treat the work with paint-resistant wax,
which had the effect of darkening the ball.[2]

Notes
[1] L. Woodhead, *Wigan Rugby League Football
Club* (Runcorn: Archive Publications, 1989).
[2] Information from Joanne Risley.

Douglas Dragonflies

Joanne Risley

December 2001
Bronze
3.8m high approx
Status: not listed
Condition: fair
Owned by: Douglas and Yarrow Valley Action
 Description: Two dragonflies resting on tall
plant forms which rise directly from the
ground.

As part of a larger project to encourage people
to make greater use of the River Douglas in
Wigan, DaY Valley Action commissioned
Joanne Risley to provide a waterside sculpture.
Funding for the work was provided by the
Mersey Basin Campaign, Wigan Metropolitan
Borough Council and Tesco plc, the latter
having built a new supermarket close to this
part of the river. Risley chose dragonflies as her
subject, producing a sculpture that showed two
bronze dragonflies resting on tall leaf forms
with a green patination. The model was created
from wire, paper, paste and wax, then moulded
and cast into bronze, using investment and
ceramic shell techniques. It was located close to
the riverbank, near a recently erected bridge.
Installed in December 2001, the work was soon
vandalised, one of the dragonflies being broken
off.[1]

Risley, *Douglas Dragonflies*

Note
[1] Information from Steve Thompson, Wigan MBC and Joanne Risley.

Darlington Street

Magistrates' Court

Justice
Maggie Humphrey

25 November 1991
Baggeridge brick
6.1m high approx × 3.9m wide approx
Status: not listed
Condition: good
Owned by: Wigan Metropolitan Borough
 Council

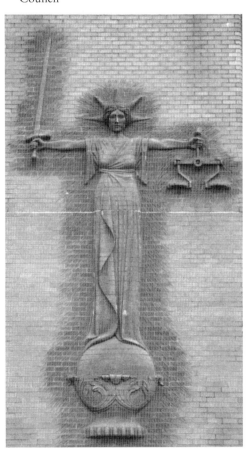

Humphrey, *Justice*

Description: Monumental figure of Justice in relief on the side wall of court building. The figure is made from brick and set into the wall. The wall bricks around the figure have been striated, adding extra depth to the figure.

Wigan's new magistrates' court was designed by Wigan Metro and officially opened by the Princess of Wales in 1991. Two brick sculptures were introduced as decoration on the exterior. The first was the royal coat of arms which was placed directly above the main entrance. The second was a representation of the figure of Justice which was placed high up on the side wall. Both were made from Baggeridge brick and were stated to have been the work of the artist and potter, Maggie Humphrey.[1]

Note
[1] Information from Richard Healey, Baggeridge Brick, Sedgley, Dudley; Ken Pouncey, Wigan Metropolitan Borough Council.

Mesnes Park

Sir Francis Sharp Powell
Ernest G. Gillick

4 November 1910
Bronze statue; granite pedestal
Statue 1.83m high; pedestal 1.17m high × 1.42m
 × 1.26m; bronze panels 1.04m × 39cm
Signed on statue and panels: E. G. Gillick 1910
Inscription in raised lettering on bronze plaque:
 SIR FRANCIS SHARP POWELL / BARONET. BORN
 IN WIGAN / 1827. M.P. FOR HIS NATIVE TOWN
 / 1857–9 AND 1885–1910. ERECTED / BY
 PUBLIC SUBSCRIPTION 1910.
Status: Grade II
Condition: fair
Owned by: Wigan Metropolitan Borough
 Council
Description: Portrait statue; a life-size bronze statue showing Powell seated in an easy attitude, his right hand raised to his chin as if in thought. A large overcoat is draped across the back of the chair. The grey granite pedestal,

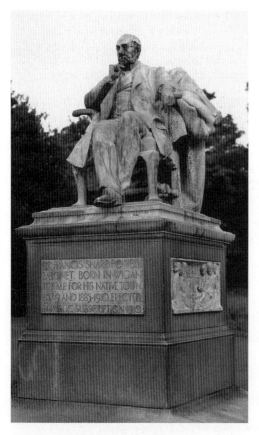

Gillick, *Sir Francis Sharp Powell*

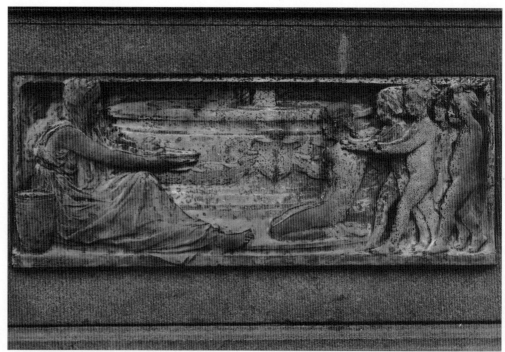

Gillick, *Public Health*

rising from a base of three wide steps, includes two bronze bas-reliefs depicting themes associated with Powell's public work. The panels represent Education, a composition of a female reading to six small children; and Public Health, a composition of a seated female figure in front of a fountain holding out a dish of water to children. The statue was enclosed by granite corner posts with ornamental bronze caps and chains, but the chains and the smaller centre posts have not survived.

Sir Francis Sharp Powell, politician and philanthropist, was born in 1827 in Wigan, the son of Revd B. Powell, vicar of St George's, Wigan. He served as Conservative MP for Wigan from 1857–9 and again from 1885–1910. He had first contested the seat in 1852. His victory in the 1881 election was disputed, and following an investigation the result was eventually reversed. He was returned again in the 1885 election and went on to serve as the borough's MP for the next 25 years. He retired as MP in 1910. Powell was a wealthy man who had inherited extensive property from his father. He was known for his philanthropy, in particular his support of education and housing for the working classes in Wigan. He made contributions to local schools, including his Alma Mater, Wigan Grammar School. He also supported the public library movement, adding a boys' reading room to the town's main library. In addition, he lent financial support to

the Wigan Mining and Technical School. He was given the Freedom of the Borough in 1895, on the occasion of the opening of the boys' reading room. His efforts to further the Conservative cause in the town saw him provide, at his own expense, two Conservative working men's clubs. Known for his strong defence of the Constitution and the Church, Powell was depicted as 'a typical John Bull'.[1] The 'Grand Old Man of Wigan' lived most of his later life at Horton Old Hall, Bradford. He died in December 1911.[2]

Councillor James O'Donahue recalled at the unveiling that in 1907, when in office as Mayor, he had been approached by several influential gentlemen of Wigan to call a town meeting to consider marking Powell's many years of faithful service. At a meeting on 12 April 1907 organised by the Mayor, it was decided to present a testimonial to Sir Francis on the 50th anniversary of his first election as the town's MP. It was suggested that this take the form of

a statue, and a committee 'of leading men' was appointed.[3] An open competition was organised, with William Goscombe John, the sculptor of the town's South African War memorial, as the assessor. In June 1908 the Powell Testimonial Fund Committee reported that John had chosen the design of the Chelsea-based sculptor, Ernest Gillick, as it was 'a most artistic work, admirably proportioned and full of dignity and repose'. Thomas Mewburn Crook, L. Fritz Roselieb (also known as Frederick Louis Roslyn) and J. Millard, who had also submitted designs, were awarded prizes.[4] By July subscriptions amounting to £753. 8s. 6d. had been promised, with £452. 1s. 6d. collected.[5] The statue was originally to be sited in the Market Place, but this was rejected in favour of a site on the main promenade of Mesnes Park, the town's principal park. The necessary permission was given by the Parks Committee.[6]

Gillick's statue was unveiled by the 17th Earl of Derby in the presence of Sir Francis. O'Donahue told the crowd that the statue was only the second in Britain to be erected to a living man, and that he hoped it would inspire future generations to emulate the public duties accomplished by Sir Francis.[7] It has become a much admired feature of the park. A suggestion in 1961 that the town had neglected it was quickly denied.[8] Long before that date it had become the local custom to touch the statue's shoe for good luck, a tradition which has left Powell with one highly polished 'golden' shoe.

Notes
[1] *Wigan Observer*, 23 September 1898. [2] H.L.P. Hulbert, *Sir Francis Sharp Powell, Baronet and Member of Parliament: A Memoir* (Leeds: R. Jackson, 1914). [3] *Wigan Observer*, 29 June 1907. [4] *Ibid.*, 30 May 1908, 4 July 1908. [5] *Ibid.*, 4 July 1908 [6] *Ibid.*, 18 June 1910, 23 July 1910. [7] *Ibid.*, 5 November 1910; *Manchester Courier*, 5 November 1910; *The Times*, 6 November 1910. [8] *Daily Telegraph*, 3 July 1961; *Wigan Observer*, 3 July 1961.

Pottery Road
Trencherfield Mill

Museum of Memories
Andy Hazell

June 1999
Copper; stainless steel; galvanised steel; plastisol sheet steel; pneumatic actuators
Mantelpiece 17m long × 2.4m × 90cm; heads 2.8m high
Status: not listed
Condition: good
Owned by: Wigan Metropolitan Borough Council
Description: The representation of a front room which is displayed on the external wall and on the forecourt area of a former mill, now a museum. A fireplace with a mantelpiece dominates the mill wall. On the chimney breast are three automata in the form of large copper heads set in rectangular boxes with stainless steel frames. The forecourt is paved to represent a living-room floor, on which are representations of various domestic artefacts, including a pile of dominoes.

Following a competition organised by Wigan Metropolitan Borough Council in 1998, Andy Hazell was commissioned to produce an eye-catching entrance feature for a new museum. The *Museum of Memories* was to be housed in part of a large Edwardian cotton mill, a building that was already part of a successful museum, the Wigan Pier Experience. The new museum displayed Robert Opie's collection of everyday domestic objects and packages: artefacts which offered a unique experience of the way people had lived in the twentieth century. Hazell's design for the courtyard area engaged directly with the principal themes of family, domesticity and memory. He used the mill wall and the courtyard to produce a large-scale work representing a typical twentieth-century working-class living room. The wall was transformed to represent a hearth, a symbol of

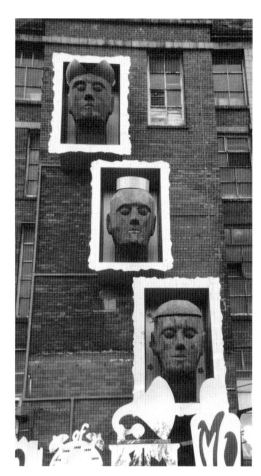

Hazell, *Museum of Memories (detail)*

the place where a family would gather to talk, tell stories, reminisce and play games. Arranged along the 17-metre-long mantelpiece were representations of objects from the museum's collection, ranging from a George V coronation mug to a robot from a 1960s TV series. Above the mantelpiece was the chimney breast, on which were three large rectangular boxes with stainless steel frames. Each box contained an automaton in the form of a large copper head, each one designed to open like a piece of packaging. Each one had a distinct appearance,

their skulls opening in different ways, a movement that represented the unlocking of personal memories triggered off by a visit to the museum. The heads were Carton Head (top), Jar Head (middle) and Tin Head (bottom). On either side of the mantelpiece, plates protruded out of the wall, suggesting a plate rack. The courtyard in front of the fireplace was paved to represent a living-room floor, including a hearthrug and wood by the fire. A pile of dominoes suggested the playing of family games. The work was installed between January and May 1999. Hazell had hoped to include other features in the design, but these were not realised.[1]

Note
[1] Information from Andy Hazell and newspaper cuttings in History Shop, Wigan.

Powell Street

Junction of Powell Street and Standishgate

Warp & Weft
Adrian Moakes

February 2002
Mild steel plate
5m high
Status: not listed
Condition: good
Owned by: Wigan Metropolitan Borough
 Council
 Description: Four intersecting arcs of welded plate steel, painted metallic blue, and sited on a sloping pavement

Adrian Moakes was commissioned by Wigan Metropolitan Council in 2001 to produce a sculpture for a site identified as an important gateway into the town centre. It was part of a wider project to install public art in and around the town centre. Moakes was one of a number of artists who, having presented their work and designs to the council, were invited to work on the project. Moakes' ideas for the work were

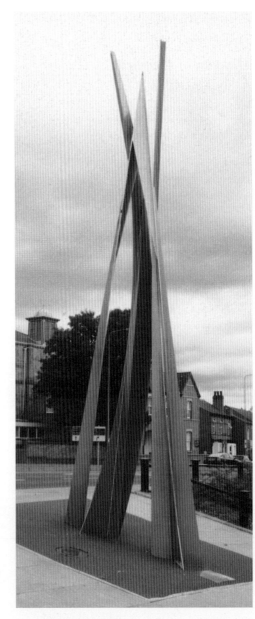

Moakes, *Warp & Weft*

further clarified through a process of discussions with council officers and public consultation. The work was to be located on a sloping section of pavement on Powell Street, close to Standishgate. The final sculpture, its arcs of steel making it a recognisably modern work, was regarded as symbolic of Wigan's future, whilst at the same time reflecting the long tradition of textile and metal-making industries in the town.[1] Moakes had envisaged a much larger sculpture, but practical concerns, including the possibility of subsidence, caused it to be reduced in size.[2] The total cost of the project, including landscaping, was £20,000, the money coming from the council and the European Regional Development Fund. The work was installed in February 2002, but there was no formal unveiling ceremony.

Notes
[1] Correspondence with Adrian Moakes.
[2] Information from Mike Matthews, Town Centre Manager, Wigan.

Standishgate

Mab's Cross

C.thirteenth century; re-erected 23 August 1921
Gritstone
1.63m high × 99cm × 1m
Inscription on plaque attached to plinth: MABS CROSS / LADY MABEL BRADSHAIGH DID PENANCE FOR BIGAMY IN 1323 / BY WALKING BAREFOOT ONCE A WEEK FROM HAIGH HALL TO / THIS CROSS SINCE KNOWN AS MABS CROSS IN MEMORY OF / LADY MABEL. ACCORDING TO THE ANCIENT LEGEND HER / HUSBAND SIR WILLIAM BRADSHAIGH WAS AWAY ON A CRUSADE / FOR SEVERAL YEARS, AND BELIEVING HE WAS DEAD SHE MARRIED A WELSH KNIGHT. / SIR WILLIAM ON HIS RETURN TO HAIGH SLEW THE WELSHMAN / AND SETTLED DOWN THERE WITH LADY MABEL. HE WAS / MURDERED IN AN AFFRAY ON MONDAY 18TH AUGUST 1333 AND / WAS BURIED IN WIGAN PARISH CHURCH, WHERE

Status: Grade II*
Condition: poor
Owned by: Wigan Metropolitan Borough Council

Description: Wayside cross; the remains of a cross consisting of a square gritstone plinth surmounted by a smaller cross base into which the stump of the chamfered shaft is set. There are leaded boreholes for metal clamps on both the plinth and base.

Mab's Cross is widely assumed to be the stump of a medieval wayside or standing cross, one of four that marked the route from Wigan to Chorley. It was named after Lady Mabel Bradshaigh (1275–1348), the wife of Sir William Bradshaigh, Lord of the Manors of Haigh and Blackrod, near Wigan. The earliest reference to a cross in this location is from *c*.1270. It is widely thought to be the scene of the penance of Lady Mabel Bradshaigh. There are two similar versions of the story of Lady Mabel. The first derives from the Bradshaigh Roll, a pedigree of the Bradshaigh family made in 1647, and the second from the Norris Declaration, written by Sir William Norris of Speke in 1563.[1] Both accounts tell of the marriage of Sir William de Bradshaigh to Mabel, daughter of Hugh le Norreys of Haigh Hall near Wigan. William is then said to have gone to war, possibly to the crusades, and after an absence of several years was presumed dead. During that time Mabel remarried a Welsh knight. On returning from the wars after a ten-year absence, Sir William confronted the usurper and killed him at Newton-le-Willows. As penance for her bigamous marriage, Lady Mabel was

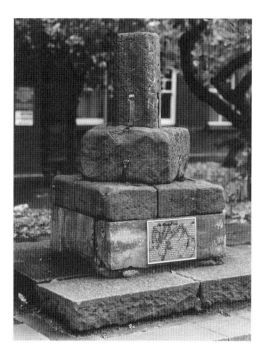

Mab's Cross

instructed to make a weekly barefoot walk from Haigh Hall to the cross in Wigan, which was thereafter associated with her name. The legend was told and retold by various Lancashire authors including Roby.[2] It reached an even wider readership when Sir Walter Scott reproduced it in the preface to his 1825 novel, *The Betrothed*.

There have been a number of attempts to provide historical background to the legend of Lady Mabel. The earliest recorded association of Lady Mabel and the cross has been dated to 1403. A deed in the Farrar Collection in Manchester Central Library refers to a grant of 'two acres of land near Mabcrosse'. Mabel was still alive in 1348, so her connection with the cross could possibly be dated to within 50 years of her death.[3] According to research by Wigan Librarian A.J. Hawkes and the Revd T.C. Porteus of Wigan, the absence of Sir William

from his estates could be explained by the fact that he was declared an outlaw after the Banastre rebellion in 1315. Similarly, the story of his attack on the Welsh knight at Newton-le-Willows was possibly a transposition of the killing of Sir William himself in Newton Park by the relatives of Sir Henry de Bury in 1333.[4]

The cross was damaged over the years and by the nineteenth century only the base and the bottom of the shaft survived. It was positioned on the pavement in Standishgate, and iron railings were placed around it to provide some protection to what was recognised as a historical landmark.[5] The cross was taken down and put into storage in October 1919, a consequence of a road widening scheme.[6] Under the direction and at the expense of the Earl of Crawford, the cross was re-erected on the eastern side of the road, and slightly further to the north, in the grounds of Wigan Girls' High School in August 1921.[7] Suggestions made in later years that the cross, now recognised as an ancient monument, might be moved to a more public and visible location were not taken up.[8] A plaque recounting the legend of Lady Mabel was attached to the base of the cross in 1980.[9] The cross remains in Standishgate, at the front of what is now Mab's Cross Primary School.

Notes
[1] F. Holcroft, *Murder, Terror and Revenge in Medieval Lancashire. The Legend of Mab's Cross* (Wigan: Wigan Heritage Services, 1992). [2] J. Roby, *Traditions of Lancashire* (London: G. Routledge, 1892 edn) Vol.I, pp.25–51. [3] *Wigan Observer*, 3 November 1934. [4] H. Taylor 'Ancient crosses and holy wells of Lancashire. The Hundred of West Derby', *Transactions of Lancashire and Cheshire Antiquarian Society*, 19 (1901) pp.217–18; 'New Light on the Mab's Cross Legend', *Wigan Observer*, 5 October 1922, 26 October 1935; T.C. Porteous, 'The Mab's Cross Legend', *Transactions of Lancashire and Cheshire Antiquarian Society*, 66 (1941–2) pp.25–44. [5] Photographs in *Wigan Observer*, 22 October 1922, 3 March 1961. [6] *Ibid.*, 29 March 1919, 11 October 1919. [7] *Ibid.*, 22 October 1921. [8] *Wigan Evening Chronicle*, 5 September 1956; *Wigan Observer*, 10 March 1961; *Lancashire Evening Post*, 9 June 1961. [9] *Wigan Observer*, 25 July 1980.

Wallgate

All Saints Gardens

Wigan War Memorial

Architect: Sir Giles Gilbert Scott

Architectural sculptor: Edward Owen Griffith

17 October 1925
Clipsham stone
13.42m high; base 6.71m diameter
Inscription inset on bronze plaques, on the
 south side facing Wallgate: REMEMBER THE
 MEN OF WIGAN WHO GAVE / THEIR LIVES TO
 THE GREAT WAR 1914–1918 / AND THE
 SECOND WORLD WAR 1939–1945. – north side
 facing All Saints Church: A GOOD LIFE HATH
 BUT A FEW DAYS / BUT A GOOD NAME LIVETH
 FOR EVER.
Status: Grade II*
Condition: fair
Owned by: Wigan Metropolitan Borough
 Council
 Description: War memorial; an octagonal
stone base, the first section of which is used as a
seat, above which are the panels inscribed with
the names of the dead. The octagonal shaft of
the cross has buttresses at each corner, with
moulded bases, terminating in crocketted
pinnacles. The upper section of the shaft is
richer in decoration. Above the pinnacles are
eight angels holding wreaths, the symbol of
victory. The shafts rise to a lantern and richly
decorated cross with tracery and crowns. Two
smaller angels flank the cross. The memorial is
inspired by an Eleanor cross but not a specific
copy. It stands in a triangular garden with low
walls.

Initial attempts to honour the dead of Wigan
were, as in other boroughs, bound up with civic
purposes. The building of an art museum and
additions to the Infirmary were two of the first
suggestions put forward in Wigan for
honouring the fallen. A memorial cross in
Mesnes Park was also proposed. Arguments
over whether a memorial should be funded
from the rates delayed the project, and the
entire scheme was eventually relaunched by the
mayor, P.J. Pagett, in February 1922. A public
meeting considered the question of what form
the memorial should take and how it should be
funded. Several people suggested that the
memorial should be either an addition to the
Infirmary or an extension to the Mining and
Technical College. Scholarships for the children
of the fallen were also proposed. However,
Pagett reminded the meeting that on being
elected he had promised to raise a fund for a
permanent memorial, which would provide a
focus for future Armistice days in the borough.
The Town Clerk, W.H. Turner, also rejected
civic schemes because 'he did not like the idea
of using that solemn occasion for doing
something which they ought to do otherwise'.[1]
If schools or an art gallery required funding,
that should be provided by the rates. The final
plan fused the practical and the symbolic: it was
agreed that £15,000 should be raised, of which
one-third would be used to provide a 'war
cross', with the remainder going towards a new
operating theatre for Wigan Infirmary. Fund-
raising began promisingly with over £1,100
being subscribed, including eight donations of
£100 and more.[2] After examining various
locations in the town centre the committee
reported that the best site for the memorial was
at the entrance to the parish churchyard. The
question of the design of the memorial was
settled by commissioning Giles Gilbert Scott,
the architect responsible for the Anglican
Cathedral in Liverpool. His design followed the
form of the old Eleanor crosses. Scott was also
responsible for designing Preston war
memorial.[3] The work of carving the cross was
put in the hands of the Liverpool sculptor and
architectural carver, Edward Owen Griffith.[4]
The chosen site at the Wallgate entrance to the
parish church yard required the partial
demolition of the Dog and Partridge Hotel,
which the owners were unwilling to
countenance. This problem was resolved in
February 1925 by the grant of land in the
churchyard by the Diocese of Liverpool. The
foundations were prepared, a task requiring the
removal of some of the graves and their
occupants' re-interment.[5]

The memorial was unveiled by General Sir
Herbert Lawrence and dedicated by the Revd
A.A. David, Bishop of Liverpool, in October

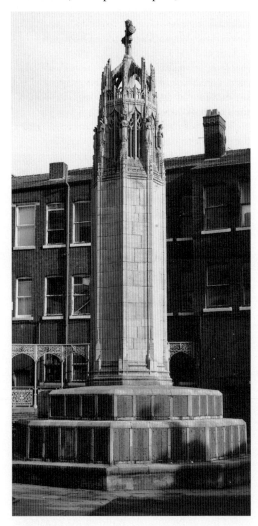

Giles Gilbert Scott, *Wigan War Memorial*

1925. At the unveiling a letter from Lord Crawford, who had been unable to attend, was read. It recalled the 'sordid and cruel conditions' of the war, which left the troops 'immobile, immured in their trenches, harassed by suffering and illness'. General Lawrence, who had commanded the Wigan men in Gallipoli and France, recalled the sacrifices of the troops, and, no doubt with the current troubles engulfing the mining industry in mind, asserted that the only way towards reconstruction was 'along the narrow path of duty and self-sacrifice'.[6] Some 1,700 names were listed on the roll of honour, all of whom were men, with the exception of Jane Johnston, who lost her life serving in the Royal Navy. The final cost of the memorial was £4,400.

In the early 1930s it was discovered that the lettering of the marble roll of honour was weathering badly and it was replaced by bronze tablets at a cost of £300.[7] In the following decades the memorial suffered from neglect and occasional vandalism. An outburst of public concern usually prompted much-needed cleaning.[8] On one occasion a group of well-intentioned army cadets used cleaning materials that turned the stone green.[9] But no amount of dirt could disguise the qualities of Scott's design, a war memorial judged by Pevsner as 'high and impressive'.[10] The memorial was cleaned and restored in 2002.

Notes
[1] *Wigan and District Advertiser*, 11 February 1922.
[2] *Wigan Observer*, 3 November 1923. [3] D. Boorman, *At The Going Down of the Sun. British First World War Memorials* (York: Ebor Press, 1988) p.139. [4] *Wigan Observer*, 8 November 1924. [5] *Manchester Guardian*, 27 February 1925; *Wigan Observer*, 28 February 1925. [6] *Manchester Guardian*, 19 October 1925; *Wigan Observer*, 24 October 1925. [7] *Daily Dispatch*, 28 January 1935. [8] *Wigan Observer*, 28 September 1973. [9] *Ibid.*, 26 November 1976. [10] Pevsner, *South Lancashire* (1969) p.425.

Wigan Lane

Tyldesley Monument

1679; restored 1886
Sandstone; slate panels
4.80m high approx × 40cm square base
Inscription on panel on west side: AN HIGH ACT OF GRATITUDE, / WHICH CONVEYS THE MEMORY OF / SIR THOMAS TYLDESLEY / TO POSTERITY, / WHO SERVED KING CHARLES THE FIRST / AS LIEUTENANT COLONEL AT EDGE-HILL BATTLE, / AFTER RAISING REGIMENTS OF HORSE, FOOT, / AND DRAGOONS, AND FOR THE DESPERATE / STORMING OF BURTON-UPON-TRENT, / OVER A BRIDGE OF 36 ARCHES / RECEIVED THE HONOUR OF KNIGHTHOOD, / HE AFTERWARDS SERVED IN ALL THE WARS IN GREAT COMMAND, / WAS GOVERNOR OF LICHFIELD, / AND FOLLOWED THE FORTUNE OF THE CROWN, / THROUGH THE THREE KINGDOMS, AND NEVER / COMPOUNDED WITH THE REBELS, THOUGH STRONGLY / INVESTED, AND ON THE 25TH AUGUST A.D. 1651 / WAS HERE SLAIN, COMMANDING AS MAJOR GENERAL / UNDER THE EARL OF DERBY. / TO WHOM THE GRATEFUL ERECTOR, / ALEXANDER RIGBY, ESQ. / WAS CORNET; AND WHEN HE WAS / HIGH SHERIFF OF THIS COUNTY / A.D. 1679 / PLACED THIS HIGH OBLIGATION ON / THE WHOLE FAMILY OF THE TYLDESLEYS, / TO FOLLOW THE NOBLE EXAMPLE OF THEIR / LOYAL ANCESTOR. – panel on south side: ERECTED AT THE EXPENSE OF THE / CORPORATION OF WIGAN, / APRIL 1886, / ALDERMAN HENRY PARK / MAYOR.
Status: Grade II
Condition: fair
Owned by: Wigan Metropolitan Borough Council
Description: Monumental column; a stone column of coarse sandstone blocks surmounted by a moulded cornice and ball finial. Slate

Tyldesley Monument

panels are inset on each face of the column, two of which carry inscriptions. It stands in a walled enclosure.

The Tyldesley Monument stands close to the spot where Sir Thomas Tyldesley, a Royalist officer, was killed in the Battle of Wigan Lane in 1651. Sir Thomas Tyldesley (1596–1651) was born at Astley in Leigh, the son of Edward and Elizabeth Tyldesley. In 1642 Tyldesley raised regiments of horse, foot and dragoons at his own expense for the Royalist cause. He served with distinction at the battle of Edge Hill and at

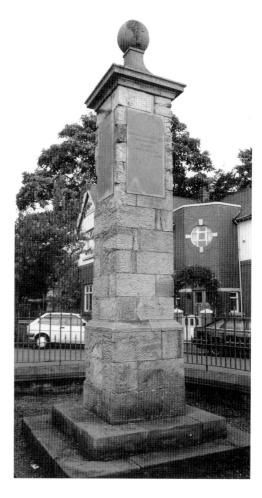

the storming of Burton-upon-Trent, after which he was knighted and promoted to brigadier. In 1644 he served under the 7th Earl of Derby in the capture of Bolton. He surrendered to Parliament in 1648 and left for Ireland, returning in 1651 to assist in Charles II's invasion of England. Tyldesley was recruiting a new force in Lancashire when he was attacked by Parliamentary troops under Colonel Robert Lilburne, who engaged the Royalists at Wigan Lane on 25 August 1651, scoring a crushing victory and killing Tyldesley. He is buried in his own chapel in Leigh parish church.[1]

The monument was erected where Tyldesley fell by his cornet, Alexander Rigby, in 1679, during his term as High Sheriff of Lancashire. According to Sinclair the monument was later taken down and rebuilt.[2] It was moved to its present location and restored in April 1886. The restoration included a new inscription, which modernised the spelling of the original. During the twentieth century the memorial, standing at the side of an increasingly busy road and in an area which was no longer open, became neglected, a 'relic of the past that has outlived its day'.[3] Private efforts to clean the memorial were welcomed by the council.[4] The memorial was eventually restored and the railings renewed by Wigan Civic Trust in 1992.[5]

Notes
[1] F. Holcroft, *The English Civil War around Wigan and Leigh* (Wigan: Wigan Heritage Services, 1993) pp.32–5; *Dictionary of National Biography*. [2] D. Sinclair, *History of Wigan* (Wigan, 1883; reprinted Smiths Books, 1987) Vol.2, p.12; E. Baines, *History of the County Palatine and Duchy of Lancaster by the late Edward Baines* (Manchester: J. Heywood, 1891) ed. J. Croston, Vol.4, p.286. [3] *Southport Visiter*, 8 August 1964. [4] *Lancashire Post and Chronicle*, 28 October 1968. [5] Inscription on stainless steel plaque at base of monument.

Mesnes Park, Mesnes Road
South African War Memorial
William Goscombe John

7 February 1903
Marble statue; granite pedestal
Pedestal 1.5m high × 2.13m × 1.42m
Inscription on pedestal: THIS MEMORIAL / WAS
ERECTED BY PUBLIC SUBSCRIPTION / TO THE
MEMORY OF / THE MEN BELONGING TO THE
REGULAR, / VOLUNTEER, AND IMPERIAL
YEOMANRY FORCES / OF WIGAN AND DISTRICT
/ WHO FELL IN THE SOUTH AFRICAN WAR /
1899–1902.
Condition: statue missing, pedestal remains in
original position
Owned by: Wigan Metropolitan Borough
Council
Description: War memorial; a marble statue
of a soldier in a heroic pose, holding a revolver
in his right hand and a flag in his raised left
hand. It surmounted a massive rough-cut block
of granite.

Wigan's memorial to the local soldiers who had
died in the South African War originated
principally in the efforts of Councillor (and
former mayor) Thomas Fyans, who had served
in the Indian army. Fyans chaired the war
memorial committee. William Goscombe John
was commissioned to produce the statue, one of
the earliest of the war memorials which helped
to secure his reputation.[1] The local population
responded to the appeal for funds, but money
was still needed at the time the statue arrived in
the town. At the unveiling in February 1903,
Fyans told the crowd in Mesnes Park that the
statue was reminiscent of the great colonial
memorials, such as the well at Cawnpore

(commemorating the massacre which occurred
there during the Indian Mutiny in 1858) and the
monument to General Havelock. Those
memorials represented 'loyalty, fidelity and
chastity, and all that was true and good', in the
same way as Wigan's tribute to the fallen of
South Africa.[2] The monument would also serve
the purpose of inculcating a spirit of martial
readiness, necessary for the mustering of a
citizen army. Unveiling the statue, Sir Francis
Sharp Powell observed that such a memorial
should inspire succeeding generations, so that
'when the opportunity arose and the sound
called them to duty their hearts would be again
equal to the occasion'. The speech of Colonel
Blundell, the local MP, took a more practical
turn when he called for schools to teach those
elements of drill that would be so necessary to a
volunteer army.[3] Placed on the rising ground in
front of the park's pavilion, the memorial
became an instant landmark.[4]

The heroic ideals which the memorial was
thought to represent did not necessarily
command universal respect. In 1919, an ex-
serviceman who had fought on the Western
Front, Edward Conway, was sent to prison for
three months for attacking the statue and
breaking off the revolver and some of the
fingers. According to one witness, Conway had
climbed the railings around the statue and
broken the hand, shouting 'I'll pull the — thing
down. It's a — disgrace.'[5] He was alleged to
have been drunk at the time, and told the court
that he had suffered shell shock, as well as five
wounds, including one to the head, during five
years' military service. The court did not see

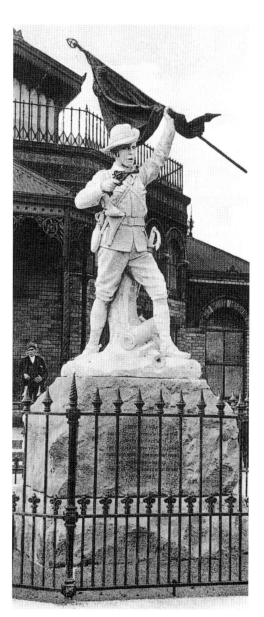

Goscombe John, *Wigan South African War
Memorial*

these as mitigating circumstances and he was imprisoned, but not before protesting at the 'scandal' which the proceedings represented.[6] Over the years the memorial suffered further damage and in 1968 it was decided to remove it.[7] The final fate of Goscombe John's statue is unknown: it is rumoured that it was buried in the park.[8] The massive granite pedestal, however, was not removed, and remains as a reminder of the site of the town's first modern public war memorial.

Notes
[1] A. Borg, *War Memorials From Antiquity to the Present* (London: Leo Cooper, 1991) p.78. [2] *Wigan Observer*, 11 February 1903. [3] *Ibid*. [4] Wigan Borough Council Property, Markets and Mesnes Park Committee, 10 March 1903. [5] *Wigan Observer*, 30 August 1919. [6] *Ibid.*, 6 September 1919. [7] Wigan Recreation and Amenities Parks Committee, 13 June 1968; 12 September 1968. [8] Information from Norma Swarbrick, Friends of Mesnes Park.

Glossary

Italicised words indicate cross-references.

abacus: the flat slab on top of the *capital* of a *column*.

acanthus: an architectural ornament, derived from the Mediterranean plant of the same name, found mainly on *capitals*, *friezes* and *mouldings* of the *Corinthian order*.

accretion: the accumulation of extraneous materials on the surface of a sculpture, for example, salt, dirt, pollutants or *guano*.

acroterion (pl. **acroteria**): an ornamental block on the apex and at the lower angles of a *pediment*, bearing a statue or a carved *finial*.

aedicule: a statue *niche* framed by *columns* or *pilasters* and crowned with an *entablature* and *pediment*; also a window or door framed in the same manner.

alabaster: a soft translucent stone which is a form of gypsum, occurring white, yellow, red, etc.

allegory: a work of art in which objects and/or figures represent abstract qualities or ideas.

aluminium: a modern, lightweight white metal obtained from bauxite.

antae: *piers* or *pilasters* placed at the ends of the short projecting walls of a *portico*, with *capitals* and *bases* of a different order from that used on the rest of the building. If there are *columns* between the antae they are called 'in antis'.

apse: a semi-circular or semi-polygonal termination to a building, usually vaulted; hence *apsidal*.

arcade: a range of *arches* carried on *piers* or *columns*, either *free-standing* or attached to a wall (i.e., 'a blind arcade').

arch: a curved structure, which may be a *monument* itself or an architectural or decorative element within a monumental structure.

architrave: the main beam above a range of *columns*, the lowest member of an *entablature*; also the *moulding* around a door or window.

archivolt: a continuous *moulding*, or series of mouldings, framing an *arch*.

armature: the skeleton or framework upon which a modelled *sculpture* is built up and which provides an internal support.

artificial stone: a substance, usually cement or reconstituted stones, moulded and then fired rather than carved.

ashlar: masonry cut into squared, smoothed blocks and laid in regular courses.

astragal: a small classical *moulding*, circular in section, often decorated with alternated bead and reel shapes.

atlantes: male version of a *caryatid* figure.

attic course/attic storey: the course or storey immediately above the *entablature*, less high than the lower storeys.

avant-garde: a term derived from military terminology which has been used since the middle of the nineteenth century to describe art which rejects the conventional in favour of the novel and strange.

baluster: one of a series of short posts carrying a railing or coping, forming a balustrade.

baroque: (i) a period of style in art history between the late sixteenth century and the early eighteenth century; (ii) florid or overwrought.

barrel vault: a continuous vault of semi-circular section.

basalt: a dark, hard igneous rock, commonly greenish- or brownish-black.

base: the lowest visible course of masonry in a wall; the lowest section of a *column* or *pier*, between the *shaft* and *pedestal*; the lowest integral part of a *sculpture* (sometimes mounted on a *pedestal*). Loosely, the lowest portion of any structure.

basement: the lowest storey of a building or architectural *monument*, sometimes partly, sometimes wholly below ground level. If wholly above ground level, the *basement* storey is of less height than the storey above.

bas-relief: see *relief*.

Bath stone: a honey-coloured *oolitic limestone* from Bath, Avon, ideal for carving.

bay: a vertical division of a building or architectural *monument*, marked by supporting members such as *pilasters*, *buttresses*, *engaged columns*, etc.

bolection: a curved *moulding* covering the joint between two different surface levels and projecting beyond both surfaces.

bollard: a thick post of stone, wood, or metal, for securing ropes, etc., commonly on a quayside or ship.

Bolsover stone: a fine-grained magnesian, or dolomitic *limestone* from Bolsover Moor, Derbyshire. As with all limestones, this type is relatively soft when quarried but becomes hard on exposure to the air.

boss: architectural term. A roof boss is a block of wood or *keystone* which masks the junction of vaulting ribs in exposed roof spaces.

brass: an alloy of copper and zinc, yellowish in colour.

broached: when an octagonal spire or *shaft* rises from a square tower or *base* it often has broaches, that is, half-pyramidal masses of masonry attached to those faces of the spire or shaft which stand above the corners of the tower or base. The broaches smooth the transition from octagon to square.

bronze: alloy of *copper* and tin, with traces of metals which affect the surface *patination* as the sculptural work weathers. A very responsive, strong and enduring substance, it is easily handled and has become one of the most common materials for *sculpture*.

bust: a representation of the head and upper portion of the body.

buttress: a mass of masonry or brickwork projecting from a wall, or set at an angle against it, to give additional strength.

cable moulding: a *moulding* imitating the twisted strands of a cable.

caduceus: attribute of Hermes and Mercury, messenger of the Gods. A staff, culminating in a pair of intertwined snakes, surmounted by two wings. As an emblem on its own, in post-Renaissance secular *iconography* it is a symbol of peace, justice, art or commerce.

Caen stone: a pale beige *limestone* from Caen, Normandy.

canopy: a roof-like projection over a *monument*, *sculpture*, *cross*, etc.

capital: the transition between a *column* and the ceiling or *arch* above it. It can either be *free-standing* or attached to the wall.

Carrara marble: see *marble*.

cartouche: an ornamental *panel* with edges simulating a *scroll* of cut parchment, usually framing an inscription or shield.

caryatid: a sculptured female figure, used in place of a *column* or *pier* as an architectural support.

cast: the reproduction of an object obtained when a material in a liquid state is poured into a mould and hardened. **Recast**: made from moulds taken from the original cast or from replicas.

cast iron: see *iron*.

castellated: fortified with battlements. By extension, the term is descriptive of something that is ornamented with a battlement-like pattern, e.g., a castellated crown.

cenotaph: (i) a monument which commemorates a person or persons whose bodies are elsewhere; (ii) a form of First World War memorial popularised by Sir Edwin Lutyens' precedent at Whitehall, London.

cire perdue (Fr. '*lost wax*'): metal-*casting* technique used in *sculpture*, in which a thin layer of wax carrying all the fine modelling and details is laid over a fire-proof clay core and then invested within a rigid-fixed, fire-proof outer casing. The wax is then melted and drained away ('lost') through vents, and replaced with molten metal. The resulting cast is an extremely faithful replication of the wax original.

classical: governed by the rules of ancient Greek or Roman art, *sculpture* and architecture.

Clipsham stone: the hardest of the so-called Lincolnshire *limestones* quarried around Clipsham in north-east Rutland, close to the Lincolnshire border. An *oolitic limestone*, usually pale cream, pale brown or buff-coloured, it contains a large number of shell fragments; it can, however, be rubbed down to produce an extremely smooth surface if necessary. Its characteristic colouring easily harmonises with older stonework and thus it has been used in the twentieth century for the restoration of a number of cathedrals, for the colleges of Oxford, and for the post-Second World War restoration of the Houses of Parliament.

clock tower: usually a square tower having a clock at the top with a face on each exterior wall having a commemorative function and/or sculptural elements.

Coade stone: an artificial stone of extreme durability and, importantly, resistance to frost, manufactured and marketed by Mrs Eleanor Coade. Her firm, operating from Lambeth, was a highly successful supplier of *cast sculpture* and architectural ornaments from 1769 to 1833.

cold-cast bronze (**bronze resin**): a synthetic resin that has been coloured by means of a powdered *bronze* filler to simulate, and so provide a cheaper substitute for, a work in *cast bronze*.

colonnade: a range of *columns* supporting an *entablature*.

colonnette: a small, usually ornamental, *column*.

column: a *free-standing pillar*, circular in section, consisting of a *shaft* and *capital*, sometimes with a *base*. An *engaged column* is one that appears to be partly embedded in a wall, also called an attached, applied, or half-column. In classical usage columns generally conform to five main types, or *orders*: Corinthian, Doric, Ionic, Tuscan and Roman or Composite.

concrete: a composition of stone chippings, sand, gravel, pebbles, etc., mixed with cement as a binding agent. Although concrete has great compressive strength it has little tensile strength and thus, when used for any *free-standing sculpture*, must be reinforced with an *armature* of high-tensile *steel* rods.

coping: a protective capping or covering to a wall, parapet, etc., often sloping to shed water.

copper: a naturally occurring red-coloured metal. Characteristically malleable, it is often used for repoussé work. It is the main constituent of *brass* and *bronze*.

corbel: a brick or stone which projects from a wall and supports a feature on its horizontal surface.

Corinthian: see *order*.

cornice: (i) the overhanging *moulding* which crowns a *façade*; (ii) the uppermost division of an *entablature*; (iii) the uppermost division of a *pedestal*. The sloping *mouldings* of a *pediment* are called raking *cornices*.

Cornucopia: the horn of plenty.

corrosion: a process in which metal is gradually eaten away through chemical reaction with acids, salts, etc.; the process is accelerated when these agents combine with moisture.

couchant: heraldic term indicating an animal

lying on its belly with its head raised.

crazing: a network of minute cracks on a surface or in a coating.

crocket: an ornamental architectural feature, usually in the shape of a bud or curled leaf, projecting at regular intervals from the inclined side of pinnacles, spires, *canopies* or gables.

cross: (i) Calvary, Wayside cross. A sculptural representation of the Crucifixion, sometimes with a *canopy*; (ii) Celtic cross. A cross with a tall *shaft* and a circle centered on the point of intersection of its short arms; (iii) Latin cross. A cross whose shaft is much longer than its three arms.

cupola: a small dome.

cusp: in *Gothic tracery*, a projecting point at the meeting of two *foils*.

dado/die: on a *pedestal*, the middle division above the *plinth* and below the *cornice*.

Darley Dale stone: a range of *sandstones* from Derbyshire. All are even-grained and, owing to their high silica content, are relatively hard. The predominant colour is yellow-brown.

Doric: see *order*.

dormer: vertical-faced structure situated on a sloping roof, sometimes housing a window.

dressed: of masonry, worked to a desired shape, with the exposed face brought to a finish, whether polished, left matt, or moulded.

drum: (i) a cylindrical *pedestal*, supporting a *monument* or *sculpture*; (ii) a vertical wall, circular in plan, supporting a dome; (iii) one of the cylindrical stone blocks making up the *shaft* of a *column*. Profile on an *Ionic capital*.

Eleanor Crosses: a series of twelve monumental crosses erected between 1291 and *c.*1296 by King Edward I after the death of his queen, Eleanor of Castile, in 1290. The *crosses*, each containing stone statues of Eleanor, marked the stopping places of her funeral cortège on its journey from Lincoln to Westminster Abbey.

engaged column: see *column*.

entablature: in classical architecture, the superstructure carried by the *columns*, divided horizontally into the *architrave*, *frieze* and *cornice*.

erosion: the gradual wearing away of one material by the action of another or by water, ice, wind, etc.

façade: front or face of a building or *monument*.

faience (Fr. name for Faenza in Italy): earthenware with a tin glaze.

fasces: originally a bundle of rods tied around an axe, a symbol of a Roman magistrate's authority. In architecture, a decorative motif derived from this.

fascia (pl. **fasciae**): in classical architecture, one of the two or three plain, overlapping, horizontal bands on an *architrave* of the Ionic, Corinthian, and Composite *orders*.

festoon: depiction of a garland suspended between two points.

fibreglass: a material made of resin embedded with fine strands or fibres of glass woven together to give it added strength. As it does not shrink or stretch, has high impact strength and can withstand high temperatures it has become a popular material for modern *sculpture*.

finial: in architecture, a terminal ornament on a spire, pinnacle, etc.

fluting: shallow concave grooves running vertically on the *shaft* of a *column* or other surface.

foil: leaf-shaped lobe created by *cusp*.

foliate: decorated with leaf designs or *foils*.

foundation stone: a stone situated near the *base* of a building or *monument*, bearing an inscription recording the dedicatory ceremony.

Founder's mark: sign or stamp on a *sculpture* denoting the firm or individual responsible for *casting*.

fountain: a structure with jets, spouts and basins of water for drinking or ornamental purposes. Component parts may include

sculptural decoration or inscription.

free-standing: of a *monument* or *sculpture*, standing independently.

frieze: in classical architecture such as Greek temples, the frieze was the middle division of the *entablature*, between *cornice* and *architrave*, which was often used for *relief sculpture*. Modern usage extends the concept of a frieze to any long, narrow sculptural relief incorporated into an architectural work, excluding *medallions* and *roundels* in their own right.

frontage: the front face of a building.

galvanised steel: *steel* coated with zinc as a protective barrier against atmospheric *corrosion*.

gargoyle: a spout in the form of a carved grotesque human or animal head, projecting from the top of a wall to throw off rainwater.

giant order: an order whose *columns* or *pilasters* rise through two or more storeys.

gilding, gilt: to gild is to cover a surface with a thin layer of gold, or with a gold-coloured pigment; gilding or gilt is the golden surface itself.

glass-reinforced concrete: cement which has been mixed with chopped, *c.*50mm long strands of glass fibre for enhanced strength.

glyptic: of *sculpture*, carved rather than modelled (cf. *plastic*).

Gothic: a term used to denote the style of medieval art and architecture that predominated in Europe *c.*1200–*c.*1450. In architecture it is characterised by the pointed *arch* and an overall structure based on a system of ribbed cross vaulting supported by clustered *columns* and flying *buttresses*, giving a general lightness to the building. In *sculpture* the figure is generally treated with naturalistic detail, but is often given an exaggerated elegance through elongation and the use of an S-curve. Although the style had an almost uninterrupted history in northern countries, especially in England, it had a

major revival in the architecture of the nineteenth century.

graffiti: unauthorised lettering, drawing, or scribbling applied to or scratched or carved into the surface.

granite: an extremely hard crystalline igneous rock consisting of feldspar, mica and quartz. It has a characteristically speckled appearance and may be left either in its rough state or given a high polish. It occurs in a wide variety of colours including black, pink and grey-green.

grit, gritstone: name often used for the coarser types of *sandstone*, e.g., *Millstone grit*.

grotesque: (i) a form of decoration composed of fanciful animal and human forms, fruit, flowers, etc.; (ii) a type of decorative *sculpture* or painting in which human figures and/or animals are fancifully interwoven with plant forms.

guano: bird excrement.

guttae: pendent ornaments, generally in the form of truncated cones, sometimes cylinders, found in series on the undersides of the mutules and regulae of Doric *entablatures*.

Hadene stone: a Carboniferous *limestone* from Derbyshire.

Hollington sandstone: a *sandstone* from Staffordshire, occurring in light grey or pink; it is relatively hard and has an even texture suitable for carving.

hood-mould: a projecting moulding placed above a window, doorway, or archway to throw off the rain.

Hopton Wood stone: a *limestone* from Derbyshire, occurring in light cream and grey. In common with other polishable limestones it is sometimes referred to incorrectly as a *marble*.

iconography: the visual conventions by which traditional themes are depicted in art under changing historical and cultural conditions. The term is also used for that method of art history which traces those transformations,

often in relation to their literary sources.

in situ: (i) of a *monument* or *sculpture*, still in the place for which it was intended; (ii) of an artist's work, executed on site.

inscription: written dedication or information.

Ionic: see *order*.

iron: a naturally occurring metal, silver-white in its pure state, but more likely to be mixed with carbon and thus appearing dark grey. Very prone to rust (taking on a characteristic reddish-brown colour), it is usually coated with several layers of paint when used for outdoor *sculptures* and *monuments*. As a sculptural material it may be either (i) cast – run into a mould in a molten state and allowed to cool and harden; or (ii) wrought – heated, made malleable, and hammered or worked into shape before being welded to other pieces.

jamb: one of the vertical sides of a door, window, or archway.

Kerridge sandstone: an even-grained, very hard Carboniferous *sandstone* from Kerridge, near Macclesfield, Cheshire, widely used for paving and roofing.

keystone: the wedge-shaped stone at the summit of an *arch*, or a similar element crowning a window or doorway.

lantern: a small circular or polygonal windowed turret, surmounting a dome, *cupola* or *canopy*.

larvikite: a dark igneous rock containing a type of feldspar called labradorite; often used as a veneer. Named after Larvik in Norway.

Latin cross: *free-standing* Victorian or Edwardian *Gothic* spire, usually with *niche* statues, after the thirteenth-century *Eleanor Crosses*, put up by Edward I.

lettering: characters which comprise the inscription. **Applied:** metal letters stuck or nailed. **Incised:** letters carved into stone or etched in metal. **Relief:** low-*relief* letters. **Raised:** high-*relief* letters.

limestone: a sedimentary rock consisting wholly or chiefly of calcium carbonate formed by fossilised shell fragments and other skeletal remains. Most limestone is left with a matt finish, although certain of the harder types can take a polish after cutting and are commonly referred to as *marble*. Limestone most commonly occurs in white, grey, or tan.

lintel: horizontal beam or slab spanning a door or window, supporting the wall above.

lost wax: see *cire perdue*.

lunette: semi-circular surface on, or opening in, a wall, framed by an *arch* or vault.

Mansfield stone: a *sandstone* from Nottinghamshire, occurring pale yellow ('white') or pinkish-brown ('red'). It is fine-grained and therefore cuts well, but it is also relatively soft and prone to weathering.

maquette (Fr. 'model'): in *sculpture*, a small three-dimensional preliminary sketch, usually roughly finished.

marble: in the strictest sense, *limestone* that has been recrystallised under the influence of heat, pressure, and aqueous solutions; in the broadest sense, any stone (particularly limestone that has not undergone such a metamorphosis) that can take a polish. Although true marble occurs in a variety of colours, white has traditionally been most prized by sculptors, the most famous quarries being at Carrara in Italy, and at Paros (Parian marble) in the Aegean. Pentelic marble from Mount Pentelikos in Greece is characterised by its golden tone, caused by the presence of *iron* and mica.

mausoleum: a monumental tomb. The term derives from the tomb (one of the Seven Wonders of the Ancient World) of King Mausolus at Halicarnassus.

medallion: a circular frame shaped like a large medal.

metope: in a *Doric frieze*, one of the rectangular surfaces alternating with *triglyphs*, frequently sculptured.

mild steel: steel containing only a small percentage – up to 0.15% by weight – of carbon. Mild steel is noted for its strength and toughness.

Millstone grit: also known as *gritstone*, it is a Carboniferous *sandstone* occurring in the southern Pennines, Derbyshire and adjacent parts of Cheshire and Staffordshire. It is brown in colour and is distinguished by the angularity and the often large size of its quartz grains. The two most sought-after gritstones are **Darley Dale** and Bramley Fell.

modello (It. 'model'): a small-scale, usually highly finished, sculptor's (or painter's) model, generally made to show to the intended patron.

monolithic: of a large *sculpture, pillar, column,* etc., made from a single stone.

monument: a structure with architectural and/or sculptural elements, intended to commemorate a person, event, or action. The term is used interchangeably with 'memorial'.

mosaic: design comprised of small, usually coloured, pieces of glass, tile or *marble*.

moulding: a projecting or recessed band used to ornament a wall or other surface.

mullion: one of the vertical stone or timber members dividing a window into lights.

mural: large-scale decoration on or attached to a wall.

Neo-classical: artistic style and aesthetic movement which spread across Europe from the second half of the eighteenth century. It drew upon a renewed interest in antique art, *sculpture* and particularly architecture.

New Sculpture: a movement in British sculpture 1877–c.1920 away from the relative blandness of mid-nineteenth-century practice towards a type of work which was both more naturalistic and more imaginative. *Athlete Wrestling with Python* (RA, 1877) by the painter Frederick Leighton is customarily regarded as the starting point, although the term was first coined in 1894.

The naturalistic side of the movement is best exemplified by the work of Hamo Thornycroft and John Tweed, the imaginative, symbolist side by the work of Alfred Gilbert. The deaths of Harry Bates and Onslow Ford and the virtual exile of Gilbert at the turn of the century are sometimes posited as the moment when the New Sculpture ran out of steam. However, the continued energy and invention of sculptors such as William Reynolds-Stephens and William Goscombe John even after the First World War suggests that a later date for its demise may be more accurate.

niche: a recess in a wall, often semi-circular in plan, usually intended to house a *sculpture*.

obelisk: a monumental tapering *shaft* of stone, rectangular or square in section, ending pyramidally.

oculus: a circular opening or window.

ogee arch: a type of archway consisting of two S-shaped curves meeting at their apex. Introduced in the late thirteenth or early fourteenth century, this *arch* was commonly used in the late Middle Ages.

oolitic: descriptive of *limestones* whose structure is largely composed of ooliths, small rounded granules of carbonate of lime.

order: in *classical* architecture, an arrangement of *columns* and *entablature* conforming to a certain set of rules. The Greek orders are (i) **Doric**, characterised by stout columns without *bases*, simple cushion-shaped *capitals*, and an entablature with a plain *architrave* and a *frieze* divided into *triglyphs* and *metopes*; (ii) **Ionic**, characterised by slender columns with bases, capitals decorated with *volutes*, and an entablature whose architrave is divided horizontally into *fasciae* and whose frieze is continuous; and (iii) **Corinthian**, characterised by relatively slender columns, and bell-shaped capitals decorated with *acanthus* leaves. The Romans added **Tuscan**, similar to the Greek Doric, but with a plain frieze and bases to the

columns; **Roman Doric**, in which the columns have bases and occasionally *pedestals*, while the echinus is sometimes decorated with an egg and tongue moulding; and **Composite**, an enriched form of Corinthian with large volutes as well as acanthus leaves in the capital.

oriel window: a bay window *corbelled* out from the wall of an upper storey.

panel: a distinct part of a surface, either framed, recessed, or projecting, often bearing a sculptured decoration or an inscription.

pantheon: originally, a temple dedicated to all the gods, specifically the Pantheon in Rome, completed c.AD 126. By extension, the name came to be used for places where national heroes, etc. were buried or commemorated.

patina: surface coloration of metal caused by chemical changes which may occur either naturally, due to exposure for example, or by processes employed at a foundry.

pedestal: the *base* supporting a *sculpture* or *column*, consisting of a *plinth*, a *dado* (or *die*) and a cornice.

pediment: in *classical* architecture, a low-pitched gable, framed by the uppermost member of the *entablature*, the *cornice*, and by two raking cornices. Originally triangular, pediments may also be segmental. In addition, a pediment may be open at the apex (i.e., an open-topped or broken-apex pediment) or open in the middle of the horizontal cornice (an open-bed or broken-bed pediment).

personification: a representation of an abstract idea, moral quality, or actual thing, by an imaginary person.

phosphor bronze: a type of *bronze* with c.1 per cent phosphorus added, giving enhanced strength.

pier: in architecture, a *free-standing* support, of rectangular, square or composite section. It may also be embedded in a wall as a buttress.

pilaster: a shallow *pier* projecting only slightly from a wall.

pillar: a *free-standing* vertical support which, unlike a *column*, need not be circular in section.

pits/pitting: small holes and other faults in a metal surface caused either by imperfections in the casting process or by *corrosion*.

plaque: a plate, usually of metal, fixed to a wall or *pedestal*, including *relief* and/or an inscription.

plaster: material comprised of lime, sand, and water, with hair or muslin as a strengthener. Easily malleable when wet, it hardens when dry. It may be carved or poured into moulds to make *casts*.

plastic: (i) any synthetic substance that can be modelled and will then harden into some permanent form; (ii) a term descriptive of *sculpture* that is modelled rather than carved.

plinth: (i) the lowest horizontal division of a *pedestal*; (ii) a low plain *base* (also called a *socle*); (iii) the projecting base of a wall.

podium: circular platform.

polychromy: the practice of finishing a *sculpture*, etc., in several colours.

portico: a porch consisting of a roof supported by *columns*.

Portland stone: a *limestone* from Dorset, characterised by its bleached white appearance when exposed to the elements.

portrait format: of *panels*, etc., rectangular, and higher than they are wide (cf. landscape format).

putto (pl. **putti**): decorative child figure, derived from classical art, featuring either as angels in a religious context or as attendants of Cupid.

pylon: strictly, the monumental gateway to an ancient Egyptian temple, consisting of a pair of rectangular, tapered towers connected by a lower architectural member containing the gate; more loosely, a tapering tower resembling one of the towers from such a gateway.

pyramid: a square-based structure with four inward sloping triangular sides meeting at an apex.

rail: a horizontal member in the framework of a door.

relief: a sculptural composition with some or all areas projecting from a flat surface. There are several different types, graded according to the degree of their projection. The most common are (i) *bas-relief*, or low relief, in which the figures project up to less than half their notional depth from the surface; and (ii) *high relief*, in which the main parts of the design are almost detached from the surface. Many reliefs combine these two extremes in one design.

reredos: strictly, a decorated screen or wall rising behind and above an altar; more loosely, an altarpiece.

Rococo: the elegantly decorative style which predominated in France in the eighteenth century during the reign of Louis XV, characterised by asymmetry; shell, rock, and plant motifs; and the use of S-curves and C-scrolls. The term is used to describe any later work which embodies those characteristics.

Roman Doric: see *order*.

Romanesque: a style of medieval art which prevailed in Europe c.1050–c.1200; in England it is also known as Norman. In architecture it was characterised by round-headed *arches*, heavy continuous wall surfaces and a wealth of simple decorative geometric patterns. In *sculpture* and painting the figure was simply drawn with drapery and hair treated as a decorative element.

rosette: a rose-shaped decorative motif.

rostrum: a platform.

rotunda: a circular building, usually domed.

roundel: circular or oval frame within which a *relief sculpture* may be situated.

Royal Academy of Arts: founded in 1768 and moving several times before being finally located in Burlington House, London, the Royal Academy (often abbreviated to RA) aims to raise the status of artists through a system of training and exhibitions of works. Annual exhibitions have provided the chance for Academicians and other artists and

sculptors to show their latest works, which would often lead to further commissions.

Runcorn stone: a type of fine-grained *sandstone* obtained from quarries at Runcorn, Cheshire.

rustication: stonework cut in massive blocks, separated from each other by deep joints. The surfaces are often left rough to suggest strength or impregnability. A rusticated *column* has a *shaft* comprising alternated rough (or textured) and smooth *drums*.

sandstone: a sedimentary rock composed principally of particles of quartz, sometimes with small quantities of mica and feldspar, bound together in a cementing bed of silica, calcite, dolomite, oxide of iron, or clay. The nature of the bed determines the hardness of the stone, silica being the hardest.

screen: a wall or other dividing element, often semi-circular, placed behind a statue or *monument*.

scroll: a spiral architectural ornament, either one of a series, or acting as a terminal, as in the *volute* of an *Ionic capital*.

sculpture: three-dimensional work of art which may be either representational or abstract, *relief* or *free-standing*. Among the many different types are (i) bust – strictly, a representation of the head and shoulders (i.e., not merely the head alone); (ii) effigy – representation of a person, the term usually implying that of one who is shown deceased; (iii) equestrian – representation of a horse and rider; (iv) kinetic – a sculpture which incorporates actual movement, whether mechanical or random; (v) *relief* – see separate entry; (vi) statue – representation of a person in the round, usually life-size or larger; (vii) statuette – a small-scale statue, very much less than life-size; (viii) torso – representation of the human trunk without head or limbs.

shaft: main section of a *column*, between the *capital* and the *base*.

silicon bronze: alloy of *copper* and c.1–3 per

cent silicon and often a small amount of manganese, tin, *iron*, or zinc. Originally developed for the chemical industry because of its exceptional resistance to *corrosion*. Its other chief characteristics are strength, hardness, and ease of welding.

slate: a metamorphic rock of sedimentary origin, its chief characteristic is the ease with which it can be split into thin plates.

socle: a low undecorated *base* or *plinth*.

spalling: the splitting away of the surface layers of stone or brick parallel to the surface. Sometimes called delamination.

spandrel: the surface, roughly triangular in shape, formed by the outer curves of two adjoining *arches* and a horizontal line connecting their crowns. Also the surface, half this area, between an arch and a corner.

stainless steel: a chromium-*steel* alloy. The alloy is rendered stainless because its high chromium content – usually between 12–25% – protects its surface with a corrosion-resistant chromium oxide film.

Stancliffe stone: a siliceous *sandstone* from *Darley Dale*, Derbyshire, chiefly prized for its hardness.

steel: an alloy of *iron* and carbon, the chief advantages over iron being greater hardness and elasticity.

stele: an upright stone slab which may be carved, inscribed or support *panels*.

stop: projecting stones, sometimes sculptured, at the ends of a hood-mould, acting as terminals.

Storeton stone: a pinkish *sandstone* from Storeton, Cheshire.

string course: a continuous horizontal band projecting from or recessed into a *façade*.

swag: representation of a drape of a curtain.

tabernacle: a canopied *niche* in a wall or *pillar*, usually containing a statue.

tablet: a stone *panel*, often inscribed.

term: a *sculptured* human figure, either just the head, or the head and shoulders, or the figure all the way down to the waist, rising from a *pillar*. Also known as a terminal figure.

terracotta: clay baked to an enduring hardness, which may come in a variety of colours dependent on the amount of iron oxide in the material. Can be modelled or *cast* in a number of ways and enamels or glazes applied.

tondo: a circular *panel*. Also known as a *roundel* or *medallion*.

tracery: an ornamental form characteristic of *Gothic* architecture, notably in windows.

triglyph: on a *Doric frieze*, one of the vertically-grooved blocks alternating with the *metopes*.

trophy: *sculptured* group of arms or armour commonly found on military *monuments* and *war memorials*.

turret: small tower, usually attached to a building.

Tuscan: see *order*.

tympanum: a section over a door or window which is often enclosed by a *pediment*. It has no structural function and so is usually filled with decoration or *relief sculpture*.

urn: a vase with lid originally made to receive ashes of the dead.

verdigris: a green deposit which forms naturally on the surface of *copper*, *bronze*, and *brass*

volute: one of the spiral scrolls on *Ionic* and *Composite capitals*.

voussoir: wedge-shaped stones used in *arch* construction.

war memorial: structure which commemorates those who served or died in particular wars.

Westmorland greenstone: a grey-green *slate*.

York stone, Yorkshire stone: a Carboniferous *sandstone* from quarries to the south of Leeds and Bradford and around Halifax. It is usually light brown in colour, has a fine, even grain and may be highly laminated. This latter quality renders it capable of being split into thin slabs which are nonetheless strong and durable. It is thus in demand for paving, coping, cladding, sills, etc.

Selected Biographies

We would like to acknowledge the help we have received from being able to use the biographical researches of other contributors to the series.

Jane Ackroyd (b. 1957)
Sculptor. Born in London. Studied at St Martin's School of Art, 1974–9, and Royal College of Art, 1980–3. In 1983 she won the Melchett Award in Steel and the Fulham Pottery Award. Public works include *Well* (Museum of Harlow Gardens) and *Cat* (Old Library, Harlow). She has work in the collections of the Arts Council of Great Britain, Goodwood Sculpture Park and Leicestershire Education Authority.

Source: Cavanagh, 2000

George Gamon Adams (1821–98)
Sculptor. Adams enrolled at the RA Schools in 1840 as sculptor and medallist, winning a silver medal in the same year. In 1846–7 he studied under John Gibson in Rome. In the year of his return to England he won the RA Gold Medal for his group, *The Murder of the Innocents*. In 1852 Adams was chosen to take a death mask of the Duke of Wellington, the marble bust he executed from it being regarded by the Duke's heirs as highly successful. His 1856 statue of *General Napier* for Trafalgar Square was dismissed by the *Art Journal* of 1862 as perhaps the worst piece of sculpture in England. Exhibited at the RA from 1841 to 1885, and elected Fellow of the Society of Arts in 1869.

Sources: Gunnis, 1968; Cavanagh, 1997.

John Adams-Acton (1830–1910)
Sculptor. Born in Acton Hill, Middlesex, he added Acton to his surname in 1868 to avoid confusion with another artist called John Adams. He trained under Timothy Butler then Matthew Noble before attending the RA Schools, 1853–8, where his talents were recognised by the award of a number of medals. In 1858 he gained the RA's travelling studentship and went to Rome. After 1865 he was resident in London. Exhibited regularly at the RA until 1892. Principal works include the *Wesley Memorial* (Westminster Abbey, 1875), *Sir Titus Salt* (Bradford, 1874), *W.E. Gladstone* (Liverpool, 1870 and Blackburn, 1889), and *Cardinal Manning Memorial* (Westminster Cathedral, 1908).

Sources: *DNB*, Cavanagh, 1997.

Lynda Addison
Sculptor. Studied three dimensional design at Manchester Metropolitan University. Specialises in glass and ceramic figurative sculpture working from studio at her home. The Rolls-Royce tablet is her major public work in terracotta.

Source: artist.

Carl Albetill
Sculptor. Listed as a sculptor and modeller, residing at 21 Mawdsley Street, Bolton in the *Post Office Bolton Directory for 1894–5*.

Source: *Bolton Journal*, 3 February 1894.

Charles John Allen (1862–1956)
Sculptor. Born in Greenford, Middlesex. From 1879–89 he worked for Farmer & Brindley of Lambeth, before going on to study at the South London Technical Art School and, subsequently, at the Royal Academy Schools, where he won four silver medals. From 1890 to 1894 he was chief modelling assistant to Hamo Thornycroft. Exhibited both at the RA (1890–1922) and abroad, and was, from 1894, a member of the Art Workers' Guild. Allen went to live in Liverpool where from 1894 he was instructor in sculpture at the School of Architecture and Applied Art and, from 1905, the Vice-Principal at the School of Art, Mount Street. Public commissions include two relief panels on St George's Hall (Liverpool, 1895–8) and memorials to *Queen Victoria* (Liverpool, 1906) and *Florence Nightingale* (Liverpool, 1913).

Sources: Beattie, 1983; Cavanagh, 1997.

Edward Allington (b. 1951)
Sculptor. Born in Troutbeck Bridge, Cumbria. Trained at Lancaster College of Art 1968–71, Central School of Art and Design 1971–4, and Royal College of Art 1983–4. Gregory Fellow in Sculpture, Leeds University 1991–3, Research Fellow in Sculpture, MMU 1993. Exhibitions include Objects and Sculpture (ICA, 1981) and The Sculpture Show (Hayward Gallery, 1983). Represented Britain in international exhibitions as part of 'The New British Sculpture'. His sculpture is influenced by Greek and Roman culture. Works include *Three Steps towards the Sea* (1985), *Fallen Pediment (Piano)* (1994) and *Cochlea* (2000). Publications include *A Method for Sorting Cows* (Manchester Metropolitan University, 1997). Teaches at Slade School of Art, University of London.

Source: artist.

The Art Department
Firm established by Liam Curtin, Wendy Jones and Michael Trainor in 1999 for the planning,

installation and maintenance of public art. It is based in Manchester's Northern Quarter where the directors had been involved in the district's public art and sculpture programme. The Art Department have managed public art programmes in Oldham and Blackpool.

Source: Liam Curtin.

Edward Hodges Baily (1788–1867)
Sculptor. Born in Bristol. Baily began taking lessons in wax modelling at 14 and later spent seven years in London as one of Flaxman's pupils. He entered the Academy Schools in 1808, winning the gold medal in 1811 for his *Hercules Restoring Alcestis to Admetus*. In 1817 he began a 25-year association with the London firm of gold- and silversmiths, Rundell & Bridge. His *Eve at the Fountain* (1818–21) confirmed his talent and was purchased for the Literary Institute, Bristol (now Bristol City Art Gallery). Major examples of his public sculpture include the frieze for the portico of the Masonic Hall, Bristol (1825) and extensive work both for Marble Arch (1826) and for Buckingham Palace (mostly 1828), London. Baily had a large practice as a monumental sculptor: examples of his work include *Earl St. Vincent* (St Paul's Cathedral, 1823), *Bishop Grey* (Bristol Cathedral, 1824) and *Viscount Brome* (Linton, Kent, 1837). Statues include *John Flaxman* (University College, London, 1849), *George Stephenson* (Euston Station, 1854) and *Charles James Fox* (Palace of Westminster, 1857). In 1839 his design for a statue of Nelson was selected for Nelson's Column, Trafalgar Square. He exhibited at the Academy from 1810 to 1862 and became an Academician in 1825; in 1863 he was made 'Honorary Retired Academician' and awarded an annual pension.

Sources: Gunnis; Read, 1982; Underwood, 2000.

George Grey Barnard (1863–1938)
Sculptor. Born in Bellefonte, Pennsylvania. Educated at the Art Institute of Chicago where he won a prize for a bust of a young woman, the money enabling him to travel to Paris in 1883 where he studied at the École Nationale des Beaux Arts and worked in the studio of Cavelier. Works from his Paris period include *Fraternal Love* (1887) and a colossal marble group *The Two Natures* which was exhibited at the Exposition des Beaux-Arts (1904). He returned to New York in 1896. Awarded gold medals for his sculpture at expositions in Buffalo (1900) and St Louis (1904). In 1904 began work on series of 33 monumental statues for the Capitol building in Harrisburg, Pennsylvania, including the figures of *Hope Upholding Failure* and *Brotherhood in Despair*. His controversial bronze statues of Abraham Lincoln are in Cincinnati, Ohio, Louisville, Kentucky and Manchester. Barnard's collection of medieval sculpture, displayed in his house, 'The Cloisters' in New York, was sold in 1925 to the Metropolitan Museum of Art. Elected to American Academy of Arts in 1930.

Sources: *Who's Who in American Art*, 1937–8; *Dictionary of American Biography*; Moffat, 1998.

Harry Bates (1850–1899)
Sculptor: Born in Stevenage, Hertfordshire. Between 1869 and 1882 he was apprenticed and worked as a carver for Farmer & Brindley. He studied at the South London Technical Art School and then at Royal Academy Schools, where, in 1883, his *Socrates Teaching in the Agora* won him a travelling studentship. He went to work in Paris where he came into contact with Rodin. In Paris he modelled a triptych illustrating *The Aeneid*. One of the leading practitioners of the New Sculpture, Bates' sculptures include *Hounds in Leash*, exhibited at the RA in 1889, *Pandora*, exhibited at the RA in 1890, and *Mors Janua Vitae*, exhibited at the RA in 1899. He was also responsible for the architectural carving on a number of buildings, including the Institute of Chartered Accountants, City of London, and Holy Trinity Church, Sloane Street, Chelsea. His public monuments include the *Lord Roberts Memorial* (Calcutta, 1896; copy at Kelvingrove Park, Glasgow) and the *Queen Victoria Monument* (Dundee, 1899).

Sources: Beattie, 1983; Noszlopy, 1998.

Gilbert Bayes (1872–1953)
Sculptor. Born in London. He studied at the City and Guilds Technical College, Finsbury before entering the RA Schools in 1896 where he was taught by George Frampton and Harry Bates. After winning the gold medal and travelling studentship in 1899, he spent a year studying in Italy and Paris. Inspired by medieval legend and romance, his early style was a blend of French Symbolism and English Arts and Crafts. His early work consists largely of equestrian knight statuettes, for example: *Sirens of the Ford*, 1899 (version at Preston); *Knight Errant* (Oxford, 1900), and decorative panels such as *Jason Ploughing the Acre of Mars* (RA, 1900), mostly cast in bronze. He also made many reliefs in terracotta, stone and various metals, decorating pedestals (*Sigurd*, RA, 1910) and buildings (*The Aldeburgh Memorial*, RA, 1917) as well as fountains and memorial sculpture. Statues include an over life-size marble figure of the *Maharaja of Bickaneer* (RA, 1914) and Sir William Chambers and Sir Charles Barry on the Victoria and Albert Museum. He designed and modelled stoneware for Doultons, including an ornamental clock for Selfridges and the frieze on the façade of Doulton's London headquarters. Exhibited regularly at the RA until 1952; Salon des Artistes Français 1922–30. President of RBS, 1939–44.

Sources: Spielmann, 1901; McKenzie, 2002.

Frantisek (Franta) Belsky (1921–2000)
Sculptor. Born in Brno, Czechoslovakia, son of economist, Joseph Belsky. At 16 he won prize in sculpture competition in Prague. Family fled to England in 1938. Belsky studied at the Central School of Arts and Crafts. He joined other Czech exiles in the army to fight during

the war, serving in the artillery, and was decorated for his wartime service. He restarted his education, studying sculpture at the Royal College of Art. As a sculptor he was known for his portraiture but also produced abstract sculpture and architectural works. Portrait busts include Cecil Day-Lewis (National Portrait Gallery, 1952), Admiral Lord Cunningham (Trafalgar Square, 1967), Harry S. Truman (Presidential Library, Independence, Missouri, 1974), John Piper (National Portrait Gallery, 1987) and Winston Churchill (Churchill College, Cambridge). Belsky also executed many busts of members of the royal family. His public statues include Winston Churchill (Westminster College, Fulton, Missouri; British Embassy, Prague) and Lord Mountbatten of Burma (Horseguards Avenue, London, 1983). Other sculptures include *Joy Ride* (Town Square, Stevenage, 1957) and *Triga* (Callex House, Knightsbridge, 1958). The massive Shell Centre Fountain (Lambeth, 1963) is also by Belsky. Long-serving member and president of RSBS. Governor of St Martin's School of Art, 1967–88. He married Margaret Owen in 1964, who was to become better known as the cartoonist, Belsky. She died in 1989. In 1996 he married the Czech sculptor, Irena Sedlecka. Vaclav Havel presented Belsky with Presidential Medal of Merit in 1999.

Sources: Belsky, 1992; *Guardian*, 7 July 2000.

Percy George Bentham (1883–1936)
Sculptor. Studied at the City and Guilds of London School of Art, the RA Schools and in Paris as well as under Alfred Drury and W.R. Colton. Bentham was based in London. His works include ideal figures, portrait busts and war memorials. He exhibited at the RA from 1915 to 1930. His work included *The Angler* (1916) and *The Bubble-blower* (1917). Bentham also provided figures for a fountain in Hayling Island.

Source: Usherwood, 2000.

Charles Bell Birch (1832–93)
Sculptor. Born in Brixton, London. Studied at the School of Design, Somerset House, 1844–6, before continuing his studies at Berlin Royal Academy and in the studios of the sculptors, Ludwig Wilhelm Wichmann and Christian Rauch. On his return to England in 1852 he entered the RA Schools, gaining two medals. Birch's life-size sculpture, *The Wood Nymph*, won a £500 prize from the Art Union for the 'best ideal figure' in 1864. He worked as pupil and then principal assistant to J.H. Foley, on whose death in 1874 he succeeded to his Regent's Park studio. A frequent exhibitor at the RA, noted for his naturalistically-conceived military groups. These included the memorial to Lieutenant W.R. Pollock Hamilton VC, who died defending the British Residency in Kabul, and *The Last Call* (1879). His portrait statues include a colossal bronze *Disraeli* (1883) and *Major-General William Earle* (1887), both outside St George's Hall, Liverpool. A bronze study of *Queen Victoria* had versions commissioned for India and England. Birch was elected ARA in 1880.

Sources: *DNB*; *Magazine of Art*, 1894; Cavanagh, 1997.

John Blakeley (b. 1929)
Sculptor. Born in Stockport. He worked as a cabinet-maker before spending two years in the Royal Marine Commandos. He then became a lumberjack in Canada. Blakeley studied sculpture at Stockport Art College and then under Professor Carlos Nicholi in Italy. Blakeley returned to Stockport. Among his works is a memorial at Ravensbruck Concentration Camp in the form of a bronze statue of a mother and child, and *Young Christ in the Temple* in St Mary's Church, Stockport. His portrait busts include Joseph Smith, commissioned by the Mormon Church, Salt Lake City.

Source: *Stockport Messenger*, 18 September 1981.

Sir Reginald Blomfield (1856–1942)
Architect and writer. Born in Devon. He trained as architect, articled to Arthur Blomfield, 1881. Established his own practice in 1884. Blomfield became a leading figure in the Art Workers' Guild in the 1880s. He was also an influential writer, books such as *The Formal Garden in England* (1892) touching on a subject that was to be one of his primary interests. In 1918 he was appointed by the Imperial War Graves Commission, with Edwin Lutyens and Herbert Baker, to design the military cemeteries in France and Belgium. His own contributions included the symbolic War Cross and the Menin Gate at Ypres.

Source: Fellows, 1985.

Judith Bluck (b. 1936)
Sculptor. Born in London. Apprenticeship in engraving. Yorkshire-based sculptor working in different media including bronze and brick. Animal sculptures include *Small Workhorse* (Ealing Broadway, 1985), *Sheep* (Milton Keynes) and *Otter Group* (The Lanes, Carlisle). Works in brick include *The Legend of the Iron Gates* (Sainsbury supermarket, Wilmslow, Cheshire). Other commissions include *St Francis of Assisi* (Bristol), Security Doors (Crown Courts, Portsmouth), Crucible Fountain (Sheffield, 1979), *Natural Force II* (Yorkshire Building Society, Bradford), *Jimmy Dyer* (Carlisle) and *Boy on a Capstan* (Whitehaven). Fellow of RSBS, member of the Society of Portrait Sculptors and Art Workers' Guild. Winner of Otto Beit medal and awards from the Société des Artistes Français.

Sources: artist; Yorkshire Building Society.

Ferdinand Victor Blundstone (1882–1951)
Sculptor. Born in Switzerland. Studied art at Ashton-under-Lyne before moving to London where he studied at South London Technical Art School. Entered the RA Schools where his awards included the Landseer Scholarship. He exhibited at the RA and at many leading

galleries. During the war he may have lived for a time with family members in Heaton Chapel, near Stockport. Blundstone executed a number of war memorials including one for the London office of the Prudential Assurance Company and a memorial in Folkestone. He was awarded a silver medal for garden sculpture at the Paris Exhibition 1925. His public commissions include the *Samuel Plimsoll Memorial* (Victoria Embankment, 1929). One of his final works, a statue of *Wendy* for Hawera, New Zealand (1951), was completed by Gilbert Bayes.

Sources: Bénézit; Waters, 1975.

Joseph Bonehill

Architectural sculptor *fl.*1860–90. Joseph Bonehill was listed as a stonemason in Slater's *Manchester Directory* for 1858. Three years later he was described as a 'sculptor and architectural carver', occupying city-centre premises, near Cross Street. By 1871 the firm is identified as J. and T. Bonehill, 'sculptors in marble, wood, monuments, chimneypieces, headstones, reredoses, screens, pulpits, fonts, tombs &c'. In 1889 the firm became W. Bonehill and Co. By 1900 the directories only identify a William George Bonehill, a stonemason with an address in Moss Side. There is no known list of the firm's principal ecclesiastical and secular commissions, but the quality of the work identified in this survey suggests that Bonehill possessed a considerable talent.

Sources: Manchester Directories 1858–1900; *Builder*, 5 June 1869, 3 May 1879.

James Bowden & Sons

Stonemasons. Bowden & Sons was a Bolton firm, premises at Parkend, operating throughout the late Victorian and Edwardian years. John William Bowden was one of the sons. The Fielding monument appears to have been their only public statue.

Sources: Bolton Directories; *Bolton Journal and Guardian,* 11 July 1896.

Robert Bridgeman & Sons

Architectural sculptors. Founded in 1879 by Robert Bridgeman, the practice of Bridgeman & Sons of Lichfield specialise in ecclesiastical and architectural sculpture, carving and restoration work. They have carried out work in most cathedrals in England as well as colleges, halls, churches and mansions. They also have work in Australia, New Zealand, USA, Italy and Sweden.

Sources: Keyte, 1995; Noszlopy, 1998.

John Broad (1873?–1919)

Modeller. Broad was employed as modeller by Doulton of Lambeth. He produced a considerable quantity of terracotta work. The six vitreous enamelled terracotta panels at St Bede's College were among his earliest work. He exhibited at the RA from 1890 to 1900. His public commissions included the terracotta monuments of *General Gordon* and *Queen Victoria* in Gravesend. He also modelled *Queen Victoria* and *India* for the *Doulton Fountain* (Glasgow, 1888).

Source: McKenzie, 2002.

Stephen Broadbent (b. 1961)

Sculptor. Born in Wroughton, Wiltshire. Educated at Bluecoat School, Liverpool. Trained with Liverpool sculptor, Arthur Dooley, 1979–83. Work developed from limited edition bronze sculpture into larger public sculptures, including environmental sculpture and water features. Established Broadbent Artworks Ltd in 1997. Public sculpture includes *Reconciliation* (Liverpool, 1989, also Glasgow and Belfast), *A Celebration of Chester* (Capital Bank, Chester, 1990), *Trades and Professions of Edinburgh* (Saltire Court, Edinburgh, 1994), *The Bull Ring* (St Andrew's Gardens, Liverpool, 1999), *Encounter* (Birchwood Science Park, Warrington, 2002). Water features include *River of Life* (Warrington, 1996) and *Seasons* (Cathedral Gardens, Manchester, 2002).

Source: artist.

Bromsgrove Guild

Founded by Walter Gilbert in 1898, offshoot of Arts and Crafts movement, in Bromsgrove, Worcestershire. The guild's work included metalwork, stonework, plasterwork, woodcarving and stained glass. A branch was established in Montreal in 1911. The gates of Buckingham Palace (1910) were among their most publicised commissions, but their list of private and public clients was extensive, including shipping companies. H. Crichton modelled the figure of Punch, for the magazine's offices in Bouverie Street, London. A bronze bust of *Wallace Hartley*, bandmaster on the *Titanic*, (Colne, Lancashire, 1915) was also the work of the Guild. The Guild became a limited company in 1921. It ceased business in 1966.

Source: Watt, 1999.

John Brooke

Architect. Articled to Frederick Bakewell of Nottingham 1867–71. Educated at Nottingham School of Art. Practised in Manchester from 1873. In partnership with Alfred Hugh Davies-Colley (1846–1917). ARIBA 1881 and 1908 FRIBA. Member of Council and then President of the Manchester Society of Architects. Went into partnership with C. Ernest Elcock in October 1912. Also designed Holdsworth Hall, Manchester, 1911. Designed Manchester Royal Infirmary with E.T. Hall. Brooke was also the architect of several churches in Manchester as well as the Deansgate arcade.

Source: Felstead, 1993.

Keith Brown

Sculptor. Studied at Sunderland Polytechnic (DipAD 1967), Michigan University (Clemenstone Scholarship, 1969), Manchester Polytechnic (HAD, 1971), and the Royal College of Art (MA, 1972–5). Received the Sir James Knott Scholarship in 1975. Exhibitions include the 7th Symposium of Art and Technology, Connecticut, and Innovation and Tradition, Fine Arts at Manchester, Portland

and Eugene, Oregon (both 1999); The Birth of the Baby: Manchester and the Modern Computer (Manchester Museum, 1998). Currently Head of Fine Art Sculpture at Manchester Metropolitan University (formerly Manchester Polytechnic). President and founder of FasT-uk (Fine Art Sculptors and Technology in the UK).

Source: artist.

James George Bubb (1782–1853)
Sculptor. Bubb studied at the Royal Academy Schools, winning a silver medal in 1805. He was employed as a sculptor at Mrs Coade's artificial stone works at Lambeth. In around 1818 he began manufacturing terracotta in partnership with his former teacher, John Rossi. Works executed by Bubb included reliefs for the Commercial Rooms, Bristol, London Customs House and the Italian Opera House, Haymarket. He also executed funeral monuments and busts. Bubb exhibited at the RA from 1805 to 1831. His work was not highly regarded among his fellow sculptors, an assessment coloured by his conduct in obtaining the commission for the Pitt monument in 1806.

Sources: Gunnis, 1968; Kelly, 1990.

Burmantofts Works, Leeds Fireclay Company
Firm established in 1842 as Lassey and Wilcock, coal proprietors and brick makers, at Burmantofts, Leeds. By the early 1870s the firm had become Wilcock and Co., specialising in sanitary tubes and salt-glazed bricks. In 1879 James Holroyd took over as manager and was responsible for transforming the business into a nationally-known firm making architectural ornamentation in faience and terracotta. In 1888 the firm was renamed The Burmantofts Company Ltd. Burmantofts employed a number of first-rate artists as principal designers, notably W.J. Neatby and E. Caldwell Spruce. Burmantofts Works closed in 1957.

Sources: Stratton, 1993; Cavanagh, 2000.

Neville Northey Burnard (1818–78)
Sculptor. Born in Cornwall, the son of a mason. Sir Charles Lemon MP persuaded Chantrey to employ Burnard in his studio. In 1848 Lemon's influence secured permission to model a bust of the Prince of Wales, which was exhibited at the RA in the same year. Burnard continued to exhibit there until 1873. Following the death of his wife he took to drink, eventually dying in Redruth Workhouse. Principal public works include statues of *Richard Lander* (Truro, 1852) and *Ebenezer Elliot* (Sheffield, 1854). He also produced busts of Lord Macaulay (1859), Richard Cobden (1866) and William Gladstone (1871).

Sources: *DNB*; Gunnis, 1968; Martin, 1978.

Henry Burnett
Stonemason. Listed as tobacconist and monumental mason in Oldham commercial directory.

Source: Woralls' *Oldham Directory*, 1871.

James Butler (b. 1931)
Sculptor. Born in London. Educated at Maidstone School of Art and St Martin's School of Art (1948–52). After National Service he worked as stonecutter for the Giudici Brothers, and from 1960 also taught sculpture and drawing at the City and Guilds School of Art in London. Butler's reputation as a portrait sculptor began with a commission for a statue of *Jomo Kenyatta* (Nairobi, 1973). Subsequent public statues include *John Wilkes* (New Fetter Lane, London and Wilkes University, Pennsylvania), *Thomas Cook* (Leicester), *Billy Wright* (Molineux Stadium, Wolverhampton), *James Brindley* (Canal Basin, Coventry) and *Duncan Edwards* (Dudley) He is also known for his figures of dancers, children and the female nude. Other work includes the Dolphin Fountain (Dolphin Square, London). Elected ARA in 1964, RA in 1972, FRSBS in 1981, and President of Society of British Portrait Sculptors.

Sources: artist; Strachan, 1984.

Holme Cardwell (1815–64)
Sculptor. Born in Manchester. Trained at Royal Academy Schools on the recommendation of Chantrey. He then went to Paris where he studied under Pierre Jean David, and subsequently to Rome where he established a studio. Exhibited at the RA from 1837 to 1856. Works include *Greyhounds Playing*, *The Good Samaritan* and *Sabrina*. His Manchester connections led to commissions for busts of John Kennedy, Thomas Henshaw and John Dalton. *Venus Victrix* and *Huntsman and a Stag* were among his works displayed at the Art Treasures Exhibition, Manchester, 1857.

Source: Gunnis, 1968.

Hilary Cartmel (b. 1958)
Sculptor. Born in Wendover, Buckinghamshire. Studied at Exeter College of Art (1976–7) and Trent Polytechnic (1977–80). Works chiefly on site-specific sculptures, figurative and abstract, in metal. Public commissions include *Lambis Shell* (Wesley Green School, Oxford, 1983), *Traffic Flow* (wall relief, Maid Marian underpass, Nottingham, 1985), *John Tradescant* (Wilkinson Street, Lambeth, 1988), *Carmen* (Theatre Royal, Nottingham, 1989), *Marathon Gates* (Don Valley Stadium, Sheffield, 1990), *The Filleters' Gate* (Fish Street, Hull, 1992), *Portrait of Rotherham* (Rotherham Transport Interchange, 1995–7) and *A Bird in the Hand* (Royal Mail Headquarters, Chesterfield, 1996). Recent work includes artworks at Home Farm Shopping Centre (Beaumont Leys, Leicester, 2001–2) and *Henry Pease* (with Michael Johnson) (Saltburn, 2001).

Sources: artist; Cavanagh, 2000.

John Cassidy (1860–1939)
Sculptor. Born in Littlewood, Slane, County Meath. Educated at Drogheda under a private tutor, and worked on the family farm. He studied art briefly in Dublin but left Ireland for London, eventually going to Manchester where he studied at the School of Art. Within three

years Cassidy won four national medals for sculpture and several Queen's prizes. He began sculpting professionally in 1887. At the Manchester Royal Jubilee Exhibition of that year, he was reported to have modelled 185 portrait busts and received commissions for many more. He decided to establish a studio in Manchester in preference to London. In the late 1880s he had premises in the Barton Arcade, Manchester, describing himself as a 'modeller for bronze castings'. The decision proved successful, a steady supply of commissions arriving for busts, plaques and statues. Lancashire works include the statues *John and Enriqueta Rylands*, *Ben Brierley*, *James Dorrian*, *Benjamin Dobson* and *Edward VII*. Other major works included portrait statues of *Edward Colston* (Bristol, 1895) and *Queen Victoria* (Belfast). The influence of the New Sculpture was evident in works such as *Adrift*. He exhibited at the New Gallery, London. After the First World War he sculpted many war memorials in the north of England and north Wales. Elected FRBS in 1914 and became successively Vice-President of the Manchester Academy of Fine Arts and President of the Manchester Sculpture Society. He had a studio in Lincoln Grove, Plymouth Grove, Manchester, but his final years were spent in Ashton upon Mersey. At the time of his death he was working on a bust of Pius XII.

Sources: *Manchester Faces and Places* (vol.IX); *Manchester Evening News*, 20 July 1939.

Joseph Hermon Cawthra (1886–1957)
Sculptor. Trained at Royal College of Art schools. Hermon Cawthra exhibited at the RA 1912–65; elected RBS. His work included imaginative sculpture, portrait busts and architectural sculpture. He produced sculpture for a number of war memorials including Shipley, Yorkshire and the figures representing the armed forces for Bootle (1922–5). Models of the civil and military friezes for the Bury war memorial were exhibited at the RA. His architectural sculpture included *Peace and Plenty* and *Benevolence and Prudence* (Corn Street, Bristol, c.1935), Africa House, Kingsway, London and the two niche figures for Harris's Manchester Town Hall extension, the latter being exhibited at the Royal Academy in 1937. Cawthra also provided statuary for the renovated Burns Mausoleum, Dumfries (1936).

Sources: Royal Academy, 1985; Bénézit, 1976.

Basil Champneys (1842–1935)
Architect, late exponent of the Gothic style. Educated at Charterhouse and Trinity College Cambridge. Articled to John Prichard, diocesan surveyor of Llandaff Cathedral. Began practice in 1867. Won the Royal Gold Medal in 1912. Specialised in educational buildings including several in Oxford, Cambridge, and London. The Rylands Memorial Library was based on his earlier library at Mansfield College. It was said of him that 'as an architect he was learned and correct, refined and scholarly, rather than highly original'. He took, it is said, what may be called the 'literary' view of architecture, being 'more concerned that the details should be historically right and symbolically suggestive than that they should satisfy from a more formal point of view'.

Sources: Archer, 1985; Felstead, 1993.

Sir Francis Legatt Chantrey (1781–1841)
Born Norton, near Sheffield, son of a carpenter. Apprenticed to a carver and gilder in Sheffield but did not complete his training. He took up portrait painting and went to London, where he struggled to make a living, turning again to wood carving. Marriage in 1809 to a wealthy cousin, Mary Ann Wale, provided him with the financial security to pursue his interest in sculpting. His first notable work, a bust of Horne Tooke, was exhibited at the RA in 1811. He had first exhibited at the RA in 1804. A statue of George III for the Guildhall was also completed in 1811. A stream of successful commissions for statues, busts and church monuments in the following years secured Chantrey's position as one of the country's finest sculptors. Public statues included *William Pitt* (Hanover Square, London), *William Roscoe* (St George's Hall, Liverpool) and marble and bronze statues of *James Watt* (Handsworth Parish Church, Greenock and Glasgow). He also executed the equestrian statues *George IV* (for Marble Arch but later Trafalgar Square, 1829) and the *Duke of Wellington* (Royal Exchange, 1840; completed by Henry Weekes). Elected ARA in 1815, RA in 1818, Royal Society in 1822 and knighted in 1835. Chantrey's considerable fortune was used, after his wife's death, to establish the Chantrey Bequest.

Sources: *DNB*; Gunnis, 1968; Cavanagh, 1997.

Giovanni Ciniselli (1832–83)
Born in Novate near Milan and studied at the Milan Academy. Established a studio in Rome, where he was celebrated for his sculptures of mythological and religious subjects. His 'fantastic creations attracted strong partisans at all the exhibitions at which they appeared'. Sculptures include *The Ruses of Love*, *Dawn and Dusk*, *Suzanne*, and *Ruth*. Awarded medal at Melbourne Exhibition of 1881.

Source: Bénézit, 1976.

Clegg and Knowles
Architects. Charles Clegg (1828–1922). Articled to Edwin Hugh Shellard for five years. Started practice 1851. In partnership with John Knowles as Clegg and Knowles. Took his son Charles Theodore Clegg into partnership from 1882. John Knowles, partner of Charles Clegg. The firm was responsible for many commercial buildings in Manchester city centre, including the Pickles Building on Portland Street and Princess Street.

Sources: Tracy, 1899; Felstead, 1993.

Benjamin Clemens
Sculptor. Based in London, working in first half of twentieth century. Works include *Cain*

(1904), *Immolate* (1912), *VAD Worker* (1920), Stockwell War Memorial (1922) and *Madonna and Child* (St Stephen's, Bournemouth). Clemens also sculpted the lions for the Government Pavilion, British Empire Exhibition, Wembley, 1923. He died 27 December 1957.

Sources: Bénézit, 1976; Royal Academy, 1985.

Henry Collins (1910–94)
Sculptor. Studied at Colchester School of Art and the Central School of Arts and Crafts. With his wife, Joyce Pallot (b. 1912), he worked on designs and murals, including those at the Shell Centre, the General Post Office Tower and for British Home Stores. He taught graphic design at St Martin's School of Art and Colchester School of Art.

Sources: Buckman, 1998; Usherwood, 2000.

Sean Crampton (1918–99)
Sculptor. Born in Manchester. Studied at Vittoria School of Art and the Central School of Art in Birmingham. He went to Paris where he was apprenticed to Fernand Léger. He joined the London Irish Rifles in the war, was wounded and awarded the George Medal. After the war he became Professor of Sculpture at the Anglo-French Art Centre, London. Nudes, animals and birds were important subjects in his sculpture. His preferred medium was phosphor bronze. His Catholic faith influenced his art, most obviously in works such as the Stations of the Cross which he created for his local church, St Edmund, Calne, Wiltshire. Public commissions included a memorial for the London Irish Rifles, and *The Three Judges* (Churchill College, Cambridge, 1970). His work was shown in group and solo exhibitions, and he was particularly associated with the Alwin Gallery. Crampton became a member of the RSBS in 1953 and served as president from 1966–71. Following his death, the RSBS organised a memorial exhibition in 2000.

Sources: *Who's Who*, 1999; Lloyd, 2000.

Douglas Cranmer (b. 1927)
Carver and artist. Born in British Columbia, son of Dan Cranmer, famous First Nation activist. Worked in the fishing and logging industries. Cranmer's grandmother was married to Kwakwaka'wakw carver, Mungo Martin, and in 1955 Cranmer was taught the fundamentals of carving totems by Martin. Cranmer worked with Martin on other projects before he joined Bill Reid on the construction of Haida Houses for the University of British Columbia Museum of Anthropology. Cranmer has also worked in paint, creating a series of 48 works between 1974 and 1975. In 1994 he completed a residency at the UBC Museum of Anthropology.

Source: Jonaitis, 1988.

Mitzi Solomon Cunliffe (b. 1918)
Sculptor. Born in New York City. Trained with the Art Students' League in New York before studying at Columbia University (1935–40). She married the academic, Marcus Cunliffe (1922–90) and came to live in Manchester where she resided 1949–64. She later lived in Brighton and London. She contributed decorative sculptural work, including the door handles, to the Regatta Restaurant at the Festival of Britain, 1951. A bird sculpture, *The Quickening*, and *Loosestrife* (1951) were purchased by the University of Liverpool for their Civic Design Building. During the 1950s she designed ceramics for Pilkington's and textiles for David Whitehead Fabrics. The mural for Heaton Park Reservoir Valve House was one of her largest works. The well-known BAFTA award is based on the design she made for the Guild of Television Producers and Directors, first presented in 1955. In later years she suffered from dementia but continued to work. A sculpture prize for undergraduates at Oxford University is named after her.

Sources: Strachan, 1984; Buckman, 1998; Cavanagh, 1997.

Liam Curtin (b. 1951)
Sculptor. Born in Liverpool. Trained as a teacher at Christ College, Liverpool. Self-taught artist and potter. First public artworks produced in early 1990s. His public art includes both permanent and temporary installations, often using water. Curtin played a leading part in the public art programme in Manchester's Northern Quarter as one of the principal figures in Majollica Works. He is now one of the directors of The Art Department. His works include the *High Tide Organ* (with John Gooding), a sculpture on Blackpool promenade. It uses the power of the waves at high tide to make music. The organ was influenced by an earlier temporary work, a musical fountain, located in the canal near the Bridgewater Hall, Manchester. It received a £65,000 award from the National Endowment for Science, Technology and the Arts (Nesta).

Source: artist.

Thompson Dagnall (b. 1956)
Sculptor. Born in Liverpool. Educated at Liverpool Polytechnic (1974–5), Brighton Polytechnic (1975–8), and at Chelsea Art College (MA, 1978–9). Tom Dagnall contributed a number of works to the Ribble Valley Sculpture Trail between 1988 and 1991. Public commissions include *Mining Monument* (St Helens, 1996), *Altar and St. Chad* (Chadkirk Chapel, Stockport, 1996), *Spruced Up Heron* and *Orme Sight* (Beacon Fell Country Park, 1996), sculpture (Lower Eccleshill Link Road, Blackburn, 1998) and *Tolpuddle Martyrs Memorial* (Tolpuddle, 2001). Exhibitions include The Orangery, London, Manchester City Art Gallery (1991, 1993) and successive Manchester Academy Annual Exhibitions.

Source: artist.

Alfred Darbyshire (1839–1908)
Architect. Born in Salford. Educated at Friends' School, Ackworth, and at Alderley Edge.

Articled to Peter Bradshaw Alley. Began practice in Manchester from 1862 at the age of 23. He made his reputation building theatres, including the Comedy Theatre and the Palace in Manchester. He also made extensive alterations to the Theatre Royal and the Prince's in Manchester, and renovated the Lyceum in the Strand. He designed the Manchester city abattoirs in Water Street and the lodges of Alexandra Park. Worked on the model of Old Manchester and Salford for the 1887 Manchester Exhibition. Elected FRIBA and President of Manchester Society of Architects, 1901–2. As president he helped set up a chair of Architecture at Owens College. He published an autobiography in 1887 entitled *An Architect's Experiences, Professional, Artistic and Theatrical*.

Sources: Lockett, 1968; Felstead, 1993.

Shirley Diamond

Sculptor. Studied at art school in Kingston upon Hull and Manchester Metropolitan University. Residencies in universities at Perth and Newcastle, Australia. Exhibitions at Whitworth Art Gallery, Manchester and Yorkshire Sculpture Park. Awarded Henry Moore Foundation Bursary, 1996.

Source: artist.

Sir William Reid Dick (1879–1961)

Sculptor. Born in Glasgow. Served apprenticeship as a stonemason before studying at Glasgow School of Art (1906–7). Established studio in London and began exhibiting at the RA in 1908. Works before 1914 included *The Catapult* (RA, 1911). After the war contributed to a number of war memorials, notably the gigantic lion on the Menin Gate (Ypres, 1927). He worked with leading architects including Lutyens and Blomfield. At Port Sunlight he contributed to the memorial to Lord Leverhulme, architect James Lomax Simpson. He executed the sculpture for the Kitchener Memorial Chapel (St Paul's Cathedral, 1922–5).

He became ARA in 1921, RA in 1928, and served as President of the RSBS 1933–8. He was knighted in 1935. As the King's Sculptor in Ordinary in Scotland from 1938, and then the Queen's Sculptor, he produced many statues and busts of the royal family, including *George V* in Old Palace Yard, Westminster. *Franklin D. Roosevelt* in Grosvenor Square and *Sir John Soane* at the Bank of England are among his other London statues. Regent's Park is the location of his *Boy with Frog Fountain* (1936). His bronze *Lady Godiva* was unveiled in Coventry in 1949. His other works include a bust of Sir Edward Lutyens and a statue of Our Lady of Liverpool, both of 1933, and statues of Lord Duveen and the Countess of Jersey.

Sources: *DNB*; Fell, 1945; McKenzie, 2002; Ward-Jackson, 2003.

Driver and Webber

Architects. Charles Henry Driver (1832–1900), worked with Sir Joseph William Bazalgette (1819–91). ARIBA 1867, FRIBA 1872. Exhibited at the RA. With Bazalgette he designed pumping stations at Crossness and Abbey Mills and also worked on the Victoria Embankment. Also designed many of the stations on the London, Brighton and South Coast Railway. Worked for the Metropolitan Board of Works on drainage covers and ornamental lamps. Designed Buenos Aires station with Edward Wood, along with the pier at Nice. Designed memorial to Sir Tatton Sykes and many private houses. Was an active Freemason and designed the Mark Masons Hall in St James's Street, London.

Source: Felstead, 1993.

Chris Drury (b. 1948)

Sculptor. Born in Colombo, Sri Lanka. Educated at Camberwell School of Art (1966–70). Began as a figurative and animal sculptor, but after 1974, influenced by Hamish Fulton, became interested in landscape art. Solo exhibitions include 'Silent Spaces', Janus

Avivson Gallery, New York (1998) and 'Shelter' at Fabrica in Brighton (1999). Site-specific works include *Vortex* (Lewes Castle, Sussex, 1994), *Wave Chamber* (Kielder Reservoir, Northumberland, 1996), *Shimanto River Spheres* (Kochi Province, Japan, 1997), *Coming Full Circle* (Stacksteads, Irwell Sculpture Trail, 2001, and *Eden Cloud Chamber* (Eden Project, Cornwall, 2001). Awards include the Pollock-Krasner Award, 1995.

Sources: artist; Drury, 1998.

Earp, Hobbs and Miller

Architectural sculptors. Thomas Earp (1828–93) studied at Nottingham School of Art and Design before working for George Myers. He moved to London where his stone-carving skills, particularly on ecclesiastical buildings, saw him undertaking work for George Gilbert Scott, Pugin and Teulon. A close working relationship developed between Earp and G.E. Street. The *Eleanor Cross* (Charing Cross, 1863) was one of Earp's many successful works. Earp's already considerable business, based in Lambeth, South London, expanded further in 1864 through a partnership with Edwin Hobbs. The firm opened premises in Manchester on Lower Mosley Street. Edwin Hobbs oversaw the Manchester business, residing in Chorlton-upon-Medlock and, later, Moss Side. Their reputation as ecclesiastical architectural carvers was of the highest, but they also undertook extensive work on public and private buildings throughout the country. The firm operated under the name of Earp, Son and Hobbs from the early 1890s, the founder dying in 1893. By 1910 they had become Earp, Hobbs and Miller, continuing under that name in Manchester until the early 1940s.

Sources: Manchester Directories; Read, 1982; Mitchell, 2002.

John Eaton

Architect. Pupil of Richard Moffat Smith of Manchester from 1856. Educated at Manchester

School of Art 1857–60. In office of father at Ashton-under-Lyne. Travelled on the continent. At his death was senior partner in John Eaton, Sons and Cantreel of Ashton-under-Lyne. Elected FRIBA 1882 and Vice-President of Manchester Society of Architects 1904–5. Designed public and commercial buildings in Ashton-under-Lyne and surrounding area, including Heginbotham Technical School, School of Art and Free Library in Ashton.

Source: Newspaper cuttings, Tameside Local Studies.

Arthur Sherwood Edwards (1897–1960)
Artist and sculptor. Born in Leicester in 1897 and educated at Grimsby Art School. Lived in London and Grimsby before settling in Ashton upon Mersey in early 1920s. Most of his working life was spent as an architect with Manchester City Council. Exhibited at the RA, Royal Glasgow Institute and Royal Cambrian Academy. His paintings, including one of Sale's Town Clerk, J.W.I. Fowkes, were exhibited at the RA, and at the Walker Art Gallery in Liverpool. Many of his works were of local scenes in Ashton, Altrincham and Sale, and of group studies in the style of the Manchester School. He also completed the 'Battle of Peterloo' painting for the Manchester Free Trade Hall.

Source: Newspaper cuttings, Trafford Local Studies.

Julie Edwards (b. 1965)
Sculptor. Born in Birmingham. Studied at Walsall College of Art, 1981–3 and Nottingham Trent University, 1983–6. Awarded Margaret Bryan Travel Scholarship, 1986–7. Solo exhibitions include Bonnington Gallery, Nottingham, 1986–7, Leicester City Art Gallery, 1989 and Gallery Joux Massif, 1998. Artist-in-residence at Abbey Park, 1990 and Grimsby Fishing Heritage Centre, 1994. Public commissions include *Stainless Arc* (G.E.N. Electricity Plant, Killinghome, 1993).

Source: artist.

John Ely
Architect. Articled to Henry John Paull (d. 1888) and Oliver Aycliffe (d. 1897), from 1864–9. Architectural assistant to the Salford Corporation 1872. Chief assistant to Edward Salomons, 1873–4. Partnership with Salomons, 1875–86. Practised alone from 1887 onwards. Elected FRIBA 1888, and served as member of the Council. President of Manchester Society of Architects, 1897–8, and Vice President, 1903–4. Winning architect in the Salford Royal Hospital extension competition, 1907. Also worked on Women's and Children's Hospital, Manchester.

Source: Felstead, 1993.

Paul Fairclough
Stonemason and sculptor. Leonard Fairclough established a successful business as a stonemason and builder in Adlington, Lancashire in 1883. Civil engineering projects began to be undertaken by the early twentieth century and this became the principal business of the firm which expanded to become one of the town's largest employers. Fairclough's four sons went into the business, Paul continuing his father's original trade as a stonemason and carver. A sandstone statue of Queen Victoria unveiled in Adlington in 1887 was the work of Leonard Fairclough.

Source: Smith, 1991.

Harry Smith Fairhurst (1868?–1945)
Architect. Born in Blackburn. Articled to James Wolstenhome, 1883–8. Improver with Maxwell and Tuke and William Charles Tuke, 1888–91 and assistant to J.H. Stones and A.R. Gradwell. Experience with William Frame in Cardiff. Travelled in Italy. Passed Qualifying Exam 1891. Started independent practice 1895 in Blackburn. Moved to Manchester 1901 and entered into partnership with J.H. France. Partnership dissolved 1905. In partnership with son Philip Garland Fairhurst from 1929. Succeeded by son in 1941. His first major commission was for India House, Whitworth

Street, followed by Lancaster House (1906) and Bridgewater House (1913). Also designed model housing in Gorton as well as the offices of Manchester Liners and headquarters of the Manchester Ship Canal (exhibited RA, 1926). Elected ARIBA in 1926.

Source: Whittam, 1986; Felstead, 1993.

Farmer & Brindley
Architectural sculptors. One of the country's leading firms of architectural sculptors from the 1860s onwards, occupying premises on Westminster Bridge Road, Lambeth. William Brindley (1832–1919) was the executant under the direction of William Farmer (1823–79) who also handled the contracts. They worked for most of the major Victorian architects especially George Gilbert Scott, Alfred Waterhouse and Lockwood and Mawson. Brindley's stone-carving contributed to a number of prestigious projects including the Albert Memorial, Natural History Museum and major ecclesiastical restorations at Exeter, Lichfield and Worcester. The firm carved the controversial reredos designed by Bodley and Garner for St Paul's Cathedral. They employed and helped train a large number of British and Continental stone-carvers including Charles J. Allen and Harry Bates. The firm amalgamated with another in 1929, when all their records appear to have been lost.

Sources: Hardy, 1993; Cavanagh, 1997.

Brian Fell
Sculptor. Born in Liverpool. Studied sculpture at Manchester Polytechnic, awarded MA in 1979. Sculpture Fellow, Cheltenham College of Art, 1979–80; Henry Moore Fellow, Yorkshire Sculpture Park, 1989–90. Based in Glossop, Derbyshire, with strong interest in public art. Fell works in metal, especially steel. Public commissions include the *Merchant Seafarers' War Memorial* and *Cargoes* (Cardiff Bay, 1998, 2000), *Footplate* (Flint Railway Station, 1999) and the Tern Project (Morecambe Bay,

1995–2000). *Ajax Bow* is at the Open Air Museum of Steel Sculpture, Ironbridge.

Sources: Groundwork Trust; artist.

Janet Fitzsimons (b. 1963)
Educated at Tuson FE College, Preston and University of Wolverhampton (BA Three-Dimensional Design, 1981–4). In 1985 began work at Salford City Council, taking up the post of landscape technician in 1988, working with multi-disciplinary design teams on the Trinity and Ordsall Projects.

Source: artist.

John Ashton Floyd
Sculptor. Based in Manchester in the interwar years with addresses in Daisy Bank Road and Plymouth Grove. His works include war memorials and architectural carving (Midland Bank, Manchester). ARCA.

Source: Manchester Directories.

John Henry Foley (1818–74)
Sculptor. Born in Dublin. Followed his brother Edward in training as a sculptor, first at the Royal Dublin Society's School and from 1835 at the RA Schools. His *The Death of Abel* and *Innocence* were well received when exhibited at the RA in 1839. In the following year he carved the marble group, *Ino and Bacchus,* for Lord Ellesmere. Such works helped to build his reputation. Foley executed a considerable number of public portrait statues including *John Hampden* (St Stephen's Hall, London, 1847) and *John Fielden* (Todmorden, 1863). Statues of the temperance advocate, *Father Matthew* (Cork, 1864), *Daniel O'Connell* (Dublin, 1866) and *Edmund Burke* (Dublin, 1868) were among commissions received from Ireland. An impressive equestrian statue of Viscount Hardinge (Calcutta, 1858), was one of a number of public commissions he received from that city. Foley also produced several statues of Prince Albert, including the gilt bronze one for the Albert Memorial in London

(completed after his death by his pupils). Elected ARA in 1849 and RA in 1858.

Sources: Gunnis, 1968; Cavanagh, 1997.

Edward Onslow Ford (1852–1901)
Sculptor. Born in London. Ford studied first as a painter in Antwerp and Munich in the early 1870s before deciding to take up sculpture. Established studio in London. An important early commission, won in public competition, was the statue *Rowland Hill* (King Edward Street, London, originally outside the Royal Exchange, 1882). Other commissions followed including *General Gordon Riding a Camel* (Brompton Barracks, Chatham, 1890 and Khartoum, later Gordon's Boys' School, Woking) and *Gladstone* (National Liberal Club, 1894). The Shelley Memorial in University College, Oxford, was completed in 1893, a gift to the college that had expelled the poet when a student. A leading figure in the New Sculpture, Ford was recognised for his bronze studies of female figures including *Folly* (1886), *Peace* (1890) and *Echo* (1895). Exhibited at the RA from 1875 and was elected ARA in 1888 and RA in 1895. He died in 1901, the year in which his much criticised Victoria Memorial was unveiled in Manchester.

Sources: Read, 1982; Beattie, 1983; Usherwood, 2000.

Sir George James Frampton (1860–1928)
Sculptor. Born in London. Worked in an architect's office and then for a firm of architectural stone-carvers, before training at the Lambeth School of Art under W.S. Frith and, in 1881–7, at the Royal Academy Schools. His group, *An Act of Mercy*, exhibited at the RA in 1887, won the Gold Medal and Travelling Scholarship. In 1888–90 he was in Paris, studying sculpture under Antonin Merci. Frampton's *Angel of Death* gained a gold medal at the Salon of 1889. Frampton was an important figure in the New Sculpture movement. He was also a member of the Art Workers' Guild from 1887 and Master in 1902.

He was elected ARA in 1894 and RA in 1902. In 1908 he was knighted. In 1911–12 he was President of the Royal Society of British Sculptors. He developed a large practice producing ideal works, monuments, busts and statues. His principal public commissions included statues of Queen Victoria in Calcutta, Winnipeg, St Helens and Leeds, and the memorial to Edith Cavell (St Martin's Place, London, 1920). Best remembered for his bronze *Peter Pan* (Kensington Gardens, 1912), a replica of which for Sefton Park, Liverpool was completed shortly before his death.

Sources: *DNB*; Cavanagh, 1997.

David Fryer
Sculptor. Educated at Goldsmiths' College (BA Hons Textiles, 1985–8) and Royal College of Art (1998–2000). Fryer has taught at Camberwell and Reading Schools of Art and at the Architectural Association in London. Recent exhibitions include Home Alone post design, Milan (1999) and Young Parents at the Castlefield Gallery, Manchester. Major commissions include *England's Glory* (Ikon Gallery, 1995) and Holly Street Public Arts, Dalston, London (1995).

Source: artist.

Elisabeth Frink (1930–93)
Sculptor. Born in Thurlow, Suffolk. Studied at Guildford School of Art (1947–9) and Chelsea School of Art (1949–53) under Bernard Meadows and Willi Soukop, making her first visit to France in 1951. She received public recognition after her first exhibition at the Beaux Arts Gallery in 1952 and for her prize-winning entry for the Monument to the Unknown Political Prisoner competition in 1953. Taught at Chelsea School of Art 1953–61, at St Martin's School of Art 1954–62 and the Royal College of Art 1965–7. Her early work was based on memories of growing up during the Second World War, as she translated the aggressive forms of war machines and missiles

into anthropomorphic human and animal forms. The male figure, animals and birds were constant subject-matter throughout her career. Public works include *Wild Boar* (Harlow New Town, 1957), *Blind Beggar and his Dog* (Tower Hamlets, 1958), *Our Lady of the Wayside* (Solihull, 1964), *Horse and Rider* (Dover Street, London, 1974), *Running Man* (Barbican, 1982) and *Christ* (Liverpool Anglican Cathedral, 1993). Awarded CBE in 1969, and created Dame of the British Empire in 1982. A major retrospective of her work was held in 1985 at the RA, where she exhibited regularly after 1954.

Sources: Gardiner, 1998; Noszlopy, 1998.

Hideo Furuta (b. 1949)
Born Hiroshima. Educated in Hiroshima including Hijiyama Art College. Trained in sculpture and quarry work in Hiroshima. Left Japan in 1983 and settled in Wales in 1985. Since then he has had many posts as artist-in-residence or as a lecturer at various universities in the United Kingdom, including Grizedale Forest, 1994 and at the University of Northumbria 1992–4. Works include: *Kido* (Edinburgh University, 1989); *East-West* (Margam Sculpture Park, Port Talbot, 1991), *Quiescence* (Bottisham, Cambridgeshire, 1994–5) and *Axiom* (Gateshead Sculpture Park, 1993–6). Awarded Henry Moore Fellowship by UNN in 1992.

Sources: Oldham Public Art Officer; Usherwood, 2000.

Stefan Gec (b. 1958)
Sculptor. Born Huddersfield, Yorkshire. Studied art at Huddersfield Polytechnic, Newcastle Polytechnic, 1984–7 and Slade School of Fine Art, 1991–3. Site-specific and process-based art inspired by living history and his Ukrainian father's experiences. Solo and group exhibitions include Transmission Gallery, Glasgow (1989), ICA, London (1996), Lux Gallery, London (2001) and Yorkshire Sculpture Park (2002). Works include *Trace Elements* (1990), *Detached Bell Tower* (1994–5), *Natural History* (1995) and *Fragment/ Vengeance* (2001). Gec submitted a sculpture for the fourth plinth, Trafalgar Square.

Sources: Bewley, 2002; Irwell Sculpture Trail.

Emanuel Edward Geflowski (1834–98)
Born in Poland. Exhibited four works at the RA from 1867–72. Commissions include public statue of Queen Victoria for Singapore (1889) and portrait busts, including Garibaldi (Walker Art Gallery, Liverpool) and Edwin Waugh (Salford Art Gallery and Museum). His commissions for ecclesiastical sculpture included All Souls Chapel, Oxford and reredos at Holy Trinity, Cirencester.

Source: Bénézit, 1976.

John Geraghty
Stonemason. Born in Bootle, c.1853. Geraghty is listed as monumental mason and sculptor in the commercial directories at the end of the nineteenth century and the beginning of the twentieth century. His works address was Stanley Road, Bootle. In the 1901 census he was married and living in Exeter Road, Bootle.

Sources: Mark Sargant, Crosby Library; Kelly's Liverpool Directories.

Sir Alfred Gilbert (1854–1934)
Sculptor. Born in London. His formal art training began at Heatherley's School of Art in 1872 and continued at the RA Schools. He also served as an assistant to Joseph Edgar Boehm. In 1875 he went to study at the École des Beaux-Arts, under Pierre-Jules Cavalier and Emmanuel Frémiet. He studied and worked in Italy from 1878–84 where Donatello's sculpture proved particularly influential. He favoured bronze over marble. He sent *The Kiss of Victory* from Rome to the RA in 1882. *Icarus,* modelled using the neglected *cire perdue* process, was one of his first major works. Commissioned by Lord Leighton, it was one of the outstanding exhibits at the RA in 1884. Gilbert became a leading figure in the New Sculpture movement and his work quickly confirmed him as one of the country's foremost sculptors. His commissions included the Fawcett Memorial (London, 1887) and the Shaftesbury Memorial Fountain (Piccadilly Circus, London, 1893). Outside London his public statues included the Victoria Jubilee Monument (Winchester, 1887; Newcastle, 1903), *John Howard* (Bedford, 1894) and *David Davies* (Llandinam, Powys, 1894). Gilbert also received commissions from the royal family, including the prestigious tomb of the Duke of Clarence for Windsor. His financial problems combined with a scandal surrounding the Clarence commission led him to leave the country in 1901. He did not return until 1926, following requests from George V to complete the Clarence tomb. His last major work was the Queen Alexandra Memorial Fountain (Marlborough Gate, London, 1932). Gilbert's talents were also evident in his work as a goldsmith, jeweller and stuccoist. He was elected ARA in 1887, RA in 1892 and knighted in 1932.

Sources: *DNB*; Beattie, 1983; Dorment, 1986; Usherwood, 2000.

Eric Gill (1882–1940)
Sculptor, engraver, letter-carver and typographer. Born in Brighton, the son of a minister. In 1897 the family moved to Chichester and Gill attended the art school there for two years. In 1900 apprenticed to the architect W.D. Carse but found contemporary notions of architecture not to his taste. He took lessons in masonry and lettering, the latter under Edward Johnston at Central School of Art and Design. In 1903 Gill left the architect's office and worked as a letter-cutter. In 1904 he married and by 1907 was living in Ditchling, Sussex. About this time he began engraving and in 1909 made his first stone figure, not following the traditional method of first producing a clay model for replication in stone, but carving directly from the stone. By now

Gill had acquired influential friends, including Roger Fry and Augustus John, the latter of whom helped him set up his first solo exhibition in 1911 at the Chenil Gallery, Chelsea. Always of a deeply religious mind, in 1913 Gill converted to Roman Catholicism (becoming in 1918 a Dominican tertiary) and in the same year was commissioned to carve the Stations of the Cross for Westminster Cathedral. Following the First World War, he was commissioned to execute war memorials at Bisham, South Harting and Trumpington. He also continued working on religious commissions including another set of Stations of the Cross, 1921–4, for St Cuthbert's Church, Bradford. In 1924 Gill moved to Capel-y-ffin, Wales, for four years. In this period he executed *Mankind*, a colossal torso in Hoptonwood stone, later acquired by the Tate Gallery. In 1928 he moved to Pigotts, near High Wycombe, and over the next three years published *Art-Nonsense* (1929), his first full-length book; some of his finest illustrations; and, in 1929–32, his sculptures for the exterior of Broadcasting House, including Prospero and Ariel. From 1935–8 he was engaged on his large relief, *The Creation of Adam*, for the League of Nations Palace at Geneva. In 1935 he was elected honorary ARIBA and in 1937 he was made an honorary associate of the RBS and was elected ARA (thereafter exhibiting at the RA 1938–41). He died in 1940, the year his *Autobiography* was published. Retrospectives include Kettle's Yard, Cambridge, 1979, and Barbican Art Gallery, 1992–3 (and tour).

Sources: *DNB*; Cavanagh, 2000.

Ernest George Gillick (1874–1951)
Sculptor. Born in Bradford. Studied at the Nottingham School of Art and then at the Royal College of Art where he won the Italian travelling scholarship in 1902. Gillick became a member of the Art Workers' Guild. Public commissions include the figures of J.W.M. Turner and Richard Cosway on the façade of the Victoria and Albert Museum (1899–1908)

and a memorial fountain to the novelist Ouida (Marie Louise de la Ramée) at Bury St Edmunds. Glasgow's principal war memorial was the work of Sir John Burnet and Gillick (George Square, 1924). He also executed the memorial to Sir George Frampton (St Paul's Cathedral, 1928). Nottingham Museum has his bronze medallion portraits of Thomas Miller and Robert Millhouse. Elected ARA in 1935.

Sources: Bénézit, 1976; McKenzie, 2002.

Keith Godwin (1916–91)
Sculptor. Born Warsop, Nottinghamshire. Studied at Mansfield Art School before going to Nottingham and Leicester Colleges of Art (1935–9). Attended the Royal College of Art before and after the war, 1939–40, 1946–8. Teaching posts at Bromley School of Art and Hammersmith School of Art before moving to Manchester Regional College of Art, later Manchester Polytechnic. Godwin developed a close collaboration with architects and designers. Abstract and figurative sculpture in different media, including stone, cement, terracotta and bronze. Godwin was responsible for the *Neptune* relief in Basil Spence's Sea and Ships Pavilion, Festival of Britain, 1951. Other commissions include *The Philosopher* (Harlow), *Polar Theme* (Philips Laboratories, Redhill), Fountain (ATV Building, Elstree) and *The Architect and Society*. Godwin also produced works for British Railways, Reed Page Group and the National Union of Teachers. Sculptures in Imperial War Museum, London and Red Army Museum, Moscow. Member and President of the Manchester Academy of Fine Arts, which presents the Keith Godwin Sculpture Award to a young sculptor in his memory.

Sources: Strachan, 1984; Manchester Academy of Fine Arts.

William Venn Gough (1842–1918)
Architect. Born Frome, Somerset. Pupil of Henry Masters, elected ARIBA in 1872. Worked in Charles F. Hansom's office in

Bristol before establishing partnership with Archibald Ponton from 1870 to 1878. Then worked on his own. Principal works included churches and schools in and around Bristol. Described as 'undoubtedly very short of architectural tact, yet on occasion could bring off a remarkable theatrical tour de force, whose very brashness was persuasive'.

Source: Gomme, 1979.

Richard Reginald Goulden (1877?–1932)
Sculptor. Studied at Royal College of Art. Lived in London, created FRBS and ARCA. Exhibited at the RA in 1909. Also produced war memorials including ones at Gateshead and Congregational Church, Surbiton. Philip Jackson's *Gurkha Soldier* (Whitehall, London, 1997) was based on a life-size statue Goulden sculpted in 1924.

Source: Bénézit, 1976.

Betty Leuw Green
Sculptor. Born in Holland, moved to England as a young child in 1921. Studied at Manchester Regional College of Art, where she was awarded a prize in 1959, and later at other art colleges in the region. Her main influences come from the European and Dutch schools. Specialises in terracotta sculptures. Examples of her work are in Salford Art Gallery, Haworth Art Gallery, Accrington and the Portico Library, Manchester.

Source: artist.

Edward Owen Griffith
Sculptor. Exhibited at the Walker Art Gallery five times from 1888 to 1912. Executed sculptural work on the New Post Office (Victoria Street, Liverpool) and worked with William Birnie Rhind on the New Cotton Exchange (Old Hall Street, Liverpool). He also executed the stone-carving in the Church of the Holy Trinity, Southport.

Source: Cavanagh, 1997.

E.T. Hall

Architect. Born in Lowestoft the son of architect George Hall. South Kensington School of Art 1865–7. In office of Joseph Fogarty c.1865–76, as manager from c.1870. Travelled widely on the continent to Belgium, France, Switzerland, and visited Germany, Russia and India to study architecture. Started independent practice in 1876, architect and surveyor to various estates. Consulting architect to King Edward VII Sanatorium, Sussex, and to the General Infirmary, Leeds. Designed the Liberty's building in Regent Street, London, as well as several hospitals, including military hospitals. The Manchester Royal Infirmary, according to Paul Waterhouse, was a 'monument of his special skill in the achievement of those essential and intricate elements in a building of hygienic purpose which are not always classed as architecture'. He also had an extensive practice in factories and churches. Was Vice-President of the London Society and author of a design for an Imperial Memorial (1915) which involved replacing Charing Cross Station with a piazza. He won two gold medals at the Milan Exhibition for his architectural exhibits. Vice-President of RIBA 1905.

Source: Felstead, 1993.

Marshall Hall

Hall served in the Royal Navy before deciding to study for an art degree. He joined the fine arts course at Manchester Polytechnic in 1989. The sculpture *Combustion* was a work he had begun developing before coming to the polytechnic.

Source: Christopher Rose-Innes.

James Theodore Halliday (1882–1932)

Senior partner in Manchester architectural firm of Halliday, Paterson and Agate. Battersea Power Station (with Sir Giles Gilbert Scott) is his best-known building.

Andy Hazell (b. 1959)

Sculptor. Born Altrincham, Cheshire. Studied at University of Reading, 1977–81 and then Slade School of Fine Art, 1984–6. Hazell now lives in Powys, Wales, specialises in public art and tin automata, working with a wide range of materials. Commissions include *The Ride of Life* (Meadowhall Shopping Centre, Sheffield, 1990), *The Singing Horse* (Bradford Industrial Museum, 1993), *The Temple of Disagreement* (Dunham Massey, 1995), *Buried Light Bulb* (Bradford, 1998), *Ring of Railway Wagons* (Hengoed, Caerphilly, 2000), *Thumbprint* (Swansea, 2001) and *Malt Shovel* (Burton upon Trent, 2001).

Source: artist.

Charles Heathcote (1850–1938)

Architect. Articled to church architect Charles Hansom of Clifton. Awarded Medal of Merit by the Royal Institute, 1868. Worked for a year in the offices of Messrs Lockwood and Mawson. Started practice 1872. Major works in Manchester include Lancashire and Yorkshire Bank (now Lloyds Bank, Cross Street), Commercial Union Assurance Offices (now Eagle House), Alliance Assurance Company offices (corner of St Ann's Street), as well as the Institute for the Blind, Cheadle Royal Lunatic Asylum, and a number of other hospitals, warehouses and commercial buildings, including the Westinghouse offices in Trafford Park.

Sources: Tracy, 1899; Felstead, 1993.

John Henning the Younger (1801–57)

Sculptor. Eldest son of the Scottish-born sculptor, John Henning (1771–1851). Awarded the Silver Isis medal from Society of Arts for his relief, *The Good Samaritan*. Collaborated with his father on many works, including the classical martial reliefs on Decimus Burton's screen at Hyde Park. Henning executed the reliefs on the column raised to honour Thomas Coke, Earl of Leicester (Holkham, 1845) and

on the Colosseum (Regent's Park, London, 1845). He also completed reliefs based on Hogarth's idle and industrious apprentices for the Freeman's Orphan School (Brixton, c.1850). He produced many busts including Ann, Duchess of Bedford at Woburn Abbey and the first Duke of Marlborough at Windsor Castle. Exhibited at the RA, 1828–52 and the Society of British Artists.

Source: Gunnis, 1968.

Barbara Hepworth (1903–75)

Sculptor. Born in Wakefield. Hepworth attended Leeds School of Art 1920–1, where she met fellow student Henry Moore, and the Royal Academy 1921–4. Worked in Rome with John Skeaping 1924–6 whom she married. First major exhibition in 1928 at the Beaux Arts Gallery, Hampstead (with Skeaping), her work there consisting of stone carvings of figures and animals. During the early 1930s carving in both wood and stone, her work became entirely abstract, a process encouraged by her association with Ben Nicholson, who was to become her second husband. They joined Abstract-Creation and Unit One in 1933. In 1939 they moved to St Ives, where Hepworth stayed for the rest of her life, allowing the Cornish landscape to influence her abstract forms. In the 1950s her reputation as one of the leading figures in the abstract movement was further consolidated. She continued to explore in her sculptures the relationship between mass and space, working in wood, stone and bronze. Her international reputation was confirmed with many high-profile commissions including the memorial to Dag Hammarskjöld, *Single Form* (United Nations Building, New York, 1963). Retrospectives include Wakefield Art Gallery, 1951; Whitechapel Art Gallery, London, 1954, 1962; São Paulo Biennale, 1959; Tate Gallery, London, 1968; Yorkshire Sculpture Park, 1980 and Tate Gallery, Liverpool, 1994. Awarded CBE 1958 and OBE 1965. She died in a fire in her studio at St Ives in

1975. The studio and garden, as she wished, is now a museum explaining her life and displaying her work, administered by Tate St Ives.

Sources: *DNB*; Nairne and Serota, 1981; Curtis, 1998; Noszlopy, 1998.

James Hilton
Stonemason. Hilton was a sculptor and marble mason in Manchester between *c.*1869–1910. The business was described as 'sculptor and marble mason, monumental tombs, mural tablets and headstones in granite, marble and stone, and slate merchant' in the *Manchester Directory*, 1881. Around this time the firm moved away from the city centre to premises near Southern Cemetery.

Source: Manchester Directories.

Julia Hilton (b. 1962)
Sculptor. Educated at University of Durham (1980–3) and Edinburgh College of Art (1988–92). She has held teaching appointments at Worcester College of Higher Education, Gray's School of Art, Aberdeen. Commissions include *Entrances* (Paxton House, Berwick-upon-Tweed, 1994) and sculptures (Worcester College of Higher Education, 1996). Group exhibitions include New Designers, Business Design Centre, London, 1991, 1993; Ceramic Contemporaries, Victoria and Albert Museum, 1993; Garden of Earthly Delights, Hannah Peschar Gallery, Ockley, Surrey, 1996.

Source: artist.

William Loynds Hindle
Stonemason. Hindle was a monumental mason in Stalybridge during the final decades of the nineteenth century. He had premises in the High Street. He carved the Thompson Cross to a design provided by Ashton's leading architectural firm, Eaton and Sons.

Sources: *Ashton Reporter*, 3 June 1893; Kelly's Cheshire Directory, 1896.

Jesse Horsfall (1859–1910)
Architect. Educated privately at Todmorden and Blackpool, articled with G.H. Goldsmith of Manchester. Horsfall began practice in 1870. His major work was Rochdale Art Gallery, and he also designed a number of chapels, schools, clubs, houses and commercial buildings. Made FRIBA in 1893.

Source: Felstead, 1993.

Horton and Bridgford
Architects. William Horton articled to Edward Banks of Wolverhampton 1845–53. Remained two years as office manager. In offices of John Horton of London, and William Milford Teulon (1823–1900), then Starky and A.D. Cuffley of Manchester. Started independent practice 1861 in partnership with A.D. Cuffley, joined later in 1861 by Henry Bridgford. Henry Bridgford (*c.*1854–94) articled to Starky and A.D. Cuffley in 1854 for five years, and remained as assistant for two years. Travelled in France and Italy. Began independent practice 1861, Manchester in partnership with Cuffley and William Horton.

Source: Felstead, 1993.

Byron Howard (b. 1935)
Sculptor. Born and lives in Yorkshire. Self-taught as a sculptor. Principally portrait and figurative sculpture. Exhibited works at Patteson Fine Arts in 1970s and also Royal Academy Summer Exhibitions. Mainly portrait commissions but public work includes *Sir John Barbirolli* (Royal Festival Hall, London; Bridgewater Hall, Manchester) and war memorial (St Nicholas Church, Thorne).

Source: artist.

Glyn Hughes
Patternmaker and sculptor. Educated at Hindley Grammar School. Lives in Adlington, Lancashire. Self-taught as a patternmaker and industrial sculptor. Designer of cast-iron domestic stoves; the 'Yorkshire' domestic

woodburning stove received a Design Council Award in 1999. Hughes described the Turing statue as 'another piece of precision pattern carving'.

Source: artist.

Malcolm Hughes (1920–97)
Artist. Born in Manchester. Trained at Manchester College of Art and Royal College of Art. Artist and teacher. Hughes taught at Chelsea College of Art and at Slade School of Art (1968–82). Co-founder of Systems Group, 1971. Exhibitions include Whitechapel Art Gallery, 1972, Hayward Gallery, 1975, Royal College of Art, 1988. His partner, the artist Jean Spencer, died in 1998.

Source: Barker, 1996.

John Hyatt
Painter, designer, print-maker, sculptor and writer. Exhibitions include Rochdale Art Gallery, 1984, British Art Show, 1986, Cornerhouse, Manchester, 1991 and Cleveland Art Gallery, 1999. A novel, *Navigating the Terror*, was published in 2000. Hyatt was Head of Department of Fine Arts, Manchester Metropolitan University, 1991–2002, and is now Head of the Manchester Institute for Research and Innovation in Art and Design (MIRIAD) at the university.

Source: artist.

Philip Jackson (b. 1944)
Sculptor. Born Scotland. Educated at Farnham School of Art and worked for Henry Moore. Awarded Sir Otto Beit Medal in 1991, 1992 and 1993. In 1991 Jackson won the Mozart Bicentenary Sculpture Competition to provide a statue of the composer in Belgravia, London. Other public commissions include *The Yomper* (Eastney, Hampshire, 1992), *Jersey Liberation Sculpture* (St Helier, 1995), *Wallenberg Monument* (London, 1997; Buenos Aires, 1998), *The Gurkha Monument* (Horse Guards' Avenue, London, 1997), *Minerva* (Chichester,

1997), *Constantine the Great* (York Minster, 1998), *St Richard* (Chichester Cathedral, 2000), *The In-Pensioner* (Royal Hospital, Chelsea, 2000) and *George VI* (Britannia Royal Naval College, 2002). An equestrian statue of Elizabeth II, commissioned by the Crown Estate for the Golden Jubilee, will stand in Windsor Great Park. Jackson is Fellow and Vice-President of the RSBS. He lives and works in Midhurst, West Sussex.

Source: Jackson, 2002.

Sir Thomas Graham Jackson (1835–1924)
Architect. Educated at Brighton College, Wadham College, Oxford. Articled to Sir George Gilbert Scott (1811–78) from 1858. Started independent practice 1861. Awarded Royal Gold Medal 1910. Fellow of Wadham College 1865–80, ARA 1892, Treasurer RA 1901–12. Bt. 1913. One of the principal Victorian proponents of the English Renaissance or Jacobean style, particularly in his Oxford Examination Schools. Published *Small Gothic Architecture* in 1873 which decried the influence of the Gothic Revival, despite his use of its motifs in the Ellesmere Memorial only four years previously.

Source: Felstead, 1993.

Charles Sargeant Jagger (1885–1934)
Sculptor. Born in Sheffield. Jagger was apprenticed at the age of 14 to a metal engraver. After his apprenticeship he became a teacher of metal engraving at night school, passing the days studying sculpture. In 1907 the West Riding of Yorkshire awarded him a scholarship to the Royal College of Art, where he won a travel scholarship. On graduating he earned his living by becoming studio assistant to his former professor and by teaching at Lambeth Art School. In 1914 he was awarded the Prix de Rome for sculpture, but instead of travelling to Italy to further his studies he joined the Artists' Rifles. He was wounded at Gallipoli and in France. He was awarded the Military Cross. He

drew on these experiences to produce a series of stylised bronze pieces which led to commissions for war memorials. These include Portsmouth (1921), West Kirby (1922), St Michael and All Angels, Birmingham, the Anglo-Belgian Memorial, National War Memorial in Brussels, Royal Artillery Memorial, Hyde Park Corner, Tank Memorial, Cambridge and Great Western Railway Memorial, Paddington Station. Jagger could equally turn his skills to other sculpture, producing the relief *Scandal*, the triptych *The Holy Roof* made for the priory chapel of the Society for the Sacred Mission, Newark, and the statue of Sir Ernest Shackleton (Royal Geographical Society, South Kensington). He died of a heart attack in 1934.

Source: Compton, 1985.

William Goscombe John (1860–1952)
Sculptor. Born in Cardiff, son of a wood-carver. Trained in London for an architectural carver, Thomas Nicholl, 1881–6 before studying at the South London Technical Art School. Entered the RA Schools where he won the gold medal and travelling studentship in 1889. He set up a studio in Paris for a year where he came under the influence of Rodin. Throughout the 1890s he exhibited ideal bronzes and in 1900 won a gold medal at the Paris International Exhibition for *The Elf, Study of a Head* and *Boy at Play*. As well as ideal and poetic works he received many commissions for public monuments, portrait busts and church memorials. John's works include the *King's Liverpool Regiment Memorial* (St John's Gardens, Liverpool, 1905) and *Engine Room Heroes Memorial* (Pier Head, Liverpool, 1916). John was also responsible for many First World War memorials including Port Sunlight (1921) and *The Response 1914* (Barras Bridge, Newcastle, 1923). Among his Welsh commissions were statues of Thomas Ellis (Bala, 1902), Charles Rolls (Monmouth, 1911), David Lloyd George (Caernarvon, 1921) and Archdeacon James Buckley (Llandaff,

1927). John was a member of the Art Workers' Guild from 1891. He was elected ARA in 1899, RA in 1909 and knighted in 1911. He exhibited annually at the RA until 1948.

Sources: Beattie, 1983; Cavanagh, 1997; Usherwood, 2000.

Kevin Johnson
Artist and sculptor. Kevin Johnson (Dalton-Johnson) is an artist and teacher. Member of Black Arts Alliance. The Moss Side commission was his first public sculpture. Group exhibitions at Manchester Metropolitan University, Lowry Centre, Salford and Zion Centre, Hulme, Manchester.

Source: artist.

Albert Bruce Joy (1842–1924)
Sculptor. Born in Dublin. Bruce Joy (sometimes Bruce-Joy) studied at the National Art Training School and the RA Schools from 1863, and then in Paris and Rome. He worked in J.H. Foley's studio and on his master's death in 1874 unofficially inherited the commission for the statue of Robert James Graves, 1877 at the Royal College of Physicians, Dublin. He developed a reputation as a skilled portraitist and produced numerous busts, including Matthew Arnold in Westminster Abbey. His public statues include John Laird (Birkenhead, 1877), William Harvey (Folkestone, 1881), W.E. Gladstone (Bow Churchyard, London, 1882), Lord Frederick Cavendish (Barrow-in-Furness, 1885), John Bright (Birmingham, 1887) and W.H. Hornby (Blackburn, 1912). Refused ARA in 1878 but was elected ARHA (Associate of the Royal Hibernian Academy) in 1890 and RHA in 1893. He exhibited at the Royal Academy, London, from 1866. His brother was the artist, George William Joy.

Sources: Spielmann, 1901; Noszlopy, 1998.

David Kemp (b. 1945)
Sculptor. Born in Walthamstow, spent early childhood in Canada. Educated at Farnham and

then Wimbledon School of Art, 1967–72. Painter and sculptor who uses found objects and recycled scrap metal in his public sculptures. Works include *Deerhunter* (Grizedale Forest, 1982), *Iron Horse* (Newcastle upon Tyne Civic Centre, 1982), *Lower Orders* (Yorkshire Sculpture Park, 1982), *The Old Transformers: The Miner* (Co. Durham, 1990), *King Coal* (Pelton Fell, Co. Durham, 1992), *Navigators* (London Bridge, London) and *Tropic Trader* and *Industrial Flame Plants* (Eden Project, Cornwall). Kemp has lived in Cornwall since 1972. A book on his sculpture, *Things Reconstructed* (Penzance: Alison Hodge) was published in 2002.

Sources: artist; Cavanagh, 1997.

Kirkpatrick Brothers
Stonemasons. James and William Kirkpatrick established themselves as stone- and marble masons in Manchester, around 1888. The firm developed into one of the major general stonemasons and carvers in the city. They were initially located in Ardwick but later removed to Trafford Park. They were still operating under their original name in the 1960s.

Source: Manchester directories.

Thomas Rogers Kitsell (1864–1917)
Architect. Educated at George Watson's College and Edinburgh University (Fine Art Classes). Articled to Sir Robert Rowand Anderson (1834–1921), 1878–83, and assistant in his office until 1888. Chief assistant to Francis Grinham Howell, assistant to John Alfred Gotch of Kettering and chief assistant to Charles Edward Ponting. Won the Tite Prize 1892, passed Qualifying Exam 1891. Began independent practice in Plymouth in 1901. He designed St Mary the Virgin, Laira, Plymouth.

Source: Felstead, 1993.

Gilbert Ledward (1888–1960)
Sculptor. Born Chelsea, London, son of Richard Arthur Ledward, sculptor. Studied at

Chelsea Polytechnic, Goldsmiths' College, RCA under Professor Lanteri, and at the RA Schools. Awarded the first British School of Rome Scholarship in Sculpture 1913 and the RA gold medal and travelling studentship in the same year. Served as lieutenant in Royal Garrison Artillery during the First World War. Figurative sculpture, chiefly using stone. Works include war memorials in Blackpool (1923), Harrogate and Guards' Division Memorial, Horse Guards' Parade (1925). He also provided sculpture for Imperial War Graves Commission at Ploegsteert, Belgium (1929). Marble altar relief, Stonyhurst College, Lancashire (1920). His last major work was *Vision and Imagination* which was installed in Barclays Bank, Goodenough House, Broad Street, London (1960, later removed). Ledward was Professor of Sculpture at the RCA, 1926–9. Elected ARA 1932 and RA 1937. He served as PRBS in 1954–6. Awarded OBE in 1956.

Sources: Ledward, 1988; Moriaty, 2003; Ward-Jackson, 2003.

Henry Stormouth Leifchild (1823–84)
Sculptor. Entered RA Schools in 1844 on recommendation of F.S. Cary and then studied in Rome from 1848 to 1851. Exhibited at RA from 1844 to 1882. His *Rispah Watching Over the Dead Bodies of Her Sons* was shown at the Great Exhibition of 1851. Major works included *Athene Repressing the Fury of Achilles*. His Manchester commissions included busts of George Wilson and A.J. Scott. The majority of Leifchild's works were presented by his widow to Nottingham Museum but were subsequently destroyed.

Source: Gunnis, 1968.

Rosie Leventon (b. 1946)
Sculptor. Trained at Croydon College of Art 1976–9 and St Martin's School of Art, 1979–80. Works in stone and other materials to make permanent and semi-permanent sculpture installations. Solo and group exhibitions include

South London Gallery, 1981, Yorkshire Sculpture Park, 1983, Glasgow Garden Festival, 1988, Frankfurt Art Fair, 1992, Bonnington Gallery, Nottingham, 1996, Dean Clough Galleries, Halifax, 1997, Dostoyevsky Museum, St Petersburg, 1999, Atrium Gallery, London 2001. Her work, *A Long Way From the Bathroom*, toured Holland and the UK in 1996–7. Public commissions in Sunderland and Hull.

Sources: artist; Usherwood, 2000.

Paul Frank Lewthwaite (b. 1969)
Sculptor. Born in Douglas, Isle of Man. BA Fine Art and Postgraduate Certificate in Arts Practice, University of Sunderland. Commissions include *Echoes of the Opened Earth* (Moreton Morrell Campus, Warwickshire College, 1998) and *The Generation of Possibilities* (UMIST, Manchester, 1999).

Source: artist.

Henry Lord (1843–1926)
Architect. Born in Chester. Educated at Manchester Grammar School and Making Place Hall, Ripponden, near Halifax. Articled to Charles Sacre, engineer at the Manchester Railway Works, Gorton. Lord gave up engineering because of illness but was shortly afterwards articled to the architect Ernest Bates of Manchester. Began practice in 1871, and elected FRIBA in 1888. He was also active in Conservative politics, being Vice-Chairman of the South Salford Conservative Association. He was also a Salford councillor and a senior magistrate. His principal work was the Royal Technical School at Salford, along with the Central Board School in Deansgate and other school buildings in Manchester.

Source: Tracy, 1899.

Princess Louise, Duchess of Argyll (1848–1939)
Sculptor. Princess Louise Caroline Alberta,

fourth daughter of Queen Victoria, born in Buckingham Palace. She displayed artistic talents in drawing and sculpture from an early age. Mary Thornycroft was her art tutor. In 1868 attended National Art Training School, coming under the influence of Joseph Edgar Boehm. She married John Douglas Sutherland Campbell, Marquess of Lorne, in 1871, becoming the Duchess of Argyll in 1900. Her husband pursued a political career as an MP (for a time he represented South Manchester) and Governor General of Canada. She sculpted many busts of her family and exhibited at the RA. Her statue of Queen Victoria in Kensington Palace was completed in 1893. She also produced a memorial in St Paul's Cathedral to Canadian soldiers who fought and died in the South African War .

Source: Wake, 1988

Sir Edwin Lutyens (1869–1944)
Architect. Lutyens was educated at the Royal College of Art (1885–7). His early career was marked by a series of commissions for country houses, many of them obtained through Gertrude Jekyll, for whom he built Munstead Wood (1896). Later on, classicism came to play a more important role in his work. His most important work of this period was the New Delhi planning commission that he accepted in 1912, and he designed the Viceroy's House, probably the most important example of European Renaissance architecture in India. However, the characteristic style of the middle period of his career was a simplified version of Queen Anne, relying on fine proportions and mouldings, such as Middlefield, Cambridge-shire (1908). During the 1920s, he designed the Cenotaph and more than 50 other war memorials. From 1926 onwards, he collaborated on many large blocks of flats, including his Westminster housing scheme (1928–30). Other works from this period include the British Embassy in Washington (1926–9) and Campion Hall, Oxford (1934).

His most ambitious work of the 1930s was his design for Liverpool's Roman Catholic Cathedral, which was never realised. Lutyens was elected ARA (1913), RA (1920), and President of the Royal Academy in 1938. He received a gold medal for architecture from the RIBA in 1921, becoming the organisation's Vice-President in 1924.

Source: *DNB*.

Michael Lyons (b. 1943)
Sculptor. Born in Bilston, Staffordshire. Educated at Wolverhampton College of Art (1959–63), Hornsey College of Art (1963–4) and University of Newcastle (1964–7). Taught in art colleges throughout his career, in particular at Manchester Polytechnic, later Manchester Metropolitan University, from 1974 to 1993, becoming head of sculpture in 1989. He was a founder member of the Yorkshire Sculpture Park, and has acted as an adviser on exhibitions there. In 1984 he had a residency at Grizedale Forest and in 1987 was Artist-in-Residence at Lethbridge University in Alberta, Canada. He has exhibited in Britain and Europe since 1966, including Whitworth Gallery, Manchester, 1978 and retrospective at Yorkshire Sculpture Park, 1998. Lyons was instrumental in introducing steel sculpture techniques into China following his visit as artist-in-residence at the National Academy of Art, Hangzhou, Zheziang Province in 1993. Sculptures in China include *The Lake Afire* (Hangzhou) and *Greeting the Sun* (Yanqing). Lyons has works displayed in Museum of Steel Sculpture, Ironbridge, Broomhill Sculpture Garden, Barnstaple and Millennium Sculpture Trail, Dudley. Lives and works near Selby, Yorkshire. Elected Vice-President of the RSBS.

Sources: Lilley and Glossop, 1998; artist.

Rita McBride (b. 1960)
Sculpture. Born Des Moines, Iowa, USA. Educated at Bard College and California

Institute of the Arts. Her sculpture is influenced by architecture, exploring the legacies of the Bauhaus and Le Corbusier, as well as the use and meanings of everyday objects. Group and solo exhibitions in United States and Europe, including Artists' Space, New York, Alexander and Bonin, New York, Santa Monica Museum of Art, California, Witte de With, Rotterdam and Mai 36 Galerie, Zurich. Works include *Toyota, Parking Garages* (1990), *National Chain* (1999), *Two Towers* (2000) and *Machines* (2001). *Arena* was first exhibited at Witte de With, Rotterdam in 1997. Public collections holding her work include San Diego Museum of Contemporary Art and Witte de With Centre for Contemporary Art, Rotterdam.

Sources: McBride, 2001; Irwell Sculpture Trail.

Walter Macfarlane & Co. (1849–1965)
Architectural ironfounders. Founded in 1849 by Walter Macfarlane in Glasgow, the firm was one of the leading manufacturers and exporters of ornamental ironwork, especially drinking fountains, bandstands, shelters, benches, lamp standards and architectural features for public parks. The firm also manufactured glasshouses, railway stations and bridges at their famous Possilpark Saracen Foundry. George Smith's Sun Foundry was their principal competitor. Macfarlane's produced patterns designed by the architects James Boucher, James Sellars, John Burnet and Alexander 'Greek' Thomson, and employed sculptors such as James A. Ewing to craft the commemorative busts and other interchangeable sculptural features incorporated into the designs.

Source: McKenzie, 2002.

Andrew McKeown (b. 1970)
Sculptor. Studied Fine Arts at Coventry University, 1990–3. Lives in Middlesbrough and has worked principally in the North-East, including artist residencies in schools. Public commissions include *Millennium Green*

Sculpture (2000, Newfield, Co. Durham), relief sculpture for public square (2001, Guisborough, Teeside), marker sculptures for 21 Groundwork Trust sites in England and Wales (1999–2001) and Riverside Park Sculptures (2002, Chester-le-Street).

Source: artist.

William McMillan (1887–1977)
Sculptor. Born in Aberdeen. Studied at Gray's School of Art, Aberdeen, and then at the Royal College of Art, 1908–12. He exhibited at the RA from 1917. His London portrait statues include those of Goodenough (Mecklenburgh Square, 1936), George VI (Carlton Gardens, 1955), Sir Walter Raleigh (Whitehall, 1959), Viscount Trenchard (Victoria Embankment, 1961), Thomas Coram (Brunswick Square, 1963) and Charles Rolls and Henry Royce at Rolls Royce (Buckingham Gate, re-sited 1978). There is also a statue of Turner in the Royal Academy. His memorial statue of the Manchester airmen, Alcock and Brown, was commissioned for London Airport (1954). A statue of George V is in Calcutta (1938). Among his war memorials are Aberdeen and the Naval Memorial, Plymouth. McMillan contributed to a number of fountains including the East Fountain (Trafalgar Square, 1948) and the Goetze Memorial Fountain (Regent's Park, 1950). Elected ARA 1925 and RA 1933, ARBS 1928 and FRBS 1932. He was Master of the RA Sculpture School from 1929 to 1940.

Source: Waters, 1975.

Sydney March (1875–1968)
Sculptor. Born in Kingston-upon-Hull in 1876. Lived and worked in Farnborough, Kent. His statues include *Colonel Samuel Bourne Bevington* (Tooley Street, London Bridge, 1911) and *Lord Kitchener* (Calcutta, 1914; Khartoum, 1921, removed to Royal School of Military Engineering, Chatham, 1958). Among his portrait busts were *Cecil Rhodes* and *Edward VII* (National Portrait Gallery, 1901).

March also executed a number of war memorials including Bromley Parish Church (1921) and the United Empire Loyalists Memorial (Hamilton, Ontario, 1929). His younger brother Vernon (1891–1930) was also a sculptor and is remembered for the Canadian National War Memorial (Ottawa, 1939). Other works include the war memorial at Whitefield, near Radcliffe.

Source: Bénézit, 1976; Whyler, 1986

Paul Margetts (b. 1959)
Sculptor. Born Bromsgrove, Worcestershire. In 1975 entered on a four-year blacksmithing apprenticeship. Studied metalworking in Africa. In 1988 studied art at Birmingham Polytechnic. Under the name Forging Ahead, Margetts designs and produces decorative and functional metal sculpture. Garden sculpture includes fountains, sundials, weathervanes and gates. Commissions include *Water Gates* (Worcester Cathedral, 1996), *Flying Geese* (Belper, Derbyshire), *Up and Away* (Wolverhampton Business Airport, entrance area) and *History Post* (Stirchley, Telford, 1998).

Source: artist.

Walter Marsden (1892–1969)
Sculptor. Born in Church, Accrington, Lancashire. Apprenticed Accrington Terra Cotta Company. Studied sculpture at Accrington School of Art, Manchester School of Art and Royal School of Art, received travelling scholarships to visit Italy. In the First World War he joined the Artists' Rifle Corps and later served as junior officer in the 1/5th Battalion Loyal Regiment. Works include war memorials at St Anne's on Sea, Bolton, Heywood, Church and Tottington, all in Lancashire; also the Howitzer Brigade Memorial, Plumstead. Marsden also executed the panels on the memorial pulpit at the White Church, Fairhaven, Lytham St Anne's. Married the sculptor, Hilda Beatrice Hoare. Exhibited at the RA between 1915 and 1961 and became

Fellow of the Royal Society of British Sculptors.

Sources: Royal Academy, 1985; Hughes, 2002.

William Calder Marshall (1813–94)
Sculptor. Born in Edinburgh. Studied in London under Chantrey and Baily and at the RA Schools, winning a silver medal in 1835. He studied in Rome from 1836 to 1839. His *Bacchus and Ino* was awarded a gold medal in Manchester in 1841. In 1844 he sent statues of Chaucer and Eve to Westminster Hall, and was commissioned to produce statues of Clarendon and Somers for the Palace of Westminster. *Ophelia, Paul and Virginia* and *The Broken Pitcher* were among his works displayed at the Manchester Art Treasures Exhibition, 1857. In the same year he won the competition for the national Wellington Monument but in the end it was entrusted to Alfred Stevens, leaving Marshall to provide a series of bas-reliefs in the chapel of St Paul's. His public statues include *Thomas Coram* (Foundling Hospital) and *Edward Jenner* (Trafalgar Square, 1858; removed to Hyde Park). He also contributed *Agriculture* to Scott's Albert Memorial. Marshall exhibited at the RA from 1835 to 1891 and the RSA from 1836 to 1891. Elected ARA in 1844 and RA in 1852.

Sources: Gunnis, 1968; Grove Dictionary of Art; Ward-Jackson, 2003.

Craig and Mary Matthews
Sculptors. Craig Matthews studied at the School of Industrial Design, Liverpool Polytechnic. Mary Matthews studied at Wallasey School of Art and Alsager College of Education. They work under the name of CAMM Design. Public commissions include *Sundial* (Hoylake Holy Trinity School, Wirral, 1995); *Streets for the People* (Cavern Quarter, Liverpool, 1996), *Spire* (Runcorn, 1998*), Millennium Column* (Llandudno, 1999), *Friezes* (Children's Hospital, Stepping Hill, Stockport, 1999) and *Floorscape* (King Street, Wigan 2001).

Source: artists.

Maxwell and Tuke
Architects. Francis William Maxwell, head of the firm of Maxwell and Tuke. Educated at the Friends' School, Kendal and Owens College. Major works include Blackpool Tower and buildings, New Brighton tower and a number of hospitals, schools and other public and commercial buildings in Lancashire. William Charles Tuke died in 1893.

Source: Pevsner, 1969.

William Charles May (1853–1931)
Sculptor. Born in Reading. Trained at the RA Schools and in Paris. Studied with Thomas Woolner and Signors Raffaele, Monti and Carpeau. Lived in London and exhibited at the RA between 1875 and 1894. May was known for his portraits, medallions and busts. Principal works include National Armada Memorial, Plymouth Hoe, monument to C.S. Rolls (1911) and busts of King George V, William Palmer, Noel Edward Buxton, J. Fuller Maitland and Lord Tollemache. His *Vision of St Cecilia* was in Reading Museum but appears to have been destroyed in 1947. A terracotta frieze on Reading Museum is also attributed to May.

Sources: *Who's Who*; Reading Museum; Bénézit, 1976.

John Jarvis Millson
Architectural sculptor *fl. c.*1870–1914. Millson was based in Manchester, initially as part of Williams and Millson, marble and stone sculptors and carvers. By the early twentieth century Millson was listed in the directories without Evan Williams. The firm was based in City Road, Hulme. By the late nineteenth century Millson was recognised as one of the most versatile and talented architectural sculptors in Manchester, executing carving for many churches, public buildings, commercial buildings and private homes. Work was also exported to the Colonies. His sculptural ornamentation, in wood and stone, at churches such as All Saints, Stockport and Lichfield

Cathedral was described as 'marked by great beauty of form, delicacy of expression, and perfection of finish'. What may have been one of his final commissions, Bolton Infirmary Nurses' Home, is a reminder that his skills also included portrait statuary. In 1914 he was listed as 'wood and stone carver, sculptor, modeller', living in Portugal Road, Prestwich.

Sources: Manchester Directories; *Bury Times*, 12 October 1901.

William George Mitchell (b. 1925)
Sculptor. Born in London, trained at Southern College of Art, Portsmouth and at the Royal College of Art where he won a scholarship which enabled him to study at the British School in Rome. He established the William Mitchell Design Consultants group and produced abstract sculptures in concrete, wood, plastics, marble and brick. Mitchell has been a member of the Design Advisory Board, Hammersmith College of Art and Trent Polytechnic; member of Formwork Advisory Committee and the Concrete Society. Public sculptures include the abstract relief decoration of the porch and belfry (Metropolitan Cathedral of Christ the King, Liverpool), *Ways of the Cross* (Cathedral Church of St Peter and Paul, Clifton), wall reliefs for Watergardens (Harlow New Town, 1963). His *Corn King and Spring Queen* (Wexham Spring, South Buckinghamshire, 1964) was listed in 1998.

Sources: Strachan, 1984; Noszlopy, 1998.

Adrian Moakes (b. 1959)
Studied at Preston Polytechnic, BA Hons Fine Art, 1977–80. Postgraduate Fellowship, North Manchester College, 1985. Group exhibitions include Aberdeen Art Gallery, The Cornerhouse, Manchester, South Hill Park Arts Centre, Brewery Arts Centre, Kendal. Research and development work with Public Arts, Wakefield, 1992, Trafford MBC/North West Arts Board, 1995–6, Darts and Doncaster Museum and Art Gallery, 1999, Groundwork

Macclesfield, 2000. Public commissions include *Vault* (Norton Priory Museum and Gardens, Runcorn, 1994), *The Broken Arcs,* with Noah Rose (All Saints Park, Blackburn, 1995), *The Big Fish* (Birtle, 1997) *Up, Up & Away* (Blackpool, 2000), *The Learning Curve* (Watford, 2001) and *Timelines* (Dunstable, 2002).

Source: artist.

Temple Lushington Moore (1856–1920)
Architect. Born in Tullamore, Ireland in 1856. Moore was articled to George Gilbert Scott, 1875, and continued to work for Scott after he opened his own practice. His reputation rested on his ecclesiastical buildings which included St Peter's, Barnsley and St Columba's, Middlesbrough. Giles and Adrian Gilbert Scott were his pupils. He died suddenly in 1920 and commissions such as St Wilfred's, Harrogate were completed by his son-in-law, Leslie Moore.

Source: Felstead, 1993.

Locky Morris (b. 1960)
Sculptor. Born in Derry. Educated at the University of Ulster at Jordanstown (1979–80) and Manchester Polytechnic (BA Fine Art Sculpture, 1980–3). Exhibitions include Orchard Gallery, Derry, 1985, British Art Show (touring, 1990), Strongholds, Tate Gallery Liverpool, 1991. Awards from the Arts Council of Northern Ireland and RSA Art for Architecture. Work informed by history of Derry where he lives. Public commissions include *Atlantic Drift* (Derry) and *Dry* (Bundoran, Co. Donegal).

Source: artist.

Kerry Morrison
Sculptor. Educated at Crewe and Alsager College of HE, Creative Arts BA, 1985–8; Wimbledon School of Art, MA Site-Specific Sculpture, 1990–2; Manchester Metropolitan University, MA Fine Art, 1992–3. Public

commissions include works on Ribble Valley Sculpture Trail and Irwell Valley Sculpture Trail.

Source: artist.

Alexander Munro (1825–71)
Sculptor. Munro was brought up on the Duke of Sutherland's property in Scotland where his father worked as a stonemason. His talents came to the notice of Harriet, Duchess of Sutherland, who brought him to London and secured him a position with Charles Barry, working on the stone carvings for the new Houses of Parliament. After 1849, portrait sculpture became his main occupation and he produced many statues, busts, medallions and occasional group sculpture. Sympathetic to Pre-Raphaelite Brotherhood, teaching with Ruskin and Woolner at Working Men's College. He shared a studio with Arthur Hughes, 1852–8. Public statues included *Herbert Ingram* (Boston, 1862) and a marble *James Watt* (Birmingham, 1866). Works such as *The Sleeping Child* (Great Exhibition, 1851), *The Ingram Children* (1853) and *The Gladstone Children* (1856) established him as a fine sculptor of children. He exhibited at the RA from 1849 to 1870. He suffered from a disease of the lungs and died in Cannes, France.

Sources: Gunnis, 1968; Read and Barnes, 1991; Noszlopy, 1998.

William James Neatby (1860–1910)
Sculptor, designer and painter. Born in Barnsley, trained as architect. When aged 23 he went to work for Burmantofts Potteries in Leeds, designing, painting and making tiles for interior decoration. In 1899 he joined Doulton's of Lambeth, in charge of their architectural department, again designing and making ceramics. Art Nouveau-style designer, he made great use of both terracotta and Carrara Ware and introduced new processes such as polychrome stoneware and Parian Ware. In 1900 or 1901 he set up a partnership with E. Hollyer Evans manufacturing furniture,

metalwork and stained glass, but he continued to design for Doulton. His major commissions included painted ceramic panels for the Winter Gardens Ballroom, Blackpool (completed 1897), City Wholesale Market, Leicester (1900, later demolished, Mermaids panel re-erected West Bridge, Leicester, 1980), glazed terracotta frontage for the Edward Everard printing works, Broad Street, Bristol (completed 1901), City Arcade, Birmingham (1901), interior decoration of the Restaurant Frascati, Masonic Hall, Oxford Street, London (1902, demolished) and interior ceramic decoration of Harrods Meat Hall, London (1902). He was a member of the Royal Society of Miniature Painters and exhibited as a painter at the RA in 1906 and 1909.

Sources: Atterbury and Irvine, 1979; Noszlopy, 1998.

Ludwika Nitschowa
Sculptor. Born and lived in Poland. Nitschowa's best-known work is her heroic-size stone *Syrena* in Warsaw. The sculpture was erected in 1939 on the banks of the Vistula and survived the Nazi occupation. Her image of the mermaid has been incorporated into the city's coat of arms and reproduced as a postage stamp. Nitschowa's other works include busts of Polish heroes, including Kosciuszko, and a statue of Marie Curie.

Source: Chopin Society of Poland.

Matthew Noble (1818–76)
Sculptor. Born in Hackness, near Scarborough, Yorkshire. Trained in London under the sculptor, John Francis (1780–1861). He exhibited over 100 works, chiefly portrait busts, at the RA from 1845 to 1876. His public statues numbered over 40, the Manchester Wellington monument establishing his reputation. His major Manchester and Salford public monuments began with Sir Robert Peel (Peel Park, Salford, 1852) and concluded with Oliver Cromwell (Manchester, 1875, removed to Wythenshawe Park). Other important

commissions with Manchester connections included busts of Queen Victoria (1857), Joseph Brotherton (1857), Prince Albert (1858), William Fairbairn (1860), Oliver Cromwell (1861) and Sir Thomas Potter (1865). He provided statues of Peel in Tamworth (1852), Liverpool (St George's Hall, 1854) and London (Parliament Square, 1876). Statues of Prince Albert were commissioned for Manchester, Salford, Leeds and Bombay. His studio was described as 'a manufactory of busts'. His funeral monuments included Sir John Franklin (Westminster Abbey, 1847), Archbishop Musgrave (York Minster, 1860) and the Earl of Derby (Knowsley, 1872). His friend and assistant Joseph Edwards completed his unfinished works. His widow presented his models to the Corporation of Newcastle.

Sources: Robinson, 1886; Gunnis, 1968; Cavanagh, 1997.

James and John O'Shea
Architectural sculptors. The brothers are recognised as among the most talented and inventive of architectural sculptors in the Victorian period. The architects, Deane and Woodward brought them from Ballhooley, Cork to work on the University of Oxford's Natural History Museum. They contributed significantly to the building's ornamental distinctiveness but were dismissed before the work was complete. Apart from the Manchester Assize Courts, their stone-carving can also be seen in Trinity College Museum and the Kildare Street Club, both in Dublin.

Sources: Read, 1982; Trodd et al., 1999.

Ben Panting
Sculptor. Studied at Royal College of Art. Group exhibitions include London Institute, 1997. Works include bronze bust of Jimmy Murphy (Manchester United, Old Trafford, 1999) and Millennium Leap sculpture (Christison Hall, Dulwich College, 2002).

Source: *Manchester Evening News*, 3 February 1999.

Edgar George Papworth (1809–66)
Sculptor. Born in London, son of sculptor and
stuccoist Thomas Papworth (1773–1814). Pupil
to Edward Hodges Baily. Entered RA in 1826,
winning gold medal in 1833 for his *Ulysses
Receiving the Scarf from Leacothea*. Married
Caroline Baily, E.H. Baily's daughter. Studied
in Rome on RA scholarship, returning to
England in 1838. Known for his imaginative
sculpture and portrait busts. Works include
Cupid and Psyche, *A Nymph of Diana* and *The
Moabitish Maiden*. His *Startled Nymph* was
exhibited at the Manchester Art Treasures
Exhibition, 1857. Busts include *Rowland Hill*
(1833), *William Murdock* (1839) and *Captain
Speke* (1865). Manchester subjects include a
bust of Charles Swain (Manchester City Art
Gallery). Exhibited regularly at the RA until his
death in 1866. His son of the same name, born
in 1832, was also a sculptor, exhibiting at the
RA from 1852 to 1882. He had closer
connections with Manchester, occupying
premises in Cross Street in the city during the
1870s and 1880s.

Source: Gunnis, 1968.

Patric Park (1811–55)
Sculptor. Born in Glasgow, his father and
grandfather were statuaries and masons.
Following his schooling, he was apprenticed as
a stone-cutter. Park was next employed as an
architectural carver at Murthley Castle. When
he went to Rome in 1831, he studied under
Thorvaldsen. On his return to Britain in 1833,
he set about establishing himself as a sculptor.
Exhibited at the RA and RSA from 1836 to
1855. He competed unsuccessfully in
competitions, including the Scott Monument in
Edinburgh and the Nelson Monument in
London. Moved from Edinburgh to
Manchester in 1852. Portrait busts were to
provide his main work and included Charles
Dickens (1842), Adam Smith (1845), Sir Charles
Napier (1853). Manchester subjects included Sir
William Fairbairn (Reform Club, undated).

Elected an Associate of the Royal Scottish
Academy in 1849 and a full member in 1851.
Park died at Warrington railway station from a
burst blood vessel sustained in trying to help a
porter lift a heavy trunk.

Sources: Gunnis, 1968; McKenzie, 2002.

Partnership Art
Public and environmental art company
established in 1984 by Terry Eaton, Jem
Waygood and David Howie as the trading arm
of the Environmental Art Organisation.
Originally based in Manchester before moving
to Hyde and then Stockport. Public art
commissions include Southport seafront
(1990–8), Plymouth Barbican (1994–) and
Watford High Street (1999). Partnership Art
Ltd was dissolved in 2000.

Source: Terry Eaton.

James Patteson
Stonemasons. Manchester-based firm of stone-
and marble masons operating from the early
nineteenth century until the late 1970s. The
founder of the business appears to have been
James Patteson who is recorded as a
stonemason in Portland Street in the
Manchester and Salford Directory (1804). By
the late 1820s the firm was occupying premises
in Oxford Road and described as builders and
providing statuary. Samuel Patteson joined his
father in the business. James died in 1840 and
Samuel in 1842, but the firm continued under
their names, managed by Henry Gore, Samuel's
father-in-law. The premises were now
identified as being in Oxford Street. By the
mid-1850s the firm was in the hands of
Samuel's sons, James and Henry. Pattesons
offered a broad range of stone-cutting and
carving services, work on prestigious projects
such as the Albert Memorial and local churches
being carried out alongside more prosaic stone-
cutting and carving jobs, as well as the sale and
fitting of marble chimney pieces in suburban
homes. Henry Patteson (1839–87) is the best-

known family member of this generation
because of his political career. He was elected as
a Manchester city councillor in 1861, eventually
serving as mayor in 1879–80. The firm
continued after his death, run by two of his
sons, James and Henry. In Slater's *Manchester
Directory* for 1900 Pattesons' were described as
'general contractors and merchants in stone,
marble manufacturers of chimney pieces,
monuments, marble, mosaic adamant and
ceramic floors, dealers in grates, fenders, ranges,
encaustic and geometrical tiles, marble and slate
slabs, adamant cement &c'. In 1910 the
proprietors are named as J.H. Burgess and J.E.
Mills who continued to trade under the name
of Patteson. The firm was still located in
Oxford Street. After the war the firm was
responsible for many war memorials in the
Manchester region as well as in other parts of
the country. Premises had also been opened on
Barlow Moor Road, close to Southern
Cemetery. The firm continued in business until
the late 1970s.

Sources: Manchester Directories; *Momus,* 13
November 1879; *Manchester Guardian*, 12 September
1887; information from Evelyn Vigeon.

Barbara Pearson (1919–92)
Sculptor. Born in Manchester. Pearson moved
with her husband, Dr Alex Pearson, to
Holsworthy, Devon in 1949. She took pottery
classes at Beaford Centre, Torrington. She later
studied at the University of Exeter. The first
exhibition of her sculpture was due to the
encouragement of Sir John Rotherstein. A
number of her large bronze sculptures are on
public display in Holsworthy, including
Friday's Child (Holsworthy Hospital), *Doves
of Peace* (Holsworthy Surgery) and *Shelter*
(Holsworthy Museum). The latter is a copy of a
work in Mexico City, made as tribute to the
victims of the 1985 earthquake. Other
sculptures include *Flowers for my Beloved*,
Pancho and *Madonna and Child*; reliefs include
Tree of Life, *The Bird that Sang for Christ* and *I
Light a Candle for my Beloved*. Some of her

major works are in Mexico where her daughters live. Barbara Pearson died in 1992.

Source: Holsworthy Museum; Heather Herrera

Alec Peever
Stone-carver, special interest in letter carving. Educated City and Guilds Art School. Left art school in 1976. Works include churchyard monuments, commemorative plaques, garden features and public sculpture. Commissions include heraldic shields in Chapter House, Manchester Cathedral, D-Day monument, Southampton, stone features, Mowbray Park, Sunderland and boundary markers, Stony Stratford. Peever has also executed commemorative plaques in St Paul's, Westminster Abbey (Matthew Arnold) and in Birmingham, Canterbury, Chichester and Truro cathedrals.

Source: artist.

Pennington and Bridgen
Architects. Thomas Edward Bridgen (1832–95) born in Wolverhampton. Articled to Nockalls Johnson Cottingham from 1851 and in partnership with him until 1854. In partnership with Nathan Glossop Pennington from 1859. Designed a number of hospitals in the Manchester area, as well as two in London including the North Western Hospital at Hampstead. Bridgen died in Fallowfield, Manchester.

Source: Felstead, 1993.

David Petersen (b. 1944)
Born in Cardiff. Worked in GKN steelworks before studying fine art at Newport College of Art, 1961–5. Sculptor in metal, studio in St Clears, Carmarthenshire. Exhibitions include 'Wrought' (2000, touring). Principal public commissions include Welsh Division War Memorial (Mametz Wood, Albert, France, 1987), *Coal, Steel and Water* (mural, County Council Headquarters, Cardiff, 1989), *Millennium Beacon* (Cardiff, 2000) and statue

of *Howard Winstone* (Merthyr Tydfil, 2001). Petersen is particularly known for his sculptures of dragons. He has served as the chairman of the British Artist Blacksmiths' Association.

Source: artist.

John Birnie Philip (1824–75)
Sculptor. Born in London. At 17 he entered the Government School of Design at Somerset House. His first employment was as ornamental sculptor under A.W.N. Pugin at the Houses of Parliament. His longest working relationship, however, was with Sir G.G. Scott, much of his work being for churches the architect was either building or restoring. These included Tamworth Parish Church, 1853, Ely Cathedral, 1857, St George's Chapel, Windsor, 1863, St Michael's, Cornhill, London, 1858 and Lichfield Cathedral, 1864. His best-known work for Scott is on the Albert Memorial, 1863–76, notably the marble podium friezes representing 87 great architects and sculptors (1864–72), and the bronze figures of Geometry, Geology, Physiology and Philosophy on the canopy. Philip also ran a successful studio executing funerary monuments, including those to *Queen Katherine Parr* (Sudeley Castle chapel, Gloucestershire, 1859), the *Revd W.H. Mill* (Ely Cathedral, 1860) and *Lord and Lady Herbert of Lea* (Wilton Church, Wiltshire, 1864). His public statues include *Richard Oastler* (Bradford, 1866), *Lord Elgin* (Calcutta, 1869) and *Colonel Baird* (Calcutta, 1870) and *Colonel Edward Akroyd* (Halifax, 1875). He also carved eight statues of British monarchs for the Royal Gallery, Houses of Parliament. Exhibited at the RA from 1858 to 1875.

Sources: Gunnis, 1968; Read, 1982; Cavanagh 2000.

Arthur Beresford Pite (1861–1934)
Architect. Son of the architect, Alfred Robert Pite. He trained with his father and at the South Kensington School. Joined architectural practice of John Belcher in 1881. In the

following year he was awarded the RIBA Soane Medallion for his drawing of a 'West End Club House'. He was a founder member with Belcher of the Art Workers' Guild in 1884. Belcher and Pite designed the influential Institute of Chartered Accountants in London, completed in 1893. Pite engaged Frederick E.E. Schenk to carve the architectural ornamentation on 37 Harley Street (1899). In his later years Pite became well known as a teacher. His publications included *The London Series of Architectural Examples for Students* (1926) (with A.R.H. Jackson).

Source: Hanson, 1993.

Frederick William Pomeroy (1856–1924)
Sculptor. Born in London, he was first apprenticed to a firm of architectural carvers, attending the South London Technical Art School part-time where he learnt modelling from Jules Dalou and W.S. Frith. Attended the RA Schools, 1880–5, winning the gold medal and travelling studentship in 1885. He travelled to France and Italy, studying in Paris under Antonin Merci. In 1887 he collaborated with Frith on the Victoria Fountain in Glasgow. He exhibited with the Arts and Crafts Society from 1888 and was a medallist at the Paris International Exhibition of 1900. He worked on a number of buildings by architect E.W. Mountford, including Paisley Town Hall (1890), Sheffield Town Hall (1890–4) and the Central Criminal Court, Old Bailey, London (Pomeroy is responsible for the gilt bronze figure of Justice surmounting the dome). His ideal sculpture includes *Perseus* which was shown at the Royal Academy in 1898. Pomeroy's portrait statues include *Dean Hook* (Leeds City Square, 1900) and *W.E. Gladstone* (Houses of Parliament, 1900). He was a Member of the Art Workers' Guild from 1887 (Master from 1908) and was elected ARA in 1906 and RA in 1917. He was also, in 1911, a founding member of the Society of Portrait Sculptors.

Sources: Beattie, 1983; Cavanagh, 1993.

Guy Portelli (b. 1957)
Sculptor and painter. Born in South Africa. Studied Interior Design and 3D Design at Medway College of Art, 1974–8. Group exhibitions include Mall Galleries, London, 1985, Havelet Court, Guernsey, 1996, Royal Society of British Sculptors, 2000 and Manchester Art House, 2000, 2001. Public commissions include *Greek Goddesses* (London Pavilion, Piccadilly Circus, 1987) and Group Captain Peter Townsend memorial (West Malling Airfield, Kent, 2002). Elected RBS, 1998.

Source: artist.

Edward Potts (1839–1909)
Architect. Born in Bury. Articled to George Woodhouse in Manchester, 1854 and then John Prichard and J.P. Seddon in London. Established practice in Oldham, later Manchester. He was head of Potts, Son and Hennings, Victoria Buildings, Manchester. Potts designed many public buildings, especially Board Schools. The Corn Exchange is his best-known Manchester building (1903). Potts was a member of Eccles Council and a JP.

Sources: Tracy, 1899; Felstead, 1993.

Jane Poulton (b. 1957)
Artist and sculptor. Studied at Manchester Metropolitan University, BA (Hons) Textiles, 1982–5, and MA Textiles, 1985–6. Trained in textiles but works in several media and formats including paintings and photography as well as public art. Commissions include logo and letter forms for Winterburn Park housing development (Liverpool, 1997) and children's playground (Rochdale, 1997). Exhibitions include Dixon Bate Gallery, Manchester, 1996 and Primavera, Cambridge, 1999. Worked as Town Centre Artist for Stockport Metropolitan Borough Council from 1998–2002.

Source: artist.

James Caldwell Prestwich (1852–1940)
Architect. Prestwich was born in Atherton, 1852. He was articled to Rowland Plumbe in London. He established his architectural practice in Leigh in 1875 and was responsible for many of the public buildings in the town in the late Victorian and Edwardian years, including the Town Hall. Outside of Leigh, the firm designed Atherton Council Offices (1898–1900) and Stockport Public Baths. Ernest Prestwich worked alongside his father until the latter's retirement in 1930. Ernest designed Leigh's cenotaph and was one of the architects of Swinton municipal buildings (1937). The firm continued after the Second World War, designing, among other local buildings, the Turnpike.

Sources: Leigh Library biographical cuttings; Tracy, 1899.

William Pym (b. 1965)
Sculptor. Born in Wiltshire. Studied sculpture at University of Newcastle, 1984–8. Sculpture and functional metalwork, especially in steel. Permanently sited sculptures include *Aurum Lily* (Longbenton Community High School, North Tyneside, 1992), *Benwell Bird* (Colston Street, Benwell, Newcastle upon Tyne, 1997), *Swarm* (Monkton Business Park, Hebburn, South Tyneside, 2000) and *Flow* (Witton Country Park, Blackburn, 2000).

Source: Irwell Sculpture Trail.

Jill Randall
Sculptor. Born in Kirkby in Ashfield, Nottinghamshire. Studied at Falmouth School of Art (BA Fine Art Sculpture) and Manchester Polytechnic (MA Fine Art Sculpture, 1983). Solo exhibitions at Le Chat Noir Gallery, London, 1992, Turnpike Gallery, Leigh, 1997 and The Lowry, 2003. Residencies include Grizedale Forest Sculpture Trail and Magnesium Electron, Swinton. Public works include *Screen* (George Square, Oldham) and *Torment of the Metals* (Grizedale Forest, Cumbria).

Source: artist.

Peter Randall-Page (b. 1954)
Sculptor. Born in Essex. Studied at Bath Academy of Art (1973–7) before moving to London where he worked with Barry Flanagan for a year. He worked on the conservation of thirteenth-century sculpture at Wells Cathedral, Somerset. In 1980 he was awarded the Winston Churchill Memorial Trust Travelling Fellowship to study marble-carving in Italy. He was visiting lecturer in Sculpture at Brighton Polytechnic from 1982 to 1989. He has exhibited his work regularly in Britain and abroad. In 1989 he began 'Local Distinctiveness', a project concerned with placing sculpture in the environment with particular care for its relevance and sensitive siting. He works mainly in stone, and uses natural forms such as shells, fossils, fruits, eggs and pods, as well as expressive knots. Works include *Untitled* (Milton Keynes, 1980), *Still Life* (Basingstoke), *Secret Life II* (Dublin, 1994), *Inner Compulsion* (Ardingly, 2000) and *Ebb and Flow* (Newbury, 2003).

Source: Hamilton, 1992; artist.

Mario Raggi (1821–1907)
Sculptor. London-based sculptor, produced chiefly portrait busts and some ideal works. First exhibited at the RA in 1854. Raggi's works include the bronze reliefs on the monuments honouring Dr Evan Pierce (Denbigh, 1872) and the naked Vulcan on Sheffield Town Hall (1897). His best-known portrait statue is of Benjamin Disraeli (Parliament Square, London, 1883). Other public statues include *Howel Glynn* (Victoria Gardens, Neath, Port Talbot, 1889) and *Henry Hussey Vivian, 1st Baron Swansea* (Victoria Park, Swansea, 1886, removed to St David's Centre). His portrait busts include *Admiral Roux* (1878) and *Cardinal Newman* (1881), both in terracotta. His last exhibit at the Royal Academy was a marble bust of the Duchess of Rutland (1895).

Sources: Graves, 1904; Read, 1982.

Thomas Rawcliffe
Stonemason. Long-established firm of stonemasons in Chorley. General stone-carving business and monumental masons. Thomas Rawcliffe was responsible for the font (after Thorwaldsen, Copenhagen Cathedral) in St George's Church, Chorley. Statuettes included *The Angler*, *The Bubble-blower* and *Meditation*. Bentham also sculpted a group for a fountain in Hayling Island.

Sources: Graves, 1904; Lancashire Directories; Cornish, 1959.

David Willingham Rawnsley
Artist and sculptor. Born in Sevenoaks. Educated at Westminster School and then studied architecture. Became painter and scenery designer, and following the Second World War he was art director at Elstree Studios. He and his wife, Mary, established Chelsea Pottery in 1952. In about 1959 he moved to the Bahamas, leaving Brian Hubbard to continue the pottery. In Nassau he painted, sculpted and set up Chelsea Pottery Bahamas.

Source: www.antonymaitland.com

George Tunstall Redmayne (1840–1912)
Architect. Articled to Alfred Waterhouse and remained as his assistant. Passed Voluntary Exam. Started independent practice early 1868. Paul Waterhouse wrote of him: 'His personal thought and personal labour entered every detail of his designs, and he was exceptionally careful in making sure that nothing should appear in his work which was meaningless or nugatory'. He built churches and other public buildings in the north of England. His work on St Andrew's Chambers, originally built for Scottish Widows Insurance, proved, according to Waterhouse, that 'there was real art and real sense in that medieval revival which is today so readily despised. It is virile and fresh.'

Source: Tracy, 1899; biographical cuttings, Manchester Local Studies Library.

Adam Reynolds (b. 1973)
Sculptor. Born Macclesfield. Studied at Wimbledon School of Art (BA Fine Art Sculpture, 1997). Commissions include *Drip* (Waterside Mill, Macclesfield, 2000), *Moving* (Bull Arts Centre, Barnet, 2001), and *Butterfly* bicycle racks and fountain (Birchwood Park Estate, Warrington, 2001).

Sources: artist; Axis database.

Joanne Risley
Sculptor. Born in Knutsford. Studied fine art at University of Dundee (BA, 1987) and University of Ulster at Belfast (MA 1989). Public sculpture includes *Crocus* (bronze fountain, Whiteabbey Hospital, Co. Antrim, 1996), *Night and Day* (Liverpool Women's Hospital, Liverpool, 1999) and *Shell Forms* (Mater Hospital, Belfast, 2002). Collaborative work with Barry Calaghan includes *Kinetic Bloom* (Palace Demesne, Armagh, 1998) and canal boat sculptures (Monmouth and Brecon Canal, Newport, 2000).

Sources: artist; www.designbank.org.uk

Andy Robarts (b. 1956)
Sculptor. Born in Cambridge. Studied Fine Art at Manchester Polytechnic, completed in 1983. Helped to establish SIGMA sculpture studios in Manchester. Exhibited work in Belfast (1987), Cologne (1989) and Turin (1989, 1991). Public sculpture commissions include sculpture (Barrow-in-Furness Hospital, 1990). Teaches at the University of Salford.

Source: artist.

Ted Roocroft (1918–91)
Sculptor. Born Eccleston, Lancashire, Edward (Ted, as he was known) Roocroft was educated at Edinburgh and Manchester Schools of Art, and at the Slade, where he won prizes for sculpture. In the early 1950s he joined the staff at Manchester Regional College of Art, later Manchester Polytechnic, and lectured there for almost 30 years. In 1979 he won a major award

from the Arts Council. Exhibitions at Harris Museum and Gallery, Preston, and Yorkshire Sculpture Park. Roocroft worked mainly in wood, and was known for his carving of animals, especially pigs and apes. His work is displayed throughout the North-West, including *Embryo* (Edge Hill College, Ormskirk,) as well as in Europe and Zimbabwe. Works in Stockport Art Gallery and Harris Art Gallery, Preston. There is an unpublished memoir of Roocroft by Keith Hamlett.

Sources: Keith Hamlett; *Guardian*, 16 October 1991.

Noah Rose (b. 1965)
Sculptor. Born in Nahariya, Israel. Educated at Middlesex Polytechnic (1984–5) and Manchester Polytechnic (BA in Three-Dimensional Design, 1985–8). Exhibitions include 'International Symposium for Electronic Art' (ISEA, 1998), 'Steel', Oldham, Stockport, Blackpool, Birkenhead and Rotherham Art Galleries, 1992–3, GAIA 92 in Hulme, Manchester, 1992. Three-dimensional sculpture, chiefly in metal. Public art commissions include *Elephant Seat* (Ashburner Street, Bolton, 1995), *Celestial Seats* (All Saints Park, Blackburn, 1996), *A Horse with no Name* (Morecambe, 1997), *Oscillate* (Jubilee Street, Blackburn, 1998), *Ribtide* (Birkenhead, 2000) and *Plasma-Plasmawr* (Penmaenmawr, 2001).

Source: artist.

Christopher Rose-Innes (b. 1926)
Scientist and sculptor. Born in London. Studied physics at University of Oxford. Professor of Physics and Electrical Engineering, UMIST. On his retirement in 1989 he studied sculpture on the foundation course and then the undergraduate degree in fine arts at Manchester Polytechnic (1989–93). One of his student works, a cube, became the basis of the commission for the UMIST Cube. Rose-Innes was instrumental in establishing and chairing UMIST's Campus Appearance Committee. His public sculptures include *Insulator Family*

(UMIST), *Sunbird* (Grosvenor Place Hall of Residence, UMIST) and a terracotta sculpture, *Our Lady of Compassion* (St Theresa's, Wilmslow). ARBS. He is Emeritus Professor of Physics and Electrical Engineering at UMIST.

Source: artist.

Louis Frederick Roslyn
Sculptor. Roslyn was born in London in 1878. Studied at City and Guilds London before entering the RA schools where his awards included the Landseer scholarship and a travelling scholarship. Roslyn executed a large number of war memorials including examples at Darwen, Buxton and Port Talbot. He also executed a war memorial in Trinidad, West Indies. The Duchess of York and Duchess of Connaught were among his portrait busts.

Source: Dolman, 1929.

Royle and Bennett
Architects. Robert Isaac Bennett (1841–1901) was articled to Nathan Glossop Pennington, 1857–9, but articles cancelled after two years. Articled to Philip Nunn, 1859–62, and remained his assistant until 1867. Succeeded to practice of Nunn on his death in 1867, in partnership with William Alfred Royle (1839?–1904). Royle and Bennett designed many schools and other buildings in and around Manchester, including the Higher Grade Schools at Cheetham and the Armenian Church, Upper Brook Street.

Sources: Tracy, 1899; Felstead, 1993.

Ulrich Rückriem (b. 1938)
Sculptor. Born Düsseldorf. Trained with traditional stone-masons in Duren and Cologne, 1957–9, his work has reflected this training. His rough-hewn, split and reassembled granite monoliths established Rückriem as one of Germany's best-known sculptors. He uses stone principally from quarries in Spain, France and Finland. Over 100 exhibitions include Museum of Modern Art, Oxford, Serpentine Gallery, London, Stedelijk Museum, Amsterdam and Ace, New York. Group shows include Documentas, 5, 6, 7, 8 and 9; Paris, Venice and São Paulo Biennales, Munster Sculpture Projects 87 and 97. Rückriem's work is represented in collections of the Tate Gallery, London, and the Stedelijk Van Abbemuseum, Eindhoven.

Sources: Rückriem, 1991; *Mont Joie*, 1998.

Edward Salomons (1828–1906)
Architect. Born in London, 1828. Son of Manchester merchant H.F. Salomons. Educated privately in Manchester, and as the pupil of J.E. Gregan, Salomons was first a draughtsman to the firm of Bowman and Crowther, illustrating much of their *Churches of the Middle Ages*. He began practice in 1852. Salomons' principal works include (in Manchester), the Reform Club, the Manchester and Salford Savings Bank, Lee's Warehouse and the Prince's Theatre. He also designed the Alexandra Theatre in Liverpool. He was also known as a water-colourist and exhibited at the New Gallery in London and in Manchester. He was twice President of the Manchester Society of Architects, and was a member of the Committee of Manchester School of Art. The 1922 history of the Reform Club said of Salomons: 'It is to be regretted that the Manchester press always paid more attention to the epicurean knowledge which Mr. Salomons displayed in the menus of the annual dinners of the Manchester Society of Architects than to his undoubted architectural ability'.

Sources: Feldstead, 1993; Beenstock, 1996.

Sadashiv Dattatray Sathe (b. 1926)
Sculptor. Born in India. Government diploma in modelling and sculpture, 1948. Portrait sculptor. Exhibitions in Delhi, Bombay, Moscow, London and The Hague. Public statues include *Mahatma Gandhi* (New Delhi; Oslo), *Lokmanya Balangadhar Tilak* (New Delhi), *Chief Justice Mohammed Ali Chagla* (Bombay High Court) and equestrian statue of Chatrapati Shivaji Maharaj (New Delhi). Another bust of Mahatma Gandhi is in Rome. Founder member of All India Sculptors' Association.

Source: www.painternet.com

Shaws
Lancashire firm which supplied a wide range of architectural faience, especially in the inter-war years. It supplied the faience tiles for many cinemas and the Palace Theatre, Manchester. The firm, Shaws Glazed Brick Company, was located in Darwen, Lancashire. Its successor continues to make terracotta products.

Source: Cochrane, 1999.

Timothy Shutter (b. 1954)
Sculptor. Born in Cambridge. Trained at Manchester Polytechnic (BA Fine Art, Sculpture, 1980–3) and Wimbledon School of Art (MA in Site-Specific Sculpture, 1992–3). Since then he has worked as an assistant to sculptors such as Anthony Gormley and Anish Kapoor while developing his own career. Works chiefly in stone, providing works that are publicly accessible, functional and humorous. Public commissions include *Table and Chair* (Chiltern Sculpture Trail, 1990), *Grandad's Clock and Chair* (Bradford, 1992), *Lexicon* (Southwark, 1995) and *Pleasure Craft* (Coventry Canal, 1997). His representation of a post-box in Portland stone, *From Pillar to Post*, placed outside the Castlefield Gallery, Manchester, in 1995, as part of an exhibition, with the intention that it would become a permanent work, was vandalised.

Sources: artist; Axis database.

Speakman and Charlesworth
Architects. John Charlesworth (1832–81) pupil of Isaac Holden (d. 1884). In office of Speakman from 1852, partner from 1862. Elected FRIBA in 1867. Their Manchester buildings include Lloyd House, Albert Square

and Bow Chambers, Cross Street. Speakman later established Speakman, Son and Hickson whose Manchester buildings include Chepstow House and the Wholesale Fish Market.

Sources: Felstead, 1993; Hartwell, 2001.

Colin Spofforth (b. 1963)
Architect. Trained in graphic design, essentially self-taught as a sculptor. Studio, Brimstone Artworks, in Altrincham. Main work is figurative sculpture in bronze. In addition to the commissions at the Trafford Centre and in Manchester, Spofforth is completing some 25 sculptures of children and animals for the Cypress Point Development, Lytham St Anne's. Exhibitions include Bruton Street Gallery, London, Kingfisher Gallery, Edinburgh, Baron Fine Arts, Chester, Manchester Art House, Manchester.

Source: artist.

Edward Caldwell Spruce
Modeller. Principal modeller for Burmantofts in 1880s and 1890s. Exhibited at the RA 1906–15. He was responsible for hundreds of works for Burmantofts most of which remain unidentified. Known works include relief panels for the exterior of the Midland Hotel, Manchester, Memorial to Sam Wilson, Lawnswood Cemetery, Leeds and relief of St George and the Dragon, Church of St George the Martyr, Southwark.

Source: Tiles and Architectural Ceramics Society Database; Cavanagh, 2000.

Edward Bowring Stephens (1815–82)
Sculptor. Born in Exeter. Trained under E.H. Baily in London. In 1836 he won a silver medal from the Society of Arts for a model of a figure. In the same year, he joined the RA Schools and in the following year won the RA Silver Medal for his model, *Ajax Defying the Gods*. In 1838, he won his first commission, a bust of Miss Blanche Sheffield. From 1839 to 1841 he lived and worked in Italy. He returned to the RA

Schools in 1842 and won the Gold Medal for his relief, *The Battle of the Centaurs and Lapithae*. His *Satan Tempting Eve* was shown at the Great Exhibition and his *Preparing for the Chase* at the Manchester Art Treasures Exhibition, 1857. He executed statues of Joseph Priestley for the University Museum, Oxford (1860) and Leonardo da Vinci, Christopher Wren, and Sir Joshua Reynolds for the façade of Burlington House, London (1873). Exhibited at the RA, 1838–83, and the British Institution, 1838–53. He was elected ARA in 1864.

Sources: Gunnis, 1968; Cavanagh, 1997.

David Watson Stevenson (1842–1904)
Sculptor. Born in Ratho, Midlothian, son of a builder. Stevenson studied for eight years under William Brodie in Edinburgh (1860–8) whilst at the same time attending the School of Art and the Royal Scottish Academy. He completed his studies in Rome. He contributed two of the groups on the base of Steell's Prince Consort memorial in Edinburgh. Later commissions included the figure of William Wallace for the Wallace Monument (Abbey Craig, Stirling, 1869), Robert Tannahill (Paisley, 1884), *Highland Mary* (Mary Campbell) (Dunoon, 1896) and Robert Burns (Leith, 1898; Toronto, 1902). He collaborated with his brother, William Grant Stevenson (1849–1919), who was also a sculptor. Elected member of the Royal Scottish Academy in 1886.

Sources: Bénézit; Usherwood, 2000.

Anthony Stones (b. 1934)
Sculptor. Born in Glossop, Derbyshire. Influenced by Rodin sculptures in Manchester City Art Gallery. Educated St Bede's College (1945–9) and Manchester Regional College of Art (1950–1). Emigrated to New Zealand, continuing his education at Auckland Teachers' College 1959–61. Lived in New Zealand 1952–83, where he pursued career as sculptor, writer and designer, the latter in New Zealand television. Returned to England in 1983. Now

lives in Oxford, studio in Northmoor. Principal interest is portrait sculpture. Portrait bronzes include Samuel Johnson (Lichfield), Sir Isaiah Berlin (Wolfson College, Oxford), Ben Kingsley (Theatre Museum, Stratford-upon-Avon), John Piper (Reading Civic Centre), Captain Cook (National Maritime Museum, Greenwich, 1993) and equestrian statue of Charles Edward Stuart (The Young Pretender) (Derby, 1995). Statues in New Zealand include Lord Freyberg (Auckland, 1978) and Peter Fraser (Parliament Buildings, Wellington, 1990). President of Society of Portrait Sculptors.

Source: artist.

Everard Stourton
Sculptor. Stourton exhibited only one work, a relief entitled *Disturbed* at the RA, 1891.

Source: Graves, 1904.

Joseph William Swynnerton (1848–1910)
Born in Douglas, Isle of Man, father was monumental sculptor. Swynnerton briefly attended the Edinburgh Academy before, in 1869, going to study sculpture at the Academy of St Luke in Rome. Later he established a studio in Rome where he completed many of his commissions. Exhibited at RA. Major works include *Cain and Abel* (Salford Museum and Gallery), *Cupid and Psyche*, *Hiawatha and Minnehaha* and *Immortal Youth*. Portrait statues include Queen Victoria (Southend-on-Sea, 1898). Received many commissions from Manchester region including busts of Edwin Waugh, Abel Heywood and Mrs Boddington. For a time in the 1880s he had premises in the Barton Arcade, Manchester. His bust of Garibaldi was presented to Salford Art Gallery. He was member of Manchester Society of Fine Arts. Married Salford-born artist Annie Louisa Robinson (1844–1933) in 1883. Died at Douglas.

Sources: F. Swynnerton, 1914; *Manchester City News*, 13 August 1910.

Wendy Ann Taylor (b. 1945)
Sculptor, print-maker, draughtswoman and teacher. Born in Stamford, Lincolnshire. Trained at St Martin's School of Art, 1961–7. She taught at Ealing School of Art, 1967–75, and the Royal College of Art, 1972–3. Numerous solo and group exhibitions. Examples of her work are in British and foreign public collections, including the Victoria and Albert Museum and Geffrye Museum, London. Recipient of several awards, including the Sainsbury award and the Pratt award. Commissioned work includes *Timepiece* (Tower Hotel, St Katherine Docks, London, 1972–3), *Essence* (Milton Keynes, Compass Bowl, 1982), *The Whirlies* (East Kilbride Development Corporation, 1988), *Globe Sundial* (Swansea Maritime Quarter, 1987) and *Spirit of Enterprise* (Docklands, London, 1987). Awarded CBE in 1988.

Sources: Lucie-Smith, 1992; Cavanagh, 2000.

William Theed the Younger (1804–91)
Sculptor. Born at Trentham, Staffordshire, the son of the sculptor, William Theed the elder (1764–1817). After some initial instruction from his father, he worked in the studio of E.H. Baily and attended the RA Schools. In 1826 he went to Rome and studied under Bertel Thorwaldsen, R.J. Wyatt and John Gibson. It was through Gibson that he was commissioned to execute two statues – *Psyche* and *Narcissus* (1847) – for Osborne House. Theed continued to receive commissions from the royal family and on the death of Prince Albert in 1861, he was chosen to take the death mask. Victoria continued to commission work from Theed, including the marble statue of Victoria and Albert dressed as ancient Saxons (Royal Mausoleum, Frogmore, 1868). He also executed the colossal group, *Africa*, for the London Albert Memorial (1869). Theed received acclaim as a portrait sculptor. His statues included *Sir Isaac Newton* (New College, Oxford, 1857 and Grantham, 1859), *14th Earl of Derby* (St

George's Hall, Liverpool, 1869) and *Sir Robert Peel* (Huddersfield, 1873). He exhibited at the RA from 1824 to 1885. His *Rebekah* was shown at the Manchester Art Treasures Exhibition, 1857.

Sources: *DNB*; Gunnis, 1968; Cavanagh, 1997.

George Harvard Thomas (1893–1933)
Sculptor. Born in Sorrento, Italy, the son of the sculptor, James Harvard Thomas (1854–1921). Studied at the Slade School of Art. Thomas served in the war and was awarded the Military Cross. Exhibited at the RA, 1919–28. Thomas was an accomplished portrait sculptor. He also executed a number of village war memorials including Waterhead and Abertilly; the figure for the Milnrow memorial was shown at the Royal Academy in 1925. His study *Boy's Head* was acquired by Manchester City Art Gallery. He was a teacher at the Slade.

Sources: Dolman, 1929; Bénézit, 1976.

John Thomas (1813–62)
Sculptor. Born at Chalford, Gloucestershire. Apprenticed to a stonemason after being left an orphan, he later went to Birmingham where a brother was an architect. His work came to the notice of Charles Barry who employed him to execute the ornamental stone and wood carving on Birmingham Grammar School. By the late 1840s Thomas' skill as an architectural sculptor was widely recognised. His output was immense and he received commissions in most of the major cities. The statuary on the new Houses of Parliament is among his best-known work. In Manchester he provided sculptural decoration for the Free Trade Hall and the Royal Cotton Exchange. The lions on the Britannia Bridge, Menai Straits are also his work. His church monuments include those of Dr Arnold (Rugby School Chapel, 1844) and John Brooks (Prestwich, Lancashire, 1851). His final work was a colossal statue of Shakespeare displayed at the International Exhibition of 1862. Thomas also worked as an architect

designing individual buildings in Glasgow, Oxford and Windsor, and in the case of Somerleyton, Suffolk, a complete village.

Sources: Gunnis, 1968; Noszlopy, 1998.

Sir William Hamo Thornycroft (1850–1925)
Sculptor. Born in London. He studied under his father the sculptor Thomas Thornycroft (1815–85) before attending the RA Schools. He then went to Rome, and on his return assisted his father, modelling figures of Shakespeare, Fame and Clio for the *Poets' Fountain* (formerly Park Lane, London, 1875). His group, *A Warrior Bearing a Wounded Youth from the Battle*, won the RA Gold Medal in 1875. His *Artemis* which was shown as a plaster at the RA in 1880 was commissioned in marble by the Duke of Westminster. In 1881 his RA entry, *Teucer*, was purchased by the Chantrey Trust. Works such as *The Mower* (1884) and *A Sower* (1886) added to his standing in the New Sculpture. He executed many public monuments and statues, including *General Gordon* (Trafalgar Square, removed to Victoria Embankment Gardens, 1888); *Oliver Cromwell* (outside Westminster Hall, 1899), and the Gladstone Memorial (Aldwych, The Strand, 1905). He was also responsible for the figurative friezes on John Belcher's Institute of Chartered Accountants at Moorgate in the City of London (1890–1). Outside London his public statues include *Alfred the Great* (Winchester, 1901) and *Lord Armstrong* (Barras Bridge, Newcastle, 1906). Thornycroft himself is included among the eminent Victorians portrayed on Lancaster's Queen Victoria monument (1907). He was elected ARA in 1881 and RA in 1888, and knighted in 1917.

Sources: *DNB*; Read, 1982; Cavanagh, 1997.

George Tinworth (1843–1913)
Modeller and sculptor. Born in Walworth, London, into a poor working-class family. Practised carving in his father's wheelwright's shop. In 1861 he began evening classes at

Lambeth School of Art where his talents were recognised by the headmaster, John Sparkes. Tinworth was admitted to the RA Schools in December 1864. In 1866 he exhibited a plaster group at the RA. Under Sparkes' influence, Tinworth obtained a position at the workshops of Doulton and Co. in 1867, where he stayed on to become their principal modeller. In addition to his terracotta panels and decorative pottery, his art works reflected his evangelical Christian background, and often dealt with biblical scenes or figures. His *Descent from the Cross* was bought by the Prince of Wales. His work received a major exhibition at the Conduit Street Galleries in 1883, after which Edmund Gosse described him as a man 'who has been lifted by the force of his own genius out of the poorest class, and who has become a distinguished artist without ceasing to be an artisan'. A number of his important public works, including his monument to Henry Fawcett (London), have been destroyed.

Source: Rose, 1982.

Albert Toft (1862–1949)
Sculptor. Born in Birmingham. His father was a modeller for Elkington. Studied at Birmingham and then at Hanley and Newcastle under Lyme Schools of Art whilst also serving apprenticeship as a modeller at Wedgwood. In 1879 he won a scholarship to the National Art Training Schools and studied under Lanteri. His reputation was based on his representations of the female form. An early success was *Lilith* (Birmingham Museums and Art Gallery, 1889). This was followed by *Mother and Child* (Preston, 1889), *Fate Led* (Walker Art Gallery Liverpool, 1892) and *The Spirit of Contemplation* (Laing Art Gallery, Newcastle, 1901). Public monuments include statues of Queen Victoria in Leamington (1902), Nottingham (1905) and South Shields (1913). He produced many war memorials beginning with South African war memorials in Ipswich (1905), Birmingham (1906) and the Welsh National Memorial in Cardiff (1905). His First

World War memorials include the allegorical statues on the exterior of Birmingham Hall of Memory (1925). Portrait busts include Sir George Frampton, Sir Henry Irving and Sir Alfred Gilbert. Toft exhibited at the RA from 1887 to 1947. He was author of *Modelling and Sculpture: A Full Account of the Various Methods and Processes Employed in these Arts*, first published in 1911.

Sources: Read, 1982; Noszlopy, 1998.

Charles Trubshaw (1841–1917)
Architect. Trained in the office of his father Charles Trubshaw, Staffordshire County Surveyor, 1856–62. Joined engineering and architectural staff of the London and North Western Railway 1864–74. Architect to the Northern Division of Midland Railway, 1874. Chief Architect to Midland Railway until 1905. Elected ARIBA, 1865 and FRIBA, 1882.

Source: Felstead, 1993.

E.D. Turner
District Engineer and Surveyor of Failsworth.

Edward Walters (1808–72)
Architect. Born in the City of London, son of architect John Walters (designer of the Commercial Sale Rooms, Mincing Lane, and St Philip's Church, Stepney, one of the first attempts at Gothic revival style). Walters was educated at Brighton and worked in the offices of Isaac Clarke, who had been a pupil of his father. Walters remained there two or three years. From there he worked in the office of Thomas Cubitt and then that of Lewis Vulliamy. He became assistant to Sir John Rennie by whom he was sent to Constantinople (1832–7) to superintend the building of an arms factory. He then travelled in the Middle East and Italy. While in Constantinople he met Richard Cobden and decided in 1839 to move to Manchester, obtaining from him one of his first commissions, the warehouse at 16 Mosley Street. At this time he also built several chapels and schools, but became chiefly known for the

warehouse palazzo style which he first employed in 1851 for Messrs Brown and Co. at the corner of Aytoun Street and Portland Street, and then in other buildings along Portland Street. In 1853 he won the Free Trade Hall contract in a limited competition and in the next seven years worked on the Manchester and Salford Bank and stations on the Midland Railway at Matlock, Bakewell and Miller's Dale. After 1860 his popularity declined and he withdrew from active practice. According to the *Builder*, all his buildings contain 'a great breadth of design, a fine eye for proportion, a decided originality in combination, and a very careful study of detail'. His failure to win the contract for the Manchester Assize Courts (which went to Alfred Waterhouse's Gothic design) 'had a very painful effect on his sensitive nature' and precipitated his withdrawal from the profession and the handing over of his business to his former pupils, Barker and Ellis.

Sources: Stewart, 1956; Felstead, 1993.

Alfred Waterhouse (1830–1905)
Architect. Educated at Grove House School, Tottenham, and articled to Richard Lane and Peter B. Alley. He continued his studies in France, Italy and Germany, and began to practise in Manchester in 1853. Elected FRIBA, 1861 and in 1866 member of the Architectural Association. He served as President of RIBA, 1888–91. The Royal Gold Medal was awarded to him in 1878, and in January 1878 he was elected ARA, and in 1885, Royal Academician. In 1867 he won the Grand Prix for Architecture at the Paris Royal Exhibition, followed by a 'Rappel' at the Exhibition of 1878. His Manchester buildings include the Assize Courts, the Town Hall, Owens College, Whitworth Hall, Christie Library, the National Provincial Bank of England and the Refuge Assurance Company offices.

Sources: Cunningham and Waterhouse, 1992; Felstead, 1993.

Sir Charles Thomas Wheeler (1892–1974)
Sculptor. Born in Coldstall, Wolverhampton.
Attended the Wolverhampton School of Art
and then the RA Schools until 1917. The
architect Herbert Baker procured him some of
his early commissions, a collaboration that led
to their working on the rebuilding of the Bank
of England (1927–45). Wheeler's contribution
included *Ariel*, the figure on the dome on the
Princes Street and Lothbury Street corner. The
gilded Springbok on South Africa House was
completed in 1934. After the war Wheeler
completed the sculpture on the Jellicoe
Fountain in Trafalgar Square. In the 1950s he
produced the monumental figures of Earth and
Water on the Ministry of Defence building in
Horse Guards' Avenue. His Poseidon group
(1969) and *Hercules and the Lion* (1970s) are in
George Square. Commemorative statues
outside London include Thomas Paine
(Thetford, 1964) and William Walker
(Winchester Cathedral, 1964). He also executed
the sculpture for Maufe's extensions to the
Royal Navy War memorials at Chatham,
Plymouth and Portsmouth. His statue of Lady
Wulfrana, the founder of the city, stands
outside St Peter's Church, Wolverhampton.
Wheeler was elected ARA in 1934 and RA in
1940. He served as President of the RA from
1956 to 1966, the first sculptor to hold the post.
His autobiography, *High Relief*, was published
in 1968.

Sources: *DNB*; Wheeler, 1968; Ward-Jackson, 2003.

Joseph Whitehead
Sculptor. Exhibited busts and statues in marble
at the RA 1889–95. Public commissions
included the statues of the four miners' leaders
(Durham, 1876), South African War Memorial
(Crewe, 1903) and statue of Charles Kingsley
(Bideford, Devon, 1906). The firm of
Whitehead's was based in Westminster until the
Edwardian period when they moved to the
Oval, Kennington. The firm continued in
business as J. Whitehead & Son until 1964.

Other commissions included the Metropolitan
Drinking Fountain and Cattle Trough
Association's Jubilee Fountain (Holborn,
c.1911). In the late 1920s Whitehead's worked
on the interior of Nottingham Council House,
opened 1929. After the Second World War they
executed war memorials for the General Post
Office (King Edward Street, London) and
Stafford (Victoria Street).

Sources: Graves, 1904; Usherwood, 1997.

W. Hargreaves Whitehead
Sculptor. Whitehead studied at the Oldham
School of Art and the Manchester School of Art
in the 1930s. Exhibited at Oldham Society of
Artists exhibitions. The Sarah Lees monument
is the only known public sculpture by him in
the town. In 1957 he was listed as a sculptor
with a studio in YMCA Chambers, Rhodes
Bank, Oldham.

Sources: *Manchester Guardian*, 27 September 1937;
Oldham County Borough Directory, 1957.

John Royle Whittick
Sculptor. Resident in Altrincham in the late
nineteenth and early twentieth century.
Sculptor of *Eve*, given by public subscription to
Altrincham Council to be displayed in
Stamford Park in 1881. (Sculpture now in
Stretford Town Hall.) Whittick also carved the
death mask of Martha Foxcroft of Bowdon,
1877.

Sources: Manchester Directories; Altrincham Park
Committee minutes.

Frederick John Wilcoxson
Sculptor. Born in Liverpool in 1888, son of the
sculptor, William Henry Wilcoxson. Studied at
Liverpool School of Art before entering the RA
Schools where his awards included the
Landseer Scholarship. He was pupil and
assistant to Francis Derwent Wood. Wilcoxson
was an instructor in the School of Sculpture,
Royal College of Art, 1919–24. Exhibited at the
RA, 1913–40. He produced chiefly figurative

sculpture. He executed busts of A.H. Gilkes
(Dulwich College, 1915), Ramsay Macdonald
(1924) and Sir Thomas R. Hughes (1934). He
also provided sculpture for the Rajah Brooke
monument (Kuching, Sarawak, 1921) and a
statue of Dr Loke Yew (Selangor, 1928). His
last major work was a statue of Captain Francis
Light (1940), now in the grounds of Penang
Museum, Malaysia.

Sources: Graves, 1904; *Altrincham, Bowdon and Hale
Guardian*, 17 March 1922.

Alfred Wilde
Stonemason and architectural sculptor. Alfred
Wilde worked as stone-carver in Stalybridge in
the late Victorian period. He and his brother
Herbert are listed as sculptors, High Street,
Stalybridge and St Paul's, Stayley in *Morris and
Co's Commercial Directory of Ashton-under-
Lyne and District* (Nottingham, 1878).

Source: Stalybridge Commercial Directories.

Thomas and Evan Williams
Architectural sculptors and carvers. Williams'
executed most of the statues and carving on
Manchester's Albert Memorial and the panels
on the Reform Club, King Street. The firm was,
alongside Bonehill and Earl and Hobbs, the
leading Manchester architectural sculptors in
the mid-nineteenth century. The firm appears
to have been established by Thomas Richard
Williams in the early 1850s: the 1852
Manchester Directory identifies T.R. Williams
as a 'heraldic and ornamental sculptor'. He was
later joined by Evan Williams. They occupied
various premises in the city during the mid-
Victorian years, including Lower Mosley Street.
T.R. Williams is listed as both architect and
sculptor in the commercial directory for 1881.

Source: Manchester Directories.

Francis John Williamson (1833–1920)
Sculptor. Born in Hampstead, London. Entered
RA Schools where he was taught by John Bell
before entering the studio of John Foley where

he remained as pupil and then assistant for over ten years. Established home and studio in Esher where he lived for the remainder of his life. Received many commissions from Queen Victoria, executing busts, statues and memorials for the royal family. His public statues of Queen Victoria include Hastings (1902), Christchurch, New Zealand (1904) and Wakefield (1905). Other outdoor statues include Joseph Priestley (Birmingham, 1874) and Sister Dora (Walsall, 1886). Ideal works include *Hetty and Dinah* and *Hypatia.* Memorials include the tombs of Dean Milman (St Paul's Cathedral, 1876) and Princess Charlotte (St George's Church, Esher).

Sources: Spielmann, 1901; Noszlopy, 1998.

T. & W. Wills
Sculptor brothers who were based in London. They became specialists in the design of iron drinking fountains, produced chiefly for the Metropolitan Free Drinking Fountain Association. Their bronze female figure of *Temperance* or *Rebecca* also adorned fountains in Liverpool and Bolton. The fountains were cast by the Coalbrookdale Company. They executed a number of commemorative public statues, including *Richard Cobden* (Camden Town, 1868), *Sir Humphry Davy* (Penzance, 1872), *Lord Mayo* (Cockermouth, 1875), *Sir Thomas White* (Coventry, 1883), *Henry Edwards* (Weymouth, 1886) and *William III* (Newquay, 1889). They exhibited works at the RA from 1857–84.

Sources: Davies, 1989; Cavanagh, 1997.

James Wines (b. 1932)
Born Oak Park, Illinois, USA. Graduated from the School of Art, Syracuse University in 1955. Worked as a sculptor. He established himself as a successful designer in landscape, interiors and products. In 1970 he co-founded SITE Environmental Design which became recognised for its creation of environmentally sensitive designs for buildings, interiors and public spaces. Private and public commissions in North America and Europe, including *Ghost Parking Lot* (Hamden, Connecticut, 1977). Wines has held academic posts at the Parsons School of Design, New York, New School for Social Research, New York, Cornell University and University of Pennsylvania. Exhibitions at Witney Museum, New York (1973) and Museum of Modern Art, New York (1975). Awarded Pulitzer and Guggenheim Fellowships and awards from the Graham Foundation and Ford Foundation. Publications include *Architecture as Art* (1980), *De-Architecture* (1987) and *Green Architecture* (2000).

Source: archINFORM.

Axel Wolkenhauer
Sculptor. Educated at Ottersberg, Germany, where he studied art therapy (1970–3), and at London Art School (1974–8, Diploma in Fine Arts). Between 1978 and 1990 Wolkenhauer worked in England, before moving to France in 1990 and setting up the Atelier des Mouches print-making workshop. In 1994 he became a member of BBK Sudbaden (German National Artists' Association). He has been the recipient of prizes and awards including the Southern Arts Award (1986 and 1989) and two major commissions won through open competition. Residencies include the Garden Festival, Weil am Rhein, Germany (1998) and 'SUCK Alsace' Installation project, France (1996). Solo exhibitions include Maison Voltz, Kayersberg, France and Lesard Gallery, Colmar, both in 1999.

Source: artist.

John Warrington Wood (1839–86)
Sculptor. Born in Warrington. Studied at the School of Art at Warrington, taking the name of his birthplace to distinguish himself from two other students also called John Wood. A well-received early work was *Spring* (1862). He went to Rome where he received tuition from John Gibson. He remained in Rome for most of his working life, being elected in 1877 to the Guild of St Luke. Exhibited at the RA between 1868 and 1884. His main works were ideal sculptures but he also received commissions for portrait statues and busts. The brewer, Andrew Barclay Walker, was one of his earliest and most important patrons, his first purchase being *Eve* (1871). His statues of *Raphael* and *Michaelangelo* are at the entrance to the Walker Art Gallery, Liverpool, for which he also executed the female figure of Liverpool. *St Michel overcoming Satan* is in Warrington Art Gallery. Wood died in Warrington in 1886.

Source: Cavanagh, 1997.

Marshall Wood (?–1882)
Sculptor. Wood first exhibited at the RA in 1854 where his works were chiefly busts and portrait medallions. He executed a number of statues of Queen Victoria for the colonies, including Ottawa, 1871, Montreal, 1872 and Calcutta, 1878. A bronze statue of Victoria was displayed at the Sydney International Exhibition, 1879. A marble bust of Queen Victoria was also commissioned for the Parliament House of Toronto, Canada, 1875. Wood was also responsible for the busts of Queen Victoria, Prince Albert, and the Prince and Princess of Wales in Halifax Town Hall, Yorkshire. His ideal works included *Proserpine* (1857) and *Hebe* (1870). His *Song of the Shirt* was inspired by Thomas Hood's poem of the same name.

Sources: Grant, 1953; Steggles, 2001.

Paul Wood (b. 1961)
Sculptor and print-maker. Studied at Loughborough College of Art (Foundation course and BA Fine Art, 1979–83). Solo exhibitions include Station Craft Centre, Millom, Cumbria (1996), Cupola Gallery, Sheffield (1998) and Y Theatre, Leicester (1999). Residencies include Clitheroe Castle (1996–7) and St Thomas Estate, Radcliffe (1997–8).

Commissions include *From Little Acorns Grow* (Leicester Business Park, 1992), *Charlie Boy* (Museum of the Moving Image, London, 1997) and *Community Wildlife Totem* (Ratby, Leicestershire, 1998). Member of Knighton Lane Artists' Group, Leicester.

Source: artist.

Woodhouse and Willoughby

Architects. John H. Woodhouse, architect and surveyor, born in Manchester, 1847. Articled to Philip Nunn of Manchester, began practice in partnership with S. Taylor Smith. Subsequently became partner with George Willoughby. Elected president and fellow of the Manchester Society of Architects. The firm was successful in obtaining contracts in open competition and in this way secured contracts for Technical Institutes at Blackburn, Rochdale, Widnes, Heywood and Hyde as well as for Bury Art Gallery. He and Willoughby also worked on several board schools in the Manchester area. George Harry Willoughby, architect and surveyor, born Stockport, 1859, educated at Stockport Grammar School and Bedford Grammar School. Partner in Woodhouse and Willoughby, whose major work was Bury Art Gallery and Library. FRIBA and fellow of Manchester Society of Architects.

Sources: Tracy, 1899; Felstead, 1993.

Jonathan Woolfenden (b. 1966)

Sculptor. Born in Glossop, Derbyshire. Studied at Northwich School of Art, 1982–3 and Bath Academy of Art, 1984–7. Work includes installations with complex mechanical mechanisms and acoustic elements. Exhibitions at Righton Gallery, Manchester, Turnpike Gallery, Wigan and Bluecoat Gallery, Liverpool. Public commissions include *Fantastic Parade* (National Museum of Labour History, Manchester). Woolfenden was founder artist member of Arch Three Studio, Manchester.

Source: artist.

Thomas Woolner (1825–92)

Sculptor. Born at Hadleigh, Suffolk. Studied with the sculptor William Behnes before attending RA Schools in 1842. Among his earliest works were *Eleanor Sucking Poison from the Wound of Prince Edward* (1843) and *The Death of Bodicea* (1844). His friendship with Rossetti led him to become a member of the Pre-Raphaelite Brotherhood in 1848. He contributed poetry to the *Germ*. In 1852, following his failure to win the competition for the Wordsworth Monument in Westminster Abbey, he emigrated to Australia, eventually establishing a studio in Melbourne. He returned to England in 1857. He established his reputation as a portrait sculptor of both busts and portrait medallions. Tennyson (1851, 1857, 1867), Carlyle (1851, 1855, 1865), Maurice (1861), Dickens (1872) and Gladstone (1868, 1873) were among his subjects. A bust of Sir William Fairbairn and his study of Constance and Arthur Fairbairn were shown at the 1862 International Exhibition. Woolner also executed a memorial tablet for Fairbairn (1875), but not the Manchester statue. The marble portrait medallions of John Owens and Sir Joseph Whitworth in Owens College, Manchester were by Woolner. His London public statues included Lord Palmerston (Parliament Square, 1876) and John Stuart Mill (Victoria Embankment, 1879). Birmingham commissioned marble statues of George Dawson (1881) and Queen Victoria (1884). A statue of John Godley stands in Christchurch, New Zealand (1867) and a colossal Captain Cook in Hyde Park, Sydney, Australia (1879). Woolner continued to produce ideal works and funerary monuments. He was elected RA in 1875. He occupied the position of Professor of Sculpture at the RA from 1877 to 1879.

Sources: *DNB*; Woolner, 1917; Underwood, 1933, Noszlopy, 1998.

Thomas Worthington (1826–1909)

Architect. Thomas Worthington was born in Salford. Articled to Henry Bowman in Manchester. Began practice in Manchester in 1850. Elected FRIBA, 1865. Worthington designed a number of Manchester's pre-eminent Victorian buildings including the Memorial Hall, Albert Memorial, City Police Courts and Nicholls Hospital. His son Percy Scott Worthington became a partner in the firm in 1889 and continued the firm after his father's retirement in 1907.

Sources: Pass, 1988; Felstead, 1993.

Marjan Wouda (b. 1960)

Sculptor. Born Aduard, Holland. BA Fine Art (Sculpture), North-East London Polytechnic 1984–7; MA Fine Art (Sculpture), Manchester Polytechnic 1987–8. Exhibitions include Flaxman Gallery, Stoke-on-Trent 1990, Chanticleer touring exhibition 1995–8, Curwen Gallery, London, 1997, The Mare's Tale touring exhibition 2000–2. Commissions include sculptures at Barnard Wharf, Rotherhithe, 1992, Civic Centre, Walsall, 1993 and River Lane Millennium Park, Lancaster, 2000. Works in public and private collections.

Source: artist.

Austin Wright (1911–1997)

Sculptor. Wright was brought up in Cardiff. He began to sculpt in the late 1930s and was shown in exhibitions in Wakefield City Art Gallery beginning in 1941. Wright was a teacher at Bootham School, York for 12 years and then at York Art School before becoming a full-time sculptor. He produced almost 400 works from 1939 to 1992 beginning with wood carvings and then different media including stone, clay, lead and aluminium. By the 1950s the distinctiveness of his abstract works was recognised. His work featured in the British Council's travelling exhibitions, Younger British Sculptors (1956–7) and Ten Young British Sculptors (1957–8). Solo exhibitions included a 70th birthday retrospective at the Yorkshire Sculpture Park in 1981. Awarded the Purchase Prize at the São Paulo Biennale, 1961. Wright lived and worked

in Upper Poppleton, near York for most of his life.

Source: Hamilton, 1994.

Jack Wright (b. 1959)
Sculptor. Born in Newcastle upon Tyne. Trained Jacob Cranmer College, Leeds and Manchester Polytechnic (3D Industrial Design). Works include *Nailing Home* (Radcliffe, 1999) and astronomical charts (Mill Gate Centre, Bury, 2001).

Sources: *Bury Times*, 5 January 2001; artist.

George Wyllie (b. 1921)
Sculptor. Born in Glasgow, educated Allan Glen's School Glasgow. Pursued various careers before attending art classes at Royal Technical College and Glasgow School of Art in the 1970s. Interest in sculpture and regenerative artworks. He employs different media in his work which he refers to as Scul?ture. Produces both permanent and semi-permanent installations. Public commissions include works at Cheshire County Hall, General Accident Offices, Perth, *Berlin Burd* (Berlin) and *Blake's Bike* (St James's, Piccadilly). A number of his most important works have been produced for Glasgow, including *Straw Locomotive* (1987), *The Paper Boat* (1990) and *Just in Case* (1995). Honorary president of SSA.

Sources: artist; McKenzie, 2002.

Kan Yasuda (b. 1945)
Sculptor. Born Bilbai, Hokkaido, Japan. Studied sculpture at Tokyo National University of Fine Arts and Music (MA, 1969). The following year he travelled to Italy on a fellowship from the Italian government, studying under Professor Pericle Fazzini at the Academy of Arts in Rome. He established a studio in Pietrasanta in Northern Italy, known for its marble quarries. He works mainly in marble, producing massive polished sculptures. His major exhibitions have been in Italy, beginning in Rome, 1973, and Japan, beginning in Sapporo, 1976. In Britain his exhibitions have included 'Sculptures from Carrara, Massa, Pietrasanta', Yorkshire Sculpture Park, 1988, and 'Marble and Bronze', Yorkshire Sculpture Park, 1994–5. Public commissions include *Ishinki* (Sapporo, Japan), *Tenpi* (Iwamizawa, Japan) and *Tensei, Tenmoku* (Tenerife). Yasuda has also completed *Touchstones* for the Tokyo International Forum and Aurora Place, Sydney.

Source: artist.

Bibliography

1. Books and Articles

Aikin, J., *A Description of the Country from Thirty to Forty Miles Round Manchester*, 1795; reprinted New York: A. Kelley, 1968.

Alexander, S., *Philosophical and Literary Pieces*, London: Macmillan, 1939.

Allen, R.J., *The Manchester Royal Exchange. Two Centuries of Progress*, Manchester: Manchester Royal Exchange Limited, 1921.

Allen, S.M., *Myles Standish: with an account of the exercises of consecration of the monument on Captain's Hill, Duxbury, August 17, 1871*, Boston, 1871.

Anderson, D. and Farnie, A., *Wigan Coal and Iron*, Wigan: Smiths Books, 1994.

Archer, J.H.G., 'A civic achievement. The building of Manchester Town Hall', *Transactions of Lancashire and Cheshire Antiquarian Society*, 81 (1982), 3–29.

— (ed.), *Art and Architecture in Victorian Manchester*, Manchester: Manchester University Press, 1985.

Art Journal Illustrated Catalogue of the International Exhibition 1862, Wakefield: EP Publishing, 1973.

Arts in Partnership. Bolton's Cultural Strategy for the 90's, Bolton: Bolton Metropolitan Borough Council, 1993.

Ashmore, O. and Bolton, T., 'Hugh Mason and the Oxford Mills and community, Ashton-under-Lyne', *Transactions of Lancashire and Cheshire Antiquarian Society*, 78 (1975), 38–50.

Astle, W., *History of Stockport*, Stockport, 1922; reprinted S.R. Publishers, 1971.

Atterbury, P. and Irvine, L., *The Doulton Story*, Stoke-on-Trent: Royal Doulton Tableware, 1979.

Aumonier, W. (ed.), *Modern Architectural Sculpture*, London: Architectural Press, 1930.

Axon, W.E.A. (ed.), *An Architectural and General Description of the Town Hall, Manchester*, Manchester: A. Heywood, 1877.

— *Annals of Manchester*, Manchester: J. Heywood, 1886.

Baines, E., *History of the County Palatine and Duchy of Lancaster by the late Edward Baines*, 5 vols; revised edition (ed.) J. Croston, Manchester: J. Heywood, 1886–93.

Ball, D., *The Story of Failsworth*, Oldham: Oldham Cultural and Information Services, 1987.

Barbeau, M., *Totem Poles*, National Museum of Canada, Bulletin No. 119, Ottawa, 1950.

Barclay, J., 'John Milson Rhodes, 1847–1909', *Manchester Region History Review*, 6 (1992), 107–12.

Barker, I., *Malcolm Hughes, Alan Reynolds. Recent Work*, London: Annely Juda Fine Art, 1996.

Barnard, J., 'Victorian on the tiles: the work of W. J. Neatby in ceramics', *The Architect and Building News*, September 1971, 46–51.

Barnes, J.A., *The Worsley Trail*, Salford: City of Salford Education Department, 1978.

Bayley, S., *The Albert Memorial. The Monument in its Social and Architectural Context*, London: Scolar Press, 1971.

Bayliss, D. (ed.), *Altrincham. A History*, Timperley, Altrincham: Willow Publishing, 1992.

Beattie, S., *The New Sculpture*, New Haven: Yale University Press, 1983.

Beenstock, R., 'Edward Salomons', *Manchester Region History Review*, 10 (1996), 90–5.

Beesley, I. and Figueiredo, P., *Victorian Manchester and Salford*, Halifax: Ryburn Publishing, 1988.

Belchem, J., *Orator Hunt: Henry Hunt and English Working-Class Radicalism*, Oxford: Clarendon Press, 1985.

Belsky, F., *Franta Belsky: Sculpture*, London: A. Zwemmer, 1992.

Bénézit, E., *Dictionnaire Critique et Documentaire des Peintres, Sculpteurs, Dessinateurs et Graveurs*, Librairie Grund, 1976.

Benson, A.C. and Esher, V., *The Letters of Queen Victoria*, 3 vols, London: Murray, 1908.

Bentley, J., *Dare To Be Wise. A History of the Manchester Grammar School*, London: James and James, 1990.

Bewley, J. (ed.), *Stefan Gec*, London: Black Dog, 2002.

Billings, J. and Copland, D., *The Ashton Munitions Explosion 1917*, Ashton-under-Lyne: Tameside Leisure Services, 1992.

Billington, T. (ed.), *Parish Church of St. Mark, Worsley. A Souvenir Handbook*, Birkenhead: Merseyside Press, 1954.

Blakeman, B., *Wigan A Hundred Years Ago*, Staining: Bob Dobson, 1990.

Bohman, W., *Commemorative History of Bury Arts and Craft Centre 1894–1994*, Bury, 1994.

Boorman, D., *At The Going Down of the Sun. British First World War Memorials*, York: Ebor Press, 1988.

Booth, A., 'Popular Loyalism and Public Violence in the North-West of England, 1790–1800', *Social History*, 8 no.3, (1983), 295–313.

Borg, A., *War Memorials from Antiquity to the Present*, London: Leo Cooper, 1991.

Borough of Ashton-under-Lyne, *Unveiling of the Ashton-under-Lyne War Memorial*, [1922].

Borough of Heywood, *War Memorial Unveiling Ceremony. Saturday, August 22nd, 1925*, [1925].

Borough of Stretford, *Presentation and Unveiling of Bronze Groups*, Stretford, [1934].

Boutflower, A., *Personal Reminiscences of Manchester Cathedral 1854–1912*, Leighton Buzzard: Faith Press, [1913].

Bowman, W.M., *England in Ashton-under-Lyne, being the History of the Old Manor*, Ashton: Ashton-under-Lyne Corporation, 1960.

Bowness, A. (ed.), *The Complete Sculpture of Barbara Hepworth 1960–69*, London: Lund Humphries, 1971.

Bradley, S. and Pevsner, N., *Buildings of England, London I: The City of London*, Harmondsworth: Penguin, 1997.

Brian Clarke. Designs on Architecture Oldham Art Gallery 2 October–19 November 1993, Oldham: Oldham Leisure Services, 1993.

British Empire Exhibition 1924 Wembley, London. Palace of Arts Catalogue, London: Fleeting Press, 1924.

Brockbank, W., *The Honorary Medical Staff of the Manchester Royal Infirmary 1830–1948*, Manchester: Manchester University Press, 1965.

Brotherton Memorial. Specifications of the Designs and Models sent in for competition, Manchester: I.W. Petty, [1857].

Brotherton Memorial Committee. Final Report of the Proceedings of the Committee, Salford, 1861.

Brough, J., *Wrought Iron: The End of an Era at Atlas Forge Bolton*, Bolton: Bolton Metropolitan Borough Council, [n.d.].

Brumhead, D. and Wyke, T., *A Walk Round All Saints*, Manchester: Manchester Polytechnic, [1986].

— *A Walk Round Manchester Statues*, Manchester: Walkround Books, 1990.

Buckle, R., *Jacob Epstein: Sculptor*, London: Vista Books, 1963.

Buckman, D., *Dictionary of Artists since 1945*, Bristol: Art Dictionaries, 1998.

Bullen, A. and Fowler, A., *The Cardroom Workers' Union*, Rochdale: Amalgamated Textile Workers' Union, 1986.

Busco, M., *Sir Richard Westmacott*, Cambridge: Cambridge University Press, 1994.

Butler, A.S.G., *The Architecture of Sir Edwin Landseer*, London: Country Life, 1950.

Butterworth, J., *History and Description of the Town and Parishes of Ashton-under-Lyne*, 1823; reprinted Didsbury, Manchester: Morten, 1972.

Cardwell, D.S.L., *James Joule. A Biography*, Manchester: Manchester University Press, 1989.

— (ed.), *John Dalton and the Progress of Science*, Manchester: Manchester University Press, 1968.

Carpenter, J., *The Life and Works of Charles John Allen, Sculptor 1862–1956*, [Typescript], School of Architecture and Building Engineering, University of Liverpool, 2000.

Cash, J., *Where There's a Will There's a Way! or, Science in the Cottage, an Account of the Labours of Naturalists in Humble Life*, London: Robert Hardwicke, 1873.

Catalogue of Small Collection of Sculpture by John Cassidy, Manchester: G. Falkner and Son, [n.d.].

Catalogue of the Remaining Works of the late Thomas Woolner R.A., [1913].

Causey, A., *Sculpture since 1945*, Oxford: Oxford University Press, 1998.

Cavanagh, T., *Public Sculpture of Leicestershire and Rutland*, Liverpool: Liverpool University Press, 2000.

— *Public Sculpture of Liverpool*, Liverpool: Liverpool University Press, 1997.

Ceremony of Unveiling the Statue of the late John Bright M.P., Manchester, 1891.

Chadwick, W., *Reminiscences of Mottram*, Stalybridge, 1882; reprinted 1972.

Chaloner, W.H., 'Robert Owen, Peter Drinkwater and the early factory system in Manchester 1788–1800', *Bulletin of John Rylands Library*, 37 (1954–5), 78–102.

Chapman, S.D., 'The Peels in the early English cotton industry', *Business History*, 11 (1969), 61–89.

Churchill, W., *My Early Life, A Roving Commission*, London: Odhams Press, 1930.

City of Manchester Town Hall Extension, Manchester: Manchester Corporation, [1938].

Clapp, B.W., *John Owens Manchester Merchant*, Manchester: Manchester University Press, 1965.

Clarke, H., *Cheadle Through the Ages*, Manchester: Morten, 1972.

Clarke, P., Cook, A. and Bintliff, J., *Remembered. Marple Men Who Fell in the Great War*, Marple, 1999.

Cleveland, S.D., *The Royal Manchester Institution*, Manchester, 1931.

Cochrane, R. and McErlain, A., *Architectural Terracotta*, Manchester Metropolitan University Department of History of Art and Design Slide Sets, 1999.

Cole, J., *Rochdale Revisited. A Town and its People*, Littleborough: G. Kelsall, 1990.

— *Yesterday's Rochdale*, Nelson: Hendon Publishing Co., 1983.

Collins, J., *Eric Gill The Sculpture A Catalogue Raisonné*, London: Herbert Press, 1980.

Colvin, H., *A Biographical Dictionary of British Architects 1600–1840*, London: J. Murray, 1978.

Compton, A. (ed.), *Charles Sargeant Jagger. War and Peace Sculpture*, London: Imperial War Museum, 1985.

Coombs, T., *Rising from Reality. Art in Oldham from 1820 to 1890*, Oldham: Oldham Leisure Services, 1990.

Cornish, E., *The Story of the Parish of St George, Chorley*, Gloucester: British Publishing Company, 1959.

County Borough of Oldham, *Unveiling of the War Memorial*, Oldham, 1923.

County Borough of Salford, *Catalogue of Loan Collection of Pictures Jubilee Exhibition*, Salford, [1894].

Credland, W.R., *The Manchester Public Free Libraries*, Manchester: Public Free Libraries Committee, 1899.

Crick, B., *George Orwell. A Life*, London: Secker and Warburg, 1980.

Crompton, D.C., 'Infant Mortality in Wigan 1900–1914', unpublished MA thesis, University of Manchester, 1990.

Crompton War Memorial Souvenir, April 29th 1923, [1923].

Crosby, A.G., *'A Society With No Equal': The Chetham Society 1843–1993*, Manchester: Chetham Society, 1993.

Cunningham, C., *Victorian and Edwardian Town Halls*, London: Routledge & Kegan Paul, 1981.

Cunningham, C. and Waterhouse, P., *Alfred Waterhouse, 1830–1905. Biography of a Practice*, Oxford: Clarendon Press, 1992.

Curtis, P., *Barbara Hepworth*, London: Tate Gallery, 1998.

Darby, E. and Smith, N., *The Cult of the Prince Consort*, New Haven: Yale University Press, 1983.

D'Arcy, C.P., *The Encouragement of the Fine Arts in Lancashire 1760–1860*, Manchester: Chetham Society, 1976.

Darke, J., *The Monument Guide to England and Wales. A National Portrait in Bronze and Stone*, London: Macdonald, 1991.

Davies, P., *Troughs & Drinking Fountains*, London: Chatto & Windus, 1989.

Denton War Memorial. Unveiling Ceremony Souvenir, [Denton, 1921].

Description of the Hundred of Salford Assize Courts of the County of Lancaster, Manchester: Beresford and Havill [1863].

Diggle, J.W., *The Lancashire Life of Bishop Fraser*, London: Sampson Low, 1889.

Dixon, M., 'Onslow Ford R.A.', *Art Journal*, 1898, 294–7.

Dobb, A.J., *1846 and After. An Historical Guide to the Ancient Parish of Bury*, Eccles Parish Church Council, 1970.

Dobson, B. Palin, *History of the Bolton Artillery 1860–1928*, Bolton: Blackshaw, Sykes and Morris, 1929.

Dolman, B., *A Dictionary of Contemporary British Artists*, London: Art Trade, 1929.

Dorment, R., *Alfred Gilbert*, London and New Haven: Yale University Press, 1985.

— *Alfred Gilbert. Sculptor and Goldsmith*, London: Royal Academy of Arts, 1986.

— 'Alfred Gilbert' in *Victorian High Renaissance*, Minneapolis: Minneapolis Institute of Arts, 1978.

Dowsett, H., *Holcombe Long Ago*, Manchester: J. Heywood, 1902.

Drury, C., *Silent Spaces*, London: Thames and Hudson, 1998.

[—]. *Chris Drury. Vessel. Sculpture 1990–1995, Collaboration between Inverleith House, Royal Botanic Garden Edinburgh and the Towner Art Gallery, Eastbourne*, [1995].

Duckworth, M., 'Lawrence Earnshaw. A remarkable clockmaker', *Journal of British Astronomical Association*, 78, no.1 (1967), 22–7.

Dunkerley, S., *Francis Chantrey Sculptor: from Norton to Knighthood*, Sheffield: Hallam Press, 1995.

Dunphy, E., *A Strange Kind of Glory. Sir Matt Busby & Manchester United*, London: Heinemann, 1991.

Eagle, M., *The Oil Paintings of Tom Roberts in the National Gallery of Australia*, Canberra: National Gallery of Australia, 1997.

Edsall, N.C., *Richard Cobden: Independent Radical*, Cambridge, Mass.: Harvard University Press, 1986.

Edwards, M.S., *Purge This Realm. A Life of Joseph Rayner Stephens*, London: Epworth Press, 1994.

Engels, F., *The Condition of the Working Class in England*, Oxford: Basil Blackwell, 1958.

Epstein, J., *Epstein. An Autobiography*, London: Studio Vista, 1963.

Evans, J., *Lancashire Authors*, London: Houlston and Stoneman, 1850.

— 'Memorials of a Manchester parish church', *Papers of the Manchester Literary Club*, 5 (1879) 106–32.

Fairbairn, W., *Observations on Improvements of the Town of Manchester: particularly as regards the importance of blending in those improvements, the chaste and beautiful, with the ornamental and useful*, Manchester, 1836.

Farnie, D.A., 'Enriqueta Augustina Rylands 1843–1908 founder of the John Rylands Library', *Bulletin of John Rylands University Library of Manchester*, 71, no.2 (1989), 3–38.

— *John Rylands of Manchester*, Manchester: John Rylands University Library of Manchester, 1993.

— *The Manchester Ship Canal and the Rise of the Port of Manchester, 1894–1975*, Manchester: Manchester University Press, 1980.

Farnworth War Memorial. Unveiling and Dedication Sunday, November 16th, 1924, [Farnworth, 1924].

Fell, H.G., *Sir William Reid Dick K.C.V.O.*, London: A. Tiranti, 1945.

Fellows, R.A., *Sir Reginald Blomfield: An Edwardian Architect*, London: Zwemmer, 1985.

Felstead, A. et al., *Directory of British Architects 1834–1900*, London: Royal Institute of British Architects, 1993.

Fishwick, H., *The History of the Parish of Rochdale*, Rochdale: J. Clegg, 1889.

Fishwick, Alderman (ed.), *Rochdale Jubilee, A Record of Fifty Years' Municipal Work 1856 to 1906*, Manchester: G. Falkner, 1906.

Fowler, A. and Wyke, T. (eds), *The Barefoot Aristocrats. A History of the Amalgamated Association of Operative Cotton Spinners*, Littleborough: G. Kelsall, 1987.

French, G.J., *Life and Times of Samuel Crompton*, 1860; reprinted Bath: Adams & Dart, 1970.

Frost, R. and Simpson, I., *Woodley and Greave. All about two villages*, Stockport: Stockport Leisure Services Division, 1988.

Gabriel Tinto [pseud.], *The Wise Judgement; being a chapter on the competing models for the Manchester Wellington Testimonial*, Manchester, 1853.

Gale, M. and Stephens, C., *Barbara Hepworth. Works in the Tate Gallery Collection and the Barbara Hepworth Museum St Ives*, London: Tate Gallery Publishing, 1999.

Galvin, F., '130 years of Stockport Museum', *Manchester Region History Review*, 5, no.1 (1991), 40–5.

Gardiner, S., *Frink: The Official Biography of Elisabeth Frink*, London: Harper Collins, 1998.

Garratt, M., *Cheadle Hulme*, Wilmslow: Sigma Leisure, 1998.

— *Samuel Bamford. Portrait of a Radical*, Littleborough: G. Kelsall, 1992.

Gilbert Ledward RA, PRBS 1888–1960: Drawings for Sculpture: A Centenary Tribute: January 25th – February 19th, London: Fine Art Society, 1988.

Ginswick, J. (ed.), *Labour and the Poor in England and Wales 1849–1851*, London: Frank Cass, 1983.

Glover, W., *History of Ashton-under-Lyne and the surrounding district*, Ashton-under-Lyne: J. Andrew, 1884.

Gomme, A., *Bristol. An Architectural History*, London: Lund Humphries, 1979.

Gordon, C., *The Foundations of the University of Salford*, Altrincham: J. Sherratt, 1975.

Gosse, E., *A Critical Essay on the Life and Work of George Tinworth*, London: Fine Art Society, 1883.

— 'The New Sculpture, 1879–1894 III', *Art Journal*, August 1894.

Grant, L., *Built to Music. The Making of the Bridgewater Hall*, Manchester: Manchester City Council, 1996.

Grant, M.H., *A Dictionary of British Sculptors from the XVIIIth Century to the XXth Century*, London: Rockliff, 1953.

Graves, A., *The Royal Academy of Arts. A Complete Dictionary of Contributors and work from its foundations in 1796 to 1904*, 8 vols, London: H. Graves and Co., 1904; reprinted Wakefield: S.R. Publishers, 1970, 4 vols.

Gray, A.S., *Edwardian Architecture. A Biographical Dictionary*, London: Duckworth, 1985.

Greenall, R.L., *The Making of Victorian Salford*, Lancaster: Carnegie Publishing, 2000.

Greenaway, F., *John Dalton and the Atom*, London: Heinemann, 1966.

Grieves, K., 'C.E. Montague, Manchester and the remembrance of war 1918–25', *Bulletin of John Rylands University of Manchester Library*, 77, no.2 (1995), 85–104.

Groundwork Trust, *Changing Places. Breaking the Mould*, Birmingham, Groundwork UK, [2001].

Gunnis, R., *Dictionary of British Sculptors 1660–1851*, London: Odhams Press, 1953; rev. ed., London: Abbey Library, 1968.

Guppy, H., *The John Rylands Library Manchester 1899–1924*, Manchester: John Rylands Library, 1924.

Guscott, S.J., *Humphrey Chetham 1580–1653*, Manchester: Chetham Society, 2003.

Halpin, M.M., *Totem Poles. An Illustrated Guide*, Vancouver: University of British Columbia Press, 1981.

Hamilton, J. *The Sculpture of Austin Wright*, London: Lund Humphries, 1994.

Hamilton, J. et al., *Peter Randall-Page*, Leeds: Leeds City Art Gallery, 1992.

Hardy, E., 'Farmer and Brindley: Craftsmen and Sculptors, 1850–1930', *Victorian Society Annual* (1993), 4–17.

Hanson, B., *The Golden City: Essays on the Architecture and Imagination of Beresford Pite*, London: Prince of Wales Institute of Architecture, 1993.

Harrison, W., 'Ancient beacons of Lancashire and Cheshire', *Transactions of Lancashire and Cheshire Antiquarian Society*, 15 (1897), 16–48.

Harrop, S. and Rose, E.A. (eds), *Victorian Ashton*, Tameside Libraries and Arts Committee, 1974.

Hartog, P.J., *The Owens College, Manchester*, Manchester: J.E. Cornish, 1900.

Hartshead Pike, Stalybridge: Whittaker, [n.d.].

Hartwell, C., *Manchester*, London: Penguin, 2001.

Haynes, I., *Cotton in Ashton*, Libraries and Arts Committee, Tameside Metropolitan Borough Council, 1987.

Heginbotham, H., *Stockport: Ancient and Modern*, London: Sampson Low, Marston & Co., 1892.

Henderson, W.O., *Charles Pelham Villiers and the Repeal of the Corn Laws*, Manchester, 1975.

Henry, W., *Memoirs of the Life and Scientific Researches of John Dalton*, London: Cavendish Society, 1854.

Hickey, J. Edward, *Dukinfield Past and Present*, 1926; reprinted Leeds: M.T.D. Rigg Publications, 1992.

Hill, J., *Irish Public Sculpture. A History*, Dublin: Four Courts Press, 1998.

Hill, S., *Bygone Stalybridge: Traditional, Historical, Biographical*, Stalybridge: Whittaker, 1907; reprinted 1987.

Hodson, D., 'Civic identity, custom and commerce: Victorian market

halls in the Manchester region', *Manchester Region History Review*, 12 (1998), 34–43.

Holcroft, F., *Murder, Terror and Revenge in Medieval Lancashire. The Legend of Mab's Cross*, Wigan: Wigan Heritage Services, 1992.

— *The English Civil War around Wigan and Leigh*, Wigan: Wigan Heritage Services, 1993.

Holden, G., 'The Bolton engineers' strike of 1887', *Manchester Region History Review*, 3, no.2 (1989–90),15–20.

Hollis, P., *Ladies Elect. Women in English Local Government 1865–1914*, Oxford: Clarendon Press, 1987.

Holyoake, G.J., *Life of Joseph Rayner Stephens. Preacher and Political Orator*, London: Williams and Norgate, 1881.

Hudson, J., *Radcliffe in Old Photographs*, Stroud: Alan Sutton, 1994.

Hudson, K., *Exploring Our Industrial Past*, London: Hodder and Stoughton, 1975.

Hughes, B., *The King: Denis Law, Hero of the Stretford End*, Manchester: Empire Publications, 2003.

Hughes, R., 'Walter Marsden: soldier and sculptor', *Stand To!*, no.63, January (2002), 37–40.

Hughes, T., *James Fraser, Second Bishop of Manchester. A Memoir, 1818–1885*, London: Macmillan, 1887.

Hulbert, H.L.P., *Sir Francis Sharp Powell, Baronet and Member of Parliament: A Memoir*, Leeds: R. Jackson, 1914.

Inauguration of the Peel Statue, Bury. Programme, Bury: J. Heap, [1852].

Ingham, A., *A History of Altrincham and Bowdon*, 1879; reprinted Warrington: Prism, 1983.

Jackson, P., *Philip Jackson. Sculpture since 1987*, Midhurst: Studio Gallery, 2002.

Jenkins, T.A., *Sir Robert Peel*, New York: St Martin's Press, 1999.

Jeremy, D. and Shaw, C. (eds), *Dictionary of Business Biography*, London: Butterworths, 1984–6.

Jezzard, A., 'The sculptor Sir George Frampton', unpublished PhD thesis, University of Leeds, 2 vols, 1999.

John Rylands Library, *Memorial of the Inauguration, 6th October, 1899*, Manchester, 1899.

Johnson, F., *Goscombe John at the National Museum of Wales*, Cardiff: National Museum of Wales, 1979.

Jonaitis, A., *From the Land of the Totem Poles. The Northwest Coast Indian Art Collection at the American Museum of Natural History*, New York: American Museum of Natural History, 1988.

Jones, G., *Francis Chantrey, R.A. Recollections of his Life, Practice and Opinions*, London: E. Moxon, 1849.

Jones, R.W. and Wyke, T., 'John Dalton: The man who started the chain reaction', *BBC History Magazine*, vol.5 no.1 (2004), 32–5.

Jones, S., *The History of St George's Church, Stockport 1897–1997*, Stockport: Stockport Council, 1997.

Kelly, A., *Mrs Coade's Stone*, Upton upon Severn: Self Publishing Association, 1990.

Kemnitz, T.M. and Jacques, F.J., 'Stephens and the Chartist movement', *International Review of Social History*, 19 (1974), 211–27.

Keyte, O., *The Annals of a Century. Bridgemans of Lichfield 1878–1978*, Lichfield, 1995.

Kidd, A., *Manchester*, Edinburgh: Edinburgh University Press, 3rd ed., 2003.

Kimbrough, S.D., *Drawn From Life: The Story of Four American Artists*, Jackson: University of Mississippi Press, 1976.

Kirk, N., *Growth of Working Class Reformism in mid-Victorian England*, London: Croom Helm, 1985.

'Lancashire Fusiliers' War Memorial', *Lancashire Fusiliers' Annual*, 1905.

Lane, J. and Anderson, D., *Mines and Miners of South Lancashire 1870–1950*, Parbold: D. Anderson, 1980.

Latter, J.C., *The History of the Lancashire Fusiliers 1914–1918*, Aldershot: Gale and Polden, 1949.

Laver, D. and Rendell, D., *Hale and Ashley. The Past 100 Years*, Hale Civic Society, 1987.

Law, B.R., *Oldham Brave Oldham. An Illustrated History of Oldham*, Oldham: Oldham Metropolitan Borough Council, 1999.

Lawton, N.P., *Owd Archie Peyeke*, [Typescript, Tameside Local Studies Library, n.d.].

[Leake, R.], *Piece Work in the Overtime of a Business Man*, Manchester: Palmer, Howe & Co., 1893.

Leaving Tracks: Artranspennine98: An International Contemporary Visual Art Exhibition Recorded, London: August Media, 1999.

Ledward, G., *Gilbert Ledward. Drawings for Sculpture: A Centenary Tribute*, London, Fine Art Society, 1988.

Lee, D., 'Sod off Rückriem!', *Art Review*, 50, August (1998), 60–2.

Lloyd, J., *Nothing is Profane: Sean Crampton, Sculptor*, Calne: St Edmunds Publications, [2000].

Lilley, C. and Glossop, C., *Michael Lyons*, Wakefield: Yorkshire Sculpture Park, 1998.

Lock, A., *Ashton in Old Photographs*, Libraries and Arts Committee, Tameside Metropolitan Borough Council, 1981.

— (ed.), *Looking Back at Stalybridge*, Libraries and Arts Committee, Tameside Metropolitan Borough, 1989.

Lockett, T., *Three Lives: Samuel Bamford, Alfred Darbyshire, Ellen Wilkinson*, London: London University Press, 1968.

Longford, E., *Wellington*, 2 vols, London: Weidenfeld and Nicolson, 1969–72.

Lord, J., *Memoir of John Kay of Bury*, Rochdale: Aldine, 1903.

Lucie-Smith, E., *Wendy Taylor*, London: Art Books International, 1992.

— and Frink, E., *Frink: A Portrait*, London: Bloomsbury, 1974.

Lunn, J., *A Short History of the Township of Tyldesley*, Tyldesley:

Tyldesley Urban District Council, [1953].

— *The Historical Past of a Lancashire Borough*, Leigh: Leigh Borough Council, 1960.

McBride, R. et al., *R. McBride: Werkshow*, Verlag der Buchhandlung Walther Konig, 2001.

MacCarthy, F., *Eric Gill*, London: Faber & Faber, 1989.

McKenzie, R., *Public Sculpture of Glasgow*, Liverpool: Liverpool University Press, 2002.

Maddison, J., 'Basil Champneys and the John Rylands Library', in J. Archer (ed.), *Art and Architecture in Victorian Manchester*, Manchester: Manchester University Press, 1985.

Manchester 50 Years of Change. Post-war Planning in Manchester, London: HMSO, 1995.

Manchester Post Office Staff War Memorial Benevolent Fund, Order of Service for Unveiling Peace Memorial in Manchester Post Office, [1929].

Manning, E., *Marble and Bronze. The Art and Life of Hamo Thornycroft*, London: Trefoil Books, 1982.

Marcroft, A., *Landmarks of Local Liberalism*, Oldham: E.J. Wildgoose, 1913.

Marple 1220–1918. For Remembrance, Marple, [1922].

Martin, M., *A Wayward Genius. N. N. Burnard, Cornish Sculptor 1818–1878*, Padstow: Lodenek Press, 1978.

Maxim, J.L., *Rochdale Town Hall*, Rochdale: G. and A.N. Scott, 1959.

Mead, F.B., *Heroic Statues in Bronze of Abraham Lincoln*, Fort Wayne, Ind.: The Lincoln National Life Foundation, 1932.

Medieval Architecture and Sculpture in the North West, Manchester: Whitworth Art Gallery, [n.d.].

Middleton, J., 'The Old Road'. *A Book of Recollections*, Oldham: E.J. Wildgoose, printers, [1920].

Middleton, T., *Annals of Hyde and District*, Manchester: Cartwright and Battray, 1899.

Miles, M. (ed.), *Art for Public Places*, Winchester: Winchester School of Art Press, 1989.

Miller, A., *Orrell in Old Picture Postcards*, Zaltbommell, Netherlands: European Library, 2000.

Millett, F., *Looking Back at Lees*, Oldham: Oldham Education and Leisure Services, 1996.

Mitchell, A. and Mitchell, O., *Thomas Earp: Eminent Victorian Sculptor*, Buckingham: Baron Books, 2002.

Moffatt, F.C., *Errant Bronzes. George Grey Barnard's Statues of Abraham Lincoln*, Newark: University of Delaware Press, 1998.

Monkhouse, W.C., *The Works of J. H. Foley, R.A., Sculptor*, London: Virtue, Spalding & Co., 1875.

Mont Joie: Festschrift für Ulrich Rückriem zum 60, Düsseldorf: Richter, 1998.

Moorhouse, G., *Hell's Foundations. A Town, Its Myths and Gallipoli*, London: Hodder & Stoughton, 1992.

Morgan, S., *Edward Allington: New Sculpture*, London: Riverside Studios, 1985.

Moriarty, C., 'Narrative and the Absent Body. Mechanisms and Meaning in First World War Memorials', unpublished PhD thesis, University of Sussex, 1995.

— *The Sculpture of Gilbert Ledward*, London: Lund Humphries, 2003.

Moules, J., *Gracie Fields. A Biography*, Chichester: Summersdale, 1997.

Muirhead, J.P., *The Life of James Watt*, London: J. Murray, 1858.

Mullen, B.H., *Salford and the Inauguration of the Public Free Libraries*, Salford, 1899.

Nairne, S. and Serota, N., *British Sculpture in the Twentieth Century*, London: Whitechapel Art Gallery, 1981.

Nevell, M., *The Archaeology of Trafford*, Trafford Metropolitan Borough Council, 1997.

— *Tameside 1066–1760*, Tameside Metropolitan Borough Council, 1991.

Nicholls, R., *Trafford Park: The First Hundred Years*, Chichester: Phillimore, 1996.

Nicholls, Revd W., *History and Traditions of Radcliffe*, Manchester: J. Heywood, 1910.

Nichols, S., *Vimto. The Story of a Soft Drink*, Preston: Carnegie Press, 1994.

Nicodemus Newcomb the elder, *The 'Wise Judgement' Examined, and Gabriel Tinto also. An epistle which may be found to have something of Gospel in it and in which revelations of the Peel statue form the basis of prophecies as to the Wellington one addressed to the promoters of fine art embellishments in Manchester*, Manchester, 1853.

Nickson, C., *Byegone Altrincham. Traditions and History*, Altrincham: Mackie & Co., 1935; reprinted 1971.

Northern Quarter Association, *Applied Art in the Northern Quarter*, Manchester: Northern Quarter Association, [n.d.].

Noszlopy, G.T., *Public Sculpture of Birmingham including Sutton Coldfield*, Liverpool: Liverpool University Press, 1998.

Official Programme of the Inauguration of the Crompton Statue at Bolton on Wednesday, September 24th, Bolton, [1862].

O'Neil, R., *Cardinal Herbert Vaughan*, Tunbridge Wells : Burns & Oates, 1995.

Opening of the Bolton Town Hall, Bolton: Tillotson and Sons, [1873].

Openshaw, E.M., *The Story of St Paul's Church Heaton Moor 1877–1976*, [1976].

Parkinson-Bailey, J.J., *Manchester: An Architectural History*, Manchester: Manchester University Press, 2000.

— (ed.), *Sites of the City. Essays on Recent Buildings by their Architects*, Manchester: Manchester Metropolitan University, 1996.

Parry, Rev. W. Augustus, *History of Hurst and Neighbourhood*, Ashton-

under-Lyne, 1908.

Pass, A.J., *Thomas Worthington Victorian Architecture and Social Purpose*, Manchester: Manchester Literary and Philosophical Society, 1988.

Pavasovic, M., *Men of Dukinfield. A History of Dukinfield during the Great War*, Radcliffe: Neil Richardson, 1997.

Pavey, R., 'Tib Street trail', *Crafts*, no.157 (March/April 1999), 20–3.

Pearce, R., 'Revisiting Orwell's Wigan Pier', *History*, 82 (1997), 410–28.

Pearson, F., *Goscombe John at the National Museum of Wales*, Cardiff: National Museum of Wales, 1979.

Pearson, G., *Reg Harris: An Authoritative Biography*, London: Temple Press, 1950.

Pepinster, C., 'Trafford Park Manchester UDC', *Building*, 25 September 1987, 44–5.

Perkins, T., *The Cathedral Church of Manchester*, London: G. Bell, 1901.

Pettigrew, W.W., *Municipal Parks Layout, Management and Administration*, London: Journal of Park Administration, 1937.

Pevsner, N., *South Lancashire*, Harmondsworth: Penguin, 1969.

— and Hubbard, E., *Cheshire*, Harmondsworth: Penguin, 1971.

Philip Jackson. Sculpture since 1987, Midhurst: Studio Gallery Publications, 2002.

Plant, J., *The Memorial Statues and Royal Free Museum and Library, Peel Park, Salford*, [Salford], 1879.

Pole, W. (ed.), *The Life of Sir William Fairbairn Bart 1877*, reprinted Newton Abbot: David & Charles, 1970.

Pollard, S. and Salt, J. (eds), *Robert Owen. Prophet of the Poor*, London: Macmillan, 1971.

Port, M., 'Francis Goodwin 1784–1835: An architect of the 1820s', *Architectural History*, 1, (1958), 61–71.

Porteous, T.C., 'The Mab's Cross Legend', *Transactions of Lancashire and Cheshire Antiquarian Society*, 66 (1941–2), 25–44.

Powell, J., *Longdendale in Retrospect*, Longdendale Amenity Society, 1977.

Proceedings at the Opening of Farnworth Park, presented to the Township by Thomas Barnes Esq., M.P., on the 12th day of October, 1864, Bolton: T. Cunliffe, 1865.

Proctor, W., 'The Manchester Assize Courts', *Journal of Manchester Geographical Society*, 53 (1945–7), 44–6.

Programme. Bolton War Memorial Unveiling Ceremony, Bolton, 1928.

Programme John T. Fielding Statue, Daily Chronicle, Bolton, [1896].

Proposed Memorial to Lancashire Dialect Writers, [Rochdale, 1896].

Public Art Policy For Wigan, Wigan: Wigan Metropolitan Borough Council, 1996.

Pullan, B., *A History of the University of Manchester 1951–73*, Manchester: Manchester University Press, 2000.

Raines, F.R., and Sutton, C.W., *Life of Humphrey Chetham*, Manchester: Chetham Society, 2 vols, 1903.

Ray, C., *The Story of XX. The Lancashire Fusiliers*, London: B.T. Batsford, 1963.

Raymond, A.J., *Life and Work of Sir Francis Chantrey*, London: A. and F. Denny, 1904.

Read, B., *Victorian Sculpture*, New Haven: Yale University Press, 1982.

— 'Thomas Woolner' in B. Read and J. Barnes (eds), *Pre-Raphaelite Sculpture. Nature and Imagination in British Sculpture*, London: Henry Moore Foundation and Lund Humphries, 1991.

— and Skipwith, P., *Sculpture in Britain between the Wars*, London: Fine Art Society, 1988.

— and Ward-Jackson, P., *Courtauld Institute Illustration Archives: Archive 4, Late 18th and 19th Century Sculpture in the British Isles, Part 6 Greater Manchester; Part 8 Lancashire; Part 9 Lancashire*, Harvey Miller Publishers, 1978–9.

[Redding, C.], *The Pictorial History of the County of Lancaster*, London: G. Routledge, 1844.

Redstone, L.G. and Redstone, R.R., *Public Art. New Directions*, New York: McGraw Hill Book Company, 1981.

Reid, C., *John Barbirolli. A Biography*, London: Hamilton, 1971.

Reilly, C.H., *Some Manchester Streets and their Buildings*, Liverpool: Liverpool University Press, 1924.

Report of the proceedings of the Executive Committee for arranging the assemblage of Sunday School Scholars in Peel Park on the occasion of Her Majesty's visit, Manchester: Cathrall and Co., [1851].

Richards, T.T., *History of Henshaw's Blue Coat School*, Stalybridge: Whittaker & Sons, 1947.

Richardson, M. (comp.), *Catalogue of the Drawings Collection of the Royal Institute of British Architects. Edwin Lutyens*, Farnborough: Gregg International Publishers Ltd, 1973.

Richardson, N. and Richardson, S., *Fallen in the Fight: Farnworth and Kearsley Men who died in the Great War 1914–1918*, Radcliffe: N. Richardson, 1990.

Robertson, W., *A History of Rochdale. Past and Present*, Rochdale, [1875].

— *Life and Times of the Right Honourable John Bright*, London: Cassell & Co., 1884.

— *Old and New Rochdale and its People*, Rochdale: The Author, [1881].

Robinson, J., *Descriptive Catalogue of the Lough and Noble Models of Statues, Bas-Reliefs and Busts in Elswick Hall, Newcastle-upon-Tyne*, Newcastle upon Tyne, 1886.

Roby, J., *Traditions of Lancashire*, London: G. Routledge, 1892 edition.

Rochdale Household Almanack, Rochdale, 1874.

Rochdale Observer, Souvenir of the Rochdale War Memorial, Rochdale, 1922.

Rolt, L.T.C., *James Watt*, London: Batsford, 1962.

Roscoe, I., *Peter Scheemakers 'The Famous Statuary' 1691–1781*, Leeds: Henry Moore Institute, 1996.

Rose, M.E., 'Samuel Crompton (1753–1827), inventor of the spinning mule', *Transactions of Lancashire and Cheshire Antiquarian Society*, 75–76 (1965–66), 11–32.

Rose, P., *George Tinworth Chronology of Principal Works compiled by Desmond Eyles*, Los Angeles, California: C.D.N. Corporation, 1982.

— *The Manchester Martyrs. The Story of a Fenian Tragedy*, London: Lawrence and Wishart, 1970.

Royal Academy of Arts, *Royal Academy Exhibitors, 1905–1970*, Calne, Wiltshire: Hilmartin Press, 1985–7.

Rubinstein, W.D., *Men of Property. The Very Wealthy in Britain since the Industrial Revolution*, London: Croom Helm, 1981.

Rückreim, U., *Ulrich Rückreim*, London: Serpentine Gallery, 1991.

Sale Urban District Council, Joule Memorial Tower, July, 1902, [1902].

Salis, D. de and Stephens, R., *'An Innings Well Played': the Story of Alleyne's School, Stevenage, 1558–1989*, Stevenage: Alleyne's Old Boys Association, 1989.

Salveson, P., *The People's Monuments*, Manchester: Workers' Educational Association North Western District, 1987.

Service, A. (ed.), *Edwardian Architecture and its Origins*, London: Architectural Press, 1975.

[Sharples, J.], *Rochdale Town Hall. An Illustrated Guide*, Environment and Employment Department, Rochdale MBC, [n.d.].

Shaw, C.H., *The Bicentenary of the Failsworth Pole*, Failsworth Local History Society, [n.d.].

Shaw, G., 'Edwin Butterworth. His life and labours', *Transactions of Lancashire and Cheshire Antiquarian Society*, 22 (1904), 61–72.

Silber, E., *The Sculpture of Jacob Epstein*, Oxford: Phaidon, 1986.

Sinclair, D., *History of Wigan*, Wigan, 1883; reprinted Smiths Books, 1987.

Smith, M.D., *Adlington and District, Lancashire*, Chorley: Nelson Brothers, 1991.

Smith, N.C., 'Imitation and invention in two Albert Memorials', *Burlington Magazine*, April 1981.

Smyth, B., *A History of the Lancashire Fusiliers formerly the XX Regiment 1688–1903*, Dublin: Sackville Press, 1903.

Souvenir of Farnworth Park Jubilee 1864–1914, Farnworth Urban District Council, [1914].

Spielmann, M.H., *British Sculpture and Sculptors of Today*, London: Cassell and Co., 1901.

Stamp, G., 'George Gilbert Scott, the Memorial Competition, and the Critics' in C. Brooks (ed.), *The Albert Memorial*, New Haven and London: Yale University Press, 2000.

Stancliffe, F.S., *The Manchester Royal Eye Hospital 1814–1964*, Manchester: Manchester University Press, 1964.

Stedman, M., *Salford Pals*, London: Leo Cooper, 1993.

Steggles, M.A., 'Set in stone. Victoria's monuments in India', *History Today*, February 2001.

Stevens, T.H.G., *Some Notes on the Development of Trafford Park 1897–1947*, Manchester, 1947.

Stewart, C., *The Architecture of Manchester: An Index to the Principal Buildings and their Architects*, Manchester: Libraries Committee, 1956.

— *The Stones of Manchester*, London: E. Arnold, 1956.

Stewart, P., *Central Manchester*, Stroud: Chalfont Publishing, 1995.

Stirling, A.M.W., *Victorian Sidelights from the papers of the late Mrs. Adams-Acton*, London: Ernest Benn, 1954.

Stockport Messenger, Vernon Park Jubilee 1858–1908. Town Hall Sketches, [Stockport, 1908].

Stoker, R.B., *The Saga of Manchester Liners*, Douglas, Isle of Man: Kinglish, 1985.

Strachan, W.J., *Open Air Sculpture in Britain: A Comprehensive Guide*, London: A. Zwemmer Tate Gallery, 1984.

Swain, N.V., *A History of Sale – from the Earliest Times to the Present Day*, Wilmslow: Sigma Press, 1987.

Swindells, G.A., *A History of Marple*, Marple Antiquarian Society, 1974.

Swindells, T., *Manchester Streets and Manchester Men*, Manchester: J.E. Cornish, 1906.

Swynnerton, F., 'A Manx sculptor and his work', *Mannin*, vol.2, no.3 (1914), 129–36.

Taylor, H., *The Ancient Crosses and Holy Wells of Lancashire*, Manchester: Sherratt and Hughes, 1906.

Taylor, M.J., 'Between Phidias and Bernini. The Life and Work of John Warrington Wood 1839–1886', Diploma in Art Gallery and Museum Studies, University of Manchester, 1984.

Tazzi, P.L., 'Romancing the stone', *Artforum*, September (1990), 143–7.

Thackray, A., 'John Dalton' in *Dictionary of Scientific Biography*, New York: Scribner and Sons, 1971, vol.3, 545–6.

The Ascroft Memorial 1903. A souvenir and programme, Oldham, [1903].

The Diaries of John Bright, London: Cassell, 1930.

The Inauguration of the Statue of Joseph Brotherton, Esq. M.P., in Peel Park, Salford, Manchester: I.W. Petty, 1858.

The Manchester Athenaeum: Commemoration Notice of the Origin, Progress and Present Purpose of the Institution, Manchester, 1903.

Tillmanns, M., *Bridge Hall Mills*, Tisbury, Wiltshire: Compton Press, 1978.

Toft, A., *Modelling and Sculpture: A Full Account of the Various Methods and Processes Employed in these Arts*, London: Seeley and Co., 1911.

Tomlinson, V.I., 'Postscript to Peterloo', *Manchester Region History Review*, 3, no.1 (1989) 51–9.

Tracy, W.B. and Pike, W.T., *Manchester at the close of the Nineteenth Century. Contemporary Biographies*, Brighton: W.T. Pike, 1899.

Trodd, C. et al., *Victorian Culture and the Idea of the Grotesque*,

London: Ashgate, 1999.

Ulrich Rückriem, London: Serpentine Gallery, 1991.

Underwood, E.G., *A Short History of English Sculpture*, London: Faber and Faber, 1933.

Usherwood, P., Beach, J. and Morris, C., *Public Sculpture of North-East England*, Liverpool: Liverpool University Press, 2000.

Views of the Ancient Buildings in Manchester drawn from nature by John Ralston and on stone by A. Aglio, Manchester, 1825; reprinted 1975.

Wadsworth, A.P., 'The early factory system in the Rochdale district', *Transactions of the Rochdale Literary and Scientific Society*, 19 (1935–7), 135–56.

Wake, J., *Princess Louise: Queen Victoria's unconventional daughter*, London: Collins, 1988.

Walker, J. and Nevell, M., *The Folklore of Tameside*, Tameside: Tameside Metropolitan Borough Council, 1998.

Ward, C. and Ackers, N., *The Old Town of Leigh*, Leigh Local History Society, 1985.

Ward-Jackson, P., *Public Sculpture of the City of London*, Liverpool: Liverpool University Press, 2003.

Waterhouse, A., 'Description of the new Town Hall at Manchester', *Royal Institute of British Architects Transactions*, February (1877), 117–36.

Waters, G.M., *Dictionary of British Artists Working 1900–1950*, Eastbourne: Eastbourne Fine Art, 1975.

Watkin, A.E. (ed.), *Absalom Watkin Extracts from his Journal 1814–1856*, London: T. Fisher Unwin, 1920.

Watt, Q. (ed.), *The Bromsgrove Guild. An Illustrated History*, Bromsgrove: Bromsgrove Society, 1999.

Weaver, L., *Memorials and Monuments*, London: Country Life, 1915.

Webb, N., *Standish and Shevington*, Stroud: Tempus, 1999.

West, W.K., 'Some recent monumental sculpture by Sir George Frampton R.A.', *The Studio*, 54 (1911), 35–43.

Wheeler, C., *High Relief: The Autobiography of Sir Charles Wheeler*, Feltham: Country Life Books, 1968.

Whiffen, M., 'The Architecture of Sir Charles Barry in Manchester and Neighbourhood' in J.H.G. Archer (ed.), *Art and Architecture in Victorian Manchester*, Manchester: Manchester University Press, 1985.

Whittam, W., *Fairhursts. The History of a Manchester Practice*, Manchester: Manchester Polytechnic, 1986.

Whyler, F., 'Goddendene and the March Family', Typescript, Bromley Central Library [1986].

Wigan Town Centre Trail, Wigan MBC, 1998, 2nd ed.

Wild, A.S., *Top o' th' Steps. A History of St Chad's Parish Church, Rochdale*, Rochdale: St Chad's Educational Trust: Rochdale, 1981.

Wild, R.B., 'Hyde's Cross', *Transactions of Lancashire and Cheshire Antiquarian Society*, 26 (1908), 114–23.

Wilder, J., *Elisabeth Frink Sculpture. Catalogue Raisonné*, Salisbury, Wiltshire: Harpvale, 1984.

Williams, M. and Farnie, D., *Cotton Mills in Greater Manchester*, Preston: Carnegie, 1992.

Wilmot, T., 'John Warrington Wood, Sculptor', *Magazine of Art*, 14 (1891), 136–40.

Woodhead, L., *Wigan Rugby League Football Club*, Runcorn: Archive Publications, 1989.

Woolner, A., *Thomas Woolner R.A. Sculptor and Poet. His Life in Letters*, London: Chapman and Hall, 1917.

Worden, B., 'Putting the Protector on a Pedestal', *BBC History Magazine*, 3, January (2002), 40–2.

Wrigley, A., *Rakings Up. An Autobiography*, Rochdale: E. Wrigley, 1949.

Wyke, T., *A Hall for All Seasons. A History of the Free Trade Hall*, Manchester: C. Hallé Society, 1997.

Wyke, T. and Rudyard, N., *Manchester Theatres*, Manchester: Bibliography of North West England, 1994.

Wylly, Colonel H.C., *History of the Manchester Regiment*, 2 vols, London: Forster Groom, 1925.

Yarrington, A. et al., *An Edition of the Ledger of Sir Francis Chantrey, R.A., at the Royal Academy, 1809–1841*, Walpole Society, 1991–2.

Young, C., 'Reminiscences' in Manchester Buildings, *Architecture North West*, no.19 (1966).

2. Archives and Manuscript Sources

Bolton Archives and Local Studies
Bolton Art Gallery Correspondence
Bolton War Memorial Committee Minutes and Correspondence
Borough of Bolton. Proceedings of Town Council
Bradshaw, Gass and Hope, Architects Correspondence
Chadwick Statue Correspondence
Edward VII Memorial Committee Papers

Bury Archive Service
Bury Art Gallery and Library Committee Minutes
Bury Council Minutes
Bury and District Operative Cotton Spinners' Association Reports
Peel Memorial Committee Book

Chetham's Library, Manchester
Chetham's Library Feoffees Minutes
Prince Consort Memorial Fund Manchester Minute Book

City of Manchester Archives and Local Studies
Prince Consort's Memorial Appeal Committee Papers

Proceedings of Manchester City Council
Police Commissioners Letter Books
Royal Manchester Institution Minutes
Daltonian Professorship and Monument Committee Minutes
Record of all the transactions referring to the erection of my late father's
 monumental statue in the Cathedral of Manchester effected at the joint
 and equal cost of my sister and myself, arranged by William Fleming
 MD, 1868
New Town Hall Committee Report and Correspondence
Town Hall Committee Letter Book and Minutes
Unveiling of John Bright Statue Papers
Unveiling of James Prescott Joule Statue Papers
John Thompson Papers
Absalom Watkin Correspondence and Papers

City of Salford Archives
City of Salford Art Galleries, Museums and Libraries Committee Minutes
 and Annual Reports
City of Salford Parks and Cemeteries Committee
City of Salford. Proceedings of the Council

Henry Moore Institute, Leeds
William Calder Marshall Household and Studio Accounts
Sir Charles Wheeler Correspondence and Photographs
Austin Wright Notebooks and Papers

Manchester Cathedral
Meetings of the Dean and Chapter Minutes

Manchester Royal Infirmary
Manchester Royal Infirmary General Board Minutes

John Rylands University Library of Manchester
Dalton Testimonial Committee, John Dalton Papers
Fielding Memorial Committee, Bolton Operative Cotton Spinners'
 Provincial Association, Manchester Reform Club Archives
John Rylands Library Letter Books
Owens College Minutes

Oldham Local Studies and Archives
Crompton Council Minutes, Parks and Cemetery Committee
Failsworth Urban District Council Minutes
Oldham Free Library and Museum Committee Minutes
Oldham Industrial Co-operative Society General Minutes
Oldham Operative Cotton Spinners' and Provincial Association Minutes
 and Reports

Oldham Parks and Cemeteries Committee
Royton Urban District Council Minutes
Shaw Free Library and Baths Committee

Rochdale Local Studies
Heywood Council General Purposes Committee
Heywood Council Park and Cemetery Committee Minutes
Milnrow War Memorial Committee Minutes
Rochdale Council General Purposes Committee
Rochdale Council Public Libraries, Art Gallery and Museum Committee
 Minutes
Rochdale Council Proceedings

Stockport Local Studies
Marple Urban District Council Minutes
Stockport War Memorial Fund Minutes

Southwark Local Studies
George Tinworth Autobiography and Correspondence

Tameside Local Studies
Dukinfield Council, Park and Recreation Grounds Committee Minutes
Stalybridge Borough Council Minutes

Trafford Local Studies
Borough of Stretford General Purposes Committee Minutes

Wigan Archives Service (Leigh)
Leigh Borough Council Minutes
Tydesley Urban District Council Minutes
Wigan Borough General Purposes Committee Minutes

3. *Newspapers and Periodicals*
Altrincham, Bowdon and Hale Guardian
Altrincham Express
Altrincham Guardian
Art Journal
Ashton and Stalybridge Reporter
Ashton Herald
Ashton Reporter
Ashton Standard
Ben Brierley's Journal
Bolton Chronicle
Bolton Evening News
Bolton Journal and Guardian
Bolton Review

Bolton Standard and Weekly Advertiser
British Architect
Builder
Building News
Bury Guardian
Bury Times
Co-operative News
Cotton Factory Times
Daily Dispatch
Daily Express
Daily Mirror
Daily Telegraph
East Lancashire Review
Eccles and Patricroft Journal
Farnworth and Worsley Journal
Farnworth Weekly Journal
Gorton and Openshaw Reporter
Guardian
Heywood Advertiser
Hyde Reporter
Illustrated London News
Lancashire Evening Post and Chronicle
Lancashire Post and Chronicle
Lancashire Review
Leigh Chronicle
Manchester City News
Manchester Courier
Manchester Evening Chronicle
Manchester Examiner
Manchester Faces and Places
Manchester Guardian
Manchester Mercury
Manchester Metro News
Manchester Weekly Times
Middleton Albion

Middleton Guardian
North Cheshire Herald
Oldham Chronicle
Oldham Evening Chronicle
Oldham Express
Oldham Standard
Radcliffe Times
Rochdale Express
Rochdale Observer
Rochdale Times
Royal Institute of British Architects' Journal
Saddleworth and Mossley Reporter
Sale Pioneer
Sale and Altrincham Guardian
Sale and Altrincham Messenger
Sale and Stretford Guardian
Salford Chronicle
Salford Quaylink
Salford Weekly News
Southport Visiter
Sphinx
Stalybridge Reporter
Stockport Advertiser
Stockport County Express
Stockport Echo
Stockport Express
Stretford Borough News
Swinton and Pendlebury Journal
Tameside Advertiser
Tameside Reporter
The Times
Wheeler's Manchester Chronicle
Wigan Examiner
Wigan Observer
Wythenshawe Reporter

Index